THE OXFORD
COMPANION TO
GARDENS

SIR GEOFFREY JELLICOE, CBE, architect and landscape architect, is author of many books including the classic *Italian Gardens of the Renaissance* (1925, with J. C. Shepherd) and *Studies in Landscape Design* (3 vols., 1959, 1966, 1970). His recent work includes the redesign of the gardens at Sutton Place, near Guildford, in collaboration with the late Susan Jellicoe.

DR SUSAN JELLICOE, designer and plantswoman, was author of *The Landscape of Man* (1975, with Geoffrey Jellicoe) and *Town Gardens to Live In* (1977, with Lady Allen of Hurtwood).

DR PATRICK GOODE is Senior Lecturer in landscape history at Thames Polytechnic, Kent, and co-author of *Humphry Repton. Landscape Gardener 1752–1818* (1983).

MICHAEL LANCASTER is an architect and landscape architect and Head of Division of Landscape Architecture at Thames Polytechnic. He is author of *Britain in View: Colour and the Landscape* (1984).

THE OXFORD COMPANION TO

GARDENS

Consultant editors

SIR GEOFFREY JELLICOE
SUSAN JELLICOE

Executive editors

PATRICK GOODE
MICHAEL LANCASTER

Oxford New York

OXFORD UNIVERSITY PRESS

OXFORD
UNIVERSITY PRESS

Great Clarendon Street, Oxford OX2 6DP

Oxford University Press is a department of the University of Oxford.
It furthers the University's objective of excellence in research, scholarship,
and education by publishing worldwide in

Oxford New York

Athens Auckland Bangkok Bogotá Buenos Aires
Cape Town Chennai Dar es Salaam Delhi Florence Hong Kong Istanbul
Karachi Kolkata Kuala Lumpur Madrid Melbourne Mexico City Mumbai
Nairobi Paris São Paulo Singapore Taipei Tokyo Toronto Warsaw
with associated companies in Berlin Ibadan

Oxford is a registered trade mark of Oxford University Press
in the UK and in certain other countries

Published in the United States
by Oxford University Press Inc., New York

© Oxford University Press 1986

British Library Cataloguing in Publication Data
Data available

Library of Congress Cataloging in Publication Data
Data available

ISBN 0–19–860440–8

1 3 5 7 9 10 8 6 4 2

Printed in Italy by Giunti

PREFACE

IN their popular and universal appeal, gardens embrace both art and science to become one of the great unifying factors of today. We regard their design as one of the major contributions to the visual arts. Whereas in the past the interchange of garden knowledge and experience was limited and relatively localized, today it is world-wide. Beginning as early as the idea of Eden, gardens are older than architecture and certainly more varied. While architectural garden plans themselves can be repeated, a law of nature that decrees that no single plant is repeated also decrees that no two gardens are ever identical. Moreover, the influence of site and climate on garden design is inevitably greater than it is upon architecture.

The *Companion* is the first comprehensive reference work to deal with the art of garden design on a world-wide scale from the earliest records of civilization to the present day. The first consideration in its compilation has been the limitation of subject. With so vast a canvas it has been necessary to give some definition to the edges. Where, for example, do domestic gardens leave off and private parks begin? If private parks are included, why not public parks? Indeed, many public parks were once private gardens. The criteria that have been applied to these and other questions are set out in the Introduction that follows.

The second consideration has been to determine the scope within the general limitation. The *Companion* is primarily concerned with locating and describing gardens of all kinds. It is not a compendium on how to design, construct, and plant a garden, but it is planned to arouse interest and encourage further study in the specialized subjects. It touches upon the influences such as geography, climate, and ethnic and social factors that have conditioned gardens of all ages. It includes brief biographies of the principal designers and of those patrons, such as the Medici family, who have often determined the course of landscape history.

The third consideration has been to achieve a balanced selection, the part proportionate to the whole; no mean task when equating the gardens of the entire world, past and present. The editors have endeavoured throughout not to impose their own canons of taste, but to accept (a) the test of time in the evolution of taste as the criterion of editorial judgement and (b), with some exceptions, the facts and judgements presented by the specialist over his or her initials.

The editors are deeply grateful to the contributors. The invitation to take part assumed that, as each was a specialist in his or her subject, no original research would be necesssary. This has not always been so, and for many their contribution has been a labour of love, giving added pleasure to the reader. Several of the contributions had to be translated, tested, and sometimes adjusted before they could be accepted. From some countries there has been no response at all, despite repeated endeavours. The illustrations are necessarily limited but are intended to convey the great variety of the subject. The editors wish to acknowledge their debt to the first editor, Peter Hunt, who died soon after his appointment and whose early decisions and studies have been incorporated in the present work. The editors are grateful, too, for the help in production given by the Oxford University Press.

Finally, we, the consulting editors, wish to express our appreciation of the executive editors—Michael Lancaster and Patrick Goode; in general, the former edited the entries on the twentieth century and on the developing countries, the latter those on all other periods before that and on all other places. It is they who have had the task of organizing,

editing in detail, and carrying through this immense work to completion. We do not pretend to have reached perfection, but are consoled by the view of Dr Johnson himself that perfection in such a work is an impossibility.

GEOFFREY JELLICOE

SUSAN JELLICOE

London, 1986

INTRODUCTION

GARDEN design as an art form has been the central idea underlying the shaping of the *Companion*, determining both the subjects covered and the content of each article. Our most far-reaching decision has been the exclusion of those gardens which, although of considerable horticultural interest and possessing some excellent details, seem to us neither representative of a trend nor outstanding in their own right for the quality of their design. Thus, many gardens familiar to readers, especially in Britain and the United States, have not been included. Nor have we attempted a comprehensive coverage of botanical gardens, plant collectors, and plant illustrators. Instead, these and other related subjects are discussed in general articles which concentrate on the relationship between developments in horticulture and botany and their influence on design.

We have also consistently excluded those historic or literary associations which, however interesting in their own right, have no direct connection with design. For instance, in some recent work by garden historians there has been much emphasis on the iconographical programmes of certain gardens—a fascinating speculative exercise, but one which lies outside the scope of this book, since it often sheds little light on the gardens themselves. A similar consideration applies to individuals: many who have been involved in design, or have contributed to the subject in important ways, are or were not primarily gardens designers—Bacon, Rousseau, Pitt, Washington, and Goethe are interesting examples—and the biographical details included here are necessarily those which shed most light on the individual's role in garden design. Likewise, on the subject of patronage we have aimed to give prominence only to those individuals who one can be reasonably certain had a definite influence on design over and above financial support.

In attempting to represent the full range of styles and types of garden, we have not limited ourselves to those gardens that are open to the public (although many of them are) nor to those that are preserved in good condition. Indeed, some described here no longer exist, and all are susceptible to change.

Nor did the distinction between publicly (or corporately) and privately owned gardens and parks seem a reasonable one to make in seeking to limit our subject. Rather, our work includes both the private garden, which may be less than a hectare in size, and the large-scale public park, such as Versailles, since both are properly understood to be the subject of garden history. In determining which public parks merited an individual entry, we have attempted to identify those which have contributed substantially to the development of garden design. In addition, some others which do not have an entry of their own are examined in the context of specialized articles on, for example, roof-gardens, indoor gardens, public parks, and zoological gardens.

We have aimed as far as possible to represent the gardens of the world. This has presented the most difficult problem in selecting entries dealing with historical aspects (covering the period roughly up to 1900), as there has been relatively little research into the history of gardens outside Europe. Even for Europe itself, certain periods and places (such as 17th-century France and 18th-century England) are well documented, while others (notably Eastern Europe and, surprisingly, 19th-century England) have been comparatively neglected. For the well-researched periods we have aimed at a representative rather than a comprehensive coverage in the interests of balance and because of the limitations of space.

The assessment of 20th-century gardens has presented a number of additional difficulties, both theoretical and practical. The main theoretical problem is one of definition: in the 20th century private gardens have, with few exceptions, been limited in size, while their number has increased enormously. To them has been added a range of gardens and designed landscapes associated with recent urban and industrial developments—largely the province of a new profession, that of the landscape architect. To all these developments the terms garden design and landscape design are variously applied, according to the country, the locality, and the creator. In Britain and the United States, for example, many landscape architects prefer not to use the title 'garden designer' because it is felt to be too limiting; perhaps also they wish to avoid confusion with the large number of amateurs in that field. In some other countries in which the profession of landscape architect has only recently developed, both garden and landscape designs are often undertaken by architects, albeit rarely displaying a sensitive use of plants.

Inevitably the kind of information provided and the quality of judgement exercised by contributors has varied from country to country. For example, much of the development of garden design in the countries of South America is perceived in terms of public gardens and squares, in comparison with Denmark and West Germany, both of which have considerable and well-documented histories of private gardens up to the present day—a situation that is unusual even in Europe, since developments of the 20th century have been largely neglected by historians.

It is also true to say that much of the work of gifted designers has had little effect upon the art as a whole, garden design being one of the most conservative of the arts. This is particularly true of Britain, which has been generally unreceptive to the influence of new ideas expressed in the 'fine' arts and in other fields of design; the bulk of published material is concerned with the process of gardening rather than the art of garden design. Apart from historic gardens, in which the country is particularly rich, British gardens tend towards the expression of the plantsman's skills, working within well-defined traditional limits.

A further difficulty is that of access. Gardens of the 20th century are more private than their historical counterparts. Some of the most recent and most extravagant—for Arab princes—are shrouded in secrecy for reasons of security. Less dramatically, many owners restrict access to their gardens, and it is only when these have been illustrated that the development of the designer's work can be effectively studied. Gardens in the developing countries especially are not easily accessible, either physically or through publications. For some of these countries no information was forthcoming; for others, we have included general descriptions and reference to examples which we consider significant.

The lack of published information and analysis is particularly acute for the latter part of the 20th century; the most useful source material here is to be found in design journals, and in a few studies of the work of individual designers, such as Thomas Church and Roberto Burle Marx, although even this tends to be illustrative rather than analytical, with much of the material being produced by the designer himself. The *Companion* thus brings together for the first time in one volume information on the gardens and their designers of all periods from the earliest recorded examples to the present day.

Illustrations have also presented their own problems. The ideal would be to present plans and other drawings showing the designer's intentions, together with photographs or paintings showing the garden at a reasonable stage of maturity. But when is that stage reached? This might vary from the five years or so needed for herbaceous planting to half a century or more for forest trees to mature. Each case has been judged on its merits. Where the present-day appearance does represent the designer's intentions, photographs have

been used; where this is misleading (as more commonly occurs in the case of historic gardens), contemporary plans and views have more frequently been used as illustrations.

We would like to thank all of our contributors and particularly the following people who have acted as sole authors or sub-editors for whole countries or subject areas: John Byrom (Indian sub-continent); Ursula, Gräfin zu Dohna (most of the historic gardens of Germany); William Lake Douglas (20th-century United States); Peter Hayden (USSR); Florence Hopper (historic gardens of the Netherlands); P. Francis Hunt (plants and botany); Preben Jakobsen (20th-century Scandinavia); Maggie Keswick (China); Sandra Raphael (plant collecting, botanical illustration, botanical gardens); Richard Stiles (20th-century Germany); Kenneth Woodbridge (France); also Mavis Batey who provided much general help, especially with England. We are most grateful to Sandra Assersohn for picture research, Alice Park for her detailed attention to copy-editing, and Sandra Raphael for checking plant names. At Oxford University Press, we would like to thank Bruce Phillips, who commissioned the *Companion*, for his patience and persistence, Susan le Roux for organizing the illustrations, our editor, Pam Coote, without whose unflagging enthusiasm and tireless devotion to detail the *Companion* would never have been finished, and all their colleagues who have contributed to the work in significant ways.

<div align="right">

P. G.
M. L. L.

</div>

London, 1986.

LIST OF CONTRIBUTORS

The editors are grateful to the many contributors who have assisted with the compilation of this work. The initials at the end of each entry refer to the main contributor(s) of the article. The following list gives the contributors' initials followed by their names in alphabetical order.

M.A.	Marina Adams	R.D.	Ray Desmond
R.A.	Robert Adams	U.GFN.D.	Ursula, Gräfin zu Dohna
G.A.	Baron Gösta Adelswärd	W.L.D.	William Lake Douglas
C.A.	Caroline Ahrens	I.G.D.	Canon Ian Dunlop
J.A.	Jorge de Alarcão	X.D.	Xavier Duquenne
M.AL.	Mea Allan	R.E.D.	Ruth Duthie
J.AN.	John Anthony	G.E.	Garrett Eckbo
G.AP.	Gloria Aponte	P.E.	Paul Edwards
R.A.	R. Arioli	B.E.	Dr Brent Elliott
A.D.B.	Annette Bagot	J.EL.	Joe Elliott
J.B.	Prof. John Baines	R.M.E.	Roberto M. Elzaurdia
G.W.B.	Gordon Weetman Ballard	J.E.	Jeremy Epstein
E.B.	Mrs Elizabeth Banks	M.F.	Martha Fajardo
I.B.B.	Iris Bannochie	J.B.F.	J. B. Falade
O.B.	Dr Olga Bašeová	W.G.	William Gardener
M.L.B.	Mavis Batey	C.G.	Charlene Garry
D.A.B.	Diana Armstrong Bell	M.GI.	Michael Gibson
H.BI.	Hugh Bilborough	M.G.	Maria Golescu
H.B.	Heather Blackett	P.H.G.	Peter H. Goodchild
W.J.W.B.	Wilfrid Blunt	P.G.	Dr Patrick Goode
W.C.J.B.	Prof. W. C. J. Boer	K.M.G.	K. M. Goodway
P.B.	Patrick Bowe	D.B.G.	David Green
W.A.B.	Dr W. A. Brogden	P.GR.	Prof. Pierre Grimal
J.BRO.	John Brookes	J.DE G.	J. de Gryse
J.BR.	Jane Brown	H.GÜ.	Dr Harri Günther
M.BR.	Magne Bruun, Associate Professor	C.H.	C. Harris
J.BY.	J. Byrom	J.H.H.	Dr John H. Harvey
G.R.C.	George Carter	P.H.	Peter Hayden
C.-Z.C.	Chen Cong-Zhou	S.M.H.	Sheila Haywood
D.C.	Douglas Childs	A.H.	Arthur Hellyer
J.C.	J. Chitty	F.N.H.	F. Nigel Hepper
G.B.C.	G. B. Clarke	H.-R.H.	Dr Hans-Rudolf Heyer
G.A.C.	Geoffrey A. Collens	P.HI.	P. Higson
D.E.C.	David Coke	M.A.H.	Alison Hodges (née Milner)
P.J.C.	Pamela Coote	R.H.	Robert Holden
S.C.	Dame Sylvia Crowe	K.A.H.	Keith A. Honess
B.W.C.	Prof. Barry Cunliffe	F.H.	Dr Florence Hopper
S.M.D.	Dr Stephanie Dalley	M.H.	Michael Hough
M.J.D.	Margaretta J. Darnall	P.F.H.	P. Francis Hunt

J.D.H.	Prof. John Dixon Hunt	J.O'N.	Jean O'Neill
G.F.A.J.-S.	Gervase Jackson-Stops	H.B.O.	Prof. Hubert B. Owens
D.L.J.	David Jacques	S.P.	S. Palentrier
P.R.J.	Preben Jakobsen	A.M.P.	Alice Park
W.F.J.	Prof. Emerita W. F. Jashemski	I.L.P.	Ian Phillips
G.A.J.	Sir Geoffrey Jellicoe	J.P.	Sir John Pilcher
S.J.	Dr Susan Jellicoe	H.P.	Hugh Prince
M.K.	Maggie Keswick	S.R.	Sandra Raphael
R.G.K.	Rosa Grena Kliass	R.R.	Rodolfo Rodriguez
D.B.K.	Brian Knox	C.R.	C. Rosengren
D.A.L.	Denis Lambin	N.J.R.	Nicholas J. Rowson
M.L.L.	Michael Lancaster	C.R.	Catherine Royer
R.L.	Renate Lancaster (translator)	A.R.R.	Allan R. Ruff
S.L.	Dr Susanne Lang	H.B.R.	Prof. Brian Rycroft
K.S.L.	Kedrun Laurie	J.G.R.	Mrs Joan Rycroft
H.M.L.	Dr Helen M. Leach	J.S.	John Sales
M.L.	Maurice Lee	K.N.S.	Kay N. Sanecki
M.LE G.	Prof. Dr M. Le Glay	S.J.S.	Stephen J. Scrivens
J.L.	Prof. Jonas Lehrman	H.S.-P.	Harriett Secchi-Phillips
A.L.	Ann Leighton	S.S.	Shigemaru Shimoyama, MLACP
K.LE.	Kenneth Lemmon	D.T.S.	Prof. D. T. Sougarev
H.M.LE R.	Hazel Le Rougetel	W.T.S.	Prof. William Thomas Stearn
B.L.	Barbara Levinge	E.F.S.	Edwin F. Steffek
D.-H.L.	Li De-Hua	R.STI.	R. Stiles
R.J.L.	Dr Roger Ling	J.G.S.	Prof. J. Godfrey Stoddart
A.R.L.	Prof. A. R. Littlewood	R.S.	Roy Strong
G.L.	Georgina Livingston	D.N.S.	Miss Dorothy Stroud
K.L.	Kathleen Llanwarne (translator)	R.ST.	Rik Sturdy
D.L.	David Louwerse	M.W.R.S.	Michael Symes
X.-W.L.	Luo Xiao-Wei	T.T.R.	Tamara Talbot Rice
C.L.	Charles Lyte	H.N.T.	Howard Tanner
E.B.M.	Prof. Elisabeth Blair MacDougall	C.T.	Christopher Thacker
D.K.M.	Prof. Diane Kostial McGuire	G.S.T.	Graham Stuart Thomas
L.M.	Dr Longin Majdecki	N.T.	Neil Thomson
E.M.	E. Malins	J.M.T.	J. M. Turfa
B.MA.	Betty Massingham	T.H.D.T.	T. H. D. Turner
B.M.	Barbara Matthews	M.V.	Marta Viveros
P.M.	Paul Miles	W.L.W.	William L. Warren
N.M.	Prof. Naomi Miller	H.W.	Dr Helen Whitehouse
M.MO.	Prof. Mihály Mőcsényi	K.E.K.W.	Kim Wilkie
G.M.	Graeme Moore	P.W.	Peter Willis
S.M.	Sergio Moreira	D.W.	Denis Wood
M.M.	Monique Mosser	K.A.S.W.	Kenneth Woodbridge
E.N.	Elspeth Napier	M.T.W.	Michael Trevillian Wright
P.J.N.	Dr Patrick Nuttgens	G.-Z.W.	Wu Guang-Zu
D.K.O.	Prof. Dušan K. Ogrin	A.Z.	Prof. Anna Zádor
J.O.	John Oldham	S.Z.	Sarah Zarmati
R.O.	Ray Oldham	L.M.Z.	Prof. L. M. Zawisza

ABBREVIATIONS

ABAP	Brazilian Association of Landscape Architecture
ALI	Associate of the Landscape Institute
ASLA	American Society of Landscape Architects
CELA	Council of Educators in Landscape Architecture
CIAM	Congrès Internationaux de l'Architecture Moderne
FST	Swedish Institute of Landscape Architects
ICOMOS	International Council on Monuments and Sites
IFLA	International Federation of Landscape Architects
MLACP	Master in Landscape Architecture in City Planning
NCILA	National Conference of Instructors in Landscape Architecture
OED	*The Oxford English Dictionary*
RIBA	Royal Institute of British Architects
TTOK	Turkish Touring and Automobile Association

NOTE TO THE READER

ENTRIES are arranged in strict alphabetical order of their headword, except that names beginning with 'Mc' are placed as if they were spelt 'Mac' and 'St' as if it were spelt 'Saint'. Entries on individual gardens appear under the name of the garden (rather than the locality), ignoring the word 'Villa', 'Palazzo', or 'Château', where this is part of the name (e.g. the entry on the Palazzo Farnese appears thus: Farnese, Palazzo).

Within the text, an asterisk (*) in front of a word denotes a cross-reference and indicates the headword of the entry to which attention is being drawn. Cross-references are given only when reference will provide further information relevant to the subject under discussion; they are not given automatically merely to indicate that a separate entry can be found. Cross-references at the end of an entry or section of an entry are shown by means of small capitals, inverted where necessary to show the operative headword. The same system of cross-references has been used to draw the reader's attention to illustrations which are relevant to more than one entry. In addition, each general article on a particular country contains cross-references to all of the gardens within that country which have their own entry; so that the reader with a special interest in French gardens, for example, can easily find the French garden entries by referring to the general article on France.

Aalto, Alvar (1898–1976), Finnish architect, designer, and artist. In addition to being one of the greatest architects of the modern movement, Aalto made notable contributions to garden and landscape design. He was an intuitive designer and the private house Villa Mairea (in which his wife participated) demonstrates his ability to fuse the house and garden with nature. His stylization of contours in close proximity to the Maison Louis Carré, Bazoches, France (1956–8) and the earlier grass steps as an integral part of the design for Säynätsalo Town Hall (1950–2) bear evidence of this concept in landscape terms. The experimental house at Muuratsalo (1953) was for him both work and play; here he used a combination of sculptural walls and brick patterns which have since been a source of inspiration for many Scandinavian landscape architects. P.R.J.

Abelin, Carl Rudolf Zacharias (1864–1961), Swedish pomologist and garden architect, turned to gardening, which he studied in Denmark and during his widespread travels, after being forced to abandon humanistic studies by an eye disease. He urged reforms in horticulture and garden design and it was due to him that a higher standard was achieved in these and in a general level of gardening education in *Sweden. His gardens are characterized by formality of layout close to the buildings and sensitive landscape design in the English style elsewhere; he was an advocate of flower borders of perennials rather than of bedding plants. He laid out model gardens at Norrviken to demonstrate his ideas. Author of many popular publications advocating his theories, which were often of a controversial nature, his influence was considerable and he was still in great demand in his 80s. He also designed gardens in Germany and Norway. G.A.

See also ADELSNÄS.

Abercrombie, John (1726–1806), Scottish author and gardener, was the son of a market gardener near Edinburgh, where he served an apprenticeship to his father, before moving to London where he worked at *Kew, Leicester House, and other gardens. In the 1760s he was living in Hackney where he had a small nursery and market garden for a time, later selling seeds and plants in Tottenham Court and Newington.

He is probably better known as a best-selling writer on practical gardening. *Every Man his own Gardener*, first published in 1767 under the name of Thomas Mawe, head gardener to the Duke of Leeds, ran to many editions, the seventh (1776) and subsequent ones acknowledging the real author. The two names were linked again, with as little

justification, on the title-page of *The Universal Gardener and Botanist* in 1778. Abercrombie's other books included *The British Fruit-gardener* (1779), *The Gardeners Daily Assistant* (1786), *The Hot-house Gardener* (1789), and another best seller, *The Gardeners Pocket Journal*, first published in 1789 and, with *Every Man his own Gardener*, still being reissued over 50 years after the author's death. S.R.

Abreuvoir, a drinking place for animals. It was sometimes used as an architectural feature, as at Marly in France. K.A.S.W.

Achabal, Anantnag (Islamabad), Kashmir, lies to the south-east of Srinagar, where the Vale of Kashmir dies out against the mountains. The site is that of an ancient spring, Akshavala, which pours out with great force at the foot of the hills. The quality of the water was remarked upon in contemporary records, and no other Mogul garden retains a water feature of such power and volume. The great waterfall at the top of the garden, once lit from behind by lamps, broadens out below in a succession of pools filled with fountains. An island pavilion, reached by causeways, is set in the first pool; beyond, the water passes under the main pavilion, continues down two side *chadars* to yet another level, and thence to the river.

On either side of the garden two more canals carry a rushing flow of water cascading down tall water chutes and then running nearly level with the ground. Great plane trees surround the heart of the garden and solid stone platforms (*chabutras*) are set at intervals among them. To one side is a *hummum* or bath. The existing pavilions are of later date, set on the old Mogul bases. François *Bernier records that the garden was once full of fruit-trees: 'Apples, Pears, Prunes, Apricocks and Cherries'. The design (*c.*1620) is attributed primarily to the Empress Nūr Jahān, wife of *Jahāngīr. The garden is currently in a good state of repair and the natural abundance of the water has preserved its original character to a remarkable degree. S.M.H.

Adam, William (1698–1748), is generally known as an architect, working principally in his native Scotland, yet like Sir William Bruce of Kinross (with whom he is thought to have trained) and Alexander Edward, he also designed gardens. Plans were made by Adam of gardens and plantations at, among others, *Arniston House; Craigston Castle, Aberdeenshire (Grampian Region); Duff House, Banffshire (Grampian Region); *Hamilton Palace; *Hopetoun House; Leslie, Fife (Fife Region); Marchmont, Berwickshire (Borders Region). Although it is clear that Adam 'made out plans for grounds', he also surveyed existing work (as at Hopetoun), or was the architect for

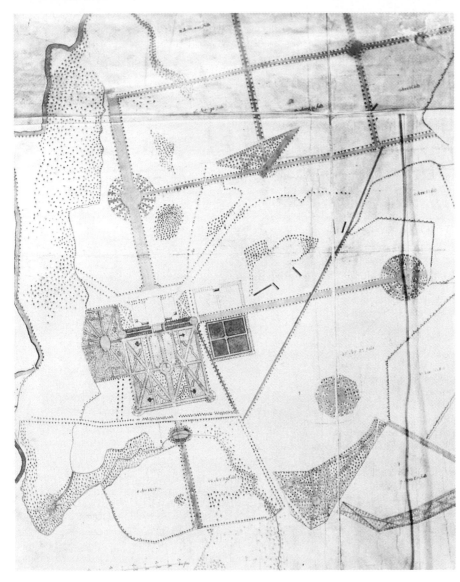

Arniston House, Midlothian,
Scotland, improvement plan
(c.1726) by William Adam

building (as at *Newliston), so we cannot always be sure in what capacity he was acting. Two of Adam's four sons were architects and designers, notably his second son, the celebrated Robert Adam. W.A.B.

Addison, Joseph (1672–1719), English poet, essayist, and statesman, discusses aspects of landscape gardening in his essays in the *Spectator* and particularly in his creation of the character of Sir Roger de Coverley. The *Spectator*, No. 37 (12 Apr. 1711), describes the perfect garden, in which Nature and Reason go hand in hand: 'Rocks shaped into grottoes covered with woodbines and jessamines . . . springs made to run among pebbles.' Works of nature were 'more delightful than artificial shows' (No. 414, June 1712). Then he mentions the freer landscaping of the Chinese, who

laugh at the plantations of Europe that are laid out by rule and line (see *Chinoiserie). In saying that the 'marks of the scissors' are 'upon every bush', Addison gave Pope fuel for his article in the *Guardian* (29 Sept. 1713). Addison describes his own garden at Bilton near Rugby (in No. 477, 6 Sept. 1712) as having flowers of 10,000 different colours, planted irregularly, though from the contemporary plan of Bilton it looks more formal than one is led to believe from this account. But there is no doubt of Addison's influence on all the followers of Pope, who preserved 'the beautiful Wildness of Nature, without affecting the nicer Elegancies of art'. E.M.

See also ENGLAND: DEVELOPMENT OF THE ENGLISH STYLE.

Adelsnäs, Östergotland, Sweden. Interesting late 18th-c. plans exist for a park in the *anglo-chinois* style; later plans and descriptions show this garden and park to the south of Linköping as having large orangeries and hot-houses, garden buildings, and many elaborate features.

In the beginning of the 20th c. most of what remained from the earlier period was replaced by a sunken garden, designed by the architect of the existing manor-house (completed 1920), a small Renaissance garden, and perennial flower borders. The main effort was expended on the park, which for a long period was under the supervision of Rudolf *Abelin. It is considered one of the finest modern examples in Sweden of the English landscape park. G.A.

Afghanistan. See MOGUL EMPIRE; BĀBUR; BAGH-I-BĀBUR SHAH; BAGH-I WAFA.

Africa

The continent of Africa is a great tilted plateau punctuated by a series of mountain ranges in the north, the south, and the east. Climatically it is tropical and subtropical, with temperate areas in the north and south, and notionally seasonal rainfall in all but the Equatorial lowlands where it is heavy and variable. The vegetation is of desert and grassland type with or without trees, with thickets and dense rain forests covering only about one-tenth of the total land area. Everywhere it is altered by man, animals, and fire, all of which hasten the degradation from humid forest to dry savannah, from broad-leaved woodland to grassland with scattered trees, and from this to desert.

Beyond the barrier of the Atlas Mountains, which support European plants such as the cork oak (*Quercus suber*) and the Atlas cedar (*Cedrus atlantica*), the exposed soils of the desert and savannah are characteristically exhausted—lacking calcium and phosphorus—and have an excess of sodium salts. The open country south of the Sahara is inhabited by herds of grazing and browsing animals, in contrast to the forest regions in which animals are relatively scarce.

The country generally is characterized by a subsistence peasant farming of nomadic herdsmen and cereal cultivators. This traditional form of shifting agriculture—formerly regarded as primitive—is now beginning to be considered an appropriate recognition of the need for tropical soils to rest and regenerate.

The importance of plants as a means of livelihood is universally recognized, and their cultivation is intimately associated with religious practices. But where goats and sheep are the commonest animals, where there is a need of wood for building and fuel, and where the rains and the crops are liable to fail, the survival of plants—let alone of gardens—is strictly limited.

Access to the continent from the outside began very early with the civilization of the Nile Valley, and it continued through the development of ports along the Mediterranean and North Atlantic coasts. But penetration of the interior of the continent had always been relatively difficult and was not much attempted by Europeans before the scramble for African colonies in the 19th c. The lack of deep gulfs and sheltered bays, the presence of sand-bars across river mouths and surf-bound beaches backed by lagoons have all inhibited access by sea. Trade with Europe, when it did begin in the 15th c., was largely in slaves who were brought to the coast by African and Arab overseers. This trade and the long-standing trade in gold, ivory, malaguetta pepper, and dyed cotton cloth provided the economic base for a number of essentially African cultures such as that centred on Zimbabwe, and the West African 'empires' of Songhai and Bornu-Kanem, and the kingdoms of Jukun, Nupe, Oyo, and Benin. M.L.L.

WEST AFRICA. West Africa is one of the most fertile parts of the continent. From an early period the larger settled communities such as the Hausa, Kanuri, Edo, Nupe, and Yoruba built palaces for their rulers. These were often laid out around courtyards, some with murals and carved verandah posts, with water catchment tanks in the centre, and some containing trees and plants. To some were attached groves of trees and even 'hunting parks'. The explorer Clapperton in 1826 described two of these. One was the royal park of the palace of the 'divine' ruler of the Yoruba city-state of Oyo (at that time covering some 840 ha.), which he described as well laid out and planted imaginatively. The other was a garden of Moorish influence attached to the palace of Shebu Omar of Kukawa, the capital of the Kanem 'empire'. This was planted with date palms, fig trees, and pomegranates. Fifty gardeners were employed in its upkeep. As the king or ruler had divine attributes which prevented him from appearing in public, such gardens were private to the royal household. They contained the graves of deceased members, and temples and groves dedicated to various deities. Such sacred groves are common in the forest regions—the tropical forest being like a garden itself, full of useful and sacred trees, all of which are individually known to the inhabitants.

European influence in West Africa dates from 1470 when the Portuguese landed in the Gold Coast (Ghana). Subsequently a number of forts and trading posts were established but the effect upon gardens did not occur until considerably later when settlements of a more domestic nature took place. The cession of Lagos in 1861 marked the beginning of a period of the development of the English garden with exotic overtones, which still continues today. The obligatory lawns are decorated with beds of portulaca, zinnias, and canna lilies, and shaded with frangipani, hibiscus, cassia, and flame of the forest, and the houses are

festooned with bougainvillaea. Such gardens are typical of the housing areas, and of many public building developments, including most of the universities. Exceptions are the University of Ibadan and the University of Ife in Nigeria. In both the landscape was given due importance and, through the retention of existing trees and the careful integration of new planting and built elements, successful attempts have been made to give a specific African expression to the buildings and their surroundings. Landscape plans have also been drawn up for the Universities of Sokoto and Benin, but little has been achieved on any significant scale. Whether the ambitious plans for the landscape design of the new capital city of Abuja will be realized remains to be seen.

The British established botanical gardens at Aburi in the Gold Coast (Ghana) in 1890, and at Lagos in 1893. These and others have been developed and are now administered by their respective governments. At Jos, on the central plateau of Nigeria, the residential hill-station was developed as a park containing a small zoo, a museum, and an open-air museum of traditional Nigerian buildings. Since independence other zoos, wildlife reserves, and national parks have been developed in these countries and in many parts of Africa. J.B.F./M.L.L.

EAST AFRICA. By contrast with that of the west, the climate of East Africa was attractive to European settlers. Although the area includes a humid coastal region and areas of semi-desert the high general elevation gives it an equable climate. The former East African colonial territories cover an area c.1,800 km. long × 1,300 km. wide, from latitude 5° north to 11° south, comprising a large-scale open landscape dominated by geological extremes: from the perennially snow-covered Mount Kenya standing on the Equator to the country of the great lakes. The vegetation is extremely varied, ranging from humid tropical coastal zones, through arid and dry grassland and bush, moist woodland, highland, moorland, forest, and alpine zones. Before the advent of Europeans the country supported a variety of African communities, both nomadic and settled, based upon livestock and cultivation.

The European settlers around the turn of the century brought more productive cropping methods, better seeds, and an appreciation of the ornamental uses of plants, which they were at first little able to indulge. Their first priority was to farm the land taken from the Africans; the garden was initially a relatively minor adjunct to the house. In the hotter areas the garden was essentially a place to look at from the verandahs of the house rather than a place to be in. It was a plot of bright-coloured flowers, mostly grown from imported British seeds, surrounded by thorn hedges for protection from animals. Later, with the growth of towns and cities, substantial resources could be devoted to the development of gardens, which are more often associated with government buildings and public spaces than with private houses.

The use of indigenous plants was originally limited to such features as hedges and shade-trees, but as interest in ecology grew there developed a growing awareness of their value in creating a positive sense of identity. This was particularly true in the towns and cities which enclose the space and carry the resources for the new landscapes—the public gardens and parks of the late 20th c. Nairobi is an outstanding example. For the 30 years following the Second World War the city parks department under the direction of Peter Greensmith succeeded in creating a landscape image which is unique in East Africa. He was able, like Roberto *Burle Marx in Brazil, to use his profound knowledge and love of plants objectively, arranging them according to form, texture, and colour to achieve particular effects in his grand design. The City Park, Jeevanjee Gardens, and the gardens adjoining the Ainsworth Bridge and the cathedral are particularly noteworthy, as also is the street planting of Nairobi. His example in the use of indigenous plants, particularly in areas of water shortage, was later to be followed in private gardens. R.A./M.L.L.

See also EGYPT; ISLAM; NORTH AFRICA; SOUTH AFRICA; SUDAN.

Agra, India. See I'TIMĀD-UD-DAULA; RAM BAGH; TAJ MAHAL.

Aiton, William (1731–93), Scottish gardener and author, found employment at the *Chelsea Physic Garden under Philip *Miller, the author of the famous *Gardeners Dictionary*. In 1759 he was engaged by Princess Augusta to tend the small botanic garden at Kew House and under George III eventually took over the management of the entire Kew estate. His *Hortus Kewensis* (1789) which lists some 5,500 plants in cultivation at Kew is a valuable reference work for the provenance and dates of introduction of plants. Much of the botanical content of the work was provided by D. C. Solander (see *Linnaeus and his students) and J. Dryander. R.D.

Aiton, William Townsend (1766–1849) was born at Kew and entered the gardens there as an assistant to his father, William *Aiton, whom he succeeded as superintendent in 1793. With the assistance of J. Dryander and R. Brown he produced an enlarged edition of his father's *Hortus Kewensis* (1810–13). He relinquished control of the botanic garden at Kew when Sir William J. Hooker became director in 1841, but remained in charge of the adjacent pleasure-grounds until his retirement in 1845. Under George IV he also had charge of other royal gardens at Kensington, Buckingham Palace, and the *Royal Pavilion, Brighton. He was one of the founder members of the (*Royal) Horticultural Society of London. R.D.

See also REGENCY GARDENING.

Aix-en-Provence, Bouches-du-Rhône, France, the ancient capital of Provence, was the favourite residence of René of Anjou (1434–80) who made a large garden there with a lodge which he used in his declining years. Neither this site nor his terraced garden on a hill at Gardanne

survive. In the 16th c. Fabri de *Peiresc collected rare plants in his Aix garden. There are country houses in the district dating from the 17th and 18th cs. whose gardens are mainly formal arrangements of terraces, steps, basins, and canals with *parterres of clipped box, Italian rather than French in style. Many are semi-derelict, but with surviving architectural features and sculpture.

Among those which are well maintained, La Gaude has an outstanding box parterre, evidently a circular labyrinth in origin, surrounded by canals. Le Pavillon de l'Enfant has an 18th-c. axial arrangement of basins, box, and lawns lined with chestnuts and limes. At Albertas there is a remarkable Italianate ensemble of terraces, canal, basins, and sculpture made in the mid-18th c. to relate to a new château which was never built. Arnajon also has a notable architectural framework of steps, a grotto, and terraces (incorporating a transverse canal), overlooking what was formerly a parterre terminating in a rectangular basin. There are other important architectural and sculptural survivals in the gardens of Bourgogne, Galice, Fonscolombe, and La Mignarde.

<div align="right">K.A.S.W.</div>

See also FRANCE: THE FRENCH RENAISSANCE GARDEN.

Akbar (1542–1605), 3rd Mogul Emperor (1556–1605), became the greatest of the Moguls, extending his empire to cover more than half of India. Renowned for his valour and statesmanship, he was also a prolific builder, a patron of literature and painting, and an active sportsman. Major works of his reign were the Fort at Agra and the city of Fatehpur Sikri. He also built the fort of Hari Parbat, at Srinagar, Kashmir, commanding the views of Lake Dal. His conquest of Kashmir in 1586 was of the greatest significance to later garden design, for it provided superb opportunities for his successors, with ample water, brilliant sunshine, and a fertile soil. He once called it his private garden. His interest in gardens included the importation of trees and flowers to Agra, and their subsequent care. He also commissioned much road building and tree planting. A vivid picture of his reign is provided by the *Akbar-nama* and the *Ain-i-Akbari*, prepared on his instructions by Abu-'l-Fazl. His policies of religious and racial tolerance, his employment of Rajput craftsmen, and his marriages to Rajput wives gave rise to new concepts in design, resulting in a fusion of Indo-Islamic art.

<div align="right">S.M.H.</div>

A l'anglaise. See JARDIN ANGLAIS.

Albertas, Aix-en-Provence, France. See AIX-EN-PROVENCE.

Alberti, Leon Battista (1404–72), a leading Italian architect and humanist scholar. His great influence on garden design, particularly important in the area around Florence, his native city, is derived chiefly from his treatise *De re aedificatoria libri X* ('Ten Books on Architecture'), completed in 1452 and printed in 1485. This work, only one of several treatises he wrote, was studied closely by patrons such as members of the *Medici and Este families. He draws heavily upon the writings of 'the ancients', such as *Pliny the younger and Vitruvius, who taught that beauty came from a harmony of all the parts. His recommendation of hillside sites on account of their exposure to sun and wind, and for views overlooking 'some City, Towns . . . an Open' Plain, and the Tops of some known Hills and Mountains (Bk. V, ch. xvii), with 'the Delights of Gardens' in the foreground, was taken up at the Villa *Medici, Fiesole, and other gardens of the Renaissance. Planting was to conform to the classical precedent, in particular the formation of *topiary using box and scented evergreen herbs—a practice followed at the Villa *Quaracchi, which Alberti may have designed. His treatise gives no clear directions for the form of the layout or for architectural elements, apart from a detailed account of the making of *grottoes, in which Alberti makes his only reference to visual experience—in all other cases, his treatise relies upon the authority of classical literary sources.

<div align="right">P.G.</div>

See also FRANCE; ITALY: RENAISSANCE; NETHERLANDS: THE DUTCH CLASSICAL GARDEN.

Albi, Tarn, France, Palais de la Berbie. See PALAIS DE LA BERBIE.

Albury Park, Surrey, England, was acquired by Thomas Howard, 2nd Earl of Arundel, in the 1630s. The environs of this favourite retreat were recorded on six prints by Wenceslaus Hollar in 1645, one of which shows vineyards and classical garden buildings on the far, or northern, bank of the nearby Tillingbourne. Further improvements from 1677 by Arundel's grandson, Henry Howard, were to the designs of John *Evelyn, whose intention it was to form a natural philosopher's garden. They included a vast upper terrace, a tunnel or 'Pausilippe' (alluding to that near Virgil's tomb on Mount Posilippo), waterworks, canals, and vineyards. The design was markedly Roman in character—especially the *nymphaeum or alcove with niches in the centre of the terrace. There were also *quincunxes on the slope between the terrace and the canal which runs parallel with the terrace. Evelyn considered purchasing it when Howard (then 6th Duke of Norfolk) died in 1684. The present extensive collection of trees was begun c. 1822, and was catalogued in 1912 and again in 1973.

<div align="right">D.I.J.</div>

Alcázar, Seville, Spain, located immediately south-east of the cathedral, was the palace of the kings of Seville for nearly seven centuries. The original 12th-c. building was destroyed, but in the 14th c. was rebuilt by Moorish architects in the Mudéjar (Spanish-Christian architecture following the Muslim) style. The Alcázar garden, with an area of 15·75 ha., is the largest surviving garden in Spain that preserves the Moorish tradition.

The palace contains several arcaded courtyards with a low pool or basin in the centre. Outside and immediately adjacent to the palace is the Garden of Maria Padilla. Gateways pierce the walls, which are topped by promenades. In the north-east corner of the garden is a rectangular pool, bordered by a long gallery.

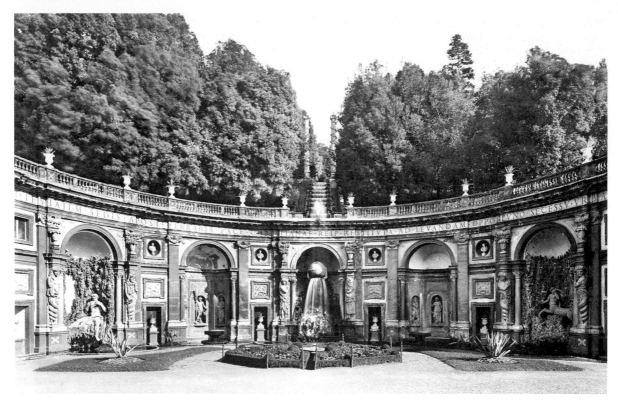

Villa Aldobrandini, Frascati, the Water Theatre

The large centre portion of the garden has eight sections divided by clipped hedges. At the far end of the garden is a pavilion built by Charles V in the 16th c., and also a second pool.

The boundary walls of the Alcázar garden are not strictly parallel, probably due to the exigencies of adjacent land ownerships, and the total design is not unified. There are three sections at different levels, despite the flat site, and many fountains of varied design, some at ground level and others on pedestals. Later additions and alterations, many influenced by the gardens of the Italian Renaissance, such as the *burladores* or joke fountains, have affected the original design, but the Moorish character is still strongly evident in the enclosing wall, geometrical layout, and raised paths, fountain basins, and glazed tiles. Low benches, recessed window seats, glittering water, paving of brick or unglazed terracotta, cypress, palm, orange and lemon trees, and many intimately scaled views add to the garden's overall attraction. J.L.

Alcázar Nuevo, Cordoba, Spain, 250 m. south-west of the cathedral, lies on the site of a palace begun for Alfonso X in the late 13th c., enlarged in 1328 for Alfonso XI, and occupied by the Inquisition from 1482 to 1821. To the south-west are gardens, some of whose details such as the low fountain basins, although of relatively recent date,

clearly continue the Moorish heritage. Until 1492 water from the Guadalquivir was supplied by a great wheel housed in an Almohade palace by the river, and fragments of this palace still remain. J.L.

Aldobrandini, Villa, Frascati, Lazio, Italy, is a classic Roman baroque garden. It is favoured by a virtually perfect site—'a uniformly inclined plane of considerable extent, sloping almost directly in the direction of Rome, with hardly an irregularity in its surface' (C. L. Franck, *The Villas of Frascati*, 1966, p. 116)—the architect Giacomo della Porta also found that his client Pope Clement VIII (Ippolito Aldobrandini) was well provided with funds. Water was plentifully available, brought by the aqueduct given to the Pope by Duke Giovan Angelo Altemps in October 1603. The work began at the end of 1598 and was finished in 1603 a year after della Porta's death by Carlo Maderno and Domenico Fontana, since the elderly Pope wished to see the family villa completed as rapidly as possible.

In front of the villa are three terraces intersected by oval ramps, setting the tall house in an imposing position overlooking the town and surrounding Campagna. But it is at the rear that the really dramatic effects are to be found. A large semicircular retaining wall, far outflanking the villa, is cut into the hillside, forming a water theatre. This consists of five niches containing statues, with water-jets rising in front

of them; in the central one Atlas carries the globe. Above the theatre the water falls down a staircase of eight steps, disappears, and then flows through the Aldobrandini emblem, the Star, to fall as a veil on to the Atlas figure. Because of the steepness of the hill, the water theatre had to be placed so close to the villa that there was no room for the flower *parterre, which therefore had to be placed to one side, with the *giardino segreto on a lower terrace. Elsewhere in the garden is a garden salon, the Stanza dei Venti, famous among 17th- and 18th-c. travellers because of its ingenious *giochi d'acqua. Evelyn writes of the latter: 'in one of these Theatres of Water, is an Atlas spouting up the streame to an incredible height, & another monster which makes a terrible roaring with an horn; but above all the representation of a storm is most naturall, with such fury of raine, wind and Thunder as one would imagine ones selfe in some extreame Tempest' (Diary, 4–5 May 1645). Originally the garden was richly adorned with statues, few of which remain, but many beautiful *fountains survive such as the two in the form of a ship (the barchette fountains) on the lowest retaining wall of the oval ramp. P.G.

See also ITALY: VILLAS OF FRASCATI.

Aleksandria, Ukraine, Soviet Union, has a landscape park laid out for Count Branitsky at the close of the 18th c. on the bank of the River Ros near the city of Belaya Tserkov. It lies on a plateau with an oak wood, which gives a singular atmosphere and scale to the park, and an immense grass slope (9 ha.) descending to the river. A great variety of trees are planted singly and in groups on the slope, among them English oak, red oak, horse-chestnut, honey locust, tulip trees, beech, walnut, birch, spruce, and pine. Wild flowers—bluebells, violets, and forget-me-nots—are an additional seasonal feature. The deep ravines which originally bordered the slope on each side were later transformed into picturesque pools embellished with rocks, boulders, and bridges. There are fine views of the pools and of the landscape beyond the river. An interesting classical garden building called Echo stands between the oak wood and the grass slope. S.P.

Alexandria, Gardens of ancient. See EGYPT, ANCIENT: GRAECO-ROMAN PERIOD.

Alfabia, Majorca, was originally the country estate of the Moorish governor; although much altered, it retains many Moorish features. It is approached obliquely from the road by an avenue of tall plane trees curving over the hillside to the great baroque façade of the gatehouse. The gates are Moorish in style with patterns of nails, as is also the coloured geometric ceiling above, probably dating from the 15th c. They lead into a courtyard with a fountain which links up with the 17th-c. house, giving spectacular views of the mountains.

The garden is entered from outside, again obliquely, beside a fountain, but it was originally approached by another avenue of plane trees further up the road. It begins with a ramped path flanked by small water channels, rising

up within an avenue of palms in terraced beds planted with shrubs. At the top is a shell fountain set in the wall of the old porter's lodge, which feeds the channels under the paving; also there is a dovecot, and a vaulted cistern. Behind the cistern is another minute courtyard with a stone table which leads into a long ramped vine-covered pergola terminating in a space with a large oval stone table overlooking the traditional eight terraces once planted with vines and fruit orchards. The lower half of this arcade is flanked by classical pedestals containing water-jets which play across the diagonal patterned paving. From the midpoint of the arcade another path leads via a ramp into a formal garden with box hedges and ornamental trees and shrubs, past a palm-fringed pool to the Italianate double curved steps adjoining the loggia of the house. From there the garden is a maze of winding paths between dense plantations of trees, bamboos, scented shrubs, succulents, and mature trees, threaded by water channels connecting pools and fountains. It provides a dramatic contrast to the remnants of Islam.
 M.L.L.

Alhambra, The, Granada, Spain. The Alhambra (Al Qal'a al-Hambra) or Red Castle was established in the mid-13th c. as a royal residence by Mohammed ben Al-Ahmar. Rising steeply from a valley of the Darro which supplies its water, the Alhambra is located on a plateau immediately to the east of the city of Granada. The century following its founding saw many additions to the complex, but as it was also a fortress, its gardens were placed within the total enclosure of 10.75 ha. After 1492 when Granada surrendered to Ferdinand and Isabella, the buildings were restored, although some were later demolished by Charles V (1516–56) who erected in their place an incongruous Italianate palace which obtrudes on the Moorish work. Yet despite repairs and some considerable alterations to the buildings and gardens, the Alhambra's presence, the proportions of its patios, and the imagination, assurance, and skill with which water was introduced, have enabled it to remain as a remarkable Moorish achievement. The total effect of the warm coloured buildings on their plateau encompassing some of the most beautiful gardens in *Islam, with rocky tree-covered slopes below and the snow-capped Sierra Nevada behind, presents a strong and justifiably famous image.

The Alhambra's main entry leads into the Mexuar or council chamber, and from there eastward into the Patio del Cuarto Dorado (Gilded Chamber) or Court of the Mosque, built for Mohammed V. It has a low-set circular fluted basin set in an octagonal overflow channel. From here, a door at the side leads into the Patio de los Arrayanes (Court of the Myrtles), also known as the Patio de la Alberca (Court of the Pool), built by Yusuf I in the mid-14th c. Measuring 37 m. × c.24 m. its well-ordered sunlit space encountered after the confined entry is unexpected. Down the centre is a long rectangular pond bordered by paths and clipped myrtle hedges of more recent date. The surface of the water is only slightly below the level of the surrounding paving and therefore clearly reflects the battlemented mass of the sunlit

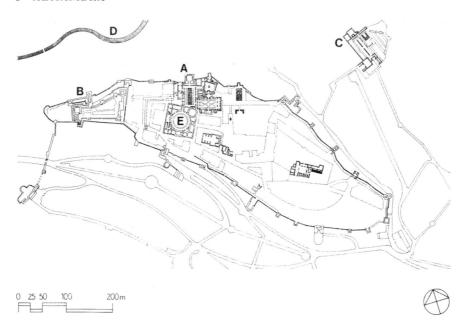

Site plan of the Alhambra, Granada, showing the Palace (A), Alcazaba (B), the nearby Generalife (C), the Valley of the Darro (D), and the Palace of Charles V (E)

Torre de Comares at the north end; below it is a graceful arcade topped with carved plaster filigree. The rear wall of this arcade is faced with coloured *azulejos*. Facing the Torre to the south is a similar arcade of six arches, while to the east and west the court is bounded by two-storey wings of the palace, unadorned except for an occasional elaborately carved stucco panel over a door or window.

The Patio de los Leones (Court of the Lions) is entered from the south-east corner of the Patio de los Arrayanes.

Begun in 1377 by Mohammed V, it measures 38·3 m. × 15·8 m. Its architecture is rich and decorated. It is surrounded by closely spaced triple arches on slender clustered alabaster columns. Behind the arcades are four rooms located on the axes of the central fountain. These rooms have gilded stalactite ceilings. In front of the east and west rooms, and within the rooms to the north and south, water bubbles from a small fountain within a circular pool set at ground level. From there, linking interior with exterior, the

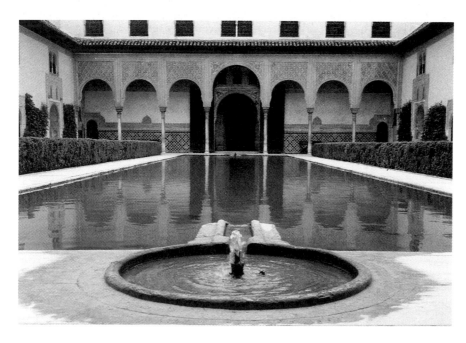

Alhambra, Granada, the Court of the Myrtles

water flows along a narrow shallow channel to a hexagonal stone base on which is a 12-sided marble fountain basin in the centre of the court. Around the edge of the basin which is 4 m. in diameter is carved an ode by Ibn Zamrak acknowledging the beauties of the Alhambra and its abundant supply of water. The basin is supported by 12 simply carved lions possibly from the 11th c. and from whose mouths a thin jet pours somewhat incongruously. There is little planting in this courtyard, but it is probable that its level was once a metre lower, so that shrubs and flowers would not obscure the architecture.

Leading from the north of the Patio de los Leones is the Patio de Daraxa, or de Lindaraja. This still retains an early Moorish flavour, and the raised fluted basin of its centrally placed fountain is Arab. It is planted with cypress and orange trees, and with box edging, but this is later in design. Nearby to the west is the small Patio de la Reja or de los Cipreses, containing a fountain and four tall cypress trees.

After a long period of neglect, the Alhambra was declared a national monument in 1870, and careful restoration dates from this time. J.L.

Ali Qapu, Isfahan, Iran, the Gate of Ali, was built by Shah Abbas I in the early 17th c. as a monumental gateway on the west side of the Maydan, in Isfahan. From there to *Chahar Bagh Avenue it led to a vast complex of royal buildings surrounded by trees, ponds, fountains, and channels of flowing water; this area is now largely built over. The six storeys of the Ali Qapu itself contain the throne room, royal apartments, and rooms for reception and entertainment, all richly decorated. There is also a large porch, with its roof supported by 18 slender wood columns. Below is a lead-lined marble basin, which once contained three fountains fed by water drawn to an upper level by oxen. On this porch the Shah entertained guests and observed the city skyline, as well as the many varied activities in the Maydan below.

The Maydan (Garden of the Plain) covers an area of 9·2 ha. and is one of the largest public squares in the world. Also laid out by Shah Abbas I, with the Royal Mosque to the south, the Masjid-i Shaykh Lutfullah on the east, the entrance to Isfahan's great bazaar to the north, as well as the Ali Qapu on the west, the Maydan links some of Safavid architecture's greatest monuments. The two-storey front-age with its unifying series of niches completely surrounds the square; although its upper level is mostly façade, the lower bays once sheltered a great variety of merchants, whose wares spilled out into the Maydan on market days. At other times in the square the Shah could observe or with his courtiers take part in horsemanship, marksmanship, and polo. Some commercial activity is still to be found along the square's periphery, and its grand scale and monumental buildings remain, but municipal planting has completely altered the original surface treatment of the square itself.
 J.L.

Allée, a general term for a walk bordered by trees or clipped hedges in a garden or park. In the French formal garden the *allées* constitute the framework and are its most important

features. They run between **palissades*, hedges, or lawns, and are proportioned to their lengths and to the features they encompass or lead to. An *allée* may be made of sand, gravel, or turf. It is not a narrow path; nor, although it may be quite wide, is it the same as an *avenue. D.A.L.

See also PATTE D'OIE; ROND-POINT.

Allée en berceau, a short fragrant walk protected from the sun by climbing plants. D.A.L.

Alloa, Clackmannanshire (Central Region), Scotland, was the early 18th-c. estate of John Erskine, 11th Earl of Mar, an amateur architect and garden designer of considerable skill. Covering some 80 ha. altogether in gardens and woodland, the grounds are shown in a plan of 1710 laid out as a very large series of vistas, each terminating on a significant prospect, such as Stirling Castle or the Palace of Elphinstone. The areas formed by the crossing of these lines of vistas were laid out as *parterres, gardens, or woodlands, but the effect must have been from the breath-taking irregularity of the whole. The grounds were maintained by the Government during Mar's exile in France from 1716 after his unsuccessful backing of the Jacobite rebellion, and this ensured the influence of their design on the early 18th c. W.A.B.

Allotments, or recreation and leisure gardens as they are more commonly becoming known, owe their origins in Great Britain to want and necessity among the labouring classes stemming from the enclosure of common land.

Enclosures began in a relatively small way during the reign of Elizabeth I, but between 1760 and 1818 a total of 3,500 Acts of Parliament resulted in over 2,000,000 ha. of land being enclosed. The rural landless poor either migrated to the burgeoning industrial towns and cities, or hired out their labour to the landowners who had benefited from the enclosures. A handful of magnates, who included the Earls of Winchelsea and Chichester, Lord C...rington, the Dukes of Ancaster and Marlborough, and Titus Salt, the builder of Saltaire (West Yorkshire), realized that too much had been taken from the peasants, and set aside parcels of their land to be used as allotments.

An Act of 1782 provided for up to 4·05 ha. of waste land to be enclosed beside poorhouses so that the inmates could grow their own vegetables. In 1819 parish wardens were given the power to rent up to 8 ha. of parish land as allotments. Twelve years later the limit was raised to 20·23 ha. The General Enclosure Act of 1845 gave the Enclosure Commissioners the authority to allocate land for allotments.

Despite these attempts to make land available for the poor, provision was painfully inadequate. In 1869 only a little over 813·5 ha. was assigned for allotments out of the 248,803·5 ha. that had been enclosed during the preceding 24 years.

In Birmingham 'Guinea Gardens', so named because that was the annual rent, were established during the second half of the 18th c., but in Southampton, for example, allotment land was not made available until 1850.

While the main purpose of allotments was to afford the working classes the chance to produce food for their families, the plot-holders also raised flowers with great skill and expertise. This was particularly true of Nottingham, where, in the 1860s, it was estimated that as many as 30,000 people gardened on 10,000 plots on Hunger Hill, and it was those gardeners who staged the first rose show in Britain at the General Cathcart Inn in 1860 on Easter Monday. They had raised their blooms in tiny greenhouses! The great gardener and rosarian, Dean S. Reynolds Hole, who visited Hunger Hills, wrote in *A Book About Roses*: 'And where will you see such Roses as are produced upon the Hunger Hills by these amateurs—such cabbage and lettuce, rhubarb and celery?'

The failure of Government to ensure that the demand for allotment land was met resulted in allotments becoming the centre of a considerable political issue, which came to a head in 1887 when an Allotments candidate beat a well-backed Conservative candidate in a by-election for the Spalding, Lincolnshire, parliamentary seat. Immediately an Allotments Bill, which had virtually been shelved, became the Allotments Act of 1887, obliging local authorities to provide land where there was a demand for allotments.

Despite enshrining allotments in law, local authorities continued to prevaricate until two years later, again in Lincolnshire, the 'Allotments Party' took control of the County Council at the local elections.

With the political battle fought and won, the allotments movement grew. Between 1873 and 1895 plots in Great Britain nearly doubled from 244,268 to 482,901.

From 1914 to 1945. At the declaration of war in 1914 there were 600,000 allotments in England and Wales, but with the special powers granted under the Defence of the Realm Act to requisition land, councils increased this to 1,500,000 by 1918, all enthusiastically cultivated by recruits to the 'Every-man-a-Gardener' campaign. At the cessation of hostilities 20,234·5 ha. of requisitioned land was restored to its owners.

During the years between the wars the fortunes of the allotment movement waxed and waned. Three new Acts were passed designed to safeguard the provision of allotments, although demand fell towards the end of the 1920s. It rose again in 1931 from the effects of the Depression.

At the outbreak of the Second World War in 1939 there were 44,516 ha. of allotments in Britain. Emergency powers increased this total to 1,400,000 allotments by the end of 1942. As part of the 'Dig for Victory' Campaign they produced an estimated 1,300,000 tons of food.

Post-war decline. With peace the movement again declined. Despite the Labour Government's 'Dig for Plenty' Campaign, the demand for plots fell. The Government-backed Allotments Advisory Committee reported in 1949 that there should be 1·6 ha. of allotment land for every thousand of the population. Had this recommendation been observed there would have been 80,938 ha. of allotments by 1960; instead there were only 30,301 ha. Forty per cent of

that land was in rural areas, which left the remainder to be shared between the 40,000,000 of the urban population.

In the 14 years between 1950 and 1964 the number of allotments had slumped from 1,100,000 to 79,013, and the lack of interest provided local planning authorities with the argument to justify buying allotment areas for development. During the late 1960s and early 1970s there was a revival of interest in allotment gardening. It was largely an urban middle-class movement and short-lived.

The state of allotment gardening has been complicated by being governed by no less than seven Acts of Parliament from 1908 to 1950, collectively known as the Allotments Acts.

Allotments for recreation. In an attempt to rationalize the situation and design a future for allotment gardening the Departmental Committee of Inquiry into Allotments was set up under the chairmanship of Professor H. Thorpe of Birmingham University. It reported in 1969 with a massive 457-page document and over 90 recommendations. The Committee visited allotments throughout the country, and 48 students wrote theses in connection with its work.

The Thorpe Report, as it came to be known, summed up the situation 16 years ago in these words: 'The allotment movement today stands at the crossroads. The poverty of its image, the anachronisms of the law under which it operates, and the lack of imagination in the administrative systems imposed upon it, have not only combined to deter many who might have swollen its ranks but also threaten to undermine the allegiance of some of its most fervent disciples. The number of allotment gardeners decrease every year, and whole sites are closed without replacement, while the proliferation of vacant plots adds continually to the general air of dereliction and serves only to increase its deterrent effect on newcomers. Thus, the movement finds itself drawn inexorably into a process of accelerating decline which, if unchecked, must eventually destroy it.

'The paradox of this situation is that, while large tracts of allotment land disappear or lie barren, while local authorities see little point in providing new sites which may subsequently prove to be either unnecessary or unsightly, there exists in our towns and cities an unknown but growing number of people who would like a small plot of land to cultivate as they choose.'

The latest available Department of the Environment figures for allotments, which are nearly 10 years old, show an overall increase in allotment land in England and Wales—20,127 ha. in 1976 compared with 19,204·5 ha. in 1975. However, in that period the statutory area of land fell from 10,684·6 ha. in 1975 to 10,439·7 ha. in 1976. While there are no up-to-date figures available, it is generally believed that the amount of land for allotments has continued to decline.

One of the Thorpe recommendations was that there should be a new Act called the Leisure Gardens Act. At the time of writing Parliament is considering, 16 years on, the Recreational Gardening Bill, which, if enacted, will shepherd all the other Acts under the portmanteau title of

the Recreational Gardening Acts 1908 to 1985. Basically it is a piece of tidying-up legislation. By putting allotments into the area of recreation the movement is growing closer to the Continental style of allotment gardening. The National Allotments Society formed in 1930, which became the National Allotment and Gardens Society in 1947, has again changed its name and is now known as the National Society of Allotment and Leisure Gardeners.

Europe. The marked difference between Continental and British allotment gardening is that on the Continent allotments were not originally seen as a charitable provision for the suffering poor, but as a genuine form of recreation.

From this approach has developed the chalet garden system under which a garden with a lawn, flowers, shrubs, fruit, and vegetables is developed around a summer-house or chalet. It is a place where the family can work and relax. The best known examples of this approach are the German *Kleingärten.*

The United States. In the United States, Community Gardening, as the allotment movement is called, is relatively new, arising as it has from the Victory Gardens of the Second World War. The emphasis is almost exclusively on vegetables, although the United States Department of the Interior will allow some flower planting of species with a proven record of augmenting control over garden pests. Because there is such a demand for community gardens regulations are strict. Providing a gardener uses his or her plot productively the tenancy can be held indefinitely, but if the garden is neglected, depending on the degree of neglect, the gardener is put on probation or expelled. There is no lack of takers for vacant plots. In 1982 there were 1,500,000 American families involved in community gardening, and a Gallup Poll conducted that year revealed that 7,000,000 more would be in the movement if the land was available.

C.L.

Alphand, Jean-Charles-Adolphe (1817–91), French engineer, landscape architect, and administrator, was invited by Haussmann to join him in 1853 and take charge of remaking the *Bois de Boulogne, which is now almost exactly as he planned it. He was advised on planting and design by *Barillet-Deschamps, with whom he established nursery gardens and greenhouses in the Bois de Boulogne with the object of studying and acclimatizing exotic plants for use in public gardens. Together they altered the Champs-Elysées, the *Parc Monceau, and the Bois de Vincennes, and made parks of *Buttes-Chaumont and Montsouris, and the gardens of Champ-de-Mars.

Although more an engineer than an artist, Alphand has left his mark on the Parisian landscape, not only in the parks but in the Boulevards Saint-Germain and Saint-Michel, the Avenue de l'Opéra, the Avenue de la République, and the Boulevard Voltaire. He transformed the 16th *arrondissement* next to the Bois de Boulogne; finished the buildings of the Hotel-Dieu, the Sorbonne, and the Palais de Justice, and designed the large suburban cemeteries. His theory of landscape design is contained in *Les Promenades de Paris* (1867–73) and in *L'Art des jardins* (1886, with Baron Alfred Auguste Ernouf).

D.A.L.

See also PARIS.

Alpine, scree, and rock-garden. These three garden types are grouped together as all are characterized by small plants that can thrive on dry rocky surfaces with relatively little water. Where bare rock outcrops naturally in a garden, both native and introduced plants can be grown; thus the

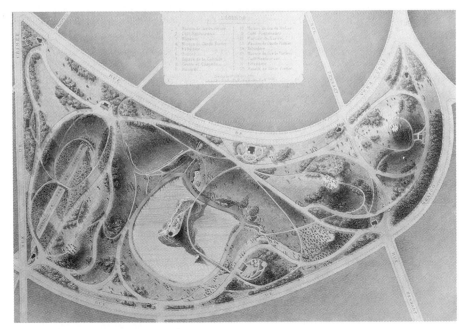

Buttes-Chaumont, Paris, plan by J.-C.-A. Alphand, from *Les Promenades de Paris* (1867–73)

first rock-gardens occurred because of geological location. Some of the earliest ornamental plants cultivated in England could be grown as rock-garden species. Native examples include the self-heal (*Prunella vulgaris*) and stonecrop (*Sedum anglicum*); introductions were the rue (*Ruta graveolens*) and the wallflower (*Cheiranthus cheiri*).

There are rock-loving species growing wild in almost every country of the world. Some are from rocky coastal areas whereas others are from the uplands. Many of them may be translocated easily from one country to another and from the uplands to lowland gardens, but many others are very intolerant of changed conditions. The mountainside plants often thrive in the wild under an unvarying annual cycle of up to six months' snow cover followed by a bright, warm, but windy season and then snow again. When transplanted to a lowland rock-garden, often with a fluctuating winter climate, the plants rarely flower and soon die. Excessive winter rain and the damage it causes can be reduced by covering the plant with a sheet of glass raised on struts but this can be unsightly and is only acceptable where the plants are being grown as rarities.

The exploration of the world's mountainous areas from the early 19th c. onwards led to the discovery of a wild flora much more colourful and much more concentrated than that of most lowland areas. Rock gardening quickly became a major branch of horticulture with plants grown either in outdoor rock-gardens or in very cool, usually unheated greenhouses called alpine houses.

Today rock and alpine growing continues to thrive, and the specialist societies, such as the Alpine Garden Society, draw large crowds of the public to their frequent flower-shows.

Unfortunately, until quite recently wild plants were collected unthinkingly from their native habitats and many of the world's most threatened plants are those from the European uplands. For example, among the 21 species protected by legislation in Britain 10 are lithophilous, including the alpine gentian (*Gentiana nivalis*), Cheddar pink (*Dianthus gratianopolitanus*), and the tufted saxifrage (*Saxifraga caespitosa*). However, most serious enthusiasts today are aware of the damage caused by their predecessors and rare species are cultivated and propagated to reduce the drain on natural populations.

In attempts to cultivate species that would not normally survive or flower freely in cultivation, a recent innovation has been the use of cooled beds in the alpine house. A glasshouse with refrigeration equipment is the horticultural status symbol of the 1980s as was the overheated steamy 'stove house' of 150 years ago.

Some upland plants do not grow well in the crevices of large rocks but are found more often in the rock debris continually flaking off by the action of the frost. This mixture of different-sized rock fragments accumulates on the sides of mountains and several species of plants thrive in this unstable 'scree'. Scree beds are now a feature of many rock-gardens and contain species from many countries.

The first rock-gardens were undoubtedly based on natural rock outcrops but since the late 17th c. rock-gardens have been created by piling up introduced rocks. In Japanese gardens stones have been used as garden features in their own right for at least the last 1,500 years but the use of groups of rocks as independent landscape features in England did not emerge until the 18th-c. *Chinoiserie period. Such early works as the rockery at *Chelsea Physic Garden (1780s) served for the display of geological rather than botanical specimens.

Reliance on eclectic materials and ostentatiously artificial construction (with shells, burrs, lava, and spars) continued well into the early 19th c. An alternative tradition, possibly descending from the late 18th-c. love of the sublime and primitivism, as shown in the mock Druid ruins at Swinton Park, Yorkshire, favoured massive blocks of stone arranged as rock faces or as free-standing piles; by the 1850s this tradition had been augmented by the use of artificial stone, as manufactured by James *Pulham, who arranged his boulders to suggest the natural stratification of sandstone outcrops.

Ferns formed much of the early planting of such rockeries: alpines were more often grown in sheltered beds or imitation moraines, until Continental influence led to their use in soil pockets on rockeries, a practice prominently demonstrated by the *Backhouse Nursery's rockery in York (1859). More ambitious attempts at geological accuracy were the imitations of mountain scenery, first evidenced at Hoole House, Cheshire, in the 1830s, where Lady Broughton's rockery was based on the mountains of Chamonix, using spar to produce an effect of ice. It was not until the 1880s that this tendency became widespread, and from then until the First World War several such landscapes were designed; for example, the Matterhorn at Friar Park, and Mount Fujiyama at Fanhams Hall, Hertfordshire. This tradition could be said to have culminated in J. J. Joass's concrete mountains, the Mappin Terraces at the London Zoo (1913). During the Edwardian period, Reginald *Farrer's writings repopularized the moraine as a growing medium for alpines, and moraines and scree beds characterized the post-war rockery until the 1930s, when H. J. Symons-Jeune once more advocated the cause of natural geological stratification.

A popular material is 'water-worn' or 'Westmorland' limestone which is actually pieces of 'limestone pavement' produced by the action of glaciers at the time of the Ice Age. It is not an ideal rock for plant growth as it is non-absorbent and can heat up excessively in the summer sunlight. At the Royal Botanic Gardens, *Kew, most of the limestone has been replaced by Horsham sandstone during the last 30 years. Nevertheless, it is still sold for rock gardening and much of the original geological exposure has been desecrated by its removal. It is now illegal to remove it and much of the area in which it occurs is now a geological nature reserve.

One of the most spectacular 'water-worn' limestone gardens is the small rock-garden at Sizergh Castle at Kendal in Cumbria. This National Trust property's rock-garden was constructed in 1926 by T. R. Hayes and Son for Lord Strickland. Of particular interest are the large

collections of specimen dwarf conifers and hardy ferns.

Another variation of the rock-garden is the wall garden, where mural- and cliff-plants can be grown. Boundary and retaining walls become the home of many plants naturally but for the last hundred years walls have often been built for the primary purpose of growing plants.

Today, as more and more gardens are created in large towns and cities and most of them are much smaller than those of the past, the demand for rock-growing, scree, and alpine species, most of which are dwarf, has grown considerably. The most notable increase has been in plants suitable for growing between paving stones. P.F.H.

See also JARDIN DES PLANTES.

Althorp, Northamptonshire, England, was purchased by the Spencer family in 1508 and remains in its hands today. A *deer-park was licensed in 1513 and a huge house built within the moat in 1573. Soon after the Restoration of Charles II in 1660, Robert Spencer, 2nd Earl of Sunderland, planted a double avenue south of the house terminating in a semicircular scoop at the forecourt gates. North of the house avenues were planted to form a vista to embrace the moat, while to the east a vast walled garden was formed. John *Evelyn remarked on Althorp in 1675: ''tis placed in a pretty open bottome, very finely watred & flanqued with stately woods & groves in a Parke with a Canale, yet the water is not running, which is a defect: . . . above all are admirable & magnificent the severall ample Gardens furnish'd with the Choicest fruite in England, & exquisitely kept: Great plenty of Oranges, and other Curiosities.'

There is a good view by *Kip of *c.*1700. Horace *Walpole noted the 'Pretty park. Avenue of old Ash & Oak from the Gate, bowering over' in 1760, and this remains in Henry *Holland's surviving plans for improvements dated 1790. However, the moat, forecourt, and eastern garden were laid down to grass. D.L.J.

Alton Towers, Staffordshire, England. The grounds were laid out mainly between 1814 and 1827 by the 15th Earl of Shrewsbury as an elysium in the Churnet valley, where, in a steeply-sloping romantic setting of *c.*200 ha., a great variety of garden buildings were erected, among them a fine domed conservatory, a three-storeyed cast-iron Gothic *prospect tower, the well-known three-storeyed cast-iron Pagoda Fountain (all by Robert Abraham), the Corkscrew Fountain, a two-tiered megalithic structure inspired by Stonehenge, and a Swiss cottage for a blind harper. 'The work of a morbid imagination joined to the command of unlimited resources', was the verdict of J. C. *Loudon (*Encyclopaedia of Gardening* (1822), pp. 327–35), whose plans had been rejected.

Now a pleasure-park, the present owners have added cable-cars, a giant swing-boat, a dinosaur park, a log run, and the Corkscrew Roller-Coaster—a descendant of the *montagnes russes* of 18th-c. Russia. P.H.

See also FOLLY; GARDENESQUE STYLE.

Amanzimnyama, Natal, South Africa, lies near the Indian Ocean amongst rolling green hills of sugar-cane and the climate is subtropical. The gardens, replanned from 1936

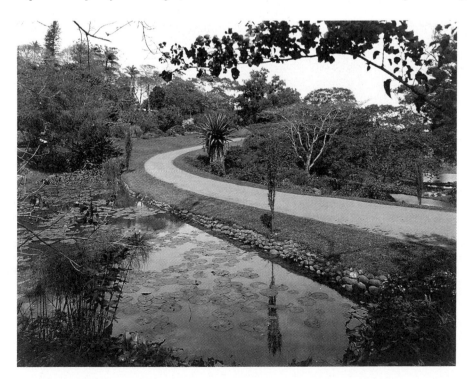

Amanzimnyama swamp garden (begun 1936), Natal, South Africa

The American garden at
Fonthill, Wiltshire, England,
photographed in 1901

with the assistance of Gwelo Goodman, are maintained at a
high standard of perfection and include many collections of
plants such as palms, bougainvillaea, ficus, brunsfelsia, and,
most recent, indigenous forest-trees. This is part of an
indigenous garden which is being designed by Patrick
Garland and created by Ian Garland, a distinguished con-
servationist with an intimate knowledge of the unique flora
of subtropical Natal.

Water has been used for both formal and informal
features. For example, near the entrance to the property is a
circular pool, featuring a statue of dolphins. In another
place, bordering formal pools with *Nymphaea* hybrids is a
graceful pergola, covered with lovely vines which include
Strongylodon macrobotrys, the jade vine. There is also a
Japanese garden and a swamp garden. A major new water
garden to the east of the buildings was recently established
with the help of Ernest Thorpe of the Durban Botanic
Garden, who also started the orchid house. Statuary has
been used extensively; there are eight major works, includ-

ing a statue of a fisherman and his family placed in the
courtyard in the centre of the office building, and a flame
fountain, placed in front of Amanzimnyama House. J.G.R.

Amber, Jaipur, India, capital of the powerful Rajput state of
Jaipur from 1037 to 1728, was the home of Jodh Bai, the
Rajput princess whose marriage to *Akbar, the 3rd Mogul
Emperor, not only helped to consolidate the *Mogul empire
but greatly extended Rajput influence, architecturally as
well as politically. Two gardens at Amber, one adjoining the
*zenana quarter in the old palace and the other a lake
garden, display complicated stone parterres with an under-
lying star pattern. The details are more Rajput than Mogul.
S.M.H.

Amboise, Indre-et-Loire, France, was the chief residence
of Charles VIII (1483–98) who, after his campaign in Italy to
establish his claim to Naples, invited Italian artists and
craftsmen to work there, including the gardener, *Pacello

da Mercogliano. The garden was made on a high terrace within the château precincts enclosed by buildings on two sides, and by a gallery with windows giving spectacular views over the Loire. *Du Cerceau's drawings, made c.60 years after Charles's death, show the garden divided into 10 square or rectangular areas. The main feature is the large wooden Renaissance-style pavilion sheltering a fountain, similar to those at *Blois and *Gaillon. K.A.S.W.

American garden, a concept dating in England from the second part of the 18th c. when hardy North American plants were comparatively easy to obtain. It was due to the London merchant, Peter *Collinson, that they became available, for in 1735 he arranged with John *Bartram of Philadelphia to collect and send to England seeds of American plants which he then distributed amongst various subscribers. Landscape architects such as 'Capability' *Brown made use of native trees, but later Humphry *Repton, the self-styled 'landscape gardener', designed American gardens 'for plants of that country' at *Ashridge, Bulstrode, and *Woburn Abbey, among other places.

The pattern for American gardens varied: sometimes American rhododendrons, magnolias, or kalmias were placed in formal beds; alternatively American trees such as tulip trees, swamp cypress, or liquidambars were planted informally within a given area and, as many North American shrubs were ericaceous, they were grown in peat or 'beds of bog earth'; all such plantings were classified as American grounds or gardens. In time new species from elsewhere were included in these gardens and eventually outnumbered the American plants until finally, after the First World War, the term died a natural death. Today it is only in a few old gardens such as Bicton, Devon, or *Fonthill Abbey that examples of American gardens still survive. J.O'N.

Ammerdown House, Somerset (Avon), England, presented Sir Edwin *Lutyens in 1901 with the aesthetic problem of creating for Lord and Lady Hilton a new garden adjoining James Wyatt's sophisticated late classical house in a park. The existing orangery, set at an angle to the garden front some way from the house, was to be incorporated. Lutyens's ingenious solution was to design a 'scissors' plan, in which the axial approaches to both house and orangery meet, crossing another path at a similar angle. The pivotal point of the plan is the Italian garden, an 'open-air room' some 25 m. in diameter, with sculptured walls of dense yew topiary enclosing a complex of box-bordered planting. From it, paths lead also to the park and to a circular rose-garden, seemingly carved from the topiary thicket which embraces further courts and a small open-air theatre. This garden provides a good example of Lutyens working unaided and at the peak of his form as a garden designer. I.L.P.

Amphitheatre. In England the word first appeared in the 14th c., but the concept of a rounded auditorium embraced in the landscape dates from antiquity. In the Italian Renaissance Raphael revived the architectural semicircular Roman auditorium as part of the landscape of the Villa *Madama. In Tuscany Buontalenti associated the Villa *Pratolino with a natural amphitheatre of hills, and inspired the most famous amphitheatre of the Italian Renaissance at the *Boboli Gardens, made from the quarry that had provided stones for the Pitti Palace; even here half a century elapsed before the present 'framework' of stone benches was added.

Evidently the term had a different meaning in late 17th-c. French garden design, for A. J. *Dezallier d'Argenville writes that 'Slopes of Grass, placed and disposed with Symmetry ... are called Amphitheatres. The Amphitheatres are adorn'd with Flowring-Shrubs, Yews, and Horn-beam Hedges Breast-high, with Vases, Cases and Flower-Pots, set upon Plinths of Stone' (*Theory and Practice* ... trans. John *James, Part 2, Ch. III). The illustration given (ibid., Fig. 4) shows shallow terraces of grass, but not cut into the shape of a classical amphitheatre.

Charles *Bridgeman seems to have been the only well-known designer who consistently aimed to create the effect of an amphitheatre by using turf—so much so that *Pope talked of his own small turf amphitheatre at Twickenham (1726) as a 'little Bridgemannick theatre'. The largest and most dramatically sited is at *Claremont (before 1725; now restored), other examples being at Cliveden (a remnant survives); Gunton Park, Norfolk; *Kensington Gardens; and Rousham. In his plan for Cliveden (c.1723) he placed a turf amphitheatre next to a sunken enclosure in the shape of a Roman circus.

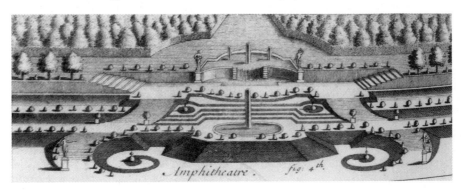

Proposed design for an amphitheatre, from John James, *Theory and Practice of Gardening*, part II, a translation of Dezallier d'Argenville's *Théorie* ... (1712)

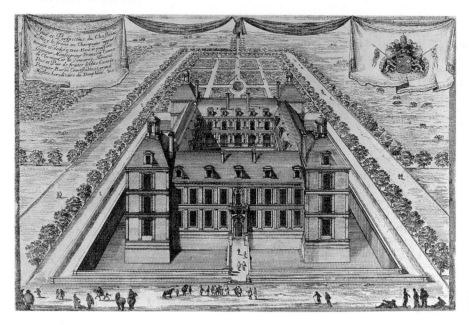

Ancy-le-Franc, Yonne, France, engraving (*c.*1650) by Israel Silvestre (Bibliothèque Nationale, Paris)

The small oval amphitheatre constructed in 1726 for the garden of the *Arcadian Academy, Rome, is a rare example of a modern stone amphitheatre in a garden. P.G./G.A.J.

See also CLEVES.

Ancy-le-Franc, Yonne, France, was begun *c.*1546 for Antoine de Clermont, brother-in-law of Diane de Poitiers, to a design by *Serlio but was completed by another architect who was probably French. *Du Cerceau's drawing shows house and grounds disposed in a regular rectangular plan. An unprecedented feature was a raised terrace making a promenade with a view of the gardens. Compared with its contemporary *Anet, Ancy is Italian in conception, and may be compared with plans of Castello and *Poggio Reale. The gardens and the park on their level site were extended by Michel de Tellier, Marquis de Louvois, in the late 17th c. and laid out with *parterres de broderie* and *bosquets* in the manner of *Le Nôtre. The Louvois family also made *c.*1740 an elegant fountain on an island in the lake. In the château there is a room with panels from the early 17th c. illustrating a variety of flowers. K.A.S.W.

Andersson, Sven Ingvar (1927–), Swedish landscape architect, was trained in Sweden and now practises in Denmark, where he is Professor of Landscape Architecture at the Royal Academy of Fine Arts. His early work in Sweden consisted mainly of private gardens, housing projects, and small parks. Notable early projects included the courtyard gardens for the Archive for Decorative Art in Lund (1961), and the Town Hall square in Höganäs, where in the water courtyard he combined fire and water by using gas and water-jets together. In his designs he endeavours to obtain the maximum from the minimum, that is, he uses the fewest possible materials with the richest variations in detail. A good example of this important component of the Danish aesthetic tradition can be seen in his design for Klarskovsgard (1966), where the building materials chosen for their calming effect are enhanced by the garden design.

Andersson has participated in many competitions and in 1972 he won the Karlsplatz competition in Vienna together with Professor Odd Brochmann. Their design has now been executed and the sculptural oval forms are a testimony to his art-based training, which is also expressed in the use of topiary in the garden of his Swedish holiday home.

P.R.J.

André, Edouard François (1840–1911), French landscape architect, was born near Bourges, the son of a horticulturalist. He started work in the nursery garden of Leroy in Angers, and in 1859 took a course at the Muséum d'Histoire Naturelle in Paris. At the age of 20 he was invited by Alphand to join the team led by Haussmann which was to transform Paris.

André extended the culture of exotic plants from the United States and the Far East with a view to growing them in *public parks. His fame spread rapidly and he designed gardens all over Europe including, in England, Sefton Park in Liverpool, with L. Hornblower (1867–72), and Woodhouse Park in Leeds. He also worked in Guernsey, Luxemburg, the Netherlands (see *Weldam), the USSR (see *Palanga), Monte Carlo, and Rome where, among other things, he redesigned the grounds of the Villa *Borghese. In 1875 he undertook a botanical study tour of South America. He had a strong interest in urban development in the United States, and prepared plans for the renovation of Montevideo in Uruguay. In 1890 he was appointed to the first chair of landscape architecture at the Ecole d'Horti-

culture de Versailles (now the Ecole Nationale Supérieure d'Horticulture).

His *L'Art des jardins: Traité générale de la composition des parcs et jardins* (1879) is a comprehensive treatise on the subject, beginning with the history of gardens and the principles of their design, followed by practical instruction in all aspects of their execution. He attempts a systematic classification of types of garden. The *ferme ornée*, he declares, is a Utopia, 'as detestable to the farmer as to the aesthete'. His book shows all aspects, good and bad, of the adaptation of English landscape gardening to public parks, a style developed by *Alphand and *Barillet-Deschamps which André codified, and which was unfortunately applied to many gardens. 'The designer of parks and gardens', says André, 'needs to blend science and art.' In his case science too often prevails. D.A.L.

See also TWICKEL.

Andromeda Gardens, Barbados, West Indies, on the north-east coast of the island, were started in 1954 as a modest garden surrounding a new house built by Harry Bayley and his family.

The main axis of the garden runs along the bed of an ancient stream, littered with giant fossil-encrusted boulders of the Pleistocene period, embedded in a deep oceanic clay. The name derives from these rocks, which also provide focal points, giving rhythm and unity to the landscape. The small stream, which is all that remains of the ancient cataracts that brought down the rocks, has been diverted and dammed to form a number of pools which give character to different parts of the garden.

Three ha. have been fully developed embracing a variety of microclimates and soil conditions. Characteristic groups

Andromeda Gardens (begun 1954), Barbados

of plants are represented including aroids, bromeliads, bougainvillaeas, bamboos, ferns, heliconias, hibiscus, orchids, palms, lilies, fruiting trees, xerophytes, and rare species collected from all over the world.

Apart from its great beauty as a tropical garden, Andromeda has become established for its significant collection of plants and for its efforts to protect species which could become extinct. I.B.B.

Androuet du Cerceau, Jacques (*c.*1515/20–*c.*1584), French architect and engraver. See DU CERCEAU, JACQUES ANDROUET.

Anet, Eure-et-Loir, France, had one of the most celebrated of French Renaissance châteaux (1546–52), designed by Philibert de *L'Orme for Diane de Poitiers, Duchesse de Valentinois. The gardens were incorporated within an architectural framework. The relief over the entrance and the fountain in the courtyard (now in the Louvre) associate Diane with the divine huntress. Two small gardens, of which only one remains, flanked the gateway to the main courtyard; in each a grove led by oval steps to a terrace closed at the far end by a chimneyed building in the form of a sarcophagus: a memorial, as it were, to Diane's late husband.

The main garden, as seen from a terrace built over a cryptoporticus at garden level, was designed as the climax to an axial approach. The compartments immediately below were laid out with heraldic designs representing Diane de Poitier's ancestry and royal connections; they were replaced after 1582 by the first *parterre de broderie*, designed by Etienne du Pérac and built by Claude *Mollet, gardener to Diane's grandson, the Duc d'Aumale. The garden was enclosed on the remaining three sides by stone galleries, with pavilions in the north-east and north-west corners; between them a room for bathing and entertainment opened into a crescent-shaped basin formed from the castle moats.

Between 1681 and 1688 Louis-Joseph de Vendôme employed André *Le Nôtre to redesign the grounds on a scale which dwarfed the Renaissance scheme. L'Orme's galleries were swept away, and Diane's garden was engulfed in a huge *parterre five times the size. On the west the waters of the Eure were collected in a canal which was balanced on the east by a tree-lined lawn (the Friche). Another garden (the Boulingrin) masked the stables from the house.

Elaboration of this framework was continued, especially between 1732 and 1753, by the Duchesse de Maine. Among those who worked at Anet in the 18th c. were the Sieur de Saussay who published *Traité des jardins* (1722) and Nicholas Michot who gained a reputation as a garden designer. The Duc de Penthièvre, a grandson of Louis XIV, lived there unmolested during the Revolution, but on his death in 1793 the estate was sold. Much of the château was destroyed between 1804 and 1811; restoration of the remaining parts was begun by Adolphe de Riquet, Comte de Caraman, in 1840. The grounds were transformed into a

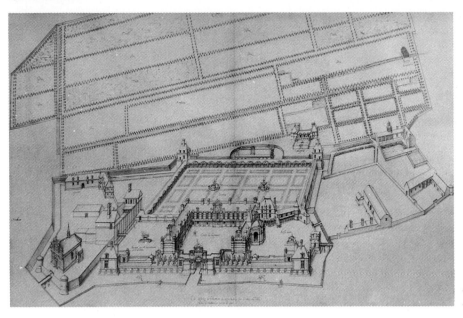

Anet, Eure et Loir, France, drawing (c.1576) by Jacques Androuet du Cerceau

park *à l'anglaise*, the canals assuming the appearance of a river. The Friche became a public open space. K.A.S.W.

Angers, Maine-et-Loire, France, is the centre of an important horticultural and wine-growing area. René, the last independent Duke of Anjou (1434–80), made gardens, which included a menagerie, in the castle precincts. After being occupied by the army from 1817, the castle was restored to the civil authority as a historic monument in 1945. The main courtyard is laid out formally with squares of grass and arches of clipped yew; vines are cultivated on the ramparts, where there is also a small garden planted with flowers represented in the 15th-c. *mille-fleurs* tapestries. Traditional *parterre designs of cut turf and bedding plants are laid out in the moats.

At Chanzé, east of the city, a picturesque rock jutting into the River Maine, is the site of La Baumette, where René of Anjou founded a hermitage and made a favourite garden retreat. Remains of his lodge exist. Other manors where he made gardens survive at Ponts-de-Cé and Baugé.

K.A.S.W.

Anglesey Abbey, Cambridgeshire, England. From 1930 Lord Fairhaven effected a remarkable transformation (to his own design) of a flat, 40-ha. virgin site. The most striking feature of his layout is the Great Avenue (planted in 1937 to commemorate the coronation of King George VI) originally consisting of a central avenue 17 m. wide, lined with alternating plane trees and chestnuts, and flanked on each side by two narrower avenues 7 m. wide. A continuation of this avenue was planted in 1939. A cross avenue terminates in a triple ring of birches to the south, poplars to the north.

Another coronation (that of Queen Elizabeth II in 1953) inspired the creation of the Temple Lawn, an irregular contrast to the geometric grid of the earlier layout. Terminating the secondary cross axis of the Coronation Avenue is an arrangement of 10 Corinthian columns in a circle, surrounded by a yew hedge, with the entrance marked by two life-sized lions cast in lead by van Nost the elder.

The avenues and the Temple Lawn are not orientated on the house, which is surrounded by a series of smaller gardens—the Monks' Garden, the Dahlia Garden (a long, curving, beech-bordered grass corridor), and the Herbaceous Gardens. To the east are the Warriors' Walk and the Emperors' Walk, both graced with fine lead or marble statuary.

Anglesey Abbey was acquired by the National Trust in 1966. P.G.

Anglo-Indian gardens. See INDIA: ANGLO-INDIAN GARDENS.

Anguri Bagh, Agra Fort, India, the Grape Garden, was the private garden of the Mogul royal ladies, and adjoins the Khas Mahal, or private palace, with its gold-roofed pavilions. It was probably named after the jewelled inlays of vines upon the buildings. The jeweller Tavernier, describing it in the 17th c., remarked that even the wealth of *Shāh Jahān had not been sufficient to complete the whole design. Principal features are a fine reflecting pool with scalloped edges in front of the Khas Mahal, a marble cascade, and an intricately patterned parterre below. The soil was said to have been brought originally from Kashmir, and with the water flowing, the cascade illuminated, and the parterre richly planted, it must have been a place of delight. It fell

into disrepair, and was later restored on the instructions of Lord Curzon. Today it is a courtyard rather than a garden.

S.M.H.

Anhalt-Dessau, Franz, Prince of (1740–1817), was a gifted German landowner who with the help of German craftsmen laid out his extensive estates in accordance with English ideas and impressions gained on his travels. Careful consideration was given to agriculture, forestry, and horticulture. From 1764 over a period of 50 years he and his gardeners J. G. *Schoch and J. F. *Eyserbeck created the Gartenreich (Garden Kingdom), covering c. 150 sq. km. and containing a number of parks, which was much admired by his own contemporaries.

The landscape of the Gartenreich was given a park-like character, emphasized by farm buildings in classical forms, without detriment to the economic aspects of the estate. Anhalt brought the neo-Gothic style to the Continent through his connection with Strawberry Hill in his Gotisches Haus at Wörlitz.

From 1765 he worked on the *Wörlitz Park, one of the earliest landscape gardens on the Continent, and on the *Luisium. In 1777 he built the hermitage of Sieglitzerberg (42 ha.) on the high banks of the Elbe; this had affinities with *Stourhead, with a small Schloss (1777), a Roman burial tower (1779–80), statues, vases, and gate-houses, all integrated in an 'ordered natural setting'. At *Oranienbaum he created a Chinese garden and buildings in the *Chinoiserie style. He had a decisive influence on the planning of the Georgium Park which is wrongly attributed to J. F. Eyserbeck.

H.GÜ.

An Lan Yuan, China, lies in the small town of Hai-ning, now called Yan Guan, 40 km. north-east of Hangzhou in Zhejiang province. When built by Chen Yu-jiao between 1573 and 1620, on the site of a ruined garden owned in the Southern Song dynasty by the Prince of An Hua, it covered only 2 ha., but in 1733 one of his descendants doubled its size. The garden was given the name Yu Yuan, then later Sui Chu Yuan, but was always locally known by its owner's family name.

On four of his six journeys south of Chiangjiang (formerly Yangtze River) between 1751 and 1784, the Emperor Qian Long made this garden his temporary palace, and in 1762 gave it its name An Lan which, since the sea is quite near, literally means Calming the Waves. In his Preface to a *Book of Poems*, the owner of the garden describes it modestly as 'quiet and tastefully laid out, simple and unsophisticated . . . (with) only some water surfaces, bamboos and rocks'. During the two decades of intermittent imperial visits, however, it became increasingly elaborate, was enlarged to c.6 ha. and acquired at least 30 new groups of buildings— among them 12 *lou, unique in Chinese garden planning. Though the garden thus lost its Ming simplicity, literary men of the time—and the Emperor himself—still praised in poetry its naturalness and the delicious fragrance of its plum trees. And in 1764 the Emperor commissioned a replica of An Lan Yuan bearing the same name, in the *Yuan Ming

Yuan near Beijing. Today nothing remains of either except a few scattered rocks and mounds.

C.-Z.C./M.K.

Anne's Grove, Co. Cork, Ireland, lies on the Awbeg River near the village of Castletownroche. The 18th-c. walled *demesne is entered through a castellated gateway designed by the Pre-Raphaelite architect, Benjamin Woodward. Its walled kitchen garden was decorated in the 19th c. with a raised mount on which is perched a thatched summer-house in decorative twigwork. About 1920 Richard Grove Annesley began a woodland garden on a plateau overlooking the valley. It is in the so-called 'wild' style initiated by William *Robinson and uses plant species collected by Kingdon-Ward and George Forrest in the Himalayas. Later a wild water-garden was developed along the river, creating scenes reminiscent of Claude Monet's garden at *Giverny. The walled garden has been developed as an ornamental garden of compartments divided respectively by a herbaceous walk and an Irish yew walk.

P.B.

Ansouis, Vaucluse, France, has a 12th-c. hilltop château, modified in the early 17th c., with hanging gardens planted with box, and a long basin with a *buffet d'eau at the foot of the hill.

K.A.S.W.

Anuradhapura Gardens, Sri Lanka. Although probably first settled in the 5th c. BC the major development of Anuradhapura dates from the planned growth of the city under King Pandukabhaya (308–275 BC) when the city reached a size of some 4,000 ha. He laid out flower gardens along the Kadamba (Malwatte Oya) River, built massive city walls with great gates facing the cardinal points, and created a large garden, the Mahamegha, planted with fruit-trees and flowering shrubs. In the Mahamegha was planted the sacred Bo-Tree (Tree of Wisdom) which survives today 2,300 years later, a subject of great veneration. The tree was planted as a sapling from the *Ficus religiosa* beneath which the Gautama Buddha himself attained enlightenment. Today the tree is supported by iron crutches surrounded by a special platform, a Bodhighara. Its leaves are said to provide the shape from which Sri Lanka's dagobas are designed. Saplings have been planted outside other temples throughout the island and as far away as Burma. The original gardens were under the care of monks of the Great Monastery, but the tree has been under the hereditary custodianship of just one family throughout its life.

Royal pleasure-gardens covering 16 ha. still exist by the Tisa Wewa tank. Through their length are scattered great boulders many of which were capped with summer-houses. Rock pools with fine reliefs of elephants lead to the 3rd-c. rock temple of Isurumuniva. Two perfect monks' bathing-ponds (Kuttam Pokuna) dating from the 3rd c. can be seen to the north, water entering the pools through beautifully carved gargoyles.

N.T.

Approach, a term used by Humphry *Repton to denote what would today usually be called the 'drive' (by which

Repton meant a circuit *within* the park) leading from the entrance to the park to the courtyard in front of the house.

P.G.

Aqueducts were first built in ancient Rome to supply water to the city. The only source which was never wholly cut off in the medieval period was the Acqua Vergine (built by Agrippa *c.* 15–19 BC), which runs under the Villa *Giulia. In 1583 Pope Gregory XIII (1572–85) began the restoration of the aqueduct of Alexander Severus, which may have inspired the making of the ruinously expensive aqueduct for the Villa *Aldobrandini. On a much smaller scale, two aqueducts were constructed for the Villa d'Este (by 1565), the larger of which is 130 m. long and supplied water at the rate of 1,200 litres per second. However the most grandiose aqueduct of all was the one which brought water 40 km. to feed the cascade of the *La Reggia at Caserta. It was so expensive that the original plans for the garden had to be abandoned.

The problem of providing enough water at pressure for fountain displays was never really solved in the gardens of 17th-c. France. The Arcueil aqueduct was designed in 1612 to bring water for the *Luxembourg. The scheme to bring the waters of the Eure to the gardens of *Versailles was not completed, but ruins of the aqueduct may be seen near *Maintenon. In the south of France the aqueduct bringing water 7 km. to *Castries may still be seen, as well as that which ends in the Peyrou at *Montpellier. A miniature aqueduct in the gardens of La Mogère near Montpellier supplies the *buffet d'eau.

P.G./K.A.S.W.

See ISLAM, GARDENS OF; MEXICO.

Arabic gardens. See ISLAM, GARDENS OF.

Aranjuez, Madrid, Spain, was the most famous of Philip II's gardens. A palace had existed on the site since 1387, and some sort of garden was probably laid out during the reign of Charles V (1516–56). Philip II (1556–98) converted the shooting-box into a permanent summer residence, and altered the gardens around it. Following Arab practice, his first concern was to build a reservoir in the lake of Ontigola. The gardens were then (*c.* 1562) laid out, according to royal instructions, in squares and rectangles. The king had had a Flemish upbringing, and always employed Dutch or Flemish gardeners, preferring the Dutch style of small compartments with clipped hedges. The only Italian features are the statues of mythological heroes. Throughout there were two types of fountains: some, low, in the middle of squares; others, tall, with basins mounted one above the other. Today there is no trace of this original layout, and it is not possible to say whether the existing fountains are original.

It was not until the early 1580s that the king thought of joining the Tagus Island (separated from the palace by the river of that name) and the Ria Canal on to the main layout. It is now called the Jardin de la Isla. The character of the original layout is not clear, and the major transformation did not occur until considerably later. By 1661 Cosimo Lotti (see *Buen Retiro) had created the Hercules Fountain,

which rises in the centre of a large *bassin*, crossed by two bridges—clearly a reminiscence of the Isolotto in the *Boboli Gardens, Florence, where Lotti and his two fellow gardeners had previously worked. In 1660 the gardens were redesigned by Sebastian Herrera Barnuevo for Philip IV—a rather austere design of narrow paths and a single axis along which there is the Avenue of the Fountains. All 17th-c. travellers agreed that the fountains were the most attractive feature of the gardens—the abundance of water even made possible *giochi d'acqua*; for example, unwary pedestrians walking along the path called Los Burladores (the Jokers) would soon find themselves soaked.

The Bourbon King Philip V (1700–46) carried out a further transformation of the gardens, using some elements of the French style. A new parterre, with a *ha-ha in front of it, was laid out; long avenues of lime trees, used for the first time in Spain, were planted; hedges of hornbeam were formed, another innovation; and the walks were covered with an arch of *treillage*. The gardens were tended by successive members of the Boutelou family, French in origin, who from the 1740s cultivated exotic plants, building a conservatory for this purpose in 1747. During this period, strong walls were built to protect the Jardin de la Isla against the rising of the river.

P.G.

Arboretum, a living collection of trees grown to illustrate the diversity of species and forms. One of the first to be developed was Henry *Compton's at the Bishop of London's palace at Fulham, from *c.* 1675. He grew many trees for interest and amenity, particularly those from North America which thereafter became fashionable in continental European estates. During the 18th c. arboreta and *pineta were established by landowners on their country estates. In lands where trees were still abundant, such as North America, the concept of the arboretum developed only during the 19th c.

Although established primarily as living catalogues for scientific study and tree selection with related specimens grown together, arboreta are usually designed to provide aesthetic enjoyment also. While many have been planted within *botanic gardens, *public parks (e.g. *Derby Arboretum—see J. C. *Loudon), and private estates and gardens, several of the major ones occur in large forests and national parks, particularly in Europe and North America. They often include trial plantings of newly introduced trees that may prove successful for commercial timber and other crop production; for example, in England at the National Pinetum at Bedgebury (Kent) the state Forestry Commission has over 120 forest plots of potentially useful species. Specimens are carefully monitored for their suitability to the climate, soil, and cultural operations of the area, the effects of endemic pests and diseases are recorded, and control techniques are tested.

The first arboreta were probably the sacred groves of trees planted by many peoples in the early days of the older civilizations such as those of China, Japan, the Mediterranean countries, and South America. In the Middle Ages throughout Europe trees were planted to produce timber

and fruit, for medicinal and ornamental purposes, and as shelter for game and other animals, but little evidence exists of collections grown primarily to show the range available.

Botanic gardens and private parks from the 16th c. onwards included many collections of trees but it was not until the late 18th c., when overseas exploration and exploitation resulted in so many more species becoming available, that arboreta became widespread elements of landscape design. The discovery of so many apparently suitable trees in North America and the temperate regions of Asia by the botanical collectors such as *Douglas, *Hooker, Kerr, and the French missionaries changed the cultivated landscape of Europe. Arboreta were established in this period in the main colonizing countries such as Britain, France, Germany, and Portugal.

The major ones in Britain were at Westonbirt near Gloucester (1829), Derby Arboretum, Bolderwood (1861) and Rhinefield Terrace (1859) in the New Forest, and Scone Palace (1852) near Perth in Scotland. However, there are probably just as many arboreta of much more recent origin than those that date from the 19th c. The National Pinetum at Bedgebury was established in 1924 under the joint auspices of the Royal Botanic Gardens, Kew, and the newly founded Forestry Commission. The national tree collection at Kew was suffering from increasing atmospheric pollution and Kew itself was threatened by urban expansion and therefore a move to a more hospitable area became necessary.

Changing national forestry policies and the social upheavals of the Second World War gave greater emphasis to woodlands as facilities for recreation and general amenity; Speech House Arboretum was established in the Forest of Dean (England–Wales border) and similar collections were planted in the newly established Forest Parks in Scotland and Wales. In Ireland the John F. Kennedy Memorial Arboretum in Co. Wexford is a very recent venture with plantings on a vast scale.

Internationally famous tree collections in the United States include the *Arnold Arboretum (Massachusetts), *Longwood Gardens (Pennsylvania), and the Fairchild Tropical Gardens at Coconut Grove (Florida).

Today most countries in temperate and tropical regions are continuing to develop their forestry industries for timber and tourism and as a result arboreta are still being planned and planted. No international comprehensive listings of arboreta have been published but national botanic gardens and forestry departments can usually provide information.

P.F.H.

Arcade, a tall hedgerow (usually of hornbeam) clipped into the form of a row of arches supported on smooth treetrunks resembling columns; a feature in the gardens of *Marly.

D.A.L.

Arcadian Academy Gardens (Il Paradiso or Bosco Parrasio), Rome. Situated on the steep slopes of the Janiculum, beside the Via di S. Pancrazio, the garden was laid out in 1725 by Antonio Canevari for the Accademia dell'Arcadia,

after its members had been excluded from meeting in the Farnese gardens on the Palatine.

The Academy, founded in Rome in 1690 as an offshoot of the academy established by Queen Christina of Sweden (1632–54), was the most famous of the Italian literary societies. It aimed to re-create the primitive simplicity of Arcadia with the Pipes of Pan as its device and its members named after Arcadian shepherds. Their first meeting in the new garden took place on 9 September 1726.

The garden centres round a concave baroque stairway winding up from the small theatre fronted by an oval amphitheatre, past two terraces sparsely covered with pines and cypresses, and a modest fountain, finally arriving at the wistaria-covered *casino (also known as the Villa degli Arcadi). The rest of the garden consists of a wooded glade with fountains.

I.L.P./P.J.C.

Archer, Thomas (1668–1743), a wealthy English country squire, spent four years abroad, almost alone among contemporary British designers in studying the high baroque style of Bernini and Borromini. Before 1702 he began works at *Chatsworth for the Duke of Devonshire by constructing the Cascade House, a sculptured, grotto-like temple with 'surprise' floor-jets (*giochi d'acqua), from whose dome and fountains water streams down for 60 m. over steps toward the house—a design reflecting the Villa *Aldobrandini water-staircases near Rome. At *Wrest Park Archer built for the 1st Duke of Kent in 1711 a unique hexagonal Banqueting House, facing the mansion at the end of a long canal.

I.L.P.

See also HEYTHROP.

Arkadia, Poland, made famous by the writings of the poet Delille, was established in 1778–85 as the summer residence of the Radziwiłł family, 80 km. from Warsaw. Its founder and creator was Helena Radziwiłł (1753–1821), then the owner of *Nieborów, which is near by; it was laid out by Szymon Bogumił *Zug (1733–1807), Henryk Ittar (1773–1850), and Wojciech Jaszczołd (1763–1821).

The 15-ha. park is a good example of the romantic style of the period, and is also the best preserved of its kind in Poland. Its leading theme was the Arcadian myth which contained symbols of happiness, love, and the tragedy of death. This was stressed in the inscription on the tombstone placed on the island of poplars: Et in Arcadia ego (cf. *Ermenonville). The main focus of the layout is the large *bassin with an irregularly shaped island. The bassin is surrounded by a variety of picturesque garden structures, most of them still in existence. Nearest to the bassin is the Temple of Diana (1783) decorated with a portico of four columns on one side, and a semi-rotunda on the other. Nearby is the Przybytek Arcykapłan (Sanctuary of the High Priest, 1783) raised in the form of an artificial ruin made of stone, brick, and iron ore, and decorated with numerous Gothic and Renaissance sculptures. Murgrabia House and the Greek Arch (1785) are similar in character. Further on, attention is focused on a Gothic House (1785), with a Cave of the Sibyl made of large granite stones.

Arkadia, Poland, drawing (1953) by H. Dabrowski based on map and field sketches of 1839

The park has further attractions—the artificial ruins of an aqueduct with a cascade, an obelisk from an ancient circus, and a variety of sculptures. An amphitheatre and a circus in imitation of the antique no longer exist. The diversity of views is increased by the picturesque patterns of trees and shrubs, along with an irregular layout of walks, pond, cascade, and creek on the border of the park. Since 1945 it has been open to the public. L.M./P.G.

Arkhangelskoye, Soviet Union, *c.*20 km. north of Moscow, was the home of the Golitsyns in the 18th c. and of the Yusupovs from 1810 until 1917. The late 18th-c. classical house by the Chevalier de Huerne was built at the top of a slope running down to the River Moskba, with exceptional views of picturesque meadows and woodland beyond. The two garden terraces by Trombaro are copiously ornamented with statues and vases, while the stone stairways lead down to a vast *tapis vert* (240 m. × 70 m.), a formal representation of the Russian meadow, flanked by avenues of limes and extending to the river. A 'natural' landscaped setting might have been expected at this period rather than what seems to be the retention of the lines of an earlier formal scheme.

Among the architectural features in the park are an attractive small tea-house, a monument to Pushkin (a visitor here in 1828 and 1830), and a colonnaded mausoleum (1916) built in vain for Prince Yusupov. P.H.

Arnajon, Aix-en-Provence, France. See AIX-EN-PROVENCE.

Arniston House, Midlothian (Lothian Region), Scotland,

was designed *c.* 1726 by William *Adam and his plan gives us some idea of his contribution to garden design. The estate is typical of its period—a series of rectangular parks outlined by avenues, and relieved by a few slant lines and wooded streams. The garden occupies one of these large rectangles and is formed by a raised terrace walk with bastions at the corners: the house, also by Adam, lies on the axial line of the garden at the north end, and from it a *parterre reaches to the centre of the platform where it terminates in a circular basin and *jet d'eau*. The rest of the garden is wooded and there are subsidiary walks, some of them serpentine, leading through the densely planted quarters. On the axial line to the south and outside the garden is a cascade and basin set in a relatively informal park: the woodlands to the west of the gardens are similarly natural, occupying the steep slope down to a burn. W.A.B.

Arnold Arboretum, Massachusetts, United States. In origin pleasantly rolling farmland, the 160-ha. site of the Arnold Arboretum was left by Benjamin Bussey to Harvard College in 1842 for use as a school of agriculture and horticulture. Asa Gray, the eminent botanist and instructor at Harvard, was able to promote the transformation of this farmland into an arboretum in 1872 with a bequest from Hames Arnold of New Bedford, to be 'applied for the promotion of Agricultural or Horticultural Improvements'.

Charles Sprague Sargent (the author of *Manual of the Trees of America*) was appointed professor and curator and had the vision to persuade Frederick Law *Olmsted to help lay out the grounds and to include the arboretum in his plan of linking municipal parks into an 'emerald necklace' around the city of Boston, thereby making the city responsible for some maintenance services. The Arnold bequest enabled the trustees to afford a professor and to collect, grow, and display 'as far as practicable all the trees, shrubs and herbaceous plants, either indigenous or exotic, which can be raised in the open air at the said West Roxbury'. This broad intent has attracted such eminent plantsmen as Ernest Henry *Wilson and the present administrator, Peter Ashton. A.L.

Artificial hill. Man's endeavour to make his mark on a hostile earth by creating artificial hills or mounds that might last till eternity has found expression through broadly three different kinds of structure: the tumulus, the view-point towards earth or heaven, and the 'biological'.

The first appeared in many parts of the inhabited world long before recorded history, and were the earliest signs of man's intention to establish his identity on earth and express his search for immortality. Prehistoric mounds are found in especial abundance in Europe. In India the Great Stupa at Sanchi (2nd c. BC) probably represents the climax of the conception of a man-made holy mountain. In Egypt the pyramids are the abstract idea of the tumulus translated into architecture.

The second class of artificial hill appears dramatically in the form of the ziggurats of *Mesopotamia and Central America, the purpose of which was to bring heaven to earth

and earth to heaven. This purpose finds a distant echo in the late-medieval garden *mount, intended, however, to give a view not so much of heaven as of the countryside beyond the garden walls.

The third class, the 'biological', is by far the most important in garden and landscape design today, for its 'ethos' is as prevalent now as it was in ancient China where it evolved. The aim is to mould the land into rounded forms to which man can respond emotionally, seeing them as a reflection of his own mind. Chinese paintings depict this kind of artificial hill and provide the clue to this early association of man and his environment (see *jia shan). 'In your fancy you enter a painting' says the ancient Chinese teacher, and he goes on to say that you must contemplate the hills in such a way that there is a human relation of one to another such as that of a host to his guests, or a prince to his vassals.

The resemblance to the purpose of the English 18th-c. landscape school is clear, although the Chinese purpose is first and foremost to evoke 'feeling' while that of the English is basically intellectual. It was Edmund *Burke who first analysed the appeal to man of such an environment of soft curves as being sexual (*A Philosophical Enquiry into the Origin of our Ideas of the Sublime and the Beautiful*, 1757), and this idea lay behind the curves and undulations of the landscape created by his admirer 'Capability' *Brown. It is certain that in gardens and parks this appeal remains as virile as ever in this modern age of mechanical technology. G.A.J.

See also BEHAI PARK; BELGIUM: THE EIGHTEENTH CENTURY; MONTAGNE RUSSE.

Arts and Crafts gardening. The Arts and Crafts Movement, inspired by John Ruskin and William Morris and a reaction to Victorian mass production, called for the unity of the arts and for designer-craftsmen who understood the materials of their craft. In gardening it produced William *Robinson's aversion to *carpet bedding, the *Lutyens–*Jekyll unity of the vernacular house and its garden, and the cult of cottage gardening, old-fashioned flowers, and traditional garden craft. Craft was preferred to style and mixing styles was permissible, which led to gardens compartmented in the *Hidcote manner. The *Blomfield–Robinson controversy as to whether a garden should harmonize with the architecture of the house or stand on its own was resolved by J. D. *Sedding in *Garden Craft: Old and New* (1891) with a Queen Anne style garden that 'curtseys to the house'. Alfred Parsons, the Broadway painter, was an Arts and Crafts gardener *par excellence*. He cultivated a Cotswold garden image of tiny planted courtyards against old stone buildings, peacocks cut on yew hedges, and lilies under pleached limes, as at Court Farm, Broadway. This Arts and Crafts 'nookiness' was the perfect setting for a Kate Greenaway child, with all the old-fashioned flowers to be found in Tennyson's Maude's garden. The Arts and Crafts garden can be seen in early *Country Life* articles and at Morris-influenced Wightwick, Wolverhampton, where Parsons and *Mawson both worked, and at Webb's Standen, Sussex.
 M.L.B.

Forest cemetery (1917–40), Enskede, Stockholm, Sweden, by Gunnar Asplund and Sigurd Lewerentz

Ashridge, Hertfordshire, England, lies on a level site of 95 ha. immediately surrounding the mansion (1808–13) by James Wyatt with a garden proper of 36 ha. The design is based upon work done by Humphry *Repton for the 7th Earl of Bridgewater in 1813. Here Repton delighted in the prospect of a series of small gardens and heralded the style of the Victorians. A rosarium, 'monk's garden', *parterre de broderie*, grotto, *mount garden, and *American garden were all laid out, although somewhat differently dispersed from Repton's plan, by the Countess of Bridgewater. Today, the circular rosarium remains in the form and on the site which Repton suggested. Dramatic rhododendron planting of the 1870s and an unremarkable *arboretum are well maintained. K.N.S.

Asplund, Gunnar (1885–1940), was Sweden's leading architect during the period between the two world wars, but is known less for his buildings than for his remarkable ability to integrate them with their sites and with the design of the landscape itself. A supreme example is the Forest *Cemetery (Skogskyrko-gǒrden), Enskede, near Stockholm. This was the subject of a competition and subsequent commissions, implemented by Asplund and his partner Sigurd Lewerentz between 1917 and 1940. In it they have transformed a nondescript site of old gravel-pits and pine-woods, bounded by roads and a railway, into one of the finest landscapes of the 20th c. The grandeur of the great earth sculpture enclosing the processional way up to the cross is reminiscent of 'Capability' Brown; it balances perfectly the intimacy of the pine forests which accommodate the graves, cemetery, and crematorium buildings.

M.L.L.

Atget, Eugène (1857–1927), French photographer, was perhaps the only famous photographer who was consistently successful in making photographic compositions out of garden scenes. After a varied career he became a full-time photographer in 1897. Initially he may have used 17th-c. gardens around Paris as a practice studio but eventually he realized their artistic qualities, shabby and neglected as they were at that period. He seems to have photographed all the major parks, especially *Versailles, with the exception of *Vaux-le-Vicomte. His visions of virtually empty spaces peopled by apparently arbitrary figures greatly influenced some of the Surrealists. P.G.

Athelhampton, Dorset, England. The formal gardens to the south-east of the 15th-c. house are so convincingly 17th

Versailles, Paris, view along
the Allée Royale, photographed
in July 1901 by Eugène Atget

c. in style that it would be easy to accept them as such if the records did not show that most of them were constructed from 1891 onwards by Alfred Cart de Lafontaine, though whether he followed the original plan is not known. The division into separate enclosures around a central circle could well be an early design and the grey limestone, specially quarried from Ham Hill, is completely in character. The topiary specimens, mainly cut in yew, have grown to massive size which exaggerates their apparent age. The largest enclosure is flanked by a high terrace and two matching stone *gazebos which enable the pattern of the garden to be viewed from above and enjoyed in full. On the west side is a more recent garden laid out after 1891 by Inigo Thomas—an advocate of *Blomfield—with lawns, sweeping flower-borders, and shrubs established in semi-wild conditions and surrounded by rough cut grass. The whole provides a striking confrontation of old and new methods of garden making. A.II.

Attingham Park, Shropshire, England, remodelled in 1783 by George Steuart for Noel Hill, later 1st Lord Berwick, incorporated an earlier house, Tern Hill, where the family had been established since 1701. Some attempt to lay out the grounds had already been made in the 1770s by an obscure designer, Thomas Leggett (who may perhaps be identified with the Thomas *Leggett who is known to have worked in Ireland in the late 18th c.), when a good deal of planting was carried out. In 1797 Humphry *Repton was consulted on improvements, his proposals being set out in one of his notable Red Books, in which he advocated further planting both within the park, and by shelter-belts around it. He also advised damming the River Tern to produce a lake-like effect before it flowed under the bridge built by William Hayward in 1782, and which now became a prominent feature in the new landscape although actually beyond the estate boundary.

The property was acquired by the National Trust in 1953. D.N.S.

Attiret, Jean-Denis (1707–68), French painter, studied at Rome, became a Jesuit, and accompanied missionaries to Peking (Beijing), where he decorated their chapel, and also the palace of the Emperor who appointed him Mandarin. He was authorized to visit the gardens of the palace, and in a letter (1 Nov. 1743), he expressed admiration for 'mountains' and valleys, pavilions and grottoes, a winding piece of water with islands and rocks, arched bridges allowing the passage of boats, menageries and fish-ponds—in short, an irregular garden, 'a rustic and natural country-side', the description of which appealed to the dawning taste in France for the *jardin anglais. The letter published in Lettres édifiantes . . . Ecrites des missions étrangères de le Compagnie de Jesus (1717–76) was translated into English in 1752 by 'Sir Harry Beaumont' (Joseph Spence) under the title, A Particular Account of the Emperor of China's Gardens near Pekin.
 D.A.L.

See also JARDIN ANGLO-CHINOIS.

Audley End House, Essex, England. This great Jacobean house had already been reduced to less than half its original size by the time Sir John Griffin Griffin inherited the estate in 1760 and first commissioned Robert Adam to carry out the redecoration of the principal rooms. In 1763 'Capability'

*Brown was summoned to advise on the extension and landscape planning of its surroundings and a contract for work amounting to £660 was agreed and put into operation. Three years later a second contract was begun but there were delays in carrying it out which gave rise to complaints from Sir John, who also considered that in damming the River Cam to form a lake in front of the house a wrong turn had been made. An acrimonious correspondence ensued and by the end of 1767 Brown had terminated his supervision of the work. Much of the laying out of the grounds had, however, been completed by then and formed a splendid setting for the bridge, the Temple of Victory, and the tea-house which were already built to Robert Adam's designs. Seven years later the owner employed an obscure character, Joseph Hicks, to 'correct' what he considered a fault in the course of the water and to make minor changes, but the landscape in the main is Brown's creation. D.N.S.

Augustusburg, Brühl, North Rhine-Westphalia, German Federal Republic. The Archbishop and Elector of Cologne, Clemens August, a son of the Bavarian Elector Max Emanuel, was responsible for the building of the Schloss at Brühl, the Augustusburg, which was intended as his summer residence. The architect Johann Conrad Schlaun began work in 1725 but building took some 40 years and was only completed by the Archbishop's successor. This was mainly due to the changes made to the original plans by the architect François Cuvilliés the elder, of Munich. The Schloss consists of three wings and the garden is laid out in front of the south wing.

Work on the garden was begun in 1728 to a design by Dominique Girard who worked on the gardens at *Nymphenburg and *Schleissheim. From the Schloss one crosses a terrace to the lower-lying parterre. The middle axis stretches beyond the pond which forms the boundary of the *parterre de broderie, and extends far into the grounds. Lime trees, cut to form a pergola, enclose this beautiful parterre on each side. In the eastern part of the original rococo garden stood two delightful pavilions, the Schneckenhaus and the Indianisches Haus, both of which had to be pulled down at the end of the 18th and beginning of the 19th cs. A network of canals ran through the garden and gondolas could be sailed along certain sections. Also worthy of mention is the Falkenlust, the hunting-lodge built by François Cuvilliés in 1729 in the rococo style; it lies 2 km. from Brühl and is connected to the park by a wide avenue.

With the exception of the parterre the garden to the south was redesigned as an English landscape park in 1842 by the Prussian court gardener Peter Josef *Lenné.

Between 1933 and 1937 and again, after the Second World War, in 1947 the parterre was reconstructed in accordance with the original design.

Both the Schloss and Falkenlust were damaged during the Second World War but have been completely restored.
U.GFN.D.

Aurangzīb (1618–1707), 6th Mogul Emperor (1658–1707), deposed his father *Shāh Jahān and embarked upon a long reign of almost incessant war and religious controversy. A complete contrast to his predecessors, deeply religious and with little interest in the arts, his achievements were of buildings rather than gardens. Notable works were the Badshahi mosque at Lahore, the Moti Masjid in the *Red Fort at Delhi, and a great external gateway to the same fort. He set up his southern capital at Aurungabad, and two gardens here are linked with his name, the Mausoleum of *Rābi 'a-ud-Daurāni, and the Pan Chakki water-mill. From his reign, however, date some of the most complete accounts both of the Mogul gardens and of Kashmir, by European writers such as François *Bernier and Jean-Baptiste Tavernier.

Together with a decline in the arts, Aurangzīb's policies of repression led to tensions within his empire, which contributed to its decline under his successors and its eventual disappearance under British rule. S.M.H.

Austen, Jane (1775–1817), English novelist, was an admirer of William *Gilpin, whose picturesque ideas she quotes in *Northanger Abbey*, *Sense and Sensibility*, and *Pride and Prejudice*. Following his condemnation of improving natural scenery, she praises Mr Knightley's Donwell Abbey and Mr Darcy's Pemberley whose landscaped garden respects the Derbyshire scenery. Landscape gardening is discussed in *Mansfield Park* where Humphry *Repton is mentioned by name and his fee (of 5 guineas a day) revealed. She knew of his work from her cousin the Revd Thomas Leigh at Adlestrop and Stoneleigh Abbey. The treatment suggested by Henry Crawford for Sotherton Court is that advocated by Repton in the Stoneleigh Abbey Red Book: removal of the bowling-green walls, widening of the river, and clearing of perimeter woods to give peep-hole views back to the house. 'Your best friend . . . would be Mr Repton' is not necessarily her stamp of approval, however, since the remark was made by Maria, whose judgement on other matters was unreliable. M.L.B.

Australia

Sir Joseph *Banks is generally considered to be the founder of gardening in Australia, and his influential report on conditions there encouraged the British Government to think that it could establish (1788) an agrarian settlement at Sydney utilizing an essentially urban convict workforce.

His voyage with Cook to Australia in 1770 had provided the basis of his interest in New South Wales and he advised the first Governor, Arthur Philip, on economic plants for

the First Fleet. This carried seed obtained in England, and seeds and plants obtained at Rio de Janeiro and the Cape of Good Hope. Oaks and myrtles were the only ornamental varieties included. The plants and seed brought to the new settlement of Sydney were placed at the head of the bay to the east, now the site of *Sydney's Botanic Gardens. The success of these beds was essential for the survival of the infant colony, and their lines survive today in the beds of the Middle Garden. Due to Banks's interest, the plants of 'New Holland' became sought after in England. Plant 'cabbins' (tubs and closed casks of living plants and seeds) were shipped to Sydney by English collectors and exchanges made, thus rapidly increasing the stock held by the Sydney garden, which became a centre for acclimatization and propagation.

When Lachlan Macquarie was appointed Governor and came to Sydney with his wife Elizabeth in 1809, garden design began to change. Mrs Macquarie was active in laying out the grounds around Government House and adjacent to the 'Governor's Farm' and nursery. Under the Macquaries the land around Farm Cove and Government House was 'improved' by open lawns, winding drives, and informal plantings of trees and shrubs, creating intriguing vistas of Sydney Harbour and its islands. In 1816 Governor Macquarie inaugurated the Farm Cove area as a Botanic Garden and appointed Charles Fraser as Superintendent. By 1825 Fraser had introduced almost 3,000 new species of plants and fruit-trees into the gardens.

Sydney's first nurseryman, Thomas *Shepherd, arrived in 1826. Governor Darling granted him land on the south-western edge of the town where he established the Darling Nursery. Apparently Shepherd envisaged getting commissions to landscape large estates and he became disillusioned by his limited success. In an endeavour to educate the public he gave a series of lectures whose publication (*Lectures on Landscape in Australia*, Sydney, 1836) provided the first works on horticulture and landscape design related to Australian conditions. The lectures include descriptions of Alexander *Macleay's celebrated garden at Elizabeth Bay to the east of Sydney and of Lyndhurst at Glebe. No specific garden can be attributed to Shepherd (although he may have advised on Lyndhurst), but these descriptions were included in *Loudon's *Encyclopaedia of Gardening*, 1840 edn.

In the 1830s the ideal in both New South Wales and Tasmania was a Greek Revival house set in an Arcadian landscape of grassy meadows and clumped trees, except where wilder scenery encouraged more picturesque effects. As early as 1821, Hobart's and Sydney's estuaries suggested Scottish lochs and castellated architecture. Conifers, araucarias, and native figs provided a darkly foliaged setting.

The Victorian taste for elaboration began to manifest itself in the colonies with the garden created by Alexander Macleay's son George at *Brownlow Hill, south-west of Sydney. Its parterre, ivy-clad urns, and aviary offer direct parallels with that much publicized example of the fashionable *gardenesque taste, Mrs Lawrence's garden at Drayton Green, near London. The gold wealth of the 1850s

endorsed the gardenesque, and numerous nurseries and handbooks facilitated the creation of 'perfectly dazzling' horticultural triumphs. Massed colours and textures and *carpet bedding became paramount. The glasshouse and *conservatory became a feature of the large establishments which continued to flourish until the 1880s. *Rippon Lea at Elsternwick, Melbourne, with its giant shade-house, lake, cascade, and wide lawns, is a rare survivor from this period.

The vogue for spending summer at a mountain retreat came into fashion in the 1870s. Whole families moved, Darjeeling fashion, to the hills beyond each colonial capital, to escape the heat of the summer and to enjoy the fern gullies, tall-timbered forest, and mountain outlook. Timber cottages were erected in clearings in the forest; gradually quite elaborate houses and gardens were formed, with ponds and gazebos and exotic plantations (especially camellias, azaleas, and rhododendrons) providing a blend of local and introduced flora. *Mount Wilson in New South Wales and *Mount Macedon in Victoria are the best surviving examples. H.N.T.

See also GOVERNMENT HOUSE; MAWALLOK; QUEEN'S GARDENS; STRAWBERRY HILL FARM; WOOLMERS.

THE TWENTIETH CENTURY. Life in Australia was changing at the end of the 19th c. Due to the new trams and trains the expanding middle classes could settle in comfort close to the cities. They had time to enjoy making gardens and great debates took place in Melbourne as to whether these gardens should be formal or natural in design.

Two architects, Walter Butler and Robert Haddon, said they must be formal, while Charles Bogue Luffman, Principal of a new horticultural college at Burnley, supported the natural style. In their 1903 address to the Royal Institute of Architects, Butler argued that the architect should design the garden in the same style and materials as the house, which should be projected into the garden as a series of outdoor rooms; while Luffman favoured 'those gardens that came nearest to the finest expressions of Nature'. Both designed gardens based on their theories. Butler built Sefton near Mount Macedon, which had extensive gardens, a private golf-course, a swimming-pool, and magnificent mature trees. At Marathon overlooking Port Phillip Bay he designed a series of terraces which enjoyed superb mountain and water views framed by pergolas and hedges.

Supported by Luffman, William Guilfoyle, Director (1873–1909) of *Melbourne Botanic Gardens, advocated 'Natural' design. He sought to rationalize garden design by combining botanical interest with an overall concept of landscape planning. His predecessor, the leading botanist Dr Ferdinand von Mueller, had pursued the ideal of a teaching garden; Guilfoyle moved trees and opened up vistas, maintaining horticultural diversity within a tight visual framework. He also designed many gardens in and around Melbourne, including *Dalvui, and *Mawallok—all in the informal manner of William *Robinson. Luffman designed the gardens of Burnley Horticultural College:

creating 'enchanting shrubberies, merging into great borders . . . with half wild flowers'.

As the century progressed, many beautiful gardens were established in Victoria by talented amateurs, especially at Mount Macedon and, in the Dandenong Range outside Melbourne, Burnham Beeches by Alfred Nicholas and Pallants Hill by Mr and Mrs Tindale. In Sydney, William Hardy Wilson and Professor Leslie Wilkinson, both architects, favoured the cottage garden. Wilkinson's own garden had beds of culinary herbs and flowers bordering the paths; at *Eryldene he worked with the owner Professor Waterhouse to create outdoor rooms, including a temple, a tea-house, a pigeon loft, and a fountain. In Wilkinson's own garden, Greenway (at Vaucluse), his buildings formed courtyards among existing gum-trees (*Eucalyptus*). In a garden Michelago near Canberra he formed subtle vistas to the main garden features in courtyards amongst old trees.

Fine gardens were also built by their owners in New South Wales, including Nooroo at Mount Wilson; Everglades, also in the Blue Mountains, designed by Paul Sorenson for Henry Van de Velde; Springfield at Goulburn by Mrs Irwin Maple-Brown; and *Milton Park at Bowral.

Adelaide had an extensive Botanic Garden which was augmented by taking over 'Beechworth' in the Hills, established early in the century by Frank Snow. South Australian architect Walter Bagot developed gardens in the Renaissance style at *Forest lodge and Nurney. The Royal Tasmanian Botanical Gardens in Hobart continued to develop and expand. In both Hobart and the country areas in Tasmania many fine gardens were laid out, including Mawherra at Sandy Bay, by Mrs Reg Lewis, and Red Hill Farm, Deloraine, created by Mrs Piers Ranicar.

In tropical Queensland two fine botanical gardens were established later in the century. One, the Green Mountains Botanical Gardens in Lamington National Park, was an exciting bush garden, by conservationist Colin Harman for Peter and Vince O'Reilly, and Mount Coot-tha Botanical Gardens with its splendid views of Brisbane designed by Dennis Miller as part of Brisbane Botanical Gardens. Among the many delightful private gardens throughout Queensland is one west of the Gold Coast at Mount Tambourine where Ken and Muriel Baker have established a mountain retreat. Others are on the heights near Brisbane, including the prize-winning garden by Dennis Hill at Toowoomba.

Although some Australian plants were used in the early gardens, they were generally uncharacteristic. But gradually the Australian bush began to exert an appeal. The Royal National Park near Sydney was set aside as early as 1879, the first of many National Parks in Australia. The small park established at Perth in remote Western Australia in 1871, was later developed as a native botanical garden under the name King's Park.

Walter Burley Griffin reflected this enthusiasm for the Australian landscape when he came to Australia in 1912, winning the competition for the design of the new federal capital at Canberra. In the early 1920s he moved to Sydney and set up in private practice. With his wife Marion Mahony he developed the estate Castlecrag in natural bush on the shores of Sydney Harbour. Houses were built with minimum disturbance of the bush (no red roofs, no fences!)—each householder could feel the whole of the bush was his.

Edna *Walling, who came to Melbourne in 1916 at the age of 20, studied at Burnley College and soon became established as an outstanding garden designer. She greatly admired Gertrude *Jekyll but developed her own style. One of the many gardens she designed is Markdale, New South Wales, which has sweeping lawns and massed, informal heath plantings among fine old trees. She built a house and garden for herself in Mooroolbark near Melbourne, then gradually developed a garden estate around it called Bickleigh Vale. She became enthusiastic about native plants, propagating them and using them in her gardens. Her assistant, Ellis Stones, later became a talented designer who established his own practice. Together with the architect Alistair Knox they developed houses and gardens at Eltham, near Melbourne, of a very special character and beauty.

A National Botanic Garden in Canberra was started in 1949 on the recommendation of Dr Lindsay Prior. It was not officially opened until 1970. It is unique as it specializes in the growth and study of Australian native plants. In 1980 The Australian Garden History Society was formed under the Presidency of Dame Elisabeth Murdoch and is making excellent progress.

LANDSCAPE ARCHITECTURE. In Western Australia the architect and planner John Oldham was appointed the first full-time State Government landscape architect in 1956. He designed gardens for schools, hospitals, housing estates, and public buildings. To defend the bushland character of King's Park which was under threat he planned it as a native botanical garden linked with the other foreshore parks of Perth. He also designed the landscape for the Serpentine, Wellington, and Ord River Dams. The profession spread to eastern Australia a little later when architects and graduates of the Burnley Horticultural College decided to make landscape architecture their profession, studying in England and then returning to Australia.

Mervyn Davis, who had been a member of IFLA since 1959, took the initiative in forming an Australian institute of landscape architects in 1967, just two years after Peter Spooner, the first president, had started the first part-time course in landscape architecture at the University of New South Wales.

Following Walter Burley Griffin's concept of a great artificial lake through the centre, Richard Clough carefully related Canberra to its existing natural and man-made landscapes. As part of the Canberra Development, Dame Sylvia *Crowe was commissioned to design a 'Commonwealth Park' on the shores of Lake Burley Griffin.

There are now over 300 qualified landscape architects in Australia carrying out schemes of a high standard. Notable

examples are the two foreshore parks on Sydney Harbour—one at Peacock Point (by Bruce MacKenzie, in association with Finn Thorvaldson), the other at Long Nose Point (by MacKenzie and associates). Paths of split sandstone wind their way along the rocky cliff edges revealing expansive tree-framed views of Sydney and the Harbour Bridge.

R.O./J.O.

Austria. Except for *Hellbrunn, built under Italian influence in 1615, no gardens of repute were made in Austria before the defeat of the Ottoman Turks in 1688. In 1618 the German states were thrown into chaos by the Thirty Years War and subsequently by the wars with Louis XIV of France on the one side and the Turks on the other. The raising of the siege of Vienna in 1688, however, created such emotion that for a period of some 60 years Austrian baroque art and landscape was unsurpassed. Politically, beginning with Leopold I (1657–1705) and ending with Maria Theresa (1740–80), the Habsburg empire rose to be, superficially, the first power in Europe.

The principal gardens were designed on a heroic scale. Outside the walls of Vienna and overlooking the city are the *Belvedere Palaces for Prince Eugene of Savoy, the hero who saved Austria from the Turks, and the *Schwarzenberg Palace for his neighbour and rival, Heinrich Mansfield. Beyond the suburbs, resembling Versailles in its relation to the capital, is the Imperial palace of *Schönbrunn, which developed under successive monarchs. Other gardens were at *Schlosshof, the country seat of the indefatigable Prince Eugene; *Schönborn in the countryside; and the *Mirabelle gardens in Salzburg.

Owing to lack of designers in a country under duress, architects and craftsmen were at first imported from Italy to deal with the rush of buildings immediately following 1688. Later these were superseded by native talent, among whom Fischer von Erlach (1656–1723) and Lukas von Hildebrandt (1666–1745) came to dominate architecture. At the Belvedere especially, Hildebrandt proved himself a master equal to Le Nôtre; with his death the great age of Austrian baroque came to an end.

Austrian baroque gardens were created by an élite aristocracy and express the grandeur of the age rather than its domestic side. Essentially they are the concepts of architects, and are a formal extension of the geometry of the buildings.

The climate of the country varies. Owing to the proximity of the Alps many of the western towns such as Salzburg are pleasant, mainly in July and August. Vienna, on the other hand, though noted for its breezes, is too hot during these months. Heat and wind promoted hedge planting, for which soil and climate offered the widest scope. The planting of hornbeam, chestnut, maple, beech, lime, and sycamore as well as the smaller-scale yew and box, produced the grandest clipped hedges and avenues. Juniper and acacia were used for variety. The most prolific forest trees were larches, firs, and Siberian pines; deciduous trees for such plantations as those at Schönbrunn were oak, ash, beech, and elm. The cypress was never planted. Of fruit-trees, besides the more common varieties such as apple, there were fig, olive, almond, lemon, and pomegranate. Lemon trees were used decoratively in pots. Turf was not an integral part of every garden, as in England, and was not used for its design value as much as in France. This was possibly due to an affinity with Italy, where grass could be used only with difficulty and played little part in garden design. In general, while the architecture derived jointly from Italy and France, the planting was indigenous.

Like that of most European countries, Austrian landscape in the 19th c. was influenced by English romanticism. An exception was the great Ringstrasse on the site of the old bulwarks with its remarkable assembly of buildings and public gardens in 1857 by the Emperor Franz Josef.

G.A.J.

Automata have been allied since antiquity to trick fountains and water jokes (*giochi d'acqua*). Generated by concealed pipes, and often accompanied by acoustic devices and contrivances simulating the motion of animals, they provided unexpected amusements to those off guard. A document of 1299 records the 'gallerye aux joyeustés' in the park at *Hesdin where rain and storms were produced, and 'conduits and suitable contrivances . . . all along the wall of the gallery, squirt water in so many places that nobody could possibly save themselves from getting wet'. Count Robert II of Artois's hydraulic engineers were apparently familiar with Arab technology, available in al-Jazarí's *Book of Mechanical Devices* (1206), and in the 9th-c. treatise of the Banū Mūsa: diagrams show machines for raising water and automata displaying simple laws involving levers, pulleys, and siphons such as may have been used for the spectacular gardens of early 10th-c. Baghdad.

Based on the inventions of the school of Alexandria were the writings of Ctesibius, Philo Byzantinus, and *Hero (1st c. AD), whose *Mechanics* and *Pneumatica* were especially significant for Renaissance waterworks. G. B. Aleotti's Italian translation of *Pneumatica* and B. Baldi's Italian edition of Hero's tract on theatrical automata were both published in 1589. Automata, however, had appeared earlier in Francesco Colonna's *Hypnerotomachia Poliphili* (1499), and in the hydraulics of villa gardens at Villa *d'Este, Tivoli, Villa *Lante, Bagnaia, and *Pratolino. In the Villa *Aldobrandini at Frascati (c.1601), John *Evelyn writes of 'singing birds moving and chirping by force of the water . . . In the center of one of these roomes rises a coper ball that continually daunces about 3 foote above the pavement, by virtue of a Wind conveyed seacretly to a hole beneath it, with many other devices to wett the unwary spectators, so as one can hardly [step] without wetting to the skin.' (*Diary*, 4–5 May 1645.) President Charles de Brosses in 1739 gives vent to more ribald moments: 'We were revenged on Legouz, to whom we owed the shower bath in the forecourt. He turned on a water cock to water us, but this cock was only there *pour tromper les trompeurs*, and with vicious force shot a water jet as thick as an arm right into Legouz' stomach.'

Solutions to problems posed by the ancient authors

culminated in the scientific experiments of the 17th c. Descartes marvels at the grotto-terraces at *Saint-Germain-en-Laye, probably known too through the works of Salomon de *Caus. He was particularly impressed by the automata: 'You may have observed in the grottoes and fountains in the gardens of our kings that the force that makes the water leap from its source is able of itself to move diverse machines and even to make them play certain instruments . . . according to the various arrangements of the tubes through which the water is conducted.' (*Treatise on Man*, 1629.) N.M.

See also LUNÉVILLE; WATER IN THE LANDSCAPE.

Avenue. The idea of the avenue is as old as antiquity, and has always remained a mark of authority. The formal Egyptian avenue of sphinxes denoted the power of the priesthood. There were no avenues in classical Greece, but they existed throughout the autocratic Persian and Roman empires—the trees formally planted have been likened to soldiers at attention. They declined in importance in the Middle Ages, but reappeared in Renaissance Italy with the revival of the concept of individual power. The tree was usually the cypress. North of the Alps many roads, especially in France and the Netherlands, were planted for timber and shade. Aesthetically the concept of the avenue culminated in the designs of Le Nôtre in France, ultimately forming the inspiration for town planning.

In England, avenues, as at Sutton Place, denoted the dawn of the Renaissance in the early 16th c. Usually formed of lime or elm (though horse chestnut was also used, as at *Windsor Great Park), they might be several km. in length, or even longer (as at *Boughton House, where the Duke of Montagu intended to make an avenue as far as London, *c*.100 km. away!), forming a notable feature in the landscapes illustrated by *Kip or *Knyff. With the triumph of the natural style by the middle of the 18th c., avenues were, with few exceptions, swept away (especially by *Brown), to be replaced by a more open, irregular style of planting. William Kent experimented with clumps to retain the visual effect of avenues, but to allow lateral views. At the end of the century Humphry *Repton opposed their complete destruction and suggested (e.g. in the Red Book for Langley, Kent) that the general line of trees should be retained. The problem with avenues lies in their restoration, for trees do not die simultaneously. Examples of this difficulty today are the avenues at Hampton Court, and Osborne in the Isle of Wight (where the Prince Consort had designed an avenue of mixed species), and the Churchill (or Victory) Avenue at Chequers. G.A.J./P.G.

Aviary, a decorative feature in gardens in all parts of the world since ancient times. *Varro wrote a description of the aviary in his Villa Casinum, near Cassino, Italy, *c.* 35 BC, and there may also have been private aviaries at *Pompeii. These classical examples were followed by others in the 16th-c. gardens of the Villa *Doria (Genoa), and at several

of the villas of the Marche region of Italy in the 18th c. Examples in other European countries are: a small aviary at *Nymphenburg, built in 1757 (no longer extant); a magnificent early 19th-c. Chinese aviary at Dropmore House, Buckinghamshire, the central feature of which is an octagon surmounted by a fretwork dome, which allows small birds to fly freely in a comparatively large space; and a fine large pheasantry aviary built at Waddesdon, Buckinghamshire, in 1888.

Aviaries became particularly popular with the development of zoos and menageries in the early 19th c. In 1829 Decimus Burton designed a raven's cage (since destroyed) for *Regent's Park Zoological Gardens. G.W.B./P.G.

Avrig, Transylvania, Romania. See ROMANIA.

Ayazmo Park, Stara Zagora, Bulgaria, rises around and over a hill and has a distinctly exotic look, which is due to most favourable climatic conditions—moderate minimal temperatures, a hot and dry summer, a warm autumn, and a mild winter—giving the vegetation period an average duration of eight months. The park was created in 1895 by Bishop Methodius Koussevich, who is now buried there; he organized the first planting of the almost bare and eroded hill (formerly disrespectfully called by the Turks Akhmak Baïr—Fool's Hill) and coupled this with an irrigation scheme. It owes its exceptional scenic beauty to a combination of factors, among which the lush vegetation and highly original location stand out. It has a green walk of cypresses, a cedar grove, and a group of Judas trees, as well as many single specimens of exotic species, such as the Aleppo oak, the bay tree, the paradise apple, and the pencil tree. As special attractions it contains a miniature zoo, an arboretum, and a botanical area. D.T.S.

Azulejo, from the Arabic word *zuleij*, 'burnt stone', a tile made from sand, water, and a little glaze, baked in ovens or left to harden in the fierce sun. The practice, which reached the Iberian peninsula in the 8th c. with the invasion of the Moors, was common, from far back in time, all over the Mesopotamian region. The Moors, a desert people to whom water and shade meant much, used the *azulejo* to beautify their fountains, tanks, and pavilions, when they colonized Spain. Decorative, but also practical, the *azulejo* was cool, never faded, could be washed clean, and was almost indestructible. Only a few colours were used at first—mostly lemon-yellow, turquoise, and sage-green—as well as white. Each colour was divided from the next by a narrow ridge, often in black. According to Islamic law, the tiles bore only arabesque or geometrical designs.

By the 12th c. a tile-making centre had opened up in Seville. In 1248 the Moors were driven out of all Spain except for the kingdom of Granada, but the tile remained, and found its way across the mountains into Portugal, there to become a uniquely Portuguese idiom. More colours came into use and the dividing ridge disappeared as the colours

fused. With the Christian conquest of the peninsula the abstract Muslim designs of the *azulejo* gave way to pictorial subjects revealing the human figure. Nor did a single tile show just one design any longer; often it consisted of a section of an overall picture, several together thus making up a panel. The earliest dated panel is of Susanna and the Elders at Bacalhoa, from 1565. By the 17th c. factories making *azulejos* were opening in Lisbon and after that the tile appears everywhere, its designs reflecting the baroque, the rococo, and other subsequent moods in taste. B.L.

Babelsberg, Potsdam, German Democratic Republic. In the course of his efforts for the improvement of the Isle of Potsdam Peter Josef *Lenné wanted to complete the eastern part of the area. In 1833 he drew up the first plan for the future Emperor Wilhelm I, and this was partly executed. Karl Friedrich *Schinkel designed the neo-Gothic Schloss (1833–4). The court gardener Kindermann carried out the technical work on the garden. Work ceased in 1838 because of financial problems, and *Pückler-Muskau took over the work in 1843. Large-scale extensions were made to the park in 1841, 1865, and 1867, to an area of over 200 ha., but this has since been reduced to 110 ha.

The very undulating terrain harmonizes with the calm waters of the River Havel. Between the Schloss and the Havel is the much-admired Bowling-Green, joined on the western side by a pleasure-ground (reconstructed in 1977) with flower-beds enclosed by tiles. Many statues stood around the Schloss, which was destroyed in 1945. The Lenné-Höhe, a lookout point towards Potsdam, was the park boundary until 1841; from 1871 this was emphasized by the addition of the Berlin Gerichtslaube. Scattered oak trees, some trained to grow into bushy shapes, and tall trees which serve to direct the eye, characterize the park which has become woodland in parts.

Further paths were laid down to facilitate exploration of the area around Potsdam and of particular buildings; skilful use of the terrain and careful planting of individual trees or groups of trees result in a highly picturesque landscape. Individual buildings aid the creation and enjoyment of landscape scenes: the Kleines Schloss on the Havel (1841–2), kitchen buildings, the Flatow tower (1853), the Court Nursery (1862–3), and the Victoria Column; at the entrances to the park stand gatehouses modelled on English lodges. Despite the proximity of the river a number of lakes of various sizes were created, and because of the hilly terrain some have waterfalls which greatly enliven the park. H.GÜ.

Bābur (b. 1483), 1st Mogul Emperor (1508–30), a descendant of both Genghis Khan and *Timūr Leng, was, throughout a lifetime of incessant and successful warfare, devoted to the making of gardens and the cultivation of the arts. At the age of 14, he briefly captured *Samarkand, and remained much influenced throughout his life by its splendours. In 1504 he became ruler of Kabul, Afghanistan, styling himself Emperor in 1508. Here he began to lay out gardens, and to develop the love of trees, fruit, and flowers that absorbed him all his life. After a period of comparative peace, Bābur's invasions of India began in 1518, and in 1526 he was proclaimed Emperor in Delhi. Kabul he regarded always as his home, but his life lay henceforward in India. In conditions less appealing to him than those in Kabul, he and his followers laid out a series of splendid sites, mainly along the banks of the River Jumna in Agra. Of these, the *Ram Bagh, Zahara Bagh, and Dehra Bagh have been attributed to Bābur himself. Water was first controlled to provide wells, reservoirs, and aqueducts, and the gardens, in a climate of dust, heat, and humidity, evolved as enclosed paradises.

Bābur's own memoirs, the *Bābur-nama* (translated into English by A. P. Beveridge, 1922), included vivid and detailed accounts of the construction of his gardens and their planting. He was buried temporarily in one of his gardens in Agra, but later, as he had wished, in *Bagh-i-Bābur Shah at Kabul, overlooking his favourite views.

S.M.H.

Babylon, Hanging Gardens of, were one of the seven wonders of the ancient world, but they are not mentioned in cuneiform sources. There are two traditions in classical writings. According to Josephus they were built by Nebuchadnezzar II (604–562 BC); the layout imitated the mountains and trees of Media. According to Diodorus they were built by an Achaemenid king and were terraced, with many trees. The sources agree that the gardens were raised on stone vaults and were watered straight from the Euphrates River. Since the river changed its course within the city between those two periods, it is possible that the Achaemenid kings built a new garden to replace the old one. Excavations in the palace of Nebuchadnezzar revealed an area with strong brick vaults and machinery for raising water, but this construction was too far from the river and lacked the stonework and the dimensions of the Greek sources; so its identification as the site of the Hanging Gardens is probably wrong. S.M.D.

See also ROOF GARDENS.

Bacalhoa, Estremadura, Portugal. Built in 1480, the Quinta da Bacalhoa, a house of singular beauty, was bought in 1528 by Afonso de Albuquerque, son of the first Viceroy of the Indies, in whose family it remained until it eventually fell into ruins. Fortunately in 1930 it was bought by an American lady who has skilfully restored both the house and its garden.

The small square-shaped formal garden fills an L formed by the main body of the house and a wing. The third side is contained by a tall hedge and the fourth is wide open, a significant Renaissance requirement, replacing the totally enclosed medieval garden. Thus from the house's lovely arcaded loggia on the first floor one looks down on to the garden and out beyond over orchard and fields. The design

Quinta di Bacalhoa, Portugal, the pavilion and water-tank

of the box hedging—subdivided into four blocks centred round a fountain, each section intricate, high, allowing for few if any flowers—is typical of the period.

An exceedingly long and important terrace extends from the left of the formal garden to the water-tank. A high wall flanks it on one side, a low parapet fringes it on the other. The high wall is interspersed with seats in early green-and-white *azulejos*, in between which grow climbing roses, jasmines, and other shrubs. The wide parapet, dotted with box obelisks, carries troughs planted with succulents, scented herbs, and flowers. What the formal garden lacks, the terrace provides.

The water-tank and its pavilion are justly famous. The south side of the huge square of water is entirely taken up by an enchanting fantasy comprising three little lodges linked by an arcaded, roofed loggia. Each lodge is capped by a pyramidal turret. Doorways in the lodges lead into the water. The interior of the pavilion is a surprising series of tiny rooms, all in lines with early *azulejos* in greens, blues, and yellows—the earliest dated tile picture (1565) in Portugal—showing Susanna and the Elders. The whole conception of water, building, and flower-filled terrace is a perfect fusion of East and West, of Moorish tradition and Renaissance inventiveness. B.L.

Backhouse, James (1794–1869), English plant-collector, was a member of a Quaker family. In 1816, with his older brother Thomas (1792–1845), he acquired the Friars' Gardens nursery at York, formerly owned by the Telford family and the site of a nursery as early as the 17th c. James Backhouse collected in Australia from 1831 to 1838, travelling as a missionary and an advocate of temperance, and sending plants back to his brother 'to test their hardiness in England'. His account of his visit to the Australian colonies was published in 1843, and the genus *Backhousia*, evergreen trees or shrubs belonging to the myrtle family and native to Australia, was named in tribute to his collections and

descriptions of Australian plants, though he has not been credited with many new introductions. He also visited Mauritius, southern Africa, and, later, Norway. His son, the younger James (1825–90), joined in his plant-collecting in Britain, and father and son built several large rock-gardens in the dramatic style of the period. S.R.

Bacon, Francis, Viscount St Albans (1561–1626), philosopher, jurist, and English pioneer of the scientific method, became Lord Chancellor in 1618. His *Essays*, first published in 1597, were printed in their present form containing 58 essays in 1625. The essay, *Of Gardens, XLVI*, magisterially lays down fundamental principles of gardening and contains such by now familiar observations as 'Roses, Damask and Red are fast Flowers of their Smels; . . . That which above all Others yeelds the *sweetest smell* in the *Aire* is the violet . . . ' and 'the Strawberry-Leaues dying which yeeld a most Excellent Cordiall Smell'. Bacon was a slightly younger contemporary of John *Gerard. D.W.

Bacon, who began his essay with the famous lines 'God Almighty first planted a garden', laid down how a contemporary garden should be planned. It should be under 30 acres (12 ha.). There should be a green approach of 4 acres, a main garden of 12 acres, and a *wild garden of 6 acres. Alley-ways on either side should cover 4 acres, which, together with hedges, would give shade in summer. He discouraged the medieval *knot garden with its coloured earths, topiary, stagnant pools, and classical statues, but considered that there should be a mount, banqueting houses, fountains, and bathing pools; and of course flowers.

The description illustrates how contemporary English design, although basically influenced by the Continent and therefore geometrical, was adjusted to climate and a national temperament essentially domestic and nature-loving. G.A.J.

Badeslade, Thomas (*fl. c.*1715–*c.*1750), English surveyor and draughtsman. The two main published sources of his bird's-eye views of country houses and their grounds are J. Harris, *The History of Kent* (London, 1719) and J. Badeslade and J. Rocque, *Vitruvius Brittanicus* [*sic*], *Volume the Fourth* (London, 1739). He contributed at least 33 views to the former and at least 23 to the latter, but there are other views by him which do not appear in these. P.H.G.

Badminton House, Gloucestershire (Avon), England, was the home of Henry Somerset, Duke of Beaufort (1629–1700) where he lived in truly ducal splendour, at least between being created duke in 1682 and the fall of James II in 1688. Probably this was the time when he laid out the gardens and parks as shown on Kip's views of 1699. The parks were criss-crossed by many kilometres of avenues, but in front of the new Palladian north front he kept a vast parade. Eastwards lay an elaborate *parterre, with a *wilderness beyond, and substantial areas for the Duchess of *Beaufort's cultivation of exotics. She maintained her eminence in this field from the 1680s till her death in 1715, at which time she was the patroness of Richard *Bradley.

After the succession of the 4th Duke of Beaufort in 1746 William *Kent designed Worcester Lodge and a number of other buildings in a landscape based on the great radiating baroque avenues shown in Canaletto's well-known view (1748). The avenues and the emphasis on forestry recall the nearby *Cirencester Park. From c. 1750 Thomas Wright worked for the 4th and later for the 5th Duke. There is an elaborate plan for groves, flower-beds, and irregular walks by Wright dated 1750, and other designs exist. He was responsible for the lake head, Castle Barn and possibly other barns, the Hermit's Cell, Ragged Castle (all of which survive), and some other follies—a grotto, rotunda, and pavilions. Wright continued to advise on plantings etc. until the 1770s, and *Brown's long supposed involvement is now doubted. D.L.J./M.W.R.S.

Bagatelle, *Bois de Boulogne, Paris, is one of the first so-called *jardins anglais* designed in 1775 by Thomas *Blaikie and F.-J. *Bélanger for the Comte d'Artois (see *Charles X). It included a lake bordered by rocks, a winding river, and cascades, with picturesque scenes ornamented by artificial rocks and *fabriques* designed by Bélanger: the Philosopher's Grotto in the Gothic style; the Hermitage; the Chinese Bridge; the Isle of Tombs with a marble mausoleum covered with creepers and clematis; a classical sarcophagus called Pharaoh's Tomb; and a Temple of Love. These no longer exist, and the park is now a public garden. K.A.S.W.

Baghdad, Early Islamic gardens, Iraq. Caliph al-Mansur founded Baghdad in 762 as the new capital of the Abbasid dynasty. The city was built beside the River Tigris; the ground was fertile, and water was obtained not only from the river but also from *qanats* or underground canals. The city was given a circular form, with concentric walls protecting its inhabitants; palaces with magnificent gardens were located with terraces overlooking the river banks, and the gardens of some contained trees of silver and mechanical birds. Baghdad lay on a major trade route, and it became a leading centre for education and science, including horticulture and the export of plants. Many flowers were grown, and a perfume industry was established. In 1258 Baghdad fell to the Mongols, and it was laid waste. J.L.

Bagh-i-Bābur Shah, Kabul, Afghanistan, is the tomb of the first Mogul Emperor, Bābur (1508–30), who was finally buried here after interment for some years at Agra. The site is that of a garden with four terraces, on the hill Shah-i-Kabul. He had left instructions that he should be buried here in a simple grave, open to the elements. G. T. Vigne, in the mid-19th c., shows a drawing of the grave, and a later headstone, amongst shrubs, and refers also to the garden as being planted throughout with wild cherry. A modern shelter has now been built over the grave. Bābur's son Hindāl is buried beside him. Shāh Jahān added a mosque to the site in c. 1640. S.M.H.

Bagh-i Delgosha, Shiraz, Iran, the Garden of the Heart's Delight, dates from the 18th c. and is located in the north-east part of the city of Shiraz on Bustan Boulevard near the Mausoleum of Sadi. Set at the foot of a barren mountainside to the north, the garden at one time contained a long canal, a pool and fountains, and flower-beds and orange trees, as well as a Qajar residence. J.L.

Bagh-i Eram, Shiraz, Iran, the Garden of Paradise, was set out in the 19th c. at the foot of a mountain range in northwest Shiraz. The garden extends for over 23 ha. A path leads from an entry on the north to a Qajar pavilion set on the garden's central axis. A water channel runs through a tiled room at a lower level of this pavilion. In front is a large reflecting tank from which runs a narrow channel with several offshoots; these, with tall trees and straight paths, provide long internal vistas. There are also many shrubs and flowers, including a rose-garden. Garden and pavilion are typical of 19th-c. Iranian garden art and architecture. J.L.

Bagh-i Fin, Kashan, Iran. The perennial spring of Fin is to be found 6 km. from the town of Kashan, located near the great Dasht-i Kavir. The early buildings established by Shah Abbas I that marked this oasis in the desert in the 16th c. have disappeared, and the present 1·5-ha. garden, also known as the Bagh-i Shah (King's Garden), dates from Fath Ali Shah in the early 19th c. Outside the high walls is the arid countryside; within the garden the spring, located in a far corner, provides a constant flow of water to various channels as well as to a large pool located in front of a centrally placed pavilion. The channels are lined with green tiles, and there are many fountains. Plane and cypress trees border paths, and flowers are in abundance. J.L.

Bagh-i Gulshan, Shiraz, Iran, the Rose-Garden, also known as Afifabad, was established in 1863. It is located at the west end of the city of Shiraz; over 500 m. in length, it extends for 20 ha. and was formerly owned by the Shah. The entry complex itself contains a small courtyard with fountain and pool. From here a long tank leads to a large pavilion built of local stone, placed on the central axis of the garden. The pavilion has many rooms and a large reception hall. The garden contains several pools with fountains, many trees and rose-bushes, long straight paths, and extensive areas of grass. J.L.

Bagh-i Takht, Shiraz, Iran, the Garden of the Throne, was situated on the northern edge of the city of Shiraz and occupied an area of 1·4 ha. at the foot of a rocky hillside. It was established in the 11th c. by Atabek Qaracheh, a local ruler, although the name Bagh-i Takht was only acquired some time after the mid-19th c. In his *Six Voyages . . . through Turkey into Persia and the East Indies* (London, 1678), Tavernier described the garden as 'belonging to the ancient kings of Persia, called Bagh-i Firdaus. It is full of fruit trees and rose trees in abundance. At the end of the Garden upon a descent of a Hill stands a great piece of Building and below a large Pool affords it water.' The water which supplied the hillside garden and filled the artificial lake on which small

boats plied originated from a spring in the rock. Its pressure was also sufficient to maintain jets of water that could be opened and closed.

By the early part of the 20th c. the Bagh-i Takht was neglected and in ruins. Although it was later somewhat restored, the site has since been devoted to housing. J.L.

Bagh-i Wafa, Kabul, Afghanistan, the Garden of Fidelity, was the favourite garden of the 1st Mogul Emperor Bābur and is described in his memoirs. It was divided into the four plots of the classic *chahar-bagh* with running water and a reservoir. Here the emperor had imported and planted such trees as citron, orange, plantain, and pomegranate, together with sugar-cane. A later painting of the Mogul school shows Bābur directing the construction of this garden. He was able to visit it during a pause in his campaigns, and to enjoy it in its full maturity. His reference to the mildness of the climate, and the nature of the vegetation itself, suggest that it was not in the town of Kabul, but at a lower and milder altitude. There are the remains of a garden on the Mogul pattern, lower down near the River Kabul at Nimla near Jelalabad, but no firm identification of the site can be made.
S.M.H.

Balbianello, Villa, Lenno, Lombardy, Italy. Set on the solitary promontory of Dosso di Lavedo, Lake Como, the *casino* stands surrounded by flowers—the porticoed loggia, with its stone balustrades and *amorini* (cupids), affording superb views over the lake, whilst the gardens, interspersed with cypresses and fountains, step down in terraces to the water's edge. Built in 1790 for Cardinal Durini, and once the home of Silvio Pellico, it is now privately owned.
H.S.-P.

Balleroy, Calvados, France, is one of the few surviving examples of François *Mansart's work as a garden designer, showing the attention given to the siting of the château (1626–36) with an extended approach across a valley (see *Maisons). Offices and other buildings are strung out along the forecourt. These culminate in a courtyard before the house, with terraces on either side flanked by pavilions. The garden proper has long been turned into a park. K.A.S.W.

Bamboo, one of the most impressive of all garden plants. Graceful and elegant, and moving and bending in the slightest wind, they have been grown in Chinese and Japanese gardens for over 2,000 years. Many species of this woody subgroup of the grass family are native to the Far East and others are found throughout tropical, subtropical, and warm temperate regions. They are all evergreens and grow in the wild in large colonies, often forming extensive tracts of dense bamboo forest in upland areas. Not all species are forest and forest-edge plants. There are many waterside types and most species will grow well in very wet habitats. Bamboos produce a wide range of building materials and foods and are cultivated in many countries. Although not native to Britain, they are grown in warmer areas to produce canes for garden use; just over 50 of the hardier species can be grown, the two commonest being

Sinoarundinaria murielae, introduced by Ernest *Wilson in 1913 from China, and *Sasa veitchii,* a Japanese species. Several of these are now naturalized in various parts of the country; similarly, many species have escaped from cultivation in Europe and North America.

They are generally rampant growers and quickly form thick clumps. Because of this they are very useful as hedges and shelter-screens: some tropical species are among the fastest growing plants in the world with up to 50 cm. being added every day. A major problem is that the majority of bamboos are spasmodic in their flowering, and most of these flower only once before dying. However, several of the garden species do survive a flowering and with some of them the flowering periods may be up to 120 years, by which time subsidiary colonies will have developed. It is interesting that the long-interval flowerers often bloom simultaneously throughout their wild and cultivated geographical range.

The major introductions to cultivation into Britain were made during the *Chinoiserie period at the end of the 18th c. and in the early 19th c. However, it was not until the end of the 19th c. that bamboo gardens, as opposed to hedge plantings or specimen plantings, were established. Probably the best example is that at the Royal Botanic Gardens, Kew, which was constructed in 1891–2 in a disused gravel-pit.
P.F.H.

Bangkok Asian Institute of Technology, Thailand. The campus and courtyard planting of the Asian Institute of Technology in Bangkok, designed by Maurice Lee, was strongly influenced by environmental factors. Planting has been used to reinforce the shade of covered ways between buildings, to provide reservoirs of cool air to induce gentle air movement in the humid stagnant heat which is experienced for many months in the Bangkok plain, and also to alleviate the radiant heat of both paved areas and vertical building surfaces.

Through the centre of the academic and administration zones a wide canal was designed to take surface water drainage. Along its course shrub and foliage planting provides colour, texture, and perfume bordering the tree-shaded walks and sitting places.

The courtyard of the administration building was planted with *Delonix regia* and *Pterocarpus indica* to give a feathery ceiling through which dappled light falls upon the frangipanis and the ornamental water to form a cool oasis.

The residential blocks for students, raised above ground, surround interconnecting courtyards which are shade planted to aid the movement of cool air through the undercrofts.

The upper level of shade planting throughout the campus has been achieved mainly with *Samanea saman, Delonix regia, Peltophorum pterocarpum, Ficus benjamina,* and *Terminalia catappa.* The intermediate storey allowed the use of colourful bauhinias, cassias, lagerstroemias, plumerias, and callistemons. At ground level a wide range of shrubs and climbers are used as ground cover. M.L.

Bangkok Australian Embassy, Thailand. The garden was designed by Bruce Mackenzie of Sydney, with William

Warren of Bangkok acting as local consultant.

The property, containing a number of large rain trees which were carefully preserved during the construction, is divided into two parts, one containing the Embassy itself and the other the Residence of the Ambassador. The two areas are linked by the main landscape feature—a large lake, occupying *c.*70 per cent of the site, with both day- and night-blooming water-lilies and planting mostly on islands and along the sides.

Mackenzie's aim was to produce a tropical-jungle garden, using masses of plants that would require as little maintenance as possible. One large island, for example, is almost entirely planted with self-heading *Philodendron* (*P. selloum*), another with ferns, and another with *Spathiphyllum cannaefolium*. The predominant effect is one of greenery, occasionally highlighted by the coloured leaves of plants such as *Cordyline*, *Dracaena*, and certain heliconias. In contrast the open sunnier area around the Residence is planted with flowering trees, shrubs, and climbers. W.L.W.

Bangkok British Embassy, New Chancery Gardens, Thailand. The existing British Embassy has stood since the mid-1920s in a park of *c.*2·5 ha. adjoining the Lursakdi Garden of which it was once a part. Over 40 years or so it has been very well planted by successive members of the British Foreign Service and also benefited from time to time from advice given by M. R. *Pimsai Amranand.

The site for the new Chancery, at the end of a rectangular lake along the north side bordered by enormous rain trees, is restricted, not only in space but also on account of strict security. The main problem for the designer, Maurice Lee, was to achieve a sense of openness and continuity of the garden while controlling both access and some angles of view.

The building was planned as a hollow square of three storeys in height with an open side towards the lake at ground and first floor levels. Thus with a lattice screen right across the entrance verandah, a view is maintained from the public street right through the central courtyard and parts of the Residence garden to the lake beyond.

The central courtyard is extensively planted with low ground cover such as calathea, maranta, philodendron, and ferns, and at the next scale with bold heliconias, alpinias, and other ginger species. In the centre a single specimen of *Erythrina indica variegata* gives a clear sculptural form in winter, followed by its brilliant red blossoms on the bare branches before the yellow and green trifoliate rhomboid leaves appear. The floor of the courtyard is paved with large slabs of natural laterite and planted intermediately with the broad-leaved grass *Axonopus compressus*. M.L.

Bangkok Hilton International Hotel, Thailand. A number of people took part in the planning of the garden at the Hilton, but the selection and siting of plants were largely done by Khunying Lursakdi Sampatisiri, owner of the property, and William Warren, who acted as consultant.

Three or four existing trees on the site were retained, but most of the planting was done at the time of the hotel's construction in 1984. This includes flowering trees scattered about the grounds and massed beds of ornamental shrubs including varieties of hibiscus, neon (*Centaurea gymnocarpa*), ixora, canna, heliconia, red ginger (*Alpinia purpurata*), jasmine, dwarf lantana, and butterfly ginger. One lawn has been mainly devoted to local fruit-trees, such as tamarind, mango, guava, breadfruit, pomelo, and jackfruit. There are two ponds, a smaller one containing hybrid water-lilies and a larger one planted with *Victoria amazonica* (formerly *V. regia*). W.L.W.

Bang Pa-In, Thailand, the royal summer palace on the banks of the Chao Phraya River *c.*60 km. north of Bangkok, was first developed in the mid-17th c. by King Prasatthong but its gardens were enlarged to their present form as a 19th-c. pleasure-garden by King Mongkut and King Chulalongkorn. They are now open for recreation to the public.

Bang Pa-In is in the grand manner, an eastern echo of so much of 18th-c. Europe, with formal balustraded canals and lakes. In the middle of one stands, or floats apparently, the famous water pavilion. The large Chinese pavilion was shipped from China in its component parts and reassembled. There is a great avenue of mango trees bordering the lake, rounded rather formal groups of asoka trees (*Saraca indica*) and *Millingtonia hortensis*, groups of clipped tamarinds, and a menagerie of topiary animals in the modern Thai manner. M.L.

Banister, John (1654–92), English botanist, was sent by Henry Compton, Bishop of London, as a missionary to the American Indians in 1685. He studied the natural history of Virginia and sent seeds to Compton and others, including Bobart at the *Oxford Botanic Garden. He also described plants he observed in Virginia to the leading naturalist of the day, John Ray, who published the list in his *Historia Plantarum* (Vol. II, 1688). Banister's death is variously attributed to his falling from a cliff while botanizing or being shot by a companion while out hunting. Among his introductions are several ornamental trees: the balsam fir (*Abies balsamea*), the box elder (*Acer negundo*), the honey locust (*Gleditsia triacanthos*), the sweet gum (*Liquidambar styraciflua*), and the scarlet oak (*Quercus coccinea*). Perhaps his most important new plant was the first magnolia to be cultivated, *M. virginiana*. S.R.

Banks, Sir Joseph (1743–1820), English naturalist, travelled on Cook's voyage round the world in the *Endeavour* (1768–71), taking with him D. C. Solander, one of *Linnaeus's pupils, and the draughtsman Sydney Parkinson, who died on the way home. The whole series of plates engraved from Parkinson's drawings of the plants found—over 700 of them—are only now being printed, in colour, in a limited edition which will not be complete until the late 1980s. Botany Bay was named on this voyage, and Banks's later interest in the Australian colonies, including his introduction of merino sheep from Spain, led to his recognition as one of the country's founding fathers. Among the

Australasian plants he brought back to Europe were banksias, belonging to a genus named in his honour, the glory pea (*Clianthus puniceus*), the bottle-brushes of the genus *Callistemon*, and New Zealand spinach (*Tetragonia expansa*). The Banksian climbing rose, *Rosa banksiae*, was an introduction from China named for Lady Banks, his wife.

Seven years after his return from the Antipodes, Banks was elected President of the Royal Society, a position he held until his death, becoming a central figure in an international network of botanists and other scientists. His appointment as scientific adviser to George III in 1771 also helped to make him an influential patron of science. From this date he was virtually director of the royal gardens at *Kew, from which collectors were sent out to bring back both ornamental and economic plants. The earliest Kew collector was Francis *Masson in South Africa; other plant-hunters working for Banks included George *Caley in Australia, Adam Afzelius and A. P. Hove in West Africa, and William Kerr in China. He sent Archibald Menzies on Vancouver's voyage (leading to the introduction of the monkey puzzle (*Araucaria araucana*), among other South American plants) and arranged the planting of breadfruit in the West Indies and tea in India, establishing Kew as a centre for the transfer of economic plants to suitable areas other than their native ones.

Banks's own botanical knowledge, backed up by an enormous correspondence, a fine library, and a large herbarium, often produced detailed instructions for his collectors. His library and herbarium were always open to other scholars and his house in Soho Square was a meeting-place for the scientific world in London. At his death, his collections were left to Robert Brown, a leading botanist, and later to the British Museum. S.R.

See also PLANT-COLLECTING.

Ban Mu Yuan, Beijing, China, was once described as 'the most beautiful Chinese garden in Peking', but its fame rests also on that of its owners and the fine art collections they gathered there.

Originally built *c.*1680 by Li Yu, a well-known dramatist, poet, and essayist, for an official in the Ministry of Construction, it lies off Huang Mi Hu Tung near the north-east corner of the Forbidden City, and still contains a 'false mountain' of rocks supposedly composed by Li himself. Ban Mu means Half Acre, a modest name in keeping with the one Li Yu chose for his own Peking home: 'The Garden Small as a Mustard Seed'.

In the early 19th c., after many ownership changes, a high Manchu official named Lin Jian Ting heard of Ban Mu Yuan while drinking tea in the Mustard Seed garden. Though he had to wait 30 years to acquire it, in 1840 he began to restore the estate, added to its art and rock collection, and eventually left an intimate record of it in his woodcut-illustrated diaries.

Today the garden still has much that was built in Lin's time: in plan the most interesting feature is the pavilion shaped like a Greek cross that stands on a rocky isle dividing the Pond of Rippling Jade. The characters for this name,

encouraging an optimistic interpretation of murky grey-green city water, were once cut into one of the edging rocks. To the south a hexagonal pavilion on a rocky mound overlooks the whole garden, with its zigzag *lang* gallery connecting halls and study rooms to the east and, to the west, Li Yu's old rockery of yellow stones from the Yong-ning mountains near the Western Imperial Tombs. Though small, Ban Mu Yuan is significant as perhaps still the finest example of an old Beijing garden, and for the strangely unchanging atmosphere it preserves. C.-Z.C./M.K.

Ban Qiao, Republic of China, has long been the most famous private compound on the large and subtropical island of Taiwan. This garden in the suburbs of Taibei was built between 1888 and 1893 by Lin Wei-yuan, a minor official in the Qing government and a member of an immensely successful merchant family who had moved there, four generations earlier, from Fujian province on the mainland.

The garden, covering *c.*1·6 ha. north-east of the family courtyards, uniquely combined the rockeries, ponds, and clustered buildings of Southern Chinese gardens with European-influenced axial planning and flower-beds. It was composed of four building-groups, including a banqueting hall, guest houses, and the master's study, mostly connected by open *lang* corridors. An irregular-shaped Pond of the Tree Shadows lay between them and an artificial rockery which rose in swooping curves along the boundary wall. For viewing the garden by moonlight, a pavilion set in the lake was built with a flat roof, something rare in China. Although it was neglected for years after the Japanese occupation (1895–1945), extremely detailed plans and reconstructions, which give an excellent idea of the garden, have been made for its proposed restoration.

D.-H.L./M.K.

Barbados, West Indies. Because of its low altitude and its isolation in the middle of the Atlantic, far from any land mass, Barbados enjoys an equable climate. The mean annual temperature range is 5°C and the mean daily range also 5°C. In July and August the midday temperature rarely reaches 90°F and on the coldest January night rarely falls below 65°F. Rainfall is very variable and unpredictable. A wide variety of plants flourish in the open air in this climate, the main constraints being the alkalinity of the soil and the narrow temperature range.

In the 18th and early 19th cs. the planters enjoyed a period of great prosperity. Large houses were built and elaborate gardens established round them, one of the most notable being that of Sir Graham Briggs, in whose garden at Farley Hill House the beautiful variety of maidenhair fern called *Adiantum tenerum farleyense* was first reported. The planters imported many varieties of plants and most of them are still grown in the island today.

With the advent of Atlantic air travel in the 1950s a new class of wealthy resident became established, particularly along the sheltered west coast of the island, and they were often keen gardeners. Sir Edward Cunard settled in the

mid-1930s and built himself a fine house and garden at Glitter Bay, and about the same time Murtagh Guinness redecorated Porters, a historic plantation house. Later, Ronald Tree influenced large numbers of rich Americans, British, and other nationalities to build large houses with gardens in the St James area. Hotels were also being built and it was partly to meet the demand for exotic plants that the *Andromeda Gardens were established in the early 1960s. The Company has supplied vast quantities and varieties of plants for over 20 years to gardens all over the island and throughout the Caribbean.

The speed of air travel has also facilitated the introduction of new plants which previously could not survive long sea voyages. When the Sandy Lane Hotel and the estate around it were being developed in the 1950s and 60s for luxurious winter homes the owners employed a young landscape gardener, Richard Coghlan, who has had a considerable influence throughout the island. Russell *Page has also been a frequent visitor and has worked on several garden designs. There is no official botanic garden but the Andromeda Gardens, in a beautiful setting on the north-east coast, has thousands of species and hybrid plants which were brought to Barbados and established there over the last 30 years. During the early months of the year several large private houses and gardens are opened to the public in aid of the funds of the Barbados National Trust, which has developed Welchman Hall Gully as a pleasant nature walk. The Barbados Horticultural Society is developing a garden at its headquarters at Balls, Christ Church, near the airport. The Parks and Beaches Commission, now renamed the National Conservation Commission, has done much to develop parks on the island in the last 10 years; these include the Queen's Park, Farley Hill Park, Barclay Park, and King George V Park.

In an endeavour to prevent the indiscriminate development of beach resorts which has occurred on the south and west coasts of the island, the Government has plans to create a national park on the east and north coasts. I.B.B.

Barbarigo, Giardino, Veneto, Italy. See GIARDINO BARBARIGO.

Barbaro, Villa, Maser, Veneto, Italy, is described in detail in *I Quattro Libri di Architettura* (1570) by *Palladio, who designed this magnificent garden for his friends, the brothers Barbaro, during the 1560s. Situated on the slopes of a small hill, the villa looks out across the Padua road towards a great fountain with a strident Neptune, and a long avenue of lime trees leading down the hill. Little remains of Palladio's original layout—with its arbours and parterres, its boundary wall topped by stone warriors, and the access drive flanked by Olympic gods. The modest *giardino segreto* has, however, survived. This is classically Roman in design—enclosed on three sides by the villa, and backed by dark conifers on the hillside; it is part lawn, part small-stone paving. On the fourth side a large round pool reflects the ornamented semicircular *exedra (the work of Alessandro Vittoria), with its statues of stucco. The supporting Atlanti

are flanked by 10 classical figures and two central river-gods pouring water. H.S.-P.

Barillet-Deschamps, Jean-Pierre (1824–75), French landscape architect, originally called Barillet, came from a farming family in Indre-et-Loire and became superintendent and gardener in a model penal colony for young delinquents at Mettray. He was sent to study horticulture at the *Jardin des Plantes; and in 1850 he set up as a landscape architect at Bordeaux where he established greenhouses and a winter garden. In 1860 J.-C.-A. *Alphand brought him to Paris as chief gardener to the city. He supervised the greenhouses and nurseries which provided plants for the *Bois de Boulogne; and with Alphand designed the Bois de Vincennes, the gardens of the Champs-Elysées, and the *Parc Monceau, and provided plans for the Paris exhibition of 1867.

His 'decorative horticulture' (wide paths with ample curves, ground shaped into little dells in the middle of hollow lawns, trees in bold isolation or leaning over round flower-beds or clumps of shrubs) was applied to the landscape engineering of Alphand and his circle. His style of little dells was doubtless borrowed from Sir Joseph *Paxton who was working for James de Rothschild at Boulogne, and at the vast landscape garden surrounding the château of Ferrières (Seine-et-Marne). Barillet's style was developed by Edouard *André and applied unthinkingly to many small private gardens, as the work of the landscape architect Victor Petit shows. D.A.L.

See also LAEKEN.

Bark house. See MOSS HOUSE.

Barncluith House, Lanarkshire (Strathclyde Region), Scotland, has a spectacular setting on the southern edge of the town of Hamilton among ancient woodlands on the River Avon, a tributary of the Upper Clyde. On a very steeply sloping south-facing bank a terrace garden had been laid out perhaps as early as the late 16th c. Its form today belongs basically to the 17th c., with added architectural ornaments gleaned from Hamilton Palace which stood nearby. The terraces are necessarily very narrow and somewhat crowded with topiary and a banqueting house, and the steps linking them are steep. The architectural and horticultural elements form a pleasing contrast to the wooded gorge making Barncluith what John Macky called 'a very Romantick garden' (*A Journey through Scotland*, 1723). W.A.B.

Barragán, Luis (1902–), Mexican landscape architect, is known chiefly as an architect, the spiritual leader of three generations of Mexican Minimalists; but he was trained as an engineer, and likes to call himself a landscape architect. His early houses, reflecting Muslim influences—particularly of Spain and Morocco—led naturally, via Le Corbusier and the International Style, to a preoccupation with the relationship of houses to the landscape.

From 1940 he designed a number of gardens,

Plaza del Bebedero de los Caballos, Las Arboledas (1958–62), Mexico City, by Luis Barragán (drawing: Michael Lancaster)

experimenting with the juxtapositioning of stone retaining walls and horizontal planes; with water in pools, channels, and artificial waterfalls. Important influences were the naïve painter Jesus Reyes, the German-born sculptor Mathias Goeritz, and 'the architecture of the poor': the indigenous buildings of the Mediterranean and the Mexican pueblos. From these he has developed his own highly personal idiom, contrasting pure forms which are sometimes broken down into almost abstract planes, with the wilder forms of nature. Memories of his native Guadalajara—the brightly coloured houses, the elevated wooden aqueducts which carried water to the pueblos, the life and colour of the market-place, and, above all, the horse—are ever-present in his work. Many of his designs are actually for horses: ranches in which trees, coloured walls, and water are combined to form a kind of theatre in which they can be displayed. The water element in one of his most distinguished designs, that of the Plaza del Bebedero de los Caballos (1958–62) in Las Arboledas, is in fact a horse-trough. Using the simplest of materials—water, a single species of tree, and walls (one white to provide a backcloth for tree shadows, one blue to suggest distance)—he has achieved a majesty worthy of his Islamic masters.

In El Pedregal (the rocky place) (1945–50), the site of an extinct volcano, he attempted to create a residential development in which all the houses and gardens would be in harmony with the fantastic lava land-forms and the existing vegetation. 'My house is my refuge', he wrote, 'an emotional piece of architecture', and 'the garden a magic place for the enjoyment of meditation and companionship . . . the garden is the soul of the house'.　　　　M.L.L.

See also MEXICO: THE TWENTIETH CENTURY.

Barrington Court, Somerset, England, has had a house since medieval times but until after the First World War there was no garden.

In 1920 Colonel A. A. Lyle became tenant of the National Trust which had owned the property since 1907. He entirely restored and rehabilitated the Tudor mansion and employed the architects Forbes and Tate to build a complete set of farm buildings and staff cottages in traditional style. They also converted the 17th-c. stable block, which dominates the garden, into a dwelling.

Colonel Lyle also employed Forbes and Tate to design the main lines of the garden and the subsidiary buildings associated with it and the stable block. Gertrude *Jekyll provided planting plans for all the borders and beds and the originals are in the Beatrix Farrand collection at the University of California, Berkeley, together with many other Jekyll papers. It is one of the best preserved of her garden schemes; although not exactly according to her precise design, it is very much in her style. Like many other gardens with which she was associated it consists of a series of formal designs, supported by planting of subtle colours and varied textures enclosed by the garden walls and buildings. A large walled kitchen garden is laid out in traditional style with paths bordered by flowers and divided into quarters by espalier fruit-trees.　　　　J.S.

Barron, William (1800–91), English landscape gardener and nurseryman, was head gardener to the Earls of Harrington at *Elvaston Castle from 1830 to 1865, during which time he re-landscaped the estate, using 17th-c. sources as the model for a topiary garden. He became the century's greatest expert at transplanting mature trees, moving specimens, including already crafted topiary, into the grounds at Elvaston; in 1880 he caused a controversy by transplanting the thousand-year-old yew tree in Buckland Churchyard to a position where it could not damage the building. His 1852 treatise, *The British Winter Garden*, dealt with conifers and transplanting. In 1865 he established himself as a nurseryman and landscape gardener at Borrowash, his major commission being Abbey Park, Leicester (1877–81), one of the first public parks to adopt an axial layout.　　　　B.E.

Barry, Sir Charles (1795–1860), English architect, was knighted in 1852 on the formal completion of the Houses of Parliament, commissioned 16 years before. Despite the Tudor-Gothic style of those buildings, however, he had first won fame as the popularizer in England of Italianate domestic architecture, in a series of clubs and country houses beginning in the mid-1830s, and in the gardens he created to accompany some of these houses he helped to establish the fashion for the *Italian garden. The first of these was at *Trentham where in 1840 he coped with the difficulties of a flat site by creating a series of low terraces leading to the lake. From then until the early 1850s he laid out further terraced gardens at Dunrobin Castle, Sutherland (Highland Region), *Harewood House, *Cliveden, and *Shrubland Park, in each case using staircases, balustrading, urns and tazzas, fountains, and loggias based

on those of Renaissance Italian gardens observed during his Continental tour of 1817–19.

Barry's garden designs are primarily architectural, and he was content to leave the details of planting to the head gardeners of the different estates, most notably George Fleming at Trentham, John Fleming at Cliveden, and Robert Foggo at Shrubland Park. At Trentham his architectural ambitions were checked: he had intended to turn the island in the lake into a miniature *Isola Bella by means of formal terracing, but it was allowed to retain its wooded character as part of Brown's surrounding park. The Italian garden on Barry's model was a dominant feature of country house garden design in England from the 1840s to the 1860s, although its horticultural treatment increasingly showed the influence of W. A. *Nesfield. B.E.

Barth, Erwin (1880–1933), German garden designer, created some of the most influential public parks and open spaces of his day. A pupil of Fritz *Encke, Barth worked with parks departments at Hanover and Bremen, and was manager of a private nursery before becoming Garden Director in his home town of Lübeck. Here he undertook numerous private commissions as well as being officially concerned particularly with the design of public cemeteries and sports facilities, but also with allotment gardens and aspects of nature and landscape conservation.

In 1911 he accepted the post of Garden Director at Charlottenburg, a rapidly growing suburb of Berlin, where he designed and built a large number of urban squares (including the Gustav-Adolf-Platz, Karolingerplatz, and Sachsenplatz, a novel, 'ecological' demonstration park) and small parks, the plans for 10 of which were awarded a gold medal at the Altona horticultural exhibition in 1914. As Garden Director from 1926 of the newly created Greater Berlin authority, he was influential in shaping the plans for many of the new open spaces in Berlin.

Barth had taught garden design to architecture students

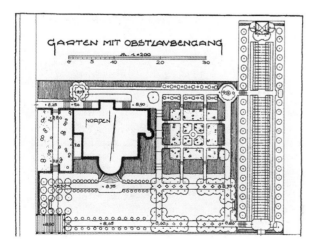

Plan of Paul Juliusburger Garden (1921–2), Berlin, by Erwin Barth

at Charlottenburg Technical University since 1921, and had been an honorary professor there since 1927; in 1929 he was appointed as first holder of the newly created Chair of Garden Design at the Berlin Agricultural University. R.STI.

Bartram, John (1699–1777), was a Quaker farmer in Pennsylvania, who turned to botany and became a collector of North American plants, sending regular consignments to Peter *Collinson, Philip *Miller, Lord Petre (see *Thorndon Hall), and others in England, among them the nurserymen James Gordon and Christopher Gray, who helped to establish his plants in many gardens. Subscribers paid a regular amount for a box of about a hundred different kinds of seed each year, though live plants were also sent to some of his correspondents. Between 1736 and 1766 Bartram made a series of expeditions to explore the American flora, visiting New Jersey, Maryland, Virginia, Connecticut, Carolina, Georgia, and Florida, and studying the animals and minerals as well as the plants. Some of his observations were published in the *Philosophical Transactions* of the Royal Society. Among the plants found on these journeys were *Magnolia acuminata* from Lake Ontario, Venus's fly-trap (*Dionaea muscipula*) from Carolina, the first large-leaved rhododendron (*R. maximum*), and quantities of tree seeds for the eager foresters across the Atlantic. He brought c.200 new species into cultivation, and the trees he sent included sugar and silver maples, black, red, and white oaks, pines long- and short-leaved, and American ash, elm, and lime. In 1765, thanks to Collinson's influence, he was appointed King's Botanist, at an annual salary of £50. *Linnaeus praised him as the greatest of field botanists.

Bartram started his own botanic garden at Kingsessing, near Philadelphia, c.1729 (see *Bartram's Nurseries). S.R.

See also PLANT-COLLECTING.

Bartram, William (1739–1823), the fifth son of John *Bartram, made his first collecting trip with his father in 1753, but a more important one was their journey to Florida in 1765–6, where they explored the St John river. William then settled in Florida for a time. He was a skilled natural-history artist and sent or sold drawings to several of his father's patrons, including John Fothergill, who, in 1772, commissioned him to go on a collecting trip in Carolina, Georgia, and Florida. The journey lasted from 1773 to 1777, but the outbreak of the War of Independence in 1776 made it difficult for Bartram to send his collections to England, although some live plants, dried specimens, and drawings got through. His introductions included *Oenothera grandiflora* and *Hydrangea quercifolia*. S.R.

Bartram's Nurseries, Philadelphia, United States. On the family farm of John *Bartram (1699–1777), pen-friend and plant-collector for Peter *Collinson, there was what Washington referred to as a 'Botanical Garden' when he visited it in 1787. From its catalogue of 'American Trees, Shrubs and Herbacious [*sic*] Plants' (1784) he was later to

order largely for *Mount Vernon, as the garden had become the leading nursery for what Washington called the 'clever' sorts of trees and shrubs, under the management of Bartram's sons. Seventeen sorts of oaks are listed and such desirable specimen trees and shrubs as the *Stewartia malacodendron* (the silky camellia), *Rhododendron maximum* (the great laurel), and 'Three undescript shrubs lately from Florida'. The 'Alatamaha', listed in brackets with philadelphus and gardenias, may be the franklinia discovered and named by John Bartram, secured for his garden and never seen again in the wild. Washington commented that 'though stored with many curious plants, shrubs and trees, many of which are exotics', it was not large nor 'laid off with much taste'.

Later periods of neglect did not completely obliterate the garden. In 1923 it became the responsibility of the Fairmount Park Commission, and later on the John Bartram Association took over the supervision of the house and garden. Nearly a hundred surviving plants were listed, and replanning and replanting have restored the garden to a condition appropriate to its importance. A.L./S.R.

Basket. As a decorative feature the flower basket dates back to classical antiquity, but it does not appear to have been a major garden feature in England until used by Humphry *Repton to overcome the problem of flowers in a Repton landscape. The impact of flowers from all parts of the world created problems in the very English scenes of trees and grass and Repton's idea was to place them in baskets in the landscapes as furnishings, rather than as integral parts of the garden design. Thus used, baskets had to be of considerable size (as, for example, the Hardenberg basket designed by J. A. *Repton) and give the illusion, but not the reality, of having a basket bottom. The visible interwoven edges are metal, sometimes resembling the ropes that were fashionable after the Battle of Trafalgar (1805). G.A.J.

See also CORBEILLE.

Bassin, a tank or reservoir; in gardens an ornamental pond or small lake. K.A.S.W.

Bastie d'Urfé, Loire, France. The château, transformed by Claude d'Urfé, ambassador to the Vatican from 1549 to 1551, incorporates one of the earliest grottoes in France, with outstanding *rocaille* work. In the garden there is an Italianate open rotunda of the same period, with a low-pitched conical roof on rounded arches supported by coupled columns with Ionic capitals. The place has associations with Claude's grandson, Honoré d'Urfé (1567–1625), author of *L'Astrée*. K.A.S.W.

Bastion. See TERRACE WALK.

Bath, bath-house. Baths, often inspired by classical models (see *Pliny the younger), were a feature of 18th-c. gardens in Europe. They were often constructed on the site of a spring, as was the 'Roman' bath-house at *Painshill (c.1790), and were thus extremely cold: Greville noted that

the bath in the grotto at *Oatlands was 'as clear as crystal and as cold as ice'. Bath-houses, sometimes elaborate in design, such as those at Packwood House, *Wrest Park, and *Corsham Court, might house changing rooms and fires in addition to the bath itself. The bath-house at the Villa *Garzoni had separate enclosures for men and women, and recesses where musicians played hidden from view. Alternatively the bath might be situated al fresco as at *Rousham. M.W.R.S./P.J.C.

Bauer, Walter (1912–), Swedish landscape architect and artist, is perhaps best known for his reconstruction work on historic parks and gardens, notably the baroque garden at Drottningholm from Nicodemus Tessin the younger's drawing, the park at Gunnebo Castle, Mölndal, from Carl Wilhelm Carberg's drawings of c.1780, the Botanic Gardens in Uppsala from a plan by Carl Hårlemann, and also gardens at Forsmarks Bruks and Leufsta Bruk, both in Uppland.

Following a period with the Stockholm Parks Department, he started his own practice in 1946, undertaking work in the Middle East and India as well as in Denmark. He has written widely in the professional press and taught at the Technical High Schools in Helsinki and Stockholm, and the Art Academy in Stockholm. In 1981 he collaborated in the exhibition 'Fredrik Magnus Piper and the Romantic Park', and had an exhibition of his own drawings and watercolours at the Art Academy in 1985. He was awarded the Gustav-Adolf medal in 1978 and the Prince Eugen medal in 1984. P.R.J.

See also SWEDEN.

Baumann, Ernst (1907–), Swiss landscape architect, started a practice in garden design and implementation at

Garden in Canton Zurich, Switzerland, by Ernst Baumann

Thalwil in Switzerland in 1932. His designs are based upon a clarity of planning and spatial organization and he was able to fulfil his clients' expectations by means of sensitive design detailing and impeccable execution. His planting plans in particular were always distinguished by the careful selection and placing of plants according to 'ecological' and aesthetic principles, anticipating the 'natural' gardens of recent years without ever becoming narrow or one-sided. In addition his designs exhibited an exemplary use of natural building materials as well as a restrained use of concrete.

R.A. (trans. R.L.)

Bayreuth, German Federal Republic. See EREMITAGE; SANSPAREIL.

Beaton, Donald (1802–63), a Scottish-born gardener and horticultural journalist, was probably the most influential figure in the establishment of the *bedding system. Serving in his early years in a number of nurseries and gardens, he became famous for his flower gardening at *Shrubland Park in the 1840s; he retired on his savings in 1852, and devoted himself to journalism and plant breeding. He had begun writing for Loudon's *Gardener's Magazine*, and from its start was associated with *The Cottage Gardener* (later the *Journal of Horticulture*). His contributions to bedding were the restriction of the choice of plants to a limited range of highly hybridized plants (pelargoniums, petunias, verbenas, and calceolarias above all), the development of 'shading', or gradual blending of hues, in borders, and an emphasis on contrast of colour for public display. In the 1850s he was involved in a controversy with John Lindley over colour schemes, Lindley arguing for the use of complementary colours as recommended by the French scientist *Chevreul; this system was tried briefly and abandoned by public gardens. Beaton's garden works at Shrubland disappeared during Barry's alterations, but his maze still survives today.

B.E.

Beaufort, Mary Somerset, 1st Duchess of (1630–1715), was a talented English gardener and an enthusiastic botanist, as well as a patron 'much celebrated throughout Europe for promoting natural learning'. She was a friend of Sir Hans *Sloane, her neighbour in Chelsea, where Beaufort House was near the Physic Garden. Two of her brothers, Arthur (1st Earl of Essex) and Henry Capel, shared her interest in horticulture. The first had a fine garden at *Cassiobury Park, the second at *Kew. In the garden at *Badminton House the Duchess collected 'the most curious plants from all quarters of the earth', especially the Cape of Good Hope, and tended some of them herself in her 'infirmary'. Many of her plants are recorded in the paintings of Everhard Kick, a Dutch artist who worked at Badminton in the early 1700s.

S.R.

Beaumont, Guillaume, French garden designer. See LEVENS HALL.

Beckford, William (1760–1844), was described by Byron as 'England's wealthiest son' (*Childe Harold*, i. 22) and it was the inheritance of his vast fortune that enabled him to translate his romantic ideas into realities. It was whilst living at *Montserrate in the Sintra hills in Portugal that he created his first garden which he described as 'a beautiful Claude-like place' (Letter, 18 Dec. 1818).

Upon his return to England he began to build in Wiltshire his Gothic *Fonthill Abbey with the help of the architect James Wyatt. Around the Abbey he created another landscape garden, this time in the more rugged Salvator Rosa image, and also an *American garden. His ideas were undoubtedly influenced by Sir Uvedale Price's *Essay on the Picturesque* (1794) but his travels on the Continent also had a great effect on his building and gardening, which for Beckford were both 'a passion and a joy'. The Abbey was begun in earnest in 1796 and completed 20 years later. However, in 1822, because of the failure of his Jamaican estates, he was forced to sell Fonthill and retreat to Bath, where he created yet another garden near his house in Lansdown Crescent. It was Vincent, his gardener from Fonthill, who provided the expertise, even transplanting fully grown trees.

K.A.H.

Bed, bedding. A bed is, strictly speaking, any area of a garden well demarcated from its surroundings and devoted to the cultivation of a particular group of plants; outside the kitchen garden, it is most commonly given over to a pattern of ornamental flowers. A bed is distinguished from a border primarily in that a border has a wall or hedge as a backdrop, although in some cases freely sited beds are called borders if they are significantly longer than they are wide, especially in the case of ribbon borders.

Bedding or change-bedding denotes the practice of planting beds with different subjects at different times of the year, by removal and replanting. The sudden alteration of most of the contents of a flower garden was often indulged in as an exhibition of royal authority, as in France in the gardens at Versailles and the Trianon in the 18th c. Bedding-out is the operation of stocking a bed during the warmer months with tender or half-hardy exotics which need protective covering in the winter.

The bedding system was a term used in England in the 19th c. for the art of ornamenting flower-beds by bedding-out, and it originated by implied contrast with the unsystematic experiments at bedding exotics during the 1820s and early 1830s. The pioneers of the bedding system in the 1830s were John Caie at Bedford Lodge, Kensington, George Fleming at *Trentham Park, and Donald *Beaton at *Shrubland Park, the last a prominent journalist whose writings helped to fix the selection of plants chosen for summer bedding. From the 1840s to 1870s the favoured plants were pelargoniums (which have always remained prominent), petunias, salvias, lobelias, verbenas, and calceolarias; these were planted for high contrast of colour.

During the 1860s the system was extended into the other seasons. Spring bedding, using a range of bulbs (tulips, hyacinths, and, only much later, daffodils), was primarily associated with John Fleming at *Cliveden, and William

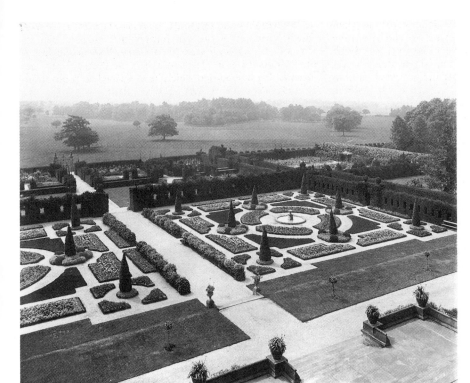

Late Victorian bedding
scheme at Hoar Cross Hall,
Staffordshire, England, in a
1902 photograph

Ingram at Belvoir Castle, Leicestershire. The use of chrysanthemums helped to extend the system into the autumn, and there were sporadic examples of winter bedding, using dwarf conifers and evergreens.

The late 1860s saw the sudden popularity of foliage plants, often claimed by their supporters to display a subtler range of colours than the 'garish' contrasts of the bedding system. *Subtropical bedding, employing large and coloured-leaved plants, appeared first, followed shortly by *carpet bedding, which used dwarf foliage plants and succulents. These competed with the bedding system until the 1880s.

The last quarter of the 19th c. saw the introduction of tuberous begonias, polyanthus, gazanias, and alyssum into the system, and a gradual decline in the use of calceolarias and verbenas. Under the influence of William Wildsmith, the incorporation of shrubbier planting in flower-beds (e.g. abutilons) became popular, and this trend continued through the Edwardian period with an increased popularity for taller, spiky, or ball-headed flowers such as dahlias and antirrhinums as bedding plants. The former distinction between bedding plants as annuals and border plants as herbaceous perennials began to disappear, as part of a process that continued up to the popularity in mid-century of island beds with groups of tall perennials massed in the centres. Roses began to be used as bedding plants in the 1890s, and the 20th c. has seen the rise of tagetes, lantanas, heliotropes, etc., in the place of many of the Victorian favourites. The principal names associated with bedding fashions in the present century have been Thomas Hay, of Hyde Park, between the wars, and J. R. B. Evison, of the Brighton parks, in the 1950s and 1960s. B.E.

See also MOSAÏCULTURE.

Bee bole. Before the era of the modern beehive, the old straw bee-skeps were kept for winter protection in bee boles, which were simply niches, often with arched tops, set in a thick garden wall. The dimensions were such as to accommodate the skeps comfortably, normally c.60 cm. wide and deep and 90 cm. high, and either at ground level or raised in the wall. Sometimes the arches could be quite decorative. An excellent surviving example of a series of bee boles is at *Packwood House. M.W.R.S.

Beeckestijn, Velsen, Noord-Holland, The Netherlands. The former 14th-c. farmstead was transformed into an elegant country house soon after 1716 by the Amsterdam merchant Jan Trip the younger. In 1719 he laid out a Régence garden (see The *Netherlands: Régence, Rococo, and French Picturesque) in which along the central axis flanked by lime trees was a large scalloped-edged pond and such decorative ornaments as 'dry basins' of grass, typical features of the Kennemerland gardens. A plan by J. G. Michael, made in 1772 for Jacob Boreel, reveals the influence of *Switzer and *Langley. Within the existing formal layout, sinuous paths between rigid avenues of trees, meandering walks through a *quincunx of oaks, and

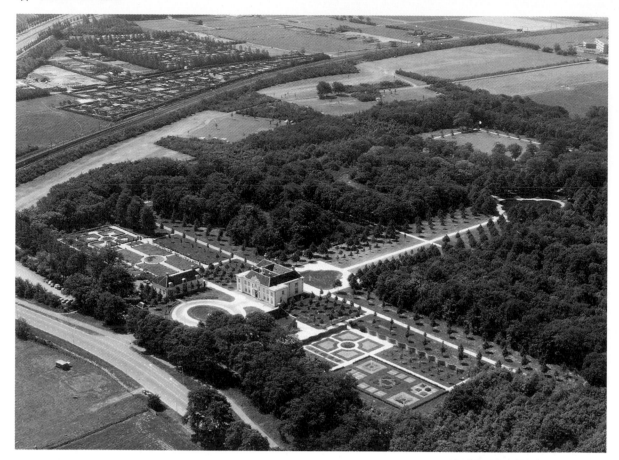

Beeckestijn, Netherlands, aerial view

serpentine paths around scattered flowering shrubs on a lawn were introduced.

An extension of the gardens on the west was a more daring essay in the emulation of 'nature' in which the centre-piece, a cornfield, was framed by trees and paths set in undulating patterns and by a meandering brook. This area was embellished with a hermitage, a Gothic chapel, a triumphal arch, and cottages for a gardener, an architect, and a hunter.

After a long period of neglect the property was bought in 1952 by the municipality of Velsen which had the house and the main lines of the garden restored. F.H.

Beihai Park, China, is located north-east of the Forbidden City in the centre of Beijing; with a name that, literally translated, means North Sea, this is the oldest and largest park in the Chinese capital. It was first recorded under the Liao dynasty in the 10th c. as the site of the Precious Islet Imperial Lodge. In 1179, under the Jin dynasty (on the outskirts of whose capital Zhongdou it then lay), the land was dredged and an artificial hill called Qionghua (the Isle of Fine Jade) was made from the earth. On it was built the

Guanhan dian or Hall in the Moon Palace, and the whole became part of a great villa—the Daning Gong—which was used for short royal visits. When in the early 13th c. Zhongdu was destroyed, the Daning Gong was left undamaged and in 1260, when Kublai Khan began to build his new city of Da Du on the same site, he made as its centre the Qionghua Islet, reshaped, renamed the Ten Thousand Year Hill, and planted with evergreens and rocks of lapis lazuli. Marco Polo described its 'trees and rocks alike . . . as green as green can be . . . no other colour to be seen'. Under Kublai the lake was renamed Tai Yi or Pool of Heavenly Water, and further palaces—later destroyed by the first Ming Emperor—were built on its east and west banks. Under the Ming and Qing emperors, still more buildings were added and since the middle of the 17th c. the 36-m. high White Dagoba, a Tibetan-style tower shaped like a fat-bellied bottle, has added its commanding silhouette to the top of the island. Today, nearly all of the buildings below it, including the elegant double-storeyed walkway that runs for 30 m. along the north shore of the island, date from the time of the Emperor Qian Long in the 18th c.

More than half of the park's present 67 ha. is made up of

water. At its centre, the isle of the White Dagoba, with the Eternal Peace Temple and the Propitious Clouds Tower on its southern slope, is linked to the main entrance on the shore by a wide bridge of white marble. In summer the lake here is completely covered by the blue-green umbrella leaves of lotus rising to make a new vegetable surface more than a metre above the water. Nearby massive grey walls rise around the terrace of the so-called Round City with its temple hall and magnificent white-barked pines overlooking the lake. From here wide paths lead away around the lake shore to many different building complexes, halls, and artificial hills (*jia shan) with hollows and grottoes said to be made of rocks salvaged from the imperial garden *Gen Yue of the Song dynasty. Remarkable among all these are the Five Dragon Pavilions built out on zigzag causeways over the water, and the splendid Yuan-dynasty Nine Dragon Screen made of multicoloured glazed bricks. A number of small, walled gardens-within-the-garden are also spread along the lake shores, among them the Limpid Mirror Studio or Jing Qing Zhou, renovated in 1982 and considered among the best of Beijing's old courtyard gardens.

Beihai is a large public park much used by the people of Beijing. For students of gardening it is significant for the delicate play of contrast between its open areas of park and lake, and the enclosed, more intensely landscaped 'little sceneries' scattered along the shores.　　　　G.-Z.W./M.K.

See also CHINA: EXTRAVAGANT ENTERTAINMENTS; ZHONGHAI AND NANHAI.

Beijing, Hobei province, China. Settled from prehistoric times, the site of Beijing (formerly Peking) already supported a town under the Zhou and Qin dynasties (c.1027–206 BC). In the 12th c. it became the Jurched Tartars' capital, with imperial gardens watered by the Lian Hua Chi pool, and Kublai Khan made it his Great Capital (Da Du) in 1261. Between its double walls he kept many kinds of deer, ermine, and squirrels while Marco Polo described also Kublai's great lake and river and the artificial Green Hill thick with trees transplanted there, fully grown, on the backs of elephants. In 1403 when the Ming Emperor Yong le again made Beijing the capital, he greatly increased the lake-parks, *Beihai and *Zhonghai and Nanhai. Later, despite the dry climate, gardens were still flourishing under the Qing emperors within the city (*Ban Mu Yuan; *Jin Shan), inside the imperial palace (*Yu Hua Yuan; *Qian Long Garden; Chung Shan Park), and in the suburbs (*Yi He Yuan; *Yuan Ming Yuan; *Chang Chun Yuan). In the Western Hills beyond the city, monasteries and private villas took advantage of the forested landscape to 'borrow views' (*jie jing). As well as these, Qing princes and aristocrats built a number of grand palaces with gardens around the Hou Hai, or back lakes, in the city, some of which still exist today (although they are not open to the public).

In general these northern gardens are stiffer and more formal than those of the Chiangnan region and the south; often their pools are edged with cut stone rather than irregular lake-rock; and their *lang galleries run in straight lines and at right angles instead of in the irregular zigzags familiar from Suzhou. At the Xiang Shan hotel in the Fragrant Hills outside Beijing, a new garden using rocks from the Stone Forest at Kunming has recently (1981) been made along traditional lines. It includes a 'wine-cup stream' in the style of the Qing dynasty cut into the stone floor-slabs of a bridge in memory of the famous poetry-writing competition at the *Lan Ting. An impressive programme of tree planting under the People's Republic (see also *Nanjing) has helped lessen the effect of dust storms and wind, and several public parks with small lakes have been made in the city. Among famous buildings set in their own parks are the Temple of Heaven, with splendid ancient junipers, southeast of the old city walls, and the Ming and Qing tombs set in hills within driving distance of the city. Beyond the Great Wall lies the Qing imperial park and palace *Bi Shu Shan Zhuang.　　　　M.K.

See also CHINA: EXTRAVAGANT ENTERTAINMENTS; GONG WANG FU; XIE QU YUAN.

Belan, Co. Kildare, Ireland, whose ornamentation was begun at the beginning of the 18th c. with the construction of canals, avenues, and formal groves, was further enhanced in the 1770s by the erection of a grotto, a monopteral temple, and a hermitage. A Gothic temple and a camera obscura were constructed in 1792. There were also a Chinese bridge and no less than three obelisks, one of which survives along with the earlier temple in the now ruined *demesne.　　　　P.B.

Bélanger, François-Joseph (1744–1818), French architect, stayed several times in England between 1770 and 1778, the date of his projects for Lord Shelburne's gallery in London. His sketch-book shows his interest in landscape gardens and the principal protagonists of neo-Palladianism. Appointed designer for the *Menus-Plaisirs*, the body responsible for temporary decorations and stage scenery for the court, he soon became the architect to the Comte d'Artois, brother of Louis XVI, for whom he built stables at *Versailles, and above all the Pavillon and gardens at *Bagatelle.

He had a great influence on the art of the *jardin irrégulier*, excelling in laying out picturesque landscapes enhanced by numerous fanciful *fabriques, such as the *Folie Saint-James; work for Jean-Joseph *Laborde at *Méréville; the garden of the writer Beaumarchais; and projects for the Prince de *Ligne at *Beloeil.　　　　M.M. (trans. K.A.S.W.)

Belgentier, Var, France. See PEIRESC, NICOLAS-CLAUDE-FABRI DE.

Belgium

MEDIEVAL GARDENS. Very little is known of the history of parks and gardens in Belgium in the Middle Ages. From the rare sources available, we see that the gardens of this period were enclosed, small, laid out in an extremely ordered manner, and situated frequently in the courtyard of the house, on an adjoining terrace, or in a cloister. The well-ordered appearance of the garden is the result not only of the way in which it was laid out but also of the fact that it was enclosed. The garden, symmetrical in its design, was divided into relatively simple right-angled sections, each surrounded by a stone edging and separated from one another by straight pathways. These sections were decorated with grass, moss, and flowers and also with clipped shrubs and other greenery planted in tubs or directly into the soil, not always in strictly symmetrical arrangements. A focal point was sometimes provided by a fountain or a piece of sculpture. On occasions, at the base of the enclosure, there was a low wall on which flowering plants were set; alternatively, an ornamental hedge was planted there.

The ornamental garden frequently doubled up as a kitchen and herb garden or orchard. In the course of time the ornamental function of the garden gained in importance and its size increased, but it tended to remain enclosed for quite some time, and the geometrical layout was a feature of gardens on into the last quarter of the 18th c.

Sometimes the garden was just one part of larger grounds, which generally included a game reserve and fish-pond. The area surrounding the garden, where it merged into the rest of the estate, was sometimes arranged along more naturalistic or landscaped lines, a style found throughout Europe in the 15th c. The main example of a medieval garden, dating for the most part from the 14th and 15th cs., was to be found in the grounds of the *Brussels Court.

THE SIXTEENTH CENTURY. In the 16th c. gardens increased in size but remained enclosed, retaining an orthogonal and symmetrical layout, and divided into separate sections, although, within these sections, the design became more complex. Meanwhile, increasingly common features of gardens were arbours and *cabinets de verdure* on wooden supports with some sculpture incorporated, enabling the occupants to experience the sensation of being in a labyrinth. The new private garden at the Brussels Court, created for Charles V *c.*1520, already contained such features and they were retained when it was redesigned at the end of the century. This period also saw the appearance, in gardens or on public squares, of round or polygonal bowers, formed by a tree pruned in layers and supported by a framework of small columns; an example of one of these can still be seen at Macon-Momignies.

In the second half of the 16th c. the art of garden design underwent more change, influenced by the new taste from Italy. The collection of plans by Jan Vredeman de Vries, *Hortorum viridariorumque formae*, published in Antwerp in 1583, may be regarded as representative of the Flemish Renaissance ideal pursued in these provinces. Gardens designed according to this style were still enclosed—either by clipped shrubs, low walls, lattice work, or balustrades—and the enclosure sometimes subdivided the garden.

The garden consisted of parterres laid out in a sometimes very intricate geometrical and symmetrical pattern, even including a *guilloche* or maze design, and either extending over the whole area of the garden or being repeated within this area. The parterres, dotted with pruned shrubs, were surrounded or crossed by a regular pattern of *palissades* or arbours which sometimes formed loggias or *cabinets de verdure* down the centre or along the sides. The overall design was, on occasions, further enhanced by fountains, statues, or sculptures incorporated into the framework of the arbours or the enclosure, and sometimes a tree with a straight bare trunk stood in the centre of the parterre. There was also now some attempt to integrate the garden and the buildings, and this was encouraged by the gradual replacement of medieval residences by houses built according to the new regular patterns. The fact that the gardens were generally rather modest in size, added to the flatness of the land, meant that not so much use could be made of terraces, which, as in Italy, would have given a more architectural treatment of space.

Another point to be borne in mind is that in the 16th c. the taste for gardens was one aspect of the new humanism and that it derived considerable benefit from a widespread enthusiasm for the art of plant growing, closely linked with the science of botany which was making great strides forward at the time, as is evidenced by the publications of *Dodoens of Mechelen (Malines). New plant species were introduced, in particular the tulip and the lilac. Pieter Coudenberg's garden, begun *c.*1550 at Borgerhout, near Antwerp, was soon to contain more than 600 foreign plants. However, the new enthusiasm for gardening and botany suffered a serious setback with the religious and political disturbances of the last third of the century, which occasioned widespread destruction and caused many gardening enthusiasts and designers to emigrate.

THE SEVENTEENTH CENTURY. In the 17th c. gardens continued to increase in size, but the preference for the traditional orthogonal and symmetrical layout was retained. The four-sided beds thus formed seem to have been planted more often with clipped bushes (yew and box) and decorated with sculptures, fountains, and ornamental ponds as well as with foreign species of shrub, such as laurel, myrtle, and orange, planted in tubs. The parterres were still arranged according to a frequently complex geometrical pattern, but the French example of sweeping arabesque patterns in plant material (*broderie*) was growing in

popularity, as evidenced by a view of Affligem Abbey, published in 1658 (which also shows a maze of hedges), or the gardens belonging to the Comte de la Tour de Tassis, created in Brussels *c.*1670. The treatise by the Prince of Orange's gardener, van der Groen, which was reprinted in Brussels in 1672, actually proposed both types of parterre arrangement.

Another trend at this time was the diminishing importance, and in some cases the disappearance, of the enclosures, bowers, and arbours. This made for greater simplicity, and contributed to the integration of the whole; such integration, now emerging in France, did not, however, make any great impact in the Belgian provinces until the 18th c.; the same is true of attempts to arrange the garden in such a way as to form a harmonious whole with the house. In addition, the garden continued to retain its own identity, separate from that of any grounds lying beyond it, although there was a tendency for straight, tree-lined avenues bisecting the whole estate which, on occasion, took the form of an impressive drive, as at the château at Broechem.

Finally, it was the first half of the 17th c. which saw the development of rockeries, sometimes also incorporating shells, designed according to the Italian taste. These sometimes included ornamental waterworks.

The first significant achievement of the 17th c. was the Belvedere gardens at Akkergem, near Ghent, laid out *c.*1620 for Bishop Triest. These gardens consisted of a vast pattern of some 20 rectangles, separated by straight *allées*, most of them cross-divided into four and planted with vegetables or botanical species. Separated from these by a ditch were four rectangles, grouped together near the house, made up of parterres of a complex geometrical design which constituted the garden proper. Its outer limit was marked by a *palissade* in the form of a series of arcades surmounted by broken pediments. Dotted around the gardens were various statues, obelisks, and bushes, while, alongside the enclosure, baroque **fabriques* had been set at the end of the main *allées*. Although the disappearance of the internal enclosures did mean that the gardens could be viewed as a whole, they could not yet, consisting as they did of a juxtaposition of rectangles, be said to exhibit a genuinely integrated design.

Dating from the same period, Rubens's garden in Antwerp was also subdivided into four rectangular parterres, surrounded by a low hedge; the gardens of the royal château at Mariemont were composed of a set of rectangles, containing parterres of different geometrical shapes, surrounded by hedges. On one of these hedges could be seen a remarkable series of giant topiary figures and animals.

The gardens at **Enghien*, built principally in the mid-17th c., constitute by far the major achievement of the century. This impressive large-scale creation contained separate, virtually autonomous, sections, each spectacular in its own right.

One of the first major attempts to create a classical garden along French lines, with parterres and lake bordered by rows of full-grown trees, and, thanks to one major perspec-

tive centred on the château, forming an integral whole, would seem to have been made at Bouchout, near Antwerp. This garden, which is known to us from an account of 1725, probably dates from 1675 at the earliest.

THE EIGHTEENTH CENTURY. The 18th c. witnessed a distinct revival of parks and gardens. While several abbeys and châteaux were redesigning their gardens in accordance with current tastes, many new ones sprang up, particularly in the areas surrounding the three prosperous cities of Brussels, Antwerp, and Ghent. Once the French classical garden had gained full acceptance, it was the informal English garden which then began to come into its own.

During the first decades of the century, gardens were still designed, to some extent, according to the old style: they were frequently very small and enclosed, and divided up into the traditional array of parterres, as at the châteaux of Freyr and Seraing. However, the sweeping floral *broderies* were becoming increasingly popular, as were *palissades*, as at the châteaux at Florennes and Farciennes.

The garden of the royal château at Mariemont, redesigned by Charles of Lorraine *c.*1755, is an impressive example of a transitional style. Behind the château, with which it had been carefully harmonized, the open space of the main garden was bisected by a central *allée* of the same breadth as the central section of the front of the house. This *allée* was bordered on either side by a sweep of sumptuous parterres in varying shades of flowers, surrounded by orange trees and exotic bushes. Down each side of the park, at the centre of which was an ornamental *bassin*, ran a gallery of **charmille*, level with the outermost sections of the château. Behind the main garden, separated from it by a transverse *allée*, were the secondary gardens, through which the central *allée* continued to run. While the rococo style was in evidence in the main parterres at Mariemont, it gave way, by and large, to shapes characterized by curves and counter-curves, such as those of the lateral parterre at **Beloeil* and the ornamental lake at the château at Grimbergen.

During the first three-quarters of the century—until the introduction of the English style—the garden, still formal in its layout, was modelled increasingly often on the French classical garden. One central perspective and a series of secondary ones now formed a framework for an integrated design which took in, as well as the house, the whole of the grounds, now opened up. However, in the trees to the sides, recesses were made, in which *fabriques*, such as Chinese *cabinets*, were sometimes set. But this trend was rather slow to develop and there were few outstanding examples of fully-fledged gardens of this type.

It was not until the mid-18th c., at Beloeil, that the French classical garden finally gained a firm hold in the Belgian provinces. The park at Leeuwergem, dating from the same period, was similarly inspired, albeit along less grandiose lines. In its original form, its axis, running down from the château, included a rectangular shaped pond with one curved end, set between *bosquets* in the classical style, and beyond this a lawn, followed by an avenue. At Sterrebeek, which was designed *c.*1760, the central axis was

formed by a rectangular lake. On either side stretched parterres, divided up in a variety of ways, and at its centre stood the house. Annevoie, on the other hand, which dates from the same period, was designed and later altered by its owner. It was laid out as a random arrangement of ornamental *bassins* and formal gardens, according to a personal taste.

The first example of a complete classical arrangement is to be seen in the landscape design of the château grounds at Seneffe. The work was begun in 1763 by the architect Dewez, who also designed gardens for his other buildings, most of them abbeys. At Seneffe the plan, designed to set off the château, has one central axis, some 1,200 m. long, which, beginning with a triangular pond, moves along the 600-m. drive of the château, then through a grassy forecourt bordered with beech quincunxes, and through the château courtyard. In the grounds on the other side it continues as an *allée* lined with parterres and bowers, as at Mariemont,

moves through a round *bassin* and ends as an open vista through the trees. In the park, two oblique *allées* were cut through the lateral wooded areas, to converge near the centre of the back façade of the house. Other transversal paths were cut through the trees and clearings made for *fabriques*, including an orangery and a theatre designed according to the ancient Roman style. Secondary gardens (a vegetable garden and an orchard) were located at one side, arranged on three staggered terraces.

The *Brussels Park, begun in 1776, is the last of the great formal gardens. This large square-shaped area, most of it covered with trees, has a series of straight *allées* cut through it to make it an integral part of the new quarter in which it was located.

During the last quarter of the 18th c. there was a revolution in the art of gardening. The formal style which had predominated for centuries was replaced by the

The Rocher at the château of Attre, Belgium, lithograph (*c.*1825) after A. Boens

informal English style, enabling the most to be made of nature, while also meeting the need for personal liberation. The garden, which now tended to extend over the whole area of the grounds, was henceforth characterized by irregularity, in terms both of layout and elevation. This resulted in quite a variety of picturesque sites and vistas, 'natural' in appearance but exhibiting, none the less, a taste for sophistication, in the form of Graeco-Roman pavilions dotted around the place, and sometimes even more unlikely whims, such as rocks, Gothic ruins, pagodas, rustic cabins, or bridges; meanwhile, integration of house and garden became less important, and parterres of flowers, pretty freely designed, became almost optional extras. Examples of the new taste were sought in England as well as France. The refined variety of the English garden brought about an increase in the use of foreign plants—in particular the Lombardy poplar and the rhododendron—cultivation of which was encouraged by many knowledgeable gardening enthusiasts, by the Louvain University botanic gardens (which underwent remarkable development in mid-century), and by the *Manuel de l'arboriste et du forestier belgiques*, published in 1772 (and later) by the Baron de Poederlé.

The new fashion caused changes to be made to some of the older gardens, such as Beloeil (by the Prince de *Ligne), Baudour, Leeuwergem, Enghien, and Seneffe (by the Frenchman Brongniart), but it was not long before it gave rise to entirely new creations. These included Trois-Fontaines at Vilvorde, Evere, the Rivierenhof at Deurne, the Belvedere and the royal estate at *Laeken, Wannegem, and Wespelaar (by the architect Henry).

Among the more outstanding legacies of the new taste should be mentioned the artificial rock in the château grounds at Attre. Built *c.*1785, within a landscape designed according to the English style, on the edge of a pool and of hewn stones of sometimes gigantic proportions, this rock, which attains the exceptional height of 24 m., consists of a hollow mound surmounted by a ruined tower, which can be reached, heart in mouth, by winding pathways climbing between jagged stones.

The overthrow of the Ancien Régime, at the end of the 18th c., was the occasion of widespread destruction, and this particularly affected the enormous gardening heritage of the abbeys.

THE NINETEENTH AND EARLY TWENTIETH CENTURIES. In the 19th c. the landscaped garden, designed along increasingly simple lines, became extremely popular. Existing gardens were redesigned and new ones were laid out—in particular, the new municipal parks. Enthusiasm for gardens, which was channelled largely by architects specializing in landscape design, went hand in hand with a spectacular expansion of horticulture. The first became evident right at the beginning of the century, principally at Enghien and in the Ghent area. Ghent was soon to become a world centre for the cultivation of the camellia and the azalea. Jean Linden deserves to be known as the 'father of the orchid', for he successfully grew in Brussels a large number of species of this plant which he had brought back from the United States. This expansion of horticulture was a response, on the one hand, to the fashion for new types of parterre, particularly the 'basket' (*corbeille*), a bulging and opulent mixture of unusual flowers and greenery, and, on the other hand, to the popularity of winter gardens, increasingly built of metal, either as an extension to the house or set apart from it, to accommodate species such as the palm tree. The most important such garden still survives in the grounds at Laeken. Finally, the number of tree varieties to be found in estates increased with the proliferation of species such as the weeping willow, the cedar of Lebanon, the sequoia, the monkey-puzzle (*Araucaria araucana*), and the maiden-hair tree (*Ginkgo biloba*), while the rhododendron came to play a decisive role.

In the first half of the 19th c., gardens continued to be designed along English lines, making for increasing contrast with the style of the house, which was becoming much more regular and stylized. The first two decades thus witnessed the creation of gardens at Duras, Bazel, Meise, and the garden on the Piers estate at Laeken, all of which were designed by the French architect and town planner Verly (who had designed the Colisée landscaped park in Lille, opened in 1787). A great number of other informal parks were designed subsequently, such as those at Mariemont and at Bouchout, near Brussels, which was later joined together with the one at Meise and the whole area purchased by the State in 1938 for its botanic gardens. It may be pointed out here, incidentally, that André *Parmentier, a native of Enghien and brother of the well-known horticulturalist, designed a number of gardens in the naturalistic style in the United States and Canada, where he played an essential role in popularizing this style.

The number of informal gardens continued to increase during the second half of the 19th c., and this trend received additional impetus from the increasingly urban mode of life which led to the creation of municipal parks. However, these parks tended rather to exhibit the influence of the landscape style proper, which was so popular in France. Characterized by a circuit of principal and secondary paths, some of which were suitable for vehicles, and forming a pattern of more or less irregular ovals, the new style of garden allowed for a wide choice of walks and vistas in a more natural arrangement. There was less use of *fabriques*, but rocks remained popular, and chalets and metal greenhouses became more common. The park at Antwerp was even the site of a large metal suspension bridge (the first bridge of this type had been built *c.*1820 in the park at Bazel, designed by the engineer Vifquain). The principal garden designer of this second half of the 19th c. was Edouard Keilig, who arrived in 1853 from Germany where he had been trained. His creations include the park of the château at Jeneret (at Bende) and the municipal parks at Brussels (the *Bois de la Cambre), Antwerp, and Ostend.

Although in the 19th c. it was the informal garden which predominated, some formal gardens were also laid out at this time: the Brussels botanical gardens (1826), the Kalmthout nurseries, founded by Charles Van Geert (1858), the final stretch of the Avenue Louise, designed by Keilig, and

the square of the Petit Sablon in Brussels, designed by the architect Beyaert (*c.* 1875), using ideas from Belgian 16th-c. styles. The squares of the Quartier Nord-Est, Brussels, designed in 1875 by the architect Bordiau, combine landscaped and classical style; they appear also as an important example of the integration of the garden in town planning, which is characteristic of this century. Although in these instances there may have been specific reasons for the choice of a formal layout, in the final analysis they also bear witness to a change in taste and this received full confirmation with the creation of the classical gardens at Tervuren for the 1897 international exhibition, by the French architect Lainé.

This return to a formal layout was confirmed during the first half of the 20th c., although informal designs were not abandoned and there were instances of a combination of the two styles. The Arboretum at Tervuren (1902) was designed according to a landscaped style, while the fashions for alpine and Japanese gardens also served to promote the informal style. However, the combined style—formal and informal—was gaining ground, as evidenced, for example, by the plans made by the Frenchman Girault in 1906 for the grounds of the royal chalet at Ostend. Meanwhile, the formal style—often in traditional vein—won new favour early in the century, as can be seen from the work of the Frenchman *Vacherot, of Jules Buyssens (influenced also by the English wild garden) or of Louis Van der Swaelmen. At this time there are even instances of centre parterres being revived along classical lines, for example at Seneffe by Vacherot, or at Attre by Coutant. X.D. (trans. K.L.)

MODERN GARDENS. The formal style of André and Vacherot was expressed from *c.* 1920 in the *jardin construit*—the renewed integration of house and garden, along regular but not necessarily symmetrical lines, which sometimes contained relatively autonomous subdivisions. The garden was arranged on a series of different levels, separated by low walls. Clipped bushes emphasized the architectural character of the design, although plants were also arranged in a freer, albeit balanced, fashion, as, for example, in the 'mixed border'. An example of a garden in this style adjoins the house of Dr Martens at Astene. The architect Henry Van de Velde drew up plans for both house and garden *c.* 1930.

This style was also continued by Jules Buyssens, who successfully combined the roles of painter, designer, and contractor in laying out a number of gardens in Belgium and eastern Europe. These include the Astridpark in Brussels, the gardens of the Abbaye de la Cambre, elements of the 1935 Brussels Exhibition, and the famous Osseghempark on the Heyselplateau, a blend of different styles. He pioneered the making of terraces from stone found on site, thus establishing a strong physical relationship between site and design. His collaborators included Alfred van Hout, advocate of the Green Plan with particular reference to the use of trees, René Pechère, widely known for his work in *France and Belgium, and René Latinne. Pechère's work is eclectic, with a strong tendency toward the formal, and distinguished by marked attention to detail, as in the modification of Buyssens' Garden of Hearts and the Labyrinth adjoining the van Buuren Museum in Brussels, and the Four Seasons Garden at the 1958 Brussels Exhibition.

During this period a number of designers worked independently of the formal tradition, notably Dumonceau, Janlet, and Canneel-Claes. The last-mentioned is one of the few landscape designers (cf. Guevrékian in France) to come to terms with the Modern Movement of the 1930s.

The social movements of the 1940s with their emphasis on people and ease of maintenance are reflected in the work of René Latinne, who concentrates on the use of perennials, often in combination with water, in a neo-classical idiom. The emphasis upon public landscapes also led to the establishment of a number of landscape design schools, the first of which was started by Latinne in association with Paul Dewitt. This and successive schools have helped establish the profession of landscape architecture in Belgium. X.D./J. DE G.

Beloeil, Belgium. The present gardens are the result of a rearrangement made for the most part in the mid-18th c. under Prince Claude-Lamoral II de Ligne, assisted principally by the French architect Jean-Baptiste Bergé.

The main section of the gardens, which covers a rec-

Design for Veyrier-du-Lac, Haute Savoie, France, by the Belgian, René Pechère

Garden (1935) in the Dendre
Valley, Flanders, Belgium, by
Jean Canneel-Claes

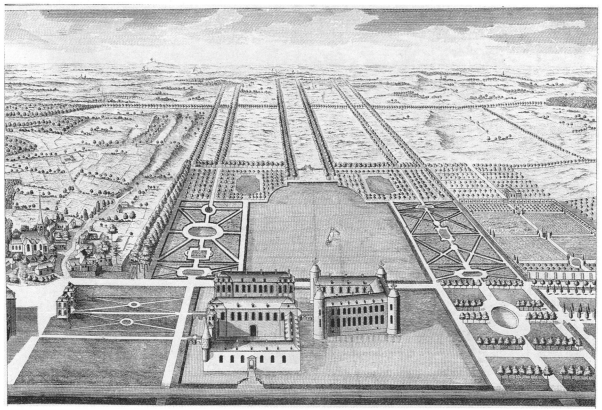

Beloeil, Belgium, engraving (1747) by de la Marcade

tangular area of 20 ha.—a quarter of the ordered part of the estate—is the principal example in Belgium of the classical French style. This majestic composition is given its overall shape by a long stretch of water which leads down from the château and is bordered on either side by *bosquets* containing clearings. The stretch of water, measuring 440 m. × 130 m., with its rounded top end decorated with a monumental fountain, forms an imposing perspective, framed on the sides by clumps of trees and extended, beyond a parterre, by an axial *allée* which cuts through a formally laid out wood and peters out into the countryside. On either side of the water, beyond two lateral *allées* of *charmille*, *bosquets* create a secondary axial perspective, parallel to the main one, as well as a series of transverse and oblique views. Divided up geometrically, these copses contain two successions of green clearings, different in appearance but similar in size, both decorated with ponds.

To the right of this composition and of the château are the vegetable gardens, divided into rectangles, and sweeping *parterres de broderie*. The part near the château was turned into an English garden *c*.1780, with assistance from the French architect *Bélanger, by Field Marshal Prince Charles-Joseph de *Ligne, the well-known author of *Coup d'œil sur Beloeil et sur une grande partie des jardins de l'Europe* (1781). X.D. (trans. K.L.)

Belon, Pierre (1518–63), French plant collector. See PLANT COLLECTING.

Belsay Hall, Northumberland, England, an early and important, pure and severe Greek revival house, is surrounded by extensive parkland. Tall elms and limes frame the hall built by Sir Charles Monck (1779–1862) in 1807. Terraces and a 4·5-m. arched *ha-ha drop into the valley, where the still waters of the lake reflect the stature of the Hall. Behind lies a deep, unexpected, picturesque quarry garden filled with many rare semi-hardy exotic trees and shrubs which add to the mystic qualities of the sheer sandstone cliffs topped with dark drooping yews. The quarry was formed by the extraction of the stone with which Sir Charles built the Hall, and was filled with plants by his grandson, Sir Arthur Middleton (1838–1933). A high arch, an ivy-clad pinnacle, a secret door draped with tangled branches beckon the visitor deeper into the ravine. Through a tight passage, under an enormous laburnum, the Tower Castle and ruined Manor are seen. The Hall, castle, and gardens were taken over by the state in 1980. E.B.

Belt. The term is used in two senses in 18th-c. English landscape in particular. First, there is the sense of a planting of trees round the perimeter of an estate, with or without a walk or drive. Designs for belts can be found in *Switzer and many of Brown's plans included a belt of trees, good examples being at *Bowood Gardens, *Petworth House, and *Wimpole Hall. Since the belt delineates the boundary of the grounds, it is in this respect opposed to the approach of William Kent who opened up the estate to let the country outside seem part of it.

The second sense is the perimeter drive or walk itself. This is a prominent feature of both the famous *fermes ornées*, The *Leasowes and *Woburn Farm. From the belt walk the visitor could look continually into and across the garden within. M.W.R.S.

Belvedere, literally 'beautiful view'; a look-out or turret usually sited in a commanding position, either as a separate building, or as part of a villa. Particularly common in Italy, perhaps the finest is by Bramante in the Vatican Garden (see *Belvedere Court). The Belvedere Palace in its park in Vienna has a large baroque building commanding views over part of the city and over extensive gardens. The most imposing English example is the belvedere created by Vanbrugh at Claremont (1715) to afford a view over the lake and landscape. G.W.B.

See also GAZEBO; MIRADOR; PROSPECT TOWER.

Belvedere, Weimar, Erfurt, German Democratic Republic. The park extends over the Eichenleite hills, covering an area of 41 ha. and reaching down into the valley. The Schloss and many other buildings dating from 1724 to 1726 are by J. A. Richter, who also designed the garden, completing the plan for the whole grounds in 1756 and the Kavalierperspektive in 1758. The park was designed in a regular star shape; the various sections contained animal enclosures. The horseshoe-shaped orangery with its wealth of orange trees was built to the east of the Schloss between 1739 and 1753.

Because of the very high maintenance costs the adjacent buildings were demolished one by one. Under Duchess Anna Amalie the park was extended *c*.1766–7 to the south to the Possenbach pond, where a grotto and hermitage were built and the Giant Avenue laid out on rising ground through the woods. Between 1780 and 1830 under Duke Karl August the park was redesigned in the landscape style. Goethe was actively involved in adding to the plant-collections.

Subsequent additions were a Russian Garden (1810), a small garden theatre (1823), and a maze (1843). The park was rearranged between 1843 and 1850 in its present form which preserves parts of the baroque garden; a large flower-garden was laid out to the south of the Orangery, and to the north of the Schloss a Soviet cemetery was made for soldiers of the Russian army killed in 1945. Extensive reconstruction work has been under way since 1972. H.GÜ.

See also SCKELL, JOHANN CONRAD.

Belvedere Court, Vatican. Begun *c*.1505 by Donato Bramante for Pope Julius II. Nicholas V had established monumentality as the characteristic of Roman Renaissance architecture and, when Julius II commissioned Bramante 50 years later to link existing buildings adjoining St Peter's with the old Villa Belvedere, he was following in a tradition of grandeur from which the Papacy has never wavered. The design proved to be a revolution in landscape architecture. The court, *c*.300 m. × 100 m., was immense; it was totally

enclosed architecturally and divided into three parts whose proportions were clearly inspired by the original terrain. The largest and lowest was an arena for pageants, surrounded by arcades and seats for spectators; the middle part was formed by seating overlooking the arena, punctuated by a central stairway and extending the full length between two projecting bays; the third part, a museum to exhibit ancient statues, was a formal garden with a semicircular niche as a climax. The sense of theatre, inherited from classical Rome, pervaded the whole concept; the three parts, indeed, could be likened to an auditorium, a proscenium, and a stage with green scenery. At a later date the niche was raised to form the present semi-dome and the length was subdivided into two separate parts by the library of Sixtus V in 1580. Nevertheless, the imagination can still re-create what was perhaps the noblest of all internal architectural landscapes.

G.A.J.

Belvedere Gardens, Akkergem, Belgium. See BELGIUM: THE SEVENTEENTH CENTURY.

Belvedere Palaces, Vienna, Austria, lie to the south-east and immediately outside the medieval city on land made safe after the raising of the siege by the Ottoman Turks in 1688. The land slopes upwards from the city, providing a natural view over roofs and spires and giving a sense of space far removed from that within the old walls.

The palaces formed a group of great gardens in the following order: the Botanical Gardens, the Salesian Nunnery, the Belvedere main garden and subsidiary, and the *Schwarzenberg Palace. The Lower Belvedere was completed in 1716 and the Upper in 1732 for Prince Francis Eugene of Savoy. The architect was Lukas von Hildebrandt, who designed the gardens in collaboration with François Girard. The main garden is a rectangle joining the two palaces and is in fact two gardens (lower and upper) so ingeniously blended as to form a whole that is unique among gardens of any period.

A painting (in the Kunsthistorisches Museum, Vienna) by Bernardo Bellotto (1720–80), a nephew of the more famous Canaletto, shows in meticulous detail the view from the Upper Belvedere. It is virtually what exists today, and from this can be appreciated the full glory of Austrian baroque landscape design with its ground modelling. Pools, fountains, parterres, paths, stairways, sculpture, and tall immaculately clipped hedges are the foreground to a sky and cityscape that together form a single spectacle. There is a magnificent forecourt to the Upper Belvedere and to one side was a menagerie whose animals formed the nucleus of one at Schönbrunn.

G.A.J.

Belvoir, Villa, Zurich, Switzerland. Between 1826 and 1831 a rich merchant, Heinrich Escher, had a villa with the first large landscape garden in Zurich built on a rise of the western lake-shore. The park was substantially enlarged later in the century and was at that time considered the 'pearl' of English landscape design in Switzerland. In front of the villa lay flower-beds and pleasure-grounds, connec-

ted by groups of magnolias to the picturesque wildness of the nature park which contains groups of conifers, large single specimens of deciduous trees, and high islands of planting, the dark green of the different conifers punctuated by light green trees. The large lawn with extensive view of the lake has a fountain at its centre. Contrasts and changes of mood are created through the use of weeping willows, natural thickets, copper beeches, and birch trees according to the postulates of Hirschfeld and Sckell. The garden has been preserved as a public park.

H.-R.H. (trans. R.L.)

Bengal cottage, a variety of mid-19th-c. English summerhouse with mud walls, bamboo frames for door and window, and a reed roof. In fact, there was a fashion at the time for timber buildings in a number of quasi-national styles: in addition to the Bengal cottage, we find the Scots cottage, the Polish hut with a roof of fir, and Russian, Danish, and Swedish huts.

Oriental and cottage-style buildings from the late 19th c., made from Douglas fir with hazel inside, are to be found at the Larmer Tree Gardens, Wiltshire.

M.W.R.S.

Benrath, Düsseldorf, North Rhine-Westphalia, German Federal Republic. The Neues Schloss was begun in 1756 by Elector Karl Theodor, whose architect and park designer was Nicolas de Pigage, who also built Schwetzingen. Representative of the style of a *maison de plaisance* or country seat, the palace consists of a main building with two wings arranged in a semicircle round a pool, a form that draws attention to the pavilion-like central block while setting it back from the road as an integral part of the garden. Thus the private apartments at the sides of the main building had their own gardens, separated from the main garden, the formal garden being reached through the banqueting hall.

The layout was skilfully designed within existing grounds. The principal axis is formed by a canal joined on the west by the main *bosquet*. The square ground-plan is divided into a star pattern, wide hedged avenues issuing from the centre, their outer ends connected by a circular avenue. Twisting paths run through the *bosquet*, originally forming hedged or trellised *salles de verdure* at points of intersection. The *bosquet* is encircled by a narrow canal, water playing an important part in the design of the garden as a whole. Despite loss of shape the original design is still discernible.

U.GFN.D.

Berceau (or berso), a vault-shaped trellis, on which creepers, vines, roses, and other climbing plants are trained.

D.A.L.

See also ALLÉE EN BERCEAU; TONNELLE.

Bernadini, Villa, Saltocchio, Tuscany, Italy. The garden composition, dating from *c.* 1590, consists in a grand, formal axial woodland garden, now in decay, and a cross-axial, enclosed water garden. The significance of the garden as a whole lies in the silvan character of the main axis. This idea had already been realized in the *Boboli Gardens, Florence, but the *boschi* (see *bosco) at Bernardini have an

added delight: on either side of the central grass avenue are two parallel rectangles of once thriving woodlands, within each of which was a sequence of unexpected little spaces.

G.A.J.

Bernier, François (d. 1688), a French physician, entered the service of Danishmand Khan, a supporter of the Emperor Aurangzīb. Over the years 1658–64 he travelled widely in India, and followed the emperor to Kashmir in the course of Aurangzīb's only visit there. Bernier's memoirs of travel were later published (*Collection of Travels through Turky into Persia and the East Indies . . . being the travels of Monsieur Tavernier Bernier and other great men*, London, 1684), and provide vivid accounts of the journey to Kashmir, and of gardens both there and in India. His descriptions of *Achabal, *Shalamar Bagh, and *Vernag in Kashmir, and of the *Red Fort, Delhi, and the *Taj Mahal, Agra, highlight the part played by water in all the gardens. His account of the irrigation throughout the interior of the Red Fort at Delhi is of particular interest. He refers, too, to the widespread use of fruit and flowers, and to the illumination of cascades.

S.M.H.

Betz, Oise, France. A vast landscape composition was created by Hubert *Robert and the Duc d'*Harcourt for the Princess of Monaco who acquired the estate in 1780. It is a perfect example of the romantic style which, with the picturesque and the poetic, constitutes the basic trilogy in the theory of the *jardin anglais*.

Although many of the *fabriques* have now disappeared, there remain a few little buildings in the neo-Gothic taste, the first of their kind in France: the column of Tancrède, a neo-romanesque hermitage with grinning masks, and a *corps de garde* (guard-house) with several ogival windows and a watch turret. But the most picturesque building is the old ruined castle with keep, naïve statues of knights, and inscriptions invented by La Curne de Sainte-Palaye, a historian specializing in chivalry. Well before Alexandre Lenoir, creator of the Musée des Monuments Français, authentic remains were reused at Betz; thus, in the Vallées des tombeaux planted with cedars, firs, and poplars, were collected old tomb-stones from the Cemetery of the Innocents in Paris, recently secularized. The finest edifice in the park is still the Temple de l'Amitié by the architect Leroy, containing an original cast of Pigalle's group, *L'Amour et l'Amitié*.

M.M. (trans. K.A.S.W.)

Białystok, Poland. The 15-ha. park and palace in the town of Białystok, 170 km. from Warsaw, were developed from 1728 to 1758 as the residence of the Branicki family. They are among the most beautiful baroque palace and garden developments of the first half of the 18th c. in Poland. The entrance to the palace leads along the main axis through the monumental tower gate (1755–8) and then through the double palace courtyard. Behind the palace there is a *parterre de broderie* decorated with many sculptures and vases. The parterre is surrounded on both sides by an asymmetric brick wall bearing the balustrade and the irregular moat with *bassins* at the end, and a small cascade.

The Arcadian bridge over the moat is at the end of the main axis. The lateral sections of the garden on the upper and lower terrace are covered with *bosquets* and linked with the axis of the side *allées*, each closed at the end by a pavilion, a survivor of the numerous examples existing at one time.

The park now partly belongs to the Medical Academy and is occasionally open to the public.

L.M./P.G.

Bian, or calligraphic board, is a rectangular wooden board usually lacquered and sometimes with carved borders, hung horizontally in Chinese gardens under the eaves of a building or on an interior wall. On it is displayed the fine calligraphy—the name of the structure, or a phrase in praise of the owner or the view—essential to any Chinese garden of merit. These names and phrases were usually taken from poetry or prose well known, in that highly cultivated society, to all garden visitors. The Hall of Distant Fragrance (Yuan Xiang Tang), in the *Zhou Zheng Yuan for instance, refers to the line from the Song-dynasty poet Zhou Dunyi: 'A distant fragrance is all the more pure.' Recollecting the context of a quotation like this gave added meaning to the pavilion and was itself an enjoyable literary game, but choosing the names was equally important: a whole chapter in the famous novel *Dream of the Red Chamber* (*Hong Lou Meng*) is given over to deciding the characters for the *bian* in a newly-made garden, the Da Guan Yuan.

X.-W.L./M.K.

Biddulph Grange, Staffordshire, England, though only 8 ha. in area, has one of the most remarkable and innovatory English gardens of the 19th c. From the 1850s onwards, James Bateman, a distinguished horticulturist, with the aid of Edward Cooke, designed a framework of picturesque settings which would provide the variety of conditions he needed to grow a wide range of plants. Though in need of restoration and replanting, much of the garden still remains, including the rhododendron ground, the glen, the Egyptian court, the Cheshire cottage, 'China' (a Chinese garden), the lime and deodar avenues, the pinetum and traces of the *arboretum, and the 'stumpery', an area of old gnarled oak stumps interplanted with woodland plants.

The various parts of the garden were carefully secluded by skilful landscape design, while one area was linked to another with great ingenuity. The Egyptian court, with its flanking sphinxes and monumental entrance under a yew pyramid, is joined by a dark passage-way to the Cheshire cottage which leads into the pinetum. From a cave in the glen a winding flight of steps leads to 'China', the most striking of all the garden scenes at Biddulph, with its temple in a willow-pattern setting, dragon *parterre, bamboos and maples, Great Wall, look-out tower, and joss-house.

At the time of writing, the National Trust is hoping to acquire and restore the gardens.

P.H.

See also EGYPTIANIZING GARDENS; HOT-HOUSE PLANT.

Bijhouwer, Jan Thijs Pieter (1898–1974), Dutch landscape architect, as a freshly graduated agricultural engineer in the early 1930s was appointed consultant landscape architect for the planting of the first Zuiderzeepolder and

Biddulph Grange,
Staffordshire, the
Egyptian garden

the Wieringermeer villages. In the 1940s he continued his work on the Noordoostpolder. Working with the government service Staatsbosbeheer, he applied his considerable knowledge of the landscape in pioneering methods of ecological analysis and design which have become standard practice. As a member of the Dutch group of CIAM, 'De 8 en Opbouw', he participated in the first research project on the needs of open-air recreation, in Rotterdam in 1938.

He was a pioneer in the development of the profession of landscape architecture, and in particular its relationship with architecture and town planning. He is well remembered for his stimulating teaching at the University of Wageningen, and for a number of influential books including *Nederlandsche Tuinen en Buitenplaatsen* ('Gardens and Country Seats in the Netherlands') (1942), *Leven met groen in Landschap, Stad en Tuin* ('Living with Green in Landscape, Town, and Garden') (1960), and *Het Nederlandsche Landschap* ('The Netherlands Landscape') (2nd edn. 1977).

W.C.J.B.

See also SCULPTURE GARDEN.

Biltmore House, North Carolina, United States, built between 1891 and 1895 for George W. Vanderbilt, was designed by Richard Morris Hunt (architect) and the gardens laid out by Frederick Law *Olmsted (landscape architect). It is an outstanding example of the early eclectic period, from the 1880s to 1929. The French château residence with 365 rooms is surrounded by 4,100 ha. of spectacular mountain scenery. The formal gardens, covering 10 ha., have massive plantings of native laurel, rhododendrons, azaleas, boxwoods, and hollies. There is also a 1·6-ha. espaliered walled English garden, an Italian garden with pools, a rose-garden, and a greenhouse with an orchid display. (*See over.*)

Olmsted was engaged to assist in the acquisition of lands for the estate in 1888. He responded enthusiastically to the

social problems of industrialization and urbanization in the United States and was deeply interested in Vanderbilt's pioneer efforts with scientific forestry at Biltmore. The surrounding forest which serves as a buffer for the estate was donated to the United States Forest Service and became the nation's first National Forest.

Biltmore was the choice illustration of the United States' greatest of Great Houses and planned environs. It was also an important influence in the Country Place era movement.

H.B.O.

Bingham's Melcombe, Dorset, England, an early medieval manor-house with Tudor and Jacobean extensions, has gardens probably unique in showing three historic periods of indigenous English landscape design unaffected by foreign influence. Two walled gardens are typical of the enclosed gardens of the Middle Ages, either filled with useful or medicinal plants or as 'flowered rooms', as they are today (see *botanic garden; *medieval garden). By contrast, the ground extending from the late Jacobean west front was designed in open terraces falling from north to south. The uppermost was planted with a yew hedge, now so large (over 6 m. thick) as to envelop the original path. The second terrace is a great bowling-green that leads to views of the beautiful agricultural valley in which the complex is set. The third terrace is now (and may always have been) a formally planned kitchen garden. Encircling the formal gardens, which have had some unpretentious additions, is an 18th-c. romantic woodland landscape, with earlier stew-ponds, stretching along the stream that must have determined the original choice of site.

G.A.J.

Birkenhead Park, Liverpool, England, was the first designed *public park. The original site was very unattractive, swampy, low-lying land which fell 20 m. in a fairly uniform slope. It had no views, being surrounded by the

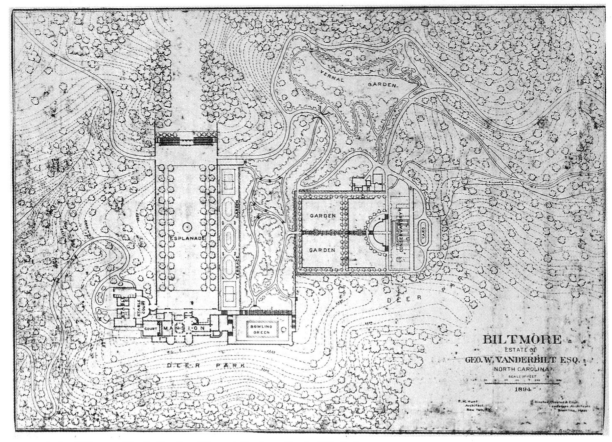

Plan (1894) of Biltmore, North Carolina (Harvard Graduate Scool of Design)

growing suburb of Birkenhead. Of the original area, 48 ha. were made into the park, the remaining 24 ha. were sold as private building lots.

*Paxton's design (1843) is an ingenious resolution of the problems. It is also quite original, owing little if anything to the 18th-c. landscape tradition. He created two major areas of interest around the lakes in each half of the park. Each lake, sinuous in outline, contains an island, which prevents the whole expanse of water being seen immediately. The larger eastern lake is crossed by a foot-bridge and over-looked from a stone boat-house surmounted by an observation platform. A series of views changing every few metres is seen from the path system which winds towards and away from the lakes. The element of surprise is heightened by the concealment of the further course of the paths by solid planting or massed rock-work at path junctions.

The lakeside areas are strongly enclosed by artificial mounds—up to 10 m. high and planted with tall trees in the eastern section. Originally the mounds were also planted with shrubs, heaths, and ferns, and the rock-work with mosses and rock plants. By contrast with these enclosed areas, the rest of the park, with the exception of a third smaller lake (now drained) and flower-beds, is a large open space. From the beginning one part was laid out for archery and cricket, an unusual provision for the period.

The circulation system connecting the town and the park is equally ingenious. Different types of traffic are clearly separated by means of a 'carriage drive' for pleasure traffic only, boundary roads outside the park for town traffic, and a transverse road across the park with restricted access. Originally nine lodges were proposed, two within the imposing main entrance (completed before 1847).

The design of the park was extremely influential, most notably perhaps upon F. L. *Olmsted who visited it in 1850 and reproduced its circulation system in a modified form at *Central Park. He was also impressed by the fact that '... the privileges of the garden were enjoyed equally by all classes', observing that '... in democratic America, there was nothing to be thought of as comparable with this People's Garden ...' (Walks and Talks of an American Farmer, 1852, pp. 72, 79).

The creation of the park was a considerable feat of engineering, directed by Paxton, with the assistance of Edward *Kemp. The whole site had to be thoroughly drained, the lakes excavated, and the spoil used to create the mounds. The rocks found or dug up from the site were then

used either as the foundations of the paths or for the rock-work at path junctions.

The park survives in reasonable condition today, although some of the buildings are in a poor state and the paths are railed in. P.G.

Birmingham Botanical Garden, West Midlands, England, provided J. C. *Loudon with his first opportunity to put into practice his ideas for a public garden for the study of botany (see *public parks, cemeteries, botanical collections, and public parks). He was asked 'to combine a scientific with an ornamental garden, and these to a certain extent with a nursery and market gardens so as . . . to lessen the annual expenses of keeping' (quoted in Phillada Ballard, *An Oasis of Delight, The History of the Birmingham Botanical Gardens*, 1983, pp. 18–19).

The most striking feature of his plan (published in the *Gardener's Magazine*, Aug. 1832) for the 6·4-ha. site, was a circular range of hothouses on the highest part of the site, near the main entrance on the north side. He adopted this form so as to avoid the unattractive view of the back sheds necessarily presented by a rectangular hothouse.

Unfortunately the Gardens Subcommittee rejected the hothouses on the grounds of expense and a conventional rectangular range was erected instead. Loudon was so incensed that he did not wish to be associated with the design in any way (*Gardener's Magazine*, 1832, p. 428) and called it a 'miserable failure' (op. cit., 1835, p. 657). He had to wait eight years for a similar opportunity, at *Derby Arboretum. P.G.

Birr Castle, Co. Offaly, Ireland, is an 18th-c. walled *demesne of 60 ha. adjoining the town of Birr and watered by the Rivers Camcor and Brosna. The latter is diverted at one point to form a lake and is spanned at another by what is probably the earliest suspension bridge in Ireland (*c.*1820). The present aspect of the early 17th-c. castle, the castellated gatehouse, and the entrance gates were all designed by John Johnston in the early 19th c. and the Vaubanesque ramparts by Colonel Richard Wharton Myddleton in 1845. In the same year the Giant Telescope House in the Gothic style was erected in the park. Outside the kitchen garden, and on the banks of the lake, is a Victorian fernery.

Inside the kitchen garden, and centred around a greenhouse by Richardson and Co. (*c.*1900), a suite of formal gardens was laid out in the 1930s to the designs of the Dowager Countess of Rosse. The *parterre contains a pair of baroque urns, and is enclosed by the Hornbeam Cloisters, alleys of pleached hornbeams, the ceilings of which take on a curving baroque form. A second garden has as its backdrop a pair of box hedges, 9 m. high. A Robinsonian wild garden, dating from the same period, extends along the banks of the Brosna as it flows beneath the castle walls. Both here and in the park is a rare and extensive collection of trees, many from the *Wilson, *Forrest, *Kingdon-Ward, Comber, and Professor Hu plant-hunting expeditions. These were arranged under the guidance of the 6th Earl of Rosse, an expert plantsman, and the Dowager Countess, whose principal interest has been in its design. P.B.

Bi Shu Shan Zhuang, China, is located beyond the Great Wall in Chengde, Hebei province, 260 km. north-east of Beijing; this Mountain Resort to Escape the Heat is the largest imperial garden remaining in China today. Also known as the Rehe (formerly spelt Jehol) Xing Gong or Hot River Summer Palace, its boundary wall winds and falls some 10 km. around a group of natural hills that rise in the centre of a valley. Outside the park, in the foothills of the

Eastern Lake boat-house, Birkenhead Park (1843), Liverpool, by Joseph Paxton

surrounding rim of mountains, eight great Outer Temples in Mongolian, Tibetan, and traditional Chinese styles are visible above the river and, with a strange geological formation—the Club Peak, shaped by the elements into a gigantic pestle silhouetted on the horizon—contribute dramatic borrowed views to the garden (see *jie jing*). This, and the genial climate, first impressed the Qing Emperor Kang Xi when he toured the region in the early years of his reign. Construction of the park started in 1703 and continued on a large scale for 87 years. Both the Emperors Kang Xi and Qian Long personally gave inscriptions for 36 scenes; and from 1711 the Qing emperors regularly moved their courts there in summer so that it became an important political centre.

The park covers 1,400 ha., four-fifths of it hilly and the rest low-lying, with lakes drawn from the hot spring. The emperors dwelt and held temporary court in several palace complexes near the main entrance. One group, with Song He Zhai (the Pine and Crane Hall) as its main structure, was the Empress Dowager's; the others are the Eastern Palace, where in summer operas were staged for the court on a large, covered stage (destroyed by fire in 1945), and Wan Huo Song Feng or Valley of Soughing Pines, used as a studio. Within the principal palace, the main building —Dan Bo Jing Chen Dian or Hall of Simplicity and Sincerity—is built of nanmu, a highly prized aromatic hardwood, with carvings of bats and scrolls on its ceiling and partitions. The imperial boudoir, poetically named Refreshing with Mists and Ripples, lies behind it. The whole palace area is formally planned with straight, covered walkways linking a succession of finely proportioned halls and courtyards enclosed by walls and planted with old pine trees. The effect, calm and ageless, is unique in China, and the simplicity and elegance of the architecture harmonize agreeably with the natural landscape.

The park beyond is in three parts: lakes, lowland, and mountains. The lakes lie in the south-east but north of the palace. Dotted here and there with small islands, they are crossed by willow-planted dykes and surrounded by embankments and low hills. At the southern end is the Mid-lake Pavilion and, in the centre, an island called As you Wish, on which stand several clustered towers and *tings* known as Moon White and Water Tunes. This is where the emperors and their families came on moonlit nights to celebrate the serenity of the lake. Another tall building, Misty Rain on the Heliotrope Islet, was modelled after its namesake in the South Lake of Jiaxing, Zhejiang province, and used for viewing the lake on misty days. In the east, on the islet Golden Hill, an octagonal three-storeyed building was built in imitation of the God's Chamber in the Golden Hill Temple at Zhenjiang, Jiangsu province. A stele engraved with the characters 'Rehe Spring' and several pavilions with the high surrounding hills beyond, are reflected across the water.

Further north is a grassy plain known as the Garden of Ten Thousand Trees, once a deer-park. Here the Emperor Qian Long (1736–95) entertained Mongolian princes and the Banchan Lama VI of Tibet to imperial picnics, and

received Lord Macartney, Britain's first envoy to China (see Sir George *Staunton). The Library Wen jin Ge, in the western part of the lowland, is a replica of the famous Tianyi Ge, at Ningbo, Zhejiang province. Two great collections, 'Gu Jin TuSu Ji Cheng' (Collected Works, Ancient and Contemporary) and the 'Si Ku Quan Shu' (Four Vaults of Classics), were once among other treasures in this library. On the other side of the flatland stands the Pagoda of Buddha's Remains, a version of the Glazed Tower in the Temple of Gratitude at Nanjing, destroyed in 1851, and of the Pagoda of Six Harmonies, built in 1163.

The western part, covering most of the Resort, is made up of natural hills with the ruins of over 40 garden structures scattered among them. Recently a few of them—the Pavilion of Viewing Southern Hill Deep in Snow, Sunset at Club Peak, and the Pavilion Facing Clouds and Hills Around—have been rebuilt.

Bi Shu Shan Zhuang is exceptional among imperial gardens for the elegant simplicity of its palace buildings, unusual in the Qing dynasty, and the combination of this with the lyric grace of China's landscape tradition south of the Chiangjiang (formerly Yangtze River). Above all, however, it is the changing effects of seasonal mist and clear northern light on the borrowed scenery of the surrounding hills and temples that makes it exceptional.

G.-Z.W./M.K.

Blaikie, Thomas (1758–1838), was a Scottish gardener who worked mainly in France. He entered the service of the Comte de Lauraguais (1733–1824) who introduced him to the architect, *Bélanger. He was employed by the Comte d'Artois (the future *Charles X) for whom, with Bélanger, he laid out the gardens of Bagatelle; and by the Duc de Chartres (later Duc d'Orléans, Philippe Egalité) at Le Raincy and the *Parc Monceau. Blaikie travelled widely in France, recording his observations on gardens such as Guiscard, *Ermenonville, Mortefontaine, Neuilly, the *Désert de Retz, and Manicamp as (published as *Diary of a Scotch Gardener*, 1931). He promoted the English style of gardening, and was scornful of the French fashion for the *jardin anglo-chinois*. He introduced gardeners from England and Scotland into France, and collected plants from England for his employers on visits there. He survived the Revolution and died in Paris. K.A.S.W.

Blaise Hamlet, Gloucestershire (Avon), England, a unique group of 10 cottages for pensioners, was commissioned by John Scandrett Harford from John Nash, who had already added a conservatory and probably the thatched dairy to the same client's nearby house, Blaise Castle, and whose assistant on this work was George Stanley *Repton. Built largely of rubble masonry with some weather-boarding, the cottages are thatched and have porches, bay windows, and unusually tall chimneys, these varying considerably in the way in which they are assembled so as to give a 'picturesque' effect to the whole group. There is one attached pair of cottages, but the rest are single and disposed in roughly oval formation round a small green with a

central column bearing Nash's name as designer, and the date of completion, 1811. D.N.S.

Blenheim Palace, Oxfordshire, England. On 22 June 1705, four days after Blenheim's foundation-stone had been laid, *Vanbrugh wrote to the Duke of Marlborough in Flanders: 'The garden wall was set agoing the same day with the house and I hope will be done against your Grace's return . . . The kitchen-garden walls will likewise be so advanc'd that all the plantations may be made . . . The whole gardens will be form'd & planted in a year.' This was optimistic. The finished plan, signed by *Bridgeman, showing the bastioned 'military garden' on the south, the kitchen garden with smaller bastions and, on north and east, elaborate elm avenues, is dated 1709. Henry *Wise and his team made the gardens, but the idea of mock-fortifications for terrace walls may well have been Vanbrugh's or indeed Marlborough's own. The first owners moved into the palace in 1719; but Marlborough did not live long to enjoy his prize—he died at Windsor in 1722.

Since then the 4th, 5th, and 9th Dukes have made major alterations to the grounds. In the 1720s Marlborough's widow Sarah had the River Glyme canalized, with a formal pool on the west, and a cascade beneath Vanbrugh's bridge. On either side of that bridge, in 1764, Lancelot *Brown created two large lakes for the 4th Duke. Sarah's cascade was then drowned and the 'military' state garden destroyed; but at the western extremity of the lakes Brown made his Great Cascade, in the neighbourhood of which the 5th Duke (1817–40), a keen botanist, created gardens for the newly imported hardy exotics.

The 9th Duke (1892–1934) engaged Achille *Duchêne to restore the north forecourt, grassed over by Brown, and to replant the long elm avenue leading to it. With the same architect he then began to make formal gardens on the east and west, the latter comprising two water-terraces completed in 1930. These water-terraces, noble as they are as a formal setting for the west front, are in design closer to that of the *parterre d'eau* at *Versailles, which the Duke and Duchêne had studied and criticized, than to anything boisterously baroque, such as the long cascade at Saint-Cloud or even the more tranquil one at Chatsworth, which Vanbrugh, who left Blenheim long before a western garden had been begun, may have had in mind. Outworks include the Triumphal Arch (Woodstock entrance) by *Hawksmoor (1723) and the Column of Victory by Lord Herbert and Roger Morris (1730). The temples and the New Bridge near Bladon, for the 4th Duke, are by Sir William Chambers and John Yenn.

In the case of Blenheim one has always to remember that Vanbrugh regarded it, as he said, 'much more as an intended monument of the Queen's glory than as a private habitation of the Duke of Marlborough'; though it was of course military glory in which Marlborough had had the giant's share. Vanbrugh could have built a castellated castle or a barracks, 'with the true rust of the barons' wars'. Instead, he used his military theme in a more subtle way, stressing it only here and there with a trophy or a flaming

urn; or in the state garden, now gone, with bastions and curtained walls. D.B.G.

See also ENGLAND.

Blickling Hall, Norfolk, England. A map of 1729 in the house shows the early formal scheme and already the outline of the rectangular garden to the east is apparent with its great terrace walk at the far end. Within this was a formal wilderness, a pattern of paths and hedges, and near the house a large open stretch of lawn. The formal avenues into the park and the lake shown to the west on this survey were altered to the English landscape style at the end of the 18th c. either by Humphry *Repton or his son John Adey *Repton at the time he designed the orangery in the formal garden and extended the park to the east.

In 1872 the Marchioness of Lothian employed W. A. *Nesfield and Sir Digby Wyatt to lay out a vast formal scheme. A complicated *parterre of beds in the Victorian French style was enclosed by brick retaining walls to form the foreground to an imposing axial view leading to a classic temple built in 1760. The 17th-c. formal *wilderness was extended towards the house and avenues of trees planted to make a series of *allées and *ronds-points lined by evergreens.

In the 1930s Norah Lindsay was engaged to simplify the scheme. She planted the existing design of four large beds of herbaceous plants with borders of Poulsen roses around them, using two colour schemes. Mixed herbaceous borders along the walls completed the effect.

The property was acquired by the National Trust in 1942. J.S.

Blois, Loir-et-Cher, France, the seat of the Ducs d'Orléans, was adopted as a royal residence by Louis XII and Anne de Bretagne who made large gardens on two levels between 1499 and 1515, connected to the château by a bridge across the moat. The lower garden was supported by huge walls to create a level area c.200 m. × 75 m., surrounded by wooden galleries. Facing the entrance, astride the intersection of the axis and the third of four lateral paths, was a substantial pavilion of wood sheltering a marble fountain. On the north-east side was the Pavillon d'Anne de Bretagne, an octagonal building of two storeys, with a high pitched roof and four wings, one being an oratory. A stair led down to the small Jardin de Bretonnerie. *Pacello de Mercogliano had charge of the main garden until his death in 1534. Du Cerceau's drawing shows it divided into 10 rectangular compartments laid out in geometric patterns. Contemporaries noted the variety of vegetables and fruit, including orange and lemon trees in tubs stored in a shed in winter, possibly the first orangery in France. The upper garden, probably a *potager* (kitchen garden), adjoined the forest, where a great avenue of elm and oak was made in the late 16th c.

*Henri IV began a magnificent two-storied gallery between the upper and lower gardens in 1598. In the early 17th c. Gaston d'Orléans formed a botanical collection

under the direction of his doctor, Abel Brunyer, whose catalogue lists 2,232 species and varieties. Illustrations of the plants on vellum by Daniel Rabel and Nicolas Robert are now in the library of the Musée National d'Histoire Naturelle, Paris.

After Gaston's death the gardens declined. In 1890 the construction of the Avenue Victor Hugo destroyed the lower garden, of which only the Pavillon d'Anne de Bretagne (now the Syndicat d'Initiative) and the massive north-east corner of the terrace walls survive. K.A.S.W.

Blomfield, Sir Reginald (1856–1942), was a distinguished English architect and author of *The Formal Garden in England* (1892), in which he dogmatically opposed the freer and informal style of gardening energetically supported by William *Robinson. He strongly advocated a return to formal gardening, using architectural shape, structure, and materials with plants as decorative adjuncts. To him gardens were primarily works of art.

His principles are exemplified at Godinton Park, Ashford, Kent, where there are side by side an Italian garden, formal gardens, topiary, and herbaceous borders. They can also be seen at *Athelhampton, where part of the garden was designed by a Blomfield advocate, Inigo Thomas, who drew the illustrations for *The Formal Garden*. Blomfield's contention created two schools of thought in gardening, one supporting the more natural approach of William Robinson and the other advocating formality. C.H.

Blondel, Jacques-François (1705–74), French architect and writer, was, after *Dezallier d'Argenville, the most important theorist of classical French garden design in the mid-18th c. His *De la distribution des Maisons de Plaisance* (1737) offers four schemes for country houses, and sets out his views on garden design generally. These are expanded in the fourth volume of *Cours d'architecture* (1773), in which he restates the traditional French position *vis-à-vis* the new fashion for the *jardin anglais*. While advocating regularity he concedes that this appears to greater advantage if contrasted with a 'négligence pittoresque' at the limits of big gardens. He follows Dezallier d'Argenville in the general arrangement of the parts of the garden (*parterres, bosquets*), but with more emphasis on grass slopes in accommodating levels, and more turf in the parterre. There are rococo elements in his buildings and trellis-work. K.A.S.W.

See also CREUX DE GENTHOD.

Boat-house, ranges in England from the simple shelter in timber on a small lake as at Buckland House, Oxfordshire (1750), to a fine stone boat-house with a room above, on a large lake, as at Exton, Leicestershire (c.1765), or at *Enville (designed by Sanderson *Miller, 1750). The remains of a rocky boat-house exist at *Stourhead, opposite the grotto. G.W.B.

See also BIRKENHEAD PARK.

Boboli Gardens, Florence, Italy. Cosimo I de' Medici acquired the unfinished Pitti Palace and the terrain in 1549.

In the same year Niccolò Tribolo designed the central axis from the *cortile* up the hill including the amphitheatre and the pond above. In the earliest complete view, the *Utens lunette (1599), this layout has a strong resemblance to the Villa *Medici, Castello, also designed by Tribolo. One can imagine what a dramatic treatment a Roman designer would have given to the amphitheatre, but Tribolo simply made the naturally existing hollow into a horseshoe shape and laid out thick plantations on its banks.

The architectural features now associated with the gardens are from a later date. It was not until the 17th c. that the plantations were cleared and tiers of seats were installed, for the amphitheatre was not used as a site for festivals until the Equestrian Ballet of July 1637 celebrating the marriage of the Princess of Urbino and Ferdinando II de' Medici. Until then, the courtyard of the Pitti Palace was used for theatrical festivals. Beyond the amphitheatre is a series of terraces; further on—a 17th-c. addition—is the little Giardino del Cavaliere, a *giardino segreto* made for Cosimo III (1642–1713).

To the side of the palace, at the entrance to the passage between the Uffizi and the Pitti, is La Grotta Grande (1583–93), the most fantastic surviving grotto of the period. The upper storey of the entrance façade and the three grottoes in the interior were designed by Bernardo Buontalenti, the leading director of *spettacoli* of the day. From the first grotto, with its four statues of slaves (by Michelangelo), a passage of artificial rock leads into a smaller grotto, and culminates in the third, in the middle of which there is a nude statue of Venus by Giovanni da Bologna (1592). There are countless shells on the pedestals of the statues and a mosaic wall-fountain. It once had *giochi d'acqua.

The long western axis of the garden leads by an avenue through the woodlands to the Piazzale dell'Isolotto—the Ocean Fountain (1567–76), designed by Giovanni da Bologna, surrounded by water. The setting was designed by Alfonso Parigi (1618), supposedly based on the Maritime Theatre at *Hadrian's Villa, Tivoli. A similar ensemble, the Hercules Fountain at *Aranjuez, was created by Cosimo Lotti who had worked here.

The incongruity between the statue and its setting (which are far less well balanced than in the similar feature at Villa *Lante) is due to the fact that the statue formerly stood outside the Pitti Palace. Relocated in the Isolotto it was seen from a greater distance and in a more open position than that for which it was originally designed. Furthermore, it was originally surrounded by a hexagonal balustrade, from which inward-facing figures poured water into the pool.

By the end of the 17th c. the layout was complete, substantially as it exists today. P.G.

Boccaccio, Giovanni (1313–75), Italian writer and humanist. See ITALY: PRE-RENAISSANCE GARDENS; PALMIERI, VILLA.

Bodnant Garden, Gwynedd, Wales, was begun by the 3rd Lord Aberconway's great-grandfather after he purchased the estate in 1875, and several of the larger conifers in the

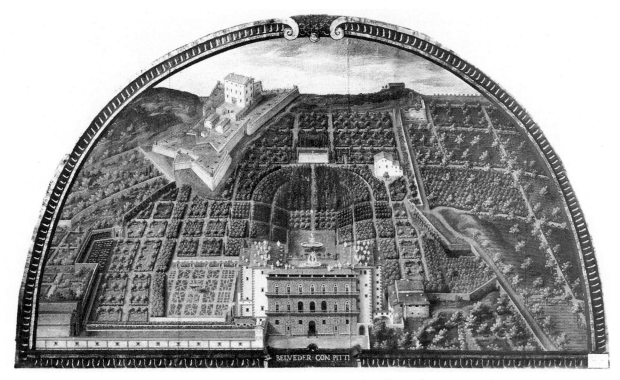

Boboli Gardens, Florence, lunette (c.1599) by Giusto Utens (Museo Topografico, Florence)

valley and the lawns and shrubberies south of the house, which were designed by Edward *Milner, date from the end of the 19th c.

The major development came after the turn of the century when the 2nd Baron Aberconway took control. It was he who designed and planted the five Italianate terraces (see *terrace walk) in front of the house, taking maximum advantage of the dramatic glimpses of the River Conway and views of Snowdon beyond. The series of terraces gave unity as well as concealment and surprise to a highly original design in which disciplined simplicity is contrasted with rich planting and architectural detail, including pools and fountains, rose-gardens, and an outdoor stage. The Pin Mill, built c.1740 as a summer-house, was moved from Woodchester in Gloucestershire and reconstructed for its original purpose on the Canal Terrace in 1938.

Below the terraces is a remarkable collection of magnolias; beyond is the Dell with its enormous range of *Rhododendron* species. Among these and between and beneath the sheltering oaks is an enormous variety of other shrubs and conifers on either side of the beck known as the River Hiraethlin, dammed at one point to make a bridge and cascade.

In 1949 Bodnant Garden became the property of the National Trust. J.S.

Boer, Willem Christiaan Johannes (1922–), Dutch landscape architect, gained early practical experience in the family nursery business at Boskoop. His interest in the history of architecture and contemporary developments in the Netherlands directed him towards the professions of architecture and planning, and from 1947 to 1952 he

The designer's own garden (1964) at Berkel en Rodenrÿs, near Rotterdam, Netherlands, by W. C. J. Boer

worked at the Rotterdam Town Planning Office (ASRO). In the stimulating atmosphere of post-war reconstruction he met a former Bauhaus student, Charlotte Stam Beese, who invited him to join the Dutch CIAM group 'De 8 en Opbouw'. His work with the group included the design of communal gardens and public open spaces; in particular the residential areas of Pendrecht and Alexanderpolder in Rotterdam, and the village of Nagele in the Noordoost-polder. Later he was employed privately as landscape consultant for the new town of Spijkenisse, for Expo Brussels 1958, and, after successful competitions, notably the Gÿsbrecht van Amstelpark in Amsterdam, for a number of parks and urban areas.

Since 1973 he has been Professor of Urban Landscape Architecture at the Technical University of Afdeling Bouwkunde in Delft, for which he wrote two books on the developments of the design of gardens, parks, and urban landscape design in their relationship with architecture and town planning. Characteristic of his views on building and environment is his own settlement in Berkel en Rodenrÿs, near Rotterdam; a simple ground-plan inside and outside, interwoven with a spontaneous development of natural flora. D.L./M.L.L.

Bogor Botanic Garden, Indonesia. See KEBUN RAYA.

Bois de Boulogne, Paris, a park of nearly 900 ha. at the gates of the city, was originally a royal forest. François I built the Château de Madrid (begun 1528) overlooking the Seine on the west side; and in 1556, to keep out bandits, the woods were surrounded by a high wall pierced by eight gates, among them those of Maillot and La Muette. In the 17th c. Colbert, Minister of Louis XIV, had straight roads and *ronds-points* made, including La Croix-Catelan. The gates were opened to the public by Louis XIV and the Bois became a pleasure-ground. The Comte d'Artois built the Pavillon de *Bagatelle in 1777, and in 1779 was allowed to enclose 7 ha. adjoining the Château de Madrid to make a park à l'anglaise. The Bois became a fashionable promenade until it was deserted at the Revolution, and devastated by the Allies after the defeat of Napoleon in 1815. The oaks disappeared and plantings of maples, chestnuts, acacias, and other trees changed its appearance.

Napoleon III gave the Bois to the city of Paris in 1852 to be developed as a public promenade and place of outdoor recreation. Under *Haussmann, *Alphand and his team (which included *André and *Barillet-Deschamps) gave it its present form. The surrounding wall was pulled down, the grounds of *Folie Saint-James, Bagatelle, and Madrid were added, and other pieces of land were acquired to extend the Bois to the Seine on the west in order to establish the Longchamp racecourse (1857). An artesian well was sunk to provide water for two lakes at different levels; the earth from the excavations was used to make a hill, the Butte Mortemart. Masses of rock were used (especially beside the Grande Cascade at Longchamp) to give variety to ground that for the most part was flat, and Barillet-Deschamps added pines, cedars, and other trees arranged in clumps to leave open clearings and vistas. The Jardin d'Acclimatation for plants and animals was made in the northern part, and a municipal nursery garden in the south. In the central part is the Pré-Catelan, to which has now been added the Shakespeare Garden with plants mentioned in his works.

The main work was finished in 1852, and two years later the Avenue de l'Impératrice (now the Avenue Foch, 140 m. wide) was opened, becoming a fashionable promenade for coaches. The Auteuil racecourse was established after 1870, and the Parc des Princes and Jean-Bouin sportsgrounds even later. The recent construction of a ring road has further encroached on part of the Bois, but it remains a good example of the French adaptation of the English landscape style of the period to make an urban park.

D.A.L.

Bois de la Cambre, Belgium, a landscaped park of 124 ha. and one of the most important in 19th-c. Belgium, was created from 1862 by the Brussels municipality to a plan by the landscape architect Edouard Keilig; a 2-km. expanse of the Fôret de Soignes was appropriated especially for the purpose. The park has remained virtually intact.

At the park's centre edge (on the town side), the Avenue Louise, which was drawn in the park's axis so as to join it conveniently to the town, passes through two neo-classical pavilions (brought from the old boulevard) and straight into the major route for vehicles. This runs right through the park, making two circular shapes by means of a distorted figure of eight. In addition to this main circuit, there is a further irregular network of minor paths for pedestrians and horseriders.

The first circular part, set in the forest, consists of an undulating lawn, scattered with groups of trees and cut across by a hollow which was there already. The hollow is crossed on the left by a cavernous monumental bridge made of rock, providing passage for vehicles. The second circular part has, towards the bottom, an irregular-shaped artificial lake with a wooded island and landing stages. The lake is surrounded at one point by a wooded escarpment and elsewhere by a wide, gently-sloping lawn, with clumps of trees. This wooded area is planted with species originally found in the forest—especially beech, to which other varied species have been added—and is interrupted in places by wide vistas but these do not extend beyond the edges of the park which are everywhere wooded. X.D. (trans. K.L.)

Bolotov, Andrei Timofeyevich (1738–1833), was a prolific and influential Russian writer on agriculture with a special interest in gardening. He was a leading member of the Free Economic Society in St Petersburg (Leningrad) and founded their journal, the *Ekonomichesky magazin* ('Economic Magazine'). The 40 volumes which he edited during the 1780s constituted a virtual encyclopaedia of articles on agriculture, estate management, gardening, and related subjects.

He rejected the artificiality of the French formal garden and advocated the landscape style, but he was anxious that Russian parks should have a national character rather than

merely imitate English models which he considered too loosely planned. There should be some formality in the area near the house, with a flower garden, and there should also be a place for the fruit-trees and bushes which were traditional in Russian gardens. In the park the designer should seek to bring out the best in nature at different times of the day and different seasons of the year. Bolotov particularly liked 'delicately melancholy' effects, which still or slowly flowing water and shady trees could help to achieve.

Of his work as a designer, the park at Bogoroditsk in the Tula region is the outstanding example. The plan he drew in 1785 with the assistance of his son, P. A. Bolotov, has survived, along with his detailed description.　　P.H.

Bomarzo, Italy. See ORSINI, VILLA.

Bombicci, Villa, Colazzi, Tuscany, Italy. Probably built in 1560 for Dino Agostini—and long associated with Michelangelo, but now attributed to Santi di Tito—the villa is privately owned. It is beautifully sited on the edge of a ridge of hills south of Florence and, though never completed, displays a subtle balance of proportion and harmony with its surroundings. A fine cypress avenue leads up to the villa past a pool which reflects the eastern façade. On the northern side, a terrace enclosed by the villa on three sides offers extensive views of the surrounding countryside. The south-east façade, recently completed according to the original plan, overlooks an elaborately built-up terrace with a lemon garden below.　　H.S.-P.

Border. See BED; HERBACEOUS BORDER.

Borghese, Palazzo, Piazza Borghese, Rome. The small courtyard has one of the best-preserved baroque gardens in Rome. The first garden, with two wall-fountains, was made between 1608 and 1614, but with the acquisition of a new source of water, new fountains were planned (begun 1672).

The irregular shape of the site posed several problems: the fountains were to be seen from three points of view (a ground-floor audience chamber, the garden door of the palace, and the palace entrance); and the acute angle of the walls where they were to be placed was not directly opposite the garden door of the palace. A typically baroque solution was found by J. P. Schor (1615–74), sculptor and set designer. Three big fountains project dramatically from the walls. The central fountain was placed on the angle of the walls, with a left and right fountain balancing each other. The fountains were approached by a path leading from a 'theatre' of fountains and statues, creating three radiating vistas, a Piazza del Popolo in miniature.　　P.G.

Borghese, Villa, Rome. The existing gardens which adjoin those of the Pincio, overlooking the Piazza del Popolo, are only a fragment of the original. Laid out after 1605 for Cardinal Scipione Borghese, the complex with a circumference of more than 7 km. was one of the earliest of the great Roman park villas of modern times, in which the

buildings were a subordinate part of the layout. There was no overall symmetrical plan of the French type and the design consisted of extensive plantings of trees of many varieties, intersected by *allées* with statues, fountains, grottoes, and lakes interspersed at intervals.

The *casino*, built by the Flemish architect Ivan van Santen (Giovanni Vasanzio) between 1613 and 1616, was used to exhibit the Cardinal's remarkable collection of antique sculptures. Immediately around the *casino* were formal gardens of a more traditional Renaissance style, laid out between 1617 and 1619 by Girolami Rainaldi. To the east of the *casino* he constructed an open-air theatre. The formal gardens included parterres, a *giardino segreto*, and an alfresco dining-room designed as a temple. At a later date (1688) an aviary and a further pavilion, the Palazzo della Meridiana, were built on either side of the *casino*.

Early in the 19th c. the park was enlarged and redesigned in the English romantic style. Later some of the balustrades and fountains in front of the *casino* were bought by Viscount Astor for *Cliveden and replaced by copies. In 1902 the villa and grounds were acquired by the state and now form a single urban park with the Pincio gardens, abutting on to the gardens of the Villa *Giulia.　　G.A.J./P.J.C.

Borrowed view. See JIE JING (CHINESE); SHAKKEI (JAPANESE).

Bosco, in principle the idea of the mythological *grove domesticated and made part of the garden. Like the *giardino segreto* it was so named in the Italian Renaissance and, like it, provided an escape from the rational geometry of the gardens as a whole.

A *bosco* was generally a grove of evergreen ilex, giving deep shade, mystery, and the stimulus of the constantly changing shape of tree-trunks. The most significant examples are at the Villa *Gamberaia at Settignano near Florence which are within a few steps of the mansion itself. The *boschi* of the Villa Bernardini at Lucca (c. 1590), with their sequence of little formal open spaces, may have been the prototype of the later French *bosquet*.　　G.A.J.

Bosquet, in gardening an ornamental grove, thicket, or shrubbery pierced by walks, at first in geometric patterns (stars, circles), but at the end of the 17th c. also sinuous in shape (see *wilderness). Particularly fashionable in big gardens throughout Europe from the mid-17th c. to the mid-18th c., some were designed as *labyrinths, while others enclosed a central space with a lawn, basin, fountain, or more elaborate set piece (as at *Versailles). The larger of such spaces were called *salles*; the smaller *cabinets* (hence, *salle de verdure*, green room). *Bosquet découvert* (open grove) was one where the trees were widely spaced, with no thickets, so that the vision throughout was unimpeded.

　　K.A.S.W.

Botanical illustration, from its earliest period, has been concerned with accuracy, allowing the identification of the plants to be shown, so that the beauty of many examples of

the art is a by-product of its main purpose. The link between medicine and botany, for plants provided most of the drugs used in the treatment of illness until quite recent times, made it essential for physicians to know their flora, so that some of the earliest botanical pictures surviving are those of the *Codex Vindobonensis*, a manuscript of a herbal by *Dioscorides produced in 512. Other manuscript and printed *herbals copied each other's illustrations, in general creeping further and further from an accurate representation of nature, with occasional exceptions like the Carrara herbal and the flowers found in the decorated borders of missals or books of hours. Leonardo's flower studies also record precise observations.

In 1530 the publication of the first part of *Brunfels's *Herbarum Vivae Eicones* marked the beginning of a series of fine herbals with woodcut illustrations. His artist, Hans Weiditz, began by making water-colours of his subjects, nearly 80 of which were found in the Berne Botanical Institute in 1930, incorporated in the herbarium of Felix Platter. The work of Weiditz has been compared with that of his contemporary, Albrecht Dürer. It sometimes suffered a little in its transition to the wood-block, but even the printed version is a world away from most earlier drawings of plants. A little later, the illustrations of *Fuchs's herbal, *De Historia Stirpium*, first published in 1542, were also drawn from nature, although his artists were less gifted than Weiditz.

Many of the other herbals with woodcut illustrations drew their pictures from a hoard established in Antwerp by the printer, Christophe Plantin. His collection held engraved blocks and also original paintings, most of them by Pierre van der Borcht (1545–1608). Nearly two thousand of his plant drawings—including the original of the dragon tree used in the second edition of *Gerard's *Herball*—were later in the Staatsbibliothek in Berlin, until the Second World War, when they were taken to Silesia. They have now been traced to the Jagiellonian Library in Cracow. The quality of the originals is not often reflected in the blocks made from them, perhaps because the printed copies are usually rather small and cramped.

By the end of the 16th c. engraving on metal was beginning to be used as an alternative to woodcuts, and florilegia, or books of flower drawings with no didactic purpose, had begun to appear. *Botanic gardens were founded in several Italian towns in the 1540s, the idea gradually spreading across Europe, and collections of ornamental plants had to be recorded. The Veronese artist Jacopo Ligozzi (1547–1626) was a court painter to several Medici princes and specialized in natural-history subjects. Many of his water-colours are preserved in the Uffizi, those of plants showing brilliant impressions of patterns and habits of growth.

In 1608, when the etched or engraved copper plate was becoming a familiar medium of illustration, allowing more precise details to be represented, Pierre Vallet's florilegium, *Le Jardin du très Chrestien Henry IV*, was published, with 75 plates designed to serve as patterns for needlework, although they are botanically accurate too. The author worked in the royal gardens and most of his plants were also found there. The plates of this book were good enough to be copied in later florilegia. Another set of engravings was made early in the 17th c. from drawings by Pierre Richer de Belleval, founder of the Montpellier botanic garden—nearly 500 plates of European plants, which were not printed until much later.

Basil Besler's *Hortus Eystettensis* (1613) is a gigantic florilegium. Besler was an apothecary in charge of the gardens of the Prince Bishop of Eichstätt, a flower-loving patron rich enough to pay for the production of this enormous catalogue. The original drawings were made by Besler, the plates—nearly 400 of them showing over a thousand flowers—by a team of engravers. Each plate shows several plants, arranged in a decorative design to display the patterns of flowers, leaves, and roots, and labelled with attractive calligraphy.

In 1614 the *Hortus Floridus*, by Crispijn van de Passe the younger, illustrated garden plants season by season in about 200 plates. The plants are set in soil (with bulbs and roots shown above ground) and decorated with bees, butterflies, or a mouse nibbling a corm. Instructions for colouring the plates were included. So popular was this book that Dutch and English editions followed the Latin one, and modern reprints continue to make it available.

One of the largest series of flower paintings was begun in France in the 17th c. by Gaston d'Orléans, younger brother of Louis XIII, who engaged Nicolas Robert (1614–85) to paint on vellum the most unusual plants and animals in his collection. After Gaston's death in 1665 the drawings went to Louis XIV, and later, greatly increased by the work of Robert and other artists, the series found a home in the Jardin des Plantes (Muséum d'Histoire Naturelle) in Paris. Robert confirms the conviction that the best botanical artists are those trained by botanists, and he was the obvious choice for an artist to illustrate Dodart's *Mémoires pour servir à l'Histoire des Plantes*, a book planned by the Académie des Sciences, the first part of which appeared in 1675, the bulk of the plates in 1701, and the whole trio of volumes much later in the century, with Robert's work supplemented a little by Abraham Bosse (who also engraved some of the Robert drawings) and Louis de Châtillon. The book was a landmark in botanical illustration, the etchings indicating the depth of coloration, in the absence of the possibility of printing in colour. Robert's other work, originals or printed copies, displays the freshness of his drawings from living plants and the beauty of his view of them.

Claude Aubriet (1655–1742) was another contributor to the royal collection of plant drawings, an artist of such talent perhaps deserving to be remembered by a more spectacular plant than the humble (and variously misspelled) aubrieta. He was trained by the botanist Tournefort, Professor of Botany at the Jardin du Roi, and went with his teacher on a voyage to the Levant in 1700, a voyage that lasted two years and allowed the travellers to discover many new plants. Aubriet coped with the usual difficulty of travelling artists faced with quantities of plants to be recorded quickly by making rough sketches in the field, to be worked up into finished pictures later, perhaps with the help of dried

specimens. Engravings from Aubriet's drawings illustrate various editions of Tournefort's *Elemens de Botanique* as well as his account of the Levant journey and books by other botanists. His paintings have a particular clarity, a little more stylized than those of Robert, but still faithful to the demands of botanical exactitude.

17th- and 18th-c. Dutch influence on the collection and cultivation of plants is appropriately reflected in the work of a school of flower-painters, whose work in oils displays the richness of gardens of the period. These painters rarely worked direct from nature, but constructed their bouquets from preliminary studies of individual flowers, several of which have survived. Jan Davidsz. de Heem (1606–83), Jan van Huysum (1682–1749), and Rachel Ruysch (1664–1750) are perhaps the best-known members of this group, and their pictures are some of the most familiar flower-pieces, rich compositions of lilies, tulips striped and plain, roses, irises, carnations, and other garden flowers, with ears of corn, caterpillars, butterflies, or snails hovering near the edges of the pictures.

The influence of the Dutch school affected other artists, in particular Maria Sibylla Merian (1647–1717), a member of a German family of engravers and painters, though the flower-painter, Jacob Marrel, was her stepfather. Entomology was her main study, and her earliest work was on European insects, illustrated among their food-plants. In 1698 she went on a voyage to Surinam with one of her daughters, spending two years collecting and painting flowers and insects there for a splendid book about them published in 1705. She also drew, engraved, and coloured pictures of plants without accompanying insects, with almost as much delicacy as the little animals demanded. Her work shows careful craftsmanship and a detailed knowledge of the plants and insects portrayed.

The 18th and early 19th cs. are perhaps the finest period of botanical illustration. Jacobus van Huysum (c.1687–1740), a younger brother of the more famous Jan, settled in England in 1721 and illustrated John Martyn's *Historia Plantarum Rariorum* (1728–36) and the *Catalogus Plantarum* (1730) published by the Society of Gardeners. His *Historia* drawings of plants in the *Chelsea Physic Garden were engraved and printed in a sort of mezzotint. Some colour was used in printing, more added later. The book was published in parts, and was one of the earliest to be produced in this way, thus spreading the expenses of both printer and buyer. The *Catalogus* was a kind of joint catalogue produced by a group of nurserymen and horticulturists, surveying newly introduced plants. Most of the plates are hand-coloured etchings. One member of the Society of Gardeners was Robert Furber, a Kensington nurseryman whose *Twelve Months of Flowers* (1730) is a particularly lavish list of his stock. The paintings by Pieter Casteels (1684–1749) show the plants blooming in each month, and lists of them are attached.

Georg Dionysius Ehret (1708–70) was the major botanical artist of the middle part of the 18th c. and one of the greatest of any period. He was born in Heidelberg and became a gardener before beginning to paint some of the

MAGNOLIA *altissima Lauro-cerasi folio flore ingenti candido*
The Laurel leaved Tulip tree.

Botanical illustration of *Magnolia grandiflora* by Ehret, body colour on vellum (1743)

flowers in his care. After working for a number of patrons in Germany, particularly the Nuremberg physician C. J. Trew, he travelled in France and Switzerland, meeting leading botanists. He even encountered *Linnaeus in the Netherlands in 1736, providing some illustrations for *Hortus Cliffortianus*, as well as a broadsheet plan of Linnaeus's system of classification. Ehret spent about a year in England in 1735, returning there after his visit to the Netherlands. In 1738 he married the sister-in-law of Philip *Miller, curator of the Chelsea Physic Garden, and for the rest of his career he was at the centre of a group of enthusiastic botanists in London. His skill as draughtsman, colourist, and engraver, his botanical knowledge, his elegant designs, and his access to a large supply of new plants combined to give him a supreme position among botanical artists. He taught both drawing and botany to a number of aristocratic pupils, influenced other artists, and became a Fellow of the Royal Society.

His production of paintings, on vellum or paper, was large. For his own book, *Plantae et Papiliones Rariores* (1748–59), he engraved the plates too, and the careful colouring makes as close an approach as possible to the quality of the originals. He also illustrated books for Trew and a number

of other writers, contributing some pictures to the pair of volumes published by Miller in 1760 to accompany his *Gardeners Dictionary* and a few to the *Natural History of Carolina* (1730–47) by Mark *Catesby, who solved the problem of the cost of publishing his book by learning the necessary skills and becoming his own engraver.

Sydney Parkinson (*c.*1745–71) was a protégé of Sir Joseph *Banks and went with him on his voyage round the world with Cook in the *Endeavour* in 1768. He did not live to return home, dying in the Indian Ocean in 1771, but some finished drawings and more sketches, later completed by other artists, survived in Banks's collections and were engraved, though never published. In 1905 a selection of the Australian plants appeared in lithographs, but in 1981 the publication of the entire collection began, over 700 of them, printed in colour from the plates engraved 200 years before. *Banks's Florilegium* will not be complete until the late 1980s, but the project is making available at last, in the most accurate form possible, a collection of early records from the voyage during which Australia's Botany Bay was first christened. Appropriately enough, the Australian flora is a particularly important part of the collection.

Others to benefit from the patronage of Banks were the Austrian brothers Francis (1758–1840) and Ferdinand Bauer (1760–1826). Ferdinand was recruited by John Sibthorp in 1784, on his way to Vienna to look at the *Codex Vindobonensis* before going on a botanical tour of the Levant, on which the younger Bauer accompanied him. The journey included a period in Greece, during which Ferdinand made the sketches later developed into finished drawings for the *Flora Graeca*, engraved by James Sowerby and published in 10 folio volumes from 1806 to 1840, after Sibthorp's death. In 1800 Ferdinand went on a longer journey, to Australia with Matthew Flinders and Robert Brown, a leading botanist and another of Banks's protégés. Bauer's illustrations of the Australian flora were published in 1813, engraved and coloured by the artist, but the book foundered after only 15 plates had been issued. His pictures for A. B. Lambert's *Description of the Genus Pinus* (1803–42) fared better; they are marvellously skilful representations of needles, cones, and branches, without any of the monotony that might be expected from a series of drawings of one group of plants.

Ferdinand Bauer spent the last part of his life near Schönbrunn, but his brother Francis remained in England, where Banks made him artist to the royal gardens at *Kew in 1790. Here he stayed for the next half-century, the first fruits of his employment being his illustrations for *Aiton's *Delineations of Exotic Plants* (1796). His printed work is often less beautifully produced than that of his brother, though the originals are in no way inferior.

The most celebrated botanical artist of his day was Pierre-Joseph Redouté (1759–1841), a Belgian who worked in France. His early association with the botanist C. L. L'Héritier de Brutelle, whose books he illustrated, gave him an acquaintance with the demands the science made upon its artists. A further influence was that of Gerard van Spaëndonck (1746–1822), since 1774 the resident painter at the Jardin des Plantes, but his most famous patron was Joséphine Bonaparte, who acquired her garden at *Malmaison in 1798 and thereafter published a series of large folios with Redouté's pictures of her choice plants, reproduced in stipple engraving printed in colour. Of these books *Les Roses* (1817–24) is the most familiar, thanks to endless copies of its pictures, but *Les Liliacées* (1802–16) is equally brilliant, and the two other books on the garden hardly less so. Redouté's drawings of succulent plants, published in A. P. de Candolle's monograph on them (1798–1829), are also worth attention, and many other books contain examples of his work. The largest collection of originals, many on vellum, remains in Paris, but others are widely distributed elsewhere. Redouté's eminence has tended to overshadow his contemporaries and pupils, though the best work of Turpin, Bessa, and Prévost, among others, deserves more notice.

The illustrations of *The Temple of Flora*, by R. J. Thornton, are nearly as devalued by over-exposure as Redouté's roses. The book was published in parts from 1799 to 1807, with large plates using aquatint, mezzotint, or stipple engraving, printed from originals by Philip Reinagle and Peter Henderson, among others. The book was intended to be scientific, an object blurred by the theatrical landscape settings of the plants, as well as the botanical ignorance of many of the artists. The whole project was fantastically expensive, bankrupting its author and causing endless bibliographical variations between copies, as the printing was piecemeal.

William Curtis (1746–99), an apothecary turned gardener, published his *Flora Londinensis* from 1777 to 1787, the two large volumes collecting both praise and debts. In an attempt to restore his fortunes he founded the *Botanical Magazine or Flower-Garden Displayed* in 1787, employing James Sowerby (1757–1822), the first of a whole dynasty of natural-history artists, and Sydenham Edwards (1769?–1819). The *Botanical Magazine* still flourishes, its production reflecting the changes in the printing of botanical illustrations, from hand-coloured engraving to chromolithographs to gravure to photolithography, that have taken place during its history. The work of many Kew artists, including Walter Hood Fitch (1817–92), has been and still is published in the *Magazine*, which was popular enough to be copied by many similar periodicals in the 19th c., all of them essentially plates of new or little-known plants with descriptions and notes on their cultivation and history.

Sowerby's other major project was *English Botany*, nearly three thousand plates printed from 1790 to 1814, with text by Sir James Edward Smith, founder and president of the Linnean Society. Fitch's work can be found in many monographs of the period, from Bateman's orchids to Hooker's rhododendrons and Elwes's lilies.

After the middle of the 19th c. lithographic printing and the cost of producing flower books on the former scale ended the finest period of botanical illustration, though the need for artists to record what a camera cannot has never been superseded. Among the current crop of artists the work of Margaret Stones is outstanding and may be seen in many recent *Botanical Magazine* plates and W. Curtis's

Endemic Flora of Tasmania (1967–78).

Flower-painting in China and Japan, though well developed earlier than in Europe, was less closely linked to the science of botany. The traditions of Chinese and Indian painters were reflected in the work they did for travellers and settlers in the 18th and early 19th cs. Local artists were employed to record the riches of the flora of unfamiliar countries, especially those in which the East India Company had an interest, for many Company people were enthusiastic naturalists, eager to send news and pictures of their discoveries to professional and amateur gardeners in Europe. S.R.

Botanic garden. Although the monastic gardens of the Middle Ages (see *medieval garden) grew a wide variety of plants, especially those used as herbal remedies, they cannot be regarded as even prototype botanic gardens. For many centuries, and especially since the time of Paracelsus, it had been an accepted principle that all plants were for the use of man, hence there was no excuse for not growing any plant in a botanic garden, whether its use was known or not. If no use was known, then it was assumed that one still had to be discovered. The 'doctrine of signatures', whereby the virtue of a plant was indicated by the similar appearance of a part of it to a human organ, helped to intensify this belief: a plant with heart-shaped leaves was assumed to be a sure remedy for a heart condition, one with spotted leaves would be helpful for diseased lungs, and so on. The writings of *Dioscorides and Galen had long been accepted uncritically without further observation. Plant classification and the principles of plant geography were also unknown at that time.

But after the Middle Ages the questioning and observation of naturalists such as Fuchs and Dodoens began to affect the concept and content of botanic gardens. The first one to be founded was at *Pisa in 1543, closely followed by those at *Padua (1545) and Florence (1550). Such a garden was called a *hortus medicus* or physic garden and many others were established in the 16th and 17th cs., for example, at Leipzig (1580), *Leiden (1587), Heidelberg (1593), *Oxford (1621), Paris—the *Jardin des Plantes (1635), Uppsala (1665), *Edinburgh (1670), *Chelsea (1673), and Amsterdam (1682).

The earliest gardens were established in the southern part of Europe, where they drew upon a wide range of medicinal herbs native to the Mediterranean region. The 17th c. saw others founded in northern Europe, through the influence of the world trade then being developed by maritime powers such as the Netherlands and Great Britain (see *plant-collecting). Seeds and living plants were brought back from far and wide and planted in gardens, while tender kinds were grown in the glasshouses which had been developed for the overwintering of evergreen shrubs. The latter were known as 'greens', hence a house to protect them was called a *greenhouse, a name persisting to the present day. Exchange of living plant material helped to build up large collections of exotic species and the influence of certain gardens, such as Chelsea, was greater than its size

would indicate. New species often went to private estates or commercial nurseries and thence to botanic gardens.

By the 18th c. the wealth of plants coming from the ends of the earth necessitated a more convenient naming procedure than the clumsy one then in use. As the plant names were too long to be accommodated on garden labels some botanic gardens, such as *Montpellier and Leiden, had the plants numbered against a printed catalogue. Carl *Linnaeus revolutionized nomenclature and classification by studying plants grown in botanic gardens and preserved in *herbaria. He adopted a convenient binomial nomenclature for each species and developed a sexual system of classification, which later gave way to a more natural one. Some gardens, such as *Kew, arranged the plants by Linnaeus's system, but by 1758 *Louis XV's garden at Petit Trianon was already being arranged according to Bernard de Jussieu's classification, using the concept of plant families.

At that time large private collections of living plants were becoming fashionable as a status symbol for the wealthy. The Anglo-Dutch merchant banker George Clifford, for example, had a fine garden at Hartecamp near Haarlem where Linnaeus studied before settling at Uppsala. Royalty also developed their private estates as botanic gardens, like those at Schönbrunn in Vienna and Kew near London. Imperial countries such as Great Britain, France, and the Netherlands were at a great advantage, since they had ready access to plant material in their overseas territories. Clifford could draw upon the Dutch East Indies (Indonesia), while Peter *Collinson encouraged John *Bartram in north-east America to collect for his London garden and those of his friends. The King of France sent abroad Plumier, Tournefort, and others, and later Sir Joseph *Banks at Kew dispatched Francis *Masson to South Africa, where he collected with Peter Thunberg, Linnaeus's pupil from Uppsala; Charles III of Spain sent *Ruiz and Pavon to South America.

All this activity had a profound effect upon botanic gardens and private collections. Although owners tended to vie with one another for larger hoards of plants, the concept of a scientific collection was becoming a reality. Scholars were able to describe and publish a multitude of species new to science, while artists made superb drawings of live plants. A great change was evident in that these gardens contained plants cultivated for their own sake, instead of for their medicinal potential.

Vast collections were built up in some gardens with little or no system or documentation and without aim except to have the greatest possible diversity, while other gardens were closely supervised and maintained. The latter was true of certain highly developed tropical botanic gardens such as those in *Calcutta (1786), Bogor (*Kebun Raya) (1817), Peradeniya, Sri Lanka (1821), and *Singapore (1822) which were staffed by British and Dutch trained personnel. Most of them were established for the scientific study of the local flora, particularly from an economic point of view, and they had a profound influence on the economy of these countries, as well as on the food and medicine of their population. The introduction of rubber plants to

*Singapore Botanic Garden founded the important rubber industry of the Malayan Peninsula. At Rio de Janeiro the royal garden was created in order to grow economically useful plants in Brazil that were already known in the Portuguese East Indian colonies.

In due course some gardens gave rise to or were transformed into experimental stations, while others relinquished an economic role altogether. Today many developing countries justify the maintenance of their botanic gardens by directing their research and display towards economic and amenity plants. As much less is known about tropical plants than about those in the temperate zones, there is still urgent need to carry out pure scientific research on them. Tropical botanic gardens should play an important part in this research, yet the trend is against such a role, in spite of the fact that tropical flora is being assaulted and eliminated before thorough investigation has taken place.

Modern role. Accurate naming of plants is only one aspect of the documentation which is seldom seen by the public who visit botanic gardens. Complete records are essential for research purposes, since the provenance of all specimens should be known. Other details need to be recorded and now data banks are replacing manuscript log-books. There is today a greater awareness of the scientific value of material collected in the wild, in place of that previously grown from seeds of unknown origin, distributed by botanic gardens throughout the world via their exchange seed-lists. In this way botanic gardens have built up their collections as a resource of experimental material for plant physiology, cytology, and biochemistry.

Although there is still an important place for the demonstration of plants grouped according to their taxonomic relationships in families in the traditional manner, many botanic gardens now display other relationships. Ecological groupings, such as acid- or alkaline-loving plants, aquatics, rock-plants, and dry-country species, make informative displays. Comparative morphology is used to demonstrate adaptations of various organs in plants such as those of climbing or succulent habit. Geographical groupings lend themselves to displays both out of doors and under glass, so that in a single garden visitors may experience, for example, in the open air, landscaped terrain of European limestone territory and, inside, Australian desert plants in a temperate house and African forest trees in a tropical glasshouse.

While many botanic gardens provide a wide range of plant life, others now specialize in certain aspects or groups of plants and international co-operation is reducing duplication by encouraging the publication of computer-aided inventories. For example, in Florida, the Marie Selby Botanical Garden is devoted to epiphytic plants while the Fairchild Botanical Garden specializes in palms. In South Africa the National Botanic Gardens at Kirstenbosch grow and study the native flora almost exclusively. At Copenhagen the University Botanic Garden has developed cooling greenhouses that simulate growing conditions for Greenland plants, while at *Cambridge University Botanic Garden stress is being placed on the conservation and propagation of rare plants of the East Anglian fens and sandy Brecklands.

Modern techniques also have a large part to play in the conservation of nature. *In vitro* culture of callus tissue is one that has great potential. Another is the storage of seeds in seed-banks: controlled, low-temperature stores where stocks of well-documented seeds are maintained indefinitely in a viable condition. Long-range planning, based on sound scientific principles, has become a priority for botanic gardens, which have an important future as well as an interesting history. F.N.H.

See also BIRMINGHAM BOTANICAL GARDEN; CARIBBEAN ISLANDS AND THE WEST INDIES; GLASNEVIN NATIONAL BOTANIC GARDEN; JAPAN: TOKYO; MEDIEVAL GARDENS: BOTANIC GARDENS; MELBOURNE BOTANIC GARDEN; MISSOURI BOTANIC GARDEN; SRI LANKA; SYDNEY BOTANIC GARDENS.

Bothmar, Schloss, Malans, Grisons, Switzerland, the best preserved baroque garden in the country, was created between 1740 and 1750. Lying beside the palace, which dates from the 16th and 17th cs., the garden is set into the hillside in such a way that its central axis does not lead towards the palace. Only a plan can now show clearly the design of the stepped terraces with their fountains and box-enclosed turf-beds, as impressive clipped box trees right across the garden impede the view. It looks as if the designer intended to give the effect of a labyrinth. The remoteness of this garden amidst the mountains heightens the contrast between its formality and the surrounding natural landscape. Formerly a *bosquet* of yew and of *Thuja*, an aviary, and the artificial ruin of a tower were to be found beside the present garden. The feeling of intimacy and its position and design distinguish this typically Swiss baroque garden from French examples. H.-R.H. (trans. R.L.)

Boucher, François (1703–70), French painter. Admitted as Academician in 1734, he entered on a brilliant and fertile career as a decorative painter, working in the 'petits appartements' at Versailles, Fontainebleau, and Choisy, as well as for private patrons, especially the Marquise de Pompadour whose drawing-master he became. As a landscape painter he drew at *Moulin-Joli, designed by his friend *Watelet, and Arcueil; but he transformed nature into a setting for pastoral scenes or stage sets (he worked for the Paris Opéra from 1742 to 1748). However, this 'picturesqueness' reveals a taste for irregularity and exoticism (see *Chinoiserie) which was to play an indirect part in changing the style of gardens. M.M. (trans. K.A.S.W.)

Bouges, Indre, France, has an elegant small château in the tradition of the Petit Trianon (see *Versailles: the Petit Trianon) built *c.*1759 for the tax collector, Charles Leblanc de Marnaval, and restored in the 20th c. There is a fine parterre of cut turf and box *broderie* surrounded by a stone

balustrade. From the house this forms the foreground to a view of the park *à l'anglaise*. K.A.S.W.

See JARDIN ANGLAIS.

Boughton House, Northamptonshire, England, has a park and gardens of some 60 ha., laid out in the formal style in the 17th c. and enlarged in the 18th c. The 1st Duke of Montagu, who had been Ambassador in Paris, inherited the estate in 1683, and gave the house and grounds a French appearance. For the gardens he employed Van de Meulen, a Dutch garden designer. From *c.*1720 the formal gardens were enlarged to include new courts, a formal pond, much new tree planting, and rides through the park and the estate farmlands. The 2nd Duke's enthusiasm for tree planting earned him the title of 'Planter' John. Within the grounds of the estate is the Dower House, with its notable plantsman's garden created by Sir David and Lady Scott (Valerie Finnis). P.E.

Boulingrin, a sunken ornamental lawn surrounded by sloping banks. The word is a corruption of 'bowling-green'. K.A.S.W.

See SAINT-GERMAIN-EN-LAYE.

Bourges, Cher, France, Pré-Fichaux. See PRÉ-FICHAUX.

Boutcher, William (d. 1738), was a Scottish garden designer and nurseryman in Edinburgh whose practice flourished in the 1720s and 30s. His son, also William, went on to write a distinguished *Treatise on Forest Trees* (1775). He was not a 'professor' as were William *Kent and *Brown, but, like George *London and Stephen *Switzer, was as closely involved in the business end of garden-making as the artistic.

Boutcher's style was similar to that of *Bridgeman in his use of a series of architectural and formal adjuncts to the house, augmented by extensive avenues. Also like Bridgeman his plans show that he could exploit irregularity in design and so his schemes accommodate a variety of sites, and occasionally also incorporate natural elements. He provided designs for, among others, the Duke of Argyll at Inveraray Castle, Argyllshire (Strathclyde Region); Admiral Graham at Airth, Stirlingshire (Central Region); Thomas Cochrane at The Grange, Peeblesshire (Borders Region); and Lord Stair at *Castle Kennedy Gardens. W.A.B.

Bowles, E. A. (1865–1954), British plantsman. See MYDDELTON HOUSE.

Bowood Gardens, Wiltshire, England, are pleasure-grounds of *c.*33 ha., laid out between 1761 and 1786 by 'Capability' *Brown who, characteristically, began by making a sinuous lake, to be a major part of a splendid prospect from the house, now with a direct view to a Doric temple on the far shore. The cascade at the entrance to the lake was built in 1785, having been designed a few years earlier by Charles Hamilton of *Painshill in imitation of a painting by Gaspard Poussin.

Some time after Brown's death in 1783 the formal terraces in front of the house, of which he would not have approved, were laid down: the upper one by Charles Smirke in 1818 and the lower one by George Keene in 1851. Together they constitute the Italian Garden—a pattern of small beds punctuated by flat-topped clipped yews.

The Mausoleum by Robert Adam was completed in 1765. It stands on higher ground beyond the lake and commands a view to the house. In a separate garden of 21 ha. are the Rhododendron Walks on the greensand, providing brilliant colour under a protecting canopy of large pines and oaks set in a tide of bluebells in spring. D.W.

Boyceau, Jacques de la Barauderie (d. *c.*1633), French author and garden designer, was best known for his *Traité du Jardinage selon les raisons de la nature et de l'Art* (1638), published after his death by his nephew Jacques de Menours. Boyceau was born in Saintonge; *c.*1602 he was appointed *gentilhomme ordinaire de la chambre du roi*; and by 1610 he was recognized as an authority on garden planning. Fabri de *Peiresc asked his advice on the design of his garden at Belgentier. As *intendant des jardins* under Louis XIII Boyceau is assumed to have been responsible for supervising the construction of the *Luxembourg gardens for *Marie de Medici.

Designs for *parterres de broderie* in the *Traité du Jardinage* are the earliest representation of garden decoration in this style, for which reason he has been credited with its invention; but his designs resemble those of the *Mollet brothers very closely. Boyceau's book was the first French text to be devoted to pleasure-gardens and their ornament, stressing the importance of variety, not only in the plan (segments of the circle as well as straight lines) and in relief (*bosquets*, *berceaux*, *salles de verdure*, pavilions, fountains, sculpture), but in the use of sites where there are differences of level. K.A.S.W.

Boye, Georg (1906–72), Danish landscape architect, was President of the Danish Society of Landscape Architects from 1949 to 1959 and Vice-President of IFLA from 1956 to 1964. He was actively involved in the education of landscape architects and was Professor of the Garden and Landscape Department of the Royal Veterinary and Agricultural College. His first projects, in the 1930s, when he was employed first by the Park Administration in Aarhus and later by C. Th. *Sørensen in Copenhagen, were chiefly private gardens. On leaving Sørensen, he turned to municipal housing, from single blocks to large housing estates, and then became occupied with a number of public projects, including parks, cemeteries, hospitals, schools, industrial and commercial properties, and still found time for private gardens.

For many years he was landscape architect for the State mental hospitals and institutions for the mentally handicapped; other projects have included barracks, the zoo, the *Tivoli Gardens, town halls, embassies, road intersections and squares, Kastrup Airport, the Television House, and the ministerial buildings on Slotsholmen in Copenhagen. In

1959 he published *Anlægsgartneri* ('Landscape Gardening') and in 1972 *Havekunsten i kulturhistorisk belysning* ('Garden Art from a Cultural Historic Viewpoint'). P.R.J.

Boyle, Richard (1695–1753), English patron of the arts. See BURLINGTON, EARL OF.

Bradley, Richard (*c.*1686–1732), English writer and naturalist, though without formal education in botany, began a journal of whatever he 'found remarkable in gardening or agriculture' *c.*1706. He became proficient in drawing plants and animals, and in 1710 he issued a prospectus for an illustrated *Treatise of Succulent Plants*. He was elected to the Royal Society in 1712. In 1714 he purchased plants in the Netherlands for the Duchess of Beaufort and the nurseryman Thomas Fairchild. Some coffee trees in Amsterdam prompted *A Short Historical Account of Coffee* (1715), the first of his numerous publications. The third part of Bradley's *New Improvements of Planting and Gardening* (1717–18) was dedicated to the Duke of Chandos, whose splendid garden at *Canons he was then planting. However, Bradley disappointed Chandos by 1719, somehow lost his plant collection in 1720, and was in pecuniary difficulties till his death in 1732.

Though Professor of Botany at the University of Cambridge from 1724, Bradley obtained no money and the university no lectures. He fell prey to the booksellers, and he was sometimes suspected of plagiarism. Nevertheless, his works abound with incidental facts about contemporary gardens and nurseries, and his *Gentleman and Gardeners Kalendar* (1718), and *Botanical Dictionary* (1728), offered valuable knowledge. D.L.J.

Bramham Park, West Yorkshire, England has been described as the outstanding example in England of the French style of Le Nôtre. The house and garden were the work of Robert Benson (later Lord Bingley) who began building in 1699 and it is to him and to John Wood, whose *c.*1725 engraving of the garden would almost serve as a garden guide today, that we owe the high beech hedges which are such a feature of Bramham, the *allées*, with their *salles de verdure* at the intersections, the Broad Walk, the *parterre*, now the rose-garden, with its symmetrically shaped and positioned Irish yews, and the T-shaped canal (*c.*1728). The *bassin* in the centrally placed semicircular recess at the far end of the parterre once took the flow of a 30-step French cascade.

The 2nd Lord Bingley, George Lane-Fox, who married Benson's daughter and inherited in 1731, added the temples and fashioned six differently shaped and sized obelisk ponds and cascades with their curious dragon-mouthed outlets. He was also responsible for building the rotunda (*c.*1750) and the obelisk (1768) in the area of woodland known as Black Fen.

The Broad Walk, terminating to the north in James Paine's Ionic Temple (1750–62), stretches southwards past the house to the Obelisk Pond and then on through Black Fen to the rotunda and obelisk. In Black Fen are some of the trees of the original planting, Spanish chestnut (*Castanea sativa*) and lime.

The beech avenues are behind Paine's temple, five of them meeting at the Urn of the Four Faces, and one being aligned on the T-shaped canal. The splendid avenues of mature tall beech which led the eye from the Obelisk Pond to the Gothic Temple (1750) and the Open Temple (*c.*1745–50) were razed to the ground in the gale of Feb. 1962 when over 400 fell. Replanting has taken place. K.LE.

Brandt, G. N. (1878–1945), was an eminent Danish landscape architect who defined the art of garden design in Denmark: 'for reasons of economy as well as aesthetics modern architecture renounces the geometrically designed garden and prefers a more natural layout with irregularly planted vegetation forming a background to the sharp lines and simple form of the houses.' He nevertheless retained many formal elements in his designs; for example at Swastika in Rungsted, his self-contained June garden with yellow and white flowers (1926) consisted of square and rectangular planting beds asymmetrically placed with equal width grass walks between, the main area in front of the house being designed with informal groups of trees. This garden quickly became a model for designers and its influence can still be seen today.

Brandt followed the principles of the English garden movement established by William *Robinson and Edwin *Lutyens and Gertrude *Jekyll. He paid particular attention to the relationship between the architectural elements of the garden and the natural 'ecologically appropriate' elements, as expressed in a number of typical details, including strips of grass with wild flowers, grass walks flanked by informal hedges, and stone dykes with plants growing out of the cracks. He called himself a gardener although he designed and carried out a large number of projects. But he never discussed his ideas with clients.

His work included the model Hellerup Beach Park and numerous parks and gardens in Copenhagen, including the delightful Tivoli Gardens, the zoo, a roof garden for Radio House, Ordrup churchyard, and Mariebjerg Cemetery for which he received the C. F. Hansen medal in 1927. It is outstanding for the intimacy and variety of the burial spaces arranged within a strong axial layout. P.R.J.

See also CEMETERY: DESIGN FEATURES.

Branitz, Cottbus, German Democratic Republic. After the sale of Muskau, Prince *Pückler-Muskau began in 1846 to lay out the 70-ha. park of the old family estate of Branitz, in which Humphry *Repton's influence was less noticeable. Work continued until his death in 1871, interrupted only by his visit to England in 1851. His nephew continued the work to its completion in 1910.

Two plans, dating from 1846, are partly surveys and partly designs. In 1846–53 the first section of the Schmiedewiesen up to the Cottbus Gate was completed. In 1846–52 alterations were made to the Schloss (1772) by

Gottfried Semper and a terrace was laid out; existing farm buildings were altered by the addition of neo-Gothic gables and rebuilt as the Kavalierhaus and the Marstall (1846–50). Between the two an 'Italian Wall' was built by Semper in the form of a pergola, which encloses the courtyard, and cast-zinc statues and terracotta reliefs were made by Thorwaldsen. On the terrace were cast-zinc pans and, on the park side, two griffons (since demolished).

East of the Schloss the Schmiedewiesen were laid out c.1850 with the façade structure of the Smithy; impressive groups of trees of monumental size lead towards the Schloss. Around the Schloss were the pleasure-ground (originally enclosed by gilded fencing) with the Mondberg, the Kiosk with the bust of the singer Henriette Sonntag, a statue of Venus on the island in the lake, and the Blauer Garten with the Rosenhügel; originally there were also flower-beds within basket-like enclosures. From the Schloss vistas lay along three well-proportioned axes, partly over the lake (1849–50) and the Schilfsee (1857–8) to the Poetenhügel. Gently undulating ground results in evocative yet stimulating scenery. On the northern boundary there is a greenhouse with two large lions (1849).

The park was extended to the west from 1853; from 1868 the technical work was supervised by the Park Director, Georg Bleyer. Beyond an intermediate grove and placed at right angles were extensive areas around the Pyramidensee with one pyramid (1854–6) in which Pückler and his wife were buried, the Stufenpyramide (1863), the Schlangensee (1868), and an incompleted third pyramid, the Hermannsberg. Final extension to the west was to the so-called Bleyer Park, distinguished from the remainder of the park by its rather less refined forms. Later plans (mostly surveys) date from c.1870, 1903, and 1970. H.GÜ.

Brazil. See SOUTH AMERICA.

Brécy, Calvados, France, has a manor-house whose interest lies in the architectural framework of the early 17th-c. garden which rises to five stages, the first being the width of the house, each successive one becoming wider. A central walk with four flights of steps rises to the top balustraded terrace and a monumental gateway with a wrought iron grille opening on to a green vista. The Mannerist sculptured decoration is notable. The restored gardens are laid out with box in designs of *broderie* or clipped into sculptural forms. K.A.S.W.

Brenthurst, Witwatersrand, South Africa. The first garden, laid out in a series of stiff terraces, was redesigned from 1958 until her death in 1974 by Joan Pim and is one of the finest examples of her art.

The kopje behind the house has been preserved as a wild garden, with cobbled paths leading up steps, over bridges, and between weathered rocks and indigenous plants (some growing naturally and others introduced). These blend with a collection of Australian shrubs, which thrive on the warm sunny slopes. At the foot of the kopje is a Japanese garden, the focus of which is a huge wooden water-wheel.

Below the house, the garden falls away in a series of broad, lawned terraces, each of which has a separate theme, incorporating pools, fountains, and sculptures including Rodin's statue of *Venus Victrix*.

To the west of the terraced gardens is the working area: orchard, vegetable garden, glasshouse, and an orchid house. To the east, paths wind through woodland glades, where pink *Hydrangea macrophylla* var. *hortensia* grow in summer, and narcissi in spring, and where further sculptures can be found. In the woodland sections ground covers have been skilfully used: for example, forget-me-nots growing under an avenue of crab-apple trees. J.G.R.

Brenzone, Villa, San Vigilio, Veneto, Italy. The garden was constructed c.1540 from drawings by Michele Sanmicheli for the well-known philosopher and lawyer, Agostino Brenzone, who wrote a treatise on the joys of the solitary life. It is dramatically situated on a promontory overlooking Lake Garda. Silvano Cattaneo (1484–1559) visited the garden c.1550 and mentioned 'a fine, spacious road . . . between laurels and myrtles and many handsome and beautiful gardens of cedars, lemons and oranges' (*Salò et la Riviera*, published much later in 1745, Venice). There was also a Garden of Apollo surrounding a tomb of Catullus. A *tempietto* of S. Vigilio still remains but the most notable survival of the original garden is an artificial *mount surrounded by cypresses and architectural niches with busts of Roman emperors in an *exedra. This may have provided the inspiration for William *Kent's attachment to the exedra form, which he employed, for example, at *Chiswick and *Stowe. G.A.J.

Bridge. The concept of a bridge as a decorative motif in gardens and landscape began in China long before it appeared in the West. The most popular has always been that which makes, by reflection, a complete circle. The culmination of Chinese bridges as a landscape feature is probably the Bridge of the Seventeen Arches in the restored Summer Palace (*Yi He Yuan) near Beijing. In the West bridges were largely functional and architectural until the Romantic revolution and Chinese fashion established the bridge solely as an element of decoration. G.A.J.

Although of course of practical use, in spanning a piece of water (or a road), in English gardens bridges became progressively more ornamental in the 17th and 18th cs., even to the extent of 'dummy' bridges as at Kenwood, London. The architectural style varied considerably: there are classical bridges at *Chatsworth (by Paine), *Chiswick House (Wyatt), and Weston Park, Staffordshire (Paine), and simple rustic bridges often of wood with a diagonal criss-cross design. Sometimes such bridges are described as Chinese because the designs are often identical to the *Chinoiserie of the pattern-books.

Palladian bridges merit particular attention in the 18th-c. landscape garden. The simplest structure of all is the wooden bridge illustrated in Woollett's engraving of *Painshill; the stone bridge at *Stourhead is based on Palladio's

bridge at Vicenza and that at *Castle Howard on his work at Rimini; but the most elaborate and beautiful are those with colonnaded superstructures, starting with that at *Wilton House (1735–7) and its copies at *Prior Park and *Stowe. A smaller copy once existed at *Hagley Hall. *Vanbrugh's bridge at *Blenheim was originally intended to have a superstructure. Robert Adam designed a number of bridges, ranging from the neo-classical at *Audley End and at Compton Verney, Warwickshire, to the semi-Palladian tetrastyle Ionic bridge temple also at Audley End, now known as the Tea-House Bridge.

Bridges often affected the way water was shaped. They can also fulfil a symbolic function, as for instance in Japanese gardens where they may link two conceptually distinct areas. M.W.R.S.

See also QU QIAO.

Bridgeman, Charles (d. 1738), English landscape architect, is a key figure in the evolution of the English landscape garden which—as the *jardin anglais*, *englische Garten*, or *giardino inglese*—was to sweep 18th-c. Europe. As such, Bridgeman played a crucial role in the transition from the geometric layouts of the late 1600s and early 1700s to the freer designs of William *Kent and Lancelot 'Capability' *Brown.

Horace *Walpole's opinion, expressed in his essay *On Modern Gardening* first published in 1780, was that Bridgeman was 'the next fashionable designer of gardens' after *London and *Wise. Although, says Walpole, he still 'adhered much to straight walks with high clipped hedges', he had 'many detached thoughts, that strongly indicate the dawn of modern taste', notably his introduction at Richmond of 'cultivated fields, and even morsels of a forest appearance', and his use of the 'simple enchantment' of the *ha-ha which 'pointed out new beauties and inspired new ideas'. The ha-ha was the 'capital stroke, the leading step to all that has followed'. Its impact was decisive. 'How rich, how gay, how picturesque the face of the country!' exclaimed Walpole. 'The demolition of walls laying open each improvement, every journey is made through a succession of pictures.'

The features of Bridgeman's work may be categorized as formal, transitional, and progressive: the formal can be seen in *parterres, kitchen gardens, avenues, and rectilinear, round, or octagonal lakes or ponds; the transitional in lawns, *mounts, amphitheatres, statues, garden buildings, and irregular *cabinets*; the progressive in the use of ha-has, rides, and walks to exploit key vantage points. The final impression, as Bridgeman fuses these diverse elements, depends upon their context and his exploration of the *genius loci*. It depends, too, upon the increasing significance given to literary, historical, and mythological meaning in landscape design as the 18th c. progresses; the continuation of the *beatus ille* tradition expressed in the virtues of country life leads to that 'Farm-like Way of Gardening' advocated by Switzer and to the *fermes ornées* found on such estates as Dawley in Middlesex, where Bridgeman may have assisted Lord Bolingbroke.

Bridgeman was able to combine work on such estates as Dawley with an official post: from 1728 to 1738 he was Royal Gardener to George II and Queen Caroline, in which he was successor to Henry Wise, who had held the position under Queen Anne. Strictly speaking, the Royal Gardener did not form part of the establishment of the Office of Works, but in effect Bridgeman was in charge of the royal gardens and parks at *Hampton Court, St James's Park, Windsor, and Hyde Park and *Kensington Gardens (where he was responsible for the Round Pond and the Serpentine). More significantly, he assisted Queen Caroline at Richmond Gardens, where Kent designed several buildings—notably the Hermitage and Merlin's cave, with its three pairs of wax figures. The Queen's gardening idiosyncrasies became a political pawn and the subject of widespread derision in such journals as the *Craftsman*. Anticipating Walpole's comment on Bridgeman's activities there, Sir John *Clerk of Penicuik noted the 'fields of corn interspersed' when he visited Richmond in 1733, and remarked that they had been introduced chiefly 'for the benefit of the game'.

Much of Bridgeman's contribution to the royal gardens consisted of preserving the existing layout rather than initiating new and adventurous schemes, and Hampton Court and Windsor retained their formality. The most rigid of Bridgeman's designs for private clients seems to have been at Eastbury in Dorset, for the Dodingtons, illustrated in the third volume of Campbell's *Vitruvius Britannicus* of 1725. Elsewhere he could be much more adventurous, as when employed by Sarah, Duchess of Marlborough, at *Blenheim, by Lord Harley at *Wimpole Hall, or at *Claremont for the Duke of Newcastle during the 1720s. Claremont boasts a temple by Kent, a *belvedere by *Vanbrugh, and an admirably-preserved amphitheatre based on Bridgeman's design (published in Switzer's *Introduction to a General System of Hydrostaticks and Hydraulicks* of 1729). At *Rousham House, for the Dormer family, Bridgeman once more is linked with Kent in the exploration of the pictorial qualities of an exquisite site.

The most magnificent of these private estates was *Stowe, seat of Richard Temple, 1st Viscount Cobham, and the most celebrated English landscape of the day. Shortly after 1713 Bridgeman seems to have begun his activities there, working alongside Vanbrugh, Gibbs, Kent, and Flitcroft. Numerous poems and guidebooks attest to Stowe's glories, and in 1733–4 Bridgeman commissioned Rigaud and Baron to prepare their sumptuous set of views of Stowe which (with a plan) were published by Sarah Bridgeman in 1739, the year after her husband's death. These show a remarkable fusion of formal, transitional, and progressive elements within a cohesive and dramatic layout, and incorporate an adventurous and judicious use of walks, hahas, regular and irregular planting, waterscape, and numerous temples and garden features—many of them embodying personal, literary, historical, religious, and mythological themes. All told, it is a supreme reflection of the Cobham family motto of *Templa quam delecta*.

Such ideas must have stemmed in part, at least, from

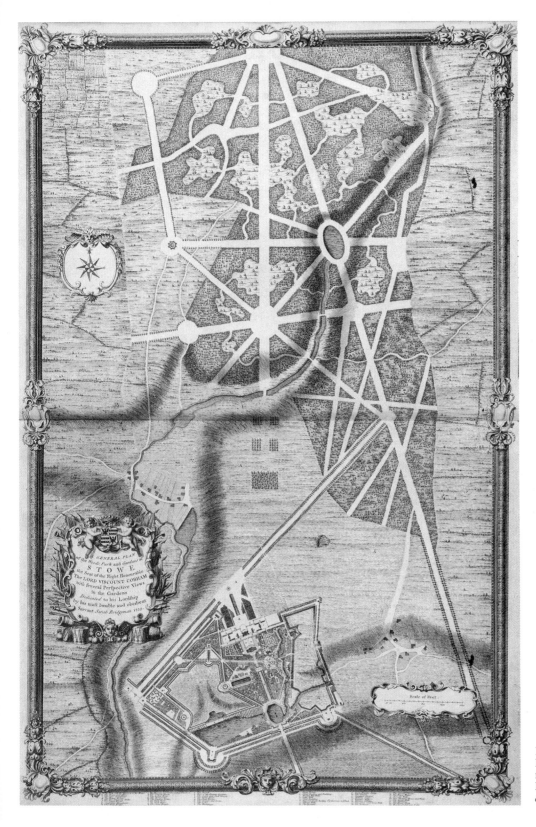

Plan of Stowe,
Buckinghamshire,
from Sarah
Bridgeman, *Views
of Stowe* (1739)

Lord Cobham, but they also reflect Bridgeman's own friendship and collaboration with architects (notably Vanbrugh, Gibbs, and Kent), writers (such as *Pope and *Prior), and painters (such as Wootton, Mercier, and Thornhill). Through them—and, for instance, through his membership of the exclusive St Luke's Club of Artists, to which he was elected in 1726—Bridgeman would be conversant with the progressive thinking of the day. Such progressive thinking, and the landscapes it inspired, was taken up abroad in a passion for *anglomanie*: although a parody, the *jardin anglais* which was to spread throughout Europe, and further afield, owed more to Bridgeman and Kent than to 'Capability' Brown.

When Bridgeman died in 1738 at his home in Kensington the gardening revolution in England was all but won, and in 1755 the journal *The World* could only note its positive delight at 'the rapid progress of this happy enthusiasm'.

P.W.

See also CHISWICK; CLIVEDEN; ENGLAND: DEVELOPMENT OF THE ENGLISH STYLE.

Brighton Pavilion, England. See ROYAL PAVILION, BRIGHTON.

Broderie. See PARTERRE.

Brookes, John (1933–), English garden and landscape designer, began his professional training at the Durham County School of Agriculture where he studied commercial horticulture, followed by a three-year apprenticeship to Nottingham Parks Department. Subsequently he attended the course in landscape design at University College, London, under Peter Youngman while working as assistant, first to Brenda *Colvin and later to Sylvia *Crowe. For a time he was assistant editor of *Architectural Design,* before setting up his own practice in 1964.

His interest in architecture and the garden as an outdoor room is expressed both in his work and in a number of books: *Room Outside* (1969), *Gardens for Small Spaces* (1970), *Garden Design and Layout* (1970), *Living in the Garden* (1971), *The Financial Times Book of Garden Design* (1975), *The Small Garden* (1977), *The Garden Book* (1984), and *A Place in the Country* (1984). He is currently working on a book on the new gardens of Islam. He has lectured at many colleges and institutions, including the Royal Botanic Gardens, Kew; was Director of the Inchbald School of Garden Design, London and Tehran; and has lectured in the United States and South Africa. He runs his own school of garden design at Fontwell, near Arundel, West Sussex.

Although his work has included a variety of landscape projects, Brookes is chiefly known for the design of gardens, in which he reveals an assurance in the handling of both the geometric and the organic elements which is rare in British designers.

M.L.L

Broughton Hall, North Yorkshire, England, is one of the best surviving examples of the work of W.A. *Nesfield, who from 1855 to 1887 laid out the garden to accompany

alternations by the Bradford architects Andrews and Delaunay, who designed the conservatory. In the park he sited statues and planted a semi-natural landscape; on the new walled terrace he created a *parterre using a scroll and feather design in box on coloured gravels. This was turned into a lawn in the 1870s, but (omitting the blue and white gravels) restored to Nesfield's design at the turn of the century.

B.E.

Brown, Lancelot (1716–83), English landscape designer, generally known as 'Capability' from his references to the 'capabilities' of the places on which he was consulted, was from c.1732 to 1739 in the employment of Sir William Loraine, of Kirkharle Tower, Northumberland, where he learnt the rudiments of building and land management, proving himself sufficiently capable for Sir William eventually to entrust him with the laying out of part of his grounds. His reputation for landscape works was to spread, so that towards the end of the 1730s he was consulted on other estates including that of Robert Shafto at Benwell Tower near Newcastle. In 1739 he decided to move south and was next heard of in the Buckinghamshire–Oxfordshire area, his first southern commission being from Sir Charles Browne of Kiddington near Woodstock, who required a lake and general landscape designing of his grounds.

By the beginning of 1741 Brown had come to the notice of Lord *Cobham whose gardens at *Stowe were already regarded as among the finest in the country, the late 17th-c. *parterre having been altered and enlarged by Bridgeman and embellished with buildings by *Vanbrugh, *Gibbs, and William *Kent. The latter was still supplying designs, but the fact that his visits were, at most, occasional meant that their execution became the responsibility of Lord Cobham's own staff, and in particular of his head gardener. Until 1741 this post had been held by William Love whose departure in that year left a vacancy which Brown was to fill, and within a short time he was also acting as clerk of the works and paymaster. In the ensuing years he was thus closely concerned with carrying out William Kent's designs, notably for the Palladian Bridge, the Temple of Venus, and the grotto. Through this work Brown absorbed both Kent's theories and his manner of composition. Kent was not, however, the only influence on Brown at this time for James Gibbs was also providing Lord Cobham with designs which included the Temple of Friendship, the Ladies' (now Queen's) Temple, the Boycott Pavilions, and the Gothic Temple. Gibbs was the source of many details used by Brown when he came to prepare his designs for the bath-house at *Corsham Court, the (unexecuted) pavilions at Rosamund's Well in Blenheim Park, and by the lake at Rothley, and the greenhouse which was built at *Burghley House. Brown was laying out the Grecian Valley at Stowe in 1747, and in the same year was concerned with the building of the octagonal column designed by Gibbs and intended by Lord Cobham as a *prospect tower, but which was to become the latter's memorial after his death in 1749.

During the 1740s Lord Cobham had recommended Brown to some of his closest friends and to his nephew

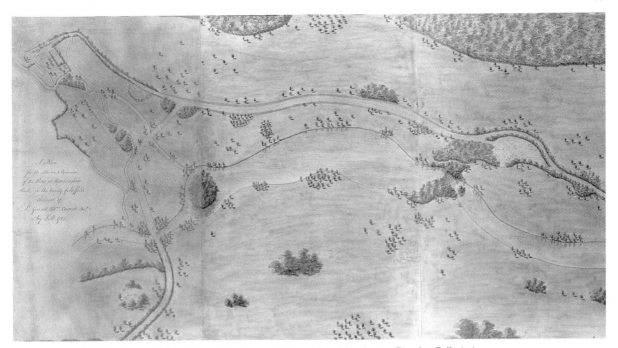

Heveningham, Suffolk, plan (1781) by 'Capability' Brown (Heaton Hall, Manchester City Art Galleries)

Richard Grenville for whom Brown remodelled an earlier garden at Wotton. From 1745 he was supervising alterations to the grounds at Newnham Paddox for Lord Denbigh; in the two years following Lord Cobham's death he had in hand schemes for the grounds of Packington Hall, Warwickshire, and *Petworth House (see plate XVII*a*), and was advising on the gardens of *Warwick Castle on which Horace Walpole commented to George Montagu in a letter of 22 July 1751: 'The view pleased me more than I can express, the river Avon tumbles down a cascade at the foot of it. It is well laid out by one Brown who has set up on a few ideas of Kent and Mr. Southcote.' It was by now apparent that Brown was the new master in the art of landscape design, able to give not only the designs but the directions necessary for their execution, which frequently involved the making of lakes, widening of rivers, altering of contours, and planting of areas far greater than those with which Kent had been concerned. His proposals would be submitted either as designs for which his clients could use their own estate workmen, or for which Brown would be responsible under contract. As only one of his account books has survived, details of many of his early works are missing or come from such drawings or other documents as have survived in the houses for which they were prepared.

His earliest surviving plans are for the layout of the grounds at Packington Hall, dated 1750 and 1751. They show that Brown had by now evolved a characteristic method of setting out his proposals, usually in ink but occasionally tinted, as in the large schemes for *Heveningham Hall and Brocklesby, Lincolnshire. The Packington design of 1751 has inset details for the cascade,

gateway, and Ladies' Temple, the cascade having affinities with that at Stowe, while the temple derives from Gibbs's similar building there before it was remodelled by Blondel in 1773. Traces of the cascade survive, but the temple and gateway were not built.

In 1750 Brown was consulted on the building of a new house and the landscape designing of the park at *Croome Court. This involved the building of a Palladian mansion with corner turrets and a tetrastyle Ionic portico on the south side, a feature adopted by Brown in several later houses. In the grounds created out of what had been 'as hopeless a spot as any in the island', he formed a serpentine lake, built a grotto at the head of the water, and designed a tunnel under the main road to link parts of the estate. In this demanding commission, his success established beyond doubt his ability as an architect as well as a landscape designer.

Brown moved from Stowe to the outskirts of London in the late autumn of 1751. From 1752 he was at work on Kirtlington Park for Sir James Dashwood, *Moor Park Mansion for Lord Anson, and Belhus for Lord Dacre. He returned to Newnham Paddox in 1753 to provide the house with a new façade and additional rooms; and in the following year was altering both the house and grounds at Beechwood for Sir John Sebright. Towards the end of 1754 came a major commission for alterations to the house and grounds at Burghley House. Later in the decade Brown was advising at Maddingley, *Longleat, *Wrest Park, Ashridge, and Burton Constable, the latter involving designs for a new hall, which did not materialize. In 1760 Paul Methuen asked him to enlarge Corsham Court; Brown's plan for

altering the grounds survives, and shows that he replaced a semi-formal layout by Thomas Greening.

An attempt by several of Brown's patrons to obtain for him a royal appointment in 1758 was not successful, but in 1764 he was given the office of Master Gardener at Hampton Court in succession to John Greening. The post carried with it an official residence, Wilderness House, within the Palace grounds, where Brown and his family were to spend much of their time although he was also to acquire a property of his own in Huntingdonshire in 1767. In the grounds of Hampton Court he made few changes beyond maintenance and a small amount of planting which included the Great Vine which is still producing its annual crop of Black Hamburg grapes. His duties, however, extended to the Old Park at Richmond, now part of the Royal Botanic Gardens, *Kew, where his 'great alteration and improvements' included the rhododendron walk. They also involved the destruction of Merlin's Cave, the bizarre little building which had been designed by William Kent for Queen Caroline some 30 years before.

Up to the time of his appointment, Brown had no assistance in his practice but with the increasing volume of work he now (1765) found it necessary to take on two draughtsmen for the initial surveying which his commissions entailed. Those selected were Samuel *Lapidge and John Spyers, both then living in the Hampton Court neighbourhood, and both of whom were to remain with him until his death. Another employee taken on in this year was the working gardener Michael Millican, previously employed at Chatsworth, and now put in charge of work at Richmond where he became a character of some note. Meanwhile Brown's private practice had extended to enlarging Kent's garden work at *Holkham Hall, and to laying out the grounds at Kimberley, *Audley End House, and Redgrave, where he was later to remodel the house. *Chatsworth had been in hand since the beginning of this decade, as were the gardens of Branches, Temple Newsam, Milton Abbey, and Castle Ashby where, from 1761, he had been forming the extensive lake and the lake-side temple and menagerie, as well as a bridge and a dairy.

Brown was first consulted by George, 4th Duke of Marlborough, in 1763 when the latter asked for plans for Langley Park and *Blenheim. Brown prepared the plan for Langley and dispatched it some time early in June of that year, but the Duke then decided that it was more important to go ahead with the alteration of Blenheim Park, and postponed the Langley work. Brown's plan for the 'Intended Alterations' at Blenheim is undated but it was in hand by the beginning of 1764, continuing over the next 10 years until the amounts received by him finally amounted to over £21,500 out of which he paid for the carrying out of the work. The principal features were the damming of the little River Glyme to form two extensive lakes, one on either side of Vanbrugh's bridge, the piers of which were, however, partly submerged in the process. At the far end of the western lake, where it turns south and narrows again, Brown constructed a wide rockwork cascade which survives, as do many of his original plantations, now grown to immense

size. 'You and I, Sir!' remarked Dr Johnson to James Boswell when they visited Blenheim in 1776, 'have, I think, seen together the extremes of what can be seen in Britain: the wild rough island of Mull, and Blenheim Park.' In general the Park received enthusiastic praise from contemporary visitors, and Thomas *Jefferson, whose comments on English gardens were not always flattering, was not only impressed by it but recorded that 200 people were employed in its upkeep, and that the garden turf required to be mown every 10 days.

The year 1763 also saw the initiation of another extensive work, and one which led to further commissions for the same client, the 3rd Earl of Bute. This was Luton Hoo, Bedfordshire, which the latter had purchased in the previous year. Only one fragment of Brown's plan for the grounds has survived, and is now in the Metropolitan Museum, New York. His account book, however, shows that the work here continued for over 10 years by which time payments to him had amounted to more than £10,000. The grounds at Milton Abbey and Tottenham Park were also begun in 1763, and two years later came the creation of the lakes at Rothley, alterations to the house and gardens at Broadlands, and a column designed by Brown at the request of the Earl of Chatham and erected at Burton Pynsent as a memorial to the latter's benefactor, Sir William Pynsent. These works were followed by the laying out of the grounds at Sandbeck (incorporating the ruins of Roche Abbey) in 1766, at *Wimpole Hall and Compton Verney in 1767, and the first stages of rebuilding the house and laying out the grounds at Fisherwick in 1769.

In the ensuing years it became clear that none of Brown's three sons had any inclination for their father's profession, and by the end of this decade the ever-increasing number of his commissions led him to look elsewhere for a partner who could relieve him of part of the architectural work involved. His choice fell on Henry *Holland who, on joining Brown in 1771, took over much of the internal finishing of *Claremont, the most important work Brown had in hand. Through his association with Brown, Holland was brought to the notice of several influential patrons from whom, after Brown's death, he received commissions which established him as one of the leading architects of the day.

In the 30 years from 1753 until his death Brown was without any serious rival in the realm of landscape design. Although towards the end of his life a handful of 'improvers' were at work, notably, Richard *Woods, William *Emes, and a certain *Richmond, who was mentioned by Walpole as a 'scholar of Brown', their achievements were limited, and it was not until Humphry *Repton turned to garden design in 1788 that a comparable successor appeared. Brown left no published account of his theories but in a letter of 2 June 1775 to the Revd Thomas Dyer he set out what he considered to be the essentials for good landscape design, or, as he termed it, 'place-making'. These, he maintained, should be 'a perfect knowledge of the country and the objects in it, whether natural or artificial, and infinite delicacy in the planting etc., so much Beauty depending on the size of the trees and the colour of their

leaves to produce the effect of light and shade'. Thought should also be given to planting trees for shade, and shrubs for their scent. Attention to such details would ensure that 'the English garden' would be 'exactly fit for the owner, the Poet and the Painter'.

In 1770, three years after his acquisition of the Manor of Fenstanton, Brown served as High Sheriff of Huntingdonshire. In 1772 his advice was sought by the Master of St John's College, *Cambridge, on repairs to the eastern bank of the Cam and the laying out of the *Wilderness in the College grounds, for his trouble over which he was presented with a 'piece of plate' to the value of £50. A scheme which he prepared for the Senate of the University in 1779 for unifying and landscaping the Backs was not, however, adopted although for this he was given a silver tray bearing the University arms.

Brown died suddenly from a seizure on 6 Feb. 1783 in London. He was buried at Fenstanton where his Coade stone monument is inscribed with an eulogistic verse by William Mason. D.N.S.

See also BOWOOD GARDENS; ENGLAND: DEVELOPMENT OF THE ENGLISH STYLE; EUSTON HALL; HAREWOOD HOUSE; NUNEHAM PARK; PRIOR PARK; SHEFFIELD PARK GARDENS; TRENTHAM PARK; WALLINGTON.

Brownlow Hill, New South Wales, Australia, is where George Macleay, son of Alexander *Macleay, introduced (c.1840) to Australian gardening many features of the *gardenesque style.

Sited on a plateau, the house is visible from a distance, and then disappears from sight as the road enters a straight section originally lined by stone pines (*Pinus pinea*). Inside the gates, classic urns on a stone wall define the margin of a large pond set with water-lilies. A gentle slope between clipped box and olive hedges leads to the front of the house.

On its east front the lawn slopes to a steep bank which extends along the brow of the hill as a grassy sward leading the eye towards the aviary, a curious little brick building, with arched openings. The whole effect is remarkably similar to J. C. *Loudon's view of Mrs Lawrence's 'Italian walk' (*The Suburban Gardener and Villa Companion*, 1838, pp. 582–3). Adjacent are a group of geometric flower-beds, centred on a sundial inscribed 'Macleay 1836', which compare with Mrs Lawrence's French parterre. H.N.T.

Brühl, North Rhine-Westphalia, German Federal Republic. See AUGUSTUSBURG.

Brunfels, Otto (1489–1534), was a physician, born near Mainz. After some years as a Carthusian monk, he became a Lutheran convert and ultimately the town physician of Berne, where he died. The first part of his *Herbarum Vivae Eicones* was published in Strasburg in 1530, followed by a second in 1532, and a third in 1536, a book that marked the beginning of the greatest century in the production of printed *herbals. A German translation followed in 1532–7. Although he encouraged his artist Hans Weiditz to draw plants from nature, demanding 'new and really lifelike

figures', Brunfels himself was still more interested in those with a good pedigree in classical literature, especially *Dioscorides. He seems never to have realized that different regions have different native plants, although some are common to many countries. He even wanted to segregate the plants known only by vernacular names into a mere appendix. The artist seems to have rebelled, for he drew what he liked, regardless of the status of the plant, turning the book into a high point in the development of *botanical illustration. S.R.

Brussels Court, Belgium. References can be found to the grounds of the former Court of Brussels—replaced in the 18th c. by the present park—as early as the beginning of the 14th c. These grounds covered an area of c.35 ha., divided into a few irregular sections by enclosures. The terrain was uneven, its principal feature being a dip running alongside the palace which was built on a hill. Three-quarters of the grounds consisted of woodland (mainly oak, beech, and elm), which was initially a game reserve, but later was turned into a leisure area, populated by deer and accessible to a select public. The rest of the park lay in the dip, between the wood and the back of the palace, and contained a private garden, a flower garden with a loggia going back to the 15th c., a fish-pond, a palm-court, a tournament field, and, on the slope adjacent to the wood, a vineyard. The grounds also contained an orangery, an aviary, and a menagerie.

The garden for the Court's private use lay on the upper slope of the dip, below the edge of the palace hill, in the direction of the outer rampart. This garden originally consisted of an orchard, to which a wooden summer-house and a fountain decorated with sculptures had been added in the 14th c., while the approaches were arranged along naturalistic lines. The garden was transformed c.1520 by the Emperor Charles V to look like a labyrinth, planted with trees all of the same type and pruned to form *allées*, porticoes, *cabinets de verdure*, and bowers; the new garden was decorated with fountains, and also contained a bathing pool, in the middle of which stood the summer-house, now raised up on marble piles.

About 1600 the grounds were further enhanced by Salomon de *Caus, who, close by the private garden, began to build rock and shell grottoes in the Italian style, with astonishing ornamental waterworks which drove automata and caused music to play. He also renovated the 'labyrinth', making it into a sloping rectangle, surrounded and bisected at right angles by a continuous bower of pruned greenery which formed a border for gardens containing parterres and fountains, as well as the former pond with its summer-house on piles; another pavilion, set further up the garden, housed a collection of paintings. X.D. (trans. K.L.)

Brussels Park, Belgium, the last major formal garden to be created in Belgium in the 18th c., constitutes, along with the Place Royale, the classically designed quarter of Brussels which was built between 1775 and 1783 to replace the former palace (destroyed by fire in 1731) and its grounds.

The park, a huge public square planted with full-grown

trees and surrounded by streets, was begun in 1776. It formed a rectangle measuring 13 ha., with its front corners (facing the Place Royale) cut off (this trapezium-shaped end section was amputated in 1904 to form a square in front of the new royal palace). The layout, in harmony with that of the new quarter, was designed by the architect responsible for the overall plans, the Frenchman Guimard.

The park is laid out geometrically with straight *allées*, carpeted with a central grass border and arranged in a Y-shaped pattern, centring on a **rond-point* situated towards the bottom centre. The axial *allée*, which runs the whole length of the park, offers a dual perspective: towards the bottom it looks towards the *rond-point*, and beyond that to the peristyle of the former Brabant Council (now the Parliament), while, towards the front, it used to be prolonged by an avenue through the quarter (replaced by the royal palace). The two oblique *allées*, which move out from the *rond-point*, on either side of the axial *allée*, run along to the cut-off corners beyond which the perspective is also prolonged, in one direction in the axis of the Place Royale, in front of which it forms a green expanse. The Y-shape is cut across by two transverse parallel *allées*, their perspectives extending into the streets to the side. Apart from these five *allées*, bordered with rows of fully-grown trees, there is an *allée* bordered by **charmille* running around the whole park, alongside the four streets in which monumental entry-gates have been built.

The large number of thoroughfares thus created were none the less subtly combined with recesses, because the various wooded areas separated by the roadways are criss-crossed with small walks, most of them at a slightly higher level. Moreover, at the front of the park the former dip was not completely filled in and this lower area was initially arranged as an English garden.

The *rond-point*, with perspective views in four directions, has from the beginning been surrounded by a series of busts of Roman Emperors on a background of *charmille*. Its centre, where it had been planned to set an obelisk-shaped monument and a fountain dedicated to the Austrian monarchy, has since the 19th c. been occupied by a large round pond. An octagonal *bassin* is also to be seen on the axial pathway where it cuts across the transverse *allée* at the upper end of the park. In addition, the park has, from the beginning, been enhanced by several statues, as well as a small theatre and a 'Vauxhall' (see **pleasure-garden*) (café, restaurant, and shops), built *c.*1783 near the street at the lower end. X.D. (trans. K.L.)

Bruun, Andreas (1936–), Danish garden designer, has designed gardens which express, more than those of any other Danish landscape architect, the character of the smaller Danish gardens of today. His *Danske Haver i Dag* ('Modern Danish Gardens') (1971) contains many of his own gardens which clearly demonstrate the links with the past in the Renaissance ideals of the chequerboard herb and knot gardens, combined with a continuing preoccupation with geometry expressed in clipped hedges and carefully selected plant forms. P.R.J.

The designer's own garden (1960) at Lyngby, Denmark, by Andreas Bruun

Drawing of the Bruun garden at Lyngby

Buchlovice, South Moravia, Czechoslovakia, was founded in the late 17th c. and built according to the designs of the Roman architect Domenico Martinelli. Despite the harsh climate of the Chřiby hills he designed a structure of the Italian villa type, situated on slightly sloping terrain.

The originally regular garden with several low terraces covered an area of *c.*5 ha. In the first half of the 18th c. the garden was rearranged in the French fashion and enriched by yew topiary and trimmed path borders. Later years brought further architectural changes, fortunately always in keeping with the original character of the edifice. The courtyard, joining two separate parts of castle buildings, was decorated with stone statues, urns, and rail fences. The two fountains, situated in the courtyard and in the garden, were connected with the central axis to which, in the year 1794, an obelisk was added by the new owners of the estate, the Berchtold family.

In the early 19th c. a landscape park of *c.*50 ha. was added to the castle garden. It did not have an architectural layout at first. Later on a considerable number of exotic shrubs were planted by the brothers Dr Leopold and Dr Bedřich Berch-

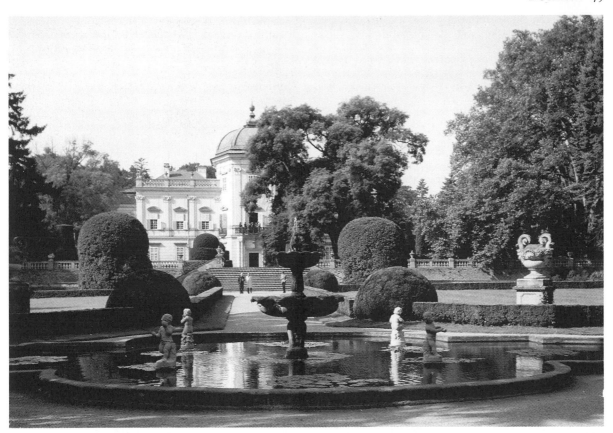

Buchlovice, Czechoslovakia

told, both natural scientists who had travelled widely. Their gardener, Bedřich Böhm, also played a decisive role in the formation of the landscape park.

Today, the park of Buchlovice boasts 60 subspecies of conifers and 143 deciduous trees. The castle, garden, and park belong to one of the best preserved areas in Czechoslovakia. O.B.

Buen Retiro, Madrid, Spain, the last of the Spanish Habsburg gardens, was designed by the Florentine Cosimo Lotti (see *Aranjuez) from 1628 onwards, on the eastern edges of the new royal capital. It was enlarged in stages, which perhaps accounts for its lack of unity and perspective. Thus the great square *bassin* is out of line with and invisible from the palace. The great lake, 152 m. × 83 m., which used to have square pavilions in the corners, has an oval island which was the scene of lavish entertainments. A canal, navigable by gondola, led out of its south-eastern corner to other *bassins*. In 1637 meetings of literary academies, with Lope de Vega and Quevedo present, were held here; and Calderón organized a poetry contest. During the reign of Philip IV (1621–65) there were at least seven hermitages in the gardens, the occupying hermits being given an allowance.

After Philip's death, the gardens were greatly neglected. In 1712, the Princess de los Ursinos corresponded with the Parisian architect Robert de Cotte (1656–1735), who sent his assistant René Carlier to deal with the project. In 1714 de Cotte himself drew up a grandiose formal plan. This was rejected as being too ambitious, but even his more practicable plan of 1715 was not realized. The only significant alteration was the transformation of the Octagonal Garden into a French parterre.

The gardens were opened to the public in 1767. After 1868 they became the property of the municipality of Madrid, and are now the Parque de Madrid. P.G.

Buffet d'eau, an ornamental architectural gardening feature placed against a wall or in a niche, with water flowing over it into bowls, basins, or troughs. There is a particularly fine example at La Mogère, *Montpellier, in France.

D.A.L.

See also ANSOUIS; VERSAILLES, TRIANON.

Bühler, Denis (1811–90), French landscape architect, began his career as a gardener, and assisted his younger brother, **Eugène Bühler** (1822–1907), to pursue his studies, joining him later in the profession of landscape

architect. The Bühler brothers created a great many parks and gardens, among which are the *Parc de la Tête d'Or at Lyon, the *Jardin Thabor at Rennes, and gardens at Touches in Touraine and Epernay. Their broad manner perhaps lacks imagination: a small number of functional paths with generous curves and wide crossings; huge lawns with clumps of trees of a single variety very far apart from one another (with few shrubs); fine stretches of water. Esclimont, not far from Ablis, is a good example of a regular park transformed by them into a *jardin anglais. D.A.L.

Buitenhof, The Hague, The Netherlands. In *c.* 1620 *Maurits, Prince of Orange, created his garden (1·8 ha.) and 'villa in the city' as an integrated unit at the Stadholder's quarters in The Hague. The ground-plan is the earliest known example of a Dutch garden conceived according to the Vitruvian-Albertian principles of symmetry and harmonic proportion. A contributing factor to this paradigm of the Dutch classical garden was Maurits's earlier application of these principles to the design of army camps and fortifications.

The geometric structure of the plan expresses the Albertian ideal of abstract design. Conceived in the form of a double square (60 m. × 30 m.) which contained two squares with inscribed circles, the design reflects one of the Pythagorean-Albertian harmonic ratios and embodies the two most perfect geometrical figures.

Translated into tangible form these figures become walks surrounding circular *berceaux*. Other figures of squares and circles in the corners of each square become arbours, and the numerous small circles and quarter sections within the *berceaux* are flower pots and embroidered parterres. Within the loggia of the Italianate villa was an aviary and the earliest example in the Netherlands of a grotto, a phantasmagorical Mannerist creation by the Dutch artist Jacques de Gheyn who designed all of the ornamentation for the garden.

F.H.

Buitenzorg, Java, Indonesia. See KEBUN RAYA BOTANIC GARDEN.

Bulb. Many plants survive the unfavourable season when water is either not available (in hot, dry summers) or not accessible (in cold winters), as bulbs or corms. Usually these water- and food-storage organs remain completely underground but some species typical of sand deserts have their bulbs resting on the soil surface.

Well-known ornamental bulbous plants include allium, snowdrop (*Galanthus* species), hyacinth, *iris, *tulip, *narcissus, and most varieties of lily; those with corms include gladiolus and crocus. Some tropical epiphytic and terrestrial *orchids possess specialized organs called pseudobulbs. Many ferns and alpine species and forms of flowering plants often produce small bulbs, usually termed bulbils, which easily become detached and quickly form new plants on reaching the soil.

Bulbous plants are ideal as house-plants and for cultivation generally as they are usually easier to store and to handle than other plants. In addition resting bulbs will nearly always respond to the provision of growth requirements by readily producing roots, leaves, and flowers whereas seed germination is much less reliable.

Tender or half-hardy bulbs that are usually grown indoors or in the greenhouse, such as hippeastrum (*Amaryllis*), vallota, clivia, nerine, freesia, and lachenalia, will often survive out of doors in sheltered locations. Hardy

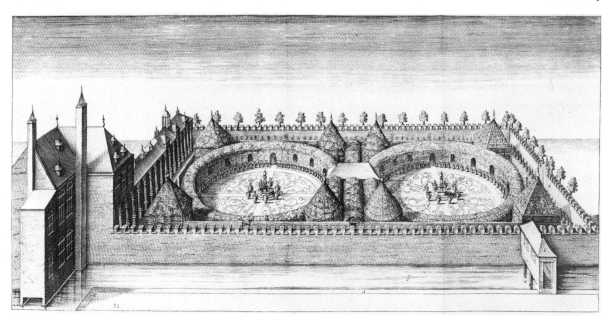

Buitenhof, Netherlands, engraving from Hendrik Hondius, *Institutio Artis Perspectivae* (The Hague, 1622)

bulbous plants can also be grown under protection where they can be forced into flower earlier in the season than when cultivated outside.

The first ornamental bulbous plants cultivated in England were probably the wild daffodils (*Narcissus pseudonarcissus*), snowdrops (*Galanthus nivalis*), bluebells (*Endymion nonscriptus*), and possibly the now almost extinct tulip (*Tulipa sylvestris*) and snake's-head (*Fritillaria meleagris*). The local meadow saffron (*Colchicum autumnale*) was certainly grown for its medicinal and culinary values, as was wild garlic (*Allium ursinum*). The onion (*Allium cepa*) was brought to Britain by the Romans not as a crop plant but for its curative properties. Its culinary reputation was not

great and it was not used as a vegetable for another 700 years.

No true lilies are indubitably native to Britain but the martagon lily (*Lilium martagon*) and the madonna lily (*L. candidum*) were certainly cultivated in the 13th c. or earlier. We know that in Crete and Egypt this latter species was cultivated as early as 1750 BC as it is represented on pottery of that time.

The exploration of southern Africa in the 18th and 19th cs. introduced many bulbous plants to Europe such as the 'Guernsey' lily (*Nerine sarniensis*), many gladioli (*Gladiolus blandus* and *G. tristis*), and *Vallota speciosa*.

P.F.H.

Bulgaria

ANTIQUITY AND THE MIDDLE AGES. Numerous monuments dating back to ancient times are still preserved in Bulgaria. A crossroads of the Mediterranean world and a gateway to the Orient, it was a meeting-place of various cultural foci in Antiquity. In the Thracian town of Seuthopolis the dwellings were laid out around an inner courtyard or garden with colonnades. Traces of garden drains and courtyard drain wells, a prime condition for the creation of gardens, have been found.

Roman civilization left behind even deeper marks. In Oescus and Nicopolis ad Istrum, two relatively well-preserved towns dating back to Roman times, the outlines of atria are still clearly visible. Particularly typical in this respect is the villa discovered in Abritus (Razgrad), probably the property of a big landowner; it had a large rectangular atrium (25 m. × 125 m.), paved with marble slabs and interspersed with colonnades in an Ionic style, which was surrounded by 27 residential and other buildings.

In the early 10th c., under the reign of Tsar Simeon, a period generally known as the Golden Age of the First Bulgarian Kingdom, favourable conditions for the development of landscape gardening were created. Preslav was surrounded with two fortress walls, an outer and an inner one; palaces, churches, and monasteries (among which was the Golden Church) made their appearance, situated amid parks and gardens and adorned, according to the description of Ioan the Exarch, on the outside 'with stone and wood' and on the inside with 'marble and copper as well as with silver and gold'.

The natural surroundings determined the architectural and landscape layout of Veliko Turnovo, the capital of the Second Bulgarian Kingdom (1186–1391). The Tsarevets and Trapezitsa hills offered the builders of the new capital excellent opportunities for the establishment of a unique medieval fortress-town. The streets running down the two hills were narrow and crooked, and the gardens were terraced. The architects of those days must have had a fine feel for suitable contrasts and dominant accents in the landscape, to judge by the clever distribution of the build-

ings, which formed a harmonious entity with the natural setting.

Interesting albeit schematic data on the layout of gardens in Bulgaria during that period can be found in church murals. Church and monastery courtyards with trees, paved walks, and fountains form the background of many icons, decorative images, and prints. The scenery, however, is gloomy and most of the land is untilled, so that the natural landscape has a virginal and wild look. Passing through Bulgaria on their way to the Holy Land, the crusaders spoke with amazement about the impenetrable forests which they called Silva Bulgariae.

BULGARIAN NATIONAL REVIVAL (EIGHTEENTH–NINETEENTH CENTURIES). During Ottoman rule (1391–1878) landscape gardening was confined to the layout of church and monastery courtyards, where herbs were grown for medicinal purposes. The boyar estates were turned into big farms of beys and agas, while the Bulgarian population fled from the towns to withdraw to safer mountain fastnesses, where gradually new Bulgarian towns sprang up: Koprivshtitsa, Panagyurishté, Kotel, and Tryavna. In the late 18th and the 19th cs. these towns became the cradle of the economic and cultural upswing of what has become known as the Bulgarian National Revival, characterized by the rapid progress of domestic industry and trade. The steady growth of the Bulgarian urban population gave an impetus to the construction of residential and public buildings.

The courtyard or garden was usually small in size (0·2–0·5 ha.) and irregular in shape. The asymmetric composition of the house determined the appearance of the garden. The cobble-stoned street in front of the house, the flower garden, and the orchard somehow fitted together in a peculiar manner. The garden was inseparably connected with the house and this linkage found its best expression in the vine-arbour, which represented a *sui generis* pergola stuck to the house. The vine-arbour or trellis vine was made of wooden props on which thinner beams and laths forming

Garden of the Zoeva House, Karlovo, Bulgaria

a grid were arranged. Vine leaves and branches were intertwined in this grid, thus forming a veritable laid-out ceiling, a natural fresco.

There were no pronounced compositional axes in the courtyard design. The fountain, the well, and the flower garden were so situated as to meet the functional needs of the craftsman: the fountain and the garden next to the house and the well next to the lean-to or annex. Whenever the terrain was even, the courtyard or garden would be on one or at most on two levels and be larger in size (for instance, in Karlovo), while in steep and mountainous places it would be smaller in area and terraced (Kotel, Zheravna, and Gradets).

The way in which the Bulgarian courtyard was organized reveals a sense of proportion. The outline of the architectural framework is calm and well balanced. The sole dominant in this space is the chestnut tree, the old pear tree, the oak, or the sycamore whose mighty branches rise skyward and which seem to be set there to protect an inward-looking pastoral life. A multitude of flowerpots whose colourful geraniums stand out brightly against the white walls round off the picture. Some of the Karlovo courtyards had as many as 500 flowerpots and even more.

Water occupied a privileged place in the Karlovo gardens. The rills which in the past traversed all the courtyards lent a specific touch of beauty to these spaces and to the physiognomy of that town as a whole.

Everywhere a harmonious entity was achieved between the miniature territory of the courtyard and the surrounding landscape. In this respect the monastery courtyards had no peer; their architecture and layout seemed to grow out of the ground, to form an integral entity with the rocks, the woods, or the river, while the scenic beauty of the surrounding nature was mirrored in the painted murals (the Rila Monastery, the Troyan Monastery, and the Bachkovo Monastery).

POST-OTTOMAN EMPIRE. Bulgaria's liberation from Ottoman domination following the Russo-Turkish War of 1877–8 found its towns almost entirely devoid of public parks and gardens. Sofia's sole green spot was in the central area, where the City Park is now located, in front of the town hall of Makhzar Pasha, the last Turkish vali; like all Turkish courtyards, it was planted with willows, mulberry trees, poplars, chestnuts, and other fruit-trees. The remaining green area was rapidly extended and enriched with new vegetation; flower-beds, a small fountain, a refreshment stall, a pavilion for the Guards' music, and even copies of ancient statues—all features typical of that epoch—made their appearance. That is how Sofia's first public garden gradually acquired a distinct character of its own. Since then it has been restored on several occasions, the last time in 1978 when in its central part a monumental fountain was built, which to a certain degree integrates the garden with the pedestrian zone in front of the National Theatre.

The new principality immediately set about designing public and other gardens. Distinguished landscape architects and gardeners from abroad were invited to lay the groundwork, including Daniel Neff from Switzerland (1879), Karl Betz from Germany (1882), Josef Fray from France, and the Czech Anton Kolar. It took several decades to build up the most important one, *Freedom Park (formerly Boris Gardens), Sofia. Hardly less important for the development of landscape gardening was the subsequent establishment of the botanic and the zoological gardens, the first of their kind in the whole of the Balkan Peninsula.

The example of Sofia was followed by other towns in the country. In Plovdiv the Dondukov Garden (1879) and the Princely Garden (1880) were created. Central parks sprang up in Sevlievo (1887), Turnovo (1891), and Shoumen (1897), followed by the beautiful *Maritime Park in Varna (1894), the Park of the Liberators in Plovdiv (in the wake of the first exhibition in 1892), the Maritime Gardens in Bourgas (1900), the Mausoleum and Skobelev Park in Pleven (1904–7), the Central Park in Roussé (1906–7), and the *Danubian Gardens in Vidin (1907–8).

The gardens created in Bulgaria during this period, from its national liberation in 1878 to the establishment of socialist rule in 1944, were strongly influenced by the compositional techniques which were fashionable in those days in western and central Europe. The experts who came from Germany, Austria, Switzerland, France, and Great Britain brought with them, along with the culture of their nation, the conceptions of mixed landscape and geometrical eclecticism which they had imbibed there. Their greatest merit was that they enriched Bulgarian gardens with new plant species (trees, decorative shrubs, and flowers). This was done with exceptional skill in the royal residences at Vranya, Euxinograd, and Krichim, where the dendrological variety made it possible to create interesting groups of trees and shrubs, artistically laid-out landscapes, rock-gardens, and lakes with aquatic flowers. Even such rare species as the giant water-lily, *Victoria regia*, were cultivated in the greenhouses of Vranya.

See also AYAZMO PARK.

POST-1945 PARKS. The spectacular rise of the urban population (from 20 to 60 per cent in the post-war years) has led to the appearance of new gardens, parks, and forest parks and to the aggrandizement and refinement of the existing ones. The new green areas have architectural and sculptural elements, aquatic effects, and well-distributed playgrounds for children. Depending on their size and location within the city, the parks often include band-stands for concerts, open-air theatres, libraries, areas for dancing, and other amenities. In such cases it has become the practice to isolate the noisy sections from the quiet by means of suitable vegetation.

In the post-war years several new big gardens have sprung up in Sofia. Among these, the two most significant ones are South Park, designed by a woman, the architect M. Karlova, and West Park, designed by the architect I. Boyadjiev. Sofia's most recent acquisition in the field of landscape gardening is the little park in front of the newly built Lyudmila Zhivkova Palace of Culture, with which it forms a most impressive ensemble—a most welcome addition to the city centre. Connected with the magnificent building in a single monumental axis, the composition stands out with its grandiose system of fountains forming a cascade. The designers of this original park are an architectural team headed by another talented woman in this field, the landscape engineer V. Atanassova.

The most intensive designing of gardens and laying-out of parks and lawns in the past two and a half decades were connected with the building up of the new Black Sea resorts. The biggest and most complete among them are the Zlatni Pyassutsi (Golden Sands) and Slunchev Bryag (Sunny Beach) seaside resorts. Much of the research and design in connection with the layout of these two fine resorts was carried out by the landscape engineer Yordan Kouleliev.

In the course of this century quite a few fairly large forest parks for recreational purposes have been established in the environs of several towns. Those near Sofia, Stara Zagora, Kyustendil, Roussé, and Lovech deserve particular mention: pride of place here goes to Mount Vitosha, Sofia's beautiful landmark. D.T.S.

Buonaccorsi, Villa, Potenza Piacena, Marche, Italy. Lying on a green hill overlooking the Adriatic, south of Ancona, these gardens are among the best preserved of the 18th c. in Italy. Although there is little evidence of their history, a painting in the house apparently dating from the middle of the 18th c. indicates a design that more properly belongs to the 16th-c. Renaissance. The scene today with its enclosed gardens, box parterres, sculptures, lemon trees, and architectural features is almost identical to that in the painting. The most remarkable survivals are the boundaries of the parterres, made of stone, and in the shape of stars, diamonds, or other geometrical forms. This exquisite garden, a national treasure, has survived only through the personal care of Contessa Giuseppina Buonaccorsi. G.A.J.

Buontalenti, Bernardo (1536–1608), Italian artist, architect, military engineer, and director of *spettacoli* for the Medici. He designed part of La Grotta Grande (1583–93) in the Boboli Gardens; and the grottoes and automata at Pratolino are usually attributed to him. He is known not only for his fascination with mechanical garden detail but, more important, as the precursor of surrealism in garden design. P.G./G.A.J.

Burghley House, Stamford, Northamptonshire, England. Such earlier gardens as existed at Burghley were transformed when the 9th Earl of Exeter, on succeeding to the estate in 1754, commissioned 'Capability' *Brown not only to make considerable alterations to the south front of the house and several rooms within, but to landscape the grounds. The latter involved damming a stream to form a large serpentine lake which was crossed by a three-arched bridge. Brown also built a new stable block and an orangery, a game-keeper's lodge, a dairy, and an *ice-house. The most attractive surviving small building in the grounds is, however, a lake-side summer-house, the design for which was clearly inspired by a Jacobean 'banqueting house' at Chipping Camden in Gloucestershire. Brown's various works at Burghley continued over a period of nearly 30 years, ending only with his sudden death in 1783. His portrait by Nathaniel Dance still hangs in the Pagoda Room there. D.N.S.

Planted wall in his own garden at Sitio San Antonio da Bica, Campo Grande, Brazil, by Roberto Burle Marx

Burke, Edmund (1729–97), British statesman, philosopher, and political thinker. His *A Philosophical Enquiry into the Origin of our Ideas of the Sublime and Beautiful* (1757) is one of the most important aesthetic works of the 18th c. Burke turned to a careful study of the causes and physiological concomitants of aesthetic phenomena, believing that they could not be explained by the concept of proportion and that 'our gardens, if nothing else, declare . . . that mathematical ideas are not the true measures of beauty'. He found the basic aesthetic categories to be the Beautiful and the Sublime, and it is notable that 'Capability' Brown's serpentine lines and aesthetic objectives were essentially 'Beautiful' in Burke's sense. The Sublime was associated with terror, darkness, greatness of size, and irregularity of line. Towards the end of the 18th c. more of these qualities were introduced into gardens after theorists (such as Uvedale Price) had identified an intermediate aesthetic category, known as the *picturesque, between the Beautiful and the Sublime. T.H.D.T.

Burladores, literally 'practical jokers', the Spanish equivalent (see *Alcázar) of **giochi d'acqua*. P.G.

Burle Marx, Roberto (1909–), Brazilian landscape architect, is unique, not only as a designer in his own right, but as the creator of a style of landscape design which is at once essentially Brazilian and wholly of the 20th c. He was born in São Paulo, the fourth child of a Brazilian mother of French descent and a German-born father. In 1913 the family moved to Rio and lived in a house ideally situated between the mountain forest and the sea. His mother was interested in gardening, and Roberto had his own garden from the age of 7. When he was 19, the family spent 18 months in Berlin, where he had an opportunity to study painting and singing; and he spent much of his time studying the native flora of Brazil in the Dahlem Botanic Garden. He returned to Brazil with two ambitions: to paint and to create a style of gardening using native plants.

Brazil had no indigenous tradition of garden design; traditional influences were the formal Portuguese and the French (Dom Pedro II had actually imported French designers in the 1840s), and their influence can still be seen in the surroundings of churches and the squares and *pracas* of small country towns. To fulfil his first ambition Burle Marx began to study painting at the School of Fine Arts in Rio, where he came into contact with architects and architecture. It was a feature of the course at that time that art students studied architecture in their first year, and students of architecture studied fine art. In his second ambition he was encouraged by a meeting with the great botanist Henrique Mello Barreto. He had already begun to reorganize the family garden to include native plants, which led to a commission to design a garden for the architect Lucio Costa. This was followed by a public commission to redesign the municipal gardens at Recife, and three years later, in 1938, the garden and two roof terraces for the new Ministry of Education and the Resurgeros Insurance building in Rio (1939). They are characterized by native plants arranged as sculptural groups within the free-flowing pattern of ground cover, pools, and paths which were to become identified as the Burle Marx Brazilian style. This 'painting' with different colours of ground-cover plants was developed in a number of much larger gardens and parks during the next decades: notably the Monteiro Garden (1948), the Cavanelas Garden (1954), and the Kronforth Garden (1955).

Such an identification with 'style' is perhaps unfortunate because Burle Marx hates formulas, regarding each of his designs as essentially a unity between art and nature. They are as remarkable in their diversity as in their scale: from that of jewellery design to the 5-km.-long promenade at Copacabana beach, from paintings and stage sets to gardens

and parks. It is, however, in the gardens that he has managed to combine the two great driving forces of his life, a love of art and a love of plants. M.L.L.

Burlington, Richard Boyle, 3rd Earl of (1695–1753), English patron of the arts. The Burlington circle, as it has become known, included artists, architects, and writers concerned not only with the introduction of Palladianism into England but, of greater importance, with the concept of a new romantic pictorial landscape around it to take the place of classical formality. Following the Grand Tour common to the *cognoscenti*, he commissioned William *Kent and Charles *Bridgeman to design the gardens of his new Palladian villa at *Chiswick House in a style transitional between classical and romantic. Praised by Alexander *Pope in his *Epistle to Burlington* (1731), the gardens are pioneers of the English school of landscape design which reached its climax in the work of 'Capability' Brown. G.A.J.

Busch (or Bush), John (*fl.* 1730s–90s), English landscape gardener of German descent, was born in Hanover, but moved to England in 1744 and had a nursery in Hackney, which he sold to Conrad *Loddiges in 1771 before going to Russia to work as a landscape gardener for Catherine the Great. According to J. C. *Loudon, Busch's first assignment was at Pulkova. Catherine was delighted with the result and he was then asked to landscape a large area of the grounds at *Tsarskoye Selo (Pushkin) in the English style, working with the architect Vasily *Neyelov. A plan of the park published *c.*1780 bears Busch's signature. One of his daughters married Charles *Cameron. P.H.

Buscot Park, Oxfordshire, England, has a remarkable garden scheme by Harold *Peto (*c.*1904–11) lying between the house and the lake not far away: an *allée* cut straight through old trees forms a vista to a distant temple and its reflection in the lake. The *allée* contains a water garden—a fountain and a succession of shapely pools and canals running into the lake—and at the same time it is a gallery of sculptural ornament. The scheme is just out of sight from the house, cleverly placed to be inconspicuous in the 18th-c. park landscape all around, but that consideration has now been abandoned and impressive avenues and *allées* radiate in every direction from the house.

Buscot Park has been owned by the National Trust since 1948. G.M.

See also EGYPTIANIZING GARDENS.

Bush, John (*fl.* 1730s–90s), English landscape gardener. See BUSCH, JOHN.

Bushell, Thomas (1594–1674), English eccentric, mineralogist, minor writer, and gardener, was employed as a secretary by Francis Bacon, whom he passionately admired, and whose influence is apparent in his garden work. He left Bacon's service *c.*1620 to live a 'hermetical life' in the Isle of Wight, the Calf of Man, and, *c.*1625, at *Enstone in Oxfordshire, where he built his celebrated grotto and garden-hermitage. During the Civil War he was royalist 'governor' of Lundy from 1645 to 1647. Subsequently, fearing creditors and political enemies, he lay low in London, in Lambeth, for several years, walking in his garden and orchard by night. He died in London and was buried in the 'little cloysters' at Westminster Abbey. C.T.

Bushy (or Bushey). See HAMPTON COURT PALACE.

Buttes-Chaumont, Paris, is a park of 25 ha. in the Belleville district, laid out on the site of old quarries, very hilly, and one of the most picturesque gardens of the city. Created by *Haussmann, designed and planted by *Alphand and *Barillet-Deschamps, it was begun in 1864, opened in 1867, and finished in 1869. From the highest points there are views of Montmartre, and of the Plaine Saint-Denis to the north of Paris. In the lowest part a lake surrounds a high needle of rock rising to 50 m., surmounted by a round temple recalling Tivoli. A cascade falls some 30 m. into a cave. Artificial features blend fairly happily with the natural aspects of the site, although William *Robinson complained that the seams in the rock-face were filled with plaster, and that the opportunity for a striking use of rock-plants was entirely lost. D.A.L.

Buys, Pieter, A. M. (1923–), Dutch landscape architect, received his professional training at Boskoop in the Netherlands, and in Denmark where he was impressed by the sobriety of the Danish school, which influenced him is his private work. He has an affinity with the work of architects

Buttes-Chaumont, Paris, view of the rock and belvedere

of the 'Bossche school' and their spiritual leader Dom van der Laan, and the clarity and spirit of their style is reflected in many of his garden designs.

He has lectured at the academies of architecture at Amsterdam, Arnhem, and Tilburg, and at the Agricultural University at Wageningen. W.C.J.B.

Byodo-in, Uji, Japan. The Phoenix Hall is the sole survivor of a number of sacred buildings erected within the precincts of this monastery half-way between Kyoto and Nara. In 998 it was the site of a villa belonging to the powerful Fujiwara family. In 1052 Regent Fujiwara-no-Yorimichi, father of the author of *Sakuteiki on the making of gardens, entered religion and converted the villa into a monastery, adding new buildings dedicated to the worship of Buddha Amida (Amitabha). The temple itself shows strong Chinese influence and has been described as 'Tang with a difference'. The upward fling of the roof tips, the two bronze phoenixes on the gable ends, the rich ornamentation and vermilion colouring of the exterior, above all the symmetrical balance of the central hall and two flanking bays, are nearer to Chinese than to Japanese tradition. Only in the handling of the building in relation to its setting does Japanese influence predominate.

What remains of the garden is a late Heian paradise of the Amida type. The pool in front of the temple is the treasure pond, the temple itself is the treasure hall. Presumably, worshippers entering at the south gate would have crossed one bridge on to the island in the lake and reached the temple by a second, but today there are no bridges. In the temple, a magnificent Buddha of lacquered wood covered in gold leaf, by the sculptor Jocho, faces towards the pond.
 S.J.

Byzantium.

Sources. Evidence for Byzantine gardens is sparse. Archaeological excavation has revealed extremely little; visual representations, especially in the annunciations to St Anne and to the Virgin Mary, follow a conventional iconography sometimes stemming in part from the rhetorical depiction of spring; and literary descriptions, even when of real gardens, are deliberately coloured by the fused traditions of earthly and heavenly paradises. Literary evidence is, however, our principal source of information and may be divided into four categories: descriptions of genuine gardens, notably two in prose by John Geometres, the leading poet of the 10th c., of his own fairly small garden in the centre of Constantinople (Istanbul); descriptions of the heavenly paradise or, often lengthy and very elaborate, of wondrous terrestrial gardens that are an almost essential feature of the Byzantine romance; incidental references; and the *Geoponica* (Eng. trans. by T. Owen, 2 vols., 1805–6), a compilation of excerpts from agricultural treatises that is a mixture of crass superstition and much sound advice. Although it was dedicated to the Emperor Constantine VII Porphyrogenitus (913–59), it appears to be in large part merely an earlier compilation made probably in the 6th c. by a certain Cassianus Bassus, who incorporated into it personal

observations gleaned from his estate in, possibly, northern Syria.

Despite the fact that it contains much information derived from the Hellenistic and Roman worlds, the *Geoponica* is of considerable value in trying to establish Byzantine practice, since it was widely read, as the numerous manuscripts attest, and, we may assume, was generally regarded not only as a collection of antiquarian lore but also as a practical manual (certainly the patriarch Photius was able in the second half of the 9th c. to comment upon one of its then still surviving forerunners through knowledge gained from personal experimentation: moreover, certain sections of the *Geoponica* were chosen, and others perhaps added, for their applicability to the Constantinopolitan climate). It was clearly intended for the Byzantine country gentleman, who was less interested in the peasants' daily toil in growing cereals than in viticulture, the production of olive oil, and the financially unremunerative creation of aesthetically pleasing gardens and parks graced by his own carefully cultivated hybrids.

Attitudes. The Byzantines' delight in trees, shrubs, flowers, and herbs is manifest in their visual art and literature and was shared by all classes of society from the poorest to the most aristocratic. Indeed, the outstanding horticultural and agricultural enthusiast, with the resources to have his wishes implemented, was the Emperor Constantine IX Monomachus (1042–55), although we must treat with some caution the satire in the words of his biographer, Michael Psellus. 'If ever he wished to create a grove or put a wall around a park or widen a race-track, not only did he carry out his original intention but other ideas at once came to him, and while some meadows were covered with soil others were straightway fenced about, while some vines and trees were uprooted others were spontaneously created together with their fruit. How was this done? Suppose the emperor wished to convert a barren field into a fertile meadow. His wish was immediately carried out, for trees growing elsewhere were transported thither together with their fruit and planted firmly in the earth while soil from mountain groves was heaped up to cover the plain entirely. Unless without delay cicadas were chirruping on his spontaneously created trees and nightingales singing about his grove, the emperor was very upset.'

The Byzantine garden, often regarded as a flawed copy of the masterpiece of God himself, was a direct descendant of Greek and Roman gardens. Evidence for its development over the 1,123 years during which Constantinople was capital of the Roman Empire is extremely scant, but some interchange of ideas with the Muslim world, dominated aesthetically by Persia (Iran), may be discerned (the *Geoponica*, or some of its sources, was probably translated into Pahlavi in the 7th c. and certainly several times into Arabic as well as into Syriac and Armenian).

Byzantine pleasure-gardens. Although we find not infrequent references to their healthiness, the two main purposes of Byzantine pleasure-gardens were the provision of a

comfortable place to linger out of doors and the delectation of the senses. To accomplish the first, a site had to be chosen that would protect its owner from the cold winds of winter and the fierce heat of summer, the latter largely through the planting of shady trees. We may assume that for many regions of the Byzantine world, such as the Anatolian plateau, the use of a garden in winter was severely restricted and that even in Constantinople itself the inclement weather of that season sometimes limited the inhabitants' enjoyment of gardens to the literary tradition inherited from more southerly climes and to the view from indoors upon which importance was laid.

The second purpose gave great scope for artistry to satisfy the Byzantines' sense of sight, of smell, and even of hearing, in overall effect as well as in the details. A highly developed appreciation of colour demanded in every direction a harmonious combination of hues and this was often achieved through juxtaposing rows of flowers, shrubs, ever-greens, or fruit-trees (the colour of whose blossom and fruit was taken into account), great care being exercised that in all seasons of the year the garden should offer a pleasing aspect. Flowers were rarely mixed (unless of similar size) or placed in round beds, but formed a rectilinear arrangement alternately with shrubs and trees. This was dictated by a grid of numerous water channels, for the aridity of summer made the proximity of water to each plant a great con-venience if not a necessity. Paths, too, alternated with the lines of vegetation and water. The rigidity of this pattern was often softened by the creation of different levels, hillocks being utilized, or even artificially created as recommended by the *Geoponica*, terraces built, and sunken gardens dug, so that new and surprising vistas could open up before the stroller. Plants and trees, not always specifically identifiable, that were appreciated for their beauty as well as, in some cases, their usefulness, include: the rose, violet, crocus, lily, iris, narcissus, ivy, myrtle, box, bay, apple, pear, pomegranate, fig, various citrus trees and nut trees, fir, pine, cypress, palm, willow, poplar, oak, elm, ash, and, above all, the ubiquitous vine. The sense of smell was satisfied by the fragrance of fruit, blossom, and flowers and by aromatic herbs such as basil and marjoram. Fountains served not only to moisten and cool the air but also to give delight through sound, a purpose also achieved by careful choice of trees with 'whispering' leaves and by the presence of birds, which in plumage and song were considered an integral part of a Byzantine pleasure-garden.

In the countryside the large estates had extensive gardens that provided charming, shady alleys and also fruit-trees, vegetable plots, and fish-ponds. Many monasteries were similarly endowed and we may assume that most peasants had more than just a trellis of trailing vines. The necessarily smaller private gardens of the cities were outdoor exten-sions of the house and, sheltered from the dust, dirt, and noise of the streets, havens where flowers could be cherished to bloom past their proper season. A good exam-ple of these is John Geometres's garden that afforded him great pleasure throughout the year: its most distinctive feature, he claimed, was a beautifully shaped bay that overtopped the wall to greet passers-by. Flowers, shrubs, and trees were planted also in pots placed in courtyards, on balconies, and even on roofs, the sole recourse of the poor urban horticulturalist. Many churches in cities were sur-rounded by public parks; a notable one with lawns, flowers, hanging gardens, trees, and fountains was planned by Constantine IX for the Church of St George of Mangana. The Great Palace in Constantinople was a complex of palaces interspersed with gardens, among which were those known as the Mesokepion near the polo-field and the Anadendradion by the Magnaura Palace. In one garden of fruit-trees, whose exact position is uncertain, Constantine had a concealed pool constructed that, we are assured by Psellus, caused him great merriment when people tumbled in. Good garden soil, discovered by excavators but unfortunately never analysed, proves that some form of vegetation formed the centre-piece of the famous mosaic floor of probably the 6th c. Further palatial features, all exaggeratedly reflected in many Byzantine romances, include garden pavilions and baths, fountains embellished with ingeniously created automata of beasts and warbling birds, over which from the time of the Emperor Theophilus (829–42) the Empire and the Caliphate engaged in techno-logical rivalry, and imitations of gardens in the mosaic encrustations of rooms and colonnades.

Although the private garden, rather than the farm, was the Byzantine nursery of both horticultural and agricultural innovation in many areas and especially in grafting and the producing of hybrids, it was regarded by all, from the lowest to the highest, as primarily a place of beauty and peace set apart from the daily toil and bustle of the world. It is not inappropriate that one of their words for a garden is also the name for that bourne which all Byzantines devoutly yearned one day to attain—*paradeisos*. A.R.L.

Cabinet de verdure, on the analogy of a *cabinet* (a small room in a house), a small garden enclosure within a **bosquet* or surrounded by clipped hedges (e.g. as at **Marly).

K.A.S.W.

Caerhays Castle, Cornwall, England. The garden was begun in the 1890s by John Charles Williams who made sheltered clearings for plants sent from China and Upper Burma by E. H. **Wilson and George **Forrest, chiefly rhododendrons and magnolias, from some of which Williams made notable crosses. *Williamsii* hybrid camellias originated here when cultivars of *C. japonica* were crossed with *C. saluenensis.*

D.W.

Calcutta Botanic Garden, India, was established on the banks of the River Hooghly in 1787. Under the superintendence of such distinguished botanists as W. Roxburgh, N. Wallich, and H. Falconer, all servants of the East India Company, it became an important centre for the cultivation and study of the flora of India and other tropical countries.

R.D.

Caledon, Co. Tyrone, Northern Ireland, has a landscape park begun *c.*1740 by John, 5th Earl of Orrery, a friend of Alexander **Pope, Jonathan **Swift, and Mary **Delany, and to whom Stephen **Switzer dedicated *The Practical Fruit Gardener* (1724), perhaps because he had worked for him on his English estate at Marston, Somerset. In 1746 a 'Rustick Cascade' had been formed, a hermitage constructed, and classical statuary positioned in the Wilderness. In 1747 the remarkable Bone House was built. Sixty years later in 1807 John **Sutherland was paid £2,024 for the erection of hot-houses and *c.*1829 William Sawrey **Gilpin was commissioned to design a pair of terraces, to which a third was added by his patron, the 2nd Earl of Caledon. The **demesne is still in a reasonable condition today.

P.B.

Caley, George (1770?–1829), English plant-collector, was a quarrelsome protégé of Sir Joseph **Banks, who encouraged his interest in botany by finding him work at the **Chelsea Physic Garden before sending him to collect in Australia in 1798. Banks paid Caley's salary in return for botanical specimens for himself and plants and seeds for **Kew. Caley arrived in Sydney in 1800 and established a botanic garden at Parramatta, as well as exploring parts of central and south-eastern Australia. He left the colony in 1810, having sent seeds of nearly 200 species back, including several orchids (one genus of which was called *Caleana* in his honour), the staghorn fern (*Platycerium bifurcatum*), and possibly the incense plant (*Humea elegans*). In 1816 he

became superintendent of the botanic garden at St Vincent in the West Indies, from which he sent plants to the Horticultural Society in London.

S.R.

Calligraphic board (in Chinese garden design). See BIAN.

Cambridge College Gardens, England, contribute greatly to the impression of sophisticated buildings in a rural setting which Oxford once shared with Cambridge, but has now lost. Except for the Fellows' Gardens most of the college gardens are open to the public and among the especially notable ones are the following:

Emmanuel College has large gardens planted naturalistically with a pond and a large oriental plane tree. Christ's College too has extensive gardens, large enough to create almost a parkland effect with an 18th-c. swimming-pool and garden house in the Fellows' Garden. A mulberry tree still grows here from the 300 planted by the college in 1608. This one is associated with Milton. Clare College has a perfume garden and a sunken garden where plays are performed in June. There is an enormous copper beech in the Master's Garden. Behind Peterhouse is a garden with fine trees known as the Grove, separated from Coe Fen and the River Cam by a 14th-c. garden wall. At St John's College the Fellows' Garden or Wilderness was designed by 'Capability' **Brown in 1773 on a site across the Cam from the main buildings. In spite of large scale 19th-c. rebuilding nearby this garden remains intact and is famous for the martagon lilies growing beneath Brown's trees.

Brown had a further contact with Cambridge towards the end of his life. In 1779 he prepared a plan for transforming the land to the west of the town, containing the course of the River Cam and known as the Backs, into a parkland setting for the splendid line of colleges along this side of the town. The land was owned by a number of colleges who were reluctant to collaborate to this extent and the plan remains a vision of what might have been. The present landscape of the Backs, however, is hardly less beautiful than even Brown could have made it.

On the eastern side of the city a series of large open spaces, Midsummer Common, Christ's Piece, and Parker's Piece, help further to create the illusion of a small academic town set in parkland.

J.AN.

Cambridge University Botanic Garden, England, is a subdepartment of the University Department of Botany and exists primarily to provide for botanical teaching and research in the University, but it is open to the public. The present area of 16 ha. was acquired in 1831, and the planting of the western half was begun in 1846. The

development of the eastern portion was not undertaken until 1951, following a large bequest from Reginald Cory.

Notable features are its collection of trees, a limestone rock-garden arranged geographically, a collection of tulip species and other special collections, a scented garden, a winter garden, and systematic beds of herbaceous plants arranged according to their families. There is also a display of species introduced into British gardens from the earliest times to the present, arranged chronologically in order of introduction. A range of glasshouses shelters bays between them for the growing of tender plants in the open. Part of the garden (not open to the public) is reserved for experimental grounds, research glasshouses, and a laboratory. There is a rich library of books on botany and horticulture and a *herbarium of cultivated plants.

In recent years the garden has undertaken formal commitments to botanical conservation, of which the establishment of the British Conservation Section under contract to the Nature Conservancy Council is the most important.

F.N.H.

Camellia house. The great age of the camellia in Britain was the 19th c., although a few plants had arrived earlier from the Far East. The popularity of the camellia and its many hybrids coincided with the rise of practical Victorian garden buildings—conservatories, orchard houses, and so on—and camellia houses were built specifically to stock the plants. The houses were of brick or stone, sometimes taking advantage of the recent introduction of cast iron, and had large windows which could be opened in summer. Examples can be found at *Bodnant, Wentworth Woodhouse, South Yorkshire, and *Woburn Abbey. The need for camellia houses declined when it was realized that camellias could in fact grow outdoors throughout the year. M.W.R.S.

Cameron, Charles (c. 1743–1812), an architect and landscape architect of Scottish descent, was probably born in London, where he was apprenticed to his father, a member of the Carpenters' Company, and studied architecture under Isaac Ware. His deep interest in the forms of classical antiquity led him to Rome, and the publication of *The Baths of Rome* in 1772 earned him international recognition. He went to Russia, probably in 1779, to work as decorator, architect, and landscape designer for Catherine the Great, to whom he represented himself as a Jacobite aristocrat, and his achievement and influence there in the field of park and garden architecture were to be very considerable. Recent research has shown that he was responsible not only for major additions and alterations to the palace and park at *Tsarskoye Selo (Pushkin) and for designing the Palladian palace and its setting at *Pavlovsk, but also for planning the integrated development of many thousands of hectares of land which encompassed both these royal residences.

When Catherine died in 1796 Cameron was dismissed by Paul I, but was re-employed by Alexander I on Paul's death five years later. In 1803 he was appointed Architect-in-Chief to the Admiralty and in this post he designed many notable buildings before his second dismissal in 1805. His work in the provinces included the restoration of the Khan's palace at Bakhtchisarai in the Crimea. P.H.

Campen, Jacob van (1595–1657), Dutch painter and designer. See VAN CAMPEN.

Campi, Villa, Florence, Italy, is an extensive, little-known villa situated on a hill above Signa, probably built in the late 16th c. for the Pucci family. The *casino stands on the summit of the hill, sheltered by ilex woods to the north and east, and with expansive views over the Arno valley to the south-east. It is divided into two pavilions by a sunken parterre of flowers, below which is a grass terrace with a stairway and path leading to an octagonal pool. Here there is a balcony and another broader stairway marking the termination of the garden proper, and overlooking olive woods and vineyards on the slopes beyond. The main axial line of the design is continued by a fine cypress avenue, at one time peopled with statues. H.S.-P.

Canada. If one defines garden art in terms of the great classical and romantic garden movements supported by wealthy private patrons, then Canada cannot be said to have developed a great garden tradition. While a legacy of garden making does exist, her history, climate, and landscape have steered the development of her cultural landscape in rather different directions.

The Canadian environment has dominated and shaped the character and culture of the white settlers who in a matter of two centuries radically altered the land they took over from the Inuit and Indian peoples. Until 1867 Canada was a colonial territory and the primary reasons for settling in the country were to exploit her vast natural wealth. The harsh climate, short growing season, and the mission to conquer a vast wilderness for profit have been major influences in the shaping of the landscape, which historically has been an expression of necessity—the need to survive—and exploitation rather than art. The transformation of the land from a virgin state to one surveyed and controlled by man has continued to the present day. Rural farmsteads and remnant woodlands have replaced forest in the more urbanized southern regions; immense wheatfields, whose skyline is broken by grain silos and shelterbelts, have replaced unbroken prairie grasslands; clear cutting and hydroelectric projects are radically altering the face of northern forest regions.

Art has had little impact on the visual make-up of this changing environment. The development of early gardens in the stricter sense of the estate or private space, therefore, was strongly influenced by the overwhelming scale of the land and by the perceptions of nature peculiar to a physically and culturally evolving country. Art belonged to those islands of human culture where nature had been brought under control. Their foundation lay also in a traditional interest in botany and horticulture and on the picturesque style and popular taste imported from Britain and the writings and work of both American and English landscape designers. From the early 19th c. the widespread interest in

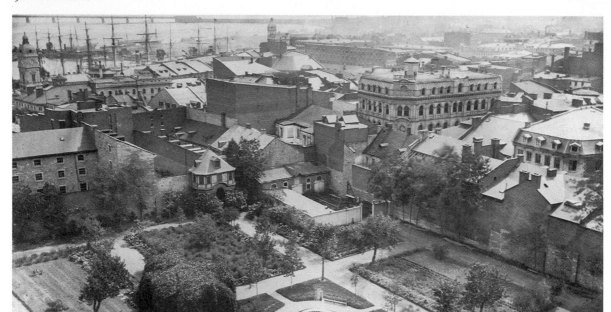

St Sulpician Seminary garden (*c.* 1680), Montreal, Canada

horticulture and gardening led to the founding of numerous horticultural societies modelled on the *Royal Horticultural Society in Britain. Early expressions of this interest were to be found, for instance, in the railway gardens, horticultural show-pieces that decorated the railway stations across the country.

With the collection of plants by botanists as early as the 1630s, 'Jardins du Roi' were established as holding plots for native materials prior to shipment to botanical gardens in Europe. Botanical gardens and nurseries were established in a number of cities for the propagation and display of plants, notably the Skinner nursery, Dropmore, Manitoba (now no longer operational) and the federal experimental farm programme of the 1880s in Ottawa.

Publications by J. C. *Loudon and other English garden authors were responsible for bringing the *picturesque style of gardening to Canada. This probably had more influence on Canadian garden-making as an art than earlier styles from abroad, although classical gardens in the French tradition exist, the oldest example being the walled garden at the St Sulpician Seminary in Montreal, dating from the construction of the monastery in the 1680s. In addition, settlers from other countries created gardens that were an expression of their own particular culture. The Nitobe gardens at the University of British Columbia are a 20th-c. example of pure Japanese garden style transported to Canada. With the influx of Loyalists into colonial Canada,

the private estates of wealthy British colonialists were laid out in the picturesque style popularized by Uvedale *Price and others: a style that suited the rugged 'picturesque scenery' of the Canadian landscape described by travellers of the time. Efforts to design properties in this style were undertaken as early as 1790. The major difference between Canadian and British gardens lay in their settings. In the undeveloped Canadian landscape a house would be sited to take advantage of natural features while preserving its essential natural character. In Britain it was more often a case of remodelling both building and landscape. In the context of how the Canadian landscape was perceived, such large-scale manipulations would, in fact, have been inconceivable.

Of greater significance, however, to Canada than the private garden was the development of the public park. The growth of the industrialized city in the 19th and 20th cs. and the social and physical problems it created have been as much a part of the Canadian scene as in the United States and other industrialized countries. The horticultural show-piece, oriental garden, and picturesque estate became metamorphosed into public places. With the 'rural cemeteries' movement that began *c.* 1840, *cemeteries became the first urban parks: the Protestant burial-ground on Mount Royal in Montreal, and Toronto's Mount Pleasant Cemetery, planted with every growable tree species in the region in the early part of the 20th c., are examples.

F. L. *Olmsted was undoubtedly the best known of the garden designers who left their mark in Canada during this era. Influenced by the English landscape style and motivated by the need to bring nature back into the cities, he laid out a number of public gardens. Among his major works were the design of the Niagara Parkway gardens whose purpose was to protect and develop the American and Canadian lands surrounding the river under the control of the Niagara Parks Commission. The Englishman Thomas Mawson also greatly influenced the evolution of the public garden in Canada. He travelled widely and was consulted from coast to coast. By inclination a classicist and a captive of the stylistic and eclectic tendencies of the period, he, like Olmsted, was motivated by social concerns. The gardens for the new Houses of Parliament at Regina Saskatchewan (now known as the Wascana Centre), and the layout of the Saskatoon campus of the University of Saskatchewan are among the best known of the works that have survived. A Canadian landscape designer, Todd, was particularly influential in the development of the public landscape during the depression years of the 1930s. Among his best known works were the Plains of Abraham Park in Quebec City and the rehabilitation of St Helens Island in 1938.

Public consciousness of the larger landscape was awakened to a very large degree by the landscape painters of early 20th-c. Canada. The Group of Seven painters, formed in the 1920s, painted its rocks, pine forests, and lakes and fostered an appreciation for wild scenery that had its own inherent aesthetic: to be admired but not duplicated by man. As Canada pushes back her last frontiers the significance of the larger landscape as a common heritage for Canada has begun to emerge. This has been reflected in regional and parks planning policies for the preservation of wilderness areas. The most notable urban example has been the planning of the National Capital Region in Ottawa by Greber, the French planner, who in the 1950s laid out a network of linked parks and gardens that has remained unequalled in North America. Thus the garden tradition, while it has not had a major impact on the Canadian scene in itself, may be said to have contributed to the beginnings of a 20th-c. landscape tradition concerned with social and environmental issues that are unique to Canada's cultural development and indigenous landscape.

Until the 1960s, landscape design of all kinds, public and private, was the work of expatriates or naturalized Canadians. The preoccupation with horticulture for its own sake, the gardenesque leanings of the period, and an absence of schools of design militated against the development of an indigenous design philosophy. The establishment of professional schools of landscape architecture from the 1960s onwards has now provided the setting for this philosophy to evolve.　　　　M.H.

Canal, as opposed to a moat (*douve*) became a feature of French gardens in the 16th c. serving both ornamental and useful purposes, such as drainage or water storage. Monumental canals are typically French. The earliest on record is at *Fleury-en-Bière, near *Fontainebleau, where another was made shortly after in 1609. Huge canals are an integral part of *Le Nôtre's schemes for *Chantilly, *Vaux-le-Vicomte, and *Versailles. *Tanlay is a notable pre-Le Nôtre example. Among other existing examples are Anet (see Philibert de *L'Orme), *Courances, *Maintenon, and *Sceaux.　　　　K.A.S.W.

See also ISLAM, GARDENS OF; MOGUL EMPIRE; PETERHOF; SCHLEISSHEIM; WATER IN THE LANDSCAPE: ISLAM.

Canary Islands. See LANZAROTE.

Cane, Percy S. (1881–1976), English garden designer, was inspired to take up this profession after a visit to Harold *Peto's Easton Lodge. During his early years he wrote for *My Garden Illustrated*, which from 1918 to 1920 he was to edit and own, as he did the quarterly *Garden Design* from 1930 to 1939.

Cane's private practice was international, ranging from the gardens of *Dartington Hall (from 1945) for Mr and Mrs Leonard Elmhirst, to the gardens of the Imperial Palace, Addis Ababa, for the Emperor Haile Selassie. Although he worked mostly for private individuals, there was the occasional public or corporate commission, for example the British Pavilion at the 1939 World's Fair in New York, or the Kent Oil Refinery on the Isle of Grain, for the Anglo-Iranian Oil Company.

His comment in 1916 that 'there should be no rival claims of formal and landscape styles' sums up his theory of garden design. A terrace typically provided an architectural setting for the house while the garden was derived from the atmosphere and character of the site itself. Paved walls and steps led to carefully balanced and proportioned glades with sweeping beds of flowers and shrubs.

Percy Cane was awarded eight gold and three silver-gilt medals by the Royal Horticultural Society for his exhibits at the Chelsea Show, and in 1963 was given the Society's Veitch Memorial medal in recognition of his work.　　　　K.S.L.

See also ENGLAND: THE TWENTIETH CENTURY.

Cang Lang Ting, Jiangsu province, China, in the south of the city of Suzhou dates back to the 10th c. Later, in 1044, a noted poet Su Zimei built for himself a garden on the old site, naming it Cang Lang Ting or the Pavilion of the Dark Blue Waves, after an ancient saying which counsels acceptance of the vicissitudes of life: 'When times are good I wash my ribbons of office in the waters of the Cang Lang River—when times are bad, my feet.' Later again, the garden belonged to General Han Shizong, a national hero in the Southern Song dynasty (1127–79). What survives are the remains of successive reconstructions made during the Qing dynasty (1644–1911).

The layout of the garden is unique in Suzhou in that a hill, rather than a pond, lies at its centre. Its entrance is across a bridge, slightly zigzag, above a wide canal. In the gatehouse, there is a rare portrait engraved on a stone by the Buddhist monk Ji Fong at the end of the last century, showing the garden as it was in 1884—it is almost

unchanged today. Beyond the gate one faces immediately an earthy artificial hill, embellished with yellow rocks in the east and *Taihu rocks in the west, which occupies the whole width of the garden. This is the highest of the artificial hills in Suzhou; the Cang Lang pavilion (unfortunately rebuilt in concrete) on its top, gives its name to the garden. Covered *lang galleries dotted with small pavilions and halls surround the hill and open *lou chuang windows allow views of the canal to become part of the garden. There are several structures south of the hill, one of which is the double-storeyed Kan Shan Lou, which literally means Seeing Mountains since it draws into the garden distant views (see *jie jing) of the hills beyond the southern suburbs.

D.-H.L./M.K.

Cannon. Guns and cannon have been used for garden ornaments, sometimes with the intent of creating remembrance of battles fought at or near the site (e.g. at the Alameda Gardens, Gibraltar). They may also emphasize the military or fortified aspects of the grounds. In Britain there are examples of cannon at *Hever Castle and Dover Castle (both in Kent). M.W.R.S.

Canon, Calvados, France, has gardens created between 1768 and 1783 by Elie de Beaumont, avocat to the Parliament of Paris. The axial design is continued behind the château in a lawn, a rectangular canal, and an avenue of beech trees, and is ornamented by an unusual arrangement of free-standing sculpture. The *bosquets which frame this scheme reflect the 18th-c. fashion for *fabriques, with a tetrastyle Temple de la Pleureuse and a Chinese kiosk closing vistas on either side. The old Renaissance Manoir de Bérenger is preserved as a feature in the woods. Unique to Canon is the series of 13 intercommunicating walled fruit gardens or *chartreuses. K.A.S.W.

Canons, London, belonged to James Brydges, Earl of Carnarvon (1673–1744). *Switzer wrote that 'that noble Design of . . . the present Earl of Carnarvon, at Edger [Edgware]' was 'the very last Undertaking' of George *London (d. 1714). A survey of 1717 recorded a 2·8-ha. *bassin, 3·2 ha. of wilderness, 4 ha. of *parterre, and other areas giving 11 ha. within iron palisades, which did not include the 4·4 ha. of kitchen gardens. From 1717 Carnarvon used Richard *Bradley to help stock the gardens, but by 1719 was accusing him of mismanagement. Carnarvon was created Duke of Chandos in 1719, and some time between 1720 and 1724 Tilleman Bobart moved to Canons from *Blenheim.

The completed layout was considered magnificent by Daniel Defoe who commented particularly on the pleasing effect of the diagonal avenue, but it was the subject of controversy when identified with 'Timon's Villa', Alexander *Pope's idea of archetypal bad taste and misspent wealth in the Epistle to Burlington (1731). In 1741 Chandos was employing Alexander Blackwell, an agricultural improver, at Canons, but had no more satisfaction than he had from Bradley. The house was sold for materials on Chandos's

death and the land reverted to agriculture though the field pattern perpetuated the main lines of the layout. D.L.J.

Capponi, Villa, Arcetri, Tuscany, Italy. Built c.1572 for Gino Capponi, the villa is one of the finest existing examples of the many small homes that sprang up in Tuscany during the indeterminate period known as Mannerism, between the end of the Renaissance and the emergence of baroque. The ethos is domestic rather than monumental and the gardens, as an extension of the house, are clearly designed for personal use rather than entertainment. On the upper level is an exposed grass terrace, probably intended for bowls, having a superb view over Florence and the Fiesole hills behind; adjoining to the north-east and continuing on the same level is an enclosed parterre garden with lemon trees. To the north-west, and originally reached from the house only by a tunnel beneath the grass terrace, are two walled gardens in descending levels. These outdoor scented flower-rooms, as they may be called, are totally enclosed by walls whose tops are fashioned with baroque curves. A solitary window looks out high above the public road. Within about half a hectare this highly individual garden seems to combine the elementary requirements for privacy, good situation, and fruitful use of space with the dignity of life associated with contemporary Florence. G.A.J.

Caprarola, Italy. See FARNESE, PALAZZO.

Caraman, Victor-Maurice de Riquet, Comte de (1727–1807), French nobleman, was descended from a Florentine family (Arrighetti) who emigrated to the south of France, where his ancestor P.-P. de Riquet personally financed the making of the Canal du Midi (1666–80). At his 17th-c. château at Roissy-en-France (of which only traces remain) Caraman designed a big garden, celebrated at the time, and illustrated in *Le Rouge, Cahier III. While the main divisions were regular, the interior of the bosquets had serpentine paths, and part was laid out as a jardin anglais. Caraman was consulted for the plans of a jardin anglais at the Petit Trianon. By his example he contributed significantly to the new style of gardening in France. D.A.L.

Careggi, Villa Medici. See MEDICI, VILLA.

Caribbean Islands and the West Indies. Of the many thousands of islands in these groups only a few hundred are inhabited, and of these only a very few have been sufficiently settled for any garden traditions to develop. In most cases these are centred on botanic gardens which were often started as private collections. St Vincent has the oldest, dating from 1765; the others, in Trinidad, Tobago, Grenada, Dominica, the Dominican Republic, Cuba, Montserrat, and Jamaica, date largely from the 19th c. Jamaica is unusual in having four, representing the habitats at four different altitudes.

Some of the islands, such as *Barbados, favoured by planters, enjoyed a period of prosperity in the late 18th and early 19th cs. which led to the establishment of large houses

and gardens. To some extent these have been taken over or supplanted by the rich settlers of the 1930s and the subsequent influx of settlers and tourists from the 1950s. The *Andromeda Gardens are an outstanding example dating from this period.

The establishment of gardens, new public buildings, large houses, and hotels has provided an impetus for landscape architects and designers such as Richard Coghlan in Barbados, Russell *Page in various islands, and Derek Lovejoy and Associates in the Bahamas. This development has given rise to nursery industries and some very active horticultural societies. It has also drawn attention to the vulnerability of the landscape: the problems of pollution and the need for conservation, which in some of the islands are being met by the designation of national parks and conservation areas.　　　　　M.L.L.

Carlotta, Villa, Cadenabbia, Lombardy, Italy. Laid out in 1745 for the Marchese Clerici, and subsequently known as the Villa Sommariva, it was bought in 1843 by the Princess of Prussia as a wedding present for her daughter Charlotte, Duchess of Saxe-Meiningen, from whom it took its present name. To the classical 18th-c. layout of terraces arising out of the lake, with a *bosco and *giardini segreti, a picturesque English landscape garden was added during the 19th c. with massed banks of azaleas. The boundary wall rises from the water, its central part with a baroque iron *grille* protruding on massive angle piers overgrown with roses, its balustrade supporting figures depicting the seasons. Behind, the circular court with a fountain is enclosed by high hedges. Beyond is the double-ramp stairway and the terraces in three levels, the central one with pergolas and lemon trees, the lower with an ilex *bosco*. Upon the topmost level stands the *casino, the screen wall with grotto concealing the bare rock face of the hillside.　　　　　H.S.-P.

Carolingian gardens. Little is known of gardening after the fall of the Western Roman Empire for some five centuries, 500–1000. There is, however, one major exception: from the period of Charlemagne and his immediate successors (c.800–50) several important documents have survived. The most noteworthy are the *Capitulare de villis* listing plants to be grown; the *St Gall plan; the *Hortulus* of Walafrid Strabo, a poem; and a gardener's calendar in Latin verse by the monk Wandelbert. Besides these, other official records and chronicles provide a narrative of events and some particulars of social life.

The 'Capitulare de villis' or Decree concerning towns. The revived Empire of Charlemagne, as constituted from 800 to his death in 814, comprised most of western Europe from the Netherlands to northern Spain and central Italy, and from the Atlantic to the borders of Hungary. Within this wide area there was great variation of climate involving considerable differences in the plants normally grown. This intrudes an element of difficulty into the interpretation of the Decree, which lists 88 (or 89) species to be grown on the Crown estates at all towns in the Empire. The capital,

Aachen, lay in north-west Germany, but some plants such as gourds, rosemary, and the peach-tree are distinctively southern. It is certain that, wherever the list was compiled, there would in practice have been variation in what was planted. Of the list, 72 (or 73) species are herbs and the rest trees; apples and pears had named varieties, and there were also several sorts of plums, cherries, and peaches. Additional species, not listed, occur in surviving inventories of the imperial gardens and other official documents, and seven cereal grains were grown agriculturally, bringing the total of botanical species in cultivation up to 100. Among the herbs, largely medicinal but including also salads and pot-herbs, are the root vegetables carrot, parsnip, and skirret, the onion tribe, and the industrial plants madder and teasel; to which other records add flax and hemp.

It has repeatedly been suggested that the list of plants in the *Capitulare* was a mere compilation from literary texts and glossaries. None the less, it was demonstrated by Fischer-Benzon (*Altdeutsche Gartenflora*, Leipzig, 1894) that 29 of the 89 plants listed cannot be found in classical sources, or in the *Hermeneumata*. Thus there can be no doubt that the plants of Charlemagne's gardens represent a fresh approach to horticulture. The inclusion of distinctively southern species, in a list primarily for use in northern France and Germany, lends colour to the suggestion that the principal compiler was Abbot Benedict of Aniane in Languedoc (Hérault, France). Benedict exchanged medicinal plants with Alcuin of York, Abbot of Tours from 796 to 804, and on one occasion travelled as far as Inda (Kornelimünster, North Rhine-Westphalia), where he met Abbot Tatto of Reichenau, the master of Walafrid Strabo (see below). It seems likely that a compact group of leading personalities, notably the heads of great abbeys, were Charlemagne's chief advisers on gardening.

St Gall Plan. This is one of our major sources of understanding Carolingian Gardens. The great parchment plan (see W. Horn and E. Born, *The Plan of St. Gall*, Berkeley, 1979, 3 vols.), preserved in the monastic library at St Gall, Switzerland, is for an ideal rather than an actual monastery. It shows church, cloisters, guest-houses, workshops, and three gardens, and was designed for Abbot Gozbert who ruled St Gall from 816 to 836. The author may have been Abbot Haito of Reichenau. The gardens comprise an infirmary garden of medicinal herbs beside the house for the resident physician; a kitchen garden by the poultry yards; and the monks' cemetery treated as an ornamental orchard planted with different sorts of trees.

The physic garden is square and contains borders divided into eight beds inside its walls, and eight narrow free-standing beds, separated by paths running north and south. The herbs named are 'Kidney Bean' ('fasiolo', probably *Vigna* sp.), costmary (or tansy ?), cumin, fennel, fenugreek, purple iris, lily, lovage, mint, water mint, pennyroyal, rose, rosemary, rue, sage, and (winter ?) savory.

The vegetables and pot-herbs were grown in a large rectangular plot lying east–west containing 18 isolated narrow beds, on each side of an east–west central path. The

species were: beet, black cumin (*Nigella sativa*), carrots (?), celery, chervil, coleworts, coriander, dill, garlic, leek, lettuce, onions, parsley, parsnip, poppy, radishes, (summer ?) savory, and shallots (or Welsh onions). This kitchen garden had no wall-borders.

The cemetery was planned around a central cross, with both wall-borders and isolated beds and provided for: almond, apple, sweet bay, cherry (? or stone pine, *Pinus pinea*), sweet chestnut, fig, hazelnut, medlar, mulberry, peach, pear, plum, quince, service, and walnut.

In all, 49 species (if we assume both summer and winter savory) were to be grown, all of them appearing in Charlemagne's list, which had been roughly halved to yield the most important of the then domesticated flora. The gardens were strictly utilitarian, but grew several ornamental plants: rose, lily, and flag iris; and the cemetery was laid out to a deliberately axial design of the simplest character. The long narrow beds of the physic and vegetable gardens were probably about 1.20 m. across, to allow of cultivation by reaching from the paths on each side, and may have been raised behind boards or dwarf walls, as in many later medieval gardens.

Walafrid and Wandelbert. Walafrid's *Hortulus*, the 'Little Garden' (text with English translation eds. R. Payne and W. Blunt, Pittsburgh, 1966), is a Latin poem of *c.*840–2 by Walafrid Strabo (*c.*809–d. 849) from Swabia, an oblate at the abbey of Reichenau on Lake Constance, who was sent in 826 to Fulda (Hesse) as a pupil of the learned abbot Hrabanus Maurus. Three years later Walafrid was appointed tutor to the Emperor Louis's son Charles; in 838 he became abbot of Reichenau. The poem sings the praises of 23 plants which Walafrid cultivated with his own hands, and also mentions a dozen other species incidentally; most occur in the *Capitulare* or the Inventories, but the author also refers to the grapevine, white horehound, hyacinth, mugwort, pomegranate, violet, and wormwood. Walafrid shows a keen appreciation of perfume as well as of visual beauty and a lively sense of colour.

His contemporary Wandelbert, a monk of Prüm (North Rhine-Westphalia), also wrote Latin verse, producing a gardener's calendar with the works for each month. This is, however, a far less personal outpouring than Walafrid's, though it undoubtedly was intended to supply a demand for horticultural information.

Charlemagne's gardens. Charlemagne himself not only had royal gardens for the production of food and medicine, but also parks and pleasure grounds. In these he kept a menagerie of animals and birds, including peacocks. He showed a keen personal interest in wine-growing and succeeded in bringing to the vineyards around his palace at Ingelheim (Rhineland-Palatinate) stocks from many distant places: Burgundy, Italy, Lorraine, Hungary, and Spain. This transport of living plants on a grand scale and over great distances shows that the technique of gardening had recovered the skills of classical times. J.H.H.

Carpet bedding appeared in England at the end of the 1860s. It consisted of the making of patterned beds using dwarf or creeping foliage plants (especially the new South American introductions, alternantheras and iresines), which could be trained into a surface as uniform as a carpet; dwarf succulents (echeverias and sempervivums) and some plants with unimportant flowers, like sedums, were added for special effects. Early carpet beds used geometrical patterns, but after the success of some butterfly-shaped beds at the Crystal Palace in 1875, zoomorphic and emblematic shapes were briefly popular. The fashion for carpet bedding on private estates was fading by the mid-1880s, but remained a staple of public park practice until well after the First World War. Through its enthusiastic reception on the Continent (in France and Belgium, as *mosaïculture*; in Germany as *Teppichgärtnerei*, introduced by Pückler-Muskau) and in the United States, carpet bedding formed a truly international style in the later 19th c. B.E.

Carton, Co. Kildare, Ireland, has a walled *demesne of 445 ha. adjoining the town of Maynooth, west of Dublin. In 1687 a formal park was laid out by the Duke of Tyrconnell, James II's Lord Deputy of Ireland, after a plate in André *Mollet's *Le Jardin de plaisir* (1651). In the 1750s the 1st Duke and Duchess of Leinster, having failed to entice 'Capability' *Brown to Ireland, proceeded on their own account to transform the park in his style. 'New river is beautifull. One turn of it is a masterpiece in the art of laying out, and I defy Kent, Brown, or Mr. Hamilton to excel it. This without flattery', wrote the Duchess of her new serpentine 'Sheet of Water' in 1762. In 1763 a classical bridge was designed by Thomas Ivory to cross the River Rye as it flowed through the park.

Plan for carpet bedding at Hampton Court, from Karl Götze, *Album für Teppichgärtnerie* (*c.*1890)

The Duke and Duchess were assisted in their planting by Peter *Collinson and by Jacob Smyth who, after a long period as planter at Carton, established himself as a professional landscape gardener in Ireland in the early 19th c. In the 1760s the Rye was dammed to create a series of cascades and the Shell Cottage built along its banks. In the 1830s the 3rd Duke widened the river to create a lake and laid down the Italian garden in front of the house. It remains one of the most extensive and important landscape parks in Ireland. P.B.

See also IRELAND.

Cascade. The term is often used rather loosely to mean a dramatic fall of water, but this may take several forms. The most striking is the water-staircase, of which the earliest large-scale examples occur at Frascati, such as the Villas *Torlonia and *Aldobrandini, created in the opening decades of the 17th c. It was a development of the *catena d'acqua* in which the centre of a ramp is occupied by a narrow channel of water. The channel may be elaborately sculpted, as in the original example at the Villa *Lante, and the very similar example at the Palazzo *Farnese, Caprarola; or quite plain, as at the Villa *Cicogna, or Villa *Garzoni.

The cascades of Frascati were widely influential. The most grandiose imitation, on a larger scale than any cascade in Italy, is at *Wilhelmshöhe, Germany, where the difference in height between the head of the cascade and its termination is more than 200 m. over a distance of more than 1,000 m.

The gently undulating terrain of France rarely allowed such dramatic displays. Thus the cascades at *Rueil, *Sceaux, and *Villette tend to be less steep, while more in the Italian manner are those at *Saint-Cloud and the great cascade at *Marly, known as La Rivière. The latter was the inspiration for Peter the Great's cascades at *Peterhof which greatly excel all others in the use of sumptuous materials (see plate XIV). In the garden there is the Marly Cascade or Golden Hill, and the Chessboard Cascade, a regular incline of black and white marble; and, in a unique position for a large cascade, one directly in front of the house. Other remarkable 18th-c. cascades are that at *La Granja, made of marble and coloured jasper; and the series of cascades at *La Reggia, Caserta—at over 3 km. probably the longest in existence.

The cascade is a rare feature in English 17th-c. gardens, the only surviving example being at *Chatsworth. In the 18th c. the dam helping to create the artificial lakes of 'Capability' *Brown were sometimes made as cascades with irregularly placed boulders (as, for example, at *Blenheim, *Bowood, or *Virginia Water).

In the 19th c. the cascade as a vertical fall of water from a rocky outcrop dominates the park of *Buttes-Chaumont, Paris; Paxton's cascade at Chatsworth, similar in form, is less strikingly placed.

In gardens outside Europe the grand cascade is a relatively rare feature, even where the climatic conditions are suitable. In the Vale of Kashmir, there is a fine example at *Shalamar Bagh. On a smaller scale, the *chadar* or water-chute is a fairly common feature in Islamic gardens. P.G.

See also LIANCOURT; WATER IN THE LANDSCAPE.

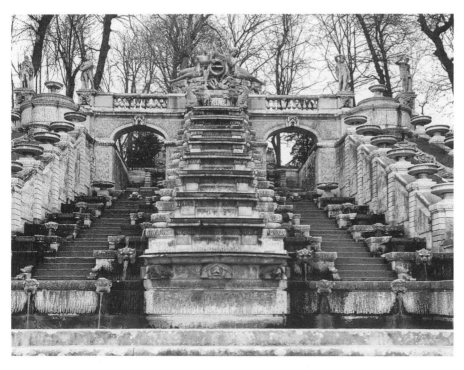

Saint-Cloud, Paris, the cascade

Caserta, Naples, Italy. See LA REGGIA.

Casino, a term used mostly in connection with Italian gardens of the 16th–18th cs. to describe an ornamental lodge, pavilion, or small house, often but not invariably in the grounds of a larger house. Fine examples are to be found at the Palazzo *Farnese and Villa *Lante. P.J.C.

See also GAILLON; MARINO; PIA, VILLA.

Cassan, Val d'Oise, France, was bought in 1773 by Pierre-Jacques-Onésime Bergeret, *trésorier-général* at Montauban. He already owned Nointel nearby, which had celebrated gardens, but he preferred Cassan, and after a journey to Italy with his eldest son and the painter *Fragonard he made ambitious plans for its embellishment. The principal motif was a serpentine lake with islands, on one of which stood the house. The estate was badly damaged by bombardments during the Second World War in 1944–5; part was subsequently sold off as lots. The Chinese Pavilion, a rare example of 18th-c. *Chinoiserie, attributed to Jean-Marie Morel, has survived; it is a brightly painted wooden 'teahouse' raised on a solid stone vaulted basement in classical style, restored in 1971–4 by M. Choppin de Janvry for the Municipality of Isle-Adam. D.A.L.

Cassiobury Park, Hertfordshire, England, was formed into an unusual forest garden by Sir Arthur Capel, created Earl of Essex in 1661, with the assistance of his head gardener, Moses Cook, from c.1669. Behind the house they planted a kite-shaped arrangement of walks and to the right, below a *parterre, a double avenue down to an oval bowling-green. John *Evelyn commented on Essex that 'no man has been more industrious than this noble Lord in Planting about his seate, adorn'd with Walkes, Ponds, & other rural Elegancies; but the soile is stonie, churlish & uneven, nor is the Water neere enough to the house . . . onely Black-Cherry trees prosper even to Considerable Timber, some being 80 foote long: They make also very handsome avenues: There is a pretty Oval at the end of a faire Walke, set about with treble rows of Spanish firr-trees: The Gardens are likewise very rare, & cannot be otherwise, having so skillfull an Artist to governe them as Mr. Cooke.' Cook's book *The Manner of Raising, Ordering, and Improving Forrest-trees* was published in 1676, and in 1681 he left Essex to be a founding partner of the Brompton nursery. There is a Kip view of c.1700 of Cassiobury. D.L.J.

Castell, Robert (d. 1729). Nothing is known of Robert Castell except his publication, *The Villas of the Ancients Illustrated* (London, 1728) and his death in a debtor's prison in 1729.

The book, dedicated to Lord *Burlington, contains the Latin texts and translations of *Pliny the younger's letters describing his villas at Tusculum and Laurentum, and quotations from Varro, Columella, and Palladius on the selections of sites for villas. These texts are illustrated by reconstructions by Castell of the villas and their gardens. The gardens, which are designed in a mixture of the formal style of the 17th c. and the new informal or landscape style, are similar to designs by Stephen *Switzer. They are a better indication of the taste of the period, than accurate reconstructions of Roman gardens. E.B.M.

Castellazzo, Lombardy, Italy. See CRIVELLI SORMANI-VERRI, VILLA.

Castello, Villa Medici, Florence, Italy. See MEDICI, VILLA.

Castello di Montegufoni, Italy. See SITWELL, SIR GEORGE.

Castelo Branco, Beira Baixa, Portugal. In 1598 the Bishop of Guarda built his palace and laid out his remarkable garden on one of the contours of Castelo Branco, a hill-town in the Serra da Estrela range. The garden is ingeniously carved out on different levels.

From the present-day street below, steps, dividing round an *azulejo fountain, curve up to the main parterre. This formal garden is flanked on three sides by severe box walls and pleached trees; the vast prospect of the plain of Alentejo fills the fourth side. The intricacies in design of the box beds—all of them high and tight and bold, no two the same, studded with rotund box towers and a number of statues—add up to an overall effect of symmetry. At one point the beds cluster round an exquisite basin, its deep rim all coils, from whose centre-piece candle-like jets of water play high—a water device Moorish in origin. Two staircases, facing each other, are noteworthy for a procession of statues of crowned kings descending the balustrades. A hidden corner contains a pool, whose surface is broken up by beds, low-rimmed in marble, arabesque in shape, in which flowers are planted—islands of colour floating in the water. This pleasing fantasy has travelled from Persia (Iran) and from India via the Moors.

The final glory of the garden is the topmost terrace and its exceptionally beautiful oblong water-tank. Stone banisters line the edges. The walled east end opens to a flight of spacious steps coming down to the water. Once bearded masks, pebble inlays, and *azulejos* decorated the tank but few traces of such lavishness now remain. B.L.

Castille, Gard, France, has one of the rare examples conserved in the south of France of a *parc irrégulier* (see *jardin anglais), made by Gabrielle-Joseph Froment-Fromentes, Baron de Castille, shortly before the Revolution, but mostly under the Empire. Influenced by his travels in Italy, he re-created round his traditional Provençal *bastide* the colonnades, temples, cypresses, and maritime pines of the Roman campagna A series of radiating *allées* led from the house to numerous *fabriques*: a column and triumphal arch erected to the glory of Napoleon; a pyramid; an oriental well with a cupola surmounted by a crescent; and a temple in the form of an open rotunda. In a more original vein, the owner made small-scale copies of a fragment of the Pont du Gard and the Tour Fénestrelle, the famous Romanesque bell-tower of the church of Uzès nearby. Finally, a romantic note: there can still be seen a strange wood of tombs, a kind of labyrinth of evergreen oaks where, in the windings of the

Plan of Pliny the younger's villa at Tusculum, reconstruction by Robert Castell in *Villas of the Ancients Illustrated* (1728)

Castelo Branco, Portugal

paths, cenotaphs and steles to the memory of parents or friends are successively disclosed. M.M. (trans. K.A.S.W.)

Castle Drogo, Devon, England. Sir Edwin *Lutyens started building Castle Drogo for Julius Drewe in 1910 and tried to persuade him to have a large formal garden adjoining the castle. (Lutyens's designs for this garden, dated 1915 and 1920, are with the Drewe Papers at the Royal Institute of British Architects' Drawings Collection.) Lutyens also introduced Drewe to Gertrude *Jekyll, who suggested schemes for wild planting along the approach road, but her schemes seem not to have been carried out.

In the 1920s Drewe employed George Dillistone to create the present enclosed garden on the slope to the north-east of the castle. This garden is rectangular in shape, with raised walks flanking rose-beds, and enclosing yew hedges formed into squares in the corners. These square 'rooms' are roofed with standard *Parrotia persica* (Persian ironwoods) which have replaced the original weeping elms. The raised walks are of a pattern found in Indian tile-work, an idea possibly suggested by Lutyens to Dillistone whilst work on the garden was in progress (Lutyens was visiting Drogo to supervise building throughout the 20s, the period when he was also building *New Delhi). At Drogo, steps lead up from the formal garden through a small herb garden and sloping shrub borders to a lawn, contained within a great yew circle. There is also a small formal garden close to the chapel, and there are extensive plantings of rhododendrons and azaleas. Castle Drogo now belongs to the National Trust. J.BR.

Castle Howard, North Yorkshire, England, is with *Stowe one of the foremost examples of what Christopher *Hussey has called 'the Heroic Age of English landscape architec-

ture'. For grandeur of scale and conception, it even surpasses *Blenheim—indeed 'the grandest scenes of rural magnificence' (Horace Walpole, Letter to George Selwyn 12 Aug. 1772).

The landscape is very much the creation of an amateur, the 3rd Earl of Carlisle (1670–1738), as are its contemporaries at Stowe (Lord *Cobham) and *Holkham (Lord Leicester). Initially he considered plans by *London for a layout of canals with four broad avenues radiating diagonally from the house to circular lawns (a similar feature appeared at *Cassiobury). This scheme may have already seemed old-fashioned to the Earl, who then turned to *Vanbrugh, whose first visit to the site was in the summer of 1699. Here he was able to realize his taste for theatrical effects which was to be partly denied to him at Blenheim.

The first step in creating the landscape was to set the house parallel with rather than at right angles to the *approach so as to create a broad open view. Unlike Stowe, which was continually enlarged, Castle Howard was conceived from the first on a vast scale. Its scenic inspiration derived primarily from the generalized images of epic poetry (rather than from the specific pictorial landscapes which inspired Stowe or *Stourhead).

However, this conception was not realized immediately. Until *c.*1723, Vanbrugh was occupied with creating the approach on the north side of the house, which passed via an obelisk (1714) through the Pyramid Gate (1719), on either side of which was later built the bastioned park wall (1725 onwards). The kitchen garden (begun 1703) on the south side is entered from the Broad Walk by the Satyr Gate (1705). Here, too, Vanbrugh designed a large parterre, laid out not with topiary but with obelisks.

The decision not to impose upon Wray Wood (26 ha. in area) an *étoile* in the conventional manner (such as had

Castle Howard, Yorkshire, plan reproduced from the 1856 Ordnance Survey map

featured in London's original proposal) was decisive for the development of the 'natural' style of English landscape. Between 1718 and 1732, possibly with the help of *Switzer, it was turned into a labyrinth of tangled paths, enlivened by various fountains.

Of similar importance was the departure from the rectilinear system shown by the Terrace Walk. A continuation of the Broad Walk along a line following that of the old village street, it is at an oblique angle to the house. Along this wide grass walk which follows the natural contour of the slope Vanbrugh set the Temple of the Four Winds (finished in 1728, two years after his death). *Hawksmoor's Mausoleum (begun 1729) marks the scenic climax of the whole landscape. A later addition, the 'Roman Bridge' (c.1744), is slightly less heroic in character. *Walpole was moved to comment: 'Nobody had told me that I should at one view see a palace, a town, a fortified city, temples on high places, woods worthy of being each a metropolis of the Druids, the noblest lawn on earth fenced by half the horizon, and a mausoleum that would tempt one to be buried alive.' (ibid.) (*See over.*)

In 1850 *Nesfield planted a new south parterre, using yew hedges to frame the lawns and the Triton Fountain taken from the Great Exhibition. P.G.

Castle Kennedy Gardens, Wigtownshire (Dumfries and Galloway Region), Scotland, provided Lord *Stair with an excuse to garden on a large scale and in a novel form. The old castle, destroyed by fire in 1717, stands near the sea at the centre of an isthmus between two lochs—the White and the Black—and this apparent island, relatively long and narrow, became Lord Stair's garden. There is a parade/ *parterre element at the front and back of the castle as well as a number of broad straight walks, but otherwise everything is irregular or even curvilinear, and as it appears to have been laid out in the early 1730s this is remarkable enough in itself.

Although the scheme seems to have been derived from one by *Boutcher, Stair appears to have been his own designer. The basic design consisted of sets of green covered banks leading up from the shores, with occasional formal areas within the predominant woodlands towards the

Castle Howard, Yorkshire,
the mausoleum and bridge,
seen from Vanbrugh's
Temple of the Four Winds

centre of the garden. The use of these basic materials—
woodland, earthworks, and water—was typical of the early
18th c. Unlike *Bridgeman, however, Stair did not build
regular, though complex, amphitheatres; instead the banks,
glacis (ramps), and other features taken from field fortifica-
tions were all deployed irregularly.

The grounds remained as Stair left them until the 19th c.
when restoration was carried out; a rhododendron garden is
one of the present features, probably as a development of
J. C. *Loudon's proposals whose planting plans date from
1842. Castle Kennedy was succeeded by Lochinch Castle
in 1867. W.A.B.

Castletown House, Co. Kildare, Ireland, has an early
18th-c. *demesne adjoining the village of Celbridge, west of
Dublin. The house, the largest in Ireland, was erected
c.1720 by William Conolly, Speaker of the Irish House of
Commons, and his wife Anne. To the west of the house a
park in the French baroque style was laid out, the termina-
tion of the central vista being provided by an obelisk (the
Conolly *Folly) supported on high tiers of arches decorated
with carved eagles, urns, and pineapples, which was
designed by Richard Castle in 1740. An axial vista to the
north was answered with the Wonderful Barn, built in 1743.
Conolly's son and daughter-in-law, Tom and Louisa Con-
olly, continued the development of the house and park. In
conformity with the new natural landscape style, they sof-
tened the lines of the baroque garden to the west and
created a new landscape park to the east. Along the banks of
the River Liffey were erected a Gothic lodge after a design
by Batty *Langley, an *ice-house, a domed rotunda dedi-
cated to the actress Mrs Siddons, and a picturesque bridge
over the river. The park is in reasonable condition today.
P.B.

Castres, Tarn, France. The Bishop's Palace (now the
Hôtel de Ville), designed by Hardouin-Mansart in 1666,
has a garden by *Le Nôtre with a *parterre de broderie* which,
though the box has grown too large, is one of the finest
examples of the style. K.A.S.W.

Castries, Hérault, France, has a 16th-c. château with
gardens designed by *Le Nôtre in 1666 for René Gaspard
de la Croix, Marquis de Castries. A terrace on the founda-
tions of a demolished wing forms a platform with two
circular basins and fountains, with a view down to a large
basin and an avenue of trees in false perspective; while to the
left, at right angles, there is a small *parterre de broderie* framed
in ramps which lead from the terrace on either side. The
design shows in miniature the hand of the master. Water is
brought in an aqueduct (1670–6) 7 km. long, by the
engineer Riquet, ending in a dripping grotto. K.A.S.W.

Catesby, Mark (1683–1749), English plant-collector and
author, lived in Virginia from 1712 to 1719, visiting the
West Indies, especially Jamaica, in 1714. In 1722 a group of
patrons, including Sir Hans *Sloane and other members of
the Royal Society, sponsored another journey, which lasted
four years and took him to the Carolinas and the Bahamas.
His collections of plants, animals, and drawings of them
provided material for his *Natural History of Carolina, Florida,
and the Bahama Islands* (1730–47), the first large illustrated
book on the fauna and flora of North America, for which he
etched and coloured the plates himself. Among the Ameri-
can plants he sent back to London were *Magnolia
grandiflora, Catalpa bignonioides,* and *Wistaria frutescens.* S.R.

Catherine de Medici, (1519–89), Queen of France
(1547–59), was born in Florence, the daughter of Lorenzo,

Duke of Urbino, and Madeleine de la Tour d'Auvergne. She married Henri II and was mother of François II, Charles IX (she was regent during his minority), and Henri III. She had a passion for building; gardens were important to her both in themselves and as venues for diplomacy and elaborate festive occasions. Her château of Montceaux-en-Brie, begun in 1547, was left unfinished until the 17th c. At *Fontainebleau a team of artists under Primaticcio transformed the Jardin de la Reine between 1560 and 1563, and created Mi-Voie, a retreat with a dairy in the park, which she used for private entertainment. She had ambitious plans for Saint-Maur-les-Fosses and *Chenonceaux, but the almost continuous civil wars militated against such projects. The palace of the *Tuileries was her most far-reaching enterprise, begun in 1564 by Philibert de l'Orme. The garden was finished c.1572. The Florentine expatriate Bernardo Carnessecchi supervised the planting; Pierre *Le Nôtre was head gardener; and Bernard *Palissy, who dedicated his 'Dessein du jardin délectable' (1563) to her, was employed to build a grotto. K.A.S.W.

Cato, Marcus Porcius (234–149 BC), Roman farmer and statesman, was the author of the oldest book on agriculture in the Latin language, the *De agri cultura* (c.160 BC), which has the character of a notebook of disorganized but extremely valuable comments based on personal experience, and gives practical information to the farmer as well as directions for the management of an estate. In assessing what sort of farm is most profitable, Cato puts an irrigated garden second only to a vineyard (1.7). He advises that on a farm near a town the garden should be planted with all manner of vegetables, and every kind of flowers for garlands (8.1). Cut flowers were not used by the Romans.
 W.F.J.

Caus (or **Caux**), Salomon de (c.1576–1626), French Huguenot engineer, garden designer, and author, studied mathematics and mechanical engineering. He travelled in Italy before 1605, in which year he was employed by the Archduke Albert at Brussels as an engineer (see *Brussels Court). He left Brussels in 1610, and was procured for the English court. He advised Prince Henry, elder son of James I, on waterworks at Richmond, and dedicated *La Perspective, avec les raisons des ombres et miroirs* (1612) to him. He also worked for James's queen, Anne of Denmark, at Somerset House and Greenwich, and for Robert Cecil at Hatfield House. When James's daughter Elizabeth married Friedrich V, the Elector Palatine, in 1613, de Caus followed her to Heidelberg as engineer in charge of buildings and gardens which he illustrated in his *Hortus Palatinus* (1620). His *Les Raisons des forces mouvantes* (1615, 2nd edn. 1624) set out the principles of hydraulics on which the waterworks of 17th-c. gardens were founded; it includes illustrations of *automata for *grottoes. K.A.S.W.

See also ENGLAND: RENAISSANCE GARDENS.

Cause, H. (1648–99), was a Flemish engraver who worked

in the Netherlands and illustrated the gardening manual *De Koninglycke Hovenier* (Amsterdam, 1676) which was published in England as *The Royal Gardener* in 1683. As with *van der Groen's book, the manual was mainly horticultural with a section devoted to designs of parterres and mazes derived from Renaissance models. Although according to *Triggs (*Garden Craft in Europe*, 1913) these designs were very popular in England, they were no longer in favour in the Netherlands. Through their dissemination abroad, the parterre designs in both manuals generated the misconception that they were typical components of the Dutch garden during the second half of the 17th c. F.H.

Caux, Salomon de. See CAUS, SALOMON DE.

Celsa, Villa, Siena, Italy. Laid out during the early 16th c. and attributed to Baldassare Peruzzi (1481–1536), the gardens have, however, been so substantially altered that they have lost all semblance of their original design. The formal parterres and trellised paths have disappeared, together with a circular fountain sited in the curve of the boundary wall from where once radiated avenues of clipped trees forming the *bosco. In the 17th c., as part of a grand project never fully realized, a central screen linking the two wings of the castle was erected, three elaborate gateways were added, and the circular fountain was replaced by a semicircular pool. After the Second World War the present owner, Prince Aldobrandini, restored this pool, together with the parterres, reinstating at the same time the central clipped avenue of the *bosco*, and leaving the rest as wild woodland, still surrounded by a wall. H.S.-P.

Cemetery.

The nineteenth-century cemetery tradition. The modern cemetery emerged as a result of religious and sanitary reform movements at the beginning of the 19th c. On the one hand, propagandists of religious minorities advocated public burial-grounds where burial, and the right to use the services of one's own denomination, were not limited to members of the established church; on the other hand, sanitary reformers objected to the increasingly speedy disinterment of bodies necessary in overcrowded urban churchyards to allow room for burials.

Paris set a precedent for banning churchyard burial in 1804, and in the same year land to the east of the city was purchased as the site for the cemetery of Père-Lachaise. Alexandre-Théodore Brongniart's ground plan combined a central structure of formal avenues with a network of winding paths to cope with the steep site, and featured a *rond-point planted with poplars (perhaps in tribute to the *Ile des Peupliers* where Rousseau had been buried). Père-Lachaise became the world's most celebrated cemetery, the one most cited as a model by reformers, and its influence dominated most 19th-c. cemetery design.

Non-denominational cemeteries began to appear in England during the 1820s and 1830s. These early years saw

experiments in three basic styles. The informal landscape park served as a model for Norwood Cemetery, London (1837), with its serpentine walks, undulating ground, and clumped trees. Most cemeteries of the period followed Kensal Green, London (1833; Richard Forrest, landscape gardener), in adopting a modified landscape manner, with a few formal elements, such as avenues, being given central emphasis; Brompton Cemetery, London (1840), went furthest of the early cemeteries toward a purely geometric layout. Some few exploited picturesque or sublime effects, such as St James's, Liverpool (1829), laid out in an abandoned quarry, the Glasgow Necropolis (1831), and Highgate, London (1839), with the roads carved out between steep banks, some lined with catacombs. By the 1840s, simple symmetrical layouts were coming to be preferred to informal ones, as better adapted to the disposition of graves; after the example of *Paxton's Coventry Cemetery (1847), many cemeteries used the formal terraces as organizing features.

Early British cemeteries were planted largely with the restricted choice of trees associated with the 18th-c. landscape garden; George Loddiges's planting of Abney Park Cemetery, London (1840), as an arboretum popularized the more widespread use of the exotic species. *Loudon, himself a cemetery designer, argued that a cemetery should have a distinct character that could not be mistaken for that of any other type of landscape, and for this purpose recommended planting trees in avenues or as regularly placed specimens, and relying largely on conifers, especially the fastigiate forms (see his *On the Laying Out, Planting and Managing of Cemeteries and on the Improvement of Churchyards*, 1843, repr. 1981). These recommendations dominated British cemetery planting until the 1870s.

In many cities, cemeteries were provided before *public parks, and so initially served the functions of the park. In the United States the notion of the cemetery as public pleasure-ground was taken further than in England, and the major cemeteries of the 1830s and 1840s followed the example of *Mount Auburn Cemetery, Boston (1831; Jacob Bigelow *et al.*) in adopting an informal, asymmetrical path network with lakes and clumps of trees. Some important examples from this period are: Laurel Hill, Philadelphia (1835; John Notman); Greenwood Cemetery, Brooklyn (1838; David Douglass); Green Mount Cemetery, Baltimore (1839; Benjamin Latrobe, jr.); and Spring Grove, Cincinnati (1845), which boasts a notable arboretum. Many 19th-c. cemeteries in continental Europe, by contrast, pushed much further than the English in the direction of monumental formality, from the series of descending architectural terraces at Montmartre, Paris (1804, redeveloped extensively 1867), through the Staglieno in Genoa (begun 1844), which features a series of colonnades converging on an open square, to the immense Zentralfriedhof in Vienna (opened 1874), where tree-lined avenues stretch uniformly across the cemetery.

The American park cemeteries began to be extensively publicized in England in the 1870s, at the same time as the horticultural community began to revolt against the Loudonesque reliance on conifers and rectilinear layout, now perceived as excessively sombre. Both colourful flower-bedding and the use of deciduous trees came into fashion, and the revival of informal landscape design gradually got under way, the stages of which can be seen in the extension of St Pancras and Islington Cemetery, London, in the 1870s, and H. E. Milner's cemetery at Stoke-on-Trent a decade later. The spread of the informal tradition to the Continent was signalled by the turn-of-the-century debate in Germany over the 'park-like cemetery', exemplified by Ibach's Südfriedhof in Cologne. B.E.

Twentieth-century developments. The achievement of the War Graves Commission in dealing with the losses of both world wars influenced both the approach of other combatant nations and the design of civilian cemeteries in Britain. The uniform treatment of enclosed, level grave areas, the restrained use of trees and shrubs arranged for simple maintenance, and the symbol of a 'Cross of Sacrifice' (Blomfield) or 'Stone of Remembrance' (Lutyens), enclosing walls and buildings were all adapted to the topography and horticultural conditions of each battlefield. The original intention was to evoke the feeling of an English garden, yet retain the essential character of a cemetery. However, the major burial-grounds of the Somme and Flanders are dominated by the later addition of classically derived architectural features such as triumphal arches, gateways, colonnades, and pavilions, employed as memorials to the missing—particularly striking when viewed across a flat agricultural landscape. One of the most haunting of all the First World War sites is the vast French ossuary at Fort Douamont Cemetery, Verdun. Of a different period and character are the dramatic Italian cemeteries and ossuaries built during the 1930s. At two such, Monte Grappa and Redipuglia near Udine Monfalcone, both by Giovanni Greppi, massive stone terraces step up the hillsides.

By contrast, the cemeteries of the Second World War are more subdued in character. Two late examples derived from local topography are Bloemendaal, the Netherlands (c.1950) in open country, fortress-like with sculpture, and the German Military Cemetery at Cannock Chase, Staffordshire (1963) by Derek Lovejoy & Partners, in which the gentle valley setting, the existing trees, and heathland planting are used to break the oppressive effect of row upon row of uniform graves.

The Lawn Cemetery. Robert Auzelle (*Dernières Demeures*, 1965) has identified three types of 20th-c. civilian cemetery commonly found in northern Europe and the United States: the Lawn Cemetery, the Forest Cemetery, and the Architectural Cemetery. The Lawn Cemetery or Cemetery Park derives from an unbroken tradition of private garden cemeteries first promoted in the United States in the 1840s by Andrew Jackson *Downing after J. C. *Loudon. The simple device of flush graves and markers permits a relaxed layout of spacious grassland, with clumped trees, informal paths, and drives. The most notable example is Forest Lawns, Los Angeles (originally 1906) redeveloped from

1917 by Frederick Hansen, where the 120 ha. of parkland are 'filled with towering trees, sweeping lawns, splashing fountains, singing birds . . . to educate and uplift a community' (Hubert Eaton, 'The Founder'). This very lack of cemetery character, and hence of adequate focus for the bereaved, contributes to the sense of general unease frequently found in lawn treatment. Greenlawn Memorial Park, Surrey (1938), was the first lawn cemetery in Britain, but the method proved unpopular. Instead a modification based on war graves practice, with kerbless plots and stones of standard proportion, is now widespread both for new cemeteries and for the piecemeal conversion of older ones into instant memorial parks.

The Forest Cemetery. The second type, the Forest Cemetery, has had only a limited application, relying as it does on a combination of low burial densities and mature woodland, but it has had a significant influence on cemetery design, particularly in northern Europe. Such cemeteries have come to be regarded as local parks rather than simply as burial grounds. Waldfriedhof, Munich, by Grässel, with the burial clearings linked by serpentine paths, is an early example. At Friedhof Osterholz, Bremen (1900), Laüger and Freye achieved greater densities and spatial variety by means of a cellular layout with strong structure planting and the use of hedges for screening. The best-known example is still the extension to Forest Cemetery, Stockholm, made between 1917 and 1940, by *Asplund and Lewerentz. Its sombre woodland setting is used as a key to the landscape character: the buildings, though integral, are always subordinate. Ancient burial imagery and Christian symbolism are

Cemetery extension (1961–3), Gossau, Switzerland, by Willi Neukom

combined to evoke a powerful atmosphere which varies from the enclosed setting of the tiny, nordic Forest Chapel (1918–20), to the famous long vista of the Way of the Cross sweeping up to the entrance to the serene crematorium building added in 1932–5.

The Architectural Cemetery. The practice of short-term burial and the reuse of burial land in the more populous areas of Europe is clearly best suited to the regular gridiron layout which characterizes the Architectural Cemetery. By tradition, in southern Europe the design emphasis centres on the individual tomb or memorial, rather than the cemetery. Typically the character is that of a necropolis: hard, urban, and walled. There are exceptions. Two such in the built tradition yet derived from their mountain settings, are the village cemeteries in the area of Vajont, Italy, created by Graseleri and Varnier, following a major disaster in 1963. One is built on an exposed hillside with concentric terraces, massively hewn walls, a single stone cross, and a walled processional route. The other at Erto a Monte is more sheltered, again terraced but using the terrace edges to form a series of complex spaces. The cemetery at Longarone, Belluno, is in a similar location. Enclosure here is created by stone walls and terraces in a loose association of geometric forms.

Design features. High burial densities can be achieved using soft materials. A strict rotation is the basis of Hörnli Canton cemetery in Switzerland by Klingelfüss. The design centres on a variety of buildings and their axes by means of a hierarchy of avenues, parterres, and hedges which define the burial sections. This form of the Architectural Cemetery has been adapted throughout northern Europe, though it is ill suited to hilly sites and can easily become monotonous on flat ones. At Mariebjerg Cemetery, Copenhagen, G. N. *Brandt has softened the grid plan by variety both in the arrangement of avenues and in the enclosed burial areas which range from 'wild' forest clearings and irregular grassy plots to ordered bays with clipped hedges. This hybrid approach, combining as it does the design freedom of the Cemetery Park, the naturalism of the Forest Cemetery as a framework, with the unifying rhythm and density advantages of rows of graves, is easily adapted to varying local conditions and has been widely used in both Germany and Switzerland.

Typically, every aspect of these cemeteries is considered, from planting and earthworks to the treatment of existing vegetation and the fine detailing of hard surfaces. Burial plots, lying unmarked in grass or with modest memorials and ground-cover planting, are grouped into small enclosures with quiet seating areas and walkways. Urns are buried or set into walls with planting on top. Sometimes there are central display areas for wreaths and sculpture; water is frequently used as a focal point. The individual grave is always subordinate to the communal ethos. Contrary to British practice, the design of cemeteries is an important aspect of architectural and landscape work in northern Europe. Schemes are regularly featured in the

professional journals, competitions are well supported, and the reuse of burial land ensures that funds are available for maintenance and remodelling works.

See PISKARYOVSKOYE CEMETERY.

Cemetery conversion. Since legislation in 1887 and 1906, disused burial land in Britain may be converted into public open space, but generally the results are dull. An exception is Bunhill Fields, London (1965), by Peter Shepheard, with choice planting, well detailed paving, and quiet sitting areas. Local authority and amenity group interest in the reuse of cemeteries in Britain and the United States has centred on the early 19th-c. examples, chiefly as amenity open space, but also as natural habitats and relict landscapes. Many fine cemeteries have suffered from indiscriminate lawn conversion. Enlightened management and restoration work is possible, as, notably, at Highgate Old Cemetery, though not without a compromise between the differing interests of landscape historians, naturalists, and 'tomb-trail' enthusiasts.

Crematoria gardens. Clearly the treatment of the dead in different cultures is influenced by varying religious beliefs, social mores, economic status, and national legislation. By the 1880s, 30 years after the principle of permanent burial was accepted in Britain, the demand for grave space was seen to be insatiable and it began to be argued that cremation was the only long-term solution. Today the British cremation rate is the highest of any western country apart from Japan, whereas in southern Europe cremation is still regarded as anti-clerical.

William Robinson gave early support for the idea of Arcadian cremation parks freed from the functional constraints of grave spaces, and exemplified this in his layout of Golders Green Crematorium (opened 1902). Most early crematoria, however, functioned as parts of cemeteries, with gardens of remembrance set aside for commemoration in a restricted area; most of these were laid out in a standardized 'old-fashioned garden' manner—a good example can be seen at Putney Vale, London (1938)—despite a few imaginative novelties, like E. A. Peak's columbarium in Pulham-style artificial rockwork at Hedon Road Cemetery, Hull (1902). It was not until the 1960s that British crematorium designers adopted the open, naturalistic setting used so effectively by Gunnar Asplund at the Forest Cemetery and Crematorium, Stockholm, and subsequently developed throughout northern Europe. Three examples can be found: at Mountsett Fall, Durham, by Brian Hackett, which has an open rocky landscape with heathland; at Grantham, Lincolnshire, by Geoffrey *Jellicoe, which has ground modelling and a central cross edged with trees and hedges; and at Bretby, Staffordshire, by Mary Mitchell, where the existing woodland and water have been adapted with great care. H.B.

Central Park, Manhattan, United States. In 1857 Frederick Law *Olmsted became Superintendent of Works

for the park site, which he described as follows: 'The site is rugged, in parts excessively so, and there is scarcely an acre of level or slope unbroken by ledges. With a barely tolerable design, tolerably executed, the park will have a picturesque character entirely its own, and New Englandish in its association much more reflective of any European park.' Calvert Vaux persuaded Olmsted to enter the competition for designing the park, initiated 30 Oct. 1857, and on 1 Apr. 1858 they submitted their Greensward plan for the 345-ha. site. There were 32 other competing and two non-competing plans, which were judged by Edward *Kemp and a Frenchman whose name is not known.

In their accompanying report, Olmsted and Vaux explained that they aimed to re-create a variety of rural scenes. The upper section, between the reservoir and 106th Street, had sweeping broad slopes; the lower section, more diverse, had a long, rocky, wooded hillside. To preserve this rural feeling, the partners proposed a bold system of sunken transverse roads to keep the park clear of traffic, which they foresaw would increase enormously as the population on Manhattan Island grew. Olmsted was not concerned with visual appearances only. He thought of a public park as a democratic institution which would have a great influence on the moral health of the citizens.

Work began in May 1858, but from the start it was a continual struggle to maintain the integrity of the original design because of political pressures. By April 1860, however, most of the work was finished. Construction languished during the Civil War, when Olmsted was occupied elsewhere. He resigned in May 1865; reappointed in July, he continued to supervise the maintenance, until the years of the Tweed Ring (Nov. 1868–Nov. 1871) when the landscape was 'simplified'. The park was eventually completed by 1877. It has been subject to repeated intrusions by inappropriate buildings ever since, but still represents a major tribute to its designer. P.G.

See also PUBLIC PARKS: THE PARKWAY SYSTEM.

Cetinale, Villa, nr. Sienna, Tuscany, Italy. The estate was laid out in 1680 by Carlo Fontana as a summer residence for Cardinal Flavio Chigi, nephew of Pope Alexander VII. The gardens consist in the development of a single axial line extending from a colossus of Hercules in front of the house through lessening degrees of formality to an avenue ascending the wooded slopes of a hill to a hermitage on the skyline. As at Villa Celsa, the *bosco placed at a distance from the house was surrounded by a wall, since it was considered unsafe to allow trees to grow too near to the house lest they provide cover for brigands. G.A.J.

Chabutra, a square stone dais, usually *c.*60 cm. high, sometimes found in Mogul gardens (for example, *Ram Bagh). Large enough for two people to sit in comfort on carpets and cushions, its purpose was to catch the lightest breeze in hot weather and give a view over the surrounding garden. S.J.

See also ACHABAL.

Chadar, a form of water-chute often used in Persian and Mogul gardens, generally to conduct water from one terrace to the next. The water flows down a stone slab that is tilted away from the top at an angle of *c.*45° so that it always catches the light, no matter what the position of the sun. The stone has a raised pattern of shells or fish scales which increases the sparkle and sound of the water. *Chadars* (the word means a shawl or sheet) are usually between 60 cm. and 90 cm. wide and vary in length from 60 cm. to 6 m.; the longest is at Chasma Shahi on Lake Dal in Kashmir. S.J.

See also ACHABAL; CASCADE; LOTUS GARDEN, DHOLPUR.

Chahar bagh, literally 'fourfold garden' (*chahar*, 'four'; *bagh*, 'garden'). The earliest Persian gardens, dating back to 2000 BC, were square enclosures divided into four equal parts by intersecting water channels. Throughout the centuries this pattern has been the basis for all gardens designed in the Persian tradition, wherever they may be.
 S.J.

See: ISLAM, GARDENS OF.

Chahar Bagh Avenue, Isfahan, Iran, forms a major axis of Isfahan's town plan established by Shah Abbas I in the mid-17th c. Located to the west of the Maydan and early palace complex, it runs for almost 2,000 m. on a slight gradient from north to south. The avenue terminates at the 17th-c. Allahverdikhan Bridge crossing the Zayandeh-Rud River to an area that once contained further royal gardens. Built to serve as a promenade, Chahar Bagh Avenue was originally 75 m. wide and edged by palatial apartments and handsome kiosks with shady gardens beyond. Down its centre and bordered by stone paving flowed a canal that cascaded from successive terraces. There was also a wide variety of pools and fountains along its length, and poplar and plane trees at its borders. The central canal has since disappeared along with many of the plane trees, and although the central strip remains popular with pedestrians, it is now bounded on both sides by shopping streets fronted by heavy vehicular traffic. J.L.

Chahar Chenar Island, Lake Dal, Srinagar, Kashmir, a squared artificial island, was built probably by King Zain-ul-Abidin, in the 15th c. The name is a later one, commemorating a visit by the Emperor Shāh Jahān, when he planted four plane trees, one in each corner (*chahar chenar* meaning, literally, four plane trees). In the mid-19th c. it contained a garden, fed by a water-wheel from the lake, together with a small central tower, but these have now been lost. The site, however, is still delightful, offering a romantic view of the lake and mountains. S.M.H.

Chamars, Besançon, Doubs, France. The Chamars (corruption of Champmars), a piece of land adjoining the River Doubs, was one of the earliest public promenades in France, planted with lime trees in 1653. A double line of fortifications was built by Vauban between 1678 and 1682, dividing the area into the Petit Chamars within the walls, and the Grand Chamars next to the river. Between 1755 and 1785 these were combined into a fine public garden to the design, first of C. F. Longin and then, between 1774 and 1785, of C. J. A. Bertrand. K.A.S.W.

Chambers, Sir William (1723–96), English architect, had visited China twice (1744 and 1748) at a time when there was a growing European vogue for *Chinoiserie*—much of it charmingly inauthentic. In 1752 *Attiret published his eye-witness account of the Emperor's gardens, but it was from Chambers that any real Chinese influence in England was derived.

In 1757 he published his *Designs of Chinese Buildings* with his own sketches of buildings, costumes, and furniture, just as he was beginning to lay out the Botanic Gardens at *Kew for Princess Augusta (mother of George III) with numerous structures which were illustrated in *Plans of the Gardens and Buildings at Kew* (1763). Among these were a Chinese temple, aviary, menagerie, and flower garden (1760), a mosque, a Palladian bridge, more than 20 classical temples, and the Great Stove, the largest hot-house in existence. Of those remaining today, the ten-storeyed pagoda (1761) and Roman 'ruined' triumphal arch are outstanding: the orangery (1760) is now Museum III.

When Chambers published his famous *Dissertation on Oriental Gardening* (1772)—'a piece of Nonsence of my own'—it was really a protest against the devastation and bareness of the Brownian landscape. His plea for the garden of varied form, texture, and toned colour, designed to awaken curiosity and to evoke contrasting sensations of pleasure, surprise, or alarm, anticipated the *picturesque and aroused controversy lasting until modern times.

Two notable examples of Chambers's formal designs are the splendid Triumphal Arch at *Wilton House—his first work in stone—for Lord Pembroke (*c.*1755) and the *casino, *Marino, for Lord Charlemont (1761–81) a garden pavilion of classic perfection. I.L.P.

See also WOBURN ABBEY.

Champs, Seine-et-Marne, France, has a château (1701–7) whose gardens were laid out before 1727 in the manner of Le Nôtre, and modified by Jean-Charles Garnier de l'Isle for the Duc de la Vallière who leased the property to the Marquise de Pompadour in 1757. After the Revolution the gardens were transformed into a *parc à l'anglaise*; they were restored *c.*1900 in the spirit of the original by Henri and Achille *Duchêne. The two elongated pieces of *broderie* are particularly notable examples of the 17th-c. style. The sculpture which terminates the central vista is a modern copy after *The Horses of Apollo* by Marsy at Versailles.
 K.A.S.W.

Chang Chun Yuan, Beijing, China, was the first Qing-dynasty 'imperial short-stay villa' type of garden. Called the Garden of the Exuberant Spring, it was built after Emperor Kang Xi's two southern tours in the 1680s, on the ruined site of Qing Hua Yuan, an estate once owned by Li Wei of the Ming dynasty. The 91-ha. garden was located

somewhere near the present Beijing University on the outskirts of the capital, and was planned, designed, and supervised by *Ye Tao, an artist born south of the Chiang-jiang (formerly Yangtze River) who specialized in landscape painting. The rockeries were executed by *Zhang Ran, the best-known rock master of the time. After it was complete, the Kang Xi Emperor spent most of his time there, and Emperor Qian Long lived and studied in it from his childhood until he came to the throne.

The eastern part contained the palace, court, and imperial lodge with, behind them to the north, a big park dominated by a lake which narrowed and widened along its course and was divided by islets and dikes. The buildings, some in groups and some scattered at random, were arranged to accord with the natural contours of the land. The western part was made up of even more water surfaces, and contained two building complexes used by the young princes. Along with the other great imperial gardens near Beijing, Chang Chun Yuan was severely damaged in 1860 by French and British troops. C.-Z.C./M.K.

Chang Wu Zhi ('On Superfluous Articles') is one of the most important works on landscape architecture in Chinese, written at the end of the Ming dynasty by Wen Zhen-Leng (1584–1644). His great-grandfather, Wen Zhen-ming, was one of the 'Four Great Painters' of the dynasty, and had once been closely connected with *Zhou Zheng Yuan, the Garden of the Unsuccessful Politician, in Suzhou. The book—variously translated as 'On Superfluous Articles' or 'On Daily Articles', depending on which meaning the reader wants to stress—consists of 12 chapters in which Wen suggests how to make an art of life's everyday activities. Although he did not explicitly discuss gardens, his chapters on the house, on trees and flowers, on selecting books, on the use of water and rocks, and on how to combine the two—which deal with details of construction as well as the principles of composition—greatly influenced garden design. C.-Z.C./M.K.

Chanteloup, Indre-et-Loire, France, Pagode de. See PAGODE DE CHANTELOUP.

Chantilly, Oise, France, was the seat successively of the families of *Montmorency, *Condé, and Henri d'*Orléans, Duc d'Aumale; it now belongs to the Institut de France. The marshy site gives abundant water, and the château (19th c. on 16th-c. foundations), with the Petit Château, stand in large pond-like moats. The extensive grounds comprise *Le Nôtre's Grand Parterre and canal; a large park on the east, containing the Maison de Sylvie and the

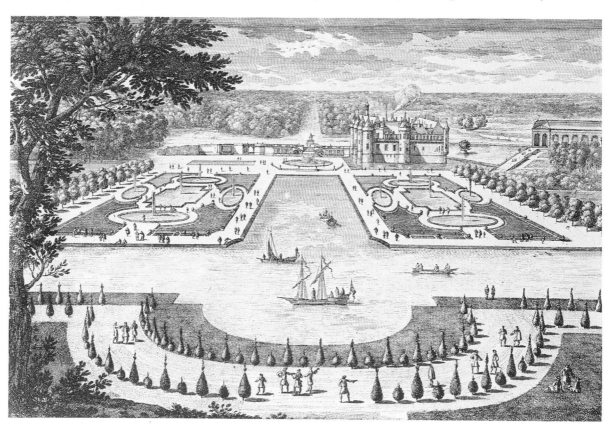

Chantilly, Oise, France, view from the *vertugadin*, engraving (c.1685) by Perelle

Hameau; and a 19th-c. park *à l'anglaise* on the west, with a few features remaining from elaborate 17th-c. and 18th-c. gardens.

Anne de Montmorency enclosed a park between 1522 and 1567, and made gardens (shown in *du Cerceau's plan) west of the moats. The raised terrace east of the château, where his statue (erected 1886) now stands, was begun in 1538. The Petit Château (*c.*1560 by Jean Bullant) was an island, and had a loggia opening on to a small garden. In 1643 Chantilly passed to the Condé family.

Louis II de Bourbon (the 'Grand Condé') enlarged the park from 100 to 1,200 ha., and from 1663 employed Le Nôtre to redesign the grounds, assisted by Claude *Desgots, *La Quintinie, the architect Daniel Gittard, and the engineer Jacques de Manse. The scale of Le Nôtre's design (later than *Vaux-le-Vicomte, but before *Versailles) imposed regularity on an irregular site. The main axis ran south–north, parallel to the façade of the château, and extended into the forest at either end. A new approach sloped up from the gates to Montmorency's terrace from where the whole scheme was revealed. Monumental steps (the Grands Degrés, 1665), designed by Gittard, with colossal river gods by Jean Hardy in niches on either side, led to the Grand Parterre: in the foreground a circular basin with a fountain (the Grande Gerbe); beyond, the Manche (a branch of the grand canal), separating two vast symmetrical compartments, each with two round and two oval basins. On the far side of the canal the axis terminated in a bay and crescent-shaped theatre (the Vertugadin), formerly lined by busts of the 12 Caesars.

The Grand Canal (1670), running east–west, is formed from the River Nonette whose waters are collected in a large circular basin, falling by a cascade into a hexagonal one. Thence the canal is in two stretches, the first 1,800 m. long × 80 m. wide; the second continuing obliquely for 1,000 m. A further canal at right angles connects with the pavilion in the south-west corner of the grounds, housing the machine (1679–82) designed by Jacques de Manse to supply water to cascades and fountains in the gardens west of the château. These were a series of more intimate interconnecting gardens made between 1676 and 1680, covering a strip of land over 1 km. long and *c.*200 m. wide; they contained fountains and two architectural cascades by Gittard (the Grande Cascade and the Cascades de Beauvais). Porticoes and pavilions of trellis-work were made by Dutch craftsmen. Montmorency's garden was redesigned by Le Nôtre (1663) with an orangery by *Hardouin-Mansart (1682–6). The flower gardens of the 'Grand Condé' were celebrated; he collected varieties of tulip, narcissus, anenome, daffodil, pink, and hyacinth. The gardens were fully illustrated in engravings by Adam *Perelle in the 1680s. Plans of the grounds, with elevations of *fabriques* erected in the 18th c., were made by Chambé in 1784, and presented to Catherine the Great in a magnificent volume now at Chantilly.

In the park east of the château, woods enclose the Maison de Sylvie, a pavilion with a small garden. In 1623 Théophile de Viau, condemned for the licentiousness of his poems, was given protection by Henry II de Montmorency. In his verse he addressed the young duchess as 'Sylvie', giving the name to the house where he took refuge. The present building dates from 1670. Among the various *bosquets* arranged in the park on this side was a huge labyrinth (1679) by Claude Desgots. It was replaced in the 18th c. by another with a Chinese kiosk at the centre. In 1774 Jean-François Leroy transformed a meadow east of the Grand Parterre into a *jardin anglais*, in which various features (ponds, lawns, a flowered trellis, an orchard, a straight canal, a picturesque rock) were enclosed in a wood with winding paths and streams. At the east end the Hameau (1773), a group of thatched rustic buildings round a green, anticipated the Hameau at the Petit Trianon.

During the Revolution the Condé property was confiscated and most of the land alienated. The château was used as a prison and later razed to the level of the terrace. The Petit Château, the Maison de Sylvie, and the Hameau were preserved. Some of the land was bought back by the Prince Louis-Joseph de Condé when he returned from exile in 1814 aged 78. The ground, formerly occupied by parts of the gardens on the west and meadows as far as the canal, was laid out *à l'anglaise* by the architect Victor Dubois between 1817 and 1819. The château which now rises from the moats was built between 1875 and 1882 to the design of Honoré Daumet for Henri d'Orléans, Duc d'Aumale. He left Chantilly to the French nation, together with his collection of books and works of art, which included the illuminated manuscript of *Les Très Riches Heures du duc de Berry*. Le Nôtre's Grand Parterre and canal, the Hameau, and the Maison de Sylvie have been restored. The town has spread over the extreme western parts of the 18th-c. grounds. All that survives of the Grande Cascade is a street of that name; but the Pavillon de Manse still stands, marking the bounds of gardens which once rivalled Versailles in magnificence and extent. K.A.S.W.

Charles X (1757–1836), King of France (1824–30), brother of Louis XVI. As Comte d'Artois, before the Revolution, he employed the Scottish gardener Thomas *Blaikie to work with his architect F.-J. *Bélanger in designing parks in the English style at *Bagatelle and *Maisons. Among numerous projects he had grandiose schemes for rebuilding the Château-Neuf and its terraces at *Saint-Germain-en-Laye, but these were not carried out. K.A.S.W.

Charleston, South Carolina, United States. In both this charmingly compact, perfectly scaled, small city, and in the surrounding countryside where handsome plantation houses still stand above rice-fields now restored to natural landscapes, are outstanding examples of the best in small town gardens and in grand country estates where drainage ponds were transformed into 'butterfly pools' and vast slopes were laid out in great formal terraces or 'falls'. The beauty of these city and country gardens lies in the use of exotic trees, shrubs, and vines to enhance both the smallest and the largest in garden designs. While visitors are made to feel welcome, there is no hint of changes having been made

in the natural order of Charleston gardening to dazzle the passing stranger. Spring is the obvious season to see this unique small kingdom of bloom along city streets and parklands among cypress swamps. A.L.

Charlottenburg, Berlin. The Elector Friedrich III of Brandenburg, who was crowned the 1st King of Prussia (as Friedrich I) at Königsberg in 1701, built the Schloss (1695 onwards), which at the time was still known as Lietzenburg, for his wife Sophie Charlotte, the daughter of the Electress Sophie of Hanover who had laid out the famous garden at *Herrenhausen. Like her mother, Sophie Charlotte was a close friend of the philosopher Leibniz and was known as 'the philosophical Queen'.

The style of the baroque garden which was laid out on Sophie Charlotte's instructions by Siméon Godeau reveals more a Dutch than a French influence, a particularly suitable choice as the Schloss is situated beside a river—the Spree. The river bounded the garden on two sides. A large *bassin*, fed from the river, was constructed at the end of the long parterre, which was flanked by avenues laid out in rows of four; beyond the parterre on the west side were garden rooms made out of hedges. Many statues stood on the terrace in front of the Schloss and in front of the orangery at the side of the main building. Charlottenburg, which at the time stood outside the gates of Berlin, was the favourite summer residence of Friedrich and Sophie Charlotte who enjoyed the view into the surrounding countryside from the Schloss over the *tapis vert* and through a wide cutting in the woods.

Under Friedrich Wilhelm II (1786–97) and Friedrich Wilhelm III (1797–1840) the garden was redesigned as an English landscape park; the parterre was completely re-arranged and the *bassin* transformed into a natural lake. Peter Josef Lenné was mainly responsible for these changes.

There are three outstanding buildings in the park: the belvedere, built under Friedrich Wilhelm II by the architect C. G. Langhans, which today houses a collection of porcelain; the mausoleum, built as a temple to a design of Karl Friedrich *Schinkel by Friedrich Wilhelm III after the death of his wife Luise; and the pavilion also designed by Schinkel, built by Friedrich Wilhelm III in the eastern part of the garden as a continuation of the terrace. Both the Schloss and the garden suffered extensive damage in the Second World War, but the Schloss has been completely restored and the parterre and garden rooms reconstructed to baroque designs. U.GFN.D.

Charlottenhof, Potsdam, German Democratic Republic. See SANSSOUCI: CHARLOTTENHOF PARK.

Charmille, a tall hedge clipped to give a smooth wall-like surface. The word comes from *charme* (hornbeam) which is traditionally used to make such hedges. D.A.L.

Chartreuse, a small isolated country house built for retirement; in French gardens a series of sheltered enclosures for plants (as at *Canon), or with pavilions (as at Nancy). The word comes from the Grande Chartreuse, the Carthusian monastery in Dauphiné, France, founded by St Bruno *c.*1084. D.A.L.

Chasma Shahi, Srinagar, Kashmir. The original garden was built in 1632, probably under the instructions of the Emperor Shāh Jahān. A small enclosed garden, high above Lake Dal, it made dramatic use of levels. It was known as the Garden of the Royal Spring, by reason of a powerful spring at the top of the site. Here the water rose up into a fine lotus basin (now lost) in the upper pavilion. From this, a small cascade (**chadar*) and canal led to a wide rectangular pool, in which was reflected the main pavilion. Here a dramatic change of level occurred. The pavilion was set on a high retaining wall, where the water discharged down a steep cascade to fill another water garden below. The garden has since been much altered.

The Mogul work comprised canals and tanks, with their cascades and fountains, together with the bases of the two pavilions. The pavilions themselves were Kashmiri, while the entrance gate, though Mogul in character, is probably not original.

The outward views are superb, and it is especially a garden for the afternoon and evening, with views of Lake Dal, its islands and background hills, all glowing in the setting sun. S.M.H.

Chatham, Earl of. See PITT, WILLIAM.

Chatsworth, Derbyshire, England, one of the grandest houses and gardens in the country, was constantly remodelled for 150 years from the end of the 17th c. The engraving by *Kip (after *Knyff) shows one of the most grandiose layouts of the period, notable features being the great parterre laid out in front of the west front by *London and *Wise between 1687 and 1706, and the dramatic siting of the geometrical layout continuing up the steeply rising hillside quite regardless of natural contours. In 1694 Grillet, a pupil of Le Nôtre, laid out a cascade, which was remodelled from 1698, being made wider and longer, perhaps inspired by *Marly. The Temple or cascade house (completed, with additions by 1711) designed by *Archer, stands at its head, the whole being described by Defoe in 1724 thus: 'out of the mouths of beasts, pipes, urns, etc., a whole river descends the slope of a hill a quarter of a mile in length, over steps, with a terrible noise, and broken appearance.'

The 4th Duke (1720–64) engaged 'Capability' *Brown who proceeded to destroy most of the earlier layout. He widened and altered the course of the River Derwent, for which James *Paine designed a new bridge. Vast plantations were created throughout the parkland.

*Paxton, appointed as head gardener in 1826 by the 6th Duke (1790–1858), made further substantial changes. He planted trees extensively (including the pinetum and arboretum); designed the Emperor Fountain of 1843 whose jet can reach 88 m.; and created massive rockeries including

Chatsworth, Derbyshire, the cascade

the Wellington Rock, with a ruined aqueduct whose cascade leads to an L-shaped pond, the Strid, beneath. But his most influential work was the Great Stove or Conservatory (1836–40), the greatest area of glass in the world (mostly demolished shortly after the First World War). He also designed and built the still extant 'Conservative Wall', against which are positioned a range of glass cases; the central one contains some of the *Camellia reticulata* Paxton planted *c.* 1850. A new greenhouse (1970) now houses the water-lily, *Victoria amazonica* (formerly *V. regia*), which first flowered in Britain at Chatsworth in 1849.

A fine serpentine avenue of beech hedging was planted in 1953 by the present Duke, who also laid out a parterre in golden box to represent the ground plan of Chiswick House, London. P.G.

Cheere, John (d. 1787), was an English sculptor and caster, who had a yard at Portugal Row, Hyde Park Corner, London, and whose brother, Sir Henry Cheere (1703–81), was also a sculptor. Among his most notable lead figures are those at *Stourhead: the River God, the Nymph of the Grot, and Meleager and Diana in the Pantheon there. Stock replicas of contemporary rural characters were widely distributed from his yard. K.N.S.

Chehel Sutun, Isfahan, Iran (the Forty Columns), which lies to the north-west of the Maydan in Isfahan, was built as a royal pavilion at the end of the 16th c., subsequently extended by Shah Abbas II, and repaired after fire at the beginning of the 18th c. The partially enclosed space of the great porch is wholly interrelated with the adjacent garden. The roof of the porch is supported by fluted cedar columns; at the terrace floor level is a white marble basin into which four carved lions once spouted water, in turn reflected in tiny panels of mirror contained in the painted wood mosaic ceiling above. The porch overlooks a long pool; its 20 columns, doubled by reflection, gave the pavilion its name. The 6·75–ha. garden in which the pavilion is set is well treed, and contains geometrically subdivided parterres. Originally there was more than one pool with several fountains and entry pavilions, but apart from the central reflecting pool these have all but disappeared. J.L.

Chehel Tan, Shiraz, Iran, possibly dating from the late 18th c., is a small garden, behind the customary high wall, in the north-east part of the city of Shiraz. The name Chehel Tan (Forty Bodies) refers to the graves contained in the garden, which has many tall trees. At one end across the full width of the garden is a pavilion. J.L.

Chellah, Rabat, Morocco, a district immediately outside the city walls, was founded by the Romans, and building resumed in the 14th c. The Chellah gardens are surrounded by fortifications, and entered through a richly adorned gateway inscribed in Kufic. A path leads down to a spring, several shrines, a mosque, and a mosaic-tiled minaret. There is also a tank fed by two shallow fluted basins set at ground level. Mosaic once covered many of the surrounding surfaces. J.L.

Chelsea Flower-Show. See ROYAL HORTICULTURAL SOCIETY.

Chelsea Physic Garden, London, was founded in 1673 by the Society of Apothecaries with the purpose of demonstrating medicinal plants, hence its name *Physic Garden. After more than 300 years of continuous service it still provides plant material to various institutions for instruction and research. Almost from the start there were financial problems, yet from Chelsea issued a stream of roots and seeds of unusual plants to other gardens and gardeners; this international exchange still continues. In 1722 Sir Hans *Sloane rescued the garden from destruction and his statue is prominently placed within it. In the same year Philip *Miller, who later published his great *Gardeners Dictionary*, was appointed curator and made it the most richly stocked botanic garden in the world.

Crises continued during the 19th c. until a charitable trust took over its management in 1899, to be replaced by an independent board of trustees in 1982. At the end of the 19th c. William Hales was appointed curator and, together with Professor John Bretland Farmer of Imperial College, he laid out the garden as it is today. It is an oasis in the heart of London where trees and well-stocked flower-beds echo a long history that is still in the making, yet it covers such a small area (1·6 ha.) that public admission is not always possible, although regular open days have been arranged. F.N.H.

See also FORSYTH, WILLIAM.

Chenonceaux, Indre-et-Loire, France, has one of the most attractive of Renaissance châteaux, notable for its situation, actually standing in the River Cher with gardens bordering the river on either side of the forecourt. On the east the massive terrace enclosing *c.*1 ha. was made for Diane de Poitiers between 1551 and 1555. It was divided into rectangular beds (as shown by *du Cerceau) and planted with fruit-trees, vegetables, and flowers. *Catherine de Medici, who took possession in 1560, erected a circular fountain in the form of a rock enclosed by trellis, the site of which is marked by the circular depression in the garden west of the forecourt. She made a large garden on the south bank of the river whose axis was a continuation of the approach avenue and the bridge and gallery which linked the two banks of the river. The château was restored in the 19th c., and the gardens on the north bank of the Cher are at present laid out in a modern interpretation of the French classical style, with *broderies*, flowers, standard hibiscus, and clipped box. K.A.S.W.

Chequers, Buckinghamshire, England, was presented as a country home for British prime ministers in 1917 by Lord Lee of Fareham. The house, reconstructed in its present form by William Hawtrey in 1565, lies in a great park set against the south slopes of the Chiltern Hills. Walled gardens are known to have existed but were demolished in 1744 under the influence of the romantic movement. The new formal gardens that exist today were made in 1911, probably by Inigo Thomas. The great Churchill (now Victory) avenue was planted in 1948. A landscape plan co-ordinating all parts of the estate was commissioned in 1972. G.A.J.

Chevreul, Michel Eugène (1786–1889), was a French chemist and director of the Gobelins tapestry works, for which he carried out researches on colour, devising a series of colour wheels for use in establishing the complementarity of colours. In 1839 he published his treatise on the law of simultaneous contrasts, in which he applied his theories to the planting of flower-beds, advocating the use of complementary colours and graded sequences of 'warm' and 'cold' colours. His theories were promoted in England by John Lindley, but opposed by Donald *Beaton, who argued that the effects of complementary colours in bedding plants were nullified by the background formed by the green leaves. After a brief period of trial in the 1850s his theories were abandoned by English gardeners until their revival for the herbaceous border by Gertrude Jekyll. B.E.

Chi Cheng (b. 1582), Chinese landscape and rock artist. See JI CHENG.

Chile. See SOUTH AMERICA.

China

The Chinese have the oldest continuous tradition of garden design in the world. It is also quite unlike any other, although it greatly influenced that of *Japan (which was probably inspired by a 7th-c. ambassador's visit from *Kyoto to the court of Sui Yang Di). Yet, since the 18th-c. European vogue for *Chinoiserie was based on a very imperfect knowledge of actual Chinese gardens, the distinctive character of the Chinese garden tradition has only recently been fully appreciated in the West. In particular, it expressed ideas about man in his relation to nature and an appreciation of undomesticated scenery that are very ancient in China.

The philosophical background. Of the two main indigenous Chinese philosophies, while Confucianism concentrated on man's relationship to man, Daoism (Taoism) sought to discover how he could best fit into the great universe in which he lived. The *Dao* was the 'totality of all things'—past, present, and future—in its constant state of transformation through time. And Daoists, seeing man inescapably as part of this pattern, aimed to become so finely tuned to its changing currents that they would become one with the forces that produced them. Daoists often opted out of organized society but their philosophy, apparently so opposed to the official Confucian emphasis on rites and duties, proved in time to be its necessary complement. Daoism provided a release from the constraints of being a 'superior man' and the Chinese (being practical people) found both philosophies valuable. Ultimately, both the Daoist's love of nature and Confucius' encouragement of self-cultivation lie behind the planning and design of the Chinese garden.

Many gardens were quite separate from the owner's house. 'Well worth preserving', says one scholar, 'was the distance that lent enchantment.' But they also usually contained a very large number of buildings, often lived in—

like those of the Da Guan Yuan in the famous novel *Dream of the Red Chamber* (*Hong Lou Meng*)—by a great many people. Despite this, however, no one would have confused the house (*fang-zi*) with the garden (*yuan*). One is based on formality, order, and symmetry; the other on spontaneity, imagination, and the delights of confusion. Indeed, the classic Chinese house, with its symmetrical progression of rectangular courtyards, may be seen as a reflection of the Confucian desire to regulate human relationships, while the Chinese garden, with its apparent disorder, its irregular winding waterways, its rocky hills and pavilions tucked into trees, mirrors the Daoist principle of harmony with nature. This is true equally of both main types of Chinese garden—the great parks of Emperors, and the private gardens, made sometimes by merchants but traditionally by scholar-officials who were the élite of old China. Both are ultimately based on the idea of nature enhanced by harmonious contact with man. Almost equally important, however, are two other ancient themes which early came to be represented in Chinese gardens: one was the idea of the garden as a microcosm; the other of the Magical Islands of the Immortals.

The garden as microcosm. We know from hieroglyphs on oracle bones dating back to the second millennium BC that, like rulers elsewhere, the ancient princes of China set aside vast tracts of land for hunting and military exercises. Legend suggests these were later embellished with artificial lakes and terraces, and by the 4th c. BC a royal garden described in a collection of Southern poems has the scarlet balconies, latticed pavilions, winding waterways, and views of distant mountains, still visible, some 15 cs. later, in the *Yi He Yuan today. Under model rulers like King Wen of the Zhou dynasty (c.1027–256 BC), these imperial lakes and terraces were open to the public and used for religious rituals, but similar parks were also seen as classic temptations to imperial excess: the legendary King Qieh of Hsia (2000–1600 BC), the Shang dynasty (said to have reached an unpleasant end in c.1027 BC), and the tyrant Zhou all 'extended their parks and terraces without limit' until, according to the philosopher Mencius (Meng-tse), 'with the arrival of birds and beasts' their empires dissolved into chaos.

Under the man who first unified the ancient Chinese states in 221 BC, however, these birds and beasts began to take on new significance. In the Shanglin Park beyond his capital, Qin Shi Huang began to collect rare animals and vegetation as tribute from all corners of the conquered Empire. These were accepted as a potent symbol of imperial power and the Han Emperors who followed him (206 BC–AD 220) continued this collection; it is in descriptions of their parks in the great prose poems of that dynasty, where myth and fact are mixed to produce a magic portrait of the Empire in miniature, that we have the first flowering of the

idea that the garden is not simply a particular landscape of nature embellished, but a microcosm symbolizing all the riches and variety of the Universe; it is an idea that still—in the close-packing of many effects in small spaces—affects gardens in China today.

The islands of the Immortals. It was the Han Emperor Wudi who also first gave form, in gardens, to the search for immortality. The legendary Chinese Immortals were thought to live partly in the Western Mountains and partly on movable islands in the Eastern Sea which, like the Immortals themselves, dissolved into mist as human travellers approached. Qin Shi Huang had already sent an unsuccessful expedition to find them; Han Wudi instead built replicas of their magical islands in the great lake of his park thinking thereby to encourage them, flying by on the backs of storks, to descend and reveal to him their secrets.

Though the Emperor lived a not unusually extended life, the fame of the hunting parks of Han, which also contained palace complexes, farms, and orchards, set a pattern for imperial gardening, embodying lakes and islands, which was enthusiastically followed right up to modern times.

Extravagant entertainments. The great park of Emperor Yangdi (604–18) of the Sui dynasty contained all three themes: the natural landscape embellished; the riches of the Empire symbolized, and the isles of the Immortals re-created—but he added to them extravagant devices for entertaining imperial guests. These included a unique collection of mechanical figures, 60 cm. high and sumptuously dressed, which sailed in boats along specially constructed channels to perform 72 scenes from Chinese history. A report describes the park's bare trees in winter decked out with silk flowers; in summer its real lotus flowers were increased by artificial flowers 'constantly renewed'. A 'million' people reportedly worked to create this park, of which one in five were said to have died in the process. Destroyed in the rebellion which finished both Emperor and dynasty, it encouraged the idea of gardens as symbols of imperial indulgence, but did little to curb the landscaping ambitions of later emperors. Even the first great Emperor of Tang, responsible for the destruction of Yangdi's park, built a garden for imperial entertainments around his 'Palace of Great Brilliance'; while, at the end of the 7th c., Empress Wu moved her unwilling court in summer to a retreat in the Shensi mountains. Tang Xuan Zhong (712–55) continued an old association of imperial gardens and beautiful women by building many gardens for his mistress, the concubine Yang Guifei, including one with a pavilion ingeniously contrived so that water rose up inside its four corner pillars and fell as cooling screens in place of the walls. (See also *Hua Qing Gong.)

Among the most famous of all imperial gardens was *Gen Yue built by the cultivated Emperor Zhao Ji (Hui Tsung) of the Northern Song dynasty on the advice of the imperial practitioners of *feng shui* (Chinese geomancy). By adding, to the north-east of the capital, height considered necessary for the successful manipulation of favourable forces in the

landscape, the gigantic rockery of Gen Yue was expected to increase the Empire's stability. Unfortunately, the disruption caused by its building helped further to weaken the dynasty which was overrun by northern tartars. The court, which fled south, took as its capital the prosperous city of *Hangzhou (formerly Hangchow) in Zhejiang province and, along the willow-fringed shores of its West Lake, once again built palaces and gardens. These, in turn, Khublai Khan left to crumble when he finally conquered the Southern Song in 1276, excavating instead for himself a great lake (see *Beihai; *Zhonghai and Nanhai) near his new capital where Beijing stands today. When the following dynasty, the Ming, moved their court from Nanjing to Beijing in 1408, they enlarged this lake and built their great palace next to it—the park, with its now long-established use of pavilions, palaces, lush trees, and reflections, providing a necessary release from the oppressive conservatism of the Ming court and the symmetrical, rectilinear grandeur of their imperial city.

The last Qing dynasty, the foreign Manchus, continued the tradition. 'Every Emperor', wrote Qian Long, the great garden-maker, 'when he has retired from audience and finished his public duties, must have a garden in which he may . . . refresh his heart. If he has a suitable place to do this, it will regulate his emotions and relax his mind. If not, he will become engrossed in sensual pleasures and lose his will power.' Since this justified his fourth great park, Qian Long's subjects might have been excused a little scepticism. (See *Bi Shu Shan Zhuang; *Chang Chun Yuan; *Yuan Ming Yuan.) They would, however, have agreed in principle. For, at least since the 1st c. AD, they too had been making gardens and, like their emperors, had wavered between the ideal of the garden as a peaceful retreat counteracting worldly vanities, and the possibilities it afforded to indulge them.

Private gardens. Before the Han dynasty, literary records of private gardens are scarce and, so far, archaeological evidence is non-existent. During the Han, however, Liu Wu, Yuan Guanhan, Cao Wei, and Liang Ji are all recorded as owners of large artificial ponds and constructed scenery which already included—even allowing for exaggeration—remarkable rockeries: Yuan's was said to be 30 m. high and Cao Wei's Fragrant Grove Garden to include 'eight gullies and nine streams'. But these were northern gardens, near the Han capitals along the Yellow River (Huang He), and their large halls, connected by open walkways, and collections of rare oxen, birds, and trees mimicked the style of imperial parks.

The Confucian element. With Confucianism adopted as the state orthodoxy however, gardens even as early as the Han dynasty were increasingly likely to be made not by hereditary aristocrats, but by the new elite appointed to run the civil service. Since Confucius required an ethical man to render service to the state, such appointments became the only socially acceptable route to success in China for almost 2,000 years, and since they were awarded only to those who

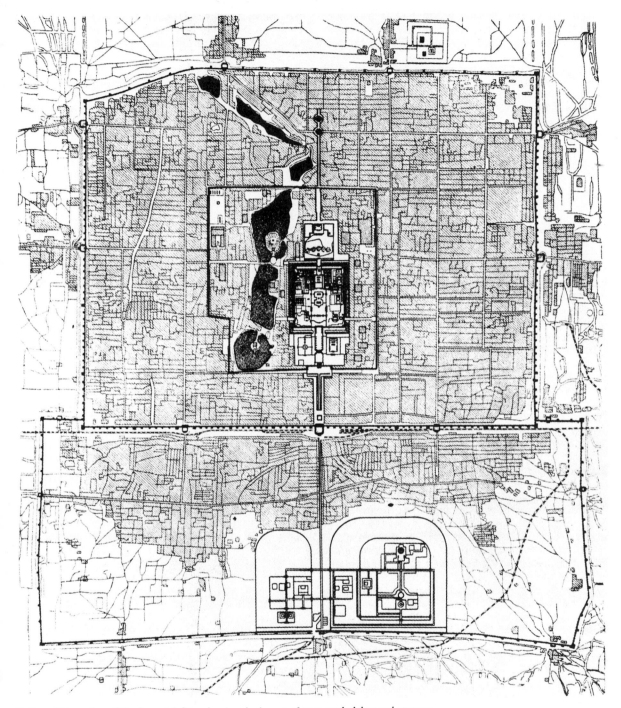

Beijing, China, plan of the Imperial City, showing the layout of man-made lakes and streams

were successful in stringent examinations on the classics, anyone wealthy enough to own a garden was also highly intelligent and exhaustively educated. Luckily Confucius himself had spent most of his life out of office, so his ethics included an ideal of 'recreation through the arts' both to replenish an official's energy and to make best use of his time when out of favour. Gardens thus developed as places for self-cultivation often, as time went on, sited in cities where, with the right attitude, a man could find 'peace in the heart of town' and still fulfil his duties to the state and his family.

The cultivated scholar's retreat. When the long collapse of the Han dynasty led to a loss of faith in the values which had once supported it, such thinkers as the 3rd-c. Seven Sages of the Bamboo Grove escaped from a disintegrating society into nature and metaphysics, while Shi Chong, whose *Jin Gu Yuan garden has gone down in history as one of the most opulent estates in China, described it himself as a 'simple pastoral retreat'. Meanwhile many survivors of the Han fled south to regions hitherto scarcely colonized and, in the rich well-watered lands known in China as Chiangnan, 'South of the (Yangtze) river', found ideal conditions in which to develop a love of natural scenery. So, in the 4th c., members of the aristocratic Xieh family wandered among the hills of Guei Qi and came home 'reciting verse. They had no worldly thoughts', and Dao Yuanming (378–422) first gave poetic form to the ideal of a cultivated scholar's retreat: 'I had rescued from wilderness a patch of the southern moor/ And, still rustic, came back to field and garden. . . . Long I lived checked by the bars of a cage;/Now I have returned again to nature and to freedom.'

Landscape painting. Landscape poetry in turn inspired paintings, and by the Northern and Southern dynasties garden-makers were already discussing not only 'poetic spirit' but 'painterly ideals' in their work, while the mention of 'concealed vistas' begins to suggest an increasingly sophisticated handling of nature, both within and beyond the garden wall. From now on, the garden is less a borrowing of nature than an interpretation, an illusion conveyed by skilful manipulation of space and form. From the 5th c. Buddhism, gradually spreading into China from the west, also began to affect men's thinking, and Buddhist monasteries set among the hills enhanced the association of nature with spirituality. The example of Vimlakirti also affected gardens. As a householder who achieved Buddhahood by 'remaining unmoved in the midst of movement', he reinforced the indigenous Confucian tradition (so unlike that of Europe's celibate priests) of a married ́élite—whose gardens were thus used for family parties as well as for contemplation.

In the Tang dynasty (618–907) all this found its perfect—and lasting—expression in the country estate of Wang Wei, a poet, painter, calligrapher, and musician who was himself a devout Buddhist. The scroll painting and poems he kept of his *Wang Chuan Villa, endlessly copied and recopied down the years, made its gentle hills, its river, and various pavilions bowered in trees some of the best known in the history of Chinese country retreats. Its atmosphere of tranquillity and cultivated scholarship was one which, the modern historian Wango Weng says, 'every Chinese scholar since would like to recreate around him.'

Petromania. Tang gardeners also took another well-established interest to a new level, as well-known public figures, like Niu Sengju and Li Deyu, competed in collecting rare and strangely shaped stones. These they displayed in their gardens in groups or, if they were especially fine, as commanding objects on stands or plinths. Since the Han dynasty, large garden rockeries (*jia shan)—like the stone cave 'over 200 paces long' in Xiao Yi's Liang dynasty (907–23) garden—had occasionally been recorded, but the unique Chinese passion for collecting and displaying unusual *single* stones (*shi feng) both big and small, in gardens and on scholars' desks, seems to have taken hold particularly from the Tang. By contrast, the Japanese were to develop a more disinterested attitude and prefer stones of simpler, less extravagant shapes. Later, the Song Emperor Zhao Ji (1101–1126) in his garden Gen Yue, the calligrapher Mi Fei, who bowed to his finest stone and personified it with the honorary title of 'Elder brother', and the Qing dynasty owner of the *Ban Mu Yuan, with its special pavilion to house his collection, all became famous for their love of stones. From the Song dynasty onwards, no garden was complete without rocks, and in *Suzhou people would 'move houses and rebuild walls to display them'. This southern city, later to surpass all others in the number and standing of its scholars and gardens, had already recorded a famous garden belonging to Ku Pichang in the 4th c. By the 5th c., 'all' of its people were said to 'pile rocks and channel water, plant trees and dig grottos, and in a short time it all flourishes and looks natural'. During the Five Dynasties period after the fall of Tang, the Wu and Yu Kingdoms around Suzhou, by avoiding civil war, became the richest provinces in China. The son of Qian Liu (who ruled them from his capital at Hangzhou) built many terraces and ponds while in charge at Suzhou, and aristocrats and officials followed his lead—among them his General Sun Chengyou who made a garden where the *Cang Lang Ting now stands.

Golden age of gardens. It is, however, the Song dynasty that is often nostalgically seen as China's golden age of gardens, perhaps because so many were in cities and open to the public on festivals and holidays. But, perhaps also because the standard of achievement under the Song is so extraordinary in all the arts (and particularly in the related area of landscape painting), it seems that gardens too, though only descriptions remain of them (see *Luo Yang Ming Yuan Ji*), must have reached a unique level of refinement. Under the following Yuan dynasty private gardens continued to flourish because old families, loyal to the conquered Song, refused to take active political part in the new Mongol government. From this dynasty we have still the name of the *Shi Zi Lin garden in Suzhou, which though unrecognizably altered since, was first made by the Yuan painter Ni

Zan. By the time the Ming dynasty returned a Chinese Emperor to the throne in 1368, the Confucian ideal of the retired scholar-without-portfolio had acquired new strength and, since the Ming was a repressive dynasty, it continued to be acceptable for a gentleman to devote his time, with like-minded friends, to the cultivation of his spiritual, literary, and artistic life in the elegant setting of an urban garden. Men like Wen Cheng-ming developed into major poets, painters, calligraphers, and gardeners while calling themselves amateurs, with only brief and usually unsatisfactory excursions into public office. The *Zhou Zheng Yuan, partly designed by Wen, still exists, though much changed from the garden he recorded in verse and little paintings soon after its making. But even more important perhaps, for preserving and recording Ming tradition, is the treatise on gardening *Yuan Ye, or 'Garden Tempering', published in 1634 and the most comprehensive in Chinese. The author states firmly that 'in garden design there are principles but no fixed formulae' and his work aims to teach through suggestion and example rather than by rules. Other important books with chapters on gardening (see *Chang Wu Zhi and *Li Yu), which continued to classify and regularize the tradition of garden design, also appeared under the Ming and Qing.

In fact, from the mid 16th c. private garden-making flourished as never before in *Beijing, many towns and cities of Chiangnan, and later in Guangzhou (Canton) and the south, and families of master craftsmen in the art of 'piling mountains' grew famous. Though the gardens of the capital seem more stiff and formal than the lyrically graceful southern gardens of Suzhou, the similarity of design in gardens as far apart as Beijing and Taipei is more remarkable than the differences. Those who commissioned them were now sometimes successful merchants as well as gentlemen scholars, and in 1865 Yuan Xuelan described how 'members of rich families compete to embellish pools and pavilions . . . In Spring they open their gardens and people wander in to admire, staying till the moon is full'. Certainly some of these gardens were rather vulgar interpretations of the tradition, built more for praise than personal pleasure, and rather better on lavish general effect than in refinement of detail. Today, the gardens which remain, though they cover a wide range—from Qing imperial parks (like Yi He Yuan) to the private gardens of merchants (like *Li Yuan) or of scholars (like *Wang Shi Yuan)—have all been greatly altered and restored during their usually long histories. Mostly, after the wars and revolutions of the last 150 years in China, they are urban gardens hidden, except for the topmost branches of their trees, behind high white walls in the midst of cities. The most famous of all are in Suzhou, and, just as it is possible to trace the rise and fall of dynasties by the building and destruction of imperial parks, so the poignant histories of these old private retreats—endlessly neglected, sold or gambled away, rescued, rebuilt, and sold again—reveal the instability of traditional Chinese society.

For foreigners unused to the tradition such a garden may be at first confusing, but it is hardly surprising if a quick tour leads to visual indigestion. Made to be savoured over a lifetime, like Pan En's *Yu Yuan in Shanghai, they often took a lifetime to make, while for a woman with bound feet in old China, her family garden (if she was lucky enough to have one) might be the sum total of her universe.

The making of a Chinese garden. For the garden-maker this is a task that requires not only individual skill and imagination but serious consideration of *feng shui principles, and a tradition that supports the suspension of disbelief. 'The question of reality will not bother the visitor', says the modern historian Chuin Tung, 'as long as he ceases to be in the *garden* and begins to live in the *painting*.' Just as the connoisseur of painting unwinds a landscape scroll from right to left, and sees the hills and valleys rise and fall around the little human figures travelling through it, so a gardener should unfold a series of linked views around the visitor as he strolls along its three-dimensional paths. But the scrolls are linear and the gardens enclosed, and to make the most of each successive vista the garden-maker creates a labyrinth, in which available space is layered by gateways and subdivided by walls that wind among the trees and rocks with the regular undulations of sea snakes or dragons. Each garden is a composition of courtyards, some large, some small, some disappearing round corners, some open-ended, some cul-de-sacs, some fitted together like pieces of a puzzle. And the visitor is lead on through them, not only by pebble-patterned pathways (*luan shi pu di) and open doorways (*di xue), but by the constant suggestion of something new and delightful half revealed through the latticed windows (*lou chuang) or above the walls (*yun qiang) of the next enclosure.

Rocks and water form the structure of these gardens, then architecture, and only then trees, shrubs, and flowers; for the Chinese word for landscape (*shanshui*) means 'hills and waters' and, while in English we speak of 'planting' a garden, a common phrase for garden-making in China translates literally as 'piling rocks and digging ponds'. The two elements are inseparable. Rocks are not only built up into 'false mountains' (*jia shan*) or used singly, like pieces of sculpture (*shi feng*) in the garden, but also represent 'the bony structure of the earth'; as the 'masculine' (*yang*) element—hard, rough, and unmoving—they must, in the Chinese phrase, 'harmonize' with the soft, reflective *yin* of water. *Yin* and *yang*, the two elemental forces which the Chinese see lying behind all creation, are also quite consciously balanced out in the garden as high places lead to low, open to closed, shady to sunny, and wide to narrow, in a finely-tuned patterning of opposites. In practice the effect can be almost magical. By leading him on through twisting galleries (*lang) or over bridges (*qu qiao), by allowing the glimpse of a distant roof (*lou; *ge; *fang; *xie; *xuan), or an end vista (*dui jing), by turning him back or suggesting a momentary pause (*ting; *mei ren kao), or by 'borrowing a view' (*jie jing; *Ji Chang Yuan; *Sui Yuan) beyond the garden wall, the Chinese designer manages so to confuse the visitor that the space of his little garden seems to extend indefinitely.

Trees, shrubs, flowers. Planting increases this layering of space. Obviously there are great regional differences between, for example, plants in a Beijing garden with its dry climate and extreme variations of temperature, and those of the subtropical south, but no garden is complete without the 'Three Friends of Winter'—pine, plum, and bamboo. All old and especially twisted trees, like the junipers in the *Yu Hua Yuan, are valued for their age and dignity as are fruit-trees—crab-apples, persimmon, and peach in Beijing, loquat and kumquat as well as flowering cherries further south. A great many plants, especially *Wistaria sinensis* in Chiangnan, lilacs in the Yi He Yuan, and all the languorous frangipanis of the south, are chosen for their scent, but few for their horticultural novelty.

In fact, though China has one of the richest natural floras in the world, the Chinese do not appreciate plants for their rarity but rather for their accumulated symbolic and literary associations. Among others the lotus, which in summer makes a new, swaying, blue-green surface some 1·2 m. above the level of garden pools, symbolizes the Buddhist soul rising, in the words of the 11th-c. Zhou Tunyi, 'without contamination from the mud, reposing modestly above the clear water, hollow inside and straight without'. Bamboo, which bends with the wind but does not break, suggests an honourable man, and the orchid a true gentleman because it scents a room so subtly nobody notices it until he leaves. The peach, hallowed by centuries of cultivation, lore, and legend, still promises fecundity and immortality; the peony wealth and elegance. Under the Song, peony growing became almost a national obsession, with Luoyang the greatest centre. Today they are mostly grown in raised beds to make a short but dazzling seasonal display. Chrysanthemums, the symbol of autumn, and probably the oldest cultivated flower in China, are grown in pots and set along garden *lang* or formally on the terraces (*tai) of grander halls (*bian*; *ting*), while *peng jing*, the Chinese bonsai, tended in special courtyards of their own within the garden, are brought into halls and pavilions to decorate stands and tables often silhouetted in open *lou chang* window frames.

There are, however, no open areas of grass. A cultivated Chinese, visiting England in the 1920s, wondered about the appeal of 'a mown and bordered lawn which, while no doubt of interest to a cow, offers nothing to the intellect of a human being'. The Chinese are rice-growers, and to them cows can only suggest (if anything) hordes of barbarian cattle-raisers riding to plunder peaceful Chinese settlements. In China it is water, not grass, that is the peaceful, contemplative element in a landscape, and at the heart of every garden lies a smooth but rock-bordered pool overhung by latticed balconies from which the visitor can lean out to 'catch the moon in the palm of his hand' on summer nights.

A lawn is also undeniably mindless and a Chinese garden, while a place to 'refresh the heart' by contact with nature, has also to engage the intellect. All the arts come together in the garden—which not only needs a painter to design it, but to appreciate it too, a poet to immortalize it, and a calligrapher to write it down. As far as possible, all these accomplishments were combined in each garden visitor, who,

using the *nom de plume* that absolved him from the formalities of life outside, would write poetry with the aid of a little yellow wine, in pleasant competition with his friends or family. These poems, engraved on stone tablets and let into the garden walls, record—from perhaps 50 or 100 years ago—the same sights and sounds that still surround a visitor today. Thus, a Chinese garden gradually acquires an extra dimension over time, while the names of halls and the couplets chosen for tablets (*bian*) on each side of pavilions—names drawn from earlier poems or literary works known to everyone in that highly cultivated society—make another link with great men of the past.

Chinese gardens were not, however, the holy places of hushed reverence this might suggest. Though the intellectual pleasures they offered might seem austere—and the formally arranged furniture of garden pavilions, though elegant, was, in modern terms, decidedly uncomfortable—unlike the gardens of Japan, they can accommodate without violation a wide variety of human activities, from family festivals to amorous assignations. The Chinese garden, though it reveals a profound and serious view of the world and man's place in it, is above all a sensuous delight, and full of joy and laughter as well as peaceful contemplation. M.K.

See also AN LAN YUAN; DU LE YUAN; GONG WANG FU; JI CHENG; JIAN ZHANG GONG; JIN SHAN; LAN TING; LIN YOU; LIU YUAN; LU SHAN CAO TANG; NANJING; NEI YUAN; OU YUAN; PING QUAN VILLA; QIAN LONG YUAN; QU-JIANG; SHI SUN; SHI TAO; WUXI; XIE QU YUAN; XING QING PALACE; YANGZHOU; YE TAO; YI YUAN; YUAN MING YUAN; ZHANG LIAN.

Chini-kanas, rows of small stone niches or pigeonholes set in the wall at the back of some Mogul cascades. The water is projected away from the wall by a stone overhang, leaving a gap of at least 30 cm. At night lamps were put in the niches and shone through the water; in the palaces of the Indian plains gold vases with silver flowers stood in the marble niches in daytime. S.J.

Chinoiserie, literally 'in the Chinese fashion'. The Chinese classics were first translated in France in 1687, and in 1697 Leibniz published the *Novissima Seneca*, which praised Confucian virtues. These revealed a whole new world of decorative architecture to European eyes, although appreciation of a new philosophy of life was superficial. The new fashion appeared all over Europe and even in the colonies of North America. France, Germany, and Russia were technically the most accomplished, Sweden the most graceful, and England the most literary. G.A.J.

Sir William Temple's essay (*Upon the Gardens of Epicurus*, written in 1685) was the first to recommend what was imagined to be the Chinese way of planting: 'without any Orders or Dispositions of Parts'. Temple coined his own term, *Sharawadgi, for this type of beauty, but did not attempt to incorporate it in his own garden at *Moor Park. At this stage the Chinese taste was adduced as an extra support for the argument that it was necessary to break away from the geometric style. For example, in an essay of 1712

*Addison wrote: 'Writers who have given us an account of China, tell us that the inhabitants of that country laugh at the plantations of Europeans, which are laid out by the rule of line.' However, this still remained a literary attitude rather than a practical precept: it did not have any direct influence upon the laying out of gardens, or indeed on planting, as Chinese plants were not introduced until the end of the 18th c. Even the first 'Chinese' garden building did not appear in an English garden until *c.*1745—the House of Confucius at *Kew (see also *Shugborough)—but the style remained intermittently popular until the 1820s (see *Alton Towers).

In this first period of Chinoiserie, it was valued more for what it was not, than for what it was—a studied plea for whimsical irregularity. It was based mainly on travellers' descriptions, which were rather vague until *Attiret's description of *Yuan Ming Yuan, translated into English in 1752. No picture of even this example appears to have reached Europe before 1760, and it was not published until 1776 (by *Le Rouge).

A second phase, more directly influential upon garden design, began from the 1760s, with the publication of Attiret and *Latapie, and of Sir William *Chambers's *Dissertation on Oriental Gardening* (1772), which argued the opposite of Temple: 'the Chinese are no enemies to straight lines because they are generally speaking productive of grandeur ... nor have they any aversion to regular geometrical figures, which they say are beautiful in themselves.' This argument was perhaps intended more as a polemic against *Brown's style than as a support for Chinoiserie, and it won little favour in England.

It was, however, influential in Europe, particularly in Germany (*Englischer Garten, Munich; *Mosigkau; *Oranienbaum; *Pillnitz; *Schönbusch; and *Veitshöchheim) and in France as the *jardin anglo-chinois*. There are isolated examples of Chinoiserie elsewhere (see *Csákvár; *Drottningholm; *Eszterháza; *Haga; *Liselund; *Puławy; and *Wilanów). Interestingly enough, even remarkable examples such as the Chinese House at *Sanssouci were originally surrounded by regular layouts. P.G.

Chiswick House, London, begun in 1725 for Lord *Burlington, was modelled mainly on *Palladio's Villa Capra (La Rotonda), near Vicenza. Its setting, designed by William *Kent and Charles *Bridgeman, showed influences as diverse as the Roman *campagna* and the idyllic landscapes painted by Claude Lorrain. The layout was asymmetrical, with vistas leading to temples, columns, and rustic houses. Kent himself is said to have spent the whole night meditating beside his domed temple which overlooked a garden with orange trees in tubs (taken indoors in winter). This garden dipped down, terrace after circular terrace, to a pool with an obelisk.

Within a comparatively small area there is a river with a cascade and a rustic bridge, an *exedra, a deer-house, an avenue of cedars, urns and sphinxes, a banqueting house, a Doric column, and much else. Neither formal nor informal, it was sufficiently original for its owner to be immortalized by *Pope in his *Epistle to Burlington* (1731) as the first garden

Chiswick House, London, the exedra

owner of importance to 'consult the genius of the place' and to respect its natural contours.

On the death of Burlington in 1753 the estate passed to the Dukes of Devonshire, who added a bridge by James Wyatt and a greenhouse by *Paxton. After the Dukes' ownership had ceased, the grounds became a public park. The exedra, sphinxes, obelisk, and several other features are still very much in evidence, but the planting is generally very unsuitable. D.B.G./G.A.J.

Chlumec nad Cidlinou, East Bohemia, Czechoslovakia, is a baroque château, lying on a conspicuously dominant hill, built in 1721–3 by F. Max Kanka following the designs of Giovanni Santini. The radial ground-plan of the château itself is emphasized in the park by an axial system of *allées* continuing far into the landscape. The open-air staircases connect radially with three castle wings.

The original garden in the baroque style is known only from the engravings by G. Ringl from drawings by B. Werner (1745). The monumental *allées* were the main element in a regular orchard and, further on, the enclosure. At the beginning of the 19th c. the garden was changed into a landscape park, 18 ha. in extent. The composition was connected with the surrounding landscape not only by radial *allées* (still extant), but also by beautiful vistas. The park was enriched by romantic scenery, artificial ruins, elements of the antique, and a *bassin*. In front of the early 19th-c. orangery in the Empire style, a new parterre of flowers and a *bassin* with a statue in the centre were established in the 20th c. O.B.

Choiseul, Etienne-François, Comte de Stainville, Duc de (1719–85). See PAGODE DE CHANTELOUP.

Chrysanthemum. Over a third of the 13,000 species of the

daisy family (Compositae) have been grown as ornamental plants. Among them are *Dahlia, Aster, Zinnia*, and *Chrysanthemum* species, well-known names in gardens throughout the world.

Chrysanthemums have been grown in China for well over 2,000 years and in Japan for almost as long. The Mikado's personal emblem was a chrysanthemum and we know that chrysanthemum shows were held in Japan over 1,000 years ago. At one time chrysanthemums were so revered that only the emperors and senior nobility were allowed to grow them. The 'Rising Sun' of the Japanese flag is in reality a chrysanthemum with 16 petals.

However, it was not until the 18th c. that chrysanthemums became widely grown in Europe. Today they are one of the greatest fancies in the plant kingdom. Professional and amateur growers, in greenhouses and in beds, continually hybridize and select new cultivars. The commercial catalogues are full of fresh types and there is a wide variety of groupings for the different types: Charms, Cascades, Koreans, Pompoms, Reflexed Decoratives, Intermediate Decoratives, Incurved Decoratives, Spoons, and Rayonnante, among other groups and subgroups. All have their following and commercial nurserymen often cater for particular interests. These chrysanthemums are primarily grown as flowers for cutting as indoor decorations. By careful manipulation of growth requirements, particularly day length, it is now possible to produce chrysanthemum flowers, either as cut blooms or as flowering pot plants, for any time of the year.

Most of these florists' chrysanthemums can also be grown as border plants although it is not usually practicable to carry out the detailed cultivation techniques, such as disbudding and flower-protection, to produce large flowers. There are also other species of *Chrysanthemum* cultivated in a variety of garden situations. Annual species include the tricoloured *C. carinatum*, the native corn marigold (*C. segetum*) and the medicinal feverfew (*C. parthenium*) with its many cultivars. *C. alpinum*, *C. hosmariense*, and *C. weyrichii* are upland 'alpine' plants. Among the perennials are the border 'pyrethrums', tansy (*C. vulgare*), and the Shasta daisy (*C. maximum*) which includes the well-known cottage garden variety 'Esther Read'. P.F.H.

Chumbhot, Princess, of Nagor Svarga (1909–), Thai patron of arts, is the daughter of Prince Devawongse Varodaya, Ambassador to Washington, Berlin, and Copenhagen (where she spent her childhood), and later Minister of Foreign Affairs. In 1930 she married Prince Chumbhot who died in 1959. An active and influential patron of both ancient and contemporary Thai arts, Princess Chumbhot set up the Chumbhot-Pantip Foundation to aid students. With Prince Chumbhot she created a garden in the grounds of *Suan Pakkad Palace, a setting with many rare trees and plants for a group of traditional Siamese buildings and collections of Siamese and Khmer art and artefacts. She also created a garden at Plai Na and the *Wang Takrai country park and arboretum at Nakorn Nayoke. M.L.

Church, Thomas (1902–78), American landscape architect and pioneer of what later became known as the 'California style', evolved an original approach to the problems of 20th-c. garden design, transcending both the Beaux Arts-inspired formalism previously dominant in the United States, and the picturesque manner usually seen as the only alternative. After education at Berkeley and Harvard in the Beaux Arts tradition, he began his practice in California in 1930, having already rejected this tradition in theory (along with *Kiley, *Rose, and *Eckbo).

Faced with the challenge of small irregular plots and steep hillside sites, his response—asymmetrical plans, raised planting beds, seat walls, bridges, paving, and broad timber decks—established an entirely new vocabulary of garden design. In these he responded positively to the needs of modern life—especially to the increasing use of garden space by families living in smaller houses and the need for low-maintenance gardens. He made a place in the landscape for the motor car; and realized that as the modern house evolved with walls of glass the garden had to become a functional extension of the house, an outdoor living-room.

During the early 1930s most of his work consisted of small gardens in the San Francisco area. He began to experiment with angular forms giving the illusion of greater size—the most innovative and widely-known example being the Sullivan Garden (San Francisco, 1937), where the longer arm of an L-shaped path covers two-thirds of the diagonal of a rectangular site.

In 1937 he made his second visit to Europe. In Finland he met Alvar Aalto, whose architecture and glassware inspired him to adopt more relaxed, informal, and organic garden plans with curvilinear forms. This new approach was first realized in two garden designs for the Golden Gate exhibition (1939). The central axis was finally abandoned in favour of a multiplicity of viewpoints and the use of asymmetrical lines to create greater apparent dimensions to the site. His justification for this new style was essentially functional rather than aesthetic.

Between 1939 and 1949 he produced a wide variety of gardens for numerous clients throughout California, including one of the most famous 20th-c. gardens in the world, the *El Novillero garden at Sonoma (1947–9). Designed on a hilltop encircled by mature oaks and overlooking the Sonoma valley, the garden extends visually to the countryside beyond. The kidney-shaped swimming-pool and the edges of the paving echo the rolling hills and winding salt-marshes of the valley.

Although Church undertook public commissions during the war years and after, the small residential garden continued to be his dominant concern until a serious illness in 1976. By this time he had been responsible for over 4,000 residential gardens and projects. His first book, *Gardens are for People* (1955), affirms his view of the garden as a work of art—a composition in form and space, but one which must emerge from the needs of the client and the nature of the site. Major Californian figures, such as Eckbo, *Halprin, and Royston, were considerably influenced by his example. G.L.

Private garden (1935) in San Francisco, California, by Thomas Church; the dynamic diagonal serves visually to increase the space to give unusual perspectives

Cicogna, Villa, Bisuschio, Piedmont, Italy. Built as a hunting-box in the 15th c. for the Mozzoni family, the villa is set between a hillside and the village of Bisuschio, its skilful layout exploiting the changing levels so that each floor of the house has access to a different garden. A vaulted loggia leading directly from the street opens into a central court; from there a second identical loggia gives access to the villa. To the left the courtyard opens into a garden of clipped hedges, gravel paths, and fountains, bounded on one side by a high retaining wall set with niches, busts, and statues, below which are a pair of balustraded pools. One of the finest water-staircases in Italy links the formal gardens with the woods and meadows on the upper slopes of the hill overlooking the Lombardy countryside. H.S.-P.

Cirencester Park, Gloucestershire, England, measures 8 km. from east to west and some 4·8 km. at its widest point, making it one of the largest landscape gardens of the early 18th c. It is the most perfect example of Stephen *Switzer's 'Rural and Extensive Gardening', and its general design is probably due to him, although Lord Bathurst as owner was

keenly interested in the execution and the detail of the design.

The house is unusually close to Cirencester and is separated from the town only by a large forecourt enclosed by an enormously high yew hedge. The structure of the landscape design is one of great lines and woodland, punctuated by a few buildings. The main axis connects the house with a column to Queen Anne: south of this line is a very short 'toe' of a *goose-foot, leading to a closely wooded short walk, while to the north the 'toe' is greatly extended through a long thin woodland with terrace walks along north and south edges giving views to parkland and arable fields. At the end of this long walk is the first of several *ronds-points, Seven Rides, ornamented with early Gothic-revival stables, and from this point the second main axis (extended backwards to Cirencester Church in the late 18th c.) leads the visitor through Oakley Wood, or to the other more outlying parts of the estate.

Pope's first visit to Cirencester was in 1718 when Lord Bathurst was engaged in a radical transformation of his estate. A knowledgeable arboriculturist, Bathurst clothed the open landscape with carefully disposed woodlands linked by a long avenue. He was possibly influenced by Pope's gardening precepts enunciated in his famous essays; Pope approved enthusiastically of the irregularly shaped woods, interspersed with fields and open spaces. His link with Cirencester is commemorated by a small classical pavilion, known as Pope's Seat, about half-way down the avenue. W.A.B./R.D.

Cistern. Used in gardens for collecting and storing rainwater, cisterns were usually rectangular in shape and made of lead or cast iron although in Roman gardens they were often of stone (as at Pliny the younger's Tuscan Villa). Decoration, cast from moulds, with friezes or panels, was often elaborate. Most surviving English examples date from after 1600, as at Bolton Hall, Yorkshire (1678); Deanery Garden, Exeter (1694 and 1703); Sackville College, East Grinstead (1750); and Ayscoughfee Hall, Spalding, Lincolnshire, which has heraldic devices on an unusual circular cistern dating from the 17th c. There is a large cistern in the gardens of the *Fronteira Palace, Portugal.
 M.W.R.S.

See also BACALHOA.

Claire-voie, any kind of open-work fence, at the further end of an *allée, which does not completely block the view. Voie is probably an irregular form of the French verb voir, to see, and not the noun voie, a way, walk, or path. Clairvoyée is an alternative rendering. D.A.L.

Claremont Landscape Garden, Surrey, England, survives as one of the most significant historic landscapes in Britain, although the 19.5 ha. owned by the National Trust is only part of the estate which was broken up in 1922. It shows the work of a succession of the great landscape designers of the 18th c., each in the English tradition adding

Claremont, Surrey, the amphitheatre, engraving from Switzer, *An Introduction to a General System of Hydrostaticks and Hydraulicks* (1729)

to and adapting what went before rather than sweeping all away to begin again.

In 1711 Sir John *Vanbrugh sold his country retreat to Sir Thomas Pelham-Holles, later Earl of Clare, who was immensely wealthy. He retained Vanbrugh to design a new house and garden. After 1715 when the Earl was created 1st Duke of Newcastle he enlarged the estate and employed Charles *Bridgeman to extend the grounds. A plan of 1725 shows the layout, the core of which, Vanbrugh's Belvedere and bowling-green with serpentine walks through the surrounding woods, still survives. Bridgeman made a round pond, later to become the lake, and the superb Amphitheatre, a unique survival now restored by the National Trust.

After Vanbrugh's death the Duke turned to William *Kent, and John Rocque's survey of 1738 shows that, while retaining the essence of Vanbrugh's and Bridgeman's layouts, he reduced the formality and made the irregular lake and the Grotto. When Lord Clive bought the estate he employed Lancelot Brown to design the existing mansion (now a school) higher and to the north-east of the Vanbrugh house which was demolished. During Brown's time the Portsmouth road was diverted further away from the lake

but most of his plantings have been built over during this century.

Many exotic trees, rhododendrons, and laurels were planted in the 19th c. when it was a favourite retreat of Queen Victoria, who eventually secured it for her younger son, the Duke of Albany. In 1950 part of the estate came to the National Trust and since 1975 with the help of the Slater Foundation it has been restored by removing unsafe and superfluous trees and much of the blanket of rhododendron and laurel that had engulfed it, and by sowing grass and repairing the buildings. J.S.

Clark, Herbert Francis (Frank) (1902–71), English landscape designer, author, and teacher. He was consultant to Stevenage New Town, to the Festival of Britain in 1951, and later to the new University of York where the great central lake and continuous landscape is a tribute to his understanding of ecology and change. He was President of the Institute of Landscape Architects from 1959 to 1961 and President of the *Garden History Society, of which he was a founder member, at the time of his death. He published numerous articles in professional journals of architecture, landscape, and town planning and two books, *England and the Renaissance Tradition* (1945), and *The English Landscape Garden* (1948). His main influence was as a teacher, first at the University of Reading from 1946 to 1957 and then at the University of Edinburgh from 1959 to 1971, where he taught architects and planners and founded the first postgraduate course for landscape architects. P.J.N.

Clark, Captain William (1770–1838), British explorer. See LEWIS, CAPTAIN MERRIWETHER.

Clausholm, Jutland, Denmark, has one of the finest manor-house gardens in the country, the buildings and the terraced formal garden together comprising one of the earliest baroque layouts, probably designed in 1722 by Nicodemus *Tessin the younger. The gardens were extended *c.* 1760 with planting in the natural style to the west of the original baroque garden. Professor C. Th. *Sørensen recently reconstructed the cascades after Tessin's original plans. P.R.J.

Clerk, Sir John, of Penicuik (1676–1755), Scottish landowner, occupied a central position in the political and artistic life of Edinburgh at the beginning of the 18th c., and is an important figure in the history of gardens. He was an enlightened landowner, spending his Exchequer stipend on planting and other improvements at Cammo, *Mavisbank, and *Penicuik House from 1700 onwards, and he was a member of the Society for Improving Knowledge in Agriculture. He gave advice on garden design to such friends as Lord Hopetoun at *Hopetoun House or the Duke of Queensberry at Drumlanrig, Dumfriesshire (Dumfries and Galloway Region). He was also a critical visitor of gardens as well as a poet and antiquary.

All these facets of his character impinged on his creation of the poetic landscape at Penicuik House, where, from *c.* 1730 onwards, he exploited the nature of the site and its associations—poetic, historical, or visual. His younger contemporary Lord Kames wrote of this way of making gardens in his popular *Elements of Criticism* (1762), and through Clerk's friends, such as William Stukeley, those ideas would have been current in the 1750s. W.A.B.

See also SCOTLAND.

Cleveland, H. W. S. (1814–1900), American landscape architect. See LANDSCAPE ARCHITECTURE: UNITED STATES.

Cleves (Kleve), North Rhine-Westphalia, German Federal Republic. The first experiment in Germany of integrating parks and gardens with a city was conducted here between 1647 and 1678 by *Johan Maurits of Nassau-Siegen, while serving as Stadholder to the Elector of Brandenburg. Combining Dutch and Italian ideal forms with German monumentalism, Johan Maurits created, in the hilly surrounds, five unique complexes of parks or classical landscapes and gardens linked to the city by a network of avenues. Baroque in concept and Mannerist in detail, each had a distinctive character which bore his personal stamp and each embodied the arts, the sciences, nature, and horticulture as well as affording pleasure and meditation. Equally unique were the various trophies erected throughout as focal points.

Connected to the Nassauer Allée (1653), planted with lime trees from the Netherlands, was the Freudenberg (*c.* 1650) containing pleasure-gardens, animal parks, and fish-ponds. The New Deer Park encompassed the amphitheatre garden of Springenberg (1652–7) conceived by Jacob *van Campen, and the Sternberg (1656) whose radiating avenues led far into the distance. The intimate Prinzenhof pleasure-gardens (*c.* 1670) had a hedged *rond-point as central motif and a wilderness along a steep slope where nature was given free rein. In emulation of the Romans, Johan Maurits placed his tomb along a road at Bergental (1670–8), his final creation, where he spent his last days in a hermitage. In an Arcadian setting, the tomb was flanked by a brick *exedra adorned with grottoes, urns, and Roman antiquities in niches and it was linked to the park by one arm of a *patte d'oie. F.H.

Climber. Many flowering plants, both woody and non-woody, have weak stems that in the wild require the support of more rigid plants or rocks. In cultivation support can also be provided by pillars and other garden structures. Thus climbing and scrambling plants serve two distinct horticultural functions—as ornamental plants in their own right and as a visual screen covering unsightly objects such as dead tree-trunks, old garden sheds, and fences and unsuitable walls.

Plants usually climb by twining and are assisted by the development of hooked thorns, clasping tendrils, or pad-like suction discs. Although the stems of climbers are structurally weak they often have a great tensile strength and can bind the host plant or other structure either by strangling it or keeping it upright.

Not all climbing plants are ascending: if there are no upright plants to support them, they may creep along the ground. This particular group of ground-cover plants is often planted on a large scale to stabilize a loose surface or to prevent soil erosion. Climbers can also descend as on a rock-garden or even dangle in the air, for example from a hanging basket.

Climbers such as *Clematis* species (*C. montana, C. orientalis*, for example) and hybrids ('Nellie Moser' and the 'Jackmanii' group) and the rambling roses, derived from *Rosa luciae* ('Albertine', 'Mermaid', 'Mme Grégoire Staechelin', and 'Zéphirine Drouhin'), are grown primarily for their flowers and resultant fruits. Others are cultivated mainly for their ornamental leaves such as the inedible-fruited vine (*Vitis coignetiae*), the edible-fruited fox grape (*Vitis labrusca*), the grape-vine (*Vitis vinifera*), and the Virginia creepers (*Parthenocissus quinquefolia* and its allies). To produce a very quick-growing cover, the Russian vine (*Polygonum baldschuanicum*) and related species are very useful.

Pergolas and arches made of stone, brick, wood, wire, or even concrete feature in many gardens. In many cases chains, ropes, and wires link a row of pergolas to form a tunnel-like structure on which climbing plants thrive. Roses, ornamental vines, and passion-flowers (*Passiflora coerulea*) have been used on the pergola at Kew, and at Gravetye Manor *Wistaria floribunda* is grown. Also found are the green-briars or smilax (correctly *Asparagus medeoloides*), winter and summer jasmines, honeysuckles (especially *Lonicera japonica* and the native European *L. periclymenum*), and the ivies, particularly *Hedera canariensis*. The native British ivy, *Hedera helix*, is found in over a hundred different cultivated varieties and the value of many of them is that they thrive in both dark and light and in damp and dry places. P.F.H.

Cliveden, Buckinghamshire, England, was built in 1666 by the Duke of Buckingham on its superb site overlooking the Thames and right on the edge of the steep slope to the river. He perched the house, designed by William Winde, on a great high terrace formed by levelling the top of the hill to obtain, in John *Evelyn's words, 'a circular view to the utmost verge of the horizon'. The house has been rebuilt twice following fires in 1799 and 1849.

The present house and terrace were designed by Sir Charles *Barry and are set above the famous balustrade brought from the garden of the Villa Borghese in Rome by the 1st Viscount Astor in 1896. Beyond is the impressive *parterre, a simplified version of a design made by John Fleming, head gardener to the Duke and Duchess of Sutherland after they acquired Cliveden in 1849. Fleming is credited with being the first to adopt the biannual bedding-out system. West of the parterre is the Octagon Temple (1735) designed by Giacomo Leoni, who also designed the Blenheim Pavilion for the Earl of Orkney when he owned the estate from 1687 to 1739. Lord Orkney also employed Charles *Bridgeman to design many of the walks and the Amphitheatre (*c.*1723).

The Ilex Grove is a tranquil plantation of holm-oaks attributed to Frederick, Prince of Wales, who owned the house from 1739 to 1751. Nearby, the Long Garden, created by the 1st Viscount Astor who loved Italian Renaissance gardens, contains statuary and is planted with clipped box and yew topiary. The Water Garden is principally the creation of the 2nd Lord Astor who extended a skating pond made by his father. The most recent addition is the Rose Garden which was designed for the 3rd Lord Astor by Geoffrey *Jellicoe in 1959. The garden has been much restored and replanted by the National Trust. J.S.

Cloister garden. See MEDIEVAL GARDEN.

Cloud wall. See YUN QIANG.

Clusius, Carolus (or L'Ecluse, Charles de) (1526–1609), an eminent Flemish humanist, doctor, and botanist, was Europe's first scientific horticulturalist who introduced and distributed throughout Europe many exotic garden plants, bulbs in particular. Called 'le père de touts les beaux jardins' by the Princesse de Chimay, Clusius was largely responsible for transforming the composition of northern European flower gardens which prior to 1560 contained a limited selection of ornamental plants.

European plants were introduced by Clusius as the result of his explorations in southern France (1550), Spain and Portugal (1563–4: narcissi, Spanish irises), Austria and Hungary (*c.*1575: *Hemerocallis lilo-asphodelus, Hepatica triloba, Iris sibirica, Primula auricula*), the findings of which he published in 1575 and 1583. His horticultural fame lies in particular with the cultivation of exotic bulbs and tubers from western Asia (crown imperials, irises, hyacinths, anemones, turban ranunculus, narcissi, lilies, and *tulips). Of these brilliant and varicoloured plants which astounded European plant-collectors, his name is above all linked with the garden tulip. While prefect of the imperial gardens in Vienna (1573–7), Clusius received seeds and bulbs from Busbecq, former imperial ambassador to the Turkish court at Constantinople (Istanbul) (1554–62). Clusius published the first monograph on the tulip in his book on Spanish flora (*Rariorum aliquot stirpium per Hispanias*, 1576) which was later amended in his book on Austrian flora (*Rariorum aliquot stirpium, per Pannoniam, Austriam*, 1583) and further expanded in his *Opera Omnia* (*Rariorum Plantarum Historia*, 1601). He described numerous varieties of yellow, red, white, and purple early, intermediate, and late-flowering tulips. He observed the peculiar phenomenon of tulips 'breaking', today known to be due to a virus disease, by which a single-coloured tulip develops into a variegated form. This peculiarity led to the tulipomania in the Netherlands in 1634–7.

Clusius gave an indubitable impetus to the development of horticulture in the Netherlands where he spent his remaining years. In 1594 he supervised the planting of the Hortus Academicus at Leiden University which concentrated on ornamental rather than medicinal plants, soon outranking Padua as a botanic garden. He was instrumental

in laying the foundation for the Dutch bulb industry which flourishes today. F.H.

Coal Hill, Beijing, China. See JIN SHAN.

Cobbett, William (1762–1835), English writer. Throughout his very active life he maintained an interest in journalism, social reform, and agriculture. While in the United States from 1792 to 1800 he edited William Forsyth's *Treatise on the Culture and Management of Fruit-trees* for American growers. His second visit from 1817 to 1819 resulted in *The American Gardener* (1821) which he adapted for the English market as *The English Gardener* (1829), a popular work which went through four editions in 16 years. Soon after his return to England in 1819 he established a nursery at Kensington. His *Catalogue of American Trees, Shrubs and Seeds for Sale by Mr Cobbett* first appeared in his newspaper, the *Political Register*, in 1827. All his works offer sound, practical advice in a clear and vigorous style; few people have had his ability to make gardening literature not only informative but also entertaining. His shrewd comments on the English countryside in *Rural Rides* (1830) also include his impressions of some of the famous gardens he visited. R.D.

Cobham, Richard Temple, 1st Viscount (1675–1749), English soldier, patron, and garden enthusiast, was the eldest son of Sir Richard Temple, Bt., from whom he inherited *Stowe in 1697. In 1715 he married an heiress, Ann Halsey, and immediately began the large-scale improvements to his gardens which were to continue for the rest of his life. He was of minor importance in politics until 1733, when he fell out with Walpole over the Excise Bill and joined the 'Patriot' opposition, turning Stowe into a centre of political intrigue. This was reflected in the iconographical programme of his temples and garden layout, which became a manifesto of the Patriots' ideals.

As a patron Cobham was alert to changes in taste, employing a succession of eminent artists and craftsmen. *Vanbrugh, an old friend, was succeeded as architect by Gibbs, William *Kent, Giacomo Leoni, and possibly Flitcroft. His first garden designer was *Bridgeman, followed in the 1730s by Kent; during the 1740s Stowe's head gardener and clerk of works was 'Capability' *Brown, whom he encouraged to prepare designs for outside clients. In fact, both Brown and William *Pitt owed the first steps in their respective gardening and political careers to Cobham's patronage.

During his lifetime Stowe became one of the most famous and influential gardens in Europe. How far Cobham himself initiated, and was personally responsible for developing, the new style of gardening is debatable; but after actively improving his estate for over 30 years, he must have gained as much expertise as most professionals. The dedicatory inscription on his monument at Stowe credits him personally with 'adorning his country by a more elegant notion of gardening, first revealed in these grounds'. This claim may well be just. G.B.C.

Coffin, Marian (1880–1957), American landscape architect, studied at the Massachusetts Institute of Technology as the only female member of the Class of 1904. Like her contemporaries, most of her work was for large estates. *American Landscape Architecture* (1924) pictured six gardens (in New York, Delaware, New Jersey, and Connecticut), and the *ASLA Yearbook* (1931) featured two estates. She was awarded the Gold Medal of the Architecture League of New York City in 1930. M.L.L.

Collinson, Peter (1694–1768), was an English Quaker cloth merchant and naturalist. His trade with the American colonies made him acquainted with settlers there and he enlisted their help in collecting plants and seeds for him. From the 1730s John *Bartram was his main source of plants, as he became virtually Bartram's agent in London. His first garden was at Peckham, his second, after 1749, at Mill Hill, where his garden at Ridgeway House is now the site of Mill Hill School. Collinson, according to his friend Dr John Fothergill, was 'the means of introducing more new and beautiful plants into Britain than any man of his time'. He has been credited with the introduction or reintroduction of nearly 200 species, over a third of them North American ones from Bartram, including *Phlox subulata* and the bergamot *Monarda didyma*, as well as several trees. He also sent seeds and plants, including vines, almonds, the horse-chestnut, and the cedar of Lebanon, back across the Atlantic to Bartram and other American friends. His botanical and horticultural friends and correspondents included *Linnaeus, Sir Hans *Sloane, Lord Petre, the Duke of Richmond, and Philip *Miller. S.R.

See also CARTON.

Colombia. See SOUTH AMERICA.

Colonnade, an architectural term for a regular line of columns, sometimes set as an open screen before the façade of a palace, and used in the same sense in topiary art, in which back wall, transoms, and columns consist of clipped hornbeam, yew, box, or thuya. The *colonnade de verdure* or green colonnade at Marly was one of its wonders. D.A.L.

See also ARCADE.

Columella, Lucius Junius Moderatus (1st c. AD), Roman landowner, was the author of *De Re Rustica* (c.AD 60–5), a treatise in 12 books which is the longest and most comprehensive and lucid of the Roman agricultural manuals. Book 10 deals with gardening and is written in hexameters in response to the invitation in *Virgil's fourth *Georgic*. The layout of the garden, the water supply, the plants to be grown, and details regarding their culture are all treated. Attention is given to flowers as well as to vegetables and herbs. The last third of Book 11 is a prose treatise on gardening with specific instructions regarding the selection of the garden site, the best way to enclose it, the preparation of the soil, the use of fertilizers, the choice of specific vegetables and herbs to be grown, and details regarding their culture. No mention is made of flowers. W.F.J.

Riverside garden at Buscot, Berkshire, England, by Brenda Colvin

Colvin, Brenda (1897–1981), English landscape architect, was a founder member of the Landscape Institute and of the International Federation of Landscape Architects, and was President of the Landscape Institute from 1951 to 1953. She studied with Madeleine Agar. She exhibited a lifelong devotion to the cause of landscape architecture which she expressed in her practice and in one of the first standard books on the modern profession, *Land and Landscape* (1947, rev. 1970). She was also author of the standard book on trees, *Trees for Town and Country* (1947), illustrated by S. R. Badmin, which has run into several editions. As consultant she was responsible for the military town of Aldershot, for a number of reservoirs, land reclamation schemes, power stations, and urban design projects. In 1969 she entered into partnership with Hal Moggridge; and was later created CBE.

In a number of gardens, notably the Manor House, Sutton Courtenay, Oxfordshire, and her own garden, Little Peacocks, Filkins, Gloucestershire, she expressed her knowledge and love of plants and her considerable skills in planting design. M.L.L.

Compiègne, Oise, France, adjoins the finest beech forest in France. The present palace was started in 1751 for Louis XV by Ange-Jacques Gabriel (1698–1782), who designed the gardens left incomplete at the Revolution. Napoleon I continued the work, cutting the Grande Allée des Beaux-Monts extending to the horizon behind the palace.

K.A.S.W.

Compton, Henry (1632–1713), was Bishop of London from 1675 to 1713, in which period he made the gardens of Fulham Palace famous for the exotic trees and shrubs collected there. George *London, early in his career, was

his gardener. In Switzer's words, 'He had above 1000 species of exotick plants in his stoves and gardens, in which last place he had endenizon'd a great many that have been formerly thought too tender for this cold climate.' North American trees were one of his specialities, including the scarlet oak (*Quercus coccinea*), the black walnut (*Juglans nigra*), and the first magnolia grown in Europe. These three plants, and many others, were sent home by John *Banister, a missionary and plant-collector in Virginia. S.R.

Compton Wynyates, Warwickshire, England. The topiary garden, which gave such a perfect setting for the early 16th-c. house, was not made until 1895. It was designed by the 5th Marquis of Northampton, partly to economize on the high cost of upkeep of the Victorian *parterres which it replaced, partly as being more in keeping with the style and period of the building. The topiary specimens, cut in yew and box, were all placed on the south side of the house where they were arranged in groups of a pattern, rather like giant chessmen. Elsewhere ample lawns provided a contrast of open spaces to this rather crowded scene and there were also beds round some of the topiary specimens, filled with low-growing herbaceous perennials to bring seasonal colour to the garden. In 1983 the topiary garden was grubbed up. A.H.

Condé, Princes de, a branch of the Bourbon family. **Henri de Bourbon,** Prince de Condé (1588–1646), married Charlotte de Montmorency. Anne of Austria, Louis XIII's widow, gave Charlotte *Chantilly, which had been confiscated by Louis after Henri II de Montmorency's execution. Charlotte's son, **Louis II de Bourbon** (1621–86), known as the 'Grand Condé', was a brilliant military commander. He greatly increased the size of the park at Chantilly, and in 1663 employed *Le Nôtre and a team of artists to lay out grounds on a vast scale. He took an active part in the planning, and after 1675 supervised the work himself. He employed Dutch craftsmen to make porticoes and pavilions of trellis, and his flower gardens were celebrated.

Louis-Joseph (1736–1818) conceived the Jardin Anglais and the Hameau. When he returned to Chantilly in 1814 he found the old château razed and the park sold off in lots. He set about recovering his property and parts of the garden west of the moats were laid out *à l'anglaise* by Victor Dubois. K.A.S.W.

Conifer, the colloquial name applied to members of the gymnosperm group of primitive plants. A conifer is a tree or shrub bearing a cone, which distinguishes it from the more advanced flowering plants or angiosperms. Some gymnosperms such as yew (*Taxus baccata*) and maidenhair tree (*Ginkgo biloba*) do not bear cones but are still commonly referred to as conifers.

Conifers are popularly considered to be evergreens but some such as the larches (*Larix* species), the swamp cypress (*Taxodium distichum*), and the dawn redwood (*Metasequoia glyptostroboides*) are deciduous. The leaves of most conifers

are needle-shaped or very narrow and most species occur in the cooler regions of the world. Again, however, there are exceptions such as *Ginkgo*, which has broad leaves, and several other species which are found in Equatorial forests.

Cultivated as a major crop for timber for construction, cladding, fuel, and paper, conifers are also widely grown in gardens and other designed landscapes. Conifers manufacture resins in special tissues and these often exude on to the bark. The characteristically pleasant odour, which is quite unlike that produced by other plants, is a good reason for including conifers in planting schemes for parks and gardens.

The tallest tree in the world is a 120-m. high conifer, a coast redwood (*Sequoia sempervirens*) growing in California; another Californian redwood (*Sequoiadendron giganteum*) is the largest living thing in the world and weighs at least 4,500 tonnes. A specimen of *Pinus aristata* (bristle-cone pine) is reputedly the oldest plant, being considered to be at least 5,000 years old. Some conifers are among the fastest growing temperate plants, an example being the bigeneric hybrid × *Cupressocyparis leylandii*, frequently planted as a visual screen and wind barrier because it is effective soon after planting.

However, many cultivars of otherwise normal conifers are extremely slow growing and hence can be grown in rock-gardens, window-boxes, sink- and trough-gardens. These plants are called dwarf conifers and have become increasingly popular in the last 20 years, with some nurseries specializing in their propagation and sale. Dwarf conifers are obtainable in as wide a range of leaf colour and overall shape as their normal relatives but differ in that they do not 'cone' well. In some species creeping and prostrate cultivars have been developed. These are increasingly used as evergreen ground cover, e.g. *Juniperus horizontalis* and *J. sabina* 'Tamariscifolia'.

There are few records of conifers being deliberately grown, even for timber, in medieval times, although the native yew was planted in churchyards. Many such yews are now over 1,000 years old. However, many of the venerable trees found today in churchyards are the late 18th-c. introduction from Fermanagh, *Taxus baccata* 'Fastigiata', commonly called the Irish yew.

By the early 17th c. conifers from southern Europe and other areas of the Mediterranean are recorded in English gardens. Examples include the western Atlantic cedar (*Cedrus atlantica*) and the eastern cedar of Lebanon (*Cedrus libani*). The botanical exploration of European colonial possessions in the 18th and early 19th cs. yielded many new conifers now widely grown. The majority came from North America but many were from China, Japan, and South America, the most famous from this last being the monkey-puzzle (*Araucaria araucana*).

British and European gardens owe a great deal to the prodigious collector in North America, David *Douglas, who died in 1834. He introduced 16 conifers, such as the Douglas fir (*Pseudotsuga menziesii*), Sitka spruce (*Picea sitchensis*), the pines (*Pinus ponderosa, P. contorta,* and *P. lam-*

bertiana), and the silver firs (*Abies nobilis, A. delavayi,* and *A. grandis*). P.F.H.

See also ELVASTON CASTLE; POWERSCOURT.

Conímbriga, Beira Litoral, Portugal, a deserted Roman town, has an excavated area which is small compared to the total walled surface of the town. The forum, four bath-buildings, two *insulae*, and four rich private houses have been totally excavated. The houses are centred on a peristyle but they are distinguished from most Roman provincial dwellings by the fact that the central open area is not the usual terrace planted with shrubs and trees and supplied with water from small ground-level basins. The usual proportion between garden and pool is entirely reversed; instead of the pool being one among other features of the garden, the flower-beds are like isles emerging from the pool which occupies the entire open space of the peristyle. The masonry flower plots are very formally laid out, their contours being outlined by semicircular and right-angled indentations. In at least one house the peristyle was enlivened by the sound of more than 400 small fountains. J.A.

See also ROMAN EMPIRE.

Conservation and restoration of historic gardens in Britain. The concept of the historic garden, as opposed to land attached to a historic building, was first introduced into legislation in Britain in the Town and Country Amenities Act, 1974. Although this covered only grant-aid and not protection against alteration, it was necessary to have a definition and an inventory for what had now been deemed national assets. Criteria were agreed by ICOMOS, the *Garden History Society, and the Historic Buildings Council, and county lists were drawn up largely by the Garden History Society. The sole criterion for listing was the historic importance of the garden or park, and in order to qualify for grading its essential character must have been retained. The garden was either the work of a famous designer, or was strongly representative of a style of gardening, or provided a setting which was an integral part of a historic building, or had been associated with famous people or events.

These lists were incorporated into the official Register of Parks and Gardens of Special Historic Interest in England set up by the Historic Buildings and Monuments Commission (English Heritage) following the 1983 National Heritage Act. The new Commission was then required by statute (para. 10 of Schedule 4) to send copies of all entries to owners, local planning authorities, and to the Secretary of State for the Environment, and a Gardens Inspector was appointed within the Inspectorate. Although no new controls were applied, the register serves to alert planners and statutory bodies to the need to protect historic gardens. The setting up of County Trusts, pioneered by Sussex and Hampshire, has also been an important step in the conservation of garden heritage.

The accepted idea of restoration as the rehabilitation of

an object already in existence, albeit in imperfect form, cannot be applied to gardens which are by nature organic. Scholarly reconstruction through excavation and pollen analysis has been undertaken for the Roman garden at *Fishbourne. The National Trust at *Ham House, *Westbury Court, and *Pitmedden, and the Department of the Environment at *Wrest Park have reconstructed gardens from original plans and engravings. Features such as the *Claremont amphitheatre, the *Swiss Garden (Old Warden), the Sanderson Miller landscape at *Wroxton Abbey, and the Chinese garden at *Biddulph Grange are all being authentically restored. The most ambitious restoration scheme is being undertaken at *Painshill on Hamilton's derelict landscape. Other gardens, which had not previously existed in that form, have been created to provide authentic historical settings and associations: a monks' physic garden at Michelham Priory and a topiary chess set at Brickwall by the Sussex Historic Gardens Restoration Society; a Tudor garden for the Tudor House Museum in Southampton and a medieval garden at Winchester Hall for the Hampshire Gardens Trust, created from 16th-c. texts; a maze at Greys Court, Henley; and at Lambeth, by the Tradescant Trust, a garden of plants introduced by the *Tradescants created in St Mary's churchyard, where they lie buried. Twentieth-c. gardens are now historic, and gardens of the *Lutyens–*Jekyll partnership have been authentically restored at *Hestercombe and Lindisfarne. Creative restoration or new historic gardens in the mood of the period have been made by Sir Geoffrey *Jellicoe at *Sutton Place, Mottisfont Abbey, and *Ditchley Park. Many gardens such as *Studley Royal, *Stowe, *Shotover, *Rousham House, *Stourhead, and *Levens Hall have been maintained with historic integrity for a long period, but the type of comprehensive survey, pioneered by the National Trust and now commissioned by the Countryside Commission, has become a necessity for future management policy.

Historic gardens are not only of increasing interest in themselves but provide study documents for those concerned with today's environment. At the first Conservation Conference in 1968 Frank *Clark, the first President of the Garden History Society, stressed the need to propagate the value of traditions expressed in the great gardens. 'The inheritance of a tradition confers both riches to an indigenous culture and responsibilities to the new generations that inherit it. . . . Variety of visual experience, forms that are rich in association, forms that are expressions of the richness and complexity of nature, forms that allow the processes of life to go on; all these are as important now as they were 200 years ago.' M.L.B.

See also DEMEURE HISTORIQUE.

Conservatory. The term refers primarily to a glasshouse for tender decorative plants, either attached to a house or standing free (see also *greenhouse; *orangery; *palm house; *winter garden). Originally it referred to any place, such as a storehouse or an ice-house, where things were preserved. In the mid-17th c. the term began to be used in

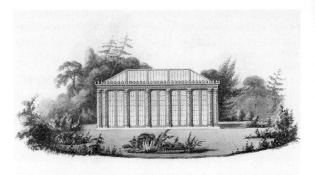

Conservatory designed by J. A. Repton, pen and wash (1810) (RIBA Library, London)

Britain to refer to a special building with large south-facing windows, in which tender plants (notably citrus fruits) could be conserved against harsh winter conditions; in the 19th c. it referred to a glass-covered extension of a dwelling house which could be entered from a living-room, and also to an ornamental iron-framed free-standing glasshouse, often domed, big enough to accommodate palms.

Among the first conservatories to use the new techniques was the now-restored example at Syon Park Gardens, London, erected by Charles Fowler between 1827 and 1830 for the Duke of Northumberland. *Paxton, the architecturally-minded head gardener of the Duke of Devonshire, built at *Chatsworth between 1836 and 1840 the Great Conservatory—so huge that Queen Victoria and Prince Albert drove through it in a carriage and pair. It measured 90 m. × 40 m., with a central dome rising to 22 m. and with 666 sq. m. of glass, supported by 48 iron pillars, but it was almost completely demolished in 1920. Fortunately other examples survive from this period—at the Belfast Botanic Gardens, the Glasnevin Botanic Gardens, Dublin, and Bicton, Devon.

The domestic conservatory attached to the house likewise reached its peak of development during the Victorian period. Reductions in the price of coal, iron, and glass (due to the repeal of the Glass Tax, 1845) facilitated the widespread distribution of conservatories, and for the increasingly prosperous Victorian middle class it now became fashionable to own a small conservatory attached to the house. This expansion of the market stimulated much experiment on the horticultural use of glass and iron, as is evident from the horticultural literature of the period. Similar developments took place in Europe during this period. Those conservatories still extant which are attached to country houses show a wide range of styles in the colour, angle, curvature, and nature of the glass used, but unfortunately many seem doomed to ruin through increasing costs of repair and upkeep. W.T.S.

Cooper, Anthony Ashley (1671–1713). See SHAFTESBURY, 3RD EARL OF.

Corbeille, originally an elegant wicker basket for the display of fruits or flowers; in gardens a round or oval flowerbed usually raised on a lawn, to be admired for its colour scheme. D.A.L.

Corby Castle, Cumberland (Cumbria), England, was acquired by Lord William Howard by 1624; his grandson Thomas (1677–1740) inherited in 1708. The castle is on a high sandstone bluff above the River Eden, and Thomas was particularly struck by similarities to John Milton's description of Eden in *Paradise Lost*. To the ancient oaks of Inglewood Forest he added *c.*1720 much other planting including Scots pines. In 1734 Sir John *Clerk of Penicuik noted other beauties: 'a very agreable winding walk down to the River where there are some artificial grotos . . . on the River side is a large walk . . . beautified all along with grotoes & Statues of the Rural deities. at the end of this walk next the house is a Cascade 140 feet high.' The carvings of the statues and cascade are reminiscent of those at *Bomarzo in Italy but have no parallel in England. However, William *Gilpin disliked them: 'The late proprietor . . . hired an artist of the country, at four-pence a day (for labour was then cheap) to make statues. Numberless were the works of this genius. Diana, Neptune, Polyphemus, Nymphs and Satyrs in abundance soon became the ornaments of the woods.' Nevertheless Gilpin praised the natural situation and was just one of the numerous tourists who have enjoyed Corby's picturesque walks. D.L.J.

Cordès, Orcival, Puy-de-Dôme, France, has an unusual early 18th-c. garden with parterres on terraces either side of a sunken entrance drive. They are surrounded by high beech *palissades* which open out in a wide semicircle before the 15th-c. château built on the edge of a steep escarpment which does not permit gardens on the side of the main rooms. K.A.S.W.

Cordoba, Spain. See ALCÁZAR NUEVO; MEDINA AZAHARA; PATIO DE LOS NARANJOS.

Cornbury House, Oxfordshire, England, was largely rebuilt in 1632–3 by Henry Danvers, Earl of Danby, who in 1621 had founded the *Oxford Botanic Garden. The park wall was perhaps erected at the same time. At the Restoration of Charles II in 1660 Danby's heirs lost the estate to Henry Hyde, the king's chancellor and Earl of Clarendon from 1661. In 1664 John *Evelyn accompanied Clarendon's son, Lord Cornbury, to Cornbury 'to assist the Planting of the Park'. They 'set out the Walkes in the Park, & Gardens', and Evelyn noted 'the Ponds very convenient; The Parke well stored'. In 1666 Cornbury jokingly wrote 'you should have been dragged ere this by importunity to Cornbury, to finish the work you have begun, whither I go now . . . we have this yeare planted 2000 trees'. Evelyn's design was for groves, a great avenue across the park and into Wychwood Forest, and a broad vista eastwards. In 1665 a new east front and a garden terrace were built to take advantage of the vista. Robert Plot, when considering walks

for his *Natural History of Oxfordshire* (1677), wrote that 'the most curious I have met with . . . are those elegant ones of trees of various kinds in Cornbury park'. Later improvements include some in a quarry painted by Mary Delany in the 1750s. Time, however, has been the most potent medium in dissolving Evelyn's layout. D.L.J.

Corsham Court, Wiltshire, England, although retaining its formal 17th-c. character in the entrance to the house with an imposing stone gateway flanked by what were originally stable buildings, had changes made to the grounds in the mid-18th c. A signed but undated design by Thomas Greening, probably drawn between 1740 and 1750, shows a rectangular pool in a small formal garden to the north of the house, but by 1760 'Capability' *Brown had prepared an estimate for laying out the grounds, although he retained the great avenue of limes and elms which stretched northward to the Bath road. The new pleasure-ground was to be protected by a 'sunke fence' or *ha-ha extending as far as the churchyard, and the total cost was to be £1,020 exclusive of the trees which were to be provided by the owner, Paul Methuen. This garden work was, of course, additional to Brown's enlarging of the house, begun at the same time, when the east and west wings were doubled in size. He was also responsible for an elegant Gothic bathhouse, set back from the north walk. In 1795 Humphry *Repton was consulted on the grounds but the Red Book which he is known to have prepared does not survive. It was probably through him that John Nash was introduced for further alterations to the house. D.N.S.

Corsi-Salviati, Villa, Sesto, Italy. This differs from other Tuscan gardens in as much as the site—in the Arno valley—is flat, and it was made in five different periods of history. The estate, bought by Jacopo Corsi in 1502, consisted of a small Tuscan house and simple garden of grass squares for bowls. There were minor adjustments in 1593, major alterations in 1644 which established the present ground-plan, and baroque additions in 1738 aimed at counteracting the flatness by giving flamboyancy to the skyline. In the 19th c. a romantic landscape of lake, mound, and mock castle was added. The gardens were restored in 1907, a green *theatre being incorporated in the formal design. G.A.J.

Côte d'Azur, France. Though the discovery of the benefits of the climate of the Côte d'Azur goes back to the 18th c., it was mainly in the 19th c. that two men, the writer Alphonse Karr and an Englishman, Lord Brougham, thanks to their writings, undertook to make this region known throughout the world. Numerous villas surrounded by parks and gardens were built between Toulon and Menton; the garden of the Villa Eléonor at Cannes, created by Lord Brougham between 1835 and 1839, is one of the most brilliant examples. From the beginning of the 20th c. sumptuous villas and magnificent gardens multiplied all along the coastline, and some of those have been conserved till the present day. Many were conceived by the owners

Garden (1925) on the Côte d'Azur for the Vicomte de Noailles at Hyères, France, by Gabriel Guevrékian

themselves, enthusiasts for botany and garden art, as well as by professional garden designers.

Certain landscape architects acquired a great reputation at this time. Achille *Duchêne, already well known, was responsible for, among others, the gardens of Lou Sueil at Eze-sur-Mer, the property of Colonel and Mme Basan. Octave Godard designed the gardens of the abbey of Roseland, the Château Fielding, the Villa des Palmiers at Nice, the Villa de la Croix des Gardes at Cannes, and the Villa La Tournelle at Saint-Jean-Cap-Ferrat. Jacques Gréber, who was chief architect for the 1937 exhibition, was responsible for the gardens of the Château de la Malbosc and the Castel Saint-François at Grasse.

But others, such as Ferdinand Bac and Lawrence Johnston, have equally contributed to the art of gardens on the Côte d'Azur. After travelling widely, both discovered their vocation as garden designers. Bac, who had first been a painter and man of letters, must be considered the forerunner; he invented the so-called Mediterranean style, 'bringing into play the light of the south, the natural flora of the coast and provençal stone, in an unaffected manner'. He designed the gardens of the Villa Croisset at Grasse, La Fiorentina at Cap-Ferrat, and above all those of Colombières at Menton. As for Lawrence Johnston, who in the course of his extensive travels had shown himself a fervent amateur botanist, he had already created his celebrated

garden at *Hidcote Manor in England when he decided to make that of the Serre de la Madone near Menton, in which, the Vicomte de Noailles tells us, 'he cultivated plants too delicate for England, which he brought back from successive journeys in China, South Africa and elsewhere'.

The gardens of the Côte d'Azur are mixed in style. Their makers, who were fond of developing the natural beauties of the sites, gladly drew from the antique, Italian Renaissance, Hispano-Moresque, oriental, or medieval repertoires to make up the elements of the decoration; thus there are large numbers of pergolas for supporting climbing plants, antique temples and medieval cloisters, and porticoes and vases in the form of urns or earthenware jars. The plants were either indigenous or imported by the collectors. C.R./S.Z.

See also FRANCE: GARDENS OF THE RIVIERA; PAGE, RUSSELL.

Cottage garden. The traditional English cottage garden consists of a seemingly casual mixture of vegetables, flowering plants, fruit-trees, and shrubs. The need to grow vegetables imposes a restraint so that the garden, though colourful, is never garish. The path leading to the door and usually those paths between the plots are bordered with flowers, mostly perennials left undisturbed but with a scattering of hardy, often self-sown, annuals. The whole area is enclosed by a low wall or hedge and the gate may have an archway of clipped yew or of flowering quince; perhaps there is a piece of topiary or the door will have honeysuckle or winter jasmine trained over it. On the cottage there may be a well-trained pear or plum tree or even a grape-vine, though now more probably purely decorative climbers.

If the space is small, it may be devoted entirely to flowers, but even if larger, the traditional front garden does not have a lawn. Paths are straight and usually made of stamped earth, though in some areas of brick or stone. As the borders consist of perennial flowers, new acquisitions must be planted wherever space can be found so that plants of different heights are mixed, but trimness is frequently provided by having an edging of only one kind of flower, such as pinks or pansies. Some shade is given by the fruit-trees, the decay of whose leaves helps to maintain the fertility of the soil, though this must now be augmented by fertilizer bought for the purpose, since there is no longer a pig providing manure as well as bacon.

Depending on the space available, and whether an allotment is also cultivated, a good range of vegetables is grown, though it is probable this was even wider when the cottager had to be self-sufficient (excellent descriptions of rural gardens in the 1880s can be found in Flora Thompson's trilogy, *Lark Rise to Candleford*, 1945). Vegetables are not planted casually but in neat rows, and these well-grown vegetables are also decorative since they provide a contrast of colour, form, and texture: for example, the dark upright leaves of onion beside the yellow-green of rounded lettuce, the silver sheen of developing broad beans against the glaucous colour of cabbage or the broad leaves of rhubarb. Some culinary herbs are grown for use, but rosemary has

now joined lavender, southernwood, and daphne as an ornamental shrub.

Until fairly recently new flowering plants were not purchased but exchanged, so many old varieties were preserved in cottage gardens. Now new ones, including hybrid tea and floribunda roses, are bought, though some of these associate less well with the old cottage garden flowers, so much better suited to this mixed way of planting than are modern delphiniums or gladioli. However, the cottage gardener has never been pedantic in his choice, for tall hollyhocks and annual sunflowers are popular, while crown imperials and madonna lilies seem to thrive particularly well; these tend to be planted in rows, their unsightly decaying foliage hidden by the growth of later plants.

These unpretentious gardens have had an important influence on modern gardening—the so-called 'natural' style, introduced by William *Robinson and Gertrude *Jekyll and others towards the end of the 19th c. This kind of gardening developed as a reaction to *carpet bedding with half-hardy annuals which had become such a ubiquitous feature of the gardens of the better-off. Robinson, in the many editions of his influential *The English Flower Garden* (1st edn. 1883), pointed out that it was only in cottage gardens that flowers could be seen growing in a pleasing and natural way; while Gertrude Jekyll, in her many books, also praised them and went on to create a style of gardening that used this casual manner of planting but within a carefully designed plan. Not only was there an overall formal design but even the seemingly casual planting took full account of the form and colour relationships of the plants used. As she said, one of the lessons she learnt from the cottage garden was restraint. This stylized cottage gardening requires skill if it is to avoid the accusation of sentimentality so often levelled against it; (but it is not the genuine cottager who indulges in features such as wheelbarrows festooned with petunias).

As well as this traditional form, two other styles are associated with cottage gardening. It is customary in market gardening areas to fill beds and borders with bedding plants and this also is the kind of front garden that wins prizes from local authorities for 'the best-kept cottage garden'. Very effective such gardens can be, but they demand much labour since they must be planted out twice a year for spring and late summer flowering.

The other manner of treating the front garden can be seen occasionally in front of rows of estate cottages, where the gardens were designed as a series of formal box-edged beds, separated by gravel paths. They generally date from about the mid-19th c. but may well have had a much longer history since up to the early 18th c. such geometrically edged beds were the invariable components of flower gardens (apart from the more complex knots and parterres to which they were related).

It seems probable that those pre-18th-c. cottages which still exist always had useful, and sometimes even decorative, gardens, as described in Elizabethan times by William Harrison and in the 17th c. by John Worlidge. However, it is likely that the typical *front* garden became much more common after the Parliamentary Enclosures (mainly 1750–1850): once animals were kept within hedged fields, while the contemporary metalling of the roads allowed them to be narrower, it became possible for cottagers to fence in some of the verge in front of the house. Of course, too, the loss of rights of common which occurred at the time of the Enclosures made the cultivation of every scrap of additional land valuable. It is these front gardens which appear in paintings and photographs from the mid-19th c. onwards.

Traditional cottage gardens can still be seen but are less common than formerly. The most interesting were always created by rural craftsmen or such a person as the village postmaster—people who could regard gardening as a recreation as well as a necessity, often with the wife attending to the flowers and the husband to the vegetables. As cottages pass into the hands of owners with a different background inevitably the style of gardening changes. However, there is a fair hope for their survival since this kind of garden suits its cottage so well and the home production of vegetables and fruit has once more become appreciated. R.E.D.

Cottage orné, a small, usually asymmetrically designed building containing elaborate rustic elements such as decorated weatherboarding, used as a feature in a park, or as a lodge or for housing. It is generally associated with the *picturesque style in England. A notable example was built at *Endsleigh. P.J.C.

See also FERME ORNÉE.

Courances, Essonne, France, has an outstanding arrangement of water in a park setting based on a traditional 17th-c. layout, with a central vista extended on the axis of the house into the park. After a period of neglect in the 19th c. the estate was bought by Baron de Haber, from whom it descended through his daughter to the de Ganay family. Before the First World War the then Marquise de Ganay employed Achille *Duchêne to restore the park in the French classical style. The approach from the north is bordered by canals set in an avenue of plane trees planted in 1782. The château (brick with stone quoins) stands on a platform within the moats which, together with other basins, are fed by springs giving the water a remarkable clarity, and enlivening the scene with numerous mirror images.

The long axial vista to the south—terminating in a terrace with a statue of Hercules overlooking a large round pond—the box parterre in the foreground, and the rectangular *miroir d'eau* beyond, are convincing evidence of the hand of a master. On the east an *allée* of little cascades links the main vista with the canalized River Ecole (555 m. long) enclosed in woods and opening at the northern end into a large circular clearing, with *palissades* of hornbeam encompassing a 10-sided basin. East of the château Duchêne added a horseshoe canal and a basin backed by a small cascade surmounted by the statue of a nymph. In the north-west quarter there is an early 20th-c. Japanese garden made by an Englishwoman. K.A.S.W.

Cour d'honneur, the principal courtyard of a château, where visitors are received. P.G.

Court. See FORECOURT.

Courtyard and courtyard garden in Islam. A courtyard is a space open to the sky but enclosed by walls or buildings. It is thus formed by and integral with the surrounding architecture, and is therefore more likely than an unenclosed garden to retain its original character. The courtyard is usually square, or nearly so, in shape, and more often than not surrounded by an arcade. It is a useful urban form, appropriate to high densities, while it excludes the noise and dust of the outside world.

Courtyards in the Islamic world are found within secular buildings such as dwellings, palaces, and forts, and within religious buildings such as mosques and *medersas* (theological seminaries). The courtyard provides a private space, supplying light and cool air to the surrounding rooms, and, in most of the Islamic world, protection from the ubiquitous dust and heat. It is thus largely a reaction to climate and resultant living traditions, not only for the humble dwelling with a potted plant and the occasional tree, but also in the palaces and apartments of the nobility; in such instances planting, running water or pools, and shade also symbolize paradise. Muhammad's own dwelling, way of life, and manner of teaching were the probable source of the courtyard (*sahn*) of a typical mosque.

For their part, the caravanserai (caravan hostels for travellers, merchants, and their goods) were often grouped round a courtyard, similar in form to that of the *medersa*. Courtyards are also to be found off the main arteries of bazaars as in Isfahan and Kashan, where they provide fresh air, sunlight, and relative quiet.

Although plants and trees are often present, the Islamic courtyard is usually surfaced with stone, marble, or mosaic. This hardness, together with its inherent integration with the surrounding building, generally ensures the preservation of the original design concept, in contrast to a garden which is always subject to the ideas and whims of successive owners and gardeners. In welcome contrast to the hard surface, water is almost invariably present, supplied from a fountain or contained in a pool. Centrally placed, it is always the focus of attention when viewed from the surrounding arcade.

Examples of the courtyard and courtyard garden are found throughout the Islamic world. An early secular building containing several courtyards is the mid-9th-c. Bulkawara Palace in Samara, Iraq, of which only some ruined walls remain. An early religious and typical example is the Masjid-i Jami, Isfahan, a noble Seljuk monument dating from the 11th c. The various parts of the building are grouped around a large stone-paved courtyard with an ablution pool in the centre. Around the periphery is a two-storey arcade with an *iwan* (high entrance portal) in the centre of each side. With minor variations, this courtyard reflects the general pattern for mosque and *medersa* throughout the Islamic world. J.L.

See also ISLAM, GARDENS OF; MADRASSA MADER-I SHAH; SPAIN: ISLAMIC GARDENS.

Crescenzi, Pietro de' (1230–1305), Italian author of *Liber ruralium commodorum*, written in Bologna in 1305. The treatise was based on readings of classical authors such as *Cato and *Varro, and on contemporary scientific research, particularly that emanating from the kingdom of Sicily. It discusses garden design in the Middle Ages, dividing it into three classes: the small herb or flower garden, the garden of 1–1.5 ha., and the garden of 8 ha. and more for a monarch and the very rich. The treatise reveals how the philosophies and delights of the early Renaissance garden were drawn as much from the Middle Ages as from antiquity. G.A.J.

See also MEDIEVAL GARDEN: GARDENING BOOKS.

Creux de Genthod, Geneva, Switzerland. In 1723 the Geneva patrician Ami Lullin had an extensive baroque garden, designed by the French architect Jacques-François Blondel, laid out on the lakeside not far from the town. The main axis, containing a tree-lined avenue as a drive, a courtyard, the house, and a *parterre* of *broderie* and of water, is aligned with the lakeside; the parterre has now become an unadorned lawn. The lateral axis leading towards the lake contained a parterre with a vegetable garden which was redesigned as a rose-garden in the 20th c. It is apparent from Blondel's other surviving sites that the cruciform layout of this design owed much to French baroque gardens. H.-R.H. (trans. R.L.)

Crinkle-crankle wall. See SERPENTINE WALL.

Crivelli, Villa, Lombardy, Italy. On the outskirts of Inverigo, this villa—a reconstruction of an earlier castle—is dominated by its remarkable cypress avenue, the Scala del Gigante. Stretching from the summit of a small hill where stands the enormous statue of Hercules from which it takes its name, the avenue crosses two main roads which flank the villa, and runs on across the landscape for over a kilometre. Leading down from the villa, numerous stairways connect the terraced parterre gardens, adorned with statues and fountains, and between them runs the avenue. From the main terrace, the central vista of the Scala can be followed in both directions. To the south it crosses the valley and disappears into the cypresses which surround the statue on the hills beyond. To the north it runs across the hilly countryside, sometimes visible, sometimes hidden by cypresses, and punctuated by statues and obelisks, until it fades into the distant woodlands. H.S.-P.

Crivelli Sormani-Verri, Villa, Castellazzo, Lombardy, Italy. The original gardens of this villa—now owned by the Marchese Crivelli—were laid out in 1627 in the grand Italian style by Count Galeazzo Arconati. They were already famous when, early in the 18th c., the last of the Arconati Visconti commissioned the Frenchman Jean Gianda to revise the layout completely. This new garden became even more famous than its predecessor. Laid out exactly accord-

Creux de Genthod,
Geneva, site plan (1723)
by J.-F. Blondel (Musée
d'art et d'histoire,
Geneva)

ing to Gianda's design (which can be seen in the engravings of Marcantonio dal Re, 1743), it is unique in Italy as the only one of its kind to have been preserved in almost every detail. Recognizably French in character, with elaborate parterres in front of the main façade of the villa, outlined by clipped trees, the whole is surrounded by tall hedges. Though much reduced in scale, the classical French elements are present: simple *cabinets of trimmed hedges, a great *berceau which divides the *bosquet in two, at its centre an octagonal enclosure where it crosses the allée of the fountains, and a curious rococo menagerie. H.S.-P.

Croome Court, Worcestershire (Hereford and Worcester), England, a Jacobean house, was sited on marshy ground between the Rivers Avon and Severn, and 'Capability' *Brown's first task on being commissioned to rebuild in 1750 was to construct culverts to drain off the water, which was then used to feed a serpentine lake, one of his proposals for laying out the park. The new house which he designed for Lord Deerhurst, later 6th Earl of Coventry, went up without delay and was almost complete when Richard Wilson painted it in a setting which included Brown's bridge over the lake, and his rebuilding of the nearby church. Brown was also responsible for a small classical summer-house on an island in the lake, and for a rock-work tunnel constructed under the main road to connect the park with a further part of the estate. In 1797 Lord Coventry set up a small memorial (destroyed some years ago) near the lake with a tablet to Brown whose 'inimitable and creative genius' had 'formed this garden scene out of a morass'.

The present owners, Chaitanya College, are undertaking restoration work in part of the grounds (1984). D.N.S.

Crowe, Dame Sylvia (1901–), English landscape architect, was President of the Landscape Institute from 1957 to 1959. From 1948 to 1968 she was actively involved in the foundation of the International Federation of Landscape Architects, of which she became Secretary and later acting President. She derived her interest in the landscape from a childhood spent on a Sussex farm, and entered the new profession through the study of horticulture at Swanley in Kent and working as a pupil in Milner White's office, largely on the design of gardens.

With the encouragement of (Sir) Geoffrey Jellicoe and Brenda Colvin she was able to establish a private practice immediately after the Second World War, and was appointed consultant for two of the New Towns, Harlow and Basildon. Her practice has been wide-ranging, both in scale and kind, including master-planning for two more New Towns, Warrington and Washington, a park for Canberra, *Australia, projects for coastal reclamation, forestry, power stations, and a number of urban projects. Gardens include those for the Commonwealth Institute, London, and a *roof-garden for the Scottish Widows' Fund and Life Assurance Society offices in Edinburgh (1976).

Between 1950 and 1960 she wrote a number of important books which have remained standard works for the pro-

Roof-garden (1976) for the Scottish Widows' Fund and Life Assurance Society by Sylvia Crowe

fession. These include *Tomorrow's Landscape* (1956), *Garden Design* (1958), *The Landscape of Power* (1958), and *The Landscape of Roads* (1960). In 1964 she was appointed first landscape consultant to the Forestry Commission and in 1966 she produced *Forestry in the Landscape*. She has received honorary awards from the Royal Institute of British Architects and the Royal Town Planning Institute as well as a number of universities for her work in landscape architecture. In 1967 she was created CBE and in 1973 she was made a Dame of the British Empire. M.L.L.

Crystal Palace, London. See CARPET BEDDING; PAXTON, SIR JOSEPH.

Csákvár, Hungary. The garden features in several descriptions of the first half of the 19th c., but there is little evidence concerning its original layout. It is thought that this house and garden, which belonged to the Counts Esterházy, were planned and constructed c.1781. Among a series of nine gouache designs by Peter Rivetti is one dated 1783 which shows a garden in the anglo-chinois manner (see *jardin anglo-chinois). The other gouaches depict various small garden buildings typical of the period, such as a Temple of Apollo, a *gloriette chinois, a pyramid, a bâtiment turc, and an Egyptian pavilion. The buildings are surrounded by a

jardin anglais which may have been laid out in the 1790s. At the end of the century an engineer, Franz Böhm, enlarged the house and was perhaps also active in transforming the garden. In 1810 an earthquake ruined house and garden.

A.Z./P.G.

Culpeper, Nicholas (1616–54), English physician and herbalist. See HERBAL.

Cunningham, Allan (1791–1839), English plant-collector, worked at *Kew early in the 19th c., helping with the second edition of William *Aiton the elder's *Hortus Kewensis*. Late in 1814 he went to Brazil with James Bowie, but the two collectors separated, Bowie going to South Africa and Cunningham to Australia, where he arrived at Sydney in 1816. His explorations of the continent began very soon, starting with the plains beyond the Blue Mountains and a journey north to Moreton Bay, the site of Brisbane. Between 1817 and 1822 he travelled several times on the survey ship *Mermaid*, going round Australia and as far as Mauritius. Until his return to England in 1831 he explored western and northern parts of Australia and visited Norfolk Island and New Zealand too. He sent enormous collections of seeds and bulbs to Kew, but after the death of Sir Joseph *Banks in 1820 the gardens there were less well cared for and records of Cunningham's material are not always certain. He probably introduced the first cultivated *Eucryphia*, *E. lucida* from Tasmania, *Clianthus formosus*, and many species of acacia, among other plants.

Charles Fraser, once his travelling companion, had become Colonial Botanist in Australia, where he died at the end of 1831. The post was offered to Cunningham, who refused it in favour of his younger brother **Richard Cunningham** (1793–1835) who had also worked at Kew. Richard arrived in Australia in 1833, but he was killed by aborigines two years later, while exploring the Darling River system. The elder Cunningham then accepted the post, arriving back in Sydney in 1837. After a collecting visit to New Zealand, he died at Parramatta, where the botanic garden in his charge was situated. Thanks to him, Australia is scattered with geographical features named after botanists he knew: both Aitons, Robert Brown, *Caley, Dryander, Lambert, J. E. Smith, and Cunningham himself are all commemorated. The Moreton Bay pine, *Araucaria cunninghamii*, and other plants are also named for him.

S.R.

See also PLANT-COLLECTING.

Cunninghame, James (*fl.* 1698–1709) was a Scottish surgeon in the service of the East India Company and one of the first Europeans to study the plants of China and the Far East. In 1698 he went to Amoy in the Strait of Formosa, collecting plants at various ports of call on the way. His stay there was short, but he collected paintings of nearly 800 plants, with their names and some of their uses. He was back in England in 1699 but left the following year for Chusan, where he stayed for some time. He sent seeds and dried plants, among them the first known specimen of a camellia,

to the botanist James Petiver, and he was one of Sir Hans *Sloane's correspondents. In 1703 he was transferred to the island of Pulocandore off Cambodia, where he was the sole survivor of a massacre in 1705. He was imprisoned in Cochin-China for two years and released in 1707, but it is believed that he died on the journey home.

S.R.

Cuzzano, Villa, Grezzana, Verona, Veneto, Italy. A rare example of a surviving 17th-c. parterre garden in the Veneto, the original layout of this villa at Grezzana, designed by G. B. Bianchi for the Allegri family, remains intact to this day. The garden's principal feature is an exceptional parterre laid out on the terrace in front of the house, and originally approached by a straight drive leading from the road, thus affording vistas at both ends. Though the garden is typically Venetian in design, including even an aviary and dovecots, the complex box-outlined parterres show a strong French influence. From the terrace, the yews and cypresses below lead directly into the open valley of the Valpatena which surrounds the garden, and the long lines of the design as a whole are skilfully blended into the strictly horizontal landscape of the Veneto vineyards in which the garden is situated.

H.S.-P.

Czechoslovakia. The earliest gardens are known from written records, commercial transactions, and illuminated manuscripts. In the 12th-c. donation document of the Czech ruler Sobeslav I, reference is made to the garden of Vysehrad diocese. Later records are a source of information about the garden of the bishop's court (now in the Malá Strana, Prague), various gardens within the monastery, and about paradise courts as in Zlatá Koruna, Vyšší Brod, and Tišnov. All that survives of *medieval gardens are open spaces with stone wells and fountains.

Renaissance gardens. The philosophy of the Renaissance prepared the way for the acceptance of a new approach to garden design. In the Czech countries, however, Renaissance gardens remained walled for a long time, and their simple rectangular division still recalled the utilitarian medieval gardens. This type of garden continued to exist until Italian architects and gardeners brought with them the artistic spirit of their own country, adapted to the severer climatic conditions.

In the first half of the 16th c. a large Renaissance garden was formed behind the fortifications of Prague Castle. This royal garden was gradually extended to the west and decorated with fashionable adjuncts such as an aviary, an *orangerie*, a fig-house, and even a lion-court. The Italian influence was now joined by that of the garden architecture of the Netherlands. Especially during the rule of King Rudolph II (16th c.) the royal garden was modified in the Dutch manner by Vredeman *de Vries, and tulips from Turkey were introduced for the first time in Europe. Other gardens of this period were: the royal seat in Brandýs nad Labem, laid out in several terraces; Kratochvíle by Netolice, where the castle and parterre were enclosed by a moat; Jindřichcûv Hradec, with a central summer-house and a

single-storey arched gallery enclosing the space of the castle garden, at the centre of which is a star-shaped stone *bassin*; and the Renaissance château and garden of a similar design at Telč.

In the 17th c. Bohemia and Moravia (which together with Slovakia make up Czechoslovakia today) were prosperous states. Castles within spacious decorative gardens and hunting enclosures were frequently to be found, and a great number of these ensembles still exist. Several gardens of a type transitional between the Renaissance and the baroque were created at the beginning of the 17th c. From this period dates the *Valdštejn garden of Prague, whose grandiose composition included the monumental *sala terrena* by G. Pieroni and statues by Adrian de Vries.

The baroque period and the nineteenth century. Several remarkable baroque gardens, for example in Velké Losiny, are known only from documentation (see *Chlumec nad Cidlinou). The courtyard and garden of *Buchlovice represent a beautiful example of Italian influence. The rules for the disposition of staircases, *bassins*, and statues were not overthrown by 19th-c. fashion, and they have seldom been planted over with exotic trees. The outstanding example of compromise between the Italian and the French manner is Troja garden, Prague. The closest resemblance to the French classicist style is at *Jaroměřice upon Rokytná. French influence is also clearly perceptible in the original project for *Dobříš.

The sheer slope of Prague's Malá Strana inspired the ingenious staircases and terraces of palace gardens, exhibiting workmanship of unique quality, specifically Czech. *Gloriettes, galleries of statues and vases, fountains, and *bassins* linked up with palaces located on the lowest level of the garden. A rare view of Prague can be seen from the observation points situated on the upper terraces. The outstanding architects of this period—F. M. Kaňka, G. Santini, J. Palliardi, J. B. Alliprandi—were involved in designing these gardens.

The English landscape park strongly influenced Czech garden art. Among the first examples in Czechoslovakia were the parks in Vlašim, Veltrusy, the romantically sentimental park Terezia's Valley in Nove Hrady (New Castles), and others. At *Kroměříž the rococo-style garden was transformed into a landscape park with classical buildings. The park at *Lednice, of true European significance, forms with the adjoining Valtice Park an extensive landscape with belvederes and other romantic structures.

At the beginning of the 19th c. a series of spa resorts was established in Bohemia and Moravia, including Francensbad, Marienbad, Teplice, and Luhačovice, where spacious parks with ornamental flower-beds were laid out. During the 1850s the public municipal park came into prominence, several of them being laid out on the ruins of town fortifications. An outstanding example is the municipal garden of Landfras in Jindřichcův Hradec. Eventually there was a revival of the formal garden, as at *Ploskovice Castle.

The twentieth century. Developments in town planning and architecture at the beginning of the 20th c. inspired a series of original works. The endeavour to design 'garden cities' led architects to establish new parks and gardens, and many city villas were built with architecturally designed gardens of a high quality, e.g. the gardens of Jan Kotěra and Adolf Loos (Prague), or of Mies van der Rohe at the Villa Tugendhart (Brno). Also the arrangements of gardens in historical surroundings clearly represented an extremely creative trend, as is shown by the modifications of the neglected Palace Gardens (by Plečnik) or by Thomayer's work in municipal parks.

Within recent decades there has been an increasing interest in garden architecture, both historical and contemporary, together with an increased concern for protecting the environment. However, at present relatively few new gardens (but see *Lidice) and parks are being established, so that it is difficult to identify the trend of creative design. Neglected historical gardens are gradually being reconstructed and restored to a satisfactory condition.

O.B.

See also KONOPIŠTĚ; MILOTICE; PRUHONICE PARK.

Daigo Sambo-in Garden, Fushimi-ku, Kyoto, Japan, 1.5 ha. in area, is considered the best example of the Momoyama period (1573–1603). The all-powerful military lord of the time, Toyotomi Hideyoshi, was personally involved in its construction, starting in April 1598, by expanding a pre-existing garden, moving in a number of fine rocks from his other estate grounds, and constructing the waterfall. By the following month the basic work of the garden was completed. Unfortunately, however, Hideyoshi died in August of the same year without seeing its final completion. The construction was continued under Priest Gien-Junkō, a close friend of Hideyoshi. The construction of this garden is regarded as a most important event in the history of Japanese gardens. The record also mentions as participants in the work of the garden the names of three brothers, Senka, Kentei, and Yoshiro, who had previously been gardeners at the Fushimi castle of Hideyoshi.

The present Sambo-in Garden constitutes the central garden to the south of the *shoin* or guest room; it has a winding pond with three islands, a shore lined with stone-work, and a three-tiered waterfall in the south-west corner. The islands have bridges in a variety of forms, built of wood, earth, and stone. Toward the west side is a group planting of cycads, the Japanese sago palm. S.S.

Daisen-in, Kyoto, Japan, lies in the temple complex of Daitoku-ji. Completed *c.*1513 it has been variously ascribed to *Soami or to Kogaku, a Zen Buddhist monk. Although it is a garden of contemplation it differs notably from Ryoan-ji. The L-shaped garden runs round two sides of the temple verandah and is in two parts, separated by a partition with a bell-shaped window. Both are dry landscapes, but one is partly an allegory, the other intended for meditation. In the smaller part, vertical rocks simulate mountains, a waterfall and other hazards being negotiated by a small boat-shaped stone, representing man's fate, sailing through waters of white quartz. Rounding the corner of the verandah the scene opens out into a large rectangle of quartz, called by some the Ocean of Nothingness, raked into a pattern of lines. Only two low conical mounds of quartz relieve the flatness. S.J.

Dalrymple, John (1673–1747), Scottish landowner. See STAIR, EARL OF.

Dalvui, Victoria, Australia, lies on a site near Mount Noorat, which, though in part a reclaimed lagoon bed, was generally rockstrewn and windswept. In the 1900s William Guilfoyle formed the sweeping lawns, ponds, and clumps of exotics in a design reminiscent of his *Melbourne Botanic Gardens.

Viewed from the Camperdown–Noorat Road, a solitary clump of *Cordyline australis*, incongruous on the windswept plain, provides a hint of the luxurious plantings to come. Great sweeps of smooth lawn spread out from the house, their serpentine edges bounded by dense plantings of shrubs and trees. Rose-clad Gothic frames form arbours at the edge of the lawns. A camellia walk links two arms of lawn and provides a bank of colour in late winter. The garden's chief feature is a series of ponds, whose margins and small islands are stocked with succulents, lilies, iris, and blossoming trees.

Beyond, a stone retaining wall makes an effective *ha-ha, and the avenue of gnarled trees marking the line of the old drive hides the fields from view. All vistas are closed by protective peripheral plantings. H.N.T.

Dam. Probably the earliest dams known to have been made for the prime purpose of an artificial landscape were those of the Chinese. These were probably earth dams, the scale of the fishing-park, as it was described, being prodigious—it is recorded that in the year AD 607 the Western Park of the Sui Emperor Ti was 200 sq. km., and included five lakes and five seas, requiring a million workers.

In western Europe, the dam has been used since the beginning of history for the purely functional purpose of a reservoir, but as landscape art, absorbed into a romantic landscape, it was first developed by the English in the 18th c. 'Capability' *Brown, in making a lake appear as a river, endeavoured either to conceal the dam or weld it into his contours. G.A.J.

Dampierre, Yvelines, France, is one of *Le Nôtre's major compositions based on a 16th-c. layout illustrated by *du Cerceau. This shows the grounds *c.*1560–70 in the time of Charles de Guise, Cardinal de Lorraine, as a series of rectangular enclosures including a large garden surrounded by canals fed by the River Yvette. A dam and causeway across the valley divide the château moats from a large, irregular, straight-sided lake on the west. The present château was built for the Duc de Chevreuse (grandson of Louis XIII's favourite the Duc de Luynes) by *Hardouin-Mansart between 1675 and 1686, with an approach through a hierarchy of courtyards. Le Nôtre orientated his design of parterres, basins, and cascade along this axis, across the valley, extending it by vistas at the park at either end. Thus while retaining the framework of the earlier causeway and canals he changed the emphasis. The essentials of his

scheme survive, but without the detail which gave it richness and variety. K.A.S.W.

Danubian Gardens, Vidin, Bulgaria, were established in 1902 at the suggestion of the Teachers' Union. Stylistically they were in tune with the neo-baroque buildings of that period. At their western end rises the Baba Vida (Grandma Vida) Fortress, one of the most typical medieval monuments of the 12th–14th cs., the two lending a distinctive touch to Vidin's skyline as seen from the Danube. The gardens' composition develops linearly along the river with well delineated perspectives towards the water area. Covering a relatively modest area (10 ha.), it has a rich vegetation (poplars, ashes, limes, yews, thujas, and other species), as well as fountains, statues, playgrounds for children, and a restaurant on the banks of the Danube. D.T.S.

Dark Ages, Gardens in the. See CAROLINGIAN GARDENS.

Dartington Hall, Devon, England, has in its garden a fine example of 20th-c. landscape design round a very old stone building, some parts of which are said to be of the 14th c. The garden owes much to Percy *Cane who worked on it from 1945 but other designers had preceded him, including Beatrix *Farrand, who made the Quadrangle garden. Much of the garden spans a small valley, in the bottom of which a level lawn has been made for use as an open-air theatre. It is overlooked by steep grassed terraces and a row of very large trimmed yews, the 'Twelve Apostles', said to have been planted in the 19th c. Stone steps lead into and out of the theatre and a much longer flight sweeps up the valley side to a stone balustraded *belvedere and a Henry Moore sculpture of a reclining woman. The surrounding garden is planted in a natural style with many trees and shrubs, including rhododendrons, camellias, and daffodils in the grass. A.H.

David, Armand (1826–1900), French missionary and naturalist, was a member of the Lazarist order and went to Peking (Beijing) in 1862. The material he sent back to the Muséum National d'Histoire Naturelle in Paris was sufficiently interesting for him to be commissioned to collect for that institution. He made three journeys, in 1866, 1868–9, and 1872–4, exploring Inner Mongolia, Szechuan, western regions as far as the Tibetan border, and the Tsin-ling Mountains and Fukien in the south-west, before illness forced him to return to France in 1874. Among the animals he encountered were the giant panda and Père David's deer, as well as wild silkworms, but birds were his favourites and he eventually published an illustrated account of Chinese ornithology. The new plant species he found—*c.*250 of them—included the handkerchief tree, *Davidia involucrata, Buddleia davidii, Rosa xanthina, Clematis armandii,* and *C. davidiana.* Seeds from his collections were distributed to many European botanic gardens from the *Jardin des Plantes in Paris. S.R.

Deanery Garden, Berkshire, England. The years 1900–2 were ones of important work for *Lutyens, stemming from his introduction by Gertrude *Jekyll to Edward Hudson, founder of *Country Life,* for whom he built the house called Deanery Garden at Sonning.

An old, high, brick wall forms the roadside boundary; a small gate through it opens into a wide, vaulted passageway to the front door, with arched openings to a paved fountain-court on one side, and to a small formal garden on the other. Straight through the house is the garden doorway in a deep embrasured arch; this gives on to a broad terrace which prolongs the axial line further, towards a generous flight of semicircular steps. Here formality gives way to rough-mown grass rides through the trees of the old orchard.

Eastward is a series of lawns and *parterres linked to one another and to the house by paved paths, clipped hedges, and dry walling. To the west of the garden door, in the angle of the great oriel window, a squared flight of steps leads to the lower lawn; it is linked to a twin flight of steps by a balustraded 'causeway', which carries the terrace on a vaulted archway over a circular pool—a favourite Lutyens device. This pool forms a terminal feature to the iris rill which, broken midway by a square fountain-pool, bisects the calm expanse of the lower lawn and ends in a circular lily-pond backed by winding steps. These lead up to a paved viewpoint at the boundary wall encircling the garden.

The harmony and balanced asymmetry of this whole design, achieved in the earlier years of the partnership, set a standard difficult to surpass. I.L.P.

De' Crescenzi, Pietro (1230–1305), Italian writer. See CRESCENZI, PIETRO DE'.

Deepdene, The, Surrey, England, was remodelled in the 1650s by Charles Howard in an Italianate manner. The naturally U-shaped hill on which it was sited lent itself to the building of the terraced amphitheatre. William Camden's *Britannia* (rev. E. Gibson, 1722) mentions 'frequent grots here and there, beneath the terraces leading to the top' and Aubrey's *Antiquities of Surrey* (1718) describes a cave 36 paces long, 4 broad, and 5 high, as well as a subterranean passage which pierced the hill, opening a view to the south part of Surrey and the sea. Both Aubrey and *Evelyn refer to an 'Elaboratory' or laboratory.

Thomas Hope (1769–1831), the rich amateur architect, decorator, and garden designer, bought the estate in 1807. The symmetrical late Palladian (*c.*1768) house he bought is shown in a painting of 1770–2 attributed to Theodore de Bruyn. It shows a vista cut into the heavily wooded hillside centred on the stable block and terminating in a *gazebo near the summit. In front of the house is a sloping lawn with large irregular shrubbery beds.

Hope set about transforming the house and garden in *c.*1817. His improvements are well documented in two manuscript volumes by John Britton (one of 1821 in the RIBA Drawings Collection, the other of 1826, in the Minet Library, Brixton). Hope championed Payne *Knight's views on *Italian gardens and, in his essay 'On the Art of

Gardening' (1808), the argument for the reintroduction of the formal garden. He realized his ideas at The Deepdene with the assistance of the architect Thomas Atkinson (c. 1773–1839). They developed the house and its appendages outwards into the garden following Humphry *Repton's ideas on picturesque planning. Hope, describing his ideal house, wrote: 'the cluster of highly adorned and sheltered apartments . . . shoot out, as it were, into . . . ramifications of arcades, porticoes, terraces, parterres, teillages, avenues'. One of these spinal ramifications at The Deepdene comprised an orangery, conservatory, sculpture gallery, and amphitheatre. It was built in 1823 in a mixed Italianate, Gothic, and Greek style at an angle of 45° to the house. From the highly dressed grounds near the house the gardens filtered by degrees into a *gardenesque area and thence into wilder regions which merged into the surrounding landscape. J. C. Loudon described The Deepdene in 1833 (*Encyclopaedia of Cottage, Farm and Villa Architecture*) as 'the finest example in England of an Italian villa united with the grounds by architectural appendages'. G.R.C.

Deer-park. In England deer were originally royal beasts hunted only in the king's forests until, in the Middle Ages, licences were granted to landowners, including bishops and abbots, to enclose land for deer-parks. These parks were surrounded by a ditch and huge earth bank, topped by a pale (the symbol for a park in early maps) with an occasional gap for allowing deer in but not out—the deer leap. Originally part of the manorial economy supplying fresh meat and timber, the park, through *Evelyn, was seen also as an ornamental setting to the house. Notable examples of landscaped parks which evolved from deer-parks are *Blenheim, *Chatsworth, *Mount Edgcumbe, Althorp, and Highclere. M.L.B.

See also CLEVES; SINGRAVEN; TWICKEL.

De Keukenhof, near Lisse, The Netherlands, is a property which over 500 years ago belonged to Princess Jacqueline of Hainault (1401–36), wife of Duke Humphrey of Gloucester, brother of King Henry V of England. Today her former hunting-grounds are a world-famous park for the display of bulbous plants. The initiative for this display was taken by the Royal Dutch Association of Bulb Growers who leased some of the land in 1949 and planted thousands of bulbs in an area which today covers 28 ha.

The setting for this display is greatly enhanced by a layout of 1854 by Jan David *Zocher the younger, who together with his son Louis Paul Zocher designed undulating ponds and watercourses accented by trees. Under the dappled light of ancient beech trees and along the water flowers of vibrant colours have been planted. In other parts of the park different gardens, each with a distinct character, contain massive beds of one colour or various collections of tulips, narcissi, and hyacinths. In the greenhouses the newest tulip cultivars are displayed. Throughout, the grounds are graced with sculptures by outstanding artists. From the end of

March to the end of May thousands of visitors come to admire the kaleidoscopic array of an unparalleled bulb spectacle: the fruition of *Clusius's pioneering work with bulbs of nearly 400 years ago. F.H.

Delany, Mary (1700–88), Irish watercolourist, maker of shell grottoes, gardener, diarist, and *collagiste* (her collages of flowers are now mainly in the collection of the British Museum). In 1743 she married Patrick Delany, Dean of Down and friend of Jonathan *Swift, Alexander *Pope, and Thomas *Addison. Delany had begun to lay out the landscape of Delville, his 4·5-ha. estate in the suburbs of Dublin, in 1728 and for 25 years after their marriage they continued its improvement in a whimsical, rococo style. They made rustic seats and bridges, a temple, a shell grotto and a bowling alley, an orangery and a menagerie. They could boast 'an Irish harper sometimes playing tunes under the nut trees'. It was to become the essence of the romantic-poetic garden in *Ireland. A biography, *Mrs Delany*, by Ruth Hayden was published in London in 1980. P.B.

Delhi, India, See HUMĀYŪN'S TOMB; NEW DELHI; RED FORT; SHALAMAR BAGH.

Del Tè, Palazzo, Mantua, Italy. See TÈ, PALAZZO DEL.

Demesne, a term used in Ireland to refer to the ornamental parts of a gentleman's estate. P.B.

Demeure Historique, La, an association founded in France by Dr Joachim Carvallo (see *Villandry) in 1924 to promote the study and conservation of houses, parks, and gardens of historic or artistic interest, and to make them known. Owners of places classed or listed as *monuments historiques* are entitled to be *membres titulaires*, and may receive grants for maintenance or restoration varying according to whether or not the house is open to the public. The Association's illustrated journal, *La Demeure historique*, is published three times a year. K.A.S.W.

Denmark. It was no coincidence that the Danes called their country 'field (mark) of the Danes'. It is a region of well-defined, well-planted, and well-tended farms, presenting from the air a neat pattern of trim fields interspersed by tidy little villages. Most of today's towns have grown up at road junctions and harbours, and around cathedrals and monasteries of the 12th and 13th cs.

Horticulture was introduced to Denmark by the monks, with an emphasis on medicinal plants, and herb and vegetable gardens. However, it was not until c. 1700 that garden making in Denmark could be described as an art. King Frederik IV (1699–1730) saw the great gardens of *Le Nôtre in France and returned home overwhelmed by his impressions. In the mean time, the King had succeeded in establishing an absolute monarchy, reducing the feudal nobles to a dependent status.

The result was the building of *Frederiksberg Castle (begun 1699); in the same year the Swedish architect Nicodemus *Tessin (the younger) made a design for the garden which unfortunately was not carried out, as a design by Hans Henrik Scheel was realized instead. The work was later taken over by Johan Cornelius Krieger, a gardener who acted as both architect and landscape architect, and who formed the terraced grounds around the castle. In 1717 Frederik IV started building *Fredensborg Castle: the master builder was an Italian, Marcantonio Pelli, with Krieger designing the garden. A far more difficult commission was undertaken by Krieger when he created the garden at *Frederiksborg Castle. Regrettably the cascade and parterre constructions are lost, but the interplay between the lime-tree avenues and the oval pond still makes a powerful design statement.

The nobility was also captivated by the new garden ideals. Financial constraints meant that if they could not afford marble terraces and cascades, they substituted grassed and planted earth ramparts, and excavated ponds edged with timber or glacial boulders. Thus, rather than being empty imitations of the more refined Italian and French gardens, they became a Danish expression of the great European epoch of garden-making.

The rise of the middle classes at the end of the 18th c. led to the demise of the formal garden. The aesthetes of the period thought that the simple cottage in a field, with woods, hedgerows, and grassy bank, suddenly seemed as beautiful as the most ingeniously designed formal garden (see *Liselund). In Denmark the landscape garden developed in much the same way as in other European countries, beginning with romantic natural scenery and gradually becoming set in empty formalism. The great landscape architects of the time were *Rothe (1802–77), *Flindt (1822–1901), and *Glæsel (1858–1915), who can perhaps be regarded as the founders of the Danish landscape architecture profession. Many landscaped parks were laid out in grounds of castles and manor-houses, but a number of fine baroque gardens were lost, for example at Frederiksberg.

Landscape architecture. Public works became more prominent with the development of parks and landscape planning around public buildings. During the first decade of the 20th c. a more formal type of garden design began to assert itself, so that by c.1920 strictly formal gardens were intricately bound up with the symmetrical houses of the time. This was a rich period for emerging personalities, such as E. Erstad-Jorgensen (1871–1945), I. P. Andersen (1877–1942), and G. N. *Brandt (1878–1945), who formed the vanguard of the modern landscape movement in Denmark. Brandt in particular can be regarded as the great personality of that period; he designed many cemeteries and crematoria, whose landscape design has reached a highly developed stage in Scandinavia. Today they are regarded as part of the parks system, and as such have a manifold function. Woodland cemeteries are refuges for wildlife, and urban cemeteries are parks for passive recreation. Other important landscape architects were S. I. *Andersson, Andreas

*Bruun, E. *Langkilde, P. *Wad, and the architect Arne *Jacobsen. P.R.J.

See also CLAUSHOLM; EGESKOV; GISSELFELD; GLORUP; SCULPTURE GARDEN; TIVOLI, COPENHAGEN.

Derby Arboretum, Derbyshire, England, is a landmark in the development of *public parks. Opened in Sept. 1840 it gave its designer, J. C. *Loudon, the opportunity to create a public arboretum and to use the *gardenesque method of planting—an opportunity denied him at *Birmingham Botanical Garden (1831), where his plans were not executed.

The 4·4-ha. site was given to the town of Derby by a philanthropist, Joseph Strutt, to be laid out as a public garden, open free throughout the year for two days a week (one of which was Sunday) with only moderate charges on other days, thus making it much more accessible than any other botanical garden of the period. It was to be inexpensive to maintain; two lodges were to be built, one of which was to be considered a public room.

The site, then on the edge of the town, was well drained but in other respects most unpromising. Loudon rightly considered that 'with reference to its adaptation for a garden of recreation' its main disadvantage was 'that there is no distant prospect, or view beyond the grounds, worthy of being taken' (*The Derby Arboretum*, 1840, p. 71). To deal with this problem mounds of soil varying in height from 2·2 m. to 3·1 m. were raised in order to shut out the surrounding views—this is the most innovative and successful feature of the Arboretum.

This may also have helped concentrate the visitor's mind on the central purpose of the Arboretum—'to excite an interest in the subject of trees and shrubs in the minds of general observers' (ibid., p. 1). Loudon had decided against a collection of herbaceous plants because it would be too expensive to make and to maintain, and there would be nothing to see in the winter; he rejected the idea of a general botanical garden as 'a mere composition of trees and shrubs with turf, in the manner of a common pleasure ground [which] would become insipid after being seen two or three times' (ibid., p. 72).

The ground plan (made in May 1839) also served this central purpose, following principles previously stated by Loudon ('Remarks on laying out Public Gardens and Promenades', *The Gardener's Magazine*, 1835, p. 645): that there should be one main walk, along which the main objects should be seen (there are in fact two at Derby, but for the same purpose); that the walk should begin and end with a main entrance; and that the 'small episodical walks' should branch off from the main walk.

The main features of the Arboretum exist in reasonable condition, although some unsatisfactory later additions within the grounds rather spoil the simplicity of Loudon's original design. P.G.

Désert de Retz, Chambourcy, Yvelines, France, was created by François Nicolas Henry Racine, Baron de Monville (1734–97), who acquired the estate in 1774, and

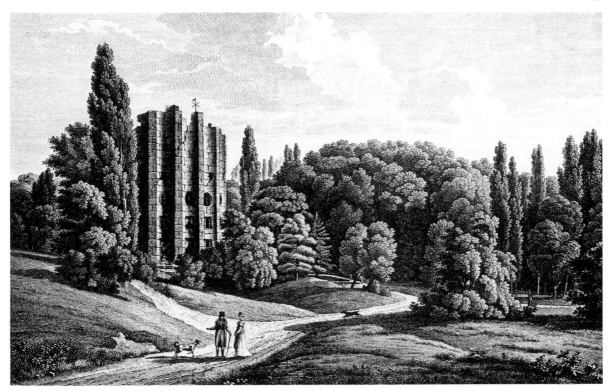

Le Désert de Retz, Yvelines, France, from A. de Laborde, *Nouveaux Jardins de la France* (1808)

from that time until the Revolution, assisted by the designer Barbier, devoted the whole of his immense fortune to laying out the Désert, which reflects the odd character of its owner, and is one of the strangest and most poetic creations inspired by the taste for the *jardin anglo-chinois*.

Access was through a vast pile of rocks forming a grotto and past a pyramidal *ice-house covered with weeds, before arriving at the house (1780), a strange building with the external appearance of the shaft of a colossal broken column, and containing apartments on three storeys, skilfully arranged and luxuriously furnished. Monville's first residence had been the Maison Chinoise (1776), the only private dwelling of its kind in Europe. Built of teak beside a pond, it illustrates the fashion for ethnological exoticism introduced into Europe by the publications of William *Chambers. Other features included the temple of Pan, the genuine Gothic ruins of the old village church, and the *mur de scène* of an open theatre. Heated glasshouses and Chinese orangeries housed many rare varieties of plants; and a model farm with a kitchen garden, where the master of the house engaged in agricultural experiments, completed this unique ensemble. Long abandoned, the estate is today the object of careful restoration. M.M. (trans. K.A.S.W.)

See also RUIN.

Desgots, a family of French royal gardeners and garden designers. **Jean Desgots** was in charge of the *allées* and *palissades* of the Tuileries in 1614. His brother **Pierre Desgots** (d. 1688), who held the post until his death, married Elizabeth, sister of André *Le Nôtre, with whom he collaborated. **Claude Desgots** (d. 1732), son of Pierre, worked closely with his uncle, André Le Nôtre. A project for Choisy (for Mlle de Montpensier) is signed jointly by him and his father. He designed the Labyrinthe (1679) at Chantilly, and is thought to have made the designs for Anet (1681–8). He visited England on Le Nôtre's behalf in 1689, concerning plans for Greenwich and Windsor; there are two plans of parterres by him for Cliveden, dated 1713. On Le Nôtre's death in 1700, Claude Desgots succeeded him as *contrôleur général des bâtiments*; he became a member of the Academy of Architecture in 1717. Among his works were: redesigning the gardens of the *Luxembourg and Palais Royal; projects for the Duc de Lorraine; the reconstruction of the château of Perrigny in Burgundy; and plans for the parks of Bagnolet, *Rambouillet, and Saint-Maur.

K.A.S.W.

See also GARNIER DE L'ISLE.

D'Este, Villa, Cernóbbio, Lake Como, Lombardy, Italy. Built *c.*1570 for Cardinal Tolomeo Gallio (1527–1607) by Pellegrino Pellegrini, it was renamed Villa d'Este by Caroline of Brunswick (wife of the English king, George IV) when she bought it in 1815. The villa has long been a hotel, and of what was once one of the finest Renaissance gardens

on Lake Como there remains only the double water-staircase flanked by a superb avenue of cypresses and magnolias. H.S.-P.

D'Este, Villa, Tivoli, Lazio, Italy. In 1550 Cardinal Ippolito II d'Este (1509–72) of Ferrara, was appointed governor of the hill town of Tivoli, 30 km. east of Rome. Whenever his papal ambitions were frustrated in the four conclaves between 1550 and 1559 he returned to Tivoli, but it was not until the summer of 1560 that work began in earnest on the gardens, which were mainly completed by 1575. He aimed to excel his great rival Cardinal Farnese, who was building the magnificent Palazzo *Farnese, Caprarola; he did so, not in architecture, but by making the most spectacular of all Italian gardens.

It lies on the steep western slopes of the town, with views south-west across the *campagna* to Rome and north-west to the Sabine Hills. The design was influenced by the neighbouring *Hadrian's Villa and the terraces of the

Temple of Fortune at *Praeneste, the ruins of both of which had been studied in detail by Pirro *Ligorio, the Cardinal's iconographical adviser. The Villa d'Este, however, is more than a reconstruction of a Roman villa, for it is a highly imaginative Renaissance garden in its own right.

The house stands at the summit of a series of majestic terraces linked by a dramatic central stairway and adjoining ramps, aligned along one central axis. Originally the entrance to the garden was by a gateway at the lowest level, upon which the first notable feature is a circular plantation of cypresses (the Rotunda of Cypresses), which was flanked by four mazes.

The first major cross axis runs from the north-west to the south-east from the Fountain of the Organ, from which the water originally fell by an irregular cascade into three rectangular fish-ponds (four were planned). It now falls via the Fountain of Neptune (1927). The second level has the Fountain of the Owl at the south-east end. The next ascent is managed the most dramatically—on the central axis by

Villa d'Este, Tivoli, engraving (1573, after du Pérac) which includes features not actually completed

means of two ramped staircases curving as a semicircle around the Fountain of the Dragons; and, to the east, the Bollori staircase, so called because of the 42 low water-jets on its flanking walls, which give the impression of boiling water.

This brings one to the third level, with the Pathway of the One Hundred Fountains, which consists of three rows of small fountains (see *water in the landscape). At the back of the middle row were 100 stucco reliefs (few now surviving) of scenes from Ovid's *Metamorphoses*. The pathway terminates at the north-west end of the Fountain of the Oval, near which is the Grotto of Venus, and at the south-east end in the Rometta, a fountain arranged (by Ligorio) to portray the Seven Hills of Rome and their major monuments, such as the Colosseum, the Septizonium, and the Pantheon. Little of the Rometta now remains. A series of ramps then leads to the uppermost terrace, which is terminated by a Roman triumphal arch framing the distant view. At the south-east end of the terrace is the Grotto of Diana.

The lavish water displays which are the outstanding feature of the garden were made possible by two main sources—an aqueduct from the distant Monte Sant' Angelo and a conduit diverting water from the River Aniene. The latter (completed by 1565) ensured the constant flow of water (at 1,200 litres per second) at sufficient pressure to make the water displays possible.

The fountain displays are still very impressive, but the water-powered *automata have completely disappeared. Water was used to make artificial sounds—such as the music from the Fountain of the Organ (begun 1568) which generated a trumpet call, followed by a harmonious sound (du Pérac's claim in 1573 that the organ 'plays by itself any madrigal tune one desires in four or five voices' is perhaps exaggerated); and the Fountain of the Dragons, which, *Montaigne noted, produced the sounds of 'cannon-shots and muskets'. The most complex was the Fountain of the Owl (begun c.1566), in which birds, perched on branches made of bronze, were made to chirp, and their song would stop when an owl appeared and began to hoot mournfully.

The water was also shaped to produce remarkable effects. Around several ponds fountains were arranged so as to make a 'thick and continuous rain . . . fall in the pond. The sun falling upon it produces at the bottom of the pond, and in the air, and all around the place a rainbow so natural and distinct that in no way falls short of what we see in the sky' (Montaigne, *Journal*, 3 Apr. 1581).

There were also *giochi d'acqua. The writer of an early, invaluable description of the gardens (Antonio del Re, *Dell'Antichità Tiburtine*, Rome, 1611, Capitolo V) mentions four 'deceits' (*inganni*). One of them was on a flight of steps— an unknowing visitor standing in a particular place on the steps would be drenched from the waist downwards by water gushing from above. An illustration by Venturini (1685) shows visitors fleeing from at least three groups of *giochi d'acqua*.

A major feature which has completely vanished from the garden is the statuary, much of it taken from Hadrian's Villa. Without this, it is difficult to visualize the extremely elaborate iconographical programme drawn up for the Cardinal by Ligorio. Essentially it symbolized the dual dedication of the garden—to Hercules (symbol of strength, from whom the d'Este family had imaginatively traced their ancestry) and to Hippolytus (symbol of chastity). The symbolism was incorporated in the gardens by the placing of the statues in important positions (for example, the statues of Hercules were placed along the main axis) or by the organization of the axes in relation to the placing of statues so as to present the spectator with a choice. Thus, the crossroads at the Fountain of Dragons leads either to virtue (the Grotto of Diana) or to vice (the Grotto of Venus). (For an excellent account of the programme, see David R. Coffin, *The Villa d'Este at Tivoli*, Princeton, 1960, Ch.V.)

The gardens were reasonably well maintained and even some new features (such as the Fountain of the Bicchierone, attributed to G. L. Bernini) were added in the 17th c. Their decline began at the end of that century—F. M. Misson noted in 1688 that 'the greatest part of the Water-Pipes are unfortunately stopp'd, and the Machins out of Order' (quoted ibid., p. 121); in 1740 the gardens were completely neglected (de Brosses). During the 18th c. the movable statuary was almost entirely removed. The picturesque decay of the gardens inspired painters such as Hubert Robert and Fragonard, who spent the summer of 1760 there. Fragonard made a series of red chalk drawings of the fountains, now in the Museum of Besançon. The garden has been the property of the Italian state since 1918—the planting is somewhat overgrown but the water-works are well maintained. P.G.

De Voorst, Gelderland, The Netherlands. Jacob *Roman, with the collaboration of Daniel *Marot, was mainly responsible for this country house and its gardens, which were commissioned in 1685 by Arnold Joost van Keppel, created Earl of Albemarle in 1697 and a favourite courtier of William III.

The general rectangular outline of the gardens (290 m. × 430 m. or c.12 ha.) is similar to that of *Het Loo, with an enclosed garden below each wing and, before the house, a wide terraced lower garden containing Renaissance square parterres enlivened by a fountain in the centre and followed by an upper garden whose semicircular arboured termination is reminiscent of *Richelieu.

Marot's designs for some of the ornamentation are illustrated in his engravings of which one is a fountain derived from Charles Le Brun's Bassin d'Apollon at *Versailles and another is an ornate *treillage arbour with statues, fountains, and seats in niches. F.H.

De Vries, Hans Vredeman (1527–1606), Dutch painter, decorative designer, architect, and designer of gardens and garden ornament, was the first to publish garden pattern books (*Hortorum viridariorumque elegantes et multi plicis formae*, 1583) and the first Netherlander to conceive of the garden as an art form. Exponent of the Netherlandish Mannerist garden which was medieval in structure and

Mannerist in ornament, his influence is reflected throughout northern Europe.

His gardens are characterized by a series of separate trellised or galleried plots adorned with highly intricate parterres, topiary, arbours, and fountains, the designs of which were a personal interpretation of the classical orders. He designed gardens and fountains for the Duke of Braunschweig (c.1587) at Wolfenbüttel and for Emperor Rudolph II (c.1596) in Prague and garden pavilions and *trompe-l'œil* panels of garden vistas in Antwerp and Hamburg.

His most significant contribution to European gardens was his use of *parterres de pièces coupées* (see *parterre), intended for the display of exotic plants. As intricate as his strapwork designs, the de Vriesian parterres were employed throughout northern Europe during the 17th c., from the *Hortus Palatinus in Heidelberg to a small Middelburg garden in Zeeland and from the Swindius garden in Frankfurt to the volute parterres, albeit in a modified form, at the Trianon de Porcelaine at *Versailles. His gardens are reflected in designs by Hans Puec (c.1590), in Crispijn van de Passe's *Hortus Floridus* (1614), in Laurembergius's *Horticultura libris II* (1632), in Furttenbach's *Architectura recreationis* (1640), and in Jan *van der Groen's *Den Nederlandtsen Hovenier* (1669). F.H.

See also CZECHOSLOVAKIA: RENAISSANCE GARDENS; MAZE, LABYRINTH.

De Wildenborg, Vorden, Gelderland, The Netherlands. When H. D. Staring added two wings on either side of an existing medieval gate tower in 1782, he laid out formal gardens on the former site of the castle which was surrounded by a double moat. In the early 19th c. A. C. W. Staring (1767–1840), the Dutch poet, added a winding beech tunnel leading to a woodland and, on the main axis of the house, a long rectangular carp pond.

The grounds were landscaped in c.1840, the formal moat being transformed into a curving lake linking up with the pond. Swamp cypresses (*Taxodium distichum*), cedars of Lebanon (*Cedrus libani*), trees of heaven (*Ailanthus altissima*), and Indian bean trees (*Catalpa bignonioides*) were planted. Other additions were a rectangular swimming-pond enclosed by hornbeam, a rustic pavilion, and a boat-house.

After 1930 A. Staring brought the gardens to perfection, interjecting within the existing framework a series of square and circular verdant rooms, highlighted by 17th- and 18th-c. statues, leading to unexpected vistas. F.H.

Dezallier d'Argenville, Antoine-Joseph (1680–1765), French naturalist, engraver, and writer on art. In 1709 he published anonymously *La Théorie et la pratique du jardinage*, which owed much to his close contemporary Jean-Baptiste *Le Blond. His treatise popularized the manner of *Le Nôtre and his school in the laying out of ornamental gardens: parterres, *bosquets*, fountains, basins, and cascades. Following the first edition, an augmented version in 1713

enlarged on the technical aspects of planting and hydraulics. In 1722 the publisher Mariette put Le Blond's name on the title-page; but, in a foreword to the fourth edition in 1747, Dezallier claimed authorship, while acknowledging his indebtedness to Le Blond for three-quarters of the plates. The book ran to 11 editions, in three languages. John *James's English translation of the first edition appeared in 1712. It introduced the concept of the *ha-ha, and anticipated Pope's famous dictum on the 'genius of the place' by saying that the designer of gardens should never swerve from Reason, but constantly conform 'to that which suits best with the natural situation'. K.A.S.W.

Dijon, France, Parc de la Colombière. See PARC DE LA COLOMBIÈRE.

Dioscorides (1st c. AD), was born in Asia Minor and became a physician, probably an army doctor. No contemporary copies of his collection of plant descriptions known as *De Materia Medica* survive, one of the earliest versions extant being the manuscript known as the *Codex Vindobonensis*, an illustrated copy made c.512 for Juliana Anicia, a Byzantine princess. This manuscript has been kept in the National Library in Vienna since late in the 16th c., except for a brief period after the First World War, when it was taken to Italy. The *Codex* is illustrated with nearly 400 full-page drawings, each c.38 cm. × 30 cm., and most of the illustrations are coloured. It is at once a corner-stone of *botanical illustration and early botany. Its influence on later *herbals was immense, through copies, translations, adaptations, and commentaries, in both manuscript and printed form.

Some of the plants mentioned by Dioscorides are still well known as sources of useful drugs—the opium poppy, for example. Many of his plant-names have also survived, attached to similar or quite unrelated plants in modern systems of botanical nomenclature. His advice to herbalists to study live plants and learn their characteristics in order to recognize them accurately seems essential in any age. S.R.

Dipping well, a small pool, half vaulted over, below a terrace. It was fed by a wall fountain, and in turn it would feed further pools at lower levels. Great use was made of dipping wells by Edwin *Lutyens, at The *Deanery Garden, *Hestercombe, and Abbotswood, Gloucestershire, among other places. M.W.R.S.

Disabled people, Gardens for. The curative and therapeutic value of horticulture has been recognized since the 18th c., but it is only in the 20th c. that it has gained professional recognition and the design of gardens for disabled people has been studied. Early work concentrated on the training of occupational therapists in the use of horticulture as an alternative therapy to traditional methods. Courses were started in the United States in 1919 at the Menninger Foundation in this new discipline of 'Hortitherapy', and by 1950 Michigan State University offered a Master's degree in the subject.

In Britain active research into gardens and gardening for disabled people started in 1964. Research gardens were set up at the Nuffield Orthopaedic Centre, Oxford, at Mount Vernon Hospital, Middlesex, and at the Wolfson Rehabilitation Centre, Wimbledon, and a research gardener was appointed at the first of these. In 1970 the first public display garden was opened at Syon Park, London. Designed to demonstrate the design concepts and gardening techniques developed at the research gardens, this garden was followed by other display gardens at Battersea Park, London (1975) and the Royal Horticultural Society Garden, Wisley (1977).

Three distinct locations for gardens for disabled people exist, each with its own style of design. The first is the open-air therapy unit located within hospital grounds; this is now becoming accepted as an integral feature in the range of facilities used in the assessment and therapy of patients. Usually located in close proximity to toilets and the Occupational Therapy Unit, these gardens are designed for intensive active use by patients, who use either gardening or the garden itself as a therapeutic tool. Features most commonly included are a greenhouse (with wheelchair access), a tool-shed, cultivated ground (for heavy work assessment and practice rather than crop production), and raised planters and worktops of varying heights. The hard landscape includes elements intended to simulate conditions experienced in everyday life, such as kerbs, bus platforms, steps, and different types of uneven surfaces. Permanent planting is included to provide structural and visual links with the rest of the landscape and plant material for associated hobbies and therapy (such as for cooking), and to keep the garden looking attractive during periods when it is not being actively used.

Secondly, there are institutional gardens which may be designed for a range of disability groups; the Cheshire Foundation Home, Timsbury, Avon, for example, has gardens planned to provide a refreshing environment for the residents, as well as areas where residents can carry out their own gardening. Shelter, shade, views out of the building, and views to the outside world are important features. Planting is designed to have a multiple use: thus trees are selected which will give shade and provide structure to the garden, as well as produce flowers which can be cut and fruit which can be picked. Because of the disorientation of long-stay residents, the planting is also designed to give strong seasonal interest. Alternatively, gardens may be designed for a specific group; the Baytree Special School, Yatton, Avon, for example, has been planned to provide a pleasant and educative environment which will give a high level of sensory stimulation for the profoundly mentally handicapped who use it. A double-width contour slide accessible from a wheelchair is included, together with play water-features. All plant material which could be allergenic or toxic has been excluded.

Finally, there are gardens for disabled people in public areas. Apart from display gardens, the most common examples are allotments for disabled people, as at Stockton Road, Haringey, London, and Cheetham and Crumpsall, Manchester; and leisure gardens for disabled people set within a public park, such as those in Roundhay Park, Liverpool and Mesnes Park, Wigan. These feature raised planters, and plants trained to bring the 'working area' within reach of the user, such as cordon apple trees. In some areas the gardens of sheltered housing units provided by local authorities are designed specifically for the disabled, as, for example, at the Banim Street and Munden Street schemes in the London Borough of Haringey, where a wide range of facilities is provided for both communal and private use, and where features such as aviaries are used to establish link points with the local schools and the community. In public areas provision may also be made for a specific group such as disabled children, whose adventure playgrounds feature such things as soft play equipment and climbing frames accessible from wheelchairs.

Gardens for active or passive use by disabled people can be found in many countries. It is notable that in other countries botanic gardens often play a much greater social and educative role than in the United Kingdom, and many of them make provision for disabled people. The United States probably has the greatest number of gardens for disabled people. For example, 21 per cent of the hospitals of the Veterans Administration have gardens for disabled people, and many public parks and gardens are now designed for integrated use. In Canada the Royal Botanic Gardens, Hamilton, are used extensively by all types of disabled people, and many parts of the gardens are specifically designed for them. Seven of Australia's botanic gardens have gardens and training facilities for disabled people. In Europe many examples of gardens for disabled people exist; the Park House, Dublin, for example, has training and demonstration gardens for physically handicapped people, and the De Drie Hoven old peoples' centre in Amsterdam concentrates on gardens designed and used by the community. In the Third World, organizations such as the Cheshire Foundation and the Landuse Volunteers of Horticultural Therapy are active in producing gardens for the disabled but in many cases this work concentrates on the use of horticulture and agriculture as a means of self-sufficiency and employment, as at the National Rehabilitation Centre, Zimbabwe. N.J.R.

Ditchley Park, Oxfordshire, England, is shown in a 1726 survey with its new house by James Gibbs on a 213-m. long terrace built on Grims Ditch. Tree-planted walks had been extended for 40 m. along this Saxon earthwork in the 17th c. There was already some forest gardening in the *Evelyn manner, with 'lights' running through Wychwood Forest and aligned on the old house, but the radiating avenues with triumphal arches and temples, said to have been part of the Gibbs design, were not carried out. A rococo scene appeared in the valley in the 1750s with a menagerie enclosure and a Chinese bridge across the fish-pond around which was a walk to a grotto head. About 1760 some naturalizing took place; the terrace was removed and smooth lawns swept down to the lake, on the other side of which a rotunda by Leadbetter was built on a knoll. Ameri-

can trees were planted in the quarry. In 1806 J. C. *Loudon altered the shape of the lake and introduced groups of exotic trees and shrubs on the lawns. In 1936 Geoffrey *Jellicoe reinstated the terrace and made formal gardens near the house. M.L.B.

Di xue means moon door or, literally, ground hole. In Chinese garden design, this is a decorative doorway in either a boundary or an interior garden wall. The openings vary from octagonal or circular 'moon' shapes (the circle in China signifies Heaven) to the more fanciful outlines of a gourd, leaf, or vase—this last is popular since the word for vase (*ping*) sounds like the word for peace. Such doorways usually lead to an end vista (*dui jing*). X.-W.L./M.K.

See also GE YUAN.

Dobříš Castle, Central Bohemia, Czechoslovakia, was built between 1745 and 1770 following the design of the architects Robert de Cotte and G. Servandoni for the owner of the estate, J. P. Mansfeld. De Cotte probably also designed the large orangery and the garden. The garden, spread over five terraces, with a main axis c. 200 m. long, is prolonged visually by the position of statues, clipped trees, and *trompe-l'œil* wall paintings by Quirin Jahn on the north façade of the orangery. Finished in 1767, it reminded its owners of the garden at *Schönbrunn.

About 1800 a landscape park of 32 ha. was laid out under the old fortress, Vargač. Its most interesting features are the shaping of the banks of the lake and a romantic inlet. The large meadows with many fine specimen trees, mostly of local origin, were enriched with natural stone terraces with romantic caves and a terrace with views of the Vargač fortress and the castle.

The original parterre with the circular *bassin* near the castle was altered according to the designs of the French architect Touret in 1911 and has survived. O.B./P.G.

Dodoens, Rembert (1517–85), Flemish herbalist, studied medicine at Louvain and travelled in France, Italy, and Germany before returning to Malines. Late in his life he took the chair of medicine at the University of Leiden, where he died. His *herbal or *Crüÿdeboeck*, which owes much to that of *Fuchs, including its pictures, was published in 1554 and, through the medium of a French translation by *Clusius, became the basis of Henry Lyte's *Nievve Herball*, published in 1578. A larger botanical book, in fact his collected botanical works, *Stirpium Historiae Pemptades Sex*, was published in 1583. He worked in collaboration with his younger compatriots, Clusius and *L'Obel; the books of all three were influenced by those of the others in the group. S.R.

Donà dalle Rose, Villa, Veneto, Italy. See GIARDINO BARBARIGO.

Doria-Pamphili, Villa, Rome. The park lies on the Janiculum, within sight of the dome of St Peter's. The pleasure *casino* and garden, rather a minor incident in the vast park 9

km. in circumference, were designed by Alessandro Algardi in 1650. A slightly later engraving (G. B. Falda, *Le Fontane di Roma*, Rome, 1691) shows a Fountain of Venus set in the retaining wall of the terrace immediately in front of the house. Two staircases lead down from the terrace to a *giardino segreto* which has simple *parterres de broderie* enclosed by low walls.

After 1850 the whole area was laid out in the English romantic style and, when the new landscape had matured, the park inspired artists like Corot and is recalled in a painting by De Camp now in the Wallace Collection in London. P.G.

Doria Principe, Palazzo, Genoa, Liguria, Italy. Situated on a hillside at Fassolo, just outside the city walls, the palace was built by an unknown Genoese architect for Admiral Andrea Doria (1468?–1560), the founder of the Genoese republic. The three terraces were added in 1543 by Giovanni Angelo Montorsoli (1507?–63), who also laid out the extensive gardens, containing numerous fountains, parterres, and pergolas, which stretched from the hillside to the sea.

As at the Villa *Medici, Castello, where he had worked previously, the focal point for the whole garden was a large statue—a larger than lifesize stucco figure of Neptune—in the lower garden by the harbour. This was later replaced by a marble fountain, *Neptune on a Sea Chariot* (Taddeo Carlone, 1599), which depicts Neptune and horses surrounded by the Dorian eagles. According to Evelyn (*Diary*, 17 Oct. 1644), there was also 'an Aviary . . . supported with huge Iron Worke very stupendious to consider'.

The Palazzo Doria gardens were a place for formal entertainments (such as the Festival of Unity, held annually from 1528 to 1797 in celebration of the founding of the Genoese Republic) and triumphal entries.

The gardens were swallowed up in the 19th-c. expansion of the city, although the statue of Neptune survives on its original site. P.G.

Dornburg, Gera, German Democratic Republic, has a park of 3.9 ha. divided into several terraces and containing three palaces. Goethe spent much time here and commemorated the gardens in such poems as 'An den aufgehenden Vollmond', which he wrote here.

On the long, narrow piece of ground which extends down the hillside through vineyards stands the Altes Schloss, built in its present form from 1451, the Renaissance Schloss (built after 1539) in which Goethe stayed, and the Rococo Schloss (1736–47). Work on restoration of the palaces was completed in 1962, and on the gardens c. 1965, partly to plans by H. Schüttauf.

By the Renaissance Schloss at the side of a wide forecourt with a fountain is a small, regular garden divided by a *treillage* walk; statues add greatly to its charm. On the other side plantations on different levels of ground separate the Rococo Schloss. A spacious pergola leads to the Altes Schloss and affords a view over vine terraces far into the Saale valley. Behind the pergola is a rococo garden,

enclosed by lime hedges, which contains a pond framed by flower-beds, surrounded by box trees and lawns. There is a profusion of roses everywhere and it is these, and narrow herbaceous borders, which give the grounds their distinctive character. H.GÜ.

Douglas, David (1798–1834), Scottish plant-collector, worked at the Glasgow Botanic Garden under William Hooker, who recommended him to the (Royal) Horticultural Society as a collector in 1823. He made a short visit to eastern North America in that year, visiting *Nuttall and the garden established by John *Bartram. In 1824, with the help of the Hudson's Bay Company, he sailed for the west coast, making his base at Fort Vancouver for three years, while he explored British Columbia and Oregon. From this journey came the Douglas fir (*Pseudotsuga menziesii*) and so many other conifers that he wrote to Hooker 'You will begin to think that I manufacture Pines at my pleasure'. One of them was the Sitka spruce (*Picea sitchensis*), as well as other trees important in modern forestry. Other plants included the flowering currant (*Ribes sanguineum*), the Californian poppy (*Eschscholtzia californica*), and *Lupinus polyphyllus*, the ancestor of most garden lupins.

In 1830 he returned to North America, travelling in California till 1832, when he visited Hawaii. From California he sent back *Garrya elliptica* and many annuals, among them godetias and the poached-egg plant (*Limnanthes douglasii*). An attack of rheumatic fever inhibited his work in Hawaii, and he returned to Fort Vancouver and more exploration of British Columbia, where his canoe was wrecked on the Fraser River. His journals, notes, and collections were all lost. He went back to Hawaii in 1834 and was killed there when he fell into a pit-trap which already held a wild bull. S.R.

Dovecot. See PIGEON HOUSE.

Downing, Andrew Jackson (1815–52), American landscape gardener, was the first American authority on taste and the interdependence of beauty and usefulness in both gardens and architecture. The son of a nurseryman, he grew up on the banks of the Hudson River among the large estates first settled by the Dutch. By the time he built his own house upon the Hudson and designed his garden (see *Newburgh Garden), he had read widely on gardening and architecture in the works of *Burke, *Gilpin, *Price, Humphry *Repton, and, in particular, J. C. *Loudon, his chief arbiter and influence, although Downing felt Loudon lacked imagination and that his books were unsuitable to the American soils and climate. Besides his still valid books on fruit-growing, Downing laid down his own rules for domestic architecture and garden design in the first important books by an American author on these subjects, *A Treatise on the Theory and Practice of Landscape Gardening* (1841) and *Cottage Residences* (1842).

Downing's influence was incalculable. His approaches were typically American. Drawing examples from the landscape, he sketched for his illustration of the beautiful a scene not unlike the estates he was used to along the Hudson: an undulating plain of emerald turf; noble groups of roundheaded trees interspersed with specimens with foliage dropping to the turf beneath them; the sky reflected in a sylvan lake with banks covered with flowers and shrubs. For the picturesque, he proposed a woody glen or romantic valley with banks overhung by vines and clustered trees; against the sky a horizontally branched larch or pine; in the foreground rough and irregular trunks; open glades of bright verdure opposed to dark masses of shady foliage; water confined to a cascade leaping over rocks, or the sound of a noisy brook; and, perhaps, an old mill with its wheel turned by the stream. By fixing these two different views in our minds, Downing says, we will be able to see 'the difference in the expression of even single trees' as when, in a single American elm, we see 'the perfect balance of all its parts resulting from growth under the most favourable influences . . . the finest form of a fine type'.

Downing offered choices of houses appropriate to his two sorts of landscape. The first man's property, beautifully groomed with curved walks following undulating surfaces, drooping branches, water in sheets with curved margins embellished by shrubs with flowers arranged in 'dressed portions' near the house, should have a house in 'the classical modes', preferably Italian, either Tuscan or Venetian—since these lend themselves to the 'graceful accompaniment of vases, urns, and other harmonious accessories'. For the 'picturesque' landscaped garden with its abrupt surfaces, old and irregular pines, wild water cascading, and with the whole less carefully kept than in the 'graceful school', the style of house should be a Gothic mansion or an old English cottage.

Reducing his ideas to the reach of the smallest householder—since the American goal was to have every man own his own home—he asserted that the beautiful could be achieved by one perfectly grown tree in a mown lawn bordered by flowers and shrubs, and the picturesque by a Gothic cottage sited cleverly in a wild wood. Americans, he remarked, seemed to prefer the picturesque approach, probably because it was the easier to realize in a wild landscape and possibly because of an American preference for violence over calm.

Downing was also the first proponent of the idea of American public parks. He supported his idea with an appraisal of the popular appeal of rural cemeteries as recreation resources, such as the Woodlands and *Mount Auburn. As editor of *The Horticulturalist* in 1849, he hailed 'as one of the most remarkable illustrations of the popular taste in this country . . . the rise and progress of our public cemeteries'. He wrote that 'The great attraction of these cemeteries is not in the fact that they are burial places . . . all these might be realized in a burial ground planted with straight lines of willows and sombre avenues of evergreens . . . [but] in the natural beauty of the sites, and in the tasteful and harmonious embellishment of these sites by art.'

In 1850 he visited England, ostensibly to search for a young architect to assist him. He secured the services of Calvert Vaux who was later to help him in laying out the

grounds of the Capitol, the White House, and the new Smithsonian Institution. After Downing's tragic death in 1852, Vaux worked with *Olmsted on *Central Park, so Downing's ideas were finally implemented in the development of American public parks. His death deprived American landscape gardening of its leading author and practitioner. A.L.

See also UNITED STATES: DEVELOPMENT OF AN AMERICAN STYLE.

Dragon wall. See YUN QIANG.

Drottningholm, Stockholm, Sweden. This royal palace and garden, the finest example of the baroque style in the country, was completed between 1680 and 1700 for the dowager Queen Hedvig Eleonora. Nicodemus *Tessin the elder designed the palace and made several plans for the garden, one of which (c. 1665) is very advanced. It is unlikely that Tessin could have produced such a modern plan, and it is now generally believed that it was drawn up in France under the supervision of Le Nôtre.

The plan adopted from 1681 is by *Tessin the younger. It has many ideas in common with the earlier plan but is better adapted to local conditions. The garden is c. 800 m. × 180 m., and entirely enclosed by a double avenue of limes. Between a *parterre de broderie and *bosquets a water parterre is situated on a lower level. Of very high quality are the

sculptural adornments—such as the fountain of Hercules by Adrian de Vries—which are mostly war trophies from Denmark and Prague.

Although many details are borrowed from Italian and French gardens (as, for example, the water parterre from Chantilly), the layout as a whole is an independent creation. The water parterre, including the cascade wall which was ruined during the 19th c., was restored in 1961, since when the garden as a whole has been under continuous restoration.

Adjoining the park is the rococo *Chinoiserie folly called Kina which has a little park of its own in a somewhat freer style dating from 1763, and an English park landscaped by Gustavus III and F. M. *Piper, c. 1780. G.A.

See also TURKISH TENT.

Druid cave (or cell), the name given to some *hermitages in the 18th c. when there was considerable antiquarian interest in the Druids, e.g. the Druid's Cell at *Stourhead.
 M.W.R.S.

See also FOLLY.

Drummond Castle Gardens, Perthshire (Tayside Region), Scotland, are the first gardens in which an old style of design has been consciously revived. At the time it may have seemed more like restoration, but it was effectively the

Drummond Castle, Tayside, Scotland

re-creation of an idea of the 17th-c. Scottish garden, a subject often returned to during the 19th and early 20th cs.

Drummond Castle itself is a tower-house, and next to it, across a courtyard, is the house; below them is the great *parterre garden, laid out generally in the shape of a St Andrew's cross. At its centre is the famous sundial made for the house in 1630 by John Mylne, Master Mason to Charles I, but apart from this, the grounds date from the 19th c. Lewis Kennedy, who worked at Drummond from 1818 to 1860, appears to have been responsible for the design and execution of the garden, which is in the shape of a rather long rectangle, the diagonals of the St Andrew's cross being consequently stretched out: on this pattern a central square with flanking rectangles was established by three main walkways.

Although now much simplified, the compartments generated by these lines were originally filled with shrubs and herbaceous plants. Old photographs indicate that this was a more satisfactory arrangement than today's: it made a happy confusion of plants without the structure of the garden appearing too prominent. W.A.B.

Dry landscapes. See KARE-SANSUI.

Du Cerceau, Jacques Androuet (c.1515/20–c.1584), French architect and engraver, travelled in Italy sometime between 1534 and 1544, and was granted a monopoly for the sale of his engravings by François I in 1545. His workshop in Orléans was destroyed during the religious wars; and, as a Huguenot, he took refuge at *Montargis with Renée of France, supervising the rebuilding of the castle, and serving her as almoner and envoy.

Livre d'architecture (1539) was the first printed architectural handbook by a Frenchman, preceding Philibert de *l'Orme's by two years. *Second Livre d'architecture* (1561) has designs for *fountains and garden pavilions, overloaded with ornament and Mannerist in the full sense of the term. Imaginary reconstructions of Roman gardens occur in *Monuments antiques* (1560); small gardens in the style of Vredeman *de Vries in a series of *petites habitations*; and he left a collection of knot designs (*entrelacs*), intended for gardens since they recur in one of his projects for a *bâtiment de plaisir*. Best known are his two volumes of *Les plus excellents bâtiments de France* (1576 and 1579), whose text and engravings are the main source of information on French garden design in the 16th c. (see Montargis). These included designs for Charleval and Verneuil, which are attributed to him, although he himself did not claim authorship. His sons, Baptiste (c.1544/7–90) and Jacques II (d. 1614), were architects; and his daughter Julienne was the mother of Salomon de Brosse, who subsequently worked at Verneuil. K.A.S.W.

See also DUMBARTON OAKS; FRANCE: THE FRENCH RENAISSANCE GARDEN.

Duchêne, Achille (1866–1947), French garden designer and restorer, was the son and principal collaborator of his father, **Henri Duchêne** (1841–1902), who started the restoration of French parks and gardens in the classic style. Besides contributing largely to the reconstruction of historic parks like *Vaux-le-Vicomte, Le Marais, *Champs-sur-Marne, and *Courances, they created new ones, such as Voisins and Condé-sur-Iton, a reconstruction in the 18th-c. manner. It is difficult to assess their individual contribution, as they worked together on the same projects. The success of these works gained Achille Duchêne a commission to design the gardens of *Blenheim for the Duke of Marlborough.

Social upheavals at the beginning of the 20th c. and the decrease in great private fortunes led Achille Duchêne to think that there was no more call for designing grand gardens purely for ornament, but that the future lay with communal gardens. Some years before the 1932 international economic crisis, he prepared his work *Les Jardins de l'avenir*, published in 1935, in which he showed projects of his own conception. 'They are gardens for use by the community; for education, recreation and rest; gardens for sport, games and the enjoyment of all', wrote Ferdinand *Duprat in *La Revue horticole* of 1948. C.R./S.Z.

Dui jing means facing view or end vista. In Chinese gardens much attention is given to arranging paths, turnings, successive doorways, window openings, and trees so that the line of sight is led to whatever view can be created.

 X.-W.L./M.K.

Duin-en-Berg, Noord-Holland, The Netherlands. This garden, which was laid out c.1730 along the dunes to the north of Haarlem, is notable for its asymmetrical layout, probably the first in the Netherlands (*see over*). On an irregular terrain of c.14 ha. which incorporated sloping dunes, dense woods were pierced by winding walks and rectilinear *allées* intersecting at oblique angles. *Utile dulci* was represented by the skilful integration of meadows and orchards against the backdrop of the woods and by statues, *bassins*, mounts, and mazes. F.H.

Du Le Yuan, China. The fame of this 11th-c. Garden of Pleasure in Solitude rests on a collection of poems written about it by its maker, the great historian of the Northern Song dynasty, Sima Guang (1019–89). At one time Prime Minister and leader of a conservative faction, he later suffered such setbacks that he retired from active politics to the old capital city of Luoyang in Henan province and devoted himself to history and his garden. Compared to other gardens of the time described in 'The Famous Gardens of Luoyang' (*Luo Yang Ming Yuan Ji*), it was a modest retreat with beds of herbs, wooden fences, and thatched pavilions, lying in the southern part of the city and separate from his house. A 'fisherman's hut' was made of tree bamboos planted in a ring and then bent over and tied together at the tips. However, the historian also collected a library of some five thousand volumes in the Book Reading Hall where, he says in his preface, he took 'the sages as his teachers and the many virtuous men [of antiquity] as his friends: if his resolve was weary and his body exhausted, he took a rod and caught fish, held up his sleeves and picked

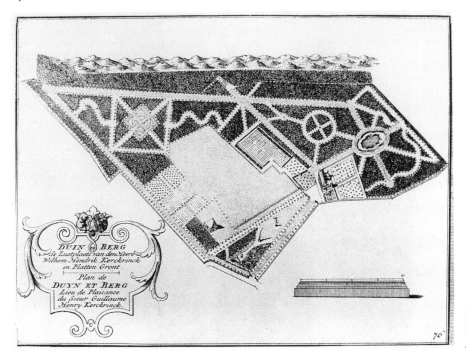

Plan of Duin-en-Berg, Netherlands, engraving by Hendrik de Leth in *Het Zegenpralent Kennermerlant*

herbs . . . His eyes, lungs, feelings were all his own. What enjoyment could be greater than this?' His words inspired many later gardeners and artists, among them the Qing painter Qiu Ying (1510–51) whose long and exceptionally beautiful handscroll follows the historian's descriptions of his garden. C.-Z.C./M.K.

Dumbarton Oaks, Washington, DC, United States, designed between 1921 and 1947 by Beatrix *Farrand with her client Mildred Barnes Bliss, is one of the United States' finest gardens and one of its few remaining well-maintained examples of a type of garden representative of the Country House Era. When work began in 1922, there were on the property some fine trees, primarily native American oaks, many of which were integrated into the garden scheme. In addition there were outstanding specimens of silver maples, Japanese maples, paulownia, katsura, and beech which Beatrix Farrand carefully preserved. She also relied on

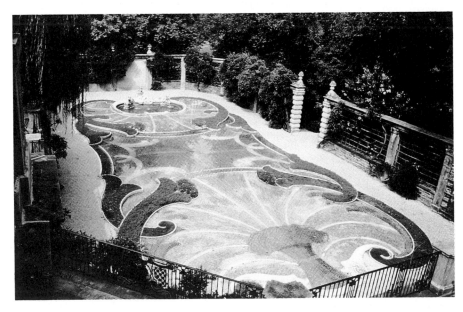

Pebble garden at Dumbarton Oaks, Washington DC, by Beatrix Farrand

broadleaf evergreens to form the structure of the design and to provide strong textural interest. The plants most commonly used in the design—oak, yew, holly, and boxwood—are the embodiment of the deepest associations with the older gardens of England.

The present garden, consisting of all the original formal spaces and some of the naturalistic portions, was presented to Harvard University in 1941. The dominant part is the Rose-garden, characterized by a wash of colour, deepening in hue from north to south. Also of importance are the North Vista, the Pebble Garden, the Green, and the Urn and Fountain Terraces. The Arbor Terrace features an arbour of tidewater cypress modified from a design of *du Cerceau, while the Lover's Lane Pool is directly below a garden theatre adapted from the open-air theatre on the slopes of the Janiculum Hill at the Bosco Parrasio (see *Arcadian Academy). The garden is European in feeling with important details representative of the *Arts and Crafts movement including ironwork together with teak and cypress. The design of many of the gates is characterized by a plant motif and this varies considerably in elaborateness and stylization. Garden furniture has been designed for specific places in the garden. The Orangery, built c.1810, has recently been restored. D.K.M.

Duncombe Park, North Yorkshire, England, is a landmark in the development of the English natural style (see *Eng-

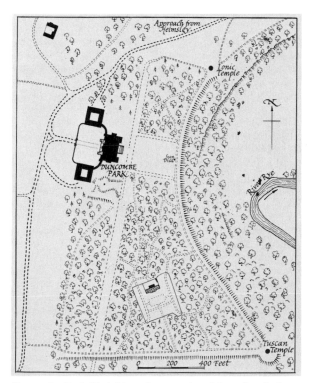

Duncombe Park, Yorkshire, plan reproduced from the 1856 Ordnance Survey map

land: Development of the English style), antedating Castle Howard, on account of the terrace created between 1713 and 1718 by Thomas Brown Duncombe. Instead of a formal avenue, centred on the house, we find the house deliberately sited so as to take advantage of views over the landscape. It may have been *Vanbrugh who advised Duncombe in taking this momentous step.

A large square of levelled lawn (c.50 sq.m.) leads from the house (now a school) to a Father Time sundial ascribed to *van Nost, on the inner edge of the terrace. The grassy *terrace walk, 0·8 km. long, sweeps away from the house left and right in a concave curve along the lip of an escarpment with a sensational prospect eastwards through woodland openings down to the River Rye in its winding cascaded course far below in the valley. To the left of the house the terrace leads to Vanbrugh's Ionic, domed, open rotunda (c.1718), below which is a massive serpentining *ha-ha wall, preceding *Bridgeman's at Stowe and one of its first uses in this country. To the right, the terrace curves to a wooded promontory where a closed circular Tuscan temple (c.1730) has views over the Plain of York. It is sometimes claimed that *Rievaulx Terrace was envisaged as a continuation of this terrace. K.LE.

Dunmore Park, Stirlingshire (Central Region), Scotland. See PINEAPPLE, THE.

Du Pérac (or Pérat), Etienne (1525/35–1604), French architect, went to Rome in 1559. He published an engraving of the Villa *d'Este at Tivoli (1573), which may have been drawn before its completion as it shows features which were never made. A book of etchings, I vestigi dell'antichità di Roma (1575), includes the Mausoleum of Augustus laid out as a circular garden. *Henri IV appointed him architecte du roi in 1595; it may be assumed that he supervised the terracing at *Saint-Germain-en-Laye. K.A.S.W.

Duprat, Ferdinand (1887–1976), French landscape architect, designed more than 300 parks and gardens in France, Europe, Asia, Africa, and America, of which two have become classified sites: *La Roche-Courbon in Saintonge, and Vayres in Gironde. He also prepared a design for *Villette in the Ile-de-France but this was not carried out.

From 1904 to 1925 he studied in Paris, Belgium, England, Italy, Spain, and Morocco. In 1930 he became the President of the Société Française des Architectes de Jardins, which he created, and Vice-President of the International Federation of Landscape Architects (27 nations from five continents) founded in 1948. On 20 Nov. 1934, he was appointed professor of garden architecture and town-planning at the Ecole Nationale d'Horticulture at Versailles. Thus he has contributed much to the development of teaching landscape and the art of gardens in France.

He won the Prix d'Honneur and the Grand Prix in the World Exhibitions at Barcelona, Antwerp, Brussels, and Paris. He was entrusted with the publication of Jardins d'aujourd'hui by the committee of the art of gardens of the Société Nationale des Horticulteurs de France. He

published numerous reports on the architecture of gardens and sports grounds, carried out town-planning works such as the garden city of 'Providence' at Pont-Faverger (Marne), and gave plans for the extension and improvement of Alençon (Orne) and Pyla Plage (Gironde). C.R./S.Z.

Durdans, Surrey, England, is shown in a painting of 1673 at Berkeley Castle, Gloucestershire, as having a large walled square garden of four grass plats (see *parterre) surrounded and divided by gravel walks. Each plat had a border and a central brass statue, and a fountain and circular pool stood at the centre of the whole garden. Facing the house across the garden was a double terrace remarked upon by John *Evelyn and Celia *Fiennes. The garden was one of a number of Italian-inspired terraced parterres of the 1630s but with plain grass instead of cut-work or *parterre de broderie. Other examples could be seen in the Privy Garden at *Hampton Court and at Temple Newsam and Much Hadham. Beyond the terraces was a woodland garden with a grotto, whose central axis continued the axis of the parterre. John Evelyn was deeply impressed by Durdans, and it often appears in his letters and other writings. D.L.J.

Dutch colonial gardens. Under the aegis of the Dutch East and West India Companies, established in 1602 and 1621 respectively, gardens were laid out in such diverse parts of the world as Indonesia, New York, Brazil, Surinam, South Africa, Ceylon (Sri Lanka), and India. They reflected the mind of the Dutch who transported to alien soil their Calvinist-classical ideals and scientific, botanical, and horticultural expertise, as well as a certain mercantile zeal. Most gardens were based on the principles of the Dutch classical garden (see The *Netherlands) and many, due to similar geographic conditions, were intersected and encompassed by canals. By the end of the 17th c. a cultural syncretism took place, in particular in the East Indies, where an oriental influence is reflected. A significant achievement throughout the colonies was in the field of botany and horticultural science where indigenous and foreign plants were cultivated and acclimatized.

Brazil. The most outstanding example of a Dutch classical garden in the colonies was that laid out by *Johan Maurits of Nassau-Siegen at Vrijburg Palace (1639), Mauritsstad (Recife), Brazil, where he served as Governor-General of the Dutch colony (New Holland) from 1637 to 1644. Linking the sciences with *utile dulci*, Maurits, possibly assisted by Pieter *Post, skilfully incorporated within a unified plan botanical and zoological gardens, pleasure and kitchen gardens. Following the contour of the land, the gardens of *c.*6 ha. were trapezoid in shape and surrounded by wide avenues of coconut palms successfully transplanted at an advanced age. Significant in this geometric design were the variety of the parts and an appreciation of natural forms as evidenced by irregular-shaped ponds and islands. A long central avenue flanked by palms extended from the Palladian palace through the gardens to the Capibariba River. Along this central axis were citrus and fig groves,

banana plantations, bowling-greens with circular galleries, and, near the river, fish-ponds containing islands with plantations and rabbit warrens. On either side of the palace were cruciform arbours, planted with pomegranates and vines, which served as a framework for herbs and shrubs enclosed by espaliered lemon trees.

See also SOUTH AMERICA: BRAZIL.

New York. In contrast with Brazil, no gardens in the grand manner or of exceptional design were laid out in New Netherland, the earliest colony established by the Dutch West India Company in 1624. Similar to the small city or farm gardens of the Netherlands, the gardens were utilitarian in nature with occasional flower parterres in de Vriesian patterns. Gardens of a certain allure were those laid out by the Company and by Peter Stuyvesant, Director-General from 1646 to 1664, whose garden at his mansion on the Battery in Manhattan (*c.*1658) recalls *van der Groen's simple plan with compartments of parterres and orchards on either side of a main axis. Dutch horticultural expertise is reflected in a list of ornamental plants compiled by Adriaen van der Donck who settled in New Amsterdam (Manhattan) in 1642 (*Beschryvinge van Nieuw Nederlant* 'Descriptions of New Netherland', 1655). He mentions tulips, crown imperials, snakeheads, autumn crocuses, roses, carnations, lilacs, and such American natives as sunflowers, lilies (*Lilium philadelphicum, L. superbum, L. canadense*), morning stars, and three species of lady's-slippers (*Cypripedium acaule, C. reginae,* and *C. pubescens*).

South Africa. By the end of the 17th c. the renown of the Dutch East India Company gardens at Table Bay on the Cape of Good Hope was almost legendary. Established in 1652 by van Riebeeck, the colony's first governor, the gardens became an important centre for the experimentation and cultivation of indigenous and foreign plants, like Johan Maurits's short-lived Brazilian gardens. Père Tachard (*c.*1683) regarded them as 'one of the most beautiful and curious gardens' he had ever seen, whose beauty lay in the fine collection of trees and flowers from 'all parts of the world'. Derived from the accounts of travellers, Sir William *Temple concluded that they represented 'the Hesperides of our age'. The elongated orthogonal framework of the gardens surrounded by water and trees formed an integral part of the rational plan (*c.*1656) of the settlement. Three broad avenues of camphor and bay trees flanked by lemons, oranges, and pomegranates were intersected by transverse axes which formed square hedged compartments containing European and exotic trees, herbs, and flowers. Under Simon van der Stel (governor from 1679 to 1699) the gardens were enlarged and enhanced by ornamental plants and fanciful parterres.

See also SOUTH AFRICA.

Indonesia. The Dutch classical canal garden was a model for the numerous 17th-c. country places in the Dutch East Indies (Indonesia). However, a significant example of the

juxtaposition of oriental ornamentation to the rigid Dutch framework was the garden (*c.*1737) of Governor-General Adriaan Valckenier outside Batavia (Jakarta). A miniature Chinese sacred mountain incongruously surmounted by a gilt Neptune was the focal point at the end of the central avenue. Pagodas with ponds and spouting dragons, Palladian villas, ruins, bridges, hermitages, and dwarf trees formed miniature landscapes around the craggy surfaces. Pavilions with classical columns and Chinese roofs were further ornamental additions. Of botanical importance was Buitenzorg (Sanssouci or Bogor), a large country estate laid out by van Imhoff in *c.*1743 which developed into one of the leading botanical institutions of the world, known today as Hortus Bogoriensis or *Kebun Raya. F.H.

Dyrham Park, Gloucestershire (Avon), England. William Blathwayt (1649–1717), Secretary of State to William III, employed William Talman and George *London to lay out a new house and gardens here from 1698. The western forecourt and gardens and the elaborate *parterre with clipped greens to the east were conventional, but the irregularity of the surrounding limestone hills led to an otherwise unusual layout. The greenhouse south of the house formed the termination of a string of water features parallel to the main axis through the house. From a hill in the park the water ran down a cascade of 224 steps, said by one visitor to be the finest in England excepting *Chatsworth, through pools and fountains into a long canal. North of the parterre there were terraces and above these a wilderness. Stephen *Switzer admired the 'beautiful Irregularity' of the situation and the many excellent prospects. Notwithstanding the sums of money spent to bring the gardens to perfection, evident from Kip's view, he considered 'that Nature has a greater share in the Beauties I am proceeding to than Art'. By 1835 little trace of Blathwayt's formal gardens remained, and this may have been connected with Humphry *Repton's visits and his Red Book of 1802.

Dyrham Park became the property of the National Trust in 1961. D.L.J.

Eckbo, Garrett (1910–), American landscape architect and city planner, was brought up in California, which later became the base for his extensive practice. He has been a pioneer in modern landscape design, not only in relating it to modern art, but by his concept that gardens are for people, and for each individual in particular. His philosophy has been presented in his book *The Landscape We See* (1969) (with co-authors Dean, Austin, and Williams) in which he emphasizes the complexities of domestic garden design, writing that 'Residential design is the most intricate, specialized, demanding, responsible, and frustrating field for designers'. His city planning projects, mostly in south-west Asia, have all been imbued with a similar sense of 'people'.

Eckbo has long been associated with the University of California at Berkeley, where he is Professor Emeritus.

Among his numerous awards is the Medal of the American Society of Landscape Architects, of which he is a Fellow.

<div align="right">G.A.J.</div>

Ecology and gardens. The connection between ecology and the garden is not a recent phenomenon. Ecology—the science of the relationship between living organisms and their physical environment—is in fact fundamental to understanding the garden. What has been happening in the 20th c., and at an accelerating rate in recent years, is a redefinition of the relationship between man, nature, and the garden.

In 1597 it was possible for Francis *Bacon in his essay *Of Gardens* to define the garden as an escape from nature because nature still posed a threat to man. In the 20th c.

Shade garden in Los Angeles by Eckbo, Dean, Austin, and Williams

we know the reverse is true, and natural features, particularly in the urban environment, have become increasingly scarce.

Pioneers in the United States. One response to this situation has been the development of a conservation movement to protect the natural landscape. This began in the middle years of the 19th c. when philosophers like Henry Thoreau began to appreciate the growing threat to nature from increasing urbanization. Thoreau believed that this was not simply a rural problem but that it was the natural features, such as waterfalls, rocks, forests, and individual trees, which made a township handsome.

One of the earliest pioneers of a natural approach to garden design was Jens *Jensen who emigrated to the United States from Denmark in 1884. He formed a friendship with Frank Lloyd *Wright and together they developed the 'Prairie Style' of architecture and landscape, using indigenous plant material. The finest surviving example of Jensen's work is the Lincoln Memorial Garden in Springfield, Illinois, begun in 1933. This was developed on 24 ha. of farmland on the shores of Lake Illinois and, like that of many recent natural landscapes, the plan is deceptively simple. Its form is a series of large meadows separated by lanes, each one given over to a single species or association, leading down to the lakeside walk. The garden was planted over many years using 'masses of young trees and shrubs planted close together for informal protection as in nature'; Jensen's plan allowed considerable freedom of execution but demanded strict adherence to principle. Today the garden is so completely natural that it is hard to believe that it is an artificial landscape. But Jensen's landscapes were not a slavish duplication of nature. As Alfred Caldwell wrote in his book on Jensen, *The Prairie Spirit*, 'the sense of space repudiates the tyranny of closure. It repudiates the sterile masonry terrain of the cities today that are prisons, spaceless and visionless. It asserts the right to wide green earth.'

The Netherlands. Jensen's desire to bring the city dweller a message from the countryside outside the city walls would have been readily understood by the Dutch teacher and biologist Jaques P. Thijsse. Thijsse was aware of the change that would inevitably come to the Dutch landscape when towns and industry began to expand, and believed that the landscape would be destroyed before people were aware of its beauty or significance. He was also acutely conscious that existing parks and gardens failed to give people an experience of their natural environment. In 1925 the Thijsse Hof opened in Bloemendaal near Haarlem and on a 2-ha. site Thijsse and his gardener C. Sipkes created a natural garden, following the design of the landscape architect Leonard Springer. The garden contains a small woodland, a pond and marsh, a piece of heathland, a dune landscape, and a cereal field with rare arable weeds. The garden was intended for use by teachers, children, and other visitors, a function it still performs.

Such early instructive gardens as the Thijsse Hof and the landscape garden in the Zuider Park in The Hague led to the development of the *heem* park and garden. The oldest

and most beautiful of these is called appropriately the Jaques P. Thijsse Park in Amstelveen, south of Amsterdam. This 2-ha. *heem* park, started in 1940 by Broerse and later developed by Landwehr, takes the form of a series of woodland glades, each one successfully creating a landscape picture. A broad ecotone (the edge between the woody vegetation and the water) is designed to bring together the widest range of habitats and plants. Here, in Landwehr's words, 'it is possible for a wider public to be educated about wild flora so people will become aware that nature is something we cannot replace or do without'. In spite of their naturalness, *heem* parks and gardens like the Thijsse park require careful maintenance to remove unwanted plants. To overcome this, the phytosociological garden has been developed in which the characteristic habitats and plant communities of the surrounding area are re-created. The most attractive example of this approach is at Madestein in The Hague, opened in 1982. Madestein is close to the North Sea and is located on what was formerly a market garden. The fertile top-soil has been removed to reveal sand dunes and dune slacks whilst differences in topography have been further exaggerated, and drainage ditches, dikes, different shorelines, and shallow lakes have been constructed. The result is a landscape with limestone-rich and limestone-poor dunes, damp dune slacks, dune woodlands, and islands for birds. In time it is expected that this garden will require only annual mowing of the grass and reeds and an occasional thinning of the trees.

One further idea being pursued by ecologists in the Netherlands is the creation of parks and gardens by encouraging the spontaneous development of vegetation. This approach derives from detailed study of natural communities which reveals that the richness and diversity of species reflect the variation in the abiotic environment of which the principal components are soil and water, with the added factor of a low nutrient status. By paying particular attention to the laying down of the soil and its water relationship, Dr Londo believes that the spontaneous development of vegetation supported by sympathetic management will lead to a new, self-maintaining garden. He has established an experimental garden at the Rijksinstituut voor Natuurbeheer in Broekhuingen.

These examples can be described as specialist gardens in which botanical aspects perhaps predominate. Today there are examples of these nature-like gardens stimulating and synthesizing the more general design of gardens and parks associated with houses, offices, and factories. The new landscape at the Nederlandse Omroep Stichting Television Studios demonstrates how a gradual transition can be achieved from a visibly artificial environment in the neighbourhood of the buildings to an area of naturalistic design beyond. In so doing the landscape architect Jan Boon has achieved a successful 'gradient between the intensive and extensive environment, from the activities of the human milieu to the natural environment where the values of man and nature come into balance'.

Britain. In Britain the development of a natural approach to

park and garden design and the use of ecological principles have been slow to develop, although there has been a fast-growing interest in wildlife both in the garden and in the city. Typical of this development is the William Curtis Ecological Park created on the site of a former lorry park close to London's Tower Bridge. This park is not beautiful in the sense of the Dutch heem parks and gardens but it shows how natural areas can be simply created in cities and towns. In a space of less than half a hectare a wide range of biotopes has been created with considerable spontaneous development of vegetation. In this respect the William Curtis park has been highly successful, since out of a total of 348 species of plants as many as 205 have established spontaneously. The record with fauna is equally impressive. The other success of the William Curtis park and similar ecological parks is in providing new educational opportunities for children.

These developments illustrate ways in which the relationship between man, nature, and the garden is changing during the 20th c. Of course, the notion of whether a spontaneously developed garden is a garden at all will be strongly contested. What is certain is that these developments are once again putting nature in a central place of influence in the design of parks and gardens. A.R.R.

See also WILD GARDEN.

Eden, Garden of. According to Genesis, 'a river went out of Eden to water the garden; and from thence it was parted, and became four heads'. The concept of Eden as a garden is also to be found in non-Christian religions. Thus the quadripartite garden (or *chahar bagh*), and the idea of the garden as paradise, are parts of Persian (Iranian) culture, dating back to 6000 BC, which was continued by the gardens of *Islam. The idea of Eden was also a powerful source of inspiration in the gardens of *Byzantium. Traditionally it was located in *Mesopotamia. P.G.

Edinburgh, Royal Botanic Garden, Scotland, lies near the heart of the Scottish capital city with its 24·8 ha. of garden, famed for their beauty and their science. Originally started on another site in 1670 by Robert Sibbald and Andrew Balfour, for the demonstration of medicinal herbs to university medical students, it was not until the 1820s that the present site was acquired by Robert Graham, the Regius Keeper. William McNab was the principal gardener in charge of the move, during which he developed new techniques for transplanting trees and shrubs, and in 1834 the large Palm House was built and placed in his charge. James McNab succeeded his father while Professor John Hutton Balfour was Regius Keeper and it was they who built the first rock-garden, known today as one of the finest in the world after its reconstruction by Balfour's son Isaac in 1908. Now vast and splendid, it is landscaped with rock outcrops, moraines, and streams to create habitats for thousands of alpines growing there, within sight of the spires and towers of the city centre. Many of the new plants raised from seed collected by George *Forrest in China from 1904 to 1931

were grown there during the Keepership of Isaac Bayley Balfour (son of J. H. Balfour), who was responsible for its reconstruction. Elsewhere extensive plantings of new species of *Rhododendron* and *Primula* transformed it into the leading garden for the study of these and other Asiatic genera.

There are many other features, including displays of live hedges composed of different shrubs, and the large exhibition plant-houses opened in 1967, with exterior roof supports allowing a large clear space for tropical plants. The new *herbarium building dominates one side of the garden near experimental greenhouses which are used for specialist research, and there is a large exhibition hall. The house that was once the Keeper's residence is now a gallery of modern art. F.N.H.

Education for garden design, Britain. Since 1945 the subject of garden design has been to some extent overshadowed by the rapid growth of the profession of landscape architecture, which is now well served by design courses in publicly financed educational institutions in Britain (see *landscape architecture: education for landscape architecture in Britain). The parallel growth of the landscape industry represented by horticulture, plant nurseries, garden centres, and landscape contracting has highlighted a similar need for courses specifically for the design of gardens. This is just beginning to be met by a few private courses, including those at the Chelsea Physic Garden, and at the Inchbald School of Design, both in London; and a course run by John *Brookes at Fontwell, near Arundel in Sussex. Subjects include art and design appreciation, basic design, graphic communication, materials, construction, and planting techniques. J.BRO./M.L.L.

Edzell Castle, Angus (Tayside Region), Scotland, a fairly typical tower-house with ruined wings forming a quadrangle on its north-east side, has a slightly larger walled enclosure on its south-east side forming an early 17th-c. *pleasance, the last feature to be added to the castle and by far its principal ornament. The design of Edzell is thought to be the work of the owner Sir David Lindsay and his mason, and it attests to the skill and civility of men in his position in late 16th- and early 17th-c. *Scotland.

The garden is entered from the castle courtyard by a gate on the south side; a bath-house and slightly smaller summer-house stand in the southern corners. But it is the design of the walls themselves that is most remarkable. They are divided regularly into panels of flower-boxes (or birds' nests) alternating with bas-relief sculpture: for the east wall, the planetary deities; for the south wall, the liberal arts; and for the west wall, the cardinal virtues. The figures are taken from Continental engravings.

The layout of the garden itself is unknown. It is certain that it was more richly furnished with plants than is now the case. The walls would probably have been set off with rows of trees on the garden side making effective galleries. But it is only because of the stone sculptured walls that some idea of the garden has survived. W.A.B.

Egeskov, Fyn, Denmark. The grounds around the 16th-c. fortified manor-house which rises from a lake are the most elaborate and best known in Denmark, and contain a series of gardens in different styles, separated by hedges of beech and hornbeam. The French Renaissance garden (1550) has been newly restored and contains a maze of clipped beech

(1861). One enclosure is planted as a traditional farmhouse garden, another is a flower garden. There is also a baroque garden (1730) and an English garden. A new informal garden, with shrubs, evergreen trees, and herbaceous plants, and a silver and grey garden lie to the south-west.

P.R.J.

Egypt, Ancient

DYNASTIC PERIOD (*c.*2950–332 BC). Egypt is the source of the world's oldest pictures of gardens and the location of an exceptionally long and seminal tradition of gardening. The basic type of garden was probably established by the Old Kingdom (*c.*2600–2150 BC) and greatly developed during the New Kingdom (*c.*1530–1070).

Climate; origins. The country is temperate to subtropical and almost rainless, so that the annual inundation of the Nile was necessary for agriculture, allowing winter crops to be produced after the flood water receded, from roughly the middle of October. From the first, however, perennial irrigation and weeding of small areas must have been necessary in order to raise vegetables. The climate allows these to be grown virtually all year round, as was desirable with a largely cereal diet, and in the hot summer months the labour of watering was best shaded. Palms and fruit-trees needed most attention in summer when the fruit ripened, and they provided shade; they could be irrigated, or their roots could tap the ground water. Gardens also needed protection from unwanted flooding—although some encroachment is beneficial—and from the persistent winds. Settlements were generally on slightly elevated ground near the river, from which water could be drawn if a garden contained no pool, so that villages were naturally integrated with gardens. The pool was essential to all gardens of any size, being valued for its cool appearance, its plants, its provision of irrigation water, its attraction for birds, and its fish. In difficult locations pools or wells were dug out to extraordinary depths so that ground water could be reached. This pattern of gardening in or on the edge of settlements may go back far into prehistory, when food production was more horticultural than agricultural in scale.

The general importance of gardens emerges in short 'biographies' of Old Kingdom high officials (*c.*2350–2150) which describe an ideal life in stereotyped form. People say 'I came from my town; I returned from my estate [typical journeys]; I built a house and set up doorways; I dug a pool and planted trees.' In this vision of estate life, pleasure is taken in observing agricultural work and watching or participating in agricultural or marsh pursuits. Nearer home, house, pool, and trees form the core of a garden; laying out a garden is integral to a full life. Vegetables, which were so important that professional growers were employed for people who lived in the desert and could not produce their own, are never mentioned in these texts. This shows that

they had no great prestige, not that gardens did not contain them.

Gardens never left their origins behind entirely. None seem to have been exclusively ornamental: all produced at least fruit from trees and vines, as well as flowers for cutting. They were set among walls and buildings; layout was highly formal and geometric. The natural landscape was not imitated or 'domesticated', which is not surprising in a country which consists largely of the flat floodplain with its few trees and the plantless desert plateaux and mountains. Another important characteristic is the lack of ground cover. Bare, unirrigated earth surrounds and defines the plants, all of which must be irrigated and intensively weeded; where there is no irrigation, only deep-rooted trees and palms grow.

Representations and descriptions. The first indication of gardening is on one of the earliest preserved reliefs (*c.*3000 BC), which shows an area crossed by waterways, in one part of which is a palm with a protective enclosure round its base; this must be a 'specimen' plant rather than part of a grove, either in a building compound or in a settlement.

From the Old Kingdom no pictures of ornamental gardens are known. A few scenes show vegetable plots, some fruit-trees, and pools. Everything here was used, including the lotus in the pool, the Egyptians' favourite flowers, which were cut in vast quantities, and the papyrus on the pool edge, which was also harvested. In detail these austere reliefs show elaborate chequer-board arrangements which optimize the watering of each small plant. These beds were laboriously irrigated from pots carried in pairs hanging from yokes. Some actual beds have been excavated at the Egyptian fortress of Mirgissa in the northern Sudan (*c.*1800); the squares had a side of *c.*45 cm. and the complete plot was 13 m. square. A comparable system survives to this day for the horticultural crops of Egyptian smallholders. The general design of a garden is implied in one relief where beds flank a central pool. This disposition suggests that real gardens were already arranged symmetrically, and were visually satisfying as well as productive.

The reliefs do not tell the whole story. Texts of the Old and Middle Kingdoms (2550–1640), during which pictures show us no real developments in garden design, refer to a house plot of about a hectare, much of which would be garden. Others mentioning life at court refer to the *she* of the palace, which may be the pool, or garden, or both, suggest-

ing that the king conducted business by a landscaped and colonnaded pool. A later cycle of stories (c.1600) depicts King Snofru (c.2550) boating on his 'pool', which is large enough to take a boat rowed by 20 beautiful women clad only in nets. Another story in the same papyrus shows a wife taking advantage of her husband's absence to invite her lover to spend a day in a pavilion in the garden (similar to the shelters used by the wealthy in the fields and marshes). When evening comes the lover goes for a swim in the pool, which later harbours a crocodile sent by the husband.

These texts tell us about associations of gardens but do not allow us to envisage them. A minimal pleasure-garden is preserved in a model of c.2000 BC. A house portico with two rows of grand columns faces on to a small enclosure, more than half of which is filled with a pool, round whose edges are seven trees; there could have been flowers beside the pool. From the New Kingdom (c.1500–1250 BC) there are paintings of estate gardens. The earliest (c.1480) includes a list of the trees, among them 73 sycamores, 31 perseas, 180 date palms, 120 dom palms (*Hyphaene thebaica*), 5 fig trees, 2 moringa trees, 12 grape-vines, 5 pomegranate trees, 1 *Medemia argun* palm (now extinct), 9 willows, tamarisks, and various unidentifiable species. Most of these plants bore fruit, but some may have been kept for other properties including, for the *Medemia argun*, rarity. The picture shows a wall enclosing a house with granaries, a pavilion, a pool, and rows of trees in no particular order—a productive estate that was also enjoyed as a garden. The lack of elaborate arrangement is compensated in later pictures, all of which show some planning.

The grandest of all these paintings belonged to the 'overseer of the plantation of [the god] Amun' of c.1400 BC, from which 'all sorts of plants' were presented to the king. The picture probably shows this 'plantation', which is approached from a quay, beside which is a row of trees in front of a large temple-like entrance in the enclosure wall. Inside are four pools, many stands of trees, a large area of grape vines, inner groups of trees surrounded by their own walls, two pavilions, a small temple with another pool with marsh plants beside it, and a house. The pools will have been distributed for ease of irrigation, but they also create a set of areas centred on water rather than a massive field. This 'additive' design is in keeping with the formal spirit of all these gardens, which can also be seen here in the strictly symmetrical total layout. Since this was the garden of a god, one is left wondering who was privileged to sit in its pavilions.

These large gardens would have contained flower-beds, often next to the pools, but the beds are seldom shown, perhaps because of problems of scale. Of the more than 100 species of garden plants known from Egypt, many were valued for their flowers, the most important being lotus (two species and later a third), papyrus for its umbels, corn-flower, poppy, *Chrysanthemum coronarium*, and mandrake. Reliefs of the 7th–4th cs. BC show lilies (species uncertain) being harvested and pressed to make perfume. A number of herbs and spices were grown and valued both for their flowers and for flavour, medicinal purposes, and use in preservation and mummification; among these were dill, marjoram, rosemary, coriander, and cumin. It is uncertain whether vegetable gardens were separate from the formal tree gardens we know, and how far spices and flowers were grown in market-garden style. Such gardens might be attached to the palace, great temples, and major administrative institutions, but there was little 'market' for perishables, because in the non-money economy people mostly received them as part of their 'pay' or produced them for themselves. The definition of a parcel of land by reference to a cucumber patch in an inscription of the mid-1st millennium BC shows that some 'market' gardens could be landmarks. More modest part-pleasure-gardens probably continued to include a pool, trees, flowers, and vegetables.

Landscape design and temples. From before 2000 BC temples could be approached through groves of trees which both landscaped public spaces and acted as a transition to the inner areas, where many of the architectural elements were derived from plant forms, particularly aquatic plants, symbolizing the swamp-like environment of the world at creation. For the temple of Nebhepetre Mentuhotpe at Deir el-Bahri in western Thebes (c.2020), tree pits up to 10 m deep were dug in the desert forecourt. States of the king were set up in the shade of the larger trees (*Ficus sycomorus*), and there were large separate flower-beds. There was a similar scheme in front of the adjacent terraced temple of Hatshepsut (c.1470), where the trees were imported incense trees from Eritrea or Somalia, which would keep their resit perpetually available for the god (the introduction was a failure).

The most striking example of plants in a temple is a set of reliefs of many different species (mostly unidentifiable) with a large variety of birds in a court, often called the 'botanical garden', of the temple of Karnak (c.1440). These are said to be 'all sorts of plants and flowers which [King Thutmose III] brought' from campaigns to Syria and Palestine, although many Egyptian plants are also shown. The plants are presented as 'specimens' with detached fruits, and are probably offered to the god as a token of his beneficence in creating the world of nature. With the title of books on the moringa tree and the pomegranate (?) preserved from c.1360, these reliefs constitute rare evidence for 'plantsmanship'.

In the 14th c. BC the ceremonial capital, Thebes, was laid out on a grand scale with alleys of sphinxes up to 3 km. long linking temples; these were probably planted with trees, as later renewal programmes certainly were. An enormous temple was built on the opposite, west bank of the Nile near a vast palace; an artificial harbour, 1 km. × 2.5 km. in size, was excavated between the two. The outer parts of the temple contained plants, as surely did the palace, and the entire project was probably landscaped, the most colossal marriage of architecture and plants known from Egypt. In a text from the same area, the *maru* of Amun, a 'pleasure temple', is said to be the 'place of relaxation of [the god] . . . planted with all sorts of beautiful flowers. The primeval

waters were in it at all times. It had more wine than water, like the rising of the inundation'. Thus flowers, vines, and pool, perhaps here the artificial harbour/lake, celebrated the god and re-established the world at the creation. The rising of the inundation is the annual sign of the renewal of nature.

Later New Kingdom developments. In *c.*1350 BC a spacious capital city was laid out at el-Amarna, 300 km. south of Cairo, on the low desert. Here the grander houses were arranged suburban fashion on large plots with surrounding walls, and had gardens whose construction and maintenance, in which soil and water had to be brought from a distance, was extremely laborious. Several significant innovations are visible. Some gardens abandon the traditional, strictly formal layout in favour of looser schemes (known both from preserved remains and from pictures). There is also the first painting of the *shaduf,* a water-lifting device of great value in horticulture. Gardens now invade dwellings. In palaces there were rooms painted all over with plants, birds, and swamp life, and containing birdcages or nests. The rooms looked on to courtyards with pools and plants, so that distinctions between interior and exterior, dwelling and garden, were minimized. Even floors were painted with foliage and wildlife. The same tendency is visible in the *maru* of the god Aten, which consisted largely of water and plantations of trees.

The symbolism of gardens was important, especially for the afterlife. In the boating excursion quoted above, the king appears as the creator on the primeval waters and looks through the marsh to the solid land of the world. In the next world the dead drink from pools planted with palms. Some plants were identified with deities, such as the dom palm with Thoth, one of whose forms was as a baboon, the animal used to gather the dom fruits. Sycamores were fused with a goddess who holds out food offerings and libations to the deceased. Such scenes can be placed before a pool, creating a minimal, symbolic garden which may have luxuriant vegetation, in contrast with the plantless desert of real tombs. The landscape at the foot of the desert, near many tombs, often contained swamp and palms, and may have influenced this conception. A rather less garden-like belief is in the 'fields of Earu', where the deceased cultivated a strip in an ideally luxuriant, watery landscape. Both these themes are frequent in the Ramessid period (*c.*1300–1070), but real gardens are rarely shown, although there is an interesting tomb of a chief temple gardener under Ramesses II (1279–1213), whose ability to afford such a memorial testifies to their importance.

The secular side of gardens now appears in a new type of text, the love poem. Like the adulterous couple in the story, the lovers meet in the garden, in this case without being judged guilty. They wish to be close to the beloved and to be his or her beloved, or gardener. A character can be identified with a tree, or a tree can speak on behalf of the lovers, who meet in its shade or in a reed hut while it promises, if properly watered, to keep their secret. One of these poems, probably spoken by the pomegranate, includes information about the tree itself and self-praise of it, probably as indirect praise of the woman. These associations and literary types are fascinating parallels for later periods and other cultures, from the Old Testament on. Formal and orchard-like though the Egyptian garden is, it is the place of delectation, shade, and water that appears again and again in different times and places.

GRAECO-ROMAN PERIOD (332 BC–AD 641). Although climate and the irrigation system ensured that the pattern of gardening remained substantially unchanged in this period, Ptolemaic rule brought a number of innovations; some of these were the result of direct royal influence, with Ptolemy II Philadelphus manifesting a personal and scientific interest in the trial cultivation of certain species. New crops and varieties were introduced—different strains of wheat, vines, garlic, and cabbage among them—and others previously known but not widely exploited were now cultivated to meet the needs of the Greek settlers, who wanted the wine, olive oil, and types of vegetables familiar to them in their native country. Thus, Philadelphus's Minister of Finance, Apollonius, undertook the planting of large numbers of olive trees at Memphis and on his estate at Philadelphia in the Faiyum depression *c.*100 km. to the south-west; the latter area and the environs of Alexandria were singled out by Strabo as the two centres of olive cultivation in Egypt in his *Geography* of the early Roman imperial period.

By firm administrative control and a policy of settlement on the land, particularly of military reservists, the new rulers increased the area under cultivation throughout the Nile valley; many new settlements like Philadelphia were created by the reclamation of land in the Faiyum, which was henceforward known for its horticultural richness, prolific in grain, pulses, fodder crops, and vegetables. It was also noted for its vineyards, another form of cultivation which gained importance in Ptolemaic times. The most celebrated viticultural area, however, was around Lake Mareotis, south of Alexandria, where a wine was produced that was esteemed throughout the Mediterranean world. Dotted with islands and fringed with settlements, the lake was also a resort for the people of Alexandria. Strabo records the popularity of boating parties among the tall thickets of the Egyptian bean—the pink-flowered Indian lotus *Nelumbo nucifera,* which had been introduced into Egypt in late dynastic times and had come to replace the traditional blue and white *Nymphaea* lotuses both in cultivation and in iconographic and religious significance; seeds and root were edible. A more notorious resort was the town of Canopus, east of Alexandria, the site of an important temple of Serapis, but also renowned for the licentious behaviour of its visitors. The wayside inns which lined the canal leading from Alexandria to Canopus probably counted among their attractions gardens with pools, shade-trees, and cool arbours of the kind sometimes featured in contemporary terracottas, sheltering a popular deity such as Harpocrates, reclining with an amphora of wine or a jar of dates; the remains of a Roman inn excavated on an

island in Lake Mareotis suggest that it, too, featured such places.

In Alexandria itself, gardens formed part of the great public and royal building complexes, like the palaces of the Ptolemies, within whose confines Ptolemy II Philadelphus, curious to know more about animals as well as plants, created a zoo; later, the Roman Caesareum, the vast temple of the imperial cult, was described by Philo in the 1st c. AD as containing 'walks and consecrated groves'. The larger private houses also had gardens at all periods—the Byzantine writer John Moschus, describing the city shortly before the Arab conquest, remarked on the *paradeisoi*, 'parks', belonging to the houses of the great in the centre. Centuries earlier Strabo had noted 'the many gardens and tombs' of the western Necropolis suburb; but such gardens were probably commercially exploited, to judge by contemporary evidence for tomb gardens to the east, which produced a high yield of fruit and vegetables and must have presented an orchard-like appearance. Throughout the country the emphasis was probably always on the productivity of gardens, exceptions being the sacred temple groves, like that of acacia trees at Abydos and the grove of Osiris on Biga island, or occasional large estates with space for pleasure-gardens. Most settlements would have consisted of a dense mass of housing and an adjacent area of cultivation, with sporadic trees and vegetation marking the course of river or canal, and domestic gardens confined to potted greenery beside doors or on roofs.

In all periods, all types of cultivation—market gardening in the city, crop raising in the fertile Delta and Faiyum, and the specialized industries such as papyrus growing and the supply of scented flowers and the aromatic products of certain trees as raw materials for the perfume trade in Alexandria—ultimately depended on the efficient working of the irrigation system. The mechanics of this were gradually improved by the introduction of two water-lifting devices in addition to the *shaduf*: the Archimedes screw, and the water-wheel drawn by oxen, which came into prominence in the Roman period. For agriculture and market gardening, an important body of evidence exists in the fragmentary documents recovered from certain sites, especially the Faiyum settlements; these have yielded copious information on land-holding, types of crops, methods of cultivation, and the economics of farming, but much detailed work remains to be done. Rare evidence for the working conditions of a gardener is afforded by a contract of the 3rd c. AD between a lady garden-owner and her prospective employee, who is to take charge of all irrigation work, make the soil-carrying baskets after his day's work in the garden is over, and take his wages in produce or cash; the garden seems to be primarily a vineyard, and the owner imposes strict measures to prevent pilfering by the gardener.

For the visual appearance of gardens, there is little evidence from Egypt itself; they probably continued to be formal in character, defined by irrigation channels and dykes. Our best pictorial source is Roman mosaics and paintings, created to satisfy a foreign demand for pictures of the 'land of wonders'; in the Palestrina mosaic of *c.* 100 BC, a procession of priests passes along the causeway outside a temple whose crenellated walls enclose a grove of trees, while elsewhere a drinking party is in progress beside a canal shaded by a vine-covered pergola; a Pompeian frieze of picnic and boating scenes includes a Canopus-type inn where a labourer works a screw, while ducks swim in neat basins outside the inn. The Roman creation of *Egyptianizing gardens implies the existence of prototypes in Egypt itself but is also related to an idealized concept of the country. Its temperate climate and extraordinary fertility and the mysterious phenomenon of the Nile flood always attracted admiration in the ancient world: Callixeinus of Rhodes, describing a midwinter banquet given by Philadelphus, related how the floor of the specially built pavilion was strewn with all kinds of flowers that were elsewhere rare or bloomed only briefly—such was the abundance of Egypt. To some extent, the country offered the ideal garden landscape, in which the hand of man apparently produced the maximum with the minimum of effort; in due course, the Roman iconography of the Nile, its canals, and gardens was adapted to Christian needs and came to depict the riverine Paradise.　　　　　　　　　　　　　J.B./H.W.

Egypt, Modern. The strongest landscape design influences in Egypt are French, in spite of the fact that Cairo is essentially an Islamic city. Islamic garden influences are confined to a few small areas adjoining mosques, and some recent examples such as the small El Andalus water-garden beside the Nile and the remarkable walled garden of the Manyal Palace on al Rawdah Island, at present occupied by the Club Méditerranée. The palace was built in the 19th c. in an oriental rococo style for Prince Muhammed Ali, brother of King Fuad. The garden, now marred by a kidney-shaped swimming-pool and a number of dull chalet buildings, has grown to splendid maturity. It is a simple quartered plan dominated by a tile-paved, banyan-shaded footpath leading from the entrance gate to a giant banyan tree which is used as an outdoor dining space. The profuse vegetation, including palms, fruit-trees, succulents, and ornamental shrubs, is well organized and carefully maintained—a true oasis in the city.

The larger-scale parks are less effective because of their reliance on grass, which rarely looks good, and high maintenance shrubs rather than trees for effect. An exception is the old garden of Ismail Pasha's palace which was laid out as the Zoological and Botanic Gardens in 1891. They are linked by an elaborate system of serpentine pools shaded by a rich variety of trees and shrubs, and in places they still contain some of the original polychrome pebble paths. The zoo particularly, because of the combination of mature trees, high density, and good maintenance, is a singularly impressive garden.

The Islamic characteristics of shade, abundant water, and strong enclosure are particularly appropriate for the gardens of hotels—refuges in an alien environment. Where they have been adopted, as in some of the older hotels such as the Winter Palace Hotel in Luxor, they provide a perfect complement to the building. Where attempts have been

of Canopus near Alexandria (see Ancient *Egypt: Graeco-Roman period); it was designed to evoke the town's essential features, with a long canal decorated with statues—including crocodiles and pastiches of Egyptian sculpture—leading to a vaulted *nymphaeum recalling the temple of Serapis.

In European gardens such extensive schemes have been rare, though individual Egyptian features have been fashionable—notably the ubiquitous pyramid in 18th-c. parks. Ice-houses, gateways, and pavilions modelled on Egyptian architecture were included among the picturesque garden buildings featured in design books of the 1790s, and with the French invasion of Egypt in 1798 the fashion intensified, continuing throughout Europe for the first three decades of the 19th c.; Canina's Egyptian portico in the Borghese Gardens, Rome (1827–8), is a late but handsome example of the genre.

Egyptian antiquities have also been deployed in modern gardens: Le Nôtre's placing of two sarcophagi in the park at Vaux-le-Vicomte (c. 1698) and his subsequent plan to install them in a pair of pyramids in the Tuileries are an early instance. A later and more ambitious example is the Egyptian section of Angelo Querini's garden at the Villa Altichiero, near Padua (c. 1787), a formal scheme with five Egyptian statues set at the centre and axial points of a diamond-shaped arrangement of parterres; some of Querini's sculpture later passed into non-specific use in the garden of the Villa Melzi at Bellagio. The Egyptian area of the garden at *Biddulph Grange, Staffordshire (J. Bateman and E. Cooke, 1856), set a sculpted doorway and flanking sphinxes in a masonry-like mass of topiary, with a crowning pyramid. A late addition to the genre is the Egyptian avenue in the grounds of *Buscot Park, Oxfordshire (Lord Faringdon, 1969), guarded by paired sphinxes at either end and embellished with Coade stone statues of Antinous as an Egyptian, from the original discovered at Hadrian's Villa.

H.W.

Manyal Palace, Cairo

made to create an English style landscape, as in the undulating green lawns of the Mena Palace Hotel by the pyramids at Giza, the effect is less appropriate.

M.L.L.

See also ISLAM, GARDENS OF; MIDDLE EAST.

Egyptianizing gardens. Gardens embellished with Egyptian statuary or landscaped and decorated to evoke the margins of the Nile were popular in the Roman world at least from the conquest of Egypt in 30 BC. Already in the late Republic, Cicero had mocked the extravagance of those who wished to create 'Niles and Euripuses' in their gardens, and a number of Pompeian gardens and outdoor dining-rooms of the 1st c. AD combine elaborate pools and fountains with Nilotic landscape paintings and sometimes appropriate small sculptures as well. Wall-paintings of the same period show Egyptian sphinxes and statues set amidst luxuriant vegetation, the kind of effect presumably achieved on a larger scale in imperial parks like the gardens of Sallust at Rome, embellished with imported Egyptian statues of Pharaohs and Queens, and an obelisk. The apogee of the fashion is marked by the Egyptian garden in the grounds of *Hadrian's Villa at Tivoli (c. AD 138), named after the resort

Ekaterintal (Kadriorg), Tallin, Estonia, Soviet Union, is an outstanding baroque palace and park built in 1718 by Peter the Great for his Estonian wife Catherine I to the plans of Niccolo Michetti. Mikhail Zemtsov also worked there, probably following Michetti's appointment as Architect General in St *Petersburg (Leningrad) on the death of *Le Blond in 1719.

The palace, externally well preserved, is situated outside the city on sloping ground near the sea and is the centre of the composition with formal gardens in front and behind. The main avenues and the trees—predominantly chestnut, oak, and larch—have survived in the lower garden (270 m. × 150 m.), but the parterres are much altered. According to a contemporary description, there were 10 grass *parterres with tulips, narcissi, carnations, and rose-bushes in flower-beds, and vases of flowers on wooden pedestals. The same account refers to 18 semicircular summer-houses, to the covered walks which flanked the garden, and to the canal which surrounded it on three sides. The upper garden (72 m. × 158 m.) was also laid out with grass parterres and

flower-beds with flanking covered walks. A week before his death Peter instructed Zemtsov to install two fountains in the upper garden and two in the lower. Beyond the canal and to one side of the lower garden there is a large, rectangular ornamental pool, reminiscent of the similarly situated American Pool at Strelna—where Michetti also worked—and there are other compositional similarities between the two parks. P.H.

El Laberinto, Horta, Barcelona, Spain, so called on account of the great cypress labyrinth occupying the principal terrace, is the only surviving neo-classical garden from the numerous examples in the area. There is a parterre garden near the house, but the new layout, on a different level, which was begun by the Italian Domenico Pagutti in 1794, is not centred on the previous garden. A semicircular cypress hedge, strengthened at intervals by tall stone posts, conceals the difference between the two levels. The terraces beyond the hedge merge into the woodlands. Cascades, pools, *grottoes (one probably modelled after that at *Stourhead), and stairways all centre upon the labyrinth. At its entrance a marble plaque represents Ariadne giving Theseus the thread to enable him to retrace his steps; but in the centre of the maze, contrary to one's mythological

expectation of the Minotaur, is a figure of Daphne. An avenue flanked by cypresses leads to the great reservoir surrounded by a white balustrade, with a beautiful neo-classical pavilion on the water's edge. P.G.

El Novillero, Sonoma, California, United States. The pool garden which Thomas *Church created for Mr and Mrs Dewey Donnell in 1947–8, is one of the most significant gardens of the 20th c. Situated on a wooded hill with views over the salt-marshes of San Pablo Bay, it comprises a swimming-pool with guest-house, summer-house, and bar, surrounded by concrete paving and redwood decking, in the rocky terrain of the Californian Live Oak woodland. Following the precepts of response to the site, to spatial organization, and to the needs of the client, Church (with the assistance of the young Lawrence *Halprin, George Rockrise, who designed the buildings, and Adeline Kent, who made the sculpture) has combined these elements into a design of great elegance and simplicity. The essential features of the site—the meandering channels of the salt-marsh, the rocky hillside, and the oakwoods—are all emphasized: the winding salt-marshes are echoed by the strong curvilinear forms of the pool and the sculptured

El Novillero garden (1947–8), Sonoma, California, by Thomas Church

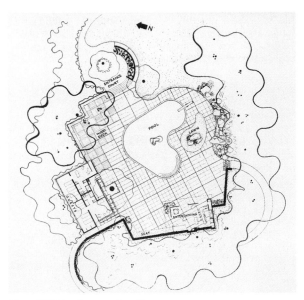

Plan of El Novillero garden, Sonoma

island; the rocks and trees are emphasized by the paving and decking which they penetrate.

Informed by the Cubist idea that a scene may be seen simultaneously from a number of viewpoints, and by his feeling that a garden should have no beginning and no end, Church, typically, has placed the rounded V-shaped pool so that it cuts across the pattern of concrete and redwood squares, each stressing the rhythm of the other. Line plays against line, form against form, the whole uniting, with admirable restraint, into a composition which has its own unique identity and at the same time belongs essentially to the site. M.L.L.

Elvaston Castle, Derbyshire, England, lies on unpropitiously flat terrain, yet the grounds were transformed into a major garden for the 4th Earl of Harrington between 1830 and 1850 by his head gardener, William *Barron. The first years were spent in draining the ground and making ready; planting began in 1835. As immediate effect was required, Barron was forced to become expert in the transplanting of trees, and thousands of mature specimens were transported from great distances—including fully formed pieces of topiary. By mid-century the garden boasted an arboretum with virtually every species of conifer that could survive the climate, and many grafted specimens. One major avenue, for instance, was lined with parallel rows of Irish and golden yews, monkey-puzzles, deodars grafted on to Lebanon cedars, and pines. The centre-piece of the garden was a topiary collection, surrounded by immense yew walls, based on a 16th-c. design; but it also contained an artificial lake and rockwork, praised by the Duke of Wellington as the most realistic he had seen.

The gardens were unknown to the public until the 4th Earl's death in 1851; his impoverished successor had to cut back on the maintenance of the garden, but at the same time it became widely visited, and Barron's innovations—though many of the features have since been lost—were emulated by other gardeners. B.E.

See also ENGLAND: THE NINETEENTH CENTURY.

Emes (or Eames), William (1730–1803), had an extensive practice as an English landscape designer and 50 commissions are known. There is no evidence that he was a pupil of 'Capability' *Brown but he worked in the same style. However, at Sandon, Staffordshire, in 1781 he designed a circular flower garden immediately below the windows of the new drawing-room and advised planting flowering shrubs as a background for a border of flowers around a central goldfish basin.

He also had a reputation for creating lakes and cascades. At Tixall, Staffordshire, in 1770 he deliberately widened and landscaped Brindley's new canal where it passed through the grounds within sight of the house. In 1774 Dr Johnson had admired the 'striking scenes and terrific grandeur' of *Hawkstone Park, Shropshire, but criticized the lack of water. Twelve years later Emes built the 'River Hawk', a 3-km. stretch of canal-like water along the side of the hill below the house, planting trees on the lower side to give the impression that it lies in the bottom of a valley.
 K.M.G.

See also POWIS CASTLE.

Emirgan Park, Istanbul, Turkey, was once part of the historic forest of Istanbul. In the 19th c. Misir Hidivi Ismail Pasa built a large wooden *yali* (waterside residence) on the Bosphorus. He used the forest behind as his back garden and built three pavilions. These three pavilions have recently been restored by the TTOK and several refreshment kiosks added. A major feature of the park is a large man-made lake with an impressive grotto, an island, and a waterfall. For the last 20 years the annual tulip exhibition has been held in this park every May. R.ST.

Encke, Fritz (1861–1931), German landscape architect, was one of the most important figures in the development of modern German landscape architecture. He was one of a group of young designers, who around the turn of the century broke with the *Lenné tradition of landscape gardeners, and began to call themselves garden architects to reflect their new formal and functional approach to the design of open spaces, both large and small. This split in the profession involved the formation of the *Deutsche Gesellschaft für Gartenkunst* (German Society for Garden Art), of which Encke was chairman between 1908 and 1913.

After working with the Berlin Parks Department and as manager of a landscape gardening firm in Berlin, he taught at the Königliche Gärtnerlehranstalt (Royal Horticultural College) at Wildpark near Potsdam from 1890 to 1902, where he had formerly been a pupil. In 1903 he was appointed Parks Director for the City of Cologne, where he was particularly associated with the recognition of the social functions of parks and open spaces in densely populated

conurbations. In Cologne he was also given the freedom to work privately in 1909, as is reflected in his publication of a book on private gardens, *Der Hausgarten* (1913). Encke was the first German garden architect to be awarded an honorary doctorate, which he received from the Agricultural University in Berlin shortly before his death. R.STI.

Encombe, Dorset, England, was landscaped by William *Pitt (later Lord Chatham) for his cousin John Pitt, the architect of the house (1735). The lake is designed to appear, from the house, to be an inlet of the sea. A wooded walk leads, in fact, from the lake-head, alongside a constructed stream with cascades, to the sea-shore, at which point the stream first plunges underground to emerge as a waterfall to tumble down the cliffs into the sea.

A Doric temple (probably contemporary with the laying out of the landscape) overlooks the house and lake, the whole concept dating from the early 1740s. A rock arch bridge with three passages leads to an open loggia, probably a 19th-c. addition, near the head of the lake. The stone seat in an outlying cliff area overlooking the sea was designed by George *Repton for his father-in-law Lord Eldon, who acquired the house in 1803. Repton also designed the obelisk to Lord Stowell's memory, on high ground inland, and overlooking the whole estate. K.N.S.

Encyclopédie, *ou Dictionnaire raisonné des sciences, des arts et des métiers* (1751–72), is an immense work of reference, combining information on all human activities with propaganda, in which gardens are relatively unimportant, yet conscientiously discussed, e.g. *'Fabrique', 'Fontaine artificielle', 'Fontainier', 'Jardin', 'Jardinage' and, illustrated with plates, 'Agriculture: Jardinage'. Most of these articles are written by Antoine-Joseph *Dezallier d'Argenville. They are conservative (as is the *Encyclopédie* in other matters concerning aesthetics), admiring the gardens of the 17th c.,

though 'Jardin' does refer with brief approval to the English landscape garden. The plates illustrating 'Agriculture: Jardinage' show equipment for maintaining formal gardens, and variations of the *parterre. C.T.

Endsleigh, Devon, England, a *cottage orné*, was designed in 1810 for the 6th Duke of Bedford by Jeffry Wyatt (later Wyatville), but the laying out of its surroundings on the banks of the Tamar was the work of Humphry *Repton. It is likely that he visited the site to make notes shortly before his serious carriage accident in Jan. 1811, as the Red Book was produced only towards the end of his convalescence. The main feature carried out was the wide grassy terrace stretching away from the cottage, with a steep drop on one side to a meadow grazed by cattle, while on the other a rustic version of the covered corridor at *Woburn Abbey led from the cottage to a conservatory. The property has changed hands in recent years and although the essentially picturesque character of the cottage and its surroundings remains, some of the garden buildings are in a precarious state. D.N.S.

End vista (in Chinese garden design). See DUI JING.

Enghien, Belgium. In 1606 the Enghien estate was purchased by Prince Charles d'Arenberg who soon began work on redesigning the grounds, starting with the entrance gardens. About 1630 his eldest son Philippe began to redesign the main grounds, according to sumptuous plans drawn up by his brother Charles, a Capuchin monk and the architect of his order. This work went on for some 50 years and was never quite completed; all that remains is a gateway, a pavilion, and some vestiges.

Mlle de Montpensier, who in 1671 accompanied the court of Louis XIV on his visit to Enghien, wrote that it was 'the most beautiful and extraordinary thing in the world'. At

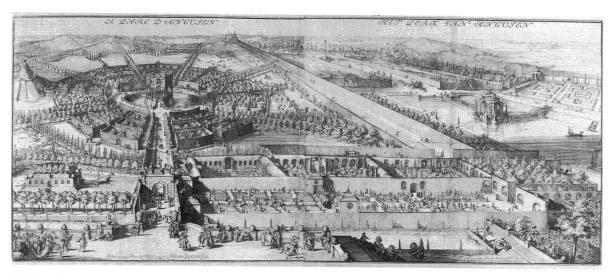

Enghien, Belgium, drawing and engraving (*c.*1687) by R. de Hooghe (Bibliothèque Royale, Brussels)

this period the Enghien gardens, by far the most important creation of the century in the Belgian provinces, were exceptionally large, occupying around half of the total area of the 100-ha. estate, which also contained a game reserve and other parts which had not been landscaped. The gardens were composed principally of three virtually separate spectacular sections, made the more impressive by long straight *allées* which provided relief or linked them together. To the right of the entrance was a set of subdivided gardens, beyond them a lake, and, in the centre, a circular garden planted with trees.

At the entrance to the grounds, near the château, stood a triumphal arch, a monumental gateway with four open sides, decorated with embossed patterns and surmounted by an equestrian statue surrounded by slaves. On the ground, concealed jets of water were designed to surprise passers-by. The gate opened on to the central *allée* which led straight to the heart of the circular garden. The left bay of the arch looked towards the fish-pond and on an island, in the middle of this pond, stood the Mound, a sort of truncated pyramid with tiers of greenery. Beyond this lay Mount Parnassus, a conical mound, surmounted by a sort of tower of Babel. The opposite bay of the gateway, to the right, gave access to the rectangular enclosure of the entrance gardens which, for the most part, dated back to the early 17th c.

This enclosure contained three gardens in succession, surrounded by galleries of plant material. The first was formed of tiers leading down to a rectangular pond—the Bath of Melusine—bordered by orange trees and containing a fountain in the form of three goddesses supporting a basin with a powerful jet of water. The second garden had a central *rond-point surrounded by *palissades de verdure from which pathways radiated out and divided up the parterres decorated with sweeping plant *broderie* and dwarf fruit-trees, pruned or left to grow naturally. The third garden contained a labyrinth, at the centre of which stood an arcaded temple which housed a fountain with its jet shooting through the vault. The other series of gardens, parallel to this one but located on the edge of the grounds, was composed of two parts, bisected by an axial *allée*. The first had two fountains placed along the central axis and was divided into parterres of sweeping plant *broderie* surrounded by statues of children and plants in tubs; in its four corners stood four square pavilions containing grottoes with fountains and waterworks as well as picture galleries. The far end of this garden was marked by a marble balustrade, surmounted by classical statues of gilded metal, which opened at its centre on to a flight of marble steps, first concave and then convex, leading down into the next garden which was given over to flowers. Within this garden the same balustrade formed the top of a wall containing niches decorated with shells and separated by pilasters of white and blue marble. This second garden was laid out in complex geometrical parterres decorated with potted shrubs such as pomegranate, laurel, and myrtle. At its centre was a fountain.

Leaving the enclosure at the far end, there was an axial view to the left, formed of a long stretch of water with a monumental fountain and then an *allée*, drawn between two enclosed gardens, and extending as far as the Coliseum at the far end of the grounds. This Coliseum consisted of rows of arcades in plant material placed above one another and encircling an obelisk-shaped fountain with a number of jets of water. Parallel to this axis, towards the centre, the whole of this section was crossed by an *allée* intended for the game of mall; it was paved with marble and bordered by high *palissades de verdure*.

Behind the triumphal arch at the entrance to the grounds began the park's central *allée*, which led to the Star in the centre, a very large circular garden, planted with trees and surrounded by a heptagonal enclosure, the angles of which were marked by small bastions. At the centre of this radial formation was a round *bassin* with, in its centre, the Temple of Hercules, a heptagonal belvedere of stone and marble, set upon an Ionic colonnade whose upper terrace (to which access was by a mechanical staircase that could be folded away in the bridge) afforded a view over the whole grounds. The colonnade also formed the point of convergence of seven regularly spaced straight *allées*, each bordered with trees of a different species. These *allées*, together with subdivisions of radiating straight paths and concentric circular ones, separated a set of tiny curved woods surrounded by thorn *palissades*. X.D. (trans. K.L.)

England

MEDIEVAL GARDENS. The story of gardening in England goes back to Roman times (see *Roman empire) but between AD 400 and 800 there is a total gap, and we cannot relate our subsequent tradition to classical prototypes. Some Saxon plant-names derived from Latin may imply the survival of introduced species. After 800 the pattern of gardening in England followed that of *medieval gardens elsewhere, though the garden flora was somewhat more restricted. The climate, rather warmer than now, nevertheless allowed the successful cultivation of grapes as dessert fruit and for wine, of which large quantities were produced in the southern counties.

By the time of King Alfred (d. 899) there were many Old English names of plants, and the vocabulary of Ælfric (d. 1020) includes over 200 herbs and trees, many of them grown in the larger monastic gardens. Although Ælfric's interest in words was grammatical, there is no reason to doubt that there was, notably among physicians, already a considerable knowledge of practical botany. This led to the layout, especially at large monasteries, of gardens devoted

mainly to medicinal herbs. Later evidence suggests that the presence of beautiful flowering plants such as the rose, lily, and violet, then credited with physical virtues, introduced a leaven of aesthetic interest into the utilitarian herbary.

It is only after the Norman Conquest that we learn anything of actual gardens. The first to be mentioned is that of the Benedictine nuns of Romsey Abbey (Hampshire), visited c. 1092 by King William Rufus and his courtiers 'to look at the roses and other flowering herbs'. By 1110 Rufus's brother Henry I was enclosing a large park at Woodstock with a stone wall, the first recorded English work of large-scale landscape gardening (see *pleasance). Other royal gardens of importance were at Kingsholm by Gloucester, Kingbury by Dunstable (nearly 4 ha.), and Havering-atte-Bower (Essex), at the palace of Westminster, and at Windsor.

These gardens and landscapes of the English Middle Ages have disappeared or else have been completely transformed by later earthwork and planting (as Blenheim has replaced Woodstock). It is only in a very few instances that even the earthwork of significant medieval gardens survives. The most notable example is the double-moated Pleasance-en-Marys at Kenilworth, made for Henry V in 1414–17 and based on the type of the lost Abbot's Herbarium at Peterborough, formed in 1302. Traces, such as moats and fishponds, survive from many gardens, but none of these sites has yet been systematically investigated. The slight amount of successful garden archaeology has produced evidence only of the plants grown in urban kitchen gardens at Southampton, Hull, York, and elsewhere. The loss of gardens is matched by the lack of any representations of what has gone. The trellised fences and rows of herbs shown diagrammatically in the Infirmary garden at Canterbury on the waterworks plan of c. 1165 provide the only view of an actual English garden earlier than 1545. Much valuable detail is found in the famous illumination of a king and queen playing chess in a castle garden (MS Bodley 264, fo. 258).

Even in documentation the record is fragmentary, and has to be pieced together from what is known of many different sites. Naturally the voluminous accounts for royal works include much scattered information for castles and manors, and surviving monastic documents (e.g. at Norwich) show the continuity of extensive utilitarian gardening, for medicinal herbs, kitchen produce, and fruit. Flowers, too, were grown to adorn the altars, and in a few cases there are records of pleasure gardening on the estates of nobles, bishops, abbots, and priors. It is consistent with what is known of other medieval activities that there should be relatively slight differentiation between the gardens of various ranks, once the 'high table' has been reached. The principal influence on aesthetic gardening was that of Islam, via Spain, Italy, and Sicily, and this tended towards the intimate and towards exquisite quality rather than size: the garden never dominated the landscape as it did in classical and Renaissance times. Except in parks, where the main interest was in the chase and in spectatorship, the typical pleasure-ground for king, courtier, or churchman was of modest size and consisted largely of a level lawn (Royal MS 20 D. iv, fo. 187) surrounded by flowering trees, particularly pear, cherry, and medlar. Outside this there might, at the homes of royalty and the greater magnates, be a pleasure orchard for walking in, of say 1–3 ha.

Owing to the lack of evidence, both material and illustrative, it is impossible to give an account of stylistic changes through the four centuries from 1100 to 1500. During the 13th c. there was considerable emphasis on the planting of trees for adornment, and in regard to churchyards this won official approval from Archbishop Pecham in 1280. It constituted a noteworthy component of the royal garden works throughout the reigns of Henry III and Edward I. The making of extensive lawns, for their aesthetic value as well as for bowling-greens, is also well documented. From this time onwards the tunnel-arbour of wooden poles, supporting ornamental grape-vines, honeysuckle, and other climbers, became a principal feature surrounding the lawns and borders, and was to continue beyond the end of the period. The forerunner of the herbaceous border is clearly seen in the English picture of the garden game of chess, of c. 1400. Double-moated gardens, with rows of trees planted along the narrow lists between the moats, are evidenced from the opening of the 14th c. and were probably dying out by the middle of the 15th c., when Burgundian fashions became dominant. The introduction of rosemary in 1340 marked an increasing interest in evergreens, and the sweet bay had become a substantial article of commerce by the reign of Henry VIII. Juniper and perhaps holly and box were fashionable by the middle of the 14th c. Clipped evergreens, knot-gardens with quasi-heraldic patterns marked out with lead strips, and the cult of the double clove carnation, brought from Turkey by way of Italy, Spain, and France, characterized the final phase. J.H.H.

See also BINGHAM'S MELCOMBE.

RENAISSANCE GARDENS. The period from 1485 to 1642 may be divided in terms of garden history into four main phases:

1. *Early Tudor, 1485–1558.* In the aftermath of the Wars of the Roses (1455–85) the impulse to develop the medieval *hortus conclusus* into the pleasure-garden and make it an essential aspect of palace planning came from the court of Burgundy; Henry VII's Richmond Palace (1497–1501) had such gardens laid out as a series of enclosures linked by covered walks and galleries. The major garden development, however, came with Henry VIII and reflected direct rivalry with François I. Three important royal gardens were created: *Hampton Court Palace (1531–4), Whitehall (completed 1545), and *Nonsuch Palace (1538–47). These all shared the same basic format: situated beneath the state apartments on the *piano nobile so that the gardens could be looked down on, they were square and laid out in quarters in open and closed knots (see *knot garden) with a fountain at the centre and surrounded by covered walks. Their source was French but they had a unique English overlay of painted wooden heraldic decoration.

2. *Elizabethan, 1558–1603.* In the late 16th c. France continued to be the main source of inspiration but there was often an overlay of Netherlandish detail. Developments shifted to the gardens of the aristocracy: the pleasure-garden became an essential feature of any country house of substance and the growth of interest in gardening can be seen to follow the graph of the building boom which began in the 1580s and lasted into the 1620s. The extension even further down the social scale is reflected in the stream of garden literature beginning with Thomas Hill's *The profit-able Arte of Gardening* (1568), which included plans and instructions for knot gardens. Reflecting the rest of the arts, style remained static and represented the transplanting to the great country house of the early Tudor palace formula but with a superficial addition of decorative detail in the Netherlandish Mannerist fashion (see *Kenilworth Castle; *Theobalds Park; and *Wimbledon House). Nonsuch Palace alone had a grotto and other more directly Italianate features.

3. *Jacobean, 1603–1625.* With the accession of James I and peace on the Continent England was open for the first time since the 1530s to outside influences. More importantly the crown once more exercised avant-garde patronage in the arts. A garden revolution was spearheaded by Anne of Denmark and Henry, Prince of Wales, who both employed Salomon de *Caus (c.1576–1626) to redesign their gardens: Somerset House, Greenwich Palace (both c.1609), and Richmond Palace (1610–12). De Caus had studied in Italy in the 1590s, especially at *Pratolino, and was also familiar with the gardens created by the *Francini for Henri IV. The essentially new features pioneered by de Caus in England were the architectural alignment of house and garden, the use of monocular perspective in planning, and a preoccupation with hydraulics in the form of highly symbolic fountains, grottoes, and *automata. As a result there was a garden craze. Existing gardens (for example, Wimbledon House and Theobalds Park) were expanded in size and a series of new ones planted: Worcester Lodge, *Ham House, Twickenham Park (all c.1609), Ware Park (c.1606–13), Gorhambury (begun 1608), and Chastleton (completed 1614). Salomon de Caus left England in 1613 and there was a lull until the arrival of his brother or nephew Isaac (1590–1648) who worked in the same style but was of lesser talent. He was responsible for a whole series of gardens and grottoes through the 1620s and 1630s: the Whitehall Banqueting House (1623–24), Woburn Abbey (completed 1627), Moor Park (1617–27), and *Wilton House (begun 1632), which, although still essentially in the de Caus manner, includes items such as the *parterres de broderie* which are more naturally expressions of the following period.

4. *Caroline, 1625–1642.* The dominating figures of this period were to be Inigo *Jones (1573–1652) and André *Mollet (d. 1665). Jones, whose main visit to Italy was from 1613 to 1614, actively promoted the Palladian style after his return and must have been greatly influential in establishing the integral relationship of house and garden in Renaissance villa terms. He certainly designed garden gates and a whole series of gardens betray features which can only be categorized as Jonesian: Arundel House, London (1614 onwards), Oatlands Palace (1616–17), *Albury Park and Tart Hall (both probably 1630s), Danvers House, Chelsea (begun 1622–3), and Hadham Hall (c.1632–c.1639). Henrietta Maria, wife of Charles I, was a major innovative force in that she brought over André Mollet whose broad proto-baroque style, including elaborately scrolled *parterres de broderie*, was introduced at *St James's Palace (c.1629–33) and Wimbledon House (1641–2).

Renaissance garden ideology. In simplified terms the pleasure-garden came to embody a complex of attitudes and ideas which are essential to its comprehension as a phenomenon of Renaissance culture: (i) as an expression of man's ability to subject and tame nature; (ii) as an attribute of regal and aristocratic magnificence and hence as an index of social status; (iii) as a living encyclopaedia of God's creation reflected in the quest for rare trees and plants and the desire to categorize them; (iv) as a setting for alfresco entertainments and the reception of royalty (e.g. as in Sidney's *Lady of May*, 1598) and hence an aspect of regal power; (v) as a symbolic vehicle related to a magico-hermetic view of the universe with allusions that could range from the streams, woods, and grottoes necessary for the melancholic through the symbolism of each individual tree or plant to an allegorical intent behind even the geometry of the hedges and knots.

R.S.

See also BUSHELL, THOMAS; ENSTONE; HARTWELL HOUSE; HATFIELD HOUSE; WOLLATON HALL.

1660–1714: THE FORMAL GARDEN. Garden design in England during the period 1660 to 1714 was, in common with the rest of Europe, much influenced by the French style. There were attempts in both 1662 and 1698 to persuade André *Le Nôtre to cross the Channel, but a number of French gardeners were attracted to England, starting with André Mollet who was made Royal Gardener at St James's in 1661. Furthermore, the best English gardeners, including George *London, had been trained at least partly in France, and translations from the French by John *Evelyn and John *James were amongst the better gardening books. English gardens were, however, given a peculiarly English flavour. For example, a liking for plain grass *parterres with statues had developed before the Civil Wars (1642–60) and persisted after. These, and *gazon coupé*, were thought of as English by foreigners, and this is borne out by the very rare use of *parterres de broderie*, of which the most famous was the one at Hampton Court made in 1690 by Daniel *Marot, a Frenchman working for *William III; it was replaced by a much plainer arrangement in grass in 1707, possibly by John *Vanbrugh. Certainly the bold and imaginative use of topography and garden buildings in Vanbrugh's layouts at *Castle Howard and *Claremont owes little to the French. Writings by Joseph

*Addison, Alexander *Pope, and Stephen *Switzer from 1711 to 1715 rejected the fussiness of Dutch gardens and advocated design inspired by the model of pastoral poetry. With French gardens in a recession, the way was open for English designers like Charles *Bridgeman to strike out afresh.

Soon after his restoration in 1660 Charles II installed avenues with semicircular scoops and long canals at St James's and Hampton Court, and many members of the court followed suit in their own estates. The craze for avenues was in full flood by the 1680s with vast schemes at *Badminton House and *Boughton House. Also in this decade the taste for groves modelled on French *bosquets, and found at such places as Ham House, gave way to the far more elaborate *wildernesses made at *Chatsworth and Hampton Court; the most extravagant was the 18-ha. wilderness at *Blenheim Palace, started c.1705. *Cassiobury Park was an attempt made in the 1660s to re-create the atmosphere of a French château set in a forest. However, it was not till the start of the 18th c. that forest gardens like New Park, *Bramham Park, *Wrest Park, *Cirencester Park, and Eastbury became numerous. Continental influence took on a Dutch flavour when William III ascended the throne (1689). His gardens had huge numbers of 'greens', which were areas of either permanent clipped yews and variegated hollies or of the tender orange and lemon trees that had to be moved into greenhouses in winter.

John Evelyn was one of the few Englishmen with any proficiency in garden design at the Restoration, and his views were eagerly sought at *Cornbury House and elsewhere (see *Sayes Court; *Wotton). He was one of the first members of the Royal Society; out of a lecture given to it arose his book, *Sylva, or a Discourse of Forest Trees* (1664). He designed a terraced philosopher's garden at *Albury for a patron, Henry Howard, later Duke of Norfolk. When visiting Cassiobury in 1680 Evelyn recognized a fellow enthusiast for trees in Moses Cook, who went on to found a nursery at Brompton with three partners in 1681 (see *nurserymen). Its first major commission, *Longleat House, was under way by 1685. One of the partners, George London, emerged as the nation's foremost garden designer for 30 years, and at Chatsworth in 1688 commenced his close co-operation with the architect William Talman. About 1688 the three other partners left the business and Henry *Wise was taken on. London was made Royal Gardener upon the accession of William III, and together with Talman, himself the Comptroller of the King's Works, was responsible at Hampton Court and *Kensington Palace. Wise's financial skill meanwhile helped to raise the Brompton Nursery to be the foremost in the country. It also helped him to replace London as the Royal Gardener at the accession of Queen Anne (1702). Wise was ordered to make alterations to Kensington Palace and *Windsor Castle, and from 1705 he provided stupendous gardens at Blenheim to complement Vanbrugh's architecture (see also *Hawksmoor). London continued with private commissions including Wanstead (c.1705) and *Canons, on which he was working when he died in 1714. Vanbrugh had his own ideas on garden design, displayed from 1700 at Castle Howard and from 1710 at Claremont. Soon after the accession of George I in 1714 he was made Surveyor of the Gardens and Waters over Wise.

D.L.J.

Blenheim Palace, Oxfordshire, drawing (1792) by Joseph Farington (Ashmolean Museum, Oxford)

See also CORBY CASTLE; HALL BARN; HEYTHROP; KIRKBY HALL; LEVENS HALL; MELBOURNE HALL; POLESDEN LACEY; ROSE, JOHN; STANSTEAD HOUSE; WESTBURY COURT GARDEN.

THE EIGHTEENTH CENTURY: DEVELOPMENT OF THE ENGLISH STYLE. For the first decade of its inception, 'natural' is the adjective usually found to describe the new style which replaced the excessively formal layouts prevalent in the reigns of William and Mary or Queen Anne, typical of which is the description given by Celia *Fiennes of a garden consisting of 'rows of trees paled in gravel walks, fine cut hedges, flower pots on walls, terraces, statues, fountains, basins, grass squares and exact, uniform plots'. The growing discontent with this formality was first voiced in the writings of Ashley Cooper, 3rd Earl of *Shaftesbury, and in the essays of Joseph Addison. Shaftesbury, seeing in Nature a new ideal, symbolic of humanist and liberal principles, declares in *The Moralists* of 1710 his preference for 'things of a *natural* kind: where neither *Art*, nor the *Conceit* or *Caprice* of Man has spoil'd their genuine order . . . Even the rude Rocks, the mossy *Caverns*, the irregular unwrought *Grottos* and broken *Falls* of waters, with all the horrid graces of the *Wilderness* itself, as representing NATURE more, will be the more engaging, and appear with a magnificence beyond the mockery of princely gardens.'

Addison's approach was of a practical rather than a philosophical nature. Writing in the *Spectator* he asked 'Why may not a Whole Estate be thrown into a kind of garden by frequent plantations? . . . If the *natural* embroidery of the meadows were helped and improved by some small additions of Art . . . a man might make a pretty Landscape of his own possessions.' This idea he put into practice by the introduction of irregular plantations and winding streams on his own small estate at Bilton in Warwickshire where, as he explained, 'my Compositions in Gardening are altogether after the *Pindarick* manner, and run into the beautiful Wildness of Nature'.

Powerful as these literary influences were among the wealthy landowners, it is doubtful whether they would have been sufficient to launch a revolutionary movement had they not coincided with other factors of a social and economic character. The early years of the 18th c. saw great strides in land fertility and reclamation from the heath, bog, and scrub with which more than half the countryside is estimated to have been covered. Agriculture became a science, and a series of Acts of Parliament enabled owners to enclose large areas of common land, while new and better roads and lighter vehicles made travel easier, encouraging expeditions for pleasure rather than necessity. There was, moreover, the impetus given by the Palladian revival in architecture which materialized in 1715 with Giacomo Leoni's publication of the first English translation of Palladio's *I Quattro Libri*, and Colen Campbell's production of his first volume of *Vitruvius Britannicus* (see *Burlington; *Chiswick House). These provided important stimuli for the building of new and remodelling of old houses to which a landscaped setting was widely accepted as complementary. The first half of the 18th c. was essentially a period of improvement and that word, in fact, became a synonym for the laying out of parks and gardens. In this propitious environment the seeds of the new ideals were to take root and prosper.

As to the ideals themselves, there can be no doubt that a pre-eminent medium through which they were disseminated was the Kit-Cat Club, that select coterie which forgathered at Barn Elms on summer evenings, and of which the members included the Dukes of Grafton and Newcastle, the Earls of Carlisle, Lincoln, and Scarborough, Viscount *Cobham, Sir Robert Walpole, General John Dormer (see *Rousham House), the architect Sir John Vanbrugh, and the authors Joseph Addison and Richard Steele. It was probably this contact with fellow Kit-Cats which led to a change in Vanbrugh's attitude towards garden design, for although he continued for some years to rely on the formal gardener Henry Wise to lay out parterres at Blenheim and elsewhere, an awareness of picturesque potentialities is evident in his letter to the Duchess of Marlborough in 1709, pleading for the retention of part of Old Woodstock Manor which 'would make one of the Most Agreeable Objects that the best of Landscape Painters can invent'. From 1713 onwards he is found collaborating with Charles Bridgeman who was to become a leading figure in the transitional years of the new movement. While the Kit-Cats were united in their affinity with the Whigs, the natural garden found many supporters among Tory landowners, notably Earl Bathurst and the Earl of Oxford, the diplomat and poet Matthew *Prior, and that even greater man of letters, Alexander Pope, whose influence was to be of major importance from 1717 when his miniature estate at Twickenham became a paradigm, and its owner's advice was widely sought by his gardening friends whatever their political allegiance.

For those who could claim neither Pope's acquaintance nor membership of the Kit-Cat Club, other sources of advice now began to appear, the first being Stephen Switzer's publication in 1715 of a useful handbook entitled *The Nobleman, Gentleman, and Gardener's Recreation*, enlarged and reissued in 1718 as *Ichnographia Rustica*. Switzer was a Hampshire man of yeoman background who, after some misfortune, turned to professional gardening and worked for a time in the Brompton Park nurseries of London and Wise before coming under the spell of the new trend in design, and making a name for himself as a writer. The scope of his first book, *The Gardener's Recreation*, is conveyed by its subtitle, *An Introduction to Gardening, Planting, Agriculture and the other Business and Pleasures of a Country Life*, and it was followed by nine other books on allied subjects, as well as the editing of a monthly magazine called *The Practical Husbandman and Planter* (1733). The success of these works is a measure of his influence among those wishing to embark on the improvement of their estates.

One of Switzer's early recommendations was that 'all the adjacent country [should] be laid open to view' and that gardens should no longer be enclosed with walls 'by which the eye is as it were imprisoned and the feet fettered in the midst of the extensive charms of nature', and these views

Switzer's plan of a Forest or Rural Garden, from *Ichnographia Rustica* (1742 edn.), vol. 3

may well have been in part responsible for emancipating the outlook of his one-time colleague in the Brompton Park grounds, Charles Bridgeman. Certainly it was from 1715 that the latter came into his own as the leading professional of the transitional period, and the only one whom Alexander Pope would admit to being 'in the same virtuoso class' of garden design as himself. Horace *Walpole, too, singled him out for praise for 'though he adhered much to straight walks with high clipped hedges, they were only his great lines and he disdained to make every division tally to the opposite; the rest he diversified by wilderness and loose groves.'

The 'capital stroke, the leading step to all that has followed' (Walpole) was the introduction of the *ha-ha, which Bridgeman was the first to use on an extensive scale. His surviving drawing of the enlarged gardens at *Stowe (c. 1720) heralds the important part which this feature was to play in the development of the landscape garden, and which Walpole—this time correctly—assesses as 'the leading step for these reasons. No sooner was this simple enchantment made, than levelling, mowing, and rolling, followed. The contiguous ground of the park without the sunk fence was to be harmonized with the lawn within; and the garden in its turn was to be set free from its prim regularity, that it might assort with the wilder country without.'

Outstanding among the gardens of the transitional period are those of *Duncombe Park and *Rievaulx Terrace, Castle Howard, *Studley Royal, Bramham Park, and Ebberston (all in Yorkshire), *Claremont, *Pope's Garden at Twickenham, and the royal gardens at Richmond and Kensington. By 1731 Sir Robert Walpole's grounds at Houghton (Norfolk) were sufficiently established to be described in a letter as 'seven hundred acres very finely planted, and the ground laid out to the greatest advantage. The gardens are about forty acres, which are only fenced from the Park by a fosse.' Stowe stands in a class of its own, unequalled for the number of garden buildings which were erected there over the years from 1715 onwards, and the moral or political significance which each was to represent. Most owners, however, were content to dedicate their temples or vales to minor deities or Arcadian nymphs without imposing much didactic strain on their visitors.

A major figure during this period was William *Kent (see *Esher Place; *Euston Hall; *Holkham Hall). If his studies in Italy produced a painter of no more than mediocre talent, they had at least endowed him with a deep feeling for the works of the great landscape painters and this was to prove invaluable when, under the patronage of the 3rd Earl of Burlington, he turned his attention to architecture and gardening, enabling him to visualize the setting of a house as a series of pastoral scenes such as Claude Lorrain or Salvator Rosa might have painted. Kent was, as Walpole wrote later, 'painter enough to taste the charms of landscape, bold and opinionative enough to dare and to dictate, and born with a genius to strike out a great system from the twilight of imperfect essays'. His first garden work was at Chiswick House shortly before 1730, but other commissions soon followed, and by 1734 Sir Thomas Robinson was

writing to his father-in-law, the Earl of Carlisle, that 'There is a new taste in gardening just arisen . . . after Mr. Kent's notion of gardening, viz., to lay them out, and work without either level or line. By this means I really think the 12 acres the Prince's garden [at Carleton House] consists of, is more diversified and of greater variety than anything of that compass I ever saw; and this method . . . is the more agreeable, as when finished, it has the appearance of beautiful nature.' He added that the celebrated gardens at Claremont, Chiswick House, and Stowe were already 'full of labourers, to modernise the expensive works finished in them, even since every one's memory'.

In spite of the encomiums showered on him by Walpole and others, it would be nearer the truth to call Kent a landscape designer rather than a landscape gardener, for of arboriculture itself it is doubtful if he knew much more than the difference between a willow and a holly, and that for their respective shapes and colours rather than their species. This, combined with a disinclination to travel, meant that he relied heavily on foremen or others to see his schemes carried out in the more distant places. In his lack of practical expertise he was the antithesis of the man who, after Kent's death in 1748, was to become the foremost exponent of landscape gardening for the next 35 years.

Lancelot *Brown—nicknamed 'Capability'—went to work for Lord Cobham at Stowe in 1741 and in due course was entrusted with carrying out some of Kent's later designs, imbibing in the process much of his theory of landscape. Brown, however, was no mere imitator, and when in 1751 he left Stowe and set up his own practice, he envisaged his landscapes in broad, bold sweeps and on a scale far beyond that of Kent. In his handling of large expanses of water, the creation of dams, and the planting of trees by the thousand, Brown's practical knowledge stood him in good stead. He continued to subscribe to Pope's dictum that the success of a landscape lay principally in 'the contrasts, the management of surprises, and the concealment of the bounds'.

For the 35 years during which Brown dominated his profession, the landscape scene changed little except in the extent to which it spread across the countryside. He was still at the height of his career when Walpole wrote his essay *On Modern Gardening* (1780) and included in it a tribute to Brown as the 'very able master' by whose hand the landscape garden had arrived at its then happy state. 'How rich, how gay, how picturesque the face of the country' Walpole continued, 'The demolition of walls laying open each improvement, every journey is made through a succession of pictures, and even where taste is wanting in the spot improved, the general view is embellished by variety. If no relapse to barbarism, formality, and seclusion is made, what landscapes will dignify every quarter of our island when the daily plantations that are making have attained venerable maturity.'

Brown's dominance, however, by no means meant the end of the amateur tradition, which continued to find inspiration in the pictorial and literary principles of an earlier generation—inspiration often missing from Brown's

own work. (See *Encombe; *Hagley Hall; Sanderson *Miller; *Park Place; *Piercefield; Thomas *Pitt; William *Pitt; *Wroxton Abbey.) Notable examples of landscapes inspired by the paintings of Claude Lorrain and the Poussins are *Stourhead and *Painshill, the work of the *Hoare family and Charles *Hamilton respectively. Particularly noteworthy for its literary associations is The *Leasowes, by William *Shenstone (see Richard *Graves). All these gardens are also important for their influence on French visitors and garden writers—they, rather than Brown's works, are the source of the *jardin anglais. Similarly, the *ferme ornée originates in the layout of *Woburn Farm by Philip *Southcote.

See also ENVILLE.

Brown died in 1783, and although a handful of practitioners such as William *Emes, Samuel *Lapidge, *Richmond, John *Webb, and Richard *Woods tried to emulate his formula for creating Elysian scenes, they made no great reputation for themselves and it was 1788 before a figure appeared of sufficient calibre to make his name as the third and last outstanding figure in landscape gardening. Humphry *Repton had received no orthodox training for the profession which he assumed in 1788, but was a man of culture who had taken an amateur interest in the subject and had acquired a good deal of practical knowledge of trees and land management while living on his own small estate in Norfolk. His concept of landscape design was, by his own admission, largely based on that of his predecessor, and his ability to produce delectable designs for his clients came from his considerable gift as a water-colourist. In many cases his commissions were to introduce additional features in a landscape created by Brown several years earlier as at Holkham, where he laid out a new pleasure-garden, and *Wimpole Hall, where he was responsible for enclosing a small area of ground before the north front with an iron palisade between piers supporting stone urns. His later works, in fact, often display an element of formality in the immediate surroundings of the house by way of a balustraded terrace or trellised passage but in the main he remained a firm adherent to the landscape ideal.

Unlike Kent and Brown, Repton committed his theories to print in three volumes, in which he set out at length his views on almost every aspect of landscape gardening, the first (Sketches and Hints) being published in 1795. Rather to his surprise, he found himself embroiled in a controversy (later satirized by *Peacock) with Richard Payne *Knight and Uvedale *Price over the nature of the *picturesque (see William *Gilpin). (See also *Foxley.) Repton had hitherto been on friendly terms with both men and was therefore surprised and dismayed at finding that the principles of landscape planning to which he and his predecessor had subscribed were bitterly attacked in works by both men. In practice, a small number of landscapes had been created by wealthy amateurs following picturesque principles. Uvedale Price himself gave advice in a number of cases, but perhaps the most truly picturesque creation was *Hafod, laid out between c.1785 and 1801 by Thomas Johnes (now

destroyed). At *Fonthill Abbey, William *Beckford created a landscape to match the character of his vast neo-Gothic edifice. In other cases, such as *Mount Edgcumbe, a particular favourite of Uvedale Price, or *Hawkstone Park, which dates from a slightly earlier period, walks were laid out to take best advantage of picturesque views.

The irony of the acrimony generated by their exchanges for more than a decade was that the landscape movement had already reached its zenith. Repton's practice was curtailed by his injury in a carriage accident in 1811, and the few commissions which he was to undertake thereafter were carried out largely with the help of his sons John Adey *Repton and George Stanley *Repton. He himself foresaw already that, with changes in social and economic conditions brought about by the industrial revolution, a decline in the art of landscape gardening on the grand scale was inevitable. In his last book, Fragments on Landscape Gardening, published in 1816, he wrote that it 'has felt the influence of war and war taxes which operate both on the means and the inclination to cultivate the Arts of Peace . . . The sudden riches by individuals has diverted wealth into new chanels; men are solicitous to increase property rather than to enjoy it; they endeavour to impose the value rather than the beauty of their newly purchased estates.' They were content with a few yards of lawn, banked with laurel and adorned with a monkey-puzzle tree and bright displays of bedding plants.

See also REGENCY GARDENING.

Since much of the material of which a landscape garden is composed is of a transitory nature, it is inevitable that in the course of 200 years the smaller components in the great 18th-c. creations have disappeared, leaving only the contours and slower growing timber. Because of this their designers may appear to have paid scant attention to flowers and shrubs (although see William *Mason; *Nuneham Park; and Thomas *Robins) and while it is true that the landscape often included a walled flower garden in a sheltered spot, this was intended for the protection of the more fragile species of which an unprecedented number were then being introduced into England from the East or from the United States. Elsewhere in the grounds, however, plants were widely scattered, and Batty *Langley, in his New Principles of Gardening, published in 1728, recommended that 'all the trees in your shady walks and groves be planted with sweet briar, white jessamine and honeysuckle, enlivened at the bottom with a small circle of dwarf stock, candytuft and pinks'. For Brown, too, plants and shrubs were an essential part of his schemes, as can be seen from the nurserymen's accounts for such places as *Petworth House, or the roses planted in the pleasure-gardens at Tottenham Park. In a letter to a friend, outlining his ideas on what he called 'place-making', Brown stressed the importance of 'infinite delicacy in the planting' and 'the smaller sorts of shrubs'. These, as much as the trees and lawns and water, were part of the landscape gardener's media.

D.N.S.

See also ASHRIDGE; ATTINGHAM; AUDLEY END; AUSTEN, JANE; BLAISE HAMLET; BOWOOD GARDENS; BURKE, EDMUND;

BURGHLEY HOUSE; CHEERE, JOHN; CROOME COURT; ENDS-
LEIGH; FARNBOROUGH HALL; GOLDSMITH, OLIVER; HARE-
WOOD HOUSE; HEVENINGHAM HALL; HOLLAND, HENRY;
KEDLESTON HALL; KENT, NATHANIEL; LANE, JOSIAH; MAR-
SHALL, WILLIAM; MASON, GEORGE; OAKLANDS PARK; PAINE,
JAMES; PRIOR PARK; ROYAL PAVILION, BRIGHTON;
SCHEEMAKERS, PETER; SHEFFIELD PARK; SHERINGHAM
HALL; SHOTOVER; SHUGBOROUGH; THOMSON, JAMES; VAN
NOST, JOHN; VIRGINIA WATER; WALLINGTON; WARWICK
CASTLE; WEST WYCOMBE PARK; WOBURN ABBEY; WHATELY,
THOMAS; WREST PARK; WRIGHT, THOMAS; YOUNG, ARTHUR.

THE NINETEENTH CENTURY. By the 1830s a change of taste
in gardening was becoming widespread, as the picturesque
taste declined (see The *Deepdene; *Scotney Castle;
*Swiss Garden). In Dec. 1832 J. C. *Loudon proposed the
idea of the *gardenesque style in explicit opposition to the
picturesque, but his proposal was not generally adopted.
Since the beginning of the century an increasing number of
writers had been lamenting the destruction by the 18th-c.
landscape designers of the old formal gardens, and the
preservation and restoration of those that had survived
began after 1804 with Archibald Forbes's work at *Levens
Hall in recutting the topiary. Humphry Repton was the most
prominent of the garden designers who reintroduced those
features—flower-beds near the house, trellis-work, and
terraces—proscribed by the improvers. But the change in
taste was not merely the replacement of one style by
another; it lay in the idea of the equality of styles, the notion
that no one mode of garden-making was correct, but that all
styles were potentially valid and had to be judged by their
own rules (see *Alton Towers; *Biddulph Grange). Begin-
ning with Wyatt's *Italian garden at Wilton House, archi-
tects and garden designers experimented with a wide range
of historical precedents.

By the 1830s a consensus was emerging as to the most
suitable of styles for the English country house. After
Repton's day, it was generally assumed that before the
coming of the landscape movement English gardens had
been Italian in inspiration; the French and Dutch styles
were regarded as simply variants on the basic Italian
principle. The Italian was therefore the preferred style for a
mansion of olden times, or for a modern facsimile, though
there were two very different approaches a designer could
use to achieve this effect. On the one hand, he might imitate
the features of a surviving Renaissance garden in Italy; this
approach was especially associated with Sir Charles *Barry
(see *Cliveden; *Shrubland Park; *Trentham Park). On
the other hand, he might rely on old gardening books for
inspiration, a method associated with William Andrews
*Nesfield (see *Broughton Hall; *Grimston Park) who was
particularly drawn to the parterres of Louis XIV's period
(1638–1715).

However, while design was increasingly becoming a
search through the riches of the past, the choice of plants for
a garden was not bound by historical precedent. Thanks to
the invention of the *Wardian case, nurserymen
experienced unprecedented success in the importation of

living exotic plants into Britain by the 1840s, and the rate of
introductions from all parts of the world multiplied. The
head gardener found that the cultivation of new exotics was
a compulsory part of his activities, and during the 1830s and
1840s a group of gardeners, most notably Donald *Beaton,
developed the bedding system (see *bed, bedding), a means
of using tender and half-hardy exotics for stocking flower-
beds during the summer, and arranging them for high
contrast of colour. The acceptance of this system meant that
the head gardener could change the appearance of the
garden annually, and his role in creating the garden became
as important as the architect's or landscape designer's. The
proliferation of gardening magazines from the 1820s
ensured publicity for gardeners and new developments (see
*garden journalism), and the competitive nature of the art
induced a high rate of stylistic experiment and change.

At the same time the scope of gardening expanded in
other ways. The abolition of the tax on glass in 1845 brought
the greenhouse within the means of most homeowners, and
the ornamental conservatory became an essential adjunct to
the house. And both garden and glasshouse began to be
provided for the public as well as for the private owner.
From the 1830s first *botanic gardens and then *public
parks (see Edward *Kemp) were established in most size-
able towns, and provided horticultural display for an unpre-
cedentedly wide public. Such gardens at first tended to
follow the model of the landscape park, but from the 1850s
onward, especially after the example of *Paxton's Crystal
Palace Park, offered an increasing variety of designs—
although *cemeteries, which for many communities were
their first effective parks, adopted geometric layouts before
municipal parks did. The Crystal Palace further
demonstrated the attractions of the glasshouse for the
public, not only for horticulture but for entertainment, and
in its wake, *winter gardens also spread around the country
(see *palm house).

During the 1850s and 1860s the two principles of histori-
cal revivalism in design and exoticism in planting reached
their greatest pitch of mutual development. There were
some sporadic attempts to replicate the planting schemes of
long-lost gardens, but such efforts were generally confined
to the use of *herbaceous borders (to recapture the effect of
the 17th-c. flower garden) and topiary. After William *Bar-
ron's work at *Elvaston Castle became known to the public
in the 1850s, both topiary and the grafting together of
different species for ornamental effect received a boost in
popularity. Informal gardens continued to be laid out
throughout the period, but exotic planting had come to
replace the 18th-c. goal of imitating the features of nature
(see *subtropical bedding); however, there was intense
interest in the artificial replication of certain natural
features, such as outcrops of rock (see James *Pulham). The
bedding system was extended to provide a series of seasonal
changes for year-round display; and the revivalists, most
notably Nesfield, created ever more intricate box and gravel
parterres (see *Tudor gardens). The climax of this last
development came with the *Royal Horticultural Society's
short-lived garden at Kensington, the heavy reliance of

Elvaston Castle, Derbyshire, topiary work illustrated in Veitch, *Manual of Coniferae*

which on coloured gravels for effect initiated a reaction against Nesfield, bringing informal gardens into greater favour.

The introduction around 1870 of dwarf foliage plants which could be clipped into flat surfaces gave gardeners a new device—the *carpet bed (see *mosaïculture). By the mid-1870s carpet-bedders were abandoning the emphasis on historical precedent for designs, and were experimenting with new geometric or zoomorphic shapes; eventually, by the beginning of the present century, *floral clocks and three-dimensional floral structures were forming part of the accustomed decoration of the public park. However, as carpet bedding became more highly developed, historical revivalists increasingly turned away from exotic horticultural display, and gave their attention to period accuracy in planting schemes. The 1870s saw a widespread popularity of old-fashioned flowers—those with 17th-c. or earlier associations—which grew steadily towards the end of the century, by which time the first signs of an interest in medieval *herb gardening could be seen. George Devey's restoration of the garden at Penshurst Place in the 1870s was taken as a model by younger designers, who were drawn to the less intricate styles of the early 18th c. B.E.

See also BIRKENHEAD PARK; COBBETT, WILLIAM; DERBY ARBORETUM; MARNOCK, ROBERT; REGENT'S PARK; TRESCO ABBEY.

THE TWENTIETH CENTURY. Towards the end of the 19th c. land, which had for centuries been an unshakeable investment, began to lose its value. The influx of cheap cereals and meat from the Americas around the 1880s caused food prices to fall, resulting in a series of agricultural depressions

which were to recur until the Second World War. Landowners, particularly those without alternative sources of income, were in trouble and numerous country houses stood empty or were sold, their estates broken up for housing or other development. Others were taken over by the new tycoons of industry, who could commute to their offices in the cities. By 1900 the *nouveaux riches* were injecting new life and new money into the estates, although by and large they were remarkably faithful to that curiously English vision of the country gentleman in his rambling manor-house, surrounded by green acres. Where suitable properties did not exist, they sought to build them, with the help of one of many architects, such as *Blomfield and *Lutyens, who specialized in country houses. As practical businessmen they were prepared to keep their unprofitable land to a minimum, and their houses functional.

Concern about these changes and the threats imposed by industrialization was expressed in two ways. First, the *National Trust was founded in 1895 as a charitable body dedicated to the preservation of land and buildings of historic importance to the nation. Trust property now includes many gardens, often restored to a version of their original designs. Secondly, the journal *Country Life* was established in 1897 by Edward Hudson, a businessman dedicated to the preservation of 'country' values. Both in their ways have become national institutions. *Country Life* has painstakingly documented country houses and country matters, on the inherent assumption that life in the country is better than life in the town.

One of the country-house architects whose work was illustrated, and to whom a whole issue was devoted, was (Sir) Edwin Lutyens (1869–1944). With Gertrude *Jekyll

(1843–1932) he gained a deep understanding of traditional materials and crafts, which he was able to express brilliantly in his designs for country houses and their gardens. He sought to achieve unity between house and garden by projecting the enclosures of one into the other at appropriate levels, thereby 'fixing' the house upon its site. 'Every garden scheme', he said, 'should have a backbone, a central idea beautifully phrased. Every wall, path, stone and flower should have its relationship to the central idea.' *Marshcourt, *Hestercombe (see plate XII), and The *Deanery, Sonning, are outstanding examples. Apart from planting design, Jekyll's role is difficult to ascertain, but it is no coincidence that the earlier houses and gardens which constitute Lutyens's best work were all created in conjunction with her.

See also BARRINGTON COURT; FOLLY FARM; LITTLE THAKEHAM.

Jekyll's training in *Arts and Crafts and her interest in wild flowers and gardening made her susceptible to the natural approach to garden design advocated by William *Robinson (1838–1935) and others of what came to be called the Surrey School. Starting with the garden of her own house (designed by Lutyens) at Munstead Wood in 1896 she was able to practise her theories, developed through painting, of the relationships of plants according to form, texture, and particularly colour, which have now become enshrined in much garden and landscape design teaching. She developed the herbaceous border and, in her advocacy of wild plants and her designs for wilderness gardens, anticipated the later ecological movement. While Lutyens was a master of spatial organization and detail, assimilating styles into a whole that often seemed more English than the English vernacular, Jekyll was a true innovator in the use of plants.

Although it pervaded almost every art form, including architecture, the powerful influence of the Art Nouveau Movement had little effect upon the design of gardens in spite of the fact that plant forms were its most potent source of inspiration. It is evident only in the detail of some of the garden elements of such architects as Charles Rennie Mackintosh (1868–1928).

Lutyens's achievement, in the years before 1910, was to reduce the extreme formality advocated by Sir Reginald

Folly Farm, near Reading, Berkshire: the Dutch House extension (1906) and the canal (c. 1915) by Edwin Lutyens and Gertrude Jekyll

Blomfield (1856–1942) and others to a domestic scale and integrate it with the naturalism of Jekyll. In so doing, he went some way towards making peace between the two warring factions in garden design. Robinson had reacted violently to the ideas of decorative artists in the fashionable 'bedding-out' which he called 'pastry-work gardening'. In his periodicals and books, and on his own estate at *Gravetye Manor, he deprecated all paper plans, insisting that a garden should grow out of its site and that the plan could be made only after its evolution, and not before. Blomfield, on the other hand, in his book *The Formal Garden in England* (1892), claimed that the responsibility for garden design was that of the architect, the planting being provided by a horticulturalist, a view still common today. Blomfield managed to combine elements of Italian and French gardens in a way that was well suited to the tastes of the Edwardians, but his work is not distinguished by its planting. In his espousal of formality he was not alone. J. D. Sedding (1838–91), Harold *Peto (1854–1933)—both architects—Thomas *Mawson (1861–1933), and the land-owner Sir George *Sitwell (1860–1943) subscribed to the formal tradition, albeit with varying degrees of sensitivity. Sitwell personified the passionate amateur indulging his hobby to the point of ruin at *Renishaw in Derbyshire and Montegufoni in Italy. His example was followed by other dedicated amateurs, notably A. G. Soames (d. 1934) at Sheffield Park, Laurence Johnston (d. 1957) at *Hidcote, and later Victoria *Sackville-West (1892–1962) and Harold Nicolson (1886–1968) at *Sissinghurst. Like Henry Hoare at Stourhead, they owed their success to continuous personal involvement over a long period, a condition that was becoming more and more difficult to fulfil.

The Lutyens–Jekyll partnership marked the end of an era in private garden design. Lutyens's adoption of a more grandiose classical style coincided with a decline in the partnership. The plentiful supply of cheap labour disappeared with the Second World War, effectively changing the emphasis of garden and landscape design. Although large gardens continued to be created and altered, it is the small garden that is the true expression of the age. As the towns and cities expanded, the suburb, with its leafy avenues, privacy, and sense of security, represented for many an ideal way of living. The *garden cities of Letchworth and Welwyn, and Hampstead Garden Suburb were models. The garden, like the house, remained a show-piece, but it was an individual show-piece: the creation of its owners. While a few, particularly in the remote country, continued the tradition of the *cottage garden, the majority of gardeners in one way or another subscribed to the burgeoning gardening industry. The period also marks a watershed for designers. As the scale of gardens decreased and the market contracted, some moved into the industry in the belief that designing and building was the only effective method; others saw the need for expansion to deal with more pressing problems of public open space.

The first steps towards founding a profession of landscape architecture in Britain were taken in 1927, when a handful of practitioners met at Chelsea Flower Show. A constitution was drawn up and the first meeting held in May 1929 with Thomas Mawson, the garden designer and town planner, as President. The name chosen was the British Institute of Garden Architects. Within months, however, it was changed to the Institute of Landscape Architects, following *Olmsted's description. (See *landscape architecture.)

Garden design, like architecture, was at this period in a state of uncertainty. Unlike the Art Nouveau Movement, which had a dramatic effect upon building and design generally, the international Modern Movement caused little more than a ripple upon the surface of life in England. The neo-classical and Arts and Crafts influences continued to dominate garden design. Percy *Cane (1881–1976) and Russell *Page (1906–85), who were pre-eminently garden designers, both worked in an eclectic manner, gaining wide reputations at home and abroad. Cane's claim to fame is rather for his horticultural knowledge and attention to detail, while Page's approach, elegantly described in his book *The Education of a Gardener* (1962), shows a much greater control of space, using hard materials and plants. For some years he was in partnership with (Sir) Geoffrey *Jellicoe, author, with J. C. Shepherd, of the standard work *The Italian Gardens of the Renaissance* (1925). Jellicoe was involved in alterations and improvements to a variety of large gardens, including the design of one of the last great classical gardens in England, at *Ditchley Park, Oxfordshire (1935–6). But he was also responsible for creating a significant modern structure with a roof-garden, incorporating a glass-bottomed pool, for the Cheddar caves (1933). While expressing great confidence in their form and structure, few such modern designs did more than tentatively reach out into the landscape. An exception was the house at Halland in Sussex, built in 1938, where the architect Serge Chermayeff and the landscape architect Christopher *Tunnard (1910–79) achieved a unique synthesis of architecture and landscape design: intimacy and grandeur, unity, simplicity, and sympathy with the surroundings. Using traditional techniques but forms and details that were uncompromisingly modern, they succeeded in expressing the freedom of a new age, comparable to that seen in the desert houses and gardens of Richard *Neutra in the United States. Simultaneously Tunnard was publishing what in effect was his manifesto, *Gardens in the Modern Landscape* (1938). His appreciation of past styles and indictment of those who refuse to progress are followed by a statement of faith in the new architecture. Supported by his colleague Frank *Clark (1902–71), he proposed a new landscape based upon function and utility, asymmetrical when appropriate, allowing sunlight and views, screened or framed with opportunities for activities and relaxation, avoidance of axial planning and monumental construction, and the use of contrasts: hard and soft, light and dark, rough and smooth, and colour. But he was able to show disappointingly few built examples. In 1939 he emigrated to teach in the United States, spending many years at Yale. Clark remained to develop courses in landscape architecture in Britain.

It was to be another decade before a 'modern' approach to landscape and garden design began to develop, when landscape architects were appointed as consultants to the New Towns. Modern design became identified with post-war hopes for a better Britain, providing unprecedented opportunities for designers at all scales, from planning to the design of public gardens. Working with (Dame) Sylvia *Crowe (b. 1901), the architect/planner (Sir) Frederick *Gibberd (1908–84) created for Harlow a sequence of romantic green valleys, with formal gardens in the centre. Also, over 25 years, he carefully developed his own large garden as a series of vistas, linking spaces peopled by his collection of sculptures and *objets trouvés* (see *sculpture garden). The public park, which had been in decline since the First World War, was revived as an essential component of the open space systems of the cities. Geoffrey and Susan Jellicoe created a unique urban water garden in the centre of Hemel Hempstead. The vein of romanticism which pervades many of these designs is a characteristic of English gardens, frequently dominating the planting, if not the architecture. A typical example of the former extreme is the *Savill Garden established as a series of woodland gardens by Sir Eric Savill (1895–1980) at Windsor.

The Festival of Britain in 1951 provided a further boost for imaginative work by some of the leading practitioners. These included Frank Clark, Maria *Shephard-Parpagliolo (d. 1974), who was later to do outstanding work in Italy, Peter Youngman (b. 1911), and Peter Shepheard (b. 1913), who subsequently made an assessment of the contemporary scene in his book *Modern Gardens* (1953). Selecting examples from a dozen countries, he was able to demonstrate that, like modern architecture, garden design could be inspired by the age in which we live. As well as illustrating the best of British work, he introduced the outstanding work that was being done by *Burle Marx (b. 1909) in Brazil, by Thomas *Church and others in California, and by designers working in Scandinavia and central Europe. In many of these could be seen the transformation of the garden from an area of passive recreation to an essentially functional series of spaces.

The post-war boom in housing which the New Towns were designed to accommodate led also to much that was undesirable in terms of street or environmental quality. To counter this the architect Eric Lyons began work with *Span (see plate VIII*b*) a development consortium, to produce private housing estates with carefully designed landscape and built-in maintenance safeguards provided by the collective patronage of the residents. One of their landscape architects was Preben *Jakobsen (b. 1934), who subsequently set up his own practice, producing much original work (see plate IX). The relatively small scale at which he excels is appropriate also to a few other designers specializing mainly in gardens, notably Anthony du Gard *Pasley (b. 1929) and John *Brookes (b. 1933). Brookes, through his sensitive and lively approach to design, his many books, including *Room Outside* (1968) and *The Small Garden* (1977), and his teaching, has had a profound influence on the establishment of contemporary attitudes to the design of small gardens. Numerous other books on aspects of gardening by such writers as Susan Jellicoe (b. 1907) and Lady Allen of Hurtwood (1897–1976), Miles *Hadfield (1903–82), Edward Hyams (1910–75), Christopher Lloyd (b. 1921), the author-practitioner Lanning *Roper (1912–84), and Peter Coats (b. 1910), garden designer and editor of the important journal *House & Garden*, have been instrumental in drawing attention to the special qualities of gardens and their potential as extensions of the house and microcosms of the landscape. But it is necessary to note the distinction drawn by Sylvia Crowe between the two common attitudes to plants in gardens: 'One is that the purpose of a garden is to grow plants, the other is that plants are one of the materials to be used in the creation of a garden' (*Garden Design*, 1958). Unfortunately the first attitude is all too common, and the second is all too rare.

The landscape of ideas is explored in the three volumes of Geoffrey Jellicoe's *Studies in Landscape Design* (1959–70). He is unique in his vision of landscape architecture rather than architecture as the mother of the arts, which is encapsulated in *The Landscape of Man* (1975) written jointly with Susan Jellicoe. His search for universal symbolism has been expressed in a number of works, most notably in an entirely new complex of gardens for the Tudor house at *Sutton Place. Some of the principles of the 'green' environmental movements of the 1960s and 1970s have found expression in so-called 'ecological planting' and wild gardens (see *ecology and gardens), and their voice in Ian McHarg's testament *Design with Nature* (1969). McHarg's book, and that of Nan *Fairbrother (1913–71), *New Lives, New Landscapes* (1970), which dealt more specifically with the needs of modern society, gave inspiration to a whole generation of designers. McHarg has also been more directly responsible for educating many students of landscape architecture from Britain and elsewhere at the University of Pennsylvania. The idea of conservation is now also becoming associated with a wave of nostalgia that has accompanied disappointment with the developments of the last decades. The National Trust, which since the 1930s has included gardens in its acquisitions, has recently undertaken several major restorations, but these are only a minute proportion of the many hundreds of significant historic gardens in England. Increasing costs and continuing neglect of many of these have drawn attention to the urgent need for a systematic approach to recording, management, and funding. The need for proper study was recognized by Frank Clark and others who founded the *Garden History Society in 1965, and members of the society have instigated a recording system. Since 1983, the Historic Buildings and Monuments Commission for England has begun to compile a register of parks and gardens of special historic interest. (See *conservation and restoration of historic gardens.) The subject has been further illuminated by two major exhibitions at the Victoria and Albert Museum: The Garden (1979) and Repton (1983).

The vital role of management, which has gained increasing importance in design courses, and in the expansion of the Landscape Institute in 1978, is a dominant theme of

Large Gardens and Parks: Maintenance, Management, and Design (1982) by Tom Wright (b. 1928), who has devoted many years to the problem in his work at Wye College and elsewhere. Funding, which is intimately associated with management, is a growing problem. It becomes increasingly necessary for owners, including the National Trust, to raise money, either by selling parts of the estates, or incorporating money-making functions such as motor museums, zoos, or garden centres.

Gardening journals cover all aspects of the subject from the academic to the practical. The garden centre has become as familiar as the supermarket, catering for everyday practical gardening needs in terms of plants, aids to cultivation, and labour-saving devices. Plants are bred as often for their horticultural curiosity value, for size and colour, as for their more subtle effects. Flower shows, of which Chelsea is a model, provide a national platform for these, as well as for competitions for garden designs. Academic progress continues under the aegis of the *Royal Horticultural Society and various botanical gardens, in the study and breeding of plants of all kinds. The *conservatory, which had been so popular in the 19th c., disappeared from gardens and returned later as the greenhouse; it is now reverting once more to the conservatory, as gardens become smaller. Rock and *alpine gardens, which became fashionable as a result of the vogue for travel and mountaineering in the early part of the century, have proved remarkably persistent as a substitute for banks and retaining walls; while bedding-out survives, particularly in municipal parks and gardens. The lawn, however small, has remained obligatory, at first perhaps for playing croquet, later just for walking the dog or taking tea, or perhaps merely as a symbol of what a garden should be. It is often decorated with rose-beds and flanked by herbaceous borders providing flowers to adorn the house. Although the private garden is essentially individual, elements of formality still persist in the path, the terrace, the pool, the fountain, the bird-bath: elements which have recurred in one form or another for over two thousand years of the history of the garden. In this the influence of contemporary art plays but a small part, being treated generally as an irrelevance except in a few schools. The private individual must rely upon the limited resources of the Chelsea Flower Show and the commercial outlets of the garden centres and the press for advice on design.

The English garden is a creation of ingenuity in which the expression of shape and form, texture and colour are by-products rather than generators of design, and their effect is much more dependent upon the selection and growth of plants. But the recent introduction of international garden festivals based on the German models (see *Gartenschau* at Liverpool (1984) to be followed by others at Stoke-on-Trent and Glasgow is beginning to provide a fresh focus for the many resources of the industry and a stimulus to new garden design. M.L.L.

Englischer Garten, Munich, Bavaria, German Federal Republic, lies in the heart of Munich, covering an area of 370 ha. In 1789, after his seat of government had been moved from Mannheim to Munich, the Elector Karl Theodor ordered a large public park to be laid out in the new English landscape style, and commissioned two men, an American, Benjamin Thompson (later Count Rumford, 1753–1814), and Friedrich Ludwig *Sckell (who also worked at *Schwetzingen). Using natural water-courses and mainly indigenous species, Sckell created a typical landscape park which had no specific relationship with a castle or any other building. The wooden Chinesischer Turm (1789–90), originally of five storeys, has for years been the place where the people of Munich gather on summer evenings. The park was subsequently greatly extended beyond the Kleinhesseloher lake. U.GFN.D.

Enstone, Oxfordshire, England, is the site of the now vanished *grotto and garden-hermitage created by Thomas *Bushell in the 1620s and 1630s. At Enstone he discovered a 'desolate Cell of Natures rarities at the head of a Spring', i.e. a curious rock formation which he elaborated into a grotto, with multiple hydraulic effects—including 'Thunder and Lightning, Rain, Hail-showers, Drums beating . . . the Dead arising' (*An Extract by Mr. Bushell*, 1660). In front was a pond with a revolving figure of Neptune, and walks, arbours, and flower gardens on the hillside.

Charles I visited Enstone in 1634, and again in 1636, when Bushell presented a poetical and musical entertainment, recorded in his *Severall Speeches and Songs* (Oxford, 1636). After Bushell's death in 1674 the hermitage became a banqueting room, and joke fountains were set up in the pond. The last record of their operation is in 1712 (William Stukeley, *Itinerarium Curiosum*, 1724). C.T.

Entrelacs, design of interlacing bands; such a design applied to ornamental gardens; *knot garden. K.A.S.W.

Enville, Staffordshire, England, was laid out in the 1740s and 1750s as a *ferme ornée* providing walks 'so extensive and entertaining that even a day is too short to go through them'. The setting was varied, with hills and valleys, meadows, woodland, and water, while the distant views embraced the Malvern Hills, the Wrekin, and the Welsh Mountains. A series of picturesque buildings, including a Gothic boat-house, a Gothic gateway, and a Gothic billiard-room, served both as *eye-catchers and as *belvederes. It is uncertain who laid out the landscape for the 4th Earl of Stamford, but according to tradition William *Shenstone was involved, while Sanderson *Miller designed at least one of the buildings.

The ornamental grounds were extended from 8 to 30 ha. by the head gardener John Aiton in the mid-19th c., when Enville was celebrated for its fountains, its floral display, and its domed and turreted oriental palace of a conservatory (since demolished). P.H.

Erddig, Clwyd, Wales. The walled garden dates from 1720–40 when the house, too, was greatly extended and sumptuously furnished and decorated, an interior which remains substantially unaltered today. The 1st Simon Yorke

made a dignified formal garden typical of the late 17th rather than the 18th c., with useful plants, orchards, and wall fruits, a fish-pond, and niched hedges for bees. It was accurately recorded by Thomas *Badeslade who engraved a bird's-eye view in 1739.

Between 1766 and 1782 William *Emes was employed to landscape the park but the conservative Yorkes forbade removal of the formal garden. Each succeeding generation added and altered according to the taste of the day but never destroyed the original pattern. The National Trust, given the garden and estate in 1973 by the last squire, Philip Yorke, has now restored the main framework of the garden as shown by Badeslade, complete with orchards and some of the original fruit varieties. It has also reconstructed some of the 19th- and even 20th-c. additions, including the Edwardian *parterre near the house and a formal Victorian layout of Irish yews, roses, variegated *Acer negundo*, and *Clematis jackmanii*. J.S.

Eremitage, Bayreuth, Bavaria, German Federal Republic. Art at the court of the margraves of Brandenburg-Bayreuth in the 18th c. was greatly influenced by the Margravine Wilhelmine, a sister of King Friedrich II of Prussia (Frederick the Great). Like her brother, Wilhelmine possessed many artistic talents and it is not surprising that she was particularly interested in gardening. In addition to the Hofgarten in Bayreuth, the gardens of Eremitage and *Sanspareil are especially outstanding.

The first Eremitage (the Altes Schloss) was built by Margrave Georg Wilhelm in 1715 as a place of retreat where he and his court could live in simple seclusion. They wore monks' habits and lived in tiny, bare cells arranged around an inner court. Scattered in the surrounding woods 'under low-hanging spruce boughs' were other hermitages which could be reached by irregular paths.

In 1735 Margrave Friedrich gave the hermitage to his wife Wilhelmine. She had the Altes Schloss extended and right beside it built the Neues Schloss, which was originally not used as living quarters but as a bird-house and orangery. This is indicated by the original semicircular ground-plan and division of the Schloss into three separate buildings. In the middle of the new garden stands a large basin with statuary and fountains. Further down the garden is the impressive Untere Grotte with a large basin in which stands a group of nymphs; it is surrounded on two sides by ruined archways and is equipped with an intricate system of water-jets. Especially interesting is the theatre built in the form of a Roman ruin which was intended for open-air operatic performances.

A noticeable feature of this charming garden is the completely informal arrangement of the buildings; no attempt has been made to connect them in an axial pattern. Many of them were built as ruins. U.GFN.D.

Ermenonville, Oise, France, is famous for *Girardin's landscaped estate and *Rousseau's tomb in the Ile des Peupliers. Girardin inherited château, village, and grounds from his grandmother in 1766 and purchased other land to form a continuous estate astride the valley of the Launette ('the alder brook').

Relief and soil are much varied. The domain was c.900 ha., with woods which are a continuation of the forest of Chantilly, and was divided into four parts: the Farm, on the plateau to the east of the village; the Grand Parc, surrounding the lake south of the château; the Petit Parc, in the marshy area to the north of the château; and the Désert, genuine wild country of sand hills, pine trees, and sandstone boulders (as at Fontainebleau) with Rousseau's cabin still existing among the rocks overlooking the largest lake.

The central axis of the composition ran along the valley: the windows of the Grand Salon opened, to the north, on the Petit Parc, with its large expanse of shallow water, treated as Dutch scenery: a straight canal, a water-mill, windmills, low bridges, a brewery, and a Gothic tower (the Tour Gabrielle, redesigned by Morel). Only the mill and the canal now exist. A secondary vista, at an angle with the main axis, led to the Hameau and to a single Lombardy poplar planted as an eye-catcher. In the area between vista and axis was the Bocage, a reminder of Julie's garden as conceived by Rousseau in *La Nouvelle Héloïse*. The south windows of the Salon looked over the Meaux road, across ponds and lawns to which the villagers had free access, partly for picturesque effects. Beyond, a cascade and a grotto were built into the dam containing the lake, at whose farther end lay the Ile des Peupliers, with Rousseau's Roman tomb (which inspired similar features at *Arkadia, Poland, the Rousseauinsel, *Tiergarten, and *Wörlitz, Germany). This part of the grounds evoked Italian scenes, with the Temple de la Philosophie, recalling Tivoli and left unfinished because philosophy is never-ending, overlooking the composition. Other inscriptions or monuments on the route round the lake were intended to invite contemplation, such as: Marie Antoinette's bench; a memorial to *Shenstone; funerary memorials suggesting the brevity of life; the Prairie Arcadienne, a secluded meadow with the hut of Philemon and Baucis, expressing rural felicity; and the Autel de la Rêverie, for a last look at the whole.

Girardin cleared much and planted little, except beeches and oaks, and poplars for verticals and associations. He was most successful at the gradual merging of varied landscapes into a whole, from the more sophisticated surroundings close to the château into the wild Désert or the ploughlands on the plateau. Subsequent owners added rhododendrons and other features not in keeping with Girardin's intentions. The château is private property, and the lake with the Ile des Peupliers now belongs to the Touring Club of France. The Désert belongs to the Institut de France and has been preserved in its natural condition. D.A.L.

See also JARDIN ANGLAIS.

Erskine, John, 11th Earl of Mar (1675–1732). See ALLOA.

Eryldene, New South Wales, Australia. The garden was designed by its owner, Professor E. G. Waterhouse, and his architect, William Hardy Wilson. In his book, *Old Colonial Architecture in New South Wales and Tasmania*, Hardy Wilson

constantly framed his architectural vistas with massed hydrangeas, oleanders in tubs, and delicately leafed trees, whilst fan-tailed pigeons strutted about on flagged paths.

Photographs of Eryldene in the 1920s show similar scenes with white perennial phlox, alyssum, and red China roses bordering the paths. A straight flagged path edged by flag iris and dwarf azalea leads up to the house: the whole composition recalls a 19th-c. cottage garden.

On the far side of the garden a flower-dashed moon gate leads to the tennis-court. Its pavilion or 'tea-house', Chinese in inspiration, was designed by Hardy Wilson (after 1927). The lacquer red columns and terracotta roof are complemented in autumn by the red foliage of Japanese maples and at other times by the ruddy-coloured fruits of the pomegranate. H.N.T.

Esher Place, Surrey, England, was regarded by *Walpole as one of William *Kent's masterworks: 'Kent is Kentissime' there, he wrote. Owned by Henry Pelham from 1729 to his death in 1754, Esher Place was laid out by Kent from c.1733. He designed a landscape park of 75 ha. with winding walks, a *wilderness, grove work which was praised by *Whately, and a number of buildings which made set scenes possible: for example, there was a temple in front of a pond, a *belvedere on a hilltop, and a grotto set against the hillside among woods. There were also a hermitage and a thatched house. The terrain was varied, with heights and slopes. *Pope and *Thomson described the peaceful atmosphere of the place, situated alongside the River Mole, and as a garden of retreat it resembles the one at *Rousham House. The park was broken up for development in the 1930s, and only the residual Tower house and grotto remain. M.W.R.S.

Espalier, from the Italian *spalle* (i.e. shoulder—'to lean on'); a line of fruit-trees whose branches are pruned and trained into formal patterns against a wall or fence, so as to make the most of sunshine and warmth. The wall itself against which they lean can also be called an espalier.
D.A.L.

Este villas. See D'ESTE.

Estienne, Charles (1504–64), French writer and physician, came from a family of printers. In 1554 he published a collection of his writings on agriculture, horticulture, and viticulture, largely based on Latin texts, under the title *Praedium Rusticum*. His book was put into French by his son-in-law, the physician Jean Liébault, and published in 1564 as *L'agriculture et maison rustique*. Enlarged editions appeared in 1570 and 1572; it was completely revised in

Esher Place, Surrey, engraving (1759) by Luke Sullavan

Plan of the Eszterháza,
Hungary, engraving (1784) by
Jacoby

1582 and a chapter added on laying out figured parterres, with diagrams of elaborate interlacing patterns. In his dedication Liébault says that the largest and best parts of the book are now his own work.

L'agriculture et maison rustique is concerned with the modest country house where aesthetics are subordinate to utility. It was the most important manual on planting and managing an estate until Olivier de *Serres's *Théâtre d'agriculture* (1600), and was translated into a number of languages. The first English version was by Richard Surflet in 1600. K.A.S.W.

Estrade, a French word derived from the Provençal *estrada*, a platform or tier; used as a technical term in horticulture, it signifies the special form of clipped shrub or small tree which appeared in the Burgundian style of gardening in the 15th c. Branches were trained to grow out horizontally, often upon metal wheel-shaped frames, or clipped to form successive level tiers surrounding the trunk. J.H.H.

See also TOPIARY.

Eszterháza, Hungary. Called Süttör until 1764, this estate near Fertőd was owned by the Esterházy family from 1719. Antonio Martinelli built a small hunting-lodge nearby (1719–22), and a small French garden may have existed at this period. The next phase began in 1764 when a large

French garden was planned. There were parterres on the garden side of the palace and three long avenues leading to the pine forest.

The most important years for the construction of the huge palace and garden were between 1766 and 1784, recorded by an anonymous author (probably commissioned by Prince Nikolaus Esterházy) who published a description accompanied by detailed engravings, among them the plan of the garden. The architect of the building and the designer of the garden are both unknown. *Versailles, which it greatly resembles, is surmised to have provided the model for the garden plan, which was executed by successive garden designers, and which shows all the characteristics of a French garden with a large number of buildings scattered around, including an opera house, three Chinese pavilions, temples of Fortune, Venus, and Diana, a bagatelle, and so on.

The *allées were bordered by rich statuary in stone and wood. At the crossing point of the smaller allées were located fountains and bassins, decorated with vases, while the end of the garden was raised and had a sumptuous cascade built (1782–4) by Franz Gruss. Behind this lay a garden of roses, a pheasantry, a zoo, and the pine wood, with deciduous trees such as horse-chestnuts, oaks, and limes, which grew along the three main avenues as well. The *bosquets were surrounded by clipped trees.

After the death of the Prince in 1790 the garden decayed rapidly, as was noted by every traveller who visited it. During the Second World War the palace and garden were almost completely destroyed. Restoration of the whole complex began c.1960 and work on the garden is still continuing.

A.Z./P.G.

Etang, a pond in gardens; a piece of ornamental water of natural origin (see *Fontainebleau). K.A.S.W.

Etoile, an intersection of straight walks in a forest. D.A.L.

See also ROND-POINT.

Euston Hall, Suffolk, England, was rebuilt between 1666 and 1670 by the 1st Earl of Arlington from an existing house in a French style with four domes at the angles. John *Evelyn advised on the enlarging and planting of the park in the 1670s. His work included the planting of avenues on the east and west axes. The east double avenue of ash came down to the entrance gates of the forecourt, the piers of which, and the church, attributed to John Bell of Lynn, are the only structures of this date to survive. Sir Samuel Morland (appointed magister mechanorum by Charles II in 1681) created waterworks for Arlington which included the canalization of a stretch of the river, and a cascade which operated a mill to feed the fountains. He also designed a winch-operated ferry which anticipated by a century Humphry *Repton's similar idea at *Holkham.

Though the 2nd Duke of Grafton inherited Euston Hall in 1690 at the age of 7, he made few changes until the 1730s when he 'entered into a taste'. By 1731 the canal had been replaced by a serpentine rivulet interspersed with pools. A wooden bridge was built to a design by Lord *Burlington. William *Kent was also probably involved at this date, and was certainly working at Euston by 1738. Kent's temple and archway at the west entrance to the park survive, as do three drawings by him for the Euston landscape, one at Holkham Hall, the others at Euston Hall. They show his typical use of clumps of trees, criticized by *Walpole as making a lawn look 'like the ten of spades'. Kent's proposal for a new mansion on the scale of Holkham was not carried out, though the Duke did employ Kent to design Wakefield Lodge (one of Kent's last buildings) on his Northamptonshire property.

Euston Hall was rebuilt between 1750 and 1756 to Brettingham's design for the 2nd Duke, one of 'Capability' *Brown's first patrons at Wakefield Lodge. The 3rd Duke employed Brown who worked intermittently in the park at Euston until his death in 1784; one of his improvements was a reduction in the level of the lake. G.R.C.

Evelyn, John (1620–1705), English virtuoso, garden designer, writer, and translator of gardening books. In 1642 he began a prolonged tour of Italy, France, and Germany, recording extensively in his diary the state of the arts, and especially of gardening. In 1652 he settled at *Sayes Court. His own garden was reminiscent of French ones, although his design for his brother at *Wotton was in the style of an Italian villa garden. In the 1650s he wrote a massive work on all aspects of gardening entitled Elysium Britannicum, probably modelled upon one by Jacques *Boyceau. Although this encyclopaedia was never published in its entirety, Evelyn continued to enlarge and revise it, occasionally detaching parts of it to be used in his other books. The section on groves was eventually incorporated into Sylva, while his discussion of salad plants was published separately as Acetaria in 1699. His translation, The French Gardiner (1658), from the original by Nicolas de Bonnefons, and his introduction of the word 'avenue' into the English language, demonstrate Evelyn's admiration for the state of French gardening.

He was one of the first members of the Royal Society, which he named, and one of its first publications was his book Sylva, or a Discourse of Forest Trees (1664), an encouragement to maintain the supply of timber for the Navy. Pomona, or an Appendix concerning Fruit Trees, in which Evelyn drew together contributions on cider-making from John Beale and others, was appended; so was Kalendarium Hortense (originally another part of the Elysium and later issued separately in many editions) for which some credit was given to John *Rose, whose English Vineyard Vindicated was published with the second edition (1669) of The French Gardiner. Sylva went into four expanding editions during Evelyn's life and, thanks to the large two-volume version edited by Alexander Hunter and published in 1786, remained the standard textbook on the propagation, planting, and use of trees into the 19th c. Evelyn's friendship with Henry Howard, later Duke of Norfolk, brought another patron to the Royal Society, and in 1667 he designed a natural philosopher's garden for Howard at *Albury Park.

He was also willing to be consulted on the French style, as at *Euston Hall (1671), *Cassiobury Park (1680) where he met Moses Cook, and at *Cornbury House in 1664 and again in the 1680s.

His last important book was *The Compleat Gard'ner* (1693), a translation from the French of Jean de la Quintinie, of which an abridged version by *London and *Wise was published in 1699. Evelyn is renowned for his contributions to silviculture, but, in spite of his failure to publish *Elysium Britannicum*, his prolific writing on many branches of art was more important and influential in changing the taste of the nation. D.L.J./S.R.

Exedra. The Greek word *exedra* was first applied to a building standing apart from the dwelling itself (Euripides, *Orestes* 1449), and lying widely open. Later it was used more specifically to designate any kind of hall opening on a portico, in gymnasiums, palaestras, and private houses in Greece. These halls, accessible to the light of the sun and the moon, were furnished with seats and used by 'philosophers, rhetors, and, generally, scholars' (Vitruvius, *De architectura*, 5.11.2). Exedras were introduced in Roman architecture at the same time as public and private peristyles. They are also called *scholae* (places for leisure). In Roman gardens some exedras were built independently from the rest of the villa, and placed on the edge of the *silua* (boulder) (Cicero, *De oratore*, 3.17–18). The side walls were decorated with painted pictures of theatre scenery (of tragic, comic, or satyrical character) (Vitruvius, 7.5.2).

The dominant peculiarity of an exedra is its permeability to its surroundings. One of the first aviaries established in Italy was rigged up in an exedra opening on a peristyle and closed by a net (*Varro, *Res rusticae*, 3.5.8). These exedras, in peristyles belonging to public buildings, were sometimes very large, such as the one in Pompey's Portico in Rome, where the senate assembled on the Ides of March, 44 BC (Plutarch, *Life of Brutus*, 14.2). In Roman garden architecture, exedras play a part similar to the loggias of the Italian villas of the Renaissance. P.GR. (trans. P.G.)

See BRENZONE, VILLA; CHISWICK.

Eye-catcher, a feature, often seen in silhouette, placed on a distant eminence as part of the overall landscape design, but not necessarily on the owner's property. The best known is the façade erected by William *Kent in a field opposite the gardens of *Rousham; an excellent example is the pinnacled façade at Creech Grange, Dorset (Dennis Bond, 1740). Many buildings placed on a height remote from the house (e.g. some of Sanderson *Miller's castles, or Robert Adam's Temple at Audley End) can be regarded as eye-catchers. M.W.R.S.

Eyserbeck, Johann August (1762–1801), German garden designer, was the son of J. Friedrich Eyserbeck. After an apprenticeship at *Oranienbaum, he was employed at Leipzig and in the *Grosser Garten in Dresden. He was summoned by the successor of Friedrich II of Prussia to *Sanssouci, where his main contribution was to make alterations in the sentimental manner around the Neues Palais and to introduce the landscape style. In *c.*1786–7 he drew up plans for the *Neuer Garten at Potsdam: an early, sentimental park laid out on the banks of the Heiliger See, and divided into charming gardens with Chinese and especially Egyptian façade structures. In 1786, also, he may have been involved in the Schlosspark Belvedere, *Tiergarten. From 1788 he was court gardener at *Charlottenburg near Berlin, and was responsible for the modernization of the baroque garden. He influenced the style of estate parks in Brandenburg by his advice and plans. H.GÜ.

Eyserbeck, Johann Friedrich (1734–1818), German garden designer, after a prolonged stay in the Netherlands and England from 1762 to 1817, became court gardener in the *Luisium near Dessau. In *c.*1774 he redesigned the 14-ha. park to specifications by Prince Franz of Anhalt, although he also drew up his own plans; in 1775 he laid out the 14-ha. pleasure-garden at Dessau to a regular design reminiscent of the ancient form of the hippodrome. From 1777 he advised on and partly executed the building of the hermitage of Sieglitzberg.

The plan for the Georgium in the Dessau–Wörlitz area, hitherto attributed to Eyserbeck, was probably drawn up by D. Klewitz and Prince Franz of Anhalt. Originally a park of 13·5 sq. km., it included the landscaped meadows on the banks of the Elbe; today it covers 20·5 ha., with the classical Schloss (1784), Ionic Monopteros, Roman ruins, and other small buildings. Eyserbeck had great influence on undertakings to improve the countryside and on horticulture, especially fruit-growing. H.GÜ.

Fabrique. *Watelet writes in the *Encyclopédie* (1756), that in painter's language, 'Fabrique signifies all buildings represented in this art'. He develops this rather vague idea further, saying that time renders buildings only more favourable to painting. The remains to which it gives rise are, in the eyes of painters, seductive accidents, and a class of artists has always been dedicated to painting ruins. Watelet completes his definition: 'All painters have a right to use *fabriques* in the composition of their pictures, and often the background of history subjects can or must be enriched by these.'

'Fabrique', then, originally derives from the vocabulary of painters. It is only about the 1770s that the term is used to mean all constructions erected in a garden for an ornamental or picturesque end. This shift of meaning, from pictorial representation in two dimensions to an autonomous architectural object, is profoundly revealing of the bonds which unite landscape painting and irregular gardens in the thinking of the time.

Of course, architecture had played a not insignificant role in the layout of gardens before this period, but their newfound significance emerges most clearly in Morel's *Théorie des jardins* (1776): 'It is particularly this relation of character to site that I call the art of gardens. . . . When I have dealt with each situation in a way which is suitable for each kind of building, (their character, form and mass, as well as the style and colour which will harmonise with the landscape in which they are set), I shall have fulfilled my task; that of the architect will be to see that they are soundly constructed . . . to give the exterior the expressive quality which the gardener expects for the charm and truth of his pictures. . . . Buildings considered from this point of view are those which in painting are called *fabriques*, an expression I will use to indicate all those buildings intended for effect, and all constructions which human ingenuity adds to nature for the embellishment of gardens.' The *fabrique*, according to Morel, is no longer simply an ornamental punctuation; it adds its deeper meaning, its character (yet another term of pictorial critique) to the pictures which the garden successively reveals to us; it provides a subtitle to the scene: enchanting, smiling, peaceful.

Thus, what would a wilderness be without a hermitage, an Elysium without a tomb, or an Arcadian meadow without a hut? It is the 'art of fabriques' which enables us to formulate the chief difference between England and France in the field of the *jardin irrégulier*. Even at *Kew where *Chambers calls on all the resources of his culture and imagination, even at *Stowe where the huge park conceals a considerable number of *fabriques*, the English balance

between nature and architecture is always preserved. In France, in estates often of more restricted extent, *fabriques* very quickly tend to take over. Do we see the hand of the architect at the expense of the gardener?

But the cultural role of the *fabriques* must also be stressed. Whether it is a question of an ancient temple, a Chinese bridge, or a Gothic keep, they are perceived as symbolic objects, evocative of a past age, or a distant country; signs, in short, representing the microcosm which is a landscape garden. The garden is no longer just a collection of pictures, it becomes a cabinet of curiosities, or an open-air library, for literary quotations abound there too. This 'new branch of architecture' is quickly recognized as such, which explains the success of such miscellanies as *Le Rouge's *Détails des nouveaux jardins à la mode: jardins anglo-chinois* (1776–87) (which reproduces, among other things, Chambers's Chinese travels) or popularizers like La Neufforge and Panseron. Every proprietor hopes to possess numerous *fabriques*, from a 'druidical' menhir to an Egyptian pyramid, from a Turkish mosque to a primitive hut (see *Betz; *Canon; *Castille; *Ermenonville; *Parc Monceau). The greatest artists of the time were pleased to follow this fashion: Soufflot at *Ménars or Chatou, *Bélanger at *Bagatelle, Brongniart at Mauperthuis, or Hubert *Robert at *Méréville.

The reaction at the end of the 18th c. was twofold and paradoxical. There was, first, an attempt to discover a natural landscape cleared of all this architectural apparatus, which predominates in the theorists under the Empire, or in the *jardins romantiques* (cf. the writing of M. A. de Laborde, 1808, or Lalos). But at the same time the classifying tendencies, which developed at the end of the 18th and the beginning of the 19th cs., end in reducing the garden to a sort of catalogue of *fabriques*, where one chooses according to taste and means (cf. Albums de Krafft; *Thouin, *Plans raisonnés de toutes les espèces de jardins*, 1820), and which will later result in the wood-imitation cement seats of our modern suburbs. However, it must not be denied that this architectural fashion made a major contribution both to the rediscovery of historic styles all through the 19th c. and the revaluing of cottages, farms, and other vernacular buildings, first in England, then in Europe. M.M. (trans. K.A.S.W.)

See also ROME, ANCIENT: THE FABRIQUES.

Facing view (Chinese). See DUI JING.

Fairbrother, Nan (1913–71), English writer on gardens, was among the first in Britain to grasp the essential link between ecology and landscape design. In *New Lives, New*

Landscapes (1970) she analysed with great clarity and optimism the problems of reconciling the needs of 20th-c. industrial society with those of the landscape, giving inspiration to a whole generation of landscape architects. She wrote her first book, *An English Year*, in 1954, and this was followed in 1956 by the eloquent *Men and Gardens*, a worthy successor to Sir Francis *Bacon's essay *Of Gardens*. *New Lives, New Landscapes* was published when she was already dying of cancer, and the last book, *The Nature of Landscape Design* (1974), in which she applies her analytical powers to the subject of landscape design, was edited by Sally Race and published posthumously. M.L.L.

Fairchild, Thomas (1667–1729), English nurseryman and author, established a nursery *c.* 1690 in Hoxton, then a village near London. He specialized in the cultivation of exotics, including a fine collection of North American ones sent back by Mark *Catesby. His aloes and succulent plants were also famous, as well as his fruit garden, described by Richard Bradley in 1721 as 'the greatest collection of fruits that I have yet seen, and so regularly disposed . . . that I do not know any person in Europe to excel him in that particular'. A catalogue of his grapes listed 50 different varieties.

In 1722 Fairchild published *The City Gardener*, describing garden plants able to stand London's smoky atmosphere. He also urged that the town's cobbled squares should be planted as 'wildernesses', with trees, shrubs, and other plants. At the end of the book his experiments in hybridization and other scientific aspects of horticulture are described. 'Fairchild's mule', a sterile cross produced from a carnation fertilized by the pollen of a sweet william, is said to be the first hybrid (see *hybridization) deliberately produced.

Fairchild was a member of the Society of Gardeners responsible for the *Catalogus Plantarum* of 1730, though he died just before its publication. He was buried in the churchyard of St Leonard's, Shoreditch. One of his bequests paid for a sermon to be delivered each Whit Tuesday in that church, a sermon now associated with the annual guild service of the Worshipful Company of Gardeners. S.R.

Fang, meaning stone boat, originally referred to a pair of boats tied together to stop them rocking, but in Chinese landscape architecture a *fang* is a boat-like pavilion usually in three parts: the front somewhat higher than the middle, the back with a cabin storey over the deck. Some *fang* are built in water, often of stone, but the superstructure may be stone or timber. Commonly called 'dry boats' the best known is the one which is half Mississippi steamer, half Italian loggia, built by the Empress Dowager Ci Xi after 1888 in the *Yi He Yuan outside Beijing; more traditional versions are in the *Zhou Zheng Yuan and *I Yuan in Suzhou. X.-W.L./M.K.

See also GE; LOU; TING; XIE; XUAN.

Farnborough Hall, Warwickshire, England, was bought by Ambrose Holbeck in 1684 and, although his son William altered the house, it was another William, grandson of Ambrose, succeeding in 1717, who improved the grounds. He was helped by Sanderson *Miller, an accomplished amateur architect, landscape designer, and dilettante, who lived nearby at Radway.

The great S-shaped terrace walk seems to have been made *c.* 1751 at the same time as the house was being altered and extended. An estate map of the 1750s shows it complete with its two temples placed to give views over the surrounding landscape and with the obelisk at the end, all thought to have been designed by Sanderson Miller. The terrace climbs gently for 730 m. along the ridge looking east and north to the valley below and the slopes of Edgehill beyond. It is backed by a belt of beeches, sycamores, and limes and along the edge of the terrace is a series of promontories on which elms and Scots pines, now replaced by limes, were grown. This majestic concept was conceived in the early days of the English landscape movement and ranks with *Rievaulx Terrace and *Castle Howard as steps toward the landscape parks of the late 18th c.

The northern arm of the terrace leads past the site of a former orangery, now a rose-garden, to a yew walk terminated by what appears to have been a cascade which linked Sourland Pool and the Oval Pond (now woodland) across the road with a long lake, formed by damming the river further down.

Farnborough Hall became the property of the National Trust in 1960. J.S.

Farnese, Palazzo, Caprarola, Lazio, Italy. In 1556 Cardinal Alessandro Farnese commissioned *Vignola to transform a pentagonal fortress into an imposing *palazzo* (completed 1583), which was to dominate the long street of Caprarola (19 km. south-east of Viterbo). While his great rival, Ippolito II d'Este, made his gardens at Villa *d'Este, Tivoli, the scene for displaying his taste and wealth, Farnese concentrated his energies on the *palazzo*, while the gardens are relatively simple. A further difference is that Farnese limited his iconographical programme to the *palazzo*.

The problem of making gardens to complement the vast pentagonal bulk of the *palazzo* was not really confronted—two gardens simply project from each side of the palace, leaving an awkward triangular wedge in between. These two gardens, each *c.* 70 m. square, were completed by 1578: the one on the northern side was a winter garden; that on the western side a summer garden (echoing the disposition of the rooms within the *palazzo* into winter and summer apartments). They were walled gardens—divided into four parterre squares—both fairly similar and, for their date, equally unremarkable.

From the summer garden a path leads for *c.* 400 m. to the *casino and the most remarkable *giardino segreto* in existence, an escape from the sheer size, scale, and monumentality of the villa. Its architectural setting was completed by Girolamo Rainaldi (*c.* 1620).

An introductory space with a circular pool is followed by a walled ramp flanked by large piers. Down the centre of the ramp is a *catena d'acqua* (see *cascade), sculpted similarly to that at Villa *Lante. The ramp leads upwards to water giants

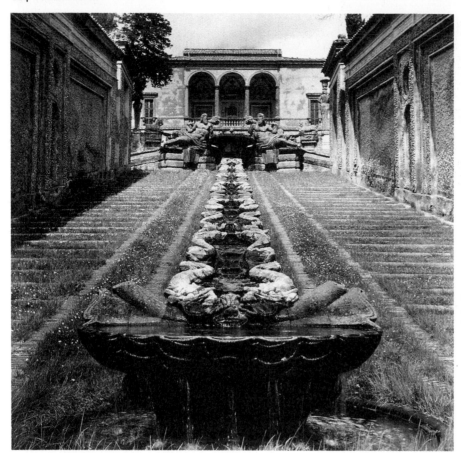

Palazzo Farnese, Caprarola, the Casino Villino

within an oval, from which curved stairs ascend to the main parterre below the *casino*. This parterre is defined by caryatids, human in scale and character. Divided stairways ascend to the final level and on the rear of the *casino*, where there are gardens with mosaic paving that extends the *casino* floor, with a level lawn and very shallow terracing. P.G.

Farrand, Beatrix Jones (1872–1959), American landscape architect, practised from 1890 to 1940, creating a number of outstanding gardens of which the two most important are *Dumbarton Oaks, Washington, DC (1921–47), and the Abby Aldrich Rockefeller Garden at Seal Harbor, Maine (1926–50).

She developed the first with Mildred Barnes Bliss as an American adaptation of the classical Italian garden with planting in the tradition of Gertrude *Jekyll. The garden contains a number of outdoor 'rooms' becoming more informal according to their distance from the house. In 1941 she recorded her work in *The Plant Book for Dumbarton Oaks* (pub. 1980), which sets out in unique detail the origins, development, and management proposals relating to the plants.

The second garden was built around Korean tomb figures and other oriental sculptures and architectural frag-

ments. In addition she designed a number of college campuses, the most important being at Princeton (1913–41) and Yale (1924–47). She also did extensive work at Oberlin College, Vassar, Hamilton, the University of Chicago, Occidental College, and the California Institute of Technology. Her collegiate work is particularly interesting for the practical use of plants—particularly wall plants—and the disposition of open spaces.

Her work extended to England, where she contributed to the design of *Dartington Hall (1933–8). She was in fact an Anglophile, influenced by the work of Gertrude *Jekyll, William *Robinson, and Thomas *Mawson. Like the first of these she preferred to call herself a landscape gardener in spite of the fact that she was the only female founder-member of the American Society of Landscape Architects.

She had intended to develop a school for horticulture and gardening at Reef Point, Bar Harbor, Maine, but when unable to do so for financial reasons, she bequeathed her extensive library, containing the original plans of Gertrude Jekyll, to the University of California at Berkeley. D.K.M.

Farrer, Reginald (1880–1920), English plant-collector, grew up at Ingleborough in Yorkshire, where he made a famous rock-garden. He wrote *The English Rock Garden* (2

The Moon Gate, Abby Aldrich Rockefeller Garden (1926), Maine, United States, by Beatrix Farrand

vols., 1918), still a classic book on the subject. His florid prose also appears in his accounts of his travels, which, after journeys in the European Alps, began in 1913 when he went to Yunnan and Kansu with William Purdom, staying for two years and bringing back, among other plants, *Gentiana farreri*, *Viburnum farreri* (formerly *V. fragrans*), *Buddleia alternifolia*, and two new lilies. After the First World War he collected in Burma, near the Chinese border, with E. H. M. Cox, in an area that had also been visited by *Forrest and *Kingdon-Ward. Cox took most of the seeds home in the autumn of 1919, but Farrer stayed on for another year, became ill, and died there. The botanical results of the journey included the introduction of *Juniperus recurva* 'Coxii', the Chinese coffin-tree (so called because its fragrant wood was in demand for coffins), two dwarf rhododendrons, and *Jasminum farreri*. S.R.

Fathabad, Tabriz, Iran. The garden at Fathabad is to be found near Shah Goli, a little east of the city of Tabriz. Following Islamic garden tradition, a long, straight channel beginning at the southern end of the property leads down a long, narrow, gently terraced garden through several small

waterfalls and fountain pools to a stone-lined tank set on a terrace in front of what was once a pavilion but is now a private house. On either side of the channel are paths, flower-borders, and trees. The garden is 50 m. wide with orchards on either side. J.L.

Feng shui is sometimes referred to as the Chinese version of geomancy which, though quite different, is the nearest Western equivalent to this ancient art. *Feng shui* (or *kan yu*) is actively practised today in Hong Kong, Taiwan, and expatriate Chinese communities round the world, although on the mainland of China it has not been encouraged by the People's Republic because of the superstitious element in its composition.

In simple terms, the basic principle of *feng shui* is that streams or currents of 'vital spirit' or 'cosmic breath' (in China called *ch'i*) run through the earth according to its topography. These currents forcefully influence the fortunes of individuals and their descendants, depending on how they place their houses and—most importantly—their graves, in relation to the winds (*feng*), waters (*shui*), hills (*kan*), and valleys (*yu*) of the landscape in which they live.

Since changes to the landscape were thought actively to affect the flow of *ch'i*, a complex set of rules and principles was developed to guide men's building activities. By the 3rd c. BC the biography of Qu Yuan, a *feng shui* expert, was already included in one of China's earliest literary works. Such experts came in time to advise not only on the siting of graves and buildings, but on remedial action (planting or cutting trees, digging ditches, relocating furniture, and hanging mirrors to deflect evil influences) if family fortunes seemed to be sliding.

Two main schools of practice exist today: one (originating in Jiangxi province) is based on the physical features—such as the shapes of hills, rocks, or trees—of a locality; the other (originating in Fujian province) on orientation (the Chinese invented the magnetic compass for geomantic use). However, for both schools the ideal dwelling should stand facing south, two-thirds of the way up a hill on dry ground, with lower, protective hills to the east and west. Water should gather in a pool below it forming a reservoir of benevolent influences, which might be carried away by a stream flowing too swiftly past the property. Since evil influences (*sha*) were thought to travel in straight lines, winding walls and roads which seem to follow the patterns of the landscape are preferred to straight ones, while in cities, no entrance should open at the end of a street or at a corner where the straight 'arrows' of evil might attack it from several directions at once. The masonry screens or 'spirit walls' built just inside Chinese courtyard entrances not only provide visual privacy for those who live inside, but deflect these arrows and protect the good fortunes of the family.

Not surprisingly, *feng shui* has had an important influence on garden layout. Before anything could be designed a *feng shui* practitioner checked the site, its surroundings, its balance of *yin* and *yang* forces, the flow and availability of water, and advised on the garden's orientation. Interestingly, of the four cardinal directions (east—the Blue Dra-

gon symbolizing spring, west—the White Tiger symbolizing autumn, south—the Crimson Bird symbolizing summer, and north—the Black Turtle symbolizing winter), it is the western that is considered most harmful: 'A garden may be built on the Blue Dragon's head, but never on the mouth of the White Tiger.' Gardens ideally should be at the back or to the east of a house, and if the site was so limited that its garden had no alternative but to lie on the west, a gate was always opened in the east wall of the main residence to make another courtyard—or sometimes, as in the *Wang Shi Yuan, even simply a corridor if space was tight—to the east; in the *Ou Yuan, the west garden is balanced by an east garden to counter the ill effects of the White Tiger's influence.

A garden is also always surrounded by a wall, which preserves its peace and holds the good influences of the site within its smooth enclosure. No large doors or low *lou chuang, from which this accumulated vitality might leak away, are allowed in this boundary. Inside it, winding interior walls further concentrate good influences and these, like the spirit screens, add greatly to the intricate charm and seclusion of the garden. Old trees, repositories of ch'i, are valuable and preserved, while some gardens grow only trees and flowers—like magnolia, crab-apple, peonies, and laurel—with names or features that suggest happiness and wealth. Water, also symbolizing wealth, is led gently through the garden landscape, and gathered in pools before the main pavilions. Its departure, often hidden by rock-work 'mountains', is made as inconspicuous as possible. In the late Qing period few caves were made in these artificial 'mountains' for fear that any evil influences overlooked in the garden's planning might accumulate in their open mouths.

Although over the centuries feng shui acquired a considerable weight of superstition, and some—and perhaps even much—of what goes on today in its practice seems unnecessary mumbo-jumbo, its basic tenets are not only endorsed by modern scientific ideas of physical and psychological well-being, but have been of great aesthetic value to China in the past. X.-W.L./M.K.

Ferme ornée (ornamental farm) was a farm made for enjoyment with paths laid alongside hedgerows which are made ornamental with mixed shrubs and herbaceous plants. The paths were protected from livestock by fences or ditches. The term was current in England in the 18th and 19th cs.; from the 1790s ferme ornée was also used to mean ornamental farm buildings. The idea was first specifically described by Stephen *Switzer in The Nobleman, Gentleman, and Gardener's Recreation of 1715: 'By mixing the useful and profitable Parts of Gard'ning with the Pleasurable in the interior Parts of my Designs and Paddocks, obscure enclosures, etc. in the outward, My Designs are thereby vastly enlarg'd and both Profit and Pleasure may be agreeably mix'd together.' Switzer was also the first to publish the term 'ornamental farm' in the Practical Husbandman (Vol. I, 1733) in a dissertation on ancient and modern villas, and later 'ferme ornée' in the 1742 edition of Ichnographia Rustica:

'This Taste . . . has also for some time been the Practice of the best Genius's of France, under the Title of la Ferme Ornée. And that Great Britain is now likely to excel in it, let all those who have seen the Farms and Parks of Abbs-Court, Riskins, Dawley-Park, now a doing.'

*Shenstone, too, mentioned a French origin in a letter to Richard Graves of 1748: 'The French have what they call a "parque ornée", I suppose approaching about as near to a garden as the park at Hagley. I give my place the title of a "ferme ornée".' The first French use of the term was much later in *Watelet's Essai sur les jardins in 1774 and this is confirmed by Duchêne in 1776 when he writes 'Aussi veut-on assez généralement trouver dans les Jardins du nouveau Genre, une Ferme Ornée.'

Joseph Spence gave a different source: 'Woburn (whence did Mr Southcote take his idea of a Ferme Ornée—Fields going from Rome to Venice)'; and this anecdote was supplemented by one attributed to 'Mr. T' and dated 1741: 'The country by the road from Ferrara to Padua grows more and more cultivated . . . and in some parts of it the cultivation of the fields has a good deal of the air of a garden. They have a level border of eight or ten foot on each side of the cornfields, which is sown with grass and after mowing makes a handsome grass walk round each field.' Small fields with broad headlands like this still exist between Ferrara and Padua.

The essence of the ferme ornée was the ornamentation of hedgerows with a wide range of shrubs and climbers and the addition of herbaceous flower-beds or borders in front. Spence's sketch of the 'Order of Planting after Mr Southcote's Manner' shows a 1·5-m. wide shrub border in front of the old hedge containing 25 species of trees and shrubs, with in front of it a border of half that depth containing 29 varieties of herbaceous plants and bulbs with an edging of pinks. All this was very similar to Philip *Miller's description of wilderness planting in his Gardeners Dictionary (1731); the ferme ornée can be described as linear wilderness planting.

Southcote was the first to practise successfully that which Switzer had proposed and the term 'ferme ornée' was then used fairly freely throughout the 18th c. to describe Shenstone's The *Leasowes, Lord Bathurst's Riching Park (later Percy Lodge) in Buckinghamshire, Lord Halifax's Apps Court in Surrey, Morgan Grave's Mickleton in Gloucestershire, Sir Henry Englefield's White Knights in Berkshire, and *Enville in Staffordshire.

The term remained current for over a hundred years; however, it is through the descriptions of *Woburn Farm and The Leasowes in Thomas Whately's Observations on Modern Gardening (1770) that the idea, if not the practice, gained most currency. R.H.

Fernery. The use of ferns to plant portions of a garden gradually became popular in Britain in the late 1840s and 1850s, when the publication of Thomas Moore's handbooks on ferns inaugurated a fern-collecting passion that lasted until the 1870s. The word fernery could equally well apply to an outdoor glen or rockery given over to ferns, or to

a glasshouse built to house them; such glasshouses continued to be built until the end of the century, even after the collecting fever subsided. The popularity of ferns in the 1850s helped to create an appreciation for foliage plants, which made itself felt in bedding schemes in the late 1860s, and also led to the introduction of rockery screens and informal 'picturesque' planting in conservatories. A good surviving fernery may be seen at *Birr Castle, Co. Offaly, and *Tatton Park, Cheshire. B.E.

Fiennes, Celia (1662–1741), English travel writer, was the daughter of a Cromwellian colonel, and herself an ardent Nonconformist Whig, who made a number of travels on horseback through England between 1685 and c.1712. These she recorded in her journal, in which she is particularly interested in newly created country houses and gardens. Her descriptions of these are a valuable record of the elusive pre-Kentian formal garden, and may be usefully paired with the engravings of Johannes *Kip and Leonard *Knyff. K.S.L.

Finland. Because of the scattered population, harsh economic circumstances, and cold climate gardening spread slowly in Finland. The formal rectilinear grid-pattern—with fruit-trees, soft fruit, and vegetables planted behind rows of broad-leaved trees—which developed elsewhere in Europe during the Middle Ages prevailed for a long time.

Eventually the idea of the landscape park found its devotees and landowners attempted to apply lessons learnt on the Continent to the improvement of their estates. Often this was not easy, as for economic reasons the size of parks had to be limited. The main feature of these parks was often a wildly serpentine path system. Mirroring sheets of water were often achieved by making use of adjacent lakes, streams, and the sea. Water formed an essential part of parks like Mustio and Fagervik. Other famous romantic parks were Monrepos near Viipuri, Aulanko near Hameenlinna, and Traskanda.

The beginnings of functionalism. After the 1930s functionalism was taken up with great enthusiasm. A lawn fringed with freeform groups of plants became one of the main elements of the garden. The retention of existing trees became increasingly important, but many exotic trees and shrubs were also planted. Typical of the period are Douglas fir, cembra pine, and, above all, silver willow (*Salix alba* 'sericea'). Paths were often surfaced with slate or other stone, which was also used to edge a kidney-shaped pool. A pergola covered with Virginia creeper with an accompanying outdoor fireplace also became a popular feature. C.R.

Modern garden design. For most Finns a garden is simply an enjoyable outdoor space. Seating and tables are essential, often grouped around a barbecue; small pools, keep-fit equipment, and sand-pits abound. Ornamental plants are generally used sparingly compared to British gardens. Particularly effective are the bold groups of large perennials,

such as lupins, day lilies, and verbascums, which often nestle against a rock outcrop or stand out in silhouette at a high point.

A typically Finnish design would tend to define space by nuclei rather than by edges, and establish a space flow that appropriates elements outside the garden often as principal features in the composition. The warm light summer evenings encourage the contemplation of distant tree-tops and excessive detail in the foreground would seem trivial. The preoccupation with nature is aesthetic or even mystic rather than ecological.

Landscape architecture. The profession is young, but its achievements already compare well with those of other design disciplines. One of the first important figures to emerge in the post-war period was Katri Luostarinen, whose early work was closely based on a study of traditional farmsteads and who crystallized in the public mind the concept of a garden as part of landscape. Her wide-ranging output includes charming gardens even as far north as the Arctic Circle. Maj-Lis *Rosenbröijer, who prefers designing private gardens, has developed an individual style using timber structures and bold planting to create simple but luxurious oases for family life and business entertainment (see plate VIII*a*). P.HI.

See also AALTO, ALVAR; JANNES, JUSSI.

Finlay, Ian Hamilton (1925–), Scottish poet, sculptor, and gardener, has chosen the garden as his principal means of poetic expression, although his reputation has been acquired largely among poets, artists, and sculptors. In the Kröller-Müller Museum at Arnhem in the Netherlands he has made a 'sacred grove' dedicated to five figures from European political and cultural life. At the Max Planck Institute in Stuttgart (*see over*) he has composed a garden using visual and verbal symbols in a way which has an analogy with the cubists' use of collage. Each object has its own reality as well as being a part of the aesthetic reality of the whole composition. His most comprehensive work is his own garden, continuously in progress, at *Little Sparta near Dunsyre in the Pentland Hills south-west of Edinburgh.
 M.L.L.

Fishbourne, West Sussex, England. The palatial Roman building excavated at Fishbourne, to the west of the city of Chichester, provides the best evidence yet available of Roman gardening in the province of Britannia (see *Roman empire). The palace and its gardens put up in the 70s (AD) were, in plan and execution, totally alien to anything hitherto seen in the country and must imply immigrant designers and craftsmen, brought in possibly from the Mediterranean world.

The main body of the palace consisted of four ranges enclosing a rectangular formal garden (83 m. × 100 m.). Another garden of roughly similar proportions lay to the south between the south wing and the sea. A small kitchen garden was created in the north-west corner, while five small peristyle gardens enlivened the north and east ranges.

Sculpture garden (c.1978) at the Max Planck Institute, Stuttgart, German Federal Republic, by Ian Hamilton Finlay and Hans Luz & Partners

Best known is the central formal garden, entirely enclosed by colonnades. It was divided into two halves by a wide central pathway linking the entrance hall of the east wing to the audience chamber in the centre of the elevated west wing. Subsidiary paths ran around all four sides. The garden had been created as a level platform by terracing into the naturally sloping clay and gravel valley side—a process which entailed the removal and replacement of topsoil over the entire area. To create a sufficient depth of soil, and to encourage root growth in this somewhat hostile subsoil, parallel bedding trenches were dug and filled with a carefully marled loam. These trenches, easily recognizable in excavation, give a clear indication of where ornamental vegetation—presumably bushes—were planted. Along the main central path the bedding trenches were so arranged as to create alternate semicircular and rectangular niches much as one sees on contemporary Italian wall-paintings. The perimeter paths were also hedge-lined with smaller regularly spaced indentations enlivening most of the rows. Only the eastern side of the garden differed. Here there appears to have been a structure of upright timbers, presumably supporting some kind of pergola, with bedding pits at intervals for trees and shrubs. The visual effect, when viewed from the terrace in front of the west wing, would have been to clothe the long east colonnade with a screen of vegetation broken in the centre to give greater emphasis to the pedimented front of the entrance hall. The pathways were ringed with pressurized water-pipes which would have served marble basins and fountains, fragments of which have been recovered.

The south garden is still little known but it extended down to a terrace on the sea edge. A central pond and length of water-pipe hint at elaborate fittings but no evidence of formal planning was discovered. Perhaps it was a wild garden leading the eye easily from the south wing to the natural landscape beyond the tidal inlet. B.W.C.

Fishing pavilion, a waterside building from which one could fish. It could be designed for the grounds of an estate in the same number of styles as a *folly; examples vary from the Chinese Fishing Temple at *Virginia Water in the 1820s, designed by Wyatville and decorated by Frederick Crace, to several designed by Humphry *Repton. M.W.R.S.

Fleury-en-Bière, Essonne, France. The park of the château has a 16th-c. canal, c.800 m. long, said to have inspired the Grand Canal at *Fontainebleau. It survived the transformation of the 17th-c. gardens into the park à l'anglaise. Adjoining the château is Le Potager, formerly an Augustinian Priory, where a garden of originality and distinction has been made, first by the Comtesse de Béhague between 1905 and 1939, and subsequently by the Duchesse de Mouchy. The series of small interconnecting gardens, each with an individual character, owes something to the inspiration of English gardens like *Sissinghurst; but the result is entirely French, with interesting modern versions of the traditional French topiary tradition. K.A.S.W.

Flindt, H. A. (1822–1901), was one of the best-known landscape architects in Denmark in the period of the

'landscape style'. Following his apprenticeship he travelled abroad, and on his return was soon in demand for re-designing the parks to the many manor-houses which were rebuilt at that time, such as *Glorup, *Clausholm, and Vallø, among others. He was involved with *c.*200 parks in all, and several gardens in Sweden. He succeeded Rudolf Rothe as Chief Inspector of the Danish royal gardens. P.R.J.

Floral clock. The idea of using flower-beds to tell the time is as old as Linnaeus, who devised a planting system based on the opening times of different flowers. The term 'floral clock', however, usually means a clock face planted in carpet bedding, with a functioning clockwork mechanism buried underneath, the hands of the clock usually ornamented with dwarf succulents. The first floral clock in Britain (preceded by examples in Detroit and Paris) was designed by John McHattie at the Princes Street Gardens in Edinburgh in 1906, and still survives. The popularity of floral clocks spread throughout public parks in the period 1910–30, but many of these have been removed or abandoned in recent years. A floral cuckoo clock may be seen in Hesketh Park, Southport. B.E.

Florence, Italy. See BOBOLI GARDENS; IL TREBBIO; LA PIETRA; MEDICI, VILLA, CAREGGI; MEDICI, VILLA, CASTELLO; MEDICI, VILLA, FIESOLE; PALMIERI, VILLA; PRATOLINO.

Florists' flowers were a small group of plants cultivated with unusual devotion by gardeners intent upon appreciating in detail the beauty of their blooms. The earlier sense of the word florist means one who cultivates flowers, not one who offers them for sale. By the late 18th c. eight flowers—auricula, polyanthus, hyacinth, anemone, tulip, ranunculus, carnation, and pink—formed the classic subjects, listed in James Maddock's *Florist's Directory* of 1792, with pansy, picotee, and sweet william added to the list later. Another key book for the florists was Thomas Hogg's *Practical Treatise on the Culture of the Carnation, Pink, Auricula, Polyanthus, Tulip, and other Flowers*, first published in 1820 and reaching a sixth edition in 1839. All the flowers were capable of almost endless variation, with double, striped, or spotted forms, or variegated foliage. Minute differences of shape or colour were distinguished, and the perfect specimen had to conform to a list of 'points' or 'properties'. The pastime has been described as a search for an ideal flower.

Tulipomania (see *tulip) was at its peak in the 1630s. The taste for the cultivation of florists' flowers may have come from the Low Countries too, though it also seems to have been linked with the arrival of the Huguenots, especially the weavers, a group that included a surprising number of florists. Certainly many of the original bulbs or plants came from the Netherlands or France.

Societies of florists began to be established in many towns about the middle of the 17th c., with those of Norwich (*c.*1630) and London (1679) among the earliest. The first societies drew their members from the gentry, supplemented by local shop-keepers and tradesmen. In the 19th c. artisans came to dominate the membership of these clubs,

which were especially thickly scattered in the Midlands. The composition of the membership may be indicated by the level of the subscription, from a couple of shillings (10p) a year to as many guineas.

Florists' feasts and shows—usually one for each flower at the appropriate season—in which the growers could match their treasures in competition were regular and universal features. A famous society was the one formed in Paisley in Scotland in 1782, specializing in the pink, although the other florists' flowers were also given attention. As many as 80 varieties of pink were exhibited, and the laced pinks, which are still cultivated, originated in the town. Another florists' flower enjoying a revival is the auricula, with old varieties returning to favour.

The taste for these plants was strong enough to support specialized periodicals dedicated to their growers. One was the *Floricultural Cabinet* and *Florist's Magazine*, which ran from 1833 to 1839 before widening its interests to become the *Gardener's Weekly Magazine*. The fashion was already beginning to decline when George Glenny's book, *The Properties of Flowers* (published in 1847 with a second edition in 1859), became the recognized authority on the shape, size, and colour of perfect florists' flowers.

As the industrial revolution gathered pace and workmen in tightly packed urban streets had neither time nor space to cultivate their gardens, the popularity of florists' flowers declined. The *Horticultural Magazine* of Sept. 1846 described 'the thousands of houses which now cover the space that used to boast of the gaudy tulip-beds of hundreds of working men'. In the 1880s interest in some of the selected flowers revived a little, perhaps as a result of the suitability of some of them, like the polyanthus, for *carpet bedding. S.R.

Flowers were first cultivated for their useful properties rather than their decorative value, as sources of medicines and culinary flavourings, like saffron and poppy seed. As man rose above the level of bare subsistence, pleasure was added to profit as a motive for growing ornamental plants for their own sake. The illustrations in medieval manuscripts already show *roses, lilies, and more humble flowers used to beautify small enclosed gardens, while the manuscripts themselves were decorated with borders of flowers obviously familiar to the painters. Mogul manuscripts are no less rich in floral decoration and pictures of gardens than European ones.

Roses, lilies, and lotuses soon acquired symbolic associations that imply familiarity and value. One of the earliest lilies known is on a fresco of *c.*1500 BC at Amnisos in *Egypt, and in many cultures of both East and West flowers have always been an accompaniment to religious ceremonies. As the lotus is a water-plant, it might be argued that its popularity in both India and Egypt helped the introduction of suitable pools into early garden designs in both these countries.

Homer mentions over 60 flowers, including violets, hyacinths, crocuses, and narcissi, and in classical times there were nurseries for violets in Attica, while the island of

Rhodes was famous for its roses, which were sacred to Aphrodite. Among the Romans, the constant use of wreaths of flowers or aromatic herbs seems to indicate the existence of flourishing gardens to supply their raw material. The most skilful Roman gardeners were able to force their plants into flowering before their proper season.

Charlemagne's directions for the model gardens he wished to see planted included roses and lilies on the list of essential plants, as well as vegetables and herbs (see *Carolingian gardens). Rose-growing was also spread with the gardens of the Benedictine order. Walafrid Strabo, writing of the monastic garden at Reichenau c. AD 840, calls the rose 'the flower of flowers' and says of its oil:

> No man can say,
> No man remember, how many uses there are
> For Oil of Roses as a cure for mankind's ailments.

Later he describes the rose and the lily as 'symbols of the Church's greatest treasures', the rose of the blood of the martyrs, the lily of faith.

In the 16th c., once the printed book allowed the easier transmission of knowledge, the great German and Italian *herbals codified the descriptions of c.6,000 plants. The first *botanic gardens (*Padua; *Pisa) were established in Italy in the middle of the same century, and their collections were inevitably rich in Mediterranean plants in particular. The influence of the classical herbal of *Dioscorides lasted all through this period and long afterwards, so that the identification and cultivation of the plants he described were constant preoccupations of botanists.

If herbals were intended for practical use, the flower books or florilegia, which began to be more frequent early in the 17th c., were consciously illustrating the riches of particular gardens or showing the range of plants available. Pierre Vallet's *Jardin du très Chrestien Henry IV*, published in Paris in 1608, and Basil Besler's *Hortus Eystettensis*, from Nuremberg in 1613, with Crispijn van de Passe's *Hortus Floridus* (Utrecht, 1614 and 1615), perhaps the three most famous florilegia, are already full of irises, lilies, narcissi, hollyhocks, and others that are still favourite garden flowers.

Fashion in flowers has always been as variable as changes of taste in any other field. The exploration of new regions brought new plants back with the travellers. The 16th-c. Flemish botanist *Clusius worked in Vienna for a time and made acquaintance with plants from Asia, thanks in part to the efforts of an ambassador in Constantinople (Istanbul), so that in time he introduced the tulip from Persia (Iran) and the ranunculus from Turkey to European gardens. By the 17th c. both plants were produced in a vast number of varieties. The Dutch *tulip craze is well known, but the same period also offered a huge choice of anemones and ranunculuses, according to the lists Sir Thomas Hanmer made in 1638.

Overseas exploration added still more to the floral repertoire, from the 16th c. on. Tobacco flowers and sunflowers came from South America, Asian *chrysanthemums came from China to the Netherlands c. 1690, followed by the first dahlia, sent from Mexico to Madrid,

Paris, and London in 1789. By the early 19 c., Berlin and England were suffering a dahlia craze. The first fuchsia was another 18th-c. import from South America, a continent that also gave endless rewards to hunters of orchids (see *hot-house plant), plants so demanding in their conditions of cultivation that they have always attracted devoted followers. Some flowers, like the carnation, began as connoisseurs' rarities and went on to become *florists' flowers, often associated with particular groups of artisans. Belgian miners grew carnations, while English and Scottish textile workers were keen florists, competing in the nurture of so-called 'mechanics' flowers', described thus by Henry Phillips in 1824.

Double flowers, once discarded as monstrosities, became another fashion, once Dutch growers began to encourage double hyacinths in the 18th c.

The mixture of native and exotic flowers—herbaceous plants, shrubs, and *climbers—gave gardeners a greater choice, and the design of gardens was adapted to display their plants. *Parterres and shaped beds echoing needlework patterns were sometimes filled with flowers. Le Nôtre preferred to grow them in the kitchen garden, although *La Quintinie, Louis XIV's gardener, kept up the supply of flowers for interior decoration by improving techniques for forcing them. Fresh flowers indoors were supplemented by those in plaster-work, wood, or silver, as well as the coloured copies of tapestries (especially the *millefleur* ones) and flower paintings, which often mixed the flowers of several seasons in one timeless bouquet. Prints of some of these paintings in their turn influenced the design of textiles, wallpaper, and porcelain, too.

With the grass of the park-like garden extending to the very walls of the house, designs influenced by William *Mason brought back the notion of a flower garden with irregular beds scattered on lawns, with urns and sculpture adding to the romantic effect. Oriental gardening, as described by Sir William *Chambers, also contributed to the renewed attention given to flowers in the design of gardens. Both these authors influenced Humphry *Repton's early garden plans, including one of 1800 in which 'the flower garden, without being formal, is highly enriched, but not too much crouded with seats & temples, & statues, vases & other ornaments.' Repton's 'flowers in small beds' on lawns made part of his 'pleasure-grounds, near a house, [which] may be considered as so many different apartments belonging to its state, its comfort, and its pleasure'. The transition from house to garden was often bridged by a conservatory, with greenhouses elsewhere also allowing the cultivation of plants too tender to survive outside.

Another of Repton's innovations made use of the wider range of plants offered by the introduction of new importations. At *Woburn in 1804 he was able to use 'a few tender kinds brought in pots' for a Chinese garden, with hydrangeas and Chinese roses, among others. American gardens also appeared in several of his plans, with evergreen or aquatic plants grouped in other special collections.

Some of Repton's planting of his flower-beds, including annuals and potted geraniums among roses and herbaceous

plants, seems to hint at the later growth of *carpet bedding, a fashion only possible when enough labour was available to grow the quantity of annuals, especially half-hardy ones, needed to furnish the geometric beds. Favourite combinations, still sometimes seen as the pride of municipal gardens, were the red, white, and blue of geranium, alyssum, and lobelia in England, or a mixture of sedum and begonia in France. Blazing salvias were also associated with this style of gardening, until a less rigid fashion began to supplant it by using hardy perennial plants, which could be left in place in their beds or borders.

On a smaller scale, the comfortable mixture of plants found in *cottage gardens has been preserved in more sophisticated treatment of small areas, keeping the informality but enlarging the range of plants grown. As the plant-hunters (see *plant-collecting) sent new material back to their home countries, so the plant-breeders (see *hybridization; *nurserymen) set to work to multiply the number of varieties available. The Asiatic primulas, fairly recent imports, are a classic case. Once again, fashion was inevitably involved. The fuchsia is one example of a plant that reached a peak of popularity in the 19th c., when hundreds of varieties were offered for sale. Though several are still available, many old varieties have vanished. A similar story can be told of several other plants, including the auricula, another 19th-c. favourite, which seems to be enjoying a revival of favour now.

The difficulties of preserving old varieties in an age when many nurseries must concentrate on the mass market to survive have led to systematic plans to ensure the survival of as many varieties of garden plants as possible. Organizations like the National Council for the Conservation of Plants and Gardens in Britain have been able to plan co-operative schemes to safeguard endangered varieties. The establishment of comprehensive reference collections of particular genera or groups is a specially important method of building a stock of a variety that may appeal to only a minority of gardeners. These collections, added to the efforts of a small band of nurserymen devoted to less common plants, should succeed in keeping alive many varieties now considered rare.

*'Wild' gardens, sometimes using exotic species in informal settings where they could be naturalized, have given way a little to the taste for adding wild flowers to the garden stock, as current methods of agriculture disturb their native habitat. Gardens may be turned into new refuges for them too, as well as preserving such oddities from earlier days as double or pink primroses, or even the green rose plantain described in John *Gerard's *Herball* in 1597. S.R.

Foerster, Karl (1874–1970), German nurseryman and plant breeder, although not himself a designer, can be regarded as the father of a school of garden design whose influence continues to be of considerable importance for modern German landscape design. It was he who was instrumental in reintroducing plant material itself, and above all perennials, ferns, and grasses, as the central

Baensch Garden (1930–5), Berlin, by Mattern, Hammerbacher, and Foerster

component of the garden, after the architectural symmetry of the years before and after the First World War.

He also exercised indirect influence through his writings, and through the group of young garden designers who worked with him at his nursery from the late 1920s, among them Hermann *Mattern and Herta Hammerbacher. R.STI.

Folie Saint-James, Neuilly, Paris, is a neo-classical pavilion with a magnificent park on the edge of the *Bois de Boulogne, laid out between 1778 and 1785 by *Bélanger for Baudard de Saint-James, wealthy treasurer of the Admiralty, who wished to rival the Comte d'Artois's *Bagatelle. Enormous blocks of rock were transported from the forest of Fontainebleau to make a grotto (containing a luxurious bathroom) framing the façade of a Doric temple from which issued a river. This flowed through a landscape crowded with islands, statues, and Chinese buildings, and was crossed by numerous bridges in every style.

The novelty of this garden consisted in a 'promenade souterraine' where one could find a Gothic dairy, a rustic salon, and corridors decorated with moss vaults and grass seats. A corner of the parterre was kept as a flower garden, very regular and ornamented with arbours and trellis in the old-fashioned way. A natural-history room with a fine collection of minerals stood between two glazed and heated greenhouses (the most recent innovation of the time), which contained rare flowers. Today, only the house and the ruins of the *grand rocher* survive. M.M. (trans. K.A.S.W.)

Folly, a species of garden structure characterized by a certain excess in terms of eccentricity, cost, or conspicuous inutility. Garden follies have been produced in many periods, wealth and leisure permitting. *Hadrian's Villa at Tivoli contained a number of buildings of this type, such as the Temple of Venus, as did some Italian Renaissance gardens, such as the Rometta at the Villa *d'Este, Tivoli.

The true folly, however, is an accompaniment of the landscape garden rather than of the formal garden and as such is a particularly English phenomenon, though there are very whimsical European examples associated with Continental *jardins anglais*. The 18th c., therefore, was its heyday; often synonymous with an *eye-catcher, as an object of fashion it was at its zenith in mid-century when gardens were often crowded with ornamental buildings (see *fabrique*). *Stourhead is a surviving example though many places had less substantial structures which have disappeared without trace. A reaction against the mania for park and garden buildings was beginning to set in by 1753 when the April issue of *The World* lampooned Squire Mushroom's over-cluttered garden. To the picturesque theoreticians of later in the century a folly was anathema, even if the pictorial possibilities of an existing castle or church tower might be exploited to the full. The strictures of *Knight and *Price, however, did not deter the less fashion-conscious folly

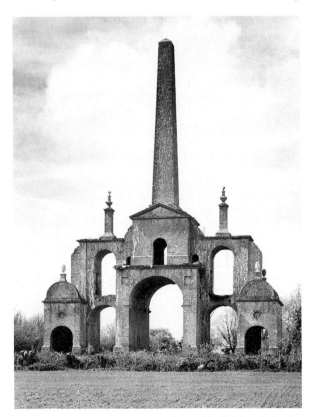

The Connolly folly at Castletown House, Co. Kildare, Ireland

builder, and they were built through the 19th c. and even up to the present.

Towers, arches, sham ruins, sham castles, and sham churches are all common types of folly; hermitages, temples, pagodas, *gazebos, stone circles, megaliths, and cairns are categories that might qualify, given prominent siting or sufficient scale of eccentricity. Towers were a favourite form: they at once fulfil the two roles of garden building discerned by Isaac Ware: 'those which are created as objects in themselves, and those from which prospects and other objects are to be viewed' (*Complete Body of Architecture*, 1756). Examples of towers are to be found at the Pagoda, *Kew (Chambers, 1761); Stourhead (Flitcroft, 1766); Prospect Tower, Gunton (architect unknown, c.1840); and Lord Berners' Folly, Faringdon (Wellesley and Wills, 1935). Arches and screens of arches provided interesting and eye-catching silhouettes on a skyline, such as the Eye-catcher, *Rousham (William *Kent, c.1740); the Obelisk, *Castletown (Richard Castle, c.1740); Shobden Arches, for Lord Bateman (c.1750); and the Treacle Eater, Barwick Park (architect unknown, c.1770).

The builders of garden follies, or their descendants, have often been at some trouble to justify their seeming profligacy. A common justification (some follies bear inscriptions to this effect) has been a desire to alleviate the distressed poor during periods of famine or depression: the Barwick Treacle Eater and Castletown Obelisk are both said to have been built to provide employment. A plaque on the conical tower, Mount Mapas, near Dublin, reads: 'Last year being hard with the POOR the walls about these HILLS AND THIS erected by JOHN MAPAS Esq June 1792.' This sort of circumstance is particularly common in Ireland.

Sham ruins, castles, and churches are very common. They added associational as well as visual interest to a park. *Walpole described Sanderson *Miller's ruined castle at *Hagley as having 'the true rust of the Barons' Wars'. Miller produced several including the ruin at Wimpole. Fake classical ruins were also devised. Batty Langley illustrated several designs for 'Ruins after the old Roman manner for the Termination of Walks, Avenues, etc.' in *New Principles of Gardening*, 1728. At Virginia Water Jeffrey Wyatville arranged for George IV some columns and capitals brought in 1821 from Leptis or Lepcis Magna, an African port, easternmost of the Three Cities of Tripolitania.

Conspicuously placed cottages and farms were sometimes new-fronted with a castle or church façade. The Tattingstone Wonder, Suffolk (c.1760) has a three-sided church tower attached, and Strattenborough Castle Farm, Berkshire (c.1792) a castellated façade which formed an eye-catcher to Coleshill House. Less substantial shams were built of wood. The sham bridge at Kenwood is one such to have survived. The drawings of Thomas Robins the elder depict numerous flimsy-looking timber shams, such as the alcove of Gothic arches at Painswick House, Gloucestershire (c.1748). Even Humphry *Repton, who took propriety in architecture very seriously, produced a timber Gothic 'reposoir' at Brandsbury (1789) and a wood and canvas Gothic pavilion at Welbeck (1789).

The predilection for gloominess, horror, and sublimity, encouraged by the Gothic novel, had its expression in garden follies, and to some extent hermitages, convents, and root-houses may be ascribed to literary inspiration. The interest in prehistory, primitivism, and the origins of architecture explored by neo-classical theorists also inspired the construction of such objects as Druids' rings, cairns, megaliths, barrows, and primitive huts. Merlin's Cave by William Kent (1735) in Richmond Park was an example, half grotto, half hermitage, that contained, amongst curiosities, bookcases for solitary study. William Wrighte's *Grotesque Architecture* (1767) contains designs for hermitages, one with library and bath-house attached. Such arrangements were still being built later in the century, and Humphry Repton describes one in *c.*1790 at Louth, Lincolnshire, devised by the Revd Jolland (MS Autobiography, Part II, in the British Library). A surviving Hermit's Cell at *Badminton House, designed by Thomas Wright, is built of rustic timber with a thatched roof and moss enrichments. Of the Druidical category there are several survivals including the Druid's Circle, Swinton Park, Yorkshire (*c.*1820) and at Templecombe, Henley, a stone circle removed from Jersey in 1785 and re-erected for General Conway.

Follies need not be entirely without function, and builder's pattern books of the 18th and early 19th cs. give numerous designs for whimsical treatments of useful park and farm buildings, such as dairies, barns, lodges, icehouses, bath-houses, kennels, cattle sheds, poultry houses etc. John Plaw's *Ferme Ornée or Rural Improvements* (1795) suggested alternative façades for cattle sheds in classical, castellated, or rustic styles. It also offered elaborate designs for a fold yard disguised as a ruin, a monastic farm, and Gothic dog kennels. After 1820 the provision of such designs by architects declined even if individual eccentrics continued to devise their own. J. C. Loudon's comments on the amazing assemblage of follies at *Alton Towers (*c.*1820) presage the prevailing judgement of the later 19th c.: 'no trifling improvement can ever improve what is so far out of the reach of reason'. G.R.C.

Folly Farm, Berkshire, England, was built round an earlier nucleus of farmhouse and barn in two stages (in 1906 and in 1912) and for different clients. This inevitably gave the garden a more complex character than any other of *Lutyens's designs. The earlier addition, built of blue-grey brick with red brick dressings, took the form of a small 17th-c. 'manor house' lying at right angles to the original Georgian building. Behind and parallel with it lies the barn—once thatched but now tiled—and in the spaces between it and the old and new houses walled courts were formed, linked by archways and by 'herringbone' brick-and-flag paths to the roadside door in the garden wall. Along this wall was formerly a bordered walk, with rhododendrons; in front, to the south, were simple lawns, and adjoining them a long herbaceous border.

Most of this was swept away in 1912, when a new owner engaged Lutyens to build another wing. Characteristically

he chose to adopt a barn-like, vernacular idiom in which to add what was virtually another house, at right angles to the 'manor house'; but as if to emphasize the continuing dominance of the latter, the new wing was joined to it by a lower section, and a long canal garden was formed on its north/south centre line. The most remarkable feature was reserved for the junction of the old with the new—the 'tank pool' with steps going down into the water in the manner of Indian temple-tanks, with a heavily buttressed 'cloister' on two sides supporting the roof, which sweeps down over the edge of the water, focusing deep shadow and reflection. In line axially with the gabled bay on the south lies the big *parterre garden, and beyond it the walled kitchen garden—always regarded by Gertrude *Jekyll as an important feature in any design. To the west, overlooked diagonally by the broad sleeping-balcony of the new wing and approached by corner flights of semicircular steps, is the sunk pool garden, planted with roses and sheltered by dense yew hedges. I.L.P.

See also ENGLAND: THE TWENTIETH CENTURY.

Fontainebleau, Seine-et-Marne, France, is named after the spring of fresh water which gave rise to the town. It is surrounded by a large and picturesque forest, strewn with giant rocks, which so fascinated *François I that he made the castle his most favoured residence. Between 1528 and 1547 he established the main form of the grounds which, though changed in detail, is recognizable today. He made the causeway from the forest; and west of it the trapezoid lake as the focus of the Cour de la Fontaine, the centre of his new additions to the château. East of the causeway he made the Grand Jardin. *Henri IV's buildings north and east of the old château, and his extension of the west–east axis in the Grand Canal, shifted the balance in that direction. Each part of the arrangement has its own history.

The Jardin de Diane, north of the palace, was a private garden with access from the royal apartments. In the time of *Catherine de Medici it was called the Jardin de la Reine, was closed on one side by moats, and adorned with beds laid out in figured patterns and a large ornamented gallery of wood. Bronze sculptures after the antique, cast and founded by Vignola for François I, included *Laocoön, Apollo Belvedere*, and the sleeping *Ariadne* (now all in the Louvre). Henri IV caused a fountain to be put there, with a statue of Diana; the present one dates from the early 19th c. The garden was redesigned by *Le Nôtre in 1645, with a *parterre de broderie*. The aviary which enclosed it on the north was turned into an orangery in 1647. Under Napoleon I the architect Hurtault laid it out in an irregular style, and restored the Fontaine de Diane (1813) with marble steps, an iron balustrade, and a bronze *Diane à la biche* from the Tuileries. Between 1830 and 1838 Louis-Philippe pulled down the ruined orangery, filled in the old moats, and gave the garden its present character.

West of the lake a piece of ground, tapering to the south, was known as the Jardin des Pins on account of the large number of pine trees planted by François I. The Grotte des Pins (whose three-arched façade, with crude giants emerg-

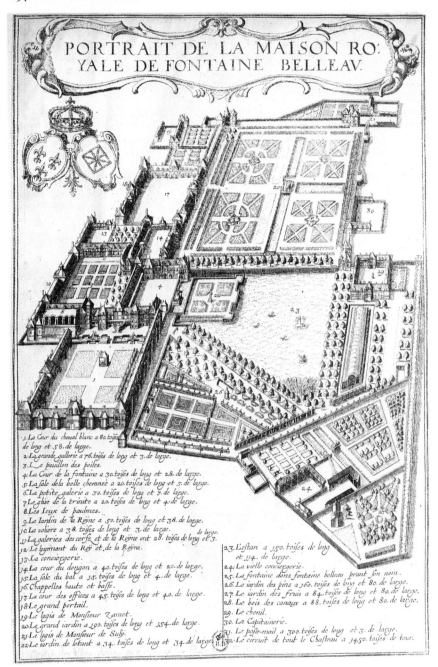

PORTRAIT DE LA MAISON RO:
YALE DE FONTAINE BELLEAV.

1. La Cour du cheual blanc a 80. toises
de long et 58. de large.
2. La grande gallerie a 76. toises de long et 5. de large.
3. Le pauillon des poiles.
4. La Cour de la fontaine a 30. toises de long et 28. de large.
5. La sale de la belle chemneé a 20. toises de long et 5. de large.
6. La petite galerie a 30. toises de long et 5. de large.
7. Le ghse de la trinite a 20. toises de long et 4. de large.
8. Les Ieux de paulmes.
9. Le Iardin de la Reyne a 50. toises de long et 38. de large.
10. La voliere a 38. toises de long et 5. de large.
11. La galeries des cerfz et de la Reyne ont 28. toises de long et 5. de large.
12. Le logement du Roy et de la Reyne.
13. La conciergerie.
14. La cour du dongon a 40. toises de long et 20. de large.
15. La sale du bal a 35. toises de long et 4. de large.
16. Chappelles haute et basse.
17. La cour des offices a 45. toises de long et 40. de large.
18. Le grand portail.
19. Le logis de Monsieur Zamet.
20. Le grand iardin a 290. toises de long et 254. de large.
21. Le logis de Monsieur de Suly.
22. Le iardin de lotant a 34. toises de long et 34. de large.

23. L'estan a 150. toises de long
et 114. de large.
24. La vielle conciergerie.
25. La fontaine dont fontaine belleau prant son nom.
26. Le iardin des pins a 160. toises de long et 80. de large.
27. Le iardin des fruis a 84. toises de long et 80. de large.
28. Le bois des canaux a 88. toises de long et 80. de large.
29. Le chenil.
30. La Capitainerie.
31. Le palle-mail a 300. toises de long et 5. de large.
32. Le circuit de tout le Chasteau a 1450. toises de tour.

Fontainebleau, Seine-et-Marne,
bird's-eye view (1614) after
A. Francini

ing from the rock, still exists) overlooked the garden from the north. It was one of the earliest architectural grottoes in France. Along the west side of the lake was the Allée Royale, where sufferers from scrofula came to be cured by the king's touch. The Fontaine Belleau was situated in the area between the Allée Royale and the Jardins des Pins. Henri IV made a long tunnel of white mulberries, surrounded by canals, south of the lake; and a kitchen garden in the south-west corner. In 1713 this medley was replaced by a unified scheme of avenues converging on a *rond-point. In 1811–12 the western part was transformed by Hurtault into a *jardin anglais, and planted with exotics such as tulip trees, sophoras, catalpas, and swamp cypresses.

The Jardin de l'Etang was a square island garden formerly adjoining the Cour de la Fontaine on the north side of the lake. It was made for Henri IV, and laid out as a *parterre

de broderie by Claude *Mollet in 1595: one of the first places where box was used for this purpose. The garden was destroyed in 1713. There is another island in the lake with a pavilion dating from the time of Napoleon I (1799–1815), although the tradition originated in the 16th c.

East of the causeway the Grand Jardin of François I (*c.*380 sq.m.) became the Parterre du Tibre under Henri IV, so called because of the statue and fountain at its centre. It was laid out with four compartments of *broderie*, and four fountains all by Alexandre *Francine. Between 1661 and 1664 Le Nôtre gave the parterre its present form. Four large compartments round a square central basin were surrounded by a raised terrace and rows of clipped trees which disguised the irregularity of the area and the asymmetrical line of buildings to the north. On the south side a large circular basin projected into the forest, from which it was separated by a moat leaving the view unobstructed. It was one of Le Nôtre's largest parterres: a design of simple grandeur, whose effect today, without the ornamental *broderie*, is bleak.

The Grand Canal, 1,145 m. long × 39 m. wide (said to have been inspired by the one at the château of Fleury-en-Bière nearby), was made in 1609. Long avenues planted with elm bordered the meadow on the south. Catherine de Medici's pleasure house, called Mi-Voye, was situated in the park to the north. An architectural cascade at the head of the canal, its back to the Grand Parterre, was designed *c.*1660 by the brothers François and Pierre de Francine, with falls and jets round a rectangular basin. This elaborate ensemble was destroyed in 1723. Only the back wall now survives, restored in 1812.

No place in France is so rich in historical associations as Fontainebleau. Of all the royal gardens only Versailles and the Tuileries exceeded it in importance. The château is now a state museum with free access to the grounds.　K.A.S.W.

Fonthill Abbey, Wiltshire, England, was the Gothic creation of William *Beckford (1760–1844), who lavished as much care on the setting as he did on the Abbey. Beyond the serpentine lake belonging to his father's Palladian mansion, he added an alpine garden, but he reserved his finest effects for the Abbey setting itself. Within the 11-km. long walls of his estate, where wildlife became tame, he decided that Uvedale *Price's principles of 'the qualities of roughness, and of sudden variation, joined to that of irregularity' should prevail.

Below the Abbey he made the artificial Bitham Lake, above which he created the *American Garden or Plantation, the seeds of whose trees William *Cobbett begged. Within the estate there were 43 km. of grass rides (the grass was cut at night), including the 5-km. stretch along the ridge to the north and the 1·5-km. Great Western Avenue leading to the Abbey itself which was surrounded by native trees. Exotic trees, which his gardeners Milne and Vincent acquired, were planted in the more secluded places. Beckford told Cyrus Redding that he regarded the creation of the flowering wilderness around the Abbey as his greatest achievement, and even today something of Beckford's wilderness and elysium still remains.　K.A.H.

Forecourt, Court. Historically the architectural forecourt has taken many forms. It was the Roman and Christian atrium, or the internal court of any mansion from medieval manor to Buckingham Palace. Essentially it has been an area for reception, its life as garden art beginning when it was no longer totally enclosed. In Tudor England the forecourt was a geometrical projection of the façade of the mansion, adding great dignity to the approach.

The garden court, or open area within a building, has a long and splendid history, perhaps reaching its peak in the proportioned architectural courts of the Roman Renaissance, culminating in Bramante's court of the Vatican. The university quadrangle is such a court, whose square shape can be traced back through the Christian cloister and the square gardens of *Islam, to the Persian paradise garden. In general, the enclosed court or patio is more prevalent in warm dry countries, where shade and the sound of water are of prime importance. The internal court becomes less agreeable north of the Alps, when it can be dark and dank throughout long winter months.　G.A.J.

Forestier, J. C. N. (1861–1930), French landscape architect, became in 1887 the collaborator of the engineer *Alphand, Director-General of Public Works in Paris and the *département* of Seine. In this way he became Keeper (*conservateur*) of the *promenades* of Paris. He distinguished himself by developing the surroundings of the château of Vincennes, which he transformed into a veritable arboretum, and by the creation of a municipal *vélodrome*. From 1905 to the end of his career he developed the gardens of the Champ-de-Mars in Paris. He restored the gardens of *Bagatelle, creating a rosary there, and designed development projects for the park of Sceaux.

In 1925 he was appointed Inspector General of Parks and Gardens for the International Exhibition of Decorative Arts. Then he pursued his work as an innovator in Florida, Mexico, the West Indies, Brazil, and Argentina. Among his creations outside France may be mentioned the public park of Maria-Luisa at Seville, the municipal park at Barcelona, and the development of the Montagne de Montjuich, works going back to 1910–13. As a town planner he drew up in 1923–4 a plan for the improvement of the town of Buenos Aires and created the 8-km. Avenue Costanera beside the Rio de la Plata. In 1925 he established the plan for the new town at Havana. Finally, from 1911, he worked on a project for the development of the principal towns of Morocco.　C.R./S.Z.

Forest Lodge, Stirling, South Australia. The Adelaide Hills, which offer some slight relief of extra shade and breeze during the Adelaide summer, became popular in late Victorian times. Weekend cottages and then larger houses were built, the whole movement being endorsed when the Governor built Marble Hill at Norton Summit in 1879.

Marble Hill was country-house Gothic, and Forest Lodge was constructed in this manner by John Bagot in 1890.

It was an age of garden experimentation and innovation. Bagot visited Japan and brought back trees and varieties of camellias new to the Colony. He laid out the garden within the typical Victorian framework of grottoes, bridges, and fountains. His son, Walter Bagot, was a notable architect who favoured a Mediterranean style of house and garden. On inheriting the property, he introduced Renaissance style vistas—massed azaleas and dark banks of cypresses, punctuated by Italian urns, pilasters and statuary, and ceramic vases and terracotta pots. His collection of conifers is one of the finest in Australia. With replanning, the once incongruous imported trees and Victorian features have merged into an eye-pleasing unity.

The drive is entered through stone gates from a country lane and ascends to the house passing through a green tunnel of foliage. Before the house is a grassy glade dotted with tall conifers; the drive ends in a hedged *exedra set with stone *herms and a bronze fountain in a bed of false dragonhead. Adjacent is a private garden, screened by hedges and tall trees. Rose-clad verandahs of delicate Gothic cast iron link the house to squared lawns and wide gravel paths. Rustic iron furniture and weathered statuary shelter beneath the branches of ancient conifers and paired cypresses. In spring, old terracotta pots of azaleas, geraniums, and succulents flower, while banks of marguerite daisies (*Chrysanthemum frutescens*) parallel the paths.

Steps descend into the forest, to a number of circulatory walks. Paths meander between plantations of azaleas and rhododendrons, shaded by the leafy umbrella of forest cover, to the extremity of the garden where lie its most grandiose features. A circular cast cement fountain spills into a water course characterized by Victorian elements: cement urns, clumps of bamboo, and an arched oriental bridge. Below, a grand vista devised by Walter Bagot leads down the slope to an enormous urn set on a classical base, emphasized by a column-like white-shafted eucalypt. Paired terracotta urns and an avenue of Italian cypress heighten the vista. H.N.T.

Forrest, George (1873–1922), Scottish plant-collector, who worked in the *herbarium of the Royal Botanic Garden, *Edinburgh, before being sent to China in 1904 to collect for A. K. Bulley of Bees Seeds Ltd. and later for a syndicate including J. C. Williams of *Caerhays. He retained his connection with the Edinburgh garden, sending thousands of specimens to the herbarium there. Forrest concentrated on Yunnan, Szechuan, eastern Tibet, and upper Burma, sometimes helped by native collectors. His series of journeys continued till his death, in spite of political troubles and fighting in parts of China. Late in 1913, after three weeks as a prisoner of mutinous soldiers, he recorded: 'Order being once more restored, I proceeded on my journey . . . packed up my collections . . . and despatched the whole to England.' He added over 300 new rhododendrons (including *R. griersonianum*), more than 50 primulas,

Gentiana sino-ornata, several camellias (including *C. saluenensis*, a parent of several hardy hybrids), and *Mahonia lomariifolia*, among many other plants, to the stock in cultivation, as well as quantities of seed of earlier introductions. S.R.

Forsyth, William (1737–1804), Scottish gardener and author, was gardener to the Duke of Northumberland at Syon House, London, until 1771 when he succeeded Philip Miller at the Chelsea Physic Garden. About 1774 he constructed at Chelsea what was probably the first rock-garden in Britain using old stone from the Tower of London and lava from Iceland. He later supervised the royal gardens at *St James's and *Kensington and was one of the founder members of the (*Royal) Horticultural Society of London. He invented a 'plaister', the chief ingredients of which were cow dung, lime, wood ash, and river sand, which he alleged would heal wounds in trees. Despite doubts about its efficacy he was awarded a government grant of £1,500. He wrote *Observations on the Diseases, Defects and Injuries in all Kinds of Fruit and Forest Trees* (1791) and *A Treatise on the Culture and Management of Fruit-trees* (1802). W.G.

Fortune, Robert (1813–80), Scottish plant-collector, was sent to collect in China by the (Royal) Horticultural Society after the Opium War ended in 1842. Another Scottish gardener, he had been trained at Edinburgh and the Society's garden at Chiswick. Descriptions and pictures of the riches of the Chinese flora, particularly those sent back by John Reeves, who had worked in Canton, led to the foundation of the Society's Chinese Committee, eager to encourage the introduction of more of these plants.

In 1843 Fortune arrived in Hong Kong, going on to visit Shanghai, the treaty ports, and as much of the interior of the country as was allowed. He returned to England in 1846 with a large collection of live plants in *Wardian cases, including such familiar ones as white wistaria, winter jasmine, the first 'Japanese' anemone, the first forsythia, the first weigela, winter-flowering honeysuckles, and three viburnums. In 1848 he began the first of three journeys covering the next decade, in search of tea plants and seeds, though he did not stop collecting garden plants too, among them *Mahonia bealei*. On a later visit to Japan he brought back the male form of *Aucuba japonica*, without which the female plants grown in England had been unable to bear fruit. Fortune is said to have introduced over 120 new species, a degree of success that led a French admirer to claim that 'all Europe is obliged to him'. S.R.

Fountain.

Classical antiquity. 'Of all things water is the best' (Pindar). For this most precious, evanescent, and volatile of elements, fountains provide the solid vessels. 'The fountains of water, whether of rivers or of springs, shall be embellished with plantings and buildings.' Plato's dictum (*Laws*, 6.761C) is hardly realized in ancient Athens, but public fountains were prominent in temple groves and parks while sacred foun-

tains, springs, and shrines to Pan, nymphs, and muses (*nymphaeum) adorned garden sanctuaries. During the Hellenistic age, the hydraulic wonders of Babylonian gardens must have enriched classical gardens as well, judging by the *automata described by Ctestibius and *Hero of Alexandria.

Roman fountains are tied to the enormous developments in hydraulic engineering and the building of aqueducts. *Pliny the younger tells of his Tuscan villa with its dining-room where 'water falling from a great height, foams round its marble receptacle . . . a fountain which is incessantly emptying and filling . . . a fountain [that] rises and instantly disappears . . . and small rills conveyed through pipes [that] run murmuring along . . .' (*Letters*, 5.6). Archaeology confirms the descriptions by Cicero and Cato of the frescos in seaside villa landscapes with their rustic shrines and grottoes and the sculptured fountains and splashing jets in the peristyle garden of the House of the Vettii in *Pompeii, before AD 79. No site proclaimed the power of water more vividly than *Hadrian's Villa at Tivoli (118–38), with its extravagant amalgam of waterworks drawn from East and West—the canopus and serapium, baths, cryptoporticus, and maritime theatre recalling *Varro's Aviary. In the late 1st c. BC, Vitruvius discusses the manner of conducting water, mechanical contrivances, water screws, organs, and pumps (*De architectura*, Book 8). Further knowledge of the elaborate organization of Roman hydraulics is found in Frontinus, *De Acquis Urbis Romae* (late 1st c. AD).

Oriental exoticism fused with Western technology in the material splendour of Byzantine fountains, which turned water receptacles into art objects like La Pigna, a gilt pinecone sprinkling water, now in the Belvedere court in the Vatican. Western art witnessed the Christianization of the forms based largely on the baptismal font, the fountain of life, known through manuscripts of the Gospels (Soissons, 9th c., in the Bibliothèque Nationale, Paris), and the cloister or monastic fountain found at the intersection of the cruciform garden, sometimes set within pavilions. Most types are variations of a circular, polygonal, or quadrilobe basin raised on steps with water passing through a column and distributed by lion-head or gargoyle spouts, the surplus running into carved stone channels.

Because of the paucity of surviving medieval gardens, data on fountains is gleaned from descriptions in such courtly romances as the *Roman de la Rose* and Boccaccio's works which find parallels in the Grand Fountain in Perugia (1277–81), the mid-15th-c. sketchbooks of Jacopo Bellini, and contemporary prints and paintings depicting gardens of love and fountains of youth. In the paradise miniature of the *Très Riches Heures du Duc de Berry* (Chantilly, 1413–16), the fountain assumes the shape of a tabernacle or cathedral lantern similar to designs of table fountains for banquets of Burgundian royalty.

The Renaissance fountain. With the revival of the classical villa in the late 15th c., the fountain became an ideal vehicle for the talents of Renaissance sculptors. Not only was the fountain the most important single feature of the garden, it was often the key to its iconographical programme. Both in Italy and in France columnar shafts were engulfed by mythological figures, while water was dispersed through a variety of orifices, as in the court fountain at *Gaillon (1508), Tribolò's Hercules and Anteus in Castello, and Giovanni da Bologna's Venus in Petraia (1538–50) (see also *Blois). But Tivoli is once more the site of the most spectacular waterworks in the Villa *d'Este (1564–72).

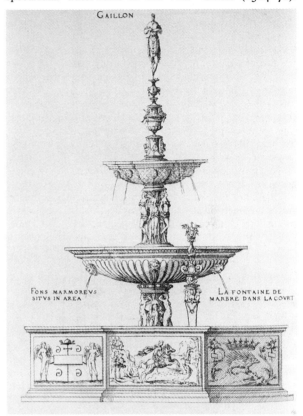

Fountain in the courtyard of Gaillon, Eure, France, engraving (1576) by Jacques Androuet du Cerceau

Montaigne writes of 'that gushing of endless jets. The music of the organ . . . effected by means of water, which falls with great force into a round arched cave . . . by means of other springs an owl is set in motion . . . The sun falling upon [continuous rain] produces a rainbow so natural' (*Journal*, 1581). Water streams from lactating sphinxes, the Diana of Ephesus, the 100 fountains along a terrace, and cascades in veiled set pieces ruled by Pegasus and Rome. In the Villa *Lante at Bagnaia (1568–87), the watercourses flow from the grottoes at the apex down water staircases (*catena d'acqua*) along a central axis to the Fountain of the Moors below—'so well provided with fountains that it seems not only to equal, but surpass even Pratolino and Tivoli'. But water was a scarcer commodity in French gardens—a mere trickle in the fountain of Diana at the château of *Anet (*c.* 1550–4).

Fountains become prominent in Valois court ballets and festivities, in Elizabethan and Stuart masques, and in Florentine *intermezzi*, and their popularity was spread by festival books, travellers' diaries, and engravings such as those in Vredeman *de Vries, *Hortorum viridariorum* (1583). The embellishment of classical motifs as also the transformation from medieval to modern works may be seen by comparing Francesco Colonna's *Hypnerotomachia Poliphili* (1499), with Carlo Fontana's *Utilissima Trattato dell'acqua correnti*... (Rome, 1696), discussing properties of water in motion. By the late 16th c., an architecture of water replaced that of sculpture in the villas of Frascati: in the Villa *Aldobrandini, John *Evelyn notes the theatre of water with 'an Atlas spouting up the streame to an increadible height... the representation of a storm' (*Diary*, 4–5 May 1645). Ultimately, this aquatic architecture culminated in the fountains of *Versailles (*c.* 1622–88). Unlike the grand water-gardens of Italy, hilltop streams were lacking; here the Machine de Marly was designed to pump water from the Seine, to make possible the fantastic array of water jets playing in diverse but symmetrically controlled combinations, as Claude Denis, the *fontainier du roi*, writes, 'to show obeisance to the King of Kings'. Fountains first created by the *Francini formed sparkling and delicate foci for the dark and shady *bosquets* and the water theatres of Latona, Apollo, and Neptune. All visitors were overwhelmed: in 1698 Martin Lister tells of waters 'ordered to Play for the Diversion of the English Gentlemen. The Playing of the spouts of Water, thrown up into the Air, is here diversified after a thousand fashions'. The fountain-jet, that gravity-defying stream, became Le Nôtre's hallmark, singularly appropriate for gardens of authoritarian monarchs. Versailles was re-created throughout Europe in *Schwetzingen (1762), in *Schönbrunn (1690), in *La Granja (1720s), in the cascade bedecked re-enactments of Ovidian metamorphoses on watery proscenia in Caserta (1750s), and, not least, in the gardens of *Peterhof (Petrodvorets) built by Peter I and designed by Le Blond in 1716–19.

Islam. Whereas fountains in the West are dominated by water in perpetual motion, and by sculptural, architectural, and ornamental accoutrements, the East concentrated on the element itself. In the dry eastern Mediterranean, origin of the Islamic conquest, the technology stressed a maximum use of skills with a minimum disturbance of the natural environment. The gardens of *Islam, brought to the West by Moorish invaders, whether in Spain or in Palermo, kept alive the formal elements of their classical predecessors. Water flowing through the *Alhambra and the *Generalife is reminiscent of Persian paradisal gardens, based on similar patterns of irrigation, with channels representing the four rivers of life. A square tank at the central crossing, often marked by a pavilion for pleasure and delight, recalls the ideal of Paradise in the gardens of the Koran, 'with gushing fountains... and rivers flowing beneath'. Concentrated in canals, or marble basins carved in circles and hexagons, water is enhanced by polychrome faiences, local stones, *azulejos*, and multicoloured pavements, or set in shallow geometrically-shaped pools. Most provocative of fountains is that in the Alhambra which gives its name to the Court of the Lions, a bronze 11th-c. fountain with 12 lions supporting a basin with a jetting fountain at the intersection of the two water axes, serving both as a cooling mechanism and a celebration of water.

Water is the all-pervasive theme in the gardens of Mogul India (see *Mogul Empire). Here, as in the West, fountains are often associated with places of worship, such as basins for ablutions in mosques. The garden at Kabul in Afghanistan, thought to be the Emperor Bābur's Garden of Fidelity (Bagh-i Wafa) (1508–9), with its water-tank and small fountain-jet and chutes of sparkling water, is a prelude to the grand fountains in Kashmir—in Jahāngīr's words, a 'garden of eternal springs'. To the *Shalamar Bagh, Srinagar, begun *c.* 1620, Shāh Jahān added a black marble pavilion set in a rectangular pool surrounded by gravity-fed jets and waterfalls. François *Bernier describes *Achabal, a contemporary fountain, in 1665: 'the water whereof diffuseth itself on all sides round about that Fabrick... and into the Gardens by an hundred Canals. It breaks out of the Earth, as if by some violence it ascended up from the bottom of a well, and that with such an abundance as might make it to be called a River rather than a Fountain.' A plentiful supply of water animates the *Shalamar Bagh at Lahore, the best preserved of all Mogul gardens. Enthroned in state on the central terrace, Shāh Jahān could revel in the play of 144 fountains and be cooled by their delicate sprays. William Moorcroft on his visit in 1820 tells of 'water made to fall in sheets from a ledge surrounding the room at the top whilst streams of water spout up through holes in the floor'.

China and Japan. 'The highest good is like that of water'—its spiritual significance as a favoured Taoist symbol is as important as its physical presence. No Chinese garden is conceivable without water and mountains; according to the *Yuan Ye*, its very site is dependent on the water supply. As William *Chambers observes in 1757: 'They compare a clear lake to a rich piece of painting... and say, it is like an aperture in the world, through which you see another world, another sun and other skies.' Fountains in the Western sense with their artificial manipulation of water are contrary to Chinese tradition for they force water to behave in an unnatural way; rather ponds and waterways were used to heighten the effects of nature. As in Chinese painting, water is used to evoke a poetic atmosphere—hence its reflective properties are exploited in mirrors of light set midst rocks and cataracts. By contrast, in the 18th c. Ch'ien Lung commissioned elaborate baroque fountains for his pleasure-gardens, the *Yuan Ming Yuan near Beijing. Built by Jesuits, the 'Great Fountains' with their obelisks bursting with jets of water are an aberration among Chinese gardens. More characteristic is the Jade Fountain in the New Summer Palace near Beijing, where it is impossible to distinguish the work of nature from that of man. Ch'ien Lung meditated and composed verses by water, purportedly as pure and clear as jade, which flows from its source into lakes and ponds and canals.

Japanese, too, prefer to use water in its natural state, and, further, to reveal its source, whether mountain stream, cascade, ravine, or spring. As in painting, ideal nature is suggestive; a spring with stones lying about it may evoke a mountain path. In courtyard gardens in *Kyoto, the focal point is the water basin, midst a low undergrowth of shrubs and pine, while the imperial villa at *Katsura (1620–63) has been deemed a veritable waterscape.

The nineteenth and twentieth centuries. Sculptural fountains fell from favour with the ascending picturesque mode of the 18th c., but they were reintroduced in the more formal 19th-c. gardens. And as fountains, like gardens, moved from the private to the public domain, they became the focuses of city parks and exhibition halls, such as those in the greenhouse ambience of the Crystal Palace in London (1851). These developments have continued in the 20th c. alongside the revival of older fountain types. While Carl Milles' fountain in Cranbrook, Michigan, harks back to a more classical tradition, recently the emphasis has been on natural water. Lawrence *Halprin's water-garden in Portland, Oregon (1961), bears testimony to a resurgence of the natural in an environment increasingly dominated by artifice; by affirming a renewed connection with the process of nature of nearby rivers, cascades, mountains, and streams, it constitutes an evocation in the West of forces dominant in the East. N.M.

Mechanics of fountains. The water was poured, not spouted, from most early fountains; there was no great pressure and the hydraulic problems were to provide an adequate flow from a healthy source. Vitruvius (1st c. BC) details the usual Roman solutions. Roman aqueducts are well known but underground conduits and pipework were probably more important. Vitruvius discusses machines for raising water, mostly bailing devices with no direct relevance to fountains. He does describe one pump and suggests that it could supply a fountain, but it is more likely that pumps were confined to special duties such as fire-fighting. This pump is also described by *Hero (1st c. AD), whose writings describe a parallel tradition of show-pieces based on hydraulic and pneumatic principles.

Medieval hydraulic technique seems to have made little advance until the 15th c. We find many schemes in manuscripts reflecting renewed interest in hydraulics, and in the 16th c. we find significant achievements, for example, spectacular high-pressure fountains such as the *jet d'eau* at *Chenonceaux of the 1550s. Despite this progress, by the 17th c. the work of key men such as Salomon de *Caus still leans heavily on Vitruvius and Hero. One important development is the use of bored wooden pipes as well as the lead and earthenware pipes noted by Vitruvius. De Caus discusses the use of the 'inverted syphon' or U-tube (usually of lead) for supplying fountains, and gives a design for a water-raising machine which is developed from a device given by Hero. His brother or nephew Isaac de Caus gives an improved version of this 'Phneumatique Engin'.

Pumped supplies were a poor substitute for the natural supply of sites like the Villa *d'Este at Tivoli or, from a later date, *Chatsworth. But however the water was supplied, usually it was brought to a high-level reservoir from which it was piped to the fountains. This eased the very real difficulty of matching supply to delivery. An important exception is found in the experiments of Sir Samuel Morland at Windsor Castle in 1681, in which water was forced through a height of 46 m., jetting 24 m. into the air. Morland's plunger pumps were later to become highly important. But Morland failed in his attempt to interest *Louis XIV of France in his high-pressure system and so *Versailles was supplied with water by the astonishing Machine de Marly with its 14 water-wheels driving 253 pumps.

The Artesian well, a borehole sunk to tap ground water under sufficient pressure to spout at the surface, was used from the mid-19th c. to feed fountains. The fountains in Trafalgar Square in London were originally so fed. Throughout the 19th c. more compact pumps and more compact (and more easily managed) power plants were developed. These took their place alongside more traditional devices for feeding fountains. The most important development was the centrifugal pump running at high speed. This lends itself to being driven by an electric motor, so that in this century, with our almost ubiquitous electrical supply, it has become the commonest way to supply a fountain. M.T.W.

See also WATER IN THE LANDSCAPE.

Fountains Abbey, North Yorkshire, England. See STUDLEY ROYAL.

Fouquet, Nicolas (1615–80), French financier, was *surintendant des finances* under Louis XIV. At his château of Saint-Mandé he assembled a magnificent collection of paintings, sculpture, medals, and books. His patronage of artists and writers was perceptive; but his lasting fame is due to bringing together *Le Vau, *Le Brun, and *Le Nôtre to create the château and gardens of *Vaux-le-Vicomte. Fouquet's ambition and self-confidence blinded him to the resentment his ostentatious way of life aroused in Louis XIV who, while accepting invitations to Vaux, was planning his host's downfall with *Colbert, his chief minister. Fouquet was arrested in 1661, a fortnight after a magnificent entertainment at his new château. He was charged with peculation and high treason, and imprisoned for life in the château of Pignerol in the Alps. K.A.S.W

Foxley, Herefordshire (Hereford and Worcester), England, was Sir Uvedale *Price's estate where from c.1770 he applied his theories of the *picturesque. The house (1717, pulled down in 1947) overlooked the home farmlands in the secluded dale of Yarsop to the north-west and, to the southeast, the village of Mansell Lacy, with Merryhill beyond. To the east a vista led up to the Round Oak Hill, close to Wormsley Grange that belonged to the Knights (see Richard Payne *Knight and Thomas *Knight). To the south-east, the dale opened on to the Hereford Plain and Price's major farmlands. Price thinned the belt of woods on

the hills round the dale, and established glades and irregular yet easy paths leading up to viewpoints, such as Ladylift with its clump of Scotch firs. To the south, the view looked out over Yazor (where Price was buried) and the Wye valley, to the Black Mountains and Vesuvius-shaped Ysgyryd Fawr. Within the dale, ponds were so contrived as to reflect the light and serve as *eye-catchers, their banks undermined so as to crumble 'naturally', or planted thickly with varied shrubs and trees. Price's minutely designed foregrounds, or isolated groupings of mixed vegetation visually linked from a distance, framed selected views of the countryside, like so many pictures. Wordsworth found that it lacked rock and water—and variety.

Sold in 1855, picturesque Foxley has slowly melted into the Herefordshire mixed-farming landscape.　　　D.A.L.

Fragonard, Jean-Honoré (1732–1806), French painter, spent the years 1756 to 1761 at the Académie de France in Rome. He worked with Hubert *Robert and the Abbé de Saint-Non in Naples, and, above all, at Tivoli, where he made a series of big drawings in red chalk of the gardens of the Villa *d'Este. In 1771 Madame du Barry commissioned him to decorate the Pavillon de Louveciennes; but on her refusal of his work he returned to Italy with the financier Bergeret, whose son later designed the park at Cassan under the painter's influence.　　　M.M. (trans. K.A.S.W.)

France

ORIGINS OF THE FRENCH GARDEN. The ancestor of the French Renaissance garden enclosed by galleries was the Roman peristyle via the cloister. Roman gardening theory was transmitted by Pietro de' *Crescenzi whose *Opus ruralium commodorum* was translated into French by order of Charles V in 1373. The part covering gardens included instructions for training elms or poplars to form battlemented walls with pavilions. Charles V's own gardens at the palace of Saint-Pol in Paris covered about 8 ha., consisting of separate enclosures (or *préaux*) surrounded by *tonnelles*, vineyards, and orchards. Flowers were cultivated, and there were ornamental features (trellis arbours with seats of turf, a carved stone fountain). The gardens are described by Henri Sauval, but pictorial records were virtually non-existent before Flemish realism penetrated book illustration, as in the *Très Riches Heures*, by Pol de Limbourg, 1416. These paintings show walled enclosures divided into rectangular beds containing small plants, with taller ones against the walls; or gardens surrounded by trellis arbours covered with vine or some other climbing plant (hop, honeysuckle, rose, jasmine, gourds). The planted areas have low wattle or trellis fences of varying elaboration.

French rulers of Naples and Sicily in the 13th and 14th cs. had direct experience of Islamic and Italian gardening. The Italian practice of decorating the garden with shrubs and flowers in earthenware containers was adopted in some French gardens by the mid-15th c.; but the aesthetic appeal, even in royal gardens, remained incidental to the function of providing fruit, vegetables, and medicinal herbs. (See *Hesdin; *pleasance.)

THE FRENCH RENAISSANCE GARDEN. Pursuit of French claims to Naples by René of Anjou (1434–80) and Charles VIII (1483–98), and to Milan by Louis XII (1498–1515), gave many Frenchmen the opportunity to see Italian gardens, and stimulated a taste for exotic fruits (oranges, lemons) and Italian Renaissance ornament. Louis XII's minister, Georges d'Amboise, imported marble *fountains from Italy for *Gaillon, where a huge painted wooden

pavilion was set up to shelter one of them. Similar pavilions were erected at *Blois and *Amboise. These gardens were still separate enclosures, having no formal relation to the house. They were divided into regular rectangular areas, each with railings of wrought timber and (as at Gaillon in 1510) planted differently with flowers or fruit-trees, or laid out in heraldic designs, or ornamented with topiary figures of box or rosemary.

A more fundamental influence on design was the Vitruvian theory of beauty as a harmony of all the parts (as formulated by *Alberti), with a consequent shift from a horticultural to an architectural emphasis. Gardens were incorporated in the overall design of the château at Le Verger (1482–8) for Maréchal de Gié. At Bury (1511–24), for Florimond Robertet, the garden was placed some 5 m. below the level of the main rooms as the climax of an arid approach through a *cour d'honneur* and the main entrance to the *logis*. This arrangement was adopted on an even grander scale by Philibert de *l'Orme at *Anet (1546–52) for Diane de Poitiers. He established the responsibility of the architect for garden design and the practice of using drainage canals for ornamental purposes.

Serlio, one of the Italians invited to work in France by *François I (1515–47), designed *Ancy-le-Franc, with château, gardens, and *bosquets* integrated within a rectangular plan. The fourth book of his treatise *L'Architettura* (1537) contains the first printed designs for parterres in geometrical patterns, although the practice existed long before that. François made important gardens at *Fontainebleau, where casts of antique statues brought from Italy by Primaticcio and Vignola between 1540 and 1543 were the basis of the first major programme of garden sculpture; Primaticcio is believed to have designed the Grotte des Pins, the first architectural grotto in France. He also worked at Fontainebleau for *Catherine de Medici between 1560 and 1563, when the carved and painted freestanding gallery was made. A similar one was built for Renée of France at *Montargis.

Members of the nobility who had inherited old fortified

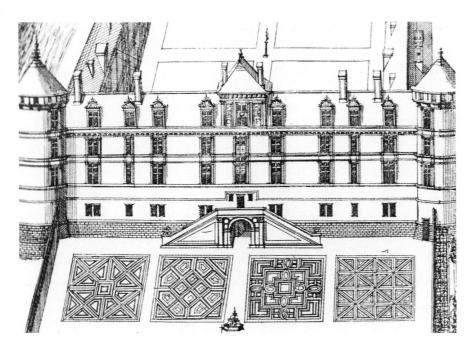

Bury, France, engraving
(1607) by du Cerceau

castles adopted the new fashions. Anne de *Montmorency enlarged *Chantilly from 1524, making a large square garden with a gallery outside the moats; and *c.* 1560 built the Petit Château, surrounded by water, and with a true Renaissance loggia opening on to a small garden. Cardinal de Bourbon added a fine stone gallery at Gaillon (*c.* 1550) and, in the manner of the Italian cardinals, built a remarkable *casino* in the park, with a canal and hermitage in the form of a rock. An independent walled garden, made by Jacques d'Albon, Maréchal Saint-André, at Vallery between 1548 and 1562, was arranged symmetrically about a central canal, with raised walks about it, and an elegant Italianate gallery linking twin pavilions along one side.

Catherine de Medici extended the gardens of *Chenonceaux and Fontainebleau which she used as settings for elaborate entertainments. Despite the almost continuous civil wars which militated against such occupations, she spent extravagantly on building. Her château at Montceaux-en-Brie, standing on a balustraded terrace with views over the valley of the Marne, set a new precedent for openness. Her most influential garden was the *Tuileries (1564–72), just outside the walls of Paris, adjoining the Louvre parallel to the Seine. The rectangular area, some 600 m. long, was notable for its size at the time. It included a ceramic grotto by Bernard *Palissy, whose 'Dessein du jardin délectable' was dedicated to Catherine.

The elaborate artifice of mid-16th-c. French gardens is illustrated in drawings for tapestries by Antoine Caron. Important châteaux and gardens, as they existed in the 1560s and 1570s, were recorded by Jacques I Androuet *du Cerceau, and designs for Charleval and Verneuil-sur-Oise are attributed to him. Although not carried out, they may be regarded as prototypes of the French garden on a level and on a steeply sloping site respectively, departing from the enclosed Renaissance style in the direction of openness and complexity. The idea of using a wide flat area, framed by trees, to display the architecture of the house, looks forward to *Vaux-le-Vicomte; while the design for Verneuil (which is contemporary with the making of the Villa *d'Este at Tivoli) anticipates the terracing at *Saint-Germain-en-Laye.

The revised edition of *Estienne and Liébault's *L'Agriculture et maison rustique* (1582) refers to recent development in the designs of parterres, and is illustrated by elaborate *entrelacs* patterns to be made with thyme, hyssop, or some other low-growing woody herb. Claude *Mollet claimed that shortly after this parterres at Anet were treated as a unit for the first time (instead of diversifying the ornamental compartments as had been the practice), thus applying the principle of the harmonious relation of the parts to the horticultural aspects of the garden as well as to their architectural setting. Mollet became gardener to *Henri IV in 1595, and established the dynasty of gardeners who served the crown until the mid-18th c. His parterre designs for Fontainebleau, Saint-Germain-en-Laye, and the Tuileries are illustrated in Olivier de *Serres's *Théâtre d'agriculture* (1600), a book which first drew attention to the need to compensate for optical distortion when gardens were to be seen from a particular point of view. Claude Mollet's sons developed a style of parterre made of flowing plant-like forms of box, with bands of turf, against a background of coloured earth, called *parterre de broderie*. In the gardens of Marie de Medici's palace of the *Luxembourg (1615–35) such a parterre, incorporating Marie's monogram, was directly related to the south side of the palace. Jacques *Boyceau, who was superintendent of the

royal gardens at the time, illustrated this and others in his *Traité du Jardinage* (1638).

The science of botany advanced largely in response to the demands of medicine. Henri IV supported Richer de Belleval in founding the first botanic garden in France at *Montpellier (1596). Fabri de *Peiresc cultivated rare plants in his gardens at Aix and Belgentier. Louis XIII's doctors, Guy de la Brosse and Jean Hérouard, founded the Jardin Royal des Plantes Médicinales (*Jardin des Plantes, Paris) in 1626 (see Jean *Robin). Cultivated varieties of flowers, particularly bulbs and corms (tulips, anemones, crocuses, fritillaries, etc.) became increasingly available in the first decades of the 17th c. Flowers were planted in parts of the garden devoted to that purpose (as shown in *Silvestre's engraving of *Liancourt in 1655) or in borders round the *parterres de broderie*.

The fountains and other waterworks of late 16th-c. Italian gardens (such as Villa d'Este at Tivoli and Villa *Lante) were much admired by French travellers (for example, *Montaigne). Between 1599 and 1610 Henri IV completed the Château-Neuf at Saint-Germain-en-Laye, with terraced gardens descending to the Seine, and grottoes with *automata in emulation of those at *Pratolino. To this end the Florentine hydraulic engineers Thomaso and Alessandro *Francini were invited to France, where they took the name Francine, establishing the dynasty ultimately responsible for the fountains of *Versailles. The principles of hydraulic engineering were set out by Salomon de *Caus in *Les Raisons des forces mouvantes* (1615); but despite advances in the science, water for increasingly elaborate fountain displays remained a problem. Supplies had to be brought from distant springs to be stored in reservoirs; and often the means were disproportionate to the ends, as in the aqueduct at Arcueil serving the Luxembourg. The most favoured form of cascade for relatively level sites was a row of fountains falling into bowls, arranged side by side as at Liancourt (and later Vaux), or stepped in monumental set pieces, as in Cardinal Richelieu's garden at *Rueil (and later at *Saint-Cloud). On the other hand, sites with marshy ground provided sheets of water serving for both ornament and use (Fontainebleau; Chantilly; *Dampierre); and monumental canals which are characteristically French (*Fleury-en-Bière, latter half of the 16th c.; Fontainebleau, 1609; *Tanlay, 1643–8).

THE CLASSIC FRENCH STYLE. In 1628 Louis XIII's great minister, Cardinal Richelieu, conceived the idea of making his family home into the greatest house in Europe, and combining it with a new town in a plan of overall regularity, designed by *Lemercier. The château of *Richelieu set new standards of magnificence, not only in extent, but in its ornamental gardens and sculpture programme. The hierarchy of courtyards leading from the entrance extended for nearly 460 m.; while behind the château the main axis was closed only by a *grille* in a great semicircular hedge flanked by architectural *grottes*. The canalized River Mable formed a second major axis at right angles to the main one (a

precedent exploited by *Le Nôtre), and provided water for the moats of the château and the town.

In landscaping grounds on this scale the concept of symmetry, implying perceptible boundaries, could no longer apply. Instead there is the idea of balance about an axis, and the possibility (in theory) of infinite extension in any direction. In fact the flatness of Richelieu offered no advantages. Effective use of the extended axis depends on choosing a site with differences in level, as Le Nôtre was to do; something he probably learned from François *Mansart's example. Mansart's imaginative use of the extended axis was first demonstrated at *Balleroy (1626–36) where he made a new village street at right angles to the old one, so that the approach to the château was across a shallow valley. Maisons (1642–51), standing on a terraced platform above the Seine, had an avenue 1·5 km. long stretching into the forest of Saint-Germain; while on the other side the château overlooked a parterre, and the axis was continued by rows of trees beyond the river. At Petit-Bourg the gardens descended in five stages, with a cascade of shell basins and more than 20 jets, ending in a crescent-shaped terrace overlooking the Seine.

In 1632 Louis XIII bought the estate of Versailles from Jean François de Gondi, enlarging the existing hunting lodge, and enclosing a park. The division by *allées* into a regular grid-like plan has remained the basis for all subsequent modifications. In *Le Jardin de plaisir* (1651) André Mollet set out the classic concept of French garden design: a hierarchy of *parterres de broderie*, *parterres de gazon* (turf), and *bosquets* arranged according to a strictly regular plan. Le Nôtre adapted this formula to the necessities of the site, choosing the ground for his great sweeping vistas dominating the landscape, with secondary axes at right angles to the main one, often used to dramatic effect (Vaux-le-Vicomte; Chantilly; *Sceaux). His genius was first apparent at Vaux (1656–61) where he worked with Louis *Le Vau and Charles *Le Brun for Louis XIV's minister, Nicolas *Fouquet, to make what is probably the masterpiece of French classic garden art. Vaux departed from Mollet's formula in the emphasis on the central axis, and the asymmetry of the parts on either side; while the divisions and differences in level are so skilfully managed that the garden presents the appearance of an unbroken whole.

The scale and magnificence of French garden design during the reign of *Louis XIV became the model for Europe, if not the world. The image was widely distributed in engravings by Silvestre, the *Perelles, Jean Marot, and, in the early 18th c., Jacques *Rigaud. None of the royal gardens escaped transformation under Louis's compulsive need for change. Versailles was rebuilt three times, and on each occasion the gardens were modified. They have been described as 'a whole logical progression from the design in stone to the open countryside' (Victor Tapie, *Baroque et classicisme*, 1972). The final version is the work of many hands; certainly of Le Nôtre, but also of *Hardouin-Mansart. To escape the enormous palace where he lived in public, Louis built retreats, first at Versailles, the Grand Trianon, then at *Marly (see *Saint-Simon). Marly owed

little to Le Nôtre and Hardouin-Mansart's design departs entirely from the classical French tradition. It may be regarded as Louis XIV's most original contribution to the art of garden design.

The cost of the royal gardens was enormous, not only their construction but their maintenance. More gardeners (305) than any other craftsmen are named in the royal accounts from 1664 to 1680; and this does not include their assistants. A large part of their task was to see that order was maintained: raking the sanded walks, clipping the box in the parterres or the smooth walls of hornbeam lining the *bosquets*. Gardeners were also specialists in such things as trellis-work, care of the orangeries, flower gardening, and kitchen and fruit gardening, as well as tree planting in the parks. Responsibility for large gardens was divided; contracts were specific, and the work was often a family preserve on a hereditary basis (see *Desgots; *Richard).

At the head of the hierarchy was Le Nôtre who was classed as an architect, but retained his family connection with the Tuileries. *La Quintinie as head of fruit gardens and *potagers* (kitchen gardens) was almost equal in status. The annual wage of head gardeners included money for the cost of tools, plants, manure, and other materials as well as for the employment of assistants. Michel *Le Bouteux's very large salary when he was at Trianon recognized the expense of cultivating thousands of pot plants to meet Louis's demands for instant gardening all the year round. Bedding out was the French method of flower gardening *par excellence*. The constant changes in the *bosquets* at Versailles involved much work in planting trees and certain men were employed to search for and transport thousands of well-grown saplings from the forests of France. The largest and most constant item in the tree bill was for hornbeam to form the smooth clipped hedges (*charmilles*) which lined the walks of the Petit Parc at Versailles, Marly, and elsewhere. Michel de Saussay's *Traité des Jardins* (1722) gives an account of gardening practice and lists of plants, particularly varieties of fruit-trees, favoured at a slightly later date.

The use of water in basins and canals is particularly suited to many French sites; defensive moats (as at Chantilly) can be turned to ornamental use, mirrors reflecting the architecture. On the other hand, enormous sums were spent on bringing water for elaborate fountains and cascades. The Machine de Marly, 14 large water-wheels to raise the waters of the Seine for the gardens of Marly and Versailles, cost over three million *livres*. At the same time the scheme for diverting the waters of the Eure by aqueduct cost well over eight million *livres* before it was abandoned. Such extravagance was not confined to royal gardens. An aqueduct 7 km. long was built to bring water to the château of *Castries near Montpellier in 1670–6.

Indeed, expense brought a reaction which was justified by theory. A.-J. *Dezallier d'Argenville's *La Théorie et la pratique du jardinage* (1709) codified the practice of Le Nôtre and his school; but in the revised edition (1722) he writes that a garden should owe more to nature than to art. Expensive and elaborate artefacts should give place to 'the noble simplicity of steps, banks, ramps of turf, natural

arbours, and simple clipped hedges' (*palissades). Even before 1700 the *parterre à l'anglaise* of cut turf was replacing elaborate *broderies* of box. The principles of regularity in the parts of the garden, as set out by Dezallier d'Argenville, continued to be followed in the first three-quarters of the 18th c., with modifications in the details of the parts and regional variations. The arabesques in J.-F. *Blondel's *De la Distribution des maisons de plaisance* (1737) have a lightness and elegance related to the rococo style of his trellis arbours and other garden ornaments. These were followed by plain areas of turf and a new rectilinear severity in J. F. de la Neufforge's *Recueil élémentaire d'architecture* (1757–68). Vertical features, like clipped yews in the borders, gave way to flowers or flowering shrubs.

Under Louis XV gardens of a more intimate character were favoured, compared with the grandiose schemes of Louis XIV. The Marquise de *Pompadour called her retreats at Versailles and Fontainebleau *Hermitages*; her house at Bellevue near Meudon was more notable for the views over the Seine than the magnificence of the gardens. In 1760, shortly before her death, she bought *Ménars, near Blois; but it was her brother the Marquis de Marigny who perfected the gardens and terrace bordering the Loire. Among the many gardens made in the regular style all over France during the 18th c., provincial examples still exist at *Canon, *Jallerange, and *La Motte-Tilly. Other regional variations occur round *Aix and Montpellier. Big gardens like Chantilly and Versailles were constantly added to and changed. The Petit Trianon, conceived by Gabriel for the Marquise de Pompadour, was completed after her death; its intimate scale was as characteristic of Louis XV's reign as the grandiosity of Marly had been for that of his predecessor. The big royal gardens of the past (the Tuileries; Versailles) had become virtually public gardens; their 18th-c. successors were the municipal promenades like those at Nîmes (see *Jardin de la Fontaine) and Besançon (see *Chamars); and the extension of garden design to town planning as at *Nancy. K.A.S.W.

LE JARDIN ANGLAIS. The concept of the landscape garden arose when aesthetic control was exercised over large areas of ground, or when distinctions between garden and park became less clearly defined. The change from an architectural to a more 'natural' style proceeded more rapidly in England, culminating with 'Capability' *Brown's great landscape parks. In mid-18th-c. France knowledge of the English style of gardening was largely second-hand, except, perhaps, for *Montesquieu at *La Brède. *Addison's essay 'The Pleasures of the Imagination' was translated into French in 1720; *Chambers's *Designs of Chinese Buildings* (1757) and *A Dissertation on Oriental Gardening* (1772) were not only sources of information, but also fostered the idea that English gardens were derived from the Chinese (see *Attiret). *Latapie, in the introduction to his translation of *Whately's *Observations on Modern Gardening* (*L'Art de Former les Jardins Modernes* (1771)) quoted at length from Chambers's book to prove 'the perfect resemblance of English gardens to Chinese gardens'. (See *Chinoiserie.)

Le Rouge published details of English gardens (*Chiswick; *Claremont; *Esher; Exton; *Kew; *Painshill; *Richmond; Wanstead; *West Wycombe; and *Windsor) in his *Nouveaux Jardins à la mode* (1776–87); and in the 15th book wrote 'everyone knows that English gardens are only an imitation of those of China'. He called the French version of the style 'les jardins anglo-chinois' (see *jardin anglo-chinois*). Chinese buildings were naturally part of this fashion, examples of which survive in the *Pagode de Chanteloup and at *Cassan.

*Stowe and *Kew were probably the best known English gardens, where buildings were used to give character by association. The architect *Bélanger, who initially did much to promote the style in France, visited England in the 1770s and took particular note of Hagley, Painshill, and *Stourhead, where his attention was directed to the buildings rather than their settings. He also visited The *Leasowes, as did the Marquis de *Girardin, who acknowledged his debt to *Shenstone at *Ermenonville (see *Rousseau). Brown's stylized 'natural' landscape design was ignored, at least until after the Revolution. The *jardin anglais* was at first often of small dimensions, added to a French-style regular garden as a kind of labyrinth or fanciful *bosquet*, sometimes having a rustic character as in the *hameaux* of Chantilly or Petit Trianon. Other gardens were *jardins anglais* only by reason of the freedom allowed to the vegetation between the straight *allées* (as in *Watelet's *Moulin Joli). At *Bagatelle, *Folie Saint-James, and *Parc Monceau buildings of many styles were crowded into a relatively small space for theatrical effect. On an altogether larger scale were the landscaped parks ornamented with ruins, monuments, or inscriptions having sentimental and romantic overtones (Roissy by the Marquis de *Caraman; Mortefontaine; Raincy; Guiscard; Ermenonville; *Méréville; *Désert de Retz; *Betz; see *Le Rouge for a record). Most of these gardens had a sinuous route linking varied scenes with inward views but closed to the outside (see *Harcourt). *Fabriques* (buildings, artificial rocks) were designed by painters such as Hubert *Robert (see *Rambouillet), whose pictures of Italian gardens in decay expressed and stimulated the mood (for other influential painters, see *Boucher; *Fragonard). The new styles were not universally admired (see *Blaikie; *Encyclopédie*; *Voltaire).

EMPIRE STYLES. The Revolution put a temporary end to the French architectural style of gardening, partly because it was associated with the *ancien régime*, but also because when the *émigrés* returned to France they found it more convenient to restore their neglected estates and parks in the English manner. Alexandre de Laborde in his *Nouveaux Jardins de la France* (1808) recorded such transformations, as well as new gardens such as *Malmaison, supervised by *Joséphine, and older parks *à l'anglaise* as they appeared under the First Empire. Among the best conserved *jardins anglais* of the Napoleonic period is that at Fontainebleau (1809–12). Laborde's theory, with drawings by Bourgeois, suggests the influence of Humphry *Repton, particularly in the comparative illustrations showing transformations from the regular into the irregular style. But it was Gabriel *Thouin (1747–1829) who first rationalized the style which became established in the course of the 19th c., reaching its climax under Napoleon III. Thouin worked out a functional scheme of walks linked to a vast circular *allée* round a lawn punctuated with vegetation. This was the style of the brothers *Bühler (see *Jardin Thabor; *Parc de la Tête d'Or), and of *Varé, designer of the *Bois de Boulogne, whose style was taken over by *Barillet-Deschamps.

A search for a practical method to be taught in schools took away much of the spontaneity from the big creations of the Second Empire. The *jardin anglais* became functional. *Haussmann and his team (*Alphand, Duvilliers, Barillet-Deschamps, and *André) no longer created landscapes, but promenades for recreation. The *allées* are amply drawn, circular, oval, or elliptical (like the sections of an egg, said W. *Robinson), enclosing lawns with rounded clumps and varied surfaces. This style can be seen in the *public parks of Paris, such as *Buttes-Chaumont or Parc Montsouris.

The interest in flower gardening revived in the mid-19th c. William Robinson (*The Parks, Promenades and Gardens of Paris*, 1869) noted with disapproval 'enormous beds of one kind of flower only' laid down in the 'freshest sweeps of sloping grass' of the Bois de Boulogne. In the Parc Monceau, Barillet-Deschamps pioneered bedding with subtropical plants of large, variegated, or otherwise ornamental foliage. The introduction of low-growing plants of this kind led to the development of *carpet bedding or *mosaïculture*, the laying out of beds in ornamental patterns.

REVIVALS AND MODERN GARDENS. Edouard *André (*Traité générale de la composition des parcs et jardins*, 1879) recognized three styles: geometric, *paysager*, and *composite* (or *mixte*) combining the two. The future of garden design he saw as belonging to the third. A reaction against the irregularity of the English style, and a revived interest in Le Nôtre at the end of the 19th c. resulted in many restorations and reconstructions in the 17th-c. manner.

France: *Lieu de repos* in a Mediterranean garden, from A. Vera, *Les Jardins* (1919)

The chief practitioners of this renaissance were the *Duchênes, father and son. Henri Duchêne (1841–1902) restored Vaux-le-Vicomte from 1875, assisted by his son, Achille-Jean-Henri (1866–1947), who reconstructed many gardens in the style of Le Nôtre (Champs; *Maintenon; *Courances; Le Marais). Voisins (Yvelines) was an entirely original essay in the grand manner. One of the most original gardens with social and political implications is the garden at *Villandry, constructed after Renaissance models by Joachim Carvallo. The tradition of the great French architectural garden was continued by Ferdinand *Duprat particularly at *La Roche-Courbon; while others (J. C. N. *Forestier; *Vacherot; Paul and André *Vera; J. Gréber) adapted the architectural tradition to smaller gardens in a more modern idiom.

Gardens inevitably decay; but examples of all historic styles survive, many carefully fostered and preserved by the state. Versailles and Vaux-le-Vicomte are magnificently maintained. But the spirit of French garden design is reflected in the orderly plantations of poplars in the landscape, the erect lines of trees along the roads, and the flower-beds of municipal gardens all over France, where the art of *mosaïculture flourishes and is second to none. In France, gardening and architecture are never far apart; town planning is intimately associated with garden design. The great axis of modern Paris stretching from the Louvre to the Arc de Triomphe on the horizon is universally associated with all that is quintessentially French. It has its origin in the Tuileries, the archetypal French garden conceived in the Renaissance and perfected by Le Nôtre.

GARDENS OF THE RIVIERA. From the mid-19th c., the French Riviera became popular as a winter resort, particularly with the English (see *Côte d'Azur). Protected by mountains from northerly winds, with frost-free winters and mild springs, the Mediterranean climate favours a great variety of flowering shrubs. Sir Thomas Hanbury acclimatized a large collection of subtropical exotics at *La Mortola (just over the Italian border) between 1867 and 1907. Gustave Thuret planted the first eucalyptus at the Cap d'Antibes in 1856, in a garden which is now maintained by the Ministry of Agriculture with a fine collection of palms. Among other fine Mediterranean gardens are La Garoupe (Cap d'Antibes) made by the Norman family, the Villa Roquebrune (now in decline), and La Chèvre d'Or at Biot. English designers working in France (Harold *Peto, and more recently, Russell *Page and Roderick Cameron) have influenced certain French amateurs who have absorbed the example of Lawrence Johnston (see *Hidcote) and Vita *Sackville-West into their native tradition. The result is a group of gardens having a French sense of style and restraint, while being richer in plant material than most French gardens (such as the Villa Noailles at Grasse; Le Potager at Fleury-en-Bière; and Kerdalo in Brittany).

D.A.L./K.A.S.W.

See also ANGERS; ANSOUIS; ATGET; BASTIE D'URFÉ; BOUGES; BRÉCY; CASSAN; CASTRES; CHARLES X; CHEVREUL; COMPIÈGNE; CONDÉ; DEMEURE HISTORIQUE, LA; DU PERAC; GARNIER DE L'ISLE; GIVERNY; LA SOURCE; LAUGIER; LE PAUTRE; LUNÉVILLE; MONTJEU; ORLÉANS; PACELLO DE MERCOGLIANO; PALAIS DE LA BERBIE; PARC DE LA COLOMBIÈRE; PRÉ-FICHAUX; VILLETTE; WIDEVILLE.

LANDSCAPE ARCHITECTURE SINCE 1945. After the end of the Second World War, the French government carried out an active policy of reconstruction, and encouraged the creation of parks, gardens, and public walks.

In this context, a department of landscape architecture was established at the National School of Horticulture at Versailles in 1945. The course 'Landscape and the Art of Gardens' led to the award of a diploma in landscape architecture. The teachers were famous landscape architects such as *Duprat, Audias, Thébaud, and Riousse. The course of study was essentially orientated to the creation of private gardens, parks, and green urban spaces, and the restoration of historic gardens.

During the reconstruction years (1945–60), the principal designers were those who had distinguished themselves before the war, such as Duprat, known for his numerous restorations of historic gardens, and Henri Thébaud, who designed the golf-course at Saint-Nom-la-Bretèche after the war.

The scope of work by landscape architects was widened by the planning policy of 1958 and local subsidies for open space; and again widened in 1965 to include a variety of types of urban and rural projects. Two recent periods show how styles have developed. The first is represented by the landscape park of La Courneuve, at the beginning of the 1970s, the result of an international competition won by John Mayson Whalley of Derek Lovejoy & Partners, with A. Provost and G. Samel. This park was a 'natural' conception, with an emphasis on grass, trees, and flowers. It belongs to the tradition of urban spaces which recognizes the social and hygienic role of green spaces. Other examples of this type from the 1960s and 70s are: the Parc Floral at Vincennes (1966–9), a contemporary public garden designed by Daniel Collin in partnership with Claude Bach, Alain Provost, and Jacques Sgard; the urban park at Cergy-Pontoise by John Mayson Whalley (see plate XVIb); and several more recent designs by Jacques Sgard, such as the Parc Leo Lagrange at Reims (1976–8) and the Parc André Malraux at La Défense (finished in 1981).

The second period is represented by the 1979 competition for the Parc du Sausset. The winning project by M. Corajoud represents a new direction, sometimes called 'anti-garden', in which composition has the primary role.

Outside these two tendencies, there are the 'symbolic' gardens, among which can be included the sculpture garden of the Museum of Contemporary Art at Dunkirk (1978–82, set right in the heart of the port and of the naval dockyard), by Gilbert Samel. In a similar spirit, the writings and projects of Bernard Lassus provide the theoretical basis of an approach to landscape which rejects empiricism in favour of exploring the non-measurable realm of the imagination.

Almost the opposite of this intellectual approach is manifested in the Parc Saint-John-Perse at Reims, one of

Patio du ces 1200 (1975–6), Ville Nouvelle de Marne-la-Vallée, Seine-et-Marne, France, by Vert, Chemetoff, Coulon, C. Corajoud, and Marguerit

the most simple and perfect of contemporary landscapes. The designer, Jacques Simon, seeks to work on the possibilities inherent in the site, considering that the outline of the plan is only a sketch for a strategy of occupation of the space. C.R./S.Z.

See also PUBLIC PARKS.

Francine (or Francini), a family of hydraulic engineers of Florentine origin, were creators of the grottoes, fountains, and other waterworks at *Fontainebleau, the *Luxembourg, *Saint-Germain-en-Laye, and *Versailles. **Thomas Francini** (1571–1651) came to France at the invitation of *Henri IV c.1599, with his brothers Alexandre and Camille, to supervise the hydraulic installations at Saint-Germain-en-Laye. In 1623 Louis XIII, for whom as a child Francini had made models of the fountains at Saint-Germain-en-Laye, put him in charge of all royal waterworks, with authority over workmen concerned with the decoration of fountains and grottoes. His status was raised to *gentilhomme servant du roi* in 1631; and in 1642 he was appointed *conseiller et maître d'hôtel ordinaire*.

The Francini brothers combined the roles of artist and engineer. Thomas designed the elaborate set pieces in the grottoes of Saint-Germain, as well as the machinery for animating the automata. The engravings by Abraham Bosse of the Grotte d'Orphée, the Grotte de la Damoiselle qui joue des orgues, and others, are inscribed 'T. de Francini inven.'; so are the designs for fountains at Saint-Germain-en-Laye and Fontainebleau. He devised the aqueduct bringing water to the Luxembourg gardens from Rungis and Arcueil, which remained in the charge of his family until the end of the 18th c. He advised Cardinal *Richelieu on the cascades and fountains at *Rueil; and in 1644 received an additional salary as superintendent of fountains and grottoes for Gaston d'*Orléans.

Alexandre Francini (d. 1648), brother of Thomas, spent most of his life at Fontainebleau, where he was superintendent of the waters and fountains. His bird's-eye views of Saint-Germain-en-Laye and Fontainebleau record the intended layout of the gardens at the time of Henri IV. He also published *Livre d'architecture* (1631) with designs for gateways and triumphal arches according to the five orders of architecture, but distinctly Mannerist in style.

François de Francine (1617–88), son of Thomas, was the creator of the fountains of Versailles. He took over the post of superintendent of the waters and fountains of France in 1651. He served in the army, became a lawyer and *conseiller du roi*, and was later Provost of the Ile de France. His works at Versailles began in 1662 with the Grotte de Thétis (completed 1668), and continued in the magnificent series of basins and fountains in the *bosquets* and parterres. Not the least of the problem was the supply of water and the increasingly powerful machines required to give sufficient pressure for the displays. Louis XIV recognized his important contribution to the gardens by an annual salary of 10,050 *livres*.

Pierre de Francine (1621–86) was the brother of François, whom he seconded as *surintendant des eaux de Versailles*. He had special responsibility for maintaining the waterworks at Fontainebleau.

Pierre François de Francine (1654–1720), son of François, succeeded his father as *intendant des eaux et fontaines*. K.A.S.W.

François I (1494–1547), King of France (1515–47), was an extravagant builder, favouring the Loire valley in the early part of his reign, enlarging *Blois, and building Chambord. Later he gave his attention to the area round Paris. He acquired the site of the future *Tuileries, built the Château de Madrid in the *Bois de Boulogne, and rebuilt *Saint-

Germain-en-Laye, with a hunting lodge, La Muette, in the park. He enlarged Villers-Cotterets where he made an important garden; and, above all, he established *Fontainebleau as a royal palace. Among the Italians employed by François who made important contributions to the design and ornament of gardens were Primaticcio, *Serlio, and Vignola.　　　　　　　　　　　　　　K.A.S.W.

Frascati, Italy. See ALDOBRANDINI, VILLA; ITALY: VILLAS OF FRASCATI; LANCELLOTTI, VILLA; MONDRAGONE, VILLA; TORLONIA, VILLA.

Fraser, James (1793–1863), Scottish landscape gardener, was described by J. C. *Loudon in *The Encyclopaedia of Gardening* as 'an excellent botanist and gardener as well as a man of general information'. He worked in the Trinity College Botanic Garden, Dublin, under J. C. Mackay. By 1819 he was gardener at Dartfield, Co. Galway, and, subsequently, at Terenure House, Co. Dublin, which at that time had the most complete arboretum in the country. In 1829, on the death in Dublin of Alexander McLeish, Loudon's pupil and friend, Fraser publicly assumed the profession of landscape gardener which for the remainder of his life he combined with the writing of a series of comprehensive guidebooks for the traveller in Ireland.

By 1834 he had redesigned the parks of Saunders Court, Co. Wexford, and Gowran Park, Co. Kilkenny, in the then prevailing *picturesque manner. These were followed by similar schemes at Castle Coole, Co. Fermanagh, and Castle Mornes, Co. Kilkenny. As late as 1855 he was commissioned to make a landscape park *ab initio* at Castle Oliver, Co. Limerick. The influence of Loudon's *gardenesque style is evident in Fraser's designs at Adare Manor, Co. Limerick, and Castlemartyr, Co. Cork. At Curraghmore, Co. Waterford, and Drishane Castle, Co. Cork, his formal *parterres and terraces are examples of the high Victorian style. His fame spread so far in his latter years that he was frequently employed in England and Scotland.　　　　　　　　　　　　　　P.B.

Fredensborg Castle, Sjælland, Denmark. The summer residence of the Danish royal family, this early 18th-c. palace lies at the centre of a *patte d'oie* pattern of radiating *allées with a *tapis vert* falling towards the lake. The original *bosquets between the *allées* (laid out by J. C. Krieger) have now grown into mature beechwoods. To the left of the lawn is a dell encircled by pollarded limes, with a circular mound complementary to it on the right. There is much sculpture in the French manner by Johannes Wiedewelt. Important sculptures include the two monuments to Denmark and Norway, and a series of sandstone sculptures by J. G. Grund depicting figures in Norwegian folk dress. The royal private garden known as the Marmorhave (Marble Garden) is an enclosed parterre independent of the main design, with much baroque sculpture by Wiedewelt, and roses, hydrangeas, and bedding plants.　　　　　　　　P.R.J.

Frederik Hendrik (or Frederick Henry) (1584–1647),

Prince of Orange, Stadholder of the Dutch republic (1625), and dilettante architect and landscape gardener whose gardens at *Honselaarsdijk were a prototype of the Dutch classical canal garden. Already in 1610 a classical inclination is evidenced at his garden of Princessetuin at Het Hof (Noordeinde Palace), The Hague, where a rectangular framework, encompassed by canals and trees, enclosed three axially aligned compartments consisting of orchards and a central circular pond with an island.

A precociously baroque plan (*c.*1636) with *patte d'oie* avenues was made for his summer residence, Huis ter Nieuwburg (demolished in 1785), near The Hague. It was not executed and in its stead a rather retrogressive design was carried out, possibly by Frederik Hendrik, which recalled in plan the early Tuileries and in detail the *Hortus Palatinus in Heidelberg. The most Italianate of his royal gardens was Huis ten Bosch (today the Queen's official residence), The Hague, which was designed by Pieter *Post.　　　　　　　　　　　　　　F.H.

Frederiksberg Castle, Copenhagen, Denmark. The original garden, created *c.*1700, was terraced in the French baroque style, but between 1785 and 1801 it was naturalized by P. Petersen in the contemporary English style with canals and forest trees planted to form glades. An Ionic temple is sited against a backdrop of trees and there is a decorative Chinese tea-house (1799) on a small island.　　　　　　　　　　　　　　P.R.J.

Frederiksborg Castle, Sjælland, Denmark, has one of the finest French baroque-style gardens in Scandinavia, laid out in 1720 by J. C. Krieger, terraced out of the hillside opposite the main north façade of the castle with interconnecting ramps. The terraces are emphasized by clipped box and pleached limes, and on the top terrace an oval *bassin*, enclosed by limes, supplies a series of cascades which fall eventually into the lake at the foot of the hillside. The hillside is laid out as parkland, and the level ground to the west is a large park with an irregular shaped lake and a 16th-c. bath-house.　　　　　　　　　　　　　　P.R.J.

Freedom Park, Sofia, Bulgaria, the foremost garden in the country, was known before 1939 as Boris Gardens, after Crown Prince Boris. When first laid out in 1882, it lay on the approaches to the city, but is now a central park (335 ha. in area), connecting the pre-war city with its most important post-war additions. Its distinguishing features are a beautiful composition, a diversified tree and decorative shrub vegetation, a lake with a fountain at the entrance, busts of eminent Bulgarian poets, writers, and public figures, and the monumental Common Partisan Grave. The park was laid out by the energetic Swiss landscape architect Daniel Neff who created a big nursery garden, in which he planted acacias, trumpet-flowers, pagoda trees, mulberry trees, planes, elms, limes, acacias, maples, almonds, and other trees. In 1888 the acacias were replaced by oaks, ashes, sycamores, birches, spruces, and pines. The nursery was transformed into public gardens, continuing as such until

1906, when the landscape architect Josef Fray considerably extended them in area, adding many new flower species. He also organized flower shows, which proved to be quite popular. In 1934 the gardens acquired a new decorative sculpture and several fountains.

In 1948 a plan for the general reconstruction of Freedom Park (now its official name) was prepared. Based on a project submitted by Professor D. T. Sougarev, it provided for the establishment of a rosarium, a landscape layout of flower-beds, and new areas for children. D.T.S.

French Riviera. See CÔTE D'AZUR; FRANCE: GARDENS OF THE RIVIERA.

Friberg, Per (1920–), Swedish architect, landscape architect, and town planner. Friberg has designed several private houses and gardens, residential areas, and various institutions, including power stations, and cemeteries and crematoria throughout Sweden—in particular at Carlskrona and Jakobsberg near Stockholm. He studied at the Royal Academies in Stockholm and Copenhagen and at Harvard University, United States, starting his own practice in 1950 in Helsingborg. In 1955 he moved to Bjerred near Lund, Sweden, where he has created an unusual garden which combines a variety of historical and ecological themes, expressing the Scandinavian trait of the clipped versus the unkempt. He lectures widely and since 1964 has been Professor of Landscape Architecture at the Swedish University of Agriculture. He has won many competitions and received several awards including the Royal Gold Medal from the Royal Academy of Stockholm. P.R.J.

Fronteira, Palace of, Lisbon, Portugal, was built in 1672, reputedly by Italian architects. Its garden remains an exceedingly fine example of 17th-c. design and details. It is divided into two by a long, raised terrace, the so-called Gallery of the Kings, reached at each end by a balustraded staircase. Set in the terrace's back wall are niches containing the busts of 15 Portuguese kings, edged by a decorative *azulejo* motif of extraordinary beauty and originality—pine apples, lustred, bronze and deep blue in colour, the lustre luminous in sunshine or moonshine. Two little pavilions, their roofs of lustred tiles, complete each end of the terrace and from them stone staircases descend to the main garden below. The eye-catching feature of this Gallery of the Kings is the lower, supporting wall to the terrace, for here, along the whole length, is a facing of 12 *azulejo* panels, each depicting a medieval, plumed knight, tilting on a prancing horse, similar to an equestrian subject by Velázquez. The

story goes that these—the Doze de Inglaterra—went to England to joust for the honour of 12 English ladies. Up against this wall an oblong water-tank, 30·5 m. wide, reflects the clear cerulean-and-white of the tiles, the cavorting horsemen, the pavilions, and the steps. Portugal possesses few lovelier water-tanks than that at Fronteira.

On the garden level the tank forms one side of a large parterre, wide open to the sun, the show-piece on which all is lavished. The tight beds are ornate with clipped box fantasies and with statuary. The planting is compressed and low, in order to show off the stone figures. Out of a central fountain rises a column adorned with cupids and shells supporting the arms of the Mascarenhas family, Condes da Torre and Marquesses de Fronteira, owners of the palace since it was originally built. More Italian than Portuguese in style, the formality of this lower garden is in the grand manner, in keeping with the house.

On the upper level of the Gallery of the Kings is hidden the Garden of Venus. Again there is a long terrace, this time studded with classical statues, interspersed with tiled ladies in arched recesses. After this is an area under tall trees of shade and seclusion, then a rotunda, its elaborate archway embossed with multicoloured stones and with shells set in striking designs. In front of it is a small pond whose convoluted, low parapet bears a pair of tritons gazing across the water at each other. Elegant ladies, always in *azulejos*, gleam unexpectedly, half-hidden in bushes, and there are stone benches, backed with *azulejos*. Between them the two gardens offer beauty to suit every mood and illustrate how many forms of art embellished an important garden in the 17th c. B.L.

Fuchs, Leonhart (1501–66), practised medicine in Munich before becoming a professor of that subject in the universities of Ingolstadt and Tübingen, where he remained until his death.

His *herbal, De Historia Stirpium,* was published in Basle in 1542, describing *c.*400 native German plants and 100 foreign ones. A German translation came a year later, followed by many editions in a range of sizes from folio to more or less a pocket book. The text was derived in part from *Dioscorides, supplemented by the observations of the author, who was a field botanist, and the work of a trio of artists, whose portraits appear, with that of Fuchs himself, in the book. As examples of *botanical illustration, the woodengravings are stiffer than the ones in Brunfels's herbal, looking like ideal plants with individual oddities tidied up.

Fuchs is perhaps most often remembered now in the popularity of the genus *Fuchsia,* which was named in his honour. S.R.

Gaillon, Eure, France, had one of the most celebrated Renaissance gardens, made by Cardinal Georges d'Amboise, Archbishop of Rouen, and Minister of Louis XII (see *Pacello da Mercogliano). The upper garden at Gaillon was made between 1502 and 1509, on a level terrace enclosed on one side by a gallery overlooking the valley of the Seine. It had a large wooden pavilion sheltering a marble *fountain from Italy, and was divided into square beds, each planted differently with flowers, fruit-trees, or box and rosemary cut into figures. One square had the arms of France made with small plants, another was in the form of a labyrinth. A unique feature was a private retreat in the park, known as Le Lidieu, with a chapel, a house, and a garden. After 1550 Cardinal de Bourbon extended it with a canal, a rock hermitage, and a sumptuous *casino, the Maison Blanche, in High Renaissance Mannerist style. At the same time a very much larger garden was made on the level ground below the upper garden. The gardens were redesigned by *Le Nôtre for Jacques Nicolas Colbert between 1691 and 1707. Only the terraced site of the upper garden now survives.

K.A.S.W.

Gamberaia, Villa, Settignano, Tuscany, Italy, was constructed over a long period and probably completed in the early 18th c. Nothing is known about its designer(s) and no plans have survived. Within an area of less than 1·2 ha. the unassuming house is the symmetrical centre of an extraordinary complex. Some eight units of composition are held together by a 240-m. grass *allée* and *giardino segreto* extending along the site from one extremity to the other. The various units include the villa terrace overlooking the olive slopes to distant Florence; a parterre water garden (agreeably modernized); two separated and secret ilex *boschi*; a grotto garden with dwarfs; and a lemon garden and house at a higher level.

G.A.J.

See also ALBERTI, LEON BATTISTA.

Garden building, structure. See FABRIQUE.

Garden City. For centuries men have been concerned with two problems arising from the seemingly irrepressible growth of cities; how to curb that growth and how to make them pleasant places to live in. Leonardo da Vinci responded to the growth of Milan by suggesting 10 'satellite' cities of 5,000 houses and 25,000 inhabitants each; and he made proposals for irrigated private gardens, and the segregation of pedestrian and horse-drawn traffic. The boom in development in the 19th c. enabled many such proposals to be carried out.

These were generated largely by two social pressures. In Britain the impetus was mainly philanthropic—to improve the awful living conditions of the workers in the industrial towns of the north. In the British colonies and North America, where land was available, the concern was to provide elegant and spacious new cities. Several of these, such as Adelaide in Australia and Christchurch (1850) in New Zealand, were planned with park or 'green' belts, and some, such as Chicago (before the fire of 1870) justified the name of garden cities. It was due to the initiative of a parliamentary reporter and part-time inventor, (Sir) Ebenezer Howard (1850–1928), that these two concepts

Villa Gamberaia, Tuscany, drawing (1925) by J. C. Shepherd and G. A. Jellicoe (RIBA Library, London)

were combined in the peculiarly English version of the garden city.

This has its origins in the philanthropic ideas of Robert Owen (1771–1858) who developed the workers' village adjoining the cloth mill built by David Dale at New Lanark in Scotland during the early part of the 19th c. Convinced that character was directly affected by environment and that industry would benefit from well-housed and contented workers, Owen set out to put his ideas into practice. Others followed, including Sir Titus Salt who built Saltaire (West Yorkshire) in 1853, the Cadbury Brothers (Bournville, West Midlands, 1879), and the Lever Brothers (Port Sunlight, Merseyside, 1887). Besides being instruments of social policy—for housing the workers—all of these towns were experiments in town planning, and some of them continued to grow. Bournville, unlike the other developments, was not restricted to Cadbury's chocolate workers, and by the time of the First World War it had its own shops, schools, churches, meeting hall, working men's college, sports and playgrounds, park, allotments, and individual gardens. The establishment of the Village Trust satisfactorily eliminated the problem of land speculation.

Impressed by these developments, and concerned by the evils of land speculation which he had observed in the United States, Ebenezer Howard became interested in land reform, and put forward his own idea for community living. In 1898 he published *Tomorrow: A Peaceful Path to Real Reform*, which in the second edition in 1902 was retitled *Garden Cities of Tomorrow*. Howard's concern was less specifically with the workers than with society in general and was more sociological than visual. His thesis rested on the belief that people must be stopped from moving into the already overcrowded cities. He illustrated his proposals with a diagram of three magnets. The city was one, the country another; but since both had disadvantages as well as advantages, he developed a third and new concept, town–country, which was to be the garden city.

The first principle of the garden city was that a surrounding agricultural 'green belt' would provide food and easy access to the countryside for the town dwellers. Industrial buildings such as factories, warehouses, dairies, markets, and coal and timber yards were to be sited on the perimeter of the town, and smoke kept to a minimum by the use of electricity for machinery. The central part of the town itself was to be divided into wards, each with a population of c.5,000 and its own school. Other public buildings such as the town hall, public library, museum, picture gallery, theatre, concert-hall, churches, and sports facilities were planned along spacious grassy tree-lined avenues, and in the centre was to be a 59-ha. park. But the most important consideration was that of land ownership: all the land was to be held in trust and leased to the residents. This had the effect of eliminating land speculation and at the same time providing effective planning control. If and when the city achieved its optimum population of 32,000, another similar city would be set up beyond its boundary.

A Garden City Association was set up in 1899, and this was followed by the Garden City Pioneer Company (including W. H. Lever and George Cadbury among its members) which designated a site at Letchworth in Hertfordshire where work began in 1903. Although the site was ideal, the scheme was inadequately financed, no trust was established, and progress was extremely slow. Although by 1919 the population had reached 10,000, the idea of a fully independent garden city had to be abandoned; as indeed it was at nearby Welwyn, started in 1919 on a smaller site. Nevertheless both 'cities' continued to grow, and in 1948 Welwyn Garden City was designated as one of the first New Towns, and taken over by the Welwyn Garden City Development Corporation which purchased the land on behalf of the residents. Because of legal complications this was not to occur at Letchworth until 1962.

Of the two cities, Welwyn is better integrated with the landscape; it has benefited from the retention of existing features such as country lanes, hedgerows, and mature trees, and has made more use of the cul-de-sac, an important development in view of the later increase in the use of the motor car. Although neither city succeeded in the terms envisaged by Ebenezer Howard—in fact their proximity to London made them into commuter communities—the concept behind them was instrumental in the development of the British New Towns which have become models of planning, and of the integration of buildings with the landscape. M.L.L.

Garden club. The garden club movement is a phenomenon peculiar to the United States. Women's clubs of various types grew rapidly in numbers during the 1870s and 80s, culminating in the 1889 establishment of the General Federation of Women's Clubs. This organization, with clubs in many American cities and towns, was an important means by which women could develop and extend their influence. This was also the period of the *garden city movement, a reaction to slums and other unwholesome effects of industrialization.

The first garden club in the world was organized in 1891 by 12 matrons of the town of Athens, Georgia—a setting which combined the advantages of north Georgia's mild climate and a university town's cultural life. Dr Edwin D. Newton, local physician and horticulturist, played an important role in encouraging the club and reorganizing it to embrace a larger membership in 1892. 'The Ladies' Garden Club' continues to provide a vital force for civil improvement and cultural development after nearly a century of operation.

The garden club movement gradually spread, primarily through the eastern half of the United States and into Texas. In 1913 the Garden Club of America, with 12 founding-member clubs, was organized in Philadelphia, Pennsylvania. The National Council of State Garden Clubs, Inc., a separate national group with 13 state garden club federations as charter members, was founded in 1929 in Washington, DC. In 1982 both national organizations were flourishing: the Garden Club of America had 183 clubs and approximately 15,000 members, the National Council had 11,000 American clubs and some 320,000

women were members. (There are a few garden clubs affiliated with the National Council in other countries, as well as a National Men's Garden Club.)

At first, the members of garden clubs were experienced in supervising the growing of vegetables, fruits, and flowers for home consumption, and also understood agricultural processes in general. After technology had transformed the country from a predominantly rural to an urban society, members tended to have little firsthand knowledge of horticulture or agriculture. Fortunately, garden club leaders anticipated this situation and created practical educational programmes for inexperienced members. A sampling of topics covered by these programmes are: conservation, garden therapy, historic preservation, horticulture, landscape design, and legislation, such as the regulation of outdoor advertising. Other educational ventures include flower-show schools, garden pilgrimages, and scholarship drives.

Among the several educational programmes administered by the National Council, one of the most successful has been the 'Landscape Design Study Courses', created in 1958 by Professor Hubert Owens of the University of Georgia. Consisting of four separate lecture sessions, these courses prepare lay people to plan healthy and beautiful private surroundings, as well as to serve intelligently as members of community planning committees such as zoning boards or park commissions. By 1981 more than 40,000 women and men had taken at least one of the courses and over 8,000 had completed all four. These and other educational programmes promoted by garden clubs are considered important cultural influences in the modern United States. H.B.O.

Gardenesque style. The term 'gardenesque' was first proposed by J. C. *Loudon in the Dec. 1832 issue of the *Gardener's Magazine*. Loudon used it to describe a style of planting design in which each individual plant is allowed to develop its natural character as fully as possible. The name 'gardenesque' was used to indicate the fact that these conditions were only likely to be found in gardens. It was intended to contrast with the 'picturesque' conditions loved by painters in which plants are often gnarled with age and limit each other's growth by competing for light and space. When he launched the term Loudon thought that it would 'startle some readers' but would soon 'find a place in the language of rural art'. If his readers were startled they did not respond by adopting the term. It was not until after Loudon's death that the term became current in gardening literature and when it did so it was not in Loudon's sense. Instead of using 'gardenesque' to describe a style of planting design, as Loudon had done, subsequent authors used it to describe a style of garden layout characterized by rampant eclecticism and lack of artistic unity.

Loudon was led to propose the gardenesque style by the *Neoplatonic arguments in Antoine-Chrysostome Quatremère de Quincy's *Essay on the Nature, the End and the Means of Imitation in the Fine Arts*. Quatremère argued that gardens laid out in the irregular or picturesque style were almost indistinguishable from wild nature and did not deserve to be described as works of fine art. In Quatremère's words 'what pretends to be an image of nature is nothing more nor less than nature herself'. Loudon's solution to this problem was the gardenesque style of planting design. He proposed that foreign instead of native plants should be used so that schemes would be instantly recognizable as works of art. The principle was carried to extremes. To make plants look as different from wild plants as possible Loudon reasoned that trees should be 'allowed to throw out their branches equally on every side, uninjured by cattle or other animals' and not 'pressed on during their growth'. 'Even the turf', he exclaimed, 'should be composed of grasses different from those of the surrounding grass fields.' Loudon described planting carried out in this manner as being in the gardenesque style.

Unfortunately for Loudon few of his contemporaries appreciated the logic of the gardenesque—though they did catch his infectious enthusiasm for exotic plants. One of the first authors to adopt and misapply the term 'gardenesque' was Edward *Kemp: 'There are three principal kinds of style recognised in landscape gardening: the old formal or geometrical style, the mixed, middle, or irregular style, which Mr Loudon called the gardenesque; and the picturesque.' Kemp's book *How to Lay out a Small Garden* (1850) was very successful and 'gardenesque style' survives in modern usage in Kemp's sense rather than Loudon's. As a style of garden design rather than of planting design, it was ably defined by Kemp: 'Its object is beauty of lines and general variety . . . It does not reject straight lines entirely near the house, or in connection with a flower-garden, or a rosary; or a subordinate building (as a greenhouse) that has a separate piece of garden to it. Nor does it refuse to borrow from the picturesque in regard to the arrangement and grouping of plants.' In other words, it was the style of the typical Victorian garden which has been much criticized for its lack of artistic unity. By far the best example of the mixed or gardenesque style is *Alton Towers, which Loudon criticized for its rampant eclecticism even while it was being constructed: 'we consider the greater part of it in excessively bad taste, or rather, perhaps as the work of a morbid imagination joined to the command of unlimited resources.' Other celebrated examples of the mixed style are *Biddulph Grange; Osborne House (Isle of Wight); *Kew Gardens; and *Tatton Park.

Although the gardenesque style was much favoured by the Victorians, the view that it was a 19th-c. invention has been challenged by historical work carried out during the 1970s. Studies of contemporary paintings, literary sources, and surviving garden plans have shown that 18th-c. gardens were not nearly as empty of flowers and other features as had been supposed. It now appears that only the largest parks were pure Brownian compositions with tree belts, clumps, serpentine lakes, and rolling lawns sweeping up to the fronts of their owners' mansions. Other estates, even if the framework was Brownian, contained a mixture of features. Thomas *Robins the elder's mid-18th-c. paintings provide a charming illustration of this point. They show

different kinds of flower gardens, aviaries, alcoves, rosaries, and numerous garden buildings. These features and some 17th-c. survivals, such as mounts and arbours, are also shown on plans for smaller estates designed by Thomas Wright, Richard Bateman, Philip Southcote, Thomas Spence, and others. This reassessment is even supported by a close study of the literary sources which led earlier historians to exaggerate the prevalence of Brown's style. *Mason describes a flower garden at *Nuneham Park; Whately wrote that 'in every corner, or vacant space is a rosary, a close or open clump, or a bed of flowers'; and even Walpole admits to a collection of flowering plants at Strawberry Hill. Indeed, so far from the mixed or gardenesque style being a Victorian invention, one could argue that Repton's 1811 proposal for 15 different kinds of garden at Ashridge was a sophisticated example of the style. T.H.D.T.

Garden History Society, The, was founded in Britain in 1965 to bring together those interested in garden history in its various aspects—garden and landscape design and its relation to architecture, art, literature, philosophy, and society; plant introduction, propagation, and taxonomy; estate and woodland planning and maintenance; and other related subjects. Its founder members, of whom Peter Hunt was a leading light, saw the need for making garden history a cohesive subject like art and architectural history. Frank *Clark, Miles *Hadfield, William Stearn, and John Harvey have been its Presidents.

The Society campaigns for a greater public awareness of the importance of historic gardens as part of our cultural heritage and for a national policy to give them a greater degree of protection. It has drawn up an inventory of historic gardens and has assisted in forming garden trusts and giving advice to local authorities and private individuals. The Society's journal *Garden History* has been published since 1972 and has established itself internationally as a vehicle for original research in garden history. Lectures, symposia, a summer conference held in different parts of the country, and visits including foreign tours are arranged annually. Membership is open to anyone interested in garden history.

M.L.B.

See also CONSERVATION AND RESTORATION OF HISTORIC GARDENS IN BRITAIN.

Garden journalism. The first British horticultural periodical is probably *A General Treatise of Husbandry and Gardening*, founded and edited by Richard Bradley, Professor of Botany at Cambridge. It embraced many subjects of rural interest with the aim of raising them 'to a much higher pitch than ever they were before'. Only 15 numbers appeared between Apr. 1721 and Sept. 1724. William Curtis launched the *Botanical Magazine* in 1787 for the 'use of such ladies, gentlemen, and gardeners as wish to become scientifically acquainted with the plants they cultivate'. It survived until 1984 when it was incorporated into a new publication, *The Kew Magazine*.

In 1797 H. C. Andrews began the *Botanist's Repository* which completed 10 volumes before its demise in 1815, the year in which the first issue of the *Botanical Register* was published. Both periodicals emulated the *Botanical Magazine* by providing coloured engravings of garden plants with brief accompanying text. Soon rival periodicals appeared on the scene but none achieved the elegance of printing and illustrations of the *Transactions* (1807–48) of the Horticultural Society of London. The competition which intensified when periodicals became cheaper proved fatal for luxury publications such as the *Botanical Register* which ceased in 1847. The *Botanical Cabinet* (1817–33), published by the Hackney nurseryman, Conrad Loddiges, Robert Sweet's *British Flower Garden* (1823–38), and Benjamin Maund's *Botanic Garden* (1825–51) were notable for the consistently high quality of their plates.

John Claudius *Loudon, strongly disapproving of periodicals which catered primarily for the gentry, brought out his *Gardener's Magazine* (1826–44) 'to disseminate new and improved information on all topics connected with horticulture, and to raise the intellect and character of those engaged in this art'. Although didactic and censorious, it was conducted with a crusading zeal and enjoyed a moderate success until challenged by the *Horticultural Register and General Magazine* (1831–6). Edited by Joseph *Paxton and Joseph Harrison, the *Horticultural Register* in its monthly issues covered natural history as well as horticulture. Paxton presumably lost interest in it when he founded *Paxton's Magazine of Botany and Register of Flowering Plants* (1834–49) in order to provide accurately drawn and coloured floral plates which were absent from the cheaper periodicals.

The era of really cheap gardening periodicals was introduced by Paxton's former co-editor, Joseph Harrison, who edited no fewer than five of them. Two were launched in 1833: *Gardener's and Forester's Record* (1833–6) and *Floricultural Cabinet and Florist's Magazine* (1833–59), both priced at only 6d. an issue. Notwithstanding its poor illustrations, Loudon praised the *Floricultural Cabinet* for its 'excellent practical matter' and Harrison claimed it was the first periodical to meet the needs of floricultural societies and florists' clubs.

In 1833 there also appeared the *Horticultural Journal and Florists' Register*, edited by the capable but culpable George Glenny who later stated that it ceased in 1840 when the *Gardeners' Gazette* (1837–44), which he also edited, was earning more revenue from advertisements. The *Gazette* was the first horticultural paper to appear weekly. Other florists' periodicals included the short-lived *Florists' Magazine* (1835–6), edited by the botanical artist, F. W. Smith, and the *Floricultural Magazine and Miscellany of Gardening* (1836–42), edited by R. *Marnock, Curator of the Botanical Gardens at Sheffield. The provocative and pugnacious reporting of the *Gardeners' Gazette* under Glenny's editorship was resented by people like Paxton who declared that 'a highly respectable paper for the Gardening World, to be conducted in a gentlemanly manner, and containing interesting matter, is very much wanted'. This deficiency was rectified when the first number of the *Gardeners' Chronicle* came out in Jan. 1841 with Paxton as general editor, assisted by John Lindley on botanical mat-

ters. This weekly periodical with many distinguished gardeners, nurserymen, and botanists included in its contributors soon established for itself a leading role amongst horticultural publications.

Women who were 'neither regular gardeners nor professional florists' were specifically catered for by the *Ladies' Magazine of Gardening* (1841). Its editor was the redoubtable Jane *Loudon, wife of J. C. Loudon, but, unfortunately, it survived for only 11 months. With the *Gardeners' Chronicle* as a model, the *Cottage Gardener* (1848–61) was conceived by the barrister and horticultural writer, George W. Johnson. It changed its title to *Journal of Horticulture* (1861–1915) after the waspish remark that 'the *Cottage Gardener* was for the occupiers of a cottage to which a double coach-house was attached'.

An inevitable result of cheaper paper and printing costs was a marked increase in periodical literature. Many were ill-conceived and subsequently short-lived but the *Florist* (1848–84) proved a successful venture for the nurseryman Edward Beck. Another nurseryman, William P. Ayres, was joint editor with Thomas Moore, Curator of Chelsea Physic Garden, of the *Gardeners' Magazine of Botany, Floriculture and Natural Science* (1850–1) which proposed to fill the gap left by the demise of *Paxton's Magazine of Botany* the previous year.

Shirley Hibberd, one of the most successful popularizers of garden literature, was the energetic editor of the *Floral World and Garden Guide* (1858–80). For a brief period the *Floral Magazine* (1861–81) employed the services of that prolific botanical artist, W. H. Fitch. The *Garden* (1871–1927) was founded by William *Robinson with the support of the practitioners of the new natural school of gardening. As it proved to be a financial burden, Robinson gambled with the *Gardening Illustrated* (1879–1956) aimed at the prosperous middle class. It was an instant success. Shirley Hibberd found time to edit *Amateur Gardening* (1884 onwards) for the first three years. *Country Life* (1897 onwards) which favoured the *Lutyens/*Jekyll school has maintained regular features on gardening and accounts of individual gardens.

The *Orchid Review* (1893) was a forerunner of specialist periodicals, often published or sponsored by societies: e.g. *Bulletin of the Alpine Garden Society* (1930), *Iris Year Book* (1930), *Cactus Journal* (1932), *Bulletin of the Hardy Plant Society* (1957), and the annuals of the Royal Horticultural Society: *Lily Year Book* (1932), *Daffodil and Tulip Year Book* (1933), *Rhododendron Year Book* (1946), and *Fruit Year Book* (1947).

A prominent feature of many 19th-c. periodicals was their illustrations of plants, normally rendered by copper engravings until that process was largely superseded by lithography in the 1840s. Colouring was applied by hand with varying degrees of competency and sensitivity. The *Floral World and Garden Guide* employed the firm of Benjamin Fawcett to engrave multiple colour wood-blocks for its plates. The *Garden* first used a half-tone block of a photograph in 1885, seven years before the *Gardeners' Chronicle* adopted the process. William Robinson remained resolutely loyal to wood engraving in his sumptuously produced monthly review *Flora and Sylva* (1903–5).

A considerable growth in horticultural periodicals also occurred in other countries. One of the first in France was the annual *Le Bon Jardinier* (1754–1933). Among the most notable during the first half of the 19th c. were *Annales de la Société d'Horticulture de Paris* (1827–54), *Revue Horticole* (1829–66), *Journal et Flore des Jardins* (1832–45), and *Horticulteur Universal* (1839–47). Probably the earliest in Germany was the *Journal für die Gartenkunst* in 1783. When *Der teutsche Obstgartner* (1794–1804) widened its scope beyond fruit culture it changed its title to *Allgemeines teutsches Gartenmagazin* (1804–11). *Allgemeine Gartenzeitung* (1833–56), like so many others, had a brief existence; *Gartenflora* (1852–1940), on the other hand, lasted for almost a century. Even a small country like Belgium produced an impressive number of periodicals. These included *Flores des Serres et des Jardins de l'Europe* (1845–80), *Belgique Horticole* (1851–85), *L'Illustration Horticole* (1854–96), and *Revue de l'Horticulture Belge et Etrangère* (1875–1914).

In the United States the *Massachusetts Agricultural Repository* (1793–1832) featured a horticultural section from 1821, but it was not until the Landreths, nurserymen of Philadelphia, brought out their *Floral Magazine and Botanical Repository* (1832–4) that there was a periodical devoted to gardening. Their attempt encouraged others, among them being *Horticultural Register and Gardener's Magazine* (1835–9), *American Gardeners' Magazine* (1835–6) which from vol. 3 became *Magazine of Horticulture* (1837–68), and *Horticulturist* (1846–75) which was merged with *Gardener's Monthly* in 1875. For 30 years the distinguished nurseryman Thomas Meehan edited and was the major contributor to the *Gardener's Monthly* (1859–87), foremost amongst American gardening magazines. A. J. *Downing, the United States' first great landscape gardener, edited the *Horticulturist* (1846–75) until his premature death in 1852. Clearly influenced by Loudon's *Gardener's Magazine*, Downing's editorials were an important stimulus to the parks movement in the United States. About 500 periodicals were published in the 19th c. but as few as 40 survived into the 20th c.

The latter part of the 20th c. has seen great changes in garden journalism with much of the output being either in newspapers and magazines devoted primarily to other subjects or as radio and television talks and discussions. The high costs of the recent improvements in colour printing have meant that the level of writing has to be 'popular' in order to achieve the high circulation figures necessary for survival. This has led to mergers (e.g. *Popular Gardening* and *Amateur Gardening* in 1984), trade support (e.g. *Horticultural Trades Journal* and *Gardener's Chronicle*) and 'captive' circulation to specialist society membership (e.g. *American Orchid Society Bulletin*). R.D.

Garden show. See GARTENSCHAU.

Garden tool. In basic design, hand tools have changed surprisingly little since Roman times—refinements in

design and materials have made only minor improvements in their efficiency. New implements appeared during the 17th c. once horticulture, as such, became a craft: the main requirement was for tools for precise grafting, cutting, pruning, or slashing, and for some means of transporting all the garden materials. The wheelbarrow had first appeared in 12th-c. China and seems to have been first known in Europe during the Middle Ages.

The next expansion in available equipment came in the 19th c., to meet the demands of the Victorian villa garden and the new public parks. In 1830 Edwin Budding invented the lawn mower, based upon a series of cylindrical blades, and before the Great Exhibition (1851) large horse-drawn and pony-drawn machines became available. The practice of scything lawns still continued, but mechanization was very popular with Victorian gardeners, becoming increasingly sophisticated in chain-driven models (1859), steam-powered monsters (1893), petrol-driven engines (1899), and electric-powered motors (1919).

Hand tools were not put to any additional uses, but, with typically 19th-c. vigour, dozens of designs of the same tool became available—by the end of the century tool catalogues show as many as 50 designs of budding and pruning knives offered by each manufacturer. The Victorians also first produced tools for ladies and children. Slashers and bill-hooks varied according to district. This proliferation of design was an English phenomenon.

French designs of the 18th and 19th c. remained nearer to those of the 17th, simply because the horticultural activities of the French were different. Equipment for maintaining formal gardens is illustrated in the *Encyclopédie*, plates on 'Agriculture: Jardinage'. Their interest lay in the *potager* (kitchen garden), not in the ornamental flower garden, or in lawns. French hand tools are usually of a different blade design, with some regional variations. Hand tools were (and still are) used far more than the spade and the fork, probably because (except in the north of France), the soils are shallow, and the workers have flimsy footwear. The mattock, and its adaptations, forming both short and long hoes, are the most popular tools for working the soil.

The widest range of equipment existed in the inter-war period, reaching a peak between 1922 and 1932. More recently, economy in manufacture has been standardized by the use of new materials such as plastic and aluminium. Mechanical cultivation of the top soil reduces the requirement of both manpower and time; and such cultivators are now universal. K.N.S./P.G.

Garden views. See BADESLADE; KIP; KNYFF; LE PAUTRE; PERELLE; ROCQUE; SILVESTRE.

Garnier de l'Isle, Jean-Charles (1697–1755), French garden designer, was elected academician in 1724 and appointed *dessinateur des plans et parterres des jardins du roi* in place of his father-in-law, Claude *Desgots. He modified the gardens of the château of Champs and collaborated with Lassurance in the creation of the château and gardens of Bellevue (1748) for the Marquise de Pompadour. For her he made designs for the gardens of the château of Crécy-Couvé, near Dreux, and for the Hermitage at Fontainebleau, a project finally realized by Gabriel. M.M. (trans. K.A.S.W.)

Gartenschau. The German *Gartenschauen* have their origin in the local garden shows traditionally organized by German towns, and such international events as the Dresden International Garden Show of 1887 and the International Horticultural Exhibition held in Hamburg in 1896. Characteristically they combine exhibitions for pro-

Garden tools, detail of engraving, from S. Kleiner, *Vera et accurata delineatio omnium templorum et coenobiorum* (1724)

Art-lovers' garden by John Mayson Whalley and Will Williams, Derek Lovejoy & Partners, at the 1983 International Gartenschau, Munich

fessional and commercial interests with the creation of public pleasure-grounds. The tradition was continued through the 20th c. including the period of the Third Reich when shows were held at Essen in 1938, and Stuttgart in 1939. But the appalling destruction of the war provided unprecedented opportunities for renewal and reconstruction.

The first post-war show was held in the Höhenpark *Killesberg, Stuttgart, in 1950. The emphasis was primarily upon new homes; secondly on open spaces and parks. The extent of the destruction allowed for the strategic planning of open spaces, occasionally using the rubble as a foundation for small ranges of hills. By this means it was possible, with guaranteed state finance, to provide employment, to make spaces for recreation, to boost commerce, to bolster local pride, and at the same time to delight the senses. The Stuttgart *Bundesgartenschau* was followed by one in Hamburg in 1953, in Kassel in 1955, Cologne in 1957, and so on. They are now held every second year in a different city, with some repeats, and they are given international status every 10 years as an *Internationale Gartenbau Ausstellung* (International Horticultural Exhibition or IGA), the latest being at Munich in 1983.

The very considerable cost of mounting a *Gartenschau* is borne largely by the host town or city backed up by support from the State authorities, but the proportions vary widely. As might be expected there is healthy competition between local authorities but there is also a growing groundswell of criticism by public and press at such extravagant use of public money, used occasionally in the redesign of some well-liked existing facilities.

Recently steps have been taken to still the criticisms from some of the smaller town authorities by holding a third category of show, the *Landesgartenschau* (State Garden Show) which will receive 50 per cent financial assistance from the State government, up to a limit of 5 million DM. So far five of this kind have been held: at Neu Ulm (1980), Baden Baden (1981), Schwabisch Hall (1982), Lorrach (1983), and Kempton/Reutlingen (1984). These authorities, while still providing an exhibition for the horticultural and other industries, stress the regional connotations of building, nature, and landscape conservation.

Planning, which usually occupies 10 years, is undertaken through the *Zentralverband Gartenbau* (Central Horticultural Association or ZVG), and a company is specially set up for the financial and executive organization and construction, which usually takes three to four years. The show spans three seasons, from April to October. It is typically much more than a flower-show, although it provides sites for horticultural exhibitions. It provides buildings for leisure and recreation generally adequate (for the *Bundesgartenschauen*) to accommodate totals of some 8 or 9 million visitors, and many of the buildings remain as permanent features. Benefits to the host city can thus be measured not only in terms of commercial success, but of permanent community accommodation, access in terms of improved transport including roads and bridges, new and improved pedestrian areas, as well as parks and gardens. The impetus given to the trades and professions in the fostering of new ideas and attracting visitors from outside makes the *Gartenschau* a sure recipe for political success. It also offers opportunities through national and international competitions for garden and landscape designers to show their ability. The world-famous tensile structures of Frei Otto first appeared in the form of a small bandstand tent in Kassel in 1955.

The sites selected, averaging 70–90 ha., have varied widely from featureless city centre areas to those with strong existing topographical features like the *Killesberg quarry at Stuttgart, or the river meadows and 18th-c. Karlsaue Park below the old city of Kassel. As the pressures for reconstruction have lessened, new themes have emerged. The recent *Gartenschau* in Kassel includes an 'ecological' park in an area of naturally regenerating gravel pits, and the proposed theme for the 1989 Frankfurt *Bundesgartenschau* is 'Nature in the City'.

Garden shows in other parts of Europe. The idea of the *Gartenschau* has been adopted by other countries in Europe including Austria, Switzerland, the Netherlands, and very

Australian theme garden by Shumack at the International Garden Festival, Liverpool, 1984

recently, Britain. The *Wiener Internationale Gartenschau* held in 1974 (WIG 74) was integrated with a large new spa complex.

The Liverpool Garden Festival (IGF 84) was the first venture of the kind in Britain and a welcome departure from the traditional Chelsea Flower Show. It had its origins in urban decay, being sited on disused docklands, and the intention was to inject a measure of new life into a city of high unemployment. A second and similar festival is planned for Stoke-on-Trent in 1986 followed by a third at Glasgow in 1988 and a fourth at Gateshead in 1990. Whatever the political implications of these events, their significance in revitalizing the horticultural industry and focusing attention on the new public gardens and landscapes of the late 20th c. cannot be doubted. M.L.L.

See also KARLSRUHE.

Garzoni, Villa, Collodi, Tuscany, Italy, was begun in 1652 for the Garzoni family. Built on the foundations of a medieval castle, the villa itself stands on a hillside, concealing the village behind. The new garden is separated from the villa by a public road but has been swung in such a way that the lower parterre can be seen from the windows.

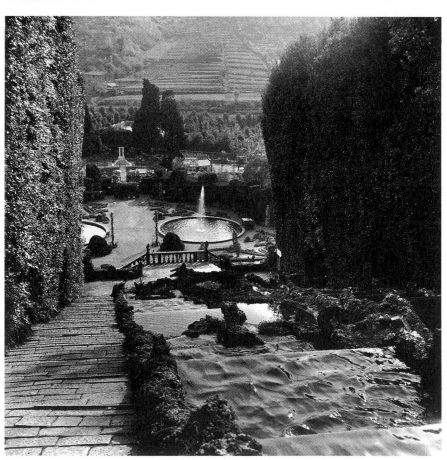

Villa Garzoni, Collodi, Italy, view from the top of the water staircase

Although there is access at the high level, it is visually an independent landscape, owing as much to Roman as to Florentine influence. The lower parterre is furnished with twin circular pools and family heraldry in box and is outlined into curve and counter-curve with double scalloped hedges. From this level, three promenade terraces rise spectacularly against a background of trees, the uppermost terminating in a charming garden *theatre. Axially in the centre, steps and stairways ascend to a great cascade (whose rocks are fashioned like an elongated giant) that parts the woods and disappears against a statue of Fame deep in the *bosco at the summit. Beside the statue of Fame is the bath-house thought to have been converted in the 18th c. from a 17th-c. hermitage. (See also *bath.) The detail throughout the garden is somewhat crude, but this does not detract from the beauty of shape. Technically the gardens, fortunately still well preserved, are a box of baroque optical tricks: the cascade, for instance, widens as it ascends, making it look more abrupt when seen from below and longer when seen from above.　　　　　　　　　　　　　　　　　　G.A.J.

Gaspar, Peeter, Dutch sculptor and caster. See SCHEEMAKERS, PETER.

Gatehouses have their origins in the gateways to the temples, palaces, and cities of the ancient world, combining functional with decorative significance as an expression of status. The tradition continued through the cities, castles, and estates of the fortified houses of the Middle Ages. A fine example of a fortified gatehouse is at St Osyth's Priory (1475), Essex, which has elaborate flint decorations.

Until the middle of the 17th c. gatehouses were usually single buildings pierced by the gateway, and providing living accommodation for the gatekeeper, often above the gate itself. One of the last built in this style is at Stanway House (c.1630) in Gloucestershire; it has Dutch gables topped by scallop shells and fine Doric columns flanking the gateway. Later gatehouses consisted of twin (or single) lodges beside the gates, sometimes linked by an elaborate arch. At Stowe this idea is developed further in a gatehouse (1767) consisting of two houses concealed within the piers of a Corinthian arch. Architectural styles varied according to that of the house itself and according to prevailing fashions (for an excellent account of British gatehouses, see T. Mowl and B. Earnshaw, *Trumpet at a Distant Gate*, London, 1985). James Wyatt (1746–1813) produced several very fine gatehouses, such as the circular Bath Lodge (c.1802) to Dodington Park, Gloucestershire (Avon). Many gatehouses were so small that the gatekeeper lived in one lodge on one side of the drive and slept in another on the opposite side.

The Gothic revival style of the 1830s brought a return to the medieval type of gatehouse: at Penryhn Castle, Bangor, Gwynedd, there is a splendid example with a portcullis, elaborate stone turrets, and extensive continuous carving in strong horizontal bands. The romantic revival of the 19th c. produced many examples of reed-thatched gatehouses,

often round and quite small, surrounded by the flower-filled cottage gardens so beloved of Victorian artists.
　　　　　　　　　　　　　　　　　　G.W.B./P.J.C.

See also GATES.

Gates. The use of gates in European gardens as a decorative feature, in addition to their protective function, began with the shift away from the small enclosed *medieval garden and the development of the large unfortified pleasure-garden of the Renaissance. The scale and the elaboration of Renaissance and later baroque and rococo gardens provided scope for the use of gates to separate different parts of the garden, to close in the diminishing perspectives of avenues, to distinguish entrance forecourts, and to provide screens through which wilder parts of the garden or more distant vistas might be viewed.

The earliest garden gates were wooden, though iron was sometimes used for the bolts and strapping. A further development was gates with wooden frames and iron bars—the beautiful gates at Groombridge Place, Kent, designed by Wren in the late 17th c., are in this style, with a crest of iron spikes and fleurs-de-lis and flanked by stone piers topped with pineapples. Wooden gates continued to be made especially where timber was a common building material. Particularly fine examples are the simple white gates of the reconstructed gardens of colonial *Williamsburg and the dramatic wooden gate and fencing at Hotvedt Drammen, Norway.

Wrought iron for gates, screens, and *grilles had been used in churches as choir screens and to protect shrines and relics from the 13th c. onwards but its widespread use for gates in secular gardens did not become established until the 17th c. The baroque style gave great scope to the skills of the smith, with its emphasis on plasticity, energy, and grandeur, and the increasing freedom of rococo also favoured the use of wrought iron for gates, as exemplified in the work of the German master smith, Johann Georg Oegg. An interesting pair of gates made by Oegg at the *Belvedere Palace in Vienna c.1720 marks the transition between baroque and rococo. Other examples of fine wrought iron gates from this period are those in France at Meudon (by Mansard) and Saint-Cloud (by Gittard); the elaborate gates and screen (by Erhard Martinelli, 1720) enclosing the forecourt at the *Eszterháza Palace in Hungary; and the open strap-work gates in a beautiful leaf design enclosing the parterre garden at the Villa *Doria Pamphili, Rome. In England the greatest smith of the period was the Huguenot, Jean Tijou, much of whose finest work is at *Hampton Court, where he also made the heraldic screen (1689) forming a *clair-voie round Queen Mary's garden. Other fine baroque English gates are those at Chatsworth (1688–9, probably by John Gardon), and at New College (1711) and Trinity College (1713), Oxford (see *Oxford College Gardens) both by Thomas Robinson. The Lion Gate at Hampton Court, an outstanding example of the smith's skill, is unfortunately dwarfed by the elaborate stone piers crowned by lions.

Gates and gate piers became far less prominent from the

middle of the 18th c. The reasons were economic as well as stylistic. Improved techniques for producing cast iron made it a competitive alternative to wrought iron; in any case the neo-classical style with its emphasis on regular forms made fewer demands on the skills of the smith and cast iron became the more common medium for gates with plain bars and rails. Furthermore, the naturalistic style of the English landscape garden (see *England: Development of the English style), which spread all over Europe, provided less scope for the use of gates as a decorative feature within the garden, and they were relegated once more to the boundaries of the estate. Other materials used for the gates at this time were trellis and wirework.

Later styles in turn have modified the design and use of gates in gardens, among them the *picturesque, *Chinoiserie, and the *Arts and Crafts movement in the 19th and 20th cs. Examples in 20th-c. gardens are the plain wooden gates by *Lutyens at Middleton Park, Oxfordshire, and the wrought iron gates at Hidcote and Sissinghurst which are used in traditional fashion to provide a screen through which the open country beyond the garden may be viewed. G.W.B./P.J.C.

See also DUMBARTON OAKS; GATEHOUSES.

Gaudí y Cornet, Antonio (1852–1926), Spanish architect. See PARQUE GÜELL.

Gazebo, facetious Latin for 'I will gaze', is a structure from which one may 'gaze out' over a garden. It is either an elevated room placed on an existing natural small vantage point, or a main room constructed on the first floor of a brick or stone garden building. There is a splendid Tudor brick gazebo at Melford Hall, Suffolk, and a fine later example looks over the River Avon at Stoneleigh, Warwickshire.

The Mogul gazebos were descended from the dovecots at the four corners of Persian gardens and there were always four of them. G.W.B.

See also MIRADOR.

Gazon coupé, literally 'cut turf'; grass with shapes cut out of turf and filled with coloured earths or gravels. A.M.P.

Ge, a type of Chinese garden pavilion. Similar to a *lou, it is a building of two or more storeys, usually with a double-hipped roof. Its windows, often surrounded by balconies with balustraded seats inset between them, open fully on all four sides. X.-W.L./M.K.

See also FANG; TING; XIE; XUAN.

Ge Yu-liang, a native of Changzhou, China, living at some time around the late 18th c., was one of the best-known Chinese garden designers of artificial rockery hills. His skill was in bonding rocks together by interlocking their natural edges like hooks. It is said the longer his rockworks stand, the more stable they become. Many gardens in the lower Chiangjiang (south of the Yangtze River), such as the artificial hill of *Huan Xiu Villa, are said to have been his work. D.-H.L./M.K.

Generalife, The, Granada, Spain. The original palace in this location dates from the mid-13th c. The buildings and gardens lie on a steep slope of the Cerro del Sol, overlooking the *Alhambra and city of Granada to the west. The complex, excluding the New Gardens to the south, covers an area of two-thirds of a hectare.

The Generalife was once the summer palace of the sultans, built for the Nazarite dynasty. The name is derived from the Arabic *Jennat al-Arif* meaning 'garden of the architect' (or 'of Arif'). The restored buildings have been much altered, and their decorations have suffered through neglect, but the gardens retain their attraction. Filled with flowers, trimmed hedges, orange and cypress trees, they are enlivened by fountain jets and pools. Water is obtained from the upper reaches of the Darro; the continuous presence and sound of water, as well as the intimate scale of the gardens (despite the extensive views that may be obtained from the periphery), well recall the early Islamic concept of the paradise garden (see gardens of *Islam).

The Patio de la Acequia (Court of the Long Pond) is the chief focus of the complex, and is the court first entered by the main approach from the south. A little under 50 m. in length, it is terminated at either end by three-storey porticoed pavilions. Partially obscured by foliage, their scale relates well to the contained space of the patio. Their predominant materials are stucco and clay tile, although marble columns and plaster grillework may also be found.

Set low in the adjacent paving which has a coloured tile inset are lotus-shaped basins supporting a bubbling jet. Facing the visitor on entry through the portico of the south pavilion is a long straight canal bordered by a loose arrangement of flowers, trimmed hedges of myrtle, and orange and cypress trees; the fine jets arching over the canal are relatively recent. The original garden was 0.5 m. lower than the present one, but the strong Islamic character remains.

This garden is bounded on the west by an arcaded gallery with a small mosque at its centre; from this gallery the Alhambra, separated by a slight valley, and the city beyond, may clearly be seen. From the north *mirador may be seen the Albaicin and Sacromonte hills; this mirador was built in 1319, during the reign of the Nazarite emir Abdul Walid Ismail. The east side of the garden is contained by a narrow service wing with further gardens of later date on the hill immediately behind.

The first of these gardens at an upper level is the Patio de los Cipreses, which has a U-shaped pool containing fountain jets, and is enclosed by cypress trees. Bounding this garden on the north is a two-storey gallery dating from the 16th c. A little higher still and dating from the same period is the Camino de los Cascades. On top of its balustrades of rough masonry is a channel down which a small cascade of water flows; there is also a small basin and tiny jet in the centre of each landing at the foot of each flight of steps. Dense foliage arches overhead.

The lush and well-watered Generalife contrasts strongly

with the surrounding harsh mountain landscape of young pines and scrawny olive trees struggling in the dry ochre earth. The garden has belonged to the state since 1921.

J.L.

See also SPAIN: ISLAMIC GARDENS.

Gen Yue, Henan province, China, was a vast man-made landscape built in 1117–23 during the time of the Song Emperor Zhao Ji (Hui Zhong). It was located north-east of the capital Bian Liang, now the city of Kaifeng. The Emperor, a painter of considerable merit, was, it seems, personally involved in planning the park, but it was supervised by Liang Shi Cheng with several imperial Commissioners working under him. One, a merchant Zhu Mian, became notorious for his pursuit of rare plants and rocks around Suzhou; another, Ling Bi, collected for the park some 1,500 km. away in South China. Originally named Phoenix Mountain, the garden's new name was made up of *yue* meaning high mountain, and *gen*, one of the Eight Trigrams—usually signifying mountain and the orientation north-east—in the ancient book of philosophy Yi Jing. The name suggests that the park had some geomantic purpose beyond that of the Emperor's own personal pleasure (see *feng shui*).

The perimeter of the park was *c.*5 km., with water in the west and hills and rocky peaks in the east. Collections of bizarre and fantastic rocks spiralled out of these ridges which rose at their highest point to the Peak of Ten Thousand Years' Longevity with a pavilion at its top. From here the Emperor beheld what seemed a microcosm of the universe with city and park spread out 'as if lying on the palm of the hand'. All around 'peaks, caverns, mature trees and grasses' blended with nature 'as if it had all been here since creation' while islands embellished with palatial halls and gazebos lay along the waterways. Among innumerable buildings were the Red Sky Chamber, the Hall of the Flower with Green Sepals, a library, and a circular Pavilion

for the Immortals. Unfortunately, the expense of building Gen Yue weakened an already tottering dynasty. Today nothing remains of it except two great monolithic rocks in the *Yu Yuan in Shanghai and the *Liu Yuan in Suzhou, once supposedly chosen for the mountain of Gen Yue.

G.-Z.W./M.K.

Geomancy, Chinese. See FENG SHUI.

Georgium, Halle, German Democratic Republic. See EYSERBECK. J. F.

Gerard, John (1545–1612), became a barber-surgeon in London, completing his apprenticeship in 1569 and becoming Master of the Company of Barber-Surgeons in 1607. He was also an enthusiastic botanist, searching for plants near London and further afield.

He looked after several gardens in and near London, including those of William Cecil, Lord Burghley, in the Strand and at *Theobalds Park in Hertfordshire. He was also the curator of the garden established by the College of Physicians in the City of London, as well as having his own garden in Holborn, where he grew 'all the rare simples' and 'all manner of strange trees, herbes, rootes, plants, flowers, and other such rare things'. A catalogue of his own garden, listing over a thousand species, was published in 1596, and included the first printed reference to the potato. A second edition, dedicated to Sir Walter Raleigh, followed three years later.

Gerard's *Herball* appeared in 1597, with a later revision by Thomas Johnson in 1633. It is probably the best-known and best-loved *herbal of all, for its influence encouraged many later botanists, including Sir Joseph *Banks. S.R.

Gérardin, Louis René, Marquis de Vauvray, Vicomte d'Ermenonville (1735–1808). See GIRARDIN.

Germany

RENAISSANCE GARDEN DESIGN. The much admired garden which Emperor Friedrich II (1214–40), accustomed to the lush gardens of Sicily, had ordered to be laid out around the Burg at Nuremberg long remained an exception in Germany. It was not until the Renaissance that a strong interest in botany as a science developed, when it found expression in numerous written works and in private plant collections. The first enthusiasts were doctors and botanists who studied in Italy and on their return to Germany laid out botanic gardens after the Italian model, for example Laurentius Scholz, a doctor from Breslau. The interest spread later to merchants and princes. For the sons of the nobility the grand tour was a necessary part of classical education and culture. But despite the very strong Italian influence national characteristics were to be found in

gardens all over Germany. Although many individual features were taken over from the Italians, they were added only piecemeal without any attempt at an overall synthesis.

Every one of the numerous princely residences in Germany between the 16th and 18th cs. had a pleasure-garden (e.g. Stuttgart, Berlin, Munich, Kassel, Kothen, and Dresden). Some major gardens belonging to members of the nobility also date from this period, and were often attached to moated castles (e.g. the gardens designed with such aesthetic sensibility by Heinrich Rantzau in Schleswig-Holstein); a great many gardens were also laid out by patricians and burghers (e.g. the Fugger in Augsburg). Among the botanic gardens, which mainly belonged to universities, that of the Bishop of Eichstätt on the Willibaldsburg is outstanding; the Bishop ordered

drawings of the flowers and plants to be made, and these are collected together in the *Hortus Eystettensis* (1613) (see *botanical illustration).

The most important garden to originate in this period was the *Hortus Palatinus attached to the Schloss at Heidelberg which displays all the characteristics of Renaissance garden design: grottoes, fountains, water parterre, labyrinth, gazebo, retaining walls, statuary, waterworks, etc.

VERSAILLES AND THE BAROQUE. The Thirty Years War (1618–48) prevented any further development of gardening in Germany and no new gardens were established. This explains why the new baroque style of garden design was imported from France and why German princes even summoned French gardeners and fountain designers to their courts or sent their own gardeners to France to be trained. Although *Versailles now became the model for the whole of Europe, in Germany there was no attempt to imitate it in every detail. The gardens of this period reveal a great deal of individuality in both ground-plan and decoration. For example, in the design of the Favorite in Mainz, the Archbishop and Elector of Mainz, Lothar Franz Count Schönborn, departed radically from the ideal by laying out the garden mainly with transverse axes. Similar designs were used at Hildburghausen and *Veitshöchheim. Or the Schloss was set in the middle of the garden, as in the *Grosser Garten in Dresden and at Seehof near Bamberg. Some gardens were laid out in a star shape, e.g. the hunting-lodge of Clemenswerth of the Elector Clemens August, surrounded by eight pavilions; the hunting-lodge of Waghäusel (also intended as a hermitage) of the Prince Bishop of Speyer, D. H. Count Schönborn, surrounded by

four pavilions; the *Belvedere of Duke E. A. von Sachsen-Weimar; and at Lindich near Hechingen and especially at *Karlsruhe, where the star design of the garden is repeated in the layout of the town itself.

The *orangery assumed a completely new significance in Germany as it not only provided winter protection for delicate plants such as figs, oranges, and bay, but was also used to stage musical and theatrical entertainments. Much thought was given to its design and to its position in the park. In the Favorite in Mainz, for example, the Orangery is the principal building, flanked by three pavilions on each side; at Gaibach it is built in the shape of a horseshoe and forms the termination of the middle axis, as it does at *Weikersheim, except that there the middle axis passes through the two wings of the building. Many gardens were laid out in a circular design, e.g. in *Schwetzingen or *Schleissheim (at the Lustheim). Where castles and palaces were orientated towards a river, the gardens were often laid out on the banks and were reached by ship, e.g. at *Pillnitz, the Japanese Palace in Dresden, or Monbijou in Berlin. Dutch influence is evident in the use of canals to enclose gardens and parterres, e.g. in *Herrenhausen, Schleissheim, Schlodien, and Hildburghausen. Hedge theatres were very popular in Germany. Only one baroque garden, *Wilhelmshöhe, followed the Italian model.

Of the baroque princes the seven Electors, who elected the Emperor, played the most important part; there were four temporal Electors—Brandenburg, Saxony (see *Moritzburg), Palatinate, and Bohemia (later also Bavaria and Hanover)—and three spiritual Electors—Mainz, Cologne, and Trier. Of the second group special mention must be made of the Dukes of Schönborn. These outstanding

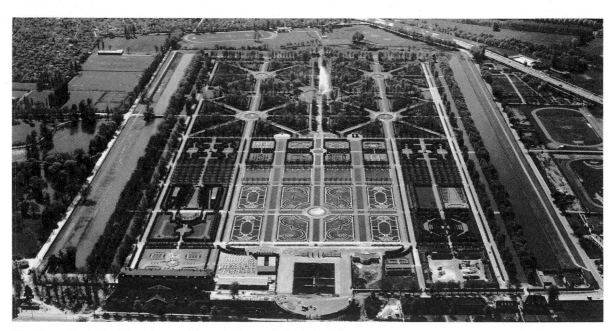

The 'Great Garden' at Herrenhausen, Hanover, German Federal Republic

The flower garden at Muskau, German Democratic Republic, lithograph from Fürst von Pückler-Muskau, *Andeutungen über Landschafts-gärtnerei* (Stuttgart, 1834)

patrons of the arts built castles and gardens such as Favorite, Pommersfelden, Seehof, Bruchsal, Gaibach, Wiesentheid, and Werneck, and followed more closely the artistic developments of Vienna than did, for example, the Wittelsbachs who looked more to France. Many baroque gardens of castles belonging to the nobility throughout the whole of Germany might be mentioned, above all at *Augustusburg, Jersbek, Nordkirchen, Ostrau, Hundisburg, and Finckenstein; but there are also some fine gardens of smaller residences, e.g. at Neuhaus, Salzdahlum, Eutin, Philippsruhe, and Erlangen. In southern Germany in particular there were notable baroque gardens, on the sites of former monasteries.

FROM THE ROCOCO TO THE LANDSCAPE STYLE. In the mid-18th c., while in England the landscape style was already beginning to develop, German garden design underwent a further development from the baroque to the rococo. The gardens attached to princely residences no longer had a merely representative function but served to promote social intimacy: they were divided into numerous small garden rooms, usually enclosed by hedges, gazebos, or trellises. There is something deliberately confusing, sometimes even labyrinthine, in the layout of these gardens. The most important examples are *Rheinsberg and *Sanssouci, the Solitude near Stuttgart, Veitshöchheim, and the *Eremitage near Bayreuth; *Würzburg and Schwetzingen should also be included here. Also characteristic of this period are the Chinese buildings in the form of pavilions, tea-houses, or pagodas (Sanssouci; *Mosigkau; *Pillnitz; and *Oranienbaum). On the other hand, there was a growing tendency towards erecting buildings in the form of

mock ruins; this can be seen in the Eremitage near Bayreuth which has some ancient ruins, such as the theatre.

Between the rococo and the English landscape style stands the garden of *Sanspareil which was an early forerunner of the landscape style. But the first noteworthy example of the new style is the garden at *Wörlitz. Most of the princes were actively involved in laying out their landscape parks; some of them, such as Prince Franz of *Anhalt-Dessau and later Prince Hermann of *Pückler-Muskau, visited England to study the landscape garden in its country of origin. Many garden experts (J. A. *Eyserbeck, J. F. *Eyserbeck, F. L. *Sckell, and P. J. *Lenné) and architects (F. W. von Erdmannsdorff) followed their example, and this led not only to the adoption of the new ideas of garden design (see *Babelsberg), but also to the introduction of the classical architectural style of Inigo *Jones, especially in northern Germany, although the influence of J. J. Winckelmann's Italian studies should not be forgotten. Poets and philosophers such as S. Gessner and J. W. von *Goethe paved the way for this new style of gardening (see *Ilm Park, in Weimar). The early gardens, with their sentimental, profuse decorations (Seifersdorfertal or Hohenheim), gave way to the mature works of the leading garden architects Sckell, Lenné, and Pückler-Muskau (see *Muskau), especially in northern Germany and Silesia (*Schönbusch; *Pfaueninsel; and *Branitz), which reached their high point in Lenné's landscape design around the Havel lakes near Potsdam. Above all there are the parks of *Klein-Glienicke, Babelsberg, Pfaueninsel, and Neuer Garten in Potsdam. Many baroque gardens (Greiz; Ludwigslust; the Belvedere Weimar; Nymphenburg; Charlottenburg) were wholly or

partly transformed in the landscape style. The first notable popular parks were laid out by Sckell in Munich (the *Englischer Garten) and Lenné in Magdeburg (1824). Their pupils and successors in the following generation Gustav *Meyer, Eduard *Petzold (see *Greiz), Weyhe, Julius Bosse, and others, created many highly regarded parks and gardens.

U.GFN.D.

THE *ARCHITEKTURGARTEN*. The spirit of the landscape garden in Germany died with Peter Joseph Lenné in 1866. Yet its form lingered on, scaled down where necessary to fit the suburban villa gardens of a new generation of bourgeois clients. A typical villa garden of this period is Köhler's Fürstenberg Garden, with winding paths and artistically situated clumps of planting. Even the rectangular form of the tennis court is decently disguised.

The impulse for change came from the architectural profession. The deciding influence was Hermann Muthesius (1861–1927) who argued that there was such an intimate relationship between house and garden that they simply could not be designed by two different parties,

architect and garden designer. In his own house (built 1906) he realized his ideas of surrounding the building with a series of individual, geometrically designed garden rooms, linked to the house with a pergola.

Although this new style was initiated by architects, it was soon adopted by a new generation of garden designers, of whom Fritz *Encke (1861–1931) was one of the leading figures. They called themselves *Gartenarchitekten* in order to set themselves apart from the landscape gardening tradition of the previous century.

In his book *Die Gartenkultur des 20. Jahrhunderts* (1913), Leberecht *Migge (1881–1935) stressed the functional benefits of the new architectural gardens: 'today's garden must be of a regular appearance for the very reason that it is only in this form that its new social and economic character can be fully exploited.' Between 1904 and 1913 he designed many private gardens and public parks in an architectural style, as well as the gardens for the International Building Exhibition at Leipzig in 1913.

One of the most important figures of the period was a friend of Migge, Erwin *Barth (1880–1933). Some of his

Plan of Fürstenberg Garden (1898), Berlin, by R. von Köhler

Lange Garden (1906), Berlin,
by Willy Lange

private gardens are classical examples of the late *Jugendstil* style (the German equivalent of Art Nouveau). His Juliusberger Garden was actually built in 1921–2, although it belongs in spirit to the *Architekturgarten* era of before the First World War. Later he became Garden Director of Greater Berlin (1926), holding the first University Chair of Garden Design in Europe (at Berlin's Agricultural University).

PUBLIC GARDENS. The social and functional aspects of public gardens also began to be increasingly recognized. A large number of influential parks and squares were laid out in Berlin and Cologne, by Barth and Encke respectively. Parks Director in Cologne between 1903 and 1926, Encke's most important works included the Klettenberg Park (1905–6), Vorgebirgspark (1912), and the Kleine Alhambra (1914), as well as the city's inner green belt. As Garden Director in Charlottenburg (1911–26), just outside Berlin, Barth designed a large number of town squares. His Gustav-Adolf Platz, Goslarer Platz, and Karolinger Platz, all dating from 1912, were all very much user-orientated in contrast to earlier merely decorative squares.

One of Barth's Charlottenburg squares, the Sachsenplatz (executed 1921), deserves special mention in that it anticipates a design tendency later to become influential in German garden design, namely, the reintroduction of landscape elements based not on the idealized forms of the English landscape school, but on the application of ecological and phytosociological principles. The site, a disused gravel pit some 2 ha. in area, was to contain examples of typical 'natural plant communities and geological formations' of the locality, laid out according to 'ecological considerations'.

The introduction of phytosociological principles into garden design can be traced back to, amongst others, Willy Lange. In 1906 he laid out his garden 'according to the laws of nature', in sharp contrast to the developing architectural style of the period. The plan of this garden differs fundamentally from the landscape gardens of the previous century in its lack of areas of grass, and in the reduction of paths to a functionally necessary minimum, without themselves representing design elements.

Until the establishment of the first university course in 1926 under Barth, the main educational route for garden designers was the Wildpark Horticultural College, later moved to Berlin Dahlem. Most young garden designers learnt their trade working for one of the large horticultural firms. Although not a designer himself, the first influential figure to emerge in this context was Karl *Foerster (1874–1970). As a nurseryman, plant-breeder, and writer on gardens, he was an innovative thinker, largely responsible for making plant material, especially the taller perennials, alpines, ferns, and grasses, the central feature of the garden. Such was his influence that even his competitor Ludwig Spath employed a planting expert taught by Foerster in the design section of his nursery during the early 1920s. Spath also nurtured the talent of such subsequently important designers as Wilhelm Hübotter (1895–1976), Otto *Valentien (b. 1897) and Herta Hammerbacher (1900–85).

During the 1920s the formalism of the *Architekturgarten* began to break down in two respects. First, the overall layout remained fundamentally geometric, but, as can be seen at the Schramm Garden (1925–31) designed by Otto Valentien for Ludwig Spath, it was no longer symmetrical in form. Secondly, the rigidity of symmetrical designs was softened by rich and varied perennial planting. This change was

inspired by Foerster, and was well illustrated by the Springer Garden designed by Foerster's early close collaborator Berthold Körting and the Goldstein Garden by Richard *Neutra, both dating from 1925.

This trend was continued by Hermann *Mattern's Bergius Garden (1927), Heidelberg, and his Weishaupt Garden (1929), Berlin. In the latter the contrast between the irregularly geometric terraces of the rock-garden (Mattern spoke of 'cubist tendencies') and the stepping-stone path across the lawn indicates the return of more naturalistic elements. Mattern (1902–71) joined Foerster's design office in 1927 after having worked briefly for Migge in Berlin. Migge had largely withdrawn from the world of conventional garden design to devote his attention to the garden aspects of the housing reform movement, thereby antagonizing much of the contemporary garden design profession. His work with architectural reformers such as Poelzig, Wagner, and Taut is now, however, being rediscovered and he is being looked upon as one of the forerunners of the modern 'self-sufficiency' movement.

During this period, there was a brief vogue for the 'expressionist garden', which reached its zenith at the 1926 Garden Exhibition in Dresden designed by Gustav Allinger (1892–1974), especially in his 'garden of the future'. This came in for special criticism from Migge for 'failing to take account of the economic and technological events of the war and post-war years'. In his 1928–30 Höcker Garden, however, Allinger made some concessions to use, with terraces forming play and sitting areas surrounding a sunken rectangular lawn, which is enclosed by planted retaining walls. Another proponent of a fundamentally architectural design style was Heinrich Wiepking (1891–1973). His own garden in Berlin (1926–8) illustrates something of his formalism. Both Wiepking and Mattern were involved in designing gardens for modern architects. Wiepking's garden for Erich Mendelsohn, with its starkly contrasting landscape and geometric sections on either side of the house, and Mattern's much smaller garden for Poelzig provide an interesting comparison.

During the 1930s, Mattern's designs, and those of the Foerster School, became less geometric, developing organically out from the house. Mattern's friendship and collaboration with the architect Hans Scharoun certainly did nothing to discourage this tendency. The Baensch Garden (1930–5) by Mattern, Hammerbacher, and Foerster on a hillside site in Berlin illustrates how completely they had turned their backs on the formalism of a few years previously. Scharoun had difficulty in obtaining planning permission from the new Nazi authorities, and the garden, too, was in more or less stark contrast to the officially approved style.

LANDSCAPE ARCHITECTURE. With the building of the autobahns, garden designers had to take into account for the first time the wider landscape. Alwin *Seifert (1890–1972), an architect by training and a self-taught garden designer, was appointed to advise on the integration of the new roads into the landscape. This was the beginning of a new field of work for the garden designers who became known as 'landscape advocates' (Landschaftsanwalte).

Seifert involved many of the leading designers of the day as part of his team, including Mattern and Hübotter, and also adopted concepts of phytosociology into his autobahn planting. In 1934 Wiepking was appointed Professor of Garden and Landscape Design at Berlin's Agricultural University to succeed Erwin Barth, and he, too, began to expand his curriculum to cover the landscape as a whole. He was also instrumental in drawing up Germany's first nature conservation legislation as a member of the Reich's Nature Conservation Office.

These developments not only laid the foundations for modern German landscape planning, but also help to explain the continuing theme of nature and native planting in German garden design which became firmly established during the 1930s and 40s. Although this was not strictly in line with the monumental thinking of the authorities, ecological and nationalist ideology were in some cases hard to separate.

The work of Hübotter in Hanover and Valentien in Stuttgart illustrates the informality of the garden design style which developed during this period and continued throughout the post-war years. Valentien's work was characterized by its refreshing simplicity and normality. His remarks on meadows in his book Gärten (1938) also provide an insight into contemporary attitudes to natural planting: 'The beauty of a meadow cannot be improved upon or replaced by the best kept of lawns, its character is so unique that it defies all comparison.' He also praised Hübotter's work as 'design without effects', with 'no empty decoration, no formalistic tricks'.

In 1922 Hübotter had been one of the first garden designers in Germany to set up a design practice which was not associated with a nursery or garden contracting service. Other contemporary figures, notably Adolf Haag (1903–66) in Stuttgart and Alfred Reich (1908–70) in Munich, carried on the 'design and build' tradition of the old nurseries until the end of the 1960s. Both of them belong to the Foerster–Mattern School. Haag studied with Mattern during the 1920s in Berlin, before setting up one of the leading practices in Stuttgart. His work is characterized more by his craftsmanship in stonework and his knowledge of plant material, than by any graphic or design skill on paper.

Reich set up a branch of Foerster–Mattern in Munich to execute a prize-winning design for the 1934 Garten und Heim exhibition in the Munich suburb of Ramersdorf, and then went into practice designing and building exclusive gardens there. In 1936 both Haag and Mattern were involved in the competition for the design of the 1939 Reichsgartenschau on the site of a disused quarry on the Killesberg in Stuttgart. The park, built to Mattern's overall design, has now been afforded the status of a historic garden, such was and still is its influence. It is specially remembered for the perennial planting and the sensitive way in which the new landscape of the park was integrated with the existing trees on the site.

THE POST-WAR PERIOD. The end of the Second World War brought about little change in West German garden design, a fact symbolized by the first post-war *Gartenschau in 1950, which was Mattern's reconstruction of his 1939 Killesberg Park. The main garden designers working during the post-war years were the same figures who had begun their careers during the late 1920s and early 1930s, many of them being associated with the Foerster–Mattern school. Gottfried Kuhn (b. 1912), Hermann Thiele (b. 1908), and Gustav *Lüttge (1909–68) all worked as apprentices at Foerster's nursery at more or less the same time.

Lüttge also studied subsequently under Wiepking, and the influence of his architectural style, with its long straight lines, pergolas, and well-detailed paving, can be recognized in much of Lüttge's work. Continuity was further ensured by Wiepking's role in building up new landscape design courses in Osnabrück and at Hanover Technical University, and through Mattern's appointment as a teacher at the newly founded Werkakademie in Kassel, where he designed another influential post-war Gartenschau in 1955, reconstructing the damaged former baroque Karlsaue Park.

In design terms, the modernism which had been condemned during the Third Reich began only gradually to creep into the naturalistic and romantic gardens of the Foerster School, with the cautious use of concrete and steel. Mattern continued to be one of the most influential and progressive designers. His house gardens reflect the overall trends: abstract and independent forms soon began to play an important role, while the character of the planting often remained essentially naturalistic, although the earlier extensive use of perennials was no longer so pronounced.

R.STI.

Gernyeszeg (Gorneşti), Romania. The garden surrounding the mansion of Count Joseph Teleki was laid out c. 1797 by a local gardener, perhaps following the instructions of the patron. A central large artificial canal—a rare feature in what was then Hungary—and many sculptures scattered around the garden underline the owner's connections with France. Three grotesque dwarf sculptures representing Louis XVI, Mirabeau, and a certain Dame des Halles are unusual. After 1800 the English landscape style became predominant, numerous dark pine trees, poplars, and oak trees lending a romantic character to the garden. A small picture from the year 1818 by the painter Joseph Neuhauser and a lithograph of 1857 by Rohbock give some idea of the garden.

A.Z.

Getty Museum, Malibu, California, United States. See J. PAUL GETTY MUSEUM.

Ge Yuan, China, was a private garden located in the city of *Yangzhou (formerly Yangchow), Jiangsu province. It was owned by Huang Yingtai, a Qing-dynasty salt tycoon and once a governor of the salt trade in the Huai River region. The garden was named after his byname, Geyuan, but the Chinese character for ge also resembles a twig of three bamboo leaves and this became a symbol of the garden. It

was built (according to Liu Fenggao in his On 'Ge Yuan') at the end of the 18th c. on the site of an older garden, Shou Zhi Yuan, and it is said that its original artificial hill was designed and executed under the direction of *Shi Tao, but no reliable information has yet been found to prove this. This hill, as it is today, is the best-known feature of the Ge Yuan. A rare example of its type among Chinese gardens, it uses various kinds of rock to distinguish different areas of the garden and to symbolize the four seasons. Thus, an idea of the Mountain Forest in Spring is suggested near the entrance moon-gate (*di xue), where needle-like inverted stalactite rocks known as stone bamboo shoots have been planted among living bamboo groves to make a juxtaposition between real and false.

In the west, summer is symbolized by an artificial hill of Taihu stones overshadowed by the dense foliage of pine trees. Crossed by a zigzag bridge, the neighbouring pool runs on underneath a rocky overhang which then widens into a shadowy room lit by water-reflected light. This cave, quiet and deep, remains pleasantly cool in Yangzhou's heavy summers, and the grey rock-shapes, wet with summer rain or dappled with light and shade, seem almost alive.

In the east, a labyrinthine hill of yellow rocks rises sharply to steep peaks. Narrow rocky passageways wind up and through it, sometimes by steep steps or across deep chasms, to tiny courtyards and a central cave room. An aged cypress grows from a crevice and on the crest—an ideal place for ascending the heights in autumn—a gazebo overlooks the mountainous miniature landscape all around and the scenery of the slim West Lake beyond it. When this hill turns rosy at sunset it is thought to look exactly like a painting of autumn mountains.

The fourth and last of the hills completes the theme of the seasons. Laid out along the wall of a courtyard facing a large hall in one corner of the garden, it uses white-capped rocks to suggest snowy peaks in winter. The Ge Yuan's artificial hill of the four seasons is Yangzhou's most unusual contribution to China's gardening tradition.

G.-Z.W./M.K.

Ghana. See AFRICA.

Giardino Barbarigo (now Villa Pizzoni Ardemani, also known as the Villa Donà dalle Rose), Valsanzibio, Veneto, Italy, was made for Procurator Antonio Barbarigo. The extensive layout (traditionally dated 1669) was determined by the amphitheatre of the Euganean Hills in which it is set. The major west–east axis leads from the hills in a series of pools to a water-gate at the lowest point, the original entrance by canal from Venice. The only slightly less important north–south axis links the arms of the amphitheatre with avenues which climb the hillside and is ingeniously modelled to contain the modest *casino and exaggerate the perspective from it. The avenues were destroyed in the Second World War but have since been replanted.

Planned round these two axes and circuited with a pleached lime walk, the garden is an approximate rectangle having a number of exciting enclosures, including: a maze,

adjoining the major axis, recently restored to its perfect square; a unique oval rabbitry (the Garena); Diana's Bath; and the Fountain of the Swan, all described and illustrated in 1702 by D. Rossetti (*Le fabbriche e i giardini dell Eccellentissima Casa Barbarigo a Valsanzibio*, Verona). These cool, green, and shady gardens must have been well worth the long water journey from Venice, for elsewhere the flat plains of the Veneto that helped create the Palladian villa could not in themselves inspire garden design. G.A.J.

Giardino Botanico Hanbury, Italy. See LA MORTOLA.

Giardino dei Giusti, Verona, Italy. Named after the family who have owned it since the Renaissance, this was once one of the most visited and famous gardens of Italy. Sited on the steeply sloping hill of San Pietro, the garden was originally laid out with terraces, fountains, and grottoes in a style typically Tuscan rather than Venetian. It was possibly the first garden in Verona, and dates from the mid-16th c. Inexplicably the garden was redesigned during the 19th c., little now remaining of the features described by certain of its noted visitors. Thomas Coryat writes in *Crudities* (1611) of 'a second paradise . . . beautified with many curious knots, fruits of divers sorts and two rowes of lofty cypresse trees, three and thirty in ranke'; the upper terraces were 'decked with excellent fruits, as figges, oranges, apricockes', and the 'delicate little refectory in whereof there is a curious artificiale rocke . . . with delicate springs and fountains'.

Evelyn noted one of the cypresses as 'the goodliest cypresse I fancy in Europe', and Président Charles de Brosses stated (1739) that the garden was 'full of rockeries and grottoes and endless terraces covered with little circular temples'. Even Goethe remarked on the size of the cypresses during his visit of 1786, but sadly few of these enormous trees have survived, and although an Italian formal garden has been restored at ground level, plans of the original design have never been found. H.S.-P.

Giardino segreto, literally, secret garden, a feature found in most Italian gardens. In 15th-c. Italian Renaissance gardens, it was at first merely the survival of a medieval feature, the small strongly enclosed garden room. It was retained in a changed form as the Renaissance began to affect garden design. Thus, at the Villa *Medici, Fiesole, the *giardino segreto* gave on to uninterrupted views over Florence and the Arno valley, while that at the Villa Piccolomini, Pienza, overlooks the Val d'Orcia.

In later periods, the *giardino segreto* became much larger—at the Villa *Gamberaia, it is over 200 m. in length—and was often an impressive composition in its own right, as, for example, at the Palazzo *Farnese, Caprarola, where it is enclosed by stone caryatids. It was an essential feature of the villas of Frascati, where it was usually placed to one side of the villa or *casino* (see *Italy: The Villas of Frascati). P.G.

See also HORTUS CONCLUSUS.

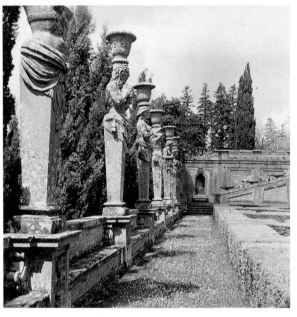

Palazzo Farnese, Caprarola, Italy, the *giardino segreto* of the Casino

Gibberd, Sir Frederick (1908–84), English architect, town planner, and landscape architect. As an architect his considerable practice ranged from Liverpool's Roman Catholic Cathedral to Heathrow Airport; as a town planner from Harlow New Town to various civic centres; and as a landscape architect from public parks to reservoirs. A unique sense of the relation between one object and another, and between these objects and their environment—whether urban, country, or garden—underlay all his work. His love of plants equalled that of architecture. As a garden designer he will always be known for his own garden at The House, Marsh Lane, adjoining Harlow New Town. Unlike all his professional work the garden was not pre-planned, and grew over a period of 22 years prior to his death. Intensely interested in contemporary art (the house contains a fine collection of paintings) he gradually created a private modern sculpture garden of remarkable variety (see *sculpture garden).

Gibberd was created CBE in 1954, knighted in 1967, elected a Fellow of the Royal Academy in 1969, and awarded the Gold Medal of the Royal Town Planning Institute in 1978. G.A.J.

Gibbs, James (1682–1754), English architect, worked for over 20 years at *Stowe where Lord Cobham in 1713 had begun the great landscape park containing nearly 40 buildings. His first design, the Temple of Diana (1726), like many others has gone, but the two Boycott Pavilions remain, once linked by an arched gateway and topped by pyramids (1730), as does his remarkable (and only) Gothic building, a triangular, towered design of reddish stone—the Gothic Temple of 1741–4, antedating Strawberry Hill by eight

years. He also built the Queen's Temple (1747–8) to contain the busts of Emperors, the 1739 Temple of Friendship (reconstructed 1982–3), and finally the belvedere column, originally supporting Lord Cobham's statue (1749).

In 1720 Gibbs built for the statesman James Johnston the Octagon Room in the existing Orleans House at Twickenham (London). This now survives as a sumptuous garden pavilion, richly decorated in the baroque style. He designed for the Duke of Bolton (c.1725) at Hackwood (Hants) a terrace with lily-pool, two pavilions, a tea-house, and a Doric rotunda, in a formal layout of radial walks. Many of these designs are to be found in his *Book of Architecture* (1728). I.L.P.

Gibbs was undoubtedly one of the 'back-room' pioneers of the English landscape school. He worked for two years in the Bernini-influenced office of Carlo Fontana in Rome and was therefore at the centre of the spatial ferment, known as baroque, then taking place. To Gibbs, with his classical background, the concept that space *between* objects could be as significant as the objects themselves must have been a revelation. On returning to England he became a fringe member of the *Burlington circle. His most interesting

Private sculpture garden (begun 1960) in Harlow, Essex, England, by Frederick Gibberd

exploration into the relation of classical and romantic was probably his works at *Hartwell House, Buckinghamshire. G.A.J.

See also DITCHLEY PARK.

Gilpin, William (1724–1804), English clergyman and author, was the true pioneer of the *picturesque. His essentially practical ideas were later developed into an abstract theory by Uvedale *Price. Brought up at Scaleby Castle in the Borders between England and Scotland and taught drawing by his father, he had a feeling for mountains, rocks, and ruined castles. When he became a schoolmaster at Cheam he gave the boys simple instructions for developing a 'picture imagination' when reading the classics, and for seeking out picturesque spots in the neighbourhood. His *Essay on Prints* (1768) instructed a new large public how to examine and appreciate prints. In the holidays he travelled to remote parts of Britain in 'search of picturesque beauty'. With improved roads and unrest on the Continent, home tours became fashionable and Gilpin's *Observations* on the River Wye (1782), on the Lakes (1789), and on the Highlands (1800) were as popular as his *Essay on Prints*. His publications linked the enjoyment of pictures and the appreciation of scenery in his admirers' minds, so that people of sensibility, like Jane Austen's Tilneys in *Northanger Abbey*, were seen 'viewing the country with the eyes of persons accustomed to drawing' and deciding on 'its capability of being formed into pictures'.

When he became Vicar of Boldre in the New Forest in 1778, Gilpin turned his attention to forest scenery. In his *Remarks on Forest Scenery* (1791) he considered the forms of individual trees and the picturesque interest of brushwood, twisted trees, exposed roots, and broken banks. He was critical of *Brown's work at Paultons where shaven lawns had been scooped out of the forest, a stream dammed, and a Chinese bridge thrown across it. In the *Observations* the reader was taught to observe the different characteristics of each region, and Gilpin's remarks on natural as opposed to stylized scenery, taken with the new concept of regionalism, influenced the reaction to systematized landscaping. Humphry *Repton, whose water-colours show the influence of Gilpin, maintained that his landscape improvements would 'accord with the face of the country'. M.L.B.

Gilpin, William Sawrey (1762–1843), English landscape gardener, was the nephew and pupil of William *Gilpin, whom he had helped with his Wye Tour (1782). He began his work as a landscape gardener in c.1806, and had a successful practice in England, Scotland, and Ireland. He was strongly influenced by Uvedale *Price and in his designs sought to apply a modified version of *picturesque principles. However, on occasion he was willing to unite the formal with the picturesque (as he did at Balcaskie in Scotland, probably prompted by the client).

By the 1830s his style was somewhat dated, although he still continued to gain commissions in Scotland. His reputation today rests not so much on this work, which in any

case rarely survives unaltered, as on his *Practical Hints upon Landscape Gardening* (1832) and his major work, *Scotney Castle. The book is rather old-fashioned in its elaboration of a series of aesthetic categories—he divides scenery into the Beautiful, the Picturesque (following Price), the Romantic, the Rural (scenery associated with the *cottage orné*), and the Grand (views over the hills and the sea). In terms of practice his ideas for intricate and varied planting can still be appreciated today at Scotney. P.G.

See also CALEDON.

Ginkaku-ji (Silver Pavilion), Kyoto, Japan. Built *c.* 1482 (in the Muromachi period) as a villa for Shogun Yoshimasa, after his death the garden was given over to a temple, known as Jisho-ji. Alterations in the 17th c. make it difficult to pick out the elements of the original paradise garden but the large treasure pond with two islands still acts as a mirror for the two-storeyed pavilion. This was modelled on the *Saiho-ji pavilion and was to have had its roof covered by silver leaf, a project that was never carried out. The garden is approached by a long narrow walk lined with bamboo fencing topped by evergreens, a spatial contrast with the openness and biological forms of the main garden. Here, immediately to the right on entering, are a large flat mound, *c.*75 cm. high, of white quartz raked into ridges to simulate waves—said to imitate a lake in China—and a flat-topped cone, nearly 2 m. high and 4·9 m. in diameter at the base, of the same quartz, from the mountains round Kyoto. These were for viewing the effects of moonlight, their luminosity standing out against the dark background of the wooded slopes of Mount Higashiyama just beyond the confines of the garden; a clever use of *shakkei. Within the woods is a very small dry landscape garden. The design of the main garden is attributed to the painter Soami. S.J.

Giochi d'acqua, literally 'water games'. The term can refer to water-powered *automata (as at the Villa *Pratolino or Villa *d'Este, Tivoli), or to devices by which the unwary onlooker can be showered with water (see Villa *Medici, Castello). They were an outstanding feature of 16th- and 17th-c. Italian gardens. Today they may seem rather childish, but 17th- and 18th-c. travellers (from *Evelyn in 1645 to de Brosses in 1739) often considered them to be the most noteworthy aspect of a garden—perhaps because of the power over Nature represented by their hydraulic ingenuity, or, in some cases, because of the obscene character of the display (as at Villa *Mondragone). However, the technology for these devices had been developed much earlier by the Arabs, and codified in the *Book of Mechanical Devices* (1206), by Ibn al-Razzaz al-Jazarí, ultimately inspired by *Hero. Directly based on this work were the water-devices at Hesdin (see *pleasance), and the *burladores* ('jokers') of the Seville *Alcázar. P.G.

See also ARANJUEZ; HELLBRUNN; WATER IN THE LANDSCAPE.

Girardin (or Gérardin), Louis-René, Marquis de Vauvray, Vicomte d'Ermenonville, called 'Marquis de Girardin') (1735–1808), French nobleman, is best known for the laying out of his estate at *Ermenonville and for his treatise on the art of landscape design, linking picturesque beauty and rural management: *De la Composition des paysages, ou, des moyens d'embellir la nature autour des habitations, en y joignant l'agréable à l'utile* (Geneva, 1777), translated into English by Daniel Malthus: *An Essay on Landscape . . .* (London, 1783).

A descendant of the Gherardini family of Florence, he served as an officer during the Seven Years War (1756–63) and proved a competent organizer. He was appointed camp-master-general to Stanislas Leczinski, father-in-law to Louis XV. Until Stanislas's death in 1766, Girardin shared the prince's interests in the arts, rural planning, and improvement. When he visited England in 1763, he found that the concept of the *ferme ornée corresponded with his own ideas of how an estate should be organized. He saw The *Leasowes 'when it had just fallen into the hands of a nabob', and later erected a memorial to *Shenstone at Ermenonville. In 1775–6 he again toured parts of Europe with his son and the painter Châtelet 'in search of the picturesque', visiting the haunts of J.-J. *Rousseau and of his characters Julie and Saint-Preux in *La Nouvelle Héloïse* (1761). Rousseau spent the last two months of his life at Ermenonville and was buried on the Ile des Peupliers, which became one of the best-known intellectual pilgrimages of France.

Girardin's liberal character and his quest for social justice led him to embrace the more humane aspects of revolutionary ideas at a time when it was dangerous to do so. Musician, draughtsman, writer, thinker, poet, he made of Ermenonville an aesthetic and economically successful whole. Although he called in J.-M. Morel for technical help, Girardin was his own landscape designer at Ermenonville. J. C. *Loudon wrote in his *Encyclopaedia of Gardening* (1822): 'In all that relates to the Picturesque, it is remarkable how exactly it corresponds with the ideas of PRICE.'

<div align="right">D.A.L.</div>

See also JARDIN ANGLAIS.

Gisselfeld, Sjælland, Denmark, one of Denmark's finest country-house parks, 35 ha. in extent, was laid out in the late 19th c. by H. E. *Milner, the English garden designer, as a setting for the fortified and moated red-brick house situated on an isthmus between two lakes. The planting is mainly informal; there are five lakes with rhododendron and rose islands, with some formal beds near the house. The orchard/kitchen garden is terraced and there is a bamboo *allée*; the conservatory (1876) contains many tropical plants. Nearby is an arboretum founded in 1814, known as the Paradise Garden. P.R.J.

Giulia, Villa, Rome, also called Villa di Papa Giulio, after Pope Julius III (1551–5) for whom it was built from 1551 by Vignola, Ammannati, and Vasari. The villa is sited *c.*1·5 km. outside the Porta del Popolo, in open gardens and scenery that stretched across the Via Flaminia to include a view along a reach of the Tiber. On occasion it served as a residence for visitors making a ceremonial entry into Rome (for example, Cosimo I, Duke of Tuscany, in 1560), for

which purpose it was connected to a landing dock on the Tiber by a long *allée* defined by pergolas and trees (Ammannati claims that 36,000 were planted by 1555).

Today only the internal courts remain to suggest the most important development of courtyard spaces since Bramante began the *Belvedere Court of the Vatican in 1505. There are three courts that become progressively smaller, proceeding downwards. The first (and main) courtyard consists of a porticoed semicircle interlocked with a square. Like the rest of the villa, this was originally richly furnished with plants and with sculpture. It has *topia* decorations in the vault of the portico, recently restored, with illusionistic frescos of pergolas bearing vines, roses, and jasmine. The second, the upper part of the *nymphaeum—joined to the first by a loggia—delightfully repeats the semicircle in its curved stairway leading to a lower level.

The horizontal axis is continued through a smaller loggia into gardens beyond, but a vertical axis leads the eye through an opening to the real nymphaeum below, to which there is no visible access. The nymphaeum consists of four caryatids supporting the upper level, and water flowing around the base on which they stand. Here, too, the walls were decorated with *topia*. It is called the Acqua Vergine after the Roman aqueduct, the conduit of which runs underneath the villa.

After the Pope's death most of the sculpture, filling 160 boatloads, was removed to the Vatican; the villa was completely stripped by 1569. However the structure remains as a beautifully detailed and a masterly interpenetration of space, both horizontally and vertically. P.G./G.A.J.

Giverny, Eure, France, is a garden of *c.*1 ha. created by the painter Claude Monet (1840–1926). After renting the house in 1883 he bought it in 1890, and over the years turned the orchard into a flower garden with trellised arches covered with rambling roses. It was a painter's, not a horticulturalist's garden, with poppies, blue corn-cockles, and yellow marguerites growing in profusion. Beyond the limits he acquired a piece of marshy ground, diverting some of the water of the River Epte to make a pear-shaped pond planted with willows and water-lilies (nymphaeas), building a Japanese bridge covered with an arch of wistaria over the narrowest part. From 1892 the water-garden was the subject of his large and important series of paintings. The house and garden have recently been restored and are open to the public. K.A.S.W.

Glæsel, Edvard (1858–1915), Danish landscape architect. About 1890 a change in garden design took place due to the growing number of much smaller gardens which demanded a new concept in layout. Glæsel started his career in 1888 as a representative of this new direction, after an extensive gardening education abroad, when he was particularly influenced by English garden design. He designed both large projects and small gardens, preferring to treat formally anything close up to a building, and, given the right conditions, he liked to place several small gardens within a garden. His noteworthy designs include the formal Town Hall garden at Vallø, Bispebjerg cemetery, and Fælled Park in Copenhagen, for which he submitted the winning design in a competition. P.R.J.

Glasnevin, National Botanic Gardens, Ireland. The earliest botanic garden in Ireland was established *c.*1687 at Trinity College, Dublin, and the Dublin Society had an experimental plot as early as 1740. The present National Botanic Gardens were founded by the Dublin Society (later the Royal Dublin Society) in 1795. Subsequent acquisitions increased the area from 11 ha. to its present 19 ha. The first director, Walter Wade, and the first curator, John Underwood, laid out the original gardens. They were redesigned by Ninian *Niven between 1834 and 1838 and modifications have been carried out by their successors David Moore (1838–79), Sir Frederick Moore (1879–1922), J. W. Besant (1922–44), and T. J. Walsh (1944–68).

The arrangement is botanical rather than geographical. A heavy alkaline boulder clay restricts the cultivation of calcifuge species, such as *Rhododendron* and *heathers, to beds where the original soil has been replaced by acid material. Nevertheless, a wide range of habitats has been created including a rock-garden, herbaceous borders, and arboretum. The yew hedge, planted before 1795, has associations with *Addison. Other outside displays include economic plants, vegetables, and herbs. Several glasshouses, including a curvilinear range, designed and built (1843) by Richard Turner, are open to the public. Ferns, aquatic plants, and cacti are grown in suitable conditions and the large palm house, built in 1884, contains tropical plants. F.N.H.

Gledstone Hall, North Yorkshire, England, the last completely new house and garden *Lutyens was to build (1922–3)—and without Gertrude *Jekyll's assistance in person—shows him in sober classical mood, and seems a conscious affirmation of stability in an uncertain post-war world. The whole concept, beautifully carried out in local ashlar, has a decidedly French flavour. The house itself stands on a wooded slope, with wings designed as attached pavilions, each with its own paved court. From a 'bridged' terrace (as at *Deanery Garden) in front of the house, a walled tank garden extends for some 60 m., its long central canal terminating in a brimming 'moon pool'. High bordered walks run parallel on each side up to pergolas on stepped bases, framing a wide view of the moors. I.L.P.

Glenveagh Castle, Co. Donegal, Ireland, was begun *c.*1860 for John Adair on a promontory of Lough Veagh in the heart of the Donegal Mountains; it is encircled by a deer forest of 11,000 ha. The 19th-c. pleasure-ground, developed following the advice of Lanning *Roper, leads up to the Belgian Walk and the Wild Garden along the steep hillside above the castle. An unbroken flight of steps, devised by James Russell, ascends in Aztec fashion to a high *belvedere overlooking the lough, the glen, and distant mountain ranges. Below, a walled garden is laid down as a formal *potager* (kitchen garden) with a Gothic conservatory designed by Philippe Jullian. A transverse walk is conducted

to the Fairy Ring, a green circle by the loughside, whence it returns to a formal garden lined with busts of the Roman emperors in the Tuscan Renaissance style. The present garden (still in an excellent state) was begun by H. P. McIlhenny in 1937. P.B.

Gloriet, in French *gloriette*; derived from Spanish *glorieta*, the literal translation of Arabic *al-'azīz* (glorious), in the specific sense of a country palace or pavilion in a paradise or walled pleasure-garden. In Spanish the word came to mean any summer-house, bower, or arbour, the open space at the centre of a garden where such a pavilion might be placed; and hence a circus where walks or avenues meet. For the medieval development of the gloriet, see *pleasance.

 J.H.H.

Gloriette, a feature constructed on the crown of a hill to form a focal point in the landscape. Perhaps the most famous example is in the grounds of *Schönbrunn Palace on the outskirts of Vienna. This baroque fantasy in stone is the culminating point in the complex landscape of avenues and canals. G.W.B.

See CZECHOSLOVAKIA: THE BAROQUE PERIOD; ŁAŃCUT; MUSKAU.

Glorup, Fyn, Denmark, is an 18th-c. country house with a deep mansard roof of glazed tiles, set round a courtyard; it adjoins a classic example of evolution in garden design over a period of 400 years, parts of which are all visible. This is one of the finest baroque gardens in the country, conceived on a grand scale, which with the passage of time has gradually changed into a romantic garden. The house is axially sited west–east and dictates the width of the garden; two parallel *allées* of limes 0·8 km. long form the sides of a large rectangle with the horizon forming the end. Immediately south of the house is the old parterre garden, which adjoins a 200-m. long mirror basin at the end of which is another parterre designed by H. A. *Flindt, now annually planted out with more than 100,000 flowering plants for visitors. The western *allée* leads from the entrance forecourt to a gate, beyond which it becomes a track; the eastern *allée* terminates at a circular temple with a statue of Andromeda by Johannes Wiedewelt. Elsewhere the grounds are informal in the English parkland style, with the remains of a neo-Gothic suspension bridge across a wooded ravine, built in 1867. P.R.J.

Goethe, Johann Wolfgang von (1749–1832), German poet, novelist, and dramatist. *Die Leiden des jungen Werthers* ('The Sorrows of Young Werther') (1774) was, like *Rousseau's *Julie ou la Nouvelle Héloïse* (1761), very influential in the development of the romantic movement, but Goethe's influence on garden design is perhaps less direct. He was very involved with his own garden around his Garden House at Weimar, (begun 1776), the woods being planted according to his own plans. Surprisingly it was not a literary garden in the manner of *Ermenonville or The *Leasowes, and contained only one inscription and one monument—

the Altar of Good Fortune. This was a plain stone cube, of about 1 m. sides, which supported an equally plain stone sphere. He also contributed to the plant collections at *Belvedere, Weimar.

His interest in garden art was further stimulated by his visit to *Wörlitz (spring 1778, before some of its more spectacular effects were completed) and by the writings of *Hirschfeld. Although he later wrote satirically of the large numbers of garden buildings at Wörlitz he valued its Elysian mood. His interest in garden planning is still manifest in his novel *Die Wahlverwandtschaften* ('Elective Affinities') (1809). P.G.

Goldsmith, Oliver (1730–74), English writer, was a friend of William *Chambers whose ideas on oriental gardening he took up in his *The Citizen of the World* essays (1762). He supported Chambers in the controversy with William *Mason on Brownian landscape gardening. While Chambers condemned Brown on artistic grounds, Goldsmith, in his long poem *The Deserted Village* (1770), deplored the social aspects of improvement which involved removing villages from landscaped parks, such as at Nuneham Park. In 'Threnodia Augustalis' (1772) he praised Chambers's work at Kew and the 'clemency' of Augusta's gardening. The neighbouring village of West Sheen had been removed by *Brown in the landscaping of Richmond Park. M.L.B.

Gong Wang Fu, China, situated in the western part of Beijing, has been a residential site since the middle of the 17th c. Around 1851 the Qing Emperor Xian Feng gave it to his younger brother Yi Xin, and it became a minor palace with a garden added behind. The mansion, elaborately ornamented, consisted of three lines of courtyards which were joined at the back by a 160-m. long, two-storied building of 40 bays. Lying behind this, the garden was composed as a 'mountain-water' landscape, with tree-covered hills, mounds, and rockeries set among winding brooks. The eastern part of the garden was enclosed by short walls and shaded by green bamboos. North of this a sheltered stage stood in front of a hall, planned in the shape of a bat, in which the audience was seated during performances, while to the west were various different scenes, including 'Elm Pass', 'Green Shade Mount', and the 'Mid-lake Pavilion'. The monumental and luxurious style of this mansion and the freedom and elegance of its garden support the belief that they were the hidden models for the Rong Mansion and Da Guan Yuan described in the classic novel *Hong Lou Meng* ('A Dream of Red Mansions').

 C.-Z.C./M.K.

Gonzaga, Pietro (1751–1831), Italian painter and landscape designer, trained as a painter and as a stage-designer in his native country and worked with great distinction in major Italian theatres and, from 1792, in the imperial theatres of St Petersburg (Leningrad) and Moscow. His many surviving stage designs testify to his skill as a perspective painter which was also evident in his work as a decorator at *Pavlovsk and later as a landscape designer there.

He transformed the former parade-ground of Paul I into a landscape of meadows, water, and wooded islands with particularly striking tree combinations. Even more interesting is his work in the area known as the White Birches (273 ha.), where he took the scenery of northern Russia as his model, creating a landscape of meadow and forest, using birch, pine, and other native species. He used clumps of trees like side-screens in stage scenery and was able to achieve a remarkable feeling of depth in his landscapes.

In his treatise, *La Musique des yeux* (1807), he saw landscape design in terms of musical composition. The landscape designer's task was to evaluate and rearrange the objects indiscriminately scattered by nature in the same way that a composer arranges sounds. He analysed the different characters of trees—gay or sad, graceful or majestic—and sought to exploit these characters in the way he grouped them. P.H.

Goose-foot. See PATTE D'OIE.

Gordon, James (1708?–80), British nurseryman, was gardener to Lord Petre at *Thorndon Hall in Essex until his employer's death in 1742, when Gordon started a nursery garden in Mile End. His skill gained him a great reputation and praise from leading botanists of the period, including Peter *Collinson, who said in 1764: 'Before him, I never knew or heard of any man that could raise the dusty seeds of kalmia's, rhododendrons, or azalea's. These charming hardy shrubs, that excel all others in his care, he furnishes to every curious garden; all the nurserymen and gardeners come to him for them.' North American plants, some of them sent by *Bartram to Collinson, were among his specialities. His botanical knowledge was great enough to allow him to correspond with *Linnaeus, to whom he also sent plants. Among the difficult subjects he managed to propagate was the Chinese maidenhair tree, *Ginkgo biloba*, for he sold an example to *Kew, where it still grows, in 1754. *Gardenia jasminoides*, 'a rare double jessamine from the Cape', was another plant he grew from cuttings when others had failed in the attempt.

After his death the nursery was carried on by his sons James and William, and later by members of the Thomson family, until the middle years of the 19th c. S.R.

Gorneşti, Romania. See GERNYESZEG.

Government House, Perth, Western Australia, has gardens which are one of the examples—rare in its State— of the English school of informal landscape design. Situated in the main boulevard of the city, with panoramic views of the lake-like expanse of the Swan River, the 4 ha. of Government domain have been created over the past 150 years, but were not designed by any one person. Each Governor and his lady have added something of beauty. A copse of fine, mature oaks and pine trees is believed to have been planted by the first Governor, Sir James Stirling (1829–38), and also an olive (*Olea europaea*) whose present

girth is 3 m. When the present Government House was being planned in Governor Kennedy's time (1855–62) the existing drive was laid out in *Hogarth's 'Line of Beauty', i.e. in an elongated S-shape, with the graceful curves adding a pleasing element of surprise.

Lawns wander informally down the slopes, with wide, terrace-like paths giving access to lower levels. Trees and shrubs are arranged informally, and annual flowers are confined to borders along the drive, in some shrubberies, and in garden urns around the terraces and steps. The only formality is a large rose-garden on the lower level, where beds were laid out in the 1950s in arabesques of the Renaissance tradition. Elsewhere the sweeping lawns impart a peaceful unity that is not disturbed by the clutter of geometric flower-beds. The great trees are allowed to grow naturally, with all the variety of their individual form.
 R.O./J.O.

Granada, Spain. See ALHAMBRA; GENERALIFE.

Grand Trianon, Versailles, France. See VERSAILLES: THE GRAND TRIANON.

Grasses. The grass family (Gramineae) includes the *bamboos as well as over 15,000 herbaceous species. Some of these are of paramount importance as food plants, such as wheat, barley, rye, oats, maize, millet, rice, and sugar-cane. Few of these are grown as decorative plants although multicoloured-cob forms of maize are popular elements in the bedding displays of municipal seaside parks.

Several grasses (e.g. *Ammophila arenaria* or marram grass) with vigorous creeping stems are used to stabilize sandy soils and these, together with many others, are the major constituents of lawns. Grasses are found in almost every habitat but their use in gardens tends to be either in *herbaceous borders as contrasting elements, or in water-gardens, both in the water itself and in the surrounding marshy margins. Moorland grasses can be planted in heather gardens. The ornamental grasses usually grown are either variously variegated or otherwise unusually coloured species, particularly those with graceful flower spikes. These spikes often remain on the plant throughout the winter until displaced by the new season's growth.

The pampas grass (*Cortaderia selloana*) from South America is hardy throughout most of Europe and North America and its large tufts of saw-edged leaves bear heavy plumes of beige-white inflorescences up to 3 m. high. More useful as a hedge-like divider is the Japanese sugar-cane (*Miscanthus sacchariflorus*) which thrives in wet soils, as does *Phalaris arundinacea*, the ribbon-grass or gardener's garters. Among the lower-growing species are forms of the wood-millet (*Milium effusum* 'Golden Grass'), sheep's fescue (*Festuca ovina* 'Glauca'), and Job's tears (*Coix lacryma-jobi*). P.F.H.

See also LAWN.

Graves, Richard (1715–1804), English minor poet and novelist, is most remembered as the author of *Columella, the*

Distressed Anchoret (1776). He was a close friend of William *Shenstone and was his contemporary at Pembroke College, Oxford. At his rectory at Claverton, near Bath, he designed his own gardens in the landscape style. The gardens were well known to 'frequenters of Bath'. P.E.

Gravetye Manor, West Sussex, England, was enlarged by later purchases after the nucleus of the estate had been bought by William *Robinson in 1885. Its greater part (covering 440 ha. in all) is woodland, bequeathed to the Forestry Commission in 1935. In the garden round the house the sloping site was terraced, views of the valley were framed in trees, an alpine meadow of naturalized bulbs was planted on the south side of the house, and a flower garden, with a tank of water lilies, on the west. Many flowering shrubs, some native, were settled on the eastern side, and a wilder part of the garden held pines and cypresses mixed with deciduous trees and rhododendrons. Trees were planted on a vast scale: willows, maples, pines, oaks, and many North American species. Magnolias, tea roses, violas or tufted pansies, and massed daffodils and small tulips were other favourite plants, with alpines sometimes used as ground cover. After Robinson's death the garden suffered periods of neglect, but restoration began in 1958. The surviving original planting has been rescued, the lake restored, the main features of the design rediscovered, and appropriate plants used to refurnish the garden. S.R.

See also WILD GARDEN.

Gray, Christopher (1694–1764), had a nursery garden in Fulham, London, near the western end of what is now the New King's Road. He was particularly well known for his collection of North American plants, and his catalogue of *c.*1737 included an engraving of *Magnolia grandiflora* by Mark *Catesby, drawn from a plant that flowered in that year in Sir Charles Wager's garden in Parson's Green. A later catalogue, dated 1755, listed 'a greater variety of trees, shrubs, plants, and flowers, . . . than perhaps can be found in any other garden, for sale, not only in England, but also in any part of Europe'. Many of his American plants, especially trees, came from Catesby or *Collinson.

Later owners of the nursery included the Burchell family and Messrs Whitley and Osborne, who maintained its reputation for American trees and shrubs well into the 19th c. S.R.

Great Dixter, East Sussex, England, an important 15th-c. manor house, was repaired and enlarged in 1910 by *Lutyens for Nathaniel *Lloyd, an unusually knowledgeable client who seems to have worked closely with Lutyens and Gertrude *Jekyll. He himself planted and trained the remarkable topiary garden, one of a number of compartments informally connected by flagged paths and bordered by carefully planned and luxuriant planting. North-west of the entrance is a sunken garden and formal lily pool, backed by farm buildings which Lutyens, in the tradition of Philip Webb, ingeniously integrated within the layout. The southern terrace, approached from the house by a wide flight of steps, borders the rough-mown orchard; along it for over 100 m. runs a flagstone path flanking the great herbaceous border. From this level, semicircular steps descend to the orchard by 'satellite' circular flights with turfed centres—a typical Lutyens 'conceit'. Great Dixter is now owned by Nathaniel Lloyd's son, Christopher Lloyd.

I.L.P.

Greece, Ancient. Physical evidence of gardening in ancient Greece dates only from the 4th c. BC. Earlier writers portray Greek attitudes ranging from lyrical appreciation of nature (as in *Homer, 8th c. BC) to pragmatic cultivation of crops (as in Hesiod's *Works and Days*, early 7th c. BC). In 408 BC the Spartan king Lysander, visiting Cyrus the younger at Sardis, was shocked to learn that his Persian host worked in the ornamental palace garden himself (Xenophon, *Oeconomicus*, 4.21). No Greek gentleman performed manual labour, certainly not in the pastime of gardening, since except in war or athletics physical labour was considered degrading.

Plants like the rose (*Rosa canina* and *R. centifolia*) were cultivated from archaic times—but most scented plants and herbs (e.g. iris, lavender, basil) were grown to produce perfume, medicine, or wreaths for sale. 5th-c. travellers returned from Persia (Iran) with specimens (e.g. peach, marjoram) and descriptions of *paradeisoi* (Persian *pairidaëza*)—royal parks with formal plantings, fields, and groves stocked with exotic game. 4th-c. writers (Aristophanes, Demosthenes) allude to small, domestic gardens (*kēpoi*) annexed to town houses; these probably held fruit-trees. In a house at Clynthus (destroyed 348 BC) an ornamental flowerpot was found.

Shrines to certain gods were set in gardens, such as the famous sanctuary of Aphrodite in the gardens outside Athens (Pliny, *Naturalis Historia*, 36.16); the gardens of Zeus and Aphrodite at Cyrene (Pindar, *Pythian Odes*, 9.55 and 5.22); and the shrine of Aphrodite at Cnidos. Adonis, associated with fertility and rebirth, was worshipped in special gardens, and Athenian women planted little 'Gardens of Adonis'—lettuce and fennel—in broken jars to be offered at springs in honour of his harvest/death.

The sacred grove (*alsos*) associated with many sanctuaries contained shade- or fruit-trees, often species symbolic of the god (e.g. bay for Apollo at Daphni). The grove included meadows, stands of timber, fields for commercial cultivation, and hills for picnicking and hunting, rather like a medieval monastery (such as the grove dedicated to Artemis by Xenophon, *Anabasis*, 3.5.7–13).

The only formal garden yet excavated belonged to the so-called Temple of Hephaistos in the Athenian Agora. On the slopes surrounding three sides of a Doric temple of the 5th c. BC were two main rows of shrubs or small trees aligned with the building's columns and separated by narrow, unpaved walks. The pattern was completed with small beds of flowering plants and (possibly) ivy or grape-vines grown against the stone precinct wall. The installation of the garden (*c.*300 BC) required an aqueduct and used square pits cut 3 Greek feet (*c.*88 cm.) into bedrock (which was

covered with only centimetres of soil). In the pits, set in ash-earth, were simple, conical flowerpots with large drainage holes. These had been deliberately shattered, recalling the practice of 'layering by circumposition' described by *Cato (*De agri cultura*, 52 and 133) and *Pliny the elder (*Naturalis Historia*, 17.97.1): a clay pot filled with earth is fastened around a branch which is cut off one or two years later, after roots have formed. This was used for plane, olive, and fruit-trees, bay, myrtle, and vines. Replacement pots in the Hephaistelon pits suggest its limited success. Studies of carbonized remains were inconclusive; the plantings were probably myrtle and/or pomegranate. (These have been restored at the site.) The garden died of neglect in the late 1st c. AD with the demise of its watering system. Its pattern of straight rows of small trees, shrubs, and flowers adhering strictly to an architectural nucleus was probably typical of classical sanctuaries. Pausanias described many as being shaded by rows of cypress, plane, or laurel trees.

Shade-trees were often planted in markets, gymnasia, and meeting-places such as Plato's Academy and the Lyceum of Aristotle and *Theophrastus (*c.*370–286 BC), whose 'peripatetic school' derived from its *peripatos* or shaded pathway. The philosopher Epicurus (341–271 BC) bequeathed his formal gardens to the city of Athens as a public park.

Greeks under Alexander camped in the *paradeisoi* of Persia (*Athenaeus*, 12.537, *Q. Curtius*, 7.2.22, 8.1.11) and Hellenistic aristocrats copied oriental pleasure-gardens. Thebes, Kleonal, Sikyon, Alexandria, and many colonies in Italy and Sicily boasted lush public parks with artificial grottoes and fountains (*nymphaea*). Such a park outside the city of Rhodes had rock-cut steps, benches, and grottoes creating a 'romantic landscape'. In the 3rd c. BC Hieron II of Syracuse had a *peripatos* of white ivy and grape-vines grown in huge pots, and flower-beds—on the deck of his flagship. Attalos III of Pergamon (170–133 BC) did his own gardening—but grew only drugs and poisons. The private Hellenistic garden had a *peripatos* wide enough for a litter to pass, with side-lanes framed by trees and flower-beds. Florid sculptures of Erotes, nymphs, satyrs, and bathing Aphrodites adorned fountains and niches. Cemetery plots, long planted with acanthus and asphodel, grew into *kēpotaphia* (funerary gardens) with stands of cypress, poplar, or willow, stone walls, wells, and even dining pavilions.

As gardening became fashionable, numerous treatises (*kēpourika*, Pliny, *Naturalis Historia*, Book 9, introd.) appeared describing famous gardens and parks. Some are preserved in the *Geoponica*, a compilation of excerpts from agricultural treatises (see *Byzantium: Sources). Theophrastus produced the first botanical books extant, the *Enquiry into Plants* and the *Aetiology of Plants*, which discuss classification and physiology. Favourite species were small fruit and nut trees, bay, myrtle, ivy, roses, lilies, violets, iris, crocus, hyacinth, narcissus, dianthus, daisy, marjoram, rosemary, sage, thyme, mint, basil, and mustard, all of which would be adopted by the Romans. J.M.T.

Greece, Modern. Greece is one of the countries of Europe with the richest flora. The topography is varied and the climate is mild and well suited to outdoor life. The ancient inhabitants showed a talent for siting their temples and cities with sensitivity in places of great landscape beauty, which perhaps accounts for the fact that no great public or private gardens have been created (see Ancient *Greece).

Monastic gardens were made during the Byzantine (see *Byzantium) and post-Byzantine periods. They were paved courtyard gardens with a well or drinking fountain which was often the central feature. Plants were grown in pots or in small beds. The land adjacent to the monasteries was frequently terraced and planted with vegetables, vines, olives, and fruit-trees.

With the establishment of the modern Greek state after 1821 came the development of towns and cities. These incorporated small parks and squares in the formal manner, with geometric parterres, avenues of trees, and broad walks well suited to the neo-classical style of the architecture which prevailed until the beginning of the 20th c. The most important garden was the royal garden, which is one of the largest open spaces in Athens today.

Between 1914 and 1930 the English landscape architect and planner Thomas *Mawson was invited by King Constantine to make designs for the royal gardens, and by the Greek government to design parks for Athens, Salonika, and Corfu. But none of these was implemented. Mawson was however responsible for the planting around the Acropolis, the Phillopapos Hill, and Lycabettos. Since then the area of the Acropolis has been the subject of a number of restorations, notably that of the Professor of Architecture, D. Pikionis, in 1958, using local materials—particularly paving—in a highly imaginative way. Later additions to his work, made by the Ministry of Public Works, are of a different character; they have been poorly maintained and the haphazard replacement of the plants has destroyed the unity of the design.

The use of local materials was promoted also by the landscape architects Robert and Marina Adams, who practised in Greece from 1965 to 1982. Their work included a regional landscape planning study for Greater Athens and the Delphi region, a scheme for the Eleusis archaeological site, and a number of private gardens. They exerted an important influence on their clients in stressing the value of the *genius loci*, using the local resources of rock, stone, and native plants to create gardens which integrate well with the Greek landscape. This is well illustrated by their project for a 10-ha. estate at Porto-Rasti designed between 1969 and 1979 (*see over*).

Among other significant private projects are the gardens for the Astir Beach Hotels in Glyphada and Vouliagmeni by Spiros and George Anagnostopoulos, architects and landscape architects. The landscape design is well structured with an effective path system with finely detailed steps, ramps, and pergolas. The planting is simple and well suited to the limited gardening skills available.

The greatest interest for garden-lovers in Greece remains the wild landscape, but it is increasingly threatened by new development. M.A.

Estate Garden (1969–79) at
Porto-Rasti, Attica, Greece,
by Robert and Marina Adams

Greenhouse, used today principally to grow, propagate, and display useful and decorative plants. But in its beginnings in Britain in the late 16th c. it was used only for the overwintering of tender greens, hence 'greenhouse'. The name, which was then used synonymously with 'conservatory' (to conserve greens), is attributed to John *Evelyn.

Gardeners required greenhouses because they wished to have more greenery around them in what were then mostly barren winters, so they bought from abroad bays, oleanders, myrtles, oranges, aloes, and variegated hollies which would stand out in tubs during the summer and be brought indoors for the winter. After early experiments with wood, those early greenhouses were made mainly of brick or stone, with opaque roofs, less glass than masonry and woodwork, and heated, at first, by primitive smoke flues or indoor enclosed stoves.

The 18th-c. influx of plants from many parts of the world gave both the amateur gardeners and the early botanists every encouragement to find the most efficient greenhouse to protect their hard-won, much travelled tender exotics from the vagaries of British weather both in winter and in summer. So it was by experiment that glass roofs became standard, correct angles for roofing were determined, and the efficiency of span, lean-to, and curvilinear roofed houses were worked out; heating by hot air, steam, and hot water all had their protagonists while ventilation came to be realized as an important and integral part of any greenhouse.

The growth of a skilful professional gardening class in the 19th c. led to the construction of vast areas of glass in the walled gardens of the noble houses for the growing of exotic flowers, palms, orchids, early fruit, and the propagation each year of thousands of plants for Victorian bedding-out (see *bed, bedding). K.LE.

Green theatre. See THEATRE.

Greenwich Park, London. The most interesting part of the 17th-c. design of the grounds here lay between the house built by Inigo *Jones for Charles I's queen, Henrietta Maria (1609–69), and the steep hill, with its grotto by Webb, leading up to Blackheath. This was a formal *parterre of arabesques in dwarf box, enlivened by three fountains; the whole encompassed on three sides by a terrace in the shape of a broken architrave, whose outline may still be traced today, although the parterre itself does not appear to have been implemented. The original design, much annotated in *Le Nôtre's hand, was discovered in Paris by the late Comte Ernest de Ganay. John *Evelyn records that in 1664 Charles II ordered avenues of elms to be planted on the upper (Blackheath) plateau. As contemporary prints show, the three avenues radiated from a double semicircle of elms, to form a gigantic *patte d'oie: a design recommended by Le Nôtre's master, Claude *Mollet, and one to be put into practice in France and England by his three sons; in particular by André Mollet, Charles II's gardener immediately after his restoration in 1660. D.B.G.

This grandest of English classical parks has suffered the fate of many historic landscapes in being allowed to deteriorate through public usage. A recent report by the then standing committee on the Royal Parks recommended that the giant green steps should be restored to their intended crispness, the 'desire lines' of the public cross paths made inconspicuous, and a plan prepared for replanting the avenue trees that were reaching maturity G.A.J.

See also HAMPTON COURT PALACE.

Greiz, Gera, German Democratic Republic. The park covers an area of 36 ha. in a wide valley at the foot of the

cone-shaped Schlossberg, and is partly bounded by the Weisse Elster.

At the beginning of the 18th c. a regular pleasure-garden was created between the buildings of the Schlossberg and the Weisse Elster; a horseshoe-shaped summer residence was built there between 1717 and 1724. Two diagonal paths cross the parterre in front of the Schloss; a central avenue divides the rest of the garden and leads to the *bosquets*; at the side is a small maze. A new summer palace was built between 1779 and 1789 and the garden was extended in regular forms. From 1790 a narrow landscape garden was created along the river. Flooding caused extensive damage in 1799; restoration work was slow and undertaken only in 1827–9 by Captain Riedl of Laxenburg.

In 1872, after hard bargaining, a railway was built on the edge of the park and this led to a rearrangement of the grounds. *Petzold drew up two plans in 1873, one of which gives technical specifications; his pupil Rudolph Reinecken (1846–1928) from *Muskau executed the plan. Various problems made it impossible to carry out Petzold's ideas in their original form: lack of funds made it necessary to preserve a section of the existing *allées*; Petzold's planned system of vistas could not be realized because the original plantations were not altered; the large reed lake with its unstable banks and islands could not be created completely as planned, and frequent flooding made it impossible to integrate the 'New World' area into the park grounds. The reconstruction work was not finished until 1885.

In 1959 a rose-garden was created near the reed lake; like the famous flower clock by the nursery, this rose-garden is much appreciated by flower lovers. H.GÜ.

Grille, a railing, fence, or gate of vertical iron rods, often elaborately wrought. *Grille d'eau*, a series of vertical jets resembling a *grille* as at *Vaux-le-Vicomte. D.A.L.

Grimston Park, North Yorkshire, England, was one of W. A. *Nesfield's most famous gardens, although not representative of his usual style. The house was remodelled in 1840 by Decimus Burton, with whom he was to work at *Kew; Nesfield designed an Italianate garden, based on a terrace walk 120 m. long, an informal garden planted with conifers and ground covers, and an 'Emperor's Walk', lined by busts of the 12 Caesars. This walk was largely devoid of horticultural dressings, and elsewhere the beds were edged with stone instead of Nesfield's customary box. In the 1920s the sculptures were sold, and the garden was gradually abandoned to its current state of dereliction. B.E.

Groen, Jan van der (*fl. c.*1669), Dutch gardener. See VAN DER GROEN.

Groote Schuur. Cape Town, South Africa. See SOUTH AFRICA.

Grosser Garten, Dresden, German Democratic Republic, is a park, extending at the present time to over 141 ha., which grew from a pheasantry. Between 1676 and 1687 further land was purchased for a garden, for which the first plan, of which only parts were executed, was by M. Göttler. The magnificent Schloss was built between 1678 and 1693 to plans by J. G. Starcke. Subsequent planning of the frequent extensions (especially those of 1679, 1683, and 1685) were undertaken by J. F. Karcher. In 1683 the lateral Herkules-Allee and Süd-Allee were laid out; in 1684 the Kavalierhäuser. Work was halted at the end of the 17th c.

From 1715 under King August the Strong a second building phase began, in which M. D. Pöppelmann also played an influential part. In August's reign the garden consisted of the long central section with three avenues, each with two lateral *bosquets*, which were divided by star-shaped *allées* converging on a central *bassin*; they were used for hunting.

In the middle of the central section stood the Schloss; a long pond was built along its axis in 1715, and in 1719 a wooden Temple of Venus was built as its termination. The Orangery was built in front of the Schloss between yew pyramids. The rectangular open area between the pond and the Orangery was taken up by eight pavilions (six of which are preserved) connected by terraces. The ornamental parterre was divided into two semicircles by each wing of the Schloss. In the area beyond the ornamental parterre were a carousel ground and a shooting range, an orange garden, a plaza enclosed by *treillage* with a sunken fountain, and an open-air theatre. To both east and west lay six *bosquets*, with star-shaped *allées* and *bassin*, which also served as a pheasantry.

Fifteen hundred statues, many of antique subjects, stood in the park. As a result of subsequent destruction statues from other parks were moved to the Grosser Garten, among them the famous groups *Time steals away Beauty* by P. Balestra and *Time reveals Truth* by A. Corradini. The valuable vase by Corradini, *Psyche*, with the relief *Women before Darius*, was severely damaged in 1945 but restored in 1977.

In 1760 in the Seven Years War and again in 1813 extensive damage was done to the park which resulted, at the beginning of the 19th c., in its being redesigned in the landscape style. In 1861 13 ha. of the park were separated off to accommodate the newly founded Zoological Garden.

In 1873 Karl F. Bouché (1850–1933) took over supervision of the garden and redesigned the *bosquets* with the shelters for the pheasants and the other areas of the park, with the exception of the area immediately around the Schloss and the main avenues, into a landscape garden. Between 1881 and 1886 he created the Carolasee from a gravel-pit and a few years later the Neuteich in the eastern part of the park. The Grosser Garten and the Schloss were destroyed by bombing raids in 1945 during the Second World War, but the Schloss was partly rebuilt and the garden has been restored from 1950 as a socialist People's and Cultural Park. The original garden has been enlivened by the addition of many new trees, flower-gardens, children's playgrounds and sports grounds, a Pioneer railway, and an open-air theatre (1954–7). H.GÜ.

Grosssedlitz, Dresden, German Democratic Republic. In 1719 Count Wackerbarth purchased the estate and village of Grosssedlitz where he created a 27-ha. baroque garden of great artistic merit, extending down a valley 350 m. × c.15 m.

The first plan (1719) was conceived by M. D. Pöppelmann and J. C. Knöffel and was half realized. The Schloss was completed in 1720. In 1723 the property passed to King August the Strong of Saxony who wanted to make both the garden and the buildings more extensive. Z. Lonquelune was called in to help with this second planning stage: he was to demolish the Schloss and Orangery to make room for a much larger castle, but the original buildings were still standing at the time of August's death in 1733. The garden had been enriched by Lonquelune's addition of the lower Orangery (demolished in 1861–4 and rebuilt to a slightly different design) and the Stille Musik, a fountain and pond with statues (by Pöppelmann) situated between two flights of steps. A third planning stage from 1732 shows the garden virtually in its present form, which represents a compromise between the preceding plans.

The Schloss suffered severe damage in 1813, was demolished in 1871, and only the eastern wing rebuilt in 1872–4. This has meant that the contours of the grounds are no longer so clearly defined, especially as the gardens could be restored to approximately only half the extent which they had in the first two plans.

At the side of the wing of the Schloss a large parterre with lawns and ponds extends along the axis to the Orangery situated on the hill; to the south of the parterre in the valley lies the Eisbassin, a water parterre, which takes its name from the icicle-like rustication on the fountains and cascades. A cascade tumbles down the opposite side of the valley through thick plantations of trees. Statuary stands in the open area between the Eisbassin and the cascade pool.

East of the parterres in front of the Orangery lies a rectangular lawn parterre, framed on its long sides by clipped trees; an axis extending from the Schloss, and emphasized by two sphinxes, leads along its short side over a ha-ha into the surrounding countryside. In 1960 the steps leading from the north into the lawn parterre were transformed into the main entrance to the grounds by the addition of the portal flanked by fountains brought from the Landhaus in Dresden. The difference in height to the floor of the valley is taken up by the lower Orangery which is built into the valley-side; in front of it lies the square Orange parterre with rounded corners. Narrow canals with water-candles flow down the length of the parterre, the upper end of which is terminated by hornbeams cut in the shape of columns. The Stille Musik fountain forms the transition to the woods which extend up the hillside; like the cascade, the fountain is enclosed by clipped hedges.

A thorough reconstruction of the garden to plans by H. Schüttauf was completed in 1939. H.GÜ.

Grotto. The primary distinction is between a natural covered opening in the earth and an artificial recess made to resemble a natural grotto; hence, art imitating and surpass-ing nature is a constant leitmotiv. There are two main types of artificial grotto: the rustic grotto in imitation of a cave and the architectural *nymphaeum. The grotto is also associated with ornamental styles: in the 16th c. with *grottesca*, a fantastic décor based on capricious human, animal, and floral forms found in excavations of underground vaults of ancient buildings; in the 18th c. with the rococo, derived from 'the shellwork in the shape of Satyrs and other wild fancies' (John *Evelyn, *Diary* entry for 1644) in the rocaille grotto of *Rueil for Cardinal Richelieu (1638).

As a feature of landscape and garden, the grotto is frequently cited in classical sources. Early references include Plato's allegory comparing the passage of life to a sojourn in a cave (*Republic*, ll. 514 ff.). Examples from antiquity include Cretan grottoes as sites of mysteries, sanctuaries such as Eleusis where enlightenment might be experienced, and grottoes in the Holy Land connected with Christian miracles. The transformation, incorporation, and revival of this motif is especially marked in the Renaissance in pastoral poetry and in the gardens of royalty and humanist prelates. Thus the grotto is recommended by *Alberti, who recalls that 'the ancients used to dress the walls of their grottoes and caverns with all manner of rough work, with little chips of pumice . . .; and some I have known daub them over with green wax, in imitation of the mossy Slime which we always see in moist grottoes' (*De re aedificatoria* (1485), 9.4). This advice was followed in the grottoes of mid-16th-c. gardens dominated by the cult of the artificial—the *Boboli (1556–93), Villa *d'Este (1565–72), and Villa *Lante (1568–87). The taste for the rustic, more fantastic elements is captured by Montaigne in his account of the grotto in the *Medici villa at Castello (begun 1546). 'All sorts of animals, copied to the life, spouting out by the water of these fountains, some by the beak, others by the wing, some by the nail or the ears, or the nostrils', while Vasari focused on the site and the water system (*Vite*, 1568). In 1543 the aesthetic of Raphael and Giovanni da Udine at the Villa *Madama (c.1516), and Giulio Romano at the Palazzo del *Tè (1530) is transported to the Grotte des Pins at *Fontainebleau. Architectonic forms govern such grottoes as that of *Meudon (1552–60) dedicated 'To the Muses of Henri II', the *Bastie d'Urfé adjoining a chapel (c.1551), and the nymphaeum of the Villa *Giulia in Rome (1550–65).

In the mid-16th c., grottoes are ideal Mannerist conceits in works as diverse as the monsters at Bomarzo (1550–70) (see Villa *Orsini), and the decomposed herms and their reptilian hoards swarming over moss-covered faience in Palissy's designs for rustic grottoes for the Duc de Montmorency at Ecouen (1563), and Catherine de Medici at *Chenonceaux (1563) and the *Tuileries (1567–70). Rediscovering the *automata of antiquity, late Renaissance hydraulic engineers sought to reproduce the mechanical plays in elaborate garden tableaux, theatrical performances, court *divertissements*, ballets, and masques. Contemporaries praised the machines designed by Buontalenti at *Pratolino (1569–89): 'There is a marvel of a grotto with many niches and rooms; this part exceeds anything we ever saw

elsewhere ... By a single movement the whole grotto is filled with water ... and if you fly from the grotto and run up the castle stairs ... he may let loose a thousand jets of water from every two steps of that staircase, which will drench you till you reach the top of the house' (Montaigne, *Journal*, mid-Nov. 1580).

Pratolino was the immediate predecessor of the lavish water displays in the terraced grottoes of *Saint-Germain-en-Laye built by the *Francini for Henri IV (1599–1610). *Evelyn praised the 'subterranean grots and rocks, where are represented several objects in the manner of scenes and other motions, by force of water ... Orpheus with his music ... Neptune sounding his trumpet' (*Diary* entry for 1644)— all allegories celebrating the king. These marvellous mechanical water devices derived from *Hero appear as demonstrations in Salomon de *Caus's *Les Raisons des forces mouvantes* (1624), and in the *Hortus Palatinus* (1620), depicting the gardens he designed for Friedrich V in Heidelberg. Practical aspects of 17th-c. science are encapsulated by Francis Bacon's secretary Thomas *Bushell in the *'Enstone Marvels' (1628–35), a reconstruction of de Caus's ingenious ball rising and falling on a jet stream. The aim was to elicit wonder; hence the grotto's most appropriate ambience became the theatre. Precedents included *Serlio's design for the Vitruvian satyric set (*Architettura* (1547), 5.6.8) and the masques of Inigo *Jones, where a cave's opening might simulate a proscenium arch. The Grotte de Thetis at Versailles (1664–72), is the supreme example of the grotto-nymphaeum; once a reservoir, it was within this triple arcaded structure that 'the King goes ... to take rest from his great works [so that he can] return with the same ardour as the Sun who begins again to light the world'. Behind the triumphal arch were niches resplendent with nymphs and tritons attending Apollo, and hydraulic machines which set in play 'an infinity of small crystal globes, among a confused mass of drips and atoms of water that seem to move in this place as the atoms of light which one discovers in the rays of the Sun' (André Félibien, *Description...*, 1676). The transference of Girardon's white marble sculpture to Hubert *Robert's romantic cavernous mount (1778–81) marks a new era in garden design.

While the vogue for the garden grotto was diminishing in Italy and France, it found a sympathetic response in the 18th-c. English landscape garden (see Thomas Wright, *Arbours and Grottos*, 1755–8). In 1711 *Shaftesbury showed a distinct preference for 'the rude Rocks, the mossy Caverns, the irregular unwrought Grottos' to the earlier formal gardens. As a 'natural' feature amidst more artificial elements, the grotto was designed to stimulate the imagination, either as an accompaniment to a muse or as a place of contemplation. Both these aspects are incorporated in *Pope's grotto at Twickenham; in a letter to Blount in 1725 he tells of 'a luminous room, a *Camera obscura*; ... when a lamp ... is hung in the middle, a thousand pointed Rays glitter and are reflected over the place'. With its collection of petrified rocks and precious 'gems, minerals, spars, and oars' as described by John Searle, Pope's gardener, the grotto paralleled the exploration of natural caves, while the

grotto at *Stourhead (*c.*1748), was the goal of an allegorically strewn path. In the early 19th c. Richard Colt *Hoare described how 'the native stone, forming natural stalactites, and the "fresh water and seats in the living rock" [Virgil, *Aeneid*, 1. 164–6] compose the interior of this cavern; the *sombre* appearance of which is relieved by two figures very appropriately placed'—the languorous 'Nymph of the Grot' celebrated in Latin verse, translated by Pope, and the River God from whose urn the source of the Stour bursts and flows through the cave.

The enthusiasm for *Chinoiserie may have influenced the impressive grotto at *Painshill (1760s), and the grottoes around Wiltshire attributed to the *Lanes. In 1757 William *Chambers wrote of 'impending rocks, dark caverns and impetuous cataracts', of lake and river banks 'variegated in imitation of nature ... steep, rocky, and forming caverns, into which part of the waters discharge themselves ... When they [artificial rocks] are large they make in them caves and grottoes, with openings through which you discover distant prospects.'

In China itself, grottoes do not reflect man's control of nature, but an ability to explore its essence. Sometimes they are part of a complex of chasms, gulleys, and ravines that form a man-made mountain, such as the rockery in the 14th-c. garden of *Shi Zi Lin in Suzhou. Summer delights are enhanced too by associations with immortality, for a grotto may be accessible to the subterranean realms of the Hsein (the Immortals) and hence to heaven.

Nostalgia for the primeval, harking back to rude natural origins, appealed to the late 18th-c. revolutionary architects steeped in the severity of neo-classical geometry. Grotto-like forms abound in the work of Ledoux in the accretions of rock-salt congelations at the entry portal of Chaux (1775–9); in the intricate designs for palaces of water nymphs by Lequeu (1792); in the simple geometric models for grottoes published by Neufforge (1757–75); in the neo-classical nymphaeum at Châtou by Soufflot (1774); in the Queen's Dairy at *Rambouillet with the nymph emerging from cavernous rocks (1783–8); and in the grotto-triclinium for the Duc de Chartres at the *Parc Monceau (1780–93), where music from the upper chamber filtered down to the dining guests.

The motif was disseminated in Germany and Austria from the early 17th c. in the water-gardens evoking the classical past at *Wilhelmshöhe near Kassel. The architect Giovanni Guerniero in *Delineatio Montis* (Rome, 1705) explains how he gathered 'the waters in the corridors and subterranean channels ... directing their courses to the sea of [Karl von Hessen's] grace'. Grottoes moved indoors in the palaces of the Prince Bishop, Lothar Franz von Schönborn of Bamberg, where they formed a transition between house and garden (*sala terrena*) at Weissenstein (1726); other grottoes in his domain at the Favorite in Mainz and at Gaibach are known through Salomon Kleiner's engravings (1726). Grottoes assumed even more varied forms in the *Eremitage in Bayreuth (1745), the grotto-belvedere with tea-house at *Veitshöchheim (1772–3), and in the rock-theatre at *Sanspareil (1746–8). At

*Hellbrunn, de Caus's theorems come alive to pay homage to pagan gods in the bishop's palace of Salzburg (1613–19). New electrical power installations heightened the glories of nature in the Venus grotto at *Linderhof (1876–7); of cast-iron stalactites, this setting from *Tannhäuser* was Ludwig II's favoured retreat.

Late 19th- and 20th-c. grottoes survive in much altered forms: the crypt in the Parque Güell of Gaudi, Spain (c. 1900), the cave-like interior of J. Utzon's design for Berlin's Silkeborg museum (1965), F. Kiesler's plan for a Grotto of Meditation for New Harmony, Indiana (1964)— and more, the subterranean infrastructure of cities with recent underground building tied to the conservation of energy and the protection of the landscape, ranging from intricate transportation networks to shopping malls and walks replicating the world above. N.M.

See also CASTRIES; FOLIE SAINT-JAMES; MÉRÉVILLE; POM-BAL, PALACE OF; SHELL-WORK; WIDEVILLE.

Grove, a group of trees, usually of a single species, either growing naturally or planted in formation. It is probably the oldest of all garden features, for it dates back to the time of primitive man in the forest.

Tree cults arose from man's sensitivity to the growth and death of trees and thus their similarity to his own life. The idea of a tree as the 'eternal soul' existed in Egypt some 3,000 years ago. The Greeks adopted the mystical nature of a sacred grove, but also accepted it on intellectual grounds (see Ancient *Greece). The Platonic Academy was conduc-ted among formally planted olives, not merely because they provided the shade so essential in Mediterranean countries, but also because the planting rhythms stimulated thought and contemplation. The later Lyceum of Aristotle was peripatetic, based on teaching while walking among a grove of trees—perhaps the earliest recognized example of environment as a stimulus to thought.

The practical Romans developed the idea of the grove, sometimes making it multi-purpose: Augustus's sacred grove of Apollo on the Palatine, for instance, was a con-venient meeting-place for all. The grove retained its mysti-cism throughout the Middle Ages, and, as the *bosco* of the Italian Renaissance and the *bosquet* of *Le Nôtre, became an integral part of garden design. The idea of the grove appealed to the English poets: 'Groves whose rich trees wept odorous gums and balm' (Milton); 'Grove nods to grove' (Pope); 'And O, ye fountains, meadows, hills and groves' (Wordsworth). Today the garden grove still retains its mystery, no less for the adult than for the child. G.A.J.

Gulistan Palace, Tehran, Iran, the Palace of Roses, was built at the beginning of the 19th c. by the Qajar, Fath Ali Shah. It is located in central Tehran immediately north of the bazaar. Both traditional and recent features are to be found. A shallow tiled fountain pool reflects the carved front to the platform of a deep porch that overlooks the garden. Adjacent to the palace are courtyards, some paved in marble. The main garden, which acts as a city park, has further pools faced with blue faience, tall cypress and pine trees, and extensive grassed areas containing anemones, daffodils, carnations, and tulips. J.L.

Haddon Hall, Derbyshire, England, stands in the valley of the River Wye with 3.5 ha. of gardens set in parkland some 150 m. above sea level. The present gardens, forming a series of terraces on the south side of the late medieval house, were constructed in the 17th c. The original stone balustrade on the second terrace is exceptionally fine. The home of the family of the Dukes of Rutland since the late 16th c., Haddon Hall was seldom inhabited after 1701 and house and gardens, although maintained, were not kept up to date. In the early 20th c. a careful restoration produced an ensemble of house and garden set in fine countryside as romantic in appeal as any in the land. J.AN.

Hadfield, Miles (1903–82), was a leading English garden historian whose comprehensive *Gardening in Britain* (1960), a survey of gardens and gardening from Roman times to the 20th c., helped to foster an already growing interest in garden history. Hadfield was a founder member of the *Garden History Society and its President from 1971 to 1977. P.H.

Hadrian's Villa, Tivoli, Italy, an ensemble of monuments erected by the Emperor Hadrian between AD 118 and 138, at the foot of the hill of Tibur (Tivoli), on ground lying between two valleys, and facing south and west. There one finds the architectural and decorative elements traditionally characteristic of the villas of the High Empire, similar to those of *Pliny the younger, but treated with a magnificence worthy of an emperor. It is said that Hadrian, himself fascinated by architecture, aimed to reproduce the buildings and the sites which he had visited in the course of his travels—the Stoa Poikile of Athens, the Lyceum and the Academy near Athens, the Canopus (a branch of the Nile delta near Alexandria) (see Ancient *Egypt: Graeco-Roman period), along with the temple of Serapis, and the Vale of Tempe in Thessaly—and finally the infernal regions guarded by a statue of Cerberus. As Cicero's villa at Tusculum already had its Lyceum and its Academy, Hadrian's villa was not so much an innovation as a development of the previous tradition of the garden as an 'imaginary place'.

The villa's buildings were either open porticoes (like the Poikile) or closed peristyles like the Piazza d'Oro (so called because of the richness of its decorations) laid out in gardens, with fountains, *bassins*, or euripes. There were also 'promenades' in the form of a stadium (like Pliny's hippodrome), baths (two in number), a Greek theatre, libraries, an odeum, and apartments for guests, soldiers, and various services of the court. The pavilions and the open spaces as well as the villa were adorned by a considerable number of works of art: mosaics, paintings, reliefs, and statues—the latter corresponding to a definite purpose (such as a stone crocodile alongside the Canopus canal).

Having fallen into ruins, the villa was excavated on several occasions: by Pope Alexander VI (Roderigo Borgia) at the end of the 15th c., Cardinal Alexander Farnese (*c*.1535), Cardinal Carafa (*c*.1540), and especially by Pirro *Ligorio (between 1550 and 1560) for Cardinal Ippolito d'Este (see Villa *d'Este), who brought to light a great number of statues and reliefs. The pillage continued until the modern era, when systematic investigation revealed the principal monuments.

In its entirety, the villa stretches from north to south *c*.1,000 m. in length, its maximum width being 500 m. in the central part, between the western extremity of the Poikile and the Piazza d'Oro in the east. Almost at the geometric centre of the whole layout is the (misnamed) Maritime Theatre: 42.5 m. in diameter, it is surrounded by a portico consisting of 40 Ionic columns; a circular canal 4.8 m. wide and 1.5 m. deep surrounds an island, upon which there stands an atrium with four curved sides. The décor consisted of friezes representing creatures of the sea, Tritons and Nereids. It is not known what this pavilion was used for —perhaps for a summer triclinium or for a resting-place.

The undulations of the ground were utilized to establish terraces opening on to vast perspectives over the surrounding countryside, while most of the buildings are situated in the hollow of a fold of ground which protects them. This dual tendency (of opening and closing vistas) is characteristic of Roman gardens: intimacy and, conversely, domination of space. Since the middle of the 18th c., cypresses and pines have been planted on the site of the villa, which, together with the ruins existing above ground, form a typical 'Italian landscape', in a style dear to romantic artists.
 P.GR. (trans. P.G.)

Hafod (or Hafodychtryd), Dyfed, Wales, was inherited by Thomas Johnes in 1783, when he was 35. He had a vision of a smiling peasantry in a smiling country, each drawing strength from each other. The estate was in the valley of the River Ystwyth, where lush pastures were surrounded by bleak mountains. Johnes was a keen horticulturalist, and had John Nash build an extensive conservatory in 1793. He also shared many of the picturesque principles of his cousin, Richard Payne *Knight. By the time that George Cumberland wrote *An Attempt to describe Hafod* (1796) Johnes had laid out an extensive system of rides and walks to take advantage of the cascades on the mountain streams.

Between 1795 and 1801 he planted 2,065,000 trees, about half larch, on the mountains, thereby gaining the first three of the six gold medals awarded to him by the Society of Arts. James Edward Smith's *Tour to Hafod* (1810) included large aquatints of views taken by the artist John Smith in 1796.

Although Hafod gained a reputation as a paradise, Johnes's tenants did not meet his expectations, and rents could not be raised to recover outgoings. He died in financial difficulties in 1816. Few of Johnes's improvements survive. D.L.J.

Haft Tan, Shiraz, Iran. The garden of the Haft Tan (Seven Bodies) possibly dates from the late 18th c. It is located in the north-east part of the city of Shiraz at the foot of a hill, and covers an area of 0.2 ha. Behind its high walls at one end is a pavilion extending the full width of the garden, still containing traces of oil painting on plaster from the Zand period. The main floor level of this pavilion, which faces south, is a little higher than the level of its fronting terrace; at the level of this terrace, placed centrally, is a rectangular pool. Below the terrace is a garden which contains several graves, to which the name of the garden refers. J.L.

Haga, Stockholm, Sweden, is a royal park designed by F. M. *Piper *c*.1785. Together with the park of *Drottningholm it is the first in Sweden to show the English landscape garden in full development. King Gustavus III (1771–92), who had his favourite resort at this beautiful place on the coast of the Baltic, commissioned Piper, then just returned from England, to embellish it according to current taste.

Piper was in charge of the landscape design and also made plans for several garden structures of which only a Turkish kiosk was erected. The king's own Maison de Plaisance, a very elegant building, was designed by O. Tempelman. A Chinese pavilion and the copperclad tents for the *corps de garde* are by the French architect Louis Deprez, who also made drawings for a big palace in neoclassical style, but only the impressive substructures were built. A *salon de *treillage* by C. C. Gjörwell and some other structures were added during the early 19th c.

Although it was never wholly completed and much has changed, the Haga park still shows Piper's command of landscape design in a grand style. G.A.

Hagley Hall, Worcestershire (West Midlands), England, with a landscape garden of some 64 ha. laid out in the mid-18th c., lies in the village of Hagley and now forms a part of the park and farmland of the estate. It was created by George, 1st Lord Lyttelton (a nephew of Lord *Cobham of Stowe), statesman and politician, patron of the poet James *Thomson, and a friend of Pope and Shenstone. He was assisted in the design by his nephew Thomas *Pitt and by Sanderson *Miller.

The site was most naturally favoured for the development of picturesque scenery, being a part of the slopes of the Clent Hills, and having wooded valleys, streams, and rising ground giving fine views to the Malvern Hills, Wychbury Hill, and the distant Black Mountains of Wales. The layout is based on a pictorial circuit route which started at the parish church and followed the stream up a valley enlivened with cascades, garden structures, and the much praised mock castle designed by Sanderson Miller. James ('Athenian') Stuart's Temple of Theseus, built in 1758, is the earliest example of the Greek revival in the 18th c.

Sanderson Miller's Castle at Hagley Hall, Hereford and Worcester

McIntyre Garden (1960), Hillsborough, California, by Lawrence Halprin

Much fine scenery still exists together with some garden buildings and monuments in various states of repair.　P.E.

Ha-ha, a dry ditch with a raised retaining wall, used to conceal the boundaries of an estate or a landscape. This feature is French in origin, appearing at *Versailles and elsewhere in the 17th c. The earliest English example, although of small extent, was introduced *c.*1695 at *Levens Hall by the French gardener, Monsieur Beaumont. Its use was also advocated in *Dezallier d'Argenville's *La Théorie et la pratique du jardinage* (1709), translated by John *James (1712). *Switzer was probably unaware of the distant example at Levens, but, following John James, he describes a feature like a ha-ha in *Ichnographia Rustica* (1718).　D.N.S.

See also SAUT DE LOUP.

Hall Barn, Buckinghamshire, England, an early formal landscape garden begun between 1651 and 1687 by the poet Edmund Waller, was completed by his grandson Harry Waller and his stepfather John Aislabie, who went on to create the garden at *Studley Royal.

Hall Barn remains a formal canal garden in *c.*3·2 ha. around Waller's house, and overlooked by his original garden seat. The one remaining rectangular canal, set simply in rolling lawn, has an early 18th-c. garden building or 'boathouse' at its head. Surrounding woodland and groves comprise a further 20 ha., with walks and groves cut straight through the woodland in Restoration style, and radiating from an Ionic domed rotunda, the Temple of Venus, built by Colen Campbell in the mid-1720s. The main walk through a beech wood—Waller's Grove—skirts the escarpment to enjoy the vista first from the temple and subsequently from a notable obelisk. From here, the 2-km. principal drive, between (originally) pleached limes, returns to the house.　K.N.S.

Halprin, Lawrence (1916–　　), American landscape architect, is one of the most influential contemporary names in his field. After working in a kibbutz, where he became fascinated by the land and man's impact upon it, he studied plant sciences and landscape architecture at the universities of Cornell, Wisconsin, and, finally, Harvard, where he was influenced by Walter Gropius, Marcel Breuer, and Christopher *Tunnard. In 1945, after war service, he joined the office of Thomas *Church and was his assistant on the design of the garden and pool at *El Novillero, Sonoma, one of the most important gardens of this century. Four years later he set up his own office in San Francisco.

His first major work was the McIntyre Garden (1960) in Bay Area, California. From the reinterpretation of the Californian garden in contemporary terms his concerns broadened via the design of housing schemes and shopping malls to the concept and use of urban spaces, the nature of cities—their infrastructure, and transport systems—and the need to educate the public to the value of the urban space as shown by the European example. His tenet that 'natural processes dictate form' found full expression during his leadership of a team of ecologists, architects, planners, and designers in the creation of Sea Ranch (1965), a planned community built in northern California, which respects in

form and layout the prevailing character of the site, its landscape setting, and the forces which have created it.

He has constantly advocated the city as a valid means of living, as opposed to the Arcadian suburban community first created by *Olmstead in Riverside, Chicago; and has urged its rehabilitation and continuance. He pioneered the restoration and re-use of old structures and thus the preservation of the character and fabric of the city, as successfully shown at Ghiradelli Square, San Francisco (1962).

In specific design terms Halprin's role in landscape architecture may be viewed as eclectic; his strength lies more clearly in his shrewd and remarkable talent for drawing together and inspiring teams of talented designers to produce works of such calibre as the Lovejoy Plaza in Portland, Oregon (1961). Perhaps his principle contribution should be viewed in his role as propagandist. By his writings, his films, and the force of his colourful personality he has brought American society to an understanding of the value of urban public space; and by directly involving people in the design and decision process of a project has made it a more valid and personal experience for them. His writings include *Cities* (1963), *The Freeway in the City* (with other authors) (1968), *New York New York* (1968), *RSVP Cycles* (1970), and *Notebooks 1959–1971* (1972). J.C.

Hameau, a hamlet; in gardens, a mock group of rustic buildings as at *Chantilly, *Versailles: Petit Trianon, and the Chinese village of *Tsarskoye Selo. The intention was for the aristocracy to experience the every-day life of their subjects. K.A.S.W.

Ham House, Richmond, London, was described by John *Evelyn in 1679: 'the Parterres, Flower Gardens, Orangeries, Groves, Avenues, Courts, Statues, Perspectives, Fountains, Aviaries, and all this on the banks of the Sweetest River in the World must needs be surprising.' The 7·2-ha. garden was laid out in 1671. The north front with clipped bay trees and a central statue was altered in the 18th c. The garden east and south of the house has been reconstructed since 1978. On the south side lies a long terrace, squares of grass divided up by gravelled walks, and a geometric wilderness of hornbeam hedges and small trees. The east side is laid out as a *parterre of dwarf box hedges, forming triangular and diamond-shaped beds, planted with cotton lavender and flanked by arbours. There is an orangery to the west with fine specimens of *Paliurus spinachristi* and *Juniperus virginiana*.

Ham House was acquired by the National Trust in 1948. P.M.

Hamilton, Charles (1704–86), English landowner and landscape designer, was the youngest son of the 6th Earl of Abercorn. After Oxford and travel to Italy, where he acquired paintings and much antique statuary, Hamilton took up a household position under Frederick, Prince of Wales, and subsequently held government posts. In 1738 he obtained a crown lease of *Painshill, and developed the

landscape until his retirement to Bath in 1773, when he sold up to meet debts incurred by the extensive garden works. A pioneer of natural and picturesque landscape, Hamilton was also a keen horticulturist who was among the first to plant many species, particularly introductions from North America.

Hamilton also advised Henry *Hoare on a new approach up to the Temple of Apollo at *Stourhead, and Henry Fox on the layout and plantings at *Holland Park; and he designed the cascade and grotto complex at *Bowood. It is also likely that he advised William *Beckford on the planting of exotics at *Fonthill. These works reflect his interests and approach at Painshill and show his widespread influence and connections. In Bath his own town garden was praised as exemplary.

A brilliant and subtle designer, Hamilton could create illusion and vary scene and mood. His work strikes a delicate balance between art and nature, between the artist and the plantsman. M.W.R.S.

Hamilton Palace, Lanarkshire (Strathclyde Region), Scotland, was a late 17th-c. great house with extensive grounds to the east of the town of Hamilton. Today the palace is gone (demolished in the 1920s), the town greatly expanded, and the park slashed diagonally by a motorway. Only two features give a clue to Hamilton's original grandeur: the Mausoleum and the Kennels, aptly, if surprisingly, named Chatelherault.

The early 18th-c. scheme prepared by Alexander Edward (1651–1708) for the grounds consisted of a great axis running north and south and centred on the palace, about which a very great variety of elements were disposed. This is the earliest known planning in Scotland on the landscape scale (it is a few years earlier than *Alloa) and shows an aspect of rural improvement then beginning to fascinate Scottish landowners (see *Scotland). But the scale of Hamilton sets it apart, as does the River Avon meandering through gorges and gentler banks back and forth across the axis of the park and through the scheme.

Edward laid out parks and woods to the north; to the south were wooded areas on a larger scale cut through with rides as in a French forest. On that side, too, William *Adam added the Kennels in the 1720s; Edward had fixed the width of the main axis, on which they were to be built. Behind his Kennels Adam designed a small garden composed of grass *parterres and sloped banks. This feature overlooks the Avon at an angle, and across the wooded gorge is Cadzow Castle, a 16th-c. fortress, obligingly forming the focal ruin for Adam's landscape. Enough of this survives to give a notion of the character of the whole scheme. It is now being restored by the Scottish Development Department. W.A.B.

Hampton Court Palace and **Bushy** (or Bushey), London. Although the grounds of Hampton Court Palace date back to the reign of Henry VIII (1509–47), who acquired them from Cardinal Wolsey, the king appears to have shown more

A GENERAL PLAN OF
HAMPTON-COURT
PALLACE GARDENS &
PARKS

Hampton Court, Middlesex,
plan (1736) drawn by
Bridgeman (Sir John Soane's
Museum, London)

interest in the tilting-grounds on the north, of which one of
the five observation towers remains, than in the Privy
Garden on the south where he raised a *mount crowned
with a *gazebo whence he could look down upon the
Thames and on the garden, peopled as it then was with the
King's Beasts: heraldic models painted, gilded, and moun-
ted upon posts or pedestals. There were also 16 sundials, a
kitchen garden, and a real-tennis-court. Queen Elizabeth
had a *knot garden made close to the south range and was
fond of walking there.

Charles II (1660–85), as he had done at *St James's
Palace, once again adopted, for the east front, the *Mollet
goose-foot plan (though now on a still vaster scale), with its
middle 'toe', the Long Canal, flanked at a distance by long,
double avenues of limes. And here again the *patte d'oie
radiated from a third double avenue of limes, planted in a
semicircle but with a more modest canal all but hidden
between them.

But the gardens had to wait for their full glory until the
reign of William and Mary (1689–1702). From 1689, when
Wren was directed to rebuild the east front of the palace,
King William seems to have set his heart upon what came to
be known as the Great Fountain Garden. This *parterre,

designed by Daniel *Marot, with long scrolls of broderie
edged with dwarf box and enriched with statues, pyramids
of yew, and globes of bay and holly, had no fewer than 13
fountains playing on the plateau between the palace and the
semicircular canal: a royal garden indeed, which Charles II
had had no time to finish.

Queen Mary was no less devoted to the Privy Garden,
laid out as a formal parterre on the south, while tender
exotics were cared for in what was called the glass-case
garden, the whole being screened at its Thames-side boun-
dary by 12 wrought-iron panels by Tijou: his most masterly
work. In wet weather the Queen's favourite resort was the
Water Gallery, a covered way for royalty, leading from the
landing-place to the palace. Here Grinling Gibbons, a
superb craftsman who became a friend, carved brackets and
pedestals for the Queen's collection of precious porcelain.

In 1694, when Queen Mary died of smallpox, the works
were abandoned until 1699, when we find Henry *Wise first
working as a gardener there. One of his first jobs was to
lower the Privy Garden by 3 m. to afford King William a
better view of the Thames from his orangery. The King had
had the Water Gallery demolished, but some of its mould-
ings, carved by Gibbons, are still to be seen in the diminu-

tive Banqueting House at the Thames end of the Pond Garden. William still had grandiose schemes, the most audacious of them being the rebuilding of the north front. Wren was prepared to undertake it and had plotted the famous Chestnut Avenue leading to it through Bushy Park when in that same park the King's horse struck a molehill and threw him. Complications set in and in 1702 the King died. His last works at Hampton Court were the Great Terrace, leading for half a mile beside the Thames to a bowling-green enclosed by Wren's four pavilions; and in Bushy Park the Chestnut Avenue, planted by Wise and still flourishing as is, on the south front near Queen Anne's orangery, the great Black Hamburg vine which in a good year produces 500 to 600 bunches of grapes, sold to the public in late summer.

Queen Anne (1702–14), keen to obliterate all memory of her Dutch brother-in-law, and also disliking the smell of box, directed Wise to set his teams to uprooting and obliterating much that William and Mary had inaugurated. The Great Fountain Garden lost most of its fountains (only one remains today); its parterres were grassed over, its yews unclipped, its limes unlopped. The Privy Garden was also neglected (fully restored in 1995). On the north however, as though in jest, she had Wise plant a formal wilderness, completed near the Lion Gate with a triangular *maze, still the delight of children. Perhaps the oddest thing she did was to get Wise to move William's lime trees, bordering the semicircular canal on the east and now nearing maturity, from the eastern to the western bank of that canal. Wise did it (a Herculean task) and so ensured that Queen Anne need never see the masterpiece devised by her forebears. As a last gesture she ordered Wise to level those fatal molehills in Bushy Park and, as at Windsor, to plot 'the Queen's ridings' for her to career along in her high-wheeled gig.

In 1838 Queen Victoria threw open Hampton Court and Bushy to the public and they have enjoyed those once-royal hunting-grounds ever since. D.B.G.

Hanbury, Sir Thomas (1832–1907). See LA MORTOLA; WISLEY.

Hanging gardens of Babylon. See BABYLON, HANGING GARDENS OF.

Hanging wood, a term frequently used in connection with the English landscape garden. It can refer to a wood which crowns a hill, or, more often, to a wood which hangs on the side of a hill. It was generally agreed by 18th-c. commentators that it was desirable to look at the wood from below, preferably so that the brow of the hill (if naked) was not visible. M.W.R.S.

Hangzhou, Zhejiang province, China, situated at the southern end of the Grand Canal, north-west of the mouth of the Zhijiang, is famous for its silk and handicrafts and for the beauty of its West Lake, Xi Hu, the place that, more than any other, epitomizes the Chinese ideal of 'hills and waters'. It covers some 500 ha. and is surrounded by an amphitheatre of gentle hills. Since flooding was always a danger to the city, willow-planted dikes named after two famous poets, Bai juyi and Su Dongpo who both became governors of the province, divide the lake into three unequal parts.

After 1126 imperial survivors of the Northern Song made Hangzhou their capital and built palaces and gardens round the lake. They often abdicated and, surrounded by poets and painters, spent the rest of their days boating and giving parties: Marco Polo described the ruins of their palaces, left to crumble by Kublai Khan after he finally overran them. During the Qing period, both the Emperors Kang Xi and Qian Long paid lengthy visits to Hangzhou, and this encouraged the building of villas by the lake. Few of these villas survive today; but a fine arboretum, parks planted with peach trees along the water's edge, and the two larger islands in the lake are open to the public. Of these, the Xiao Ying Zhou island, composed of a clover-leafed causeway surrounding four reflecting pools, is one of the most seductive places in China. Just off the northern shore of this island, three small hollow stupa-lamps rise above the lake surface: on warm nights they used to be lit, so that their three lights mingled with the reflected moon and the shadows of the willow branches. M.E.

Harcourt, François-Henri, Comte de Lillebonne, 5th Duc d'Harcourt (1726–1802), was a pioneer of informal landscape gardening in France. After a long military career he became governor of Normandy and in 1787 was appointed to direct the education of the Dauphin. He was a man of wide interests, among which were botany and gardens. He laid out part of his estate at Thury-Harcourt, overlooking the Orne valley south of Caen, in an informal manner planted with American trees brought from England. He also made a Chinese landscape, to be seen from his house, with spectacular rock-work, winding paths, and exotic trees chosen for the variety of their foliage. His garden was famous and was visited by Arthur *Young in 1788. Harcourt also wrote *Traité de la décoration des dehors, des jardins et des parcs* which remained in manuscript until it was published by Ernest de Ganay in 1919. It was however known, as the Prince de *Ligne quotes it in his *Coup d'œil sur Beloeil* (1781). It was the forerunner of other French treatises on the planning of gardens in the informal landscape style (*Watelet; Morel; *Girardin).

Harcourt put his knowledge into practice, not only at Harcourt, but in the Princesse de Monaco's garden at *Betz near Chantilly, designed c.1781. His basic principle was that in the transition from the house to its surrounding landscape via the garden and the park, each stage must blend smoothly with the next. This is what he had admired in English gardens at Kew and elsewhere.

Forced into exile by the Revolution, first to Aix-en-Chapelle, and then to England, he died at Staines, near London, in a house lent him by the Harcourts of *Nuneham Courtenay. D.A.L.

Hardouin-Mansart, Jules (1645–1708), French architect, was the son of Raphael Hardouin, 'peintre du roi', and Marie Gautier, niece of François *Mansart. Jules Hardouin entered his great-uncle's studio *c.*1661. Early in his career as architect he became associated with André *Le Nôtre and they worked together at *Saint-Germain-en-Laye, where the terrace promenade was constructed (1669–73); at *Dampierre for the Duc de Chevreuse (1675); and in the same year at Clagny for the Marquise de Montespan. From that time Hardouin rose in Louis XIV's favour, becoming chief architect in 1685, *surintendant des bâtiments* in 1699, and calling himself 'Hardouin-Mansart'. In 1678 he was entrusted with the enlargement of the palace of *Versailles, whose final form is due to him. He designed the Trianon de Marbre (Grand Trianon) in 1687; *Marly (1679–86); and worked at *Chantilly (the Orangery, 1683, conversion of the Petit Château, 1684, and the Grand Château, 1688–91). Among his other works were the Orangery and Château-Neuf at *Meudon; plans for Chambord (1684) including the canalization of the Cosson; and the exquisite small château of *Villette.

When two such men as Hardouin-Mansart and Le Nôtre work together it is often not possible to apportion credit. After 1683, however, changes in the gardens at Versailles certainly owed much to the king's architect. The final form of the *parterre d'eau* (1683) is due to him; and he is said to have widened the central *allée* of the Tapis Vert to give a better view of the canal. No doubt his main contribution was architectural, from details such as the *buffet d'eau at Trianon and the extension of *Le Pautre's cascade at *Saint-Cloud, to the monumental scale of the Orangery and the Cent Marches. His versatility is demonstrated in the contrast between this and the delicate fantasy of the *bosquets of the Colonnade and Salle de Bal or Rocailles. Indeed, Hardouin-Mansart owed his success not only to his competence as an architect but to his ability to interpret Louis XIV's needs. Nowhere was this more evident than at Marly, where the provision of separate courtiers' dwellings on either side of the king's house met the conflicting requirements of personal privacy and social life. The resulting design of horseshoe terraces backed by woods and overlooking a series of formal basins, although determined by the nature of the site, had no precedent in garden planning.

Hardouin-Mansart had many collaborators, among whom were his cousin, Jacques IV Gabriel, and his brother-in-law, Robert de Cotte, who succeeded him as chief architect in 1709. K.A.S.W.

Harewood House, West Yorkshire, England, the home of the Earl of Harewood, is an exemplary landscape created for Edwin Lascelles by *Brown in 1772 when he enlarged the lake, contrived the view of Wharfedale and Almscliffe Crag to the north, planted the clumps and encircling belts of trees, and characteristically arranged the pleasure-gardens out of sight. Charles *Barry created the Italianate terrace on the south front (1843) with its three fountain pools amidst ornamentally shaped box-hedged rose-beds. To the west of

the house is another box-parterred rose-garden below which are sloping lawns graced with camellias, huge cedars and oaks, and many species and hybrid rhododendrons. In the shade of the south-facing terrace wall tender styrax, abelia, and eucryphia flourish. The west gate into the parkland from the terrace leads past the Carr stables and the exotic bird-garden where birds from all parts of the world are housed in natural surroundings.

The path leads on downwards through thick woodland to the cascade bridge at the west end of the lake overlooking a natural bowl, and a stream-fed bog-garden. The path leads over the bridge to another woodland walk where some of the original Brown tree cover of oak and beech remains, but where later planting, particularly by the 6th Earl, shows us *Chamaecyparis* in variety, many tree-like rhododendron species, and hybrids including many of Harewood's own hybrid seedlings. The wooded walk gives way to a walk by the kitchen garden wall with a terraced rose-garden and border by the lakeside. K.LE.

Hårleman, Carl (1700–53), the son of Johan Hårleman, was a Swedish architect and superintendent of the royal buildings. After studies at home and in France and Italy, he was in charge of the work on the royal palace in Stockholm, later succeeding *Tessin the younger. Much in demand as an architect he also laid out gardens for his buildings. He handled the French style in its rococo version with mastery, skilfully adapting it to local conditions. A good example is at Osterby, near Stockholm. G.A.

Hårleman, Johan (1662–1707), Swedish garden architect, was the son of a German-born gardener summoned to Sweden by Queen Hedvig Eleonora. Hårleman got a gardening education from his father and studied architecture at home and in France, Italy, and several other countries. After returning to Sweden he was appointed royal gardener in 1687, and superintendent over the royal gardens in 1697. He co-operated with *Tessin the younger, mostly working out details, and laid out or renewed many royal and private gardens, such as the royal garden in Stockholm and in Ekolsund. He played a prominent part in introducing the French baroque garden into Sweden. The magnificent wrought-iron gates to the *Drottningholm garden are his work. G.A.

Harlow Car Gardens, Harrogate, North Yorkshire, England, the ornamental and trials garden of the Northern Horticultural Society, is less than 30 years old, but has every appearance of a mature garden. It embodies all the garden components of the present century for within its 24 ha. are sandstone and limestone rock-gardens, screes, shrub borders including shrub and old-fashioned roses, a new hybrid tea and floribunda rose-garden, a peat garden and terraces, trial beds, a foliage garden, a fine collection of rhododendrons, and one of the largest collections of heathers in the north of England. K.LE.

Harristown, Co. Kildare, Ireland, was an early 18th-c. formal park of the Eustace family with a lake on which mock

naval battles with fully rigged men-of-war were conducted after the manner of the water fêtes at *Versailles. Now a late 18th-c. landscape park, its chief ornament is the Hut of Confucius, erected here in 1946 but originally in the garden at *Stowe. P.B.

Hartweg, Theodor (1812–71), plant-collector, worked in the *Jardin des Plantes and the (Royal) Horticultural Society's garden at Chiswick before being sent in 1836 to collect in Mexico and Guatemala. He spent nearly seven years in Central and South America, in spite of the difficulties caused by political troubles in Mexico, which upset the transport of his collections to England. In 1845, on the brink of the Mexican–American war, he returned briefly to Mexico on his way to California, where he stayed for three years. *Fuchsia fulgens*, established in cultivation by seeds from Hartweg, was a Mexican plant that became a parent of many modern hybrids. Pines, orchids, cacti, and species of *Achimenes* were among the large quantity of plants he sent back. From California came the Monterey cypress *Cupressus macrocarpa*, other conifers, several species of *Ceanothus*, and the evergreen chestnut *Castanopsis chrysophylla*, first found by David *Douglas. S.R.

Hartwell House, Buckinghamshire, England, represents a saga of historic landscape design: nearly all periods can be found to underline the present confusion of mansion, gardens, and park. It is said that a feudal tenant of King John took his name and that of his home from a spring (which still exists), from which harts drank. Estate, house, and gardens blossomed under the Tudors, and again in the 18th c., when James *Gibbs was called in to reorganize the gardens and park. A vagrant Spanish artist, Balthasar Nebot, painted a series of imaginative views of the proposed (but unexecuted) gardens, that has never been equalled as a record of classical landscape ideas in England prior to the change of fashion from classic to romantic. The paintings are now in the county museum, Aylesbury.

The main lines established by James Gibbs, notably his pavilion, underwent adjustments reflecting current fashion up to the present day, including the *picturesque and the *gardenesque, as well as commemorative features such as the royal crowns in yew planted by Louis XVIII of France, who stayed there in exile. G.A.J.

Hatfield House, Hertfordshire, England, created for Robert Cecil, 1st Earl of Salisbury, between 1607 and 1612, has had a complex history with several changes in personnel and planning. The main east garden was laid out (1607–11) by Thomas Chaundler in two terraces linked by flights of steps and a fountain with hydraulics by Simon Sturtevant. In 1611–12 Salomon de *Caus was employed to redesign the garden, including a much larger fountain. From the formal gardens a stream ran down to a naturalistic water-garden with hydraulics by Sturtevant. This included two islands, one of which, the Dell, was lozenge-shaped with a pavilion over a stream, fountains, and other decorative features. The

planting of both garden and park was supervised by John *Tradescant the elder.

Since then the garden has been changed many times but it still retains a traditional, 17th-c. appearance with a large terrace filled with a pattern of beds linking the two buildings and an extensive maze on the other (eastern) side of the mansion. Beyond these formal features well-wooded parkland extends as far as the eye can see, with avenues of trees to north and south and a small modern woodland garden with many rhododendrons and azaleas. The yew-lined beds on the west terrace are planted semi-permanently with shrubs, roses, and herbaceous perennials. R.S./A.H.

Haussmann, Georges Eugène, Baron (1809–91), French administrator, politician, and creator of modern Paris. He began his career in the Gironde, where he was *préfet* from 1851 to 1852. As a convinced Bonapartist he was appointed *préfet* of the Seine by Napoleon III in 1853, and Minister for Paris in 1860. Under his direction the Emperor's plans for the modernization and security of the capital were carried out. The city was supplied with drinking water and a complete drainage system (the Paris sewers). Enormous construction schemes were undertaken, to accomplish which Haussmann applied laws of compulsory purchase passed in 1841 and 1848. He was responsible for the pattern of wide straight avenues, planted with trees, surrounding the inner city (such as the Rue de Rivoli, the Champs-Elysées, the boulevards); also for the promenades and parks (*Bois de Boulogne; Bois de Vincennes; *Buttes-Chaumont; *Parc Monceau; and Parc de Montsouris). About 40 little public gardens or squares were created: the oldest, Tour Saint-Jacques (1855), was remodelled in the 1970s; the most successful was that of Batignolles. The cemeteries were extended, and new ones planted with trees and flowers. His achievement in relating town-planning and garden design within the context of a historic city was recognized by his election to the Académie des Beaux Arts.

Haussmann was accused of encouraging speculation in real estate, of destroying working-class districts and pushing people out to the suburbs, and of demolishing fine buildings. Faced with this criticism he withdrew to Montboron, near Nice (an estate designed by *Alphand) in 1869; and later to Cestas in the Gironde. After serving as Deputy for Corsica from 1877 to 1881, he retired from public life. D.A.L.

Hawksmoor (or Hawksmore), Nicholas (1661–1736), Wren's clerk of works, had revised Wren's design in erecting Queen Anne's Orangery at Kensington Palace, his first garden building (1704–5).

At *Blenheim Palace he worked with *Vanbrugh, but was solely responsible for a number of outworks. When on the Duke's death the Duchess of Marlborough was left '£10,000 a year to spoil Blenheim her own way' (to quote Vanbrugh) she commissioned Hawksmoor to build the Grand Bridge on the north approach (1722) and the fine Triumphal Arch gateway at the Woodstock entrance (1723). Before 1730 he also made four designs for the

column of Victory, to be sited at a *rond-point* in plantations sometimes claimed to represent Marlborough's troops at the battle of Blenheim.

The Mausoleum he built for Lord Carlisle at *Castle Howard (1729–36) must be reckoned a major work of the baroque, of true Roman grandeur. The domed rotunda, built of dark local limestone and over 21 m. high, stands on a wooded ridge, dominating the landscape even from a great distance. In the grounds to the south of the house are two other buildings by Hawksmoor: a large stone pyramid, enclosing a monument to Lord William Howard, and (beyond the Mausoleum) a curious stone pillar—the Four Faces—with carved masks supported on a concave pyramid and topped by a grotesque finial. I.L.P.

Hawkstone Park, Shropshire, England, laid out near Hodnet *c.*1780–95 by Sir Rowland Hill and his nephew Sir Richard, was, like *Belsay Hall and *Mount Edgcumbe, a late 18th-c. essay in the romantic and the *picturesque. Nature had favoured the situation with precipitous cliffs and rocks, and the caves may have been the result of copper mining by the Romans. There were lakes, fortifications, a bridge, an obelisk, a tower, and a genuine ruined castle dating from 1228. A large park (400 ha.) with extensive planting has given way to the present priory and grounds and a golf course. The 'River Hawk' was laid out by William *Emes in 1786 to remedy the previous lack of water. A hermit with the beard of an old goat dwelt in the caves for 14 years, under instructions to behave like Giordano Bruno (the Italian Dominican philosopher and writer, burned for heresy in 1600). His successor was of wax, real hermits being so scarce! M.W.R.S.

Hayat Baksh, Red Fort, Delhi, India. See RED FORT.

Hazar Jerib, Isfahan, Iran, was created in the mid-17th c. in the northern part of Isfahan terminating the *Chahar Bagh. According to the 17th-c. *Travels of Sir John Chardin in Persia* (trans. E. Lloyd, London, 1927), it was 2·5 square km. in area and stepped down in 12 terraces. Twelve avenues ran north–south, crossed by three east–west. There were pavilions, variously shaped pools, water-jets, and many flowers. 'One was surprised', wrote Chardin, 'by so many fountains appearing on every side as far as one could see, and was charmed by the beauty of the scene, the odour of the flowers, and the flight of the birds, some in aviaries and some among the trees.' The Hazar Jerib no longer exists. J.L.

Hearst Gardens, San Simeon, California, United States. Begun in 1922 by William Randolph Hearst to house his antiques and art treasures, La Casa Granda and its Italian gardens were not entirely completed when he died in 1951. Even so, the 50 ha. containing the castle with its guest houses and gardens constitute one of the foremost show places in the United States.

As it nears the summit the road becomes ever more serpentine, winding through orange and lemon trees, aca-cias, pomegranates, eucalypts, and oleanders. Roses, over 2,000 of them, are everywhere. Huge Canary Island date palms in gigantic containers are silhouetted against the sky. Over 40 Italian cypresses, weighing over 5 tons each, were brought more than 64 km. to stand like exclamation points.

But it is the formal gardens themselves that are most spectacular. Constructed on several levels and composed of many inclined walks, they abound in clipped boxwoods, purple lantanas hanging over the walls, fuchsias like draperies, Washington palms shooting to the sky, tree-sized hibiscus, jasmines, myrtles, geraniums, blue lilies-of-the-Nile for ground cover, and innumerable other spectacular plantings.

Besides the many statues, carved balustrades, and unsurpassed views, one of the outstanding features is the Neptune Pool with its pillared cypresses, its floor patterned in blue, and its magnificent Graeco-Roman temple. E.F.S.

Heather, an evergreen shrub, often dwarf, belonging to the Heath family (Ericaceae) and characterized mainly by its growth requirement of an acid soil. The roots of heathers require the presence of a particular fungus to function properly and it is probably this fungus that requires the acid soil. Some species such as *Erica carnea* (grown as the cultivars 'Springwood White', 'King George V', and many others) will tolerate chalky soils. Others require a water-logged or permanently damp soil, some a dry sandy soil, but many heaths will tolerate both.

Most species of *Erica* are from southern Africa, particularly the taller hedge- and scrub-forming ones. Many of these will survive in sheltered locations out of doors in northern Europe but they are perhaps better known as conservatory and greenhouse pot plants. The remainder of the heathers are native to Europe, with eight species growing wild in the British Isles. Some are widespread throughout the area such as *Calluna vulgaris* (ling), *Erica tetralix* (cross-leaved heath), and *E. cinerea* (bell heather) but the others, *E. mackaiana*, *E. ciliaris* (Dorset heath), *E. mediterranea* (Irish heath), *E. vagans* (Cornish heath), and *Daboecia cantabrica* (Connemara heath), are restricted in their occurrence.

Some of these have hybridized in the wild and all have been further hybridized and selected by such specialists as Maxwell and Beale in the early part of the 20th c. Today there are several hundred distinct cultivars grown in Europe and North America. Although the flowers are fairly similar, all being variations on whites, pinks, lilacs, and carmine-reds, the leaves of heathers occur in almost every shade of green, yellow, gold, and bronze-browns. The leaves and stems can be hairy or smooth, and shiny or covered with a glaucous sheen. Variations can also be seen in the ways in which the branches hold themselves, some being upright, others downward-sweeping, some widely spaced, and others congested to form compact plants.

Heather gardens consist of a range of cultivars usually grown as a mosaic of adjacent contrasting types. Some well-known heather gardens are found in many *botanic gardens and the larger country-house gardens. P.F.H.

Heath house. See MOSS HOUSE.

Hedge, used originally in place of a wall or fence to protect a garden from intruders. By Roman times it had become an ornamental feature and was used to emphasize the outline of design, for which purpose box and rosemary were popular. Much greater elaboration developed in the 15th and 16th cs. in Italy and France when very small hedges, or edges, were used both to surround beds and to create patterns or knots within them, sometimes of a very intricate nature. For this purpose a dwarf variety of box, *Buxus sempervirens* 'Suffruticosa', was favoured. In Germany hedge *theatres were formed, as at *Herrenhausen and *Veitshöchheim.

The art of shaping shrubs or trees into elaborate shapes, known as *topiary, was extended to hedges, which might be ornamented with cones, balls, or figures of animals and birds or be given a greater appearance of solidity with clipped buttresses. For these purposes yew gradually superseded box in popularity because of its greater firmness but both have continued to be used to the present day. Also much planted in the milder regions of southern Europe was the Italian cypress (*Cupressus sempervirens*).

There has been increasing interest in flowering hedges of lavender, rose, various species of berberis, and, in fairly frost-free places, fuchsia and escallonia. For town gardens broad-leaved privet in both its green and golden-leaved varieties has become very popular because of its ability to thrive in poor light and chemically polluted air.

For outer hedges thorn (*Crataegus monogyna*) was for centuries a favourite because of its hardiness, strength, and impenetrably spiny growth but it is now used mainly for farm hedges. More ornamental shrubs are preferred, such as Lawson cypress (*Chamaecyparis lawsoniana*) in both its green- and yellow-leaved forms, Leyland cypress (× *Cupressocyparis leylandii*) also in green and yellow varieties, various thuyas, hollies, cherry and Portugal laurels and cherry plum (*Prunus laurocerasus, P. lusitanica,* and *P. cerasifera*) with green and purple leaves, and green-, copper-, and purple-leaved beech and hornbeam. When hard pruned, beech and hornbeam, though deciduous, retain their dead leaves in winter and this adds to their value as sturdy windbreaks.

In warm countries *Hibiscus rosa-sinensis*, highly coloured crotons (*Codiaeum*), and *Dodonaea viscosa* in both green- and purple-leaved varieties are among the many popular hedging plants. A.H.

Heem park. See ECOLOGY AND GARDENS.

Heidelberg Palace, German Federal Republic. See HORTUS PALATINUS.

Hellbrunn, Salzburg, Austria, a palatial castle and gardens to the south of Salzburg, was built by Santino Solari in 1613–15 for Markus Sittikus von Hohenems (1574–1619), Archbishop of Salzburg (1612–19). Markus Sittikus was a humanist who had lived in Italy, and was well acquainted with Italian gardens. Stone for the castle was quarried on the estate, and Markus Sittikus made the quarry into an amphitheatre (the Felsentheater), with a double archway. On 31 Aug. 1617 the first 'open-air' performance of opera north of the Alps was held here, including Monteverdi's *Orfeo* (whose first *indoor* performance was in Salzburg in 1615). The Felsentheater is illustrated in Fischer von Erlach's *Entwürff einer historischen Architectur* (Vienna, 1721), II. xiv. 81, and was twice imitated near Bayreuth, at Eremitage and at Sanspareil, in the 1740s.

In 1613 Markus Sittikus had rebuilt and enlarged the menagerie (founded before 1424), and immediately round the castle he created a sequence of temples, alcoves, and grottoes containing numerous hydraulic jokes and toys, many of which survive. They were inspired by the *Pneumatica* of *Hero of Alexandria, and by the water toys (*giochi d'acqua*) in Italian gardens. The Orpheus grotto contained singing birds, the Midas grotto a crown lifted up on a jet of water, and the Roman theatre included a stone table with a central water-channel for cooling wine (as at the Villa Lante), and with water-jets concealed in the surrounding stone seats.

The main gardens were simplified by F. A. Danreiter in the 1730s, and in 1748–52 a water-powered marionette theatre by Lorenz Rosenegger was added to the water toys. An 'English park' was added to one side at the end of the 18th c. The extensive and varied gardens now receive thousands of tourists each year, who visit the zoo, attend musical and dramatic performances in the Felsentheater, and enjoy the many spectacular water jokes and toys, which are still maintained and repaired with impressive fidelity.
 C.T.

Henri IV (1553–1610), King of France (1589–1610), was the first of the Bourbon dynasty. His patronage of the *Francini and the *Mollets resulted in considerable advances in garden design and decoration at *Saint-Germain-en-Laye, the *Tuileries, and *Fontainebleau. But these were only part of a programme of reconstruction in a country devastated by civil war. Other aspects were the planting of mulberry trees to encourage the silk industry; the promotion of Olivier de *Serres's book on agriculture; and support for Richer de Belleval in establishing the first French botanic garden at *Montpellier. He pioneered town planning in Paris (the Place Dauphine, and the Place Royale, now the Place des Vosges). K.A.S.W.

Herbaceous border, a border planted with herbaceous perennial flowers, usually set against a wall. After their recommendation by J. C. *Loudon, such borders were planted as an attempt to revive 17th-c. gardening practice; John *Parkinson's *Paradisus* (1629) was considered a source for planting schemes. The borders at Arley Hall, Cheshire, date from the 1840s; those at Newstead Abbey, Nottinghamshire, may be older, and by the late 19th c. were believed to be a genuine monastic survival. The popularity of herbaceous borders increased in the last quarter of the century, when they formed an essential part of 'old-

fashioned' gardens; but during the 20th c., after their promotion by William *Robinson as an alternative to exotic bedding, they came to be used independently of their presumed historical associations.

Toward the end of the 19th c. Gertrude *Jekyll popularized the planting of borders in large masses of colour, arranged in informal drifts; she further urged schemes based on complementary colours and the gradation of warm and cold colours as advocated in Michel *Chevreul's theories. This last principle she developed into her one-colour borders, using shades and tints of a given colour as the basis for the sequence of plants. B.E.

Herbal, according to the *Oxford English Dictionary* a book 'containing the names and descriptions of herbs, or of plants in general, with their properties and virtues'. Charles Singer's classic paper on the herbal in antiquity modifies this definition to 'a collection of descriptions of plants put together for medical purposes' (*Journal of Hellenic Studies*, xlvii (1927), 1–52). Description of the plants gave these books and manuscripts botanical as well as medical importance, though both aspects were overshadowed by the rise of scientific botany in the 18th c.

The work of Theophrastus, a pupil of Aristotle, may be claimed as an early herbal, but that of *Dioscorides, a physician who lived in the 1st c. AD, survives in a more remarkable form, in an illustrated manuscript, the *Codex Vindobonensis*, made *c.* 512 for Juliana Anicia, daughter of the Emperor of the West. *De Materia Medica*, written in Greek but better known by its Latin title, was the foundation of a whole family of herbals, and its influence lasted through manuscript and printed copies, translations, and adaptations, until the 18th c. The plants of the *Codex* are drawn in a naturalistic style quite out of keeping with contemporary Byzantine art, implying that they are copies of earlier originals that have perished. Pliny the elder gives evidence of illustrated herbals at least as early as the 1st c. BC, and a physician of this period, Krateuas, seems to have been one of the earliest botanical illustrators on record. The *Codex* illustrations are the work of more than one artist, and some at least appear to be copies of copies of some of the drawings of Krateuas.

Latin versions of Dioscorides are usually combined with the text of another herbal by a shadowy figure known as Pseudo-Apuleius, Apuleius Platonicus, or Apuleius Barbarus, to distinguish him from the author of the *Golden Ass*. The medical recipes it contains seem to have been collected from Greek sources *c.* AD 400, but nothing more is known of its background. The text was used for what may be called the earliest vernacular herbal in English, an Anglo-Saxon one written *c.* 1050 and now in the British Library. Several other fine manuscripts of this text exist, including a particularly beautiful Anglo-Norman one now in the Bodleian Library, Oxford. It was made *c.* 1200 and has pictures of the legendary people associated with the plants, as well as the plants themselves. The text of Apuleius bridges the gap between manuscript and printed herbals, as one version of it

was among the earliest herbals printed, in Rome in the 1480s.

Many of the later manuscript herbals are French or Italian. A specially remarkable one, the Carrara herbal (now in the British Library) was made in the last decade of the 14th c. for the nobleman after whom it was named. It is a translation into Italian of an Arabic treatise on medical botany, but the illustrations are its most important feature. This anonymous artist was, at last, looking at real plants, instead of copying earlier drawings, themselves a long way from nature and becoming ever more stylized.

Another manuscript herbal, now in the Vatican Library, was compiled in 1552 at a Roman Catholic college in Mexico. A local native physician provided the plant knowledge contained in it, and the Latin text was by Badianus, so that the book is usually called the Badianus Herbal. Nearly 200 plants are shown and described, in rows of little pictures with the text beneath. Another copy of the manuscript, made in Italy *c.* 1600, is now in the Royal Library at Windsor. It is certainly the earliest herbal to draw on the botanical riches of the New World.

The first printed herbal appeared in Naples in 1477, an edition of *De Viribus Herbarum* by Macer, another rather nebulous author. Although his herbal is a medieval piece of Latin verse, most of its material comes from Pliny. An illustrated version of Apuleius followed early in the 1480s, printed in Rome, with crude woodcuts apparently based on those in a 9th-c. manuscript once in the library of the Benedictine monastery at Monte Cassino.

The three other important herbals printed before 1500 were all produced in Mainz, two of them by Peter Schöffer, once Gutenberg's colleague, later his successor. The first of these is the Latin *Herbarius* of 1484, which gives pictures and descriptions of 150 plants found in Germany, both native and cultivated ones. Eleven more editions, some with different illustrations, appeared before 1500, that Plimsoll line dividing the earliest period of printing from the following centuries. Schöffer's German *Herbarius*, one of the first scientific books printed in a vernacular language, appeared in 1485. It is larger than its Latin brother, with nearly 400 plants illustrated, and its text is not related to that of the earlier *Herbarius*, being compiled, according to the introduction, by an anonymous amateur botanist, with the advice of Johann von Cube. The author began preparing his book long before the Latin *Herbarius* was published, travelling widely in the company of an artist who was commissioned to draw the plants as they were found. The results of this exercise are obvious in the illustrations, clearly made from nature. The iris and the cannabis, for example, are a world away from the diagrammatic pictures of the Latin *Herbarius*. In spite of this, the 1491 *Hortus Sanitatis* printed by Jacob Meydenbach reverted to the more primitive style: some of the pictures are crude copies of those in the German *Herbarius*, some new ones are added. The narcissus looks like an Edward Lear plant, with doll-like figures in the centre of the flowers. Both the *Hortus* and the *Herbarius* were copied or pirated by other printers, and a flood of later editions followed the first ones.

In England the first herbal was produced by the printer Richard Banckes in 1525, apparently derived from an unknown medieval manuscript. Plant descriptions take up more space than prescriptions, and the herbal, though it had no pictures, was printed over and over again. *The Grete Herball*, based on a French text of a manuscript by Platearius, with woodcuts badly copied from the German *Herbarius* or *Hortus Sanitatis*, appeared in 1526. In some cases the same picture is used for different plants—cherry and tormentil are one pair in the English version, cherry and deadly nightshade in the French original. Some of the medical advice still sounds familiar: liquorice and horehound help coughs, opium and lettuce are narcotics.

The golden age of the printed herbal is usually dated from the publication of the first part of *Brunfels's Herbarum Vivae Eicones* in 1530, two more parts and a German translation following in 1532 and 1536–7. Brunfels still gave priority to plants known in classical literature, especially Dioscorides, but his artist Hans Weiditz, who was encouraged to draw live plants, thus giving the book both its name and its importance in the development of the printed herbal, went his own way and refused to divide his subjects into first- and second-class groups. The artist became the senior partner in this project, producing wood-engravings from original water-colours that are not only beautiful but

Herbals: woodcut of the pasque-flower, from Brunfels, *Herbarum Vivae Eicones* (Strasbourg, 1530)

have the accuracy of the best botanical illustration. Some of the water-colours may have been used as a guide for the colouring of printed copies of the book. One at Kew certainly matches the surviving originals, and was apparently coloured soon after it was printed.

Brunfels encouraged the work of Jerome Bock, whose *New Kreütter Buch* was printed in Strasburg in 1539. Many more editions came later, at first unillustrated, but in and after 1546 with woodcuts, some based on those in Brunfels or Fuchs, others specially drawn by David Kandel. Bock's descriptions, written in the vernacular, were based on his own observations and experiments, and his details of the locations and habits of growth of the plants he saw prefigure the kind of treatment they might receive in a modern flora.

The third great German herbalist of this period was Leonhart *Fuchs. His *De Historia Stirpium* was first published in Basle in 1542, followed by a German edition in 1543 and many more in both languages thereafter. The introduction carries a familiar reproach about the ignorance of medical practitioners who lacked an accurate knowledge of plants. The illustrations are less striking than those of Brunfels, though both herbals provided a source of pictures for many later herbalists. Fuchs's trio of illustrators, Albrecht Meyer, who drew the plants from nature, Heinrich Füllmaurer, who transferred the drawings to the woodblocks, and Veit Rudolf Speckle, who cut the blocks, have their portraits in the book, beside that of the author.

William *Turner's *New Herball* was published in three parts, the first in London in 1551, the second (with a reprint of the first) in Cologne in 1562, and the whole work, with the third part, in Cologne in 1568. Though its illustrations came from Fuchs, the text was the first in English to include original descriptions of plants, some of which are first records of native ones. The book was dedicated to Queen Elizabeth I.

In the 16th c. the printer Christophe Plantin formed a great store of plant pictures in Antwerp, where he and other members of his family produced the books of the greatest Flemish herbalists of the day, *Dodoens and Clusius. Blocks from the Plantin collection were borrowed to illustrate other herbals too, including John *Gerard's, and some of the original drawings, mostly by Pierre van der Borcht (see *botanical illustration) were also copied.

Rembert Dodoens's *Crüÿdeboeck* was published in 1554, illustrated with blocks from an octavo edition of Fuchs. It was translated into French by Clusius and used by Henry Lyte, an amateur English botanist, as the basis of his *Nievve Herball* of 1578, printed in Antwerp (with Plantin pictures) but published in London. This book was probably the source of botanical knowledge for Spenser and Shakespeare, though the latter had Gerard's *Herball* too, after 1597.

*Clusius was the most important of the Plantin botanists. His first book was an account of the flora of Spain and Portugal, followed by another about the botany of Austria and Hungary, written while he was living in Vienna. In 1601 these and other works were brought together and published as *Rariorum Plantarum Historia*, which contains descriptions

of exotics as well as native plants. He added knowledge of several hundred new plants to those hitherto cultivated, and introduced new species of iris, narcissus, and other bulbous plants.

*L'Obel's herbal, *Stirpium Adversaria Nova*, was printed in London in 1570–1, with an enlarged edition issued by Plantin in 1576, followed by a Flemish version, the *Kruydtboeck*, in 1581, and a separate collection of its illustrations and others from Plantin's hoard, over 2,000 of them, arranged according to L'Obel's system of classification. These illustrations appear again in the second edition of Gerard's *Herball*.

*Mattioli's huge *Commentarii* on Dioscorides was first published in Venice in 1544, followed by over 40 other editions and translations, the first illustrated one in 1554. There are two sets of illustrations, one for a large format, the other for smaller ones; both were produced by Giorgio Liberale and Wolfgang Meyerpeck. The large series, in particular, has an unusual density, with the blocks often packed tight, in an effect resembling a Morris wallpaper. All the plants known to Mattioli are described, so that his commentary more than swamps the original text. The great success of this herbal may be judged by the mention of a coloured copy in the will of Sir Henry Wotton (d. 1639), diplomat and poet, who left this precious book to Henrietta Maria, wife of Charles I.

The *Herball or General Historie of Plants* by John Gerard is probably the most famous English herbal. It was first published in 1597 and its history is tangled. Essentially, Gerard took over Robert Priest's unfinished translation of Dodoens's last book, added snippets from other authors, garnished the lot with the fruits of his own gardening and exploration of the English flora, and served up the whole mixture with illustrations borrowed from a Frankfurt printer, apart from c.20 original ones, which included the first woodcut of the potato, though there was a drawing of it in the Plantin collection. The most notorious plant in Gerard's book was an imaginary one, the barnacle tree. Rather unwisely, he claimed to have observed the hatching of these geese from the tree's fruit, though earlier writers had already demolished the story. Gerard scoffed at the mandrake tales but swallowed the barnacle goose whole.

There is an almost perfectly preserved copy of the first edition in the Bodleian Library, Oxford, given by its printer to Sir Thomas Bodley, who passed it on to his library. It is obviously a copy made for the richest sort of buyer, with its lavish decoration and colouring, and its history has kept it in an unusually tidy state, in contrast to the worn look of so many copies of the book.

A second edition, revised by the apothecary Thomas Johnson, was published in 1633 and reprinted in 1636. Johnson rather smugly sorted out some of Gerard's mistakes and replaced most of the pictures with others from the Plantin collection, though he drew the famous bunch of bananas himself. The book's immense and long-lasting popularity is hard to explain. The charm of Gerard's language is certainly attractive, and his notes on his own plants or the locations of wild ones make him sound an enthusiastic and knowledgeable gardener, but these things alone are not enough to account for its lasting appeal.

Johnson's Gerard had the effect of delaying John *Parkinson's herbal, *Theatrum Botanicum* (1640), for seven years; it seems always to have lived in the shadow of Gerard, although it contains descriptions of more than 3,000 plants, well above the Gerard total. The illustrations are mostly copies of those in Johnson's Gerard, but the text includes first records of several interesting native plants, for example, the Welsh poppy and the strawberry tree that 'hath beene of late dayes found in the west part of Ireland'. It also includes some of L'Obel's hitherto unpublished observations.

Late in the 16th c. engraving on metal began to be used as an alternative to woodcuts. The little woodcuts of the 17th and later 16th c. show a technique in decline, about to make way for a different process. Fabio Colonna's *Phytobasanos*, published in Naples in 1592, was one of the first herbals with pictures printed from metal, although this fact is blurred by the frame of woodcut printers' flowers surrounding each picture. Colonna's studies were once again based on the work of Dioscorides, as he attempted to identify the plants used by the earlier author with those found in 16th-c. Italy.

Towards the end of the classic age of herbals, Nicholas Culpeper published in 1652 the first edition of his *English Physitian*, later and better known as his herbal. This book is probably the only English herbal to rival Gerard's in popularity, and its active life has been even longer, as various adaptations of it remain in print. Culpeper settled in Spitalfields as an astrologer and physician in 1640, but his astrological approach to medicine made him very unpopular with more orthodox doctors. His book adds astrological advice to details of the uses of plants, stressing the value of native ones and forming a manual of herbal medicine for housewives of the time.

As well as astrological botany, the doctrine of signatures was another current belief of the late 16th and 17th cs., that is, the conviction that some plants resembled the parts of the body they could help to cure. William Cole, in his book *Adam in Eden* (1657), carried this doctrine to its extreme, even taking the walnut as 'a perfect Signature of the Head', each layer of the nut having a link with part of the human head, help for the skull's contents coming from the nut's kernel, which 'comforts the brain and head mightily'. The theory of signatures goes back to the early 16th c. in the work of Paracelsus, though its chief exponent was an Italian, Giambattista della Porta, who published his *Phytognomonica* in Naples in 1588, with illustrations neatly mixing the appropriate plants with the parts of the body they were said to affect. A pomegranate with its seeds exposed, a pine cone, and a toothwort share a picture with a set of teeth, maidenhair fern is linked with bald heads, and so on.

Late in the 17th c. the herbal was replaced by more scientific botanical work, like that of Tournefort and Magnol in France, Malpighi in Italy, and Ray, Grew, and Morison in England—people studying the anatomy, classification, and relationships of plants in a way that started the development of botany as a science separated from medi-

cine, to which it had always been subordinated before. The word herbal was still used in titles, but the sort of book it labelled had changed.

Tournefort's *Elemens de Botanique*, first published in 1694 as a manual of the scheme of classification developed by its author, suffered a sea change in translation and emerged in English 25 years later as *The Compleat Herbal*, extended by 'large additions from Ray, Gerarde, Parkinson, and others, the most celebrated Moderns'. The translation has been attributed to John Martyn, later Professor of Botany at Cambridge, who certainly translated another of Tournefort's books, but there is little evidence to support this attribution. The book was issued in parts from 1716 to 1730, one of the earliest botanical books to appear in such a form. Tournefort became Professor of Botany at the Jardin Royal in Paris in 1683, and his pupils there included Sir Hans *Sloane. His classification of plants was widely accepted until *Linnaeus rearranged the systematics of the world's fauna and flora. The illustrations of Tournefort's book, by Claude Aubriet, are superb engravings, described in the English version as 'about Five Hundred Copper Plates . . . all curiously Engraven'.

Elizabeth Blackwell's *Curious Herbal*, published in weekly parts and collected in two volumes in 1737 and 1739, is closely associated with the *Chelsea Physic Garden, as the industrious artist collected her plants there as she needed them, and drew, engraved, and coloured all 500 plates herself. The project was designed to free her husband from debt, and it was a success, helped by the printed recommendations of several eminent members of the Royal College of Physicians. The book's reputation remained high, although the etchings are stiff and the brief text, heavily indebted to Joseph Miller's *Botanicum Officinale* (1722), adds nothing new. An enlarged edition, with a Latin text added to the English one, was published in Nuremberg in the 1750s, with redrawn plates.

As botany's independent existence became well established, its link with medicine was by no means broken, as plants were still the main source of drugs, but herbals became less encyclopaedic as they were replaced by more mundane guides to materia medica. S.R.

Herbarium, from the classical Latin *herba*, grass, or any plant but especially a non-woody plant. In medieval Latin this was the normal word for a small garden, notably a physic garden of medicinal herbs; especially for an ornamental flower garden; and for a lawn, normally the main feature of such small gardens (see also *medieval garden; *pratum). Later the word changed its meaning to an arbour, a wooden framework such as a bower or pergola over which plants were trained, and confused with the Latin *arbor*, a tree. In English the word appears as herber.

The modern meaning of herbarium is a room or building which contains a classified collection of preserved plants.
 J.H.H.

Herber. See HERBARIUM; HORTUS CONCLUSUS.

Herb garden, in its current form a distinct descendant of the ancient Greek or Roman kitchen garden and the medieval monastic collection of plants grown for use in flavouring food, making medicine or perfume, and decoration. These purposes allowed such gardens to include roses, lilies, honeysuckle, and other plants that now seem to belong in the flower garden, with the contents of the herb garden usually limited to plants with some culinary or aromatic value, their names often showing their classical roots in antiquity. The standard plants include rosemary, parsley, sage, marjoram, thyme, and many mints, plain and variegated in foliage and flavour. Angelica, basil, bay, chervil, dill, fennel, lemon balm, lovage, rue, and tarragon, with many others, are also frequent constituents of herb gardens, which are often arranged in formal patterns with beds sometimes surrounded by low hedges, once again echoing the designs of their forerunners. The plants themselves vary from small annuals like basil and sweet marjoram to low-growing shrubs like thymes and tall and stately umbellifers like angelica and fennel. The attractions of herb gardens come from the variety of colour, shape, and texture of the foliage—silver, grey, golden, or variegated, as well as plain green—and a good design will make use of complementary plants to enhance each other.

The modern revival of the taste for herb gardens is probably the work of Eleanour Sinclair Rohde (1882–1950), whose books and articles, published in the 1920s and 30s, encouraged others to pay attention to this group of plants. She also designed many herb gardens. S.R.

Herculaneum, Italy. See POMPEII, HERCULANEUM, AND THE VILLAS DESTROYED BY VESUVIUS.

Herm, strictly, a representation of a head of Hermes rising from a pedestal, used in classical times to mark boundaries. In gardens the word is used loosely to signify any head on a pedestal base, which is either rectangular or tapers towards the lower end (cf. terms, which are capped by many kinds of head, figure, or bust). They are often found opposite each other in series. *Chatsworth and *Chiswick House are but two of many examples. M.W.R.S.

Hermelin, Sven (1900–84). The doyen of Swedish landscape architecture, he participated in many organizations in Scandinavia, was Vice-President of IFLA, and wrote numerous articles in the Scandinavian professional press.

His landscape education included practical work in Danish nurseries and the Parks Department, Stockholm, followed by study in Germany, before he started his own practice in 1926. Hässelby Castle was probably his most outstanding historical project and, like that of all Scandinavian landscape architects, his work included churchyards and *cemeteries, but he was most widely recognized for his work in nature conservation.

Sven Hermelin was a pioneer, in that he refused to separate ecology from aesthetics, regardless of the situation.

He was convinced that it is the responsibility of the landscape architect to unite science and art in practical work.

<div align="right">P.R.J.</div>

Hermitage. A craze for hermitages swept Britain in the 18th c. Almost always of primitive, rustic construction (see *root-house), several designs are to be found in the pattern-books of the day. Decried by *Walpole, they none the less flourished for many years although real hermits were difficult to find: some were made of wax, or were clockwork, or stuffed! The best known hermitages were at *Badminton House, Burley on the Hill (Leicestershire), *Hawkstone Park, *Painshill, *Stourhead, and *Stowe.

Originally there may have been some serious attempt to convey the idea of retreat or meditation, but this was soon overtaken by fashion.

<div align="right">M.W.R.S.</div>

See also EREMITAGE; LUTTRELLSTOWN.

Hermitage, The, Arlesheim, Basle, Switzerland, was opened in 1785. The mountain garden was laid out by Canon Heinrich von Ligertz and his cousin Balbina von Andlau at the foot and on the hill of Castle Birseck. Natural caves and grottoes on the mountain slope above a narrow valley, with ponds, a stream, and water-mills are the main attractions of the garden which formerly had contained only romantic paths with viewing points. The caves and grottoes were named after ancient gods and goddesses such as Diana, Apollo, and Proserpina. The hermit's grotto was turned into a memorial grotto for the poet Salomon Gessner in 1789. The semi-automatic wooden figure of a hermit was placed inside a hermit's cell where it nodded its head when the door was opened. Other features to be found in different places on the mountain slope include a Chinese parasol, a charcoal-burner's mound as a tree-hut, the hermit's wood-pile as a viewing-cabin, and a Swiss mountain chalet.

The painters Johann Baptiste Sturtz and Johann Joseph Hartmann contributed to the design of the layout. The Strasburg professor Oberlin, a teacher of Goethe, wrote an inscription in honour of the builders and the painter Philippe de Loutherbourg, a friend of the legendary Cagliostro, created a new interior for the grotto of Proserpina in the spirit of occultism.

The Hermitage was destroyed in 1792 by French troops, but was reconstructed by Heinrich von Ligertz in a melancholy romantic mood in place of the earlier gayer rococo style. A cross, a chapel, and a memorial to Jacques Delille with a verse from his *Homme des Champs* were new additions.

Although from a distance the caves and grottoes are reminiscent of the hermitages of Bayreuth and Sanspareil, this Hermitage is clearly descended from the *ferme ornée*, inspired by the French rococo style. The relatively modest garden is unique in Switzerland. It lay in the bishopric of Basle, which was a part of Germany but comprised mainly French-speaking areas. Consequently the Hermitage combines French and German motifs with the style of the English landscape garden.

<div align="right">H.-R.H. (trans. R.L.)</div>

Hermitage, The, Nashville, Tennessee, United States, is the house built by Andrew Jackson for his occupation after retiring from wars and the presidency. The garden is over 0·5 ha. in extent and was laid out in 1819 by an English gardener named William Frost. Four very large squares surround a circular centre-piece of five circles, separated by four triangles. Cross-walks divide the whole into quarters. The walk towards the back of the garden leads to a 'necessary house'. When Jackson's wife Rachel—who loved flowers and was reputed always to pluck and arrange a nosegay for each retiring visitor—died in 1828, Jackson had a tomb built in the corner of one of the front squares and surrounded it with an appropriate planting of magnolias, crape myrtles (*Lagerstroemia indica*), and weeping willows.

Phlox paniculata, discovered in the exploration of the trans-Mississippi West, turns up here as a border flower with 'pinys' or peonies 'pink and white', verbenas, tulips, sweet williams, petunias, periwinkles, 'blue-bells', 'blue bottles', and 'golden candle-sticks' gracing the centre beds. There was a tree peony, rare at the time, and a collection of roses: 'large white cabbage', 'hundred-leaved pink moss', the 'old-fashioned little yellow rose', and the rose listed in letters as 'Mycrophellia' (*Rosa microphylla*, now *R. roxburghii*). Introduced into England from China in 1828, it rapidly established itself as a favourite garden rose in the southern American states.

<div align="right">A.L.</div>

Hero of Alexandria (1st c. AD), Greek writer and scientist, whose *Pneumatica* received much attention during the 16th and 17th cs., as one of the few surviving technological works from the ancient world. Circulated widely in manuscript form, the *Pneumatica* was first printed in 1575, in a Latin translation; it was translated into Italian by G. B. Aleotti in 1589, and frequently reprinted thereafter. Coupled with the garden descriptions of *Pliny the younger, Hero's explanations of hydraulic devices provide the principal sources of textual information for Renaissance designers anxious to emulate the spirit of classical gardens—though there is no evidence that any of Hero's inventions was included in the gardens of ancient Rome.

Hero's importance in Renaissance gardening begins with his influence on Pirro *Ligorio at the Villa *d'Este, Tivoli. Ligorio had studied a manuscript of the *Pneumatica* (he was a patron of Aleotti, who published the first Italian translation of Hero), and many of the waterworks at the Villa d'Este were derived from Hero's text. Most striking was the Owl Fountain (1566–8)—a group of birds whose song was produced by water-pressure, and who fell silent whenever an owl turned towards them. This comes, exactly and entirely, from section 15 of the *Pneumatica*: 'Birds made to sing and be silent alternately by flowing water'. Montaigne's description in his journal in 1581 shows the close link between Hero's text and the actual fountain.

Other gardens using hydraulic devices derived from Hero, via the Villa d'Este, were *Pratòlino in Italy, *Hellbrunn in Austria, *Enstone and *Wilton in England. Hero is also the source for the *automata—fountains, water-organs, trumpets, and fire-engines—described in Salomon de *Caus's *Les Raisons des forces mouvantes* (1615).

<div align="right">C.T.</div>

Herrenhausen, Hanover, Lower Saxony, German Federal Republic, was the summer residence of the Dukes and later Electors of Hanover as early as 1666; the first small garden also dates from this time. The celebrated baroque garden, the Grosser Garten, was the creation of the wife of Ernst August, Sophie, who was a daughter of Friedrich V of the Palatinate. (See *Germany: Versailles and the Baroque.) Her childhood in the Netherlands is reflected in the style of the Grosser Garten; her gardener, Martin Charbonnier, was sent to the Netherlands to study garden design. Sophie started planning the garden in 1680, and extended it in 1692 to its present size of 50 ha. It is rectangular in shape and is enclosed by a canal in the Dutch style. There is no adjacent hunting-park, a typical feature of French gardens of the time.

The layout is extremely regular, with a middle axis dividing the whole area. Thirty-two pieces of sculpture (vases by Chr. Vickens) adorn the large parterre, in the middle of which stands a round *bassin*. The parterre is bounded at the sides by high hedges, beyond which lie two large garden rooms: a hedge *theatre on the left and a maze on the right. Immediately to the south of the parterre are four ponds and below them a number of small hedged garden rooms which have been turned into gardens in various styles. The other half of the Grosser Garten consists of a star-shaped *bosquet*; in the middle stands the main fountain with a jet which reached a height of 35 m. (today it reaches 82 m.). *Bassins* with fountains stand at the intersections of the paths in the hedged lateral *bosquets*. Wide avenues lead around the whole garden and terminate at two pavilions at the southern corners.

The hedge theatre is an important feature of Herrenhausen. The stage, decorated with gilt-lead figures from the Netherlands, is in the shape of a trapezium (16 m. wide at the front, 8·5 m. at the back); beech hedges form the wings. A small orchestra-pit lies in front of the stage, while the auditorium is constructed in the form of an amphitheatre. Sandstone statues once stood around the sides of the auditorium. The theatre is again used for performances in the summer.

Sophie's son became George I of England in 1714 and the court was moved to London. This meant that the English landscape style was not imposed on the garden which could therefore be restored in its original form.

The Schloss was destroyed in 1943 during the Second World War and this gap in the total conception of the garden detracts from the effectiveness of the parterre. Only the orangery survived; tubs of plants have been placed in front of the building.　　　　　　　　　　　　　　　　U.GFN.D.

Hesdin, Pas-de-Calais, France, is the site of the most notable landscape park of the Middle Ages. It was the seat of an important castle of the Counts of Artois commanding the main road between Arras and its old port at Montreuil-sur-Mer. Count Robert II of Artois in 1295 enclosed a park of 940 ha. between the valleys of the Canche and Ternoise with a wall 13 km. long. The park, with the castle and the town of Vieil-Hesdin, was completely destroyed by the

Emperor Charles V after a siege in 1553. For details of the park see *pleasance.　　　　　　　　　　　　　　　J.H.H.

Hestercombe, Somerset, England, was the first garden where the partnership of *Lutyens and Gertrude *Jekyll was able to give full play to its combined imagination and skill.

The existing house of E. W. Portman had no special character; the site offered a broad upper terrace in front of the house, which remains, and a splendid wide view over Taunton Deane to the Blackdown Hills beyond.

Essentially the design (1906) is based upon the Great Plat, a large sunken *parterre diagonally divided by four long swards edged by flagstone, and bounded by stone walls supporting raised walks or terraces. On the east and west sides are narrow water-gardens with a favourite device of the partners—a central narrow rill or canal intersected by pools for water-plants. Along the south side for *c*. 72 m. runs a heavy pergola of stone with oak beams, joined by flights of steps to lower levels. At the north-east corner of the Plat, an open rotunda or water-court of Ham Hill stone forms a 'hinge' in the plan, from which another part of the design is developed on a different axis, as at *Ammerdown House. Here Lutyens built his superb orangery, in a direct line of vision from an opening in the rotunda, and on a terrace flanked by two complex flights of steps which terminates in a rose-garden in the Dutch style.

Hestercombe is remarkable for the bold, concise pattern of its layout, and for the minute attention to detail everywhere to be seen in the variety and imaginative handling of contrasting materials, whether cobble, tile, flint, or thinly coursed local stone. In the design details of steps, pools, walls, paving, or seating, Lutyens is seen here at his best. Since 1973 Gertrude Jekyll's planting has been restored from her original plans by the lessees, Somerset County Council, and the totality of the layout can once more be appreciated as a major work of art.　　　　　I.L.P.

Het Binnenhof, The Hague, The Netherlands. See NETHERLANDS: THE MEDIEVAL GARDEN.

Het Loo, Apeldoorn, Gelderland, The Netherlands. 'The Gardens are most Sumptuous and Magnificent, adorned with great variety of most noble *Fountains, Cascades, Parterres, Gravel Walks,* and *Green Walks, Groves, Statues, Urns, Paintings,* and pleasant Prospects into the Country . . . a work of wonderful *Magnificence,* most worthy of so *Great* a *Monarch;* a Work of prodigious expence, infinite variety, and curiosity', writes Walter Harris in his inimitably detailed description of the gardens laid out for *William and Mary between 1686 and 1695 (*A Description of the King's Royal Palace and Gardens at Loo,* London, 1699).

A hybrid of the Renaissance and the baroque, Dutch in layout and French in ornamentation, the gardens were the ultimate expression of William and Mary's gardening tastes in the Netherlands. According to Harris, physician to the king, Daniel *Marot was the designer of the gardens. However, the main outlines were most likely due to Jacob

*Roman, the king's architect, who executed the design of the sober hunting-lodge in 1685–6 and after the coronation in 1688 made later additions when it became a royal palace. Marot collaborated on additions and ornamentation after 1689 when the gardens were extended.

The general layout of the rectangular Great Garden (c.6 ha.), with a semicircular termination and adjoining roundel with radiating walks, recalls the pre-Le Nôtrean *Luxembourg Gardens, while in scale and intricacy it is similar to a French trianon or pavilion garden, such as the one at *Saint-Cloud where a statue of Venus was the central focus. As the most lavish of Dutch gardens, Het Loo was renowned for its ornamentation and in particular its fountains and cascades—Harris describes over 50 types of waterworks. The decorative motifs of many recall those at Saint-Cloud.

The enclosed Great Garden, whose central axis was aligned to the palace, was divided by a cross-walk, flanked by canals and oaks, into a terraced Lower Garden (220 m. × 125 m.) and an Upper Garden (220 m. × 140 m.), which was a kitchen garden until 1692. The Lower Garden contained eight square parterres accented by urns and was centred on a large marble statue of Venus supported by gilt tritons set in a basin with fountains. Along a cross-walk on either side of the Venus was a fountain of the celestial globe and a fountain of the terrestial globe, followed by a cascade of Narcissus and one of Galatea placed against the terraces. The Upper Garden was terminated by quarter-circle colonnades which formerly connected the house with the wings, and it was embellished by the monumental King's Fountain with water spouting to a height of 13 m. Instead of *bosquets* or woods, a series of intimate and enclosed *giardini segreti* were laid out around the Great Garden, such as mazes, small orangery gardens, and kitchen gardens. The enclosed King's and Queen's gardens lay under the respective royal apartments on either side of the building; the Queen's garden contained labyrinthine tunnels ('Arbour Walks'), reminiscent of those of *de Vries, which served as a model for the Bower Garden at *Elvaston in 1840.

In the park, beyond the Upper Garden on the east, was an aviary, the Grove of Saturn with six radiating avenues, nurseries, ponds, fountains, cascades, canals, and fishponds. The outstanding feature was the large square *vivier* or reservoir, 'one of the greatest beauties of the Garden; . . . planted with Limes . . . [and] Ewe Trees in Pyramids' (Edward Southwell's Journal, 1696). Leading from the aviary with its oval pond, the *vivier* was reached by a long narrow canal adorned with many water-jets. Against the wall of the pond was the most baroque decorative scheme of the whole garden, the Cascade of the Fishers or Cypher Fountain. In the centre of a stone balustraded double staircase was a cascade which fed several fountains set in a semicircle in front, as well as a highly decorative carved pattern of the royal monogram interwoven in a mosaic floor.

The gardens were transformed into a landscape park by Louis Napoleon in 1807. However, the palace and the Great Garden have been restored to their former splendour and were opened as a museum in 1984 in tribute to the House of Orange. F.H.

See also NETHERLANDS: THE DUTCH CLASSICAL GARDEN.

Heveningham Hall, Suffolk, England, was described in the Suffolk volume of the *Beauties of England* (1813) as standing 'on rising ground from where it appears to great advantage from various parts of the extensive park which abounds in fine plantations, and is diversified by a noble piece of water'. The plantations, it was also noted, were 'mainly of oaks, beeches and chestnuts' to which the soil was particularly favourable, and these still predominate in the setting of the house, with its unusually long façade of 23 bays (*see over*).

Designs for the park were prepared for the then owner, Sir Gerard Vanneck, by 'Capability' *Brown in 1781 after he had made two journeys to Heveningham, and although his sudden death early in 1783 cut short his own supervision of the work, much of what he proposed was carried out, including the damming of the little River Blythe to form the lake. Brown's account mentions 'alterations about the kitchen garden' which is shown on one of his plans and contains a 'crinkle-crankle' (*serpentine) wall. He was probably also responsible for the planting of several spectacular cedar trees which remain in the foreground of the nine-bay orangery, although the design for the building itself is attributed to James Wyatt who was working on the internal decoration of the Hall between 1780 and 1784.

After some years of uncertainty as to its future, Heveningham has now passed into the hands of a new and appreciative owner for whom an extensive programme of restoration is in progress. D.N.S.

Hever Castle, Kent, England, a 13th-c. castle, was bought in 1903 by the American millionaire W. W. Astor, who had it restored and a Tudor-style village built beside it, by Frank Loughborough Pearson. The gardens, by Pearson and the Kentish nurseryman Joseph Cheal, consist of an old English garden, in a series of hedged compartments, one of them containing elaborate topiary by Cheal; and an *Italian garden, laid out as a pair of lawns separated by a sunken garden, and terminating in a loggia by a large man-made lake. Flanking the Italian garden is a 'Pompeian wall', an exposed rock face with a border incorporating pieces of classical statuary and ornament within overgrowth suggesting encroaching nature. The separation of Italian and old English components marks a reaction against the Victorian concept of the Italian garden. B.E.

He Yuan, Jiangsu province, China, also known as Ji Xiao Shan Zhuang or the Retirement Manor, was named after He Zhidao, a local official who built it at the turn of the 19th c. It is the last known Qing-dynasty garden to have been made in the Yangzhou region, and is now blocked off from a large house, to which it was once attached.

It is composed of two sections separated by a double-storeyed *lang* walkway. In the western part, a two-storeyed *lou* of seven bays, called Butterfly Hall from its shape in

View of the park at Heveningham Hall, Suffolk, England, engraving in W. Watts, *Seats of the Nobility* (1779)

plan, faces the central pond with other buildings and *lang* surrounding it. A square **ting*, or open pavilion, which was used sometimes as a stage, stands in the middle of this pond so that the masters and their guests might enjoy performances while sitting casually in groups along the galleries around it. Climbing the steps of the rockery south-west of the pond, one reaches the first floor of another hall which overlooks the whole view. The focal point in the eastern section is a square hall open on all of its four sides with a smaller hall and *ting* beside it.

The double *lang* between the two sections greatly increases the illusion of size in the garden by allowing views of its rocks, trees, buildings, and lake from above and all round. It also separates the very different atmospheres of both sections—the western more dynamic and vivid, the eastern more peaceful and secluded. Such a use of the *lang* is rare in Chinese garden planning.　　D.-H.L./M.K.

Heythrop, Oxfordshire, England, was acquired in 1697 by Charles Talbot, 12th Earl and 1st and only Duke of Shrewsbury. Having toured in Italy from 1700 to 1705 he employed Thomas *Archer, who had also been to Rome, to build an Italian-inspired house, completed in 1716. This was accompanied by a vista to each façade, the main one being of clumps and extending for 3 km. to Heythrop

village, and extensive gardens including wildernesses and walled gardens. However, Stephen *Switzer, who was working at Blenheim in 1710, remembered the way the gardens united with the countryside when he wrote in *Ichnographia Rustica* that 'the first attempt of the kind I ever saw, and which in a great measure has prompted these thoughts, was at the Duke of Shrewsbury's in Oxfordshire'. Probably he was referring to the walks through the 'classical grove', which contained a rill and cold *bath, or those along the River Glyme which was dammed in places to give a bridge and eight cascades.

In the early 19th c. the Earls of Shrewsbury moved to *Alton Towers, and then Heythrop House was burned out in 1831. The house was restored in 1870 and many traces of the baroque gardens remain.　　D.L.J.

Hidcote Manor Garden, Gloucestershire, England, was developed during the first half of the 20th c. by the owner, Lawrence Johnston, a great plantsman with a strong sense of design. The result is a garden in which a rich diversity of plants is contained within a coherent composition.

The spinal cord of the design is an ascending walk, flanked in part by monumental yew hedges and in part by pleached hornbeam whose serried trunks give the effect of a *colonnade. This use of living material to give architectural

effects is a strong feature of the garden and is echoed in the imaginative use of topiary to provide the sculptural interest.

A series of hedged gardens lead off from the main walk. Their complete separation and enclosure allows each to appear as a carefully furnished room with its individual character. This gives scope for small-scale, detailed planting in some, while one achieves complete contrast with the simplicity of a large circular pool filling the whole enclosure.

The hedges, as well as being the bones of the design, are interesting in themselves partly by their sheer size, but also by their composition. The species used are the traditional yew, holly, and beech, but in places an interesting mottled patina is formed by mixing the species, such as holly interwoven with beech, particularly effective in winter.

The formality of the main walk is complemented by the simple lawn sweeping up to a majestic ilex and beeches. The lawn opens on to a view of the open country, but in general Hidcote is a self-contained concept, owing little either to its surroundings or to its relation with the house.

In placing Hidcote in a historical context, one can trace many influences. The concept of a safely enclosed 'paradise' garden (see Gardens of *Islam) goes back to the beginning of history, and Hidcote derives basically from the Persian (Iranian), via English Tudor gardens. But the modern ingredient is the vast influx of plants of the 19th c. The English landscape tradition relies on the restrained use of a limited range of plant species. It cannot cope with the variety of plants now available, and the desire to grow and enjoy this cornucopia has been the spur to developing a garden style peculiar to the 20th c. and exemplified at *Sissinghurst and Hidcote, both the creation of owners who combined an interest in plants with an ability to create the right setting for them.

While the strength of Hidcote's green architecture is probably the greatest impression made on visitors, it is interesting to note the number of plant varieties which bear the name 'Hidcote', and the horticultural interest also extends to a notable collection of old roses and a magnificent display of climbers on the house wall. The gardens were given to the National Trust in 1948.　　S.C.

Hilliers of Winchester, Hampshire, England, is a nursery founded in 1864 by Edwin Hillier (1840–1929), who bought the West Hill Nursery in the 1870s. His son, Edwin Lawrence (1865–1944), built up the foundation of the great collection of trees and shrubs which has made the nursery famous. He also planted a pinetum at the Shroner Wood Nursery, which was sold in 1914. Sir Harold Hillier (1905–85), a grandson of the founder and an authority on trees and shrubs hardy in the temperate zone, headed the firm from 1944 until shortly before his death.

The Winchester nursery and the associated Hillier Arboretum at Jermyns, Ampfield, near Romsey, includes about 14,000 different species or cultivars, many of them rare, recorded in *Hilliers' Manual of Trees and Shrubs*, first published in 1972 and now in its fifth edition (1981). Alan Mitchell describes the Arboretum, established in 1963, as

an 'immense collection of young trees, verging on the completely comprehensive', with 'utmost rarities galore'. In its 48 ha. there are also collections of alpine plants, herbaceous perennials, aquatic plants, heathers, and rhododendrons. The hillier Arboretum was given to the Hampshire County Council in 1977.

Hilliers have also settled some less hardy plants in the gardens of the Royal National Hospital at Ventnor in the Isle of Wight, where the local council's gardeners help to care for this newly established collection.　　S.R.

Hindu gardens. See INDIA: HINDU GARDENS.

Hirschfeld, C. C. L. (1742–92), was both a Danish emissary and Professor in Aesthetics at Kiel University at the same time. As an emissary he was required to establish a nursery near Kiel from which to distribute fruit-trees to the local farmers. He is perhaps best known for his five-volume *Theorie der Gartenkunst* ('Theory of Garden Art') (Leipzig, 1779–85), which also contains descriptions of the Danish royal gardens. This book had a profound influence on the spread of the style of the English romantic garden in Scandinavia. He maintained that 'garden art' should awaken the feelings of sorrow, happiness, or surprise, with variety in planting and by using architectural relics, to which sentimental inscriptions were added.　　P.R.J.

Hoare family, of *Stourhead. **Henry Hoare I** (1677–1725), banker, acquired the Stourton estate in 1718, and built the house designed by Colen Campbell, one of the first in the new Palladian style. His son, **Henry Hoare II** (1705–85) lived at Stourhead from 1741 to 1783, but had a house at Clapham where he died. As a banker he knew many of the leading personalities in the landscape movement: *Pope, William *Kent, *Burlington, *Switzer, and Charles *Hamilton. After his second wife's death in 1743 his passion was the making of the landscape garden at Stourhead, and the various buildings which adorn it. He acquired the habit, as he put it, 'of looking into books and the pursuit of that knowledge which distinguishes only the gentleman from the vulgar'. His reading and his discrimination as a collector of pictures are evident in the scenes he created and the literary references associated with them.

His son being dead, Henry Hoare II left Stourhead to his grandson **Sir Richard Colt Hoare** (1758–1838), son of his younger daughter Ann and his nephew Richard Hoare of Barn Elms, Surrey, created baronet in 1786. Colt Hoare inherited Stourhead at his marriage to Hester Lyttelton of Hagley in 1783, but on her early death went abroad from 1785 to 1791. Having severed connection with the bank according to his grandfather's wishes, he devoted himself to scholarship and pioneered the study of the prehistoric history of Wiltshire. Colt Hoare belonged to a new generation of patrons and plantsmen. His half-brother, Charles Hoare, employed *Nash and Humphry *Repton at Luscombe, Devon; he was connected by the marriage of his half-sister to the Aclands of Killerton; and his friend, A. B. Lambert of Boyton, dedicated the second volume of the

Genus Pinus to him. Colt Hoare added many new species of tree at Stourhead, and planted *Rhododendron ponticum* and *R. arboreum*. He cultivated geraniums and had some 600 varieties; Robert Sweet named plants after him. He left Stourhead to his half-brother.

The last major contribution to the grounds was made by **Henry Hugh Arthur Hoare**, 6th Bt. (1865–1947), who inherited Stourhead from his cousin, Henry Ainslie Hoare, 5th Bt., and lived there for 53 years from 1894. His fondness for azaleas and rhododendrons has left a permanent impression. As his only son was killed in 1917 he gave the house, gardens, and some 800 ha. to the National Trust. K.A.S.W.

Hodkovce (formerly Hotkóc), Hungary, from 1636 the estate of the Counts Csáky. The small mansion was surrounded by a garden, possibly in the French style, which at the end of the 18th c. was transformed into a **jardin anglo-chinois* with many architectural pieces including an obelisk, a *tempietto*, statuary, and so on. A detailed description is given by the writer F. Kazinczy who, invited by the owner, visited the place in 1806. Still more details are known from a picture painted by Johann Rombauer (1762–1849), who in 1803 made a 'portrait' of the garden (now in the Hungarian National Museum), showing 20 features of the garden apart from the mansion. A.Z.

Hofwijck, Zuid-Holland, The Netherlands. With the collaboration of Jacob *van Campen, Constantijn *Huygens, the Dutch diplomat-poet and exponent of Dutch classicism, created between 1639 and 1642 his *villa suburbana* and gardens of Hofwijck in Voorburg.

The gardens reflect a personal interpretation of classical and Calvinist ideals as expressed by Huygens in his country-house poem *Hofwijck* (1650–1). The symmetrical and elongated rectangular plan (125 m. × 410 m. or *c.*5 ha.) was conceived to emulate the symmetry and proportion of the Vitruvian human figure whose perfection of form reflected God's creation. Intersected and surrounded by canals and composed of trees, grass, and water, the layout followed the outline of the human body from the moated villa representing the head, through an orchard flanked by avenues representing the chest and arms to an elongated wooded area with a mount in the centre representing the legs and knees. This anthropomorphic plan symbolized in moralistic terms the path of redemption as one progressed from the terrestial world of the woods, through the perfect world of the Edenic orchard to the contemplation of God in the villa. F.H.

Hogarth's Line of Beauty. Hogarth's serpentine Line of Beauty, seen on the palette of his self-portrait in 1745, and *Burke's definition of beauty as smoothness and gradual deviations had an important influence on mid-18th-c. landscape gardening. William Hogarth's *Analysis of Beauty* (1753) sought to establish the causes of aesthetic enjoyment, particularly what shapes and forms were universally pleasing. Waving and serpentine lines, which dominated

ideas on Georgian furniture and decoration as well as landscape gardening, were readily accepted forms of grace. They were already found in rococo ornament which drew inspiration from natural objects, shells, flowers, and seaweed, in which the line wandered freely. Both eye and mind relished being led 'a wanton kind of chase' by following the serpentine Line of Beauty. M.L.B.

See also BROWN, LANCELOT.

Holkham Hall, Norfolk, England, one of the great estates of the country, was created largely between 1720 and 1840 by Thomas Coke, 1st Earl of Leicester, and his nephew T. W. Coke (Coke of Norfolk, the agricultural improver). While on the Grand Tour between 1712 and 1718 Thomas Coke met William *Kent, who was later to work on both the new house and park; drawings by Kent for the grounds still survive at Holkham.

The first approach was from the south (now north) through Kent's triumphal arch built between 1739 and 1750. The two pyramids which originally flanked it have disappeared. Kent's obelisk was the first new structure to be built in 1730. It is centred on an axis through the house and was surrounded by a wood with eight radiating vistas, the main one forming the avenue. Kent also designed the walled garden to the south of the house on the site of the present *Nesfield terrace. This comprised an oblong basin linked to the Great Lake by a serpentine river, as well as several ornamental buildings including a seat on a mount. From this garden there was a view through a *palissade* to rows of trees based on the *corps de logis* at Versailles; beyond this could be seen the obelisk.

The Great Lake was reclaimed from a tidal inlet by a dam started in 1728. An island was made in it in 1739. In 1784 William Emes made sluices against the tide, removed the island, and enlarged the north end of the lake. Humphry *Repton's Red Book (his second) is solely concerned with the creation of walks and ornamental buildings surrounding the Great Lake. These included a ferry in the form of a floating gravel walk, a picturesque cottage for the ferryman, a grotto and fishing house, the latter to a design by Samuel Wyatt who also built many of the estate buildings between 1786 and 1806. This work was for T. W. Coke who inherited in 1776. John Webb enlarged the south end of the lake in 1801–3, and in 1847 a new island was made.

In 1762 Thomas Coke's widow employed 'Capability' *Brown who was concerned only with the immediate vicinity of the house; he did not remove the vistas or alter the lake. In 1833 the park wall was built and at that period was *c.*14 km. in length, the park having been considerably extended over the years from that inherited by Thomas Coke in 1707. The grounds were significantly modified by the 2nd Earl of Leicester, who in the late 1850s reclaimed 240 ha. of land and planted a 6·4-km. shelter-belt of Corsican pines. In 1854 W. A. Nesfield designed a series of terraces around the house; on the west front, the *parterre featured the Earl's initials in box, and on the south, a pair of sunken panels with flower-beds in a Louis XIV pattern

accompanied R. C. Smith's fountain, representing St George and the dragon. G.R.C./B.E.

Holland. See NETHERLANDS.

Holland, Henry (1745–1806), although primarily a notable English architect and interior decorator, was on occasion required to advise on garden layouts for work which came to him after the death of his father-in-law, Lancelot ('Capability') *Brown, in 1783. His surviving plan for *Althorp (1790) shows the sweeping drive which arrives at the front of the house, and the screening plantations proposed for the domestic offices and rear of the stables. For the same client, the 2nd Earl Spencer, he planned the surroundings of Wimbledon Park House in 1800 (now demolished), while for the 5th Duke of Bedford his garden buildings at *Woburn Abbey in the late 1780s included the original greenhouse (subsequently turned into a sculpture gallery), and the Chinese dairy overlooking a small lake to the north-east of the house. He also devised the covered walk or 'corridor' of timber posts supporting a slate roof which stretched for a considerable distance to connect the greenhouse and dairy. This feature was later to be adopted by Humphry *Repton for several of his works. Holland's arrangement of walks, shrubberies, and flower-beds appear in some of his drawings—now in the Royal Library at Windsor Castle—for the Royal Pavilion at Brighton, which he enlarged for the Prince of Wales from 1787 onwards.
D.N.S.

Holland Park, Kensington, London, was leased by Henry Fox, later 1st Lord Holland, in 1746. William *Kent designed the terraces close to the house, and Charles *Hamilton planned the open parkland and turfed the Green Walk (now Abbotsbury Road). He introduced different species of oak, cedars, and various American trees. His work was highly praised by Elizabeth Montagu (the noted bluestocking). Hamilton collaborated in the 1750s with Peter *Collinson, who corresponded with Fox about particular flowers, plants, and trees. The park was dotted with individual trees and 'clumped' according to 18th-c. practice, but, interestingly, a star-shaped *wilderness was left, although it had somewhat deteriorated. None of Hamilton's design or plantings survives.

In the early 19th c. the first dahlias in England are said to have been planted by Lady Holland. The formal flower garden was laid out in 1812, and later in the century the Lime Avenue and Rose Walk were formed. In 1965 the Greater London Council assumed responsibility for the park (now 22 ha. in area), which has now been recognized as a conservation area. M.W.R.S.

Home, Henry (1696–1782), Scottish lawyer. See KAMES, LORD.

Homer (early 8th c. BC), Greek poet whose lyrical descriptions of nature ('rosy-fingered dawn') influenced ancient *Greece in its appreciation of landscape and garden species; funerary gardens, for example, included asphodel because of Homer's portrayal of the Underworld. Homeric epic blends contemporary Aegean culture (c.800 BC) with the heroic Bronze Age. Cretan and Mycenaean pottery (2nd millennium BC), painted with crocuses, lilies, grasses, and palms, and Theran frescos (16th c. BC), depicting mossy rocks sprouting lilies and myrtles, attest to keen interest in indigenous and imported flora. Frescos at Knossos show blue monkeys gathering saffron from painted pots in rock-gardens. At Amnisos, paintings featured lilies ('hybrids' of artistic convention) in huge pots or walled beds. Palaces (Knossos, Phaistos) probably had small gardens and potted plants in courtyards and light-wells, but cultivation (even if performed by such kings as Laertes and Alcinous—*Odyssey*, 18.359 ff., 7.112 ff.) was mainly for estates, kitchen gardens, and orchards (*kēpoi* or *orchatoi*), producing figs, olives, pears, pomegranates, apples, vines, and greens. J.M.T.

Hong Kong is faced with the problem of an enormous programme of landscape development. With the continuous expansion of the population within so small a territory, there is an intense conflict between the need to achieve a high yield of food production, the conservation of forestry and wild areas, high building densities, and the need for recreational green space. There are many significant landscape schemes in preparation by design practices from Britain and elsewhere but few have reached maturity. With the critical conditions of climate, terrain, and availability of plants, Hong Kong can bear, as yet, scant comparison with the lush urban landscape of Singapore.

Nevertheless, there are several parks, gardens, and open spaces of considerable interest. These include the strange Tiger Balm Gardens on Victoria Island, the Sha Tin racecourse park in the New Territories, and numerous lush private gardens, but the most outstanding large gardens are the Kadoorie Botanic Gardens in the New Territories. In 1951 Sir Lawrence Kadoorie (now Lord Kadoorie) and his brother Horace Kadoorie founded on a ridged and mountainous site at Paak Ngau Shek the Experimental Farm and Botanic Gardens, which provide for research and experiment over a wide range of Hong Kong altitudes. They are concerned particularly with the cultivation of amenity species suitable to Hong Kong and its problems, including the covering of unsightly rock faces which result from site and road developments.

The winding hill road within the gardens allows access by car to most of the sections, and from near the Direction Pointer Summit, at c.600 m., the gardens follow the rocky, descending course of a stream through the Orchid Falls. Particularly notable are the collections of creepers and trailing plants, native species of dwarf rhododendrons, and flowering trees such as bauhinia, erythrina, lagerstroemia, and callistemon. Below the summit of Kwun Yum Shan, at 550 m., an area of many ha. is retained as a natural mountain flora reserve.

Look-out points and pavilions are located for visitors to enjoy views of the gardens and experimental farms and the

dramatic scenery of the surrounding hills of the New Territories. M.L./M.L.L.

Hong Lou Meng (*Dream of the Red Chamber*) is China's best-known classic novel. It was written in the mid-18th c., the first 80 chapters by Cao Xueqin (b. 1763), the last forty by Gao E (*c.*1738–1815); many of its significant events are set in the Da Guan Yuan or Grand View Garden, which is vividly and precisely portrayed. The descriptions of this garden and its creation in the novel greatly influenced later Chinese garden design. The work has been variously translated as *Dream of the Red Chamber* (trans. and adapted by Chi-chen Wang, 1929), *A Dream of Red Mansions* (trans. Gladys and Hsien-yi Yang, Peking, 1978), and *The Story of the Stone* (trans. David Hawkes and J. Minford, London, 1973, 1980, and 1982). G.-Z.W./M.K.

See also BIAN; GONG WANG FU.

Honselaarsdijk, Zuid-Holland, The Netherlands. In 1621 Prince *Frederik Hendrik began rebuilding the castle and laying out the gardens which together formed an architectural unit. Lying in a polder to the south of The Hague and covering *c.*8 ha., the gardens were a prototype of the Dutch classical canal garden with their shape and disposition of parts reflecting a Dutch interpretation of the Vitruvian-Albertian principles of harmonic proportion and symmetry.

The rectangular plan enclosed by water and trees and the moated palace encapsulated by the gardens both had a proportional relationship of width to length of 3 : 4. House and gardens were united by a central axis, on either side of which were laid out three symmetrically corresponding compartments, consisting of parterres, circular hedged walks, and orchards. A dominant avenue or vista terminating in a large semicircular piazza (1625) at the forecourt served as an appropriate introduction to the palace, the theatrical effect of which reflects Dutch expertise in the laws of optics and perspective.

The gardens are one of the earliest examples in northern Europe of a total plan based on one of the Pythagorean-Albertian harmonic ratios, and of the use of a large Italianate amphitheatre and grand entrance-way. The gardens' proportions, their enclosure by water and trees, and the entrance avenue cum piazza served as a model for one of André *Mollet's plans. However, the static Renaissance nature of the garden's inner spatial organization with its emphasis on parallel axes, a typical feature of the Dutch 17th-c. garden, bore no relationship to Mollet's baroque orchestration of the inner parts.

By replacing the circular walks with one large parterre garden adorned with fountains and statues and the orchards with dense woods through which a dominant axis led the eye far into the distance, the gardens had by 1680, under William III and Princess Mary, achieved a certain baroque allure. They were destroyed in 1815. F.H.

Hooker, Sir Joseph Dalton (1817–1911), English botanist, was the younger son of Sir William Jackson Hooker and succeeded his father as Director of the Royal Botanic Gardens, *Kew, in 1865. His career as a botanist began in

Honselaarsdijk, Netherlands, engraving by A. Blooteling after a drawing (*c.*1680) by A. Bega (Leiden University Library)

1839 when he sailed to the Antarctic with Sir James Clark Ross on the *Erebus*. The botanical results of this expedition were published from 1844 to 1860 in large volumes on the flora of the Antarctic islands, New Zealand, and Tasmania. Hooker's scientific work on the voyage led to friendship with Charles Darwin and constant discussion of his work on the origin of species, which Hooker presented at a meeting of the Linnean Society in 1858 and supported in the subsequent controversy.

In 1847, the year of his election to the Royal Society, of which he was later President, Hooker left for India, where he travelled in the Himalayas, especially Sikkim, Nepal, and Bengal. When he returned to England in 1851 he brought back specimens of nearly 7,000 plants but publication of some of his drawings and descriptions had already been started by his father. Of the books based on the Indian journals and collections *Rhododendrons of the Sikkim-Himalaya* (1849–51) had the greatest influence on European gardens, for among the rhododendrons Hooker collected were nearly 30 new species, enough to establish the popularity of the genus in the south of England and suitable regions elsewhere. His other introductions from the Himalayas included *Primula sikkimensis*, *P. capitata*, and the blue orchid, *Vanda caerulea*.

Hooker was appointed Assistant Director of Kew in 1855 and there he continued work on the distribution and classification of plants, publishing *Genera Plantarum*, written in collaboration with George Bentham, from 1862 to 1883, as well as other standard books on both British and Indian flora. His last plant-hunting expedition took place in 1871, when he went to the Atlas Mountains in Morocco with John Ball, founder and first president of the Alpine Club, and George Maw, who had a garden at Bentham Hall in Shropshire and later became the author of an important monograph on the genus *Crocus*. The journey covered a relatively small area; of the plants brought back only the annual *Linaria maroccana* is frequently grown now. S.R.

Hopetoun House, West Lothian (Lothian Region), Scotland. Sir William Bruce of Kinross and Alexander Edward built the house and laid out the gardens. The site dictated an unusual arrangement: the shelf of land on which the house and gardens stand runs from east to west, and the best view is the panorama to the north, while to the south the ground rises fairly quickly. Bruce and Edward established the long axis parallel to the Forth and, according to early 18th-c. visitors, orientated on North Berwick Law. Terminations of this kind were greatly favoured by the gardening circles of Edinburgh, and were an especial favourite of Bruce, though the distance does make the prospect a remote one.

Hopetoun was greatly extended by William *Adam within 20 years of completion and it is not clear which parts can be attributed to Bruce and Edward, and which to Adam. However, the siting, the great parade at the east front, and perhaps the wilderness and terrace walk overlooking the Forth are early work: these were noted in the early 1720s by Daniel Defoe and John Macky, the travel writer, who compared the view to that from Frascati (*A Journey through Scotland*, 1723). The terraced walk with its hedges and bastioned viewpoints provides prospects of ruined castles, the town of Stirling, the estates of Fife, the busy Forth, and the park in the foreground.

Adam prepared a plan of the grounds in 1725 which shows, apart from the work of Bruce and Edward, his own design for a widened, and grandly simple great *parterre to the west and beyond that a complex of canals and *bassins* but these were never constructed, although the reservoir to feed them was built in the high park to the south.

Hopetoun survived all subsequent fashions in garden and landscape design, and remains as an excellent example of an early 18th-c. Scottish estate. W.A.B.

Horticultural journalism. See GARDEN JOURNALISM.

Hortus conclusus, literally an enclosed garden, a secret garden within a garden. There is a literary/religious symbolism dating back to the Song of Songs which associated the Virgin Mary with the term: 'enclosed' represented her intact virginity, and the fruition of the garden represented the flowers of virtue. This garden was often contrasted with the lost Eden. When the medieval cult of the Virgin was at its height, Mary was identified frequently with the rose, and 'Mary gardens' would contain flowers each with its own meaning.

In practice the enclosed garden was often a rose-garden with fountains, walks, and arbours, surrounded by a hedge or wall, sometimes with *turfed seats, a lawn, and paths. The term 'herber' was sometimes used synonymously. Some enclosed gardens were ecclesiastical, some secular, and their purpose was for delectation and entertainment. M.W.R.S.

See also GIARDINO SEGRETO.

Hortus medicus. See BOTANIC GARDEN.

Hortus Palatinus, Heidelberg, Rhineland-Palatinate, German Federal Republic. Heidelberg owes its Renaissance garden to the daughter of the English King James I, Elizabeth Stuart, who was married to the Elector Friedrich V of the Palatinate in 1613. Elizabeth summoned from England her former drawing-master, Salomon de *Caus, and instructed him to design and construct a garden around the Schloss to replace the existing garden outside the city gates. De Caus had gone to Italy at the age of 19 and had remained there for three years.

In 1615 he began work on the garden which was to be laid out on five superimposed narrow terraces; high retaining walls had to be built up from the Neckar valley to support the lowest terrace. The east terrace, which is at right angles to the rest of the garden and extends northwards towards the river valley, affords a splendid view over the valley of the Neckar. The individual terraces were divided in the Renaissance style by hedges and pergolas, as can be seen from de Caus's *Hortus Palatinus* (1620).

Typical Renaissance elements, such as a maze, gazebos, *bassins*, statuary, and tubs of plants, embellish the garden.

Hortus Palatinus, Heidelberg, German Federal Republic, view from the east, engraving (1645) by Matthaeus Merian

Most important, however, were the innumerable waterworks and grottoes designed by de Caus, most of which were musical—a unique occurrence in German garden design. The figures were moved by a water mechanism and often played a musical instrument; de Caus even composed music for his water-organs. As a result of damage during the Thirty Years War (1618–48) and the devastation of the Palatinate between 1689 and 1693 under Louis XIV, it is not possible to determine how many of these grottoes were actually constructed, but at the time the garden was hailed as 'the eighth wonder of the world'.

The Elector Friedrich V was named King of Bohemia (the Winter King) in 1619 but soon after was forced to leave Bohemia for exile in the Netherlands, and the garden at Heidelberg was never completed. There still remain today the Renaissance terraces (although they are not appropriately planted in Renaissance style), a number of grottoes, and the ruins of the bathing-grottoes and heating-chambers. U.GFN.D.

Hospital garden. Since Alvar *Aalto's pioneering Paimio (Finland) Tuberculosis Sanatorium was completed in 1932, there have been many good examples of landscape design for hospitals in the Scandinavian countries, Switzerland, West Germany, the United States, and, recently, in some of the countries of the developing Third World, where adequate resources are provided. But most of these are rather anonymous in character—few of them incorporating areas which are designed and maintained for specific user requirements. Where such areas occur they are usually outdoor extensions of the therapy departments incorporating facilities for horticulture (see also gardens for *disabled people) with little regard for the differing needs of all categories of patients, visitors, and staff.

In Britain there is a tradition of siting hospitals in old 'mansions' with mature gardens in the English landscape or Victorian styles. Wartime expansions have invariably littered these with grids of semi-permanent buildings, with the result that the landscape maintenance is divided between the upkeep of long-established tree-studded lawns and the beds and borders surrounding the newer buildings. As medical facilities have improved and the buildings have been expanded the grounds have been further eroded, as has the number of staff needed to maintain them. As a result there is a need for all hospital authorities to follow the good example of the few in commissioning master plans to cover the whole of the sites in terms of design phased in accordance with the time and labour available. M.L.L.

Hôtel du Peyrou, Neuchâtel, Switzerland, was built with its gardens between 1765 and 1771 by the Bernese architect Erasmus Ritter, who had trained in Paris, for Pierre-Alexandre du Peyrou, a French friend of Jean-Jacques Rousseau. The splendid building is raised at the front above the level of the garden, which is bordered by ramps with star-shaped sections containing a round water basin at the centre. Corner pavilions and an inward-curving gate terminate the street side. The fusion between house and garden reminds us of the classicism of the Paris architect Soufflot, Erasmus Ritter's teacher. H.-R.H. (trans. R.L.)

Hothouse plant. Many tropical plants were brought into Britain from the early 17th c. onwards but the major sensation must have been the first orchid that flowered in 1733. It was supposedly a dried, preserved botanical specimen, sent in 1732 from the Bahamas to Peter *Collinson, but despite the four months' journey the pseudobulb of the orchid showed evidence of life. It was planted in a green-

house where it soon sprouted to flower the next summer. From that time onwards orchids and other tropical plants have been imported into cooler countries to be grown in the protected conditions of *greenhouses, heated *conservatories, or indoors.

The type of plant introduced into northern countries and the year of arrival depended very much on the exploration of the tropical colonies: in the Netherlands the earliest plants came mostly from the Dutch East Indies (Indonesia); the early importations of Spain and Portugal were from Central and South America; the West Indies, West Africa, and the Himalayas provided the majority of British imports. In addition, the activities of overseas religious missionaries, particularly from France, resulted in the introduction of many tropical species. Very little was known about the cultural conditions necessary to grow these early importations successfully. The plants were never accompanied by any information about their native habitats and few people had any accurate notion of what tropical climates and soils were really like. It was assumed that all the tropics were hot and steamy jungles, or hot and completely dry sand deserts. Stove houses, such as the 'Great Stove' at *Chatsworth, were an essential department of large country-house gardens. Many plants survived but many more died.

However, this did not deter the growers whose standing among their peers was enhanced by their ability to coax exotic species into flower and fruit and vast quantities of plants were imported into England and elsewhere in Europe, particularly Belgium. Rich land-owners, such as Earl Fitzwilliam and the Duke of Devonshire, and the larger commercial nurserymen like *Veitch, Bull, and *Loddiges, became the patrons and employers of plant-collectors such as Micholitz, George Don, *Masson, and Gibson, who endured severe deprivations and hardships, and even lost their lives in satisfying the demands of their masters. Much rivalry existed between patrons and employers and between collectors from competing firms.

Many plants died *en route* to Europe but enough reached the nurserymen and private growers to enable large fortunes to be made and lost. The great horticultural auctioneers such as Protheroe and Morris played a significant but rarely recorded part in the spread of tropical plants into temperate garden greenhouses. Sanders of St Albans, the royal orchid-growers, spurred on the fashion for tropical plants, and an orchidomania, rivalling the earlier tulipomania (see *tulip), spread throughout Europe in the 1880s. Sanders had two railway sidings in use day and night unloading orchids.

Gradually, through the scientific and horticultural expertise of such bodies as the *Royal Horticultural Society and the Royal Botanic Gardens, *Kew, more care was given to the cultivation of hot-house plants. It was realized that different plants required warm, intermediate, or cool 'tropical' houses and various types of soil and amounts of water. Even today, with high fuel costs, there are several large collections of tropical plants in private hands as well as in public ownership. Bromeliads (pineapple family), orchids, ferns, aroids (arum family), and cacti are still widely grown

as species but breeding programmes have produced a still greater range of hybrids to suit many purposes.　　P.F.H.

Houston (or Houstoun), William (1695?–1733), was an English physician who went to the West Indies in 1730 as surgeon on a ship belonging to the South Sea Company. The following year the ship was wrecked near Vera Cruz, Mexico, and its surgeon stayed in the area, sending plants and seeds to Philip *Miller at the *Chelsea Physic Garden. He was commissioned by a syndicate led by Sir Hans *Sloane and Lord Petre 'for improving botany and horticulture in Georgia', but he died in Jamaica before reaching the colony. The orchid *Bletia verecunda* was one of the plants he sent back. Others were *Datura arborea*, the sandbox tree *Hura crepitans*, and the climber *Petrea volubilis*, named after one of his patrons.　　S.R.

Huang shi or yellow rock is a kind of limestone rock commonly used in making artificial hills (*jia shan*) in Chinese gardens; this is mostly quarried from places in the Chiangjiang (formerly Yangtze River) delta such as Suzhou, Changzhou, and Zhengjian. Named after its colour and very hard, in form it is characterized by flat surfaces with sharp edges and streaks that suggest the brushwork found in classic Chinese paintings.　　X.-W.L./M.K.

See also TAIHU ROCK.

Huan Xiu Villa, Jiangsu province, China, lies in Suzhou, on a site which in the 10th c. had belonged to a prince of the Qian family. After innumerable changes of ownership, it came in the mid-19th c. to a family named Wang who renamed it Huan Xiu, meaning literally A Villa surrounded by Elegance.

Most of its buildings are now ruined and, including a pond, it covers only 0·07 ha., but the whole point of the garden lies in the huge artificial hill (*jia shan*) of *Taihu rocks that takes up nearly half of the site. Said to have been designed by one of the most famous of all rock-artists, the Qing dynasty *Ge Yu liang, it has long been ranked among the best of all such works in China. The main part lies on the eastern side of the garden, where its steep cliffs and peaks are said to imitate exactly in form and structure, and in the grains and veining of the rock, those of a natural rocky hill. Moreover, the 'mountain' is built around and above interior grottoes and chambers which add a sense of strangeness and adventure to the domestic beauties of the garden. The whole is regarded as an unusually skilful and rare example of what can be done to reproduce the dramatic effects of a mountainscape in a limited space.　　G.-Z.W./M.K.

Hua Qing Gong, Shaanxi province, China, lies 20 km. east of the city of Xian. The site of this garden below pleasant hills has long been famous for its hot spring. Early in the time of the Emperor Qin Shi Huang (who first united China in 221 BC), there was already a short-stay royal villa here which the great Tang dynasty Emperors Tai Zhong and Xuan Zhong developed into elaborate palaces. Xuan Zhong (712–55), a cultivated as well as powerful ruler, spent each

winter there with his favourite concubine, Yang Yu-huan (Guifei), whose legendary beauty is supposed to have so bemused him that he lost interest in affairs of state. The whole hillside was included in his garden-palace, which was lavishly endowed with building complexes, bathing pools, pavilions, and hidden retreats. Above all, however, it was famous for the effects of its huge bluish-green fir and jade-green pines in the evening twilight. Eventually the Emperor's dissoluteness led to an uprising and the palace was greatly damaged. What today is still called the Hua Qing Spring, which includes a bathing pool said to be that of Lady Yang, is in fact only a very small part of what was then the palace. Its buildings, rebuilt and opened to the public in 1956, nevertheless still preserve names like the 'Hall of Dancing Frost', and the 'Crab Apple Flower Bathing Pool' given them in T'ang times. G.-Z.W./M.K.

Humāyūn (1508–56), 2nd Mogul Emperor (1530–56), was the only one of the six Mogul emperors who made comparatively little contribution to garden design. His most important contribution to the arts was that he had brought back from Persia two painters, Khwaja Abdus Samad and Mir Sayyid Ali, who became the founders of the Mogul school of painting, noted for its illustrations of garden design. He is said to have completed one of *Bābur's garden palaces at Agra, the Chahar Bagh. S.M.H.

Humāyūn's Tomb, Delhi, India, was built by his widow, Haji Begum, and completed in 1573, although the surrounding layout was probably begun in his lifetime. It is the earliest Mogul garden known to have survived relatively unchanged. The site is level and the design—a *chahar bagh with an intricate pattern of squares arranged round an imposing central mausoleum, shows early Persian influence in the narrow watercourses and shallow pools. It illustrates also the Mogul tradition whereby, in the owner's lifetime, the garden was treated as a pleasure-ground and sometimes dwelling place, while after death the central pavilion became his mausoleum.

The tomb itself, of red sandstone with dressings of white marble, typifies a colour contrast increasingly used in later Mogul design. A head of water for irrigation was provided by a large tank built out at the back of a false gateway on the north wall. S.M.H.

Humboldt, Friedrich Heinrich Alexander, Baron von (1769–1859), was a German scientist who spent the years 1799 to 1804 travelling in Central and South America with the French botanist Aimé Bonpland, who was later involved in the supervision of the gardens at Malmaison in France. On their way they paused at the Canary Islands, before exploring parts of Venezuela, the Orinoco and other rivers, Cuba, Mexico, Colombia, Ecuador, and Peru. They surveyed the areas along their routes, collecting zoological and geological material as well as plants and recording more general observations on the countries and their inhabitants. The results of this journey were published in *c.*30 books over the quarter-century following their return to Europe,

with Humboldt spending nearly 20 years in Paris to work on the collections. The books, especially the account of the South American journey, were influential in attracting later travellers to the continent, among them Charles Darwin and Alfred Russel Wallace. Humboldt claimed to have brought back over 40 new plant species, the most familiar ones now being several dahlias, *Lobelia fulgens*, and *L. splendens*, all from Mexico. S.R.

Hungary. Gardening developed in Hungary in the 11th and 12th cs. through the activity of monks from western Europe. As they came mainly from France, their gardens probably had some resemblance to those in their own country: that is, they were small gardens mainly for growing vegetables, fruit, and herbs, with a scattering of flowers. The layout was geometric, and the gardens were surrounded by a fence.

After the Mongolian invasion of Hungary in 1242 the rebuilding of the country was accompanied by a new trend in garden design. These gardens, created by the king and the aristocracy and not only, as previously, by the clergy, were more elaborate and had a richer variety of trees and flowers. No exact descriptions of these gardens have come down to us, but they are represented on medieval altar-pieces.

Renaissance gardens. There was a royal garden under King Sigmund of Luxemburg (1385–1433), but we do not have any information about it. The great Renaissance King, Matthias Corvinus (1458–90), had a predilection for gardening and the importation of plants and trees, mainly from Italy. He had a carefully laid out garden surrounding his palace at Buda, with fountains and aviaries as well as symmetrical parterres. His garden was described by Stephanus Taurinus (*Stauromachia*, Vienna, 1519) and Antonio Bonfini (*Rerum Hungaricum Decades*, Basle, 1572); and represented in engravings by Erhard Schön (1541) and Georg Hufnagel (1672). Matthias also enlarged the garden of his summer residence at Visegrad. This had a masterly arrangement of terraces on the slope of the hill, providing a lovely view of the Danube and its mountainous banks. Both gardens had a labyrinth and terraced gardens—a real *giardino pensile* (hanging garden). As Bonfini was interested in architecture and sculpture rather than in the garden, we have no details about it. Following the example of the king, numerous members of the aristocracy created their own Renaissance gardens. These are mentioned in documents which do not, however, give any details or illustrations. The same is true of the garden of the humanist János Vitéz at Esztergom.

From 1541 to 1686 a large part of Hungary was occupied by the Turks. During these years gardening decayed and survived only in northern Hungary and Transylvania, where gardens in the late Renaissance style were preserved. On the other hand, Hungary owes to the Turks a great many kinds of imported flowers and trees, including citrus and pomegranates, exotic shrubs, and a multitude of herbs. Tulips in all colours, including green and lilac, were intro-

duced. These new varieties were grown not only in a few particular gardens but spread all over the non-occupied parts of the country. The first book published in Hungary was *Posoni Kert* ('The Garden at Pozsony').

French gardens. After the expulsion of the Turks, the reconstruction of palaces and gardens began. In the 1700s gardens became purely pleasure-gardens. The French formal style, with its symmetrical avenues, large parterres and *bosquets*, clipped trees and shrubs, became dominant. However, in Hungary we generally do not find either the great artificial canals or *bassins* typical of French gardens, perhaps because of the dry climate. Sculptures, fountains, and buildings in fantastic styles (Chinese tea-houses, Turkish tents, Gothic ruins, and so on) were scattered over the gardens, which were not enclosed and merged into the natural landscape or hunting grounds. Many exotic plants and trees, such as chestnut, catalpa, cactus, locust trees, hornbeams, and fig trees, were imported. An impressive garden heightened the standing of its owner. The largest and most famous French garden was at *Eszterháza (near Fertőd), and its example was followed by many smaller gardens, more than a hundred, although few have been described or illustrated. More information is available after their transformation into English landscape gardens; otherwise their size is unknown. Many of them are today situated outside Hungary, in Austria, Czechoslovakia, or Romania.

English gardens. In the final years of the 18th c. the architectural rigidity of layout became more relaxed, and a wide variety of small garden buildings and theatrical structures appeared, showing the influence of the picturesque garden in England. This transition began *c.*1780 (at Bonchida; *Csákvár; *Gernyeszeg; Körmend; *Martonvásár; and *Nagycenk) and lasted almost until 1820, especially in the more remote areas.

The first large English gardens were at Eisenstandt-Kismarton and *Tata. They display the general characteristics of this style: large stretches of lawn, winding paths, and the use of the original flow of streamlets, sometimes with bridges spanning them. There are few flowers, but a multitude of trees and bushes with their various colours presenting charming groups and vistas. Hills or small eminences were also included in the layout of the garden: the dramatic landscape was an important feature of the whole composition. The relationship between building and garden changed: architecture no longer dominated, as in the French garden—on the contrary, the building was generally not exposed but appeared abruptly behind a vast lawn surrounded by groups of trees. Elaborate greenhouses, sometimes in mock medieval (i.e. Gothic) style, were important, some of them constructed of glass and iron. *Tempietti* and wooden cottages were fashionable, not only for serving tea in the garden, but also as shelter from the rain. All this resulted in greater variety in foliage, such as that of many coniferous trees and acacias.

The English garden soon became a sweeping success: it spread quickly all over the country and flourished well after the middle of the 19th c. It furthered the study of new varieties of trees and shrubs, giving rise to commercial tree nurseries and the naturalization of southern trees and plants. Not only private gardens but also city parks such as Budapest *Városliget, which may have been based on the plans of C. H. *Nebbien, appeared during this period.

Among the first specialists in the English garden was Bernhard *Petri, who transformed the formal gardens at Vedrőd (Voderady), Hédervár, and Ivánka. His most important work seems to be the Orczy garden at Budapest. Around 1800 some gardeners and garden-plans may have

Városliget, Budapest, Hungary, lithograph (*c.*1850) by Alt and Sandmann (Magyar Nemzeti Museum, Budapest)

come from Vienna, where the Hungarian nobility used to spend the best part of the year. After 1810 Hungarian gardeners were encouraged by the Palatine Duke Joseph of Habsburg, who created an elaborate English garden at Alcsut. However, apart from Petri and Nebbien, nothing is known about any other outstanding personalities in this field. A.Z.

From the mid-nineteenth century. The naturalization of plants imported from abroad became common from the middle of the 19th c. In view of Hungary's continental climate, this difficult task was carried out mainly by the owners of large parks with advantageous local climates or by those who could create ecologically suitable sites by regulating the level of subsoil water or by planting shelter plantations. In this period several hundred parks of 10–50 ha. belonging to the aristocracy were reshaped or created anew. The designers of these parks were mainly the owners them-selves, who employed well-trained professional horti-culturalists. Pioneer work was carried out by Count Sándor Erdődy, the owner of the park at Vép, and his example was followed by a great number of landowners throughout the country, the most famous of whom at the end of the 19th c. was Count István Ambrózy-Migazzi. He planted a very large evergreen park at Malonya (now in Czechoslovakia) which at the beginning of the 20th c. inspired aristocrats to plant further parks, the majority of which were laid out around the mansions built in the centre of every estate. Unauthorized persons generally had no entry to these parks.

Public parks and gardens. In Budapest, public parks created earlier were further developed: for example, Városmajor (laid out in 1785, rebuilt in 1886, in 12 ha.); Városliget (laid out in 1813, rebuilt in 1873–85, in 76 ha.); and the first trees to bind the sand of today's Népliget (People's Park, 121 ha.) were planted in 1855—it became a park in 1893–6. The Margaret Island (66·4 ha.) was Habsburg property until 1908 and was bought by the town in 1909. A great number of smaller parks and promenades were also laid out in Budapest, most famous among them being the Elisabeth Garden (the former Market Place, 2·5 ha., laid out in 1853–4); Joseph Square (2·5 ha., 1877); Stephania Coach Prom-enade (1882–5); and Kossuth Square (25 ha., 1913, rebuilt 1930).

Some recent public gardens are Gellért Hill (37 ha., 1901–5 and 1965); Tabán (17·5 ha., 1932–6); Vérmező or Bloodfield (14·2 ha., 1952); Feneketlentó or Bottomless Lake (6 ha., 1957–60); and Obuda Island (43·2 ha., 1975). Large private gardens around palaces were also laid out within the town, for example Károlyi Garden (7 ha., 1832). Several public buildings are surrounded by famous gardens, such as the National Museum (25 ha., first tree planted in 1855). In the last quarter of the 19th c. the rich bourgeoisie and the intelligentsia built villas in the healthy areas of the town, surrounding them with large and beautifully laid out gardens with valuable plants. One example is Vilmos Manninger's garden in Buda.

Outstanding park designers and directors of municipal gardens in Budapest were Emil Fuchs (1867–92), Keresztély Ilsemann (1892–1912), and Károly Räde (1912–30). Béla Rerrich was an architect, Professor of Landscape Architecture, and a prominent designer in the 1920s and 30s. M.MO.

See also HODKOVCE.

Hunterstoun, Cape Province, South Africa. The site was chosen and the garden started by David Hunter; the main design and development were carried out by his daughter, Monica Wilson, and her sons. The style of the garden is determined by its magnificent natural setting in a mountain valley and nothing is allowed to block the feeling of freedom and space which it gives.

Monica Wilson was strongly influenced by visits to Japanese and English gardens. The entrance to Hunters-toun is by an avenue of *Castanea sativa* (Spanish chestnut), underplanted with *Rhododendron simsii* and *Azalea indica*. The avenue passes the Lochan, a 1·5-ha. stretch of water in which are reflected a glorious collection of trees and shrubs, chosen either for their beauty of flower or foliage or, in the case of *Pinus radiata* (Monterey pine), preserved because the herons nest in their branches. Four streams run through the garden, one of which was dammed to form the Lochan, and lower are a series of pools edged with *Zantedeschia aethiopica* (arum lilies), *Watsonia* species, and other water-loving plants. Everywhere the natural rock has been used with great skill and restraint. West of the stream, a group of long stones has been raised to stand on end and ground-cover plants cultivated among them. This is known as 'Henry Moore'. The bridges over the streams are stone-built and benches and walls are made of dressed stone.

Other features of the garden are a reflecting pool, near the house, a swimming-pool, the orchard with fruit-trees set in rough grass and bordered by *Liriodendron tulipifera* (tulip trees) and other tall trees, a herbaceous border, and a woodland area by the eastern stream where the primeval forest has been left undisturbed. An important feature is Monica Wilson's choice of plants to give brilliant autumn colours. J.G.R.

Hussey, Christopher (1899–1970), English author, was heir to his father's elder brother Edward from whom he eventually inherited the family home, *Scotney Castle. There is no doubt that this picturesque setting, against which much of his childhood was spent, helped to foster his keen interest in houses and gardens. He was still only 20 when an introduction to Edward Hudson, the proprietor of *Country Life*, led to a long connection with that journal in which he established his reputation as an outstanding writer on architecture. For some 40 years his articles appeared regularly therein, breaking away from the previous trend towards genealogy, and introducing a new standard of scholarship and accuracy. His architectural interests, however, were by no means confined to the past, and from 1924, when he reviewed the Architecture Club's exhibition at Grosvenor House, he frequently wrote on the work of contemporary designers. Hussey's first book, *The Pic-*

turesque, originally published in 1927, became a classic, as did his later series of volumes, *English Country Houses: Early, Mid and Late Georgian* (1955–8). A complete bibliography of his writings appeared in *Architectural History*, Vol. XIII (1970). D.N.S.

Huygens, Constantijn (1596–1687), Dutch diplomat-poet and secretary to the Princes of Orange, was an amateur architect and landscape architect and an exponent of Dutch classicism. Under the guidance of Jacob *van Campen, the designs of his house and garden in The Hague (1634) and of *Hofwijck, his *villa suburbana* (1639–42), were based on an interpretation of Vitruvian principles. The elongated rectangular layout of Hofwijck was based on the symmetry and proportion of the human body with the organs corresponding to the parts of the garden. Simplicity of composition and emphasis on the arboreal and on the predominance of the garden over the house were the main characteristics of this anthropomorphic garden. F.H.

Hybridization. Many garden plants owe their origin to cross-breeding (or hybridization) between wild plants followed by selection and further hybridization. Among these are the *chrysanthemums, gladioli, *narcissi, pansies, petunias, polyanthus, begonias, and many shrubs.

The first hybrid recorded as such was in the garden of T. *Fairchild in 1717, and was a natural cross between a carnation (*Dianthus caryophyllus*) and the sweet william (*D. barbatus*). Until that time the only hybrids known were in the animal kingdom and hence the hybrid plant was called 'Fairchild's Mule'.

The realization that pollen from a flower of one species put on to the stigma of a flower of another species could result in fertile seed soon led to the raising of man-made hybrids. The early hybridizers, who crossed species of *Nicotiana*, *Dianthus*, and *Verbascum* among many others, were more interested in hybridization as the proof of sexuality in plants and the inheritance of characters than as a means of producing new plants for gardens.

In the wild many related species occupy different geographical areas and hence have no opportunity of interbreeding. However, when brought together as cultivated plants spontaneous hybridization often takes place and can produce useful plants. Among such hybrids first arising spontaneously are *Epimedium* × *warleyense* (*E. alpinum* × *E. pinnatum*); the garden strawberry, *Fragaria* × *ananassa* (*F. chiloensis* × *F. virginiana*); garden catmint, *Nepeta* × *faassenii* (*N. nepetella* × *N. racemosa*); and Russian comfrey, *Symphytum* × *uplandicum* (*S. asperum* × *S. officinale*). The red horse-chestnut, *Aesculus* × *carnea*, is of special interest as its parents, *A. hippocastanum* and *A. pavia*, are very different in their genetic structure. The original hybrid red horse-chestnut was probably sterile but in the 18th c. a genetically fertile shoot was produced, and since then the plant has acted as if it was a separate and distinct species.

Many hybrids between species in the wild have been recorded, notably in such genera as *Rosa*, *Salix*, *Hebe*, and the marsh and spotted orchids, but a vast number have been created deliberately in gardens. Perhaps the largest number has been made in the genus *Rhododendron* where the numerous introduced species, very diverse in their characteristics, are very easily cross-pollinated. First generation hybrids, usually labelled F1 hybrids, often surpass their parents in vigour and other features and can be obtained from many nurserymen.

In the orchids (see *hothouse plant) and *grasses intergeneric hybrids formed by the deliberate crossing of species of different genera are quite frequent with nearly 80,000 such 'grexes' recorded in cultivated orchids. In other plant families intergeneric hybrids are not so common.

The designations of intergeneric hybrids are often coined from parts of the names of the parent genera, preceded by a multiplication sign. Examples are × *Laeliocattleya* (*Laelia* × *Cattleya*), × *Angranthes* (*Aëranthes* × *Angraecum*), × *Amarcinum* (*Amaryllis* × *Crinum*), × *Chionoscilla* (*Chionodoxa* × *Scilla*), × *Cupressocyparis* (*Chamaecyparis* × *Cupressus*), × *Fatshedera* (*Fatsia* × *Hedera*), × *Sorbopyrus* (*Pyrus* × *Sorbus*). This nomenclatural practice was initiated by Maxwell T. Masters in 1872 when he coined × *Philageria* for *Lapageria* crossed with *Philesia*.

Names of intergeneric graft-hybrids, or chimeras as they are often called, are similarly formed but with a plus sign. Moreover different names are given to graft hybrids and sexual hybrids derived from the same genera e.g. × *Crataemespilus* (*Crataegus* × *Mespilus*) and + *Crataegomespilus* (*Crataegus* + *Mespilus*).

The first man-made orchid hybrid was raised in 1856 by Veitch's gardener, John Dominy (1816–91), and was called *Calanthe dominyi* (*C. furcata* × *masuca*). From that time onwards extensive hybridization has been carried out among cultivated orchids, not only between species of the same genera but also of very different genera, and then the intergeneric hybrids were crossed with hybrids and species of other genera. There are now individual orchids involving eight distinct genera and 40 different species in their composition. Such multigeneric plants can receive names derived from their parents only when two or three parent genera are involved. To obviate increasingly longer names for such hybrids, E. A. Bowles, as long ago as 1910, proposed that the plants should receive the name of a prominent orchidologist with the added termination *-ara*. Examples include *Hookerara* (*Brassavola* × *Cattleya* × *Caularthron*) based on J. G. *Hooker and *Knudsonara* (*Ascocentrum* × *Neofinetia* × *Renanthera* × *Rhynchostylis* × *Vanda*) based on Professor Knudson, an orchid scientist.

In most plant families there are usually inbuilt incompatability obstacles to interspecific and intergeneric hybridization: mostly the stigma refuses the entry of foreign pollen into the ovary. Thus, in *Allium* only one successful crossing has ever been made, *A. cepa* × *fistulosum*. In the genus *Viburnum* there are now several garden-raised hybrids but these have always resulted from the crossing of species within the same botanical sections of the genus. When plants of hybrid origin become very numerous within a genus such as *Iris*, *Lilium*, *Narcissus*, or *Rhododendron*, the individual member now receives only 'fancy' or cultivar

names such as 'King Alfred', 'February Gold', 'Beersheba', 'Pink Pearl', 'Queen Wilhelmina', 'Ascot Brilliant', 'Alice', 'Curlew', 'Trewithen Orange'. With most groups of plants all such names are registered by one of the internationally designated International Registration Authorities. In genera with few hybrids, the first crosses have often been given names in Latin form like those of species, e.g. *Epimedium × cantabrigiense* (*E. alpinum × E. pubigerum*), *E. × rubrum* (*E. alpinum × E. grandiflorum*), *Viburnum × bodnantense* (*V. farreri × V. grandiflorum*), *V. × hillieri* (*V. erubescens × V. henryi*). Such names must now be published with a Latin description in accordance with the International Code of Botanical Nomenclature and they cover all hybrids derived from the same combination of parental species; hence cultivars of the same parentage, which may differ greatly from one another in horticultural merit, need each to be given a special cultivar name if they are to be vegetatively propagated and distributed, e.g. *Viburnum × bodnantense* 'Dawn', *V. × bodnantense* 'Deben'.

Today probably almost all the species of major horticultural importance have been introduced into cultivation. The years 1900 to 1930 were essentially the period of the introduction into European gardens of plants from western China. The period from 1930 onwards has been essentially the period of hybrids using the earlier introductions. Unfortunately the popularity of hybrids tends to the neglect and loss of the parental species in cultivation. These have both historic interest and breeding potential and need to be carefully preserved. W.T.S.

Hyde Park, London, although one of the royal parks (154 ha.), has been open to the public since the 1630s (originally for horse-racing). Under Henry VIII (1509–47) it was a hunting-ground and continued so for 200 years. Charles II (1660–85) established it as a forum for military reviews and fashionable promenades, and this tradition lasted till the 20th c. Queen Caroline, wife of George II (1727–60), was responsible for uniting Hyde Park with *Kensington Gardens.

The bandstand, as in the case of *Regent's Park, harks back to the London of the pleasure-gardens. Today a noteworthy feature is Speakers' Corner, reflecting the freedom of speech embedded in the British constitution which *Walpole said was irrevocably linked to the English garden. M.W.R.S.

Hypnerotomachia Poliphili ('The dream of Poliphilus'), a romance attributed to the Dominican friar Francesco Colonna (1433–1527), was published by Aldus in 1499. Best known for the *c.*200 woodcut illustrations, it has detailed descriptions of gardens, particularly those of the island of Cythera, where the lovers Poliphilus and Polia are united in the Temple of Venus. Compared with earlier romances, such as *Le Roman de la Rose* (see *rose), the author's concern is with architectural embellishment and ingenious artefact rather than the sensuous appeal of scents and sounds. The illustrations of elaborate topiary and flower-beds laid out in intricate interlacing designs (see *knot garden) are the earliest of their kind. The emphasis on antique remains and inscriptions is a source of the cult of such things in gardens. William *Kent owned several editions of the book, which had a considerable vogue in France from the time of *François I (1515–47). The mixture of Latin and Italian in which the original is written makes it difficult to read. The French version (1546) by Jean Martin and Jacques Gohorry is a paraphrase rather than a translation, with the illustrations redrawn and others added. An English version, *The Strife of Love in a Dreame*, translated by Sir Robert Dallington (1592), is incomplete, and does not include the gardens of Cythera. K.A.S.W.

Ice-house. The first important one in England was built in 1660 in St James's Park, London, for Charles II, though ice-houses had long been known to the Chinese. Often built into the side of a hill, a typical house had a shaft or well, made of bricks or stone, which was packed with crushed ice, sometimes salted to harden it. The entrance to the house was lined with straw for insulation; good drainage was also necessary. The ice itself was taken from a nearby lake or river and, kept dry, could last for more than a year. Ice-houses were popular in the 18th and 19th cs. and could be elaborate Gothic or classical structures, such as those at Dodington House, Avon, or Penrhyn Castle, Gwynedd. J. C. *Loudon describes and illustrates an ice-house in his *Encyclopaedia of Gardening* (1835 edn.). M.W.R.S.

See BURGHLEY HOUSE; CASTLETOWN HOUSE; DÉSERT DE RETZ.

Iford Manor, Wiltshire, England, an ancient house, was the home of Harold *Peto from 1899 to 1933. His garden rises up the steep side of the valley of the River Frome in a series of terraces, each with some pavilion or patio of his design incorporating archaeological fragments. More fragments are displayed alongside antique sculpture on the terraces, making it something of a museum garden, but it is a flower garden as well. Plants are crammed into paving and walls, and trained over the buildings; there are rock- and water-gardens, with pools fed by springs in the beech-wood further up the hill; and the scheme is punctuated with Italian cypresses which still survive today. G.M.

Ilm Park, Weimar, Erfurt, German Democratic Republic. The 48·3-ha. park was formed over the centuries from a number of individual gardens in the Ilm valley. In 1448 the French Garden, consisting of 20 compartments and agricultural areas (6 ha.), was created to the south of the Schloss. There was considerable rearrangement in 1690, but the Schneckenberg was preserved until 1808 despite the high cost of repairs. In 1685 mention was made of the Sterngarten on the other bank of the Ilm, but this soon lost its attraction and was put to agricultural use, with fish-ponds, and a woodyard joined to a canal.

In 1776 *Goethe purchased one of the gardens, and it was because of this, and the Nadelöhr (1778), a rock stairway on the west bank of the river, that work on the park was continued. Duke Karl August was the only person who was subsequently involved. The Luisenkloster, which survives as a bark house, was added to the existing façade structures. Beyond these, on the eastern side of the Ilm near the regular sections of the star design, the Läuterquelle and the Sphinx were built in 1786, and in 1788 three pillars were erected; they collapsed in 1823 and have not been re-erected.

From 1787 onwards all the various sections, some of which were still separate units, were joined together to form one park which by 1830 had attained its present size. After much earth-moving and planting, the Dessau Stone was inscribed in 1787 with the words 'Francisco Dessaviae Principi' to commemorate the influence of the Dessau–*Wörlitz cultural circle; the symbolic Snake Stone, inscribed 'Genio huius loci', was erected at the same time. In 1786–7 the small Orangery was converted into the Salon, a large garden house in strict neo-Gothic style, which after further alterations was named the Tempelherrenhaus in 1820 because of its decorations; it was destroyed in 1945. Between 1791 and 1797 the Römische Haus was built to Goethe's designs on the high west bank of the Ilm; this building dominates large parts of the park and demonstrates a transition from the romantic to the classical style.

Between 1844 and 1852 *Petzold had to do considerable restoration work on the garden as the trees had been neglected. Under the influence of *Pückler-Muskau, Petzold created highly picturesque scenes from the increasing tree growth. Extensive reconstruction work was begun in 1960. H.GÜ.

Il Trebbio, Tuscany, Italy, the hunting lodge of the Villa Medici, at Cafaggiolo (2 km. away), has one of the few Tuscan quattrocento gardens still in existence. The house, converted from a 14th-c. castle by Michelozzo Michelozzi *c.*1451, stands on a hilltop commanding extensive views. Unlike that of the Villa *Medici at Fiesole, built only a few years later, the garden is still medieval in spirit as it does not utilize the views. It is detached from the house, and consists of a walled rectangular enclosure, originally bounded on the long sides by vine pergolas. One of these survives, retaining its original columns made of *pianelle* (semicircular red bricks), based on grey stone plinths, and capped with foliage capitals. According to a lunette (*c.*1600) probably by *Utens, within this enclosure were eight square beds of flowers and vegetables. P.G.

Imperiale, Villa, Strà, Italy. See PISANI, VILLA.

Imperial Palace Garden, Beijing, China. See YU HUA YUAN.

Imp-garden (imp-garth, imp-yard) are old equivalents for the term nursery garden. The words are found in local English place-names as far back as the reign of Henry I (1100–35). J.H.H.

See also SPRING; VIRGULTUM.

India

Peninsular India and its northern hinterland offer as varied a topography as any in the world. From west to east it stretches from the arid scrublands of Rajasthan to the heights of Assam and some of the wettest places on earth; and from south to north from the coastal rain forests below the thermal Equator, over the dry Deccan tablelands to the great river systems of the Ganges and Indus and beyond to the Karakorams and some of the highest peaks in the world.

For all this diversity the biggest hindrance to its cultural expression in gardens is a lack of water. Conservation of water for food production has always been a matter of life and death and is expressed only incidentally for aesthetic purposes in the gardens of the very wealthy and the very important. Within the villages there are no gardens and no parks. The children play in the streets, the house compounds are largely unplanted, and what time there is after working in the fields is given to cultivating useful plants. Several villages may share a *mali* or gardener but his function is to provide the flowers needed for temple offerings, festivals, and weddings.

Against this struggle to subsist, the gardens of the great assume a special and symbolic importance. They reflect a hierarchical, highly ordered society centred on the *chakravatin* ruler, or King of Kings; distinctive from at least the end of the 2nd millennium BC during the long period of cultural assimilation between the light-skinned Aryan pastoralists migrating down from the Iranian plateau, and the dark-skinned indigenous Dravidian peoples who were predominantly farmers.

Of these great Indian gardens, the first known, dating from the 4th and 3rd cs. BC, was that of the Mauryan King Chandragupta, at Patalipotra near modern Patna. A near contemporary account by Aelian refers to fish-filled tanks of remarkable beauty, tame peacocks and pheasants, cultivated plants and shaded groves, parterres planted with trees apparently trained or pleached, and buildings rivalling in splendour the Medean and Persian palaces of Ecbatana and Susa.

Therefore, even at this early period, the Indian garden seems to have owed at least something to Aryan skills of irrigation and water display; and planting had begun to combine aromatic shrubs and bright short-lived annuals of the arid north-west with the gaudy and teeming life of the rain forest.

BUDDHIST GARDENS. Central to Buddhism is the idea of a garden as a place of retreat and meditation—typically planted with mango, ashoka, and jaman trees, and furnished with great water-tanks. The most celebrated of these retreats, at Gaya, Sarnath, Sanchi, and Nalanda, survive today not as gardens but as archaeological sites. The garden tradition to which they gave birth is stronger in *Sri Lanka, Burma, *China, and *Japan. In India the best traces survive in the square garden enclosures of the many excavated *viharas* or monasteries, each one cardinally orientated and containing the stone platforms and sometimes the railed enclosures of shrines, with tree temples dedicated to the *bodhi*.

HINDU GARDENS. The most memorable of all Indian gardens are the Islamic-inspired *Mogul gardens, although Islamic culture had begun to impose itself in India well before the coming of the Moguls. From the 12th c. onwards, a Turco-Afghan dynasty had established itself in Delhi. Extending its power in all directions, it reduced the surrounding Hindu kingdoms to clients and tributaries, and destroyed the great palaces and temples of the early medieval period. In the following centuries of Mogul domination the Hindu craftsmen serving the rulers of Rajputana and the Deccan achieved a distinctive Indian balance of Hindu and Muslim traditions—the Rajput style. The gardens of the *Amber palace at Jaipur show this at its most brilliant; something of it may also still be seen in the once fine gardens surrounding the exquisite tomb buildings among the ruins of the Adil Shahi sultanate of Bijapur further south, spared by *Aurangzīb but now a shadow of their former magnificence.

The more typically Hindu gardens of a preceding period are frequently mentioned in the epics of Indian literature. Detailed descriptions of ideal features are given in the Hindu Shastras: cloud showers, lotus-shaped baths with lotus seats, creeper pavilions, tanks, lotus-shaped lakes, menageries, swings, rotating wheels, and roundabouts. Many of these details are often mistakenly considered to be Mogul in inspiration.

Further south, at Vijayanagar, beyond Muslim control, a later dynasty of Hindu princes realized such an ideal garden. All that now remains are its fine central lotus-tower pavilion (*c.*1575), a nearby bathing tank, the flanking garden walls, and the stone troughs of its irrigation system which once harnessed the waters of the Tungabahdra and brought miraculous life to its arid and dramatically boulder-strewn site.

Something of this lost brilliance may still be seen in the palace gardens at Dig (or Deeg), to the west of Agra (by Maharaja Suraj Mall, *c.*1750). Typically Hindu is its fine swimming-pool with swing set to rise through a spray of jets to cool the garden users during the close humid months of July and August. Also typically Hindu is its opulent use of colour. Throughout the year the dark foliage of shade-trees such as the mango and the jaman are used to show off the spectacular flowering of other species. The year begins with the scarlet flame of the forest, the orange of the ashoka and the silk cotton. In March the coral trees and the Persian lilac flower, in June the gul mohr, in September the bauhinias, and in November the mimosas and tamarinds.

But most typically Hindu is the emphasis upon heavily scented flowers. These include not only the frangipani, the white-flowering cork tree, and a host of other flowering

trees, but also many shrubs and herbs like gardenias, jasmine, and tuberoses, and especially those plants which open for pollination in the evening. Like much else the Hindu moon-garden was finely adapted by the Moguls. At the Delhi *Red Fort this took the form of a *chahar bagh (the *mahtab bagh*), set next to a daytime or life-giving garden (the *hyat baksh bagh*): the former symbolized by the white lotus opening at night, the latter by the pink lotus opening by day. Moonlit parties around the ponds and the planting of such gardens are among the favourite subjects of Rajput and Mogul painting; with the jewel-like detail of fruit, flowers, and faces, and the gleam of water caught by small oil-lamps hung behind *jali* screens against the dark background of the night. These Delhi gardens have suffered badly and are only partially restored.

One of the very few early Hindu palaces still intact is at Padmanabhapuram, south of Trivandrum and dating from the 13th c. Its small courtyard gardens are no longer maintained, but the palace at its centre and the enclosing walls embody the principles of the Shastras. Essentially it is a cosmogram—an auspicious symbol correctly shaped and placed to harness the cosmic forces. J.BY.

ANGLO-INDIAN GARDENS. When European traders established settlements in India during the 17th c. they planted gardens not only for food but also for relaxation. In due course they built country mansions, known as garden houses, and their gardens inevitably reflected national tastes. The French in Pondicherry preferred a formal display of geometrical flower-beds with paths sheltered from the sun by creeper-hung pergolas. The Dutch governor's residence at Sadras near Madras had an impressive 1·6-ha. garden of flower-beds divided by straight walks and water channels. Spacious parks planted with clumps of trees, reminiscent of the Brownian landscape, surrounded prosperous British homes. As visitors to Calcutta sailed up the River Hooghly, they were impressed by the many large houses with spacious lawns sloping down to the water (see also *Calcutta Botanic Garden). Although colourful species of the Indian flora were cultivated, many ornamental plants were also introduced from Europe, Africa, and the rest of Asia. No cantonment or bungalow garden was without a specimen of an Australian eucalyptus. Local topography and vegetation often dictated the character of a garden.

In 1809 Maria Graham admired such a garden planted on a hillside at Bombay. 'Walks were cut into the wood on the side of the hill, and covered with small sea-shells . . . instead of gravel . . . On each side of the walks are ledges of brick, chunamed over [chunam is a prepared lime], to prevent them from being destroyed by the monsoon rains . . . At the lowest end of the garden is a long broad walk, on each side of which grow irises . . . figs, and other fruits . . . At one end of this walk are chunam seats, under some fine spreading trees, with the fruit walk to the right hand, and to the left flower beds filled with jasmine, roses and tuberoses.' The climate and soil were crucial factors. Mrs Graham observed that in Madras the garden houses were 'usually surrounded by a field or compound, with a few trees and shrubs, but it is with incredible pains that flowers or fruit are raised'.

When Warren Hastings was Governor-General he grew exotic plants in a garden at Alipore near Calcutta and tried to acclimatize English plants. The gardens of official residences were usually formed and changed by the taste

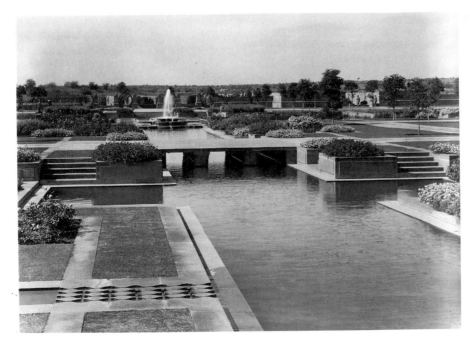

'Mogul Gardens' (1911-31), State House (formerly the Viceroy's Palace), New Delhi, by Edwin Lutyens and W. R. Mustoe

and whim of their occupants, especially the women. At Government House in Calcutta the flower-beds carefully planned by Lady Amherst were removed by her successor, Lady Bentwick. The Eden sisters made further alterations while their brother, Lord Auckland, was Governor-General.

Lady Mayo's enthusiasm for new planting was continued by Lord Northbrook and Lord Lytton, so that by the end of the 19th c. extensive formal gardens had been established around the house with mature trees, bamboo groves, and ornamental ponds. Lord Wellesley had the flat grounds of the Governor-General's country residence at Barrackpore reshaped into an undulating landscape with ponds and a graceful classical bridge. Lord Minto added a Corinthian temple. Bishop Heber who saw it in the 1820s described it as 'a park of about 150 acres of fine turf, with spreading scattered trees, of a character so European, that . . . I could have fancied myself on the banks of the Thames instead of the Ganges'. Later additions included a terrace walk, an Italian garden, rose-gardens, and even an artificial Gothic ruin.

John Goldingham, the Civil Architect of Madras, not only designed Lord Clive's garden house at Madras but also laid out its 28-ha. park with lawns, woodland, ornamental water, a mound, and a long avenue. The avenue of trees at Government House, Parell, Bombay, stretched for a mile and the grounds contained the remains of the original garden formed by the Jesuits many years earlier. The British Resident at Hyderabad had the Residency rebuilt in 1803, lavish flower gardens and orchards planted, and the park stocked with deer. His successors gradually transformed it into a formal Victorian garden.

During the hot season Europeans retreated to the cool sanctuary of the hill-stations where every bungalow had its little garden with rhododendrons and oleanders competing with roses, stocks, asters, dahlias, and fuchsias. The Viceregal Lodge at Simla boasted a splendid rose pergola. Most European bungalow gardens were modest creations comprising a drive, a lawn, some shrubs, a few flower-beds, and flowers ranked in pots on the verandah. The climate and garden pests, the lack of native gardeners with horticultural skills, and the peripatetic life of most officials conspired to frustrate any dedicated gardener. *Lutyens's imperial Mogul-style gardens in *New Delhi survive, but most British gardens have disappeared through neglect.

The Government gardens at Ootacumund engaged a gardener from the Royal Botanic Gardens at Kew in 1848, one of the first of many Kew gardeners who were to be employed in botanic gardens, municipal parks, and private estates in India. The Agricultural and Horticultural Society of India, founded in 1820, was soon followed by local societies. G. Speede's *Indian Handbook of Gardening* (1840) was one of the earliest Indian gardening manuals.

The gardens of Indian princes tended to copy European fashions. The Gaekwar of Baroda adorned the grounds of his three palaces with formal gardens, marble-paved walks, fountains, waterfalls, and also a grotto. R.D.

Among the best of the later British gardens were the beautiful tea-gardens of Assam and the high ranges of Kerala. Here there is man-made formal landscape on a vast scale, using Chinese camellias to create a close rich green mantle easily following the fold and slope of the land, lovingly leaf-pruned and manicured, and lightly touched by long lines of tall shade-trees among the mountains. J.BY.

MODERN GARDENS. Since partition and independence in 1947, India has carried out many notable projects but none greater than the huge dams in Orissa and Mysore, bringing improved cultivation on a vast scale. Notable also are a number of town planning developments including the new capital of Orissa at Bhubaneswar from 1947 (planning consultant, Otto Koenigsberger) and Le Corbusier's new capital of the Punjab, Chandigarh (from 1951). None of these projects has achieved any distinction through the design of their gardens or landscape. The beauty of Le Corbusier's government buildings is in fact marred by the naïvety of his landscape design and his failure to learn the Mogul lessons regarding the scale of external space. It was to be another decade before a similar opportunity occurred, not in India, but in the new country of *Pakistan, where British landscape architects were employed for the new capital city, Islamabad.

The lack of skilled landscape designers in the subcontinent has too often meant that opportunities offered in Public Works development have been lost. The unfortunate garden below the Ajanta caves in India is a case in point; as is the way in which the restaurant has been allowed to disfigure the royal enclosure at Vijayanagar.

Today the biggest checks upon achievement are the cost of looking after public gardens, and the need, for every 2·5 ha. of plants, to provide well over 100,000 gallons of water for every month of the dry season. Well-tended—although rarely well-designed—modern gardens may however still be seen in the grounds of some of the large private corporations. J.BY./M.L.L.

See also ACHABAL; ANGURI BAGH; CHAHAR CHENAR ISLAND; CHASMA SHAHI; HUMĀYŪN'S TOMB; I'TIMĀD-UD-DAULA, TOMB OF; LOTUS GARDEN, DHOLPUR; MACHCHI BHAWAN; NASIM BAGH; NISHAT BAGH; RĀBI 'A-UD-DAURĀNI, MAUSOLEUM OF; RAM BAGH; RED FORT, DELHI; SAHELION-KI-BARI; SHALAMAR BAGH, DELHI; SHALAMAR BAGH, SRINAGAR; SRI LANKA; TAJ MAHAL; VERNAG.

Indonesia is a republic of 120 million people inhabiting the large islands of Java, Sumatra, the Celebes, and most of Borneo, and *c.*300 small islands straddling the Equator. Summer and winter monsoons give an average annual rainfall of between 1,000 and 2,000 mm., facilitating the growth of tea, coffee, rubber, sugar-cane, and cinchona on the mountain slopes. The people are predominantly Malay with communities of Chinese. The islands were under Dutch control from 1600 until the Second World War.

The earliest gardens were founded by the Dutch (see *Dutch Colonial Gardens: Indonesia). These include the outstanding *Kebun Raya Botanic Garden in Bogor, begun

in 1817 in the grounds of the palace of Padjadjaram. They have given rise to a number of satellite gardens, notably the Cibodas mountain garden near Bogor in West Java, Parwodad in East Java, and Ekakarya in Bali. The first of these was founded in 1862 for the study of the mountain flora and fauna but it also contains exotic timber trees.

M.L.L.

Indoor garden. There is a widespread belief that interior landscape is a new development. However, the origins of the subject can be traced back to the Victorian *conservatory and even before. Early house-plants were mainly annuals which could be grown in almost natural conditions and then brought indoors for relatively short display periods. This situation changed during the 18th and 19th cs. due to exploration and the importation of plants from various parts of the world (see *plant-collecting). Unfortunately the methods of transportation at that time were not conducive to the survival of plants and many died in transit, but these difficulties were greatly eased in the early 1840s by the introduction of the *Wardian case.

The famous collector Robert *Fortune was one of the first to use the Wardian case in 1843 to take living plants out of China. Among his first acquisitions were *Phalaenopsis amabilis, Anemone × elegans, Jasminum nudiflorum*, and *Spiraea prunifolia*. These species indicate another interesting phenomenon often associated with early importations, namely that the staff receiving them were often not certain as to what conditions the plants needed; for example, all but the first of those plants were originally grown in a heated glasshouse, although today they are regarded as excellent hardy garden plants.

In spite of this many plants had a very short survival period when introduced into an indoor environment. The losses were mainly caused by low light levels, low temperatures, and incorrect watering. Other factors militating against certain species were difficulties in propagation and in preparing plants for transportation. These factors reduced the total of hundreds of thousands of plants to probably less than 100 species. In fact it could be argued that there are less than 30 truly successful forms which are used in any great number.

The plants which are now available for use indoors have been selected by a number of random pressures, and are drawn from virtually all climatic zones and continents. For example, a specimen of *Aechmea fasciata* from the rain forests of South America can be used next to *Sansevieria trifasciata* 'Laurentii' from the South African Transvaal and *Cissus antarctica* from Australia can be grown next to *Hedera helix* from western Europe. Possibly the only characteristic that these plants have in common is a toleration of low light levels, erratic watering, and general abuse. However, it must be remembered that there is a fundamental difference between an indoor plant and a shade-tolerant plant. Most temperate plants which are regarded as being shade-tolerant in no way approach the ability of house-plants to survive at low light levels. The only exceptions to this are a few plants such as *Hedera helix, Aucuba japonica*, and *Choisya*

ternata, which can survive at both low temperatures and low light levels.

Shortcomings in the environment of domestic buildings meant that only a few plants such as *Howea forsteriana* and *Aspidistra elatior* survived. This situation continued into the 20th c., when new styles of architecture started to evolve.

The United States. The American architect Frank Lloyd *Wright indicated the use of plants within buildings on his drawings in the 1920s and 30s but it was only in the early 1960s that interior planting started to appear to any great extent in architecture. Probably one of the most important figures in developing the trend for using interior plants was John Portman, an architect in Atlanta, Georgia, whose designs for hotels, adopted by the Hyatt Regency Group, had rooms built around a glazed and covered void or atrium.

The pressures for such enclosed spaces with their controlled environment are far greater in North America than in Britain and western Europe. In Britain temperatures seldom fall below 0°C or rise above 25°C. In North America temperatures as low as −20°C and up to 35°C are common. With such extremes even simple pedestrian activities become difficult and uncomfortable. By creating large spaces with controlled environments the quality of life is improved. These spaces are by their very nature rather austere and so plants have been widely used to humanize them.

In North America the first large-scale atrium buildings were probably the Hyatt Regency hotels whose balconies are often heavily planted with specimens of *Philodendron scandens*, but the single most significant building must be that of the Ford Foundation in New York. The space within the building was originally planted with large specimens of *Ficus benjamina* and *Magnolia grandiflora*, but the latter species has not prospered and the whole planting has recently been renovated. Other noteworthy American projects include that at the John Deere building at Molaine, Illinois. This vast space is the void between two buildings and contains large specimens of *Ficus benjamina* with an underplanting of ground cover which includes blocks of seasonal bedding and ivy. Other notable plantings include the IBM building in New York with bamboos over 12 m. tall, and Chemcourt, New York, which contains a number of interesting plants, including a form of black olive called 'Shady Lady'. Elsewhere in North America, Willow Creek Mall (near Dallas) and Old Mill Mall (near San Francisco) show what can be done to bring both water and trees into modern shopping developments. Of these, the former is a somewhat stylized representation of nature with geometric pools and planters; in the latter, however, the planting is very relaxed and naturalistic in its appearance.

Britain. Probably the first large building project in Britain which contained a large planted atrium was the bank of Coutts & Co. (architect: Sir Frederick *Gibberd & Partners) in the Strand, London. After some initial difficulties with the species selected for this project the planting has stabilized and is now maturing. The slightly later

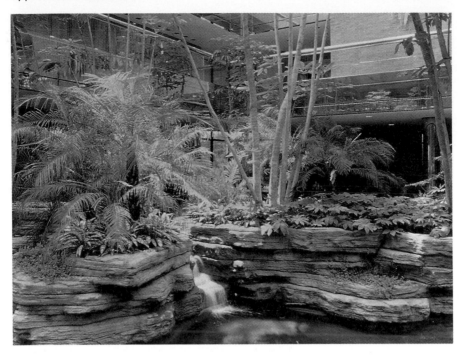

Indoor garden: atrium (1978)
at the Household Finance
Corporation, Chicago

shopping precinct at Milton Keynes also suffered similarly in the early stages, but with its unusually high light levels the planting is now well established. There have been numerous sports facilities such as the Swindon and Bletchley Leisure Centres which have been completed during the last 10 years. These have clear Perspex roofs and as a result the light levels are probably higher than those in the Palm House at Kew and therefore they should more correctly be thought of as being conservatories.

Although the use of plants in modern developments in Britain has been slow there are now a large number of interior projects which have been or are due for completion within the next few years. One of these is Bexleyheath Shopping Centre where 5-m. tall specimens of *Ficus benjamina* grow in a totally artificial environment. Another more relaxed planting is in the Riding Centre at Wakefield where specimens of *Ficus benjamina* and pools have been used together.

Probably the first true interior garden in Britain is in Sovereign House, Pimlico, London, complete with a slate rockery, water cascades, and large trees. Of the plants which have been used probably the most interesting are a 10-m. tall specimen of *Ficus benjamina* 'Exotica' and 7-m. tall specimens of *Cocus plumosa* and *Ptychosperma elegans*.

In conclusion, however, it must be said that interior planting in most cases takes the form of troughs and tubs which are strategically placed around offices and public buildings. These are now accepted as being an integral component of any good interior design. The plants are in general the same as those which are used in large atrium projects but on a smaller scale. It is very unlikely, even in the distant future, that large-scale interior gardening in large *in situ* planters will ever represent more than 5 to 10 per cent of the total interior landscape value on either side of the Atlantic. Interior gardening is a specialist art form which has a role to offer only in expensive prestige buildings where the quality of the environment is seen as being more important than the space which is lost to planting and the cost of the equipment necessary for creating a suitable environment for the plants. S.J.S.

Insel Mainau, Baden-Württemberg, German Federal Republic, which is in effect a single garden of 45 ha. lying in Lake Constance, is one of the most popular gardens in West Germany. The unusually mild climate favours a vast variety of exotic plants which are hardly to be seen anywhere else north of the Alps. Grand Duke Friedrich I of Baden, who bought the island and the baroque castle of the Teutonic Order in 1853, was mainly responsible for laying out the extensive gardens, which he filled with rare plants brought back from his travels abroad, and for planning the arboretum with its many interesting species.

The present owner, Count Lennart Bernadotte, has further extended and added to the gardens. Mainau is famed not only for its large rose-garden but also for its show of flowers in the spring (tulips, narcissi, hyacinths, etc.) and the summer and for its many varieties of dahlias.

U.GFN.D.

Inverewe, Ross and Cromarty (Highland Region), Scotland, was begun in 1862 by Osgood Mackenzie, on a small peninsula running north from the southern end of the sea-loch, Loch Ewe, on the extreme north-west coast of Scotland: the least probable site for a garden imaginable, espe-

cially as there was very little soil—when Mackenzie began work the only plants were two rather miserable dwarf willows.

He fenced off the peninsula, drained the sour peaty ground, and planted the first trees as shelter-belts, finding after a very slow start that not only was a garden possible but that many varieties once thought impossible thrived at Inverewe in the relatively mild climate caused by the North Atlantic Drift. Within this maturing woodland garden of 800 ha. Mackenzie began 'cutting out spaces, enclosing them . . . and planting them with nearly every rare exotic tree and shrub which I hear succeeds in Devon, Cornwall, and the West of Ireland'. It is to Mackenzie's great credit that Inverewe also succeeds as a design: the abruptness of the terrain is skilfully exploited and intricate paths wind up and down and in and out, always presenting the marvellous plants near at hand and in the best positions for botanical inspection.

In the course of Mackenzie's lifetime Inverewe was transformed into one of the best subtropical gardens in north-west Europe. After his death in 1922 the work was continued by his daughter, whose standard of understanding and care is now admirably maintained by the National Trust for Scotland. A good history of the garden is given in Dawn McLeod's book, *Oasis in the North*. W.A.B.

Iran. See ALI QAPU; BAGH-I DELGOSHA; BAGH-I ERAM; BAGH-I FIN; BAGH-I GULSHAN; BAGH-I TAKHT; CHAHAR BAGH AVENUE; CHEHEL SUTUN; CHEHEL TAN; FATHABAD; GULISTAN PALACE; HAFT TAN; HAZAR JERIB; ISLAM, GARDENS OF: IRAN; MADRASSA MADER-I SHAH; NARENJESTAN-I QAVAM; QASR-I QAJAR; SHAH GOLI.

Iraq. See BAGHDAD; ISLAM, GARDENS OF; MESOPOTAMIA, ANCIENT.

Ireland. Such was the troubled state of Ireland that large Elizabethan and Jacobean houses with extensive gardens like those at Knole, *Hatfield, and *Burghley in England, were rare. Only the gardens of the Great Earl of Cork at Youghal, Co. Cork, and *Lismore Castle, Co. Waterford, of the Earl of Clanrickade at Portumna Castle, Co. Galway, and of the Earl of Donegall at Carrickfergus Castle, Co. Antrim, were of any real significance. However, the remains of some fine gardens from the mid-17th c. similar to those in England can be traced. Many of these were encircled by deer-parks, with pleasure-grounds, bowling-greens, and waterworks near the house (as at *Kilkenny Castle). The design of the garden, often the main part of a semi-fortified enclosure, was in *parterres, intercepted by gravelled walks bordered by box hedges (as at *Birr Castle). Shelter was provided by walls, and flowers in pots were common on terraces. Remains of these and of an enormous walled garden with *claires-voies can still be seen at Thomastown, Co. Tipperary.

The triumph of the Protestant forces of William of Orange over James II's Catholic army at the Battle of the Boyne (1690) led to Irish Protestants sometimes showing their loyalty by affecting the Dutch school of gardening, especially in knots of flowers, small canals, and curious edgings of box, in designs of compartmental privacy. One of the greatest gardens laid out in the Dutch style was at Stillorgan, Co. Dublin, by Colonel Allen in 1695, and here the magnificent obelisk designed by Sir Edward Lovett-Pearce still stands. After the Williamite wars (1688–90) French Huguenots brought in new horticultural expertise, especially in fruit and vegetable growing in town gardens. Nurserymen such as Rowe and Bullein in Dublin propagated and sold plants.

At the beginning of the 18th c. many large gardens were laid out in the *Le Nôtre manner, as in England. Goose-foot avenues, radiating from semicircular parterres near the house, can be seen in John *Rocque's maps as late as 1750. Notable examples were at *Castletown and *Carton in Co. Kildare; Pakenham Hall, Co. Westmeath; Castlemartyr, Co. Cork; Ardfert, Co. Kerry; Woodstock, Co. Kilkenny; Templeogue and Howth Castle, Co. Dublin. The best documented is Lord Molesworth's at Breckdenstown near Swords, Co. Dublin, and the best preserved is *Kilruddery, Co. Wicklow.

The friendship between Jonathan *Swift of St Patrick's Cathedral, Dublin, and Alexander *Pope was largely responsible for the change in Ireland from formal French gardens to the freer gardening which Pope was putting into practice at Twickenham. At the same time, Patrick Delany at Delville and Lord Orrery at *Caledon laid out romantic-poetic gardens, many of which are described by Mary *Delany in her extensive diary. On account of unsatisfactory agricultural conditions or failure of the potato crop through frost or disease, landowners were constantly having to take special measures to alleviate their tenants' economic distress, and the building of miles of perimeter walls, the planting of woodlands, the extension of lawns, or the erection of majestic *follies or *obelisks like the Conolly Folly at Castletown, all of which were undertaken to give employment to the poor, bear witness to this.

It was fortunate that 'Capability' *Brown never visited Ireland for he would have found in much of the Irish terrain differences to which he was unaccustomed in England (see Thomas *Leggett; John *Sutherland). As Lord Orrery pointed out: 'Nature has been profusely beneficent to *Ireland* and *Art* has been as much so to *England*. Here, we are beholden to nothing but the Creation; there you are indebted to extensive gardeners and costly Architects.' The milder climate and greater rainfall of Ireland produce profuse horticultural growth, and the natural loughs and mountain scenery provide material which Brown in England had to try to create in his landscape designs (see *Muckross). Irish gardening is well described by a stream of travellers, chief among whom were Arthur *Young, Sir Richard Colt *Hoare, John Wesley, and Prince *Pückler-Muskau. A brief visit of four months in 1783 by Humphry *Repton to Ireland may well have influenced the manner of the landscape gardening which he later adopted in England.

After the Act of Union between Ireland and England in 1800 the problem of absentee landlords grew more acute.

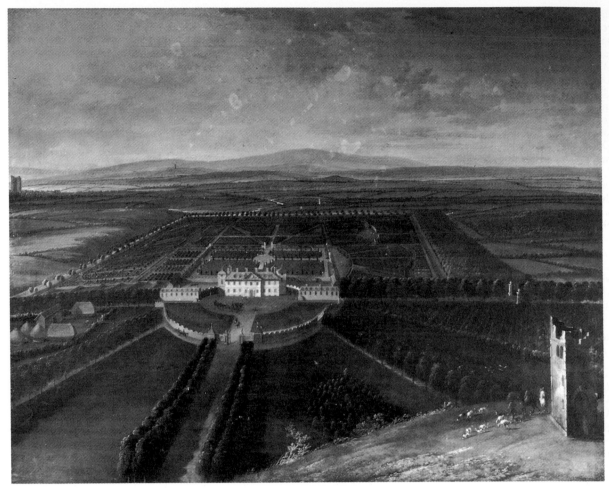

Carton, Co. Kildare, Ireland, oil painting (*c.*1730) attributed to Johann van der Hagen

From the time of the 3rd Lord *Burlington, the friend of Pope and the largest landowner in Ireland though he never set foot in the country, absenteeism had existed with socially calamitous results; but after 1800, with the seat of operational government in London, many of the landed gentry visited rather than lived on their Irish estates. Recurrently throughout the 19th c. widespread depression led to tenant-right agitations flaring up, and these were not settled until the Land Act (1903) enabled tenants to purchase their own lands on easy terms. As a result of this, many of the large estates were dismembered and trees were felled in large numbers by the new owners.

The thick growth of conifers and shrubs planted in mountainous terrains and steep valleys made the country most suitable for landscape gardening according to the *picturesque doctrines of Sir Uvedale *Price or William *Gilpin, especially in the Wicklow Mountains or at Killarney, which were the two most visited spots on the picturesque tour. Not only was the scene apposite, but ruins

of churches, castles, and houses were frequently present, which, according to the diaries of the many travellers in the first quarter of the 19th c., inspired thoughts associated with the philosophy of *sic transit gloria mundi*, so much a part of the picturesque aesthetic.

Italianate gardens in High Victorian times with their balustrades and statuary, parterres and terraces, formally bedded-out amidst gravel walks, never flourished in Ireland as they did in England or Scotland. The two leading designers of the period were James *Fraser and Ninian *Niven (see also Richard *Turner). There are a few examples to be seen: typical, though somewhat decayed by Victorian standards, are those at Baronscourt, Co. Antrim; Abbey Leix, Co. Laois; Adare Manor, Co. Limerick; *Powerscourt, Co. Wicklow; and Clandeboye, Co. Down. An army of gardeners was necessary to keep these up, and usually those industrial or business magnates who had both the means and the inclination did not live in Ireland, which has not suffered from the effects of the industrial revolution

that so ravaged England. William *Robinson, who led the reaction to this formal gardening, was born in Ireland and spent his early years in the country. His influence is most marked in the woodland gardens at Mount Usher, Co. Wicklow; *Anne's Grove, Co. Cork; *Glenveagh, Co. Donegal; and *Mount Congreve, Co. Waterford. The climate is mild in all these gardens and therefore suitable for the growth of tender trees and shrubs from semitropical parts of the world. This also shows in the planting of arboreta and pineta such as those at Castlewellan, Co. Down; Fota, Co. Cork; and Headfort, Co. Meath, in the first quarter of the 20th c.

Compartmental gardens (for example, *Rowallane), after the manner of *Hidcote or *Sissinghurst Castle, have been the order of the day recently. Combined with areas of superb woodland, Birr Castle, Ilnacullin, and *Mount Stewart, planned by Gertrude *Jekyll (see also *Lambay Island), are possibly the most interesting examples, for their fine planting as well as for their 20th-c. compartmental layout. Dublin County Council's restoration of Malahide Castle gardens, with their unique collection of southern hemisphere plants, is a welcome sign of official recognition that help is needed if such gardens are to be preserved for posterity. E.M.

See also GLASNEVIN NATIONAL BOTANIC GARDENS; HARRISTOWN; LISMORE CASTLE; LUTTRELLSTOWN; MARINO; PHOENIX PARK; TULLY; WESTPORT HOUSE.

Iris. There are over 300 species of *Iris* growing wild from the Arctic Circle to the Tropics but none occur in the Southern Hemisphere. Many thrive in British and North American gardens and several more can be grown under glass. All iris flowers have a similar structure of three outer and three inner petals and every colour and colour-combination is found except the purer reds. Unusually, some irises have brown flowers. There are many classifications of the species but the two major sections are those with rhizomatous or stoloniferous roots and those with bulbous root-stocks. Within these groupings are many subsections and smaller divisions.

The bulbous types tend to be smaller plants usually grown as clumps in rock-gardens or in pans as house-plants. Examples of these are the Eurasian species, the yellow-flowered *Iris danfordiae*, the early-flowering *I. reticulata*, *I. histroides*, and the hybrids variously termed Dutch, Spanish, and English irises and derived from the Mediterranean region: *I. tingitana*, *I. xiphioides*, and *I. xiphium*.

The bearded irises form the majority of plants in the rhizomatous section. The many species hybridize freely to produce a large range of spectacular plants, particularly in the 'Tall Bearded Irises' subsection. Iris gardens are a major feature of many of the larger botanic gardens and public parks, and although many sections are represented, it is usually these larger irises that are featured. They are usually grown in regular beds with blocks of each cultivar together to form a massed display of colours in late May and early June. However, today irises are increasingly used among other plants in herbaceous borders and the stylized settings such as those once found at Kew are less common.

Of particular interest is the Algerian iris (*I. unguicularis*, syn. *I. stylosa*) which has perfect silky sky-blue flowers opening among the grass-like foliage from midwinter onwards, undeterred by snow and frost. The native British 'yellow flag' is a marshland species (*Iris pseudacorus*) and several of its varieties are ideal for water-gardens. The native gladdon or stinking iris (*Iris foetidissima*) is unusual as it is a woodland species that grows well in shady garden borders. P.F.H.

Isfahan, Iran. See ALI QAPU; CHAHAR BAGH AVENUE; CHEHEL SUTUN; HAZAR JERIB; MADRASSA MADER-I SHAH.

Islam, Gardens of.

Antecedents of symbolism in the Islamic garden. The significance of the number four, seen in the Islamic *chahar bagh*, or quadripartite garden, long predates the Islamic era. The four elements of water, fire, air, and earth had long been considered sacred, and Genesis recounts that 'a river went out of Eden to water the garden; and from thence it was parted, and became four heads'. (See Garden of *Eden.) In Persian (Iranian) ceramics of c.6,000 years ago, a cross divides the world into four sections, with a pool or spring of life at its centre. A similar mandala is found in Buddhist iconography where a common source or centre branches into four rivers and symbolizes fertility and timelessness. Early game-preserves or hunting-grounds were also divided into four with a mansion located centrally. From here it was but a short development to the *chahar bagh*, and even to the Islamic courtyard with its axially placed fountain or pool.

Paradise gardens. The Islamic religion was founded by Muhammad in the 7th c. AD; it entailed a belief in one God and incorporated the notion of paradise. The ordained conversion of all non-believers led to the spread of Islam across North Africa, southern Europe, and southern Asia through holy wars. A basic tenet of this religion is the pervasive unity that runs through life's diverse experiences and this theme is expressed throughout Islamic art, including the art of garden design. In Islamic literature too the garden was highly regarded, and symbolic imagery involving garden, life, and soul is found together with garden analogies to the beloved.

The English word 'paradise' is derived originally from the Old Persian *pairidaēza* meaning an 'enclosure' or 'park'. The subsequent Greek word *paradeisos* came to refer not only to the beauties of the Persian garden but also to the garden of Eden, heaven, or a state of supreme bliss. It is this state of blessedness conceived as an ideal garden that is promised by the Koran as a reward to the faithful; reference is made to 'spreading shade', 'fruits and fountains and pomegranates', 'fountains of running water', and 'cool pavilions'. For believers who perform righteous acts, the Koran promises that 'the Gardens of Paradise shall be their hospitality, therein to dwell forever, desiring no removal from them'. The imagery was based on the oasis of a desert

people, but in time this description itself was made the model on which gardens on earth were based.

Such gardens provided a calm and harmonious retreat from the noisy, turbulent, and dusty world outside. The Islamic garden was therefore always enclosed, private, and protected, appreciated and enjoyed by all levels of society. Fruit-trees provided cool shade against the intense heat, flowers supplied fragrance and colour, terraces and canals assisted horticulture and irrigation, while cascades, pools, and fountains cooled and moistened the air, providing gentle sound and visual delight.

The Islamic garden was often the scene for ceremonial, but, as may be seen from many Persian and Mogul miniatures, it was also enjoyed in a simple and natural manner. An owner would take delight in his garden more by sitting on rugs and cushions in contemplation in his pavilion, than by walking through it.

Residences of the 7th- and 8th-c. Umayyad caliphate were walled and contained a courtyard, a form that suited climate and local customs, and was therefore likewise to be found in bazaars, caravan hostels, and palaces. It was also adopted by mosques and theological colleges. The *courtyard and courtyard garden in Islam and especially the Islamic garden itself were seen to reflect both human biological and physiological needs as well as the Islamic religious principle of unity and order. Design reflected both the rational and spiritual nature of man and was expressed in a remarkable unity of concept that was reflected in gardens from southern Spain to north-west India (see also *Baghdad), over a time span of 1,000 years. Common to all was the same sense of order, focus on water, and spirit of serenity. Yet each site was unique, and the geometry introduced served only to enhance the genius loci.

The spread of Islam saw many gardens established, since not only did they provide climatic relief in those parts of the world, but they granted a foretaste of the reward promised to the faithful, as well as a less spiritual but attractive reflection of the traditional royal pleasure-garden.

Elements of the Islamic garden. In form, gardens were geometrical, and symmetry was employed specifically. A pool served as focal point; alternatively, a pavilion was placed at the intersection of four avenues or water channels. The resulting four quadrants led to the term chahar bagh (four gardens) although this name was also given to a large garden containing a palace or pavilion. Consequently, the garden was best viewed from the centrally located pavilion outward to the periphery, with a secondary view from the main entry towards the central pavilion.

The shape of the Islamic garden was nearly always rectangular. It was surrounded by a wall, and an elaborate gateway gave on to a main axis often formed by a water-course with one or more subsidiary axes at right angles. Channels and pools were flanked by paths and terraces, often bordered by defined areas of flowers and shrubs with trees for shade; this planting softened the man-made geometry. With a pavilion or other form of building in the centre, all vistas were precisely terminated by a further

pavilion, gateway, or vaulted recess. Paths were always straight and paved with brick, stone, pebbles, or mosaic. Although the use of geometry was universal across the Islamic world, there is always a strong sense of place in the gardens, with remarkably little uniformity. When sited on a gradient the garden was terraced. In the large royal gardens, especially in India, the public was received only on the lowest terrace; the central terrace was private and used for formal audience; the upper (*zenana) terrace was reserved for women. At changes of level, water fell over cascades of carved chutes (see *chadar). On flat sites, channels were given a slight gradient to ensure a flow. Water in pools and channels was always contained in a precise manner.

The importance of irrigation was recognized throughout the Middle East long before the advent of the Islamic garden, and the significance and symbolism of water was not lost on the Muslim. In a hot climate and barren landscape it was a source of life, refreshing both body and spirit, and so in turn it became the central focus of both garden and courtyard. In gardens and courtyards of buildings of a religious nature it was regarded as a symbol of purity, and since paradise overflowed with water, tanks in mosques and theological colleges were filled to the brim.

The location of gardens as well as cities depended on the availability of water, which was often led from its source along a canal, aqueduct, or pipe to a tank, cistern, or public fountain. In gardens and courtyards it was often lifted to a high-level storage tank to provide a head for the fountains; subsequently it was led to flower-beds, kitchen gardens, or fields.

The possibilities of water were fully exploited. Fountains, cascades, channels, and pools provided a great variety of sights and sounds. Water could be made deep, dark, and tranquil, or swiftly flowing and scintillating. Edges of fountains and pools were often carved in stone or marble. At night, candles were set on tiny rafts to reflect in the still water of pools, or glowing lamps were placed behind glistening cascades in carved niches which during the day contained flower vases. Yet throughout most of the Islamic world water remains scarce, and despite the symbolism and pleasure that the water affords, the pattern of the channels remains primarily determined by irrigation techniques.

See also FOUNTAIN: ISLAM.

Spain. The Islamic garden form was introduced into *Spain by the Moors early in the 8th c. Muslim culture flourished on the Iberian peninsula, and by the 10th c. the Cordoba countryside had an extensive irrigation network with vineyards, orchards, and gardens. The Moorish capital was eventually transferred to Seville, but this fell to the Christians in the mid-13th c. Described by Arab historians as 'a goblet full of emeralds', Granada also fell at the end of the 15th c. when the Moors were expelled from Spain. After this, their irrigation system fell into disuse, and their text-books of agricultural techniques were burnt. However, the architectural heritage remained, and many patios and several gardens with varying degrees of authenticity are still to be seen to this day.

The Islamic garden attributes of order, geometry, coolness, privacy, and a focus on water are all to be found in these gardens. There are no large pools, and a local characteristic of large gardens was their division into small enclosures. Paths were often placed above the level of vegetation resulting in an impression of walking at the level of the tops of flowers. Due to hilly terrain, the plans of gardens were slightly irregular, but splendid views were offered. Enclosing walls were of stuccoed masonry, and tiles were used as facings on seats, pools, paths, and steps. There was great use of accessories such as benches and pots, although these may be of relatively recent vintage. Evergreens, especially citrus trees, were planted, and flowers were chosen for fragrance. There was no grass.

North Africa. Islamic gardens in North Africa first appeared in 9th-c. Tunis (see also *chellah*). Large gardens of the wealthy had flowers selected for their fragrance, as well as fruit and other trees and vegetables. Water for irrigation was often drawn from a well or from a river by water-wheel. These gardens were used for pleasure, and occasionally contained a lake. There were also smaller enclosed gardens or patios, set out formally, in the Islamic courtyard tradition. Many luxurious country houses surrounded Algiers, and were renowned for their gardens. In the early 10th c. the Moors entered Sicily. There they established new irrigation techniques, built public baths, and introduced water in many forms to garden and courtyard.

From earliest times many Egyptian houses had gardens adjacent with land cultivated by water from the Nile. Cairo, founded in the latter half of the 10th c., had several garden palaces and many courtyards, and it is the courtyard tradition in several older private houses that remains to this day. On the Arabian peninsula rain is very scarce, but there is an irregular fall in the south and west, and the early cultivation of gardens in that area was possible. The city of Riyadh's name implies the presence of gardens, and thus water in the vicinity, although there is little trace of early Islamic gardens today. Gardens and orchards surrounded the early Umayyad capital of Damascus, a city that was itself regarded as an earthly paradise.

Turkey. There was already a garden tradition in *Turkey by the time Islam reached it in the 10th c. There are few records of gardens at this time, but those found within palaces were used for formal occasions as well as for pleasure and entertainment. Often gardens were located primarily for their view over water, and since rainfall was more abundant here than in many other parts of the Islamic world, the design of the Turkish Islamic garden, although ordered, was less determined by irrigation channels and formal axes than elsewhere.

Iran. Except for the Caspian coast with its mild temperature, heavy rainfall, and intensive cultivation, Iran is generally dry, with hot summers, cold winters, and sparse vegetation, and so the maintenance of gardens is not easy. There are few year-round rivers, but much irrigation is through *qanats*,

underground tunnels aired by vertical shafts at regular intervals, that link a mountain source of melted snow to the desired destination, often several kilometres away. In such a sun-baked environment, the image of the paradise garden as described in the Koran linked with the earlier tradition of the royal pleasure-garden to provide a remarkable and influential development of the Islamic garden tradition. No Iranian garden today dates back substantially more than 500 years, but early records, miniatures, and garden carpets provide a record of the consistent use of such Islamic elements as clearly defined canals leading from a centrally placed pool, with flowers, trees, and birds. Persian gardens offered contrast to the hot plains and dusty cities and were primarily to be enjoyed. Their coolness and shade attracted all segments of the population; public holidays were spent there, and they were the scene of special occasions; they also served as a private retreat.

Typical design elements were the *chahar bagh* which was further subdivided in large gardens, with a central pool or pavilion, the whole enclosed by a high wall. Irrigation was indispensable, and determined the pattern of canals, but water whether moving or still was appreciated for its own sake. Pools were filled to the brim, and were invariably geometrically defined; in gardens they served as reservoirs, and in mosque courtyards they were used for ablutions. They varied in size from small basins to typically very large ponds. Trees were planted for shade and fruit; there were many flowers, but the rose was supreme, and there were many varieties. Birds, animals, and fish were also to be found.

See also ALI QAPU; BAGH-I DELGOSHA; BAGH-I ERAM; BAGH-I FIN; BAGH-I GULSHAN; BAGH-I TAKHT; CHAHAR BAGH AVENUE; CHEHEL SUTUN; CHEHEL TAN; FATHABAD; GULISTAN PALACE; HAFT TAN; HAZAR JERIB; MADRASSA MADER-I SHAH; NARENJESTAN-I QAVAM; QASR-I QAJAR; SHAH GOLI.

Central Asia. By the 14th c. and 15th c. garden designs and techniques were well advanced in Central Asia. Gardens flourished in Herat as well as in *Samarkand, which was surrounded by forests, orchards, vineyards, and meadows, while its individual gardens followed the Islamic tradition. Major and secondary axes in these gardens led to a centrally located pavilion in a formal, geometrically ordered and enclosed garden which was well watered, green, and peaceful. Richly embroidered tents were used for royal receptions. In Afghanistan there were many gardens around Kabul, some of which were established by *Bābur, the first of the Mogul emperors, whose knowledge of plants and familiarity with the order and geometry of the Islamic garden were introduced into India in the early 16th c.

Mogul India. Many of the gardens of *Mogul India are to be found in Delhi and Agra by the banks of the Jumna, and in Lahore, as well as in the fertile and protected Vale of Kashmir. There was already an extensive tradition of gardens in this part of the world; many were attached to Buddhist monasteries and seminaries, as well as to the

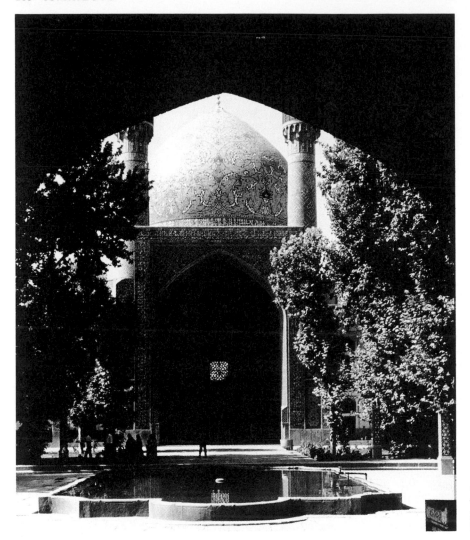

The courtyard of the
Theological College,
Madrassa Mader-i Shah,
Isfahan, Iran

dwellings of the nobility. The quadripartite plan was already present in Hindu temple gardens, and gardens in the south used running water extensively in their design. Muslim forms had been introduced before the Moguls but it was under their rule that they developed in splendour. The great period of the Islamic garden in India commenced in the first half of the 16th c. with Bābur, who entered India already familiar with gardens in Samarkand and Kabul. The design of these gardens was subsequently reinforced by the many contacts between the Mogul and Persian courts, and all the Mogul emperors were familiar with the paradise garden concept. Many gardens were established particularly under *Jahāngīr and *Shāh Jahān in the 17th c. Gardens of generous scale following Islamic principles of order were laid out on the plains, but in Kashmir the traditional geometry and symmetry were enriched by an abundance of water, a great variety of trees and planting, and magnificent surrounding scenery. Terraced gardens were located on

hillsides, and sweeping views were obtained from pavilions. Mogul gardens either surrounded a mausoleum or, as more often the case in Kashmir, were developed for pleasure and court ceremonial. Water was treated in a multiplicity of ways, many following Islamic garden tradition. Fountains, basins, chutes, channels, and other surfaces defining and in contact with the water were elaborately carved and patterned. Full records are available of the original planting of these gardens, since more than one Mogul emperor listed them in his journals. J.L.

Ismailovo, Soviet Union, was the Tsarist summer residence near Moscow, dating from the second half of the 17th c., in a large forest which was once a hunting area. The palace, service buildings, cathedral, and church were built on an island formed by damming the river, in which all the buildings with their cupolas and the bridges were reflected. Many deciduous trees—oaks, birches, willows—were plan-

ted near the palace, and gardens were laid out both on the island and in the surrounding area. All of them were formal in style with ingenious flower-beds, arbours, and fountains. Even the orchards were formally laid out. The gardens were scattered at random on the estate without any compositional link either with each other or with the buildings, but the river served as an informal and picturesque axis of the whole ensemble. S.P.

Isola Bella, Lake Maggiore, Italy. The design was begun *c.* 1630 for Count Carlo Borromeo and the gardens were completed in 1670. The setting, with views of distant snow-clad Alps, is magnificent. Three islands form a triangle in what is known as the Borromeo Gulf, off the main lake. The first to be inhabited was the fishing village Isola dei Pescatori. Isola Madre was transformed in the mid-16th c. and with its dramatically placed villa, landscape architecture, and fine trees, must have encouraged the design of Isola Bella itself. This design suggests the form of a ship, though not so crudely as originally intended. The first plan had been to geometricize the whole island, giving the impression of some monster galleon drifting across the lake. The splendid villa (or *palazzo*) lies at water level to the west. Taking advantage of the natural rock formation, the gardens extend to the east in a series of view terraces, culminating in a pyramid whose flat-topped summit is the highest point on the island. Fully exposed to the cool summer breezes and with views in every direction, this paved space was used for festivities and entertainments of all kinds. The terraces bristle with sculpture whose silhouette is suggestive of masts and spars. Today the architectural form is blurred by the foliage of trees planted subsequently, which softens the powerful underlying lines. G.A.J.

Israel is the meeting point of four phytogeographical zones, which have a strong influence on landscape and garden design. These are Mediterranean, Desert, Mountainous Desert, and a Saharo-Sudanese enclave, which together give rise to a great diversity of natural vegetation within a relatively small area. The species of plant material range from *Pinus halepensis* and *Pistacia lentiscus* in the Mediterranean zone, *Tamarix aphylla* and *Phoenix dactylifera* in the desert zone, to the tropical *Calotropis procera* in the Dead Sea area.

There are not many ancient garden sites in Israel. However, there are some in Jerusalem, including an orchard watered by the Shiloach Pool, and the Garden of Gethsemane, famous for its olive trees, said to date from the time of Christ. The site now has a small formal garden. The courtyard of the Dome of the Rock is surrounded by shady terraces overlooking the Mount of Olives and there are a number of small enclosed courtyard gardens.

The Bahá'í Gardens in Haifa were established in the 1920s and surround the shrines of the Prophet Herald and Prophet Founder of the Bahá'í faith. They were designed after their founder had taken a world tour of gardens and they incorporate features of many design styles. The Haifa garden is celebrated for its maturity and a dramatic location on the slopes of Mount Carmel. Dark avenues of cypresses enclose steep grassy terraces and brightly coloured parterres with palms and succulents.

The majority of Israeli families live in flats without a private garden and the role of public gardens is therefore of particular importance. It is almost impossible to refer to a specific style of Israeli garden design. However, the English school of landscape is evident in the gardens of the kibbutzim, where shelter-belts have been planted to enclose green lawns shaded by ornamental trees. But the most interesting examples in Israel are those in which an attempt has been made to develop new concepts within the limitations of the natural landscape. These include a number of archaeological and geological parks in various places, and the Ben Gurion Memorial Desert Garden in the Negev, designed by Lipa Yahalom and Daniel Tsur. The main feature of the garden is an artificial wadi paved with interlocking pebbles running between sculpted land-forms, where plant material is limited to a few desert species. The same designers are also engaged upon the Valley of the

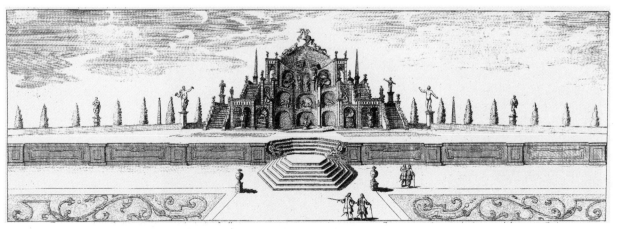

Isola Bella, Lake Maggiore, view of the theatre on the penultimate terrace, engraving (18th c.) by A. Dal Re

Gardens of the recently
completed Bahá'í seat of
the Universal House of Justice
at the Bahá'í World Centre,
Mount Carmel, Haifa, Israel

Destroyed Jewish Communities, sculpted out of the rocky hillside at Yad Vashem near Jerusalem. This will comprise a number of outdoor rooms, each representing a different country, which will be identified by appropriate symbols; the prevailing mood of desolation will be emphasized by scattered non-flowering plants. By contrast, 'from the valley a path will lead to a Garden of Resurrection and Rebirth . . . planted with trees, flowering plants and wild flowers such as cyclamen, daisies, anemones and irises'. The Avenue of Righteous Gentiles, lined with carobs, will link the valley to memorial buildings and sculpture on a hilltop surrounded by the rough-hewn walls and terraces of the Jerusalem Forest.

Among the archaeological gardens is the Timna Valley Geological Park designed by Segal-Dekal of Tichnun Nof, a large site in the southern Negev incorporating King Solomon's Mines. The National Park in Jerusalem comprises a number of archaeological gardens situated immediately outside the Old City Wall. The park is a continuous network of archaeological sites combined with paved areas,

Desert-wadi garden (c. 1982),
Ben Gurion Memorial, Sde-
Bokek-Negev, Israel, by
Yahalom and Tsur

observation points, and trees and grass covering a total of 300 ha. and linking the old and the new cities of Jerusalem.

Such systems of open spaces which unite the old and the new, incorporating footpaths and promenades, public squares and gardens, *sculpture gardens and museums, university and civic buildings, are perhaps the most significant achievement in landscape and garden design in Israel. One such site is the Rothschild Memorial Garden in Zichron Yaakov near Haifa, designed by the late S. Oren. In his design he managed to create an original garden style combining formal and informal elements and incorporating large open spaces of grass, tree planting, paved areas, and a rose-garden. Another example is the Billy Rose Sculpture Garden in Jerusalem, celebrated both for its designers, Isamu *Noguchi and Lawrence *Halprin, and for the collections of international and Israeli sculpture arranged in and around gravel-paved concrete-walled enclosures. A more appropriate integration of sculptural elements has been successfully achieved by Miller-Blum in such areas as the Ganei Carmel and the Yad Lebanim Memorial Square in Haifa, and the King David Park in Ramat Gan. This practice is also responsible for a large number of other open spaces including gardens of outstanding quality, effectively responding to contemporary needs with a harmonious integration of strong geometrical elements and natural plant materials. In them the garden has become a part of the city landscape. J.E./M.L.L.

Italian garden, a phrase used in the 19th c., originally from an idea promoted by Humphry *Repton—that English gardens from the 16th c. to the early 18th c. had been based on an Italian style, of which the French and Dutch styles of the late 17th c. were merely variants. The Victorian designer could therefore claim to be working in the Italian style while basing his parterres on those of Versailles. The Italianate revival was pioneered by James Wyatt in his terrace garden at Wilton House in the first decade of the 19th c., and popularized by *Barry in a series of gardens based on authentic Italian Renaissance models; but designers who, like *Nesfield, drew on old gardening treatises were more eclectic, and often the distinction between Italian and Tudor gardens depended more on rhetoric than on observable features.

During the second half of the century, the phrase came to be applied to any garden with a formal arrangement of flower-beds, with or without an architectural terrace. This usage lasted until the end of the century, when designers like *Peto began to base gardens more rigorously on Italian Renaissance architecture, divorced from the *bedding schemes the Victorians had used. B.E.

Italy

PRE-RENAISSANCE GARDENS

Sicily. On mainland Italy between the end of the Roman Empire and the Florentine Renaissance the art of the garden was eclipsed along with all other arts. Gardens served merely to provide vegetables, herbs, or flowers for church decoration, although something of the Roman tradition did survive, for when the Abbey of Monte Cassino was rebuilt (1070), the garden was said to be 'a paradise in the Roman fashion'. The only gardens known to us come from a different tradition, that of *Islam, and were found in parts of Italy which were to play no part in the Renaissance—Sicily and Naples.

The Muslims, whose conquest of Sicily was effectively completed in 878 with the destruction of Syracuse, made the first pleasure-gardens of post-classical Italy, importing orange and lemon trees, and many other plants which we now regard as typically Mediterranean. These gardens were completely destroyed in the Norman conquest of 1091, yet the Norman kings appear to have made pleasure-gardens in the Islamic manner—colonnaded courts, enclosed gardens, and fountains, and even a court with lions like the much later (1377) example at Granada.

In Palermo, the Cuba and Favara pavilions, standing on small artificial islands among palm trees, and two other palaces, the Zisa and the Menani, were set in a vast royal park planted with groves of oranges, lemons, and limes. No trace of this park remains, with the exception of what is now called Palazzo La Zisa (completed between 1154–89). The surviving vestibule has a wall covered with stalactites, at the base of which there is a water chute and a rill, but nothing remains of the courtyard garden.

Cloister gardens attached to churches also followed the Islamic model, for example at San Giovanni degli Eremiti, Palermo (12th c.), and Monreale Cathedral (after 1174). In the latter case, off one corner of the garden is a small courtyard containing a circular basin; immediately outside the cathedral is another courtyard with a low rectangular pool surrounded by palm trees. *Medieval gardens around monasteries, of the type existing elsewhere in Europe, are not found in Italy.

Naples. The Sicilian gardens had their greatest influence through the Hohenstaufen Emperor Frederick II (1194–1249), who had lived at the court of Palermo as a boy. He established gardens next to his castles and hunting-lodges in central and southern Italy, which may have inspired the garden descriptions in the *Liber ruralium commodorum* (1305), by Pietro de' *Crescenzi (1230–1305).

Royal gardens continued to be designed during the 14th c., in particular at Naples. In his *Visione Amorosa* written there in 1342–3, Boccaccio (c.1313–75) describes gardens filled with sculpture, unique in Italy at that date. Gardens continued to flourish at a later period, in particular *Poggio

Reale (begun 1487) for King Alfonso II (1448–94). Its beauty so impressed the young French King Charles VIII in 1495 that he took back to France a Neapolitan gardener, *Pacello da Mercogliano. However, the subsequent rule of the Spanish viceroys (1502–1734) cut the area off from the mainstream of artistic development.

RENAISSANCE

Florence. Of 14th-c. gardens in and around Florence, little is known apart from the literary descriptions of Boccaccio and Petrarch (1304–74), in whom a new feeling for the beauties of nature became apparent, although this was not as yet expressed in a new movement of garden design. Boccaccio's *Decameron* described the Villa *Palmieri, Florence (1348) as a walled garden with arbours or pergolas, a fountain of white marble, and a square plot in the middle with a thousand types of flowers. Petrarch cultivated his own small garden, strictly (if somewhat unsuccessfully) in accordance with the classical texts but it amounted to little in terms of design.

Early in the 15th c. the villa became the centre of the contemplative life, and the custom of *villeggiatura* (withdrawal to a country residence) arose (see Villa *Medici, Careggi). The garden Renaissance was inspired by the treatise, *De re aedificatoria* (1452) by L. B. *Alberti (1404–72), who may also have designed the Villa *Quaracchi (c. 1459), near Florence. The Villa Medici at Careggi, where the Florentine Academy met under the leadership of the celebrated neo-Platonist, Marsilio Ficino (1433–99), was perhaps the most complete expression of Alberti's ideas—an imitation of a Roman villa garden, with clipped evergreens.

A comparison of two Tuscan villas by the architect Michelozzo Michelozzi (1396–1472) shows the spirit of the new age. The earlier villa is the Medici hunting-lodge *Il Trebbio at Cafaggiolo, converted from a fortress c.1451, with gardens that are still enclosed but are large enough to be considered an extension of the house into the landscape. This sense of outward projection was brought to perfection only a few years later in the terraced garden of the Villa *Medici at Fiesole, although at the same time the feeling of enclosure is retained in one section of the garden, the *giardino segreto.

Sienna and Lucca also developed their own tradition of gardens, but slightly later, in the 16th c. Few of these have survived, however, as usually they were kitchen gardens, of which the charm derived from their planting. One unusual feature was the use of clipped scented herbs rather than box as edging for beds. Of a different type are two gardens near Sienna attributed to the famous Siennese architect, Baldassare Peruzzi (1481–1537)—Vicobella and *Celsa.

Although it laid the foundations for new conceptions of space and of garden design, the Florentine Renaissance did little to realize these conceptions in practice: the impetus was to come from Rome. However, one of the features which was to remain central and constant in Italian gardens until the end of the 18th c. was already apparent—the subordinate role in the whole design played by plants, which were almost entirely evergreens. Although there was an intense interest in flowers, especially during the early Renaissance, with the introduction of new species from abroad (see the list for a later period given as an appendix to Georgina Masson, *Italian Gardens*, 1961), and although Italy had the world's first two botanic gardens (*Padua and *Pisa), the flower garden was given little attention by designers.

Rome. In 1417 the Papacy returned to a Rome that was almost in total ruins. With the possible exception of the Vatican gardens themselves, those of the Roman quattrocento palaces were confined to the enclosed *cortile* (courtyard) resembling in shape the medieval cloister. The first architect to be given the opportunity to break out of this space restriction was Bramante (1444–1514), who was commissioned by Julius II (1503–13) in 1503 to redesign the *Belvedere Court of the Vatican. The space vastly exceeded in size any previously enclosed *cortile*. This the architect broadly divided into two areas linked by an imposing ramp (perhaps inspired by *Praeneste). The upper and crowning feature was the formal garden and semicircular alcove, the first setting in modern times for a collection of statuary; the lower area was an arena for spectacle. The design was enormously influential—the dramatic changes of level had no modern precedent; and the revival of the idea of the garden as a site for statuary was to become extremely important.

For the quattrocento Popes, *villeggiatura* had no important effect on architecture or gardens, as they were content to use the buildings in the hill towns left by their medieval predecessors. Thus although Pius II (1458–64) had created a small garden room with a spectacular view of the landscape when he constructed his township at Pienza (1459–62), there appears to have been no major landscape development outside Rome until 1516, when Raphael (1483–1520) began the Villa *Madama on the slopes of Monte Mario.

The remaining fragment of the Villa Madama is only part of what would have been an almost pure reconstruction of a villa of imperial Rome, including a theatre hollowed out of the hillside. The plan had considerable influence on the future, not so much for its shape as for its illustration of a revived form of country life and for the way in which such a huge building and its ancillaries could fit into the landscape.

MANNERISM. The sack of Rome in 1527 caused a major shift in intellectual values, expressed in architecture and the fine arts as Mannerism, of which the earliest (and perhaps most typical) expression is the Palazzo del *Tè, Mantua. This tendency was expressed in garden design, albeit in a more muted form, in two major developments: the elaboration of intricate iconographical programmes calculated to flatter a patron; and, as an equivalent of the distorted proportions found in the painting and architecture of the period, the use of mechanical devices to cause surprise and alarm.

The first programme of this kind to inform garden design

is at the Villa *Medici, Castello (1538), but the programme which appears to have had most influence on the arrangement of the garden and the siting of various sculptural ensembles is at the Villa *d'Este, Tivoli. Here, as elsewhere, there are two general themes: the superiority of art over nature and a celebration of the power and virtues of the patron. At the Palazzo *Farnese, Caprarola, the programme applies most clearly to the *palazzo* itself, rather than to the garden; while at Villa *Lante and Villa *Orsini, Bomarzo, the former theme is much more in evidence.

Mechanical devices powered by water (see *automata), such as singing birds or moving animals, often set in motion unexpectedly, were among the most highly prized features of the gardens of this period. The disturbed universe of Mannerism often found comic expression in *giochi d'acqua*, as unwary visitors were soaked to the skin. The ideal place for these contrivances was the *grotto, the first example of this kind being at the Villa Medici, Castello, and the most elaborate, at *Pratolino, perhaps the most internationally renowned garden of the time.

During this period it is often difficult to identify the precise contribution made to garden design by patrons, sculptors, antiquaries, and architects but the *Medici and Este families stand out, as do two figures—Pirro *Ligorio (1510–83) and *Vignola (1507–73).

Pirro Ligorio was a dedicated antiquarian. In 1550 he worked at the Villa d'Este, Tivoli, the grandeur of whose gardens seems to have been inspired by the nearby Praeneste and *Hadrian's Villa, a few miles away. Terraces descend steeply from the villa in the direction of a view across the Campagna di Roma to the Sabine Hills. Unlimited water is carried to the highest point by a conduit from the river Aniene and thereafter spread throughout the gardens in countless ways that together form a musical chord of falling water (see *water in the landscape). A few years later, Ligorio designed the Villa *Pia in the Vatican gardens, perhaps also inspired by elements in Hadrian's villa.

Vignola was a far greater scholar and artist—the most accomplished philosopher/landscape architect of the Renaissance. His first Roman commission was the Villa *Giulia, begun 1551–5, immediately outside the walls. The design is basically the infilling of an enclosed rectangle, smaller and more compact than the Belvedere Court but clearly influenced by it. There are two courts, the second being a nymphaeum on two levels. As a three-dimensional space concept it is a small masterpiece in which the climax, subterranean with the scale diminished, is an inversion of the normal.

His masterpiece is the Villa Lante, Bagnaia, in the same area east of Viterbo, where he created the Casino for the Palazzo Farnese, Caprarola. At Bagnaia, as if the idea of landscape architecture and its hidden allegory were more important than architecture, the villa itself is divided into two parts. Between this duality flows water from the woods to settle in a peaceful water parterre—a square, the universal symbol of heaven brought to earth. Despite the wealth of detail, there is an overall sense of tranquillity.

Vignola may also have been involved at Bomarzo, where the more disturbing aspects of Mannerism predominate. Giants are hewn out of solid rock; architecture, the symbol of harmony and order, is portrayed askew; and a Christian *tempietto* on high ground (conceivably designed by Vignola) alone gives assurance of salvation from these terrible forces.

FLORENCE AND GENOA IN THE SIXTEENTH CENTURY. Writing to Duke Cosimo I in 1551, Baccio Bandinelli (1488–1560), who had actually lived at the Belvedere Court and the Villa Madama, gave very clear expression to the Roman conception of landscape design: 'Le cose che si murano debbono essere guidi e superiori a quelle che si piantano' (The things that are built should be the guide of and dominate what is planted). The architectonic modelling of the site to create an impression of grandeur did not find a counterpart in Florence. At the *Boboli gardens, begun in 1549 by Niccolò Tribolo (1500–50), a naturally existing hollow was given a horseshoe shape, but the formal possibilities of the site were not exploited until at least half a century later.

The first plan of the Boboli had one major feature in common with the Roman manner, the axis centred on the house (cf. also the Villa *Bernadini). This layout had been used for the first time in a Florentine villa at the Villa Medici, Castello (begun 1538, also by Tribolo), where the major features (statues and a grotto) are placed on the central axis. Pratolino surpassed its rival, the Villa d'Este, for the ingenuity and number of its automata, grottoes, and *giochi d'acqua*, but in formal terms its simple axial layout entirely ignored the possibilities of its site.

The domestic rather than the monumental scale villa was more the rule throughout Tuscany (for example, Villa *Bombicci), and was influential elsewhere in Italy (see the *Giardino dei Giusti, Verona). Florence abounded in small gardens exquisitely designed for site and owner—the most delightful of those which have survived are the Villa *Capponi, Arcetri, made c.1572, with its special study of open and enclosed space and its exhilarating curvetting wall, and the remarkably planned Villa Gamberaia at Settignano.

The inauguration of the Genoese Republic in 1528 by Admiral Andrea Doria (1468?–1560) led to an era of prosperity. Splendid palaces were built in the Strada Nuova (now Via Garibaldi) from 1558, but the opportunities for gardens were restricted by the shortage of space between the harbour and the hills. The scenic possibilities of this natural amphitheatre were therefore not realized.

The largest and most famous garden in Genoa was the Palazzo *Doria, outside the city walls, similar to Castello in having an imposing fountain as the main feature on a central axis. Of the narrow urban gardens that once climbed the hill, that of the Palazzo *Podesta alone remains to show the use of the tiny spaces behind the *palazzi*. The most ingenious must have been the garden of the palace of Hieronymo del Negros which Evelyn delightfully recorded as being 'furnished with artificial Sheepe, Shepheards, & Wild beasts, so naturally cut in a grey-stone, fountaines, rocks, & Piscina's, that . . . you would imagine your selfe in a

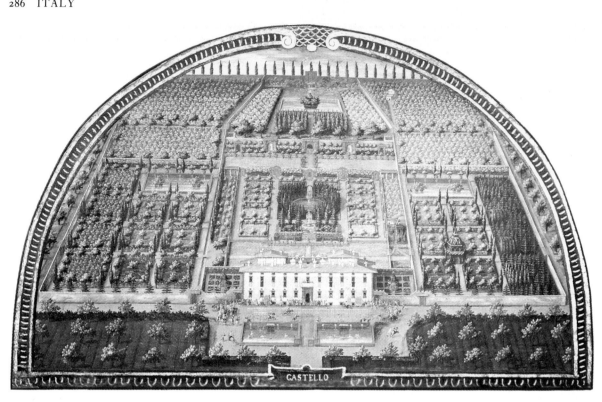

Villa Medici, Castello, Italy, lunette (*c.* 1599) by Giusto Utens (Museo Topografico, Florence)

Wilderness & Silente Country . . . all within one Aker of ground' (*Diary*, 17 Oct. 1644).

ROMAN BAROQUE GARDENS. Baroque art originated in Rome and the climate of the time dictated that the garden-building patrons, almost entirely ecclesiastics, should be lavish entertainers. Thus baroque art is primarily one of spectacle rather than contemplation; the eye predominates and is catered for by illusion and the cunning use of perspective very different from the optical corrections of the Greeks. However, in Rome itself, although parks were formed on a vast scale from the beginning of the 17th c. (such as the Villa *Borghese, from 1605—7 km. in circumference; the Villa *Doria-Pamphili, begun 1634—8 km. in circumference), they consisted mainly of geometrical plantations. The house and a relatively small formal garden, including terraces, parterres, and grottoes, became a minor incident, rather lost in the enormous size of the surrounding park. The major achievements of baroque Rome—the hierarchical organization of dramatic spaces and the creation of optical illusions—were in town planning and church design, not in gardens. (See *Arcadian Academy, for a late baroque example.)

The true seat of Roman baroque landscape art lies at Frascati, some 25 km. south-east of the capital.

The villas of Frascati. 'If you want to see something really superb, go out of Rome to Tusculum, now Frascati', wrote J. T. Sprenger in 1660 (*Roma Nova Delineata*), expressing an enthusiasm common to travellers from Evelyn (*Diary*, 1645) to Goethe (*Italian Journey*, 1786). From the end of the Roman Republic wealthy citizens had built country villas here, on the site of the old Etruscan town of Tusculum, and during the later imperial period the area was almost completely covered with buildings. The villas fell into such decay during the Middle Ages that it is difficult to identify even their sites.

Renamed Frascati in the 13th c., the area was rediscovered by Annibale Caro, philosopher and philologist, who aimed to follow the example of Cicero by establishing a 'modest Tusculum', now the Villa *Torlonia (1563). By 1620 Frascati was again covered with villas, the outstanding examples being Villa *Mondragone (1565), Villa Muti (1579), and Villa *Aldobrandini (1598–1603), the last anticipating the large-scale dramatic effects of the Roman baroque manner. In a second phase, the original layouts were enlarged, notably at Villa Mondragone (1615) and Villa Falconieri (*c.* 1650). In a final, less significant phase in the first half of the 18th c., the gardens were adapted to the current taste, as at Villa Torlonia (1720), Villa Falconieri (1724–9), and Villa Ruffinella (1740–6).

During all these phases, however, certain common characteristics can be discovered. All the villas are sited on a slope, falling towards the north, giving a broad view of the

Campagna di Roma. The placing of the villas and their gardens on these sites is not, however, determined by natural considerations, but by the attractive power of Rome, the source of the power and the culture of their owners. Thus, where the sites do not fall quite in the direction of Rome, the magnetic attraction is still apparent, even at Villa *Lancellotti, in other respects an exception.

At the rear of the sites was a steep hillside covered by natural forests of oak and chestnut, the Alban Hills having escaped the deforestation general during Roman and medieval times. To comply with these requirements, a level plateau to carry the villa and garden had to be carved out of the slope, an operation which often consumed the larger part of the total building cost: in turn this determined the characteristic form of the garden. For the retaining wall against the hillside is often cut in the shape of a semicircle, forming an amphitheatre used for systems of water displays and cascades, a veritable 'water theatre'. This form had a sound classical precedent, and a Renaissance exemplar at Villa Madama, but its practical advantages in terms of cost and construction may in fact have been decisive. Thus, it is not found at Villa Torlonia where it was not necessary in practical terms.

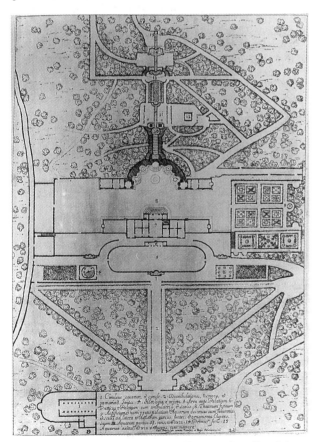

Site plan of the Villa Aldobrandini, Frascati, from Dominicus Barrière, *Villa Aldobrandini* . . . (1647)

Water displays, although not so lavish as those of the Villa d'Este, Tivoli, were a major feature. The hills had no natural reserves of water, so it had to be brought by pipeline—an enterprise probably as costly as the villas themselves. It was the water displays, especially the *giochi d'acqua*, which made the most powerful impression on visitors such as Evelyn and de Brosses (1739). Along with the fountains and the cascades, they were frequently represented by contemporary engravers (G. B. Falda, *Le Fontane di Roma, II: Le Fontane delle Ville di Frascati*, Rome, 1675; Dominicus Barrière, *Villa Aldobrandina Tusculana sive varii illius hortorum et fontium prospectus*, Rome, 1647).

Within the framework laid down by the site, ingenious variations were played on a similar theme: a *giardino segreto*, usually placed to one side of the palace (Villa Muti being one exception); utility gardens (*podere*) usually concealed from view; a parterre surrounded by pergolas and bowers; and, finally, the *bosco, behind the system of cascades or surrounding it.

BAROQUE GARDENS ELSEWHERE IN ITALY. Across the north of Italy the character of baroque garden design was richly varied through geography and climate. It is perhaps surprising that a monumental baroque garden with a dramatic water staircase, the Villa *Garzoni, Collodi (1652), should be set in the gentle Tuscan countryside north-east of Lucca. Similarly, dramatic features are found at the villas *Cetinale (a long formal axis), *Cicogna (a water-staircase), and *Crivelli (a cypress avenue). On a more domestic scale is the enclosed theatre and water garden of the Villa *Marlia (early 18th c.).

Como, with Villas *d'Este, *Balbianello, and *Carlotta on its shores, is probably the most naturally romantic of the lakes, but the finest man-inspired landscape is undoubtedly on Lake Maggiore in three islands clustered in the Borromean Gulf: *Isola Bella, Isola Madre, and Isola Pescatori. The transformation of the first from a rocky island, begun *c*.1630 for Count Carlo Borromeo, is the greatest existing example of the affinity of baroque art with its environment.

VENICE AND THE VENETO. As in the other visual arts, *Venice and its hinterland followed a different course from the rest of Italy. In Venice itself, secular gardens existed from at least 1500. The inner courtyard of Venetian *palazzi* was frequently decorated with flowers and a small geometrical garden designed to be seen from above—the central feature was an ornamental well-head underneath which a cistern stored water. Large gardens with loggias, pergolas, and flower-beds existed on the perimeter of the city, where space was less at a premium.

On the terra firma in the 16th c. the villas bordering the Brenta undoubtedly had pleasure-gardens; and in the work of *Palladio the Renaissance theory of proportions was carried over with unsurpassed subtlety into outdoor space (especially at the Villa *Barbaro). The only larger-scale garden in the region is the *Giardino Barbarigo, Valsanzibio, near Padua, from 1650: a huge domestic garden that might be a maquette for a seemly town plan with its green

streets and enclosures, its modest villas as the civic centre, and its submission to the natural amphitheatre of the hill in which it is set. (See also Villa *Brenzone; Villa *Valmanara.)

THE EIGHTEENTH AND NINETEENTH CENTURIES. For almost two centuries the garden art of Italy had a profound impact upon that of France, but by c.1660 its creative impulse was virtually spent and the initiative passed in turn to France. Unlike virtually every other European country, Italy did not in general pay *Versailles and *Le Nôtre the compliment of imitation. There are three major exceptions: the Villa *Crivelli Sormani-Verri (before 1743) with its elaborate parterres and *treillage; the Villa *Pisani, Strà, with its trompe l'œil planting; and the royal palace *La Reggia at Caserta, Naples (begun 1752). Its attempt to outdo Versailles in terms of sheer size, by means of the longest cascade in history, is magnificently decadent.

After Caserta, no major gardens were created in Italy in either an Italian or French style. The 19th c. is a doleful period when most of the major gardens were allowed to decay (although few were completely destroyed—perhaps the most grievous loss was Pratolino, in 1822); or were swallowed up in urban expansion, as in Rome; or, a worse fate, were converted into that feeble parody of the English landscape garden, the giardino inglese. Whereas it can be claimed that the French version, the *jardin anglais, has the merit of a spirited pastiche or even represents something sui generis, there is little that is distinctive about the Italian version.

The only notable Italian designer of this period is Giuseppe Japelli, about whom little is known, apart from his Villa Emo, Battaglia, in the Veneto. From the middle of the century, the initiative in garden design was taken by foreign residents, mainly English or Irish, with the creation of the Villa San Remigio (Pallanza), *La Mortola (1867 onwards), and Villa Taranto (1930s), which represent a break with the Italian tradition, in that the display of individual plant varieties becomes of great importance.

At the end of the 19th c. there was a great revival of interest in the classic Italian gardens, resulting in a spate of books by English and American authors, such as Edith Wharton, H. Inigo *Triggs, Charles Latham, and, somewhat later, Shepherd and *Jellicoe. From Charles *Platt to Thomas *Church, garden designers absorbed various features of the Italian tradition into their own practice.

In Italy itself, some notable gardens have been made around Florence by English designers. Cecil Pinsent designed the gardens of the Villa i Tati for the art critic Bernard Berenson; and new gardens were added to the Villa Palmieri by the Earl of Crawford and Balcarres and, at the turn of the century, to the villa *La Pietra by Arthur Acton.

P.G.

THE TWENTIETH CENTURY. Throughout the 20th c. Italian architects and designers have played a leading role in developing new design languages to answer modern needs, for example, Futurism, International Modern, and Ration-alism. However, this dynamic visual language was expressed mainly in the fields of architecture, product design, and graphics. Especially at the beginning of the century, the design of gardens owed more to the past and to the influence of literary figures from outside Italy, who followed a version of Italian tradition.

For the next 50 years, garden design continued to focus on the creation of new gardens for the wealthy. Gradual changes in farming methods and the depopulation of the countryside enabled wealthy industrialists and professionals to acquire old farmhouses and villas. This generated the desire and opportunity for the creation of gardens. Fore-most among the designers meeting this need was Pietro *Porcinai, whose career began in 1937. His work was greatly influenced by Russell *Page, who created several gardens in Italy, including one for Sir William Walton on the island of Ischia (1958). Porcinai's designs display a modern interpretation of the traditional Italian gardens where stone and greenery are used to create sculptural effects. The garden at the Villa Riva, Saronno, where he co-operated with the Rationalist architects, Belgiojoso, Peres-sutti, and Rogers, testifies to this.

However, the development of modern industry, com-merce, and tourism throughout the century has created a further need for the design of modern landscapes. Porcinai has made significant contributions in this field too, with his ecological park designed to complement the office building for Mondadori at Segrate (architect Oscar Niemeyer). Another outstanding landscape designer during this period was Maria *Shephard-Parpagliolo who designed gardens for the Hilton Hotel in Rome (1963) and the landscape for the RAI offices (1966). But the most extensive contribution is still being made by architects, interior designers, and engineers rather than specialist garden or landscape designers. For instance, Carlo Scarpa (1906–78) was an eminent architect whose contribution to garden design, while not prolific, has served profoundly to advance the modern movement in landscape design. His design for the Garden of Rest (1970) for the industrialist G. Brion, at San Vito di Attivole, displays great skill in the handling of form and architectural detail to create a dynamic space.

The second half of the 20th c. has seen a growing interest in large-scale public landscapes. An outstanding example is the swimming-pool centre and park at Vignola, Modena, by Cesare Leonardi and Franca Stagi. This exhibits the spatial concepts evident in their art, used in the form of sculptural compositions in concrete circles and planes, juxtaposed to create unusual visual experiences. Other designers working in the wider field of park and garden design include Augusto Cagnardi of Gregotti Associati, Marco Pozzoli, Ferrante Gorian, Giulio Crespi, Gilberto Oneto, and Alessandro Tagliolini. The communes of Modena and Brescia have also commissioned an English designer, Sir Geoffrey Jelli-coe, to create public parks (1984).

Among the foremost contemporary Italian garden designers are Francesco Clerici, Elena Balsari Berrone, Paolo Pejrone, and Ippolito Pizzetti. The last named is currently (1984) President of the recently formed Italian

South hill of the Hilton Hotel garden (1963), Rome, by Maria Shephard-Parpagliolo

Association of Landscape Architects which, along with the introduction of garden and landscape design into the architecture courses at several universities, owed much to the enthusiasm of Guido Ferrara and others. D.A.B.

I'timād-ud-Daula, Tomb of, Agra, India. Ghiyas Beg, a Persian, and father of Āsaf Khān and Nūr Jahān, received the title of I'timād-ud-Daula from the Mogul Emperor *Jahāngīr. He is buried at Agra with his wife, for they died within months of one another. The garden tomb, completed in 1628, is set on the banks of the River Jumna, on to which a graceful small pavilion opens. The drive leading to the gatehouse is planted on each side with orchards, recalling a much earlier tradition. The tomb gardens in the past were handed over to the care of priests, and the upkeep of the garden was provided for by its produce.

The design is that of Nūr Jahān, wife of Jahāngīr, and Nature was her inspiration. Trees and flowers play a major part in the decoration, which is intricately worked in white marble and *pietra dura*, an early use of the technique of inlaying semiprecious stones. Surfaces everywhere are rich with ornament, and the illustrations of plants are astonishingly lifelike. The actual tombs, very simple in yellow marble, contrast with the richness of the interior. Externally, the overall effect is pale, as of a richly carved ivory casket, reflecting the soft colour of the river. S.M.H.

Jacobsen, Arne (1902–71), one of the best-known Danish architects, worked for a time in Sweden, where he was strongly influenced by the refined detailing of Gunnar *Asplund's work. His practice started with the design of single houses and gardens in collaboration with notable plantsmen such as G. N. *Brandt. In 1953 he designed a terrace of houses at Klampenborg near Copenhagen which became a model for housing design. He lived in one of the end houses where he created a highly individual garden. Clipped larch hedges were used to divide the garden into compartments and serve as a backdrop for a varied selection of plants.

He abhorred the word 'inspiration', maintaining that a good design was only achieved through hard work on the drawing-board. His concern for integrating the landscape with the building is expressed at Munkegaard School in Gentofte, Copenhagen, where he used a mass of clipped beech to extend the building mass. Much of his later work was abroad, including St Catherine's College, Oxford (1960–4), which is remarkable for the unity of landscape and architecture. P.R.J.

Jäger, Hermann (1815–90), German garden designer and writer on gardens. After an apprenticeship at *Belvedere near Weimar Jäger travelled in Germany and southern and western Europe between 1834 and 1845. From 1845 he was court gardener at Eisenach. He carried out extensive landscape work at the Wartburg and its environs, reflecting in the landscape the romantic style of the extensions to the castle. His part in the Wilhelmsthal Park is not clear, but he designed numerous private gardens.

Jäger had a far-reaching influence on contemporary garden design through his many essays and textbooks, as well as poems and novellas: *Reichenau oder Gedanken über Landesverschönerung* (1851); *Die Verwendung der Pflanzen in der Gartenkunst* (Gotha, 1858); *Lehrbuch der Gartenkunst* (Leipzig, 1877); *Gartenkunst und Gärten sonst und jetzt* (Berlin, 1888). H.GÜ.

Jahāngīr (1569–1627), 4th Mogul Emperor (1605–27), first accompanied his father to Kashmir, and developed a lifetime's attachment to the country. He married, late in life, the Persian Nūr Jahān, and together they became the leading figures in designing the gardens of Kashmir. They created the superb royal gardens there of *Achabal, *Shalamar, and *Vernag, which became their summer homes. They visited the country regularly, and the Emperor put in hand the improvement of the roads to Kashmir, building rest-houses along the way, some of them with

gardens. His courtiers followed his example, and a count in his time recorded 700 gardens along the shores of Lake Dal, producing a considerable income from flowers. All this has vanished, leaving only Shalamar and *Nishat Bagh, the creation of Asaf Khān, together with the later Chasma Shahi.

Jahāngīr travelled widely also in the rest of his empire, for travel was a way of life with the Moguls, and court business was conducted along the way. Great pains were therefore taken over the comfort and luxury of their temporary homes along the route. While in India, the Emperor's time was divided chiefly between Agra, Ajmer, and Lahore, and it is clear from his records that *Bābur's gardens in Agra were well maintained in his day. Many distinguished minor works are also attributed to him. His wife Nūr Jahān also created great gardens—the Tomb of *I'timād-ud-Daula at Agra and the *Shahdara at Lahore.

Jahāngīr wrote his own memoirs, the *Tuzuk-i-Jahāngīri* (trans. A. Rogers, ed. H. Beveridge, Delhi, 1968), which recall those of Bābur in his delight in trees and flowers, and his understanding of nature as a whole. The memoirs give, too, a detailed picture of the times, and of the creation and development of the gardens. The Mogul school of painting, already developed by Akbar through the Persian painters introduced by *Humāyūn, reached its zenith under Jahāngīr, and included superb illustrations of birds, plants, and flowers. S.M.H.

Jakobsen, Preben (1934–), Danish landscape architect. After an early reaction against plants instigated by his family's involvement in the nursery business, Jakobsen began to study horticulture. He worked in a number of well-known nurseries in Denmark, France, and Britain before becoming a student at the Royal Botanic Gardens, Kew, where he became interested in landscape design. After returning to Denmark for military service he studied landscape architecture at the Danish Royal Academy of Fine Arts, where he came into contact with teachers who had worked with or been influenced by Alvar *Aalto, Le Corbusier, and Frank Lloyd *Wright; and particularly with the Danish landscape architect Carl Theodor *Sørensen. He returned to England to work for the architects Eric Lyons and Ivor Cunningham on the *Span housing estates in which he was able to develop his design ideas. In 1969 he left to set up his own practice with his wife Margaret. He has acquired a reputation as a designer of outstanding ability working with equal facility in the manipulation of hard architectural elements and in the use of plants. His contribution to *Design with Plants*, edited by Brian Clouston

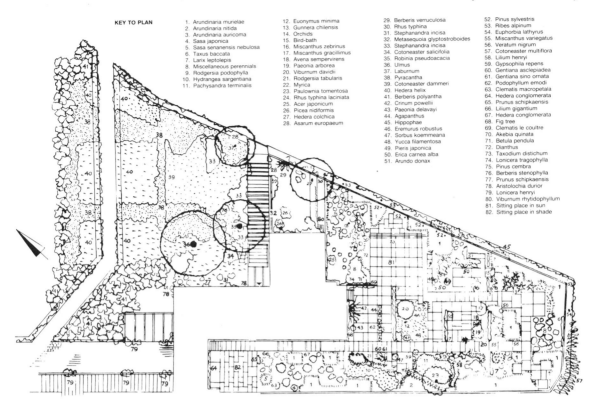

KEY TO PLAN

1. Arundinaria murielae
2. Arundinaria nitida
3. Arundinaria auricoma
4. Sasa japonica
5. Sasa senanensis nebulosa
6. Taxus baccata
7. Larix leptolepis
8. Miscellaneous perennials
9. Rodgersia podophylla
10. Hydrangea sargentiana
11. Pachysandra terminalis

12. Euonymus minima
13. Gunnera chilensis
14. Orchids
15. Bird-bath
16. Miscanthus zebrinus
17. Miscanthus gracillimus
18. Avena sempervirens
19. Paeonia arborea
20. Viburnum davidii
21. Rodgersia tabularis
22. Myrica
23. Paulownia tomentosa
24. Rhus typhina laciniata
25. Acer japonicum
26. Picea nidiformis
27. Hedera colchica
28. Asarum europaeum

29. Berberis verruculosa
30. Rhus typhina
31. Stephanandra incisa
32. Metasequoia glyptostroboides
33. Stephanandra incisa
34. Cotoneaster salicifolia
35. Robinia pseudoacacia
36. Ulmus
37. Laburnum
38. Pyracantha
39. Cotoneaster dammeri
40. Hedera helix
41. Berberis polyantha
42. Crinum powellii
43. Paeonia delavayi
44. Agapanthus
45. Hippophae
46. Eremurus robustus
47. Sorbus koemmeana
48. Yucca filamentosa
49. Pieris japonica
50. Erica carnea alba
51. Arundo donax

52. Pinus sylvestris
53. Ribes alpinum
54. Euphorbia lathyrus
55. Miscanthus variegatus
56. Veratum nigrum
57. Cotoneaster multiflora
58. Lilium henryi
59. Gypsophila repens
60. Gentiana asclepiadea
61. Gentiana sino ornata
62. Podophyllum emodi
63. Clematis macropetala
64. Hedera conglomerata
65. Prunus schipkaensis
66. Lilium giganteum
67. Hedera conglomerata
68. Fig tree
69. Clematis le coultre
70. Akebia quinata
71. Betula pendula
72. Dianthus
73. Taxodium distichum
74. Lonicera tragophylla
75. Pinus cembra
76. Berberis stenophylla
77. Prunus schipkaensis
78. Aristolochia durior
79. Lonicera henryi
80. Viburnum rhytidophyllum
81. Sitting place in sun
82. Sitting place in shade

Plan and view of the designer's own garden (*c.*1960) at Klampenborg, Denmark, by Arne Jacobsen

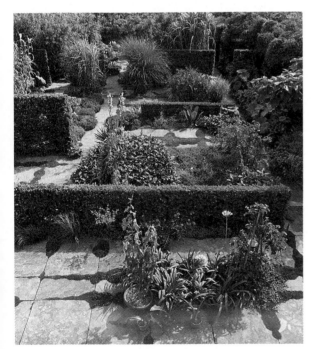

(1977), is outstanding for his clear analysis of the subject of planting design, on which he has lectured in many institutions.

Although the range of his work is wide and varied, his strong belief that landscape architecture is an art form is best expressed in the smaller scales of urban and garden design (*see over*). In recent work at Hounslow Civic Centre (1977) he has divided the site into a series of 'garden' areas of great intricacy and impeccable quality. In a private garden at Stanmore (1977) all items—fences, pergolas, paving, lighting, and plants—are designed and selected with the care and attention to detail which is a characteristic of his approach to design. M.L.L.

Jallerange, Besançon, Doubs, France, was begun in 1771 by Séguin, a *conseiller* in the Parliament of Besançon. It is still owned by his descendants and retains its original form. The courtyard and entrance to the house are at a lower level than the garden. The main rooms on the first floor open on to a parterre of four compartments round a circular basin, with the paths ornamented by orange trees in earthenware tubs. It is backed by steep crescent-shaped banks cut into the hillside, with ramps on either side leading to a *tapis vert*, which extends the axis to an octagonal grove of lime trees serving as a viewpoint. A transverse *allée* is closed at one end

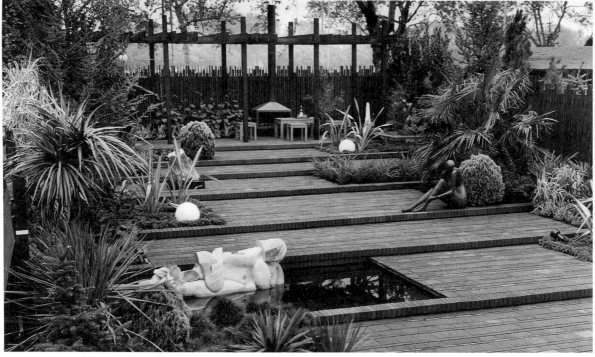

Garden designed for the 1982 Chelsea Flower Show by Preben Jakobsen.

by a *cabinet de verdure* of clipped hornbeam with a *grille*; and at the other by a grove (*salle*) of chestnut trees. The high hornbeam hedges framing the walks are cut to adjust to levels in the ground and give a regular appearance. The whole is an unusual and interesting example of an 18th-c. French garden. K.A.S.W.

James, John (1672–1746), English architect, was for many years clerk of the works at Greenwich. In 1723 he built Warbrook House at Eversley in Hampshire and designed its garden. He is reputed to have inspired John Aislabie, a former Chancellor, in laying out the gardens of *Studley Royal in North Yorkshire. His real claim to fame, however, lies in the publication of *The Theory and Practice of Gardening* in 1712. It was the only translation into English of the original, which was published anonymously by A. J. *Dezallier d'Argenville in 1709. It became the standard work on the French grand style of *Le Nôtre. C.H.

James River Plantation Garden, Virginia, United States. While attempts have been made to reconstruct the gardens of the meeting-places of the governing elders and statesmen at *Williamsburg, the clue to their tastes and accomplishments is best seen in their year-round homes, many still standing at discreet distances from each other along the James River. As the river was the chief thoroughfare for contact with friends as well as for loading and unloading tobacco and purchases from overseas, the houses and their impressive gardens were situated to preside over the river

frontage. Stately terraces (or 'falls' as they were called near Charleston, South Carolina) serve as mountings for the houses as viewed from the river. The 'falls' were architectural features not to be cluttered with growing things; from the houses they form lofty perches from which to catch the breezes and command views for miles. Where the old gardens and their walls are well preserved, they seem to have been sited to the sides of the houses. Where the plantation house stands high but far back from the river-bank, the low land near the river could become a crop-raising utilitarian area, but the view of it would be blocked from the house which would look over a parterre towards the distant water.

Great trees graced the inland drives towards the houses and framed the houses as seen from the river. The garden on one side was usually walled high with brick and decorative posts and iron gates. Inside, wide grass walks divided large square beds of flowers and shrubs and led visitors from garden seat to garden seat and sometimes past a monument such as William Byrd II erected to himself in his garden at Westover. A.L.

James Thompson Garden, the House on the Klong, Soi Kasemsant, Bangkok, Thailand. James Thompson created this waterside 'jungle' garden across the *klong* (navigable waterway) from the original weaving sheds where he founded his Thai silk industry shortly after the Second World War. The richly planted garden in which stands a collection of fine traditional Thai houses, re-erected here by Thompson, achieves total privacy from its neighbours.

Some houses are raised a whole storey above ground, and the spaces below provide cool open-sided rooms with both garden and air flowing through. The upper canopy including rain trees (*Samanea saman*), flamboyants (*Delonix regia*), and coconut palms (*Cocos nucifera*) almost obscures the sky but lets shafts of cool green light filter through. Creepers, fan palms (*Livistona*), and luxuriant foliage plants define the intimate spaces, which are floored with a variety of contrasting ground-cover plants (episcias, chlorophytums, rhoeos, calatheas, zephyranthes) which culminate around a small pond in a clearing.

The garden abounds in heliconias, gingers, ferns, and large leafed aroids. Scindapsus and *Philodendron scandens* are used both as ground cover and climbers, particularly as a setting for strategically placed Theravadian Buddhas and Chinese lions. Though almost totally enclosed, the variety of small spaces, built up of green texture and light, provides a succession of experiences which are never claustrophobic. From the terrace of the drawing-room the sparkle of the *klong* through festoons of creepers adds movement to the light.

M.L.

Jännes, Jussi (1922–67), was one of Finland's inspirational landscape architects who thrived in close contact with Finnish nature. He treated the earth as a canvas and his brush-stroke planting of the now famous phlox borders at Tapiola can be said to have strong stylistic similarities to the work of the Brazilian landscape architect, Roberto *Burle Marx. He was preoccupied with elegance and precision and represented the cool, clean, understated school of Baltic garden design. For many years he was chairman of the Finnish Society of Landscape Architects.

P.R.J.

Japan

SHINTO. Before Japan adopted Chinese civilization from the 7th c. AD onwards, there existed a national cult, which came to be known as Shinto or the Way of the Gods. This is an expression of delight in the beauties of nature, the existence and achievements of the Japanese people, and in the very islands of Japan. Any remarkable phenomenon, from a splendid tree to a striking rock, from a waterfall to a cliff, can be an object of worship and will have its divinity.

Shinto assumes that man is on a par with nature and thus with stones and plants as well as animals. Nature is therefore respected, and Shinto shrines fit into the landscape, which remains unchanged around them. That landscape presents a richly beautiful scene: the scented plum and cherries (*Prunus yedoensis*) in spring, followed by azaleas, paulownias, and magnolias in summer, crowned by maples in autumn, all silhouetted against a background of evergreens.

BUDDHISM. For centuries (from AD 575) Shinto was overlaid by Buddhism which brought to Japan a philosophy of universal application by contrast to the local and parochial admonitions of Shinto which was restricted to Japan. However, Buddhism did not change the Japanese attitude towards nature. It added importance by suggesting that portions of the departed could combine with fragments of others, who had reached the same degree of spiritual advancement, to constitute, for instance, plants. In theory, therefore, natural objects became worthy of greater consideration.

The first significant example of Chinese influence was Nara, modelled after the Chinese Tang capital, Ch'angan. Although no trace of them now remains, there were many gardens in Nara. Like the city plan and its architecture, they probably resembled the Chinese Tang model, the principal feature being a large pond with an island.

Nara remained the capital until 793. After careful study of Chinese geomancy (*feng shui*), the site for a new capital, some 60 km. distant, was selected, after another site, Nagaoka, was rejected as unsatisfactory. The new city was called Heian-Kyo, the Capital of Peace and Tranquillity, later known as Capital of Capitals (*Kyoto). It remained capital until the Meiji restoration (1868) when the capital was moved to Yedo (Tokyo).

HEIAN PERIOD (795–1195). Heian gave its name to a period of history and a degree of civilization never surpassed in Japan. It was a time when aesthetics ruled supreme. It is superbly depicted in the novel by the Lady Murasaki Shikibu (*c.*987–*c.*1031), *Tale of Genji* (translated by Arthur Waley, 1935). Garden art played an extremely important role in this highly refined civilization.

The court nobility lived in pavilions of Chinese inspiration constructed in the style known as *shinden-zukuri*. Each pavilion was a separate entity facing south joined to others by raised, covered passages. Stepping-stones (later to become a cliché) were at first a practical necessity. The areas in between, known as *tsubo* (a unit of space), had plants placed by rocks in them to suit the taste of the occupant of the pavilion. The main pavilion fronted on to a lake of a sufficient size to permit boating. There were wings, known as Fishing Pavilions, to the lake on either side, and a stream wound its way to the lake from the north-east and left the lake towards the west. There was a space covered with white sand in front of the main pavilion which was used for entertainments. The outer walls of the pavilions had shutters which could be hooked up so that at the right season of the year the occupants could be living virtually in the open air. This suited their concept of harmony with nature.

In the fictitious palace occupied by the amorous Prince Genji, each of his lady friends had a *tsubo* garden planted to suit her choice. Of his own mansion Lady Murasaki writes: 'He effected great improvement in the appearance of the grounds by a judicious handling of knoll and lake, for

though such features were already there in abundance, he found it necessary here to cut away a slope, there to dam a stream, that each occupant of the various quarters might look out of her windows upon such a prospect as pleased her best. To the south-east he raised the level of the ground, and on this bank planted a profusion of early flowering trees. At the foot of this slope the lake curved with especial beauty, and in the foreground, just beneath the windows, he planted borders of cinquefoil, of red plum, cherry, wistaria, kerria, rock azalea, and other such plants as are at their best in springtime; for he knew that Murasaki (his favourite) specially loved the spring.' (op. cit., pp. 430–1).

Another invaluable source of information is the *Sakuteiki* or 'Treatise on Garden Making' attributed to Tachibana-no Toshitsuna (1028–94). It describes the basic layout of noblemen's estates, with extensive analyses of both technical and religious questions. The book gives a great deal of advice about the highly important subject of rock placement.

Only remnants of this period are to be discovered today. Of one of the finest, the Divine Spring Garden, or Shinsen-in (c.800), which had a large lake and a pavilion in the Chinese style, only a tiny pond remains. The palace and other aristocratic villas were repeatedly destroyed, so that the court often lived outside the city while it was being rebuilt. It is these country estates which have often survived better: for example, Saga-no-in (c.823), with its temple Daikaku-ji. This gives an idea of what living in the *shinden-zukuri* style entailed. Its pond, the Osawa-ike, remains nearly intact, with some indication of its islands of the immortals and its waterfall. Another survivor from this period is the *Byodo-in (from c.998), at Uji, outside Kyoto.

THE MUROMACHI PERIOD (1335–1573). The standards of Heian civilization were very high and they alone satisfied the fastidious courtiers. Inevitably there arose hardier persons willing to face up to the rigours of provincial life. They took over the actual ruling of the country in the name of the venerated Emperor, who bestowed on them the title of Shogun or Generalissimo. In the Heian period, the effective rulers of Japan were the Fujiwara family. They were ousted by the Minamoto family, whose leader, Yoritomo, took the capital to Kamakura, 480 km. to the north-east. The austere military regime did not favour the art of garden-making.

In turn, the Kamakura government was defeated (in 1338) by Ashikaga Takauji. The Ashikaga shoguns returned to Kyoto and created the Muromachi period in which the taste of the Chinese Northern Song dynasty (960–1127) prevailed. The first important garden of the period was the *Saiho-ji, designed by Muso Soseki (1275–1351). It was a paradise garden and continues to offer a perfect homage to nature. Its dry stream and sophisticated

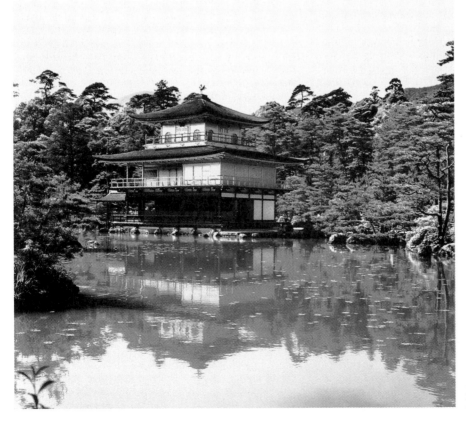

Kinkaku-ji (the Golden Pavilion), Kyoto

rock-work compel surprised admiration. A large number of the carefully selected rocks have flat tops, anticipating a later style. An outstanding achievement in its own right, it also marks the beginning of a distinctively Japanese style of rock-work.

At nearby *Tenryu-ji, rocks are used to create an illusion of mountains, perhaps a reminiscence of the great Chinese imperial landscape park known as Ken Yu. The arrangements of the boulders are subtle and discreet and the stonework around the bridge is particularly worthy of note.

The first two Ashikaga shoguns were too preoccupied with establishing their rule securely to have time for creating landscapes, but the third, Yoshimitsu (1358–1409), built a pavilion of Chinese inspiration which gave its name to the paradise garden of the Saionji family. As the *Kinkaku-ji or Golden Pavilion (built 1397) it survived well beyond the shogunate, only to be burnt down in 1950. The lake was designed for use and the scene should be viewed from a slowly moving boat.

The last of the Ashikaga shoguns, Yoshimasa (1435–90), set about the creation of the *Ginkaku-ji or Silver Pavilion to the east of the city (begun 1466, resumed in 1482, after interruption by the Onin civil war). The site was beautiful, bounded by a mountain, but the pavilion is on a smaller scale than the Golden Pavilion. There are two emplacements of white sand, one intended to simulate Mount Fuji and connected with moon viewing, and the other a raised and patterned bed.

The Japanese house as we know it started to appear with the creation of the Silver Pavilion. The *shinden-zukuri* was replaced by the *sho-in* style. The *sho-in* was the main room in a small residence temple, with a built-in desk looking through shutters on to the garden. With it goes the *tokonoma* or alcove, originally used for a Buddhist statue, but later to display a painting or pot or a flower arrangement. Matting (*tatami*) came to cover all the rooms where people sit. The main rooms faced south as before, but the garden was designed as a picture to be seen from inside. Indeed, a person actually walking in the garden would be out of scale and would probably destroy some subtle false perspective.

Zen influence: rock placement gardens. The troubled character of the times reinforced the appeal of the contemplative Zen philosophy. The Onin civil war (1466–76) forced many scholars to seek refuge outside Kyoto, and thus Muromachi art was often created outside the capital. This applies particularly to the gardens made by the Zen monk and artist, Sesshu (1420–1506). He excelled in the placement of stones, especially those flat-topped in form, in the garden.

Later gardens in Kyoto itself, including the small private temple gardens of *Daisen-in (see plate IV) and *Ryoan-ji, belong to this trend. In the former, a stream of white sand issues from surprisingly realistic 'mountains' made of rock-work, flows under a bridge past a stone like a junk, and emerges into the garden of plain sand in front of the main hall of the temple. This sermon in stones can be read as the journey through life until Nirvana is attained.

The most famous of Zen gardens is the Ryoan-ji, on its own behind a Heian lake to the north of Kyoto. After an earlier garden was destroyed by fire in 1488, it is thought to have been restored by the painter *Soami (1472–1523). It is the earliest example of pure *kare-sansui or dry stone-work garden. It is called the Garden of Crossing Tiger-Cubs. It consists of five cunningly placed groups of not very remarkable stones, which have a little moss at their bases. They could be islands in a tranquil sea or peaks of consciousness in the subconscious.

THE MOMOYAMA PERIOD (1573–1603). During the continuous civil wars in the latter part of the 16th c. Kyoto became rather dilapidated. Peace was restored by a succession of generals: Oda Nobunaga, Toyotomi Hideyoshi, and Tokugawa Ieyasu. It was Hideyoshi (1536–98) who restored the city and added many new buildings, in particular the Mansion of Assembled Pleasures (Juraku-dai), near the centre of the city.

He also built a castle-palace at Fushimi, to the south of Kyoto. It stood on a hill later so extensively planted with peach trees that it became known as Peach Hill (Momoyama), giving its name to this period which is characterized by its use of gold and rich colours. Near the castle was the *Daigo Sambo-in, an old Muromachi garden which Hideyoshi was personally involved in reconstructing. The extravagant use of rocks (perhaps as many as 700) was of great significance for the future of Japanese garden art.

Although as a rule the aesthetic spirit of the Muromachi was too refined for the grandiose tastes of the generals, it did survive in its elaboration of the tea-garden, the setting for *cha-no-yu*, or the Japanese tea ceremony. Men who in earlier periods would have become monks now became 'tea masters', finding in the tea ceremony a refuge from the perils of the times.

The greatest of these was *Sen No Rikyu (1522–91). His art and philosophy were very influential in developing the *roji* (dewy path) style of garden, so called because of the 'dewy ground' surrounding the tea-hut. In one of the Buddhist Sutras, the word symbolizes the tea-garden's retreat from everyday life.

The tea-ceremony room or hut was a rustic edifice less than a square metre in size (four and a half Japanese *tatami* or mats). It combined the functions of the Chinese scholar's study and the mountain retreat. There, in the simple, natural-coloured interior, five friends should be able to meet and drink a ceremonial bowl of tea before discussing philosophy or works of art—business or politics were specifically excluded. There should be an outside waiting-room, where the visitors can discard their cares, and a stone basin to wash away impurities. These requirements brought into Japanese gardens a sobriety far removed from the Heian taste.

The tea masters made three new contributions to the design of Japanese gardens—the stepping-stones, the stone lantern, and the stone water basin. All derive from the practical requirements of the tea ceremony—the stepping-stones to prevent the garden moss being worn, the lantern to light the path, since in the Momoyama period the ceremony

was often held at night, and the basin to provide water for washing the hands.

The ground is covered with moss, with ferns and other small plants at the base of rocks. Gone were the colourful plants of Heian gardens in favour of broadleaved evergreens—a garden should be beautiful at all seasons and not dependent on the flowering habits of plants. Azaleas were pruned ruthlessly to look like green boulders, until they burst into flower. Thus camellias were permissible, but not roses which are a sorry sight when not in flower. Somewhat irrationally tree peonies in raised stone beds were allowed, as were the rather untidy *Platycodon grandiflora*. Even chrysanthemums (the national flower) were reared in pots out of sight and placed strategically in the garden when in flower.

IMPERIAL ESTATES OF THE EDO PERIOD (1603–1867). Even though Rikyu was forced to commit suicide after incurring Hideyoshi's displeasure, the tea ceremony was firmly established and had a lasting impact on the details even of imperial gardens.

Most successful of these is the *Katsura Detached Palace. This was begun in 1620 on the site of an old garden near the Katsurayama River south of Kyoto by Prince Toshihito (1579–1629), advised by *Kobori Enshu. It is a self-contained entity, hidden from the outside world. Every detail has been endlessly considered. The right-angle bends mean that the visitor soon feels that he has entered another world. Stepping-stones for the imperial palanquins with cedar moss in between set the stage for the wonderfully functional interior. There is a stand for moon-viewing, but the intricacies of the garden layout invite a stroll. Following a path of 1,760 stepping-stones the stroller is presented with a series of unfolding views. The lake is more complicated than its Heian predecessors would have been. There are some very imaginative details, such as headlands with a stone lantern like a lighthouse.

The upper villa of the *Shugaku-in Imperial Villa (begun c.1655) is both a stroll garden and an outstanding example of the technique of *shakkei* or 'borrowed scenery', beautifully set amid the surrounding hills. This technique had been used before in Japanese gardens, but seldom as the main feature of a garden and never on such a scale. The garden of the *Sento Gosho Palace (or the Palace of the Emperor Abdicant), built in 1634, is a large stroll garden, the main features of which are a beach of pebbles, and the wistaria which envelops a covered bridge.

From the beginning of the 17th c. a new town began to grow up around Edo Castle, the shogun's headquarters, in the eastern part of Japan. Sited for strategic reasons, it had few views apart from that of Mount Fuji. Parks were laid out on the edge of the town, the earliest being Koraku-en, by the Vice-shogun Tokugawa Yorifusa (1603–61). None of them has the sophistication of the gardens of Kyoto, with the possible exception of *Rikugien Park, built by Yanagisawa-Yoshimasa (1658–1714) between 1695 and 1702. It was a stroll garden, originally designed to represent 88 scenes found in an earlier literary anthology.

With the decline of military feudalism, a complex process which lasted from perhaps the end of the 17th c. to the Meiji restoration (1868), the period of great garden estates on any scale was effectively finished. J.P./P.G.

See also SHINJU-AN GARDEN.

PUBLIC PARKS AND GARDENS. Compared with traditional Japanese gardens, the public parks and gardens made since the Meiji Restoration of 1868 are little known outside Japan. They were created under the Cabinet Proclamation of 1873, which required each prefecture to designate suitable sites for public parks. Tokyo set the example by designing five parks, of which the present Ueno Park is one.

However, there was initially no clear conception of the design of parks to suit the particular needs of modern life. This was due to the lack of contact with the West, and even the government had to refer to the example of the Western-style Yamate Park which had been constructed in Yokohama in 1870 for the exclusive use of the foreign community.

The first purely Western-style park was Hibiya Park created in the centre of Tokyo in 1903. But otherwise little progress was made due to domestic troubles and two major wars with China and Russia. It was in the succeeding Taisho Era (1912–26) that considerable activity in landscape and garden design was generated. The City Planning Act of 1919 was aimed at organizing the development of cities, of which urban parks were an essential component.

On 1 Sept. 1923 a great earthquake and consequent fire destroyed the greater part of the cities of Tokyo and Yokohama. As a result more open space was allocated for reconstruction of new parks which could be used as refuge in case of future earthquakes. The event was a turning point in the development of landscape and garden design in Japan, and was marked by the construction of the Meiji Forest Garden.

During the Second World War the parks and open spaces of Japan were placed generally under government control and devoted to anti-aircraft defences and evacuation areas for the city dwellers. Later many of them were developed into large regional-scale parks. In the occupation years immediately following the war development was handicapped by changes brought about by the new constitution demanding agrarian reform and the separation of religion from politics, which meant the removal of shrines and temples from the parks. On the other hand reconstruction of war-damaged areas provided the opportunity for acquiring sites for developing new projects. New laws included a special act for the planning of the International Cultural Tourist City of Kyoto (1950) and the Land Readjustment Act of 1954, under which the redevelopment of built-up areas was made possible, resulting in the creation of many small-scale parks, including some specifically for children.

Most landscape designers are currently concerned with works of a public nature such as designs for housing estates, roads, factories, park cemeteries, golf-courses, and hotel gardens. Only a minority of the profession is engaged in the design of private gardens. This is due to economic reasons

and the change in the mode of living of the people of Japan, which has itself created demands for public recreation and leisure facilities of all kinds.

Tokyo. Tokyo has over a dozen significant parks ranging from the small Kiyosumi Garden of 2 ha. to the grounds of the Imperial Palace extending to over 115 ha. The oldest (such as the Ueno Park from the Edo period, 1603–1867) are associated with castles, palaces, and temples from the early periods of Japanese history, the structures of which have either been retained, or in some cases rebuilt. The small Kiyosumi Garden was originally a Daimyo Garden of the Edo period, which in 1878 was purchased by a business-man, Yataro Iwasaki, and remodelled into a large type of Japanese garden with a lake in the centre served by the brackish water of the Sumida River. Iwasaki's brother adorned the garden and its lakeside with the rarest speci-mens of garden stones from all parts of the country. All the original buildings were destroyed by the earthquake and fire of 1923.

The inner and outer gardens of the Meiji Shrine were made in 1920 and 1925 respectively to accommodate the shrine commemorating the death of the Emperor and the Dowager Empress. The main features of the inner garden are the shrine and its two great Torii gates surrounded by woodlands with natural springs. By contrast the site of the outer garden is flat and it has been treated as a memorial garden incorporating a memorial picture gallery and modern sports facilities. The gardens associated with the Imperial Palace include lawns and a grove of Japanese black pines as a setting for the historic remains of the moat, the walls, and the gates.

Tokyo has two botanical gardens: the Shinjuku Garden and the Jindai Botanical Park. The former is a contribution to the development of Western horticultural techniques and was designed by the French landscape architect Henri Martinet and Count Fukuba-Hayato, with French-style formal gardens and avenues of plane trees, combined with informal gardens in the English landscape style. A pond garden with a Taiwan pavilion was added later. Of the spring flowers, the period of cherry-blossom viewing is exceptionally long on account of the large variety of cherry trees; and the chrysanthemum show in autumn is one of the best in Japan. The Jindai Botanical Park retains the features of the natural thickets characteristic of the Musachino Plain, among which the plants are displayed to their ecologi-cal advantage. They include large varieties of flowering plants such as roses, peonies, azaleas, and rhododendrons, as well as a unique display of hedge samples.

A significant Japanese traditional garden is that of Sankeien in Yokohama. It was designed by the businessman Tomitaro Hara (1868–1939) as a strolling pond-garden containing a number of traditional buildings from Kansai and Kamakura. Most of these were destroyed during the war and have since been replaced and designated National Treasures.

Significant among the more recent parks and gardens are the Hiroshima Peace Memorial Park (1955), the Tama Zoological Park near Tokyo (1958), the Komazawa Olympic Park, Tokyo (1964), the Japan World Expo 1970 Memorial Park's Japanese Garden at Osaka, representing the periods of Japanese history; and the Tsurumi Ryokuchi Regional Park, Osaka (1972), in which are represented the forests of the world. S.S./M.L.L.

See also RITSURIN PARK.

Japanese garden. Chinese gardens have been an influence in Europe since the end of the 17th c. (see *Chinoiserie), but the Japanese garden has been more often imitated. Japanese gardens became very fashionable in the West after the Meiji restoration (1868) opened up Japan. Interest in Japanese culture was, however, superficial; it was reflected with some ridicule in Gilbert and Sullivan's *The Mikado* (1885) and with sentimentality in Puccini's *Madame Butter-fly* (1904). Plants, on the other hand, were taken more seriously.

Reginald *Farrer (1880–1920), the plant-collector who lived in Tokyo in 1903 and described the country and its gardens in *The Garden of Asia* (1904), thought the Japanese hated plants because they 'butchered' them. A. B. Free-man-Mitford (later Baron Redesdale) of the Foreign Service regarded the Japanese garden as all 'spick and span', intensely artificial and a monument to wasted labour (*Tales of Old Japan*, 1871). He developed an enthusiasm for bamboos which he cultivated at Batsford Park and des-cribed in *The Bamboo Garden* (1896).

Flowers and the principles of flower-arranging were more accessible than those underlying the design of gardens. These were described in *The Theory of Japanese Flower Arrangements* (1889), written by the English architect Joseph Conder and illustrated by Japanese artists (later reissued as *The Floral Art of Japan*), and *The Flowers and Gardens of Japan* (1908) by Florence du Cane.

Between 1880 and 1910 many Japanese gardens were established in Britain, several of them created and main-tained by Japanese gardeners; but none could capture more than the picturesque outward appearance of the underlying philosophical principles of the original. One of the best was at Cowden, at the foot of the Ochil Hills in Scotland. Here in 1907 the traveller Ella Christie brought Taki Honda from a school of garden design in Japan to supervise the making of a Japanese garden. The site was a swampy field. A ditch was turned into a lake, Korean pines were raised from seed, weeping willows, spiraeas, azaleas, and primulas were plan-ted, a lantern was brought from Kyoto and washed with rice water to encourage moss to grow, and a Shinto shrine was constructed from Japanese cedar. All was done according to carefully prescribed rules; for example, no mountain stone could be placed near water. In 1925 a Japanese gardener was imported to maintain it.

Other outstanding Japanese gardens were at Tully near Kildare in Ireland, which was designed between 1906 and 1910 by Tassa Eida and his son to illustrate the story of life; and at Fanhams Hall near Ware, Hertfordshire, which was created between 1905 and 1933 by Herbert Goode, a

Japanese garden (1906–10) at Tully House, Co. Kildare, Ireland, by Tassa Eida

porcelain importer, using stone lanterns, rocks, and a number of rare trees and shrubs, all imported from Japan. It is now used as a centre for the study of the Japanese Tea Ceremony. Other examples are at Heale House, Wiltshire; *Wakehurst Place; Compton Acres, Dorset; *Tatton Park; and Charleton, Kilconquhar, Fife Region, Scotland.

Japanese gardens were made well into the 20th c. in various parts of the world, including the Netherlands (Clingendael, The Hague); West Germany (Westfalen Park, Dortmund); France (the Unesco building, Paris); the United States (Bellingrath, Alabama, and Jackson Park, Chicago); and Canada (Nitobe Gardens, British Columbia) where cultural links with Japan are strong. Some of these late 20th-c. examples ostensibly celebrate political and commercial connections, but they are used also to symbolize man's special relationship with nature and the universe. The implicit symbolism has, however, to some extent been overtaken by a concern with the aesthetic qualities, as in the Unesco garden by the Japanese-American sculptor Isamu *Noguchi.

But there is inevitably a great difference between a garden subjected to intensive public use (a condition which now applies to the original Japanese gardens in Kyoto), and one which is essentially private, like the remarkable garden surrounding a modern house in the Cotswolds (architects: Stout and Lichfield). The garden was carefully contrived by a resident Japanese garden designer using many English plants often selected for their irregular shapes. The design is less symbolically formal than many of the Japanese originals, concentrating on a close relationship with the different parts of the house and a highly sensitive use of natural materials to express their inherent qualities in a way which perhaps even the Japanese have forgotten.　M.L.L.

See also COURANCES; JURONG.

Jardin anglais (or *à l'anglaise*) is a French expression commonly used to signify the opposite of a *jardin régulier* or *à la française*, i.e. in the style of *Le Nôtre. Classical taste in France never stifled the taste for rural nature in the countryside, not even for wild nature, whence the importance of the forest of Fontainebleau in French culture. Scenes in neglected gardens, such as those of the Luxembourg, inspired paintings by Watteau; and J.-J. *Rousseau's description of Julie's garden in *La Nouvelle Héloïse* (1761), put forward the idea of a natural garden. The Jesuits considered the natural taste moral and healthy, and fostered it by the study of appropriate Latin texts, or by their own works (R. Rapin, *Hortorum Libri* IV, 1665; J. Vanière, *Praedium Rusticum*, 1674). Jesuit missionaries to China described Chinese gardens (J. B. Du Halde, 1735; J.-D. *Attiret, 1743).

Three phases in the evolution of the *jardin anglais* can be distinguished:

(1) Up to *c.*1775 boredom with the regular garden favoured a more natural style, although formality did not disappear (see J.-F. *Blondel; *Laugier). C.-R. Dufresny is said to have proposed transforming Versailles into a vast *campagne*. In 1731 *Montesquieu established big lawns *à l'anglaise* overlooking farmland at *La Brède.

(2) From 1775 to 1815 the *jardin anglais* became fashionable (see *Caraman; *Harcourt; *Malmaison), either in the form of small gardens attached to a formal layout (as at *Chantilly; *Rambouillet; *Versailles; the Parc Balbi) or large estates ornamented with buildings in an exotic style, with rocks, ruins, and other *fabriques* (as at the *Désert de Retz; *Bagatelle; *Betz; *Ermenonville; and Méréville). There is a valuable record in *Le Rouge. Gardens and parks were restored in the English style when exiles returned to their neglected estates after the Revolution (see *Champs; *La Motte-Tilly; *Liancourt).

(3) During the 19th c. a systematized *jardin anglais*, based on a network of curved paths, pioneered by Gabriel *Thouin, became the official style for public works (as at the *Bois de Boulogne and *Buttes-Chaumont).　D.A.L.

See also ANET; BELOEIL; BOUGES; CASTILLE; FRANCE: LE JARDIN ANGLAIS; LIGNE.

Jardin anglo-chinois. Although Louis XIV had built at *Versailles in 1670 the Trianon de Porcelaine in the Chinese style, *Chinoiserie was late in influencing French gardens, eventually deriving inspiration from *Chambers. In 1771 Horace Walpole suggested this reason for the term, perhaps thinking of the writings of *Latapie: 'The French have of late years adopted our style in gardens, but, choosing to be fundamentally obliged to more remote rivals, they deny us half the merit or rather originality of the invention, by ascribing the discovery to the Chinese, and calling our taste in gardening *le goût anglo-chinois*.' See, for examples in France: *Cassan; *Chantilly; *Désert de Retz; *Folie Saint-James; *Pagode de Chanteloup, which with many others are described by *Le Rouge; for examples elsewhere, see *Csákvár; *Hodkovce; *Sturefors; *van Laar.　P.G.

A fine example of a *jardin anglais*: Ermenonville, Oise, France, L'Ile des Peupliers

Jardin de la Fontaine, Nîmes, Gard, France, is a public garden (1745–60) designed by the military engineer Jacques-Philippe Mareschal, with an architectural ensemble of balustraded canals and terraces on a Roman site centred on springs. The first consideration was to provide a watering-place for horses and a supply for the town's washhouses. This was coupled with the provision of a public promenade and the preservation of Roman remains, particularly a temple and a *nymphaeum, which were incorporated in a design whose extension was to form the basis of a new town. The nymphaeum is decorated with sculpture by Dominique Raché and Pierre-Hubert Larchevêque. Mareschal intended to have a series of elaborate terraces mounting the hill (the Mont Cavalier) but only one was built. Trees are now planted, with walks leading up to an open space where there is a Roman tower. K.A.S.W.

Jardin des Plantes, Montpellier, Hérault, France. See MONTPELLIER.

Jardin des Plantes (Muséum National d'Histoire Naturelle), Paris. This royal garden was begun at a time when physic or medicinal gardens were in vogue. Thus in 1626 Guy de la Brosse, who was physician to Louis XIII, established the Jardin Royal des Plantes Médicinales (or Jardin du Roi) with Vespasian Robin as the head gardener (see Jean *Robin). It was laid out to a geometrical design with formal parterres where medicinal herbs were grown and their use demonstrated during popular lectures by La Brosse, which caused considerable friction with the Faculty of Medicine of Paris, which had a similar garden of its own. In 1644 it was visited by John *Evelyn, who wrote that the garden had within its enclosure 'both hills, meadows, growne Wood, & Upland, both artificial and naturall; nor is the furniture inferiour, being very richly stord with exotic plants'. In 1718 its name was changed to Jardin Royal des Plantes, which indicated its increasingly scientific orientation. Many naturalists of note were employed there, including Tournefort, Vaillant, B., A.-L., and A. de Jussieu, and Buffon, each of whom left his mark on the garden. After the French Revolution the garden took the name of Jardin des Plantes, and the collections, laboratories, etc. the name of Muséum National d'Histoire Naturelle. In the 18th and 19th cs. plant-collecting expeditions were dispatched around the world in order to enrich the living and preserved collections.

The garden today still follows the basic original design, although it is slightly larger (28 ha.) and is used mainly as an amenity park and zoo in the centre of the city. Many fine old trees survive, particularly on the artificial mound of the labyrinth (c.1640), such as the half-evergreen oriental maple (*Acer orientale*) planted by Tournefort in 1702. The tropical and temperate greenhouses are successors of those erected in 1732 by Dufray for exotic plants. A delightful alpine garden was created in 1931 and contains some 2,000 species. The Ecole de Botanique is a demonstration area of wild plants from Europe and elsewhere, as well as examples of cultivated useful plants, and specially prepared plots are devoted to ecological displays. Situated within the grounds are the Muséum buildings, containing vast collections for

important taxonomic research that are linked with such famous names as Lamarck, Geoffroy de Saint-Hilaire, Desfontaines, and Cuvier. F.N.H.

Jardin Thabor, Rennes, Ille-et-Vilaine, France, is a 10-ha. public park of varied character: a flat area in the regular French style; undulating ground with lawns and clumps of choice trees *à l'anglaise*; a precipitous and rocky part, planted with shrubs and furnished with cascades, a fountain, a grotto, and a rock-garden; a botanic garden arranged in concentric circles; and a rose-garden. It was originally the garden of the Abbey of Sainte-Melaine, situated in the highest part of Rennes and named by the monks after Mount Tabor in Palestine. After 1789 it was used as a public promenade, and in 1868 redesigned by the *Bühler brothers; the wide sweeps of grass with scattered groups of trees are characteristic of their style. The botanic garden, also dating from 1868, was planned by Professors Danthon and Degland of the School of Medicine. The precipitous part was acquired and laid out in 1902. There are two orangeries (1860–4), one at each end of the garden; the greenhouses were rebuilt in 1968, having been almost totally destroyed in the Second World War. K.A.S.W.

Jaroměřice upon Rokytná, South Moravia, Czechoslovakia. Originally a medieval stronghold, the castle was rebuilt at the beginning of the 18th c. in the baroque style with a 15-ha. park adjoining, all together forming a monumental complex of buildings in vast natural scenery. A drawing of the large baroque castle area (including the garden) dated 1710 gives an accurate idea of the appearance

of the scheme, which was probably designed by the Austrian architect Johann Lukas von Hildebrandt.

The main axis leading from the castle building to the summer-house was expressed in the garden by a wide promenade with two fountains; it continued across the bridge over an artificial branch of the River Rokytná to the triangular island where the garden pavilion stood. The axis of the whole composition continued far into the countryside by means of straight avenues of trees. The *parterre de broderie* and clipped trees were enriched by statues, urns, and benches. Large orchards adjoined the lines of trees on the borders of the decorative garden.

During the 18th c. there was a busy musical life in the castle and its garden, supported by the owner of the estate, all of whose inhabitants had to be musicians. They participated in music festivals held on the stage of the pavilion on the island; the first Czech opera (by F. V. Míča) was performed there as well.

The rich baroque-style garden vanished in the course of the 19th c.; the parterre was mostly transformed into the natural landscape park. Nevertheless, after the Second World War the essential features of the baroque composition were still visible. Restoration of the garden began in 1952. O.B.

Jefferson, Thomas (1743–1826), President of the United States (1801–9). A great likeness between two leading Americans during the Revolutionary War—and in the subsequent forming of the United States—lay in the mutual interest of Thomas Jefferson and George *Washington in farming practices and in their passions for designing houses

Jaroměřice upon Rokytná, Czechoslovakia, drawing (1710) by an unknown artist

The Courtyard Garden with original Jekyll planting at Goddards (1899), Abinger, Surrey, by Edwin Lutyens and Gertrude Jekyll, photographed early this century

and gardens. Jefferson, in particular, showed his interest in horticulture at an early age when he began as a very young man to record the flowers in the garden and in the woods about his first home. Like Washington, he had a consuming interest in growing American specialities, from the flowers and shrubs of his own countryside to those of lands far to the west. Like Washington, he designed his own gardens at *Monticello, including a family burying-ground in a grove.

Both men planned their gardens to suit their own tastes, although when Jefferson planned his friends' gardens and houses he obviously kept their tastes in mind. The view from the front of his house at Monticello reached to the grounds of the University of Virginia, which he had also designed, though here with obvious reference to the gardens of *Marly, where he had often walked as American minister plenipotentiary in Paris. On this, his only sojourn outside his own country, he was also able to tour English gardens with John Adams (in 1786). Admitting the excellence of English gardening practices, he reported in one instance that the box seemed 'overgrown', a comment he might well make again today in his native state. Jefferson's garden diary, his *Garden Book*, is the clearest possible record by a layman of the garden materials of the period. A.L.

Jeffrey, John (1826–54?), English plant-collector, may be said to have succeeded David *Douglas as a collector of conifers in north-western America. He worked at the *Edinburgh Royal Botanic Garden before being chosen in 1850 by the Oregon Association, a group of Scottish landowners and foresters, to collect in British Columbia, Oregon, and California. He arrived in his territory in 1851, with the help of the Hudson's Bay Company, and eventually

vanished in California in 1854. The trees he found included *Tsuga heterophylla*, and many firs and pines, among them *Pinus jeffreyi*, but there were seeds or bulbs of smaller plants as well, for he sent back *Fritillaria recurva*, *Camassia leichtlinii*, and *Lilium washingtonianum*, among others. S.R.

Jekyll, Gertrude (1843–1932), English garden designer, enrolled in 1861 as a student at the Kensington School of Art, where she studied for two years. Later she met Hercules Brabazon, the water-colour painter, from whom she learnt her lessons in colour.

On the death of her father in 1876 her family moved to *Munstead House, near Godalming. A piece of land of *c.*6 ha. adjoining Munstead was purchased, and the foundations of Miss Jekyll's own garden laid, although the house was not yet built. For many years Miss Jekyll's eyes had troubled her, and in 1891 she was prevailed upon to consult the famous eye specialist Pagenstecher of Wiesbaden. Nearly all her work was discouraged if not forbidden, in particular the two subjects she loved most, embroidery and painting. In an article written many years later she refers to the incident with these words: 'When I was young I was hoping to be a painter, but to my lifelong regret, I was obliged to abandon all hope of this ... on account of extreme and always progressive myopia.'

Perhaps the greatest compensation was to come through her partnership with the young Edwin *Lutyens whom she first met in 1889. He was the architect for Munstead Wood and in time a 'Lutyens house with a Jekyll garden' became an important contribution to the English way of life.

Her writings were now becoming known. Her first book, *Wood and Garden*, came out in 1899, followed by *Home and*

Garden (1900). *Lilies for English Gardens* (1901), *Wall and Water Gardens* (1901), *Roses for English Gardens* (1902), *Old West Surrey* (1904), *Flower Decoration in the House* (1907), *Children and Gardens* and *Colour in the Flower Garden* (1908). This last book gathers together the essence of her artistic training. One of her most general ideas about the use of colour is that flowers which bloom at the same time should be arranged close to each other. Perhaps her biggest contribution to the study of colour is that she has established that no colour stands alone and that it can only have real value if it is thought of in relation to the colours beside it.

Throughout her writings Gertrude Jekyll acknowledges not only her love for but also her debt to *cottage gardens. She wrote: 'they have a simple and tender charm that one may look for in vain in gardens of greater pretension. And the old garden flowers seem to know that there they are seen at their best'.

But it was not only the plants in the cottage gardens that she noticed on her drives with Lutyens. He must have learnt from her about the setting of a chimney, the different uses and patterns of tiles, the right proportions of windows and doorways—matters essential to his work. As Robert Lutyens wrote: 'Much has he owed to her companionship and encouragement; much to her great knowledge of rural tradition'.

She also created the planting traditions of the War Graves' Commission in Lutyens's first *cemeteries, including roses, spiraea, skimmia, buddleia, *Clematis flammula*, aruncus, with border edges of megasea, white pinks, and fillings in of columbines.

Of their work together Christopher Hussey selects especially the gardens at *Hestercombe, Somerset (recently restored): '[they] represent the peak of the collaboration with Miss Jekyll and his first application of her genius to classical garden design on a grand scale.' A substantial collection of her drawings are in the Reef Point Gardens Collection, University of California, Berkeley, United States.

B.M.A.

See also BARRINGTON COURT; DEANERY GARDEN; FOLLY FARM; GREAT DIXTER; HERBACEOUS BORDER; LAMBAY ISLAND; MARSH COURT; MOUNT STEWART; RENISHAW HALL; WILD GARDEN.

Jellicoe, Sir Geoffrey Alan (1900–), English landscape architect, town planner, and architect, studied architecture at the Architectural Association and later became the school's Principal. He made an extensive study of Italian gardens with J. C. Shepherd and together they produced a book on *Italian Gardens of the Renaissance* (1925). It was followed in 1927 by a book on *Gardens and Design* and Jellicoe has retained a lifelong interest in gardens. In 1933 he was commissioned to design a formal garden at Ditchley Park in Oxfordshire that should interpret but not copy James Gibbs's unexecuted design. He had, however, become interested in the modern movement and in 1934 Jellicoe and his partner Russell *Page completed a modern design for a restaurant with a small garden in the Cheddar Gorge.

'Musical' cascade at Shute House (1970), Wiltshire, England, by Geoffrey Jellicoe

Jellicoe's practice has included a wide range of projects. The largest were the town plans for Hemel Hempstead, Guildford, and the centre of Gloucester. At the Hope cement works in Derbyshire he pioneered the idea of preparing long-term reclamation schemes for quarry operations. He also designed the Kennedy Memorial at Runnymede and the Cathedral Close in Exeter. Water, as a design element, has dominated some of his most successful schemes: the Water Gardens in Hemel Hempstead, the *roof-garden for a Guildford store, and the garden for Shute House near Shaftesbury. In the 1980s Jellicoe received some of the largest commissions of his career, including a very large modern garden, at *Sutton Place in England, two parks in Italy, and a theme park in Texas in the United States. The planting design at Sutton Place, as in many of Jellicoe's projects, is by his wife Susan, who has also co-authored a number of books on garden design, with her husband and with Lady Allen of Hurtwood.

Jellicoe was President of the Institute of Landscape Architects from 1939 to 1949 and encouraged the fledgling profession to adapt itself to a wide range of public commissions after the Second World War. He also advised and inspired a large number of young designers. In 1948 he became Founder-President of the International Federation of Landscape Architects and later its President of Honour. The history and scope of the art of landscape design was superbly described and illustrated in *The Landscape of Man* (1975) by Geoffrey and Susan Jellicoe. In 1979 Jellicoe was knighted for his services to landscape architecture. His work on the Royal Fine Art Commission and as a Trustee of the Tate Gallery helped to win recognition for the art. The *Guelph Lectures on Landscape Design* (1983) summarizes his recent views on the subject.

T.H.D.T.

Jensen, Jens (1860–1951), American landscape architect, was born in Denmark but emigrated to the United States in 1884, and settled in Chicago in 1886, where he began professional activity as a gardener. By 1900 he had risen to be Superintendent of Humboldt Park. Sacked for political

reasons, he developed a private practice, and returned to be appointed Landscape Architect and Superintendent for the West Park system in 1906. In 1920 he again severed his connections for political reasons, to concentrate on private commissions.

His work is known for its compositions of indigenous plant material. This style, advertised as the 'Prairie Style', was well suited to public parks (such as Columbus Park, Chicago, and the parks of Racine, Wisconsin) and corresponds to the development of the 'Prairie School' of architects (such as Frank Lloyd *Wright) in the mid-west at that time. Most of Jensen's work was on estates, and few examples have survived. His work for an estate in Kentucky was illustrated in *American Landscape Architecture* (1924).

Although Jensen had a devoted following in the mid-west, he was largely ignored by the profession. He closed his Chicago office in 1935, and retired to his summer home in Ellison Bay, Wisconsin. In 1939 he published a volume of his writings, *Siftings*. W.L.D.

See also ECOLOGY AND GARDENS.

Ji Cheng or Chi Cheng (b. 1582), native of Wujiang in Jiangsu province, China, was a prominent Ming-dynasty landscape and rock artist. He was also known as Ji Wupi and by the pseudonym Pi Daoren, meaning Taoist Priest Pi. Like many other famous Chinese gardeners, he was also an artist and writer, and the many gardens he made south of the Chiangjiang (formerly Yangtze River) such as the Shadow Garden, Ying Yuan, in *Yangzhou, and Wu or Awakening Garden in Yizheng, Jiangsu province, owed much to ideas derived from poetry and painting. None of his known gardens has survived, but his greatest contribution to landscape architecture was the *Yuan Ye*, a treatise on garden planning which is the classic work in Chinese on the subject.
 C.-Z.C./M.K.

Jian Zhang Gong, China, was an imperial palace built in 104–101 BC during the reign of Han Wu Di, to the west of the ancient capital of Changan (north-west of today's Xian) in Shaanxi province. Though now only the ruins remain, according to records the palace enclosure was *c*.15 km. in circumference, included many halls, terraces, and towers, and was known as a palace possessed of 'thousands upon thousands' of doors. Jian Zhang Gong faced another imperial palace inside the capital and was linked to it by 'flying corridors' above the city wall. The front hall of Jian Zhang Gong, higher than that of its twin palace, had a *feng que*, or gateway with watch towers, ornamented with bronze phoenixes on its roof ridge. On the Terrace of Divinities, the statue of an Immortal held up a wide dish to collect the dew of Immortality, while lying north of the palace the Taiyi, or Pool of Heavenly Water, contained three islets bearing the names of those mythic islands in the Eastern Sea thought to be the homes of Immortals—Penglai, Fangzhang, and Yingzhou. The garden, which was celebrated in a series of great prose-poems, contained rivers and mounds, collections of pedigree birds and beasts, and many rare flowers and trees. C.-Z.C./M.K.

Jia shan, *artificial hill, a mound piled up with earth and/or rocks. The 'false mountain', almost always sited near lakes or streams, has been an integral part of Chinese gardens since the Han dynasty (206 BC–AD 220). Although representing untamed nature, in form artificial hills have been much influenced by traditional Chinese landscape paintings and, rather than repeat the forms of nature in miniature, they aim to inspire in the viewer a succession of emotions similar to those he might expect to experience while walking among mountains, or following the small painted figures through a landscape scroll.

Some *jia shan*, with labyrinthine paths and steps leading to pavilions concealed among them, are made of hundreds of rocks often piled up over interior caverns. Such 'mountains' usually had foundations of wooden piles and a layer of stone, and used iron to join the base-stones together. In Ming-dynasty *jia shan* a glutinous rice-paste glue was spread between the rocks and the sides were plastered, usually with lime and Tong oil. Though the designer usually first submitted a painting, then a model of the proposed mountain, the final effect depended greatly upon the characteristics of each individual stone and how it was combined with the others. Rock artists like *Zhang Nan Yang and *Shi Tao were chiefly famous for their skill in this respect. Other landscape gardeners, like the writer *Li Yu, advocated false mountains chiefly made of mounded earth, with rocks, shrubs, and trees planted in them to give a natural effect.

Aesthetically, these false mountains provide the hard, stony *yang* element necessary to balance the soft, reflective *yin* of the streams and lakes; symbolically, they suggest the homes of the mythical Chinese Immortals and, despite Chinese insistence on their 'naturalness', add a magical strangeness to the domestic beauties of a garden. M.K.

See also GE YUAN; GE YU-LIANG; HUANG SHI; HUAN XIU VILLA; QIAN LONG GARDEN; SHI FENG; SHI SUN; TAIHU ROCK.

Ji Chang Yuan, China. Though the original was destroyed in 1860, the fine reconstruction of this masterpiece of Ming garden design is said to have followed its original plan with accuracy. Also known as the Garden of Ecstasy, it was built in the early 16th c. at the foot of Hui Shan, a hill to the west of Wuxi in Jiangsu province. The site was already well known as a Buddhist monastery under the Yuan, and the country villa of a Minister of Revenue in the early Ming period.

Though it covers only about 1 ha., the garden has 'borrowed views' (*jie jing) of the hills around it and the Dragon Light pagoda nearby, to extend its views. A great artificial mountain of earth and yellow rock credited to the rock-work artist Zhang Yue, a nephew of *Zhang Lian, takes up all of the north-west part of the garden, but is so skilfully made that it seems to be part of Hui hill beyond the trees planted on its crest. From it the musical sounds of the Stream of the Octave, fed by the Hui Shan spring, bubble down a rocky gully leading to the long and narrow pool,

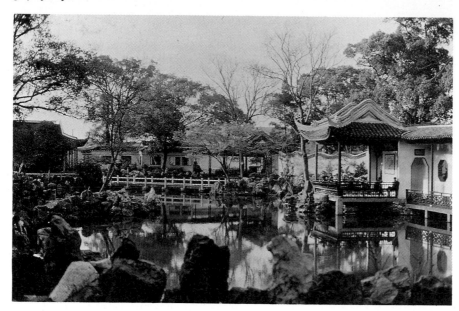

Ji Chang Yuan, Jiangsu
province, China

which takes up the eastern side of the garden. This pool also manipulates the available space to create an illusion of depth and distance: its rocky edges curl out of sight into small coves, and a tiny peninsula, jutting out on the west bank at the Beach of a Crane's Stride, draws the eye to the opposite shore where a swoop-eaved open pavilion with balustrades leans out over the water. Though this is in fact very near the garden's eastern boundary, a whitewashed wall and roofed *lang corridor cut the remaining space down to a sliver, its trees and rocks only half visible and enticing behind and above open *lou chuang windows. At the far end of the pond the Bridge of Seven Stars cuts diagonally across the water and the small space beyond it is again divided by pavilions, trees, and open corridors so that the nearby boundary wall no longer seems a barrier.

Though small, the garden's many subdivisions allow it to contain very different effects. On his inspection tour of the south, the Qing dynasty Emperor Qian Long was so taken with its simplicity and peace that, within the Imperial Garden of Clear Ripples (now the *Yi He Yuan or Summer Palace), near Beijing, he had the *Xie Qu Yuan built in its imitation. G.-Z.W./M.K.

Jie jing means 'borrowing views'. In China, as in Japan (see *shakkei*), buildings, trees, or natural scenes outside either a garden or a courtyard within a garden, are adopted whenever possible into the composition and become part of the view. It is a technique often used in small city gardens to give an illusion of greater space. X.-W.L./M.K.

See also JI CHANG YUAN; LI YU; LU SHAN CAO TANG; ZHUO ZHENG YUAN.

Jin Gu Yuan, China, was a private garden north-east of the city of Luoyang in the Western Jin dynasty (265–316) and took its name from the nearby Jin Gu Jian or Golden Valley Stream. It belonged to Shi Chong (249–300), a man of such extravagant wealth that he once put up brocaded silken screens extending for 10 Chinese li (c.5·7 km.) for a garden party. Though he described his estate as a simple country retreat, its 'many thousands' of cypresses, numerous buildings, and a private orchestra helped it to become a classic symbol of luxurious living. In addition, its name carries the allure of association with one of the Four Great Beauties of Chinese history: during the tyranny of King Sima Lun, Shi Chong was falsely arrested after refusing to give up his concubine Lu Zhu (the Green Pearl) who then jumped to her death from a tower in the garden. D.-H.L./M.K.

Jin Shan or Hill of Scenic Beauty, Beijing, China, is an imperial garden lying just outside the back gate of the Forbidden City. It is also known as Mei Shan or Coal Hill. The hill itself is 43 m. high, and was the highest point in the capital until the new buildings of the 1950s. Before the 12th c., however, it did not exist. Earth and sludge dug out to make the Taiyi or Pool of Heavenly Water first created a mound here during the Jin dynasty (1115–1234); then, when the river which encircles the Forbidden City was being dredged at the beginning of the 15th c., this became again a convenient dumping ground. Later pines, cypresses, flowers, and lawns were laid out below the hill, a paddock was opened for raising deer and cranes (symbols of longevity), and the whole place became an imperial garden.

During the Ming dynasty, a hall named Guan De, or the Observance of Virtue, was built behind the hill to the north, with a courtyard round it where the nobles practised archery. The last emperor of the Ming hanged himself from a pagoda tree (said to have survived until the early years of this century) on the northern slope of the hill. In 1749, the 14th

year of the Qing Emperor Qian Long's reign, mass construction began to the north of the hill on an architectural complex including the Shou Huang Dian, or Hall of the Ageing Sovereign, and Liu Li Fang, or Glaze-work Lane, which formed an organic system of their own and were used by the imperial family as private altars. The following year saw the building, on top of the hill, of five pavilions roofed over with glazed and coloured tiles. The biggest of these is Wan Chun Ting, the Pavilion of Everlasting Spring. A square structure with double eaves, it not only makes a dramatic silhouette on the horizon at the end of many vistas in the imperial palace, but from it there are panoramic views across the whole capital, with the Imperial City itself spread out below, the Three Seas, *Beihai, *Zhonghai, and Nanhai almost underfoot, and the outlines of the Western Hills rising beyond the suburbs in the distance. G.-Z.W./M.K.

Johan Maurits (or John Maurice) of Nassau-Siegen (1604–79), Dutch Stadholder and garden designer, was the German cousin of Prince *Maurits and of *Frederik Hendrik. His involvement with the Dutch classical garden is evidenced by his gardens in The Hague (Mauritshuis), Brazil (Vrijburg), and Germany (*Cleves and Sonnenburg) where he employed Dutch architects. With the possible assistance of Pieter *Post, he laid out the most outstanding *Dutch colonial garden of the 17th c. at Vrijburg Palace (1639), Recife, Brazil. His gardening tastes reached their culmination at Cleves where he created a series of parks and gardens linked to the city by broad avenues, resulting in one of the earliest examples in Germany of a *garden city. His baroque parks and gardens bore an influence in Germany, in particular on the Elector of Brandenburg, and in the Netherlands on the Earl of Portland at *Zorgvliet. F.H.

Johnes, Thomas (1748–1816). See HAFOD.

Jones, Inigo (1573–1652), English architect, visited Italy as a landscape painter between c. 1593 and 1603, and again in 1613–14 with Lord Arundel, imbibing Palladianism and Renaissance assumptions of the unity of building with the 'Arts of Design'. His remodelling of Arundel House grounds (c. 1615–25) partly as a setting for antique sculpture, introducing formal gateways between different gardens, was an innovation. He laid out gardens at Lincoln's Inn (1618) and at *Wilton House with Isaac de Caus (1632–3). His court masque scenery (1605–40) first demonstrated Italianate concepts of planting, landscape, and building. I.L.P.

Joséphine (1763–1814), Empress of France (1804–9), married Napoleon Bonaparte in 1796. In 1799 she acquired the estate of *Malmaison where, using Napoleon's influence, she collected plants from all over the world. She was served by a series of eminent botanists: Etienne-Pierre Ventenat, Charles-François Brisseau de Mirbel, and Aimé Bonpland who supervised her gardens from 1806. She exchanged rare plants and information with André *Thouin, sharing with the Jardin des Plantes the fruits of Nicolas Baudin's expedition to Australia in 1800–3. Her garden was immortalized by the drawings of P.-J. Redouté (1759–1841) in *Jardin de Malmaison* (1803–5) (see *botanical illustration); *Les Liliacées* (1802–16) and *Les Roses* (1817–24) also owed much to her collections. K.A.S.W.

J. Paul Getty Museum, Malibu, California, United States, is a reconstruction based upon the Villa dei Papiri near Herculaneum which was excavated in the 18th c. after having been buried by the eruption of Vesuvius in AD 79 (see *Pompeii). It comprises a number of buildings, which incorporate features borrowed freely from other buildings of the period, and several enclosed gardens. These include the Main Peristyle Garden, the Inner Peristyle Garden, the East Garden, the West Garden, and the Herb Garden, all with the characteristic Roman features of pools, paving, clipped hedges and topiary, arbours, colonnades, and mural paintings. The plants (grape-vines, fruit-trees, evergreen and flowering shrubs) have been chosen and are being arranged to match the authenticity of the buildings.

W.L.D./M.L.L.

Jurong, Japanese and Chinese Gardens, *Singapore. These two gardens, each of 14 ha., are located on islands in the Jurong River and form part of the main Jurong park, an area once dominated by swamp, and fish- and prawn-ponds. Jurong itself is a major suburb to the west of central Singapore, built from 1970. The gardens evoke traditional Japanese and Chinese themes and have quite different characters.

The Japanese garden (Saiwaen) was designed by Professor Kinsaku Nakane and is one of the largest Japanese gardens outside Japan. Surrounded by the river, the garden looks inwards to a small and a larger lake with connecting streams filled with waterworn rock, a waterfall, and islands within the lake. Traditional Japanese bridges cross the streams and a long pavilion, a summer-house, and stone lanterns all have an essentially Japanese character. Low rounded hills contain the western and northern edges of the garden, forming a backdrop to spreading shade-trees, clipped ixora bushes, pandans, and rock clusters. The garden has a controlled stylized interpretation of nature, where the relationship of one plant to another or the shape of one tree to another determines the essential character of a particular view. Thirty-six scenic spots are precisely defined to evoke a particularly Japanese order.

The Chinese garden (Yu-Hwa Yuan), in contrast, is much more naturalistic with great contrast in the texture of massed tree and bamboo planting, set against large-scale ground modelling, and distinctive Chinese buildings. The garden follows styles prevalent in the Song dynasty coupled with the style of the summer palace in Beijing (see *Yi He Yuan). The entrance to the garden is guarded by stone lions and approached over a 13-arched humped white rainbow bridge, from which paths radiate around the garden. Ahead,

The Japanese garden, Jurong, Singapore

two contrasting walled gardens (one scented, one miniature) are centred on a cloistered fish-pool. Beyond, the main path passes a Chinese arbour, crosses, on a white bridge, a stone-filled stream, and leads to the lotus pond beside which 'float' a tea-house and, opposite, a Chinese stone boat (*fang*). Through a great clump of bamboo, giant stone stepping-stones lead across a lake filled with water hyacinth to a low hill planted with pine and *Ficus* trees. The hill is topped by a seven-storey hexagonal pagoda in the style of the Ling Ku temple in Nanjing. From its top there are long views to the high-rise blocks of Jurong town, and, below, to the garden's end, a peninsula jutting into the river containing four arbours in a forest of trees and scattered rocks. N.T.

Kadoorie Botanic Gardens, Hong Kong. See HONG KONG.

Kadriorg, Estonia, Soviet Union. See EKATERINTAL.

Kaempfer, Engelbert (1651–1715), was a German physician and botanist, who was employed by the Dutch East India Company in their trading station at Deshima, Nagasaki, from 1690 to 1692. On annual visits to the emperor Kaempfer studied and collected local plants. He later wrote *Amoenitates Exoticae* (1712) which included the first descriptions of aucuba, skimmia, hydrangea, chimonanthus, ginkgo, several lilies, and many varieties of camellia. The book was intended as a precursor of another, which appeared posthumously in 1727 when Sir Hans *Sloane, who had bought Kaempfer's papers, had the *History of Japan* published in translation; it too includes a good deal of natural history. Some of his drawings of Japanese plants survive among the Sloane manuscripts in the British Library, and a selection of them, edited by Sir Joseph *Banks, was published in 1791. S.R.

Kames, Henry Home, Lord (1696–1782), was an Edinburgh lawyer whose fame rests with his *Elements of Criticism* (1762), in which he treated gardening as an art of design and attempted, with a measure of success, to establish its principles within the then newly fashionable informal style. He exploited associations of ideas and by assigning a 'value' to each 'scene' he showed how a garden could be laid out without reference either to geometry or landscape paintings. Kames's 'most perfect idea' had the various parts arranged 'in such a manner, as to inspire all the different emotions that can be raised by gardening'.

W.A.B.

Kare-sansui, dry landscapes, the name given to Japanese Buddhist gardens of contemplation. They are composed of raked sand or quartz and rocks (see plate IV), the most famous being *Ryoan-ji in Kyoto. S.J.

See also DAISEN-IN; SAIHO-JI.

Karlsruhe, Baden-Württemberg, German Federal Republic. The baroque Schlossgarten at Karlsruhe is

Karlsruhe, Federal German Republic, general plan, view from the south, after an engraving (1765) by J. Striedbeck

among the most original of this period in Germany as it is designed in the shape of a star. At the centre stands the high hunting-tower built in the Hardtwald by Margrave Carl Wilhelm of Baden-Durlach; 32 avenues radiate from this central point. It was in keeping with the spirit of absolutism of the time that, when the town was founded in 1715, the plans for both town and Schloss should be based on this same strict geometrical star design. A circle runs round the tower at a distance of 440 m. and forms the boundary of the garden. The segment of the circle between the two wings of the Schloss contained a pleasure-garden with a parterre and a *bosquet*, while the main area around the tower was left as a hunting-park.

This woodland park was rearranged for the *Bundesgartenschau* (see *Gartenschau*) of 1967 to a design by Professor W. Rossow who also directed the work. He had the difficult task of on the one hand creating a permanent leisure park for the population of Karlsruhe, while on the other accommodating the *Gartenschau* with its different aims and requirements. It comprised a large number of individual gardens, mainly of plants, and also had various attractions, such as the miniature railway which ran through the park, and architectural works, such as the pools constructed from precast concrete: all things which cannot easily be brought into harmony with a historic garden around the Schloss. The garden at Karlsruhe represents an attempt to integrate modern garden design, architecture, and the visual arts. U.GFN.D.

Kashmir. See ACHABAL; CHASMA SHAHI; CHAHAR CHENAR ISLAND; ISLAM, GARDENS OF; JAHĀNGĪR; MOGUL EMPIRE; NASIM BAGH; NISHAT BAGH; SHALAMAR BAGH, SRINAGAR; VERNAG.

Katsura Imperial Villa, Kyoto, Japan, also called Detached Palace (*Rikyu*), has an exceptionally fine *stroll garden of the Edo period (1603–1867). Begun in 1620 by Prince Toshihito, it was completed *c.*1658 by his son. The design was probably directed by the prince, whose literary interests inspired allusions throughout the garden to the Heian classic *The Tale of Genji*. Kobori Enshu is also credited with having contributed to the design: no

Katsura Imperial Villa, Kyoto, aerial view

documentary evidence exists but the touches of artificiality and the use of straight lines in paving and bridges were innovations that characterized his work.

The 10·4-ha. garden, lying on the west bank of the Katsura River, is completely surrounded by trees and turns in upon itself round the central lake which is shaped like a flying crane, with one of its islands shaped like a tortoise; both are symbols of longevity and reflect the prince's Heian tastes. Progressing clockwise along a path of 1,760 stepping-stones, new views unfold, revealing in succession: a maple mountain; a promontory on the lake shore, said to be a miniature of a much-admired spit of sand at Amanohashidate; a large tea-house (Shokin-tei) reached by a flat bridge made of a huge monolith. Stepping-stones, each chosen for its personality, continue towards a bridge leading to the tortoise island. At its highest point a small tea-house (Shoka-tei) looks out on cherry blossom in spring, brilliant maple leaves in autumn. Also on the island is a small Zen temple (Onrin-do). An arched packed-earth bridge leads back to the palace, whose three sections are arranged to give maximum opportunities for moon-viewing. S.J.

Kebun Raya Botanic Garden (or Hortus Bogoriensis), Bogor, Java, *Indonesia, is one of the great botanic gardens of the world. Formerly called Buitenzorg it was founded in 1817 on 87 ha. of the grounds of the palace of the Hindu kingdom of Padjadjaram. It lies at an altitude of 260 m. on the lower slopes of Mount Salak where the annual rainfall is heavy (4,000 mm.). The access roadways through the gardens are lined with trees, notably the Canarium Avenues with each tree festooned by a climbing member of the arum family and often linked by a giant *Entada* liana. There is a large lake with water-lilies and artificial pools for aquatic and marsh plants such as papyrus, although the River Tjiliwung passes through the gardens. The palm and bamboo collections are impressive, while native orchids are grown in the shelter of the orchid house.

Many economic and ornamental plants have been introduced into the country through these gardens and the original African oil palm tree (1848) still survives. The gardens have long been a major scientific centre for research on the flora of the Malaysian region, with the Herbarium (1844, new building 1970), the Treub Laboratory (1914), and the Zoological Museum (1894), all being sited there. F.N.H.

Kedleston Hall, Derbyshire, England. The present house (1757–65) was built on the site of the original 12th-c. manor-house, home of the Curzon family for over 800 years. The village of Kedleston, except for the church near the house, was swept away to make room for the present house and landscaped grounds. Robert Adam has left his mark, for apart from the house's magnificent south front, in the grounds are his stone, octagonal, domed summer-house, a five-bayed orangery, a Venetian windowed boat- or fishing-house, a balustraded three-arched bridge across the cascade that feeds the 12-ha. lake, a brick arched aviary

(now a loggia), and the entrance screen to the main gateway of the park of 200 ha. with its herd of deer.

In the formal gardens two stone-pillared rose pergolas flank a modern swimming-pool and lead to the heart-shaped sunken rose-garden with geometrically shaped beds designed by Sir Edwin *Lutyens in 1925, and backed by the Adam summer-house on the edge of the *ha-ha. Behind the orangery the Long Walk stretches through woodland and shrub planting, past the Hackworth Fountain of slender pillars and delicately scrolled ironwork and an iron gate with stone pillars which came from the House of Lords. K.LE.

Kemp, Edward (1817–91), English landscape architect. He was on the garden staff at *Chatsworth under Joseph *Paxton, whom he assisted in the laying-out of his design for *Birkenhead Park, 1843–7, where he served as Superintendent for over 40 years. During that time he also designed other parks and private gardens. In a series of Lancashire works—Anfield Cemetery, Liverpool (1856–63), Hesketh Park, Southport (1864–8), and Stanley Park, Liverpool (1868–70)—he followed Paxton's course in using increasingly formal designs for parks; in his influential book *How to lay out a Small Garden* (1850; 3rd edn. 1864), he adapted Paxton's methods for the suburban estate. B.E.

See also PUBLIC PARKS.

Kenilworth Castle, Warwickshire, England, had the earliest important Elizabethan garden, created between 1563 and 1575 for Robert Dudley, Earl of Leicester, as part of his modernization of the medieval castle. The format was French by way of early Tudor palace gardens; a square area was divided into quarters focusing on a heraldic fountain topped by the bear and ragged staff, Leicester's personal device. There were obelisks in each of the quarters which were planted with herbs and fruit-trees and there was a terrace, with an aviary and balustrading, from which the garden could be viewed as it could not be situated directly beneath the castle windows. R.S.

Kensington Gardens, London. William III (see *William and Mary) purchased Nottingham House at Kensington as a place of retirement close to London in 1689. In 1691 George *London laid out an intricate geometrical garden to the south, half in *parterre with clipped evergreens, and half as *wilderness work. William III also had a road made to the gate of this garden from Piccadilly. This was lit by lamps and was referred to as the 'Route du Roi' (corrupted to 'Rotten Row').

Queen Anne greatly extended the grounds, first by adding the Upper Garden north of the palace in 1704, and secondly by enclosing the 40-ha. Royal Paddock from *Hyde Park for deer and antelope in 1705. The Upper Garden consisted of three woodland quarters and a *mount and hollow divided by the main garden axis. The hollow had been a gravel-pit but was regularized into two symmetrical flights of terraces liberally adorned with clipped evergreens. The mount was 'planted round promiscuously' to increase its apparent height.

Joseph *Addison and Stephen *Switzer both admired the grounds, and in 1722 Thomas Tickell's poem 'Kensington Garden' was printed with an engraving of the sunken garden on the title-page. In 1705 a greenhouse was built near the mount. The Royal Paddock was relaid by Charles *Bridgeman in the 1720s.

Under the guiding hand of Queen Caroline (wife of George II), the Round Pond (1728) and the Serpentine (1731) took shape. William *Kent worked for her (as he did at Richmond), planting dead trees for effect until, as *Walpole tells us, he was laughed out of such excess. A mount, legacy of the earlier layout, lasted until at least 1736. In the 19th c. there was an elaborate bedding scheme by Nathan Cole. D.L.J./M.W.R.S.

Kent, Nathaniel (1737–1810), English landowner, spent his early career in the diplomatic service in the Netherlands. He took so great an interest in agricultural improvement there that upon his return to England in 1766 he devoted himself to this profession, mainly in Norfolk. His clients included William Wyndham of Felbrigg, through whom he was acquainted with *Repton.

When George III took the rangership of Windsor Great Park in 1790 he shortly after appointed Kent his bailiff. Whilst John Robinson, the Surveyor-General of Woods and Forests, sowed 11,225,000 acorns between 1788 and 1801 on the high ground, Kent put the low ground into agricultural production. The 'Norfolk Farm' was on 400 ha. of light soil and the 'Flemish Farm' on 160 ha. of better loamy soil, both farms being named after systems of husbandry. Kent made a magnificent plan of them.

In 1792 he delivered a paper to the Society of Arts on the use of the sweet chestnut. Six years later he submitted a lengthy account of his improvements at Windsor, writing that the clearance of trees and undergrowth from the valleys gave a bolder effect to the woody scenes on higher ground. D.L.J.

Kent, William (1685–1748), English landscape designer and architect, began his working life as an apprentice coach-painter in Hull. His talents attracted attention, and three patrons, Burrell Massingberd of Ormesby, Sir William Wentworth of Bretton Park, and Sir John Chester of Chicheley, enabled him to travel to Italy. Towards the end of 1714 he was introduced to the 3rd Earl of *Burlington, then making his first Grand Tour; in 1719, at the conclusion of the Earl's second visit, he returned to England with him and Burlington now became Kent's principal patron. In the 1720s he worked as an interior decorator at Kensington Palace, *Chiswick House, and Houghton Hall, Norfolk; during this period he became increasingly interested in architectural design and from 1724 edited, in two volumes, *Designs of Inigo Jones, with some additional Designs*, published in 1727.

From 1730 Kent was to emerge as an architect in his own right and launch out as a designer of landscape gardens, a venture which was to earn for him Horace *Walpole's encomium that he was 'born with a genius to strike out a great system from the twilight of imperfect essays. He leaped the fence, and saw that all nature was a garden.' In taking this latter step Kent received encouragement not only from Burlington, but also from Alexander *Pope. The poet and the artist had long been friends, and it was for Pope's miniature estate at Twickenham that Kent made one of his earliest designs for a garden building, c. 1730. Moreover, the poet's dictum that 'all gardening is landscape painting' was one which Kent made his own, freeing garden design from the last traces of formality, and in doing so creating three-dimensional pictures in which woodland and lawn, water and the contrasts of light and shade, were his media. Kent's studies in Italy had given him a wide knowledge of the paintings of Claude Lorrain and Salvator Rosa, and from these he had undoubtedly absorbed a feeling for the picturesque scene. The landscape designs which were later to emerge from his pen, however, suggest that both in the composition and the technique adopted he was strongly influenced by the masque designs of Inigo *Jones, and in particular those which had been acquired by Burlington from Elihu Yale in 1722, and with which Kent was well acquainted. This source is also apparent in the illustrations which he provided for James Thomson's poem *The Seasons* (1730), where the scene showing the arrival of Spring with her attendants in a pastoral landscape is remarkably like some of the transformation effects in the masque designs.

Kent's surviving garden designs bear out the fact that his approach to the subject was essentially visual. Not one is supported by a working plan or instructions for its execution. Whereas such predecessors as Henry *Wise, Stephen *Switzer, and Charles *Bridgeman were steeped in practical as well as theoretical knowledge of garden layout, Kent considered landscape solely as an artist and there is no evidence that he knew more about trees and shrubs than the effect of their shape and colouring on the prospect, or that he was aware of the extent to which success or failure in planting might be determined by geological considerations. Similarly his drawings for buildings, while appealing to the eye, were lacking in the minutiae necessary for their construction, which were left to the foremen or artisans. In spite of these drawbacks Kent's success both as an architect and landscape gardener was immediate, and while in the former capacity he was one of several contemporary Palladians, in the realm of fully emancipated landscape he had no professional rival. By 1734 Sir Thomas Robinson of Rokeby was writing to his father-in-law, the Earl of Carlisle: 'There is a new taste in gardening just arisen, which has been practised with so great success at the Prince's garden in Town [Carlton House], that a general alteration of some of the most considerable gardens in the kingdom is begun, after Mr. Kent's notion of gardening, viz., to lay them out, and work without either level or line. By this means I really think the 12 acres the Prince's garden consists of, is more diversified and of greater variety than anything of that compass I ever saw; and this method of gardening is the more agreeable, as when finished, it has the appearance of beautiful nature, and without being told, one would imagine art had no part in the finishing . . . The celebrated gardens

Holkham Hall, Norfolk, England, drawing (c.1738) by Kent of his proposed planting of the north lawns (Holkham Hall)

of Claremount, Chiswick, and Stowe are now full of labourers, to modernise the expensive works finished in them, even since everyone's memory.'

In addition to the four gardens mentioned by Robinson, Kent had by this time already given designs for *Esher Place, garden buildings at *Shotover Park, and the Hermitage built for Queen Caroline in Richmond Old Park. His garden work was later to include the park at *Holkham Hall from 1730, *Rousham House and *Euston Hall in 1738, and *Badminton House in 1740. Although the list of his landscape works, and the number of his surviving drawings, are small in comparison with those of his successor, Lancelot *Brown, Kent's ideas were widely disseminated and the three notable amateurs, Charles *Hamilton of *Painshill, Philip *Southcote of *Woburn Farm, and Henry *Hoare of Stourhead, owed much to them in the creation of their own estates. D.N.S.

See also KENSINGTON GARDENS.

Kenya. See AFRICA.

Keukenhof, The Netherlands. See DE KEUKENHOF.

Kew, Royal Botanic Gardens, London, have evolved from two contiguous 18th-c. royal estates: Richmond Gardens, belonging to George II and Queen Caroline, and Kew House, the residence of their eldest son, Frederick Prince of Wales, and his consort, Princess Augusta. The former was laid out by Charles *Bridgeman and embellished with garden buildings by William *Kent. After George III inherited the property on his accession in 1760, it was re-landscaped by 'Capability' *Brown who removed all trace of the earlier garden. On the death of Frederick in 1751 Princess Augusta, assisted by Lord Bute, continued the development of the gardens started by her late husband. In 1757 William *Chambers was commissioned to landscape the grounds, for which he designed a number of buildings including the Pagoda. In 1759 a modest botanic

garden of 3·6 ha. was formed, with William *Aiton the elder, trained at the Chelsea Physic Garden, as its superintendent.

When Princess Augusta died in 1771, George III replaced Lord Bute by Joseph *Banks as horticultural and botanical adviser at Kew. The following year Francis *Masson sailed to South Africa to collect plants for the royal gardens, the first of a succession of Kew plant-collectors. After Sir Joseph Banks died in 1820 the fortunes and reputation of Kew Gardens declined to such a degree that in 1837 the Treasury appointed a committee consisting of John Lindley and two gardeners—Joseph *Paxton and John Wilson—to report on the state of all the royal gardens and in particular, Kew Gardens. Lindley's report, submitted in 1838, strongly urged the transformation of Kew into a scientific and horticultural institution worthy of the nation. Under considerable pressure a reluctant Treasury accepted this recommendation and in 1841 Sir William Hooker was appointed its first director.

Sir William's responsibility was confined to the original botanic garden, slightly enlarged, but the retirement of the superintendent, William Townsend *Aiton, a few years later enabled him to expand into the adjacent pleasure-grounds. The very urgent need for more glasshouses resulted in the erection of the *Palm House in 1844–8 (designed by Decimus Burton and Richard Turner) and the Temperate House in 1860 (designed by Burton but not completed until 1898). W. A. *Nesfield reshaped large areas of the grounds, making the Palm House the pivot of his layout. Before his death in 1865 Sir William Hooker also established a museum of economic botany, a *herbarium, and a library. His son, Joseph *Hooker, who succeeded him as director, directed Kew's activities primarily in the fields of taxonomy and economic botany. The Jodrell Laboratory for research into plant anatomy and physiology was built in 1876 and the Marianne North Gallery was opened in 1882. Sir Joseph retired in 1885, the Hooker dynasty, which had lasted for more than 40 years, having laid firm and enduring foundations for the future of the Gardens.

Successive directors have made their contribution to the development and reputation of Kew Gardens but most progress has been made since the Second World War. The Australian House was opened in 1952. In 1965 the gardens at *Wakehurst Place in Sussex came under Kew's administration. Its richer soil and milder climate have made it possible for Kew to expand its plant collections. In 1972–3 Kew's Physiology Section moved to Wakehurst, where it set up a seed-bank of plants of potential economic importance. The Jodrell Laboratory was rebuilt. In 1969 Queen Elizabeth formally opened the period gardens behind Kew Palace and a further extension to the Herbarium. A new complex of glasshouses is now replacing the old 'T' range and a new museum has been approved. In the midst of all these changes Chambers's Pagoda, Orangery, and Ruined Arch and Burton's Palm House and Temperate House still survive to remind the visitor of Kew's long and continuing history. R.D.

Kiley, Daniel Urban (1912–), American landscape architect, received his professional education in landscape architecture at Harvard University's Graduate School of Design where he joined *Rose, *Eckbo, and *Church in effecting the transition from the Beaux Arts system to a modern approach to design. His early work was dominated by a preoccupation with form rather than function in the solution of design problems, but was later tempered by the belief that form is achieved as a by-product of the several functional solutions to a problem. His great strength lay in his ability to make a rapid assessment of the functional relationships of buildings on a large site in order to establish a clear spatial hierarchy and appropriate scale. 'Landscape', he said, 'is not mere adornment but an integral part of the disposition of space, plane, line and structure with which it is associated.' The geometry and layout of his schemes were frequently reminiscent of the formal qualities of 17th-c. French gardens (which he much admired) and reflected his opinion that the man-made landscape should be an obvious contrast to the world of nature. Although much of his work is on a large scale associated with public and commercial buildings, it includes a number of gardens; notably the roof and terrace gardens for the Oakland Museum and an *indoor garden for the Ford Foundation in New York City.
 M.L.L.

Kilkenny Castle, Co. Kilkenny, Ireland, 12th c. in origin, dominates a bluff over the River Nore in the city of Kilkenny. It was rebuilt by the 1st Duke of Ormonde when he was created Viceroy of Ireland by Charles II, with whom he had been in exile at the court of *Versailles. Employing a French gardener called Carrie, he began the gardens in 1664. A French *fontainier* M. du Keizar was making fountains there in 1689. In the same year a London statuary maker, John Bonnier, copied for the garden four figures in the King's Privy Garden in London and cast in lead no less than 16 cupids, emblems of the four seasons, and the signs of the zodiac. The latter were probably for the Banqueting House, which had been designed by the court architect

'Wild garden' at the 1939 Reichsgartenschau, Killesberg, Stuttgart, German Federal Republic, by Mattern and Haag

Hugh May but Sir Christopher Wren was also consulted. Below it was the Waterhouse, on which the skills of the hydraulics engineer, Sir Samuel Morland, were employed.

The castle was burned by the retreating Jacobites in 1691 and the gardens were subsequently abandoned. In 1852, Ninian *Niven made designs for a *parterre on the site of the 17th-c. bowling-green and later Hungerford Pollen, the Pre-Raphaelite decorator, made a colour scheme for a parterre on the west front. P.B.

Killesberg, Stuttgart, Baden-Württemberg, German Federal Republic. In the valley between the Schloss in the centre of Stuttgart and the River Neckar lie the gardens which were partially redesigned for the *Bundesgartenschauen* of 1961 and 1977 (see *Gartenschau*). In addition, there are on the surrounding hills a number of lovely parks, such as the park of the Villa Berg and the Rosenstein park, laid out in the English landscape style over an area of 100 ha., with its Schloss begun in 1822 on the model of an Italian villa.

The Höhenpark Killesberg in the north of the town was created by H. *Mattern for the *Gartenschau* of 1939. The 50-ha. park was laid out on rough ground, on wasteland, and in disused quarries. The first *Gartenschau* after the

Second World War was held here in 1950 and sole responsibility for the site which had been destroyed in the war again fell to H. Mattern, the co-founder of the Werkakademie in Kassel and a professor at the Technische Universität in Berlin. It is his success in achieving a synthesis between a modern popular park with rocks, glens, ponds, and dense thickets and an exhibition garden for flower-lovers and garden specialists which has earned the garden the name 'Stuttgart's Paradise'. U.GFN.D.

Kilruddery, Co. Wicklow, Ireland, is an extensive *demesne in the foothills of the Wicklow Mountains. The formal landscape garden adjoining the house was begun by the 4th Earl of Meath c.1682. The design of twin canals leading to a circular pond is similar to that at *Courances, near Paris. This vista was flanked in 1711 by 'a Pleasure Garden, a Cherry Garden, Kitchen Garden, New Garden, Wilderness, Gravel Walks and Bowling Green, all wall'd about'. The garden was extended c.1725 by an uphill vista down the centre of which ran a stepped cascade or water staircase, like that at *Marly, terminating in a pond known from its shape as the Ace of Clubs. A payment to a Mr Roe, a Dublin 'rural artist' and nurseryman, is recorded in that year.

Daniel Robertson designed terrace balustrading in 1846 for the new house. The 17th-c. garden was devastated by a storm c.1850 and was restored by the 11th Earl of Meath who added a Beech Circle and green *theatre to the original design, and cast-iron statuary by Barbezat and Kahl. A new *parterre was laid out to the west of the house c.1850. It is overlooked by an ornamental dairy designed by the amateur architect Sir George Hodson, Bt., and by a conservatory designed by William Burn, the roof of which is by Richard *Turner. P.B.

Kingdon-Ward, Frank (1885–1958), British plant-hunter, was the son of Professor Marshall Ward, a distinguished Cambridge botanist. Soon after going to teach in Shanghai in 1907, Kingdon-Ward began to explore the country. In 1911 he was engaged as a plant-collector (in succession to George *Forrest) by A. K. Bulley of Bees Seeds. His explorations in Yunnan, Szechuan, Assam, Sikkim, Burma, and Tibet continued for the rest of his life, important for their geographical as well as their botanical results, for he made surveys and maps of the areas he traversed. He wrote over 20 books describing his journeys. The yellow-flowered *Rhododendron wardii* was one of his Chinese discoveries, while the giant cowslip *Primula florindae* (named after his wife) came from Tibet; other members of both genera were well represented in his collections. The blue Himalayan poppy, *Meconopsis betonicifolia*, first discovered by Père Delavay, was established in cultivation by seeds collected by Kingdon-Ward in Tibet. S.R.

King's Knot, Stirling Castle (Central Region), Scotland. A park has existed to the south-west of Stirling Castle since the 11th c. In 1502 the corner nearest the castle was made into the New Garden. This garden, now called the King's Knot, was improved throughout the 16th c., and may have been given its present form as early as 1540 when the new palace by Hamilton of Finnart was finished for James V and his queen, Madelaine of Guise.

All traces of plantations have long since vanished, unfortunately without being recorded, but the surviving turfed earth-banks, ramps, and terraces indicate the grandeur and extent of the scheme. From the palace, some 30 m. above, the King's Knot presents an easily perceived formal pattern, in scale with both the castle rock and the Vale of Stirling beyond. The garden is a long rectangle with a central square of turf terraces in the form of an octagon. The centre of this, the actual King's Knot, is a mount which would presumably have originally held a summer-house with the deep moat surrounding it being flooded. W.A.B.

Kinkaku-ji (Golden Pavilion), Kyoto, Japan, was built in 1397 (in the Muromachi period) as a residence for the third Ashikaga Shogun Yoshimitsu on the site of an earlier paradise garden and later transformed into a temple, called Rokuon-ji after the deer-park where Buddha first preached after receiving enlightenment. This was a paradise garden for Buddha to walk in; various symbolic buildings were scattered about the park. As a lover of the Heian style, the shogun also introduced the symbolic flying crane lake and tortoise island. Originally the lake appears to have been larger and the pavilion may have stood in the water, in keeping with the palace of the dragons under the sea which it is also said to symbolize. Modelled on the *Saiho-ji pavilion, it has three storeys with verandahs, the middle one projecting out over the lake, beyond the other two; each has a different 'borrowed landscape' (see *shakkei*) view. The pavilion was burned down in 1950 but has been completely restored, even to the gold leaf. The lake—its outline accented by natural rocks and trees in the Japanese manner—is divided into two by the tortoise island. Near the pavilion the water is dotted with small islands and rocks; beyond, smooth water merges into trees on the further shore. The design shows the influence of the Song painters and is sometimes attributed to *Soami, but the relevant dates make this unlikely. S.J.

See also JAPAN: THE MUROMACHI PERIOD.

Kiosk. See OTTOMAN KIOSK.

Kip, Johannes (1653–1722), Dutch engraver and draughtsman, is chiefly known as an engraver of topographical views and book illustrations, and his name is usually associated with that of Leonard *Knyff for whom he engraved at least 82 views of palaces, country seats, etc. But Kip engraved the work of other artists as well; for example, he engraved 19 of the 33 views of country seats drawn by Thomas *Badeslade, which illustrate *The History of Kent* by John Harris (London, 1719). He also engraved his own drawings; as a series they were published later in *Britannia Illustrata*, Vol. II (1715 and 1740) and *Le Nouveau Théâtre de la Grande Bretagne*, Vol. I, Part II (1716), and Vol. II (1724). P.H.G.

Kirby Hall, Northamptonshire, England, has formal gardens laid out in the second half of the 17th c. The great west formal garden was laid out by Viscount Hatton from 1685 to 1686. The long axis of the garden which runs parallel to the house is continued by the great avenue of trees. Originally the garden had a lower terrace, a canal, raised walks, a *wilderness, and much sculptural ornament. During the 19th c. this superb house and its garden became derelict but after the Second World War the Office of Works reconstructed much of the great west garden layout.

<div align="right">P.E.</div>

Kitchen garden. The imposing stone walls of 17th- and 18th-c. English kitchen gardens such as those at *Blenheim Palace leave us in no doubt as to the boundaries of these once intensively cultivated and productive plots. The concept of the kitchen garden is harder to delimit, since the criteria we use to set apart the English kitchen garden from the flower garden—the raising of vegetables, small fruits, and exotic items for use in the kitchen, and the enclosure of the area with secure walls, fences, or hedges—apply equally to the large gardens of the Hanunóo people of the Philippines, the 'coral gardens' in the Trobriand Islands near New Guinea, and to gardens created by native peoples in the Americas, Africa, Asia, and Oceania.

A survey of kitchen gardens around the world reveals great variation in plot size even within a single culture. The Hanunóo, for example, produce food from two types of garden: tiny house-yard enclosures often devoted to medicinal, ritual, aromatic, and new plants grown experimentally, and large 'swiddens' which are made in secondary forest within 1 km. of the house cluster by cutting and burning the vegetation.

Gardening in Meso- and South America, New Guinea, and parts of Africa remained the sole method of producing plant food until Western agricultural methods were introduced. In Mexico the early stages of domestication of squash and beans by itinerant groups began as long ago as the 7th millennium BC. Maize had been added to their plant assemblage by 5000 BC. In Peru, gourds and two types of squash were in cultivation by 5500 BC, followed by lima beans and maize. At the same time as the Romans were setting up kitchen gardens in the shelter of their villas in Britain, the native peoples of Peru had gardens containing potatoes, sweet potatoes, manioc, peanuts, capsicum peppers, various beans, assorted squashes, *Canna edulis*, and other roots, as well as fruit-trees bearing guavas and avocados.

Gardening began equally early in New Guinea. By 7000 BC an indigenous group in the Highlands had both swamp gardens and hillside swiddens, in which they cultivated the sugar-cane, plantain bananas, and various leafy vegetables. Along with some additional tree crops, this complex spread to the rest of the Pacific islands and even Africa (via Madagascar) long before the period of European expansion. Parts of Africa had also been the scene of horticultural innovation. Several cereals were domesticated in the savanna lands south of the Sahara, including finger millet,

recently identified from an Ethiopian site dated to 2500 BC. At the same time it is believed that the cultivation of African yams and oil palms was already under way in forest clearings further south. In China millet and rice were cultivated as early as 5000 BC. In view of the importance of vegetables and fruits in Chou texts of the 1st millennium BC, gardening may have a similar antiquity.

Direct evidence for the presence of kitchen gardening in the Near East extends back to the 4th millennium BC. Here, the protection of an enclosed kitchen garden was probably first offered to certain plants like garlic and onions, which were not naturally widespread and which were valued for flavouring a diet increasingly based on bland cereals. Similarly the high value of the best varieties of oil-rich or sweet fruits such as olives, grapes, figs, dates, and pomegranates undoubtedly proved an incentive for the establishment of the first orchards by c.4000 BC. Botanists who have worked on the identification of these early orchard fruits stress the fact that domestication represented a shift from sexual reproduction to vegetative propagation by cuttings and offshoots. The type of care given to these cuttings, especially regular watering, transplanting, provision of shelter and supports, preparation of planting holes, and manuring may have been learnt in early kitchen gardens, or alternatively was transferred from orchard to garden. The latter is more likely, for the first vegetable remains (including kurrat leeks and garlic) from the Near East are dated to c.3000 BC. Significantly garlic has to be reproduced vegetatively and the kurrat leek needs regular watering and manuring, requirements which a gardener can meet far better than a farmer.

As early as 2300 BC the Egyptians grew the kurrat leek and a tall cos-like lettuce in irrigated chequerboard gardens. Paintings in tombs of the 2nd millennium BC often show these plots being watered from jars and planted with the help of dibber-like sticks. Grapes and melons were also depicted with their vines trained over frames. In Mesopotamia at this period, tablets refer to many different types of edible plant. Kitchen garden plants are represented by lettuce, purslane, rocket, beet, radish, turnip, leek, garlic, several types of onion, cucumbers, gourds, and the bitter colocynth.

Literary sources suggest that Greek gardens of the 1st millennium BC combined selected fruits and vegetables within a single irrigated enclosure, a pattern identified later in the gardens excavated at *Pompeii. Roman kitchen and market gardens had benefited from the legacy of vegetable and fruit varieties acquired and improved by earlier civilizations. Thus Pliny the elder was able to describe at least 12 different types of cabbage and kale, 11 types of lettuce, and numerous members of the onion family, all in cultivation. Understandably the Romans attempted to transplant their kitchen garden tradition to Britain where it appears at sites like *Fishbourne (probably between the north and west wings). Whether or not the tradition survived in England after AD 300 or was reintroduced from Europe several centuries later, is a debatable point. Nevertheless the walled kitchen garden which is increasingly well documented from

Tudor times is a clear descendant of its Mediterranean prototype. Although new plants have been added, especially since 1600, and old ones, chiefly pot-herbs, abandoned, many of the techniques and tools have not changed significantly in over two thousand years.

The walled kitchen gardens of Europe which flourished from the 17th to the 19th c. mark a high point in this tradition (see *La Quintinie). In keeping with their setting within wealthy country estates, they were designed to produce fruits, salad greens, and other vegetables of the best possible quality and over an artificially prolonged season. To this end the walls were built to a height of 4 m. which not only screened the operations from the house and walks, but created a favourable microclimate within. In the 18th c. sections of the wall were often heated from an outside furnace by a system of horizontal flues and were provided with glass lean-tos to encourage early fruiting of peaches and apricots. A constant supply of fresh dung from stables and tanner's bark (if available) was essential for the raising of melons, the prestige fruit of the 18th c. In Elizabethan times the raised dung beds were screened with mats, but glazed wooden frames came into more general use in the 18th c. Glass bell-jars were a common form of protection for young cucumbers.

The kitchen garden layout consisted of borders beneath the walls separated by rolled paths from the main beds or 'quarters'. While the borders contained the fruit-trees, small fruits, and early or late salad crops, the quarters were planted in rotation with various brassicas, legumes, onions, and root crops. The melon ground often occupied a small enclosure within the main garden, and separate beds were marked off for perennial vegetables such as asparagus and globe artichokes. One or more ponds in the centre of the complex supplied 'softened' water for dry spells. The huge investment in the fabric of these walled gardens, the continuous input of fuel and manure, and the efforts of a large number of gardeners meant that the produce that reached the table was of a quality and freshness seldom approached today. H.M.L.

See also VILLANDRY.

Kleingarten, a peculiarly German phenomenon, is a piece of land leased from the state and used as a garden by a family which does not have a garden attached to its home. Every *Kleingarten* has a chalet (*Laube*) for overnight stays only—permanent residence is prohibited. *Kleingärten* are grouped together in *Kleingärten* colonies (*Kleingärtenkolonien*), a complex of 20 to 150 plots, administered by *Kleingärten* societies.

The origins of the *Kleingärten* go back to Dr Daniel Schreber (1808–64), after whom they are colloquially called *Schrebergärten*. His disciple and son-in-law, E. J. Rauschild, founded the Schreber Society in 1864 which promoted the Schreber ideology of purification of children through work with nature. However, his therapeutic children's gardens were soon taken over by their families for vegetable cultivation.

The economic instability of the early 1900s helped the movement to spread throughout Germany. In the Third Reich the state promoted the *Kleingärten* as part of its ideological and economic propaganda. The concept of blood and soil made each *Kleingarten* tenant responsible for the future of Germany, with a strong emphasis on the self-sufficiency of the *Kleingärten* colonies.

Defeat in the war and the collapse of the economy called for an expansion of autonomous subsistence, which catalysed the authorities' interest in allotments. Allocation of land for *Kleingärten* colonies and their integration into cities were much discussed by town planners. But as Germany's economic recovery made great demands on urban sites, *Kleingärten* colonies were pushed to unattractive areas, often acting as buffer zones between motorways, airports, or industry and housing.

The absence of the economic reason for cultivating a *Kleingarten* has changed its appearance. *Allotments are rarely kept for growing vegetables, but are used as miniature ornamental gardens, providing a hobby. C.A.

Klein-Glienicke, Berlin. In 1816 the Prussian State Chancellor, Prince Hardenberg, entrusted Peter Josef *Lenné (then still a garden assistant) with the redesign of his garden at the manor of Klein-Glienicke. After Hardenberg's death Prince Carl of Prussia, brother of King Friedrich Wilhelm IV, bought the property and employed Karl Friedrich *Schinkel to extend and convert the buildings and Lenné to make significant extensions to the park.

The buildings were inspired by the idea of an Italian villa. The Stibadium in the pleasure ground, the Pompeian garden plot, and a border modelled on the descriptions by *Pliny the younger of his Tuscan villa, contributed to the idealized image of Italy as the model of western culture. In the park, on the road to Potsdam, were erected the Kleine Neugierde, a small garden temple, the Grosse Neugierde, a rotunda opposite the Glienicke bridge, the *casino, built in classical form standing above the shore of the Havel lake, and the Klosterhof.

This landscape park is an essential part of the Potsdam landscape, a comprehensive creation by Lenné, with extensive prospects and vistas to Schloss Babelsberg, the Pfaueninsel, the Marble Palace, the Belvedere on the Pfingstberg, the Heilandskirche towards Sacrow, and the town of Potsdam. Conversely, the dominant position of the *casino* in Klein-Glienicke is visible from these places.

After a lengthy and extremely careful restoration and exemplary re-creation of the original layout of the grounds, this park is now the best example of Lenné's creative work as a park designer. U.GFN.D. (trans. P.G.)

Knight, Richard Payne (1750–1824), English scholar, connoisseur and author, Foxite Member of Parliament, and member of the Society of Dilettanti. Like his friend Uvedale *Price, he deplored the landscape style of *Brown and his school, which he attacked in his poem *The Landscape* (1794) leading to a controversy with Humphry *Repton. However, he denied Price's aesthetic category of the *picturesque, and fell out with him over this. He elaborated his views in

An Analytical Inquiry into the Principles of Taste (1805). Knight handed over his estate of Downton to his younger brother T. A. Knight in 1809, and, when not in London, lived in a cottage in the grounds. D.A.L.

Knight, Thomas Andrew (1759–1838), was an English pioneer in the practical applications of science to horticulture. In 1795 he presented to the Royal Society his celebrated paper on 'the inheritance of decay among fruit trees and the propagation of debility by grafting'. He joined the Horticultural Society of London shortly after its formation in 1804 and was its President from 1811 until his death. His many contributions to the *Transactions of the Horticultural Society of London* related principally to fruit cultivation but other topics such as the construction of curvilinear greenhouses also engaged his attention. He wrote *A Treatise on the Culture of the Apple and Pear* (1797) and *Pomona Herefordiensis* (1811). *A Selection from [Knight's] Physiological and Horticultural Papers, published in the Transactions of the Royal and Horticultural Societies* was published in 1841. He was elected a Fellow of the Royal Society in 1805 and of the Linnean Society in 1807. Richard *Knight was his elder brother. R.D.

Knot garden, originally part of a garden planted in the form of a knot, a figure of continuous interlacing bands (in French *entrelacs*), expressive of an unchanging or endless situation, hence the symbol for infinity ∞. It was sometimes confused with a maze, as in the Fabyan Chronicle (1494): 'an howse wrought lyke unto a knot in a garden, called a mase' (*OED*).

The earliest record of the knot motif is a Sumerian carving of interlaced snakes belonging to the 3rd millennium BC. Knot designs figure in Roman, Islamic, Celtic, and medieval Christian decorative art. A type of rug with knot motifs was imported into Europe from the Middle East during the 15th c. The earliest representations of garden knots are the diagrams in the *Hypnerotomachia Poliphili*, published in Venice in 1499, where the background to the figure is filled with flowers and herbs, and said to resemble a 'tapeti' (carpet).

Thomas Hill's *The profitable Arte of Gardening* (1568) shows an elaborate diagram of interwoven lines, which is repeated in his *The Gardener's Labyrinth* (1577) and entitled 'A proper Knotte to be cast in the quarter of a garden, or otherwise as there is sufficient roomth', set either in thyme or hyssop. In the 1608 edition the diagram is replaced by a design from *L'Agriculture et la maison rustique* by Etienne and Liébault (1582 edn.), or from the English translation by Richard Surflet in 1600.

John *Parkinson (*Paradisus*, 1629) refers to 'open knots . . . more proper for . . . outlandish flowers' ('daffodils, fritillarias, iacinthes, saffron-flowers, flower de luces, tulipas, anemones, French cowslips or beares eares'); and he recommends setting the figure in box for clarity of form, although it may also be made with 'lead, boards, bones, tiles or pebbles'. His diagrams show no over-and-under inter-lacing bands; and by 'open knot' he evidently means one in which the bands are not too close together.

By the mid-17th c. 'knot' had lost its specific meaning and become a general term for the quarters of a square flower garden, intersected by walks at right angles, in whatever figure these were set. Today 'knot garden' is loosely used to mean 'a flower-bed laid out in an intricate design; any laid-out garden plot' (*OED*, sense 7). K.A.S.W.

See also MEDIEVAL GARDEN.

Knuthenborg, Lolland, Denmark. In 1767 the garden was said to have six long *allées* with views to the sea. In 1846 Count F. M. Knuth's gardener redesigned the 15-ha. garden in the landscape style and in 1863, when Count E. C. Knuth inherited the property, Edward Milner (a colleague of Sir Joseph *Paxton) was asked to design a typical English park. Today, the 600-ha. park is encircled by a 2 m. high × 7 km. long granite wall and contains one of the most extensive collections of rare trees in Denmark, including Californian redwoods, bamboos, and mature rhododendrons; it also has a wide variety of deer. P.R.J.

Knyff, Leonard (or Leendert) (1650–1721), Dutch painter and draughtsman, is chiefly known for a series of engravings for which he prepared the original drawings. It consists of 77 bird's-eye views of palaces, country seats, etc., one bird's-eye view of Nottingham, and a plan of St James's Park, London. The series was published in *Britannia Illustrata*, Vol. I (1707) and *Le Nouveau Théâtre de la Grande Bretagne*, Vol. I, Part I (1715). P.H.G.

See also KIP.

Kobori Enshu (1579–1649), Japanese founder of the Enshu school of *cha-no-yu* (tea ceremony) and flower arrangement, was also known for his talent in the design and construction of architecture and gardens in and around Kyoto. He studied the art of *cha-no-yu* under the famous tea master Furuta-Oribe (1544–1615), the leading disciple of Sen No *Rikyu, and he coached the third shogun Iemitsu on the art of *cha-no-yu*, with many distinguished followers.

Kobori Enshu extended and remodelled the *Kyoto Imperial Palace and gardens during the Keicho era (1596–1614), and designed the Fushimi and Nijo castles for the Tokugawa shogunate, as well as carrying out many undertakings of a semi-official nature such as the gardens of Konchi-in and Nanzenji temples. He probably gave advice on the gardens of the *Katsura Imperial Villa. Kohō-an of the Daitoku-ji temple compound of Kyoto, which Enshu built for his place of retirement, clearly shows the technical details of his own ingenious style. S.S.

Komarov Botanical Institute Garden, Leningrad, Soviet Union, was founded in 1714 as a physic garden by Peter I (the Great). The site was on an island in the Neva delta, where the garden still occupies 22 ha. During the 18th c. the garden's interests spread beyond purely medicinal plants to include ornamental ones from Siberia, China, and more distant countries. From 1735 to 1812 a second botanic

garden was maintained on Vassilevsky Island by the Academy of Sciences, which eventually took charge of the surviving garden and its research institute in 1930. It is now the principal botanic garden of the Soviet Union.

After the death of Count Razumovsky in 1822, many of the rarest plants from his garden at Gorenky, near Moscow, were taken to St Petersburg (Leningrad), accompanied by the count's equally choice botanical library and his botanist, F. E. L. Fischer, who became director of the St Petersburg garden. During his years in charge, the scientific work of the garden was established and the building of greenhouses began.

In the late 18th and early 19th cs. Russian naturalists travelled widely, collecting plants in Alaska (which was Russian territory until 1867) and Brazil, as well as parts of central Asia. The garden was the repository of most of the plants sent back. Large conservatories, which became well known in Europe, housed tropical and subtropical plants, including the huge water-lily *Victoria amazonica*, palms, and cycads, still well represented there. Since the Revolution the garden has become the main centre for the study of ornamental plants, both cultivated and wild. Its special collections include lilies, tulips, irises, rhododendrons, and a carefully landscaped, park-like arboretum. S.R.

Konopiště, Central Bohemia, Czechoslovakia. The original early 14th-c. medieval castle was adapted with its garden to the baroque style during the 18th c. In 1725 a new main entrance was made from the garden terrace and decorated by a baroque portal, designed by the Czech architect F. M. Kaňka. The accompanying sculptures were by the foremost master of Czech baroque sculpture, M. B. Braun. Next to the terrace wall were erected (*c.*1750) a small pavilion, a fountain, and statues from the first half of the 18th c. Finally, Duke Francis Ferdinand d'Este rebuilt the castle in a romantic pseudo-historical style, popular in the 19th c. In the years 1899–1902, a 200-ha. park was established. Most of it is a game enclosure with deer and pheasant shelters; it has a wooded character in naturally moulded terrain with roads passing spacious meadows containing groups of trees and a large lake.

A rose-garden, called the Italian garden, was created in 1910 in the clearing round the castle. Enclosed against the game, the regularly shaped garden was divided into several sections of flower-beds. The very centre of the whole composition was dominated by a free-standing column. Four obelisks and a gallery of statues are copies of Italian originals. The glasshouse placed on a terrace and a romantic pool with a rock-garden on the lower level were also added. O.B.

Krelage Nursery, Haarlem, The Netherlands, the outstanding Dutch bulb nursery of the 19th c. (until 1921), was established in 1811 by the German-born Ernst Heinrich Krelage (1786–1855) at Haarlem, centre of the Dutch bulb industry since the 17th c. Particularly well known for raising hyacinths and *tulips, the nursery attained international renown under Krelage's son, Jacob Heinrich (1824–1901),

a famous horticulturalist and promoter of the Dutch bulb industry. Called 'le roi du pays des Tulipes', he introduced the May-flowering Darwin tulips in 1889 and the firm introduced in 1921 the Mendel tulips (Darwin × Duc van Tol).

Krelage founded the Dutch Bulb Growers' Society in 1860, was co-founder in 1872 and chairman of the Dutch Horticultural Society, and presided over the first International Horticultural Congress in 1872–87. He founded and was chairman of the Dutch Phytopathological Society, which fosters research in the study of plant diseases. His renowned botanical and horticultural library was undoubtedly a stimulation to his son, E. H. Krelage, who wrote a definitive work on the history of the bulb trade (*Drie Eeuwen Bloembollenexport* . . . 1946) and on bulb speculation and tulipomania in the Netherlands (*Bloemen speculatie in Nederland: De Tulpomanie van 1636–37* . . . , 1942). F.H.

Kroměříž, South Moravia, Czechoslovakia, has outside its borders a pleasure-garden, later called the Flower Garden, built in 1665–75 by Bishop Karel of Liechtenstein. The original project, designed by Filiberto Lucchese in the Mannerist style, was completed by Giovanni Pietro Tencalla. The oblong shape of the garden (485 m. × 300 m.) was enclosed by high walls; the main entrance was in the middle of a long gallery, called the Colonnade. The dominant feature of the whole garden, the octagonal summer-house, has beautiful sculptural decoration, mainly in the interior. In the Colonnade was gradually formed the gallery of statues with themes from classical mythology. In 1691 when the remarkable garden was in full splendour, it was depicted in a collection of engravings by J. M. Fischer and J. van den Nypoort.

In the first half of the 19th c. a new entrance courtyard with two glasshouses was built and the flower-garden made up by the architect A. Arche. This late Empire style architecture has its own artistic value. At the end of the 19th c. alterations in the garden were made in the contemporary fashion.

In 1954 P. Janák designed new *broderies* in front of the Colonnade and the destroyed baroque fountain was restored. Further restoration is gradually taking place.
 O.B.

Kuskovo, Soviet Union. The palace and the formal gardens (31 ha.) have survived of the country estate of the Sheremetyevs, 10 km. from Moscow. Though the gardens were begun in the 1720s, they date from the middle of the 18th c. in their present form, while the palace was rebuilt in the 1770s.

The gardens were planned by the architect F. S. Argunov, a serf, who also designed some of the buildings in the gardens. The large central parterre is embellished with marble statues and has an impressive orangery (by F. S. Argunov and K. I. Blank) which faces the palace along the central axis. A network of paths leads from the parterre to form *étoiles* in the flanking *bosquets*. The trees bordering the paths frequently frame garden pavilions or views of the

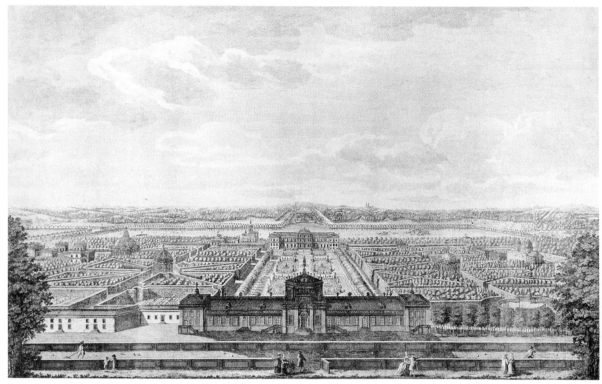

Kuskovo, USSR, view north towards the labyrinth, engraving (c.1760) by P. Lorand after the drawing by M. Makhayev (History Museum, Moscow)

palace. Argunov's Dutch House (1749), the earliest garden building, once had a small garden planted with typically Dutch flowers. *Rastrelli's influence is evident in the Grotto (by Argunov) and the Hermitage, at the meeting-point of eight paths, which was designed by serf architects under the direction of Yu. I. Kologrivov. There used to be an elaborate green *theatre and a menagerie with a collection of birds and animals. On the other side of the palace, concealed from the garden, is an artificial lake, and beyond it a canal continued the central axis and was aligned with the village church of Veshnyaki.

Kuskovo was designed as a great parade garden and was frequently the setting for receptions, theatrical performances, concerts, fêtes, and firework displays. There has been considerable recent restoration.　　　P.H.

Kyoto, Japan. See DAIGO SAMBO-IN GARDEN; DAISEN-IN; GINKAKU-JI; KATSURA IMPERIAL VILLA; KINKAKU-JI; RYOAN-JI; SAIHO-JI; SENTO GOSHO; SHINJU-AN GARDEN; SHUGAKU-IN IMPERIAL VILLA; TENRYU-JI ABBOT'S GARDEN.

Kyoto Imperial Palace and Garden, Japan, occupy an area of 90 ha. within tile-roofed earthwork walls which have nine gateways. In the course of over 10 cs. since AD 794

when the capital was transferred from Nagaoka to Kyoto, the Imperial Palace has undergone repeated destructions by warfare and fires which have changed its original features. The present palace was reconstructed in 1855; despite its comparative newness it gives visitors an adequate impression of the grandeur of the ancient days.

The most symbolic part of the palace is Shishin-den or the Hall of State Ceremonies in the south with its expansive white-sanded forecourt in the style of the Heian period. In front of the hall are the two traditional trees, the cherry tree on the east side and the mandarin orange tree, *tachibana*, on the west side. Another building, Seiryo-den Hall, also retains the ancient style of courtyard and planting.

The two landscape gardens in the Palace grounds are particularly notable for their beauty and design. The Oike-no-niwa, or pond garden, lies at the north-east of Shishin-den and on the east side of Kogosho or the Minor Palace. This is a *stroll garden with attractive wooden and stone bridges on the islands in the pond. The other is an extremely delicate garden with winding narrow streams; it lies to the north of the pond garden, at the east side of the largest structure in the palace called Tsunegoten. The palace is maintained by the Imperial Household, to which the property belongs.　　　S.S.

Laar, G. van (*fl. c.*1802), Dutch nurseryman. See VAN LAAR.

La Baumette, Chanzé, Maine-et-Loire, France. See ANGERS.

Laborde, Jean-Joseph (1724–94), French banker, created the park at *Méréville. He had the reputation of being the richest man in France, and owned a number of estates. At La Ferté Vidame, bought in 1764, he laid out the grounds in classic French style; at Taverny, bought in 1773, he had the park laid out by 'un anglais'; he made a landscape garden at Saint-Leu after 1774. He also owned plantations in San Domingo (Dominica), whose mahogany he used widely at Méréville, including the *pont d'acajou* in the grounds. At the Revolution he was arrested by the Committee of Public Safety and executed. K.A.S.W.

La Brède, Gironde, France, has a feudal castle on a small island surrounded by moats, overlooking the country of the Graves vineyards. It was the home of *Montesquieu who in 1731 transformed the surroundings of his house 'in the English manner', extending the grassland beyond the moats, opening vistas across farmland to the Landes, and making the house a focal point in relation to the area turned into lawns. La Brède is undoubtedly one of the first French examples of a garden modified in the English style (the *jardin anglais*) as it was understood at the time. D.A.L.

Labyrinth. See MAZE, LABYRINTH.

La Casa Granda, San Simeon, California, United States. See HEARST GARDENS.

Laeken, Belgium. The Laeken estate, the King's main residence, was begun by the Austrian Governors-General in 1781; virtually unchanged since then, it occupies an irregular area of *c.*70 ha., situated principally on a gently undulating piece of land sloping down towards the Brussels canal. This park was the first fully-fledged example in Belgium of the English style which had recently become fashionable (*see over*).

The entrance to the park and the château are located at the top of the hill. The château's front façade and sides are set off by grassed areas, while the back façade looks over a lawn that forms the park's axis, slopes down towards an artificial river, and extends, beyond this, as far as the canal into a large meadow scattered with clumps of trees and left as pastureland. To both sides of this broad smiling expanse

the ground is slightly undulating and planted with trees and elaborate and varied copses through which winding paths, vistas through the trees, and clearings have been cut. A long opening runs down the left side (viewed from the bottom of the hill), ending near the canal with a cross-shaped pavilion, the Temple of the Sun. On the same side can be seen a mausoleum of Empress Maria-Theresa, an artificial grotto and rock, a small castle which was already there, and a hermitage in the form of a cabin on piles, as well as an artificial waterfall—fed from a reservoir filled by a steam pump—which falls into the river. This river, after crossing the lower end of the lawn, turns around, forming an island, and meanders as far as the canal on the right side of the park.

To the right, on the edge of the lawn near the island, stands a small round Doric temple, the Temple of Friendship, set on a mound from which there is a far-reaching view of the countryside and the capital. The area of the upper part of the park to the right is cut through by a central *allée* and divided up on either side into regular gardens planted with rare plant species and vegetables; further along it is taken up by the terrace of orange trees and by a large orangery with a summerhouse, dominated by a high Chinese tower (inspired by the one at Kew), behind which are some hothouses.

In the 19th c. the Laeken estate was enlarged under the direction of *Barillet-Deschamps and received a large set of hothouses, among which a huge winter garden (*c.*1875) is particularly worthy of admiration. It consists of a broad glass and iron dome, measuring 57 m. in diameter at its base, and supported on the inside by a circle of Doric columns. The garden of rocks and palms was designed by the English architect John Wills. X.D. (trans. K.L.)

Lafayette Gregg Garden, Fayetteville, Arkansas, United States. Gregg House is Fayetteville's finest 19th-c. house not only because of its size and the elegance of its detailing, but because of its setting amid large trees and formal gardens, which were designed by Judge Gregg, a Union sympathizer during the Civil War and the commander of the Fourth Arkansas Federal Cavalry. House and garden were built in 1871, at the same time as the first building of the University of Arkansas.

The house is set in a park surrounded by large trees. On a cross-axis to the main walk is the entrance to the enclosed formal garden. This entrance is flanked by two obelisks identical in size with those at the Villa Lante. The flower-beds are laid out in a bell-shaped pattern. Planted in the surrounding curved beds are medium-sized trees, *Cornus*

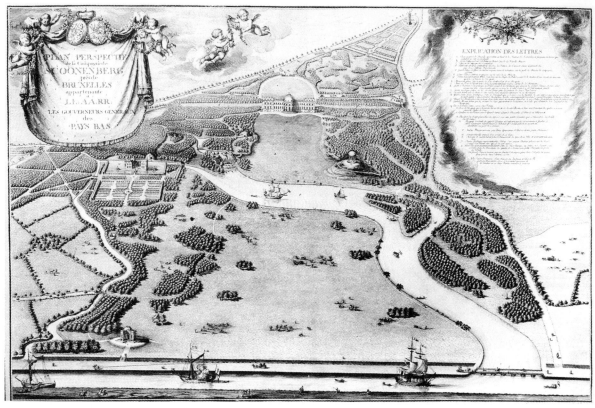

Laeken, Belgium, engraving (c.1788) by F. Landerer after F. Le Febvre

florida and *Cercis canadensis*, both plants native to Arkansas. The garden is famous for its 'Ida Gregg' crape myrtles, *Lagerstroemia indica*, native to China, which dominate the north wall of the garden and are a particularly delicate rosy-pink.
<div align="right">D.K.M.</div>

La Gaude, Aix-en-Provence, France. See AIX-EN-PROVENCE.

La Granja, Segovia, Spain. The Ermita (Hermitage) de San Ildefonso, standing at 1,200 m. on the north slope of the Guadarrama mountains *c.* 11 km. from Segovia, was chosen by the first Bourbon King Philip V (1700–46) for his new palace. It was intended as a retreat from the unpleasantly hot summers of Madrid. The gardens, which cover 140 ha., were made to remind him of the gardens of his grandfather, *Louis XIV, especially those of *Versailles. However, because of their mountainside setting and their lack of a dominant axial relationship between house and garden, the effect is very different.

The architect René Carlier, an assistant of Robert de Cotte, was involved in laying out the grounds, although only the marble cascades can be definitely attributed to him. Thereafter, a military engineer, Marchán, supervised the arrangement; Boutelou the gardening; Frémin and Thierry the fountains and other works of sculpture.

The fountains were the outstanding feature of the gardens, water being readily available from the nearby mountains. The cascade of marble and coloured jasper, at the head of which stands a pavilion of pink stone in the Régence style, centred on the king's private apartments to one side of the palace. The avenues flanking the cascade are bordered by alternate statues and vases. It was added by Isabella Farnese as a present to her husband, Philip V, who commented sadly: 'It has cost me three millions and amused me three minutes.'

Opposite the southern façade of the palace at the end of the parterre is the fountain of La Fama (Renown), with a jet 47 m. high. There are several other fountains, including the Fountain of the Frogs modelled after the Fountain of Latona at Versailles. Many of the sculptures represent Diana the huntress, perhaps in honour of Isabella Farnese. No further work was carried out after Philip V's death in 1746.
<div align="right">P.G.</div>

Lahore Fort, Lahore, Pakistan. The Mogul emperors *Akbar, *Jahāngīr, *Shāh Jahān, and *Aurangzīb all made contributions in their time to the palace fort. Two gardens remain here. Jahāngīr's Quadrangle (1617–18) contains a

large pool filled with fountains, together with a central marble platform, approached on either side by a causeway. The Paien Bagh, or *zenana garden, was based on a theme of fruit and sweet scents, for the enjoyment of the ladies of the harem. The pavings and platforms were finely executed in brick, typical of Lahore, and the present plantings of cypress and small orange trees reflect the character of the original. S.M.H.

Laiterie, a dairy; in gardens a fanciful building used mainly for amusement, as at *Rambouillet. K.A.S.W.

Lambay Island, Co. Dublin, Ireland, lies off the coast of north Dublin. On this small area of rock and turf Sir Edwin *Lutyens and Gertrude *Jekyll combined from 1907 to create a garden on a radial plan for Cecil Baring. It consists of a series of walled courts herbaceously planted and decorated with pergolas and terraces. Lutyens also extended the castle, and designed a village, farm buildings, a chapel, and a memorial which all together comprise one of his important achievements. P.B.

La Mortola, Italy. Now known officially as the Giardino Botanico Hanbury, the garden covers 45 ha. by the sea on the outskirts of Ventimiglia, close to the border between Italy and France. In 1867 the house and garden were bought by Sir Thomas Hanbury (1832–1907), who gave the Royal Horticultural Society its garden at *Wisley in 1904. His elder brother Daniel (1825–75) and his son, Sir Cecil (1870–1937) were also involved in the design and planting of the garden, which descends in terraces from almost 100 m. above sea-level to the coast. Hills inland shelter the site, allowing the mild climate and the favourable aspect to make up for the poor soil. The house is built on a terrace near the top of the garden, with the remains of a formal Italian garden, once planted with box, lavender, and aromatic herbs, on its south front. Trees from South Africa, Central and South America, and Australasia, such as palms, cycads, acacias, eucalypts, and pittosporums, were added to exotic oaks and pines and native olives and cypresses on the terraces. Aleppo pines form a little wood. There is also a great variety of agaves, aloes, opuntias, and yuccas, with maples, bignonias, clematis, echiums, anemones, and tulips among other survivors. Across the Via Aurelia, the Roman road going through the lower part of the garden, there is an orchard of several kinds of citrus fruit, with a patch of maquis near the sea.

After the Second World War the garden became the property of the Italian Government, which allowed it to fall into neglect. In May 1983 it was handed over to Genoa University, so that it may recover its former eminence as one of the most important Riviera gardens. Even in its decay, it is still a rich collection of plants in a glorious setting. S.R.

La Granja, Segovia, Spain, the marble cascade

La Motte-Tilly, Aube, France, has a restored château and grounds in the French classical style, originally designed by Jean-François Lancret (nephew of the painter) for the Abbé Joseph-Marie Terray, *contrôleur général des finances* and *ordonnateur des bâtiments du roi* under Louis XV. The spacious approaches are lined by lofty lime trees; while behind the château, terraced gardens descend to a large rectangular *miroir d'eau*, framed by *allées* of clipped limes, and closed by a hornbeam hedge which hides the road and the Seine. Beyond the river the vista is continued towards the horizon by an avenue of poplars planted in 1910. After the Revolution Claude-Hippolyte Terray transformed the gardens *à la française* into a park *à l'anglaise*. The parterres, terraces, and *miroir d'eau* were restored in 1910 by his great-grandson, the Comte Gerard de Rohan-Chabot. K.A.S.W.

Lancellotti, Villa, Lazio, Italy, is the smallest of the Frascati villas. Unlike most of the others, the site offered no opportunity for extensive views of the *campagna* or for making an imposing series of terraces. The garden is limited to the immediate surroundings of the villas.

By 1620 there was a garden behind the palace, consisting of a flower parterre, terminating in a water theatre. Although the latter does not have the dramatic siting of, say, the Villa *Aldobrandini, and although the water display is very simple, it is perfectly appropriate to its position. It gives an architectural framework not only to the garden itself but also to the magnificent view of the hill of Tusculum and of the Villa Aldobrandini, which is enjoyed from the loggia of the villa.

Originally it was quite unadorned—an engraving by Kirchner (1671) shows it without the present balustrades, statue, and clock on the cornice, which were probably added between 1760 and 1780. The villa was a German head-quarters during the Second Word War and was damaged. P.G.

Łańcut, Poland, has a château near Rzeszow which was begun early in the 19th c., and finally completed by 1904. It was created by the architects Chrystian Piotr Aigner (1756–1841) and Albert Pio, and the garden was designed by Ignacy Simon and Franciszek Maxwald.

The Łańcut park is a good example of the natural garden style combined with historicist elements. It surrounds the château within the borders of well-preserved five-pointed bastions. There is a classical conservatory with a four-column Ionic portico (1799–1802), and a winter garden formed of a green parterre, steps, pools, and numerous sculptures. There is also a court garden with a bridge over the moat in front of the main entrance and the *gloriette (c.1810).

The outer park in the natural style is much larger and contains many features, such as a *manège* (1828–30), a small château (c.1807), an orchid-house (1904), a tennis-court with a flower garden and sculptures, a summer-house, an oak grove and pond, a beech *allée*, and a circular *allée* along the château moat. The park is now open to the public. L.M./P.G.

Landscape architecture is the art and the science of the design and integration of the natural and man-made elements of the earth, with the materials of which—earth, water, vegetation, and built elements—the landscape architect is responsible for making places, for a variety of uses and habitation. The term appears to have been used first by Gilbert Meason, a friend and co-traveller of Sir Walter Scott, in his book *On the Landscape Architecture of the Great Painters of Italy* (1828), and subsequently taken up by *Olmsted and Vaux for their plan of Central Park, New York, in 1858. The title became established in the United States, but it was not until 1899 that the first professional body was formed—the American Society of Landscape Architects (ASLA). A year later the first university course in landscape architecture was started at Harvard.

The first British designer to adopt the title of landscape architect was Patrick Geddes (1854–1932). Originally trained as a biologist, he developed as an important theorist in town and country planning, and was a major influence on Lewis Mumford, the American writer and critic. In 1907 he was advertising his practice in Scotland as 'Landscape Architects, Park and Garden Designers, Museum Planners etc.' but unfortunately he was regarded as something of a maverick by the British establishment and after publishing his major work *Cities in Evolution* in 1914, he left for India where he remained until 1922. Thomas *Mawson (1861–1933) adopted the title in 1912, having first described himself variously as a 'Park and Garden Architect' and a 'Garden Architect'. Seventeen years later, at the age of 69, he was to become the first President of the newly formed British professional institute. Meanwhile the profession had been established in some countries of continental Europe, notably Germany, the Netherlands, and Scandinavia, all of which developed courses of education.

After the Second World War the profession expanded rapidly, providing opportunities for designers to work on all scales: in new, expanded, and reconstructed towns, on motorways and road systems, in Country and National Parks, reservoirs and forests, mineral extraction and industrial reclamation. Germany, which had employed landscape architects for the autobahn system in the 1930s, developed the tradition of local garden shows (see *Garten-schau) into the International Garden Shows which were instrumental in reconstructing the parks and gardens of her shattered cities. In the Netherlands landscape architects who had long been engaged in creating new landscapes from the sea were also now faced with urban reconstruction; and in Scandinavia they played a vital role in the development of the new societies of the welfare states.

Education for landscape architecture. After a slow start, professional courses began to proliferate to accommodate the considerable demand, at first in the West, and later in developing countries. The United States has currently *c.*50 courses of various kinds; Britain, East and West Germany, and Japan, each about a dozen; Korea 7; Belgium 6; the Scandinavian countries 5; Canada 4; Australia 3; the Netherlands and Switzerland each 2; France, New Zealand,

and South Africa, 1 each. Many countries are still without courses, but as industrialization spreads the need becomes increasingly felt. The Kingdom of Saudi Arabia, in response to its phenomenal growth, has recently established a course. With the spread of the profession the need for an international forum became evident. A number of leading professionals in different countries worked towards this during the post-war years, and in 1948 the International Federation of Landscape Architects was set up with Sir Geoffrey *Jellicoe as Founder-President from 1948 to 1952. The organization continues to grow, being represented in 1985 at the biannual congress by 40 nation members, plus 12 individual members representing countries which have no societies.

Most British courses have grown up in schools of planning and architecture, but elsewhere their affiliations are frequently with agriculture, horticulture, land sciences, and fine and applied arts. In the Netherlands, a land to a large extent created from the sea, the landscape architect has from an early stage been an essential member of the reclamation team. In Britain, with its ancient traditions of gardens and gardening largely sustained by amateur enthusiasm and a complex structure of parks departments, innovation has been mainly in the hands of architects, with whom landscape architects are more generally associated.

Landscape architecture and garden design. As the house can be said to be the design parameter for architects, so is the garden for landscape architects. Although there are some, such as the Brazilian *Burle Marx, who have made their reputations on the design of gardens, few can sustain a practice by such means. But there are few who do *not* design gardens, if only for themselves. In this way they can experiment and express their own ideas, uninhibited by commercial pressures and client requirements. Garden design continues also at another level. Kings and princes have always expressed their wealth and power by creating palaces and their gardens, and this is now occurring in the burgeoning economy of the oil countries of the *Middle East. Unfortunately, for security reasons, these gardens are carefully controlled, and they can rarely be illustrated. In addition there are the *nouveaux riches* of the late 20th c. in the West—sportsmen, entertainers, and, as always, businessmen—who seek through their houses and gardens to express their status and their aspirations.

Britain. The profession of landscape architecture was formally established in Britain on 11 Dec. 1929, just 30 years after its American equivalent, with Thomas Mawson as President. The title, significantly, was the British Association of Garden Architects, but within two months it was changed to the Institute of Landscape Architects (ILA). The distinction is important, indicative of the inclinations of some of the members—among whom were the architects Hill, Jellicoe, Jenkins, and Parker—and heralding the direction which the profession was to follow.

Mawson had started his career as a draughtsman in a builder's office; he then built up a plant nursery and came to

planning through landscape design. He was in fact appointed as the first university lecturer in landscape architecture at the Liverpool Department of Civic Design in 1909, and was President of the Town Planning Institute from 1923 to 1924. With *Blomfield and *Lutyens, he was one of the first members of Baldwin's Fine Art Commission of 1924. The Chairman of the ILA was Richard Sudell (1900–68), a landscape gardener, who began to publish the journal *Landscape and Gardens*, and later developed an extensive overseas practice. Membership was at first by invitation and application, and on condition that members should not engage in any commercial practices. Members included Stanley Hart, Brenda *Colvin, Marjorie Allen (Lady Allen of Hurtwood), Madeleine Agar, George Dillistone, Gilbert Jenkins, Geoffrey Jellicoe, Barry Parker, Edward White, and Prentice Mawson, son of the President. White's grandfather had worked with Paxton, and Parker was a direct inheritor of the Arts and Crafts Movement of William Morris. Together with Raymond Unwin he designed the *garden city of Letchworth, in which every house had a garden.

Some combined practice with that of their other disciplines, such as architecture and planning; others practised exclusively as landscape architects; all in their various ways, by practice, by writing, and by teaching, established landscape architecture as a profession which, while including the design of gardens, gradually expanded to include all aspects of the landscape. The post-war New Towns provided a unique opportunity for this expansion, and landscape architects were able to work on all scales from planning to detailed design. Dame Sylvia *Crowe was appointed consultant for Harlow and Basildon, Frank *Clark for Stevenage, Bodfan Gruffyd for Crawley, Geoffrey Jellicoe for Hemel Hempstead, Louis de Soissons for Welwyn, and Peter Youngman for Cumbernauld, Peterborough, and later the new city of Milton Keynes. The Festival of Britain in 1951 provided a public exhibition platform for some of their work, and since then the profession has been in a continuous state of growth. Work has included the preparation of master plans, roads and motorways, Country and National Parks, forestry and reservoirs, mineral extraction, industrial reclamation, and industrial and power installations.

A second and a third generation of landscape architects have developed practices. Teachers and practitioners have built up a body of professional literature, such as Brenda Colvin's standard work, *Trees for Town and Country* (1947) with S. R. Badmin, and *Land & Landscape* (1947, rev. 1970); Geoffrey Jellicoe's work on theory, *Studies in Landscape Design* (3 vols., 1960, 1966, 1970), and, with his wife Susan Jellicoe, the definitive history of gardens and landscape, *The Landscape of Man* (1975); and Sylvia Crowe's *Tomorrow's Landscape* (1956), *The Landscape of Power* (1958), *The Landscape of Roads* (1960), and *Forestry in the Landscape* (1966). Among important books compiled and edited by a number of practitioners are *Techniques of Landscape Architecture* (1967), edited by Arnold Weddle, *The Urban Landscape Handbook* (1970) and *Landscape of Industry* (1975), edited by

Clifford Tandy, *Land Use and Landscape Planning* (1973), edited by Derek Lovejoy, and *Design with Plants* (1977), edited by Brian Clouston.

In spite of this phase of growth, the ILA remained small in comparison with those representing architecture and planning, and, in the opinions of some, too exclusive. As the result of a referendum it was expanded in 1978 to embrace two new categories of membership, Land Sciences and Landscape Management, under the name of the Landscape Institute.

From the 1960s onwards, landscape architects and designers have been employed increasingly often overseas, particularly in the countries of the Third World. Derek Lovejoy & Partners were appointed landscape architects to the government of *Pakistan for the new capital city of Islamabad. This involved landscape design on all scales, begun by Michael Langlay-Smith and developed on the ground over a period of years by Anthony Walmsley, Michael Lancaster, and others. The same practice was later appointed to perform a similar, albeit less affluent role for the new capital of Tanzania. Brian Clouston and Partners and the Urbis Group were commissioned to undertake the landscape design for the New Territories of *Hong Kong and Maurice Lee and Neil Thompson undertook work in Malaysia. Robert and Marina Adams pioneered landscape design in *Greece. All these and many others also became involved in creating the new private and public landscapes of the desert regions of the Middle East. Rik Sturdy went to practise and teach landscape architecture in the new University of Jeddah, and John *Brookes (before the collapse of the Shah's regime in 1979) briefly opened up a branch of the Inchbald School of Garden Design in Tehran. Out of this experience came the books *Dry Lands: Man and Plants* (1978) by Robert and Marina Adams and Alan and Anne Willens, and *Landscape Design for the Middle East* (1978), edited by Timothy Cochrane. They attempt to come to terms with the very considerable problems of design and implementation in hot dry climates. Meanwhile the European Economic Community began to attract landscape architects. John Whalley, partner of Derek Lovejoy, won competitions for parks in two of the French New Towns, and for a section of the German *Gartenschau* in Munich.

The emphasis of work in Britain has shifted from housing to industry as industrialists seek to create a new 'clean' image for their work, often in 'industrial' or 'science parks'. Urban renewal, which has preoccupied landscape architects for more than a decade, has received an impetus both in scale and resources from the closures of docks and industries in the 1970s and 80s. Some of the opportunities have been wasted, but others have been taken up with the enterprise that characterizes the German *Gartenschauen*, as in the first British International Garden Festival at Liverpool in 1984 and the second projected festival of its kind, at Stoke in 1986.

Education for landscape architecture in Britain. Education began tentatively in 1909 with the appointment of Thomas Mawson as the first university lecturer in landscape architecture, at the Department of Civic Design in Liverpool—the same university which had in 1894 pioneered the idea of architecture as an academic discipline. The University of Reading followed with a three-year diploma course developed by A. J. Cobb, a lecturer in horticulture who was also Chairman of the Education Committee of the Institute of Landscape Architects. Cobb was followed by H. F. Clark (from 1946 to 1957) who subsequently developed a postgraduate course in Edinburgh (1959–71).

It was not in fact until 1946, at the beginning of the second phase of the development of the profession, that entry standards were rationalized and an external examination system set up. This phase of optimism and almost feverish development, which began with the creation of the New Towns in 1946, intended 'to conduct an essay in civilization by seizing an opportunity to design, solve and carry into execution for the benefit of generations the means for a happy and gracious life' (Lord Reith, chairman, New Towns Committee). All of the leading members of the profession were given New Towns to design, thus transporting the profession out of an era of park and garden design into one which involved design on all scales: planning, roads, parks, gardens, sports grounds, and urban centres. The demand for landscape architects began to increase, at first slowly, then dramatically as the field of work extended further to include industrial reclamation, mineral workings, power stations, motorways, reservoirs, rural recreation, and afforestation.

The Universities of Durham and London set up courses in 1948, the first a post-graduate course under Brian Hackett, later Professor at Newcastle, the second a part-time graduate course under Peter Youngman. Both, significantly, were in departments of Town Planning; they were followed by the Universities at Manchester, Edinburgh and Sheffield. The next educational boost came with the foundation of a number of courses in schools of Art and Design, most of which were to become absorbed by the newly constituted polytechnics. These included full-time diploma (later degree) courses at Gloucester and Leeds, at Birmingham (developed by Paul Edwards from 1960), at Manchester (developed by Rex Fairbrother from 1966), and a part-time course in London at Hammersmith School of Arts and Crafts (developed by Michael Lancaster from 1970 into the first full-time Honours Degree and Diploma course in London).

Most courses in Britain, unlike many in Europe and the United States, have evolved under the aegis of architecture or planning, with a consequent emphasis in these directions. But the need for specialization, recognized by the reconstituted Landscape Institute in its expansion (to include classes of membership for landscape managers and land scientists), has become very apparent. With some 700 students in education, and between 150 and 200 graduating every year, the schools have begun to seek the independence which will give them the freedom to determine their own academic future. M.L.L.

The United States. Throughout the 19th c. the profession of landscape architecture was defined by the career of Frederick Law Olmsted, the 'father of landscape architecture' in the United States, whose work included urban parks and open space systems, National Parks, campus plans, community and urban designs, and estates. The profession emerged in the 20th c. with the momentum of Olmsted's long (1857–95), varied, and national career. Almost inevitably, Olmsted rather overshadowed his contemporaries, particularly the undeservedly neglected H. W. S. Cleveland (1814–1900) whose book *Landscape Architecture as Applied to the Wants of the West* (Chicago, 1873) is an eloquent plea for landscape planning. His 1883 plans for a park system for Minneapolis and St Paul were realized many years later.

At the conclusion of Olmsted's career leadership passed to the second generation of landscape architects, led by Frederick Law Olmsted, jun. (1870–1957), John Charles Olmsted (1852–1920), and their colleagues, many of whom had worked in the Olmsted office, and it was they who founded the professional organization, the American Society of Landscape Architects (ASLA), in 1899. The development of cities and the desire of the growing middle class to live and spend leisure time in organized spaces led to the advancement of the profession during the early decades of the 20th century.

Many landscape architects viewed their profession as a vehicle for the alleviation of problems of urban congestion and unplanned development, and led by John Nolen and the ASLA founders F. L. Olmsted, jun., Warren Manning, and Charles Lowrie, city planning emerged as a separate profession. This branch, the 'City Beautiful' movement, addressed itself to issues of town planning, urban design, and community improvement. Rooted in popular Beaux Arts architectural traditions, their designs promoted public gardens, boulevards, and linear green spaces as necessary elements in the planning of cities; residential work, particularly the planning of large estates, was another major activity. Gardens of this period were strongly influenced by the study of European examples from the Italian Renaissance, 17th-c. France, and 18th-c. England. They are significant because of the attention given to detail, proportion, scale, and plant material.

American landscape architecture, published in 1924, was the first photographic record of professional work, prompted by the fact that 'professional landscape architecture never has been adequately and seriously represented'. Works of 75 landscape architects are illustrated by 135 projects: over 90 per cent (117) are private estates; the remaining projects include parks (10), college campuses (2), and a housing site, a cemetery, a regional park, a commercial 'streetscape', a museum, and a resort. Women landscape architects were active in residential work, more perhaps on account of the constraints of the times than by personal choice. One of the 11 founder-members of ASLA was Beatrix Jones (Beatrix *Farrand), who became well known for her work at Yale University and Dumbarton Oaks, Washington, DC. The ASLA Yearbook of 1930 shows that 10 per cent of its members were women, and the illustrations of their work are all residential.

With the financial crash of 1929 and the ensuing Great Depression, fortunes that supported large estates disappeared, and landscape architecture shifted from residential projects to public works. Programmes such as the Federal Housing Authority, the Farmer's Security Administration, the National Park Service, the Tennessee Valley Authority, the Works Progress Administration, and the Civilian Conservation Corps were established in an effort to provide jobs for unemployed landscape architects and to take advantage of their skills. New towns were planned, new public recreation facilities were built and older systems were renovated, and new highways were constructed as rural 'parkways'. The post-war boom and subsequent prosperity led to opportunities in residential and community planning projects. The country's confidence and optimism, industrial and technological strength, and its seemingly unlimited supply of natural resources led to enthusiastic growth on a national scale. The profession of landscape architecture, however, was hardly prepared by numbers, training, or philosophy to guide this expansion.

An important movement within the profession took shape on the West Coast in the 1950s. Known as the 'California School', it can be traced to the work of Thomas *Church in California and to Garrett *Eckbo, James *Rose, and Dan *Kiley, landscape architecture students at Harvard's Graduate School of Design in the late 1930s. They all rejected the Beaux Arts education and professional training then dominant in favour of a more informal approach based on existing site conditions and contemporary life-styles. This philosophy has endured, not only because of its popularity on the West Coast, but also because it was practised with regional variations in other parts of the country with equal success. The works of these men and their contemporaries were published in popular magazines and books: *Landscape for Living*, by Garrett Eckbo (1950), and *Gardens are for People*, by Thomas Church (1955).

Social concerns of the late 1950s were addressed by vast urban renewal programmes, designed to eliminate urban decay by removing blighted neighbourhoods. However, as Jane Jacobs pointed out in her influential book *The Death and Life of Great American Cities* (1961), this approach only exacerbated urban problems by removing the vitality and complexity that gave cities life. Large federal grants were distributed to urban areas in the mid-1960s through President Johnson's 'Great Society' programmes and landscape architects became involved in many federally-funded downtown renovation and public recreation projects, designed to make urban areas and inner-city conditions more pleasant.

Rachael Carson's *Silent Spring* (1962) alerted Americans to the imminent destruction of nature by unchecked applications of technology. National organizations, concerned by the thoughtless use of natural resources, formed active and powerful lobbies which encouraged the establishment of national policies, regulations, and environmental agencies. The cause was taken up by Ian McHarg, a native of

Scotland, who radically changed the profession with his application of natural systems as determinants for regional planning and design in his book, *Design with Nature* (1969) (see *ecology and gardens). His approach captured the imagination of young professionals who were concerned with contemporary ecological problems, and it found immediate application in the developing computer technology, which allowed vast amounts of data to be stored, evaluated, sorted, and mapped according to specific priorities. The attention to ecological concerns and the universal problems of increasing population and decreasing resources made environmental planning the main concern for landscape architecture in the 1970s. Garden design of earlier periods seemed trivial by comparison. The profession became more scientific in its approach and more global in its outlook, dealing with complex, large-scale problems. Changes in American life-styles—from single family detached houses to group living in apartment complexes—provided opportunities for planned communities that took advantage of the latest architectural technology and research into environmental amenities.

The energy of these years has subsided into the recognition that no single approach or philosophy can solve existing environmental, social, or economic problems. Computer applications, while suited to technical problems, have proved to be inappropriate for small-scale design projects. Landscape architecture in the 1980s seems to be returning to small-scale design, with renewed interest in the issues of previous decades: scale relationships, historical identity, suitability of development, uses of materials, and environmental context.

The profession does not have any generally acknowledged philosophical spokesmen. The writings of J. B. Jackson, Garrett Eckbo, and Ian McHarg have had an impact, but have not encouraged continued professional dialogues or theoretical discussions. Drawing from the career of Frederick Law Olmsted and the subsequent developments of technology, the profession has become in this century an amalgam of the fields it covers: from botany and horticulture to environmental science and resource management; from design of large-scale recreational facilities to neighbourhood parks; from new-town developments to urban redevelopment and neighbourhood renovation; from regional planning to residential garden design; from historic reconstruction to preservation of rural open spaces. Landscape architecture, perhaps more than any other discipline, has the philosophical base and the cultural heritage to address the complex problems of the built environment.

W.L.D.

Education for landscape architecture in the United States. The United States of America initiated the education of landscape architects. While it is certainly true that most of the world's classic gardens are located in older societies such as those of Europe, their designers were generally educated by apprenticeship until the 1940s. By contrast, in the United States the first degree course was established in 1900 at Harvard University. To date, almost 50 other American universities have instituted formal degree programmes in landscape architecture.

Landscape architecture education in the United States was standardized by the American Society of Landscape Architects (ASLA), which acts as an accrediting body. Founded in 1899, ASLA created in 1918 a Committee on Education, from which was formed the National Conference of Instructors in Landscape Architecture (NCILA)—from 1970 the Council of Educators in Landscape Architecture (CELA)—with members who were teaching for the profession at American universities. In 1928, at Cornell University in New York, the NCILA staged a conference whose purpose was to bring together educators and practitioners of the discipline. Together they endorsed a 'Statement of Minimum Educational Requirements in Landscape Architecture' which has been used as a standard for curriculum and instruction ever since. Through the efforts of the International Federation of Landscape Architects these guidelines have gradually influenced the development of programmes at universities around the world. Furthermore, students from many other countries have studied landscape architecture in the United States, taking the American educational approach home with them.

Landscape architecture education has changed with the profession and the period. Until the start of the Great Depression (1929), education was biased towards the design of country or suburban estates for affluent clients but beginning in the 1930s, the design of public works such as parks and roadsides became increasingly important. Public universities established degree courses in the profession, which had been taught exclusively by 'Ivy League' colleges earlier in the century. The decline of the Beaux Arts traditions or eclectic architecture in the 1930s also influenced landscape design. In keeping with the ideas of Frank Lloyd *Wright and the Bauhaus School of architecture, planning for the outdoors became freer in form, with an emphasis on relating human beings to their environment, both natural and cultural. Whole towns, indeed whole regions—rather than single residences—became the scope of the landscape architect.

Today's student of landscape architecture in the United States takes the usual core of academic subjects, such as English, mathematics, and science. In addition, he must complete courses in horticulture, plant materials, garden and park design, agricultural engineering, and forestry; art history, drawing, and watercolour painting; architecture and urban planning. Students are taken on field trips to view exemplary gardens, and illustrations of famous gardens from other parts of the world are shown in their courses. 'Terminal projects', involving real design problems for specific sites, allow advanced students to practise drawing up actual plans before receiving their degrees. Both undergraduate and graduate degrees are available. H.B.O.

See also landscape architecture subsections under AUSTRALIA; DENMARK; FINLAND; FRANCE; GERMANY; RUSSIA AND THE SOVIET UNION; SCANDINAVIA; SWEDEN; SWITZERLAND; UNITED STATES.

Lane, Josiah (1753–1833), son of **Joseph Lane** (1717–84), both of Tisbury, Wiltshire, were both makers and designers of artificial grottoes. Joseph Lane may have begun his career working for William Privett, the mason who built the grotto at *Stourhead and probably began the grotto at *Painshill before 1760—it was completed *c*.1765. Josiah Lane worked with his father from the 1770s, when they made the grotto at *Oatlands Park (destroyed 1948); he then worked on his own, building grottoes in Wiltshire at Bowood (*c*.1785), Wardour Castle (1792), and Fonthill Abbey (*c*.1794). William Beckford describes some of Lane's Fonthill work in *Modern Novel Writing* (1796), II. vi ('Lord Mahogany's Cave'). A possible work by Josiah Lane is St Anne's Hill.

M.W.R.S./C.T.

Lang is a covered but open-sided walkway in a Chinese garden. The tiled roof is supported on slim, wooden columns which often have low balustraded seats set between them. In northern gardens *lang* usually follow straight lines and right angles, like the famous corridor running for 1,728 m. in 273 spans along the lake at the Summer Palace (*Yi He Yuan) outside Beijing. In southern gardens, like *Liu Yuan, Suzhou, they more often cross open garden spaces in irregular zigzags. Sometimes a *lang* is attached to a wall with or without *lou chuang in it, while a double *lang* like the one in *Yu Yuan, Shanghai, consists of two corridors zigzagging side by side but separated by a wall. There are also double-storeyed *lang*, one on top of another, and open galleries and porticoes in front of a building are also known as *lang*. *Lang* are used in garden planning to provide shelter for those walking from building to building, and to divide, articulate, and give depth to garden space.

X.-W.L./M.K.

See also HE YUAN; PERGOLA.

Langkilde, Eywin (1919–), Danish landscape architect. An early success was a small terrace-house garden (1949) in Bagsvaerd (Copenhagen). By using granite setts in an abstract pattern in grass, associated with *Rhus typhina* and *Arundinaria nitida*, he set a future trend now commonplace throughout Denmark. On a larger scale his planted brick parterre at Hvidovre Town Hall, in association with Troels Erstad, shows a marked Islamic influence. The widely acclaimed courtyard gardens for Baltica Insurance in Copenhagen are a *tour de force* in abstract cubism; the interlocking elements of paving, pools, walls, and planting beds show superb craftsmanship. Langkilde published *Nye Danske Haver* ('Modern Danish Gardens') (1956) and *Danske Blomsterløgparker* ('Danish Bulb Parks') (1960). The influence in Denmark of the Dutch bulb gardens at *De Keukenhof is represented by three bulb parks sited in historic manor-house gardens at Gavnø, Langesø, and Vallø, which clearly show Langkilde's ability to link the new with the old.

P.R.J.

Langley, Batty (1696–1751), English landscape gardener and architect, practised in both his professions, but his identified commissions are few and he is remembered chiefly for his numerous published works, mainly architectural pattern books. His *New Principles of Gardening* (1728) expounds his comparatively advanced views on the transitional landscape garden: 'After a more grand and rural manner'. His naturalism, however, is more symbolic than visual, the countryside being delightfully conjured up within a still formal framework by a series of self-contained rural features. For instance: 'a wilderness with pleasant meanders' containing 'Paddocks of Sheep, Deer, Cows, . . . Inclosures of Corn, Grass, Clover, etc. Warrens of Hares and Rabbets, . . . and those rural objects, Haystacks and Wood Piles, as in a Farmer's Yard in the Country.' Elaborate *parterres are to be replaced by plain grass ones, but the old formal elements of canals, octagonal basins, and avenues are retained. The *ha-ha is recommended as a method of linking the garden with the surrounding landscape. Several pages of the work are devoted to lists of statues appropriate to various situations to avoid the incongruity of 'Neptune on a Terrace-Walk, Mount, etc., or Pan, the God of Sheep, in a large Basin, Canal, or Fountain'. The book also contains horticultural information. It was followed in 1729 by *Pomona or the Fruit Garden Illustrated*, a horticultural reference work.

Langley was very much concerned with the architectural embellishment of gardens and most of his works contain designs for pavilions, temples, and *umbrellas, often in the Gothic style, of which he was an early exponent and systematizer. He also supplied designs for 'Ruins after the Old Roman Manner for the termination of Walks, avenues etc.' as well as 'Frontispieces of Trellis Work' of French inspiration (*New Principles of Gardening*).

G.R.C.

Lante, Villa, Bagnaia, Lazio, Italy. The garden, traditionally attributed to *Vignola, was made by 1573 for Cardinal Gambara, who was related to the Farnese family. Unlike that of his relatives' Palazzo *Farnese at Caprarola, the garden is the main subject of the design and the twin *casini* (see *casino) are set into the garden as if they were mere garden ornaments.

On the edge of the town of Bagnaia (5 km. east of Viterbo), the formal garden consists of several fairly shallow terraces rising *c*.15 m. up the hillside. The lowest terrace is square and in its centre is a fountain, which Montaigne describes as 'a high pyramid which spouts water in a great many different ways: one rises, another falls. Around this pyramid are four pretty little lakes, full of pure and limpid water. In the centre of each is a stone boat, with musketeers who shoot and hurl water against the pyramid, and a trumpeter in each, who also shoots water.' (*Journal*, 30 Sept. 1581; trans. E. J. Trechmann, 1929, p. 269). The fountain and the pools were originally surrounded by flower parterres, replaced by the present *parterres de broderie* probably in the 17th c.

At the end of the square terrace are two *casini* defining the central axis which continues up the hill. They are each *c*.22 m. square and are cubic in form—on the left (looking up the hill) the Palazzina Gambara (completed 1578) and on the right the Palazzina Montalto (completed much later by Carlo Maderno). In the loggias of the former are paintings:

on the walls depicting the Palazzo Farnese at Caprarola, the Villa *d'Este at Tivoli, Villa Lante itself, and landscapes of the possessions of the Este, Farnese, and Gambara cardinals; and on the ceilings mythological stories, and iconographical programmes including the crayfish (*gambaro*)—the symbol of the Cardinal, a symbol which is repeated in the garden. The general theme of the park is a chronological narrative leading from the primitive Golden Age to modern civilization (see David R. Coffin, *The Villa in the Life of Renaissance Rome*, Princeton, 1979, pp. 358–60, for a brilliant interpretation).

In the centre of the retaining wall is the Fountain of the Lights, modelled as an *exedra, with grottoes dedicated to Neptune and Venus on either side of the fountain. Staircases rise on either side to the middle terrace, where a large stone table, with a central trough of water for cooling wine, is placed on the central axis. In the centre of the wall at the end of this terrace is the Fountain of the Giants, fed by water issuing from the claws of a large crayfish; the balustrade along the wall is decorated with vases from which rise vertical jets of water.

The main axis continues up the hill along a ramp, with water falling between a sculpted channel in the form of the limbs of a crayfish. In the middle of the final terrace is the Fountain of the Dolphins, formerly the Fountain of Coral (1596), which was enclosed in a domed wooden house. At the back of the terrace two pavilions stand on either side of the Fountain of the Deluge—a large grotto and the main water source for the garden as a whole. Beyond is a wooded park, formerly a hunting park, which has only one fountain remaining in its original form, the Fountain of Pegasus.

In 1590 the villa became the property of Cardinal Alessandro Montalto. He changed or destroyed most of the fountains of the park, and added a large fountain with four youths holding the Montalto device in the centre of the parterre garden, but made no significant changes in the garden itself.

The Villa Lante is the least changed and best preserved of any of the gardens of this period, and has been the subject of a recent very careful restoration. P.G.

Lan Ting, Zhejiang province, China, situated 13 km. south-west of the city of Shaoxing, is famous as the garden where, on the third of the third Lunar month AD 353, the great calligraphist Wang Xi Zhi composed his *Preface to the Anthology on Orchid Pavilion*. Since then, great changes have obscured the exact place which provided his poetic inspiration but the Pavilion of the Winding Brook and Floating Cups, standing since the 16th c. on the north bank of the stream, is said to be where Wang and his friends floated their wine bowls while they recited the poems and prose which were later collected in the *Anthology*. Each had to compose a poem by the time the floating cup passed in front of him—a literary game copied by countless gentlemen poets in the following 15 cs. Fittingly, this pavilion stands on the garden's main axis, with the entrance and the Temple of the God of Literature or Wen Chang Ge in front of it and, at its back, a Pavilion for the Royal Stone Tablets recording

visits of the Emperors Kang Xi and Qian Long. A triangular gazebo has been built to hold another stone tablet engraved with calligraphy of two words only, 'Geese Pond', supposedly in Wang Xi Zhi's own hand. The Ink Pond, enclosed by *lang and with the Pavilion of Talent in Ink in its centre, suggests a type of mid-lake pavilion surrounded by *lang* along the water's edge which was developed in the Song dynasty, and is rare today in Chinese gardens.

C.-Z.C./M.K.

Lanzarote, Canary Islands. The volcanic island of Lanzarote is the dryest and sunniest of the Canary Island group and consequently it is famous more for its red and black volcanic soil and its moon-like landscape than for its vegetation. Nevertheless, very fine planting is possible, especially if it is irrigated or artificially watered.

Tourism has recently been the subject of much development and several spectacular designs have been carried out by the Lanzarote artist Cesar Manrique, including buildings, gardens, and structures related to them. On the northern tip of the island is the Mirador del Rio which is a refreshment place with a viewing platform, built of stone

Hanging gardens (1977) at Las Salinas Sheraton Hotel, Costa Teguise, Lanzarote, Canary Islands, by Fernando Higueras and Cesar Manrique

fitted organically into the landscape. On the east coast there is a development which is partly underground, where a series of caves have been linked together to form restaurants and a nightclub called Jameos de Agua. This latter development includes ornamental gardens and a swimming-pool using his favourite combination of black volcanic rocks seen against concrete painted in blue and white contrasting with lush tropical vegetation.

The same theme on a much larger scale has been employed in the series of swimming-pools attached to the Las Salinas Sheraton Hotel at Costa Teguise on the east coast. There, the combination of black volcanic rock contrasting with the white and blue painted concrete also incorporates steps, bridges, and islands interlaced with banana trees, hibiscus, ficus, and a great variety of tropical and subtropical plants, creating a totally man-made landscape in contrast to the volcanic backcloth. G.A.C.

La Pepinière, Nancy, Meurthe-et-Moselle, France. See NANCY.

Lapidge, Samuel (1744–1806), English draughtsman, was employed from 1765 by 'Capability' *Brown for the preparation of land surveys at places where Brown was consulted. In this connection Lapidge was sent to Grimsthorpe, Hanwell, Sandleford, Wrotham, Fornham, and elsewhere. On 9 July 1778 he married Sarah Lowe of Hampton, and in the following year Brown stood as godfather to their eldest son Edward, who was later to become a successful architect. In Brown's will is the request that Lapidge should carry out any uncompleted contracts, for which he was to receive £100 in addition to his wages. He subsequently appears to have carried out garden work on his own, and in 1802 received £384 in respect of the grounds at the *Royal Pavilion at Brighton, although this is likely to have been under the direction of Humphry *Repton. Lapidge does not seem to have made any significant departure from Brown's style. D.N.S.

La Pietra, Florence, Italy, is a villa of the 17th c. with a great approach avenue and baroque walled gardens. In 1904 Arthur Acton and his Polish gardener added, axially, what was then an Englishman's conception of an ideal Italian garden.

Three broad terraces are cut out of the slope behind the house. The first has stone balustrades serving as plinths for statues; stairs on either side run down to the central and lower terraces, which have fish-pond fountains surrounded by geometrical grass plots, enclosed by clipped box hedges. The cross axes lead to circular areas bounded by hedges and statues. Planting is mostly with evergreens, and the whole garden revives the classic Italian emphasis on plants as architectural elements. Especially notable in this respect is the little *theatre with the wings formed by clipped yew and the footlights by box globes. P.G.

La Quintinie, Jean-Baptiste de (1626–88), French lawyer, gardener, and author, was the creator of the Potager du Roi (*Versailles). He studied law and philosophy at Poitiers, and on qualifying became counsel to the parliament at Paris. Jean Tambonneau, president of the Chambre des Comptes, employed him as tutor to his son. The Hotel Tambonneau, newly designed by *Le Vau in the Faubourg Saint-Germain, had a large garden where, in the course of his duties, La Quintinie developed a taste for botany. En route for Italy with his pupil c.1656, he visited the botanic garden at *Montpellier; and on his return to Paris he devoted himself to the study of the physiology of plants and trees, observing their growth, and conducting experiments to establish the function of the root, particularly in the circumstances of transplantation. In 1665 he obtained the post of gardener to the king and also to the Prince de Condé at *Chantilly. He worked for *Fouquet at *Vaux-le-Vicomte, at Choisy for Anne-Marie-Louise d'*Orléans ('La Grande Mademoiselle'), and at Saint-Ouen, *Rambouillet, and *Maisons. He considered the *potager* (kitchen garden) he made for Colbert at *Sceaux (with the Pavillon d'Aurore by Claude Perrault in the centre) 'one of the best that can be seen'.

In 1670 Louis XIV appointed him *intendant pour les soins des jardins fruitiers et potagers*; and in 1673 *jardinier en chef*. Between 1677 and 1683 La Quintinie was engaged in constructing the new *potager* at Versailles to provide for the needs of the greatly enlarged court. The king provided land near the château for a house to be built for him to the design of Hardouin-Mansart.

La Quintinie visited England twice, and corresponded with learned societies all over Europe. His *Instructions pour les jardins fruitiers et potagers* was published posthumously in 1690 by his only surviving son, Michel. An English translation in 1693 by John *Evelyn was entitled *The Compleat Gard'ner*. *London and *Wise, complaining of his 'tedious enumeration', published an abridged edition in 1699.
 K.A.S.W.

La Reggia, Caserta, Naples, Italy. The palace and gardens (also known as the Palazzo Reale) were designed in 1752 by Luigi Vanvitelli (1700–73), who supervised the work up until his death, for Charles III, Spanish King of Naples. The design is notable mainly for its size—the grandiose palace (253 m. × 202 m.) is matched by the 100-ha. park in which the main feature is the cascade and canal, which have no equal anywhere for length. Unlike *La Granja, the palace of the King's father, the cascade is on the central axis of the palace—doubtless in an attempt to rival *Versailles.

The cascade begins more than 3 km. from the palace, falls steeply (with a drop of 78 m.) over massive blocks of stone into a *bassin* with two sculptural groups at each side: Diana bathing with her nymphs, and Actaeon being torn to pieces by his hounds. The water then flows underground to emerge into a *bassin* with a fountain of Venus; then again flows underground, emerging beneath a group of Ceres and her court. Finally, it widens into an immensely long water-staircase, which ends in the planned climax of the whole ensemble—a *bassin* with statuary of Juno confronting

Aeolus. This was planned to have been 40 m. wide, with 54 figures, but was not completed.

From the next fountain towards the palace, the Dolphin Cascade (1779), water gushes into an oblong *bassin*, leading to the Fontana Margherita, decorated only with one sculptured basket. An *allée* off this fountain leads to the Peschiera Grande, a huge *bassin* with a small temple (1782) in the middle. This, and a *jardin anglais* were built for Maria-Carolina of Austria. Immediately in front of the palace there are now lawns bounded by plantations of camphor and ilex trees—originally there were elaborate *parterres de broderie*.

The water for the cascade is brought over 40 km. from Monte Taburan by aqueduct (completed 1762), which crosses the Maddalone valley via a huge three-arched bridge. Despite the use of slave labour (depicted in the sculpture of slaves shackled in pairs, on the balustrade of the Juno fountain), the King was unable to afford to complete the original plans. Vanvitelli had planned to carry the cascade under the palace, and then on to Naples (30 km. distant) as two canals flanking a restored Via Appia! He had also planned to build 20 fountains, of which only 6 were completed. The progressive simplification of the *bassin* statuary, as compared to the Diana and Actaeon group, was caused by the same problem. The other major change was that he was unable to connect the fountains with a system of parterres, as originally intended.

The sheer extent of the palace and gardens is impressive, but it lacks the genius of *Le Nôtre in its punctuation of space and is certainly without the sense of proportion that underlies the true Italian garden. P.G./G.A.J.

La Roche-Courbon, Charente-Maritime, France, is an architectural garden on a monumental scale by Ferdinand *Duprat, laid out in the 1920s for the industrialist Paul Chénerau. A castle dating mainly from the 15th c. was enlarged by Jean-Louis de Courbon (1617–90), and renamed La Roche-Courbon. The gateway and terraced garden with twin pavilions on the left of it date from the 17th c. Abandoned for most of the 19th c., it was bought and restored by Chénerau between 1920 and 1935. Duprat designed a parterre below the 17th-c. gallery of the château, and created huge sheets of water in the swampy valley of the Bruant, providing interesting reflections from many points of view. The most memorable is from above the water stairway and fountain which close the main axis, from where the château is seen reflected in a fine *miroir d'eau*. K.A.S.W.

La Source, Olivet, Loiret, France, is of interest for its association with Henry St John, Viscount Bolingbroke, who lived there in exile from 1720 to 1724. The château gets its name from the springs of the Loiret which rise in the grounds. One of them was blocked when the river was canalized in the late 17th c., causing it to burst out further to the east, forming Le Bouillon, so called because at intervals the water seems to boil up from below; the house overlooks this spectacle.

In 1735 La Source was bought by Simon Boutin, who extended the canalization and laid out the grounds in a more elaborate manner. After the Revolution, it was the home of Baron Bigot de Moroguès, a distinguished geologist and agronomist, until 1840. Sometime in the 19th c. the grounds were converted to a *parc à l'anglaise*, and the canal again took on the semblance of a river.

Since 1964 La Source has been a public park with an exhibition ground for nurserymen and landscape gardeners. K.A.S.W.

Latapie, François-de-Paule (1739–1823), French antiquary, naturalist, and botanist. His translation of Thomas *Whately's *Observations on Modern Gardening* under the title *L'Art de former les jardins modernes* (1771) was one of the first books to introduce theories of English gardening to the French. He added to it a description of *Stowe with a plan of 1763, and a *Discours préliminaire* summarizing the history of gardens. While giving preference to the English style, he asserts that it was anticipated by C.-R. Dufresny (1648–1724), and that it derived from the Chinese. He gives lengthy quotes in support of this belief from du Halde, *Attiret, and *Chambers's account of gardens in *Designs of Chinese Buildings* (1757). He also quotes a letter to him from Whately who points out that his book is unlikely to be understood by those who have not been to England.

D.A.L.

Laugier, Marc-Antoine (1713–69), was a French Jesuit priest and architectural theorist, whose advocacy of a return to first principles (the 'primitive hut') contributed an important argument in support of the neo-classical style, as opposed to the baroque and the rococo. In his *Essai sur l'architecture* (1753), while advocating regularity in garden design, he sees mere uniformity as insipid. He expresses admiration for the work of *Le Nôtre while criticizing the gardens of Versailles for their poor situation, lack of naturalness, and the oppressiveness of closed walks, comparing them with *Attiret's descriptions of the Emperor of China's gardens. Because of his plea for simplicity and greater naturalness he is regarded as an influence in establishing the fashion for the *jardin irrégulier* or *jardin anglais*.

K.A.S.W.

La Vallée, Jean de (1620–96), Swedish architect, was the son of Simon de la Vallée, a French architect working in Sweden. Trained in architecture by his father, La Vallée completed his studies in France and Rome. Back in Sweden and appointed royal architect in 1650, he had numerous assignments for churches, palaces, and gardens. A most important employer was Count M. G. de la Gardie who had original ideas on gardening; Venngarn Palace with a terraced garden, fairly well preserved, is among the works carried out for him. Although influenced by Italian and French contemporary garden architecture La Vallée developed his own independent style, equivalent to *Le Nôtre's. Characteristic features are terraces and a centralized composition. G.A.

Lawn. Gardening is normally concerned with the cultivation of individual plants or groups of plants growing together but lawns are an exception. A lawn is a plant

community in the natural sense and lawn cultivation concentrates on maintaining the balance between the different species of grasses. Used both for recreation and as a foil to other plants, lawns are probably the most characteristic feature of English gardens. The colder winters and hotter drier summers in many other parts of the world do not encourage the deep greens of lawns to develop. Nevertheless there are some fine examples of lawns in most countries, particularly in the damper coastal areas.

The first lawns were probably well-maintained fields used not for grazing cattle but as a setting for ornamental trees and shrubs. In 1260 Albert, Count of Bollstädt, wrote of pleasure-gardens that 'the sight is in no way so pleasantly refreshed as by fine and close grass kept short'.

Lawns need not consist only of grasses: the admixture of rosette and prostrate herbs such as daisies and speedwells can both enhance their appearance and mask the effects of wear and tear, and of drought. In medieval times some lawns were composed entirely of the fragrant, mat-forming camomile (*Chamaemelum nobile*, formerly *Anthemis nobilis*). Camomile lawns have been established recently in several gardens, either as a re-creation of a period garden (as at Kew Palace) or as a feature in a newly created garden.

<div align="right">P.F.H.</div>

See also MEDIEVAL GARDEN.

Łazienki Park, Warsaw, Poland, was established in 1766–95 as a summer residence of King Stanisław August Poniatowski. The 74-ha. park was created by the garden designer Jan Chrystian Schuch (1752–1813) and the architects Dominik Merlini (1730–97) and Jan Chrystian Kamsetzer (1753–95). Many of the ideas came from the king himself.

One of the most valuable and popular historic monuments in Poland, it was created on the area which served as the zoological gardens (Zwierzyniec). The centre of the spatial pattern is the group of three *bassins* with the Palac Na Wodzie (Palace on the Water) placed on an island. There are two *bassins* in front of the palace, with a cascade between them. The lower *bassin* is surrounded by a peculiar amphitheatre (1790) decorated with sculptures of famous ancient and contemporary Polish and foreign poets. A bridge with the monument of King Jan III Sobieski (1788) closes the view of the *bassin* on the other side of the palace. Close to the palace starlike *bosquets* remain as a memory of the old 17th-c. garden. Around the *bassins* are a variety of garden buildings.

The lower part of the garden, of rather a different character, was established in 1819–25 as a romantic Belvedere Garden with the Belvedere Palace and the pavilions, a Temple of Diana and an Egyptian Temple (1822) located on top of the escarpment. Next to it lies the botanical garden created in 1819. The park has been restored in the post-war period by Longin Majdecki.

<div align="right">L.M./P.G.</div>

Leadwork. Apart from its functional use (piping, roofing, *cisterns*), lead has been used in gardens for two main decorative purposes—statuary and vases or urns. Cisterns were sometimes highly ornate, as well. Lead was melted down and cast in moulds, which meant that many copies could be made from one mould. Following the fashion for lead statues and ornaments in Dutch gardens, the taste spread from the late 17th c. in England. From Antwerp came Arnold Quellin and John *van Nost, with beautifully sculpted figures and vases. John *Cheere took over van Nost's yard and moulds in 1739 and produced several excellent figures of his own, including the examples in white lead at *Stourhead.

Fine examples of lead statuary are to be found at *Blenheim Palace, *Bowood Gardens, Burton Agnes Hall (Humberside), *Castle Howard, *Melbourne Hall, *Powis Castle, *Rousham House, *Stourhead, and *Studley Royal; and of vases and urns at *Hampton Court, Melbourne Hall, Powis Castle, and *Windsor Castle. M.W.R.S.

Leasowes, The, Worcestershire (West Midlands), England, a landscape garden of *c.*60 ha., was created between 1745 and 1763 by its owner William *Shenstone. The site had a varied topography of wooded valleys, rushing streams, and higher ground affording views to local hills (Clent Hills, Frankley Beeches, and the Wrekin) and to the spire of Halesowen church. It also had the ruins of an old priory. Although Shenstone's income was only £300 a year, nevertheless in a few years he had made, in Dr Johnson's words, his 'domain the envy of the great, and the admiration of the skilful; a place to be visited by travellers, and copied by designers'. The visitor followed a prescribed route which presented scenes of grandeur, beauty, and variety. Latin inscriptions and dedications invoked classical associations, and urns were dedicated to the memory of friends to provide a desirable tinge of melancholy. There were also modest garden buildings, a grotto, bridges, numerous cascades and waterfalls, and the picturesque ruins of the priory.

Shenstone strove to make his fame from his landscape garden or *ferme ornée* and in this he was successful, as The Leasowes was visited by William *Pitt, Johnson, Spence, *Thomson, *Goldsmith, Gray, Wesley, *Jefferson, and the Marquis de *Girardin, who was inspired to design the English garden at *Ermenonville, with a lakeside memorial to Shenstone. Parts of The Leasowes survive as a golf-course and municipal park, although much of the surrounding land is now given over to urban development. Dodsley in his *The Works in Verse and Prose, of William Shenstone, Esq.*, published in 1764, includes 'A Description of the Leasowes', with a plan of the grounds, which have immortalized the gardens to students of landscape design. P.E.

Le Bied, Colombier, Neuchâtel, Switzerland, was the country seat built in 1756 of Jacques de Luze, a friend of Jean-Jacques *Rousseau. The central axis of the garden extends from the building towards the lake across terraced ground. The first parterre is terminated by a raised parapet decorated with graceful stone figures. The second parterre

is on a lower level and finishes in an avenue which leads towards the lake.　　　　　　　　　H.-R.H. (trans. R.L.)

Le Blond, Jean-Baptiste Alexandre (1679–1719), a French architect and garden designer, was a pupil of André *Le Nôtre. He designed the *parterres de broderie* which were engraved and published by Pierre II Mariette, and used by A-J. *Dezallier D'Argenville in *La Théorie et la Pratique du Jardinage* (1709). The 1722 and 1728 (English) editions have Le Blond's name on the title page. D'Argenville subsequently claimed authorship. Le Blond designed the Hôtel de Vendôme and the Hôtel de Clermont in Paris, with gardens where skilful use was made of sites to give an effect of spaciousness. His augmented edition of Claude-Louis D'Avilier's *Cours d'Architecture* (1710) was an important book of architectural theory.　　　　　　　K.A.S.W.

In 1716 he went to work for Peter the Great in St Petersburg (Leningrad), where he was appointed Architect General. Though he worked there for less than three years before his tragically early death, his influence on Russian garden design was considerable. Surviving plans show that his work was unsurpassed for the inventiveness and for the variety of its intricate detail. At *Peterhof (Petrodvorets) he corrected what he saw as errors in the work already begun, making considerable improvements to the palace, the cascade, and the park. The main lines of the park at *Strelna are based on his plan, and he also provided plans for the *Summer Garden at St Petersburg and for Ekaterinhof. His development plan for St Petersburg and its canal system was only partly executed.　　　　　　　　　　P.H.

Le Bouteux, Michel (d. 1688–9), French gardener, married a niece of André *Le Nôtre. In 1640 he was gardener to César, Duc de Vendome; and subsequently at *Versailles. In 1670 he provided a design for the gardens of the Trianon de Porcelaine, where he was in charge, receiving the very large annual sum of 18,000 *livres* for their upkeep between 1672 and 1681. He was especially a flower gardener, with the duty of providing flowers all the year round. The appointment ended suddenly in 1682. Thereafter he was in charge of the orangery at *Fontainebleau.

His son, **Jean-Michel Le Bouteux,** was in charge of the orangery at the Tuileries from 1696. He published a book of engravings, *Plans et dessins nouveaux de jardinages*, which is a valuable record of Le Nôtre's designs, and includes some by his father Michel.　　　　　　　　　　K.A.S.W.

Le Brun, Charles (1619–90), French painter, studied in the studio of Simon Vouet, where André *Le Nôtre was a fellow student. In 1658 he was invited by *Fouquet to undertake the direction of the decoration at *Vaux-le-Vicomte, which included the sculpture programme of the garden. Louis XIV's minister Colbert (for whom he worked at *Sceaux) obtained him the nomination as *premier peintre du roi*, and subsequently the direction of all works of painting, sculpture, and ornament in buildings belonging to the crown; this included control of the decoration of the gardens of *Versailles. As director of the Academy of Painting, he imposed a uniformity of style in the arts throughout France.　　　　　　　　　　K.A.S.W.

L'Ecluse, Charles de (1526–1609), Flemish humanist, doctor, and botanist. See CLUSIUS.

Lednice-Valtice Park, South Moravia, Czechoslovakia. The 17th-c. baroque château of Lednice (by Domenico Martinelli and Fischer von Erlach) stood in a magnificent baroque garden with terraces and sculpture galleries, several fountains, and *bassins*. After neo-classical reconstruction at the end of the 18th c., the appearance of the garden was completely altered.

The formal garden was changed into a romantic park. The first romantic garden buildings—the Minaret (1797), the Obelisk (1798), and the artificial ruin of John's Castle (1807)—were designed by Joseph Hardtmuth. Between 1805 and 1811 the architect Fanti created a natural park of more than 200 ha. A 34-ha. lake with 15 islets enriched the picturesque scenery.

The new trees in the park were chosen and planted by the botanist Van der Schott and new buildings were added: near the château of Valtice J. Hardtmuth built the Temple of Diana (1812), called the Rendez-vous, and J. Kornhäusel designed the mighty colonnade (1814). Not far from the baroque *allées* of lime trees which join the two châteaux, Lednice and Valtice, there were the Belvedere (1818) and the Temple of Three Graces (1825) designed by Karl Engel. Kornhäusel also designed the Border Château (1816), the Pond Château (1817), and the decorative Temple of Apollo; the neo-Gothic Chapel of St Hubertus (1855) deep in the woods was designed by G. Wingelmüller. A new glasshouse, with light cast-iron construction by E. Devien from England, was built in 1843 in place of the baroque orangery. The last reconstruction of the château of Valtice was in the neo-Gothic style in 1845 by Georg Wingelmüller, who was inspired by late Tudor Gothic during his studies in England. Today we still admire the beautiful park scenery, enriched by rare, protected waterbirds, which nest on the islets of the park lake.　　O.B.

Lee, James (1715–95), Scottish nursery gardener and author, came to London in 1732. He worked in the garden of Archibald Campbell, later 3rd Duke of Argyll, at Whitton Place, Twickenham, and possibly at Syon Park and the *Chelsea Physic Garden. In 1745, in partnership with Lewis Kennedy (1721–82), he started a nursery garden in Hammersmith, on land known as the Vineyard, reflecting its former use. The ground is now covered by the exhibition halls of Olympia.

The nursery became famous for the cultivation of exotic plants, and over a hundred are said to have been introduced or propagated there, including *Buddleia globosa* and a fuchsia, either *F. coccinea* or *F. magellanica*. Plants and seeds came from North and South America, Africa, Australia, China, and Russia. Later generations of the Lee and Kennedy families kept the nursery going until the 1890s. Its fame attracted many distinguished visitors, including Sir Joseph

*Banks, Redouté, and Sir Walter Scott, who went there in 1828 for 'seeds and flowers for about £10, including some specimens of the Corsica and other pines. Their collection is very splendid.' Among other customers was Thomas *Jefferson.

In 1760 James Lee published an *Introduction to Botany*, translating the *Philosophia Botanica* of *Linnaeus and describing that botanist's system of classification and terminology. The series of editions of this book had great influence in spreading knowledge and use of the Linnaean system, and it 'gave Mr Lee a priority in his time, that rendered his garden, or, as it was called, his Vineyard, the resort of all persons curious in botanical researches: and added not a little to his fame and his emolument.' Another publication, *Rules for Collecting and Preserving Seeds from Botany Bay*, was apparently issued *c.*1787, when the Australian penal settlement was established, and must have encouraged the governor's staff to pay attention to the new flora. S.R.

Leggett, Thomas (*fl.* 1780–1810), was a leading Irish landscape gardener of the late 18th c., who may also have worked at *Attingham in the 1770s. His recorded works include the *demesnes of Mount Bellew, Co. Galway (described by Prince *Pückler-Muskau), Marlay Park, and Stillorgan Park, Co. Dublin. He was the master of Denis MacClair, known as *Mikler in Poland, where, under the patronage of Isabella Csartoryska, he became the chief designer of landscape parks.

Leggett's style was close to that of 'Capability' *Brown, and was later criticized by the adherents of the *picturesque school, one of whom wrote: 'How much the gentlemen of this country have been led astray by the pompous and dictatorial manner of Leggett, who I frequently met in my younger days and whom I admired with the herd, he was quite the fashion.' P.B.

Leiden Botanic Garden, The Netherlands, is a historic garden of only 2·6 ha., although it was even smaller at its foundation in 1587 as a *hortus medicus*. From 1594 Carolus *Clusius, together with the head gardener D. O. Clutius (or Cluyt), set about replanning and planting it as a true botanic garden for the university. The most notable function of Leiden was the large number of newly introduced plants distributed over a long period of time to other European gardens. Geraniums (*Pelargonium*) and the evening primrose (*Oenothera*) are well-known examples. Many of the directors of this garden were famous botanists, such as Paul Hermann (1640–95) and Herman Boerhaave (1668–1738). In 1730 A. van Royen took charge and shortly afterwards he, together with Carl *Linnaeus, devised a planting plan for the garden on new systematic lines. The ancient maidenhair tree (*Ginkgo biloba*) was one of the first to be planted in western Europe (1785).

During the first half of the 19th c. Leiden continued to have a great influence on world horticulture through the introduction of numerous plants, especially those dispatched by P. F. B. von Siebold from Japan. In the present

century Professor Dr Baas Becking reconstructed the garden according to Clusius's plans. Lying as it does in the centre of the city of Leiden, the garden is a historic amenity, as well as being a research department of the university.
 F.N.H.

Lemercier, Jacques (1583–1654), French architect and engineer, established with François *Mansart and Louis *Le Vau the French classical style of architecture. He was employed by Louis XIII in 1624 to make extensions to the Louvre; by Cardinal Richelieu at the Palais Cardinal (Palais Royal); at *Rueil, where he designed the first great French architectural cascade; and at Richelieu, where two architectural *grottoes survive as examples of his style of garden architecture. K.A.S.W.

Leningrad, Soviet Union. See KOMAROV BOTANICAL INSTITUTE GARDEN; SUMMER GARDEN.

Lenné, Peter Josef (1789–1866), was an imaginative German landscape gardener with great organizational skill whose influence extended into the 20th c. After an apprenticeship under Clemens Weyhe at Brühl he travelled to southern Germany in 1809, and then worked in Paris with Desfontaines and *Thouin. He spent a short time with his father at Coblenz, before going to Munich and Vienna; in 1814 he was Garden Engineer at Laxenburg, where he helped to design the park. In 1815 he returned to Coblenz, where he drew up plans for improving existing parks and for private gardens.

In 1816 he drew up extensive plans for *Sanssouci and the *Neuer Garten at Potsdam, which were not executed. In 1826 he extended the park of Sanssouci by adding the Charlottenhof, and in 1827 added the Hopfenkrug. He also redesigned existing agricultural areas in the park: the Marlygarten in 1846, and the Sicilian and Nordic Gardens in 1857 in connection with the new gardens round the Orangery (1851–60). In these gardens Lenné introduced to an even greater degree the very regular forms of Italian Renaissance garden design which soon became highly fashionable. He had a very important influence on landscape design around Potsdam. In 1833 he drew up a 'Plan to Embellish the Isle of Potsdam' which determined the layout of the landscape for decades to come. A similar, but less comprehensive, plan was made for the Reichenbach estate (Pommern) in 1820. These aims were furthered by the setting-up of an influential Association for the Encouragement of Gardening (1822), a Gardening School, and a Provincial Tree Nursery (1824).

Lenné continued to draw up and execute plans for new gardens and for rearrangements in the royal gardens, especially in the Neuer Garten and Sanssouci, as well as on many estates and in urban parks. He also drew up and carried out over many years major plans for the *Tiergarten, Berlin (1818–40), for the pleasure-garden of the Stadtschloss in Berlin, and for the Prinz Albrecht Garden, and he contributed to the planning of Berlin with his plan, 'Ornamental and Subsidiary Features of the Residence in

Berlin' (Moabit, Köpenick, Landwehrkanal, Luisenstädt-ischer Kanal), as well as later plans for Charlottenburg and Vienna. He made plans for people's parks (*Volksparke*) at Magdeburg (1824), Frankfurt-on-Oder (1835), and Dresden (1859). H.GÜ.

See also AUGUSTUSBURG; CHARLOTTENBURG; KLEIN-GLIENICKE; LUDWIGSLUST; MEYER, GUSTAV; PFAUENINSEL; PUTBUS; SCHWERIN.

Le Nôtre (or Le Nostre), a family of French gardeners, associated mainly with the *Tuileries, although André Le Nôtre exercised much wider functions and became the leading garden designer under Louis XIV.

Pierre Le Nôtre was active *c.* 1570–*c.* 1610; his appointment as one of the chief gardeners in *Catherine de Medici's newly made garden of the Tuileries is recorded in 1572. Among his responsibilities were the parterres nearest the château, and maintaining the trellis-work pavilions and arbours, a skill he demonstrated as his *chef-d'œuvre* on being received as a master-gardener. In 1594 he was given the task of restoring the parterres after the devastation caused by the civil war; and in 1599 he was a senior member of the corporation of gardeners of Paris.

Jean Le Nôtre (d. 1655) was presumably the son of Pierre (but a René Le Nôtre is among gardeners mentioned in 1571). In 1618 he was in charge of the parterres in the *grand jardin* of the Tuileries, with a retainer as designer of parterres for all the royal gardens. He occupied a house adjoining the gardens, where his children grew up. One daughter, Elizabeth, married Pierre *Desgots, gardener in charge of the *allées* and *palissades*; a second, Françoise, married Simon Bouchard, who kept the *Orangerie*. He was succeeded in his appointments by his son André.

André Le Nôtre (1613–1700) showed a taste for painting and entered the studio of Simon Vouet, where *Le Brun was a fellow student. In 1637 he was granted the succession of his father's post at the Tuileries; and in 1640 he married Françoise Langlois, daughter of François Langlois, Sieur du Hamel, *conseiller ordinaire de l'artillerie de France*, *gouverneur des pages de la Grande Ecurie*. Among the witnesses were François de Montigny, governor of the Tuileries, and M. de Belleville, *écuyer de la Grande Ecurie du roi*, indicating the standing of the Le Nôtre family. At this time, until *c.* 1642, he was in the service of Gaston d'*Orléans at the *Luxembourg; and at some time he worked with François *Mansart, who is said to have found him an apt pupil and to have given him openings. Le Nôtre's first recorded design was for the *jardin de l'Orangerie* at *Fontainebleau in 1645; but his great opportunity came when in 1656 he joined Louis *Le Vau and Charles Le Brun in designing *Vaux-le-Vicomte for *Fouquet. Here his distinctive ability as a landscape architect became apparent: the creation of great level spaces round the house, with trees pushed well back to display the architecture; the siting of the main elongated vista on the axis of the house with a great canal at right angles; the hierarchical arrangement of parterres and *pièces d'eau*; the subtle use of levels to create surprise (the *grandes cascades*). There is such a degree of unity between château

and gardens that close co-operation with Le Vau must be assumed.

In 1657 Le Nôtre was appointed *contrôleur général des bâtiments du roi*, with a salary of 4,000 *livres* a year. This, together with a retainer of 1,200 *livres* for the design of parterres and gardens and his appointments at the Tuileries gave him over 8,000 *livres* a year regular income. Later increases in his salary at the Tuileries, and an annual gratuity of 3,000 *livres* brought it to over 16,000 *livres*. This may be compared to Le Brun's 12,000 *livres* as director of painting and the Gobelins tapestries; or 9,250 *livres* to François *Francine for directing the fountains and maintaining the Rungis aqueduct. Le Nôtre was regularly employed by the Prince de *Condé at *Chantilly from 1663 to 1686, and he looked on what he did there as among his greatest achievements. He designed the grounds at *Sceaux for Colbert (1670–7); *Dampierre for the Duc de Chevreuse (from 1675); and *Anet for the Duc de Vendôme between 1681 and 1688.

In the important royal gardens whose care he inherited, the choice of ground was limited by existing situations. At Fontainebleau his main task was to redesign the *grand parterre* (1661). In his alterations to the Tuileries (1666–71) he gave balance and regularity to the old garden, removing the wall to relate the parterre to the palace, and opening up the central vista to the future Champs-Elysées. Between 1662 and 1668 he created the setting for Le Vau's rebuilding of *Versailles, establishing the open spaces round the château, and particularly clearing the trees to the west to create the Parterre de Latone, and following that, the extension in the Allée Royale (Tapis Vert) and Grand Canal. He was also concerned in the constantly changing arrangements of the *bosquets* (the Marais, the Théâtre d'Eau, 1670–1; the Isle Royale, 1671; the Labyrinthe, 1672; the Trois Fontaines, the Arc de Triomphe, 1677). How much of the detail he attended to in person it is impossible to say. Le Brun, it is known, controlled the sculpture programme, including that of the fountains, which were also the concern of François de Francine and Denis Joly, the *fontainier*. There were also a host of assistants; 305 gardeners are listed in the royal accounts for 1664–80 (a far greater number than any other class of craftsman), many of whom held posts of responsibility.

His relatives Michel *Le Bouteux (in charge of the gardens at Trianon) and the Desgots, father and son, worked closely with him, often interpreting his ideas, so that it is difficult to distinguish their work from his. His collaboration with architects was also close, first with Le Vau, and subsequently with *Hardouin-Mansart at *Castres (1666), *Saint-Germain-en-Laye (the great terrace, 1669), Clagny for Madame de Montespan (1674), and Dampierre (1675). After 1678 Hardouin-Mansart played an increasingly important part in the developments in royal gardens. With the rebuilding of the palace at Versailles, extensions to the south involved the making of the Pièce d'Eau des Suisses (1679) and the new Parterre du Midi (1684) to match the scale of the new Orangerie. Le Nôtre was certainly associated with these projects, but the extent of his

participation is uncertain. In 1679, at the age of 66, he obtained permission to visit Italy, where he was received by the Pope, inspected and reported on Bernini's equestrian statue of Louis XIV and (according to Claude Desgots) pronounced that the Italians were absolutely ignorant of the art of making gardens. The influence of his Italian experience has been seen in designs he made after his return for the cascade at *Marly.

Drawings by Le Nôtre are extremely rare, and mostly in the form of rough sketches to show his general intention. The essence of his artistry was a sense of scale, balance, and proportion, but always with an eye to the ground, and attention to visual effect, as when the circular basin of the Tuileries parterre was placed off-centre (nearer the palace) to correct the optical distortion. Maquettes of the sculptures at Versailles were set up in position before they were made. Characteristically, Le Nôtre dominated the terrain by imposing a strong main axis, in preference siting it across a shallow valley, a practice he may have learned from François Mansart (cf. *Balleroy). This enabled him to play with differences of level, for which he had skill in devising architectural features and surprises (the *grande cascade* and *grotte* at Vaux, the horseshoe ramps and steps at Versailles and the Tuileries, and many other examples). Even when (as at Chantilly) another architect did the detail, the conception was generally his. His ideas did not always meet with a favourable reception. At Choisy Mademoiselle de Montpensier refused to cut down trees to open up the view. He was similarly frustrated by the king's brother, Philippe, Duc d'Orléans, at Saint-Cloud, where old gardens existed at different levels in a situation described by William *Robinson as 'one of the most beautiful that gardening man could desire'. By the great lines of his *allées* Le Nôtre imposed regularity on a site naturally irregular; but his plan to link the higher and lower levels by terraces on the axis of the château was not carried out. At *Meudon for Louvois after 1675 (an even more spectacular and varied site) his great controlling vista swept across the valley to the horizon.

Among the many gardens attributed to him *Castries (1666) is a charming essay of his style in miniature; others certainly by him are *Maintenon (1676) and *Gaillon (1691). A most original creation of his later years was the little Jardin des Sources (1687) enclosed on two sides by wings of the Grand Trianon, and composed of a network of tiny irregular streams, small enough to step across and surrounding some 20 islands of turf, large enough for seats and gaming tables. Besides his general occupation with the wider aspects of landscape design, Le Nôtre remained in close touch with the particulars of gardening on account of his appointments at the Tuileries. His duties included the upkeep of the parterres, the *allées* surrounding them, and the espaliers of jasmine along the terrace to the north (the side of the present Rue Saint-Honoré). He was required to stock the flower-beds and to keep the garden between the parterre and the terrace 'full of flowers, particularly in winter'. The style of his *parterres de broderie* derives from those of *Boyceau and the Mollets, trailing plant-like forms of box with interlacing bands of turf or coloured earth; but they are on the whole more open, with a pronounced use of the volute, particularly in the border. The contours are also much more varied and complex. Parterres of cut turf (*parterre à l'anglaise*) were made with increasing frequency after his creation of the Boulingrin for Henriette d'Angleterre at Saint-Germain-en-Laye.

Louis XIV gave Le Nôtre a house at Versailles; but his main residence was the house with its own garden near the north-west of the Tuileries palace. Here he lived in the last years of his life, surrounded by his collections: pictures (including paintings by Nicolas Poussin, Claude Lorrain, Domenichino, and Albani), tapestries, silver, bronzes, gems, medals, and porcelain. He had always, he said, been inclined to spend money on such things, thinking 'only of glory and honour'; his fortune was due to his wife's good management. He was, however, essentially a simple man, and the stories of his warmth and spontaneity are too consistent to be anything but true. *Saint-Simon wrote that he was valued and liked for his integrity and straightforwardness. He worked for private individuals with the same diligence that he did for the king, and he always remained unpretentious. Louis gave him wealth, and in 1693 awarded him the Order of Saint-Michel; but above all he gave him his affection. K.A.S.W.

See also TREILLAGE.

Le Pautre, Jean (1618–82), French designer and engraver, was the elder brother of the architect Antoine Le Pautre. His collections of designs for decoration had considerable influence in forming the taste in Louis XIV's reign. Not least were his engravings of imaginary Italian gardens, and his theatrical illustrations to the *Metamorphoses* of Ovid, with baroque balustraded terraces, pavilions, fountains, and sculpture in picturesque settings.

Pierre Le Pautre (1660–1744), sculptor and engraver, was the eldest son of Jean Le Pautre. He was a collaborator of J. *Hardouin-Mansart who obtained for him the post of draughtsman and engraver to the king. He made engravings of Versailles in 1678. K.A.S.W.

Le Pavillon de l'Enfant, Aix-en-Provence, France. See AIX-EN-PROVENCE.

Le Peyrou, Montpellier, Hérault, France. See MONTPELLIER.

Le Potager, Fleury-en-Bière, Essonne, France. See FLEURY-EN-BIÈRE.

Le Rouge, George-Louis, French engineer and geographer, and author of atlases and topographical works, was born at Hanover and died towards the end of the 18th c. He had the title of *géographe du roi* to Louis XV. Between 1776 and 1787 he published *Détails de nouveaux jardins à la mode* in 21 parts (*cahiers*), an invaluable engraved record of garden design of the period, especially those of the French style of the *jardin anglais* which he called *jardins anglo-chinois*. Gardens in England and Germany are also included, and

the period covered ranges from the early 18th-c. layout at Wanstead to the *Parc Monceau and *Ermenonville. There are a large number of garden plans, real and imagined, and designs for garden buildings in all styles, most of them borrowed without acknowledgement from pattern books such as Overton's *Temple Builder's most useful companion* (1766) and Wright's *Grotesque Architecture* (1767). *Cahier* V is a French edition of *Chambers's *Designs of Chinese Buildings*; *Cahier* XIII is devoted to the *Désert de Retz, and *Cahiers* XIV and XVII show the gardens and palaces of the Emperor of China after original Chinese paintings on silk. K.A.S.W.

Le Vau, Louis II (1612–70), French architect, was, with François *Mansart, one of the most important exponents of the French classical style and, with *Le Nôtre, of the development of the architecture of the garden as a setting for the house. This was most notably the case at *Vaux-le-Vicomte (1656–61) and at Versailles (1661–70). Among important precedents for Vaux-le-Vicomte were the châteaux of Saint Sepulchre, near Troyes, and Le Raincy for Jacques Bordier, *intendant des finances*, with important gardens which have been attributed to Le Nôtre. He also worked for Mazarin at Vincennes (1653), and for Abel Servien at *Meudon (1654). At Vaux it is probable that, as architect, he had a controlling role. He worked for *Louis XIV at the *Tuileries and the Louvre, but his most important work was the enlargement of Versailles, first in 1661–5 and again in 1667–71. The creation of the orangery and the terraces determined the future development of the gardens. Besides work on the château he designed the Ménagerie (1662) and a *salle de bal* in the park for the great festival of 1668. In March 1670 he made plans for the Trianon de Porcelaine, but he died in October of that year, and the work was carried out by his pupil, François II d'Orbay. K.A.S.W.

Levens Hall, Westmorland (Cumbria), England. The gardens (and park) were laid out by Monsieur Beaumont between 1689 and 1712, with small improvements being made until his death in 1727. Full documentation of the making of the gardens exists in the manuscripts at the Hall. He planted great yew and beech hedges to divide the garden into 'quarters', as he called them, although there are five divisions. These are: the *parterre with its formal beds and amazing display of *topiary, the survival of which is the chief feature of the garden today; the orchard; the bowling-green; the soft-fruit area; and the 'mellion-ground' or melon-ground, where there were heated frames and hot-beds. The long wall was planted with pears and grapes.

Many of Beaumont's original trees still stand, including the yew and great beech hedges, and the only significant change has been the planting of a cedar of Lebanon in 1810 which has overwhelmed some of the parterre. A remarkable feature of his plan is the *ha-ha with its great bastion, one of the earliest uses of this device. A.D.B./P.G.

Lewis, Captain Merriwether (1774–1809), British explorer, and his companion, Captain **William Clark**

(1770–1838), made an expedition sponsored by the American government from St Louis to the Pacific, the first to cross the continent, in the years 1804–6. Although neither man was a botanist, Lewis was given some preliminary training in natural history, and the expedition's collections of both plants and animals contained many new species. The discoveries included *Lewisia* and *Clarkia*, named after the explorers, *Philadelphus lewisii*, the snowberry (*Symphoricarpos rivularis*), and the Oregon grape (*Mahonia aquifolium*), the last two now naturalized in parts of Britain where they have escaped from gardens. S.R.

Li Yu (1611–79), alias Li Li Weng and Zhe Fan, was a native of Lanqi, Zhejiang province, China. This author, playwright, and theorist of drama was also an amateur master of garden art. His designs included *Ban Mu Yuan and the Mustard Seed Garden in Beijing, while his immensely popular *Random Notes in a Leisurely Mood*, a book on various aspects of culture and the art of living, is considered one of the most important works on garden design in China. Published in 1671 during the reign of Kang Xi, it contains 14 chapters of which VIII to XI are devoted to house furnishing and garden planning. Chapters VIII and IX discuss the positioning of windows to 'borrow' near or distant landmarks (see *jie jing), and the arranging of hills and rocks both to accord with local conditions and to express a cultivated man's delight in the antique and his appreciation of landscape painting. D.-H.L./M.K.

Liancourt, Oise, France, had one of the most admired of early 17th-c. French gardens, noted for its water. Charles du Plessys (1540–1620) rebuilt the château, and began gardens on a level site with abundant water between Clermont and Creil. These were extended by Roger du Plessys and his wife Jeanne de Schomberg in the 1630s, with numerous canals, fountains, and set pieces enclosed in *bosquets*. On the west of the château, parterres descended in two stages, separated by 22 jets falling into bowls of rose-grey marble, an early example of the form of cascade developed at Vaux. The gardens covered *c.*80 ha. in 1654, when they were recorded in a series of engravings by Israel *Silvestre. Despite neglect, they retained their essential character until after the Revolution, when François de la Rochefoucauld, Duc de Liancourt, transformed the grounds into a model estate *à l'anglaise*, with a pottery and textile mill. Neither château nor gardens have survived.

K.A.S.W.

Lichtenwalde, Karl-Marx-Stadt, German Democratic Republic. Between 1730 and 1737 an 8-ha. garden was laid out along a range of hills and was subsequently hardly extended or altered; because of its location the garden is not connected closely with the Schloss (1722–6). The original plans were burnt in 1905. The landscape gardener is unknown, but is thought to have been attached to the court at Dresden.

To the west of the avenue leading to the Schloss are kitchen gardens whose water reservoir was used formerly to

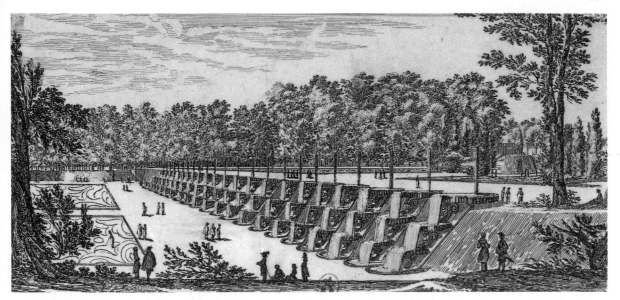

Liancourt, Oise, France, the cascades, engraving (1654) by Silvestre (Bibliothèque Nationale, Paris)

feed the numerous fountains. The ornamental garden extends over the southern slope and is divided by transverse *allées* into separate areas. As the gardens lie high above the Zschopau valley the garden rooms and *cabinets* afford delightful views of the countryside.

Between the south-west wing of the Schloss and the great lime *allée* stretches a parterre on three terraces which is bounded by small *bosquets*. An arcade leads to an avenue of lime trees, from which extend other parts of the garden: the Neues Stück, Grosse Salon with the *fer à cheval* (horseshoe), waterworks, bowling-greens, Great Basin, Small Horseshoe, and further terraces with hedges and pergolas. There are numerous statues and stairways; the original plantations survive. H.GÜ.

Lidice, Central Bohemia, Czechoslovakia. This small village, 30 km. west of Prague, was razed to the ground by the Nazis on 10 June 1942 in revenge for the assassination of the Governor, SS General Heydrich. The whole area of the annihilated village has been preserved as a memorial, and between it and the new village of Lidice the 'Park of Friendship and Peace' with several terraces, beds of roses, and fountains, has been created. Thousands of roses were sent from all over the world and planted in the park—in March 1955 5,000 were sent from England, including 1,000 from Coventry. The central point of the whole garden composition is the terrace which bears the emblems of towns and villages which suffered similar destruction during the Second World War. O.B.

Liébault, Jean. See ESTIENNE, Charles.

Lighting. The purpose of illuminating a garden at night is to create, as if by magic, a fairyland scene removed from

reality. It could be said that the first illuminated landscapes were in caves some 20,000 years or so ago. The flickering light would bring to life the animal paintings on the rock face that itself responded to light. As far as we know it was light and the movement of light that created ecstasy; and in a modified way has continued to do so ever since.

However dramatic the torchlight processions of antiquity and the torchlight illumination of architecture, history suggests that no civilization could equal ancient China in this transformation of a garden or landscape into the world of fantasy. The Chinese lantern captured the European imagination in the 17th c., and has held it firmly in the face of the technical achievements of electricity. The principle is that the point or source of light is visible, becoming in itself the most attractive as well as novel object in the landscape. The modern equivalent, other than the Chinese lantern itself in various dresses, is the suspended line of fairy lights, with naked and sometimes coloured bulbs. Transitional between this and modern concealed floodlighting is the single candle in a wind-protecting glass container, a few of which scattered about a garden can transform the smallest garden into one that is limitless and mysterious.

The idea of floodlighting from an invisible source is in principle modern, quite different from anything in history, and has evolved from the invention of electricity. Unlike gas which flickers, electricity is static. Its purpose in garden illumination is to reveal a world, preferably static as on a windless night, its values reversed from the real world of the day. The emotions are stimulated by seeing shadows that are upside down, the undersides of leaves, the sometimes uncanny pattern of tree branches. The difficulty is to know how this naked light can be placed inconspicuously; for glare can eliminate its surroundings. A good solution to illuminate low plants and ground cover is what is known as

the 'mushroom'—a bulb well below eyeline, covered with a small flat dome.

A third element of garden illumination is probably the most spectacular of all: underwater light, whether of pool, fountain, or cascade. So far as they could with the materials available, the Moguls in the *Shalamar garden at Srinagar, and elsewhere in water-abundant Kashmir, illuminated the cascades by means of niches with oil-lamps concealed behind the falling water. Compared with land lighting, water light magnifies itself in still water and breaks into columns of light in fountains. In the modern world underwater lighting is now technically easy and commercially available, even in the smallest garden. G.A.J.

Ligne, Charles-Joseph, Prince de (1735–1814), Belgian nobleman and writer, was a great admirer of Rousseau and Voltaire, and imbued with new ideas of rural economy as practised by *Girardin at *Ermenonville; for example, he laid out a rather gloomy part of the formal garden at *Beloeil as a *jardin anglais*. He advised Marie-Antoinette on the Petit Trianon, the Duc de Chartres on the *Parc Monceau, and the Baron de Monville on the *Désert de Retz. His *Coup d'œil sur Beloeil et sur une grande partie des jardins d'Europe* (1781) includes comments on a large number of gardens, besides his intended plans for Beloeil. D.A.L.

Ligorio, Pirro (1500–83), Italian architect and antiquary. Although the most knowledgeable person of his time about the antiquities of classical Rome (he left behind 50 manuscript volumes on the subject), he published only one small treatise on the subject (Venice, 1553). His greatest achievement was to use his erudition to help Cardinal Ippolito II d'Este formulate an iconographical programme for the gardens of the Villa *d'Este.

He also built the *casino* (1558–65) of Pius IV (1559–65) in the Vatican Gardens (see Villa *Pia). P.G.

The importance of Ligorio in garden history cannot be overestimated. From his profound knowledge and understanding of Roman antiquity his brilliant imagination evolved designs that were wholly original, individual to himself, and essentially of the virile period in which he lived. G.A.J.

Lincoln Memorial Garden, Springfield, United States. See ECOLOGY AND GARDENS.

Linderhof, Bavaria, German Federal Republic. Of all the fantastic castles built by Ludwig II of Bavaria—Herrenchiemsee, Neuschwanstein, and Linderhof—it is Linderhof which has the most interesting gardens. Three distinct styles come together, each represented in a different part of the grounds: Italian, French, and German. In front of the Schloss, which was built from 1874 in neo-baroque or neo-rococo style, lies a sunken parterre with a large pond in the French style. At the side of the Schloss are two small garden rooms, reminiscent of Italian *giardini segreti*; an Italian influence is also apparent in the water-steps behind the Schloss which lead up to a *gazebo, and, on the slope

facing the Schloss, in the terrace with its Temple of Venus.

The court gardener K. von Effner used the English landscape style in his design for the adjoining park, and exploited to the full the natural advantages of this valley set 1,000 m. up in the Alpine foothills. A number of curious buildings are still to be found in the park. The Hundinghütte, Grotto, and Hermitage can only be explained by Ludwig's love of the poetry and music of Richard Wagner. They might almost be described as theatrical buildings: the Grotto, for example, contains a waterfall and lake within a cave 10 m. high filled with stalactites which would be lit in a variety of colours when the King visited the Grotto. On the lake floats a gilded shell-boat; at the back of the cave is the Königssitz, a shell-throne, and a table and chairs made of coral. A huge painting from Act 1 of *Tannhäuser* covers the rear wall. Ludwig bought the Moorish Pavilion by the Berlin architect K. von Diebitsch at the World Fair in Paris in 1867 and had it erected in the park. U.GFN.D.

Lindsay, Norah (1866–1948), English gardener and garden designer. Born Norah Bourke, she married Sir Harry Lindsay in 1895 and made her famous and luxuriant garden at the Manor House, Sutton Courtenay, in Oxfordshire. She was a disciple of Gertrude *Jekyll but more of a romantic gardener—her allegiance to the 'crumbling shrines of the ancient garden gods of Florence and Rome' was more imitative, she loved pools and fountains everywhere, and her colour schemes were augmented with selfsown 'vagrants'. To Norah Lindsay gardening was a theatrical performance, which she spoke and wrote about in suitably dramatic tones; as a rare honour she was allowed to write her own description of her garden in *Country Life* (Vol. LXIX, p. 610, 16 May 1931), and this article sums up her gardening and her personality perfectly. Her sense of style and unerringly good if rich taste won her a string of wealthy clients in the 1920s and 30s, including Lord Lothian at *Blickling Hall, the Prince of Wales at Fort Belvedere, and the Trittons at Godmersham Park. Her daughter Nancy Lindsay was also a noted gardener, though of more modest reputation. Both were great friends of Lawrence Johnston of *Hidcote. J.BR.

Linnaeus and his students. The introduction of consistently two-word (binomial) names for species, consisting of a one-word generic name, such as *Calendula*, followed by a single specific epithet such as *officinalis* to form a specific name such as *Calendula officinalis*, stands as the most important and lasting of the contributions to botany and horticulture by the Swedish naturalist Carl Linnaeus (1707–78). His *Species Plantarum* (1753) has been accepted internationally as the starting-point for all botanical nomenclature. Names published earlier have no standing unless they were adopted by Linnaeus or his successors. These pre-Linnaean names varied greatly from author to author. Thus the snake's-head fritillary which in 1753 Linnaeus named *Fritillaria meleagris*, still its correct name, had been named *Fritillaria praecox purpurea variegata* by C. Bauhin in

1623 and *Meleagris*, a one-word name, by Reneaulme in 1611. Similarly Linnaeus's *Gloriosa superba* (1753) had been named *Methonica malabarorum* by Hermann in 1687, *Lilium zeylanicum superbum* by J. Commelin in 1697, and *Mendoni* by Rheede in 1688. Linnaeus replaced such diverse names by binomials.

Carl Linnaeus was born on 23 May 1707 at Råshult, Småland, in southern Sweden, the first son of a clergyman, Nils Ingemarsson Linnaeus (1674–1733). Nils, the son of Ingemar Bengttson, on entering the University of Uppsala coined the surname Linnaeus for himself from the Småland word *linn* for the linden or lime (*Tilia cordata*) with reference to a celebrated tree on a former family property, Linnegård. The name of his son Linnaeus thus did not originate as a latinized form of Linné. Nils had a well-stocked rectory garden and from him Carl acquired a love of gardening and plants and an understanding of the importance of correct names.

In 1727 Carl Linnaeus enrolled as a medical student at the University of Lund but changed in 1728 to the University of Uppsala, where he was befriended by Olof Rudbeck the younger and Petrus Artedi, a student with a similar interest in natural history. Together they conceived a plan of classifying and naming all minerals, plants, and animals according to their own system. When Artedi was drowned in 1736 the burden of this vast task fell upon Linnaeus. In Apr. 1735 he left Sweden for the Netherlands in order to obtain a doctor's degree from the University of Harderwijk and to get some manuscripts published. He became personal physician to a wealthy Anglo-Dutch merchant-banker George Clifford (1685–1760) with a well-stocked garden, menagerie, and library near Haarlem. Clifford's garden, which had four large glasshouses, filled with plants from overseas, enraptured Linnaeus; his native Sweden had nothing comparable. He worked prodigiously at preparing a detailed systematic catalogue of its plants, *Hortus Cliffortianus*, published in 1738 with engravings by G. D. Ehret and J. Wandelaer.

This work remains important for fixing the application of specific names published by Linnaeus in 1753. He noted that 'The native place lays the entire foundation for the cultivation of the plant' and then attempted to correlate the geographical distribution of plants and their treatment in gardens. His major achievement was to flower and fruit the banana where it had long been grown in vain. He celebrated his success by publishing a little book *Musa Cliffortiana floreas Hartecampi 1736* (1736). While in the Netherlands from 1735 to 1738 he also published *Systema Naturae* (1735), *Bibliotheca botanica* (1736), *Fundamenta botanica* (1736), *Genera Plantarum* (1737), *Flora Lapponica* (1737), and *Critica botanica* (1737). He was obsessed by a need for order such as the arrangement of organisms into tidy groups. Thus he arranged the plants in these works according to his system of classification known as the Linnaean 'Sexual System', based on the number of stamens and stigmas, e.g. *Tetrandia* (with four stamens), *Polygamia superflua*, *Polygamia Necessaria*, etc. Regarded at the time as 'his lewd method' and 'such loathsome harlotry', Linnaeus's admittedly artificial system both simplified botany and made it more entertaining. It was much used until early in the 19th c. when more natural systems of classifying the plant kingdom had been devised.

On his return to Sweden Linnaeus became a physician in Stockholm and in 1741 achieved his ambition by becoming Professor of Medicine and Botany at the University of Uppsala. Here he stayed for the rest of his life, teaching students, restoring and managing the botanic garden, making journeys of scientific exploration to the islands of Oland and Gotland in 1741, to Västergötland in 1746, and to Skåne in 1749, and preparing a series of important publications, among them *Flora Suecica* (1745), *Hortus Upsaliensis* (1748), and *Species Plantarum* (1753, 2nd edn. 1762–3). His health declined from 1763 onwards and he died, aged 70, on 10 Jan. 1778. His widow sold his scientific collections and library in 1784 to an Englishman, James Edward Smith (1759–1828) of Norwich who, with other naturalists, founded the Linnean Society in London in 1788.

Apart from introducing a convenient system of naming plants and animals, now universally used, Linnaeus published several works relevant to horticulture. An address in 1739 to the Royal Academy of Science in Stockholm was 'an attempt to base the cultivation of plants on Nature'. Guidance as to the natural habitats of plants could be obtained from floras and travel books: these indicated the conditions to be reproduced for plants brought into cultivation. He concluded that, in addition to its outdoor area for hardy plants, a good botanic garden should have one hot, one warm, and one cold glasshouse. Linnaeus understood clearly that the range of tolerance of plants in the wild varies but the growth of each species is bounded by limits of heat and soil conditions which the gardener must study. For him the theory and practice of horticulture was based on plant geography and ecology.

Linnaeus was a successful teacher who imparted his own enthusiasm to students. His publications made him widely known, and students came to Uppsala from Sweden, Norway, Denmark, Finland, Germany, Switzerland, Russia, Britain, and the United States. No less than 23 of his students became professors of natural history or medicine. He inspired students to travel to investigate natural history, his 'apostles' as he called them, and it saddened him to feel that he had sent five of them to their deaths far from home. Others were more fortunate and came back enriched by the experience of travel and with important natural history collections. Among them was **Pehr Kalm** (1715–79) who went to eastern North America in 1748 to collect seeds of plants. From time to time he sent back consignments of seeds and plants and in 1751 returned home. Linnaeus gratefully named the exquisite genus *Kalmia* in his honour.

Linnaeus's favourite student, **Daniel Carlsson Solander** (1736–82), an extremely industrious and competent naturalist, sailed round the world in 1768–71 with Captain Cook on his global voyage in the *Endeavour* as the companion and scientific assistant of Joseph *Banks. They returned with an immense number of specimens, drawings, and notes, together with seeds which produced the first

New Zealand plants grown in Europe. Solander came to England in 1760, aged 24, and was made so welcome for his knowledge and agreeable personality that he never returned to Sweden. After the voyage he became Banks's librarian and herbarium curator and helped to prepare William *Aiton's *Hortus Kewensis* (1789).

Another important Linnaean 'apostle' was **Carl Peter Thunberg** (1743–1828), who set out in 1770 with a travelling scholarship, intending to go no further than Paris for a short stay to improve his knowledge of surgery, medicine, and natural history but instead travelling to South Africa, Java, and Japan, under the patronage of wealthy Amsterdam businessmen. After his return he gratefully named the genera *Deutzia, Houttuynia, Hovenia,* and *Pollia* in honour of these patrons.

The Japanese kept the Dutch traders as virtual prisoners. Thunberg's acquaintance with the Japanese flora was accordingly restricted to garden flowers, sometimes abnormal and of Chinese origin, and to wild plants found in livestock herbage. Thunberg diligently searched this often mangled and withered material to get specimens. The Dutch had to make an annual journey of homage to the Shogun at Yedo (now Tokyo), a long and costly journey but a welcome escape from hot cramped Deshima. Thunberg accompanied the Dutch envoy as a medical man and occasionally managed to gather a few wayside plants, among them *Lilium japonicum* and *Chaenomeles japonica*. He returned to Amsterdam in Oct. 1778 and to Uppsala in Mar. 1779, having had the pleasure of seeing in Dutch gardens some plants he himself had introduced.

Back in Sweden he began preparation of an account of his travels and descriptions of his numerous new plants. His *Flora Japonica* was published in 1784, his *Resa uti Europa, Africa, Asia* in 1788–93 with an English translation, *Travels in Europe and Asia*, in 1794–5. A detailed annotated list of his plants is contained in H. O. Juel's *Plantae Thunbergianae* (1918). He became Professor of Medicine and Botany at Uppsala in 1784, after the death of Linnaeus's son and successor Carl von Linné the younger (1741–83), and died on 8 Aug. 1828. The genus *Thunbergia* and numerous species named *thunbergii* commemorate him.

The last of the Linnaean 'apostles' was **Adam Afzelius** (1750–1836) who visited Sierra Leone and Guinea from 1794 to 1796, introduced some West African plants, and made botanical collections which, like those of Thunberg, are at Uppsala. W.T.S.

Lin You, Shaanxi province, China, is one of the earliest imperial parks recorded in Chinese history. It was made in the middle of the 11th c. BC during the reign of Wen Wang, a wise and benevolent ruler of the semi-mythical Zhou dynasty. Located in or just near the capital Feng Jing, southwest of the present city of Xian, it was what today would be called a preservation area with a perimeter of some 35 km. Wild deer and crane roamed freely in this enclosure which was used for breeding, herding, and hunting by the King and was open also to the common people for hunting, fishing, and wood gathering. It contained a high terrace, the

Lin Tai, and a large pool, Lin Zhao (from which perhaps the terrace had been dug), where fish were bred. Since *lin* means mana and suggests a concentration of benevolent spiritual power, both terrace and pool probably had some magical significance; the philosopher Mencius praised the park as a contribution to the welfare of the Empire.
 G.-Z.W./M.K.

Liselund, Møen, Denmark, is a romantic 18th-c. rococo garden influenced by the ideas of the French writer Jean-Jacques *Rousseau. The stream has been dammed in places to form pools, a waterfall, and a lake, and the paths that wind through the beechwoods give sudden glimpses of the sea below. Rousseau's thoughts were idealized by reminiscences of death and the transient nature of possessions, hence artificial graves, mounds, and dark leafy pathways were created, combined with the wild natural scenery of rocks and waterfalls to give alternating feelings of sorrow and happiness. Features of the garden are the Swiss cottage, the Norwegian hut, and a Chinese pavilion, which once had a striped canvas tented ceiling. P.R.J.

Lismore Castle, Co. Waterford, Ireland. 'I paid Turlough and William May for diging, mowing and laying my terras at Lismore with paved hewn stones in all over one hundred and six feet,' recorded the Great Earl of Cork in his diary, which also records in 1626 payments by his mother 'for compassing my orchard and garden at Lismore with a wall of two and a half feet thick and fourteen feet high of lyme and stone and two turrets at each corner'. These, the earliest garden remains in Ireland, survive in the kitchen garden of today. The castle stands on a bluff overlooking the wooded Blackwater valley, its park ornamented with a bridge designed by Thomas Ivory in 1775.

The castle was re-created and restored between 1812 and 1822 and then much enlarged by the 6th Duke of Devonshire and Joseph *Paxton from 1848 to 1858. Pleasure-grounds were devised around an avenue of English yews which had been planted in 1717. A unique floral *parterre was laid out, its pattern based on an illuminated page from the Book of Lismore, an ancient Celtic breviary which was one of the treasures of the castle. Paxton also developed woods and drives through the estate and erected one of his 'Hothouses for the Million' in the kitchen garden. P.B.

Little Sparta, Stonypath, Lanarkshire (Strathclyde Region), Scotland. Situated on a slope of the Pentland Hills to the south-west of Edinburgh, this is a garden unlike any other. It is sometimes described as a sculpture garden, but that is too limited a definition. The elements which it comprises are recognizable as parts of the English tradition: the small formal garden, the herbaceous border, the wild garden, the landscape garden. But each is given an added dimension.

Its creator, Ian Hamilton *Finlay, who describes himself as a poet and gardener, uses the garden to express a deeper meaning than that conveyed by the senses alone. Thus his

poetic idea is given form in building or sculpture, often by another craftsman, sited in a carefully selected or created garden context, and appreciated physically, visually, and intellectually by each new visitor. The concept is one of total experience.

The garden functions both as a retreat and a poetic appreciation of the world. Invoking images from a variety of sources, including classical mythology and contemporary technology, Finlay is concerned with the 'emblematic' aspect of the garden as 'culture' rather than just 'horticulture', seeking, as he continues to extend his garden against all odds, to redefine the garden as an expression of contemporary life. M.L.L.

See also SCULPTURE GARDEN.

Little Thakeham, West Sussex, England, was built by *Lutyens in 1902 for Ernest Blackburn, an amateur gardener 'of exceptional skill'; the brief called for a broad garden framework, to be planted up by the owner. Lutyens adopted a vernacular manner, using the local golden sandstone which on this Sussex hilltop has weathered to a lichenous yellow-grey, the perfect background to the planting in the walled entrance forecourt.

The garden is approached from the house either by a stairway leading off the hall to a flagged terrace, with rosebeds and grass plats (see *parterre) in line with the two projecting gables and central bay of the house; or from the dining-room in the south-east angle, where a flight of steps some 9 m. wide—divided into four by plinths for garden tubs—descends to an oblong group of pools for waterplants. Flanking this, an enclosed parterre garden was designed, and below it, along a drystone wall planted with alpines, a grassed terrace with a sundial placed on the main axis of the house.

From this point, a pergola of alternate round and square columns supporting massive beams stretches across the lawns of the lowermost terrace on a raised causeway. It forms a strong architectural link between the setting of the house and the boundary path, from which broad steps lead down to lawns on either side and to the kitchen garden and the surrounding orchards, which have a distant view of the Iron Age hill-fort of Chanctonbury Ring and the South Downs between the oakwoods. I.L.P.

Liu Yuan, Jiangsu province, China, in the north-western suburbs of Suzhou, was the only garden in the district to survive the Taiping rebellion (1851–64). When first built between 1522 and 1566 by Xu Shi-tai, a retired official of the Ming dynasty, it was called the East Garden or Dong Yuan. However, in 1798 the property was bought by a provincial official, Liu Shu and despite his new title for it, Han Bi Shan Zhuang, or Chilly Green Manor, it was thereafter always popularly known by his family name. In 1876 when the garden was enlarged by the Lius, they cleverly kept the sound 'Liu' but changed the character to mean Lingering Garden.

Its four sections cover about 2 ha., but are so complexly planned that the whole seems much bigger. From the entrance courtyard a narrow whitewashed passage, some 50 m. long, twists and turns past various tiny open spaces and leads eventually to a corridor with views, through open *lou chuang windows, of the main pool. Bordered to the north and west by rockeries and to the south and east by varied grey-tiled buildings, this is the heart of the garden. Around it many of the garden's 700 m. of covered *lang corridors rise and fall following the terrain while, to the east, groups of halls, courtyards, open corridors, and garden rooms lead through and around each other to make a varied and

Lou chuang at Liu Yuan, Jiangsu province, China

complex architectural labyrinth. South of this, a more open section brings the visitor round to the double Hall of Mandarin Ducks (see *ting (hall)) overlooking a small pond and the 6.5-m. high Cloud-capped Peak, a water-worn *Taihu stone said to have been originally chosen for the Song dynasty imperial garden, *Gen Yue. To the west of this, the last part of the garden wraps around the central section, its earthy hills (*jia shan) capped by an open pavilion with views across the garden's internal walls to the central pond and its surrounding trees. An enclosure within the garden here houses a large and remarkable collection of miniature landscapes and *peng jing. Liu Yuan has been designated a key place of national historic and cultural importance. G.-Z.W./M.K.

Lloyd, Nathaniel (1867–1933), English architectural historian, was to a large extent an exponent of the more informal type of garden layout of William *Robinson, Gertrude *Jekyll, and others, who revolted against the harshness of many gardens of the Victorian era; although he was rather more moderate in his views than some others of this school of thought. His great quality was his outstanding ability to achieve an exquisite linkage between the house and the garden. This is displayed in a masterly fashion in the garden of his home, *Great Dixter. He had an expert knowledge of hedges and topiary and was the author of *Garden Craftsmanship in Yew and Box* (1925). His son **Christopher Lloyd** (b. 1921), who now owns Great Dixter, is a well-known journalist and nurseryman and author of several modern gardening classics such as *The Well-Tempered Garden* (1970). C.H.

Lobb, Thomas (d. 1894) and William (1809–63), British plant-collectors. See VEITCH FAMILY.

L'Obel, Matthias de (or Lobel, as in *Lobelia*, which commemorates his name), (1538–1616), French doctor and botanist. Like *Clusius, he studied medicine at Montpellier, where he met a fellow-student, Pierre Pena, who worked with him on his first book, *Stirpium Adversaria Nova*, published in London in 1570–1, after the authors had settled there and made botanical explorations of the country. Pena soon returned to France, but L'Obel remained in London for a time. His *herbal was taken over by the Antwerp printer Christophe Plantin, who published an enlarged edition in 1576 and a Flemish translation, the *Kruydtboeck*, in 1581. A system of classification set out in these books divided plants by the features of their leaves.

In the late 1570s L'Obel was living in Antwerp, before becoming physician to William the Silent in 1581. He returned to England in 1584, where he took charge of Lord Zouche's garden at Hackney. In 1607, presumably with the help of his patron, he was appointed Botanicus Regius to James I. Some of his manuscripts were later acquired by John *Parkinson, who used them for his herbal. S.R.

Lochinch Castle, Wigtownshire (Dumfries and Galloway Region), Scotland. See CASTLE KENNEDY GARDENS.

Loddiges, Conrad (1739?–1826), German nurseryman, bought the Hackney garden of John *Busch in 1771, when Busch was engaged to design a garden by Catherine II of Russia. The Loddiges family came from Hanover, and Conrad and his two sons, William (1776?–1849) and George (1786?–1846), ran the nursery, which eventually occupied c.6 ha., until the early 1850s.

The garden became famous for rare plants, especially 'the best general collection of green-house and hot-house exotics of any commercial garden', including a huge collection of palms. Camellias and yuccas were other specialities, and the nursery was one of the first to cultivate orchids on a commercial scale. More than 1,500 types of rose were offered for sale, and a large number of species and varieties of willow were available to satisfy the 19th-c. interest in this group.

The first catalogue of the nursery's plants and seeds was published in 1777, with names in Latin, German, and English. By 1818 the catalogue was labelled 'eleventh edition', and it was supplemented by lists of trees and shrubs, and special collections. A periodical, the *Botanical Cabinet*, produced in 20 volumes from 1817 to 1833, illustrated many of the plants in the garden, the greater part of the drawings being by George Loddiges. S.R.

Lomonosov, near Leningrad, Soviet Union. See ORANIENBAUM.

London. See CANONS; CHELSEA PHYSIC GARDEN; CHISWICK HOUSE; GREENWICH PARK; HAM HOUSE; HAMPTON COURT PALACE; HOLLAND PARK; HYDE PARK; KENSINGTON GARDENS; KEW, ROYAL BOTANIC GARDENS; MYDDELTON HOUSE; POPE'S GARDEN; REGENT'S PARK; ROYAL HORTICULTURAL SOCIETY'S GARDENS; ST JAMES'S PARK; SAYES COURT; WIMBLEDON HOUSE.

London, George (d. 1714), English garden-designer, was one of the last of the great formalists. In Laurence Whistler's view, London's greatest work, though it was soon superseded, was at *Castle Howard in the 1690s. He played a leading part in the creation of extensive gardens at *Longleat House, Chatsworth, *Melbourne Hall, Wanstead, and *Canons. He learned much from his visits to France, where he met John *Rose, later to garden in England for Charles II. Among his sponsors and admirers were John *Evelyn and Stephen *Switzer, who records his service at Fulham to Henry Compton, Bishop of London, whom he accompanied when Princess (later Queen) Anne was 'rescued' from Kensington Palace in 1688, as her father James II approached.

In 1681 London with three others founded a 40-ha. nursery at Brompton Park, where the South Kensington museums now stand, and c.1688 took into partnership Henry *Wise. 'They have a very brave and noble assembly of the flowery and other trees,' wrote John Evelyn, '. . . and understand what best to plant the humble boscage, wilderness or taller groves with,' while Switzer adds: ''twill be hard for any of posterity to lay their hands on a tree in any of

these kingdoms that have not been a part of their care.' The Brompton Park nursery was left in London's charge when Wise moved to Blenheim in 1705. D.B.G.

See also NURSERYMEN; PETWORTH HOUSE.

Longleat House, Wiltshire, England. The extensive late 17th-c. formal garden shown in *Kip's view of Longleat disappeared when the 3rd Viscount Weymouth commissioned 'Capability' *Brown to landscape the park in 1757. An agreement drawn up in October of that year set out the alterations which were to be made to the garden, park, terrace, and lakes, while extensive plantations were to be introduced on the surrounding slopes. In the following year a walk was formed to High Wood, and thence to the kitchen garden, its verge adorned 'with shrubs, trees of curious sorts, and turf'. Some £6,000 had been spent by the time Mary *Delany visited Longleat and found a fine lawn, serpentine river, and wooded hills '*all modernised* by the ingenious and much sought after *Mr. Brown*!' Forty-five years after Brown had initiated his scheme Humphry *Repton was consulted and produced a Red Book with proposals which included a new orangery, and the forming of an island in the lake.

The forecourt pools and the approach avenue of tulip trees (*Liriodendron tulipifera*) were designed by Russell *Page for the Marquess of Bath in the early 1950s. D.N.S.

Longwood Gardens, Pennsylvania, United States, is one of the truly outstanding American estates. In 1906 Pierre S. du Pont bought the Peirce property, primarily to save the arboretum (begun in 1798), which included yews, copper beeches, empress trees (*Paulownia imperialis*), and Kentucky coffee trees (*Gymnocladus dioica*).

In all, Longwood encompasses 400 ha. of rolling hills, woods, and open spaces, although the gardens proper cover *c.*120 ha. Most frequently visited is the conservatory, an imposing edifice covering 1·4 ha. Besides special areas for orchids, roses, ferns, tender fruits, and tropical plants of all kinds, there are two permanent exhibit areas, one for full-sized palm trees and related plants, and the other laid out in the form of a garden complete with lawn, trees, and flower-beds which are changed from time to time to keep them colourful all year long.

Facing the conservatory is the Fountain Garden, fully equal to that in the gardens at Versailles, and the open-air theatre, inspired by the theatre at the Villa Gori near Sienna, which seats 2,100 spectators. Besides these, there is an Italian water-garden, formal and informal gardens of bulbs, annuals, and perennials, a rose-garden, a gigantic rock-garden, water-lily pools, a vegetable garden, and woodland walks planted with wild flowers. E.F.S.

L'Orme, Philibert de (*c.*1510–70), French architect and theorist, was the first Frenchman to synthesize the Italian Renaissance and native traditions in an individual style. Between 1533 and 1536 he studied Roman antiquities in Italy, where he met Cardinal Jean du Bellay, who commissioned him to design a house at the abbey of Saint-Maur.

In 1547 Henri II appointed L'Orme *architecte du roi*. His most important work during this period was for Diane de Poitiers at *Anet, where he included gardens in a symmetrical design which by its scale imposed regularity on the old buildings. He wrote that an architect should show imagination when building on marshy ground, using the canals necessary to drain it to increase pleasure and profit, as he had done at Anet, where, despite a waterlogged site, he had made a garden as pleasant as could be seen anywhere. He also worked for Diane de Poitiers at Chenonceaux. At *Saint-Germain-en-Laye he designed the Maison du Théâtre (later called the Château-Neuf), on steep ground overlooking the Seine. However, the death of Henri II in 1560 ended the project with only the upper terrace finished.

*Catherine de Medici employed L'Orme throughout his life, first at Montceaux-en-Brie, where he is recorded as having designed a garden pavilion, a grotto, and a building for the game of pall-mall; then at Saint-Maur, acquired after Jean du Bellay's death. He was engaged on her palace of the Tuileries when he died.

L'Orme's treatises combine theory derived from Vitruvius, *Alberti, and *Serlio with practical knowledge from his own experience. *Nouvelles Inventions pour bien bastir et à petis frais* was published in 1561; *Le Premier Tome de l'architecture* in 1597. Besides the originality of his designs, he established the architect's responsibility for the laying out of grounds, and he pioneered the ornamental use of water in basins and canals. K.A.S.W.

Lotus Garden, Dholpur, Rajasthan, India, which is still being excavated, was discovered and identified by Elizabeth B. Moynihan in March 1978 (described in her book *Paradise as a Garden*, 1980, pp. 103 ff.). The site is a plain broken by a dark red sandstone ridge. *Bābur stopped here in August 1527, and first had a pavilion carved out of the large outcrop of sandstone, then had a garden made round it. A section of the ridge was levelled, and an octagonal roofed tank was constructed. It is not yet clear what the entire layout consisted of, although Bābur's memoirs (*The Bābur-nama in English*, trans. by Annette S. Beveridge, 1969) do give some idea.

Originally three water channels fed the large pool on the central terrace. This pool then fed two channels: one leading to Bābur's bath, the other spilled down a *chadar* to flow through a series of pools, carved to represent the lotus symbol in various forms—bud, flower, and overripe blossom. The pools are organized in a series, united by flowing water, to show the opening of the lotus flower. It is the first known example in India of such a programmatic series, and also of the brilliant fusion of Mogul design with native sculptural talent. P.G.

Lou, a type of Chinese garden pavilion, is commonly a two-storeyed building, usually situated behind a hall and near a pond or on a hill. The front of a *lou* has tall windows (some with balconies) facing the garden, and the walls of both sides are gabled. It was used for daily living or as a study.

X.-W.L./M.K.

See also FANG; GE; TING; XIE; XUAN.

Lou chuang, meaning leaking window, is a window-opening in a Chinese garden wall (*yun qiang). It serves either as an open frame to emphasize or, if filled in with ornamental lattices, to half-hide and half-reveal the view beyond. The openings are of varied and sometimes fantastic forms: square, round, hexagonal, fan- or fruit-shaped, and are sometimes thought of as the eyes of the garden. The decorative infill is most often made of different whitewashed roof-tiles combined in a large repertoire of geometric patterns—there are over 100 designs in Suzhou alone—but never with two the same next to each other. Some gardens also have windows filled in with more naturalistic designs of birds and branches, as in the *Yu Yuan, or such well-known combinations of objects as the 'four articles of scholarship'—books, pen, ink, and musical instrument, as in *Shi Zi Lin. These infills are made of hemp-covered wire, plastered, and finally whitewashed to match the wall. X.-W.L./M.K.

See also LIU YUAN; OU YUAN.

Loudon, Jane Webb (1807–58), English writer on gardening. As well as helping her husband, J. C. *Loudon, in the compilation of his books and periodicals, Jane Loudon also published nearly 20 books of her own on plants and gardens, many of them addressed specifically to female readers. *Gardening for Ladies* (the first of many English and American editions was published in 1840) and *The Ladies' Companion to the Flower-Garden* (1841 and many later editions) were full of practical advice for readers who were expected to work in their own gardens. *The Ladies' Flower-Garden* appeared from 1839 to 1848 in an illustrated series of monthly parts, which were collected in five volumes. Some of the illustrations were from her own hand. Her *Amateur Gardener's Calendar*, first published in 1847, was edited and revised by William *Robinson for a third edition in 1870.

Jane Loudon's directions, for example, those on the use of colour in garden planning, were often firm, allowing little straying from her own taste. Her professionalism was also demonstrated in her role as the first editor of *The Ladies' Companion*, a periodical founded in 1849. Its pages included reports on flower-shows and new plants, among other subjects of interest to the women who bought it. S.R.

Loudon, John Claudius (1783–1843), Scottish author and designer, was correctly described by his American admirer, A. J. *Downing, as 'the most distinguished gardening author of the age'. He was also a designer of parks and gardens but the chief reason for Loudon's historical importance is undoubtedly the quality and volume of his literary output. His career as an author began in 1803 with an article entitled 'Hints for Laying Out the Ground in Public Squares', and ended in 1845 with a book entitled *Self-Instruction for Young Gardeners, Foresters, Bailiffs, Land-Stewards and Farmers*. Between these years this immensely energetic Scotsman published approximately 60 million words on gardening, horticulture, architecture, agriculture, and other related topics. His books, encyclopaedias, and magazines were essential reference books in their day and

remain an indispensable source for historians of the period.

Loudon was the son of a farmer and moved to London at the age of 20 with the intention of establishing himself as a landscape gardener. He arrived with 'a great number of letters of recommendation', many of them from the Professor of Agriculture at Edinburgh University. One of the letters was to Sir Joseph *Banks at whose house Loudon subsequently met 'most of the eminent scientific men of that day'. His first book was published within a year and the author announced to prospective clients that 'I believe that I am the first who has set out as a landscape gardener, professing to follow Mr Price's principles. How far I shall succeed in executing my plans, and introducing more of the picturesque into improved places, time alone must determine.' (See *picturesque.) He soon established a busy practice and although little executed work survives it can be seen from his published drawings that he did succeed in following the principles of Uvedale *Price. His designs were highly 'irregular', especially with regard to the treatment of water, landform, and planting. Barnbarroch, near Wigton, was a notable example of this approach and survives as a ruin. Loudon's design for this estate and many comparable designs were published in his major work of this period, the *Treatise on Forming, Improving and Managing Country Residences, and on the Choice of Situations appropriate to every Class of Purchasers* (1806). Towards the end of the year in which this work appeared the first phase of Loudon's career was halted by an attack of rheumatic fever. It affected his left knee permanently and led to his taking up farming, first at Pinner and then at Tew Lodge in Oxfordshire, where he created a magnificent *ferme ornée in the irregular style; it survives in part and was illustrated in a charming folio volume.

When the lease of the farm was sold in 1811 Loudon found that he had saved £15,000 and set out to see Europe. In the course of several extensive tours spread over the next decade he visited and sketched many of the great gardens of Europe and began to collect material for his *Encyclopaedia of Gardening* (1822) which was the first book to treat the subject comprehensively from the historical, technical, aesthetic, and horticultural points of view. The section on taste reveals that Loudon had lost his partisan enthusiasm for irregular gardens. He observes that 'to say that landscape gardening is an improvement on geometric gardening, is a similar misapplication of language, as to say that a lawn is an improvement of a cornfield, because it is substituted in its place. It is absurd, therefore, to despise the ancient style, because it has not the same beauties as the modern, to which it never aspired. It has beauties of a different kind, equally perfect in their kind as those of the modern style.'

In the following year Loudon read an essay by the French champion of classical aesthetics, Quatremère de Quincy, which reinforced his taste for regular gardens laid out in the 'ancient style'. Quatremère was a Neoplatonist and believed that landscape gardening in the irregular style could not be admitted to the circle of the fine arts because it was almost indistinguishable from nature itself.

The idea that gardens should be different from wild

Alton Towers, Staffordshire, from J. C. Loudon, *Encyclopaedia of Gardening* (1834 edn.), bk. I

nature and recognizable as works of art provided Loudon with a philosophical support for the taste in regular gardens which he had acquired during his European tours. From 1822 onwards he praised regular gardens in each edition of the *Encyclopaedia* and on numerous occasions in the *Gardener's Magazine* which he founded in 1826 (see *garden journalism). These publications enjoyed widespread popularity and Loudon must be counted an important influence on the return to formality in garden design during the 19th c. Quatremère's arguments also led Loudon to advocate the style of planting design known as the *gardenesque, which required each plant to be displayed to its best advantage and appealed to Loudon's interest in plant varieties and to his love of order. However, Loudon did not abandon the irregular style entirely and commented in *The Suburban Gardener and Villa Companion* (1838) that each of the main styles of landscape gardening 'has its peculiar uses and beauties'. *The Suburban Gardener* was a major work and gives a fuller account of English gardening at the start of Queen Victoria's reign than any comparable book. It is interesting to note that as a result of the rise of the middle class the book is mainly devoted to small and medium-sized gardens. Only a short section is given over to the country residences which had been the subject of Loudon's 1806 *Treatise*.

Loudon was a friend of Jeremy Bentham and a supporter of numerous liberal causes. His wife believed 'there never lived a more liberal and thoroughly public spirited man'. One of the causes he supported was the establishment of *public parks in the burgeoning 19th-c. cities. He advocated the creation of new parks in the 1822 *Encyclopaedia* and published a design for a type of green-belt system of 'breathing zones' for London in the *Gardener's Magazine* in 1829. The basic idea was that London's expansion should take place in one mile wide belts of urban development separated by half mile wide belts of countryside which would act as breathing zones. Loudon was also the designer of Britain's first public park, in the sense of an open space owned by the public and designed for recreation: the Terrace Garden in Gravesend. It was laid out in 1835 but sold for building development in 1875. However the *Derby Arboretum, designed in 1839, survives in good condition and is usually said to be the oldest British public park. It has a peripheral walk, defined by sinuous mounds, which was intended to lead the visitor through the botanical orders, and a cross-axis which returns him to the starting point. Like the Terrace Garden it was designed for education as well as recreation.

Perhaps the most enduring of Loudon's many achievements was the establishment of the first periodicals to deal exclusively with gardening and architecture. The *Gardener's Magazine* ran from 1826 to 1843 and the *Architectural Magazine* from 1834 to 1838 but they were the precursors of two important branches of the periodical publishing trade. T.H.D.T.

See also DITCHLEY PARK.

Louis XIV (1638–1715), King of France (1643–1715). Early humiliations in the Fronde (the series of outbreaks during his minority, aimed at limiting the authority of the crown) implanted in his mind a distrust of the nobility and a dislike for Paris. He found at *Versailles a place where he could give Arcadian entertainments—such as the *Plaisirs de l'Ile Enchantée* (1664) and the *Grand Divertissement Royal* (1668)—to which an invitation was much sought. Molière's

plays and Lully's music made these visits never-to-be-forgotten occasions.

In the summer most of these entertainments were given out of doors, and to provide a setting, the gardens of Versailles, Trianon, and *Marly were steadily enlarged and elaborated. A huge team of artists, led by André *Le Nôtre, Charles *Le Brun, and François de Francine created the landscape, the statuary, and the fountains.

By the giving or withholding of invitations to these châteaux, and later by the opportunities to reward and to humiliate offered by the details of etiquette, Louis reduced the nobility to a position of dependence upon his own good favour. *Saint-Simon came to see that Versailles was just 'un autre manège de la politique'.

It was Louis's good fortune to be served by men of the first quality in all fields; as Cardinal Maury claims: 'he faces the judgement of posterity backed by all the great men who reached and retained their positions through his discretion.' It was those who gave his reign the title of *Grand Siècle*. His conception of monarchy may be glimpsed in his memoirs, written for his son, in which he described God as 'a superior power of which our royal power is part'. As such he exacted, and was accorded, a deference not far removed from worship. I.G.D.

Louis XV (1710–74), King of France (1715–74), was in many ways the opposite of his great-grandfather Louis XIV. He reacted against the living in public and the ceremonial of the Court. 'To separate Louis de Bourbon from the King of France,' wrote Mme Campan, 'was what the monarch found most amusing in his royal existence.' A search for privacy and intimacy led him to reconstruct his own apartments at Versailles on a small scale and in an exquisite taste. He was a passionate builder and always happy with architectural designs spread before him. This taste was developed by the Marquise de *Pompadour, who encouraged his habits of privacy and informality. His interest in gardens was genuinely scientific and he was more concerned with his botanical garden at Trianon than with the adornment of a formal layout. I.G.D.

Lou Lim Leoc Garden, Macao. A unique combination of Chinese and European styles, this villa and its walled, subtropical garden lie among squares and streets in the old Portuguese colony of Macao. Begun in 1837 by a successful businessman, Lou Cheok Chi, soon after he arrived in the city, it was built by masons from Canton and named after his eldest son. A large white Victorian-colonial style house, its second storey added in 1961, lies in the garden which, although today overlooked in places by dilapidated apartment buildings, is lushly overgrown with palm, ficus, lychee, and ginkgo trees, junipers, eight different types of bamboo, acacia, *Ligustrum sinensis*, and orchids.

The main focus of the garden—hidden, in the Chinese way, from the entrance by bamboo and rocks—is a single-storeyed garden pavilion with French doors. These open on to verandahs on all sides that overlook the irregular central pond. From here an extraordinary concrete bridge curls in tight coils to the shore above part of the lake planted with water-lilies and lotus. All around the lake, among the bamboo groves, winding paths lead past several rockeries in the Chinese style, including one with a small but elaborate cascade fitted into it.

The Portuguese government of Macao bought the garden in 1973, for 2,700,000 pesetas, and after renovation opened it as a popular public park. M.K.

Luan shi pu di is a form of pebble flooring. The courtyard and pathways in Chinese gardens are often patterned with designs made of pebbles, broken porcelain pieces, bricks, and tiles set on edge. Among others in Suzhou, there are plum blossoms and geometric patterns in the *Wang Shi Yuan, and Taoist and Buddhist symbols in the *Liu Yuan. In Beijing a bicyclist and 1920s motor car join classic flower-patterned pathways in the *Yu Hua Yuan and *Yi He Yuan. Part of the traditional enjoyment of them comes from the fact of something delightful having been made from useless and broken objects. X.-W.L./M.K.

Ludlow, Frank (1885–1971) and **George Sherriff** (1898–1967), British plant-hunters, met at Kashgar in 1929. Ludlow had come to India as a teacher, while Sherriff was vice-consul there. Their first plant-hunting journey, from Sikkim to the capital of Bhutan, was made in 1933, and was followed by another five in the Himalayas and Tibet, the last in 1949. They collected many primulas (sending some especially difficult ones home by air), rhododendrons, and meconopses, especially the blue-flowered *Meconopsis grandis* and the pink *M. sherriffii*. Each man had a new rhododendron named after him. *R. ludlowii* is a dwarf yellow one, while *R. sherriffii* has deep red flowers. The yellow tree peony *Paeonia lutea* var. *ludlowii* was another of their finds of great horticultural merit. *Euphorbia griffithii*, now so popular, was another. S.R.

Ludwigslust, Schwerin, German Democratic Republic. The building of a hunting-lodge in 1724 was followed by the foundation of a new town, Ludwigslust, where Duke Friedrich of Mecklenburg transferred his small residence in 1764. J. J. Busch supervised the planning and construction of town, Schloss, and park.

In front of the Neue Schloss (1772–6), which incorporated the remaining wings of the old hunting-lodge, extends a *bassin* area with the Great Cascade (built c. 1750 of wood; in 1775 of sandstone). Two statues of river gods with the Mecklenburg coat of arms are by R. Kaplunger. A reservoir adjoins the cascade, and beyond the extended lime avenues stretches an almost square lawn with the church as a *point de vue*.

Behind the Schloss extends a long lawn parterre, dating from the time of the hunting-lodge, which terminates in two fountains, and the Hofdamenallee, aligned upon the axis of the Schloss. A large nursery lies to the east of the parterre. The garden, dating from c. 1780, is not harmoniously arranged, although it does follow a system of canals to the north-west of the Schloss. Two paths, framed on the sides

by *bosquets*, follow the Great Canal (completed 1760); in 1780 the original wooden bridge was replaced by a stone bridge. The earth which was dug out for the canal was used to form a bank and planted. Small waterworks fed by barrage weirs enliven the very long canal: a high water-feature, known as the Monk, and, at the point where the canal widens to form a basin, the Leaps, 24 small fountains with jets of differing heights. A constant water level was maintained by means of an automatic lock.

Between the canal and the Johannis dike—a narrow path running along the top of a dam and flanked by a causeway—lay the Kaisersaal, a long garden room within a *bosquet* with 12 papier-mâché busts of emperors standing on sandstone bases (not preserved). At the side of the Hofdamenallee are a low, long, artificial ruin (1788), a Swiss Cottage (1789), and a pheasantry with a monument to Duke Friedrich who died in 1785.

To the west of the Schloss on a small island stands the Catholic church and next to it a free-standing bell-tower (1818). Two mausoleums, without separate gardens, are integrated into the park.

Efforts were made in the mid-19th c. to combine the various scattered parts of the garden into a unified land-scape garden. A plan by W. Benque of 1843 was not realized. Work on a large-scale project by *Lenné was initiated in 1852, and can still be identified today, although some parts have turned to woodland. A splendid landscape park (whose present area is 122 ha.) incorporates the grounds laid out in the 18th c., with long vistas relating the park to the surrounding countryside. The park is bounded by a ha-ha. Huge groups of trees encircled large areas of meadowland where, owing to the high ground-water level, several large *bassins* were created to the north-west of the *parterre*. H.GÜ.

Luisium, Halle, German Democratic Republic, was an almost regular garden where J. F. *Eyserbeck worked and from 1774 laid out the 14-ha. garden to specifications by Prince Franz of *Anhalt-Dessau and his own designs.

The Schloss (1774–7) forms the central point of an eight-armed star with long vistas which include the church and obelisk in Jonitz; the Prince was later buried in this church. The western half of the park is dominated by a long lake; the Schloss stands on an elevation on its northern shore. A Chinese stepped bridge leads to a classical garden house, formerly surrounded by flower-beds, and to a small grotto and fountain. From a low dike which protects the whole park against flooding there are superb views of the Elbe meadows in which stands a stud farm built as a façade structure in the neo-Gothic style.

In the eastern part are farm buildings and the Orangery (now used as a café), a neo-Gothic garden house, two neo-Gothic gatehouses, and a ruin after a model in Palmyra.

The park is characterized by very idyllic groves of trees and long vistas into the Elbe meadows; in the vicinity of the Schloss there are even three rides, radiating from a central point, which were probably originally used for hunting. Very old and valuable trees still stand from the time of the

garden's inception: oaks, limes, liriodendron, black pines, and yew. H.GÜ.

Lunéville, Meurthe-et-Moselle, France, was the favourite residence of Leopold, Duc de Lorraine, who employed Germain Boffrand to design a new château between 1702 and 1723. The gardens were greatly enlarged by Stanislaus, Louis XV's father-in-law, with a *grand canal*, *bosquets*, and a series of little houses for guests (*chartreuses*) in emulation of *Marly. The famous *rocher*, with *automata worked by water, surrounded a rectangular basin adjoining the house. It is illustrated in a series of engravings of Stanislaus's works by the architect Emmanuel Héré. None of Stanislaus's work survives, although the garden still exists. K.A.S.W.

Luo Yang Ming Yuan Ji ('The Famous Gardens of Luoyang') is a unique Song-dynasty book on the classical gardens of Luoyang (Henan province), written by Li Ge Fei who died, aged 61, in the early 12th c. It describes the layout and histories of 18 gardens and one market-place in the capital city of his day, and once was known to every educated Chinese. D.-H.L./M.K.

See DU LE YUAN.

Lurøy Garden, Nordland, Norway, which is situated on the Atlantic Coast just below the Arctic Circle, is a small, formal garden dating back to *c.*1750. The garden is partially enclosed by a rough stone wall and contains a symmetrically placed wooden pavilion and a geometric parterre with perennial flowers. The simple design of the parterre is almost identical with patterns found in early Italian gardens. This almost unknown garden at Lurøy represents the northernmost example of a gardening fashion which originated during the Renaissance in the sunshine of Italy.

About 90 years ago a small park in the Victorian style was added to the formal garden. It contains full-grown specimens of golden rain trees (*Laburnum vulgare*), purple beech, and common oak more than 15 m. tall, besides other species that thrive very well in the mild coastal climate at a latitude similar to central Greenland.

The Lurøy Garden is in private ownership and not open to the public. M.BR.

Lursakdi Garden, Bangkok, Thailand. The garden of Khunying Lursakdi Sampatisiri, adjoining the compound of the British Embassy in *Bangkok, is a *klong* garden in the grand manner. Two very large houses with stepped pagoda roofs shading deep open-sided terrace rooms seem to ride above the ground. On one side a wide, lawn-fringed inlet from one of the major *klongs* (navigable waterways) of Bangkok holds floating pavilions which provide both reception space and a guest-house.

There is a fine group of royal palms (*Roystonea regia*) at the entrance and the garden is framed with mature rain trees (*Samanea saman*) and flamboyants (*Delonix regia*). Between the two houses is a traditional garden of clipped and stunted trees. Behind the house, around three sides to form a courtyard, is a large slatted plant-house, staggered in both

The orchard garden at the Deanery (1901), Sonning, Berkshire, by Edwin Lutyens and Gertrude Jekyll

plan and section, containing many thousands of orchids suspended in space. The garden is also remarkable for the use of textured ground-cover and low foliage plants.　M.L.

Lu Shan Cao Tang, Jiangxi province, China. Literally the Thatched Cottage on Mount Lu, this is where the great Tang-dynasty poet Bei Juyi lived for two years from 817. Located to the north of Censer Peak on Mount Lu, the cottage was simply built of undecorated wattle and adobe. In front of it lay a terrace and a square-shaped pool planted with white lotus and stocked with red carp, overlooking to the south the Stone Gate Ravine with huge old pines standing on both sides. There were waterfalls and springs to the east and west, and a rocky precipice, in which grew rare wild-flowers and trees, rose steeply up behind. In his *On Lu Shan Cao Tang*, the poet describes how he could 'lift his eyes to watch the mountains, bend his head to listen to the spring and turn to the sides to see the bamboo, the trees, the clouds and the rockeries; from dawn to dusk there are ever-changing views'. He made much of the peony of Beautifully Brocaded Valley in Spring; the clouds of Stone Gate Ravine in Summer, the moonlight of Tiger Creek in Autumn, and the white snow of Censer Peak in Winter. The inspired

exploitation of the cottage's natural site and its daily seasonal variations made Lu Shan Cao Tang one of the classic examples of 'borrowing views' (**jie jing*) in China's gardening tradition.　C.-Z.C./M.K.

Lüttge, Gustav (1909–68), German garden designer, served an apprenticeship at Karl Foerster's nursery in Potsdam while *Mattern was in charge of the design section; he then studied under Wiepking at Berlin University before starting his own practice at the age of 23 in Hamburg, where he remained predominantly a designer of public and private gardens. His style is largely characterized by the use of strong linear elements—walls, paths, and pergolas used to define spaces, and carefully worked out paving patterns —contrasting with a sensitive informal use of plant materials.　R.STI.

Luttrellstown, Co. Dublin, Ireland, has a walled *demesne of 160 ha. situated on a plateau overlooking the River Liffey and the Dublin Mountains. The approach from the river bank is up through a picturesque ravine enlivened by tumbling cataracts, overhanging rocks, and a ruined Gothic arch incorporating a bridge over the stream and a many-

roomed hermitage. The park (*c.*1820, designer unknown) on the plateau is watered by a placid lake crossed by a many-arched bridge and focused on the Cold Bath which is enclosed within a Doric temple. The park is maintained by its present owner in superb condition. P.B.

Lutyens, Sir Edwin (1869–1944), English architect and garden designer, was working as an architect when he met Gertrude *Jekyll in 1889. Their first 'official' collaboration was the Duchess of Bedford's garden at Woodside, Chenies, Bucks. (1893), a formative Italianate design of interlinked compartments on a site of 0·8 ha. spanning the River Chess. Miss Jekyll was strongly influenced by the *Arts and Crafts movement and this influence first became evident in Lutyens's work at *Munstead Wood, the house she commissioned him to build in her existing garden in 1894. Having long worked with William *Robinson (see *wild garden), she sought 'a rational blend' of naturalism and formalism: Lutyens was for 'more architecture round the house'. Both were sympathetic to the organic design concepts of Philip Webb and Lethaby and their craftsman-like respect for material. It fell to Lutyens to crystallize their beliefs—increasingly as Miss Jekyll's eyesight diminished—and with typical innovative skill to demonstrate his 'central idea' springing from the given site, relating to it each component of building or garden. In practice, the initial siting, dominant features, and vistas were his, to be discussed later with his partner; hers was the responsibility for planting plans. The success of this working synthesis was manifest in the partnership's prolific years from 1893 to 1912 which created some 70 gardens.

With Lutyens's increasing commitment to public projects (such as *New Delhi from 1912 onwards), and Gertrude Jekyll's advancing age and myopia, their links became more tenuous. After the First World War Lutyens as imperial architect to the War Graves Commission showed increasing classicism in design (see *cemetery), particularly at *Gledstone Hall (1923) and *Tyringham (1924) which are among his more important surviving gardens. I.L.P.

See also AMMERDOWN HOUSE; CASTLE DROGO; DEANERY GARDEN; ENGLAND: THE TWENTIETH CENTURY; FOLLY FARM; GREAT DIXTER; HESTERCOMBE; INDIA: ANGLO-INDIAN GARDENS; KEDLESTON HALL; LAMBAY ISLAND; LITTLE THAKEHAM; MARSH COURT; MOUNT STEWART; SALUTATION, THE.

Luxembourg Gardens, Paris. The palace and gardens were begun in 1612 for Marie de Medici (1573–1642), Queen of France, partly inspired by the *Boboli Gardens, Florence, where she had lived in her youth. The architect was Salomon de Brosse; Nicolas Deschamps was named gardener in 1611, and replaced by Guillaume Boutin in 1615. A large sunk parterre, square with a rounded end, was laid out by Jacques *Boyceau de la Barauderie, with *broderies* incorporating Marie's monogram. The whole was surmounted by a stone border with pedestals for pots and statues. Further expansion south on the axis of the palace was blocked by the monastery of the Carthusians, who would agree to only minor adjustments of their boundary; so the gardens extended in a lop-sided manner to the west, with a central *allée* of elms aligned on the basin and fountain in the centre of the parterre. Water was brought in an aqueduct from Arcueil, devised by Thomas *Francini. At the east end of the *allée* running parallel to the south façade of the palace was the Grotte de Luxembourg, a substantial architectural fountain in a rustic style set against the wall of buildings closing the vista on that side. A large central niche, flanked by columns and two small niches, was surmounted

Luxembourg Gardens, Paris, the parterre, engraving (*c.*1650) by Perelle

by a pediment with the Medici arms supported by two figures representing the Rhône and the Seine. When the Rue de' Medicis was made in 1862, this was moved north to the east side of the palace, and is now a free-standing feature at the head of a canal. At the same time the figures of the rivers were replaced; others were added in the side niches, with Ottin's big group of Polyphemus discovering Acis and Galatea in the centre.

André *Le Nôtre was in charge of the gardens for Gaston d'Orléans until 1642. John *Evelyn wrote in 1644 that all was kept in exquisite order, and yet no gardeners were seen, because all the work was done early in the morning.

In 1694 Gaston's grand-daughter gave the Luxembourg to Louis XIV; for 60 years it was used to accommodate distinguished visitors and members of the royal family. The neglected gardens were the inspiration of some of Watteau's romantic paintings. Between 1782 and 1791 Louis XVI's brother, the Comte de Provence (Louis XVIII), sold part of the garden (west of the present Rue Guynemer) to pay for restorations. After the Revolution the Carthusian monastery was destroyed; and in 1798 an avenue was made extending the axis of the parterre south, to link it with the Observatoire (1668–72) designed by Claude Perrault. The author of the plan was the architect Chalgrin, who also redesigned the gardens, making two semicircular bays on either side of the parterre. The ground west of the avenue was used as a nursery until 1866, when the Rue Auguste

Comte was cut, leaving part attached to the Luxembourg to be laid out as a *jardin anglais*.

Since 1946 the palace has housed the Conseil de la République (the French second chamber). The gardens are a favourite resort for residents of the left bank. K.A.S.W.

Lvov, Nikolai Aleksandrovich (1751–1803), was a Russian poet, musician, artist, and inventor, as well as a distinguished and influential architect and landscape architect, who designed mansions, churches, and cathedrals in St Petersburg (Leningrad) and other cities, and country seats with their gardens and parks in various parts of the country. Among the latter were Wedenskoye and Voronovo near Moscow and Znamenskoye, Mitino, Vasilevo, and his own Nikolskoye near Torzhok. Like A. T. Bolotov he sought to design a specifically Russian style of landscape. He gave free rein to his enthusiasm for garden temples; he considered water a vital element—'I feel that romantic views without water can have only the beauty of a dead place'; and he liked to plant pines in close groups surrounded by deciduous trees, giving, when they developed, the effect of a *bosquet*. He wrote a treatise on landscape architecture based on his work on the park of the Bezborodka Palace on the River Yauza in Moscow. S.P.

Lyons, Rhône, France, Parc de la Tête d'Or. See PARC DE LA TÊTE D'OR.

Macao. See LOU LIM LEOC GARDEN.

Macartney, George, Earl (1737–1806), Irish plant-collector. See STAUNTON, SIR GEORGE LEONARD.

MacClair, Denis (1762–1853), Irish garden designer. See MIKLER DIONIZY.

Machchi Bhawan, Agra Fort, India, the Fish Square, was once one of the two major Mogul gardens of the Fort at Agra. Named after its tanks of sacred fish, it was richly planted, and its fountains and channels repeated the pleasures of running water which Niccolao Manucci described. In the 18th c., however, it was pillaged by the Jats, who removed much of the marble work to the palace of Deeg at Bharatpur.

Later, during the administration of Lord William Bentinck, the remaining marble and mosaic work was sold, and no trace of the garden now remains, other than its name.

S.M.H.

Macleay, Alexander (1767–1848), Australian politician and garden designer, was the New South Wales Colonial Secretary under Governors Darling and Bourke, and a public figure with unusually wide interests embracing horticulture and botany. He arrived to take up his post in Sydney in Jan. 1826, and pursued scientific interests as his chief recreation, regularly dispatching specimens to the Royal and Linnean Societies. On Elizabeth Bay to the east of Sydney he created a large garden famous for its rare plants, which was laid out before the construction of its centrepiece, a grand Greek Revival mansion, between 1835 and 1838. The steeply sloping site encouraged picturesque effects aided by the wide range of unusual plants. The garden was designed in a hybrid style combining elements of the landscape and picturesque styles. Only a small overgrown fragment has survived the intensive development of Potts Point.

H.N.T.

McMahon, Bernard (c.1775–1816), was an Irishman who settled in Philadelphia, where he ran a flourishing nursery business patronized by all the local gardeners, botanists, explorers, and others interested in his plants. In 1806 he published the first book devoted to gardening in an American setting, *The American Gardener's Calendar*, which included an extensive list of the plants available from his nursery. Eleven later editions were published, the last as late as 1857. Thomas *Jefferson entrusted him with seeds and plants from the *Lewis and Clark expedition, the first to cross the continent. His office became a sort of club-house, frequented by explorers and the local enthusiasts who helped to found the Pennsylvania Horticultural Society in 1827.

S.R.

Madama, Villa, Rome, built between 1516 and 1520, was designed by Raphael, Antonio Sangallo the younger, Giulio Romano, and Giovanni da Udine for Cardinal Giulio de' Medici (afterwards Pope Clement VII). This first Renaissance villa outside Rome was built along the eastern slopes of Monte Mario as an almost purist reconstruction of a great classical villa of the kind described in the letters of *Pliny the younger.

The plan consisted of an open central circular court within a symmetrical building from which radiated four contrasting formal landscapes. The circle co-ordinated the open space design. To the south was a *cortile* (courtyard) and monumental stair approach; to the west, an open-air classical Roman theatre excavated out of the hillside; to the north, formal terrace gardens along the slopes leading to a *giardino segreto*; and seen from the east loggia and main façade, a spectacular view towards Rome over the hippodrome with its stabling for 250 horses. Little remains beyond a fragment of the circle, the beautiful north loggia that rivals Raphael's Vatican *stanze*, and the immediate terrace, including a lower pool with three classical niches. Although the villa was never completed (and was burnt in the sack of Rome in 1527), the design with its monumental mastery of relation to site, influenced the future of Roman villa building to a degree second only to Bramante's *Belvedere Court of the Vatican.

G.A.J.

Madīnat al-Zahrā'. See MEDINA AZAHARA.

Madrassa Mader-i Shah, Isfahan, Iran, the theological college of the Mother of the Shah, was built in the early 18th c. It lies to the south-west of the Maydan in Isfahan, and is entered from *Chahar Bagh Avenue through a marble and tiled entry portal decorated with gilt medallions and intricate arabesques. Contained within the college is a courtyard garden of less than 0·5 ha. surrounded by a two-storey arcade behind which are the students' rooms. Down the centre of the garden is a long step-lined canal that links the entry portal with a vaulted recess at the east end; in the centre of the south side of the garden is a sanctuary. There are also an ablution pool filled to the brim with dark water, and several shady old plane trees.

J.L.

See also ISLAM, GARDENS OF.

Maia, Ilfov, Romania, has a garden which was abandoned when its owner, Barbu Catargi (1807–62), President of the first Romanian government after the definitive Union of the Principalities had been proclaimed (22 Jan. 1862), was assassinated upon leaving the Chamber of Deputies. The house, all shutters closed, lies in the midst of a park which must have been laid out according to the design of an architect skilled in landscape gardening, for it offered all the attraction of romantic scenery: running water spanned by arched bridges among weeping willows; Chinese pagodas—very like the blue pattern on Wedgwood porcelain; a lake and artificial mounds deepening the perspective; and a rockery and groups of exotic trees standing out against the backcloth of the wood which bordered the River Prahova.

<div align="right">M.G.</div>

Maintenon, Eure-et-Loir, France. In 1676 *Le Nôtre redesigned the grounds of an old château for Mme de Maintenon. The canalized rivers Eure and Voise supply the moats, surround the parterre, and extend in a grand canal, to which the ruins of the aqueduct, intended to bring the waters of the Eure to the fountains of *Versailles, form an effective climax.

<div align="right">K.A.S.W.</div>

Maisons, Yvelines, France, is François *Mansart's most complete expression of his idea of a country house, commissioned by the lawyer René de Longueil in 1642. The château is raised on a platform, surrounded by dry moats and a terrace overlooking gardens on three sides. The entrance is at right angles to the main axis of the château, which is marked by an enormous avenue 1·5 km. long, leading into the forest of Saint-Germain to the north-west, closed by a large circular excavation in the form of a *saut de loup* leaving the central vista open, access to the avenue being by gates on either side. The main rooms faced south-east, overlooking the *grand parterre* with the axis continued in an avenue on the far side of the Seine. In 1777 Maisons was bought by the Comte d'Artois (the future Charles X) who filled in the moats, and transformed the gardens into a park à l'anglaise. After the Revolution the park was sold in lots by the banker Jacques Lafitte, but its general lines (including the avenue and *saut de loup*) have been preserved in subsequent development. The château belongs to the State, and the parterre has been restored.

<div align="right">K.A.S.W.</div>

Majorca. The fertile land, abundant springs, and mild climate attracted Phoenicians, Romans, Moors, and Spaniards to Majorca, the largest of the Balearic Islands. In the north the land is terraced and irrigated from aqueducts fed by springs and reservoirs dug out of the mountainsides. In the plains it is characterized by innumerable windmills pumping water up from the wells and the cisterns over which each house is built. While every house has its garden in the form of a terrace shaded with vines and planted with geraniums, the decorative or pleasure-garden exists only as a by-product of the agricultural estate. Of these the largest and most important lie among the foothills and mountains to the north and east of Palma, the principal settlement of the Moors.

In all of them the siting of the buildings is of prime consideration, expressing at once the idea of integration with the landscape and of domination of the agricultural domain, across which they are approached via impressive gateways and avenues of plane trees, palms, cypresses, or olives. The buildings themselves comprise largely 17th- and 18th-c. elements grafted on to a Moorish/Spanish vernacular, the former being particularly evident in the form of the round arched Italianate loggia and balustraded terraces. The Moorish qualities are generally less evident except in the choice of sites, the use of water, and a number of details. A notable exception is the layout and a part of the garden of *Alfabia, one of the original Moorish estates, said to have been built by Moorish craftsmen from the 15th c. onwards (see plate II*b*).

Byne and Stapley (*Majorcan Houses and Gardens*, 1928) list over 20 houses, of which about half had gardens of significance. Of these, most are now either wholly or partly in a state of dereliction. Characteristically they are built up in terraces behind finely jointed polygonal limestone walls which contribute to the grandeur of the house. These terraces are usually irregular as at Son Morgas, near Valldemosa, but in some cases they have a carefully contrived geometrical relationship with the house. This occurs in the great Carthusian monastery at Valldemosa, where Chopin lived for a short while, and, in a spectacular octagonal pyramidal form, at Son Zaforteza near Puigpuñent. In some cases the terraces occur or continue behind the house where they form the basis for the garden.

The Italian influences of the 17th c. introduced the loggia to the houses and axial planning to the gardens, as at Son Moragas, *Raxa, and Canet near Esporlas. At Moragas and Raxa the terraces are divided by steep flights of steps; at Moragas, they are simple and flanked by cypresses leading

Son Zaforteza (17th c.), Puigpuñent, Majorca (drawn by Michael Lancaster from Byne & Stapley, *Majorcan Houses and Gardens*)

up to a grotto and the huge circular cistern in the pine-woods, known as 'the Arch-Duke's Swimming Pool'; at Raxa, they are elaborate with sculptured reliefs. At Canet near Esporlas the steps and terraces rise grandly up from the road like the traditional Majorcan avenue, but lined with cypresses and pines.

Moorish influences are strongest in the siting of La Granja, famed for its abundant water, in the layout and detail of Alfabia, and in the terracing of Raxa. La Granja was originally a Moorish estate, taken over by Cistercian monks and sold to the Vida family in 1477, who passed it on to the Fortunys family in 1665. It now houses a crafts museum and is something of a tourist trap, but it is still possible to appreciate its former character in the house with its ramped approaches, internal and external courtyards, and dramatic fountain jet, and in the extraordinarily long vine-covered pergola which gives unity to the narrow straggling garden.

M.L.L.

Malaysia is a green country with most of the land still under tree cover either as primary or secondary tropical forest, or under tree crop cultivation. The evergreen landscape, a product of a remarkably uniform tropical climate with rain falling throughout the year, is punctuated only at intervals by rice-fields after harvest (3 per cent of the land) and the marginal deciduous effects of the monsoonal influence, particularly in the very north of the country. The forests are non-specialized and support a tremendous diversity of plant life. In the primary forest over 2,500 tree species may be found, arranged sometimes at a density of as many as 250 genera to the hectare. There are well over a hundred edible fruits, and some species, such as the mango or durian, each have over 20 wild varieties. The high forest in the lowlands is dominated by dipterocarps, but the character of the forest is extremely diverse, dependent on local soil conditions, slope, and microclimate. Mangrove forest dominates shallow shelving seashores and the brackish reaches of rivers, *Terminalia-Barringtonia* formations on the sandy foreshores, and *Saraca* species on rocky stream-sides; and at altitudes over 1,000 m., particularly along the central mountain spine of the peninsula and the highlands of Sabah and Sarawak, the forest is composed of subtropical oaks, eugenias, laurels, and coniferous genera such as *Agathis* and *Podocarpus*.

The botanical diversity of the forests and their economic importance particularly for commercial hardwoods have meant that horticulture and garden and park design and its traditions have been comparatively undeveloped until recent times. Of much greater interest has been the desig-nation of national parks and the need to conserve the primary forests with all their opportunities for scientific study. The major national parks of West Malaysia today include Taman Negara, covering 4,343 sq. km. of the states of Pahang, Kelantan, and Trengganu, accessible only by river and jungle paths. In East Malaysia the 647 sq. km. Mount Kinabalu National Park in Sabah rises to 4,101 m. at the summit through changing vegetation zones containing oak, rhododendron, moss forest, and a summit zone con-taining subalpine plants. It is easily accessible by road to the headquarters at 1,829 m. The parks in Sarawak include the largely unexplored Gunung Mulu National Park dominated by its extraordinary limestone mountain scenery, and the coastal Bako National Park covering 26 sq. km. of coastal cliffs and sandy bays. Other parks include several islands around the coast of Sabah, and newly designated forest reserves.

Research into commercial forestry and economic botany depended both on the establishment of botanic gardens and the creation of forest research centres. In the 19th c. the British established botanic gardens in *Singapore and on Penang Island, both still important as parks although the Penang garden has not been managed as well as that of Singapore. In the 1920s the main Forest Research Institute was established at Kepong just north of Kuala Lumpur, and today contains valuable collections of forest trees planted on well-managed lawns, as well as forest plantations with trails and plant propagation areas.

The development of parks and gardens in Malaysia dates primarily from the British colonial era during the late 19th and early 20th cs. when population densities and urban growth increased. Prior to that, gardens would have been associated mainly with mosques, banyan and frangipani trees at Buddhist temples, and the grassed lawns of sultans' palaces. With the rapid development of rubber plantations in the early 20th c., particularly in the lowland dipterocarp forest on the west coast of the peninsula which occupies some 12 per cent of the land area, the British opened up small hill-stations as sanatoriums to benefit from a cooler climate. The hill-station at Fraser's Hill with its small British bungalows, 9-hole golf-course, conifers, and gardens has more of the feel of Surrey than of the tropics, as does the larger development of the Cameron Highlands where, today, tea plantations and temperate vegetable and carnation farms exist. Kuala Lumpur, a product of the development of tin mining and rubber plantations, also boasts parks and gardens dating from this era. Large private gardens exist round the houses developed in areas such as Kenny Hills and the main Lake gardens were laid out around what are today the Parliament buildings. The Tudor style Selangor club and the great Gothic railway-station adjoining the *Padang* in the centre of town symbolize the high points of building styles that can be seen to a lesser extent in smaller towns where administrative buildings have been planned around central *padangs*. Further hill-stations exist at Maxwell's Hill, approached via 72 hairpin bends, and on Penang Hill, accessible only by funicular railway, but where the climate is a temperate 75° F and walks exist amongst the conserved forest. A new forest recreational park has now been developed at Telok Bahang on the north-west slopes of the hill.

Today the rapid increase in urban populations and the destruction and over-exploitation of the tropical forests, now covering no more than 50 per cent of the country's land area, have dramatically raised the level of environmental consciousness. Recreational pressure has resulted in the opening up of the Genting Highlands, and the development

of Templers Park outside Kuala Lumpur, while the creation of new settlements and towns such as Shah Alam have necessitated the creation of parks and public gardens as part of their infrastructure. There is also an increasing need to restore derelict land, associated particularly with tin mining, both for housing and leisure areas, and an increasing demand for golf-courses and formal recreation areas. In part this desire to improve the urban environment can be attributed to the wish to compete with the dramatic planting schemes in neighbouring Singapore. Tourism and international business have required better planned hotels and associated gardens like the ones at Batu Feringii on Penang Island, in central Kuala Lumpur, or in the new resorts along the east coast of the Peninsula. N.T.

Malmaison, Hauts-de-Seine, France, was the favourite residence of *Joséphine, Empress of France (1804–9), with a garden *à l'anglaise* by Louis Berthault. Its lawns, the winding streams with miniature cascades, and the Temple d'Amour (by Alexandre Lenoir) perched on a rock are illustrated in Alexandre de Laborde's *Nouveaux Jardins de la France* (1808). The garden was the subject of two other books which include some of Redouté's finest work: E. P. Ventenat's *Jardin de la Malmaison*, 2 vols., 1803–5, with 120 plates; and Aimé Bonpland's *Description des plantes rares cultivées à Malmaison et à Navarre* 1813, with 52 of the 64 plates by Redouté (see also *botanical illustration).

The park once covered 726 ha., with a model farm and menagerie which included emus and kangaroos. There were black swans on the lake and, among other Australian introductions, acclimatized trees and shrubs such as acacia, casuarina, and grevillea. The famous hot-house built by Jean-Thomas Thibaut and Barthelemy Vignon no longer exists; and the garden is much reduced in size, with part adjoining the forecourt set aside for the cultivation of roses for which Malmaison was noted. K.A.S.W.

Mansart, François (1598–1666), French architect, was the most original of those who established the French classical style. His first work of any consequence for garden design was the château of *Balleroy in Calvados, built for Jean de Choisy between 1626 and 1636. *Maisons (1642–51), for René de Longueil, was a landmark in French château design, free-standing, surrounded by dry moats, with all approaches kept as open vistas, closed only by *sauts de loup*, the entrance gates being to either side.

Between 1630 and 1639 Mansart was architect to Gaston d'Orléans, for whom he began the rebuilding of the château of Blois. Other places where he incorporated designs for gardens in the general scheme between 1640 and 1660 were Fresnes (near Lagny), Petit-Bourg (on the Seine between Paris and Fontainebleau), and Gesvres-en-Brie, none of which have survived. His use of the extended axis and his skill in siting his buildings influenced the course of garden

Malmaison, Paris: Napoleon and Joséphine in the garden, from A. de Laborde, *Nouveaux Jardins de la France* (1808)

design through *Le Nôtre, who worked under him, and his great-nephew, Jules *Hardouin-Mansart, who carried on the architectural tradition to become Surveyor of the royal works at a time when French garden design had reached the peak of its achievement. K.A.S.W.

Mar, John Erskine, 11th Earl of (1675–1732). See ALLOA.

Maries, Charles (1851–1902), English plant-collector, was a foreman in the *Veitch nursery who was sent to Japan and China in 1877 to collect plants for the firm. He was away for three years, spending several months of each year in China, where he travelled up the Yangtze as far as Ichang, and the rest of his time in Japan. The plants he sent back included *Daphne genkwa, Hamamelis mollis*, now a favourite winter-flowering shrub, *Abies mariesii*, several maples and viburnums, and the first lacecap hydrangeas. He also sent large quantities of *Primula obconica* seed. The rest of his life was spent in India, where he was in charge of the gardens of the Maharajah of Gwalior. S.R.

Marino, Co. Dublin, Ireland, has a *demesne of 80 ha. on the north shore of Dublin Bay with wide prospects of sea, city, and mountain. Its plantations, lake, and ornamental buildings were laid out principally between 1756 and 1799 by the 1st Earl of Charlemont, patron of the Italian architect Piranesi. First built was a walled garden of pentagonal shape devised by Matthew Peters, author of agricultural treatises, who was brought up under his uncle William Love, 'Capability' *Brown's predecessor as head gardener at Stowe. In 1767 Charlemont obtained designs for a *casino from Sir William *Chambers. A Greek cross in plan, it is one of the landmarks in the revival of neo-classical architecture. Its exterior is decorated with bas-reliefs by Cipriani and sculpted lions by Joseph Wilton, based on those in the Villa Borghese in Rome.

Later, a series of garden buildings (all now ruined) were laid out along a ridge at some distance from the house to take advantage of the view which was denied to the house as it lay down near the shore. These included: a Gothic room, called Rosamund's Bower, by the Swiss architect Johann Muntz; a root-house; a cascade with poetic inscriptions on its rocks; and 'a cane house constructed after the Eastern model'. Chambers also furnished designs for a remarkable building called the Hunting Lodge, and for two sets of gates and screens which survive today. The *casino* and a small area of parkland are under restoration. P.B.

Maritime Park, Varna, Bulgaria, extends along the Black Sea coast and with its varied scenery forms an integral part of the skyline of Bulgaria's biggest port as seen from the sea. Created in 1862 by the then Turkish vali Hafuz Eyub on a very restricted area, it was rapidly extended after the nation's liberation, thanks to the efforts of its first Bulgarian mayor M. Kolonyi. During the last decade it has been merged with the Saltanat Gardens into a single landscape covering a total area of over 120 ha., thus acquiring its final appearance. The spatial conception is characterized by a harmonious combination of already well laid-out clusters of various tree species and effectively distributed single trees: maples (*Acer platanoides*), albizias, maidenhair trees, cedars, cypresses, fir trees, sequoias, euonymuses, chaste trees, rosemaries, *Caryopteris*, bladder-nuts, and magnolias. The Maritime Park is also one of Varna's cultural centres, containing a *casino*, an observatory, an aquarium, a museum, a summer theatre, and busts of eminent Bulgarians, as well as fountains, a lake and, of course, the adjacent beaches. D.T.S.

Marlia, Villa, Lucca, Tuscany, Italy, was laid out in the late 17th c. by the Orsetti family; from 1806 to 1814 it was the summer residence of Napoleon's sister, Elisa Baciocchi, who added neo-classical modifications and enlarged the garden. Immediately in front of the villa is a large green esplanade used for exercising the horses; to the east is a series of elegant open-air garden rooms, first seen from before the house as an enticing cross-axis—a pier-framed vista disappearing in perspective. The spaces seem to be carved out of woodlands, delineated by high walls of clipped yew, and are a priceless study in classical proportions when seen on plan. The first compartment, or green *salon*, is about 40 m. wide and three squares in length. The length is equally divided between a flowered parterre garden and a balustraded water rectangle culminating in a baroque fantasy with giants. The cross-axis continues across the water and, after a short rising corridor, enters a circular ante-room with a pool and fountain. Continuing through a similar corridor, it finally enters what many consider the most beautiful as well as the best preserved open-air garden *theatre in Italy. The auditorium is semicircular, the stage recedes with wings and backcloth, and the whole is encompassed within a circle whose centre is the prompter's box. The stage is permanently furnished with terracotta statues of Columbine, Harlequin, and Pulcinella; thus even without an audience it is evocative of its past. G.A.J.

Marly, Yvelines, France, was created by *Hardouin-Mansart, *Le Nôtre, and *Le Brun at the same time as the final enlargement of Versailles, which was to become, in 1682, the official seat of the Government and of the Court. The old Versailles, the beautiful *maison de chasse* of Patel's painting (*c.*1668), was submerged in the enormous palace that now engulfed it, and with it was lost the setting of Louis's exclusive house parties. He needed somewhere else for his selective entertaining and in 1679 he chanced upon the site of Marly.

The natural formation was that of a steep-cut re-entrant in the shape of a long horseshoe opening towards the valley of the Seine. The disposition of the buildings was made to conform with the lie of the land, the King's house occupying the focal point and 12 pavilions for the guests lining either arm of the horseshoe. The low ground in the centre was cast into terraces and a series of monumental lakes was contrived in the line of the main axis. On three sides high, wooded hills enclosed the site; on the side open to the valley the land fell away, revealing a magnificent prospect towards Saint-

Perspective view of Marly, France, from Matthias Diesel, *Erlustierende Augenweide in Vorstellung hortlicher Gärten und Lustgebäude* (?1717)

Germain. But although the gardens were thus left open to the north, their privacy was secured by the skilful use of ground levels. To obtain sufficient space for the Pièce des Nappes the lower gardens were banked up and ended in a high terrace overlooking the *abreuvoir. From the road it was impossible to see into the grounds; it was only to those privileged to enter the precincts that the whole glorious layout of Marly was revealed. The design was conceived to create and to sustain a flattering sense of intimacy and exclusiveness which lent their special savour to an invitation here.

In the area immediately surrounding the château everything was closely packed and heavily overhung by high banks and steep woods. In each corner was a *cabinet de verdure*, embowered by lime trees, in which was a fish-pond, tiled in porcelain and adorned with figures of birds painted in their natural colouring. To the south of the château was the Petit Parterre from which a noble flight of steps led to an all-encircling pergola which linked the château with its pavilions. Behind this a great cascade known as the Rivière brought its tumultuous waters down the steep avenue from the Réservoir du Trou d'Enfer. Too costly to maintain, Louis XV replaced it by a grass slope. To the east of the Rivière the precipitous contours were used to create the

Roulette—a switchback railway on which ran an ornately gilded toboggan. The King often brought his friends here 'to taste the pleasures of speed'. There were also courses laid out for *mail*, an ancestor of golf, and the Escarpolette— a swing so large as to require two lackeys to pull the cords.

In 1701 Dangeau relates that Louis, having spent the day inspecting the gardens, declared that he could not imagine any further embellishments possible. For the next 13 years, however, he continued to alter and elaborate them. It was the interplay of woods and gardens that gave Marly its special character. Diderot identified it as 'the contrast between the delicacy of art in the bowers and bosquets and the rudeness of nature in the dense bank of trees which overhangs them and forms the background. This continual transition from nature to art and from art to nature produces a truly enchanting effect.'

There was less statuary at Marly than at Versailles and much of what was there found its way to the Tuileries during the Regency. Four have become famous as the *Chevaux de Marly*. The original pair, a *Mercure de Pégase* and a *Renommé* by Coysevox, stood at either end of the terrace overlooking the Abreuvoir. They were replaced in 1745 by Coustou's *Chevaux Cabrés*. All four are today in the Champs-Elysées.

Marly was allowed to fall into ruins during the Revolution and finally demolished by Napoleon; but the strangely beautiful trees remain and the site has been restored in recent years, so that the broad outlines may still be traced.

<div align="right">I.G.D.</div>

Marnock, Robert (1800–89), English landscape designer, often claimed during his lifetime to be the greatest of his day, first became noted for a series of Sheffield commissions: Weston Park, the General Cemetery, and the Sheffield Botanic Gardens, of which in 1834 he became the first curator. In 1840, with Decimus *Burton, he submitted successful plans for the Royal Botanic Society's gardens in the inner circle of *Regent's Park, and in 1841 became curator there, in which capacity he served until 1869. He continued his practice as a landscape designer none the less, retiring from this work only in 1879; among his most important commissions were gardens at Rousdon, Eynsham Hall, and *Warwick Castle.

Much of his work was in a 'semi-natural' style, incorporating areas of flower-bedding, often quite formal, within the general outlines of the informal landscape park; but in this he owed as much to contemporary French practice as to the English tradition, just as he helped to popularize in England current French ideas about informal conservatory planting and picturesque layout for flower-shows. These ideas were carried on by his protégé at Regent's Park, William *Robinson, whose garden at *Gravetye Manor he helped to design in his last years.

<div align="right">B.E.</div>

See also BED, BEDDING.

Marot, Daniel (1661–1752), was a French Huguenot artist who trained under Jean Bérain in Paris before emigrating after the Revocation of the Edict of Nantes in 1685 to the Netherlands, where he became designer to William III.

With an ebullient baroque flourish Marot adapted the Louis XIV style of garden ornamentation to the Dutch classical canal garden, resulting in a Franco-Dutch style. His designs of garden ornament, many motifs of which echo those of his interiors, were disseminated by his engravings (*Oeuvres de Sieur Daniel Marot*, 1703 and 1712; repr. P. Jessen, *Das Ornamentwerk des Daniel Marot*, Berlin, 1892), which illustrate elaborate and exuberant parterres, intricate *bosquets* and labyrinths which prefigure the rococo, fountains, statues inspired by those of *Le Brun, urns, seats, pavilions, *treillage* arbours, and *berceaux*.

Marot collaborated with Jacob *Roman on the ornamentation of *Het Loo, *Zeist, and *de Voorst. At *Rosendael he designed a pavilion and ornate shell gallery and at *Twickel parterres and *bosquets*. That Marot did not excel as a landscape designer is shown by two disjointed and heterogeneous rococo plans of *c.*1730 of Huis ten Bosch and Meer en Berg, in which he introduced garden theatres inspired by the Galli di Bibiena. His influence is reflected in Belgium and Germany, and at *Hampton Court where he designed the parterres of the Great Fountain Garden and possibly the Privy Garden and the Wilderness.

<div align="right">F.H.</div>

Marshall, William (1750–1818), English writer and gardener, had a natural flair for agricultural improvement, about which he wrote forcefully. Samuel Pipe-Wolferstan of Statfold, Staffordshire, was much impressed by Marshall's *Minutes of Agriculture* (1778), and invited him to run his estate. They were as interested in 'rural ornament' as in 'rural economy', and Marshall's *Planting and Ornamental Gardening* (1785, enlarged edn. 1796) sprang from their joint endeavours. He was familiar with the writings of *Whately, William *Gilpin, William *Mason, and Daniel Malthus, and reprinted *Walpole's essay *On Modern Gardening*. He considered how the style of improvement should reflect the character of the place, and criticized *Brown's designs for their sameness and bare foregrounds.

Marshall worked more commonly on 'rural economy', but in 1791 he practised 'rural ornament' at Buckland Priory, Devon, and in 1792 he advised on it at Taymouth Castle, Perthshire (Tayside Region). To the delight of William Mason he virulently attacked *Price and *Knight in 'A Review of *The Landscape, A Didactic Poem*; also of *An Essay on the Picturesque*' (1795).

<div align="right">D.L.J.</div>

Marsh Court, Hampshire, England, the last of *Lutyens's 'Tudor' houses, was built for Herbert Johnson between 1901 and 1904. Constructed of local chalk and enriched with dressings of russet brick, it stands on a long sloping shoulder above the River Test.

The approach is from the north by a shaded drive-way, descending between steep planted banks and over a bridge into the forecourt. West and south of the house advantage was taken of the sloping site to integrate buildings and garden with the landscape by a series of terraces, bounded by hedges or balustrades. The pergola leading to a tree-fringed croquet lawn seems an extension of the house wall which supports it along one side; its western end leads to the main, informal courtyard or piazza on the south side of the house. From here the path can be taken, by several changes of level, to the long pergola, spanning a range of small pools, that forms the further boundary, with its view over the river valley. Adjoining this is the gateway to the sunk pool garden, where high balustraded walls of chalk, brick, and flint form a dramatic enclosure for a long, narrow lily-tank fringed by steps descending below water level. Round it run brick and stone patterned paths, backed by borders of Gertrude *Jekyll's mixed planting, and now emphasized by sentinel Irish yews at intervals along its edge. Running northwards from this point a long, paved yew-hedged walk leads uphill to the circular flight of steps marking the entrance to the woodland sheltering the house.

<div align="right">I.L.P.</div>

Martinsson, Gunnar (1924–), Swedish landscape architect, trained in nurseries in Sweden and Denmark prior to attending the School of Agriculture and Horticulture in Stockholm, and gained experience in landscape architectural practices in Switzerland, Germany, and Italy before returning to Sweden to work with Sven *Hermelin. In 1956 he started his own practice and later taught at the College of Art in Stockholm. Since 1965 he has been

Professor of Landscape Architecture at Karlsruhe University, West Germany. Martinsson has his own unique style of drawing, well illustrated in his *En bok om trädgårdar* ('A book about gardens') (1959) and *Mitt hem och min trädgård* ('My home and my garden') (1963). He has won numerous competitions, some of which have been carried out, and he has also designed the landscape site plans for the universities of Bremen and Karlsruhe, and urban developments in Stockholm and Ludwigshafen, for which he was awarded the BDLA (German Landscape Institute) prize in 1981. In addition, he has also received the State Prize for Town Planning and Architecture, Rheinland Pfalz, in 1982 and the Friedrich Ludwig von Sckell Honour from the Bavarian Academy of Fine Arts in 1983. P.R.J.

Martonvásár, Hungary, became the property of the Brunswick family in 1758 when it was still a marshland. By careful selection of trees according to their colours, height, and shape, it proved possible to transform the ground into a garden. The mansion and the church were connected by a long line of poplars. The French formal garden was probably laid out in the 1770s, with many varieties of trees and plants being imported from the United States. After 1810 it was altered to a *jardin anglais* by H. *Nebbien, who had worked for the same family at Alsókorompa (Dolná Krupa). This huge garden with a large *bassin* and various fine trees, such as poplars, catalpas, limes, and weeping willows, became famous through the visits of the composer Ludwig van Beethoven, who spent some time here in 1809 and 1811 as a friend of the family. A famous *rond-point* of limes is mentioned by Theresa Brunswick in her diary.

The original area of 300 ha. has now shrunk to 50 ha., but the main character of the earlier *jardin anglais*, with its impressive stretches of water, has survived. A.Z./P.G.

Mascaron, a grotesque decorative mask on cascades, fountains, keystones, etc., as at *Vaux-le-Vicomte and *Sceaux. K.A.S.W.

Mason, George (1735–1806), English writer, made tours of Yorkshire, Derbyshire, and Wales but his chief recreations were book collecting and landscape gardening at his Hertfordshire estate, Porters. Written guidance on garden design was limited to Shenstone's *Unconnected Thoughts* (1764), and Mason endeavoured to supplement these in *An Essay on Design in Gardening* (1768). He neither admired Lancelot *Brown's imitations of Nature, nor shared William *Chambers's view that garden design should excite the emotions.

Mason wrote that 'taste is by no means arbitrary', and believed it should mix imagination with logic and sense. He was one of the first published writers to state that 'the species of design should generally conform to the nature of the place'. A second edition of the *Essay* appeared in 1795 with reviews of other books. He was complimentary about Joseph Cradock, whose career and views were similar to his own, and took Humphry *Repton's part against Uvedale *Price. Nevertheless, he was favourably quoted by the latter's disciple, J. C. *Loudon, in *Observations* (1804). Mason sold Porters in 1772, and thereafter resided at Aldenham Lodge till his death in 1806. D.L.J.

Mason, William (1725–97), English poet and landscape gardener, set out his theories on landscape gardening in his long poem *The English Garden*, the first book of which appeared in 1772. Although it may not seem a very practical gardening manual, it reflects the great importance of gardening in 18th-c. taste. Mason himself usually worked on a small scale, having tried out his ideas in his own rectory garden at Aston. He was in his element decorating Richard Hurd's garden with roses, making a romantic setting for Thomas Warton's Gothic house, or placing urns and writing garden inscriptions for his friends.

Only for his friend and patron Lord Nuneham did he undertake any full-scale landscape design. Paul Sandby's famous painting of the flower garden at *Nuneham Park shows how successful was Mason's claim that he brought both 'Poet's Feeling and Painter's Eye' to his gardening art. The cult of flowers and sensibility went hand in hand in Mason's garden. The principles of informal flower-gardening were set out in Book IV of *The English Garden*, where Nerina makes an eloquent plea for the flowers that had been lost in the broad monotone landscapes.

Mason was a friend of William *Gilpin and was responsible for the publication of his picturesque tours. He translated Du Fresnoy's *De Arte Graphica* (1783), and had, according to Gilpin, his own 'very picturesque ideas'. Mason felt that systematized landscape design had brought English gardening into disrepute and he advocated a return to the true principles first established by poets and painters. M.L.B.

Massif, an architectural term for a solid mass of masonry like the foundations for a terrace; in parks and gardens a compact grouping of trees, shrubs, or flowers in ornamental clusters. D.A.L.

Masson, Francis (1741–1806), Scottish plant-collector, was a gardener at Kew who became the first official collector for the Royal Botanic Gardens when he was sent to the Cape of Good Hope in 1772. During the next three years he travelled in South Africa, sometimes with the Swedish botanist C. P. Thunberg. He later collected in the Azores and Canary Islands before returning to the Cape in 1786 for a longer stay, lasting until 1785.

At the suggestion of *Sir Joseph Banks Masson made a garden near Cape Town in which to keep his plants until they could be sent back to England. He introduced many new species, among them large numbers of Cape heaths and pelargoniums, mesembryanthemums, arctotis, lobelias, and proteas, as well as *Senecio cruentus*, parent of the modern cinerarias, from the Canaries. His book on stapelias, partly illustrated by himself, was published in 1796–7, before he embarked on his last collecting journey in North America, where he died in Montreal. The harvest of his American years included *Trillium grandiflorum*. S.R.

Mateus, Vila, Trás-os-Montes, Portugal, belongs to the Condé de Vila Real. Built in the early 18th c., it is one of Portugal's most important country houses, now doubly renowned for the wines exported from the estate. Resplendently baroque on the north—the approach front—on the south side the façade is much plainer. Interest centres on the stretch of spacious parterres which exemplify the changing taste in design among country landowners. The knot garden remains, but now the lines flow gracefully, the edgings being kept low and spaced out widely enough to allow for massed flower effects. Fountains are few, statues sparse, and *azulejos* not to be seen. A conceit of the period acts as a nodal point among the *parterres de broderie*—the Condé's coat-of-arms outlined in minuscule box, the voids being filled with the whitest of gravel, a pencilled, flat effect that catches the eye. Huge arbours of camellias offer shelter from the sun as well as breaking up the formality. The whole impression is of a wide-open, cheerful elegance. To the left a tall, dark hedge, wall-like, boxed into a square, contains a tiny secret garden of formal beds. Nearby a weeping willow hangs over a miniature pond, a modern touch. Further afield still, cherry-blossom walks surround areas of fruit and on all sides flourishes the produce of a well-stocked family garden. Pleasure-grounds merge into vineyards and on into the exquisite countryside. Seldom have house, garden, and landscape harmonized better. B.L.

Mattern, Hermann (1902–71), was one of the most influential figures in post-war German landscape architecture, both as a designer and as a teacher. Following a horticultural apprenticeship, he studied landscape design at the horticultural college in Berlin, and after working briefly for the city of Magdeburg and with Leberecht *Migge, he went in 1927 to head the design section of Karl *Foerster's nursery near Potsdam. Here, together with Herta Hammerbacher and under the influence of Foerster's enthusiasm for rich herbaceous planting, he developed a very sensitive style of garden design which soon moved away from the formality and geometry of the prevalent architectural garden to become particularly characterized by the use of subtle ground modelling to define spaces.

This collaboration continued in various forms until the Second World War, and Mattern was successful in several larger competitions, including a house and garden exhibition in Munich in 1934, and the 1939 *Gartenschau* in Stuttgart in which the *Killesberg Park was created out of a disused quarry. This was reconstructed by Mattern as the first post-war *Gartenschau* in 1950, and he followed it with the reconstruction of the Aue-Park in Kassel for the 1955 *Bundesgartenschau*. He was also involved in the initial planning of Bonn as a new capital city. His interests in the wider landscape and in design beyond the confines of landscape architecture is illustrated by his involvement in the resettlement of farmsteads as part of an agricultural resettlement programme, to which his contribution included the design of the agricultural buildings and farmhouses.

After the war Mattern was closely associated with the founding of the Werkakademie in Kassel, where he taught landscape design as a subject on equal terms with art and architecture. In 1961 he became Professor of Garden and Landscape Design at Berlin University. R.STI.

Mattioli, Pierandrea (1501–77), Italian physician and a botanist, who spent 20 years in Prague in the service of the

Bergius Garden (1927), Heidelberg, German Federal Republic, by Hermann Mattern

Emperor Ferdinand I. His most important work was a large *herbal formed by his prolific annotations of *Dioscorides. *Commentarii . . . Dioscoridis* was first published in Venice in 1544 and appeared in many editions and translations thereafter, the first illustrated one in 1554. It attempted to deal with all the plants known to the author, including some discoveries of his own from the Tyrol and descriptions of others sent to him by correspondents. Mattioli had the advantage of working on a flora not far removed from that of lands known to Dioscorides, so his attempts at the identification of the plants mentioned in the earlier writer's work met fewer problems than those faced by herbalists in more distant parts of Europe.　　　　　　　　　　　　S.R.

Maurits or Maurice (1567–1625), Prince of Orange and Stadholder of the Dutch republic, was a renowned military scientist and progenitor of the Dutch classical garden whose development is largely derived from his application of the classical principles of symmetry and harmonic proportion to the designs of army camps and fortifications. The ground plan of his garden at *Buitenhof (*c.*1620), the earliest known design of a Dutch garden, expresses in its mathematical forms the Albertian ideal of abstract design. Maurits may well have been an influence upon his brother *Frederik Hendrik in the development of the Dutch classical canal garden.　　　　　　　　　　　　F.H.

Mavisbank, Midlothian (Lothian Region), Scotland, according to Roger Gale (1738), was 'one of the most elegant villas I ever saw for structure, situation, woods and water . . . You would think yourself rather in a valley near Tivoli.' It was a convenient half-way house for Sir John *Clerk of Penicuik and was largely paid for out of his salary as Baron of Exchequer.

Mavisbank was designed *c.*1723 by Clerk with William *Adam, and is a rather tall square villa, with pavilions connected by quadrant walls, lying in a miniature valley and of a secluded character. Designs for a parterre, unusually in front of the house, were prepared by William Boutcher, but it is likely that Clerk effectively acted as his own designer. Behind the villa is a Roman fort in the shape of a mount, and the main axis of house and avenue were aligned on this feature. To the south of Mavisbank, and connected with it by a winding path through a *wilderness, is a (nearly) circular walled garden. Since 1972 the house has been a gutted ruin.　　　　　　　　　　　　W.A.B.

Mawallok, Victoria, Australia. It was laid out in 1909, the year of his retirement from the *Melbourne Botanic Garden, by William Guilfoyle—one of his last works, perhaps the grandest. Originally his beloved palms dotted the lawn to emphasize the vistas, but these were removed in the 1930s when the garden was simplified.

The entrance is between formal iron gates supported by tall drums of river cobbles. The dense green background, suggesting a forest after the openness of the plain, is a belt of pine, cypress, and conifers that rings the garden, creating an environment protected from the wind.

The drive leads between groves of trees to the forecourt of the house, an area enclosed by neatly clipped hedging, punctuated to give access to a tennis-court. The house is a picturesque composition of gables, sweeping roofs, and cream roughcast walls, very different from the formal landscape design of which it forms the centrepiece. Its main rooms look out over formal terraces, across wide expanses of lawn, to a lake and beyond to a dark grove of trees and distant mountains.　　　　　　　　　　　　H.N.T.

Mawson, Thomas H. (1861–1933), was the most prolific English garden designer of his day and the author of a highly successful book on *The Art and Craft of Garden Making* which appeared in five editions between 1900 and 1926. Mawson's style is revealed by the title of his book: he admired the *Arts and Crafts movement and joined the Art Worker's Guild in 1905. The historical designers he liked were Edward *Kemp and Humphry *Repton, because of their skill in forming a link between house and garden. Mawson's gardens, many of which survive in good condition, generally have a fine brick or stone terrace near the house and then a transition via flights of steps to lawns, shrubberies, woods, and, if possible, a fine view. Perhaps the best known of his gardens were designed for Lord Leverhulme: The Hill in Hampstead and Roynton Cottage near Rivington, Lancashire.

Mawson was born near Lancaster and became interested in horticulture as a boy. At the age of 12 he started work with his uncle, a builder. Four years later he moved to London and obtained a job with Wills and Seger, a well-known firm of nurserymen and landscape gardeners. At the age of 24 he moved to the Lake District and launched a family firm of landscape contractors. It prospered and Mawson specialized in the garden design side of the business. He entered many competitions and won a medal in the 1892 International Horticultural Exhibition. In 1908 he won first prize for the gardens of the Palace of Peace at The Hague and his scheme was implemented. Other competitions enabled him to expand his practice into the design of public parks and civic design. He gained an international reputation and carried out work in Greece, Canada, and other countries. Mawson became President of the Town Planning Institute and a founder member of the Royal Fine Art Commission in 1923. Bad health curtailed his activities after 1927 but he was elected first President of the Institute of Landscape Architects in 1929.　　　　　　　　T.H.D.T.

See also LANDSCAPE ARCHITECTURE.

Maydan, Isfahan, Iran. See ALI QAPU.

Maze, Labyrinth. Some writers use the term 'maze' to refer only to hedge mazes, while reserving 'labyrinth' for the structures described by writers of antiquity, or as a general term for any confusing arrangement of paths, or where a puzzle is involved. Given this lack of clear definition, both terms are used interchangeably here.

The hedge maze is a relatively recent development of an idea which dates back several thousand years. Though there

Design for a labyrinth, from
Hans Vredeman de Vries,
Hortorum Viridariorumque . . .
(1583)

were structural labyrinths in Egypt and Crete, none of the classical writers give precise descriptions of hedge mazes. The main period during which they were a common feature in garden design was the 16th and 17th cs. in Europe. Along with *giochi d'acqua* and elaborate iconographical programmes, they contributed to the esoteric significance of garden design, as at the Villa *d'Este, Tivoli (where four mazes are recorded in *Du Pérac's 1573 illustration). In Tudor England they first appeared as mazes of low shrubs and herbs (see *knot garden) as described in Thomas Hill's *Treatyse* of 1563. The hedge maze seems to have been a 17th-c. development, the best-known example being that at *Hampton Court, dating from *c.* 1690.

Perhaps the most remarkable example was the labyrinth at *Versailles laid out by Charles Perrault in 1667 (destroyed 1774). It consisted of 39 set pieces—a fountain and sculptural groups representing episodes from Aesop's fables—linked by *allées* whose total length was 750 m. P.G.

See also BRUSSELS COURT; CHANTILLY; EL LABERINTO; GAILLON.

Medici, the Florentine family of bankers, humanists, and art patrons, who became the ruling house of Tuscany. The greatest of the Medici villa-builders was **Cosimo the elder** (1389–1464). Through his architect Michelozzo Michelozzi he inspired the change from the medieval to the Renaissance in Italian garden design—symbolic of the changing age is the fact that while the Platonic Academy was actually founded at the Villa *Medici, Careggi, it was later moved to the Villa *Medici, Fiesole, a new classical building with long terraces overlooking the Arno valley. Other Medici villas of this period are *Il Trebbio and Villa Medici, Cafaggiolo.

After their brief exile (1433–4) the Medici returned to Florence where a descendant of the junior (Lorenzo) line, **Cosimo I** (1519–74), was created the first Duke of Tuscany. His villa garden at the Villa *Medici, Castello, is rather conservative in some respects, but it was the first to embody an iconographical programme, which celebrated the newly reinforced power of the Medici family. His son **Francesco I** (1541–87) built one of the wonders of the age, *Pratolino, in an attempt to outshine the d'Este family. The last major creation of the family was the *Boboli Gardens.

The Medici were also important in carrying the influence of Italian garden design to France. The greatest achievement in this respect of *Catherine de Medici (1519–89), wife of Henri II, was the Palace of the *Tuileries, while Marie de Medici (1573–1642), wife of *Henri IV, began the palace and gardens of the *Luxembourg Palace, inspired partly by the Pitti Palace and the Boboli Gardens.

P.G./G.A.J.

Medici, Catherine de, Queen of France. See CATHERINE DE MEDICI.

Medici, Villa, Careggi, nr. Florence, Italy, was the meeting place of the Platonic Academy, under the leadership of the celebrated neo-Platonist, Marsilio Ficino (1443–99). In 1462, the villa's owner, Cosimo de' Medici, invited the philosopher as follows: 'Yesterday I came to the villa of Careggi, not to cultivate my fields but my soul. Come to us, Marsilio, as soon as possible. Bring with you our Plato's

book *De Summo Bono*.' The land and the old manor with court, loggia, and tower were acquired by the *Medici family in 1417. Cosimo de' Medici asked Michelozzo Michelozzi to transform the fortress-like manor into a villa, adding on the west side a double loggia, which defines a small private garden. This was an imitation of a Roman villa garden, with bay, box, cypress, myrtle, and also various scented flowers, and flower-beds. The house is now the property of the Hospital of S. Maria Nuova in the suburbs of Florence, with little of the garden remaining. P.G.

Medici, Villa, Castello, Florence, Italy. The garden, fully depicted in a *Utens lunette (1599, Museo Topografico, Florence), was described by Vasari as the 'most rich, magnificent, and ornamental garden in Europe'.

It is in some ways curiously conservative in design when compared with the innovations in Rome at the *Belvedere Court and at Villa *Madama. Although the Utens lunette shows that the garden was much more closely planted than it is today (the enclosed area is now a series of parterres, with no vertical accents), the creation of significant features (the fountains and the grotto) on the main axis is a decisive break with the medieval tradition of separate unrelated spaces.

The garden was designed and laid out from 1538 by Niccolò Tribolo (1500–50), being completed after his death by Ammannati and Buontalenti. It incorporates an iconographical programme intended to celebrate the establishment (in 1537) of the *Medici family as virtually an absolute monarchy. This was devised by the scholar Benedetto Varchi (1503–65) for Cosimo, the first Medici Duke of Tuscany (1519–74).

The main features on the axis, which rises through a series of gently sloping terraces, were: the smaller and earlier fountain portraying Venus squeezing the water from her hair (now at the nearby Villa Medici, Petraia); the central feature, the statue of Hercules and Antaeus (completed by Ammannati 1559; in its original position); the *grotto; and, finally, the statue of January, also by Ammannati.

Important differences between the first two statues mentioned above are undoubtedly connected with their position in the garden. In the former, all the sculpture is in relief, while in the latter it registers as free-standing sculpture. A further extremely significant change is that Tribolo developed an animate relationship between the jets of water and the sculpture—water is precipitated from the mouth of Antaeus in a single jet.

The grotto (begun 1546, certainly completed 1569) is set into the garden's enclosing wall. The programme glorifies the rivers Arno and Mugnone as sources of fertility, symbols of the greatness of the house of Medici. In addition, water spurts from the beaks, wings, ears, and noses of a variety of animals.

*Montaigne also describes a cabinet made of evergreen, completely enclosed, in the midst of which a spring rises from a marble table; branches of trees forming the Duke's escutcheon; and *giochi d'acqua manipulated by the gar-

dener 'two hundred paces away' (*Diary*, mid-Nov. 1580, trans. E. J. Trechmann, pp. 111–12).

Although important features such as the grotto and the Hercules have survived, the present planting of the garden is rather bare and monotonous. P.G./G.A.J.

See also ITALY: FLORENCE AND GENOA IN THE SIXTEENTH CENTURY.

Medici, Villa, Fiesole, nr. Florence, Italy. Designed *c.*1458–61 by Michelozzo Michelozzi for Cosimo the Elder, this was the first true Renaissance villa. The same architect had previously designed traditional gardens at the Villa *Medici, Careggi, and *Il Trebbio, Cafaggiolo, both for the *Medici family, and all three were intended as dignified seats of the new humanist movement. The gardens at Fiesole have been superficially altered but the form remains unchanged. At unusual expense in relation to the modest villa itself, two major terraces were constructed out of the steep hillside, consciously designed for views overlooking a distant panorama, in accordance with *Alberti's recommendation. The upper terrace on which the house stands is an extension of the interior and used as an outdoor *salon*. The lower terrace is difficult of access from above and although today laid out as a formal parterre garden, was probably originally a fruit and vegetable garden. A raised vine pergola runs along the base of the upper retaining wall, giving shade against the south sun. Perambulation along the horizontal lines of the main terrace must have promoted philosophic discussion, while the little *giardino segreto west of the house (which remains unchanged) must have provided inner contemplation, with its seclusion and uninterrupted views over Florence and the Arno valley. In this lovely setting Lorenzo would entertain such distinguished members of his Platonic Academy as Pico della Mirandola and Marsilio Ficino, as well, no doubt, as the artists and scholars with which Florence abounded. G.A.J.

Medieval garden. The history of European gardens in the Middle Ages has not attracted much attention because of several difficulties. No garden of the period exists; there are few visually acceptable representations of actual gardens, but only typical scenes; and even those almost all date from after 1400. Furthermore, horticultural literature of the period (*c.*500–1500) is scanty. Not only are Roman gardens better documented, but they have been better investigated by archaeologists. Our knowledge is a mosaic of scattered facts drawn largely from sources marginal to horticulture. Substantial archives concerning gardens begin only in the 13th c.

The period starts with the fall of the Western Roman Empire in 476, but a truly dark age ensued for some three centuries until *c.*800. Gardening then differed considerably from what it had been in Roman times both in form and content. We must accept this gap and wait for field archaeology to bridge it. There was not only loss but, in spite of 10 generations of barbarism, a substantial accession of new plants and ideas from the East. From late classical times there survived manuscripts of the *De re rustica* of Palladius,

largely a gardener's calendar showing work to be done each month. In northern Europe, however, the literature counted for very little and progress lay in the hands of practical master gardeners until the 16th c. The gardeners worked for enlightened patrons including kings, queens, noblemen, bishops, and abbots concerned to obtain not only adequate food-crops of good quality but also pleasure-gardens and parks for recreation. In the Carolingian epoch (see *Carolingian gardens) there is remarkably full evidence for both utilitarian and aesthetic horticulture. For a single generation, between 800 and 840, there are: the emperor's list of some hundred plants to be grown in the Crown gardens throughout the Empire; a detailed model plan (at *St Gall, Switzerland) for a monastery with its gardens; a short Latin poem by the monk Walafrid Strabo; and a gardener's calendar by another monk, Wandelbert of Prüm. The emperor and the greater monasteries by this time had not only pleasure-gardens, but also parks stocked with animals and peacocks. This clearly indicates the theme of the Eastern 'paradise', and oriental influence was affecting the form of gardens as well as their content of plants.

Charlemagne's list includes named varieties of apples, pears, and other fruits, and Walafrid voices a keen appreciation of the beauty of the lily, rose, flag iris, and garden sage, appealing not merely to sight but also to the sense of smell. It is significant that there were diplomatic relations with the Baghdad Caliph Harun al-Rashid, who sent Charlemagne an elephant which entered Aachen on 20 July 802. Contacts with the Islamic world were to play an important role in the development of gardening and the introduction of new plants from the East and from Spain. There were also links with Britain, since the founder of the imperial Palace School—the first university in northern Europe—was Alcuin of York (735–804), who grew lilies and roses by his monastic cell at Tours and exchanged medicinal plants with Abbot Benedict of Aniane in Languedoc. Satisfactory transport for living plants, as well as seeds and bulbs, already existed.

Gardening on a scientific basis existed in Persia (Iran) and the Near East and was taken by the Muslim conquerors to Spain. Under Harun al-Rashid and his successors the scientific works of antiquity were officially translated into Arabic, and fresh botanical research began under Abu Hanifah (c.820–95), whose new *Book of Plants* was taken to Cordoba c.880 along with drugs and living plants. During the 10th c. Cordoba became the greatest city of the West and attracted leading figures in science and art, and c.936 the Caliph Abdarrahman III began the pleasure-city of *Medina Azahara. Immense gardens and orchards were laid out on terraces and the palace commanded superb views over the plain. Seeds and plants were brought from Africa, India, and Syria, and skill in the culture of exotics from many climes was rapidly developed. As al-Maqqari wrote of Murcia, the gardens of Andalusia were 'filled with scented flowers, singing birds, and water-wheels with rumorous sound'.

Notwithstanding warfare between Muslim and Christian, science crossed frontiers, and pilgrims and merchants who visited Islam brought back reports of the higher civilization which, however reluctantly, they admired. Pleasure-gardens and parks provide a notable example of influence from East and South upon northern Europe. Whereas the main tradition of northern gardening was based on cultivating individual species in separate beds or in borders against walls, in the South seeds of different flowers were sown broadcast in clover lawns, and this exotic theme of the 'flowery mead' was adopted in the North. Another contrast concerned the relative levels of planting: in dry southern lands it was usual for beds to be sunk below paths so that they could be flooded, giving the impression of walking on a carpet of plants. Under the higher rainfall of Christian Europe the problem was rather to prevent roots becoming waterlogged, and beds were raised above the walks. Throughout the Middle Ages, in South and North alike, great emphasis was placed upon perfume as well as visual beauty, and gardens were planned for all five senses. Delicious fruits were grown for plucking, birds kept in aviaries to add their sweet notes to the plashing of water, and hedges of soft-leaved plants like sage and myrtle were set alongside walks to yield tactile pleasure.

The larger landscaped park or *pleasance is described elsewhere, and here consideration is limited to the garden in its stricter sense. Several types of garden existed at once. First was the strictly utilitarian *kitchen garden for food vegetables and herbs for seasoning, with fruit-trees and nuts as standards or against walls. In second place came the physic garden with medicinal herbs for various conditions, usually in separate beds. This might be on a large scale when it belonged to the infirmary of a monastic house, or be a small adjunct to a private garden, cultivated by the housewife. Physicians and apothecaries commonly maintained their own physic gardens to supplement the costly imported drugs obtained commercially.

Pleasure-gardens. Besides the essentially utilitarian gardens there was also the pleasure-garden, which took two forms according to the space available. Most houses had an enclosed *herbarium viewed from above from bedroom windows and fit for outdoor meals or repose (see plate VIIa). This 'herber' was often square or oblong, within trellised fences, and consisted largely of a lawn. It was intersected by paths, contained a pool or fountain, and was surrounded by borders of flowers and by raised seats of turf. Where the garden was mainly of grass this might be treated as a flowery mead by including daisies and other close-growing plants. In the borders were red and white roses, madonna lily, flag iris, peony, and a few other bulbous and herbaceous plants, the number of species increasing century by century. Climbing wild roses, honeysuckle (woodbine), and grape-vines covered the surrounding trellis. In the larger gardens, outside this, there might be a 'cloister' or pergola, a tunnel-arbour built on wooden rods or withies and covered with roses, vines, or ivy. From the evidence of illustrations there was great variety in design, and by 1400 one favourite plan for the noble garden consisted of alternate chequers of turf and garden-bed; in some beds standard flowering trees

climbers, and would produce large quantities of dessert grapes even in London. In France, certain southern plants were brought northwards: first lavender, then rosemary, the latter finally reaching England with Queen Philippa in 1340. Wallflowers and stocks, already developed in several colours in Moorish Spain by the 11th c., also took some time to arrive in England, but were known by the 14th c. and may have come direct from Spain, with the hollyhock—rose of Spain or winter rose—in the train of Queen Eleanor of Castile after her marriage to Edward (I) in 1255. That Queen Eleanor was a keen gardener we know from her buying grafts of the best apples abroad in 1280, and her employment of two gardeners brought from Aragon to King's Langley.

The garden flora of Germany and Central Europe was in some ways distinctive. On the superficial level of plants frequently mentioned in literature, the prominence of the linden tree from an early period is noteworthy, as well as the pervasive fir of the forests, hardly known in Britain. Although England had as natives both of the parent species of the hybrid common lime or linden, this seems to have been a late immigrant here. The German popularity of the wall germander (*Teucrium chamaedrys*) and the colchicum is also prominent. The germander had crossed the Channel by the 14th c. and became a favourite clipped edging, but left no literary mark here; the colchicum was a native, yet hardly known as a garden plant. Canterbury bells (*Campanula medium*), long before their acceptance here, were well known in German gardens, as was no doubt a good deal of the alpine flora, including the auricula. Germany, moreover, under imperial leadership was a centre of horticultural activity throughout: in the second quarter of the 13th c. Frederick II laid out a park and hanging gardens on the walls of his palace at Nuremberg, appointing experts in the cultivation of plants brought from Spain and the lands of the Saracens. Other imperial cities—Augsburg, Bamberg, Basle, Cologne, Erfurt, Frankfurt, Mainz, Ulm, and Würzburg—were all famous for gardens, and the district around Vienna was noted for vineyards, orchards, and summer pavilions. The best of the early printed *herbals were German, and it was greater Germany that exercised the strongest influence on English botany and horticulture at the end of the Middle Ages.

Garden architecture. Garden architecture and furnishings, as seen in paintings and miniatures, showed considerable variation, but the types were mostly international. Gardens might have a close-boarded fence of vertical pales cut to points; a simple paling; a post-and-rail fence; or, most commonly, a fence of diamond (occasionally square) trellis. The raised benches might be of piled and squared layers of turf, but were usually held up by facings of stone or brick, sometimes of wattling or boarding. The earlier pools were simple rectangular tanks with a masonry margin, but later became circular or polygonal on plan and contained a fountain, which might be a pinnacled architectural structure. Paths were of compacted sand or gravel, or occasionally of stone flags or quarry tiles, often separated from the

beds by a low boarding or bricks laid flat, unless the beds were raised behind stone or brick retaining walls. Individual trees might, by the 15th c., have their butt encircled with wickerwork and filled in with soil to form a bench. Pergolas and tunnel-arbours were made of poles or withies and needed frequent replacement and repair. The finest gardens also had low wooden rails to the beds, sometimes coloured, and towards 1500 heraldic beasts appeared, carved in wood or stone. They are a mark of the Burgundian style of the second half of the 15th c., along with 'tester' or shelter arbours trained over seats, and the provision of architectural stone tables for outdoor meals. The beasts were adopted in the English gardens of the early Tudors.

About the middle of the 15th c. another sign of the Burgundian style is the clipping of shrubs and small trees into *estrade form, with several superimposed 'shelves' of branches separated by exposed sections of trunk. Plants might also be tied to a pole supporting a horizontal 'cart-wheel' framework, on which a single flat shelf of branches and twigs was trained. Contemporary with these developments was the cult of the garden carnation, first evidenced at Valencia in 1460 and thought to have come from Persia via Turkey and Italy. The tall weak stems, bearing heavy double flowers, required support, which might take the bucket form of a waste-paper basket, or a substantial trellised framework built over a whole bed and carrying a grill of bars through which the flowering stems could grow. Individual plants or small trained shrubs might be grown in ornamental pots, or in pierced flower-pots with saucers, and be placed on beds or along boundary walls, permitting replacement through the season.

Knot gardens. The last major development of the Middle Ages was the appearance of the knot, usually a geometrical pattern within a square, but at first composed of heraldic beasts, as described at Richmond Palace in 1501: 'under the King's windows, Queen's, and other estates, most fair and pleasant gardens, with royal knots alleyed and herbed; many marvellous beasts, as lions, dragons, and such other of divers kind, properly fashioned and carved in the ground, right well sanded, and compassed with lead; with many vines, seeds and strange fruit, right goodly beset'. It must be emphasized that the artistic sense of the word 'knot' derived from the carved bosses of stone vaulting or wooden roofs and implies only a circumscribed design of any kind; but soon geometrical patterns, either based on mazes and labyrinths or comparable to family badges like the 'Lacy Knot', ousted the animal forms. The full development of the geometric knot lies outside the scope of this article, as does the *mount, almost always a feature designed after 1525.

Plants. A final word must be said on the plants grown in pleasure-gardens. No detailed lists appear to survive, but in 1275 Edward I's garden at the Tower of London was planted with 500 willows, 600 vine-stocks, and 100 cherry trees, as well as three quinces and three peach trees, a quart of lily bulbs, peony roots, and several hundred red and white

roses. In 1278 a very large number of plants of sage is implied by the expenditure of 4s., equal to a labourer's pay for two weeks or more. At the royal Hotel-de-Saint-Pol in Paris in 1398 the Jardin du Champ-au-Plâtre (part only of a total of some 8 ha.) was planted with 375 ornamental vines and 75 Bordeaux grape-vines, 115 pears, 112 apples, 1,000 cherry trees, 150 plum trees, and 8 sweet bay. There were 300 bundles of white and red roses, 300 bulbs of lilies, and 300 flag iris. This same garden already contained trellised pavilions, a labyrinth, tunnel-arbours, and many sorts of odoriferous plants including rosemary, lavender, wall-flower, marjoram, and sage. The trees and plants were bought at the Pont-au-Change, showing that the trade was highly developed. Restricted as choice may have been, the best gardens of the Middle Ages must have made a splendid display. J.H.H.

Medina Azahara, Cordoba, Spain, terraced on the high slopes of the Sierra Morena, was the palace city of 'Abd-er-Raham III, the first of the Western Caliphs. Architects from Constantinople (Istanbul) designed it and much of the work from c.936 was carried out under the supervision of Byzantine and possibly also Egyptian craftsmen as some of the sculpture exhibits Egyptian influence. The garden with its canals and fountains was spread out below a marble terrace and under a dome there was a porphyry basin filled with quicksilver to dazzle beholders. Partial excavation has revealed simple quadripartite plans, with the intersection of the axes being marked by a large pavilion, and a very large pool reflecting the palace. The garden was destroyed in the civil wars of the early 11th c. and is now almost entirely a ruin, but it is one of the most picturesque of ruins to wander through, overgrown with bougainvillaeas, oleanders, exuberant wild flowers alive with butterflies, and random pencil cypresses. D.W.

Mei ren kao is a balustrade combined with a seat. In Chinese gardens, between the columns of pavilions or *lang near water, straight or gooseneck-curved wooden balustrades are fixed to low parapets to act as chair-backs and arm-rests. Literally *mei ren kao* means 'A Resting-place for a Beauty'. X.-W.L./M.K.

Melbourne Botanic Gardens, Australia. In 1845 Superintendent La Trobe chose the site, a gully leading down to the Yarra River, where a 'public domain for the purpose of rearing and cultivating indigenous and exotic plants' was established. Here John Arthur (appointed in 1846) fenced a 2-ha. paddock and laid out flower-beds and plantations. In 1857 Dr Ferdinand von Mueller was appointed Director: beds were created to show the arrangement of plants in their 'natural' order, and a national herbarium established to contain a comprehensive collection of Australian and foreign species.

However, because of opposition to his ideas, he was replaced by William Guilfoyle, who favoured a more 'natural' style. Trees were removed or transplanted, and clumps and avenues planted to reveal the vistas inherent in

the site. Existing and new shrubs were carefully integrated to complement the trees. Flowering varieties, notably camellias, azaleas, and rhododendrons, were used to add colour; later the course of the river was altered, enlarging the extent of both the lagoon and the gardens.

To satisfy the public demand for colour, and to add a variety of plant textures, small circular beds were set into the lawns, in positions where they harmonize with clumps of trees and shrubs, with highly coloured plants making a low foreground to green foliage. H.N.T.

See also AUSTRALIA: THE TWENTIETH CENTURY.

Melbourne Hall, Derbyshire, England, has a garden which is one of the few remaining examples in England of a layout of the late 17th-early 18th c. in the French style of *Le Nôtre, complete with *parterres, geometrically shaped pools, *allées, pleached walks, and classical statuary.

The royal gardeners George *London and Henry *Wise, whose contract was dated 1704, created the garden for Thomas Coke, Vice-Chamberlain to Queen Anne. They planted a 90-m. long yew tunnel, said to be the longest in Europe, south of a series of grassed terraces running down to a lake, the Great Basin, with giant taxodiums around it, and to the south of this laid out the *bosquets with their radiating avenues of limes, originally pleached, and underplanted with yew and beech. At the intersections of the avenues are pools, fountains, and classical statues including the beautiful lead urn of the Four Seasons by *van Nost (1706) whose other lead statuary stands in the garden in niches of yew. A grotto enclosing a mineral spring has an inscription signed C. Lamb, thought to be the famous Caroline Lamb, wife of the 2nd Lord Melbourne. Unique in English gardens is the domed and lacy ironwork 'Birdcage' arbour of Robert Bakewell (1706) on the east side of the lake. The lawns near the house, one parterred, are divided by a long walk edged with domed yews, leading the eye to the Birdcage and up a climbing grass avenue between trees to the skyline. K.LE.

Ménars, Loir-et-Cher, France. From 1764 to 1781 the Marquise de Pompadour's brother, the Marquis de Marigny, perfected the furnishing of the park, calling on the greatest architects of the time and assembling a veritable open-air museum of sculpture. The domain, elegantly combining the different types of garden fashionable during the 18th c., is representative of the transitional style of the 1760s. Taking advantage of a magnificent site (a stretch of gently sloping ground above the right bank of the Loire), a series of terraces were arranged in stages, linked by ramps between the château and the river, and decorated with formal parterres, basins, and vases. A superb *allée* planted with four rows of limes leads to the viewpoint overlooking the valley, while the Grand Parc on the other side of the main road, and its network of rides in the form of a star, were reserved for hunting. The Bois Bas in an irregular style and an old quarry transformed into a Désert Chinois added a picturesque note.

But above all it is the beauty of J.-G. Soufflot's *fabriques,*

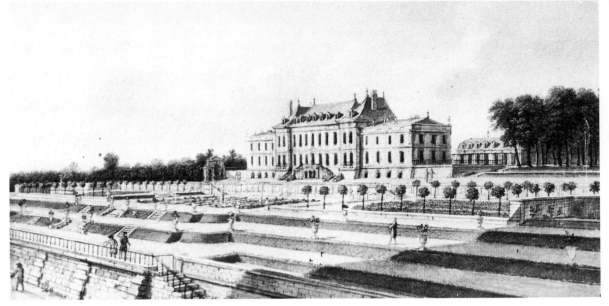

Ménars, Loir-et-Cher, France, painting by A. N. Perignon (1726–82) (Cabinet des Desseins, Musée du Louvre)

true pieces of architecture in miniature, which must be emphasized: the Temple of Abundance, a Doric rotunda below the château, the severe rusticated Orangery, and the Palladian recess in the white stone *nymphaeum, ornamented inside with columns in the Doric style without bases. The Chinese belvedere built after the designs of Charles de Wailly unfortunately disappeared at the time of the Revolution. M.M. (trans. K.A.S.W.)

Méréville, Essonne, France, has a park *à l'anglaise* made by the banker J.-J. *Laborde between 1784 and 1794 in the shallow wooded valley of the Juine. A medieval château was transformed into an 18th-c. house, and terraced gardens converted to sloping lawns planted with groves. A park of 90 ha. was enclosed and laid out to the general design of F.-J. *Bélanger, who turned the course of the river to form winding streams and two large lakes, with numerous islands linked to the mainland by bridges. Some 400 workmen exchanged earth from the hill with peat and mud from the marsh to make each suitable for cultivation. 225 species of trees and shrubs were listed in 1795.

Bélanger designed a mill where the Juine entered the grounds and a large Trajan's column which dominates the park from outside the bounds. A round temple on an artificial island collapsed, and was rebuilt on an elevated rocky site by Hubert *Robert, whom Laborde called in to advise him in 1786. Robert devised various picturesque scenes and grottoes; the largest of these had its principal opening hidden by a cascade, formed by capturing a branch of the river upstream, and bringing it into conduits 3 km. long. Other *fabriques* included the Laiterie, a grotto and room faced with a flat pedimented wall and half-round portico; a rostral column, on an island, surrounded by weeping willows, a memorial to two of Laborde's sons lost at sea; a memorial to Captain Cook, with sculpture by Augustin Pajou, who also made a statue representing *L'Amour Filial* for the temple; and seven bridges in different styles.

Laborde was guillotined in 1794. In 1824 the estate was bought by the Comte de Saint-Romain, who developed it and added farm buildings in the Swiss style. On his death it was divided into lots. Some of Robert's *fabriques* were converted to dwellings. The temple, the façade of the Laiterie, the rostral column, and Cook's tomb were sold to M. de Saint-Léon, who re-erected them at Jeurre (near Morigny-Champigny, Essonne). The château, Trajan's column, remains of the mill and grottoes, some bridges, and the general layout still exist. K.A.S.W.

Mesopotamia, Ancient. Traditionally the oldest garden in the ancient world is the garden of *Eden, in which apple trees grew. If it is to be placed in Mesopotamia, it must have been in the north where deciduous fruit-trees flourish in the natural climate, in contrast to the south where almost all plants need irrigation. The Assyrian kings who planted parks emulated the natural beauty of Syria, of the Amanus and Lebanon mountains in particular.

In the earliest texts there is no distinction between the word for an orchard and the word for a garden. Perhaps because the Sumerians developed their gardening skills under irrigation in a hot and dusty land, the pleasure of gardens was associated with shade, running water, fragrance, fresh fruit, and perhaps also crisp vegetables, with laughter and delight. In the mythical days of Gilgamesh, King of Uruk in the early 3rd millennium BC,

civic pride boasted a city of which one-third consisted of gardens or orchards.

Second millennium BC. By the 2nd millennium BC there is more evidence. Every king had a royal garden in which festivals and banquets took place, and the huge, internal courtyards of palaces were planted with trees and perhaps also flowers. At Mari on the Middle Euphrates a courtyard in the 19th-c. palace had palm trees and an ornamental pool, and perhaps also pet female kids. At Ugarit in the 15th c. one internal courtyard of the palace contained a large stone pond; and another courtyard had flower- or vegetable-beds laid out with walkways, and a pavilion with a well and a large trough. A fable of this time relates how a king planted a date-palm and a tamarisk in the courtyard of his palace, and held a banquet in the shade of the tamarisk; and ration lists show that a gardener was regularly attached to the staff of the palace.

Some temples certainly had gardens at this period, and one of their purposes was to provide fresh edible offerings for the deities. 'I planted a pure orchard for the goddess and established fruit deliveries as regular offerings,' proclaims an early Babylonian text. A less predictable use of the temple garden, particularly that of the sun-god Shamash as judge of the world, was for the swearing of oaths before judges. The arrangement of temple gardens is unknown. At Ur the excavator thought that bushes or trees might have been planted on the various stages of the *ziggurat, but there is no specific evidence to support this.

First millennium BC. By the 1st millennium BC there is evidence for large public parks in Assyria. Tiglath-Pileser I (1114–1076) formed herds of deer, gazelles, and ibex, and he imported foreign trees including cedar, box, Kanish oak, and rare fruit-trees. He may also have tried to keep in his parks a crocodile and an ape which he received from Phoenicia. With the garden of Ashurnasirpal II (883–859) at Nimrud, ancient Kalhu, we have more detail. Mountain water from the Upper Zab River was diverted to Nimrud through a rock-cut channel, and the orchards which it watered included vines, cedar, cypress, juniper, almond, date, ebony, olive, oak, tamarisk, terebinth, ash, Kanish oak, pomegranate, fir, pear, quince, fig, and apples, as well as other unidentified species. Many of them had been collected abroad on campaign as young plants or seeds; the failure rate is unknown. Like his predecessor he bred herds of wild animals which were probably enclosed in a zoological park: wild bulls, lions, ostriches, and apes. Presumably flowering plants also featured in parks and gardens, for on the stone reliefs of Sargon II (721–705) and Sennacherib (704–681), kings of Assyria, courtiers, and protective deities hold a flower called *illuru*; it has a red flower and red berry.

Sargon laid out parks around his new capital Khorsabad, north-east of Nineveh, and they are depicted on his stone reliefs with many different trees and with a small pavilion that has Doric columns. He hunted lions and practised falconry in the parks. Sennacherib moved his capital to Nineveh, and he too laid out parks, diverting mountain water to the city and planting imported trees and plants including cotton bushes, mountain vines, and olives. He tried in one place to re-create the marsh environment of southern Babylonia which had captivated his interest on campaigns: he made a swamp and filled it with cane-brakes and wild boar, and relates with satisfaction how herons came to nest there. His successor Esarhaddon (680–669) planted another great garden and tried to emulate the ecology of the Amanus mountains in Syria, planting fruit and resinous trees. Ashurbanipal (668–627) continued in the same tradition; his stone sculptured reliefs show that he hunted lions and feasted with his queen to music in the gardens.

Nothing is known at this period about palace courtyard gardens, for excavators have traced only the edge of such courtyards, and inscriptions do not refer to them in detail. However, there is good evidence for temple gardens at this time. Excavation of the temple of the New Year Festival just outside the city walls at Ashur revealed the layout of the garden plants which filled the central, internal courtyard of the building and extended all around outside it. One of Esarhaddon's inscriptions gives brief detail of a temple garden in Babylon: it was a garden of fruit-trees with channels of water and burgeoning vegetable beds, and so presumably its main purpose was still to provide fresh offerings to the gods.

Many real-estate records of this period mention gardens in the north of Mesopotamia, some of which may better be described as parts of the estates of wealthy men. Vines are very common, fruit-trees quite frequent; pools, ponds, wells, and vegetable plots are found, and once a gardener's house. Sometimes the garden includes Euphrates poplar and the unidentified *ulupu* tree.

From Babylonia comes a clay tablet naming plants in the garden of the king of Babylon Merodach-Baladan II (721–710, 703). The text was a famous set piece, copied by scribes of later generations, which presumably reflects the fame of the garden which is a forerunner of the Hanging Gardens of *Babylon. The plants are listed in sections, possibly corresponding to the beds in which they were planted. Vegetables and herbs are there, but no fruit-trees. Whether it was a roof-garden or not is unknown. Many of the plant names are Aramaic loan-words, and many of the 67 cannot be identified with certainty. However, all are edible, and some occur in later Babylonian contracts for supplying temple offerings. There are leeks, various onions, and garlic; various salad vegetables including lettuce, radish, purslane, and rocket; spices including cardamom, caraway, coriander, cumin, and fenugreek; herbs including mint, dill, thyme, oregano, and fennel; other edible plants include the snake-gourd, some kind of cucumber or gherkin, the mung bean and, surprisingly, lucerne, which may have been imported into Mesopotamia from Urartu in north-east Turkey by Sargon II in 714 BC. Since herbal remedies were important in Babylonian medicine, many of the plants would have been valued for their curative or protective properties, in particular perhaps rue, colocynth, and sagapenum.

The Hanging Gardens of Babylon consisted of gardens suspended upon vaults overlooking the Euphrates River. The site was probably wrongly identified in the excavations in Babylon. Later, Greek writers said that the gardens included many different kinds of trees, some of which bore edible fruit, and that they were landscaped with terracing to resemble the meadows and mountains of Media. The original gardens may date to Nebuchadnezzar II (605–562); after the river changed course in Babylon, a new, relocated garden may have been constructed by an Achaemenid king and was still flourishing in the time of Alexander the Great.

Nebuchadnezzar mentions in his inscriptions that he grew fruit and vegetables as offerings for Marduk, but he had to import wine and raisins, for vines do not flourish in Babylonia. Temple garden contracts show that dates above all, but also figs and pomegranates, were cultivated on plots of land that flanked the processional road up to the temple, and each plot provided offerings for one month of the year. Gardens within the temple precinct included cypress and juniper trees.

There is no evidence for public parks in southern Mesopotamia, but the lion hunt and falconry as royal sports almost certainly persisted in a controlled environment.

Persian (Iranian) influence on Mesopotamian gardens is not attested before the 6th c. BC. S.M.D.

Meudon, Hauts-de-Seine, France. 'The most beautiful gardens in the world,' wrote the Marquis de Sourches of Meudon, 'which enjoy a view the like of which does not exist in Europe.' The claims are extravagant, but they make it the more regrettable that the gardens should have disappeared.

Meudon was begun in the 1520s by Cardinal Sanguin whose niece became mistress to François I and Duchesse d'Etampes. In 1552 it was purchased by the Cardinal de Lorraine, who determined the most distinctive feature of the gardens, the double axis—one commanded by the château and one by the grotto, designed by Primaticcio, which stood nearly at right angles to it. Cardinal de Lorraine was succeeded by Abel Servien, who built up the gigantic terrace which is the most important survival today. In 1679 Servien was obliged to sell Meudon to the Marquis de Louvois, Louis XIV's war minister, who employed *Le Nôtre to design the gardens; they drew their charm from the use that he made of the natural contours of the land.

The south windows of the château looked out over a *parterre de broderie* from which a high terrace commanded the Parterre de l'Orangerie, beyond which the Allée de

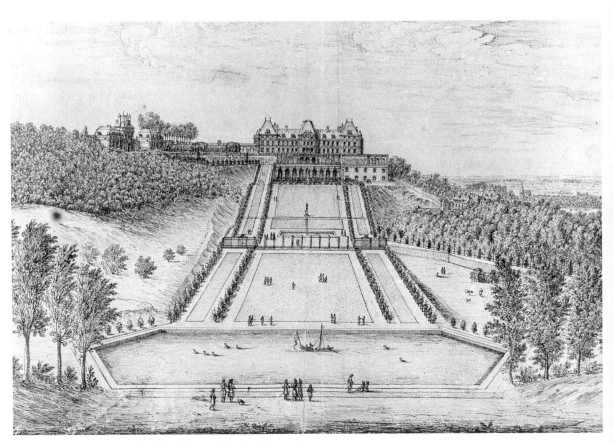

Meudon, Paris, drawing (*c.*1695) by Silvestre (Musée du Louvre)

Trivaux prolonged the perspective as far as the eye can see through the trees of the forest. The park wall should have intersected this avenue, but Le Nôtre had the charming idea of replacing the wall, where it crossed the *allée*, with a moat from which rose a number of slender jets so closely set as to merit the name of the Grille d'Eau. To the north of this axis the Grotto dominated the other perspective of the Jardin Bas, which fell away sharply until it reached the Grand Parterre de Gazon, beyond which the eye could wander over the meadows of Fleury and the wooded slopes of Issy and Clamart.

In 1695, after the death of Louvois, Meudon became the residence of the Grand Dauphin, the son of Louis XIV. Ten years later he decided to pull down the Grotto and commissioned *Hardouin-Mansart to build a second château, the Château Neuf, on its site in order to provide more accommodation for his guests.

During the Revolution the old château was burnt down. Napoleon turned the Château Neuf into a residence for his son, the King of Rome. This building was in turn burnt down by the Prussians in 1870. Its remains have been converted into an observatory. The terrace is now a public park and the Orangery an exhibition centre; some effort is being made to restore the parterre and the perspective.

I.G.D.

Mexico. The state of Mexico covers an area of almost 2 million sq. km., has a coastline 9,000 km. long, and is crossed by two mountain systems giving an average height of 2,000 m. above sea-level. These conditions result in a wide variety of climates, vegetation, and landscape types, which have strongly influenced the character, culture, and settlement patterns of the inhabitants. The layout of the ceremonial centres of the Aztecs, located on spectacular sites, was based upon a cosmic order reflecting the natural habitat: pyramids represented mountains and squares and patios the valleys between—but it is an order constantly threatened by natural forces such as earthquakes. This integration of man and nature can still be appreciated in the archaeological sites throughout the country.

Pre-Spanish gardens. Tezcotinco, favourite residence of Nezahualcoyotl (*c.*1403–*c.*1470), 2 leagues from the capital Tezcuco (capital of the Tezcucans, of the same family as the Aztecs) was laid out in terraces, 520 steps being hewn from the natural porphyry. An aqueduct several kilometres long carried water to a reservoir in the garden on the summit. It also fed three other reservoirs on lower levels, in each of which stood marble statues, respectively emblematic of the achievements of Nezahualcoyotl's reign and the three states of empire. The water then fell in cascades over rocks, or was distributed in channels throughout the gardens. They were described in Ixtilxochitl's *Historia Chichimeca* (quoted in W. H. Prescott's *History of the Conquest of Mexico*, 1843) as follows: 'The most pleasant part of the gardens and of the greatest curiosity was the Tezcotzinco wood, of enormous size ... To bring the water for the fountains, *bassins* and baths, it was necessary to build strong and very high walls of

cement from one range of mountains to another, and these were enormous in size. ... the wood was planted with a great variety of trees and sweet smelling flowers, and there was a great variety of birds in them, in addition to those which the King kept in cages, which had been brought from many lands and which sang so sweetly and loudly that one could not hear the people. Beyond the flower gardens, which were enclosed by a wall, was the mountain, upon which could be found all kinds of deer, rabbits, and hares.' At the King's own apartments at his capital there were 'intricate labyrinths of shrubbery ... gardens where baths and sparkling fountains were overshadowed by tall groves of cedar and cypress. The basins of water were well stocked with fish of various kinds, and the aviaries stocked with birds glowing in all the gaudy plumage of the tropics.' The gardens were largely destroyed by the Spanish invaders in the 16th c.

When visited by Cortés in 1519 the gardens of the royal residence of Iztapaplan were laid out in regular squares, and divided by paths bordered by trellises which supported creepers and shrubs. Water was carried to all parts of the garden by aqueducts and canals. According to Prescott 'The gardens were stocked with fruit-trees, imported from distant places, and with the gaudy family of flowers which belonged to the Mexican flora, scientifically arranged, and growing luxuriant in the equable temperature of the table-land.'

P.G.

Hispano-Moorish and other foreign influences. After the conquest in the 16th c., the Hispano-Moorish culture was rapidly established. The open spaces were linked to the church and administrative bodies for utilitarian purposes. Cloisters, churchyards, open chapels, courtyards, orchards, and public squares of this period are remarkable for their continuity in scale, style, and the quality of enclosure. The materials used in construction were rich and varied in texture and colour. Vegetation included fruit-trees, vegetables, and kitchen and medicinal herbs. Furniture was minimal, comprising fountains and benches.

After 300 years the country became independent and open to other foreign influences: Italian, English, and especially French. Buildings and open spaces were laid out in the French manner: rigid and geometric with balustrades, benches, statues, and bandstands forming central focal features to accommodate the new social uses. La Alameda Central and Paseo de la Reforma in Mexico City, and the Borda Garden in Cuernavaca are well-known examples of this period.

The twentieth century. After the revolution at the beginning of the 20th c., there was a renewal of interest in indigenous architecture, led by a group based in Guadalajara, including Pedro Castellanos, Rafael Urzua, Ignacio Diaz Morales, and Luis *Barragán who in 1925 brought back from Europe the book *Jardins Enchantés* by Ferdinand Bac. This was a book on Hispano-Moorish garden design which then became strongly influential in the work of Barragán and his

Fountain at New Chapultepec Park, Mexico City, by Eliseo Arredondo

group. It was characterized by simplicity, sobriety, and asymmetry, with a dynamic use of form and space.

In the 1940s Barragán began to express his ideas through the design of gardens, including some large private estates. The landscape was for the first time regarded with concern at the national level too. Laws were passed to control forestry and conservation, and national parks were designated. The international style in architecture found expression in such buildings as the National University by Enrique del Moral and Mario Fani. The scale is monumental, with open spaces restrained in the uses of materials and vegetation, interest being provided by changes in level and large mosaic murals on the surrounding building façades. In Guadalajara, Ignacio Diaz Morales designed a series of open spaces to give an ordered coherence to the city centre.

Interest in urban development continued through the 1950s, being marked by such projects as the series of five brilliantly coloured towers—Las Torres de Satelite—by Luis Barragán and Mathias Goeritz, which formed a landmark for the new satellite city. But the landscape content of public schemes did not become significant until the 1960s when a housing complex was designed by Mario Pani. Nonoalco-Tlatelolco in the centre of Mexico City is characterized by multiple-use open spaces, well provided with furniture and profusely planted. The ambitious Museum of Anthropology and the New Chapultepec Park date from the same period. The architect, Pedro Ramirez Vasquez, has tried to capture something of the aquatic character of Montezuma's city by constructing avenues of fountains and pools reminiscent of the Villa *d'Este at Tivoli but with monumental Aztec building and sculptural forms. The climax is a courtyard with a central sculptured column seen behind a curtain of water. Maintenance, however, is not all that it should be.

In the 1970s a conservation movement was started for the purpose of preserving and remodelling old cities and regaining open spaces for pedestrians. Some of these can be seen in central Guadalajara and around the Aztec structures in Mexico City. The largest park in Mexico City, Chapultepec, was twice enlarged, on the third occasion by the architect Eliseo Arredondo. It is well planned for active and passive recreation, with an interesting use of large-scale elements: a lake and promenades, as well as the usual fountains, seats, and areas of plants.

Recent interesting work has been done by painters, sculptors, and architects experimenting with forms, textures, and colours. Federico Silva, Helen Escobedo, and Manuel and Sebastian Felguerez designed the campus of

the university cultural centre and sculpture garden in Mexico City. The architect Fernando Gonzalez Gortazar has designed several urban parks, squares, and cemeteries, mainly in Guadalajara, in a contemporary geometrical style. Interest is provided by pure forms, the qualities of the materials, and the use of colour. But vegetation is almost absent. This is typical of the work carried out by architects in Mexico.

With few exceptions, most notably the work of Luis Barragán, the best examples of integrated landscape design in Mexico are the spontaneously created spaces of the colonial period. R.R.

Meyer, Gustav (1816–77), German landscape gardener and writer, was employed from 1836 to 1859 in the drawing office of *Lenné at Sanssouci, where he worked on the Marlygarten, the Sicilian and Nordic Gardens, the landscape gardens by the Ruinenberg, Bornstedt, and Bornim, near Potsdam, and others. His *Lehrbuch der schönen Gartenkunst* (1860) was extremely influential for many years. In 1870 he was summoned to Berlin to be the first Director of Gardens; he had already drawn up plans for the 37·5-ha. Friedrichshain in 1846 and the 37-ha. Humboldthain in 1869. The Treptower Park (1st plan 1864; final plan 1874) was the first people's park in Berlin. The hippodrome form used in both parks was derived from the work of *Schinkel. The ideal of social utility (the provision of playgrounds and areas for sunbathing) grew in importance and completely superseded that of the landscape garden. Meyer also planned the gardens for numerous villas at Wannsee and Grünewald. H.GÜ.

Michaux, André (1746–1802), French botanist, was sent by his government to collect in eastern North America in 1785, concentrating on timber trees and medicinal or food plants. Most of his plants and seeds were to be sent to *Rambouillet, with a share for the *Jardin des Plantes. His young son, **François André Michaux** (1770–1855), went to the United States with his father and a gardener, Paul Saulnier, who was left in charge of a garden Michaux established in New Jersey, 10 km. from New York, to act as a nursery for plants waiting to be sent home. André Michaux himself went south to Carolina, where he made another garden near Charleston, in a climate kinder to plants. His explorations ranged from Florida to Hudson's Bay and west to the Mississippi, and, in spite of the French Revolution which cut off his funds from the government, he went on with his American travels until 1796 before returning to France. His Charleston garden became a centre for the introduction of plants to North America—including the ginkgo—as well as an assembly point for his collections, which were rich in rhododendrons and azaleas. His large book on American oaks, with illustrations by Redouté, was published in 1801, and soon translated into English and German. His flora of North America appeared posthumously in 1803.

The younger Michaux, François André, made another visit to the United States from 1806 to 1808, carrying on his father's work to write a book on the trees of the eastern part of the continent, which was published between 1810 and 1813, with illustrations by Redouté and his pupil, Pancrace Bessa. An English translation by A. L. Hillhouse, *The North American Sylva*, was published between 1817 and 1819 in Philadelphia and Paris. The Michaux, father and son, had an influence on landscape gardening in making known the qualities of the trees of North America, many of which were introduced to European gardens. S.R.

See also BOTANICAL ILLUSTRATION.

Middle Ages, Gardens in the. See MEDIEVAL GARDEN.

Middle East, The. Geographically the term Middle East refers to the huge area extending from the Atlantic coast of Morocco to Afghanistan, embracing those countries culturally unified by Islam. Although a large part of the area is desert characterized by a hot dry climate, it contains a surprising number of local variations, including snow-capped mountains, fertile valleys, and areas of forest. It comprises the subcultures of the *magrib* including the modern states of Morocco, Algeria, Tunisia, and Libya; and the *mashriq* including Egypt, the Sudan, the Lebanon, *Israel, Jordan, Iraq, Saudi Arabia, the Yemen, the Gulf States, Oman, Iran, and Turkey. It was here in 'the fertile crescent' extending from the Nile Valley to the delta of the Tigris and Euphrates that the first known cities were built. The Neolithic era, which began *c.* 10,000 years ago with the domestication of plants and animals, led to the development of irrigation technology, which was eventually applied to gardens.

A few gardens may have been as elaborate as those recorded in the Nile Valley towards the end of the 3rd millennium BC, with fish and waterfowl, vines and flowers, but the majority were probably no more ornamental than the traditional oasis 'garden' which is still common in some parts. It consists basically of a grove of palm trees underplanted with fruit-trees such as orange, lemon, and fig. To the desert nomads such sanctuaries must have seemed like a reflection of paradise on earth (see Gardens of *Islam). Desert has in fact prevented the growth of any substantial garden traditions in all but a few peripheral areas of this vast territory. Only with the recent establishment of national identities, and with them the rapid growth of settled communities financed by oil and industrial wealth, have these been able to develop.

With the exception of Israel, which has developed separately from the Arab world, and the continuing development in the former French colonial territories of the *magrib*, the greatest expansion has occurred in Libya, in the countries of the Saudi-Arabian peninsula, and in Iraq, the 'modernization' of Iran now having largely ceased. With the new towns and cities new landscapes are being created, sometimes including a new agricultural hinterland. The former dependence upon meagre natural water supplies has been reduced by the technology of the pump and eliminated by the use of desalination plants. Technology has also

contributed more directly to garden design in providing closed pipe irrigation systems, obviating the necessity for a structured layout of pools and channels. The private courtyard garden has also expanded into the villa garden and the villa garden into the public garden, often carried out by agricultural engineers without any traditional precedent for guidance.

There are, however, exceptions. Several large civic schemes have been undertaken by landscape architects working for government bodies such as the Royal Commission for Yanbu, the international Airports Authority for the new airports at Riyadh and Jedda, and various local authorities and commercial organizations. Some of these landscapes will be outstanding when they are mature. In addition there are many private gardens for palaces and villas in which the designers have begun to achieve that sense of the garden as a spiritual refuge that lies at the heart of the Islamic traditions. Unfortunately their private nature is such that they may not be mentioned by name.

Ecological problems include very high temperatures with minimal rainfall, desiccating winds, and frequent sandstorms. Soils are often highly alkaline, salty, and of poor structure. On coastal and low-lying sites, these problems may be compounded by a high saline water-table, making it necessary to raise the ground level to incorporate a drainage layer separated by a semi-permeable one-way membrane to avoid capilliary attraction. Fertile soils may have to be brought in from nearby wadis or painstakingly built up by appropriate additions of imported peat and fertilizers.

In such inhospitable climates, lacking an established traditional horticultural infrastructure, the supply and cultivation of plants is difficult. Some have to be flown in at considerable cost, or alternatively raised from seed and cuttings. But changes are rapid. The latter method has become common practice in parts of Saudi Arabia where the number of plant nurseries has increased tenfold to well over a hundred during the last 10 years, and the range of species similarly increased from c.20 to c.500.

Irrigation is essential, but the traditional open channel and flood irrigation of Islamic gardens has been found to be both wasteful of precious water and destructive in the accumulation of salts. Likewise, watering by hand, although extensively practised, has been found to be too unpredictable. Closed pipe irrigation systems with built-in controls and systems for the application of fertilizers are now becoming standard practice, fountains and open-water bodies generally being restricted to important sites and countries of relatively mild climate where water is reasonably plentiful. But the 'ideal' conditions produced by constant irrigation and the application of fertilizers have their own disadvantages. Plants are apt to grow too fast and become weak; and they are more susceptible to disease. Also such sophisticated systems need a high degree of technical maintenance which is rarely available. There are, in fact, numerous cases of garden owners resorting to standpipes and hoses rather than mastering the intricacies of computer and solenoid valves, or calling in the services of expensive technicians.

R.ST./M.L.L.

Migge, Leberecht (1881–1935), German landscape gardener, received his horticultural apprenticeship and training in Hamburg, where in 1904 he joined the horticultural firm of Ochs, rising from the post of technician to that of chief designer, responsible for public and private gardens for city authorities and wealthy bourgeois clients. He left Ochs in 1913 to open his own practice, first in Hamburg and later in Berlin, and expressed his forward-looking ideas in *Die Gartenkultur des 20. Jahrhunderts* (1913). From this point onwards, particularly after 1920 when he sold his house in Hamburg, he moved away from the mainstream of garden design in the conventional sense to devote himself increasingly to the problems of garden design and gardening created by the growth of cities in terms of the housing reform movement, and to questions of intensive self-sufficiency gardening. His contributions in these fields—at present being 'rediscovered' by the landscape profession in Germany—are exemplified by many publications and by his work with architects such as Poelzig, Wagner, and Taut.

R.STI.

Mikler Dionizy (Denis MacClair) (1762–1853), Irish garden designer. After studying natural sciences in Dublin and horticulture in London he arrived in Poland *c.* 1790 and apart from brief intervals lived there for the rest of his life. He laid out numerous gardens: for example, at Długa stret in Warsaw, behind the palace of Chancellor Chreptowicz, and, above all, in the Wołyń and Podole regions—Beresteczko, the Palestyna park in Dubno, Gródek, Iwańczyce, Kodeń, Laszki, Mizocz, Podłużne, Poryck, Szpanów, the botanic garden in Krzemieniec (1809), and many others.

Mikler Dionizy was also involved in establishing the parks of *Puławy (1797) and *Arkadia. He found growing in the wilderness on the banks of the River Slucza *Rhododendron luteum* which he planted in many of his parks and sent to the United Kingdom, though not for the first time. L.M./P.G.

Miller, Philip (1691–1771), an English horticulturalist of Scottish descent, was appointed curator of the Physic Garden of the London Apothecaries at *Chelsea in 1722 on the recommendation of Sir Hans *Sloane. He remained as gardener in charge for almost 50 years, becoming a counsellor for every cultivator, sharing his encyclopaedic expertise through practical demonstration, painstaking correspondence, and detailed description in his publications. The many editions of his *Gardeners Dictionary* (1731, with a much smaller precursor in 1724), its *Abridgement*, and his *Gardeners Kalendar* (1732) show his wide knowledge and its use among botanists and gardeners alike.

Although medicinal research and propagation of exotic plants were carefully pursued in the Physic Garden, Miller was not confined to Chelsea. He knew intimately most great gardens in England and became adviser to the Duke of Bedford and others, though his instruction on garden design in his *Dictionary* is mostly based on that of *Dezallier d'Argenville. He travelled to the Netherlands for plant collection and corresponded with John Bartram of Philadel-

phia over their exchanges. Among many new introductions first grown at Chelsea was the tree of Heaven (*Ailanthus altissima*) from China. While being critical of agricultural economy both at home and in the new colonies, Miller advocated conservation of trees and the establishment of vineyards. He also sent cotton seed to plantations in Georgia. H.M.LE R.

Miller, Sanderson (1717–80), an English pioneer of Gothic architecture and rococo landscape design, is best known for his sham castles at Claverton Down, Radway, *Wimpole Hall, and, in particular, *Hagley Hall, which was praised by *Walpole as possessing 'the true rust of the Barons' Wars'. He was squire of Radway and one of the Warwickshire coterie of Jago, *Shenstone, Richard *Graves, and George Lyttelton, who combined feeling for landscape with an interest in local history. He assisted in Gothicizing and laying out the grounds of dissolved abbeys for friends at *Wroxton, Arbury, and Lacock, sometimes framing the landscape with a free-standing Gothic arch. Cascades on former monastic fish-ponds were a speciality.

Miller set out to make a visual interpretation of Edgehill which his own Radway Tower capped at the point where Charles I set up his standard in 1642 and those who visited its guardroom to admire the scenery were given a survey sheet of the battle. 'Surely Edgehill fight was never so fortunate to the nation as it was lucky for Mr Miller,' commented Shenstone.

Lord North gave Miller the direction of Wroxton Abbey gardens, where he made a cascade, a serpentine rill, a mount with a temple, and a ruined arch *eye-catcher. Other gardens he gave advice on were Honington, Upton, *Farnborough Hall, Hagley Hall, Wimpole Hall, and Ambrosden. M.L.B.

See also ENVILLE.

Milner, Edward (1819–84), English landscape architect, was apprenticed as a gardener to Joseph *Paxton at *Chatsworth. He studied in Paris at the *Jardin des Plantes, and in 1844 and 1852–6 respectively superintended the laying out of Prince's Park, Liverpool, and the extensive gardens of the Crystal Palace, Sydenham, both designed by Paxton.

From 1850 he practised independently, working in the so-called 'natural manner' in the tradition of *Repton, *Loudon, and Paxton. He designed public parks at Preston and Buxton, the arboretum at Lincoln, and grounds for many newly built mansions of industrialists, including part of the original layout at *Bodnant Garden (now a property of the National Trust), and Highbury, Birmingham, for Sir Joseph Chamberlain, MP (now a public park). M.A.H.

See also KNUTHENBORG.

Milner, Henry Ernest (1845–1906), English civil engineer and landscape architect, joined his father Edward *Milner as an assistant, carrying out works in the same style as his at, among other places, Bagshot Park, for the Duke of Connaught, and the lake at *Renishaw, for Sir George Sitwell.

He worked abroad in Hungary, Denmark, and Sweden, and was invested by the King of Sweden with the order of the Pole Star. In 1893 he acted as chairman of the International Horticultural Exhibition and the Forestries Exhibition. In 1896 he was one of the 60 original recipients of the Royal Horticultural Society's Victoria Medal of Honour. M.A.H.

Milotice, South Moravia, Czechoslovakia, has a castle with a garden and park of 4·5 ha. The remarkable baroque composition of the whole early 18th-c. scheme is attributed to Domenico Martinelli or Fischer von Erlach. The *cour d'honneur* in front of the castle was constructed in the second half of the 18th c., enriched by a row of statues on the bridge over the moat. The axis of the imposing entrance is stressed by lines of trees leading far into the picturesque countryside. The difference in ground level between the *cour d'honneur* terrace and the castle garden was covered by a wall of orangeries. Staircases with balustrades, in the middle of the façade of the castle which faces the garden, lead to the parterre, originally full of flower decoration. The central axis enriched by baroque fountains is closed at the opposite side by a group of trees in the landscape park; this was added to the garden at the beginning of the 19th c. To the north, the layout is adjoined by a pheasantry with star-shaped *allées* and a central pavilion at their intersection.

In the first half of the 19th c. Maximilian Erras made proposals for redesigning the garden in the English manner, but they were not implemented. O.B.

Milton Park, New South Wales, Australia, a formal Edwardian garden on a hilltop to the east of Bowral, was begun in 1910 by Anthony Hordern, senior. Once shelter had been established, the good drainage and rich volcanic soil combined to make an ideal environment for imported species of ash, elm, maple, and beech trees. The English landscape could be readily emulated here, for regular rainfall and mists combine with milder summers and warmer winters to provide a comparable environment.

In 1932 the garden was redesigned by Mary Hordern. The original tight planning and overplanting were freed by removing hedges and trees to produce the long curves and sweeping vistas that exist today. During the 1930s special species were imported, and certain plants grafted and espaliered to aid the general effect. However, the Edwardian framework continues to dominate: dark cypress-lined paths, a formal rose-garden, hedges and herbaceous borders, walled gardens and pergolas, glades underplanted with bulbs, and fountains with statuary.

Milton Park is designed as a spring garden, for at this time of year its lilacs, dogwoods, rhododendrons, and azaleas are at their best, and the striking colour compositions planned by Mary Hordern are most evident. H.N.T.

Mintaka, Cape Town, South Africa, was designed by its owner, Clive Corder, with the help of Mary Muller. When they started there was no garden, only a large lawn in front of the house. Using the lawn as a central axis, Mr Corder created a series of interlocking gardens around it. Winding

paths through a shrubbery lead to a canna garden, brilliant with red, pink, and flame colours throughout summer, then a formal rose-garden, the focal point of which is a statue of Pan and, beyond that, one of the finest features of Mintaka—the water-garden. It is a series of three large pools, filled with lilies, and linked by great rocks and waterfalls. Stepping-stones lead across the pools, which are edged with *Typha latifolia* (commonly called bulrush), *Cyperus papyrus* (the Egyptian paper-rush), and other water-loving plants.

Beyond the water-garden is a vegetable garden, the working garden, an orchid house and, leading back to the entrance, a rockery. Other lovely features are a citrus walk, a camellia walk, a fuchsia garden, and a walk edged with bougainvillea and species roses. On the main lawn, in front of the house, is an irregular fish-pond; to the right, herbaceous borders edge the lawn and to the left is a swimming-pool. J.G.R.

Mirabelle Gardens, Salzburg, Austria. Originally built outside the city wall in 1606 for Archbishop Wolf Dietrich, a new palace and garden were begun in 1689 for Count Thun a year after the raising of the siege of Vienna by the Turks. The architect was probably Fischer von Erlach. Palace and garden were again remodelled, by Lukas von Hildebrandt, in 1721–7, being partly rebuilt after a fire in 1818. The gardens were confined within existing ramparts and are ingeniously planned to lead the eye to the spectacular Hohensalzburg, the 12th-c. fortress on the opposite bank of the Salzach. The four baroque groups of sculptures in the centre of the original parterre are the most remarkable of their kind in Austria and Germany. Upon a rampart is a garden theatre in hornbeam by B. Maindl, cunningly planned for the space it fills. G.A.J.

Mirador (from the Spanish *mirar*, to look), a *belvedere on a Spanish house, giving views of the surroundings. M.L.L.

See GENERALIFE.

Missouri Botanical Garden, St Louis, United States, still known as Shaw's Garden, will always be linked with its founder and benefactor Henry Shaw. He came from England, settled eventually in St Louis, and established a botanic garden near his country home in 1859. Shaw enlisted the physician George Engelmann to be his botanist, while he developed and directed the garden himself. Engelmann established the herbarium and built up a botanical library for the important taxonomic research that still continues. Shaw's house, Tower Grove (1849), is maintained as it was in his day; the Linnaean House (1882) which was built to over-winter plants, is now used for camellias; other features, such as the Museum (1859), also date from Shaw's time. The John S. Lehmann Building (1972) now holds the herbarium, library, and educational facilities of the garden.

The most notable modern structure is the huge domed Climatron, with its collections of tropical plants from many parts of the world. The Desert Houses contain plants that have met the challenge of adaptation to hot dry climates, and the Mediterranean House includes plants from the five regions of the world with the appropriate climate. The Floral Display House is the setting for the garden's major flower-shows, as well as those staged by horticultural societies. The rose-gardens contain 4,000–5,000 rose plants of over 200 cultivars. A 4·5-ha. Japanese garden (1976) has been constructed, following an authentic plan. F.N.H.

Mociño, José Mariano (1757–1820), Spanish physician and plant-collector. See SESSÉ Y LACASTA, MARTIN DE.

Mogul Empire. The garden art of the Mogul Empire flourished during the reigns of the first six emperors, from 1508 to 1707, for they had a close personal involvement in garden design. Although the dynasty was not extinguished until 1857, *Aurangzīb (d. 1707) was the last emperor to create gardens of any merit.

The ancestors of the dynasty were the Mongols from Central Asia, directly descended from Genghis Khan and Tamerlane. During the 13th and 14th cs. they conquered territory which had previously formed part of the Persian (Iranian) Empire for long periods. Having no sharply defined culture of their own, the Mongols adopted that of the Persians—the Persian tradition of symbolism (see Gardens of *Islam) and the fourfold garden or *chahar bagh. The Mogul emperors were not, however, mere imitators—they adapted their gardens to the demands of climate and site, taking into account the difference between the high, dry Persian plateau, the lush well-watered valley of Kashmir, and the hot plains of northern India.

From Bābur to Akbar. The first emperor, *Bābur (1508–30), was greatly influenced by the gardens of *Samarkand (see *Timūr Leng), which he saw as a young boy. His first gardens, described in some detail in his memoirs (*The Bābur-nama in English*, trans. A. Beveridge, 1912–22, rep. 1969), were at Kabul in Afghanistan, the base for his invasions of India. Most of his gardens were in hilly country with abundant water, which he diverted into straight watercourses and rectangular basins. After his decisive victory at Panipat in 1526 he moved his capital from Delhi to Agra, where his court soon created a series of gardens along the bank of the River Jumna opposite Agra Fort. At least three great gardens in Agra are attributed to Bābur himself—Zahara Bagh, Dehra Bagh, and *Ram Bagh, of which only the last (also known as Nur Afshan) survives in recognizable form. It exhibits many features of later Mogul gardens, such as walks raised above ground level, and irrigation channels. The height of the raised walks varied from one garden to another, according to the nature of the surrounding planting, while the irrigation channels widened over the years as the emperors discovered the pleasures of air-cooled water—an important feature of Mogul gardens, which were dwelling-places in their own right, not necessarily connected with a house or palace. (See also *Bābur's Tomb.)

The third and greatest of the emperors, *Akbar (1556–1605), was comparatively uninterested in gardens, but had a very important general influence on design by initiating a

Mogul-Rajput style of architecture which completely replaced the purely Persian style represented by *Humāyūn's tomb. It was Akbar's annexation of Kashmir in 1586 which facilitated a further distinctive development of Mogul garden art. In the Vale of Kashmir, 150 km. long × 30–5 km. wide, water was abundant, vegetation prolific, and the steep mountainsides, continuous except in the north, offered endless possibilities for dramatic water landscapes. In all, a more striking contrast to the level, dry, scorching plains of India could scarcely be imagined. François

*Bernier, who visited Kashmir in 1665, has given us brilliant descriptions of the landscape and gardens: 'Kashmir is a garden of eternal spring . . . Its pleasant meads and enchanting cascades are beyond all description. There are running streams and fountains beyond count.' (*Travels in the Mogul Empire*, ed. Archibald Constable, 1891, pp. 350–92.)

The golden age of Mogul gardens. It was here that Akbar's son and grandson, *Jahāngīr (1605–27) and *Shāh Jahān (1628–58), created some of the finest gardens in the world.

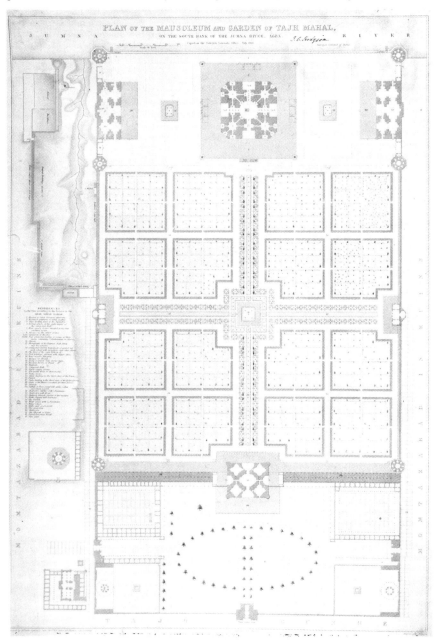

Plan (1828) of the Taj Mahal, Agra—the finest of the Mogul tomb gardens (India Office Library)

It is said that in Jahāngīr's time there were no less than 777 gardens laid out around the shores of Lake Dal, in the centre of the Vale. At least three of Jahāngīr's Kashmir gardens have survived (*Nasim Bagh has not): *Shalamar Bagh, near the capital Srinagar, *Achabal, and *Vernag (both near Islamabad). The first shows the ingenious use of the site by the creation of a series of terraces; a deceptively shallow canal and numerous fountains are its other principal features. The other two gardens make equally imaginative use of water, in different ways: at Achabal the water gushes with tremendous vigour out of the hillside, feeding a grand waterfall; at Vernag, the main features of the design are an octagonal pool surrounded by low buildings set into the hillside and a long straight canal running out at right angles towards the valley beyond. The only other Kashmir garden of this period still intact is *Nishat Bagh, a garden of 12 terraces, one for each sign of the zodiac.

The major works of Shāh Jahān's reign are in the plains in India, although he did continue the work at Shalamar Bagh, and also planted four *chenars* or plane trees on one of Lake Dal's two artificial islands. His comptroller of works had the *Chasma Shahi laid out as the next garden along the mountainside to Nishat Bagh; and his eldest son, Dara Shukoh, built the Peri Mahal, or Fairies' Palace. At Lahore, the jumping-off point for the emperors' journeys to Kashmir, Shāh Jahān himself gave orders for the construction of a large garden, Shalamar Bagh (completed *c.*1642), to celebrate the completion nine years previously of a canal which alleviated the city's water problems. This is the most grandiose of Mogul gardens, its most spectacular feature being an enormous reservoir over 70 m. broad, sparkling with the jets of over a hundred fountains. However, Shāh Jahān's major works belong more to the field of town planning than to gardens: his new capital at Delhi and the rebuilding of Agra. At the latter were two important gardens—Machchi Bhawan (Fish Square) and the Anguri Bagh (Grape Garden).

A distinctive Mogul contribution to the development of garden art was the *tomb garden, which combined the Tartar tradition of garden tombs with the Persian paradise garden. The tombs, which were monumental, were set in a large *chahar bagh* and were built in the lifetime of the future occupants, while the surrounding gardens were used as pleasure-grounds. After death the whole complex was handed over to priests. Two outstanding examples are the tomb of Humāyūn, second of the emperors (1530–56), in Delhi, and the *Taj Mahal at Agra. (See also *I'timād-ud-Daula; *Rābi'a-ud-Daurāni; *Shahdara.)

The ultimate expression of Mogul garden art is the Taj Mahal, built between 1632 and 1654. The memorial building to Shāh Jahān's best-loved wife, Mumtaz Mahal, is placed not at the centre of the classical *chahar bagh* garden layout, but at the end of the garden on a raised terrace, thus forming the climax of the whole design. This was indeed the high point of Mogul landscape art, for *Aurangzīb (1658–1707) who deposed his father, Shāh Jahān, created few gardens. His main interest was in architecture, particularly in building mosques, few of which had gardens.

In two centuries, the Mogul emperors created a series of the world's finest gardens, decisively modifying traditional Islamic designs. Especially inventive was their use of water, either in the play of hundreds of fountains or in the ingeniousness with which water was made to ripple or catch the light (see *chini-kanas*) by means of faceted stones (such as the *chadars*). Many of their gardens survive, although in poor condition and with European planting—a shadow of their former glory. P.G.

Mollet, a dynasty of French royal gardeners. **Claude I**'s posthumous book, *Théâtre des plans et jardinages* (1652), is a main source of information on French gardening practice in the late 16th and early 17th cs. Claude served his apprenticeship at *Anet under his father, **Jacques I**, head gardener to the Duc d'Aumale, and said he made the first *parterres de broderie* there to the design of Etienne du Pérac. About 1595 he became gardener to Henri IV, for whom he designed gardens at *Fontainebleau, Montceaux, and *Saint-Germain-en-Laye. He was one of the gardeners in charge of the *Tuileries, with special responsibility for the parterre east of the palace, on the side of the Louvre, known as the 'new garden' to distinguish it from the 'big garden' on the west, where he had charge of the *allée* of white mulberries and the *palissades* of Judas trees, clipped into arcades at either end of the garden. The designs of Claude Mollet's parterres for various royal gardens are shown in Olivier de *Serres's *Théâtre d'agriculture* (1600). They are not *broderies* in the sense of flowing plant-like forms, such as those by his sons André, Jacques II, and Noel, which illustrate his own book.

André Mollet (d. *c.*1665) is the best known of Claude I's sons, and author of *Le Jardin de plaisir* (1651), setting out the principles of classic French garden design. Much of his life was spent abroad. He was first in England *c.*1630 at St James's Palace, and again in 1642 when he redesigned the gardens of *Wimbledon House for Henrietta Maria, wife of Charles I. From 1633 to 1635 he was in the service of Prince Frederik Hendrik of Orange, for whom he designed gardens at Buren and *Honselaarsdijk near The Hague. He returned to France, where, in 1644, he is recorded as 'premier jardinier du roi' living in a house near the new garden of the Tuileries. From 1648 until 1653 he was in charge of the gardens of Queen Christina at Stockholm, assisted by his son Jean who remained in Sweden when his father left. Sometime before 1658 André went to London with **Gabriel Mollet** (d. 1663), possibly his brother Claude's son. In 1661 they are described as royal gardeners; André was gardener-in-chief at St James in 1663. (See also *Carton.)

Of Claude I's other sons, **Pierre Mollet** (d. 1659), the eldest, succeeded his father in the big garden at the Tuileries. **Claude II** (d. 1664) joined his father in the supervision of the new garden at the Tuileries in 1630, and in 1645 was confirmed in this post, as well as that of the upkeep of the *palissades* in the big garden. He designed the first *parterre de broderie* at Versailles in the 1630s, and he may have been responsible for the design of *broderies* in *Boy-

ceau's *Traité du jardinage*. **Jacques II**, whose parterre designs are in his father's book, was in charge of the gardens at Fontainebleau. He seems to have died *c.*1622. Claude II was followed at the Tuileries by his son **Charles** who, when the parterre east of the palace was suppressed in 1662, received an annual retainer of 500 *livres* to design gardens and parterres. His last recorded design was for the garden of the orangery at Fontainebleau in 1671. His son, **Armand-Claude Mollet**, succeeded him in 1692, the last of the family to be recorded in that post.

Much of the credit for establishing the classic tradition of French garden design, and for introducing and developing the *parterre de broderie* belongs to Claude I Mollet and his sons. After 1650 they were eclipsed by the rising star of André *Le Nôtre, although the family continued to prosper and hold important posts under the crown until the mid-18th c. K.A.S.W.

Monastic garden. See CAROLINGIAN GARDEN; MEDIEVAL GARDEN; PLEASANCE.

Mondragone, Villa, Frascati, Latium, Italy, lies on the north-western slopes of the Tusculum hill. In 1573 Cardinal Altemps began to build here to the designs of Martino Lunghi. His first building, a *casino*, had an unsurpassable view over the *campagna* towards Rome. Based on a terrace over 100 m. broad, and outflanked by it on both sides, the *casino* projects 40 m. into the slope towards the plain. The fountain (by Giovanni Fontana) on this terrace bears the heraldic dragons and eagles of the Borghese family, and dates from the 17th c. Below the terrace is an impressive cypress avenue, which runs directly to the Villa Vecchia, which was also owned by the Cardinal. In 1577, he had a new palace, the Palazzo della Ritirata, built 80 m. to the south, but it is not known what kind of gardens were made there.

A major transformation was undertaken by Scipione Borghese, who bought the villa in 1613. Giovanni Fontana created a water-theatre to the east of the retaining wall behind the Palazzo della Ritirata. The Fontana della Girandola was already finished by 1614—when visited by de Brosses (1739) it contained polypriapic *giochi d'acqua*. Between the water theatre and the *giardino segreto*, the ground was levelled and a vast flower *parterre created. After a long period of decay, the villa was used as a Jesuit boarding school (from 1865 until the 1970s). P.G.

Mon Repos, Lausanne, Vaud, Switzerland, a villa park once situated on the edge of the town but now completely integrated with it, was originally laid out among vineyards. It was built between 1819 and 1827 to a design by the Parisian landscape architect Monsaillier as a 5-ha. landscape garden containing romantic features, such as an artificial ruin of a tower (in the neo-Gothic style) and a classical orangery. Elements of the earlier baroque garden near the country house were integrated in the park resulting in a mixture of baroque and landscape garden styles. H.-R.H. (trans. R.L.)

Monserrate, Estremadura, Portugal. For centuries the Sintra hills, cool, rain-swept, and beautiful, have attracted the rich away from the Lisbon summer heat. The spectacular site of Monserrate, in particular, was crowned in the 18th c. by an impressive quinta, rented for several years by William *Beckford. By 1799, however, he had tired of Portugal and Monserrate became a ruin.

The estate was bought in 1856 by Sir Francis Cook, a wealthy young Englishman, for whom James Knowles, the English architect, constructed a preposterous Moorish extravaganza. Francis Cook took a tremendous interest in the garden, but the work on the whole was handed over to W. Colebrooke Stockdale of whom little is known. Judging by his achievements at Monserrate he must have been a considerable landscape gardener in the English naturalistic style. He reflected the local character of the landscape, using wooded hills and valleys, streams, and cascades. Both arboriculturists, Francis Cook and Stockdale set about establishing a collection of exotics from all over the world. Each specimen was placed to its best advantage—each contrasting with and showing off the next. Open spaces abounded, allowing for the perspectives Stockdale so brilliantly foresaw. Sheltered, and given the humid climate, everything prospered.

Ferdinand of Saxe-Coburg, consort of Maria II, owned a collection of trees at *Pena Palace, across the hills, and he and Francis Cook became rivals, vying over rarities. It was the hey-day at Sintra of lavish, romantic Anglo-Saxon gardening.

The Second World War put an end to the Cook family's ability either to reach or to finance their now neglected property and it was sold to the Portuguese Government.
 B.L.

Montacute House, Somerset, England, has a garden famous for its exquisite garden pavilions which, together with the balustraded walls with pierced lanterns and finials, form the forecourt to the house, the main drive at that time having been through the park from the east. Originally there were gate lodges but these had disappeared by the late 18th c. The borders were designed in the Gertrude *Jekyll style by Mrs Reiss who left her own garden at Tintinhull to the National Trust.

The shape of the garden has survived largely unaltered since the late 16th c. with its enclosures extending the lines of the house. In addition to the forecourt a survey of 1774 shows the 'Pig's Wheatie Orchard' on the site of the present cedar lawn and the walled kitchen garden south of the house (now the car-park). The main garden court appears, much as now, north of the house, where there was a *mount surrounded with 'all sorts of flowers and fruits' and a pond, all enclosed by terrace walks. When the west front of the house was reconstructed in 1785 a straight drive was made to the new entrance.

Most of the existing garden planting was carried out by the head gardener Pridham in the late 19th c. for William Phelips. During this period the balustraded pond was made in the north garden and the Irish yews, yew hedges, and

other evergreens were planted. The property was acquired by the National Trust in 1931. J.S.

Montagne russe (literally, Russian mountain), an artificial hill constructed to give carriage or sledge rides, as at *Oranienbaum. P.G.

Montaigne, Michel Eyquem de (1533–92), French essayist and philosopher. His own gardening was negligible, but as he travelled from Bordeaux to Italy in 1580–1, he recorded in his journal (*Journal de voyage en Italie*, discovered 1770, published 1774; best English translation by E. J. Trechmann, 1929) incidental comments on numerous fountains and gardens. In Augsburg he notes the joke fountains (*giochi d'acqua*), and many similar 'joyeusetés' in Italy, where he praises the ingenuity of the fountains (*Boboli, *Pratolino, Villa *d'Este), the extravagance and beauty of the gardens (Palazzo *Farnese, Caprarola, Villa *Lante— still incomplete when he was there), and the advantage of Italian hillside sites, not readily available in France. C.T.

Montargis, Loiret, France, had a castle belonging to Renée of France (1510–75), Duchess of Ferrara, second daughter of Louis XII. She was a friend of Calvin and chief patron of Jacques I Androuet *du Cerceau and made Montargis a Huguenot refuge during the wars of religion. The old castle was on a hill adjoining the town. Du Cerceau's drawings, the main source of information, show a unique arrangement of gardens radiating from the castle walls on a huge semi-circular terrace; a monumental wooden gallery to be covered with ivy leading to the entrance; and avenues of elms extending in a *patte d'oie across the fields. K.A.S.W.

Montesquieu, Charles de Secondat, Baron de la Brède et de Montesquieu (1689–1755), French political historian, philosopher, and satirist, was one of the first to introduce the English taste for landscape gardening to France. From 1728 he travelled in Europe, visiting England with Lord Chesterfield in 1729. He had been most impressed by the use of large areas of grass in English parks, and told Lord Charlemont, who visited him at his château of *La Brède in 1746, 'I have tried to put your country's taste into practice here and to set out my grounds in the English way.' François-de-Paule *Latapie, who translated *Whately's *Observations on Modern Gardening* in 1771, was Montesquieu's protégé and his son's secretary. D.A.L.

Monticello, Virginia, United States. As a very young man, Thomas *Jefferson obtained a site for his future home upon a hill within easy reach of Shadwell, his birthplace. He proceeded to improve the site by levelling the top of the hill to accommodate a comfortable, small, classical mansion— which he designed—and to allow for views around three-quarters of the horizon.

The level top, oval in shape, commands extensive views of the valley below and the distant site of the University of Virginia. Terraces for vegetables and fruits fell gradually from a truncated oval lawn surrounded by a path curving between four great oval beds for shrubberies, the path planned to be bordered on either side by garden flowers— all of this carefully noted in Jefferson's letters. In his sketch-plans, these ovals are ranged in an even number (sometimes four, sometimes six) opposite each other. His walk made long moderate curves around these beds. Behind the house and cut into the lawn is a further arrangement of small oval beds, parallel to the house, which he filled profusely with flowers. Within the whole design, the lawn is shaped rather like the sole of a shoe with the house for a heel. Halfway down the slope at the back of the hill was the family burial-ground, also designed by Jefferson.

Today the house and much of the garden are beautifully preserved and open to visitors. A.L.

Montjeu, Saône-et-Loire, France, has an outstanding ter-raced garden associated with the château built 1606–22, situated in a park of 800 ha. high in the mountains south of Autun. The terraces not only descend the hill but frame either side of the parterre, fanning out to show the extensive view. This arrangement is attributed to *Le Nôtre, but is certainly earlier, as it is shown on a scenographic plan of the beginning of the 17th c. K.A.S.W.

Montmorency, Anne de (1493–1567), Constable of France, exercised great power in the Council of State under François I, Henri II, and Charles IX. In the wars of religion he took the Catholic side, although his son and nephews, the Chastillons, were prominent leaders of the reform. He was killed at the battle of Saint-Denis in 1567. Despite his dislike of the Huguenot cause he protected Bernard *Palissy, who made a ceramic grotto for Ecouen. His château there was designed by Jean Bullant, whom he also employed at *Chantilly which he embellished with fine gardens and works of art, so that Rabelais used it as a comparison to describe the splendours of the Abbey of Thélème.

Henri de Montmorency (1534–1614) was the son of Anne and Constable of France under Henri IV. He restored and completed his father's work at Chantilly, where his statue was erected on the terrace. It was destroyed in the Revolution and one of Anne de Montmorency substituted in the 19th c. As governor of Languedoc he used his influence in helping Richer de Belleval to establish the botanic garden of *Montpellier.

Henri II de Montmorency (d. 1632) was the son of Henri and Admiral and Marshal of France. He built the house in the park at Chantilly in which Théophile de Viau took refuge, giving it the name of the Maison de Sylvie after Henri's duchess. Henri joined Gaston d'Orléans's rebellion against Richelieu, and was executed for treason at Toulouse in 1632. K.A.S.W.

Montpellier, Hérault, France, has the oldest botanic garden in France; a magnificent 18th-c. promenade; and a cluster of elegant private gardens in the immediate neighbourhood, dating from the 18th c. (La Piscine, Alco,

Château d'O). La Mogère has a fine *buffet d'eau with ornamental shell-work and a miniature aqueduct.

The Jardin des Plantes was made by Richer de Belleval between 1593 and 1607. An original feature was the oblong *mount (still in existence) with terraces facing north and south to provide microclimates. Parallel to this, plants were arranged in long troughs and labelled with numbers referring to a catalogue. Access to the various parts of the garden was through arches inscribed according to the habitat or use of the plants to be studied. 1,332 are listed in Belleval's *Onomatologia* (1598). The first garden was destroyed during the siege of Montpellier by Richelieu in 1622. Belleval remade it on a smaller scale, but its importance declined when the Jardin Royal des Plantes Médicinales (now *Jardin des Plantes) was established in Paris. Among distinguished botanists associated with Montpellier were Pierre Magnol (1638–1715), whose name is commemorated in the genus of magnolia and who devised a pre-Linnaean classification of plants; and Pierre Marie Auguste Broussonet (1761–1807), a friend of Sir Joseph *Banks.

Le Peyrou is a public promenade, first made in 1688–93, with a three-arched gate by the architect d'Aviler linking it with the town. An equestrian statue of Louis XIV was erected in 1718. In 1765 the promenade was extended by the architects Antoine and Etienne Giral. A hexagonal pavilion over the reservoir, which terminates an imposing aqueduct bringing water from springs 9 km. away, dominates a distinguished ensemble of steps and terraces from which there are extensive views. K.A.S.W.

Moon door. See DI XUE.

Moorish gardens. See ISLAM, GARDENS OF; SPAIN.

Moor Park Mansion, Hertfordshire, England. There appears to be no contemporary drawing of the celebrated garden laid out by William, Earl of Pembroke, following his purchase of this estate in 1626, but Sir William *Temple, who had spent his honeymoon here in 1655, later included a glowing account in his essay, *Upon the Gardens of Epicurus* (1685), in which it is described as 'the perfectest figure of a garden I ever saw, either at home or abroad'. It was from here that Temple took the name of Moor Park for the Surrey property which he purchased and embellished from 1680 onwards.

Lord Pembroke's estate passed to Sir Robert Franklin and was eventually acquired by Benjamin Styles, for whom Sir James Thornhill rebuilt the house in the 1720s. Charles *Bridgeman is said to have contributed a design for the garden at this time, but the surroundings of the house were transformed into an extensive landscape by 'Capability' *Brown for Admiral Lord Anson in 1753. Much of its glory has now vanished, but traces of Brown's hand can still be seen in some of the groups of trees surviving on the slopes or skirting the greens and bunkers of the present golf-course. D.N.S.

Moritzburg, Dresden, German Democratic Republic.

Between 1542 and 1546 the Elector Moritz of Saxony built a hunting-lodge, named Moritzburg after him, on a headland in the middle of an area of woodland containing a number of large lakes. In subsequent decades this vast hunting area was extended by the creation of rides and avenues.

Between 1723 and 1736 Pöppelmann rebuilt the Schloss and its environs as a hunting-ground in the grand manner for King August the Strong. By 1727 extensive terracing had been completed on the island on which the Schloss stands and the numerous statues, mostly of hunting motifs, set up. Three very large lakes were combined into one huge sheet of water, almost regular in shape, and its shores reinforced. The island (223 m. × 117 m.) forms the centre of the hunting park, to which it is linked by vistas. A wide causeway, running from north to south, gives access to the Schloss. There are only four small gardens on the island, but there are a large number of clipped trees, while on the shore to the north of the Schloss lies a rectangular parterre garden, terminating in a semicircle, which contained long garden rooms and a hedge theatre in its lateral compartments. The island and parterre together cover an area of 6 ha.

A ride, aligned eastwards upon the axis of the Speisesaal, leads to a pheasantry lodge some 2 km. away which was not built until 1769–82. A pheasant enclosure had been started there in 1728 but was not successful. The original ride was turned into a canal terminating in a circular pond and grottoes. The small, square pheasantry lodge was surrounded, not by parterres, but by ornamental cages for pheasants and exotic birds; these have not survived.

A hedged *allée* leads to the Great *Bassin* in which stands a three-storey lighthouse (c. 1780) on a gravel bank, once the site of many water festivals. Small buildings and grottoes on the shore have long since disappeared. H.GÜ.

Morocco. See CHELLAH.

Mosaïculture. In the late 1860s French and Belgian gardeners began to imitate the English use of patterned flower-beds. This was the time when *carpet bedding was being introduced in England, and French gardeners adopted both carpet and flower bedding without distinguishing between them; the resulting composite form was known as *mosaïculture*, a term coined by J. Chrétien, of the *Parc de la Tête d'Or in Lyons. At first the favoured patterns were simple geometric ones, usually a variant on the oval bed or *corbeille-parterre*; but the interest generated by Comesse's beds in the shapes of a Moorish vase and butterfly, at the Exposition Universelle of 1878, led to a fashion throughout Europe for zoomorphic and emblematic shapes, which lasted until the end of the century. In Italy, in particular, biblical scenes executed in carpet bedding were popular. Many *mosaïculteurs* justified their experimentation with patterns on the grounds that they were reviving the practice of *Le Nôtre and his generation, and by the beginning of the 20th c., genuine 17th-c. parterre designs were being recommended in pattern books. B.E.

Mosigkau, Halle, German Democratic Republic. Plans were drawn up in 1751–2 for a rococo garden (6·8 ha.), developed from a small estate garden. Work was begun in Sept. 1752 and completed in 1757. The designer of the plan is unknown. To the south of the Schloss, which shows a Saxon-Dutch influence, lies the parterre garden enclosed by a pergola and consisting of a *parterre de broderie, a fountain and pond, and a bowling-green. On the same axis, but outside the pergola, lie a maze, two garden rooms, and a goldfish pond. On the transverse axis of this part of the garden stood the old manor-house with a small ornamental garden and a kitchen garden. The manor-house was demolished in 1774 and a Japanese garden laid out, taking its name from a tea-house in the *Chinoiserie style. The garden consisted of hedged garden rooms and a small hermitage. It was redesigned in the landscape style in the 19th c.

Noticeable features of Mosigkau are its combination of agricultural use with garden design, as well as the Dutch influence seen in the plan for a canal (probably not executed), which was to enclose the whole garden. The use of a great number of topiary animals cut from yew also originates in Dutch garden design.

In the early 19th c. the garden was redesigned in the landscape style, but the original axial system and layout were preserved, as was the original statuary, although not in its entirety; after 1945 missing pieces were brought from other estate parks. Two orangeries (1775–7) house a valuable collection of rare potted plants, which are set out along the main avenue in the summer. These include a 200-year-old pomegranate (*Punica granatum*), a myrtle, and a *Magnolia grandiflora*.

The garden and Schloss were built by Anna Wilhelmine, Princess of Anhalt-Dessau (1715–80); on her death the garden passed into the control of a foundation. The Schloss is now a museum and houses a valuable art collection. There are plans to reconstruct the old rococo garden.

H.GÜ.

Moss house, a garden building, popular in England in the Victorian period, made basically of wood in a primitive style, often using branches of pine or laurel, with moss pressed between the wall slats. The mosses could be of different types, thus forming a collection or mossery. Instead of moss, heath could be used to fill in the interstices, and the exterior could be thatched with heath—thus making a heath house. A third cognate form was the bark house, ornamented or thatched with bark, although sometimes composed of wood with the bark still on. There used to be one at *Alton Towers.

M.W.R.S.

Moulin Joli, Val d'Oise, France. While on a sketching expedition in 1754, Claude-Henri *Watelet discovered an abandoned estate between Colombes and Argenteuil, comprising islands in the Seine and a deserted mill (hence the name he gave it, Moulin Joli). Attracted by the views it offered to a painter, he obtained the leasehold and devoted his life to transforming it into the ideal, set out in his *Essai sur les jardins* (1774).

The garden was in a personal style combining straight *allées* and a *cabinet de verdure* with a sinuous path round one end of the large island and freely growing vegetation. Horace *Walpole called it 'a French garden in which no mortal has set foot for the last century'. Besides Watelet's small house (designed by *Boucher) there was a model dairy, a café, and a menagerie. Moulin Joli was much visited and admired for the beauty of the views which Watelet contrived to frame at the ends of his *allées*. The garden became neglected at his death and the estate was sold in lots after the Revolution.

K.A.S.W.

Mount, a garden feature, probably functional in origin, being a convenient way of forming walled terraces creating microclimates according to the direction faced. Being hollow, it also provided storage and shelter. Mounts of this kind, for medicinal plants, are illustrated in Olivier de *Serres's *Théâtre d'Agriculture* (1600). The oblong mount at Montpellier, made about that time, still exists, as does one with a spiral ramp in the Jardin des Plantes, Paris (1626–36), originally planted with vines. The mount in the garden of the Villa Medici in Rome, shown in Falda's engraving (*c.*1683), is described as a mausoleum and is planted with cypresses.

The term 'mount' was also used for the raised walk at the end of a garden, which may have given rise to the idea that their purpose was to provide a view over the wall.

In English gardens, the mount dates from the post-medieval period when fortification was less necessary, and it was perhaps a transmutation of the watch-tower. It became a standard feature of Tudor gardens. Francis *Bacon's ideal garden (described in his essay *Of Gardens*, 1625) includes 'in the very middle, a fair mount, with three ascents, and alleys, enough for four to walk abreast; which I would form in perfect circles, without any bulwarks or embossments; and the whole mount to be thirty feet high, and some fine banquetting house with some chimneys neatly cast, and without too much glass.'

A spectacular mount, constructed in 1533–4, was raised at the south-east end of *Hampton Court. The ascent was by means of paths flanked by the King's beasts carved in stone. On the summit was the three-storey Great Round Arbour, and the Mount Garden offering prospects on to the garden and the Thames. Inspired by this example, the garden at *Theobalds Park included a somewhat smaller mount.

As a garden feature the mount seems to have survived into the 18th c. *Kip's views (drawn *c.*1700) show a number of examples, including a large circular one at Dunham Massey, Cheshire, and an elaborate example at *Wilton House. Even *Bridgeman still included mounts in his earlier designs, as at Eastbury in Dorset (*c.*1720).

P.G.

See also ARTIFICIAL HILL; OXFORD COLLEGE GARDENS.

Mountain Shoals Plantation, Enoree, South Carolina, United States. Above the lowlands of South Carolina on a

plateau where the waters of a shallow river 'rush down a precipice seventy-six feet in height, in a distance of only twenty-four chains', a modest plantation house, built in the early 19th c., has a garden of the same date which is most informative. In its design, still staunchly depicted in thin granite slabs, bricks, and box borders, in its fencing in different styles depending on the location in reference to the house, in its planting of symmetrically placed flowering trees and shrubs and still-flourishing spring bulbs and lilies, it lays before us the evidence of a much loved garden which did not have to be in constant bloom to satisfy either its designer-owner or its visitors.

Spring must have been the best time to see it, but for the rest of the year the formal layout of rectangles and squares surrounding circles, hearts, and diamonds and yet more squares and rectangles, all filled with *Vinca* (periwinkle) to hide the bulbs' demise, would have looked cool and well kept. Paths of brick or gravel or earth show the way to service or family areas, as does the front fence of spindles on granite blocks with granite posts and the side fences of pickets. The feathered grape hyacinth, *Muscari comosum* 'Monstrosum', still flourishes in quantity as does the 'green rose', *Rosa chinensis* 'Viridiflora', supposedly here first introduced from the China trade, and the blackberry lily, *Belamcanda chinensis*. Chinese plants seem to have arrived early and unheralded in the south of the United States—so quietly in fact that the Cherokee rose, *Rosa laevigata*, is popularly supposed to be a native. A.L.

Mount Auburn Cemetery, Boston, Massachusetts, United States. In 1825 Dr Jacob Bigelow (1787–1879), a noted American botanist who had written the first definitive botanical study of the New England flora and subsequently the *American Medical Botany*, was asked to plan a model cemetery. He began by persuading the newly formed Massachusetts Horticultural Society to purchase a large and attractive site in the country near Boston, and proceeded to landscape it for a combined *cemetery and 'experimental garden'.

In response to and in accordance with his concern for public health, he created a 'rural cemetery' where the landscape design followed the contours of the land and all the curving roadways were named after native trees and shrubs. There was a pond and a hill, a planned botanical garden, and several handsome statues and structures, all designed by the doctor. This cemetery—whose plan was followed shortly by other 'rural cemeteries' on great estates near Philadelphia and New York—was much visited by foreigners in its early days. Oddly enough, since the plan originated with Dr Bigelow, these cemeteries became accepted examples in the United States of the 'English style' of gardening. They can be said to be seeds of the first American public park—*Central Park in New York City— since A. J. *Downing wrote persuasively of the possibility of parks similarly laid out but purely for public enjoyment. Mount Auburn is still beautiful today, although its chief visitors are bird-watchers. A.L.

Mount Congreve, Co. Waterford, Ireland, situated some distance up-river from the city of Waterford, has a series of mid-19th-c. terraces leading down from the 18th-c. house to the river. Since 1965 the entire *demesne has been graced by one of the most extensive of contemporary planting schemes. The principal ornaments of the 40-ha. garden are the restored 18th-c. greenhouse and a Chinese pagoda presiding over a steep waterfall into a quarry below. P.B.

Mount Edgcumbe, Cornwall, England, lies on a site which affords views hardly equalled in Britain. The 1st Earl of Mount Edgcumbe (the title was created in 1789) devised walks and grounds in a substantial estate (350 ha.) which delighted that connoisseur of the picturesque, Uvedale *Price. Dartmoor is visible in one direction, Plymouth in another, and the sea in another. There are cliff walks, an ivy-clad ruin, woods, lawns, a hollow with rocks in fantastic though natural shapes, zigzag walks, a large arch, a broad grassed terrace, an amphitheatre, and a unique juxtaposition of a French *parterre garden, an Italian garden with fountain and stairway, and an informal English flower garden. It was regarded as a sublime and picturesque landscape, but essentially an outward-looking one, and in this respect it resembles *Piercefield, which also commanded views of spectacular scenery at the same period. Much remains today; the park is administered by Cornwall County Council and Plymouth City Council, who are committed to restoring the historical landscape. M.W.R.S.

Mount Macedon, Victoria, Australia, became favoured as a place of summer residence during the 1870s. Victorian gold wealth encouraged the construction of grand houses and gardens, set behind hedges with sweeping lawns and featured deciduous trees. Beyond in the gullies, ponds were formed and gazebos built, and rhododendrons mingled with tree ferns to provide dark, cool, mysterious gardens.

Perhaps Sir George Vernon's Alton set the fashion, a picturesque tile-clad residence set on a steep slope planted with imported trees. In the Government 'Cottage', Sir Henry Brougham Lock possessed 'a charming retreat, its general features resembling those of the old timber-framed houses—in Cheshire and Shropshire'. Contemporary views show a half-timbered house overlooking a wide gravelled walk and a series of grass banks and terraces, edged by pines and conifers and beyond, forest and mountain ranges.

One of the earliest Edwardian gardens was that of the late Charles Ryan, who at Derriweit Heights 'by lavish expenditure of time and money, under the guidance of taste and judgment and impelled by sustained enthusiasm, succeeded in presenting within a moderate compass an epitome of the flora of every zone of the globe, from the deodars of the Himalayas and the gigantic pines of the Yosemite Valley to the yews, and hollies of old England'. Its gardens of some 9 ha. were planned with the assistance of W. R. Guilfoyle, the Director of the *Melbourne Botanic Gardens. Others followed Ryan's example, usually on a smaller scale, for with the financial crash of 1893 Derriweit had to be sold. One of

these is Ard Cheille, created for a mining millionaire who liked his bagpipe player to escort him on his tours of inspection. Though ruinous, it is most evocative of its age: fretwork gates and pickets lost in a wilderness, a shingled pavilion set in a dark glade, a lake with a boulder-strewn island, and curvaceous shade-houses overshadowed by giant conifers.

The important 19th-c. gardens that survive are Alton, Hascombe, Durrol, Forest Glade, Sefton, and Duniera. Below, on the plain, Joan Law-Smith's Bolobek is a recent and innovative large garden, utilizing the framework of an Edwardian landscape. H.N.T.

Mount Stewart, Co. Down, Northern Ireland, lies along the northern shore of Strangford Lough, and has as the principal ornament of its 18th-c. park the Temple of the Winds completed in 1785 to the design of James 'Athenian' Stuart. In 1858 the 41-m. high Scrabo Tower was erected nearby to the design of Sir Charles Lanyon. Both towers dominate the landscape from the heights on which they are built.

However, the most important developments were in the 20th c. when the garden around the house, consisting of two suites of formal gardens, was begun (c.1922) by Edith, Marchioness of Londonderry, loosely following plans made by Sir Edwin *Lutyens and Gertrude *Jekyll. To the south a balustraded terrace leads to the Italian Garden, with sculptural ornaments made by Thomas Beattie, a local craftsman, and derived from features in the Palazzo Farnese, Caprarola, the Villa *Gamberaia, and the *Boboli Gardens in Florence. The ground plan is based on that of the *parterre at Dunrobin Castle, Scotland. The suite ends with a Spanish-style loggia which gives its name to the Spanish Garden, the ground plan of which is based on the Adam-style ceiling in the music-room of the house. A subsidiary compartment to the north, called the Mairi Garden, is a white and blue garden laid out around a dovecot.

The second suite leads from the terrace on the west front into the Sunk Garden surrounded by raised walks with pergolas. This is succeeded by the Shamrock Garden, called after its shape which was outlined by a hedge cut into topiary scenes taken from Queen Mary's Psalter in the British Library. At the centre of the paving is a bed cut in the shape of a giant's hand, the Red Hand of Ulster. Next a compartment, with an Irish harp in topiary, leads into a wild woodland and water-garden encircling a 2·8-ha. lake, dominated by a hill on which has been laid out the family burial-ground called Tir na n-Og, the Land of the Young, which holds an important place in Irish mythology. A swimming-pool and pavilion in the art deco style sit across the road on the shore of the lough.

Mount Stewart became the property of the National Trust in 1955. P.B.

Mount Vernon, Virginia, United States. Once the 'home farm' among five separated farms along the shores of the Potomac, Mount Vernon alone remains to bear witness to

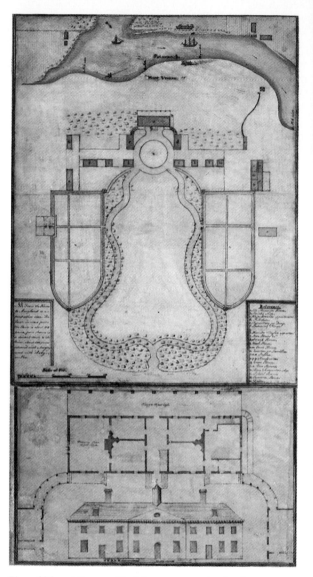

Plan of Mount Vernon, Virginia, contemporary sketch of Washington's design by an unknown artist

the interests of its owner, George *Washington (1732–99), in agronomy and animal husbandry. Situated on a bluff above the river, on land 'taken up' by the first Washington to emigrate to the New World in 1657, it was built by George Washington around an earlier small farmhouse.

Designs for the gardens and grounds of Mount Vernon are Washington's own—both in the layout and the planting. The general scheme, sketched for him by a visitor and approved by the owner, shows an enlarged plantation house with a wide verandah across the two-storeyed front, facing the river below. There is a deer-park beyond a ha-ha on one side and on the other side a way to the ship-landing. Halfway down this slope is the family tomb. Behind the house a

wide, bell-shaped terrace stretches between separated, mildly serpentine entrance drives, planted with trees on both sides to make a bell-shaped design before they converge at the lower lip of the bell and become the single, straight drive to a pair of gatehouses and the main highway. Within the curving sides of the bell, which seems to hang from the ring of grass at the back door of the house, are two rectangles with narrowed, pointed ends, like church windows, with two walled gardens—one for flowers, one for vegetables. The latter lies on the side towards the stables, the tomb, and the ship-landing. The flower garden lies on the side of the house with the large drawing-room addition, designed by Washington, with its 'Venetian' window, and the greenhouse designed and built by him with much planning and pleasure, its heating system designed to relate to the long row of slaves' quarters behind its high walls. The fruit-trees in both gardens, and the flowering and evergreen trees and shrubs in the serpentine drives and in the ovals of shrubbery are individually recorded as planted by him.

Today the house is carefully maintained by the Mount Vernon Ladies Association and the gardens and grounds have been beautifully researched and planted from Washington's records by Robert Fisher. A.L.

Mount Wilson, New South Wales, Australia. The early development of Mount Wilson is closely associated with Eccleston Du Faur (1832–1915), Australian public servant and patron of exploration and the arts, whose interest dated from his visit in 1867. The roads were plotted, and 62 lots were formed and offered for sale in 1870. Thus began what was referred to as 'Du Faur's Blue Mountain Craze', with the mountains developing a resort character.

By 1880 eight houses had been completed and their owners were busy laying out their gardens in clearings in the dense forest. A spirit of competition existed in the acquisition of rare trees and flowering shrubs. Paddocks were cleared, leaving the tree ferns standing isolated above meadows of clover, English grasses, and daisies. Beds of cottage flowers and fruit gardens surrounded the houses. Gradually quite large gardens of 'English' trees and shrubs were formed, each incorporating the customary wide lawn, a tree-lined drive, and tennis-court. The early settlers planted oaks, elms, beeches, chestnuts, walnuts, limes, laurels, ivy, lilacs, rhododendrons, azaleas, daffodils, bluebells, and a variety of conifers and other plants.

During the 1880s an avenue of Spanish and horse chestnuts, oriental planes, limes, and elms was formed from Balangara to the lodge at Wynstay. Fungus killed the Spanish chestnuts and these have been replaced with beeches. Later Queens Avenue was planted with liquidambars and pink cherries, so today the streets of Mount Wilson have a formal character quite in contrast to the tall tree ferns (*Cyathea australis*) and eucalypts of the adjacent bush. Hedges of hawthorn and cherry laurel further heighten the contrast of English gardens with lush Australian flora. The original houses still largely retain their 19th-c. grounds, and several new gardens have been created.

A number of substantial gardens from the first phase of development survive to this day; namely Dennarque, Yengo, Wynstay, Bebeah, Sefton Hall, and Withycombe. Of the newer gardens the outstanding ones are Koonawarra, with its American oak-framed vista to Barrington Tops, and Farcry, which features curving basalt walls and timber fences and sweeps of rhododendrons. H.N.T.

Muckross, Co. Kerry, Ireland, a *demesne of 4,046 ha. lying along a peninsula between the Upper and Lower Lakes of Killarney, enjoys the superb natural setting of a wooded amphitheatre of Ireland's highest mountain ranges. In the 18th c. the scenic capabilities of the demesne were developed by its owner, Edward Herbert. He incorporated in the park the ruins of a 15th-c. abbey, built a Gothic bridge and miles of carriage drive, opened up a view of Torc Waterfall, and planted the mountainsides. The present Elizabethan Revival mansion, built *c.* 1840, later became the centre of a series of formal gardens, one designed by R. Wallace in 1906 and another by Milner, Son, and White in the 1930s. It is now maintained by the State. P.B.

Munstead Wood, Surrey, England, was started by Gertrude *Jekyll in the 1880s on a 6-ha. triangular plot of sandy heath. Half the site was devoted to woodland gardening, as she describes in *Wood and Garden* (1899). The central part was reserved for her house and a field at the narrow end of the triangle was turned into the kitchen garden and nursery ground. A cottage, The Hut, was built in 1893–4 and her house, designed by Edwin *Lutyens, was built between 1893 and 1897. This period is described in *Home and Garden* (1900).

The only formal part of the design was the north courtyard, with box-edged borders of bergenias, hostas, and ferns, and hydrangeas and lilies set out in tubs. Straight paths, by way of a nut walk and shrub borders, led to the pergola and enclosed spring garden, where drifts of early flowers were planted beneath holly and hazel. From late May, Gertrude Jekyll favoured her Hidden Garden, a romantic mixture of wild and garden flowers among rocks. The cottage garden around The Hut, with roses, peonies, foxgloves, lupins, and snapdragons, was at its best in June, and from July until October the main attraction was her 60-m. long herbaceous border, the masterpiece of her artistry with sweeps of colour and contrasting textures. Her theories are described in detail in *Colour in the Flower Garden* (1908). Throughout the year there were 'flowery incidents' in the woodland, and there was also a constant supply of vegetables and fruit and of the nursery stock she supplied to her gardening clients and friends.

The garden was not maintained after her death in 1932 and is now split into several properties. J.BR.

Muskau, Cottbus, Poland/German Democratic Republic, has a landscape park covering a total of 545 ha., of which 346 ha. lie within the People's Republic of Poland and 198 ha. in East Germany. Work was begun in 1815 with Prince *Pückler-Muskau's appeal to the people of Muskau to sell land for the park. After his first journey to England in 1816 a

great deal of land was bought and extensive tree nurseries were laid out (1824). Work was directed by Pückler-Muskau, who was strongly influenced by Humphry *Repton; the working gardener was Jakob H. Rehder (1790–1852). Pückler-Muskau commissioned Wilhelm Schirmer to draw parkland views and attempted to realize them in the park. Karl F. *Schinkel drew up architectural plans, but they were not executed. After Pückler-Muskau's financial ruin Prince Friedrich of the Netherlands took over the park and extended it between 1852 and 1881, with the help of *Petzold as Director of Gardening; R. Lauche supervised the park from 1891 to 1928. It was severely damaged in 1945, and has been carefully reconstructed in parts, some areas as woodland.

The park is divided as follows: the Schlosspark or Unterpark around the Schloss and administrative building (rebuilt in neo-Renaissance style 1863–6), theatre, and the Neisse meadows as far as the eastern slopes. Sixteen bridges and viaducts connected the various parts. Huge, ancient oaks and 150-year-old plantations (beeches, oaks, limes) formed beautiful, picturesque scenes. There were small buildings for purely decorative purposes. Around the Schloss were a lake (later extended), ramps with two large gilded lions (by E. Wolff, Berlin) leading up to the extensive pleasure-ground, and, beyond, the Blauer Garten and Herren-Garten. In 1819 trees were planted on the town side so that it should not be seen from the park. In 1820 the Englisches Haus was built to embellish the north-east bank of the Neisse. In 1821 a narrow, artificial tributary of the Neisse (Hermannsneisse) was channelled into the lake around the Schloss and from there was directed into the Eich Lake (created 1821–4) by skilfully constructed embankments. Near to the spot where the channel enters the Neisse a romantic waterfall cascades over boulders. The Gloriette has a view over the Tränenwiese to the Neisse and the Schloss. Near by, but hidden by trees, are agricultural areas, the Orangery, and nurseries. The Oberpark is a hilly area traversed by gorges, then flat areas of land on Polish territory. In 1857 an arboretum of 125 ha. was laid out but it fell into disuse at the end of the 19th c.; a viaduct and observatory were built in 1861. On the hills opposite the Schloss lie the Funeral Church, built 1887–8 (now demolished) and the ancient, imposing Hermannseiche with nine stone seats. Large areas are now woodland.

H.GÜ.

See also GERMANY: FROM THE ROCOCO TO THE LANDSCAPE STYLE.

Myddelton House, Enfield, London, a 2-ha. garden created by E. A. Bowles (1865–1954), became world-famous for its superb planting. Along one bank of the river which flowed through it and following its course Bowles planted a great swathe of irises, 2·5-m. deep: the grey and lavender flowers of *Iris florentina* leading to the deep blue-purples of *I. germanica*, and the yellows of 'Golden Fleece', 'Leander', and yellow dwarf irises. June brought a rainbow effect, rich golds replacing the yellows; the mauves, lilac, and pink forms of *Iris pallida* contrasting with white and purple *I. amoenas* and on to thunderstorm bronzes and the lurid buffs of *I. squalens*. On the opposite bank of the river was a companion piece, a brilliant show of tulips.

Bowles created vistas, and as the garden—or even a particular plant—demanded it, he made other architectural features. The centrepiece of the rose-garden was Enfield's old market cross, while the Stone Garden boasted two pillars, one of them a fossilized tree. One plot, called the Lunatic Asylum, was planted with botanical misfits. His masterpiece was his rock-garden. It stood at the top of the Alpine Meadow, with its boulders skilfully positioned and the whole resembling a moraine splashed with sheets of colour. Below it, the Alpine Meadow ran down to a brook, a sequence of flowers—from the springtime crocuses, daffodils, anemones, and fritillaries to July when the meadow was cut in the alpine fashion—all growing as naturally as they did in the grassy slopes of the Alps. M.AL.

Nagycenk, near Sopron-Oedenburg, Hungary. For the French garden surrounding the manor-house of Count Ferenc Széchenyi we have three plans from the years 1750–60. It seems that an engineer, Knidinger—about whom we have no information—was the designer. The whole garden covered an area of 9 ha.; the part around the house was laid out in the French style with *parterres and trimmed *bosquets*, grouped around a central path, which led to the entrance gate flanked by two lodges. Here started a 3-km. long avenue lined with lime trees, which has partly survived. Around 1799 the house and the garden were transformed: features in the English style appeared, pleasure grounds were laid out, and various exotic trees planted. In 1820 the great Hungarian statesman, Count István Széchenyi, became the owner; as he had close contacts with England, we may assume that new ideas about gardening were imported. Documents mention plane trees, ginkgos, locust trees, magnolias, and various kinds of pine tree. An ostentatious rarity was a huge pine tree from California more than 40 m. high.

With some alterations the garden existed till the Second World War, when it was severely damaged. Reconstruction started in 1971 and is partly completed, with a parterre in front of the house (today transformed into a museum).

A.Z.

Nancy, Meurthe-et-Moselle, France, was the seat of the Ducs de Lorraine and an independent duchy until 1738. The early 17th-c. ducal gardens are illustrated in an engraving by the Nancy-born engraver, Jacques Callot. But the main distinction of Nancy from the point of view of town planning and gardens is the magnificent architectural ensemble created by Emmanuel Héré for Stanislaus Lescynski (father-in-law of *Louis XV) in the 1750s, and the adjoining public promenade, La Pepinière. Héré's buildings are of Palladian severity. The palace of the former governors of Lorraine is linked by peristyles to two rows of houses lining the Place de la Carrière, planted with an avenue of limes. At the opposite end, a triumphal arch, erected in 1754–6 in honour of Louis XV, leads to the Place Stanislaus, 124 m. × 106 m. and originally closed at the corners by fine wrought-iron *grilles* by Jean Lamour.

La Pepinière owed its foundation to Stanislaus, but was completed by Louis XV in 1766 on 20 ha. ceded by individuals and the town on condition that it should become a public promenade. Old fortifications were levelled, and the nursery was planted with 30,000 ashes, 10,000 limes, 1,700 horse-chestnuts, and 400 walnut trees. The land ceased to be a nursery in 1831, and was finally laid out as a public park between 1841 and 1877. There are some fine specimen trees; and its original character remains in the straight avenues, some planted with lime, ailanthus, or horse-chestnut, and some mixed.

Nancy also has a small botanic garden with a collection of alpines and insectivorous plants.

K.A.S.W.

Nanjing (formerly Nanking), China, is situated on a curve of the Chiangjiang (formerly Yangtze River—the dragon curling), with the Purple Gold Mountains (the tiger crouching) to the east. This capital of Jiangsu province has several times in its long history also been capital of the empire and a major cultural centre. The first three Ming emperors are buried in the Purple Gold Mountains, which are also famous for their monasteries set among cliffs and wooded hills. Just beyond the northern city walls is the Xuanwu lake park, covering today about 400 ha., which 'borrows' views of the distant hills (see *jie jing*) and has several large islands linked by bridges. Outside the western wall is the pleasant Mochou—meaning lighthearted—Lake garden which commemorates a Liang dynasty heroine. Originally laid out under the Song dynasty, it was restored in the 1950s with bamboo groves, crab-apple orchards, and pavilions around the lake. Within the city is the Zhan Yuan, an intricate Ming-dynasty garden, now overlooked by buildings but with a fine rockery imaginatively restored and enlarged in the 1950s. Once known as one of the three furnaces of China because of its unbearable summer heat, Nanjing has become much cooler with the planting of 24 million trees under the People's Republic.

M.K.

See also SUI YUAN.

Nappe, a sheet of smooth water, either falling in a cascade or spreading in an ornamental basin.

D.A.L.

Narcissus. The *Royal Horticultural Society's International Register of *Narcissus* cultivars groups them into 10 divisions and many subdivisions. There are over 7,000 cultivars derived from *Narcissus* species by hybridization, and commercial nurserymen's catalogues are full of old and new forms. The basic flower colours are white, yellow, and orange but more and more cultivars include apricot, scarlet-red, and pink in their colour combinations. Planted among grass, under trees, in flower borders, or forced in greenhouses and indoors, daffodils, as most narcissi are commonly called, are among the earliest flowers in gardens throughout northern Europe and North America. Few gardens of any size are without at least a few bulbs of the yellow 'King Alfred' or 'Carlton', the white 'Mount Hood'

or the pheasant's eye (*Narcissus* 'Actaea', derived from *N. poeticus*).

Becoming more widespread in gardens are the very early flowering cultivars such as 'Peeping Tom' and many others bred for this purpose. One of the most spectacular ways of growing these and other forms is to create an 'alpine meadow'. The daffodil field at Wisley is a particularly good example. The multi-flowered species *N. jonquilla* and *N. tazetta* are cultivated as species in their own right, but also enter into the parentage of the garden jonquils and the Christmas-flowering indoor plant 'Paper White'. The native *Narcissus pseudonarcissus* (wild daffodil) and its variety, *obvallaris* (the uniform yellow Tenby daffodil), will grow in almost any soil, but the European species such as the hoop petticoat (*N. bulbocodium*) and the angel's tears (*N. triandrus*) are more often found as rock-garden or alpine-house specimens. P.F.H.

Narenjestan-i Qavam, Shiraz, Iran, the Qavam Orange Grove, is a 19th-c. garden entered off a busy artery in the east part of the city of Shiraz. The rectangular site is scarcely more than half a ha. in area. Entry to the garden is through a vestibule forming part of a set of small rooms that serves to protect it from the noise and activity outside. Down the centre of the garden is a narrow canal lined with blue tiles that widens at intervals into pools of various geometrical shapes. At the far end of the garden across the width of the property is an elegant two-storey house whose principal rooms face south over the garden, as was customary. Its décor includes glazed tile and metal work. In front of the house is a terrace raised above the level of the garden, with a rectangular pool at its centre. Palm trees line the sides of the garden, which is flanked by arcaded walls. The garden is well planted, and has many flowers. J.L.

Nash, John (1752–1835), English architect. See BLAISE HAMLET; CORSHAM COURT; REGENT'S PARK; REPTON, GEORGE STANLEY; REPTON, HUMPHRY; REPTON, JOHN ADEY; ROYAL PAVILION, BRIGHTON.

Nasim Bagh, Lake Dal, near Srinagar, Kashmir. This corresponds with the Emperor *Jahāngīr's description of a lakeside palace belonging to his father *Akbar who visited Kashmir in 1586. He found it already fallen into disrepair, and he describes in his journals how, out of respect for his father's memory, he gave instructions for its repair and decoration. Only a few fragments of masonry now remain near the water's edge. The site was planted out in the reign of Shāh Jahān with an immense grid of plane trees, and this, when viewed from the lake, forms a powerful feature in the landscape. S.M.H.

Nasmyth, Alexander (1758–1840), was primarily a Scottish landscape painter who occasionally also practised as a landscape designer and architect. His approach was genuinely picturesque; he conceived his designs as pictures, and their power appears to have derived from their qualities as pictures rather than their merits as designs. He advised at

various Scottish estates between 1800 and 1840, including Airthrey, Dunkeld, and Taymouth, but he is best remembered for his circular classical temple known as St Bernard's Well (1789), set beside the Water of Leith in Edinburgh, where he captured more of the spirit of the Sibyl's temple at Tivoli than any one else; it has inspired countless residents of Edinburgh ever since. W.A.B.

National Botanic Gardens, Ireland. See GLASNEVIN.

National Council for the Conservation of Plants and Gardens. See FLOWERS.

National Trust Gardens. In the variety, quantity, and quality of its gardens in England, Wales, and Northern Ireland, the National Trust's collection is unique. As well as owning the greatest number it owns some of the world's most important landscape parks, historic gardens, and plant collections; taken together they constitute one of the world's greatest collections of cultivated plants.

The primary aim of the Trust is to preserve but in gardens change is both inevitable and desirable. In order to retain individuality it is necessary to have a separate policy for each, based upon a full knowledge of the history of the garden and those who made it, its plants and its features, and the climate, the soil, and the locality. In this way change can be directed along predetermined lines and the strong pressures toward uniformity that exist in gardens owned by a single organization, open to visitors, and where strict economy is needed, can be resisted.

The Gardens Adviser and his assistants are responsible for advising on policy and all aspects of management, restoration, planting, and cultivation for all gardens owned by the Trust. Following visits and discussions with the Head Gardener, the Managing Land Agent, the Regional Historic Buildings Representative, and others, detailed advice is given in the form of written reports which set out the agreed programme of work for the immediate future.

Regional Committees are responsible for the gardens as well as for other property in each of the 16 Regions and management is in the hands of Regional Directors and Land Agents. On matters of national importance Head Office Committees are responsible. The Gardens Panel is appointed by the Properties Committee and advises them on matters of policy affecting the acquisition, management, and presentation of the Trust's Gardens.

The National Trust for Scotland is a separate organization founded in 1931; it has a number of gardens in its care, some of which belong to houses also in the Trust, but others are gardens of outstanding importance unattached to great houses. J.S.

See also ENGLAND: THE TWENTIETH CENTURY; ANGLESEY ABBEY; ATTINGHAM PARK; BARRINGTON COURT; BLICKLING HALL; BODNANT GARDEN; BUSCOT PARK; CASTLE DROGO; CLAREMONT LANDSCAPE GARDEN; CLIVEDEN; DYRHAM PARK; ERDDIG; FARNBOROUGH HALL; HAM HOUSE; HIDCOTE MANOR GARDEN; INVEREWE; MONTACUTE HOUSE; MOUNT STEWART; PACKWOOD HOUSE; PETWORTH HOUSE; PINE-

APPLE, THE; PITMEDDEN; POLESDEN LACEY; POWIS CASTLE; ROWALLANE GARDEN; SCOTNEY CASTLE; SHEFFIELD PARK; SHUGBOROUGH; SISSINGHURST CASTLE; SNOWSHILL MANOR; STOURHEAD; TATTON PARK; TRENGWAINTON GARDEN; WAKEHURST PLACE; WALLINGTON; WESTBURY COURT GARDEN; WEST WYCOMBE PARK; WIMPOLE HALL.

Naumachie, a mock naval battle; also used for the ornamental basin in which this takes place, as at *Parc Monceau. K.A.S.W.

Naumkeag, Stockbridge, Massachusetts, United States. Enclosed by the Berkshire Hills of western Massachusetts, this garden started as the summer estate of Joseph Hodges Choate in the 1890s. After his death it became the home of his daughter Mabel Choate, who was responsible for most of its development. The name is an Indian word meaning Haven of Peace. During her residence here the gardens were updated and improved by the Boston landscape architect, Fletcher *Steele. Between 1925 and the late 1930s Steele created a number of smaller gardens within the garden including: a Chinese Garden with a miniature temple, Moon Gate, and twisting Devil Screen entrance, a Rose-Garden, a Green Garden, a Cutting Garden, and an Afternoon Garden enclosed by carved oak posts with clematis. The last two are linked by the Blue Steps, a modern interpretation of a Renaissance form, the blue-painted concrete steps straddling a series of small cascades falling through the birch-woods. M.L.L./E.F.S.

Nazionale, Villa, Strà, Italy. See PISANI, VILLA.

Nebbien, Christian Heinrich (1778–1841), German garden designer, laid out a garden for Joseph Brunswick at Alsókorompa (Dolná Krupa, Czechoslovakia) c.1815–20 and at *Martonvásár for Francis Brunswick. In 1817 he won a competition for laying out the City Park at Pest (*Városliget). His designs were accompanied by his lengthy description in manuscript of each detail of his plans, including the planting of special trees and shrubs, and offering an insight into his views on environmental problems.

In 1820 he presented another series of plans and elevations for the Äussere Burgtor and Garden at Vienna, but these were never realized and we do not know about a competition. Besides the usual features of an English garden, both series have sumptuous entrance gates decorated by statues and other smaller garden buildings, showing belated examples of the style of heroic French Revolution architecture. Most of his publications, dated after 1828, suggest that he worked as an expert consultant rather than as an artist or engineer. A.Z./P.G.

Nei Yuan, China, literally the Inner Garden, was built in 1709 on some 700 sq. m. to the east of the City Temple complex in the old city of Shanghai. Today it has become part of *Yu Yuan, which lies to its west, so it was also called Dong Yuan or East Garden. It is a tiny, intensely planned enclosure, its main Hall of Sunny Bright Snow or Qing Xue Tang facing and embraced by rockery hillocks on three sides. These are piled up above hollows and a rocky tunnel with pavilions and secret paths built among them. A Dragon Wall, identical to those in Yu Yuan, winds across these rocks ending in a realistically modelled head. Below it, water flows

The Blue Steps at Naumkeag (1926), Stockbridge, Massachusetts, by Fletcher Steele

out through an opening and runs into the tiny Nine Dragon Pond surrounded by *mei ren kao. A fine brick carving of an Immortal in Paradise animates one tiny enclosure, while on the west hillock a small tower once 'borrowed' (see *jie jing) a distant view (blocked now by structures built this century) of the busy Huang Pu River. G.-Z.W./M.K.

Nesfield, William Andrews (1793–1881), a retired English officer, achieved fame as a painter before becoming known as a garden designer. He began this career working with architects like Edward Blore and his brother-in-law Anthony Salvin, who were working in a variety of medieval and English Renaissance styles; his gardens attempted to reflect the olden-time character of the houses by using designs drawn from old gardening literature—which meant primarily the late 17th and early 18th cs. At Worsley Hall, Lancashire (Greater Manchester) for example, he laid out on Blore's terrace a *parterre based on a design of *Dezallier d'Argenville. His name came before the public when he was chosen to landscape the Royal Botanic Gardens, *Kew (1844–8), where he created the pond, parterre, and *patte d'oie of vistas surrounding the Palm House, as well as planting a portion of the grounds as a pinetum.

From the 1840s on he had an extensive practice as a landscape architect and designer of parterres for country houses. Although his stylistic range was varied, and he could create a resolutely classical-Italianate garden at *Grimston Park, he was best known for his parterres in 17th-c. style, using intricate patterns of box tracery on gravel beds. During the 1850s his interest in Tudor precedent grew, and led him to experiment with parterres laid out in the patterns of monograms, and with beds relying on coloured gravels rather than plants. In 1851 he submitted an unsuccessful plan for a parterre for the forecourt of Buckingham Palace; in 1860–1 he laid out the *Royal Horticultural Society's garden at Kensington, where his reliance on gravels met strong criticism from horticulturists. Examples of his parterres can be seen at *Holkham Hall and at *Broughton Hall, but most of his decorative work has been destroyed since his death; an anti-Nesfield reaction during the 1870s meant that the phrase 'natural gardening' could be applied to any flower garden, however formally laid out, that did not involve gravels or architectural dressings.

In his later years Nesfield advised on alterations in the Royal Parks, and relied increasingly on his sons' assistance. Markham Nesfield designed the Italian Garden in *Regent's Park, and the garden at Ogston Hall, Derbyshire, before his early death. William Eden Nesfield, one of the originators of the 'Queen Anne' style of architecture, used his father's work at Witley Court, Worcestershire (Hereford and Worcester)—where he had substituted a symmetrical arrangement of shaped trees for the usual parterre—as a model for the gardens of his houses. B.E.

See also BLICKLING HALL; CASTLE HOWARD; TUDOR GARDEN.

Netherlands

The Dutch garden played a significant role in the development of landscape architecture in northern Europe during the 16th, 17th, and early 18th cs., from the designs of Vredeman *de Vries to the Dutch classical canal garden, the Franco-Dutch garden, and culminating in the Dutch Régence garden. During this period Dutch horticulture was of great renown.

THE MEDIEVAL GARDEN. Though little is known about Netherlandish medieval gardens, various sources provide fragmented reconstructions. Chronicles (Jacob Maerlant, d. 1299), romances (Walewien, c.1350), and verse plays (Lancelot of Denmark, c.1390) convey their setting and symbolism; 15th-c. Netherlandish paintings and miniatures, executed with an unparalleled sense of realism and eye for detail, reveal their visual significance; and household accounts give a validity to their existence. The development of Netherlandish gardens was closely linked with those of northern Europe, in particular the House of Burgundy. Particularly notable were the gardens of the Counts of Holland at Het Binnenhof, The Hague, laid out between 1350 and 1460, which, as a series of outdoor rooms closely integrated with the castle, contained 'flowery medes' embellished with turf seats, arbours, trellised roses, lavender and carnations, and an ornate pavilion whose roof was adorned with gilded statues of the Counts of Holland. There was a great pond for boating and fishing (c.1350), still in existence today, as well as a vineyard and hand-tennis court (1388). The gardens of the Dukes of Gelder at *Rosendael were renowned for their menagerie of exotic animals.

THE ERASMIAN GARDEN. The genesis of the Dutch Renaissance garden is evoked in *The Godly Feast* (1522) by Erasmus, whose description of an ideal and emblematic garden is permeated with humanist and above all Christian moralization, characteristics which anticipate the 17th-c. Dutch garden. In contrast with the Italian humanist garden, from which, however, much of the composition is derived, an aura of piety prevails, with the presence of the symbolic fountain of St Peter greeting the visitor instead of 'Mercuries, Centaurs and other monsters', and of Jesus as the 'protector of the garden' rather than the 'filthy Priapus'.

As an extension of the *villa suburbana*, the square pleasure garden was enclosed on three sides by a gallery supported by marbled pillars which housed a library and an aviary. The gallery's frescoed walls portrayed in *trompe-l'œil a permanent microcosm of the animal and plant world. A fountain

'to refresh and cleanse the soul', whose marble channels divided the garden in half, was surrounded by separate beds of choice and fragrant plants, each accompanied by a motto. Beyond the gallery lay a kitchen garden with rare herbs flanked on one side by a turf meadow and on the other by an orchard containing 'many exotic trees' and beehives.

Although expressed in a different form, by the end of the 16th c. such Erasmian components as galleries, trompe-l'œil ornament, fountains, and parterres for rare plants were incorporated into the Dutch Mannerist garden, as exemplified by the designs of Hans Vredeman de Vries (1527–c.1606). The garden designs of de Vries, a Frisian painter, decorator, and engineer, who conceived of the garden as an art form, reveal the elaboration, within a medieval framework, of Flemish Mannerist intricacy and artifice. Through his work abroad and through the dissemination of his engraved garden designs (Hortorum viridariorumque . . ., Antwerp, 1583), de Vries's Mannerist gardens extended well beyond the Netherlandish borders.

The general layout reveals a series of autonomous, although axially aligned, square gardens enclosed by medieval latticework or hedges and often dominated by the architectural presence of the Erasmian gallery transformed into elaborate cruciform, square, or labyrinthine structures encompassing intricate fountains and parterres. His parterre designs of 1583 are a personal and anthropomorphic interpretation of the classical orders, perhaps the first of their kind, with the Doric represented by geometric patterns; the Ionic by circular and volute motifs, some resembling dismembered columns; and the Corinthian by labyrinthine forms. De Vries's garden designs and his *parterres de pièces coupées (parterres of cutwork), intended for the display of individual rare and exotic plants, had an enduring influence in the Netherlands and northern Europe.

The prominence of rare and exotic flowers in Dutch parterres reflects the renown of Dutch horticulture, the expertise of which, in the form of skilled gardeners, plants, and horticultural treatises, was in demand throughout Europe in the 17th c. A great impetus was given by the establishment of the *Leiden University botanic garden in 1587 and the appointment of Carolus *Clusius, Europe's first scientific horticulturalist and taxonomist, as its director in 1594. Considered 'le père de touts les beaux jardins', Clusius was instrumental in introducing into cultivation many plants from the eastern Mediterranean, Spain, Portugal, Austria, and Hungary. Crown imperials, hyacinths, narcissi, crocuses, Spanish and Siberian irises, windflowers, lilies, sunflowers, African marigolds, marvels of Peru, gladioli, and of course *tulips, whose cultivation led to a fever of speculation or tulipomania in 1634–7, were admired as single specimens in the de Vriesian parterres of cutwork, consisting of small variously shaped beds separated by narrow paths. Central to the house in the early 17th c. and often enclosed by galleries, such as those portrayed by Crispijn van de Passe (Hortus Floridus, 1614), these flower parterres were later placed apart in separate enclosures such as the ones at Huis ten Bosch (1645–52)

and later in the Queen's Garden at *Het Loo (c.1690). In contrast with France, flowers were planted in the scrollwork of the parterres de broderie or de compartiments, as evidenced by Daniel *Marot's engravings.

THE DUTCH CLASSICAL GARDEN. With the emergence of the Dutch republic, freed from Spanish domination in the early 17th c., the influence of classicism was soon manifested in Dutch architecture and landscape architecture, eclipsing de Vriesian Mannerism and resulting in an indigenous development. Indeed the principles of classicism came to symbolize the aspirations of the new nation. They also reflected the scientific and engineering advances made during the period.

The earliest example of a garden laid out upon the Vitruvian–Albertian principles of symmetry and harmonic proportion (see *Alberti) was most probably the *Buitenhof of Prince *Maurits in The Hague (c.1620). The plan, possibly by Maurits himself and the earliest known design of an actual Dutch garden, manifests the Albertian ideal of abstract design with its purely geometric structure and disposition of the integrated parts. Within a walled rectangle or double square were placed two concentric circles, each inscribed in a square, which were in the form of berceaux and connected by a rectangular pavilion containing trompe-l'œil frescos. In the corners of each square were circular or square pavilions and within the berceaux were parterres de broderie, some of the earliest examples in the Netherlands, centred on fountains.

After 1620 the principles of classicism determined the development of the Dutch canal garden whose distinctive rectangular framework, enclosed by canals and trees, and symmetrical disposition of the parts recall the ideal classical city designed by Simon Stevin, the famous Flemish émigré scientist and engineer. The earliest examples were the princely gardens of *Frederik Hendrik (1584–1647), followed by the proliferation of villae suburbanae of the bourgeoisie, lying almost uninterruptedly along the numerous waterways, reflecting the real character of the country.

The Dutch canal garden, characterized by its flat and static nature, its rectilinear framework encompassed by canals and trees, and its modest size and horticultural rather than arboreal nature, was conditioned by the geographic, socio-economic, and religious structure of the republic which in turn tempered the influence of Italy and France. The rectilinear outline contained by water was closely related to the medieval system of land distribution in the low-lying marshlands where regularly spaced long narrow strips were separated by indispensable drainage canals. An enclosure of trees and hedges in an otherwise barren and windswept region was an essential shield for the garden's vegetation. Unless excavated, terraces and cascades were obviously precluded. Monumentalism and the grandiose were alien to the ruling class of urban bourgeoisie, and indeed even the princely gardens of the Stadholders (provincial governors) were modest in scale. The presence of utilitarian or horticultural areas was inspired by *Virgil's

Georgics, sustained by the Calvinist ethic of man's duty to employ the products of nature provided by the Maker, and encouraged by horticultural science. An emblematic approach to the products of nature was widely expressed in the moralistically didactic Dutch country-house poems, reflecting the Erasmian spirit.

The prototype of the Dutch classical canal garden and one which served as a model throughout the 17th c. was *Honselaarsdijk, laid out in *c.*1621 by Prince Frederik Hendrik who succeeded his brother Maurits as Stadholder in 1625. Within a rectangular plan enclosed by canals and trees, the moated castle and gardens are united by a central axis along which three compartments were laid out. This axis extended beyond the palace's entrance by means of an Italianate semicircular piazza and grand avenue flanked by trees and canals. The plan's proportional relationship of width to length was 3 : 4, reflecting one of the Pythagorean-Albertian harmonic ratios. André *Mollet, who designed two parterres there in *c.*1633, was evidently inspired by the general layout and the proportions of the garden, as the second plan of his *Le Jardin de Plaisir* (1651) indicates.

Italianate classical influence was further developed after 1640 by Constantijn *Huygens and *Johan Maurits of Nassau-Siegen together with the architects Jacob *van Campen, Pieter *Post, and Philips *Vingboons. Assisted by van Campen, Huygens adapted in 1640 the Calvinist ideal of a *villa suburbana* at *Hofwijck, near The Hague, where within a rigid rectangular framework, intersected and surrounded by canals, he created a sylvan Edenic garden whose layout, with one of the earliest essays in the informal

planting of trees, was derived from the proportions of the Vitruvian human figure. Other Italianate gardens were Elswout, Nijenrode, and Huis ten Bosch which was laid out by Pieter Post for Frederik Hendrik in 1647, recalling the Villa *d'Este at Tivoli.

Unprecedented were the wooded parks linked by avenues, evoking sacred landscapes and displaying a 'wild Regularitie', which were laid out after 1647 by Johan Maurits at *Cleves near the Dutch border in Germany, in a hilly region with radiating avenues terminating in a variety of vistas. One such park on a wooded hillside contained a deer-park and a series of terraces—forming an amphitheatre with ponds, statues, and a Palladian semicircular gallery designed by van Campen—laid out in the 1650s, the axis of which was extended into the surrounding countryside by a canal flanked by lime trees. Johan Maurits's baroque parks are reflected in those of the Grand Elector's palaces at Berlin and Potsdam. The Dutch classical garden was also an influence in northern Germany and in Sweden where, for instance, Jean de *la Vallée's design of Ostermalma (*c.*1660) is based on a plan by Vingboons.

With the establishment of colonies abroad, the Dutch classical garden was transposed to Java, New York, Brazil, Curaçao (Lesser Antilles), *South Africa, and Surinam, many serving as important botanical and horticultural centres (see *Dutch colonial gardens).

After 1680, during the reign of *William and Mary, the protracted baroque central axis and ornamental flourish were adapted to the enclosed orthogonal framework of the Dutch classical canal garden, resulting in a hybrid of the

Het Loo, Netherlands, engraving from Walter Harris, *A description of the King's Royal Palace and Gardens at Loo* (1699)

Renaissance and the baroque. The inner parts, laid out on parallel axes, remained autonomous and enclosed, with a concentration on decorative detail and with little progression from the complex to the natural. From the commanding position of the house, parterres were succeeded by hedged orchards or kitchen gardens terminating at times in *bosquets*. These gardens in no way resembled the Grand Manner or unified conception of the French garden. Notable examples of the Franco-Dutch garden are *Zeist, Het Loo, and *de Voorst, all presumably laid out by Jacob *Roman, architect to William III. Het Loo may be regarded as the ultimate expression of William and Mary's gardening tastes. French influence was mainly limited to ornamentation and largely promoted by Daniel *Marot (1661–1752), decorator and architect to William III, who contributed intricate designs of decorative motifs. All the gardens exhibited an exuberance of *parterres de broderie*, Italo-Franco fountains and sculpture, and geometrical forms of topiary, and also such Renaissance vestiges as *berceaux*, mazes, and trellis arbours, while deer-parks, aviaries, and menageries were incorporated in the parks.

Specific ornamental architectural features were tea pavilions, situated along moats or canals, and orangeries, such as Huis Ter Nieuwburg of *c*.1640, which was adorned with East Indian shells, and the elaborate semicircular structure of *c*.1675 at *Zorgvliet belonging to Hans Willem Bentinck, superintendant of William and Mary's gardens in 1689, which was probably inspired by van Campen's Palladian pavilion at Cleves (1652) and which served as a model at Gaibach, Germany. By the end of the century every country house of note displayed orange trees and other exotic plants in tubs (a tradition which harks back to the Buitenhof) which were placed around circular or oval terraced basins in separate enclosures.

The Franco-Dutch garden spread to England, Germany, and Russia (see *Cause; *van der Groen). At *Hampton Court Marot designed the parterres for the Great Fountain Garden in 1689, while the Privy Garden and Wilderness recall his engraved designs. Other examples are Ragley, Bulstrode, and Melbourne in England; and *Oranienbaum, Oranienburg, *Herrenhausen, and Gaibach in Germany. In Russia, Nicolaas Bidloo (1673–1735), Dutch physician to Peter the Great, designed his own and other gardens near Moscow in *c*.1710; in St Petersburg (Leningrad) Dutch influence is reflected in the Tsar's summer palace on the Neva (see *Summer Garden).

In marked contrast with the Franco-Dutch garden was Rosendael, near Arnhem, whose wooded layout on a hilly site recalls Johan Maurits's Italianate parks at Cleves. Also different in conception were the gardens of the affluent bourgeoisie, laid out along the Vecht River in the province of Utrecht and admired by many foreigners; the intimacy, charm, and playful nature of their layout anticipated the rococo. Many simulated stage settings with Italianate walls of yew serving as *coulisses* framing house and garden. Nearly all had tea pavilions on the riverside. A typical example was Petersburg (1717) designed by Simon *Schijnvoet (1652–1727) and often visited by Peter the Great, with its series of island rooms, or *giardini segreti*, containing aviaries, orangeries with Russian bath-houses, ponds and ornate fountains, statues and numerous pavilions.

RÉGENCE, ROCOCO, AND FRENCH PICTURESQUE. The early 18th c. witnessed the innovative development of the Dutch Régence garden (*c*.1720), which in plan reflected a change in attitude toward the relationship between art and nature and in conception foreshadowed the picturesque garden. Like the French Régence and the early Georgian gardens, natural elements predominated over the artificial, reflecting A.-J. *Dezallier d'Argenville's principle 'faire cèder l'art à la nature', a principle later expressed by Pieter de la Court *van der Voort (1664–1729), the first garden theorist of the Netherlands. Unified in plan and varied in composition these gardens, laid out near Haarlem by members of the Amsterdam bourgeoisie, were closer in conception to the rococo and picturesque gardens, as they embodied elements of intimacy, contrast and movement, grace and charm, pictorial asymmetry and *utile dulci* (a combination of the useful and the beautiful).

The house was subordinate to the garden whose main structure of woods engulfed the house and nearly eclipsed the parterres. A single static viewpoint was displaced by transverse or radial avenues, piercing woods and terminating in a variety of scenic focal points within and not outside the garden. The useful and the agreeable were skilfully integrated, a tradition of earlier gardens such as Hofwijck, albeit in a less unified form. Ideal and self-contained landscapes were created within the enclosed confines of the garden, excluding any direct connection with the surrounding countryside, a characteristic which continued throughout the 18th and 19th cs. In emulation of Dezallier d'Argenville's 'noble Simplicité', grass *parterres, *bassins, *boulingrins, *allées, *vertugadins, and still ponds were employed for ornamentation.

The Dutch Régence garden totally contradicted *Switzer's condemnatory epithet of 'Dutch Taste', which pertained to the excessive ornamentation and additive designs of the Franco-Dutch as well as of the English 17th-c. garden, in particular the English penchant for Mannerist anthropomorphic forms of topiary.

A notable example which anticipated the picturesque garden was *Waterland (*c*.1720) near Haarlem, whose design was conceived as a labyrinth. From the central focus of a large *bassin*, five avenues radiated into the garden through woodland, terminating in such varied pictorial elements as an urn, an intimate green room with a triumphal arch, the villa, a camera obscura projecting moving pictures of boats on a nearby lake, and a Turkish tent. The earliest example of an asymmetrical plan within a geometric framework was *Duin-en-Berg (*c*.1730). On an irregular and hilly terrain which incorporated the dunes along the North Sea, dense woods were pierced by winding walks and rectilinear *allées* intersecting at oblique angles.

Opposed to the natural simplicity of the Dutch Régence woodland gardens were the intricate and artificial rococo gardens designed in *c*.1730 by Daniel Marot, such as Meer-

en-Berg and Huis ten Bosch. A synthesis of these two types of garden is reflected after 1750 in the early Dutch landscape garden whose designs were in the spirit of the schematic plans of Switzer. Along irregular lakes or ponds, circular or symmetrical curving paths were linked by rectilinear avenues, such as at Woestduin (1766) by A. Snoeck or *Beeckestijn (1772) by J. G. Michael, the first landscape architect of the Netherlands, who designed there such evocative objects as a Gothic temple and a hermitage.

By the end of the 18th c. the French picturesque garden, in both its pastoral and *anglo-chinois* forms (see *van Laar), was a predominant influence; the former, inspired by *Rousseau and *Girardin, is represented at Elswout and Het Manpad, both near Haarlem, and the latter at Velserbeek and *Twickel. Enclosed landscapes with winding walks, artificial hillocks in woods, meandering streams, irregular lakes, serpentine canals, wheat-fields and orchards, cattle and sheep, served as frameworks for scenes evoking distant times and places and moral sentiments. Images of China, Russia, and Switzerland, Arcadian presentiments of death (*memento mori*) or pastoral gaiety, were associated with various architectural forms, samples of which with appropriate settings were reproduced in van Laar's *Magazijn van Tuin Sieraaden* (1802, 1819, and 1831), recalling Grohmann's *Ideen-Magazin*.

THE ROMANTIC LANDSCAPE PARK. By *c.*1820 the associative picturesque garden was replaced by the romantic landscape parks of J. D. *Zocher the younger (1791–1870), grandson of J. B. Michael and the most eminent landscape architect of the 19th c. in the Netherlands. With an emphasis on water and trees, based on Brownian-Reptonian principles, his plans reflected a synthesis of the French, German, and English landscape parks. Skilfully adapting his designs to each individual site, often on flat land, he created natural and tranquil parks, harmonious in form and colour, such as those at Rosendael and Twickel. *De Wildenborg was also landscaped in this manner. After 1850 Eduard *Petzold (1815–91), protégé of Prince *Pückler-Muskau, designed parks for Prince Frederik near The Hague and at Twickel. Later Leonard Springer (1855–1940) produced landscapes and *jardins composites* derived from Meyer and Edouard *André. 'Public walks' were laid out on the great dykes of towns such as Haarlem, Breda, and Utrecht, and the first public park, *Vondelpark, was laid out by J. D. Zocher in Amsterdam (completed in 1877).

Concern for the preservation and restoration of ancient monuments, engendered by historicism at the end of the 19th c., had an influence on the Dutch garden. The first and most notable example of a reconstruction of a 17th-c. garden conceived in the spirit of its historical origins was at *Weldam Castle, designed by Edouard André in 1886. Soon afterwards, in 1889, the first history of the Dutch garden was written by Leonard Springer. F.H.

See also KRELAGE NURSERY; SINGRAVEN.

THE TWENTIETH CENTURY. Garden design during the first decades of the 20th c. was dominated by two main styles: the English landscape style (which was applied to the public walks on the dikes of towns such as Haarlem, Breda, and

Entrance of the Catholic University of Economics, Tilburg, Netherlands, by P. A. M. Buys

Utrecht) and that of the cottage garden. The Dutch interpretation of the former, pioneered by the three generations of the Zocher dynasty, characterized by curving walks, continuous moats, lakes, and lawns, was continued in a more reduced, controlled, and less voluptuous form by Leonard A. Springer, a key figure in the development of garden and park design in the Netherlands. He introduced the mixed-style design for smaller country-house gardens—with a classical parterre in front of the house and curving paths around it.

The influence of the cottage garden was significant in the work of such designers as J. P. Fokker, J. F. Tersteeg, John Bergmans, and Mien *Ruys, who looked for inspiration to *Lutyens and *Jekyll. They turned away from the landscape style, which they found unsuitable for gardens. The combination of architectural framework built up by hedges, walls, and pergolas with rock-gardens and herbaceous borders of perennials was typical of their garden designs; flowers were well balanced and controlled. The popularity of the cottage-garden style may be seen as a 'renaissance' in garden design at that time, asserting itself in the period between the two world wars.

Impact of the Modern Movement. The Modern Movement in architecture and town planning made a dramatic impact on landscape design. *Bijhouwer, *Boer, and Ruys were all members of the CIAM and instrumental in forging links between the professions and evolving a modern landscape and garden style. The new concept of space expressed by the Rietveld-Schröder house of 1925 revolutionized the earlier closed concept of the garden. Architecture and garden design, by Christopher *Tunnard in Britain, Jean Caneel-Claes (see *Belgium), C. Th. *Sørensen and Troels Erstad in Denmark, and Thomas *Church and his followers in America, provided a strong and clear geometric frame in contrast to plant material, from which flowers were increasingly excluded. They were restricted to the outdoor room, the terrace, or the *Blumenfenster* (a window for indoor planting). These ideas were later expressed in the concept of open planning at the level of the town, neighbourhood, communal garden, and public green place. W.J.C.B./M.L.L.

Among the outstanding achievements of the 1930s were the Kralingerhout, Rotterdam, and the Bos Park, Amsterdam, sited on recently reclaimed land. The watercourses, lakes, and ponds which also formed part of the drainage system were integrated into a series of clearly defined functional spaces serving a wide range of sports—rowing, canoeing, bicycling, horse-riding, and camping. The most dramatic of these spaces is the rowing course, the total length of which is 2,200 m. × 92 m. The Park was probably the first to be planted on ecological principles—nearly all the plants are native, and substantial areas are set aside as nature reserves. P.G.

The ecological approach (see *ecology and gardens) began in the 1920s with the biologist and teacher Jaques P. Thijsse. He feared that the rapid expansion of towns and industries would destroy the natural landscape of the Netherlands before people had become aware of its beauty

and significance. Following a design by Leonard Springer, in 1925 he and his gardener C. Sipkes created the Thijsse Hof in Bloemendaal near Haarlem. Stimulated by the development of botanical geography and botanical sociology, and the science of plant ecology, this led to the concept of the *heem* park and garden which is now a feature of many cities. The most notable is the J. P. Thijsse woodland park in Amstelveen near Amsterdam by Broerse and Landwehr, constructed in 1940. The ecological movement has since spread to the park system, to roads and housing estates, and has almost displaced the use of ornamental plant material.

The Second World War marked a change from the classical and the romantic to a more natural approach to garden design influenced by designers such as the German, Otto *Valentien. The post-war period of the late 1940s marked the beginning of a new unity between house and garden and a social interest in town planning and architecture, in the post-war reconstruction for which J. T. P. Bijhouwer (Professor of Landscape Architecture and Garden Design at the Agricultural University in Wageningen) became a spokesman.

Small private urban gardens are now created and maintained largely by their owners in a number of different styles with the help of popular publications and a burgeoning nursery and garden industry. Some have been organized by the artist Louis Le Roy, who calls himself an 'ecotect' and has advocated a new free urban landscape, expressing disillusion with the consumer society. In some animation projects such as that at Groningen, he encouraged people to create and maintain their own environments. This can be seen as a constructive contribution to social neighbourhood planning, of importance in the development and renovation of urban areas.

For some ecological designers architectural design is no longer important. The ecological approach has to be seen, however, as a valuable contribution to design, and not as a substitute for spatial beauty and clear urban patterns. Contributions to the discussion about the function and form of man-made and spontaneous natural environments have recently been published by a number of young landscape architects, notably Han Lörzing (*De angst voor het nieuwe landschap,* 'The Fear of the New Landscape') and Norfried Pohl (*The Rediscovery of Clarity in Dutch Landscape Architecture*), in which he presents the work of young designers—Bakker, Bleeker, Louwerse, and Bouwman.

W.C.J.B./M.L.L.

See also BUYS; PUBLIC PARKS; SCULPTURE GARDEN.

Neuer Garten, Potsdam, German Democratic Republic, is a 122-ha. park which encloses the Heiliger See on three sides and extends northwards to the banks of the Havel (at the Jungfernsee).

After his accession in 1786 Friedrich Wilhelm II bought up a large number of small gardens and vineyards to provide land for his park. The plans were executed by J. August *Eyserbeck. Considerable alterations were made in the first half of the 19th c. by *Lenné. In the middle of the western

shore of the lake stands the Marmorpalais (1787–92, by Gontard and Langhans). An avenue of pyramid oaks leads straight to the park entrance, which is framed by gatehouses in the Dutch style but with slightly curved roofs in the Chinese manner. Along the length of the avenue is the Holländisches Etablissement (1789–90), a number of gabled houses intended to suggest a Dutch village.

Between the avenue and the southern shore of the lake are winding *allées* and small groups of trees, with a neo-Gothic library (1793–4) on the shore, which corresponded to a Moorish temple (demolished 1869) on the northern shore. Directly next to the Schloss on the shore is a kitchen, in the form of a sunken temple (1789), and an obelisk (1793–4). Facing the avenue is the decorative façade of the Orangery (1791–2) with antique motifs depicting the sphinx and Egyptian gods. A flower-garden (1879–80) lies in front of the plant hall. On the garden side of the Marmorpalais is a formal flower parterre (1846, by Lenné). A narrow park extends to the north with many diagonal vistas. A commemorative urn lies in a dense plantation of trees; in the meadows are a pyramid (1791–2) and a Chinese parasol. In the northern part of the park there are appreciably larger garden rooms; a hermitage with urns and a grotto used to lie here. Schloss Cecilienhof was built in this part of the park in 1913–17.

Adjoining the Neuer Garten is the Pfingstberg on which stand the Temple of Pomona (1800, by *Schinkel) and the torso of the picturesque Belvedere, now badly damaged. The plans by Persius, Stüler, and Hesse from sketches by Friedrich Wilhelm IV were only partially executed in 1849–52. Lenné designed the surrounding park from 1849, connecting it with the Neuer Garten. H.GÜ.

Neutra, Richard (1892–1970), American architect, was born in Vienna and influenced by Otto Wagner and Adolf Loos. As an architect he worked with the landscape architect Gustav Amman in Zurich (1919–20), and with Erich Mendelsohn in Berlin (1921–2), before emigrating to the United States in 1923, where he spent a short time with Frank Lloyd *Wright.

Avoiding the temptations of Mexican building forms but using indigenous plants, he developed in southern California an architecture of great elegance and simplicity. The houses characteristically extend over the site, gaining enrichment both from their enclosed gardens and framed views of the distant landscape. His desert houses, such as the Kaufmann House or San Jacinto, California (1946), emphasize the contrast between pure geometry and the natural world and at the same time express the essential unity of man with that world. M.L.L.

Newburgh Garden, New York. In 1839 Andrew Jackson *Downing designed and had built for himself a house and garden 50 m. above the Hudson River. A contemporary writer (C. M. Hovey) described the site: 'There are no situations in the country better adapted for beautiful residences than are to be found on the banks of the majestic Hudson . . . steep and abrupt declivities clothed with lofty

pines, hemlocks, oaks, which from the height of its banks appear mere shrubs . . . broad glades . . . open country . . . ranges of mountains . . . numerous villages.'

The fact that the entrance gate is in the Grecian style, though the house is in Gothic, gives Hovey pause, but he proceeds where the drive passes by the service buildings and on past a formal flower-garden with gravel paths and box-edged beds. At the front of the house a large lawn descends to a nursery below, care being taken never to interrupt the view of the river. Arabesque beds on the lawn are for 'choice flowers such as roses, geraniums, fuchsias and salvias'. Hovey feels such beds should be introduced sparingly in a lawn whose breadth constitutes its greatest beauty. Circular beds are for 'petunias, verbena, Drummond phlox, nemophilas, nolanas, dwarf morning glories etc.' 'Specimen trees' are dotted about, as are palms in pots, 'Maltese vases', and rustic baskets. A sundial is 'an old but suitable ornament'. A.L.

New Delhi, India. At the Delhi Durbar of 1911 it was announced that the seat of government of British *India was to be transferred from Calcutta to Delhi. Edwin *Lutyens and Herbert Baker designed the complex of buildings, now known as New Delhi, in a style that incorporated both Western and Indian features. The Rajpath—the 3-km. ceremonial approach flanked by reflecting canals and lines of ashoka trees—and the garden to the west of the Viceroy's house, laid out in 1917, were inspired by the geometry of the traditional *Mogul garden. Spectacular fountains fashioned in overlapping tiers of sandstone discs, gazebos, pergolas, flights of steps, and topiaried trees combine to give a sculptural quality to a garden that is dominated by water. The garden, which is raised above the level of the surrounding plains, is contained within two massive retaining walls on each of which stretches a long narrow terrace.

In the planting of the garden, which was largely carried out during 1928–9, Lutyens was assisted by William Robert Mustoe (1878–1942), formerly a Kew gardener who came to India in 1905 to become Superintendent of the Lawrence Gardens in Lahore. The geometry of the Mogul garden was softened with English flower borders and lawns. R.D.

Newliston, West Lothian (Lothian Region), Scotland, is a small estate south of Hopetoun and west of Edinburgh lying in relatively flat countryside. It was the Earl of Stair's villa, being convenient for Edinburgh, and appears to have played a role similar to that of Lord *Burlington's *Chiswick House. Stair was a successful general and then ambassador to France, and both garden and house at Newliston reflect this background.

The designer of the gardens is unknown. A house by William *Adam was designed but not built (the present one by his son Robert is much later) and a stable block by him was built in the 1720s, so, as Newliston has a similar ground plan to *Arniston House where both house and grounds are by Adam, he was probably also responsible for the layout of the gardens here. The somewhat earlier Seaton Delaval Hall in Northumberland, perhaps by William Etty, has a

Kaufmann House (1946), Palm Springs, California, by Richard Neutra

Plan of the Kaufmann House and garden by Richard Neutra

very similar layout, and all three schemes may derive ultimately from one of the designs given by Dezallier d'Argenville in his book, *La Théorie et la pratique du jardinage* (1709).

The plan of the garden is roughly square, and is surrounded by a raised terrace walk with bastions at the corners. A stream is canalized and made to run roughly from east to west through the centre of the square, and just north of the *parterre and house the canal follows a segmental curve. The walks and sight lines from the house generate the main lines of the design, and most of the scheme is woodland. W.A.B.

New Zealand. The three islands of New Zealand (North, South, and Stewart) are the remaining parts of a great subcontinent now known as Gondwanaland, which covered Antarctica, Australia, India, Africa, and South America *c.*50 million years ago. The North Island was linked with New Caledonia or New Guinea, and thence to the Malaya archipelago and tropical north-eastern Australia. The early disappearance of the land bridge has been the cause of the isolation, both physical and cultural, which is the country's most significant characteristic.

The overall cool temperate climate has many local variations. Winters are generally mild, summers cool, with the rainfall distributed evenly throughout the year. But the distance between areas receiving over 500 cm. or less than 50 cm. of rain per year is often less than 80 km. On average the annual rainfall is between 64 and 150 cm. This even distribution throughout the year and the high level of sunshine are responsible for the remarkable growth cycle.

Of the country's flowering plants, 83 per cent are peculiar to New Zealand, and the flowers of most of these are white, yellow, or green (red being comparatively rare). The country is most widely celebrated for its ancient plants: the alpines, club-mosses, and ferns, which range from filmy microscopic forms to tree ferns some 18 m. high. But apart from plants which clearly originated in New Zealand, there is also evidence of affinities with the flora of Malaya, Australia, and South America, which pre-date the Maori and European connections.

Recent research has shown that eastern Polynesians, the Maori, were the first people to inhabit the country, migrating from such Pacific islands as Tonga, Raratonga, and Tahiti. The first arrivals *c.* AD 900 were the hunters of the moa who fired large areas of forest to drive out these primeval flightless birds. In further immigrations in 1350 large fleets of canoes brought tribal groups of Maori with a distinctive culture. They established many settlements or pahs, with surrounding gardens. These were protected from wind by stone walls in exposed places, each containing vegetables such as yams, kumaras (sweet potato), and gourds from which food utensils were made.

Joseph *Banks, who from 1768 to 1771 accompanied Captain Cook on his global expedition in the *Endeavour*, commented on the quality of the Maori vegetable gardens, and members of Cook's crew on a later voyage actually planted a garden, but they also took away botanical speci-

mens. By the end of the 19th c. there were probably more New Zealand plants in Britain than had been imported into New Zealand, but gradual transformation continued. The English oak was introduced in 1824, followed by a large number of other trees and plants, which have become commonplace throughout the country.

The first Europeans to make homes in the country were missionaries: Anglican (North Auckland), Scottish Presbyterian (Dunedin), and Roman Catholic (Auckland). They settled mostly in small communities in the far north of the North Island, where the climate was warm and humid. Although subtropical plants grew prolifically, they preferred to model the gardens of their small wooden houses on the English cottage garden, with vegetables and hardy ornamental trees and shrubs. Even the farms they established for teaching the Maori people were traditionally English. In Akaroa the French made a settlement and introduced walnuts, some of which survive to this day, as does the original oak at Paihia. Some of these places have been preserved and restored by the Historic Places Trust.

By 1839, there were *c.*1,000 settlers, and a number of companies and church societies in Britain were set up to organize emigration. The New Zealand Company began to sponsor suitable people to ensure an appropriate occupational and social cross-section. Between 1840 and 1850 the European population increased tenfold, and settlements and towns took on the character of the settlers' homes. New Plymouth, for example, was established by an organization predominantly from Devon, just as Christchurch and Dunedin had attracted other English and Scottish residents respectively; but it was the English who remained predominant. By the 1880s the rate of natural increase in the European population had overtaken that of immigration.

Farming was the great incentive, and the settlers adopted a typical pioneer attitude towards the land. The wilderness, represented by forest and mountain vegetation, was regarded as inexhaustible, if not as a direct threat to survival. Much lowland 'bush' was burned and quickly replaced by grasslands planted with familiar trees from the Northern Hemisphere. Among them, farm gardens were created incorporating some of the characteristics associated with English stately homes: close-mown lawns sweeping down to a river, with woodlands and artificial lakes complete with imported white swans (as at Centrewood, Waimate). Larger areas of land on the outskirts of the new settlements were developed for housing and large urban and suburban gardens began to appear. Details such as brick-paved and box-hedged parterres, greenhouses, and bright annual flowers completed the Victorian English fashion.

Large landscaped gardens became a feature of the larger houses and, increasingly, of town and suburban houses, and many gardeners were employed. The styles generally were English, but by the late 19th c. that meant a wide range from the 18th-c. landscape style with virtually no colour to the natural school of gardening advocated by William *Robinson and Gertrude *Jekyll, including the high Victorian love of formality and colour. Gardening was greatly facilitated in this period by the botanical explorations in Asia and South

America through which many exotic trees and shrubs were introduced by enthusiastic nurserymen.

In public parks and botanical gardens the Victorian vogue for geometric *carpet bedding was practised—and still is in some areas—but the current trend generally is towards the use of native plants. Many cities have green belts, some actually preserving indigenous vegetation. The one at Christchurch incorporates the Botanic Garden, which was started in 1864 and has become well established as a focus for the community. It is bounded by the River Avon and contains oak, ash, elm, various conifers, woodland daffodils and bluebells, a rock-garden, and a rose-garden, all in traditional English style. The botanic garden at Wellington, dating from 1840, has exotic trees which were planted by the first settlers in the 19th c.

Interest in the cultivation of native plants did not develop widely before the 1920s. This was particularly so in the North Island. At Wilton, Wellington, Dr Leonard Cockayne, a noted botanist, developed the Otari Plant Museum as an example of a new type of botanic garden, on a site where some of the natural vegetation had survived. A new regional botanic garden was opened in 1982 at Auckland, with representatives of the native and exotic plants of the region. Also in Auckland a most unusual garden has been created by a group of citizens who transformed an old quarry cut into the side of a volcano. It was the idea of a horticulturalist to cut the scoria into terraces and plant them with a range of plants from the near-tropical to the subantarctic. The New Zealand Rhododendron Society has its own trial grounds to demonstrate the plants both in the landscape and botanically. The most famous rhododendron garden is that of the Pukeiti Rhododendron Trust in Taranaki in the foothills of Mount Egmont, where the plants are seen against a background of several hundred ha. of virgin and regenerating forest.

The replanning and conservation of historic areas is now under the care of the Historic Places Trust, which, like the British *National Trust, was originally concerned primarily with buildings. The scope of its work has now been extended to include Maori settlements and vegetable gardens, as well as the gardens of the European settlers. Meanwhile the increased interest in gardens and gardening, coupled with a growing awareness of the unique qualities of native as well as imported plants, is leading slowly towards the realization of a truly New Zealand garden.

B.M./M.L.L.

Neyelov, Vasily Ivanovich (1722–82), was a Russian architect who worked for Catherine the Great in the park at *Tsarskoye Selo (Pushkin) with John *Busch and Charles *Cameron. In 1771 he was sent to England by Catherine to study English gardens and stayed for six months. His Palladian Bridge at Tsarskoye Selo was based on the bridge at *Wilton, while his buildings there in the Chinese style were influenced by the publications on Chinese architecture by Sir William *Chambers and William and John Halfpenny. The Admiralty and the Hermitage Kitchen, both in the neo-Gothic style, are also by V. I. Neyelov. Of

his sons, Ilya Vasilevic (1745–92) assisted his father and Charles Cameron with the Chinese Village and designed the Upper and Lower Baths and the Chinese Theatre. Pyotr, who had accompanied his father to England in 1771, became architect at Tsarskoye Selo in 1794. He designed the Evening Hall. P.H.

Niche. The garden niche can be traced back to the Roman semi-dome that gave to some sacred object a sense of protection as well as an added grandeur. The concept was revived by Bramante in the greatest of all niches, that terminating the *Belvedere court in the Vatican. The more modest garden niche has ranged from the baroque, containing sculpture and fountains, to the domestic arbours with seats, popular in England since the 16th c. G.A.J.

See also BEE BOLE.

Nieborów, near Łowicz, Poland, has a 25-ha. palace garden which was created in the 17th c., enlarged during the 18th c., and partially modified during the 19th c. The oldest garden was designed by the noted Polish architect Tylman z. Gameren (1632–1706). The famous architect and planner Szymon Bogumił *Zug, who worked for the Radziwiłł family who owned Nieborów until 1945, was responsible for the development of the gardens in the 18th c.

Developed in the baroque style, the old garden is well preserved, with a very harmonious layout, good proportions, and a strong affinity with the style of the palace. The main axis of the garden is based on the long driveway, the courtyard, the palace and outbuildings, and the garden behind the palace. In the baroque garden there are a large garden *salon* with a *parterre de broderie*; a wide *allée* along the palace axis; separate garden rooms hidden in the hornbeam trees which are trained against the wall; a *berceau* with circular bowers in the corners of the garden; *bosquets*; and a number of items of medieval sculpture and architecture brought to Neiborów in the past. There are also two conservatories decorated with a Tuscan colonnade. On the border of the baroque garden there is a large T-shaped canal, behind which are a natural garden with winding streams and a larger *bassin* with an island.

The garden was restored between 1948 and 1951 to a design by Gerard Ciolek (1909–66). The garden and palace are now a branch of the National Museum in Warsaw.

L.M./P.G.

Nigeria. See AFRICA.

Nîmes, Gard, France, Jardin de la Fontaine. See JARDIN DE LA FONTAINE.

Nishat Bagh, Srinagar, Kashmir, the largest of the remaining Mogul Lake Dal gardens, is generally attributed to Asaf Khān IV, a brother of the Empress Nūr Jahān, wife of *Jahāngīr. The approach was originally by boat from an inner lake, with 12 terraces (one for each sign of the zodiac) rising upwards against a background of mountains

The lowest terrace has been cut off from the garden by the same modern road that truncates the *Shalamar Bagh, its neighbour, and the main *pavilion now faces the road.

Since Nishat Bagh was not a royal garden requiring elaborate ceremonial, it comprised two sections only: the pleasure-garden, with its lavish terraces, and the *zenana garden at the topmost level. The main feature of the garden, which was laid out c.1620, was the central canal, filled with fountains, and the water once flowed through the pavilion to discharge directly into the lake. A partial blocking of the views, by later walling in the pavilion, has reduced this sense of continuity. Changes of level on the canal were finely modelled and marked by broad pools, by flights of steps, or by water thrones. These, consisting of great slabs of stone or marble, were placed so that the view, and the freshness from cool water rushing below, could be enjoyed together.

The retaining wall of the zenana terrace is particularly fine, and flanked by handsome three-storey gazebos. From here there are superb views of the rice fields and of Lake Dal beyond. The design is contained by great plane trees and orchards, and is full of colour, a striking contrast with the bare mountains beyond. S.M.H.

Niven, Ninian (1799–1879), was the principal garden designer of the Victorian age in Ireland. Born at Kelvin Grove, Glasgow, at the age of 14 he was apprenticed in the gardens of Bothwell Castle, then studied painting and drawing in Glasgow, after which he returned to Bothwell as head gardener. He soon came to Ireland as head gardener at the official residence of the Chief Secretary for Ireland in the *Phoenix Park, Dublin. In 1834 Niven was appointed curator of the Royal Dublin Society's Botanic Garden at *Glasnevin. In 1838 he published *The Visitor's Companion to the Botanic Gardens*, but in the following year resigned his position to become a professional landscape gardener and nurseryman.

After the collapse of one of his earliest projects, the establishment of a national arboretum in the Phoenix Park, he went on a tour of French gardens, on his return from which he resolved to practise an intermediate style in which the natural English and formal French styles would be 'judiciously blended'. His subsequent designs for gardens around the great houses of the Victorian nobility included those at Baronscourt, Co. Tyrone, for the Duke of Abercorn, at *Kilkenny Castle for the Marquis of Ormonde, and at Santry Court and Templeogue House, both in Co. Dublin, for Sir Compton Domville, Bt., but he also designed for industrial magnates such as Mr Roe, the distiller, at Nutley Park, Dublin, and Mr Reeves, the miller, at Athgarvan, Co. Kildare, and for hotels like the Royal Marine Hotel at Kingstown. A major part of his work consisted of laying out parks for public use such as the People's Park in the Phoenix Park, Monkstown Public Park, and the park for the Dublin International Exhibition of 1863.

He was also gardener to the court of the Lord Lieutenants of Ireland, laying out the grounds of the Viceregal Lodge, the Chief Secretary's Lodge, and the Under-Secretary's Lodge. He was obliged to widen the gravel sweep in front of his nursery at Glasnevin to accommodate the carriages of the Lord Lieutenant and his entourage when they came to buy plants, and he conducted the ceremonial plantings of trees at the Viceregal Lodge during the visits to Ireland of the British royal family.

In his latter years he published various religious tracts and a volume of verse. He died in 1879 at Garden Farm, Glasnevin, Dublin, where he had lived and conducted his nursery and a horticultural school since 1838. P.B.

Noble, Charles (d. 1898), English nurseryman. See STANDISH, JOHN.

Noguchi, Isamu (1904–1988), Japanese designer, was born of Japanese and American parents in the United States but travelled to Japan at the age of 2. Since then he has travelled widely, expressing an envy for 'those who belong'. In Japan he went to a Jesuit school, and later, at the age of 20, went to Paris to work as a stone-cutter for Brancusi, and subsequently began to work as a sculptor. But his interests soon expanded to include design for the theatre and environmental design including memorials, bridges, play parks, and gardens, including a Japanese garden for the Unesco building in Paris and a number of small courtyards and roof-gardens for the Beinecke Rare Book and Manuscript Library, Yale University (1963), the Chase Manhattan Bank (1964), and the IBM headquarters (1964), in New York, using symbolic sculptural forms to great effect, often with the minimum number of plants. M.L.L.

See also SCULPTURE GARDEN.

Nonsuch Palace, Surrey, England, was built in haste for Henry VIII between 1538 and 1547 but nothing definite is known about the gardens before the palace came into the possession of John, Lord Lumley (1534?–1609), whose father-in-law had purchased it from Mary I. The gardens and park were replanned between 1579 and 1591 as follows: (1) the Privy Garden beneath the state apartments, in knots focusing on a fountain of Diana, flanked by two marble obelisks with the Lumley popinjays and much figurative topiary; (2) a maze; (3) a *wilderness to the west laid out with walks and decorative features reflecting an iconographic programme whose central feature was the earliest known grotto with a polychrome group of Diana and Actaeon. Lumley had visited Italy in 1566 and this last feature must reflect the direct influence of what he had seen.

Nonsuch returned to the crown in 1591 and remained untouched until the Civil Wars (1642–51). Nothing now remains of the palace or garden. R.S.

Norway. The origin of gardening in Norway can be traced back to the Middle Ages, when primitive herb or apple yards were common features in the small medieval cities that existed in the country. Knowledge of gardening in a more elaborate sense was brought in by monastic orders who established a relatively large number of monasteries and

Sculpture courtyard (1963) at the Beinecke Rare Book and Manuscript Library, Yale University, United States, by Isamu Noguchi. This landscape of the imagination excludes plants but is nevertheless inspired by nature expressed in the primordial energy of the sun, in diagrams of space, and in the geometry symbolizing the life of man.

convents in Norway during the 12th and 13th cs. The traditional orchard farming in the interior fjord regions of Hardanger and Sogn represents a direct continuation of fruit-tree plantations established by monasteries 800 years ago in those areas.

The general economic and cultural depression that seized the country late in the Middle Ages and lasted for more than 200 years led to a complete stagnation in gardening too. However, a new era dawned in the middle of the 16th c., with the introduction of the Renaissance garden in Norway by the first Lutheran bishop of Bergen. This Bishop's Garden was designed by a skilled Flemish gardener who was brought in for that purpose, and it long remained one of the most beautiful gardens in the country and served as a model for the creation of many others. Thus, it was in the Flemish style that the Renaissance garden eventually reached Norwegian soil. A characteristic example is the nationally famous old garden of the *Rosendal Barony in Hardanger.

Important commercial and cultural contacts with the Netherlands and north-western Germany strengthened the Flemish influence, which was predominant in garden design all along the southern and western coasts until the end of the 18th c. The northernmost example is found at the *Lurøy Estate below the Arctic Circle, where a small garden established c.1750 still reflects the basic design pattern of the Renaissance. After 1725 a number of more representative, formal gardens were created, mainly in south-eastern Norway, such as Linderud in Oslo and Rød in Halden. Usually, attempts were made at an axial composition, with

regular terraces and reflecting pools. A certain influence from the French baroque garden is evident in this period, but Norway had no wealthy and powerful aristocracy that could carry out these concepts to their full extent, and no important master of garden design was employed here. Nevertheless, rather monumental avenue systems were planted, e.g. at the estates of Jarlsberg and Hafslund in the south-east, and in the surroundings of the city of Trondheim.

Towards the end of the 18th c. a new upper class with a solid economy had evolved. Keeping close international relations, especially with England, they soon got acquainted with the new vogue of landscape gardens. In Norway the earliest known example of a landscape garden is the still existing park at Bogstad Manor outside Oslo. This park, developed c.1780 in scenic surroundings on a lakeside, is the most important monument to the English landscape garden to be found in Norway. Several romantic parks were created in the following years, mainly in the south-east, but very few remain intact today.

The University Botanic Garden in Oslo, founded in 1815, played an important role in the introduction of new plant material. Professor F. C. Schübeler (1815–92) had a series of test stations all over the country and found the maritime climate along the south-western coast particularly suitable. As a result of this, large specimen trees of *Cryptomeria*, *Araucaria*, and *Sequoiadendron*, for example, are found here, and the little seaside town of Molde became famous for its lush plant growth and colourful gardens.

The Norwegian Horticultural Society was founded in

1884, with Professor Schübeler amongst its fathers. In its early years the Society worked for the promotion of commercial horticulture as well as for amateur gardening. Later, the former purpose was taken over by professional growers' organizations. Today the Society consists of hundreds of local garden clubs all over the country and is responsible for a variety of information programmes, with support from the national government. A public advisory system exists in all counties and within many municipal governments. Emphasis is put on the landscape of residential areas, schools and other public buildings, cemeteries, parks and urban open spaces, as well as the privately owned garden in town and country. Commercial horticulture has been developed especially in the south-eastern districts, along the southern coast, and in the Stavanger region. Typical garden districts are found in the Oslofjord region and in the suburban districts of Stavanger and Bergen. M.BR.

Nost, John van (d. 1729), Flemish sculptor. See VAN NOST.

Nuneham Park, Oxfordshire, England, was built by the 1st Earl of Harcourt (1714–77), who abandoned Stanton Harcourt for the superior possibilities of landscape planning at Nuneham. The visitor is unaware that the house stands on an eminence until he reaches the garden front and the landscape, which determined the Earl's choice of his Palladian site, opens up before him. The panoramic view of the lawns and encircling woods sweeping down through water-meadows to the Thames below is as beautiful as it is unexpected. In the 1760 improvements the village was removed to a new site outside the park and the medieval church rebuilt, with the assistance of James 'Athenian'

Stuart, as a Greek temple. The removal of the village and the transformation of the 'decent church' was the inspiration for Oliver *Goldsmith's poem *The Deserted Village* (1770), a polemic against landscape gardening.

The highlight of the Earl's classical landscape was the distant view, to the north, of Oxford, whose domes and spires are shown in Paul Sandby's painting. A winding grass terrace beyond the temple extended the views from the windows. His son the 2nd Earl, patron of William *Gilpin and the *picturesque, broke down the prospect views into small landscape pictures framed by trees. He wrote his own guide on the lines of a Gilpin tour, telling visitors where to find the 'picturesque stations'. William Sawrey *Gilpin, nephew of the Picturesque Traveller, later added to the picturesque planting. William *Mason was garden adviser and his enclosed flower garden, a rare feature in the 18th c., is based on Julie's garden in *La Nouvelle Héloïse*, the novel by Rousseau, whom the Earl greatly admired and befriended during his exile. 'Capability' *Brown landscaped the southern woods, his task being to thin rather than to plant. The building intended by Brown for the hill to the west was a ruined castle, but when Lord Harcourt was presented with the ornaments of the dismantled Oxford Carfax conduit it was decided that this would make a perfect Gothic *eye-catcher as a foil to Stuart's Greek temple.

The arboretum of Oxford University now occupies 16 ha. of the estate. M.L.B.

Nurserymen. Monastic gardens seem to have been the first to supply plants and seeds for secular gardens, but the earliest commercial nurserymen were, naturally enough, professionals employed to supervise other people's gardens. The interest of these men in the plants under their care, and

Nuneham Park, Oxfordshire, the flower garden with the Temple of Flora and the statue of Hebe, engraving (1777) after Paul Sandby

the flourishing exchange of plants between interested amateurs of gardening (apparent in the notes found in the books of *Gerard, *Parkinson, and others) made the cultivation of stocks for sale an obvious consequence. As new and larger gardens were established they needed hedging plants, shrubs, and fruit-trees in quantity, so that gardeners turned to propagating and selling plants. Nurseries specializing in fruit-trees, vegetables, and seeds are recorded before 1600, but the 17th c. saw the foundation of many more general nursery gardens.

In England the Company of Gardeners received its charter from James I in 1605, being authorized to prevent the sale of 'dead and corrupt plants, seeds, stockes, and trees'. Its members included market and nursery gardeners in and around the city of London, and the rapidly growing numbers of seedsmen also came under its control.

The *Tradescants propagated the plants they introduced and grew in their own garden in Lambeth, and spread them among their friends. North of the river, in the east end of London, the first of many nurseries in that area was established by 1630. Gradually, ornamental plants became as important as more utilitarian ones, indicated by the publication of John *Rea's Flora in 1665. The Restoration of Charles II in 1660 brought back French influence to encourage English interest in gardening. By that time, too, the trade in plants was international. In France, Jean *Robin issued catalogues of his stock in 1601 and 1619. The Dutch trade in bulbs was also established early in the century, with the tulip craze of the 1630s as its most extreme manifestation. Sir Thomas Hanmer's Garden Book of 1659 talks of irises, tulips, and anemones from France. He also patronized the nursery of George Ricketts in Hoxton, east London, where he bought both fruit-trees and flowers.

The nursery at Brompton Park, on the site now occupied by the Victoria and Albert Museum, was founded by George *London and three other gardeners, Roger Looker, the Queen's gardener, Moses Cook, and John Field, in 1681. After the death or retirement of the other three, London went into partnership with Henry *Wise. Until London died in 1714 and Wise retired, the nursery was the most important in England, furnishing the gardens designed by the partners, as well as many others. John *Evelyn took a friend there on 24 Apr. 1694 and reported his admiration of 'the store of rare plants and method . . . in that noble nursery, and how well cultivated'. The nursery also gave winter shelter to 'the King's greens, which were in summer at Kensington', though the evergreens concerned may well have come from France originally. As the Brompton Park nursery lost its pre-eminence, provincial nurserymen took over, with the Telford and Perfect families in Yorkshire and the Dicksons near Hawick, and later in Edinburgh and Perth, among the leaders.

In London, at Hoxton, Thomas *Fairchild began experiments in hybridization, a practice that has led many later nurserymen to multiply the number of varieties of cultivated plants available. Fairchild specialized in exotics, with greenhouses full of aloes, succulent plants, oranges, lemons, and other rarities, while Robert Furber issued sumptuous illustrated catalogues of flowers and fruit from his garden in Kensington Gore. Several nurserymen kept particularly good stocks of the North American plants being introduced in such quantities during the 18th c., and Furber and Christopher *Gray boosted their own stocks by buying some of the contents of the garden at Fulham Palace after the death of Bishop *Compton, when his successor, according to Peter *Collinson, 'allowed his gardener to sell what he pleased, and often spoiled what he could not otherwise dispose of'. Gray found customers in France too.

A 1764 notebook of Collinson's comments on nurseries he had known, including, c.1712, 'Mr Wrench, behind the Earl of Peterborough's at Parson's green near Chelsea, famous for tulip-trees, began the collecting of evergreens, arbutuses, phillyreas, &c.; and from him came the gold and silver hedgehog-holly, being accidental varieties of the common holly. He gave rewards to encourage people to look out for accidental varieties . . . and a variegated holly goes by his name to this day.' (See also *Whitton.)

The Catalogus Plantarum, published by 'a Society of Gardeners' in 1730, was a sort of joint illustrated catalogue of the plants available from the Society's members, including c.20 nurserymen, among them Fairchild, Furber, and Gray, though Philip *Miller, the Society's secretary, seems to have been the central figure in the enterprise, which never progressed beyond the first part, on trees and shrubs.

James *Gordon, another private gardener turned nurseryman, began his garden at Mile End in 1743. This, with the Vineyard Nursery of *Lee and Kennedy at Hammersmith and, a little later, the *Loddiges family at Hackney, formed a trio which introduced many new plants. By special permission, the Vineyard Nursery was even able to go on sending plants to the Empress Joséphine during the Napoleonic Wars (1793–1815), an obvious sign of the quality and rarity of the nursery's contents. Lee's 1774 catalogue, backed up by his study of *Linnaeus's botanical innovations, was also among the best of its period. Thomas *Blaikie was a visitor to the Vineyard Nursery, bringing both plants and orders from France.

The lack of prices in London catalogues seems to indicate a clientele that could easily afford what it wanted. Nurserymen further north, in the Midlands, Yorkshire, and Edinburgh, began to publish priced lists in the 1750s, and some of them even joined forces to harmonize their prices. Occasional catalogues late in the century, like one from Dicksons of Edinburgh, included not only the stock of the nursery concerned, but 'a list of such plants as are to be found in the British gardens: notwithstanding, we are determined to increase our collection, and make it as complete as possible, to supply the demands of the public'. Perhaps such comprehensive lists were intended to identify a market for particular new or rare plants.

The first American nursery gardens were also established during the 18th c., with John *Bartram's at Philadelphia and Robert *Prince's on Long Island, both centres for the export of American plants and the import of European ones well into the 19th c., under the direction of later generations of the families.

In France, the *Vilmorin-Andrieux dynasty of nurserymen, which still survives, was also founded in the 18th c., first taking over a seedsman's shop in Paris, and soon extending to nursery gardens elsewhere.

Late in the 18th c. several nurserymen began to specialize in *florists' flowers. The Quaker family of Maddock or Maddox had a nursery in Walworth where these plants were grown, and the elder James Maddock's *Florist's Directory* was published posthumously in 1792, with later editions by his relative, Samuel Curtis, a member of the Hampshire family that also included William Curtis, whose *Botanical Magazine*, founded in 1787 and still running, described and illustrated new or unfamiliar plants.

Sir Joseph *Banks, who was virtually director of Kew for so long, encouraged plant-collectors in many parts of the world, an example later followed by the Royal Horticultural Society and several nurserymen, alone or in collaboration. The plant-hunters' discoveries were propagated and distributed through the trade. The *Veitch nurseries probably hold the record for the number of collectors sent out by one firm—over 20 in the years from 1840 to 1906. Indeed, the Veitch nurseries in Exeter and London were among the leaders in the variety and rarity of their stock all through the latter half of the 19th and the early 20th cs. Other nurseries had connections with explorers concentrating on particular groups of plants, like Peter Lawson & Son of Edinburgh and London, who introduced several of the conifers coming from North America in the mid-19th c., a link commemorated in the name of Lawson's cypress. Many of J. D. *Hooker's Indian rhododendrons and Robert *Fortune's Chinese plants were introduced to commerce by *Standish and Noble, including *Cryptomeria japonica*. Fashions in gardening and the nurserymen to cater for them sprang up together, like the *Backhouse family at York and the growing interest in alpine plants.

International trade continued to be important, with bulbs coming from the Netherlands (the outstanding Dutch bulb firm of *Krelage was established in 1811), palms, camellias, and hardy azaleas (like the group named after Ghent) from Belgium, lilies, hydrangeas, and roses (including the forerunners of the hybrid teas) from France. The welcome for roses in England was symbolized by the foundation of the Royal National Rose Society in 1876, but long before that nurseries had begun to specialize in the large range of varieties available and to breed more. A. Paul & Son was founded in 1806, and in 1848 the first edition of William Paul's book, *The Rose Garden*, was published, its frequent later editions pin-pointing the arrival of new roses. The Rivers family ran another famous rose nursery, as well as growing fruit-trees. Other fruit specialists, like the Bunyards of Maidstone or the Laxtons of Bedford, are commemorated in the names of many varieties of apples and other fruit.

Many of the names of seed merchants well known in Britain today were first made familiar in the 19th c., *Rochford, Carters, Suttons, and Thompson & Morgan among them, all founded to cater for the growing middle-class market, as gardening was taken up by a larger social group.

Immigrants from Europe played a major part in the American trade in plants and seeds. Philadelphia was a centre from the time of the Bartrams onward, as Bernard *McMahon and, later, Thomas Meehan, who had been trained at *Kew, opened nurseries there. A leading modern seed firm, Burpee's, is still based in Philadelphia, with branches further west too. In Rochester, New York, James Vick and the Mount Hope Botanical and Pomological Garden of Ellwanger and Barry flourished in the second half of the 19th c.

In Florida the Royal Palm Nurseries were founded by the Reasoner brothers in 1882 to act as a channel for the introduction of tropical and subtropical plants, as well as the export of local products. The first nurseries in California concentrated on fruit, though William P. Walker's Golden Gate Nursery, for c.20 years from 1850, introduced many Australian plants, among them *Eucalyptus* and *Acacia* species, to a congenial new climate, in which they have made an obvious impression on the landscape. Other nurseries helped to bring in South African plants, cacti, and other species well adapted to local conditions.

One of the best known British nurseries of today is *Hilliers of Winchester, another 19th-c. foundation, whose rich stock, especially trees and shrubs, is also represented in the Hillier Arboretum at Romsey.

Fashion in plants is as changeable as varieties of taste in any other field, and one effect of it has been to make it difficult for some of the larger nurseries to keep stocks of plants for which there is not a large demand. Smaller, more specialized nurseries may make better provision for relative rarities and less common species or varieties, helped, in recent years, by organized attempts to collect and preserve cultivars which seem to be in danger of extinction. Older kinds of rose, sweet pea, and auricula, for example, have now returned to favour, with nurserymen helping in their rescue and propagation, while many gardeners, amateur or professional, who have made collections of varieties or cultivars of particular groups of plants, have found themselves acting as nurserymen as well in making rarities available to others wanting to grow them. S.R.

See also ABERCROMBIE, JOHN.

Nuttall, Thomas (1786–1859), English plant-collector, was a printer from Liverpool who went to the United States in 1808. In Philadelphia he became interested in botany and began collecting plants. His first major expedition in 1810–12 took him to the Great Lakes and St Louis, where he met John Bradbury, who was collecting for the Philosophical Society and Botanic Garden of Liverpool. Both men joined an exploring party in the northern region of the Missouri. Nuttall returned to England from New Orleans, bringing oenotheras, camassias, and other plants, some found by Bradbury. In 1815 he went back to Philadelphia, publishing his *Genera of North American Plants* in 1818. Later that year he collected in Arkansas. He was curator of the Harvard botanic garden from 1822 to 1834, making several visits to England in that period. As a member of Wyeth's expedition

across the Rockies in 1833 he found *Cornus nuttallii*, the seeds of which flourished in England, to which he returned in 1841. S.R.

Nymphaeum, a shrine or *grotto dedicated to the nymphs, and composed of fountains in imitation of a natural grotto. In antiquity the nymphaeum was allied to monumental fountains—its architectural form was usually a large vault-covered rectangular hall with rows of columns and a semicircular apse at one end in which was a grotto or fountain, such as the Doric nymphaeum on Lake Albano (1st c. AD). A Renaissance transformation of this type may be seen in the Room of Hercules with its rustic grotto at the Palazzo *Farnese, Caprarola (1559–73). In Domitian's Flavian Palace (AD 92–6) 'A sort of *Nymphaeum*, or room containing a fountain, with flowers, plants, and statues of nymphs and river-gods, was placed at one side of the *triclinium*, if not on both, so that the murmur and coolness of the water and the scent of the flowers might refresh the wine-heated guests.' (W. Smith, *A Dictionary of Greek and Roman Antiquities*, 1901.)

The nymphaeum has been compared to a *musaeum*, the dwelling-place of nymphs and muses; these rooms resemble grottoes, marked by a supply of water, the apse representing the natural grotto from which water flows. Pliny the elder describes the type: 'We must not forget to discuss also the character of Pumice. This name, of course, is given to hollowed rocks in the building called by the Greeks "Homes of the Muses" where such rocks hang from the ceilings so as to create an artificial imitation of a Cave' (*Naturalis Historia*, 36.142). References to nymphaea abound in classical literature, from *Virgil's *Aeneid*, 1.166 (Grotto), to Ammianus Marcellinus (*c.*330–95): 'the people . . . assembled at the Septizodium, a much frequented spot where the emperor Marcus Aurelius erected a Nymphaeum of pretentious style' (*Lives*, 15.7.3). Its ornamental façade was intended to 'strike the eyes of those who came to Rome from Africa' (*Scriptores Historiae Augustae*, 29.3). Similarities between the architectural function of the *frons scaenae* of the theatre of Sabratha (*c.*200), the monumental prospects of the Septizodium (203), and the grand nymphaea in Asia Minor at Miletus, Aspendos, and Gerasa have been noted. Semicircular basins before both the nymphaea and theatre façades may have been used for aquacades during the late Empire.

Renaissance nymphaea embrace a variety of modes: see the ruins of the wide arched rusticated summer pavilion at Gennazzano (1508–11), attributed to Bramante, the ovata in the Villa *d'Este (1565–72), the sunken nymphaeum at the Villa *Giulia (1551–5), and the water theatres in the Villas *Aldobrandini and *Mondragone at Frascati. Apse nymphaea were retained from the Romans and developed into niche fountains resembling classical triumphal arches. Types in the House of the Grand Fountain at *Pompeii (before AD 79), and the Neptune and Amfitrite at Herculaneum (1st c. AD), are revived in 17th-c. nymphaea in the Medicis Fountain in the *Luxembourg Gardens (*c.*1620), the Château of Wideville (1635), and the Neptune Grotto at *Sanssouci near Postsdam (1751–7).

Nymphaeum in the Villa Giulia, Rome, engraving (*c.*1582) attributed to du Pérac, from A. Lafreri, *Speculum Romanae . . .*

Roman watergates such as the Fountain of Moses (1585), and the Acqua Paolo (1612), reflect the great water displays of the only extant public nymphaeum known in the 16th c., the Acqua Julia (1st–3rd c. AD), which once served as the *castellum aquarum*. N.M.

See also JARDIN DE LA FONTAINE, NÎMES.

Nymphenburg, Bavaria, German Federal Republic, the summer residence of the Electors of Bavaria, was some two hours' drive by carriage from their residence in Munich. The Elector Ferdinand Maria gave the estate to his wife Henriette Adelaide, Princess of Savoy, on the birth of their son Max Emanuel. In 1664 Agostino Barelli began work on a building in the Italian style which today forms the central building of the Nymphenburg Schloss. A small baroque garden was laid out behind the Schloss at the same time; the parterre contained five round *bassins*, linked by paths arranged in a star pattern.

Under Max Emanuel work was undertaken from 1701 by the architects Enrico Zuccalli and A. Viscardi to extend the Schloss by the addition of two pavilions which were connected to the central building by galleries. It was only after his return from exile (see *Schleissheim) that Max Emanuel could continue the building work, this time with Joseph Effner, whom he had sent to Paris to be trained in architecture and landscape gardening.

Effner was also responsible for building the famous 'castles' in the park: the Pagodenburg (1716–19), the Badenburg (1719–21), and the Magdalenenklause (1725). The interior of the small, two-storey Pagodenburg (dia. 8 m.) is a particularly delightful example of *Chinoiserie. In the highly original Badenburg there is a magnificent room containing a large bath and equipment for heating the water. Both the Pagodenburg and the Badenburg which faces it stood originally in their own little baroque gardens with parterre, waterworks, and hedges. The Magdalenenklause was designed as a hermitage.

Max Emanuel engaged two Frenchmen to work on the lavish castle garden—C. Carbonet and after him Dominique Girard. The long central canal not only flows through the whole length of the garden behind the Schloss, but extends in front of it a long way in the direction of the town. Owing to the arrangement of the side canals the parterre and the Schloss seem to stand on an island, which reflects a Dutch influence. The *parterre was originally laid out as a *broderie* and the *bassin* in the middle was decorated with gilded statues. *Bosquets* lay on each side of the parterre. Three vistas in the form of a *patte d'oie* directed the eye to distant church-towers, while the boundaries of the park were hidden by *ha-has. The central canal terminated in a great cascade.

Max Emanuel's son, Karl Albrecht, commissioned François Cuvilliés the elder to build the Amalienburg (1739) in the park. This hunting-lodge is regarded as a gem of German rococo. The semicircular *rond-point which with its 10 Kavalierhäuser forms such a fine termination for the *cour d'honneur*, is also of this period.

Nymphenburg, German Federal Republic, the garden side, oil painting (1761) by Bellotto

Under the Elector Karl Theodor, who came from the Palatinate to govern Bavaria in 1778, the new English landscape style came into its own. F. L. *Sckell redesigned the gardens as a landscape park, but the parterre, central canal, and side canals in front of the Schloss remained unaltered. Sckell, who under Karl Theodor's successor (the Elector Max IV Joseph) became Director of Gardening in Rhineland-Palatinate and Bavaria, created two lakes in front of the Badenburg and the Pagodenburg. By the time of his death in 1823 the park had become one of his finest works.　U.GFN.D.

Oatlands Park, Surrey, England, landscaped in the natural style from *c.*1740, extended to 227 ha. by 1788, when the Duke of Newcastle, formerly the 9th Earl of Lincoln, sold the estate. William *Kent, Spence, Lord *Burlington, and possibly *Southcote advised on design in the early stages, and Stephen Wright was architect from the 1750s. The three main features were the long terrace, from which magnificent views over the Thames Valley were obtained; the lake, which by *trompe-l'œil* appeared to become the river flowing under Walton Bridge; and the tufa grotto, decorated with crystal spar and shells, the largest and most elaborate of its kind in Britain. The *Lanes provided interior decoration in this two-storey structure, including a stalactite chamber. Much of the park remains, still in good condition. M.W.R.S.

Obelisk, used as a garden feature since the time of Imperial Rome, but of symbolic significance in Egyptian temple precincts from at least the 12th dynasty. At least 50 obelisks imported from Egypt decorated the ancient city of Rome and the famous Roman gardens of Sallust acquired an obelisk during the reign of Tiberius.

From the 16th c. onwards excavated obelisks were re-erected in Roman squares and gardens. One such was set up on the back of a stone elephant in the Piazza della Minerva to designs by Bernini (1666–7). A similar assemblage is illustrated in *Hypnerotomachia Poliphili* (1499) along with several alternative designs. Vignola's Villa *Lante (*c.*1564) includes small obelisks as incidents in the water parterre. In the 17th-c. gardens of *Isola Bella they are used *en masse* to give the tiered terraces a dramatic skyline.

At *Versailles a large pair of obelisks constructed in the 1660s stood on balls and had ball finials; they flanked the circular enclosure before the main gates. The motif was used repeatedly in the gardens: *Le Nôtre's Arc de Triomphe was flanked by four obelisks of triangular plan with water cascading down each face. Topiary obelisks (one might describe them as very slender pyramids) of yew were used liberally for emphasis in parterres or to articulate more confined spaces. Obelisks of *treillage* were also used in the 17th and 18th cs. A painting of Huis ten Bosch by Jan van der Heyden (1680) shows a *treillage* obelisk encasing immature topiary, presumably to guide clipping. Topiary obelisks also appear in English gardens: one is shown in the Dutch garden at Winchedon in a view of the late 1720s.

In England an obelisk with the Lumley arms decorated the gardens at *Nonsuch in the 1580s. As a favoured architectural motif of the late 16th and early 17th cs. stone obelisks were used in profusion on buildings and garden features, as at *Montacute House. They also appear in wood surmounting gate piers and fence posts as at Denham Place, Buckinghamshire (*c.*1705). Practically a ubiquitous feature of any English or Irish garden (see *Castletown) of consequence between 1700 and 1750 (notably by *Vanbrugh at *Castle Howard), they were used either singly to terminate a vista or in pairs to frame a view, and usually carry a commemorative inscription endowing them with symbolic or emblematic significance. They were a favourite motif of the English Palladians; there is one in the centre of the Orange Tree garden at *Chiswick House, for instance, and William Kent built a massive one at *Holkham Hall (*c.*1730). Batty *Langley's *City and Country Builder's Treasury* (1740) illustrates designs for obelisks of square, triangular, octagonal, or circular plan. They were even designed, paradoxically, with Gothic detail, as in Paul Decker's *Gothic Architecture Decorated* (1759).

By the 19th c. the use of obelisks in private gardens had declined, though they continued to be used as public or funerary monuments. G.R.C.

See also BELAN.

Old Westbury Gardens, New York, were constructed in 1906 for John S. Phipps and designed by George Crawley. The entrance to the gardens is through a pair of monumental wrought-iron gates and an *allée* of European beech, originally consisting of 286 trees. From the parking space the path leads down broad steps, past great banks of rhododendrons, to a small lake and a boxwood garden on the far side. A walled Italian garden of nearly 1 ha. lies beyond, with borders which are a mass of colour throughout the season, a pool displaying lotus and water-lilies, and a trellis covered with grapes and wistaria.

Adjacent to this is the Ghost Walk, a tunnel of hemlock copied after the one at Battle Abbey in Sussex, England, with the pinetum and its collection of fine old conifers nearby. Then there is an English rose-garden and a Primrose Walk which leads to the Children's Cottage Garden with its four playhouses. A short walk from there is the great South Lawn with its grand *allée* of European lindens followed, in turn, by the swimming-pool and the large lake with its wild-flower-bordered woodland walk.

 E.F.S.

Olmsted, Frederick Law (1822–1903), American landscape architect, had a varied career as farmer, journalist, publisher, and traveller before he made his first landscape

design, for *Central Park, in 1858. Two formative experiences were his landscape tour of England in 1850, recorded in his *Walks and Talks of an American Farmer in England* (1852), where he was greatly impressed by *Birkenhead Park as a landscaped park laid out for public use; and, shortly before his book was published, his visit to Andrew Jackson *Downing at *Newburgh, where he met his future partner, Calvert Vaux.

Although Central Park owes something to the English picturesque garden tradition, Olmsted's overriding purpose and his major innovation (the system of transverse roads) were directed towards creating a public park as part of large-scale town planning. He was therefore a pioneer in *landscape architecture rather than a garden designer, and most of his subsequent career went in this direction: Prospect Park (Brooklyn), the Capitol grounds in Washington, DC, the Boston park system (see *public parks: the parkway system), the Chicago World's Fair, and his conservation work at Yosemite. One exception was his design for *Biltmore, although even there the park was set in a farm and a forest.

One of his few recorded comments on garden design dates from his 1892 visit to England, at the time of the *Blomfield–*Robinson controversy: 'a complete return to the old formal gardening is to be desired rather than the present contradictory hash of formal-natural gardening should continue. The tendency to formality is very strong here, and as for a true natural style, I see nothing of it.'

<div align="right">P.G.</div>

See also LANDSCAPE ARCHITECTURE IN THE UNITED STATES.

Oplontis, Pompeii, Italy. See POMPEII, HERCULANEUM, AND THE VILLAS DESTROYED BY VESUVIUS.

Orangery. The orange, a native of China, has been a fruit much coveted for English gardens since the 16th c., and the early efforts to conserve it through harsh winters led to the origin of the long English tradition of growing plants under glass.

According to the records, Lord Burghley and Sir Francis Carew, of Beddington, Surrey, were the first British gardeners to grow oranges. Carew bought his trees from France in 1562 and, according to John *Evelyn, they were 'planted in the open ground and sheltered in winter by a tabernackle of boards warmed by means of stoves', the so-called 'houses of defence'. In the same year Lord Burghley wrote to a Mr Thomas Windebank in Paris, who was seeking oranges for Carew there, to buy him 'a lemon tree, a pomegranate and a myrt' as he already had an orange. He also asked for instructions as to 'the ordering' of his trees and was told to stand them in a sheltered position during the summer and lift them into the house for the cold months from September to April.

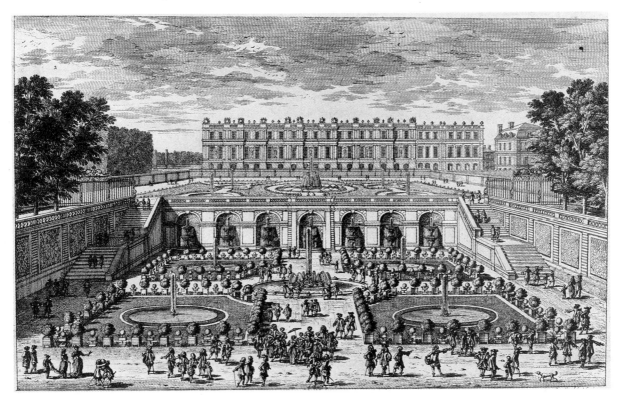

The Orangery, Versailles, Paris, engraving (before 1678) by Perelle

In other parts of northern Europe, too, the orangery was very important in sheltering delicate plants (figs, oranges, and even bay). It assumed a special significance in Germany where it also served as a venue for concerts and theatrical entertainments. Careful consideration was given to its siting within the park and to its design, as shown, for example, by the Favorite at Mainz, where the Orangery is flanked by three pavilions on each side. Other fine examples are at *Grosssedlitz; *Grosser Garten, Dresden; *Oranienbaum; *Putbus; and *Weikersheim. In France, the first orangery is probably that at *Blois, while the most magnificent in Europe is at *Versailles. In the neo-classical style, the orangery at *Ménars is outstanding.

Another early record of an orangery comes from Margam, West Glamorgan, where a ship bearing oranges for Queen Elizabeth from Philip II of Spain was wrecked on the Welsh coast, the salvaged trees finding a home and shelter at Margam, where in 1787 the original building, now restored, was refurbished to become one of the largest orangeries in the country. Pepys wrote on 25 June 1666 of Lord Brooke's oranges at Hackney: 'I pulled off a little one by stealth and eat it.' Sir William *Temple boasted of his orange trees in 1685 while Charles I's queen, Henrietta Maria, had 42 trees valued at £420 in a large garden house 'fitted for the keeping of oringe trees' in her 'oringe garden' at Wimbledon. *Kew did not get its orangery by Sir William *Chambers until 1761.

The writing about oranges in garden literature of the time must have made any ambitious gardener most envious. In *The Dutch Gardener* (1711) Van Oosten wrote: 'In all the compass of gardening there is not a plant or tree that affords such extensive and lasting pleasure; for there is not a day in the year when orange-trees, may not, and indeed ought not, to afford matter of delight whether it be in the greenness of their leaves, or of the agreeableness of their form and figure, or in the pleasant scent of their flowers, or in the beauty and duration of their fruit.' There was also the delight and novelty of seeing on the tree together at any one time ripe fruit, flowers, and the young fruit just forming.

The reign of Charles I (1625–49) brought more and more orangeries into the gardens of the nobility but by then they had become bigger and more handsome adjuncts to the garden than 'a tabernacle of boards'. They had long windows to the south set, more often than not, in classical styled masonry but with solid, opaque roofing. Most of the celebrated architects of their time—*Vanbrugh, Wren, Adam, *Brown, Wyatt, Humphry *Repton, and *Holland—built orangeries in classical, Gothic, rustic, and baronial styles to match the exteriors of the mansions whose gardens they graced. As early as 1563 Olivier de *Serres could write of orangeries: 'These magnificent sumptuosities in which the mildness of spring and summer always reigns.'

Naturally, as one would expect from a fruit which originated in China and came to Britain first from Portugal, there were many experiments before any efficient orangeries were built. At the *Oxford Botanic Garden (c.1620–50) they trundled round a fire on wheels, and there were pans of charcoal; some had Dutch enclosed stoves placed against the solid back walls, while others had hot-air flues in the walls or under the floors. The idea was to overwinter the trees in the orangeries and then place them outdoors as a novel and luxurious decoration for the garden during the summer; this led to trees being planted in splendidly decorated wooden tubs to facilitate their removal.

Heating and ventilation methods improved through the years and, almost too late, the necessity for more light was realized and glass roofs were used, but by this time the orangery had pioneered the way to the soaring conservatories and winter gardens of Victorian times such as the Palm Houses at Kew and Edinburgh, Syon House, London, and Kibble Palace at Glasgow, among others.

Original orangeries are still to be seen in the gardens of Margam, Kensington Gardens, *Ham House, Bowood, Sezincote, Daylesford, *Heveningham Hall, Burghley House, Saltram House, *Blickling Hall, *Woburn Abbey, and many others. K.LE.

Oranienbaum, Halle, German Democratic Republic, is first mentioned in 1673. The foundation-stone of the Schloss was laid in 1683 and the 33-ha. park was laid out at about the same time. Cornelis Ryckwaert drew up the plans for the Schloss, and presumably also for the park and the town, as part of a reorganization in baroque style by Henriette Catharina of Anhalt-Dessau (1637–1708), a daughter of Prince Friedrich Heinrich of Oranien. The oldest existing plan of the park, evidently an inventory, dates from 1719.

The park revealed a strong Dutch influence and comprised a horseshoe-shaped Schloss with a garden in front of it; a 2·6-ha. parterre formed by four compartments laid out around a fountain and pond and divided by diagonal paths planted with yew pyramids; a maze; an island garden, formed by diverting a stream in 1708–9, comprising three islands—two square and one round—the whole enclosed by hedges; a canal garden; a pheasant garden; a kitchen garden; and a deer-park. Only a few of the large number of statues now remain and these are in store.

The unified baroque arrangement of park, Schloss, and town with differing layouts and ground levels was preserved when the island garden was redesigned c.1795 by Prince Franz of *Anhalt-Dessau as a Chinese garden with a tea-house (1794–7) and a five-storey pagoda (1785–7) modelled on the garden at *Kew; several small Chinese bridges span the canals on which gondolas sailed.

Cultivation of oranges was important from the time the park was created. The fourth Orangery (1812–18) on the southern side of the park is 175 m. long and in the first half of the 19th c. housed some 300 orange trees over 100 years old; experts regarded the Orangery at Oranienbaum as the finest on the Continent. Almost all the orange trees died c.1960.

Between 1927 and 1936 the parterre and Chinese garden were reconstructed, and the *bosquets replanted. The Schloss houses the town archives and a museum. H.GÜ.

Oranienbaum, near Leningrad, USSR, engraving (*c*.1740) by Lespinasse

Oranienbaum (Lomonosov), Soviet Union, 41 km. from Leningrad on the Gulf of Finland, is the site of the palace and park of Prince Alexander Menshikov. Begun by D. M. Fontana in 1710 and then continued by J. G. Schädel from 1713 until 1727, Oranienbaum was one of the most magnificent residences of the time of Peter the Great. Like *Peterhof (Petrodvorets), the palace was built on a terrace facing the sea and was connected by stairways and terraces to the Lower Park, which was formally laid out with straight walks, parterres, fountains, and statues. There was a small harbour by the entrance to the park, linked to the sea by a canal, which was a projection of the central axis of the park.

In 1743 Oranienbaum became the summer residence of the Grand Duke Peter Feodorovich (later Peter III), for whom Rinaldi designed the palace-fortress complex, Peterstadt (1756–61), by the River Karost. The same architect also designed the Chinese Palace (1762–8, so-called because of its interiors) in a formal setting for Catherine II. Most of the formality in the park gave way to a landscape design in the 19th c.

Rinaldi's elegant blue and white Katalnaya Gorka (Coasting Hill) Pavilion is still a striking focal point in the Upper Park. It was once also a viewing stand, a place of rest and refreshment, and gave access to the starting platform of the remarkable coasting hill which was built between 1762 and 1769. Sliding hills, *montagnes russes*, are a traditional Russian amusement and the forerunner of the modern roller-coaster. Rinaldi's coasting hill, which was 532 m. long, was not just a simple single descent, as was usually the case, but a series of descents, the first three of which were followed by ascents, switchback fashion. 'It is thus used: a small carriage containing one person, being placed in the centre groove upon the highest point, goes with great rapidity down one hill; the velocity which it acquires in its descent carries it up a second; and it continues to move in a similar manner until it arrives at the bottom of the area, where it rolls for a considerable way.' (William Coxe, 1784.) This structure was surrounded by a colonnade with a flat roof as a promenade, protected by balustrades which were embellished with vases and statues. There was a slightly earlier sliding hill at *Tsarskoye Selo, with a pavilion by Rastrelli, and a simpler version in the courtyard of the Winter Palace.

The Chinese Palace, the Palace of Peter III, and the Coasting Hill Pavilion have been restored. Work is in progress at the Great Palace. P.H.

Orchard house, a forcing house, appropriate to various kinds of fruit, which came into being in the early 19th c. Lean-to houses were used for wall-grown fruit such as grapes and peaches, and large free-standing houses for fruit growing in pots or on trees planted in the ground.

M.W.R.S.

Orchid. See HOTHOUSE PLANT.

Orléans, Ducs de, title of younger princes of the French blood from 1392. There were three branches of the family. The Bourbon-Orléans branch descended from Henri IV and Marie de Medici. **Gaston d'Orléans** (1608–65), brother of Louis XIII, took over the *Luxembourg Gardens from his mother, and employed André *Le Nôtre to maintain them. He also employed François *Mansart to enlarge his château at *Blois. The scheme for the gardens was not carried out, but under his patronage a notable botanical collection was made by his doctor, Abel Brunyer, and illustrated by Nicolas Robert.

Philippe d'Orléans (1640–1701), only brother of Louis XIV, enlarged the château of *Saint-Cloud and employed Le Nôtre to replan the grounds. His first wife was Henriette d'Angleterre for whom Le Nôtre designed the garden of the Boulingrin at *Saint-Germain-en-Laye.

Louis-Philippe-Joseph d'Orléans (Philippe-Egalité), as Duc de Chartres (1749–93), was an Anglophile, and promoter of the 'English' style of gardening. He employed Carmontelle to design the *Parc Monceau, and Thomas *Blaikie to transform the grounds of his château at Le Raincy. K.A.S.W.

Villa Orsini, Bomarzo, the Dragon sculpture

Orsini, Villa, Bomarzo, Lazio, Italy. The gardens were made between 1552 and 1580, on a steep and rocky site at the foot of the castle on the north-west edge of Bomarzo, 20 km. east of Viterbo, and cover about 3·5 ha. They were created by Pier Francesco 'Vicino' Orsini (*c.*1513–84), Duke of Bomarzo, who referred to this extravagance as his *sacro bosco* or sacred wood. He began the garden in the middle of his career as a soldier and continued to embellish it from the time of his return from prison in Flanders in 1558 until three years before his death.

The layout of the garden is unusual, and difficult to visualize. It is organized around five distinct areas: the original entrance which crossed a bridge opposite the giant; the belvedere or theatre with its *exedra; the plateau of the vases above the theatre; the hippodrome which in the 16th c. contained the formal garden; and, on the highest level of all, the temple in the meadow. At the extreme southern edge of the gardens a huge laughing mask is cut from the living rock and topped with the globe and castle of Vicino Orsini's crest. At the extreme northern edge, far below the theatre, is an unfinished basin and sculpture. In the 16th c. fountains flowed in the gardens, connecting the various levels, beginning on the edge of the meadow near the temple with a version of the ancient Meta Sudans in Rome, and culminating with a jet in the centre of the exedra of the theatre. Steps and paths along the side of the hill also link the pieces together.

The Sacro Bosco has been renowned since the 16th c. for its colossal sculpture. Despite local legends of eastern influence and captive Turks, its significance is deeply rooted in the antiquarianism and literature of 16th-c. Italy. The conventions of Vicino's peers, particularly Cardinal Ippolito d'Este and his self-glorification at the Villa *d'Este at Tivoli, were also parodied by deliberate vulgarization. In one instance, however, apparent disorder is the result of accident (in 1564 the upper portion of the Casa Pendente fell off and was repaired with metal pins a year later). The style and subject-matter of the sculpture reflects Vicino's interest in local Etruscan funerary art and ancient Roman monuments, while at the same time depicting the trials in love and war of the mad Orlando, the central character of Ludovico Ariosto's popular contemporary epic, *Orlando Furioso* (1532). The giant warrior, ripping a woodsman apart limb from limb and identified by an inscription, introduces the theme of Orlando's madness at the entrance. The overscaled Etruscan urn on the plateau of the vases, an Ariostian moonscape, represents the one containing Orlando's wits. (Like Dante, Ariosto envisaged the moon as a place where the wits of lost souls were bottled up and stored.) Sanity is restored by the English prince Astolfo, sitting atop the war elephant, and pouring Orlando's wits back up his nose. Although many of the antiquarian and literary references at Bomarzo are obscure today, the *sacro bosco* would have been clearly understood and enjoyed by the initiated of 16th-c. Italy.

Twentieth-c. interest in the gardens was provoked by Mario Praz and Salvador Dali shortly after the Second World War. Dali made a film there, and his surrealist interpretations have influenced modern scholarship as well as inspiring the 1967 novel *Bomarzo* by Manuel Mujica Lainez, and the opera by Alberto Ginestera. M.D.

Ottoman kiosk. The earliest Islamic kiosk was a round, open-sided pavilion roofed with a sloping, circular canopy supported by pillars; some early Persian mosques containing a domed structure at their centre form what is known as the kiosk group. Although rectangular in shape the Iftariye, built by Ibrahim I in 1640 in the sacred precincts of the Topkapi Palace, Istanbul, for use by the sultans when breaking fast at Ramadan, is of the open-sided type. Enclosed or partially enclosed garden kiosks survive from the 13th c. At first, like *gazebos, they were perched on a wall, roof, or eminence, later descending to earth, preferably to stand close to water, on piles on it or surrounded by it, whenever possible containing an inner fountain or pool. The earliest of Istanbul's imperial kiosks, the Cinili (Tiled), built in 1472 and used as a museum since 1875, has glazed tiles of the Seljukid type set in its façade.

A miniature in the Surname i Vehbi in the Topkapi Museum, illustrating a night fête given by Ahmed III in September 1720, shows an open-sided, rectangular kiosk floating on the Sea of Marmara whilst the inner wall of an open-fronted one on the shore is elaborately ornamented. Well before that date it had become fashionable to decorate kiosk interiors to harmonize with the beauty of their surroundings. All the material needed for the Sultaniye, built at Topkapi by Osman Pasha as a gift for Murad III (1574–95), was brought by caravan from Persia. Lady Mary Wortley Montagu (1689–1762) was received in one 'wainscotted with mother of pearl fastened with emerald nails', in another 'panelled in cedar set off with silver nails', and yet another with 'walls crusted with Japan China, the whole adorned with a profusion of marble, gilding and the most exquisite painting of fruit and flowers'. Some 10 kiosks survive at Topkapi and, close to Istanbul, but on the Asiatic shore of

the Bosporus, a superb room, originally a free-standing kiosk, is incorporated in the Köprülü mansion. T.T.R.

Ou Yuan, Jiangsu province, China. *Ou,* meaning couple, is the name of a garden (*yuan*) situated to the east and west of an old city residence in the north-east district of Suzhou. Lu Jin, a District Magistrate in the early Qing dynasty, built the eastern part first, calling it She Yuan, and the garden acquired its present form only when the property came into the hands of Shen Bingcheng, a government official in the 19th c.

The western side was divided by a studio building into two courtyards: the one in front with an unusual rockery, the one behind accentuated by a two-storeyed study with finely carved balustrading. The eastern garden, occupying about 0·25 ha., is now much the larger. Inside its entrance, a small courtyard leads into an open space bounded by a meander-

ing white wall with several ornamental *lou chuang* windows cut into it and a fine moon gate (*di xue*) framing the garden beyond. From here the main hall, two-storeyed and double-eaved, is hidden by a high artificial mountain of yellow rock (*huang shi*), which falls steeply on its eastern flank to a narrow splash of reflecting water. Winding steps are cut along this cliff to give visitors the sensation of walking by a 'profound Valley', Sui Gu, which is its name. Then, the pond runs southwards down the garden to a summer-house with many pivoting, lattice-worked windows. A path which follows the water here was paved in the 1960s with a chequer-board of black and white stones: while the path runs straight, the checks slant off to the right, pulling the eye towards a succession of decorative windows in the gallery that runs along the enclosing wall. Along the eastern boundary, a double-storeyed *lou* rising above the walls allowed at one time views of the canal and city outside the garden. This is a garden well worth studying for its delicate

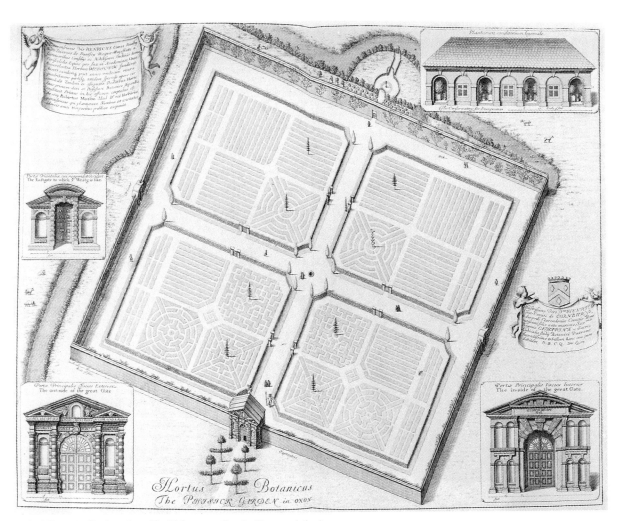

Oxford Botanic Garden, from David Loggan, *Oxonia Illustrata* (1675)

manipulation of space and light and its many peaceful and hidden corners.
G.-Z.W./M.K.

Oxford Botanic Garden, England, the oldest in Britain, was founded in 1621 by Henry Danvers, Earl of Danby, on 2 ha. of riverside land leased from the neighbouring Magdalen College. The heart of the garden is still surrounded by the high stone walls built in its early years, which were finished off with a main gateway and two more modest ones by Nicholas Stone, Inigo *Jones's master mason (*see p. 413*).

The first keeper of the garden was Jacob Bobart, formerly a soldier and an inn-keeper, who issued the first catalogue of plants in 1648. After the Restoration of Charles II in 1660 Robert Morison, who had spent part of his exile looking after the botanic garden of Gaston, Duc d'Orléans, at Blois, was appointed Professor of Botany. Bobart's son, the younger Jacob, succeeded both his father and Morison, combining the two posts. He also circulated the first list of seeds available for exchange and, indeed, sold seeds himself.

In the 1720s William Sherard revived both the garden and the Botany School by donations of plants, books, and money to endow a professorship, first occupied by the German botanist J. J. Dillenius. A later professor, John Sibthorp, is remembered for his botanical travels in Greece and the 10 volumes of *Flora Graeca*, illustrated by Ferdinand Bauer and published posthumously from 1806 to 1840. C. G. B. Daubeny, professor from 1834 to 1867, established laboratories and an experimental garden.

Two yews survive from some of the earliest planting. Within the old walls a series of rectangular beds contains systematic groups of herbaceous plants. The walls themselves are well furnished with relatively tender plants, including many roses and clematis. Beyond the walls are clusters of shrubs, a rock-garden, rose and iris borders, and the main group of glasshouses, successors of the earliest ones built in 1670.

The collection of trees in the garden is supplemented by that of the University Arboretum at *Nuneham Park, which was opened in 1968 on *c.*16 ha. of the former Harcourt estate.
S.R.

Oxford College Gardens, England. A collegium was, like a monastery, a community living under a rule, but its way of

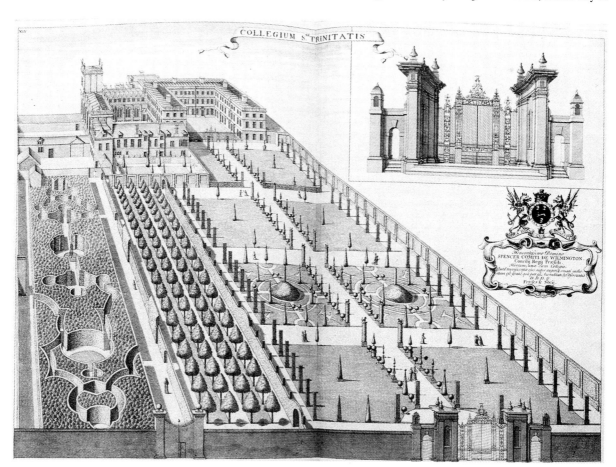

Oxford College gardens: Trinity College, from W. Williams, *Oxonia Depicta* (1773)

life was more secular with provision for recreation, including ball courts, bowling-greens, and walks. The gardens of the colleges within the town walls of Oxford were limited in size and when further building was needed even these small spaces had to be sacrificed, as at Oriel and All Souls. The colleges built on monastic land outside the walls—Worcester, Christ Church, St John's, Trinity, and Magdalen, on land belonging to the Hospital of St John the Baptist—had more scope for gardens. Magdalen's extensive rural walks included a swannery and a menagerie.

The medieval college gardens were a haphazard arrangement of *kitchen gardens, orchards, and walks, but the Renaissance brought new ideas in garden design, first seen in the covered galleries, cut hedges, and intricate knot gardens laid out for the humanist Warden of All Souls. The New College *Mount, which still exists, was made in 1529. When Oxford became the royalist capital in the first Civil War (1642–6) the quadrangles became parade grounds and some of the fortifications have become garden features. At the Restoration of Charles II in 1660 elements of baroque design appeared in the form of *parterres, fountains,

statues, and grilles. The grandest quadrangle was at Christ Church, with sunken grass plots, gravelled terrace and steps, central basin and fountain. Full-scale baroque design with interacting vistas of buildings as envisaged by *Hawksmoor was, however, rejected. College gardens were inward-looking and more influenced by Dutch than French ideas.

Landscape design took the form of lawns and informal groves at Wadham, Balliol, and St John's. Humphry *Repton's Red Book proposals for improving Magdalen's grounds in 1801 were rejected and the old-fashioned water walks, beloved by *Addison and now named after him, were retained. Worcester, an 18th-c. college whose Provost's Lodgings is virtually a Palladian country house, has the only landscaped garden with a designed piece of water.

In the two most recent colleges, St Catherine's and Wolfson, building and landscape are formally integrated (by the architect Arne *Jacobsen) in the former, and in the latter advantage is taken of the natural setting on the River Cherwell. M.L.B.

Pacello da Mercogliano (d. 1534) was a Neapolitan priest brought from Italy in 1495 by Charles VIII, for whom it is assumed he worked at *Amboise, although there is no evidence for this. From 1499 he had charge of the gardens at *Blois for Louis XII and *François I, and he advised Cardinal Georges d'Amboise at *Gaillon. The design of both gardens has been attributed to him, but apart from the laying out of *parterres in ornamental patterns, it is more likely that he was mainly concerned with horticultural matters, particularly the acclimatization of new kinds of vegetables and fruit. He grew orange and lemon trees in tubs at Blois, keeping them in a shed for the winter, the first record of this practice in France. K.A.S.W.

Packington Hall, Warwickshire (West Midlands), England. See BROWN, LANCELOT.

Packwood House, Warwickshire, England, has a garden which is notable first as an example of an intact layout, with courtyards, terraces, *gazebos, and *mount, of the 16th and 17th cs. when the house was built. Other points of interest lie in the historic restoration of the 1930s when it was owned by G. Baron Ash, who gave the property to the National Trust, and in its unique and dominating yew garden, which tradition says represents the Sermon on the Mount with Christ on top of the spiral mount, the Apostles on the terrace nearby, and the multitude of all shapes and sizes below.

Plans by James Fish (1723) and Thomas Wedge (1783) show that the Elizabethan layout has not changed substantially since the early 18th c. but by the early part of this century a great deal of Victorian planting, including flower-borders and evergreens, had been superimposed. This included the clipped yews which were mostly planted in the 1850s as a four-square pattern of topiary around an orchard. When Baron Ash altered and extended the house he also restored the garden, rebuilding two gazebos and the west wall and removing much of the Victorian flower gardening. But he left the yews and it may well have been the gardener who propagated the biblical allusion. Baron Ash also made the sunken garden and a 'Charles II parterre' nearby which was removed early on in the Second World War. The colourful border planting is also a tradition derived from his time. J.S.

Padua Botanic Garden (Orto Botanico dell'Università di Padova), Veneto, Italy. Designed by Giovanni Moroni da Bergamo in 1545, this *botanic garden is usually considered to be one of the earliest in Europe and probably in the world (cf. *Pisa). (See also *medieval garden: botanic gardens.) It was constructed under the supervision of Professor Pietro da Noale and Daniele Barbaro. The first curator, Luigi Squalerno, a student of Luca Ghini, was appointed the following year and it was his task to plant up the multitude of small beds in the central circular design that still remains basically unchanged. Since the purpose of such a garden was to teach medical students to recognize medicinal herbs, these were chosen for planting from the beginning and later a wider selection of plants was introduced. The present 18th-c. wall replaces the one built in 1551, and is ornamented with busts of famous Italian botanists. The whole garden now covers 1·85 ha. and includes three greenhouses, one of which is famous for the palm (*Chamaerops humilis*) planted in 1585, and later studied by *Goethe. There is also a small arboretum containing fine old trees, such as the oriental plane planted in 1680. F.N.H.

Page, Russell (1906–85), English landscape architect, was educated at Charterhouse and the Slade School, University of London. He also studied painting in Paris but a passion for plants from an early age impelled him towards a career in

Pool and garden of Chalet Thorenc, near Cannes, France, by Russell Page and Jacques Regnault

Painshill, Surrey, England, engraving (1828) by G. F. Prosser of a view of the five-arched bridge and Gothic temple

garden design. After a period in the office of a London landscape designer, spent principally preparing planting plans for the gardens of suburban blocks of flats, in 1935 he became associated with Geoffrey *Jellicoe, with whom he collaborated, among other works, on the projects at the Caveman Restaurant, Cheddar Gorge, and the Royal Lodge, Windsor Great Park. The partnership ended at the outbreak of war in 1939.

From 1945 to 1962 Page was resident in France, creating a one-man international practice with gardens in the United Kingdom, Belgium, Egypt, France, Germany, Portugal, Spain, Switzerland, the West Indies, and the United States. His best-known works are the Vilmorin Garden, Floralies de Paris (1957); La Leopolda, Villefranche; Palazzo Colonna, Rome; Patino Garden, Sotogrande; and the Frick Gallery and William S. Paley Garden, New York. In England he was a continuous consultant at Longleat and Badminton, and a major work was the landscape of the Battersea Festival Gardens of 1951, for which he was created OBE.

In his work his particular strength lies in his sense of plant form—a sense that has been his great contribution to garden design, and which is apparent in his discerning book *The Education of a Gardener*, published in 1962 and universally read by students and garden enthusiasts. Page was primarily an artist and only secondarily an expert horticulturalist, following in the tradition of Gertrude *Jekyll.

G.A.J.

See also PORT LYMPNE.

Pagode de Chanteloup, Indre-et-Loire, France, was designed by Louis-Denis Le Camus for Etienne-François, Comte de Stainville, Duc de Choiseul (1719–85), Minister of Foreign Affairs under Louis XV and friend of the Marquise de *Pompadour. After his dismissal Choiseul retired to Chanteloup. Le Camus enlarged the château, surrounding it by a park combining an irregular layout with great classic vistas dominated by the pagoda (1775–8), which was inspired by *Chambers's pagoda at *Kew. It has six storeys above an entrance floor surrounded by a colonnade and is dedicated to friendship. K.A.S.W.

Paine, James (1716–89), a prolific Palladian English designer, published his *Plans of Residences . . . Bridges . . . Temples and other Garden Buildings* with 175 plates in 1767–83. Notable are the Ionic temple (1750–62) at *Bramham Park; the Derwent bridge with Cibber statuary at *Chatsworth (1761–2); Gibside Chapel, Durham (Tyne and Wear) (1760); the bridge, entrance screen, and lodges at Brocket, Hertfordshire, for Sir Matthew Lamb; and the elegant Temple of Diana at Weston Park, Shropshire.

I.L.P.

Painshill, Surrey, England, was owned by Charles *Hamilton from 1738 to 1773, during which time the estate grew, by lease and purchase, from 50 to over 80 ha. Starting from a site with few natural advantages, Hamilton developed a masterly natural and picturesque landscape which had both appeal and influence. Partly park and partly pleasure-grounds centred round a lake, Painshill presented a series of 'set pieces' both visually and in mood: there were classical scenes, with a Temple of Bacchus in a colourful, cheerful setting, a Roman mausoleum in a rough, dreary setting, and a rustic hermitage set in a dark and gloomy wood. There were also illusions: the lake and the 'alpine' wood (*Walpole's term) were created in such a way as to

seem larger than they were, and the circuit undulated considerably to give the visitor a number of different angles and heights to look at and from.

Hamilton planted many exotics, especially conifers, from the United States, and was said by *Loudon to have been one of the first to introduce rhododendrons and azaleas into this country. Much use was made of colour, both in flowers and shrubs, away from the house, and Hamilton shared with Bateman, Thomas *Wright, and *Southcote a taste which was unusual for the time. A vineyard was a noteworthy feature. After much experiment Hamilton produced a sparkling white wine similar to champagne.

In addition to Hamilton's own architecture, Robert Adam designed the ceiling of, and a pedestal for, the Temple of Bacchus, and Henry Keene the *Turkish Tent. The buildings were a mixture of classical, Gothic, rustic, and oriental, but *Whately and others discerned a unity of purpose which bound them together.

The grotto was astonishing, an extravaganza of crystal spar, with side caverns, stalactites, waterfalls, and a main chamber 12 m. across. The stonework is attributed to Joseph *Lane. M.W.R.S.

Pakistan. Partition in 1947 gave independence to *India and self-determination to the new Muslim state of Pakistan. This was in two parts: East Pakistan, 'the land of the rivers' flowing into the Bay of Bengal, and West Pakistan extending from the western Himalayas to Karachi, and from the

Water garden (1965) at Government Hostel, Islamabad, Pakistan, by Michael Lancaster, Derek Lovejoy & Partners

Khyber Pass to Lahore, the old capital of the Punjab. Chandigarh was developed as the new capital of the Indian Punjab State; and in 1960 President Ayub Khan designated a site on the Potwar Plateau between Lahore and Peshawar for Islamabad, the city of Islam, national capital of Pakistan.

The city was laid out on a master plan by the Greek engineer/planner Doxiades using the services of a number of British architects and planners under the Colombo Plan, and, uniquely, a number of landscape architects working on behalf of Derek Lovejoy & Partners. The effect of the potentially sterile grid-plan and the indifferent quality of much of the architecture have been reduced by intensive tree planting and by the careful design and detailing of some of the spaces. In these the resident landscape architects, including Michael Langlay-Smith, Anthony Walmsley, and Michael Lancaster, were able to harness the abundant traditional skills available, in creating new forms and reinterpreting Islamic themes in ways appropriate to the 20th c.

The precedent established in Islamabad was unfortunately not followed in Dacca, the new capital of East Pakistan, which was later to secede as the nation of Bangladesh. A beginning has been made with the remarkable government buildings by Louis Kahn, which succeed in being both essentially 'modern' and essentially Indian in a way which those of Le Corbusier at Chandigarh and the Italian architects of the Secretariat at Islamabad (Gio Ponti, Roselli, and Farnarolli) did not quite achieve. But it is only a beginning. M.L.L.

See also LAHORE FORT; SHAHDARA; SHALAMAR BAGH, LAHORE; WAH BAGH.

Palais de la Berbie, Albi, Tarn, France. The outer courtyard of the Palais de la Berbie (Bishop's Palace, now the Musée Toulouse-Lautrec) was turned into a garden at the end of the 17th c., and is now one of the outstanding examples of the *parterre de broderie*. A walk along the battlements, covered with a *berceau* of vines, looks down on the garden on one side with views of the River Tarn on the other. K.A.S.W.

Palanga, Lithuania, Soviet Union, was developed as a seaside resort, largely because of the Polish family Tyszkiewicz. The palace was built for Count Tyszkiewicz in the second half of the 19th c. by Edouard *André, who also laid out the 70-ha. park. A pine forest and sand dunes separate the park from the Baltic, while the other boundaries are concealed by plantings of trees, so that it seems more extensive than it is. Meandering paths lead to lawns with trees, solitary and in groups, huge boulders, picturesque pools, and waterways with decorative bridges. Most rewarding is the path through the dunes with its culminating view of the Baltic. The wide variety of trees includes horse-chestnut, English oak, red oak, honey locust, ash, Norway maple, black alder, birch, larch, pines, and spruces. S.P.

Palissade, a row of trees or shrubs forming a hedge clipped

Palissades, engraving in John James, *Theory and Practice of Gardening*, a translation of Dezallier d'Argenville's *Théorie . . .* (1712)

into a green wall (generally reaching to the ground), for bordering *allées, concealing walls, or facing terraces.

D.A.L.

See also CORDÈS; COURANCES; PEIRESC, N.-C.-F. DE; TUILERIES.

Palissy, Bernard (*c.*1510–90), French potter and writer. His distinctive style of pottery, encrusted with deeply modelled naturalistic plants, reptiles, and aquatic animals, was also applied to the making of ceramic grottoes at the château of Ecouen and in the *Tuileries garden between 1570 and 1572. As there is no subsequent record of these, perhaps they were not completed. The method is described in a manuscript attributed to him, 'Devis d'une grotte pour la Royne, mère du Roy'; also in 'Dessein du jardin délectable', dedicated to *Catherine de Medici, and published in 1563 as part of *Recepte véritable par laquelle tous les hommes de la France pourront apprendre à multiplier leur thrésors.* The 'Dessein' is a description of the site and making of an ideal garden, with elaborate instructions not only for making grottoes but also for forming green rooms by training living trees (elm and poplar). Palissy's reputation depends chiefly on his writings. *Discours admirables de la nature des eaux et fontaines etc.* (1580) contains original observations on springs, soils, metals, and other natural phenomena.

K.A.S.W.

Palladio, Andrea (1508–80), Italian architect. In his treatise, *I Quattro Libri dell'Architettura* (1570), Palladio's own buildings are presented as virtually abstract ideal types (although there is one drawing extant of a site plan, for Villa Thiene). Yet he was in fact extremely sensitive to site, and often included landscape space in his designs. He recommended (Bk. II, ch. xii) siting villas near rivers, as this will 'afford a beautiful prospect, with which the estates, pleasure and kitchen gardens may with great utility and ornament be water'd, which are the sole and chief recreation of a villa.' One should not build in valleys, enclosed between mountains, because the villa will be both concealed and unhealthy. His most explicit comment on a site he actually used refers to that of the Villa Capra (La Rotonda) which 'is upon a small hill, of very easy access . . . on the other [side] it is encompassed with most pleasant risings, which look like a very great theatre, and are all cultivated . . . it enjoys from every part most beautiful views' (Bk. II, ch. iii). There is a characteristic emphasis here upon including cultivated land within the scope of the design—an emphasis that was to be rejected by English 'Palladians'.

In several cases (for example, the Villas Angarano, Badoer, *Barbaro, Campiglia, Lonedo, Meledo, and Sarego), the space immediately around the house is so organized as to continue the proportion system of the interior spaces, either by means of the hemicycle (a form probably derived from the Villa *Madama) or of the curving wings of the house. Perhaps the most ingenious example is the Villa Barbaro, where Palladio has foregone the opportunity offered by nearby steep hills of creating the kind of terraced garden then being made at the Villa *d'Este, and set the building on a slighter hill, thereby achieving a unified composition of villa, *nymphaeum, and garden. P.G.

Palm. The palms form a separate plant family (Arecaceae) of over 200 genera and nearly 3,000 species distributed unevenly throughout the tropics with the majority in Asia and Oceania.

There are a few subtropical species and one, the dwarf fan palm (*Chamaerops humilis*), is native to southern Europe. Two well-known species, the date palm (*Phoenix dactylifera*) and the coconut (*Cocos nucifera*), are unusual among palms in that they occur throughout the tropics whereas all other species are restricted to a region.

Palms are widely cultivated as crop plants as they are the source of a great range of useful products for food, fuel, fabric, and fibre. Some species are cultivated as ornamentals in the tropics in municipal parks, not usually for their flowers and fruits, but for the unusual nature of their leaves. The reduplicate fan-leaved *Raphia farinifera* is a spectacular species renowned for having the largest leaf (25 m. long) among flowering plants.

Early attempts at cultivating species out of doors in northern Europe failed because the growing points of palms are very sensitive to frost damage. Once these delicate buds are killed the stem (i.e. the trunk) and the rest of the plant dies. Only *Chamaerops humilis* and the Chusan palm (*Trachycarpus fortunei*) from southern China, introduced in 1836, survive in the British Isles in coastal areas. However, it was found that some species could be grown very successfully inside ordinary rooms.

The growing of palms as house-plants reached a peak in the earlier years of this century when the parlours of the villas of the middle classes featured ornate pots in which grew *Kentia* species, *Collinia elegans*, and occasionally *Phoenix* species. Their use extended to hotels and today they are still found in foyers and ballrooms. Before that time palms had been successfully cultivated in extra tall greenhouses, or *palm houses. P.F.H.

Palm house. Of all the types of glasshouse devoted to a particular group of plants, this proved the most enduringly popular in the 19th c.—partly because the ease with which palms could be grown meant that private owners could build up collections. *Botanic gardens in Europe built such specialized structures as major features, the Palmen Garten in Munich and the Palm House at Kew being good examples.

The latter was extremely influential. Designed by Decimus Burton and Richard *Turner, and built by 1848, it is 120 m. long, 30 m. wide, and 20 m. high at its largest point. Inevitably the cast-iron framework corroded but it was reconditioned in the late 1950s. The palms were initially grown in tubs and planting in beds did not begin until 1860. In 1985 it was again necessary to recondition at a cost of £5 million.

Many later palm houses adopted a roughly circular ground plan, which, with the height of roof required for the trees, readily distinguished them from most *conservatories (as at Sefton Park, Liverpool). In the larger botanic gardens they tended to house a variety of other tropical trees and shrubs in addition to the palm and cycad collections. The popularity of palms for permanent indoor decoration, especially when tubbed for easy re-positioning, led to the provision of palm courts in public winter gardens, such as Alexandra Palace. B.E./P.F.H.

See also PFAUENINSEL.

Palmieri, Villa, Florence, Italy. The original gardens were the setting for Boccaccio's *The Decameron* (begun 1348). The layout then consisted of a fountain standing in a flower-strewn lawn, vine pergolas, and shaded walks—standard medieval features (see *medieval garden)—but it was bigger than usual and with more elaborate planting. By 1697 it had been completely changed to the present baroque form of a terrace overlooking an oval lemon garden (laid out by Palmiero Palmieri) approached by curving stairs. Extensive new gardens were added in the late 19th c., without disrupting the old. P.G./G.A.J.

Papa Giulio, Villa di, Rome. See GIULIA, VILLA.

Paradeisos. Great estates with large enclosures filled with wild animals were first introduced to the Western world by the Greek writer Xenophon (c.430–354 BC), who described the parks of the kings and nobles of Persia (Iran) that he had seen in his travels. He uses the Greek word of Persian origin, *paradeisos*, to describe these royal gardens, which were vast enclosures that included fruit and ornamental trees, flowers, birds, and mammals.

The hunting-ground was an essential part of the oriental *paradeisos*. Xenophon, in his description of the education of Cyrus, describes the animals that the young prince was taught to hunt: bears, boars, lions, leopards, deer, gazelles, wild sheep, and wild asses. When Alexander the Great (356–323 BC) conquered the Persians, he took possession of their *paradeisoi*. His successors also acquired such parks, and when the Romans conquered the Hellenistic world they, in turn, acquired a taste for them.

*Varro (116–27 BC), in describing the large hunting preserves found on the great estates in Italy, gives a vivid description of the wild animals on the estate of Quintus Hortensius, near Laurentum. Gardens at *Pompeii and Herculaneum were frequently decorated with large animal paintings, suggesting that even the city dweller could create the illusion that he owned a *paradeisos*. W.F.J.

See also ISLAM, GARDENS OF: PARADISE GARDENS; PLEASANCE.

Paradise garden. See ISLAM, GARDENS OF.

Parc de la Colombière, Dijon, Côte-d'Or, France, was laid out between 1671 and 1685 for Henri-Jules de Bourbon, Duc d'Enghien (son of the 'Grand Condé'). A rectangular area of just over 34 ha. enclosed an octagonal wood, with *allées* radiating from a central *rond-point*. At the same time the town of Dijon commissioned the Duc d'Enghien's gardener, Dimanche Dinnard, to lay out a vast avenue with a double row of lime trees from the Porte Saint-Pierre to the gates of the park, which has been a public promenade since 1801. K.A.S.W.

Parc de la Tête d'Or, Lyons, Rhône, France, is a public garden of 105 ha. designed in 1856 by the brothers *Bühler, with a lake of 18 ha. It contains an important botanic garden with c.10,000 plants arranged according to habitat or native region. The greenhouses, covering 7,000 sq. m., house one of the richest collections in Europe. K.A.S.W.

See also MOSAÏCULTURE.

Parc Monceau, Paris, is one of the first examples of a *jardin irrégulier*, laid out from 1773 by Carmontelle on a dry and barren site north-west of Paris for the Duc de Chartres (later Duc d'Orléans, called Philippe-Égalité), a convinced Anglophile. Thanks to the collection of engravings published by Carmontelle himself it is possible to reconstruct what was intended as 'a simple fantasy bringing

together all times and places' in 18 ha. Round a pavilion furnished with the last word in refinements for luxurious living were revealed successively a wood of tombs with an Egyptian pyramid, a *naumachie bordered with a colonnade, a ruined fort, a Dutch windmill, a minaret, Tartar tents, and numerous temples. Monceau perfectly illustrates the difference between those *folies* or *pays d'illusion* constructed on the outskirts of the capital and intended solely for the pleasure of the senses and the amusement of a licentious society, and the huge English landscape gardens integrated with the surrounding countryside. At Monceau the accumulation of *fabriques* and the taste for exoticism and for the architectural picturesque get the better of the true natural arrangement of things. Transformed into a public garden at the Revolution and very much reduced in size following property speculation under the second Empire, in 1861 the park was restored in the *style romantique* by *Alphand who was able to save some of the *fabriques*.

M.M. (trans. K.A.S.W.)

Paris. The old walled town was centred round the Ile de la Cité and the Ile Saint-Louis in the Seine; on the west was the royal castle of the Louvre, and on the east the palaces of the Tournelles and Saint-Paul in the Marais district, where street names recall the former gardens. Outside the bounds were the royal forests, *Bois de Boulogne (west) and Bois de Vincennes (east). The enlargement of the Louvre and the creation of the *Tuileries (1564–72) gave the city its first large garden, which under Napoleon III was the point of departure for an intended avenue running in a straight line from *Saint-Germain-en-Laye to Vincennes. The extension of the axis of the Tuileries in the Champs-Elysées and the Avenue de Neuilly are the western limb of this project; the eastern part was not realized. Meanwhile the Place des Vosges (1605–12) and Richelieu's garden of the Palais Royal (1633) provided the basis for public open spaces north of the river (right bank); while on the south (left bank) were the *Luxembourg Gardens (begun 1612) and the *Jardin des Plantes (1626). To these were added the Esplanade des Invalides (1704–20, restored 1978–9) and the Champ-de-Mars (1765, redesigned in the 19th c.). In due course properties with big gardens formerly outside the walls were absorbed; the Plaine Monceau became a fashionable district, and Philippe-Egalité's garden a park (*Parc Monceau). *Bagatelle (1775) was incorporated in the Bois de Boulogne when it was redesigned by *Alphand and *Barillet-Deschamps under *Haussmann (see *public parks: the public park in Paris). The same team redesigned the Bois de Vincennes, created new public parks at *Buttes-Chaumont in the north, and Montsouris in the south, made promenades planted with trees (the Grands Boulevards), and transformed the cemeteries of Père-Lachaise, Montmartre, and Montparnasse.

Outside Paris, the hilly ground south and west of the Seine provided spectacular sites which were exploited to make some of the most notable gardens of the 17th and 18th cs.; *Marly, *Meudon, *Rueil, *Malmaison, *Saint-Cloud, *Saint-Germain-en-Laye, and *Sceaux are public parks within easy reach of the centre of Paris, whose built-up area extends as far as Versailles. Other gardens are L'Haÿ-les-

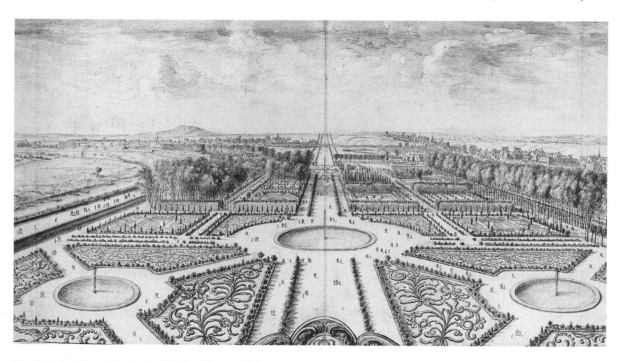

The Tuileries, Paris, drawing (*c.*1680) by Silvestre (Cabinet des Desseins, Musée du Louvre)

Roses and Jardin Kahn (south of the Bois de Boulogne); and a green belt is established on the site of Thiers's 19th-c. fortifications. The most important of the newly created parks in the Parisian region is La Courneuve (350 ha.) in the northern suburbs. Projects have been drawn up for gardens in the congested areas of the city, on the site of the Halles Centrales, and the slaughterhouses of Vaugirard (south) and La Villette (north); but in spite of the illusion created by its green avenues, Paris proper will always be poor in big gardens. D.A.L.

See also FOLIE SAINT-JAMES.

Parkinson, John (1567–1650), English gardener and herbalist, trained as an apothecary but little is known of his life before he is recorded in 1616 as settled in London, with a garden in Long Acre. His most famous book, *Paradisi in Sole Paradisus Terrestris*, that is, 'Park-in-Sun's Park on Earth', was published in 1629 and dedicated to Henrietta Maria, wife of Charles I. Its woodcut title-page is built round a large oval design of the Garden of Eden, with Adam and Eve and a collection of plants of all sorts, on a variety of scales. The book is devoted to plants for 'a garden of delight and pleasure', that is, the flower garden, the kitchen garden, and the orchard, and is illustrated with full-page woodcuts showing several varieties on each picture. It is good record of the state of horticulture at the time, with references to other botanists and gardeners, including the elder John *Tradescant, as well as the author's own collections. Its publication was rewarded with title of Botanicus Regius Primarius to Charles I.

Parkinson's *herbal, *Theatrum Botanicum*, was published in 1640, but it has always been overshadowed by the second edition of Gerard, which appeared seven years before.
S.R.

Park Place, Berkshire, England, General Henry Conway's landscaped garden (*c.*1760) near Henley, displayed his scientific and antiquarian interest: a prehistoric stone circle presented by the inhabitants of Jersey; a menagerie; a subterranean passage 250 m. long running down into the valley and terminated by a Greek ruin; a flower garden with a lavender plantation; and a Tuscan villa to house the chemistry professor in charge of its oil extraction. The Gothic cottage, conservatory, and a bridge made of stones from Reading Abbey appear to have been designed by Thomas *Pitt. The General, whose landscape design was commended by his cousin *Walpole, introduced the Lombardy poplar to England. The garden is now fragmented and in part developed. M.L.B.

Parmentier, André (d. 1830), American nurseryman. When this member of a distinguished European gardening family arrived in New York from Belgium to start a nursery in 1824, he was asked by Dr Hosack to manage his botanical garden—the first to be laid out in North America for the use of medical students; but Parmentier set out instead to sell his own skills and plant material. He chose an elaborate layout upon an unpromising and stony headland in Brooklyn, overlooking New York harbour. In no time he had laid out an artistic garden, a nursery, and a vineyard in such an original manner that he was invited to write an article on the new style in gardening for Thomas Fessenden's magazine, the *New England Farmer*. This article was such a success that Parmentier was accorded the honour of introducing natural landscape gardening to the New World. Visitors who flocked to see the ornamental section of his nursery were reportedly charmed by the 'picturesque' style which produced 'an agreeable effect' by its 'natural appearance . . . in harmony with the scenery'. Rustic seats and arbours of contorted tree-limbs later became immortalized in cast-iron replicas. A.L.

Parque Güell, Barcelona, Spain. About 1900 the architect Antonio Gaudí y Cornet was commissioned by Eusebio Güell to design a garden suburb on the model of the English *garden city, incorporating 60 building plots, with a colonnaded market surmounted by a great open-air theatre terrace, all with a view of the sea. He sought not to compete with nature but to complement it, using serpentine galleries and viaducts for the roads and terraces to avoid cutting into the slopes of the Montana Pelada (the Treeless Mountain), and structural forms to suggest the thrusting energy of natural forces, according to the laws of 'God's architecture'. In planting he took pains to use native plants, clothing the bare mountain largely with pines, anticipating the ecological movement which was to develop some 50 years later; but these have now been supplemented by ornamental and exotic species.

Gaudí intended nature to remain as a background for the tense meandering lines, the warped and bulbous surfaces, which express his essentially three-dimensional interpretation. Such surfaces could not easily be achieved using traditional materials and Gaudí, with characteristic inventiveness, used random stone from the site and broken ceramic pots and tiles for the brightly coloured surfaces. In their colour we see references back to the Moorish *azulejo traditions and to the gaily coloured village houses of Catalonia, and forward to the free surreal interpretations of the Spanish painter, Miró.

The deliberately bizarre and playful intentions have in fact been rewarded, and the park, in which only two of the 60 houses were built, has been a delight, not only for the Surrealists, but for the public ever since its inception. It remains a unique expression of its period, and one of the very few representative parks of the 20th c. M.L.L.

Parterre, a flower garden, particularly in the area adjoining the house, laid out in a regular ornamental manner. During the 17th c. this became a distinct art form, with recognized types and styles.

Parterres de broderie (embroidered parterres) with flowing plant-like designs were pioneered by the *Mollet family in France (see also *Boyceau). They were made of box against a background of coloured earth, sometimes with bands of turf. Among gardens where *parterres de broderie* were created are *Ancy-le-Franc; *Anet; *Beloeil; *Bouges; *Brècy;

Entrance to Parque Güell (*c.*1900), Barcelona, Spain, by Antonio Gaudí

*Castres (outstanding); *Castries; *Chamars; *Champs; *Fontainebleau (one of the first places where box was used in this way); *Meudon; *Palais de la Berbie, Albi (outstanding); and *Tuileries. *Parterres de broderie* were a feature of royal and noble residences in 18th-c. *Poland, such as Białystok, Nieborów, and Wilanów, and elsewhere in Europe (see in particular *Augustusburg and *Drottningholm). They went out of fashion in France after the middle of the 18th c. and were replaced by flowers and turf in designs of geometric severity; they virtually disappeared after the French Revolution (1789) until they were revived in the late 19th c.

Parterres à l'anglaise (in the English manner) had designs made of cut turf and were either of plain grass often with a statue in the centre, known in England as plats, or they had cut-out designs known as **gazon coupé*. These were easier to make and maintain than *parterres de broderie* and became increasingly fashionable from the end of the 17th c. (see, for

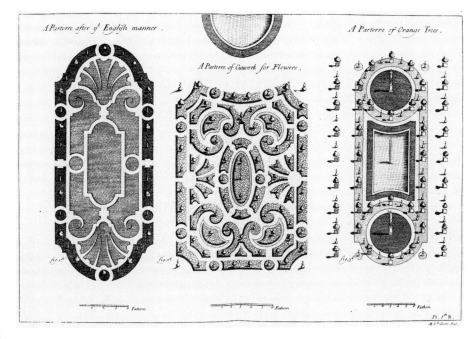

Parterre: three designs from John James, *Theory and Practice of Gardening*, a translation of Dezallier d'Argenville's *Théorie . . .* (1712)

example, *Durdans). In the 20th c. Lutyens included a version of plats in his design for *Little Thakeham.

A further variation was the *parterre de pièces coupées* (cut-work parterre) in which the individual pieces of the design were flower-beds (see Hans Vredeman *de Vries).

There was a revival of interest in parterres in general in England during the 19th c. Humphry *Repton designed parterres for Beaudesert, Staffordshire (intended especially to be seen from behind coloured glass inside the house—but these were not executed), and also for *Ashridge. However, the revival really began with the work of W. A. *Nesfield (1783–1881), following designs by A. J. *Dezallier d'Argenville and others, at *Blickling, *Broughton (a scroll and feather design in box, using coloured gravels), the *Royal Horticultural Society's Gardens, Kensington, and *Warwick Castle. K.A.S.W./P.G.

See also LUXEMBOURG GARDENS; TREILLAGE.

Pasley, Anthony du Gard (1929–), English landscape architect, started gardening in his childhood in Surrey. Later he became a pupil of Brenda Colvin while studying landscape architecture at University College London, under Peter Youngman. He became designer for a nursery

Garden (1959) in Tunbridge Wells, Kent, England, by Anthony du Gard Pasley

firm in Tunbridge Wells, and then assistant to (Dame) Sylvia *Crowe, before starting his own practice in 1970. His work, distinguished by his skill in design with plants, includes a wide range of landscape projects, as well as large and small gardens. He prefers to work for private clients and tends to specialize in gardens, particularly in the restoration of country estates in Britain and overseas. M.L.L.

Patio, originally a Spanish word meaning courtyard. See ALHAMBRA; COURTYARD AND COURTYARD GARDEN IN ISLAM; FORECOURT; GENERALIFE.

Patio de los Naranjos, Cordoba, Spain, is an example of the first Omayyad gardens with little decoration other than horseshoe arches at the sides. The 120 m. × 60 m. patio, which is divided into three rectangles, is planted with orange trees all connected at their bases to narrow irrigation channels; these are fed by the overflow from fountain basins. The lines of orange trees were planted to continue the lines of columns inside the building, of which it was an outdoor extension. The spaces under the arches were filled in with masonry after the Christian conquest of Cordoba in 1256. D.W.

Patio de los Naranjos, Seville, Spain, lies adjacent to the mosque begun by Yusuf II in 1171 in southern Seville. It is entered from the mosque (now the cathedral) to the south, as well as through the Puerto del Perdon to the north and the Puerto del Oriente to the east. Approximately 0·3 ha. in area, this courtyard contains orange trees set in regular formation; in the centre is a large circular fountain for ablutions. Water overflows from this fountain through channels that link recessed square beds at the base of each tree; the flow is controlled by small wooden blocks inserted as required.

The channels were possibly once lined with stone, although they are now edged with brick, a material which, laid in diagonal pattern, forms the surface of the Patio. A comprehensive view of the Patio and its abstract geometrical pattern of water channels may be obtained from the Giralda, the minaret of the adjacent mosque. J.L.

See also SPAIN: ISLAMIC GARDENS.

Patte d'oie, in woods, forests, parks, or towns, the place where three (even four or five, but not more) straight *allées* (or streets) meet at rather acute angles, which suggests the shape of the foot of a goose. D.A.L.

Pavilion, a widely occurring garden feature even today.
Many fine Renaissance examples are to be found in Italy. The Villa *Lante has two magnificent pavilions dedicated to the Muses, in a *parterre setting of fountains and formal gardens. The Palazzo *Farnese, Caprarola, has a pavilion at the top of a cascade bordered by stone dolphins which terminates in a shell-shaped basin.

At *Gaillon, a large wooden pavilion was set up to shelter a marble fountain imported from Italy (cf. *Amboise; *Blois). In the 16th c. galleries along a promenade overlook-

Pavlovsk, near Leningrad, USSR, the Temple of Friendship

ing parterre gardens often terminated in pavilions (*Anet; *Saint-Germain-en-Laye). Perhaps the most beautiful French pavilion is the Petit Trianon, at *Versailles (see also *Bagatelle; *Cassan). Especially fine examples are found in the Russian gardens inspired by the French model, such as the Temple of Friendship at *Pavlovsk and the Agate Pavilion at *Tsarskoye Selo (Pushkin). Notable 18th-c. English examples are at *Stowe and *Wrest.

The Chinese have built many splendid and elaborately decorated pavilions, the finest perhaps being in the Winter Palace, Beijing, and the spectacular Temple of Heaven. (See *fang, *ge, *lou, *ting, *xie, *xuan, for various types.) Likewise, Mogul gardens were not complete without a pavilion, where one sat to admire the cool shady garden. A splendid example is the 17th-c. pavilion at *Shalamar Bagh, Kashmir, which has black marble columns and a cascade of cooling water. G.W.B.

Pavlovsk, Soviet Union, is the site of Paul I's palace and extensive landscape park (600 ha.) on the banks of the Slavyanka, 25 km. from Leningrad and 3 km. from *Tsarskoye Selo. Charles *Cameron designed the palace for Paul and Maria Fyodorovna when Paul was Grand Duke, but it was considerably altered by Vincenzo Brenna and others. Cameron also laid out the private garden by the palace, the lime avenue, and other formal gardens nearby; began to design the 'natural' landscape along the wooded slopes of the river; and designed a number of fine buildings in the park. His Temple of Friendship, a large domed rotunda with Doric columns, is an important focal point and was the forerunner of many similar temples in Russia. The

role of the park as a sanctuary was underlined by the Apollo Colonnade with its statue of Apollo (one of three in the park), the protector of valleys and groves and patron of the arts. Among Cameron's other classical buildings are the Aviary and the Temple of the Three Graces. Less prominently situated rustic buildings—a thatched dairy, a hermit's cell, and a charcoal-burner's hut—reflected the sentimental tastes of the Grand Duchess and the changing fashions of western Europe, where the exotic had yielded ground to the pseudo-vernacular.

When Paul succeeded to the throne in 1796 and Pavlovsk briefly became an imperial residence, Brenna made alterations to the park to give it a more ceremonial character. The Old Sylvia is his most important addition. In a central clearing, from which 12 paths radiate, stands a statue of Apollo surrounded by Mercury, Venus, Flora, and the nine muses on the circumference of the clearing in the spaces between the radiating paths. Andrei Voronikhin designed the open-air theatre, the Visconti Bridge, and the Rose Pavilion; while Carlo Rossi contributed pretty summer-houses and arbours and some distinguished ironwork, including the Iron Bridge.

The last major landscape designer was Pietro *Gonzaga, and he, like Cameron, sought to improve nature, but, while Cameron perhaps had English models in mind, Gonzaga, particularly in the area called the White Birches (273 ha.), looked to the meadow and forest landscapes of northern Russia for inspiration. His training as a stage designer is reflected in the way he placed trees in the landscape, using clumps of trees as receding side-screens to create a remarkable feeling of depth. His laying out of the former parade-

ground of Paul I, nearer to the palace, has a different character, with water playing an important role and reflecting the trees which he grouped so effectively. Combining different kinds of trees for their form, colour, and for the mood each conveyed to him—some gay, some proud, some mournful, etc.—he sought to vary his effects by the way he concentrated them.

The palace and park have been remarkably restored following extensive damage during the Second World War. P.H.

Pavón y Jiménez, José Antonio (1754–1840), Spanish botanist. See RUIZ LOPEZ, HIPÓLITO.

Paxton, Sir Joseph (1803–65), English gardener and architect, was appointed a gardener at the Chiswick garden of the (*Royal) Horticultural Society of London in 1823 but left three years later to become head gardener to the 6th Duke of Devonshire at *Chatsworth. There he remained until the Duke's death in 1858, making substantial alterations to the gardens. He formed an arboretum, installed the spectacular Emperor Fountain, and built glasshouses including the Great Stove or *Conservatory (1836–40) which was 83 m. long, 37 m. wide, and 20 m. high. In 1849 he was the first in Britain to flower the giant water-lily, *Victoria amazonica*. He built a special house for it, his design being inspired by the structure of the ribs in the leaves of the water-lily itself. He sent gardeners overseas on plant-collecting expeditions and one of them, John Gibson, brought back *Amherstia nobilis* from India for the Duke's gardens. In 1850 he designed the Crystal Palace for the Great Exhibition in Hyde Park, for which he received a knighthood the following year; after it was dismantled, he supervised its re-erection at Sydenham.

While still at Chatsworth, Paxton began to design *public parks. At *Birkenhead Park (1843) he worked out a brilliant solution to the problems posed by this new type of design. His later parks, especially the Crystal Palace Park, Sydenham, and the People's Park, Halifax, increasingly made use of formal terraces, a device he had first used at Coventry Cemetery (1845).

He was a man of remarkable energy, versatility, and confidence. Besides being Director of the Midland Railway and Member of Parliament for Coventry, he was also a journalist and writer. He edited the *Horticultural Register* from 1831 to 1834, *Paxton's Magazine of Botany* from 1834 to 1849, and was one of the founders of the *Gardener's Chronicle* in 1841. His books include *Practical Treatise on the Cultivation of the Dahlia* (1838), *Pocket Botanical Dictionary* (1840), and with John Lindley, *Paxton's Flower Garden* (1850–3) (see *garden journalism). He was elected a Fellow of the Linnean Society in 1831. R.D.

See also LISMORE CASTLE.

Peacock, Thomas Love (1785–1866), English novelist, poet, and official of the East India Company. Before he wrote his novel, *Headlong Hall* (1816), he must have read details of the Humphry *Repton–Payne *Knight controversy, either in their writings or in the *Edinburgh Review*, Vol.

VII, Jan. 1806. In Chapter IV Mr Marmaduke Milestone (so called in parody of Repton's suggestion that the arms of the owner of *Tatton Park might be inscribed on milestones nearby) endeavours to convince the earthy Squire Headlong of the necessity for landscape 'improvement'; and in Chapter VI he gives advice on Lord Littlebrain's estate nearby. *Headlong Hall* is delightfully written, with a gentle and humorous satire in which both sides are made to look equally ridiculous. E.M.

Peiresc, Nicolas-Claude-Fabri de (1580–1637), French humanist, lawyer, naturalist, and gardener, travelled widely in Europe, gaining an early reputation as a scholar. Botany was high among his interests; while a student at Montpellier he had attended Richer de Belleval's lectures in the Jardin des Plantes. He was in regular contact with Jean *Robin, director of the king's garden in Paris, and corresponded with Jacques *Boyceau de la Barauderie, superintendent of the royal gardens. In his small garden at *Aix-en-Provence, Peiresc collected rare species of plants. His family home was at Belgentier, north of Toulon, where he made a large rectangular garden arranged about a central axis, with transverse walks at right angles dividing it into areas reserved for flowers, medicinal plants, and exotics. His parterre was of myrtle; an *allée* 73 m. long was bordered with *palissades of jasmine and lined with *orangers de Chine*. He had more than 60 kinds of European apple, and as many kinds of pear. Among the plants were yellow jasmine from the Indies and 'corail arbor' from America. K.A.S.W.

Peking. See BEIJING.

Pena Palace, Estremadura, Portugal, was built by Ferdinand of Saxe-Coburg, consort of Maria II and a cousin of Prince Albert of England, on the topmost crag of the Sintra range. In style it is baronial, laced with Moorish extravagancies. The views from the terraces are, however, stupendous, while below the palace the hills, wooded and lush owing to the rainfall that sweeps in from the Atlantic, slope away in graceful folds.

Ferdinand set about laying out the wooded surroundings in a romantic vein, creating glades and waterfalls, rides and vistas, all on a vast scale; his conception was exactly right for the environment. In so doing he introduced a fashion totally new to Portugal. As an enthusiastic and knowledgeable arborist he sought materials from all over the world, planting rare specimens so skilfully that the grounds of the palace became a silvicultural collection of great merit. Only a few miles away, at *Monserrate, Sir Francis Cook was doing much the same, and there was great competition between them. In the damp Sintra climate all their endeavours flourished. The Portuguese admired, but made few attempts to copy these foreign innovations, and kept to their own formal gardens. B.L.

Peng jing are the Chinese *bonsai*, miniature plants cultivated either on their own as 'tree *peng jing*' or arranged in shallow containers with stones, water, and sometimes

miniature buildings and figures, as landscape (or *shansui*) *peng jing*. Some are compositions of stones only. They are displayed as *peng jing* collections in special areas, like that in the *Liu Yuan, Suzhou, and used to decorate tables and stands in garden buildings and courtyards. X.-W.L./M.K.

Penicuik House, Midlothian (Lothian Region), Scotland, the home of Sir John *Clerk, was the site of some interesting and important experiments in garden design in the 1720s, 30s, and 40s. There was an old house built by Sir John's grandfather, which had a simple bowling-green and other gardens typical of the 17th c. To these Clerk began to add as early as 1700, planting to a plan prepared by William Adair in the 1690s: these were mainly shelter-belts enclosing regular fields (known in Scotland as parks), and blocks of woodland. He planted the verges of the streams which gave a series of serpentine wooded lines running diagonally across the small estate. The other main elements, apart from field enclosures, were the avenues, reaching outward from the house.

After returning from a trip to London, which he made-

especially to see gardens, Clerk began to turn Penicuik into a sort of *ferme ornée*. A wooded escarpment lying just west of the house was made into a terrace walk and terminated on the south end in a bastion: to the north it was extended, and turned west, thereby linking house, garden, wood, the High Pond, and various fields along the way. It also formed a promenade, from which wooded hills in the distance and productive fields and meadows in the foreground could be seen as a landscape.

Then in the late 1730s Clerk linked this piece of garden by a short cut to a large field at the western edge of the estate lying between two streams. He could now conduct a visitor in a circular walk through his estate, going from the terrace down into fields and meadows, along the River Esk to where a steep bank, wooded at the top, formed the opposite side of the stream, then across a light bridge to the mouth of a grotto, the Cave of Hurley. This horrid scene, which Clerk had made with the cave of the Cumaean Sibyl in mind, led on through a dark tunnel to a small chamber where a visitor could rest and be either suitably impressed or terrified. Light could be seen from the chamber and on walking

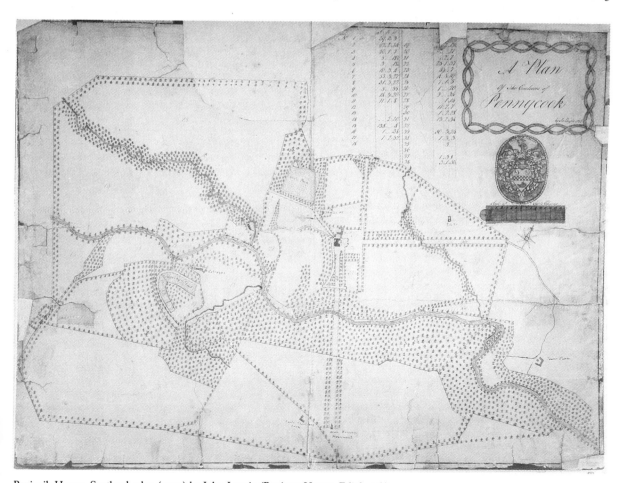

Penicuik House, Scotland, plan (1757) by John Laurie (Register House, Edinburgh)

towards it a bright and pastoral scene at 'Claremont', a little summer-house, was discovered. From there an easy walk led through Hurley Park to the Esk again, here much tamer, and across it into Blackpools Park and the south-west bastion of the terrace. W.A.B.

Peony. *Theophrastus, in his *Enquiry into Plants*, wrote about herbaceous peonies in 370 BC but they were not widely grown in Europe until Tudor times. The shrubby or tree peony did not reach England until 1787 when Sir Joseph Banks obtained a plant for Kew. Today, cultivars of nearly all the 30 known species and their many hybrids are in cultivation throughout the world and new forms are still being discovered and introduced into gardens, particularly from China.

However, in China itself peonies have been grown for over a thousand years. The moutan (*Paeonia suffruticosa*), native to northern China, was introduced to the rest of that country by AD 750 when it created a floral craze rivalled only by tulipomania (see *tulip) in Europe in the mid-17th c. The Summer Palace of Emperor Ming Huang was planted with 10,000 tree peonies of various colours. Ouyang Hisui (1007–72) recorded over 90 distinct cultivars and wrote of sophisticated cultivation and grafting techniques. The Loyang area was the centre of moutan culture for centuries but after 1700 it moved to Ts'aochow and Fahuahsing near Shanghai. Robert Fortune, the explorer, introduced 40 cultivars from this area in 1842.

The herbaceous or Chinese peony is native throughout Eurasia and *Paeonia officinalis*, as its name suggests, has long been grown for its supposed medicinal properties. *Paeonia lactiflora*, another Chinese species, the shaoyao, was cultivated from as early as 900 BC. The gardens of the Chu family were reputed to have contained over 60,000 plants of its cultivars.

Both Chinese and tree peonies are long-lived plants and many in English gardens were planted over a century ago. Tree peonies are particularly well suited to cultivation in conservatories and their growth can easily be retarded or hastened so that flowers are available throughout the year. P.F.H.

Percée, a cutting through a wood in order to establish an *allée*, create a vista, or open a view. D.A.L.

Perelle, a family of French painters, draughtsmen, and engravers, important for their records of 17th-c. French gardens and their influence in disseminating the picturesque landscape style. Their styles are so similar that it is difficult to distinguish them.

Gabriel Perelle (1595–1677) studied under Daniel Rabel (1578–1637) whose rather dry manner is evident in Perelle's earlier work. His engravings of picturesque landscape in the 1650s and 1660s, some with classical and Gothic ruins juxtaposed, are outstanding compositions in their own right. He also made numerous engravings of French gardens, some after drawings by *Silvestre, or in collaboration with him. He worked almost entirely for commercial publishers, especially Israel Henriet, Nicolas Langlois (*c.*1640–1703), Jean Le Blond (*c.*1635–1709), Pierre Mariette (*c.*1602–57), and his son, Pierre Mariette II (1634–1716).

Nicolas Perelle (b. 1631) was the elder son of Gabriel. Taught drawing and engraving by his father, he studied in Simon Vouet's studio, and is described in registers as 'painter'. He collaborated with Silvestre. The distinctive style of some of the engravings of *Rueil are attributed to him, but he was far less prolific than his brother.

Adam Perelle (1640–95), younger son of Gabriel, worked in his father's studio and engraved original picturesque compositions in his manner. He made many drawings of gardens, often in association with Silvestre (*Saint-Cloud, Rueil, *Saint-Germain-en-Laye, *Versailles). Some of these are signed 'AD. Perelle'. In 1673 he was appointed drawing master to the Dauphin, and in 1686 to the Duc de Bourbon at *Chantilly, the gardens of which he recorded in 50 little views. In his last years his skill declined, and his plates were rather crudely finished and copied by his pupil, Pierre Aveline (d. 1712). K.A.S.W.

Pergola. Although too fragile to have survived, there seems no doubt that pergolas were in use in antiquity, beginning in Egypt and later introduced into Italy. In Egypt they might have been used as 'vine arbours'; in *Pompeii frescos show them fully developed architecturally. The idea began as a simple structure to hold plants and give a shady path. Pergolas, as we know them today, originated with the Italian Renaissance—the word *pergola* is Italian, meaning 'any arbour, bower or close walk of boughs, mainly of vines' (see plate II*b*). It first consisted of a light timber construction of upright and cross members, the latter often of slats, strong enough only to support climbing plants as well as vines—wistaria in particular, whose clusters of flowers were reminiscent of grapes. Soon the supports became architectural features, such as round stucco piers with caps.

The value of the pergola as a garden element was recognized north of the Alps, where it became a great feature in the new gardens at *Blois in Touraine. It became popular in England in the 19th c., growing from the gardenesque style of design. The idea was specially developed by Edwin *Lutyens when heavy timbering made it architectural rather than horticultural (see plate XII). Later, with a change of fashion, the metal pergola with strainers became popular, seemingly emanating from Germany, though it is questionable whether metal is as satisfactory as timber for the plants themselves. G.A.J.

See also LANG.

Periodical. See GARDEN JOURNALISM.

Persian gardens. See ISLAM, GARDENS OF.

Perth, Western Australia. See GOVERNMENT HOUSE; QUEEN'S GARDENS.

Peterhof (Petrodvorets), Soviet Union, is the site of Peter the Great's *Versailles-inspired summer palace and park (120 ha.) on the Gulf of Finland, 30 km. from Leningrad. Peter chose the site and probably conceived the overall plan. J. F. Braunstein was the first architect, but *Le Blond took charge from his arrival in Russia in 1716 until his death in 1719, and much of the layout dates from that time. His successor was Niccolo Michetti, who designed some of the fountains, cascades, and summer-houses and added pavilions to the palace. Later *Rastrelli considerably extended the palace for Elizabeth. Alterations and additions to the park continued well into the 19th c. The remarkable water system, feeding the many fountains from a source 22 km. away, was the work of the hydraulic engineer Vasily Tuvolkov.

The palace is imposingly situated on a natural terrace some 15 m. high, and the cascades below the sea-facing north façade are among the most impressive in the world. The water tumbles down the marble steps of the double cascade into the basin with its spectacular gilded Samson fountain. Samson has prised apart the jaws of the lion and a jet of water gushes 20 m. into the air. This fountain, and indeed all Peterhof, celebrates Russia's recovery of her Baltic lands from the Swedes. Numerous gilded fountains and statues of ancient gods and other mythological figures grace the basin and the cascade, acclaiming Samson's prowess. The water then flows along the canal, flanked by fountains, to the sea, Russia's vitally important new access to Europe. It is to the presence of the sea, as background, as foreground, and symbolically, that Peterhof owes much of its special character.

On both sides of the canal the Lower Park is formally laid out with *allées*, *bosquets*, a great variety of fountains including some good trick fountains, two cascades, and three small palaces—Monplaisir, the Hermitage, and Marly. Monplaisir, Peter's first residence here, was the work of Braunstein, Le Blond, and Michetti, but Peter determined its position by the sea's edge and the style, which is that of a modest Dutch house. He also made sketches for the garden, which was laid out with box hedges, trellised galleries, gilded statues, and fountains. The Hermitage, by Braunstein, is also by the sea and is surrounded by a moat. The Marly Palace, again by Braunstein, is an elegant small country mansion set in a mirror parterre of fish-ponds.

The Upper Park, on the south front of the main palace, was originally designed by Braunstein and Le Blond and laid out by gardeners Harnigfelt and Borisov between 1714 and 1724. In the 1750s it was widened to reflect Rastrelli's extensions to the palace. The large formal parterre, between the palace and the entrance gates, with *allées*, grass plots, basins, fountains, and statues, is bounded on each side by covered galleries and lines of clipped trees.

The best of the adjoining landscape parks, added in the 19th c., is the Alexandria (1831–3 by A. A. Menelas) with its Cottage Palace, Farm, Gothic Chapel, Ruined Bridge, etc.

Wanton destruction at Peterhof by the invading forces during the Second World War was followed by remarkable restoration. P.H.

Petit Trianon, Versailles, France. See VERSAILLES: THE PETIT TRIANON.

Peto, Harold Ainsworth (1854–1933), English architect, connoisseur, and collector. Strongly influenced by the formal Italian garden, he set out to assemble a wide variety of classical objects—garden houses, temples, colonnades, canals, well-heads brought from Italy, courtyards, tunnels, *treillage*, and the like—into a composition that harmonized agreeably enough with the English landscape. His feeling for the integration of architectural features with plants is typified in his own garden at *Iford Manor and the canal garden at *Buscot Park, which is probably his best work. Other gardens he designed are Bridge House, Weybridge, Surrey; Easton Lodge, Essex; Garinish Island, Glengariff, Co. Cork; Hartham Park, Wiltshire; Petwood, Lincolnshire; Wayford Manor, Somerset; and several on the French Riviera. G.A.J.

Petrarch [Francesco Petrarca], Italian poet and humanist. See ITALY: FLORENTINE RENAISSANCE.

Petre, Robert James, 8th Lord (1713–42), English botanist and gardener. See THORNDON HALL.

Petri, Bernhard (1767–1853), German gardener and stock-raiser, studied in England before travelling extensively on the Continent and then working at Zweibrücken in Germany. In 1793 he came to Hungary, where he laid out the first English gardens, such as Hédervár, Vedrőd (Voderady) (1794), and Ivánka (Ivanka pri Dunasi), which were all originally French gardens. Petri was keen to utilize the potentialities of the sites, partly mountainous, partly showing the bends of the Danube. His success and fame as a garden architect was due also to the erection of an obelisk at Vedrőd, bearing his name and a laudatory inscription. His greatest achievement was the layout of the Orczy Park in Budapest, the first public garden in the town, where he managed to transform the sandy soil into fertile ground. It was due to Petri that the first acacias and robinias (varieties of *R. pseudacacia*) were naturalized in Hungary. He left Hungary *c*.1798 and worked for the Prince of Lichtenstein. In 1808 he settled at his estate at Theresienstadt where he devoted himself to breeding merino sheep. He also published some articles about his gardens. A.Z.

Petrodvorets, near Leningrad, Soviet Union. See PETERHOF.

Petworth House, West Sussex, England has a garden which grew from a small enclosure for fruit and vegetables in the 16th c. to one of importance with the enlarging of the house for the 6th Duke of Somerset from 1688. At this time a large rectangular forecourt was created, flanked by raised terraces and a greenhouse to the north, and a kitchen garden and orchard to the south. Part of this layout is likely to have been devised by George *London, to whom payments occur in the Petworth accounts between 1688 and

1693. In the middle of the 18th c., however, the formal gardens were replaced by a landscape park and pleasure grounds designed by 'Capability' *Brown, one of whose plans survives. Notable features on this are the extensive lake formed by damming a stream, and the planted slope to the north-west of the house with which he replaced the previous terraced mound. This was one of Brown's earliest works, for which the first design was drawn out when he was still at *Stowe, although the contract with Lord Egremont was not signed until 1753. The result in its present mature state is an outstanding example of his work.

The property was acquired by the National Trust in 1947. D.N.S.

Petzold, Eduard (1815–91), German landscape gardener, was Director of Gardening at Ettersburg near Weimar from 1844. Here, assisted by *Pückler-Muskau, Petzold created the celebrated Ettersburger Aushau: by judicious felling of 10 ha. of valuable beech trees the dense woodlands were transformed into a picturesque park forming a background to the Schloss. From 1848 he was Court Gardener at Weimar, where he redesigned the *Ilm-Park and Tiefurt. Pückler-Muskau's influence was important here. On his recommendation Petzold went to *Muskau as Director of Gardening from 1852 to 1881. He laid out the untouched grounds (c.500 ha.) to his own plans in a picturesque style very reminiscent of Pückler's. He created an extensive arboretum with over 3,000 species, which had an important influence on nursery management, and also tree nurseries over an area of 125 ha. Petzold himself owned large tree nurseries at Bunzlau.

In 1873 he drew up the plans for *Greiz and for Altdöbern (in Cottbus), where an extensive landscape garden was created in 1880 with much use of water, though some formal parts of the existing garden were preserved. He also made plans for a great many estate parks and large private gardens, described in his *Erinnerungen aus meinem Leben* (Leipzig, 1890). Petzold wrote many influential textbooks: *Die Landschaftsgärtnerei* (Leipzig, 1867, 2nd edn. 1896); *Arboretum Muskaviense* (Gotha, 1864); *Beiträge zur Landschaftsgärtnerei* (1849). H.GÜ.

See also TIEFURT.

Pfaueninsel, Berlin, lies in the Havel lakes to the west of Berlin and covers an area of c.1,500 m. × 500 m. Between 1794 and 1796 the master carpenter Brendel built a 'ruined' castle, flanked by two narrow towers, on the island for King Friedrich Wilhelm II of Prussia. Friedrich Wilhelm II had the whole island designed as an English landscape park by the landscape gardener P. J. *Lenné, who was to use many rare species, taking the *Jardin des Plantes in Paris as his model. A number of buildings were erected such as a neo-Gothic dairy, built as a ruin, the Kavalierhaus, whose façade came from a late Gothic patrician house in Danzig, and the famous Palmenhaus (1829–31), later burnt down, whose interior resembled an Indian palace, with decorations taken from a Burmese pavilion. A high balcony ran round the building and afforded a splendid view of the palm-trees and other exotic plants.

As the island can only be reached by ferry it was a favourite place of seclusion for Friedrich Wilhelm III and his wife Luise. It takes its name from the peacocks which have been kept on the island since the time of Friedrich Wilhelm II. The other exotic animals which lived on the island were removed to Berlin by Friedrich Wilhelm IV to form the basis of the *Tiergarten. U.GFN.D.

Pheasantry, cognate with *aviary and menagerie, an ornamental building as well as a cage in which to keep and display the fowl. The heyday of the pheasantry in England was roughly between 1750 and 1850; latterly they were often made of cast iron. There was a pheasant ground at *Kew, and Humphry *Repton designed a pheasantry for the Brighton Pavilion (though it was never built). M.W.R.S.

Phoenix Park, Dublin, Ireland, a park of 709 ha. near the centre of Dublin, was designated a royal *deer-park in 1662. After a period of neglect it was restored during the viceroyalty of Lord Chesterfield, who planted clumps of trees (illustrated by Thomas *Wright in his *Sketches and Designs for Planting*), erected the Phoenix Column (1744) (a fluted stone column of a phoenix burning in her nest), and opened the park to the public in 1747. In 1787 the Park Ranger's House became a residence of the Viceroy and c.1815 and area of 64 ha. was enclosed around it. Similar areas around the new residences of the Chief Secretary and the Under-Secretary were also enclosed. The gardens in the three enclosures were laid out by Ninian *Niven and the walled gardens of the Viceregal Lodge also gained a range of hot houses by Richard *Turner. Gate lodges to the park were designed by Decimus *Burton (1940) and the great obelisk of the Wellington Testimonial by Sir Robert Smirke. P.B.

Physic garden. See BOTANIC GARDEN; HERBARIUM; MEDIEVAL GARDEN.

Pia, Villa, Vatican, was designed in 1560 for Pope Pius IV by Pirro *Ligorio. This little papal retreat, one of the most original landscape conceptions of the Renaissance, was the first of its kind and particularly important in the history of *giardini segreti*. The central feature is an open paved oval, 27 m. × 19 m., round which are four free-standing and contrasting structures. The entrance loggia to the three-storeyed *casino* itself faces across the smaller axis to a similar but single-storeyed loggia which overlooked lower gardens (no longer existing). At each end of the longer axis are two entrance porches; all four forms are linked by a low parapet wall with seats and surmounted by vases. Externally, counter-curved ramps led to the lower gardens. The elevations are richly detailed and the group remains a unique study of four different garden buildings grouped in space.
 G.A.J.

Piano nobile, an Italian term used in architecture to describe the most luxurious floor of a house and containing the reception rooms. It usually has one floor or a basement below it. P.J.C.

Picturesque, The. During the 18th c. English landscape gardening was strongly influenced by the idea of making landscapes in the manner of pictures, in particular the drawings of Claude Lorrain and Gaspar Poussin, the brother-in-law of Nicolas Poussin. The composition of Claude's painting was nearly always the same—extensions of the scene by planes or *coulisses* through near, middle, and far distances to infinity. William *Kent must have noted this opening up of the countryside for it became one of the features of his own landscape gardening.

Otherwise there is little to lead one to suppose, from contemporary prints, that Kent's landscapes (for which he made no plans) were derived from Claude. Italian gardens and certain features from French gardens were themselves his well-spring more than the work of artists. How could Kent or any other English visitor to Rome have missed seeing the gardens at the Villa *Borghese or the Villa Pamphili, with their vast enclosures and parks, their *giardini boscherecci*, informally planted except near to the house? Or if they did not visit them they must have seen numerous prints of them on sale in Rome. It would seem that the paintings of Nicolas Poussin, in whose work Palladian buildings figure so largely, may have been the source for Kent's buildings at *Stowe and *Rousham House. It is possible, of course, to find Claudian influences in romantic-poetic gardens like Stourhead, where from different points of view on the circumambulatory walk there are constant Claudian scenes—a diagonal expanse of water terminated by a bridge, parallel recessions of planes, dark foregrounds of massed trees as wings to right and left, classical temples at the water's edge, or even the view westwards to the setting sun; all this in addition to Virgilian overtones.

In the work of Lancelot *Brown one can find little but the most superficial resemblances to the work of Claude or Gaspar Poussin, or even the wilder Salvator Rosa. In Brown's landscapes, colour plays no part, tonal contrasts were not used emotively but to show linear patterns and serpentine lines; and his use of perimeter *belts of trees shuts out the surrounding countryside—the negation of Claude's succession of views to the farthest hills on the horizon. (*See over.*) E.M.

The picturesque controversy. The principle of deriving landscapes from pictures was to be called into question in the last decade of the 18th c. The unintentional catalyst of this furore over the picturesque was the Revd William *Gilpin, an able draughtsman who took his holidays in various parts of the country, making notes and sketches in which he analysed the particular qualities of picturesque beauty which he found in the course of his visits. Encouraged by his friends, Gilpin published these *Observations* and it was no doubt the volume describing his tour along the River Wye which first attracted the attention of Payne *Knight and

Uvedale *Price. In 1792 Gilpin published three essays, the first of which expressed his view that beauty by itself was usually associated with the smooth and neat, such as might be found in landscapes designed by Brown and his school; whereas picturesque beauty implied roughness in texture and ruggedness in delineation. Garden scenes in his view 'are never *picturesque*. They want the bold roughness of nature. A principal beauty in our *gardens*, as Mr. Walpole justly observes, is the smoothness of the turf; but in *a picture*, this becomes a dead and uniform spot; incapable of light and shade.' At the same time Gilpin appreciated such contrived landscapes as at *Fonthill Abbey and *Longleat House, which he described as noble, while *Stourhead showed 'greatness in the design'. Knight and Price became keen protagonists of the picturesque school and used it in their respective publications of 1794 (*The Landscape* and *Essays on the Picturesque*) as a stick with which to belabour Brown and Humphry *Repton, the latter becoming aware of the attack in time to add a footnote to his *Sketches and Hints* in defence of himself and his predecessor. 'While mouldering abbeys and the antiquated cottage with its chimney smothered in ivy may be eminently appealing to the painter,' he maintained, 'in whatever relates to man, propriety and convenience are not less objects of good taste than picturesque effects.' D.N.S.

Piercefield (or Persfield), Gwent, Wales, was owned by Valentine Morris, who had sugar interests in the West Indies. He lived at Piercefield from 1753 to 1772 and in that time developed what was essentially an outward-looking landscape of 120 ha. The walks in the gardens were designed to give the best possible views of nearby Chepstow, its ruined castle, the flat peninsula in the Wye valley below, and the spectacular cliffs opposite. The gardens contained a grotto and a Giant's Cave, with a stone giant apparently about to hurl a huge rock, but it was the prospects, 'the finest in England' (*sic*), which made Piercefield famous. William *Gilpin admired the picturesque views; *Whately described them at some length (*Observations on Modern Gardening*, 1770); and Arthur Young was entranced by the effects (*A Six Weeks' Tour*, 1768), concluding that Piercefield was unequalled as a sublime landscape. Although the house and grounds are now derelict, the scenery remains unchanged. Chepstow Racecourse covers part of the park. M.W.R.S.

Pigeon-house, Dovecot, once as much a part of the equipment of a country estate as cowsheds or poultry runs. The young pigeons or squabs were eaten, and the droppings collected for manure. In Persia (Iran), districts near Isfahan were extensively cultivated for melons, and since it was found that these flourished when fed with pigeon manure, pigeon towers were built throughout the area.

In Britain there are some old dovecots remaining, notably the large circular one at Rousham House, and the ancient pigeon-house at Cotehele in Cornwall, restored in 1962 by the National Trust; a 15th-c. dovecot at Athelhampton has about a thousand nesting holes. D.W.

See also AVIARY.

A Brownian landscape (*above*) and the same landscape (*below*) made picturesque, from Richard Payne Knight, *The Landscape: a didactic poem* (1794)

Pillnitz, Dresden, German Democratic Republic, is a 23-ha. garden with many features, situated in a well-protected spot on the Elbe. As early as 1578 a small pleasure-garden with many plants and a summer-house existed there. After several different owners, the garden passed to August the Strong in 1718, who had many plans prepared, but only a very small number were realized.

In 1720–1 Pöppelmann built the Indianisches Lustschloss, a water palace which is joined to the landing-stage on the Elbe by a flight of steps with two sphinxes. In 1723 a matching palace, the Bergpalais, was built 120 m. to the north. The two buildings were linked by a magnificent parterre formed by 12 compartments arranged around four ponds. To the west the garden consisted of individual hedged gardens, known as Charmillen, where members of the court played garden games. On the other side of a *ha-ha a wide avenue led to Dresden.

North of the Bergpark between old lime and chestnut *allées* (still preserved) lay areas set aside for ball-games and also shooting-halls. Further hedged gardens housed a great variety of games and entertainments. In 1730 this area was terminated to the north by a circular racing-hall (to plans by Lonquelune), which has since been altered several times and is now the Orangery.

In 1788–91 wings were built to connect the two palaces with the old Schloss. In 1778 the garden was extended to take in a previously untouched area to the north-west, which was turned into a landscape garden containing a small lake with an island on which stands a bronze cast of the *Juno Ludovisi*; the English Pavilion was built here in 1784 by C. F. Schuricht. Outside the actual grounds of the garden a landscaped area, the Friedrichsgrund, stretched to the hills of the Borsberg, terminating in a neo-Gothic ruin (1785). Similarly, from 1785 a landscaped area was created beyond the lime and chestnut *allées* behind the Bergpalais; the Chinese Pavilion was built here in 1804 by C. F. Schuricht to motifs by *Chambers. Plants were reared in three hothouses.

The Alte Schloss was burnt down in 1818 and rebuilt 1818–26 by C. F. Schuricht as the Neue Palais; on its eastern side it encloses the beautiful Fliederhof with *Syringa × chinensis* (Rouen lilac) standards.

In 1867 Carl F. Bouché (1850–1933) redeveloped the by then dilapidated parterre between the two palaces into an ornamental garden with a central fountain and pond, lawns, and flower-beds. The old trees have largely been replaced since 1950.

The garden (*c.* 2 ha.) in front of the Orangery was turned into a collection of conifers in 1874. Thanks to the favourable situation 200 varieties flourished, some extremely rare, and most of them have survived. Next to the conifers is a camellia which was planted in the open in 1800 and is enclosed by a heated glasshouse in winter. H.GÜ.

Pimsai Amranand, Mom Rachawong (1929–77), Thai garden designer and writer, was a great-granddaughter of the progressive and enlightened King Maha Mongkut of Thailand. She returned to Thailand after her education in England and became a potent influence on garden design there. From 1964 onwards (succeeding William Warren) she wrote a weekly article in the *Bangkok World* Sunday Magazine, lectured widely on the history and culture of Thailand, and in 1970 published *Gardening in Bangkok*. Her upbringing and education led her to form a unique bridge between the cultures of East and West and she worked increasingly for the establishment of more street tree planting, public parks, and children's playgrounds. Since her untimely death, the Pimsai Foundation has been formed to encourage the development of public amenity planting in Thailand. M.L.

See also PIMSAI GARDEN.

Pimsai Garden, Bangkok, Thailand, was a very personal garden created by M. R. *Pimsai Amranand which reflected her great love of plants for all their inherent characteristics of form and particularly her enthusiasm for orchids and heliconias. It was a small and simple garden made apparently larger by the naturalized planting of its flanks but with a traditional lawn at the centre, and an old Siamese house re-erected to close the end view. The garden was designed very much to be seen from the wide covered verandah, a large outdoor living-room furnished with a wide range of potted and pendulous plants, particularly aroids and orchids, seen in silhouette against the rich background of the garden. Though she was an expert in orchids Pimsai's garden was not typical of the orchid fancier, and each plant, whether hanging or growing as a true xerophyte, had to fulfil its role in the general composition. Behind the house on the small *klong* (navigable waterway) was a duck pond and vegetable garden, totally Thai vernacular in character, which balanced the greater sophistication of the controlled 'jungle' garden. M.L.

Pineapple, The, Dunmore Park, Stirlingshire (Central Region), Scotland, was built for Lord Dunmore, one-time Governor of Virginia, by an unknown architect in 1761. The 15-m. high Pineapple is actually the top half of a banqueting house (at ground level on the Park side) which in turn stands on a square open porch. This *folly is the focal point of the large (2·4-ha.) walled garden and stands in the centre of its north wall. To either side were ranges of hothouses.

Why Lord Dunmore should have built a 'pineapple' is unknown. Pineapples were grown in Scottish gardens from the early 18th c. onwards, and he presumably grew them at Dunmore. The quality of the building leads one to suspect a less directly horticultural motive, perhaps something akin to *Chambers's contemporary oriental whimsies at Kew.

The Pineapple, with 6·4 ha. of surrounding grounds was given to the National Trust for Scotland in 1974. W.A.B.

Pinetum, an *arboretum composed mainly of evergreen conifers. P.G.

Ping Quan Villa, China, was the country retreat of a celebrated Tang-dynasty Prime Minister, Li De Yu (787–850). The Plain Spring Villa was situated in Henan province

near the Yellow River (Huang He), somewhere south of the present city of Luoyang. A large estate (it was said to have been surrounded by a wall 20 km. long), its bamboo groves and streams were embellished with 'more than a hundred' halls and terraces, and pavilions of several storeys. Li's particular passion, however, was collecting both rare plants, brought back from various political postings, and unusual rocks: the garden is still famous in China today because of his elegant literary record of these collections, 'On Trees and Rockeries at Ping Chuan Villa'. C.-Z.C./M.K.

Piper, Fredrik Magnus (1746–1824), Swedish architect, introduced the English landscape style into Sweden. He studied painting and architecture at home and, between 1773 and 1780, in France, Germany, Italy, and, most of the time, in England. He was much impressed by the English landscape garden and made a thorough study of the best parks of his time. After returning home he was commissioned by Gustavus III to lay out parks in the English style at *Drottningholm and *Haga, and made several plans for other royal gardens. Among private parks laid out by him the one at Forsmark, north of Stockholm, is still well preserved.

He made a great number of descriptions and drawings of famous gardens in Italy and England which are kept in the Royal Academy of Arts in Stockholm, of which he was made superintendent in 1803. G.A.

Pisa Botanic Garden, Italy. The Orto Botanico, one of the first physic gardens, was founded c.1543 by Luca Ghini (c.1490–1556) who also helped establish the botanic garden at Florence a year or two later. The first curator of the *Padua Botanic Garden, Pisa's rival for priority in its date of birth, was one of Ghini's students, so his name is associated with all three of the earliest teaching gardens.

Ghini was one of Italy's leading botanists, who came to Pisa after teaching botany and medicine at the university of Bologna, where he introduced a collection of dried plants, mounted on sheets of paper—a herbarium—as a reference tool. At Pisa the garden was planned as a means of teaching students about the plants that formed the source of most of the medicines then available, an object also helped by the botanizing expeditions in northern Italy made by Ghini and his pupils. These explorations helped to enrich the garden, so that by 1555, when it was visited by the French naturalist Pierre Belon, he was astonished at the young garden's beauty and the number of plants it held. Its contents provided material for Andrea Cesalpino, who succeeded Ghini in 1554 and was the first to classify plants by the characteristics of their fruits and seeds, rather than grouping them according to their medicinal properties.

The garden, still affiliated to the local university, covers c.3 ha. in a long narrow strip of land not far from the cathedral, in a street named after its founder. Early in the 18th c. it is said to have been the channel for the introduction to Italy of double flowers from the Netherlands. Now it specializes in plants of the lily, water-lily, and amaryllis families, though a wide range of other plants is still grown. S.R.

See also BOTANIC GARDEN; MEDIEVAL GARDEN.

Pisani, Villa, Strà, Veneto, Italy, is a vast and grandiose Veneto villa fronting a long curve of the Brenta canal on the outskirts of Strà. Begun in 1735 by Girolamo Frigimelica for the Doge of Venice, Alvise Pisani, it was completed in 1756 by Francesco Maria Preta. Following Venetian tradition, the gardens, the best preserved of any along the Brenta, were laid out behind the house, the obligatory central vista being provided by a long canal which reflects the Palladian portico of the stables opposite. At one time it was the residence of Napoleon's Italian Viceroy, Eugène de Beauharnais, and it was then that the immense gardens were laid out as a park, retaining, however, certain elements of the original design such as the famous *maze, the *gazebo, and the fine wrought-iron *grilles* which still exist today. Artfully planted trees give the illusion that the park stretches far into the distance beyond the stable block which in reality lies on its boundary. It is also known by the alternative names of Villa Imperiale and Villa Nazionale. H.S.-P.

Piskaryovskoye Cemetery, Leningrad, Soviet Union, was completed in 1960. The architects were E. A. Levinson and A. V. Vasiliev. It is a starkly and overwhelmingly impressive memorial *cemetery on the site of the mass burials of 470,000 inhabitants, most of them civilians, who died during the blockade of Leningrad, 1941–3. The whole of the space is dominated by the bronze figure of Mother Russia (by R. K. Taurit and V. V. Isaeva) holding out a wreath of oak leaves. Row upon row of long grass mounds, each c.10 m. long, 4 m. wide, and 2 m. high, with the year inscribed on a stone at each end, mark the positions of the mass graves, impressive evidence of the city's ordeal. P.H.

Pitmedden, Aberdeenshire (Grampian Region), Scotland. The Great Garden of Pitmedden was first laid out in the 2nd half of the 17th c. by Sir Alexander Seton, 1st baronet of Pitmedden, in a formal style influenced by the French classic garden of *Le Nôtre as practised in Scotland by Sir William Bruce and others.

The original house, including all papers relevant to the design of the garden, was destroyed in a fire in 1818 and the garden fell into disrepair. When the estate was given to the National Trust for Scotland in 1952, therefore, an exact reconstruction of the garden was not possible and re-creation has been based on records of other contemporary gardens, Holyroodhouse in Edinburgh in particular.

The 1·2-ha. walled garden lies in the sunken eastern half of a great square and is laid out in four parterres, divided by box hedges and grass paths. Three of the elaborate boxwood designs are based on those known to have been used at Holyroodhouse, and a fourth incorporates the coat of arms of Sir Alexander Seton, surrounded by rectangular beds cut in shapes of the Scottish thistle and saltire. Two pavilions with ogee roofs, in the north-west and south-west corners of

the wall, have been restored to their original state and a central fountain and basin contain fragments of an original Pitmedden fountain.　　　　　　　　　　　　　　A.M.P.

Pitt, Thomas, 1st Baron Camelford (1737–93), was the nephew of William *Pitt and grandson of Sir Thomas Lyttelton of Hagley for whom he designed a Palladian bridge at *Hagley Hall. His most noble piece of garden architecture is probably the Corinthian arch at *Stowe (1765–6), an outstanding example of Georgian garden decoration. In 1764 he designed a bridge of rocks, a Gothic cottage, and a conservatory at *Park Place for General Henry Conway.　　　　　　　　　　　　　　K.N.S.

Pitt, William, Earl of Chatham (1708–78), the English statesman, played an important part in the early development of the English landscape style. Sir Thomas Lyttelton consulted him at *Hagley Hall on the setting for two garden buildings, designed by his cousin John Pitt (c. 1706–87). For Richard Grenville at Wotton House, Buckinghamshire, he designed 'two miles of water scenery'. Both *Cobham and later Temple sought his guidance at *Stowe, where his likeness adorns the Shrine of British Worthies.

Pitt also advised Sanderson *Miller at Radway and Ralph Allen at *Prior Park, where he paid particular attention to the siting of an *eye-catcher. The garden buildings he disposed about the landscapes were often the work of his cousin John or his nephew Thomas *Pitt. His loveliest surviving creation is at *Encombe, where he designed a lake so beautifully managed as to appear to be an inlet from the sea.

From 1747 he transformed his own 26-ha. property, South Lodge, Enfield, into a silvan delight with lakes, bridges, temples, walks, and a pyramid. In 1753 he moved to Hayes Place, Kent, where he also made pleasure-grounds 'disposed with taste and fringed with rich plantations' (Christie's sale catalogue, May 1789).　　　　　　K.N.S.

Pizzoni Ardemani, Villa, nr. Padua, Italy. See GIARDINO BARBARIGO.

Plai Na, Thailand. The site, which lies to the north of Bangkok near Don Muang airport, adjoining a natural inlet from the Chao Phya River, was acquired by Princess *Chumbhot in 1968.

The land was originally used for rice planting (the name means 'End of the rice fields') and had to be raised and conditioned to support ornamental plants. A number of the original trees were retained, among them rain trees (*Samanea saman*), some wild figs, several large stands of bamboo, and a native tree called in Thai *ma-kok nam*; it was this tree, which bears an olive-like fruit, that gave the original town of Bangkok its name. The garden has been damaged by floods several times, most severely in 1983, leading to the erection of dykes around certain sections and also to the decision to concentrate on annuals and various shrubs that can withstand flooding.

In addition to the original trees, there are large stands of ixoras, mussaendas, plumbagos, several large yellow dillenias (*Dillenia suffruticosa*), and a striking variety of palms. Bachelor's buttons and portulaccas are used extensively as bedding plants and around lily-ponds, and one section is screened by a stand of mixed heliconias.　　　　　W.L.W.

Plant-collecting. The earliest record of a systematic expedition in search of plants is one from 1495 BC, when Queen Hatshepsut of Egypt sent a party to the land of Punt (Somalia) to bring back trees with fragrant resin, possibly *Commiphora myrrha*, which is still used to produce frankincense and myrrh. The expedition travelled down the Nile and the Red Sea and brought back 31 young trees, packed in baskets and carried on poles by four bearers. The trees were planted in the grounds of the temple of Amon at Thebes. A little later Hatshepsut's nephew and successor brought back a number of plants from Syria. They were carved and painted on the walls of the temple at Karnak, in the room now called the 'botanical chamber'.

The Romans probably took many plants to the lands that formed part of their empire. Medieval monks were great travellers and carried plants, especially medicinal herbs, wherever they went, but there is little evidence that they were active plant-collectors.

The history of the introduction of plants new to cultivation has been divided into periods based on the geographical origin of the majority in each time. Until 1560 most plants came from Europe. 1560 to 1620 was the Near East period, followed by an influx of Canadian and Virginian herbaceous plants in the years 1620 to 1686. From 1687 to 1772 the Cape of Good Hope was explored and trees and shrubs were sent back from North America. Australasian plants were especially important from 1772 to 1820, while tropical plants to be grown under glass and hardy plants from Japan and North America followed in the period from 1820 to 1900. The next 30 years saw the introduction of many plants from western China, and the current period, dating from 1930, has seen fewer new plants but more hybrids and cultivars.

The colonies established by European powers in other continents often led to plants from the new territories being introduced to the parent country. North American plants were sent back to Britain and France, while Spain concentrated on Central and South American ones. The British in India, the Dutch in the East Indies (Indonesia) and Japan, French missionaries and later British traders and officials in China, all found new plants to send home to give their compatriots some idea of the botanical riches of the countries in which they were living.

The Elizabethan navigators were more interested in gold and new trade routes than in plants, but Drake and Ralegh or members of their crews brought back tobacco from Virginia and the potato from South America. In 1575 one of Drake's men, Captain Winter, first collected *Drimys winteri* from land near the Straits of Magellan, using the bark as a cure for scurvy. Plants from the Spanish colonies in Central and South America—cannas, nasturtiums, sunflowers, yuccas, and dahlias—reached Europe in the 16th c., welcomed

in print in such books as John Frampton's *Joyful Newes out of the Newe Founde Worlde* (1577), a translation of an earlier Spanish book that included the first description of a sunflower.

Many of the 16th- and 17th-c. writers of *herbals were also collectors of plants. *Clusius was perhaps the most important of them in this respect. After his own travels in Spain and other parts of Europe, he is said to have made his third visit to England in 1581 especially to see the plants brought back by Drake and Ralegh.

In 1546 Pierre Belon (1518–63) set out on a three-year journey to the eastern Mediterranean to see the curiosities, animals, and antiquities as well as plants, mentioned by classical authors. He started in Crete, where he found the white oleander (*Nerium oleander*), *Paeonia clusii*, and *Cistus ladaniferus*, before going on through Greece to Constantinople (Istanbul) and Palestine. His book on the journey, published in 1554, contains the first mention of the cherry laurel (*Prunus laurocerasus*).

The German physician Leonhardt Rauwolf (d. 1596) travelled to Tripoli, Aleppo, Baghdad, and the Holy Land in 1573–6, looking for the plants described by *Dioscorides and other early botanists. Among his discoveries was a wild hyacinth near Aleppo (though it was already being cultivated in Europe), a species of rhubarb, a yellow-striped tulip, and a blue-flowered mandrake. He also saw the remaining cedars of Lebanon.

George Wheler (1650–1723) went to Greece and Constantinople in 1675, collecting plants as he travelled and bringing home that familiar ground-cover plant *Hypericum calycinum*, but a better-known voyage to the Levant was the one made by the French botanist Joseph Pitton de Tournefort (1656–1708). By the time he set off in 1700 he had botanized in various parts of France, visited several other European countries, become Professor of Botany at the Jardin du Roi (see *Jardin des Plantes, Paris), and devised an important system of plant classification. His pupils in Paris included Sir Hans *Sloane and William Sherard, the benefactor of the Botany School at Oxford. Tournefort set off from Marseilles, went from island to island through the Greek archipelago to Constantinople, Trebizond, Erzerum, and Persia (Iran). He was the first botanist to describe the common rhododendron, *R. ponticum*, and the oriental poppy was another introduction from this journey. His companions included the artist Claude Aubriet, who had already illustrated his botanical books and now did the same for his account of his travels, which was later translated into English.

In the same period early attempts were made to discover the Japanese and Chinese flora, though the Portuguese had been to eastern China in the 16th c. in search of spices, finding and bringing back a sweet orange. Engelbert *Kaempfer was in Japan early in the 1690s, while James *Cunninghame went to China and Indo-China in the years around the turn of the century, bringing back many paintings of the region's plants, including the camellia.

French explorers in Canada seem to have brought plants back to the Jardin du Roi by 1635, when *c.*40 were described by Jacques Cornut. Settlers in Virginia drew attention to the plants of their region. American plants were imported by the *Tradescants, father and son, who were both collectors as well. The elder John Tradescant explored in both North Africa (hence perhaps his famous Algiers apricot) and Russia, while his son made three visits to Virginia in the middle years of the 17th c. The missionary botanist John *Banister reached Virginia in 1678, sending home plants and seeds to Henry *Compton, his gardening bishop. Mark *Catesby visited his sister and brother-in-law in Virginia before setting off on the travels whose fruits are described in his beautifully illustrated *Natural History of Carolina*. He also sent seeds to Compton and other London botanists and nurserymen, but the largest traffic in North American plants was established by John *Bartram, who began his collecting career in the 1730s. His patrons, customers, and correspondents, Peter *Collinson, Sir Hans Sloane, and other gardening botanists, imported great quantities of American plants, especially trees and shrubs, to ornament the gardens of Europe.

Sloane himself had made a voyage to the West Indies, collecting plants and studying natural history in general, and he gave his patronage to William *Houston, who sent home plants from Central America and Jamaica *c.*1730.

An even greater patron of plant-collectors was Sir Joseph *Banks. After his voyage round the world with Cook in the *Endeavour*, when his own botanical collections had been especially rich in Australian plants, he became President of the Royal Society and virtually director of Kew, so that he was well placed to encourage the exploration of the botanical resources of relatively unknown regions. His protégé George *Caley spent the first decade of the 19th c. in Australia, and the *Cunningham brothers, Allan and Richard, continued to investigate the flora of the eastern part of the continent. Colonists arrived in Western Australia in 1829, accompanied by James Drummond to lay out a botanic garden, supplied with seeds by the Horticultural Society. He found himself among a rich flora and soon began to explore, collecting plants and sending them home.

The first official collector sent from *Kew was Francis *Masson, who went to South Africa in the 1770s, working for some time with the Swedish botanist C. P. Thunberg, a pupil of *Linnaeus, and sending back many plants still popular in cultivation.

Each of the colonial powers paid special attention to their own spheres of influence. *Ruiz Lopez and Pavón travelled in Chile and Peru from 1777, while *Sessé and Mociño studied Mexico, Central America, and the Caribbean, beginning 10 years later. *Humboldt and Bonpland, with the permission of the Spanish government, also went to Central and South America, later encouraging other travellers to follow their example.

Another concentrated period of investigation into the North American flora began in 1785 when André *Michaux arrived from France to begin collecting, soon followed by Thomas *Nuttall. In the years 1804–6 *Lewis and Clark managed to cross the continent to the Pacific and the botanists also turned their attention to the western regions.

From the north-west Pacific area David *Douglas in the 1820s and 30s and John *Jeffrey in the 1850s sent back great collections of conifers, several of which have become important forest trees in their adopted countries. They found many smaller plants too, as did Theodor *Hartweg, who worked in Mexico and California during this period.

The East India Company had established a botanic garden at *Calcutta in 1787. Nathaniel *Wallich was appointed its director in 1815 and used his time in India to collect in the Himalayas, Tibet, and Nepal. His discoveries included many plants destined for the warm greenhouses of European gardeners. Among other Victorian travellers in India, Sir Joseph *Hooker probably had a greater effect on gardens elsewhere than anyone else, for his collections brought back many of the rhododendrons adopted with such enthusiasm in Britain.

Kaempfer's 17th-c. visit to Japan had been in the service of the Dutch East India Company, which also employed *Siebold, who worked at its trading station in the 1820s and used his limited opportunities to collect plants as well as he could. Later in the century more of the country became accessible to foreigners and plant-collectors had more scope, among them Charles *Maries, John Gould Veitch (1839–70), and James Harry Veitch (1868–1907), all three working on behalf of the *Veitch nursery. J. G. Veitch brought home the golden-rayed lily, *Lilium auratum*, and *Magnolia stellata*, one of the finest early spring-flowering magnolias.

China had been an equally difficult country to explore, although French Jesuits had established themselves in Peking (Beijing) and sent plants back to Paris. Their accounts of all aspects of Chinese life were published late in the 18th c. The volume dealing with plants and gardens was used by Sir Joseph *Banks as a reference book when he compiled some notes for the gardeners accompanying Sir George *Staunton and Lord Macartney on their mission to the Chinese emperor in 1792. Banks's interest in Chinese plants was encouraged by paintings of them sent by his correspondents in the region, particularly John Reeves, who was an inspector of tea at Canton for the East India Company. Reeves's descriptions and the drawings by local artists that accompanied them aroused such interest that the *(Royal) Horticultural Society set up a Chinese Committee. When Robert *Fortune went to China to collect for the Society in 1842 he took with him a sort of horticultural shopping-list of the plants in which the Committee was most interested, including tree peonies and yellow-flowered camellias. One of the plants he brought back, now so common as to be unremarkable, was the yellow winter jasmine.

French links with China remained strong, with a group of 19th-c. missionary naturalists collecting both plants and animals for the Jardin des Plantes and the Muséum National d'Histoire Naturelle in Paris. Père *David went to Peking in 1862 and was soon given permission to concentrate on travelling and collecting. Jean-Marie Delavay (1838–95), Paul Guillaume Farges (1844–1912), and Jean André Soulié (1858–1905) completed the quartet of mis-sionaries in China who sent plants and seeds back to the Muséum and, in the case of Farges, to the *Vilmorin-Andrieux nursery. So many Chinese plants swamped the Muséum that it was many years before some of them were properly described. To these men we owe incarvilleas, deutzias, several species of clematis and rhododendrons, and *Paeonia lutea*, among many other familiar plants. Russian explorers also worked on the borders of China, during several expeditions in Central Asia.

About the end of the 19th c. professional plant-collectors took over in China. E. H. *Wilson began work there in 1898 for the Veitch nursery, although his later expeditions over the next 20 years, in China and Japan, were for the *Arnold Arboretum and private subscribers, launching fashionable interests in flowering cherries and evergreen azaleas. Help was given to the professionals by Augustine Henry (1857–1930), a customs official in the Chinese service who collected for Kew, sending home *Lilium henryi* and *Parthenocissus henryana*, among others. Henry also directed Wilson to the site of *Davidia involucrata*, a prime objective of his first journey.

Rhododendrons and primulas were the speciality of George *Forrest in his journeys from 1904 to 1922, as some of the members of the syndicate backing him were particularly interested in these plants. Frank *Kingdon-Ward, in a long career, worked in the Himalayas and Burma as well as China, making reports and surveys for the Royal Geographical Society while he hunted for plants. Reginald *Farrer also collected in Burma and China from 1913 to 1920, one of his finds being *Viburnum farreri*. The American collector Joseph Rock (1884–1962) lived in western China for many years from 1920, finding, among other plants, the wild form of the tree peony, *Paeonia suffruticosa*.

*Ludlow and Sherriff collected in the Himalayas, particularly Bhutan and Nepal, on several expeditions between 1929 and 1949, sending home many new primulas and meconopses. The Himalayan region has also attracted collectors in the years after the Second World War, among them Oleg Polunin, Adam Stainton, William Sykes, and L. J. A. Williams.

Turkey, Iran, and Afghanistan have also been explored again in recent years, with Rear-Admiral Paul Furse (d. 1978) bringing back new fritillaries, tulips, and irises in the 1960s. More fritillaries and other bulbous plants, including a new crocus, have been collected in Greece and Turkey by Brian Mathew.

Even a selective survey of plant-hunting makes it clear that the stock of cultivated plants is the result of much arduous travelling on the part of explorers during several centuries. Plants that now seem utterly commonplace may have an unexpectedly exotic history, for example, the long struggle to make tree peonies from China settle happily in Europe. The vagaries of horticultural fashion have meant that some of the plants collected with such effort remain relatively unappreciated, though others, like the Chinese and Himalayan primulas or Farrer's *Gentiana sino-ornata*, have spread so rapidly that their cultivated life seems longer than it is. Although the unexplored parts of the world are

now so few, discriminating collectors are still at work to enrich the garden flora. S.R.

See also BACKHOUSE, JAMES.

Plat. See PARTERRE.

Platt, Charles A. (1861–1933), American landscape architect, has come to be recognized as the principal person who shaped landscape architecture into the reasonable, sane design profession it is today. Platt was trained in painting and etching and attained success as an artist during the five years he spent in Paris in the 1890s. During this period he travelled in Italy; while there his interest in the villas was aroused and he wrote an illustrated book entitled *Italian Gardens* (1894). Through this book and a series of articles on Italian villas published in *Harper's Magazine* in the 1890s he gained opportunities for designing gardens in the United States.

Eclecticism was slowly beginning to supplant the 'landscape gardening' method of design. At that time the Americans, English, and French knew little about Italian gardens and buildings. From the beginning, Platt seemed to understand intuitively the fundamental logic of design of Italian villas—the marvellously integrated combination of indoor and outdoor space, of architecture and landscape architecture harmoniously fitted to its site, and its role in the life of the times.

He was asked to plan country places and became a leading figure in the Country Place era. In the beginning he was hampered by the architects' lack of skill in designing the house to fit the garden and this led him to design both himself; it is said he entered architecture through the garden gate. He designed many country places and a few institutional buildings in the Italian or Georgian eclectic manner. These were located in his native New England, and in Long Island, Pennsylvania, Ohio, Illinois, Michigan, and California. He strongly influenced the basic trend of landscape design at an important time in its history. H.B.O.

See also: UNITED STATES: THE COUNTRY PLACE ERA.

Pleasance. Until very recently it has been supposed that there was in western Europe no such thing as a landscape garden before the Renaissance. Furthermore it was accepted as an article of faith that, until late in the 16th c., there was no deliberate sowing or planting of forest trees apart from individual specimens in small gardens. These propositions are now known to be untrue and the deliberate creation of areas of wood and coppice, both for utility and for pleasure, can be traced back to the 11th c. at least. Parks can no longer be considered simply as areas of natural landscape enclosed to restrain beasts of the chase but must be seen as improvements for parallel aesthetic purposes and recreation in addition to sport.

The basic concept of a 'paradise' or enclosed park stems from oriental antiquity and its name is Old Persian. From the Persians of classical times the construction of large walled preserves passed to the Arabs and so became known throughout the Islamic world and eventually in medieval Christendom. Like the aesthetic elements of Gothic art, the park was thus a borrowing by Europe from the Middle East, made possible by the historical circumstances associated with the Crusades. A surviving example in the Syrian desert, north-east of Palmyra, Qasr al-Hayr ash-Sharqi, has two fortified dwellings beside a walled area of 850 ha., measuring 5 km. × 2 km., and was built by the Caliph Hisham *c.*AD 728–9. Water came through underground aqueducts (*qanats*) from a spring miles away. In such a region deliberate planting and an irrigation system were indispensable.

Parks spread throughout the Muslim lands and were taken to North Africa, Sicily, and Spain. From Sicily they passed into southern Italy, and from the 11th c. the precise means by which the concept reached north-west Europe can be traced. The Norman Geoffrey (I) de Montbray, Bishop of Coutances (1049–93), went to Italy to visit Robert Guiscard and other relatives and pupils who had just conquered Apulia and Calabria, and on his return purchased for £300 (say £300,000 in 1986) from William Duke of Normandy (afterwards the Conqueror) a very large estate beside Coutances. 'He built the bishop's hall and other offices and planted a considerable garden [*virgultum*] and vineyard . . . he also made two pools with mills . . . and surrounded the park with a double ditch and a palisade. Within he sowed acorns and took pains to grow oaks and beeches and other forest trees [*quercus et fagos caeterumque nemus studiose coluit*], filling the park with deer from England,' that is, after 1066. Bishop Montbray was able to do this because he was rewarded by William with great English estates, largely in Somerset, where in 1086 he held 75 manors of which 14 were kept in his own hands.

It seems probable that the oriental concept of the park, translated to Normandy, was brought to England by the Norman bishops and baronage, and by 1110 it is certain that Henry I enclosed a large area with a stone wall around the royal manor of Woodstock in Oxfordshire. In the park the king created a menagerie of wild animals including a porcupine. Woodstock was a material fulfilment of the pleasance described in allegorical terms by Bishop Hildebert de Laverdin in his poem *De ornatu mundi*, when banished from Le Mans to Westminster by William Rufus in 1099. Hildebert painted in glowing words the splendour of nature improved by art:

> There every tree a double honour shares:
> Its boughs bear fruit, its shadow cloaks the soil;
> Both are enjoyed by men, its fruit and grateful shade.
> . . . The apple, olive, pear-tree burgeon forth
> With apples, fresh green leaves, and ripening pears.
> The chants of birds, odour of spice, and flowers' hue
> Fill air with song, with scent the nostrils, and adorn the soil.
> Soft zephyrs waft, not harsh east wind; perfumes transpire,
> Not ice; there spring not winter reigns.

The real background for such imagery was to be found in the south, notably in the country estates of the Moors in Spain and of the arabized Normans of Sicily and southern Italy. It is there that the linked concept of the *gloriet is found. The word, which passed into English through the French *gloriette*, is Spanish in origin and is a literal transla-

tion of the Arabic *'azīz* (glorious), used to describe a pavilion bearing the same relation to a major castle or palace as the Trianons to Versailles, or Amalienburg to the Nymphenburg palace at Munich. In the royal estate at Palermo in Sicily are several such pavilions, of which the most famous (of *c.*1155) still bears an Arabic inscription: 'Here is the earthly paradise . . . this is called *al-'azīz.*' The epithet has become the name of the building, La Zisa. In Spanish usage the *glorieta* was placed at the centre of the layout, between the four quarters of a **chahar-bagh*, and the word subsequently acquired the transferred meaning of a 'circus' where avenues intersect, as well as of the pavilion placed at such a nodal point. The word seems to have come to England with Eleanor of Castile and was used to describe her island palace (1278–90) in a lake formed around Leeds Castle in Kent. Lodges of this kind had existed earlier and the most famous is the walled pleasance of Everswell, enclosed in the park at Woodstock by Henry II (1165) for his mistress the Fair Rosamond (Clifford). Its more usual name of Rosamond's Bower was given through the later Middle Ages to a whole class of pleasure-gardens, while *gloriet* might be applied to a private suite of apartments such as the block in Corfe Castle rebuilt for Richard II in 1377–8, and 'Le Gloriet' in the Prior's Lodgings at Canterbury, overlooking the great gardens. As late as 1460 permission was granted to Richard Beauchamp, esquire, to build a castellated pavilion in his new park of 520 ha. at Bronsil near Ledbury in Herefordshire.

Several different purposes were inherent in the pleasance with its lodges, pavilions, or smaller kiosks. Hunting, whether with hounds or bows and arrows, was one purpose but spectatorship was quite as important as actual hunting. Hence some park lodges were 'standings' like grandstands, for comfortable observation of the hunt and for informal social life. This applied to watching fish caught from ponds or lakes, as well as to the usual taking of game. The German Emperor Frederick I Barbarossa (who reigned 1152–90) had a shooting-box beside his park, built of red stone and having a tank of fish and an aviary of birds, described as both beautiful to look at and good to eat. Barbarossa was inspired by his diplomatic contacts with Baghdad and Cairo. To provide adequate vistas from the lodges and pavilions, launds or open glades had to be formed in the woods, if natural, or else be deliberately planned when a wood was sown. Observation of sport was by no means the only end in view. When, *c.*1190, the Bishop of Auxerre, Hugh de Noyers, improved the grounds of his manor at Charbuy (Yonne), 'he provided every pleasure and improvement that the industry of man could accomplish. The woods, beset with briers and undergrowth and thus of little value, he cleared and brought into cultivation. There he made gardens and planted trees of different sorts so that, apart from deriving pleasure from them, he also got great quantities of fruit. He surrounded a large part of the woods with a ring fence carried from the gate at the near end to the dam of the third pool, and enclosed within a pretty quantity of wild beasts. These might be seen grazing in their herds by those in the palace, a pleasing sight.' By this time the fashion must have become general, for in 1176 the Archbishop of Canterbury was mockingly asked, what glory was there in constructing ponds and shutting up wild beasts in parks.

England. Not only the country palaces of kings, peers, and bishops, but those of abbots and priors of the greater monasteries, were carrying out such improvements. The first abbey of the Cistercians, founded at Clairvaux in 1115, within a few years had within its precinct 'a wide level area containing an orchard of many different fruit-trees, like a little wood. Close by the infirmary, it is a great solace to the monks, a spacious promenade for those wishing to walk and a pleasing spot for those preferring to rest. At the end of the orchard a garden begins, divided into a number of beds by little canals which, though of still water, do flow slowly . . . the water thus serves a double purpose in sheltering the fish and irrigating the plants.' In England there were spacious grounds belonging to Lanthony Priory by Gloucester, extending for nearly a kilometre to the royal castle, and described by 1200 as 'a place so beautiful and peaceful, provided with fine buildings, fruitful vines, set about handsomely with pleasure gardens [*viridariis*] and orchards'.

In 1246 Henry III enlarged and improved the great garden and orchard outside Windsor Castle, and in 1264 he had a hundred pear saplings planted at Everswell in Woodstock for their decorative effect. Not the king alone, but his steward Sir Paulin Pever (d. 1251) could display ostentation in such ways; at his estate at Toddington in Bedfordshire, part of a total of landed property amounting to 2,400 ha., Pever not only enclosed the manor with a **palissade* and rebuilt the house and chapel, but so formed 'orchards and pools, that it became the wonder of beholders'. Hampstead Marshall in Berkshire had extensive gardens, a fish-pond, and other delights in the time of Roger Bigod, 5th Earl of Norfolk (1270–1306). At Auckland, the Bishop of Durham had a hedged garden and a large park before 1240, and later in the century the Bishop of Worcester had, as part of the amenities of his palace at Alvechurch, a garden of about a hectare surrounded by double moats and overlooking an elaborate series of fish-ponds.

Monasteries in their corporate capacity sometimes had large areas of recreational land: at Malmesbury Abbey were some 17 ha., and 16 ha. at Bury St Edmunds, with streams, pools, fish-ponds, and fruit-trees with shady walks. The monks of the cathedral priory at Winchester, in addition to several gardens serving different purposes, had pleasure-grounds and walks (*viridaria et deambulatoria*) to the south, amounting to some 1·5 ha., approached by a bridge across the public street and through a watch-tower (*garite*), perhaps a gazebo, leading to a streamside path along the Logie, a canalized branch of the Itchen. At Durham, too, the monks had their parks, and used advanced systems of management on their woods, with nursery grounds and plantations of young trees, with payments recorded for cutting branches and pruning in the park at Shincliffe as early as 1331. The priors of Winchester had their own country estate at Silkstead, with extensive gardens, an orchard, and the ornamental wood of Beauforest, sown in

1276. In 1314 the master gardener Gilot was in charge of the gardens, a large vineyard, and also the maintenance of the walks in Beauforest. Between 1317 and 1379 three successive abbots of Evesham carried out widespread planting of oaks, ashes, and other trees at Evesham and at Shrawnell Park in Badsey and created a new park of 120 ha. of land and water at Ombersley, near Worcester.

The highest development of the pleasance was at residential castles and at unfortified manor-houses such as Woodstock and Havering-atte-Bower in Essex. A succession can be traced, partly from recorded or surviving earthworks, and one main constant is the inclusion of water in the design: as lake or fish-pond, or in the form of moats which might be double as at the Abbot of Peterborough's new garden of 1302 (see *medieval garden). Actual inclusion of a spring or well from which water could be taken by channels (as at Everswell) might be contrived. We have seen that at Leeds Castle in Kent, Queen Eleanor of Castile had a gloriet built on an island in the lake, connected by a bridge to the main castle and achieving a high degree of privacy. This aspect of island sites had great importance, and it is probably significant that the gardens and groves of Lanthony Priory beside Gloucester included an island, the Naight, in the Severn. In 1277 the queen dowager, Eleanor of Provence, was living in Gloucester Castle and obtained permission from the priory to build a bridge across the castle ditch and to walk in the priory gardens. A century later Richard II, holding Parliament at Gloucester, made similar arrangements for using the priory's pleasance and this may well have suggested to him the formation of his own island pleasance on 'La Nayght' in the Thames at Sheen where he built a pavilion or gloriet in 1385–7. This in turn was the immediate inspiration for Henry V's much larger Pleasance in the Marsh, created at Kenilworth in 1414–17. Like the Alvechurch and Peterborough examples, this was a square area surrounded by double moats, at Kenilworth occupying nearly 4 ha. altogether, with 1 ha. of garden at the centre. In this were a banquet-house and three other kiosks at the angles, built of timber on stone foundations, with walks ('Aleyes') evidenced in the castle accounts. The pleasance was accessible from the castle by boat, a voyage of over 1 km. across the Great Pool, whose waters were brought into the moats.

France. Rather similar arrangements, though without the moats, can be seen in the view of the Château de Dourdan by Pol de Limbourg (1409–16) in the April calendar of the *Très Riches Heures du Duc de Berry.* A large lake lies between the castle and a separate gloriet with its own walled garden surrounded by tunnel-arbours, and rows and groves of trees form an obviously planted landscape. Another example of a gloriet built in a marsh on the borders of a lake occurs in the painting of falconry at the court of Philip the Good, Duke of Burgundy (copy of a lost original of 1442, Château de Versailles). In France several great pleasances were laid out for King René (1434–80), father of Henry VI's queen Margaret of Anjou. The great period of his gardening activity was between 1447 and 1460 and included work on a

large scale at Aix-en-Provence, Saumur, Angers, and Les Ponts-de-Cé on an island in the Loire. The most famous and best recorded of the pleasances of France was, however, that at *Hesdin in Artois. In 1295 Count Robert II of Artois enclosed a very large park (940 ha.) with a wall 13 km. long, and began a 'House in the Marsh' with a gloriet in a great pool, reached by a bridge as at Leeds Castle. It is evident that Count Robert was well aware of Queen Eleanor's works begun some 15 years earlier and it should be noted that Hesdin is very close to the queen's own county of Ponthieu, where she often resided. The original works at Hesdin included an aviary and a 'chapel of glass', still unfinished at Count Robert's death in 1302 but completed by his daughter Mahaut before 1329.

The pleasance at Hesdin was uniquely famous for the series of water-engines directly based on the Arabic *Book of Mechanical Devices* (1206) by Ibn al-Razzaz al-Jazarí of Diyarbakir. These engines, kept up for over 250 years but destroyed along with the town, castle, and park in 1553, operated surprise jets and showers (the *burladores* of the gardens of the Seville *Alcázar), a talking owl, and practical jokes such as dropping visitors into a mass of feathers and blowing soot and flour in their faces, before confronting them with mirrors. In spite of total destruction, some idea of the landscape gardening at Hesdin can be obtained, as Mlle Marguerite Charageat has pointed out, from the miniatures by Jean Miélot in the *Epître d'Othéa à Hector*, painted in 1455–61. Seen from the aspect of cultural transfer, the striking thing is that the only source for such advanced technology was a manuscript work in Arabic which, at that date, could hardly have been translated except by someone associated with the household of one of the Spanish queens, either Eleanor of Castile or, less probably, Joan of Navarre, wife of Philip IV of France. It is significant that Eleanor was the sister of the learned Alfonso X who reigned in Castile from 1252 to 1284, and under whom there had been a major campaign of scientific compilation, including extensive translation from works in Arabic into vernacular Castilian.

Although on a much smaller scale, and without the water-engines, there was a reflection of Hesdin at the lost gardens of Clare Castle in Suffolk. Under Elizabeth de Burgh, the Lady of Clare, through the middle of the 14th c. the large gardens produced a great deal of utilitarian crops, but there are also mentions of 'a house for the Lady's deer', a vineyard, the pool about the garden fed from the moat, sanded walks, a 'glass chamber in the house of pheasants', and a fountain. At Bardfield, not far away, the Lady of Clare had a second large estate with an extensive park later famous for the fine quality of its oak timber. The pheasants, then a newly introduced bird, were evidently given special treatment; in 1355 a boy was paid 2*d.* for carrying three of them from Clare to Bardfield. Another great estate of many gardens was at Highclere, Hampshire, a chief seat of the bishops of Winchester. Between the garden and the park was a bridge, rebuilt in 1379 for Bishop William of Wykeham. In 1398, during his late 70s, Wykeham had a new covered way built, leading into the garden. Its roof was tiled, and from the fact that 250 ridge-tiles were used, the total

length can be put at c.85 m. At his private castle of Broughton in Oxfordshire Wykeham in c.1380 had a most unusual belvedere built upon a loggia of two tall arches. From this he could look over the battlements of the outer walls at the moat and at the game in 'The Warren' on the hillside opposite.

Such features as Wykeham's belvedere and Henry V's banquet-house at Kenilworth raise the question of responsibility for design. In small gardens the 'architectural' features were simple and of wood, and would have been in the charge of the master carpenter. Stone fountains and channels, and buildings such as the larger gloriets were certainly designed by masons, as at Corfe Castle in 1377–8 by Master William Wynford, who had had charge at Windsor Castle and over many years directed Wykeham's works at New College, Oxford, at Winchester College, at Winchester Cathedral, Highclere, and elsewhere. To what extent was the design of landscape in the hands of such craftsmen? They were at least among the very few persons then able to make surveys and to draw to scale. Hitherto no direct evidence has come to light. At Hesdin it is on record that the great park wall of 1295 was built under Renaud Coignet de Barlette, master of works at the château. On the other hand, the decorations were in the hands of a painter Clément, and from 1299 both paintings and water-engines came under Jacques de Boulogne, whose family continued to have charge of the engines for 150 years. But in 1299–1301 a carver named Guissin was also at work on the engines, presumably on such adjuncts as the talking owl. These masters—masons, engineers, carpenters, carvers, painters—were commonly paid at a higher rate than most recorded master gardeners, and the gardeners were perhaps seldom responsible for more than the skilled culture of plants. A few, however, such as Gilot who was employed by the priors of Winchester in 1307–16, seem to have had a higher status, and the same probably applied to the 'dynasty' of keepers of the king's garden at Havering: Salomon under Henry I, then his son Ralf, and his grandson Geoffrey who served Richard I and John. The same may be true of a few later royal gardeners at Westminster and Windsor. Roger 'Herberur' (fl. 1268–1307) and Robert de Goldesburgh, made free of York in 1351 as a 'herberer', probably were experts in the layout of pleasure-gardens.

It is evident that the key to successful design, by the standards of the period, was subtlety in proportion; and it is precisely this quality that is found in the great buildings of the master masons. From the house outwards there was a progression from the small enclosed herber to the great garden, from that to the orchard, and so on into the park. Planting, though it might include straight rows of trees, was not aggressively imposed upon the landscape. Rather, in anticipation of the methods of Lancelot *Brown, it imitated nature so well as to deceive the onlooker into supposing that the skilful mixing of trees of different kinds with grass launds or glades was virgin woodland and savanna. We have seen that, contrary to what has been generally supposed, there was aesthetic appreciation of the landscape as far back as the 11th or 12th c. in north-western Europe, and that

over several hundred years there was progress in France, Flanders, and England, the countries most studied.

Much remains to be done by the careful exploitation of field and excavational archaeology, but we can now accept at their face value the remarks of Lydgate in his *Troy Book* written in 1412–20:

> And all about . . .
> Were fresh rivers of which the water clean
> Like crystal shone against the sun's sheen;
> Fair plains, as Guido beareth witness,
> And wholesome hills full of lustiness
>
> And many a lea and many a lusty well . . .
> Full many a park, full fair and fresh to seen
> And many woods and many meadows green.

<div style="text-align: right">J.H.H.</div>

Pleasure-garden. In earlier periods in England gardens had been used for pleasure as well as for utilitarian purposes (see *England: Renaissance garden; *medieval garden), but it is in the 18th c. that the term 'pleasure-garden' has a more specific meaning in England. In design terms, the first pleasure-gardens were unremarkable. They were all based on a simple grid pattern of sand or gravel walks, with grassed or wooded areas between.

The New Spring Gardens, Vauxhall, London, just up river from Lambeth Palace, whilst clearly the most important and influential garden, consisted simply of three 'grand walks' and several lesser alleys, all intersecting at right angles, and cutting through a plantation of elm and sycamore. In its whole life of almost 200 years, the essential layout of these gardens never changed from the 'pretty contrived plantation' that John *Evelyn saw in 1661.

One feature of Vauxhall that differentiated it from the private pleasure-gardens attached to, say, Marlborough House, Burlington House, Buckingham House, or the Inns of Court was its boskiness. The thickly wooded 'wildernesses' were an attraction in themselves, adding to the romance and mystery of the place, and providing a home for the larks and nightingales, those 'feathered minstrels' whose song apparently matched in sweetness that of the professional musicians in the orchestra; the illusion given to visitors was that they had been transported to the depths of some romantic Arcadian countryside, without all the inherent risks and dangers that a real journey to such a place would entail. This illusion was reinforced by the large painted canvases of ruins and distant views placed at the ends of some of the avenues, and by the strategic positioning of statuary, temples, and pavilions with their magnificent illuminations.

Most of the English public gardens were not specifically designed as such, but evolved from tavern gardens, bowling-greens, spas, or private gardens, so their layout tended to be somewhat haphazard. One major garden that can be said to have been designed specifically as a pleasure-garden was Ranelagh, adjacent to Chelsea Hospital in London. In 1741 the syndicate which then owned the property commissioned the architect William Jones to redesign the entire

Ranelagh Pleasure-garden in Chelsea, London, design (1742) for the Rotunda and gardens by William Jones (British Library)

garden, the original *London and *Wise scheme having fallen into decay through 30 years of neglect. From the 'Perspective View' of his grand design, we can see that Jones was really interested only in his 'Amphitheatrical Building' or rotunda, and that the garden was merely a setting for it; it boasts none of the fashionable adjuncts of ruins, waterfalls, serpentine walks, Gothic pavilions, or classical paraphernalia; nothing, in short, that would detract from the main feature. Judging from subsequent engravings, though, this simplicity was soon obliterated by the inevitable introduction of numbers of smaller pavilions, temples, obelisks, grottoes, and the like.

Despite the protestations of the proprietors of the lesser gardens that they were offering the public something totally new, and different from anything ever seen before, they generally followed fairly closely the lead of Vauxhall and Ranelagh; one of the more adventurous in terms of garden design was Ephraim Evans of Cuper's Garden, who advertised in 1740 that the garden had been 'altered in a beautiful manner with Serpentine Walks, different from any other Public Gardens'.

One real curiosity was the so-called 'New Georgia', constructed apparently single-handed by Robert Caston in 1737 as a tribute to the pioneers in the New World; the garden around the central log cabin was laid out in a 'delightful romantic taste', with a maze, fish-ponds, and mechanical devices and novelties contrived by the proprietor to surprise and delight his visitors.

William Staples, the innkeeper at The Spaniards, Hampstead Heath, decorated his garden (c. 1750) with over 40 designs in pebble mosaic. Subjects illustrated included the Sun in its Glory, the Signs of the Zodiac, the Tower of London, the Colossus of Rhodes, the Paths of all the Planets, Salisbury Cathedral spire, Adam and Eve, the Shield of David, the Pyramids and the Sphinx, and many others. Nothing more is known about these particular pavements, but they were obviously in fashion at this time, possibly inspired by the recent discovery of the Roman mosaic at Littlecote Manor. Lady Luxborough, in a letter to William *Shenstone in 1749, mentions contemporary examples elsewhere in the country, attributing their introduction to Batty *Langley.

By the end of the 18th c., in an effort to keep up with the fashions of the day, public gardens had become a grand hotchpotch of Chinese pagodas, Swiss cottages, German caverns, Italian walks, Islamic pavilions, Chaldean hermitages, Turkish tents, Moorish temples, and Venetian gondolas, each bearing no relation to the other, or even to their setting. As the 19th c. progressed, though, and the older generation of public gardens was dying out, a certain order began to prevail, and proprietors were more willing to throw in their lot with just one overall style or theme. The most noteworthy of this breed was Thomas Hornor, who re-created at the Colisseum, *Regent's Park, a romantic alpine landscape, complete with ravines, cascades, rocky outcrops, a stalactite cavern, a chalet, and distant mountains, all on a site of 1·6 ha.

The classic pleasure-garden, however, was really only a backdrop, the traditional satyric stage-set. Most of them came alive only at night, when the garden as such would not

be visible. It was a place to see others and to be seen, a grand setting for moonlit concerts, alfresco banquets, masquerades, illuminations and fireworks, grand emblematic transparencies, and spectacle of every conceivable sort. The public pleasure-garden was, above all, and unlike any other public or private garden, a commercial venture, sometimes employing a large staff, and designed to run at a profit from admission fees, sales of refreshments, and occasional special attractions or galas.

Pleasure-gardens continued to exist in England until almost the end of the 19th c. Notable examples were: The Eagle (1822–82), City Road, London where the gardens were decorated with Chinese lanterns, fountains, and dripping rocks; Cremorne Gardens, Fulham (1843–77)—c. 5 ha. of lawns, walks, shrubberies, and exotic buildings—in particular the Chinese orchestra; and the Surrey Gardens (c. 1831–60), consisting of 6 ha. of gardens including 1·2 ha. of water-gardens, with a large conservatory. D.E.C.

Pliny the elder [Gaius Plinius Secundus] (23/24–79), commander of the Roman fleet stationed at Misenum across the Bay of Naples from Pompeii, lost his life when he went to rescue friends endangered by the eruption of Vesuvius. In his *Naturalis Historia*, a vast encyclopaedia in 37 books, he quotes extensively, but uncritically, from previous literature, and adds numerous observations of his own. His work contains much that is valuable that is not found elsewhere. Much of Book 19 deals with kitchen gardens, their history, the preparation of the soil, the making of paths for access and irrigation, the plants to be grown, their varieties, cultivation, and uses. In Book 21 Pliny says that he 'includes everything about flowers that will seem worthy of record'. Flowers, both cultivated and wild, are discussed, and their use in chaplets, ointments, perfume, and in connection with apiaries. The identification of the many plants mentioned is difficult in any pre-Linnaean treatise; in antiquity the same name was often given to very different plants, and the same plant was often given several names. A valuable index of plants, with probable or possible identifications, is included in volume 7 of the Loeb Classical Library edition of the *Naturalis Historia*. W.F.J.

See also TOPIARIA OPERA.

Pliny the younger (c. 61–112), Roman statesman and the nephew and adopted son of *Pliny the elder, published nine books of literary letters in the last quarter of the 1st c. AD, two of which (2.17 and 5.6) describe the gardens of two of his villas: the Laurentian Villa (at Laurentum) on the coastal plain near Rome, not far from what is now Castel Fusano; and the Tuscan Villa, c. 70 km. north of Rome, in the upper valley of the Tiber, at Tifernum Tiberinum, today the Città di Castello.

Both these gardens are essentially 'open' (see Ancient *Rome: Sources), making use of the vast perspectives of the surrounding countryside (hills, mountains, vineyards, and cultivated land around the Tuscan Villa, pasture and sea views for the Laurentian Villa). However, some elements are enclosed, such as the hippodrome at the Tuscan Villa

and the little courtyard with a fountain and four plane trees, which resumes the old theme of the atrium, at the same place. The essence of their design consists in the interpenetration of nature and house. For every season, light and warmth linked to the corresponding vegetation (violets and evergreen shrubs in winter, plane trees and rose arbours in summer) make everyday life extremely agreeable. Even the baths are, as far as possible, open on to the garden: the cold bath at the Tuscan Villa, for example, makes a water feature to adorn the terrace, which is dominated by the triclinium; the water falls in a cascade into the *bassin* and animates a fountain of white marble. The diners in the triclinium see the water falling into the marble and hear the noise of the cascade.

This aim of intimately uniting house and garden leads to a marked articulation of the different parts of the house and to a multiplication of the façades, frequently provided with porticoes, open or closed (the crypto-porticus), and to the scattering in the landscape of little pavilions, such as the tower at the Laurentian Villa, which looks over the garden and the *gestatio* (an *allée* for walking in). The overall effect was similar to what we see in representations of villas in contemporary landscape painting.

Around this architectural core stretch the terraces: sometimes they are the site of *allées* bordered by a lawn (the *pratum*, as at the Tuscan Villa, parallel to the swimming-bath), or by an acanthus plantation; or, as at the Laurentian Villa, by box and rosemary. Sometimes the terrace is called a *xystus*, on the model of those used by the athletes in Greek gymnasia.

At the Tuscan Villa, Pliny's favourite garden was his 'hippodrome'. The word is borrowed from Greek civic architecture but it also refers to a very widespread Roman feature (as, for example, at the Palatine, the palace of Domitian). Pliny writes: 'The hippodrome stands in an open space, and is surrounded by plane trees, which are clad in ivy . . . The ivy twines around the trunk and branches of each tree, and binds the trees to each other in festoons. Box is planted between the trees; laurel runs round the outside of the box, and mingles its shade with that of the plane trees. The right-hand *allée* along the hippodrome is interrupted at its extremity by a hemi-cycle . . . it is surrounded and covered by cypresses, which cast a shadow that becomes blacker and denser the further it goes. The *ronds-points* within are very brightly lit. Roses also grow there making this sunlit area a delightful contrast to the freshness of the shadows. After many curves, the *allée* becomes straight again, but branches into several parallel paths bordered by box borders. Here and there is a lawn, elsewhere, box, which is cut into a thousand shapes or even letters, which sometimes spell out the name of the owner, sometimes that of the designer. There are also little rows of boundary posts [*metulae*], which alternate with fruit-trees. Thus in the refined surroundings of the villa there suddenly arises before us an image of the countryside [*imitatio ruris*]. The central space is adorned with two lines of small plane trees on either side. Behind these is acanthus, some pliant and vine-like, some cut into shapes, others into names. At the

end, there is a curved seat of white marble, shadowed by vines, which are supported by four little columns of Carystian marble' (*Letters*, 5.6.32 ff.). The spectator taking his place here would be showered by jets of water.

It seems that Pliny's gardens had very few statues—not as an economy measure, but because the fashion was for natural elements, even when artificially formed. Apart from the lawns (probably of natural grass), the plants used were acanthus, box, rosemary, rose trees, sweet-smelling violets, ivy, perhaps periwinkle, vines, and above all cypress, plane trees, and laurel, as well as unspecified fruit-trees. Water was plentiful, even at the Laurentian Villa, where it was drawn up from shallow wells. On the interior walls of this villa are paintings 'depicting birds perched upon leafy branches', and this is in a room where water flows and falls into a bowl 'with a most pleasing sound' (5.6.23).

P.GR. (trans. P.G.)

See also CASTELL, ROBERT.

Ploskovice, West Bohemia, Czechoslovakia, has a baroque castle with a garden and park of 8 ha. In the 15th c. it was the site of a fort with a herb garden on a south-facing slope, whose long rectangular shape gave the principal form to the baroque garden belonging to the new castle, built according to the design of Octavio Broggio. The situation of the castle building with arcaded galleries on both sides divided the garden into two parts on different levels. Within the castle, under the side terraces, five grottoes were built whose walls were covered by paintings and rich stucco decorations. The central grotto, joined with the garden, is the most fanciful having stone fountains in each corner; it is covered all over with shells and has statues of fauns and sea creatures.

From the rooms of the first floor of the castle one enters the terraces and can admire the garden. The upper garden was formed by three roads which lead to the castle gate and are closed by three garden pavilions at the northern wall. The lower garden, laid out in three terraces, had in the 18th c. a decorative flower parterre with a fountain in the middle. The main axis led to a large oval pool with obelisks on both sides of it, and then behind the southern wall in the poplar avenue to the statue of the Virgin.

In 1816 irregular flower-beds and paths broke up the original baroque composition although the main visual axis and the water features were retained. In 1852 a new flower garden was planted in the upper garden but the original trees and bushes remained; in the lower garden changes were made in the terrace walls. In place of the old fruit garden on the east, a landscape park was founded formed by trees of both domestic and exotic origin, and this comprises the substantial part of the castle area today. O.B.

Podestà, Palazzo Genoa, Liguria, Italy, was designed in 1563 for Niccolò Lomellini by Giovanni Battista Castello (Il Bergamasco); fountains were added by Filippo Parodi *c.*1700. The street of palaces (the Strada Nuova, now Via Garibaldi) had been laid out in 1550, presumably by Galeazzo Alessi. The street is a canyon, with openings whose average height is about two and a half times the width. Of the palaces on the north side of the Strada Nuova, laid out from 1558, which abut a steep hillside, the Podestà is the only one with its fine baroque garden still intact. The width of the site is *c.*25 m. and the depth *c.*120 m., of which over a third is taken up by the mansion. From the claustrophobic street a vista leads through the entrance hall and courtyard to a rococo fountain above which terraces suggest green distances beyond. The terraces are ingeniously arranged to connect with the first and second floors of the *palazzo*, but the real charm lies in the creation of imaginative space in a confined area. As the vista recedes, the detail tends to be reduced in scale, and while the main terrace is visible in its entirety from the upper floors, the final garden of orange trees can be seen only suggestively and remotely. This vertical design in a vertical dimension is completed by a 16 m.-high tower to view the sea beyond the roofs. G.A.J.

Poggio Reale, Naples, Campania, Italy, was the summer residence of Alfonso, Crown Prince of Naples (later King Alfonso II, 1448–94). Sebastiano *Serlio (1475–1564) mentions 'lovely gardens with . . . fruit-trees . . . many fish-ponds, aviaries and the like'. A more detailed description is to be found in the French poem *Le Vergiez d'Honneur*, which mentions summer-houses, loggias, flower gardens (probably very small), fountains, streams, antique statues, vineyards, deer-parks, grottoes, and herb and fruit gardens, although it does not specify how these elements were arranged. The gardens made such a great impression on the young French king, Charles VIII, when he visited them in 1495 that he took back to France with him a Neapolitan gardener, *Pacello da Mercogliano. P.G.

Poland has a rich history of garden design. Currently there are *c.*5,000 parks and gardens from various historical periods, all of a high historical value, and all preserved by the state.

The oldest examples of preserved medieval gardens are located around cloisters (e.g. Kamień Pomorski; Mogiła; Oliwa; Pelplin) or around castles (e.g. Bolków, *c.*1300; Chojnik, 1369).

Renaissance gardens were developed in Poland in the 16th and the early 17th cs. They consist of garden beds in a symmetrical, axial pattern linked with the house, special attention being paid to picturesque and extensive views. The most important surviving examples are: the terraced gardens in Balice (1518); Wola Justowska (*c.*1540); Prądnik Biały (1551); Gdańsk (*c.*1560); Neipołomice (*c.*1571); Książ Wielki (*c.*1595). An outstanding example is the garden in Mogilany (*c.*1560), with a modest classical layout, located on a hill with an opening on to a distant view of the Tatra mountains on the horizon. The Renaissance gardens of Baranów, Pieskowa Skała, and Brzeg, have been restored in recent years.

Baroque gardens. New forms of baroque gardens were developed during the 17th and 18th cs. From the first half of the

17th c. there is a group of residences and fortified houses combined with bastions and gardens in a homogeneous spatial unity worthy of attention, for example, the garden and castle at Krzyżtopór (1631–44) and Oleszyce. In the second half of the 17th c. the French type of layout, with the garden lying both in front of and behind the palace on a common axis, became very popular. Many of these gardens have been preserved. The most magnificent examples are the palace gardens of *Nieborów, Rogalin, Sieniawa, Wysock, and Kruszyna.

This type became fully developed in the 18th c., especially in royal and noble residences, with magnificent *parterres de broderie* (see *Białystok; Nieborów; *Wilanów), clipped trees trained against walls, numerous sculptures, *bassins*, and fountains. At the king's suggestion, two large spatial developments, still preserved, were established in Warsaw. One of them is the Oś Saska (1713–40), the other the Oś Stanisławowska, the largest development of this kind in the country, with a grand garden canal (1717–25), the palace on the escarpment, and a star-like pattern of *allées* and squares (1766–79). Similar arrangements with the garden being dominated by the palace are characteristic of numerous residences of the aristocracy, for example, Białystok, Choroszcz, Otwock Wielki, Wolbórz, Oliwa, Radzyń Podlaski. The old gardens of Nieborów and Wilanów were arranged in the same way. The numerous municipal public gardens such as Ogród Krasińskich in Warsaw (1768), Ogród Saski, opened in 1728, and municipal promenades like that in Gdańsk (1760–70) are of a different type.

The eighteenth and nineteenth centuries. The 'natural' style in Poland began in the final quarter of the 18th c., influenced by new ideas and direct cultural contact with the English art of gardening (energetically championed by S. B. *Zug) and, indirectly, by France. The earliest group consists of early-romantic gardens in an irregular spatial framework. The most famous example of this kind is *Arkadia (1778–85). Other partly preserved gardens are: Mokotów (1772–9), Na Książęcym (1776–9) in Warsaw, and Aleksandria (1776–81) in Siedlce. At the same time, classicizing tendencies became evident, most notably at *Łazienki (1784–93) in Warsaw. The parks of Jabłonna (connected with the notorious Duke Józef Poniatowski), Lubostroń (c. 1800), and Białaczów (c. 1800) are of a similar character.

At the end of the 18th c. and during the first half of the 19th c. fully developed romantic gardens became dominant, many of them designed by *Mikler Dionizy. The leading example of this kind is *Puławy (1790–1831), other examples being *Łańcut (1799 onwards), Natolin (1806–45), Skierniewice (1814–45), Klemensów (1824), Opinogóra (1812–40), and Dobrzyca (1795–1800). Some baroque gardens were redesigned in the picturesque style—for example, Wilanów, Rogalin (1820–40), and Mała Wieś (1828).

From the middle of the 19th c. public interest in botany grew and collections of decorative plants enriched the parks, some of which became valuable arboreta. The most

important of such parks are Kórnik (1826–79), Gołuchów (1876–99), and Wojsławice (1881–1930).

A separate, less powerful trend introduced the revival of baroque and Renaissance motifs (the Italian garden), for example, the parks of Kozłówka (1879–1907), Łańcut (1889–1904), and Bulowice. At the beginning of the 20th c. a wide range of garden design is evident from the naturalistic trend to the picturesque. So-called circular gardens became widespread, at Młochów (1887), Białowieża (1895), and in many others.

Public gardens. During the 19th c. municipal gardens for the public were developed. The most numerous were promenade gardens, in Kalisz (1798), Kielce (1815), Częstochowa (1826), Radom (1824), Lublin (1837), Tarnów (1846), Warsaw (1865, 1895), Łódź (1840, 1896). Around the old cities appeared the characteristic form of a circular pattern placed on the site of destroyed fortifications—in Kraków (1819–30), Wrocław (1813–38), Poznań (1903–5), and Toruń. Of a similar character are the spa parks of Krynica (1810), Ciechocinek (1825), Szczawnica (1830), and Busko (1836). Didactic gardens, new and extended, were especially significant, for instance, the botanic gardens in Kraków (1798), Warsaw (1818, 1864) and the zoo gardens in Poznań (1871) and Warsaw (1884).

Beginning in the 20th c. the trend towards a geometric arrangement of the spatial forms of gardens became dominant. The 1930s are known for the development of the modernistic type of garden, represented by the park at *Zelazowa Wola (1932–6). The characteristic feature of the most recent period is the growth and differentiation of the various types of public gardens and designed landscapes.

L.M.

Polesden Lacey, Great Bookham, Surrey, England. The house of 1632 (the second on the site) was bought by the playwright Richard Brinsley Sheridan in 1797, and he lived there until his death in 1816. The present house, designed in the Greek classical manner by Thomas Cubitt, was built in 1821–3. In 1906 it was bought by the Hon. Mrs Ronald Greville, who developed the garden over the next four decades with the help of J. Cheal & Sons. The result is a remarkable amalgam of contrasting elements—large-scale and intimate, natural and contrived, informal and formal—which characterize the English landscape.

The casual drive over the ridge, wooded with beech trees, culminates in a fine geometrical earth ramp which drops down suddenly between steep grass banks to the small forecourt marked by clipped shrubs, overlooking the 'borrowed landscape' of farmland in a deep valley. The long grass *terrace walk, made in 1761 and extended by Sheridan—the only remaining feature of the original garden—rises and falls along the edge of the beechwood, skirting the valley for 425 m. Behind the beechwood there are lawns and a collection of exotic trees. In the opposite direction, beyond the house, the long walk is extended to unite a series of hedged and *walled gardens (with viewing windows) containing irises, peonies, roses, and lavender.

The property was acquired by the National Trust in 1944. M.L.L.

Pollok House, Glasgow, Scotland, is in many ways typical of the development of Scottish gardens in the 18th, 19th, and 20th cs. A property of the Maxwells of Pollok, it began as a small house by William *Adam with relatively tight enclosures and woodland by the River Cart. Subsequent plantations in the 18th c. loosened this pattern considerably, but, as was typical of Scottish practice, the new plantations, although of a landscape scale, were not part of a designed landscape of the kind associated with *Brown.

Bankruptcy effectively ended the improvement of Pollok until it was taken over in 1880 by John Stirling Maxwell who chose it instead of Kier as his home. With him begins the last and somewhat self-consciously historical phase of the estate, starting with his avenue of limes planted on the axis due north of the house, which was itself remodelled and extended by Sir Rowland Anderson, who was also responsible for the two new terraces to the south of the house, and the pair of garden houses in the 17th-c. Scottish style reminiscent of Sir William Bruce.

Within this more architectural setting Stirling Maxwell added an alpine wall and other Edwardian ornaments. Rhododendrons were added in the 1920s and 30s, until the blackness of Glasgow's expansion overtook the estate.

 W.A.B.

Polonnaruwa Gardens, Sri Lanka. The old city of Polonnaruwa once housed hundreds of thousands of people between the Parakrama Samudra tank and 6 km. of encircling walls. Today it is uninhabited. The major buildings are, however, well preserved, and most date from the reign of King Parakramabula I (1153–86). The main building groups are the Citadel containing the Royal Palace, and the Quadrangle or Terrace of the Tooth Temple. Garden and external spaces of interest include Kumara Pokuna (the Royal Baths) by the east wall of the Citadel. The stone baths lie in a meadow, and the trees of the garden were 'twined about with jasmine creepers . . . filled with the murmur of bees drunk with enjoyment of the juice of the blossom . . . and with the cry of peacocks'. Of special interest on the Quadrangle are the carved moonstones and guardstones at the entrance to the Vatadage Temple. Outside the walls Dipuyanna (the Island Garden) lies on a promontory of the vast lake. The garden was built with pavilions—a mirror pavilion, peacock pavilion, carpet pavilion, games pavilion, and a pavilion with a swing hung with tiny pretty gold bells.

To the north of the city great monasteries were built, and hills were graded into gentle terraces with wide flights of brick stairs, each terrace planted with shade-trees and shrubs. Of the monastic baths the greatest is the lotus bath, a small bath built in tiers of eight-petalled lotus leaves. Less well preserved is a small four-petalled flower bath. Perhaps most magnificent of all is the Gal Vihara or rock shrine where huge rock sculptures of the Buddha can be seen: a 7-m. high standing guardian, a seated Buddha, and a 14-m.

reclining Buddha, lying down in his final state of enlightenment. They were once enclosed in a building. N.T.

Pomarium, from the classical Latin *pomus*, a fruit-tree; an orchard planted for utilitarian reasons, as opposed to a *viridarium*. J.H.H.

Pombal, Palace of, Oeiras, Estremadura, Portugal, was built for the Marques de Pombal by Carlos Mardel, a Hungarian architect, probably soon after the earthquake of 1775. The palace is a pale terracotta in colour, with cream stone reliefs. The entrance front on the main courtyard has semicircular wings and twin ramped staircases of exuberant rococo charm. The walls on the garden front are decorated, in between each window, with tall stone plinths carrying marble busts. Black iron balconies trim each window. Curious tilting Chinese eaves edge the roof. It is a country palace of great distinction.

Nothing was spared to beautify the Marques's property according to the lavish taste of the period. This was the age of devices—of elaborate water-works, cascades, fountains—of statuary at every turn. In their heyday these

Palace of Pombal, Lisbon, the Grotto

immense gardens must indeed have been spectacular. The Gulbenkian Foundation now owns the palace, and its dependencies—including an Agricultural Institute—have encroached on and destroyed much that was remarkable. Much of what remains, too, is uncared for. The terrace up against the house and the immediate gardens are, however, kept in good order. There is a very pretty small formal garden, with box-trimmed beds, whose entrance is guarded by two glistening white stone greyhounds. The main terrace, looking out over the grounds, has seats covered in early lemon-yellow *azulejos* set into the wide parapet, and every opening where steps descend is emphasized by tall white marble figures, standing out dramatically against a backdrop of trees. Machado de Castro, the greatest Portuguese sculptor of the 18th c., worked at the palace, and these statues are probably by him. Troughs in the parapet are planted with flowers. It is an exceptionally beautiful terrace in a grand, theatrical manner, as befits the house.

The main steps of the terrace lead down to a formal parterre of no particular interest except for its size. Side steps lead down to the lower garden where long alleys wander and twisty walks follow the Tagus which flows quietly past under tall trees. Among its features are curiosities such as a rusticated cascade, a grotto, and a pillar; the Mina de Ciro, a waterfall where the water splashes down from one semicircular basin to another; and a parterre of floating gardens as at *Castelo Branco. These are in low white marble clustered round a central block of statuary, and the beds are tightly filled with low flowers reflected in the water, a charming conceit, inherited from the Moors. The Casa da Pesca was another marvel, with a huge water-tank, *azulejos*, and a tiny, exquisite lodge. The Cascata da Taveira was an extraordinary artificial waterfall with balustraded staircases thick in *azulejos*, and with two gigantic statues. B.L.

Pompadour, Jeanne-Antoinette Poisson, Marquise de (1721–64), was the daughter of a wealthy Parisian bourgeois. In 1741 she married Le Normant d'Etioles, from whom she was separated when she became *Louis XV's mistress in 1745. Lively, gifted, and intelligent she retained Louis's favour until her death. She exercised a strong influence on the patronage of the arts. Among the many architectural projects she planned with the King were the château of Bellevue, near Meudon, the gardens of which were designed by Garnier de l'Isle, and at *Versailles, the Petit Trianon which she did not live to see completed. Madame de Pompadour had a retreat in the park at Versailles called the Hermitage, with a garden in which flowers were arranged for their scent; and another (also called the Hermitage) at Fontainebleau. She is also associated with gardens at La Celle Saint-Cloud, Crécy-Couvé, *Champs, and *Ménars. D.A.L.

Pompeii, Herculaneum, and the villas destroyed by Vesuvius. The tragedy that overtook the prosperous Campanian towns of Pompeii and Herculaneum and their environs when Vesuvius erupted in AD 79 has preserved intimate details about ancient Roman gardens that can be known from no other sites. Elsewhere in the *Roman Empire fragmentary remains have survived by chance, but in the area destroyed by Vesuvius living cities and country villas are preserved just as they were at the moment of destruction. Because of the difficulty of excavating the hard tufa-like fill that covered Herculaneum, only four city blocks, along with parts of four or five others, have been uncovered, and the limits of the town are not yet known. But Pompeii, which was covered by more easily excavated lapilli (pumice about the size of peach stones), is now about three-quarters excavated, and the limits of the city are known. Here it is possible to get the feel of the entire city, to study its plan and land use, the distribution and character not only of its public buildings, but also of its places of business and homes, and to appreciate the prominent role of the garden in the life of the people. The garden was intimately related to so many aspects of their lives, to their architecture, both public and domestic, painting and sculpture, aesthetic expression, horticulture, economics, religion, work, recreation, and city planning.

Approximately 450 gardens have been excavated thus far at Pompeii, 33 at Herculaneum. More than 50 villa gardens have been discovered. Both Pompeii and Herculaneum had public green spaces, with tall and shady trees, perhaps especially enjoyed by those not fortunate enough to have gardens of their own. There were gardens associated with temples, baths, theatres, and palaestras. Gardens also played an important role in restaurants, hotels, and various types of shops. Tomb gardens illuminate still another aspect of Roman life. But most of the gardens were in homes. The house had an inward orientation, with the house enclosing the garden to ensure privacy. Windows on the street were small and high. It was the garden that furnished light and air and ease of communication to the various rooms arranged about it. Some large town houses had as many as three or more gardens, a small house perhaps only a tiny light-well planted as a minuscule garden. The luxurious villa at Oplontis (Torre Annunziata) thus far has 13 gardens.

The garden was an integral part of the house and a significant factor in its development. Only at Pompeii can this be traced for a period of over 300 years. From earliest times the garden played a basic role in Roman life, for the *hortus*, or garden plot, formed a significant part of the primitive *heredium*, or family estate. In the early atrium house the rooms were grouped around a central court known as the atrium, and the garden was at the rear. The best preserved example of such a house excavated thus far at Pompeii, the House of the Surgeon (VI.i.10), was probably built during the 3rd c. BC. (When G. Fiorelli became director of the excavations in 1860 he divided Pompeii into nine regions. Each region was subdivided into numbered *insulae* or blocks, and each entrance in each block was assigned a number. Thus, each door has an address of three numbers.)

Ornamental gardens. The most elegant houses in Pompeii were built by the Samnites in the 2nd c. BC and these reflect

the influence of the contemporary Hellenistic house. During this century the houses of the wealthy citizens assume palatial proportions, atria became higher, larger, and more elegant, and houses now had a second area, the peristyle, about which rooms might be grouped to introduce more light and air into the home. It has often been said that the house of this period was created by adding the Hellenistic peristyle to the rear of the old atrium house. But the peristyle took on a very different aspect in the Italian house, for the Italians transformed the peristyle by making it into a garden, instead of either leaving it as a beaten clay court or paving it with cobblestones, cement, or mosaics, as was done in Classical and Hellenistic times. The House of Pansa (VI.vi.I) is one of the most significant of the old Samnite houses. It was a large house, which occupied a city block. Behind the large atrium was a beautiful peristyle garden. At the rear of the house a colonnade looked out on a second garden which occupied almost a third of the *insula*—a garden reminiscent of those found at the rear of earlier Italic houses. The House of the Faun (VI.xii.2–5), another luxurious Samnite house, was lavishly laid out with two atria and eventually two peristyles, and likewise occupied a city block.

The large number of homes built during the Samnite period made it unnecessary to build many new ones in the Roman period. Roman houses were usually less imposing, with lower atria, but with more elaborate decoration. The House of M. Lucretius Fronto (V.iv.a) is a small but elegant house of the Roman Imperial period. The House of the Vettii (VI.xvi.I) is typical of the homes of the prosperous merchant class.

The garden in the Vesuvian sites took various forms. It might be enclosed by a portico on one, two, three, or four sides. Often the columns of the portico were united by a low wall or a wooden fence. There were also houses which had an enclosed courtyard garden, but no portico. Some of the luxurious houses built on the edge of the volcanic ledge in the south-western and western part of the city such as the House of Fabius Rufus (Region VII, *insula occidentalis* 16–19) had impressive terraces or *roof-gardens looking out toward the Bay of Naples.

But there were many smaller homes of irregular plan occupied by the more humble citizens. Many were frankly commercial in character, with living quarters above, to the rear, or at the side of the shop. But even the poor, if at all possible, made places in their modest homes for tiny gardens. Many who lived in rooms behind their shops allotted precious space to gardens. The desire for a patch of green, with perhaps a few flowers, appears to have been a basic part of the Roman character. It was the same instinct which prompted shopkeepers who lived in rooms above their shops to grow a few vines to shade their balconies. A few fortunate ones were able to cut windows in their crowded quarters in order to enjoy the view of a neighbour's spacious garden. There were also large planted areas—large vegetable gardens, commercial flower gardens, orchards, and vineyards—within the city. Some of these were attached to humble homes.

Garden features. Gardens differed not only as to type, size, design, and function, but also with respect to the role of water, sculpture, and garden furniture. The introduction of the aqueduct and the more generous use of water that it made possible greatly altered the appearance of the gardens. Pools and fountains were introduced and added charm and variety to many gardens. Pools became a natural focal point and greatly influenced garden design. Some pools were so large that they formed the dominant feature of the garden. Most, however, were much smaller and more shallow and left more space for plantings. Many gardens had no pool. In others the pool was subordinated to, or combined with other garden decorations, especially fountains and small sculptures. Some fountains were simple jets; many were statuettes which were either made or adapted to serve as fountains. Showy mosaic fountains became common during the last years of the city.

Small sculptures, which often stood amid the greenery surrounding the pool, were extremely popular. Most garden statuettes were made of white marble, but bronze is occasionally found, and more rarely coloured marble. There are a few made of terracotta, and perhaps others did not survive. Many show Hellenistic influence in subject-matter and style, but on occasion we see the influence of Archaic or Classical Greek originals. The subject-matter is greatly varied: small animals, genre figures, *amorini* (cupids), members of the Bacchic entourage, theatre subjects, and deities.

Pinakes (rectangular reliefs sculptured on both sides), as well as *herms, each mounted on a small sculptured pillar, were also popular garden decorations. *Oscilla* (sculptured decorations that hung between the columns of the peristyle) took the form of theatre masks, *tondi* (which correspond to round shields), or *peltae* (the small crescent-shaped shield used by the Thracians and Dionysus), *fistulae* or Pan-pipes, and occasionally a *pinax*. Garden furniture, such as marble tables, some very elaborately sculptured, is also found, as are sundials.

Planting. The plantings which gave the gardens life leave less tangible evidence. Techniques developed in recent years, however, now make it possible to tell much about how a garden was planted. Because of the way on which the Vesuvian sites were destroyed it is possible to recover the actual shape of the roots of the trees and plants growing at the time of the eruption. When the plantings died, their roots decayed, and the volcanic debris which covered the site, gradually filled the cavities. The first step in excavation is the removal of the lapilli until the level of the garden in AD 79 is reached. At this point the lapilli-filled cavities are clearly visible. The cavities can then be emptied with special tools before being reinforced with heavy wire and filled with cement, a technique developed by the Italian archaeologist G. Spano early in the 20th c. After the cement has hardened and the soil around the cast is removed, the shape of the ancient root is revealed. This, together with the planting pattern, can be used to help identify the plantings. More recently, the use of new techniques involving the recovery,

analysis, and identification of ancient pollen and carbonized roots, branches, nuts, fruits, and seeds has made possible more complete identifications of the plantings.

The peristyle garden in the fine old Samnite House of Polybius (IX.xiii.1–3) excavated in 1973 was the first of its kind to be excavated using the new techniques. Surprisingly, five large trees, as well as a few smaller ones, had been planted in this small garden. There were also eight small trees espaliered along the west wall and a few shrubs along two edges of the garden. It became obvious that this house, which relied only on roof water collected in the large cistern underneath the portico, reflected the plantings in the old Samnite houses, before the new fashion made possible by the plentiful water of the aqueduct came into vogue. Trees, which required water briefly only until well established, were a natural choice. In the new style gardens, plantings became much lower and more formal. Such plantings required more water and this the aqueduct provided. Large trees in informally planted gardens continued to be extremely common in the last years of the city, even after the formally laid out gardens became popular.

The formal gardens were essentially green gardens the year around, planted with evergreens: the bay, myrtle, oleander, box, ivy, and rosemary. There was also the accent of flowers in season, especially the rose, the lily, the violet, the daisy, the viburnum, the opium poppy, the chrysanthemum, and the colourful oleander. Much of our information about such plantings comes from the literary sources and the plant material pictured in garden paintings.

The painting of a garden on one or more garden walls was often used to make a modest garden appear larger. Behind a lattice fence, flowering shrubs and trees appeared to grow in profusion, and statues and fountains too large for the actual garden could be enjoyed. Many garden walls contained huge paintings of an almost life-sized animal. Some owners included in their garden paintings not only fountains, trees, birds, and flowers, but also lakes or streams set in a mountainous landscape, through which wild animals roamed in profusion (see *paradeisos).

The garden was intimately connected with the private life of the Campanians. Here they worked and played, ate and worshipped. Many gardens had masonry triclinia where the family ate together during the long summer months. The presence of lararia and altars, often near the triclinium, show that the garden was a place of worship. Many of the bones found in the gardens were discards from meals taken there. Others give evidence of pets that lived in the garden.

Villa gardens. The gardens within the many villas that dotted the Campanian countryside were not unlike those found in the town houses at Pompeii and Herculaneum. But the town house was essentially inward-looking and not set in a garden landscape, as was the villa. Luxurious villas were completely integrated into the landscape, often taking full advantage of the view toward both the mountains and the sea. Only in the villa do we find intimate gardens within the dwelling, as well as the great formal gardens surrounding it, and the spectacular natural scenery of the area, all combined into one harmonious whole. This can now be visualized for the first time in the luxurious villa now being excavated at Oplontis (Torre Annunziata) not far from Pompeii. W.F.J.

At Oplontis contrived views, regular planting, and the interplay of fountains enhance the symmetry of the building. One peristyle courtyard was outlined by a row of pairs of buried plant pots exactly echoing the spacing of the colonnade. The outermost in each pair probably supported a small tree—perhaps a lemon or some other citrus fruit. The second pot in each group was tipped over towards the adjacent column and had evidently contained a plant with a smaller root. One attractive suggestion offered, by the excavator, is that they supported ivy which was trained to grow up the columns of the colonnade. Cicero, writing of his brother's gardener, is eloquent on such practices: 'He has so enveloped everything with ivy, not only the foundation walls of the villa but also the spaces between the columns of the promenade that I declare the Greek statues seem to be in business as landscape gardeners and to be advertising their ivy' (*Epistulae ad Quintum fratrem*, 3.1.5). B.W.C.

Pope, Alexander (1688–1744), English poet, essayist, and literary critic. In an essay on gardening in the *Guardian* (1713) Pope urged a return to the 'amiable simplicity of unadorned nature', rejecting the balance, regularity, and artificiality of formal gardens and elaborate topiary work. In the verse *Epistle to Burlington* (1731) he proclaimed his cardinal rule: 'In all, let Nature never be forgot . . . Consult the Genius of the Place'; in other words, local topography should suggest the character of the garden. Steeped in the classics and believing that 'all gardening is landscape-painting', he approved of classical temples, columns, and grottoes. Dramatic effects of light and shade and perspective could be achieved through the careful massing of trees and shrubs, a device he used successfully in his own garden at Twickenham (see *Pope's Garden). He valued especially variety in a garden.

Pope did not lead this trend towards informality, which had been discussed in the earlier writings of Lord Shaftesbury, Stephen *Switzer, and Joseph *Addison; his role in this change in garden taste was as a powerful and persuasive publicist. According to Horace *Walpole his theories influenced William *Kent. His practical advice on gardening was sought by his neighbours at Marble Hill and Kew and by Lord Bathurst at Richings ('Riskins') Park and *Cirencester Park. R.D.

Pope's Garden, Twickenham, London. In 1719 *Pope leased a villa on the Thames at Twickenham. A tunnel beneath the road behind the house led to the main garden and this was transformed into a grotto. Enlarged by side chambers, its walls were studded with minerals, shells, and pieces of glass. It echoed with the sound of running water and its walls formed a convenient camera obscura reflecting the external view.

The rectangular garden of *c.*2 ha. beyond the grotto was bordered by trees and shrubs with serpentine paths. One of

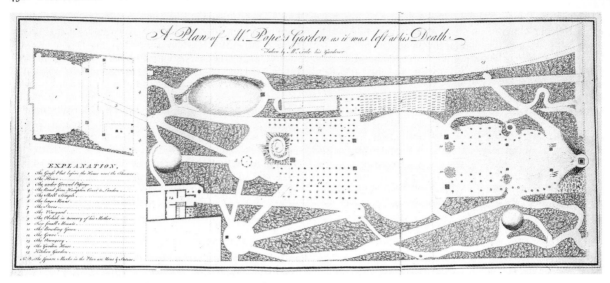

Pope's Villa, Twickenham, London, engraving published by John Serle in *A Plan of Mr Pope's Garden . . .* (1745)

the principal focal points was the shell temple designed by William *Kent. Nearby was a large mound covered with bushes and stones for viewing not only the garden but also the river beyond. A series of vistas was punctuated by statues and urns to suggest classical allusions. Flanked by cypresses, a stone obelisk commemorating Pope's mother stood at the garden's western end. Other features included a 'Bridgemannick theatre' (that is, an *amphitheatre), a bowling-green, a vineyard, and a kitchen garden.

Pope's garden, which exemplified his principles of 'pleas-ing intricacy' and 'artful wildnes', was planned for retire-ment and contemplation. A descriptive plan of the garden, which has now disappeared apart from the remains of the grotto, was published by his gardener, John Searle, in 1745. R.D.

Porcinai, Pietro (1910–86), Italian artist, furniture designer, architect, and landscape architect, began his career as a garden designer in 1937. His work was greatly influenced by the great Italian designers of the past, in his

Garden at Saronno, Varese, Italy, by Porcinai, Belgiojoso, Peressutti, and Rogers

use of art to create a setting for life. Although he mastered the practical techniques of creating gardens in a Mediterranean climate, he was firmly convinced that 'science alone is nothing—we need poetry and science working together'. His belief was exemplified by his imaginative use of space and the placing of objects, sculptures, and items of furniture, each designed to stimulate the imagination. One of his outstanding achievements is the Villa Riva Saronno (1960) where he designed a mobile sculpture and a bright band of annual plants to link the new garden with the old.

D.A.B.

Portique, an arched architectural decoration with columns, as a covered entrance or as an ornamental feature in gardens, often made of trellis or topiary work. D.A.L.

Port Lympne, Kent, England, has gardens designed by Philip Tilden for Sir Philip Sassoon, MP for Hythe, who also owned the lavish gardens of Trent Park in Middlesex. The house was intended as a constituency house and a holiday home for August, and during that month throughout the 1920s the garden was maintained in a flower-show condition by 30 gardeners.

Port Lympne is set on a south-facing hillside overlooking Romney Marsh. The garden design has a strong architectural framework, governed by terraces and yew hedges creating enclosures. The house is approached by a mile-long drive to an east court. To the west of the house, the 135-step Great Stair of Cumberland stone rises up the terraced hill from the pool court to the parkland above. The elaborate main terrace on the south front of the house, its balustrades ornamented with the initials PS, overlooks the enclosed Chess Garden, the Striped Garden, and a lawn with a swimming-pool, which formerly had side pools. Below the pool terrace are more flower terraces, and two tennis courts (one for morning, one for evening) before the garden fades into woodland. The central feature of the hillside below the house level is a double herbaceous border running down the slope, originally planted by Russell *Page. The house contains a cartouche of the original garden plan painted by Rex Whistler. J.BR.

Portmeirion, Gwynedd, Wales. See WILLIAMS-ELLIS, SIR CLOUGH.

Portugal. The Portuguese conquerors of Brazil and the East Indies in the 15th and 16th cs. brought home from their voyages immense fortunes which they invested chiefly in land and buildings. Most of the churches, monasteries, cloisters, palaces, and large town and country houses up and down the country date from the 15th to the 17th c. In architecture the adventurous spirit of the age expressed itself in the Manueline style (a specifically Portuguese variant of late Gothic) giving way later to an exuberantly imaginative baroque.

Gardens were created in keeping with the new buildings. Geographically placed as they were between the gardening traditions of the Romans (see *Conímbriga), the Moors, and those of Renaissance France and Italy, the Portuguese borrowed ideas from everybody. East and West so often meet in Portugal. Tessellated paving is a Roman legacy, among many others. From the Moors came, above all else, the *azulejo, the glazed tile. The Italian/French influence brought statuary, the parterre, and the pleaching and clipping of trees. Blended, all these many features became in the 16th and 17th cs. a unified, self-confident Portuguese style.

Their country being hilly, the Portuguese were skilled at turning its configurations into terraced gardens. As elsewhere in western Europe at that date, there were box parterres, stone ornaments, fountains, and also little clipped trees of golden euonymus, golden yew, citrus, and box punctuating the hedges of the parterres. Often, tucked away to one side of the main vista, high dark cypress hedges enclosed a small garden, which was also laid out in tiny parterres, forming a compartment, a place of sheltered privacy: the secret garden.

The Portuguese garden is unique in having adopted and incorporated the azulejo into this conventional setting. In the 12th c. the Spaniards founded at Seville a centre for making azulejos, an art they copied from the Moorish tiles which had been used to beautify all parts of their country. The skill filtered into Portugal and developed in a remarkable fashion. Until the mid-15th c. the designs were geometrical, showing their Islamic ancestry, but thereafter the Italian taste for the human figure, and for animals, plants, landscapes, scrolls, cherubs, etc. took over. The Portuguese made the azulejo their own. Pavilions, grottoes, niches, basins, fountains, inserted panels, the walls of loggias—all were embellished with tiles treated as frescos, depicting with great creative vitality classical or biblical legends, or some tale of medieval chivalry. The details obtainable, the exquisite range of colours achieved, made the azulejo the most satisfactory medium for expressing the baroque spirit. Later again, in the 18th c., at the time of rococo flamboyance, the azulejo met all demands of extravagant taste, all the twists and twirls and trompe-l'œil effects needed (as at Quinta de Azulejos). At *Queluz a little bridge over a canal is covered in azulejos and the canal itself is lined with them.

The water-tank was also common to Islam. After a life in parched deserts the Moors brought into the Iberian peninsula an intense love of cool waters reflecting skies and trees. The Portuguese adapted this idea after their own fashion. No garden is complete without a water-tank backed by a panel of azulejos. In the gardens of the new leisured classes, these tanks, placed up against a terrace or wall, are often very large, as is the superb one at *Fronteira; they are even said to have been used for bathing. They make a feature of considerable importance and the azulejos above them—indigo, cerulean, turquoise, lemon-yellow—are correspondingly ornate and eye-catching, mirrored as they are in the motionless water; the double effect is enchanting. At *Bacalhoa the tank, its water up to the very edge, backs on to a row of arcading, behind which are several small rooms. Looking out from them you see only the reflection of the skies in the water slicing across the far range of the Sintra

hills. There are fine examples of water-tanks at Quinta de Azulejos, Quintado Correio-Mor, and the Palace of *Pombal.

Portugal's hilly terrain lent itself to the water-stairway and to cascades, both Moorish delights. Monasteries frequently displayed the stairways, using the platforms at each level as the Stations of the Cross. This mixture of religious devotion and love of watery devices is very individual to Portugal.

Statuary and decorative stonework are plentiful in any garden of consequence. Less florid than in Italy whence the fashion came, what we have here is essentially Portuguese in effect. The Atlantic rains have weathered the stone. The setting is often planted dramatically with camellias and rhododendrons. Figures of saints and gods and oddities stand out on a parapet against a vast, soft landscape. A touch of provincialism about many of them is endearing. Classical busts fill azulejo-lined niches. Much use is made of balustrading. Urns, flambeaux, finials abound. Capped by a church, elaborate pilgrimage stairways criss-cross many a hillside, with a fountain or chapel at every landing (as at Lamego; Bom Jesus). A procession of crowned kings descends the flight of steps in the garden of the Bishop's Palace at *Castelo Branco and in a corner of the same garden is a charming conceit of stone parterres placed in a pond and tightly planted with flowers so that these seem to be both floating in water and mirrored in it. Dark granite against whitewash, the bold theme of baroque buildings is repeated in most gardens in the form of a pavilion, a doorway, or a staircase.

The well-tended order of Portuguese gardens makes for tranquillity, but unexpected features can surprise. Hacked out of the hillside is a grotto entirely lined with tessellated pebbles. At a turn in the path is a tiny chapel, walled inside with beautiful azulejos. The altar bears a casket containing the heart of Lord Lytton, a former Viceroy of India. His grave lies nearby, under a pine tree he planted in the garden he loved (Quinta di Penha Verde).

In the early 19th c. Ferdinand of Saxe-Coburg, consort of Maria II, introduced the 'romantic' English fashion in landscape design, on a large scale at *Pena Palace, and to a lesser extent at the royal hunting-lodge at Buçaco. Both are arboreta, but interspersed with vistas and glades, grottoes and ponds, and with paths winding round the hills. *Monserrate, near Sintra, belonged at the same period to Sir Francis Cook and was even more of an idyllic English fantasy, full of rare trees and waterfalls and beautiful shrubs. However, this concept of gardening never caught on in Portugal.

Besides wealth the Portuguese explorers brought back seeds and plants, many from China. The humid, temperate climate of central and northern Portugal suits the camellia, the wistaria, and the rhododendron among others. Camellias often reach great heights and create admirable woodland effects fringing a terrace, as well as forming shady arbours. Wistaria is either trained against a quinta wall or allowed to climb freely up another tree, the taller the better, from which its long racemes sway and interlock.

The 16th- and 17th-c. Portuguese garden was intended to be an oasis against the summer's heat and against the wildness and dangers of the surrounding countryside. The formality of clipped box parterres, the shimmer of azulejos, stone extravagances, and the sound of water endlessly splashing satisfied this need. B.L.

See also MATEUS, VILLA.

Posoni Kert ('The Garden at Pozsony') is the title of the first book on gardening in Hungary, by the Jesuit János Lippai; the first two parts were published in 1664, the third in 1667 in Vienna (2nd edn. 1753; a facsimile reprint was published in 1966 in Budapest). Although the author was not a trained gardener, his work contains everything necessary for gardening, including the layout of the garden, on which he laid great emphasis. The book is illustrated by several woodcuts—perhaps the work of his nephew György Lippay, jun. The description of a late Renaissance garden in the book is based on the garden of Bishop Lippay, brother of the author.

Its layout shows 24 symmetrical flower-beds arranged on both sides of a central path of the garden; 150 kinds of flowers are mentioned and many trees and shrubs. The garden was decorated with sculptures and had a water feature, a hermit's cell, and a grotto. The garden itself survived during the 18th c. as an elaborate French garden, and was described or mentioned by several travellers. A.Z.

Post, Pieter (1608–69), Dutch architect and painter, was an exponent of Dutch classicism and a former assistant to *Van Campen. His plans for country houses and their surrounding gardens, which were published from 1654 onwards (*Les Ouvrages d'Architecture de Pierre Post*, 1717), were totally unified in conception and revealed a sober simplicity. His most important garden designs, which reflect Italian and often Venetian influence, were Vredenburgh (1639), Huis ten Bosch (1647) (Prince *Frederik Hendrik's *villa suburbana*), and Rijxdorp (1662–8). Post may have assisted *Johan Maurits with the design of the Vrijburg gardens in Brazil (see *Dutch Colonial Gardens: Brazil). He also designed geometric parterres and classical pavilions; his *treillage* arbours and portals were illustrated in *van der Groen's gardening manual. F.H.

Pot, Tub. The earthenware garden pot for decorative use must have followed closely on the invention of the potter's wheel and the first utilitarian objects. First, there are the small domestic flowerpots, easily handled, that are put out in the sunshine—an informal use specially enjoyed by the Mediterranean countries, whether hanging from buildings or clustered on patios. From these developed the great highly decorative earthenware pots of the Italian Renaissance, whose placing on a terrace or elsewhere was vital to architectural design, and which usually contained lemon or orange trees that hibernated indoors in the winter.

Later, and especially in France, the pot transformed itself into the heroic tubs of *Le Nôtre, made of timber or slate, and important enough to demand their own winter quarters.

The great weight of these tubs (a ton or more) necessitated a special design by which they could be levered on to trolleys.

In the modern world a new concept of the pot or tub for public use was evolved by the parks department in Stockholm, whose influence was felt throughout the world. This was the low, shallow concrete container that decorates the streets in summer with flowers in bloom—an idea more successful in a country comparatively free from vandalism. The low vase reached finality in design in the circular fountain bowls grouped informally among the flowers in the *Tivoli gardens, Copenhagen. G.A.J.

Potente, Georg (1876–1945), German garden designer, worked from 1902 at *Sanssouci, where he became Director of Gardening, responsible for extensive restoration of the former Prussian gardens, including the redesign of the environs of the Drachenhaus (1902–8); the Rosengarten (1913) by the Neues Palais; the reconstruction of the Charlottenhof Park (1922–5), of the upper terrace at Schloss Sanssouci (1931), and of the remaining terraces (1933) with the present yew pyramids. From 1933 to 1937 he planted the hedges in the rococo garden. In 1935 he made designs for the parterre at Schloss Sanssouci, reconstructed the garden at the Stadtschloss in Potsdam (destroyed 1945) and also the garden at Augustusburg. In 1937 he laid out the garden in front of the Neue Kammern and in 1938 the parterre at the Obelisk portal at Sanssouci. H.GÜ.

Potsdam, German Democratic Republic. See BABELSBERG; NEUER GARTEN, POTSDAM; SANSSOUCI.

Powerscourt, Co. Wicklow, Ireland, superbly sited in the Wicklow Mountains, is a Palladian mansion, designed by Richard Castle and erected between 1731 and 1741 for the 1st Viscount Powerscourt. A map of the garden of c.1760 shows a formal design with stepped, semicircular terraces around a circular pond. Plans survive for such details as *parterres, gateways, and a circular amphitheatre. The designer is unknown but in 1746 a George Dean, describing himself as having been lately gardener to Lord Powerscourt, advertised himself as a landscape gardener and contriver of ornamental works. In the late 18th c. attention was focused more on the beauties of the natural waterfall in the deer-park.

The park was landscaped c.1830 by Edmund Murphy, a gardener in the prevailing *picturesque style. In 1841 the 6th Viscount, who had travelled in Italy, commissioned a design for an Italianate garden from the architect Daniel Robertson; he died in 1844 when the first terrace, based on one at the Villa Butera (now Villa Trabia) near Palermo, was complete. In 1858 the 7th Viscount continued the work, inviting designs for its completion from James Howe (1866), Brodrick Thomas (1867), and Sir George Hodson, Bt. (1873). A combination of their proposals was decided upon and augmented at its centre by a *perron* (or flight of stone steps) designed by the architect Francis Penrose, and incorporating a pair of 17th-c. bronze figures of Aeolus

from the garden of the Villa Arese at Lainate, near Milan. The parterre beds were then designed by Edward *Milner.

The garden is remarkable for its extensive range of statuary and other garden ornament. The copies of the *Laocoön*, the *Apollo Belvedere*, and *Diana* were purchased in Rome by the 6th Viscount, as were the plaster models from which the stone groups of *Hector and Andromache*, and *Ajax with the body of Patroclus* were copied in Dublin. Winged figures of *Fame* and *Victory*, and a pair of *pegasi* were commissioned from Professor Hagen of Berlin in 1866. The Triton fountain, based on that by Bernini in the Piazza Barberini in Rome, was cast in concrete by Sir Thomas Kirk, a Dublin sculptor. There are also bronze copies of *The Sleeping Faun* and *The Sitting Mercury* found in the classical ruins of Herculaneum, and bronze copies of urns and vases in the gardens of the Bagatelle in Paris. There was even a pair of Indian idols in soapstone in one of the summerhouses. The collection of wrought-iron ornament includes 'The Venetian Gate', wrought in Venice, 'The Chorus Gate', copied from a German original, 'The Perspective Gate', originally in Bamberg Cathedral, and 'The Golden Gates', bought at the Paris Exhibition of 1867. Ormson of Chelsea supplied the hot-houses in the walled garden.

In 1906 the 8th Viscount continued this cosmopolitan tradition by creating a *Japanese garden and a fortified folly tower. Throughout the demesne there is an important collection of ornamental conifers. P.B.

Powis Castle, Powys, Wales, stands dramatically on a ridge of red limestone, from which it was constructed, with its terraces below facing south-east. It was built by the Princes of Powis who inhabited it until William III gave it to his favourite, the Earl of Rochford, while the family were in exile between 1696 and 1722. The terraces, which are a unique survival, seem to have been made in their present form during the latter period although they may well have been begun earlier. William Winde has been suggested, but not proven, as their designer. They are 70 m. long and high in proportion to their width. Brick alcoves in the back wall of the second terrace look across to the fine lead urns and figures that top the balustrade above the orangery on the terrace below. There is also on the second terrace an aviary or loggia with sweetly scented rhododendrons.

An engraving of 1742 shows the terraces with aviary and orangery and a pattern of topiary yews, some of which have now grown into vast domes and impressive sculptural shapes. The lower 'apple slope', now covered with Edwardian shrubs and trees, is shown subdivided into three steep banks of grass. In the valley below was a formal water-garden thought to have been removed in the late 18th c. by William *Emes, who converted the park to the English landscape style. Advantage was taken of the favourable microclimate of the terraces for the production of fruit and vegetables until in the 19th c. a kitchen garden was made in the valley, east of the castle. This in its turn has now become a flower garden but as on the terraces some of the fruit-trees remain. The terraces afford superb views and are now stocked with a wide variety of unusual herbaceous plants

and shrubs enjoying the reflected warmth and the alkaline soil.

Powis Castle was given to the National Trust with an endowment by the 4th Earl of Powis in 1952. J.S.

Praeneste (now Palestrina), Lazio, Italy, is the site (38 km. from Rome) of the Temple of Fortuna Virilis, the replacement by Sulla in 82 BC of an older temple (7th or 8th c. BC). A series of gigantic terraces (the lowest was 400 m. long) linked by ramps climbing up to the summit 160 m. above the lowest terrace, its grandeur and its architectonic organization of the hillside were a great inspiration to designers of the Roman Renaissance (for example, Bramante—see *Belvedere Court) and later. Pirro *Ligorio's measured drawings and reconstruction of the site may have inspired the ramps at Villa *d'Este, Tivoli. P.G.

Pratolino, near Florence, Italy. The villa and gardens, 12 km. north-east of Florence, were created for Francesco de' Medici (1541–87) from c. 1569, completed by 1581, probably by the engineer and director of *spettacoli,* Bernardo *Buontalenti. By the end of the 16th c. the garden was probably the most famous in Europe, because of its *grot-

Pratolino, Florence, engraving in B. S. Sgrilli, *Descrizione . . . di Pratolini* (Florence, 1742)

toes, **giochi d'acqua*, and *automata. It undoubtedly expressed an iconographical programme, but no totally convincing one has yet been proposed.

According to *Montaigne (*Diary*, mid-Nov. 1580), the prince chose a barren, very mountainous, and waterless site (of 250 ha.) in order to demonstrate his mastery over nature. Its water displays, which especially intrigued English visitors from Fynes Morison (*An Itinerary*, 1617) onwards, were designed to excel those of the Villa *d'Este, Tivoli.

The house was sited half-way up a hill, which sloped southwards, with the main garden on the south side. Because of the nature of the ground, a series of terraces could not be made, making the garden seem rather old-fashioned compared to Roman designs of the same period. Around the house was a broad platform with a balustrade, under which lay one of the chief attractions, the grottoes—the first and biggest, that of the Flood, and seven others. Here were *giochi d'acqua*—in the first, when you sat down on an inviting bench to admire the sculpture 'by a single movement the whole grotto is filled with water, and all the seats squirt water to your backside' (Montaigne). As you ran up the stairs outside to escape, the gardener 'may let loose a thousand jets of water from every two steps of that staircase'.

Automata made music and noises of every kind, and gave the illusion of moving men and beasts—Pan, Silenus, and Syrinx—and 'numerous animals that dive to drink' (Montaigne). They served not only to represent an allegory (for an early interpretation see Francesco de' Veri or Vieri, *Discorsi delle meravigliose opere di Pratolino*, Florence, 1586), but also to demonstrate scientific ingenuity, in imitation of the mechanical marvels of the Alexandrian school (see *Hero).

From the centre of the balustrade ran a long avenue, '50 feet wide and about 500 paces long', bordered on both sides by a free stone wall, from which at every 5 or 10 paces sprang fountains, so that all along the walk nothing but these jets could be seen. This did not act as a central axis, however, for fountains, aviaries, grottoes, fish-tanks, and mounds were scattered quite randomly around the garden. At the end of the walk there was a fountain which discharged its water into a great *bassin* via a marble statue of a woman doing her washing. She squeezed out a table-cloth of white marble, from which the water fell, and beneath this was another vessel, where the water seemed to be boiling.

Behind the house, the rising ground was cut out in the form of an amphitheatre, dominated by the colossal statue of Appennino (attributed to Giovanni da Bologna), seated on a rock, pressing his hand on the head of a monster so that the water gushes out of its mouth and falls into a semicircular *bassin*. Behind the statue were three avenues leading to a round labyrinth, at the extreme end of which was a fountain acting as a reservoir.

The garden was destroyed to make a *giardino inglese* in 1819, and the only surviving features are the retaining wall and the statue of Appenine. P.G.

Pratum, in classical Latin a meadow; later often used in the special sense of grassland planted with trees and used for public walks and recreation. The medieval diminutives

pratella and *pratellum* might merely denote a lawn in a pleasure-garden. J.H.H.

See also MEDIEVAL GARDEN: PUBLIC GARDENS.

Préau, a small field (now obsolete in this sense); the space or quadrangle encompassed by the four walks of a cloister, or any small square enclosed orchard or garden. D.A.L.

Pré-Fichaux, Bourges, Cher, France, is a public garden laid out on a drained marsh in 1922 by the landscape architect Paul Marguerita, using as the basis for his design a causeway known as the Allée des Soupirs because it led to the gibbet. The garden is an interesting modern variation of the traditional regular style. K.A.S.W.

Price, Sir Uvedale (1747–1829), Bt., English landowner and writer, is best known for his *Essays on the Picturesque* (1794–1801, repr. 1810), an influential work of great artistic sensitivity. His analyses of the *picturesque, as a category distinct from the beautiful and the sublime, led him to express more general ideas on landscape aesthetics, differing from those of William *Burke and William *Gilpin. He discussed his views at length with Sir George Beaumont, William Wordsworth, Lord Abercorn, and other visitors to his estate at *Foxley. He was driven into fierce controversies, even with his close friend and neighbour R. P. *Knight, with whom he was usually reconciled in common hatred of what they believed to be the impoverishment and disfigurement of the English countryside at the hands of Lancelot *Brown and other professional designers, whom they accused of destroying 'variety and connection, two qualities indispensable in the composition and arrangement of scenery', as the study of Dutch, French, or Italian landscape painting taught.

Though Price thought that every landowner, as a gentleman of taste and discrimination, ought to be his own improver, he tried to find a landscape designer who would put his ideas into practice. Humphry *Repton proved a disappointment, which led to an exchange of letters on neatness and the convenience of 'picturesqueness' near houses. William Sawrey *Gilpin was more receptive, and was recommended by Price to a number of friends. He himself roamed his estate, planting, pruning, shaping foregrounds, sunk lanes, or wood verges, making clearings, and opening vistas to distant views. He also advised on improvements or even worked on friends' grounds, at Whitfield, Eywood, Cassiobury Park, Bentley Priory, Packington Hall, Guy's Cliffe, or Coleorton; or those of his Barrington uncles, at Beckett or Mongewell. 'Intricacy and breadth' remained key words for him in landscape gardening and all the other arts. He opened the way for J. C. *Loudon and 19th-c. landscape gardening, village preservation, and cottage improvements. Some of his ideas have been followed by present-day architects, landscape designers, and town planners. D.A.L.

Prince Nurseries, Long Island, New York, were founded by Robert Prince, America's first nurseryman, at Flushing Landing in 1737. His two sons, Benjamin and William (1725–1802), and William's descendants, kept the garden going until 1865, known in the latter part of the period as the Linnean Botanic Garden. For a time the nursery was the leading exporter of American plants to Europe, as well as a major importer from all regions. Its lists of fruit-trees included the best European varieties and also the new ones, especially apples, that were being developed in the New World. Scions, roots, or seeds of apples brought by some of the earlier settlers sometimes diverged from their originals to produce good, hardy, new varieties that became so popular that some of the trees were nearly destroyed by over-cutting. The Princes collected new varieties like Newtown, Esopus Spitzenburg, and Rhode Island Greening.

During the Revolutionary War the nurseries were spared by the British, who later allowed shipments for the Empress Joséphine's rose-garden to travel unharmed. George Washington patronized the Prince Nurseries in 1790, when he was President, but he reported that they came up to his expectations only in the matter of young fruit-trees, the shrubs being 'trifling' and the flowers 'not numerous'. S.R.

Prior, Matthew (1664–1721), English poet and diplomat, retired in 1719 after a somewhat turbulent life in the literary world and politics, and bought Down Hall near Harlow, Essex, where he evidently wished to emulate Horace's 'beatus vir':

> Great Mother, let me once be able
> To have a garden, house and stable
> That I may read, and ride, and plant,
> Superior to desire, or want.

But he laid out this garden somewhat formally with 'squares, rounds, diagonals and planted quincunces', which must have been unlike *Pope's later garden at Twickenham. Prior did not live long to enjoy it, for he died after two years at Down Hall. E.M.

Prior Park, Bath, Somerset (Avon), England, is pictured in a mid-18th-c. engraving by Anthony Walker, showing the house, begun by John Wood the elder for Ralph Allen in 1735, with a small lawn before it, hemmed in on one side by a kitchen garden, and on the other by a plantation screening the railed track down which ran waggons carrying stone from the Bath quarry. Firm evidence is lacking as to who was responsible for transforming this layout into a fine landscape with a Palladian bridge, closely resembling that at *Stowe, spanning the small lake which replaced the original stew-pond. Humphry *Repton's attribution to 'Capability' *Brown of an additional building for Ralph Allen suggests, however, that Brown may have been the designer and this is strengthened by the friendship between Allen and one of Brown's early patrons, William *Pitt, which could have led to his introduction. D.N.S.

Prison garden. From Roman times to the Middle Ages, common prisoners were brutally treated in filthy and often permanently dark accommodation. There is, however,

some evidence that prisoners of state—and influence—were better off, as can be inferred from a small *parterre garden in an early plan of the Bastille, Paris. 'Airing grounds', evolved from covered courtyards, first appeared in 18th-c. purpose-built prisons, but were seemingly bereft of vegetation. Some British and American prisons had vegetable gardens, but one of the first recorded examples of planting design within a prison compound for environmental reasons is the Walnut Street Prison, Philadelphia (1790). An early illustration shows a central, double line of trees and an octagonal exercise yard, tree-planted to its perimeter. Photographs of Petite Roquette, Paris (1836), also show canopies of trees filling the symmetrical, cell-lined four-storey courtyards. At the behest of their Governors, some Victorian prisons had garden features, often contrived as focal points of exercise rings, though frequently ill-sited and of inappropriate materials.

Since c.1950, a new generation of prisons has been developing in Britain, from Category A (highest security) to D (open prisons). Highest security establishments have a solid outer wall divorcing 'internal' landscape from the general surroundings. Other secure prisons have mesh fences allowing an 'internal–external' environmental relationship. Open prisons are relatively inconspicuous; a notable example is Hewell Grange, Hereford and Worcester, its 'Capability' *Brown landscape refurbished by the Home Office. Gardens were introduced in some updated and newer prisons, but most open spaces, especially in the latter, are grassed. Franklands, Durham (1982), was the first establishment to have an 'internal' landscape designed as part of its overall concept and professional landscape designers have since contributed to successive projects.

In spite of the stringent design restraints imposed by security and safety, interest can be created by use of colour, texture, and subtle changes in levels and the designer can still achieve a wide range of characteristics and visual effects enriched by seasonal change. In open prisons the choice of hard and soft material is wider, and trees can be planted more liberally. As maintenance facilities and skills fluctuate simplicity of design is essential. Prisoners are encouraged to participate in gardening when practicable. Despite the restraints, ingenuity of design can provide surroundings both beneficial to the psychological needs of different types of inmate and practical and pleasing to the staff who share the environment of those in their charge. D.C.

Promenade du Peyrou, Montpellier, Hérault, France. See MONTPELLIER.

Promenades. See PUBLIC PARKS: PUBLIC PROMENADES.

Prospect Tower, a tower built usually on a prominent part of the grounds of an English estate to provide extensive panoramic views of the surrounding countryside. Examples which survive from the 18th c. are: the Belvedere at *Claremont; the Watch Tower at *Painshill; Alfred's Tower at *Stourhead; Sanderson Miller's tower at Radway Grange, Warwickshire. Two from the 19th c. are at Rous

Lench, Worcestershire (Hereford and Worcester), and at *Alton Towers.

Prospect towers may derive from the Italian *belvederes. M.W.R.S.

Průhonice Park, Czechoslovakia, on the site of a medieval castle on the southern outskirts of Prague, is one of the country's best landscaped parks. The original single-storeyed stronghold was reconstructed (1886–97) by J. Sibral as a neo-Gothic castle. The park was landscaped by the last owner Count Ernst Emanuel Silva-Tarouca (and the dendrologist Camillo Schneider). His ideas were executed swiftly. The 200-ha. area is rich in springs along the Botic River, and the steep hills, rocks, and the three lakes were made the basic elements of the landscape plan. Silva-Tarouca planted many trees and shrubs both singly and in clumps. Today along the 40 km. of paths, in unexpected naturalistic settings of rocks, ponds, and meadows, there are plants and trees from the Alps, the Pyrenees, the Caucasus, the Himalayas, South America, and New Zealand. The mild humid climate makes excellent conditions for the planting of many varied types of rhododendrons, azaleas, and kalmias. The Upper Park contains a game reserve and a romantic temple was built near Lake Borin. The courtyard in front of the castle was designed by F. Thomayer, Prague's chief garden architect between 1884 and 1894. O.B.

Public Parks can be divided into three main types: (1) open spaces made accessible to the public, usually by royal or aristocratic grace and favour, as public promenades; (2) the *Volksgarten*, a peculiarly German development; (3) the public park proper, an open space belonging to the public as of right, and provided with facilities which could meet the demands of the new industrial cities.

Public promenades. As early as 1649, the *Tiergarten, Berlin, was made accessible to the public for 'pleasure strolling' (*Lustwandeln*), a rather doubtful pleasure on such a marshy site. The earliest cases where the site was either planned or altered so as to make promenading pleasurable were Moorfields, London (17th c.), and the *Chamars, Besançon, France, which was planted with lime trees as early as 1653.

Public promenades in France were not uncommon from the end of the 17th c., an early example being Le Peyrou, *Montpellier (1688–93, extended 1765). In the mid-18th c. they became an important part of town-planning schemes, for example, La Pepinière, *Nancy, a public promenade (20 ha.) completed in 1766 on ground given by the town and by individuals; and the *Jardin de la Fontaine, Nimes (1745–60), a public promenade on a Roman site, intended to be the basis for a new town. After the 1789 Revolution, parks formerly belonging to the aristocracy or the Church, such as the *Parc de la Colombière, Dijon, and the *Jardin Thabor, Rennes (10 ha.), were used as public promenades.

Elsewhere in Europe there were promenades in Gdansk (1760–70) and, in Warsaw, the Ogród Krasińskich (1768) and the Ogród Saski (1728). Joseph II gave free access to

the Prater, Vienna, in 1766; at its entrance an inscription (dated 1777) proclaimed that it was 'a pleasure-garden (*Belustigungsort*) for all men, dedicated by your friend'.

In Germany the town fortifications often became the site for public promenades, as at Frankfurt, *Karlsruhe, Mannheim (laid out by F. L. von *Sckell) and the Klosterbergegarten, Magdeburg (*Lenné, 1824), with the *Englischer Garten, Munich, in the heart of the city being something of an exception. Apart from the last two, very little design seems to have been involved. At Magdeburg (48 ha.; for a description, ground plan, and planting plan see J. C. Loudon, *Encyclopaedia of Gardening*, 1835 edn., pp. 142, 1,207–10) the aim was not only to provide beautiful views of the surrounding country but also to create a *Volksgarten*.

The 'Volksgarten'. The first, and most influential, statement of the idea of a *Volksgarten* is in C. C. L. *Hirschfeld's *Theorie der Gartenkunst* (Leipzig, 1779–85). It is to be a place where all social classes can mingle, for the enjoyment of nature, but what differentiates it from a public promenade is that 'Buildings with interesting pictures from the history of the nation, statues of their dead heroes and monuments to important events with instructive inscriptions can be tastefully arranged at appropriate places to very advantageous effect' (Vol. 5, p. 70). Hirschfeld rejected the sentimental monuments of the aristocratic pleasure garden in favour of those which remind the people (*Volk*) of the 'heroism of its patriots, and of its good fortune as a nation' (ibid.).

The idea was taken up by F. L. von Sckell (1750–1823) and Peter Josef Lenné (1789–1866). The former was mainly influenced by the stylistic aspects of Hirschfeld's idea, which he attempted to realize at the Englischer Garten, Munich, from 1804 onwards. With the exception of a neo-classical rotunda he was able to realize very few of his proposals which directly expressed the concept of a *Volksgarten*.

Lenné belonged to a much later generation and was perhaps more susceptible to the socio-political aspects of Hirschfeld's idea. In his 1819 plan for the Tiergarten, he proposed to create a *Volksgarten* and a *National-Denkmal*, with monuments to the war against Napoleon. At various points in the layout there were to be People's Halls (*Volkssaal*), to be decorated with statues representing patriotic heroes. In his book (1825) on the park at Magdeburg, Lenné stated that he had envisaged creating a *Volksgarten*, which would have a People's Hall and a Rotunda, both to be designed by Karl Friedrich *Schinkel. As far as is known, this part of his plan was not carried out.

The first advocates of public parks. The first major advocate of public parks was J. C. Loudon (1783–1843), who turned his attention to the question at the beginning of the 1820s. Referring to promenades laid out for the public in Europe, such as the Englischer Garten, Munich, by Lenné, or the earlier Karlsruhe, he wrote: 'our continental neighbours have hitherto excelled us in this department of gardening; almost every town of consequence having its promenades for the citizens *en cheval* and also *au pied*. Till lately Hyde

Park, at London, and a spot called *The Meadows*, near Edinburgh were the only equestrian gardens in Britain; and neither were well arranged' (*Encyclopaedia of Gardening*, 1822, p. 1,186).

The *pleasure-gardens of the 18th c. still existed, but they were not public because they were open only to those who had paid a subscription. In London, royal parks such as *Hyde Park or Richmond Park were open to the public, although in the recently established *Regent's Park it was necessary to 'be a man of fortune, and take exercise on horseback or in a carriage', for there was neither seat nor shelter for the pedestrian.

Loudon seems to have used the term public gardens interchangeably with public parks, public walks, or promenades. Their object was 'less to display beautiful scenery than to afford a free wholesome air, and an ample uninterrupted promenade' (ibid., p. 1,188). This implied a definite departure from the late 18th-c. *picturesque style which Loudon himself had practised at the beginning of his career, and a marked preference for geometrical layouts.

By the end of the 1820s Loudon had become concerned with more than mere promenades. He now thought that public gardens could 'raise the intellectual character of the lowest classes of society'. The public park as one of the instruments of social reform was a widespread public concern at the time, which found expression in the 1833 *Select Committee on Public Walks*. Evidence was given to the committee that in general not only were no public walks being provided in London or the northern industrial towns but the amount of open space freely available to the poor town dweller was actually decreasing. It was probably only the better-off artisan who could afford a small garden (see *florists' flowers).

In this context it is interesting to note the terms in which the philanthropist who gave the ground to make *Derby Arboretum praised Loudon's design. He classed the Arboretum with 'the recent improvements in our streets and public buildings . . . the establishment of our efficient Police, and . . . the almost unexampled success [of] the Mechanics' Institution . . . as instances of the adoption of measures for promoting the convenience, the good order, and the instruction of our population' (Address on the opening of the Derby Arboretum, 24 Sept. 1840, quoted in J. C. Loudon, *The Derby Arboretum*, 1840, p. 83).

Cemeteries, botanical collections, and public parks. How were these ideas put into practice? Initially it was the *cemetery (for example, St James's cemetery, Liverpool (1829) or the Glasgow Necropolis, which Loudon commended as a 'public walk'. A similar association is to be found in the United States, where the 'rural cemetery' at *Mount Auburn also included a botanical garden.

But it was to be some time before Loudon himself could put his ideas into practice. The first public park, in the sense of a publicly owned open space used for promenades and a public botanical collection, was Loudon's Terrace Garden at Gravesend. Laid out in 1835, the 1·2-ha. garden (destroyed c. 1875) contained 'the most extensive collection

of trees and shrubs which, it is believed, has been hitherto planted in any public garden, not avowedly botanical' (*Gardener's Magazine*, 1836, p. 13). However, the Terrace Garden seems also to have been a pleasure-garden.

The first public garden which fulfilled Loudon's ideal of a garden of public instruction (he had been disappointed at *Birmingham Botanical Garden) was Derby Arboretum (completed Sept. 1840). His plan for the Birmingham Botanical and Horticultural Garden (1831) was a model of a 'scientific public garden' but its execution had been a 'miserable failure' (see *The Gardener's Magazine*, 1835, p. 657). Derby is successful in Loudon's terms as a plant collection, and also exemplifies the new style of planting, the *gardenesque, which he considered more appropriate than the picturesque manner. As a plan it is not very interesting, for it consists merely of two straight intersecting main walks, with meandering minor paths on the boundary. The outstanding feature of the design is the enclosure by artificial mounds to solve the problem noted by Loudon that 'there is no distant prospect, or view beyond the grounds, worthy of being taken into consideration in laying them out' (*The Derby Arboretum*, 1840, p. 71).

The first major public park. The first public park, as opposed to public arboretum or botanical garden, was *Birkenhead Park, Liverpool (1843), designed by *Paxton. The general requirements of a public park—path systems and drives within the park, circulation systems to connect the park with the city—could not be met simply by adapting the design principles of the 18th-c. landscape park. The problem was compounded by the fact that, like most later public parks, the original site was extremely unpromising—swampy, low-lying land, with no views.

Paxton effected a brilliant solution, which owed little if anything to earlier landscape garden design. He created two lakeside areas strongly enclosed by planted artificial mounds up to 10 m. high. The lakes were sinuous in outline, very unlike the serpentine curves of *Brown. In each lake, islands were carefully placed to restrict the expanse of water visible at one glance—the paths which wound towards and away from the water's edge contributed to the effect, by offering the pedestrian a frequently changing series of views. Even at the path junctions, the intrigued pedestrian is prevented from seeing more than a few metres ahead by massed rock formations and solid planting.

An equally significant contribution was the circulation system. It separated different types of traffic—pleasure traffic within the park from the commercial traffic of the town—in such a way that the business of the town was not hindered and the views within the park were unspoiled.

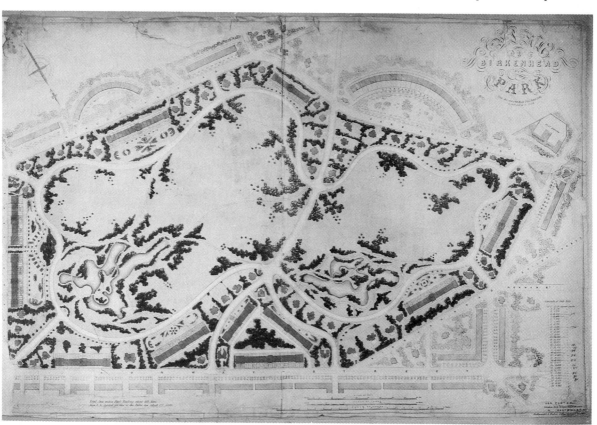

Birkenhead Park, Liverpool, plan (Liverpool City Libraries)

After this promising start the design of English public parks is somewhat disappointing. Although most areas of London and the northern industrial towns had a newly created public park by the end of the 1860s, the unattractive character of most of the original sites proved too much of a challenge. The difficulties were often compounded by delays in construction caused by economic and political factors. With the notable exception of Crystal Palace, Sydenham (1854) none matched the ingenuity of Birkenhead.

One of the most interesting ideas which was never fully carried out was the *winter garden, developed from an idea Paxton first put forward in the early 1850s. He intended it to transform the park into an all-weather all-the-year-round attraction by making the winter garden a site for permanent exhibitions of live birds, plant collections, and geological specimens. This was perhaps the last echo of Loudon's didactic conception of the public park. Unfortunately his winter garden for Queen's Park, Glasgow (proposed 1860) was never built and that at Crystal Palace was an imperfect realization of his aim.

The public park in Paris. The next significant development in the design of public parks occurred when they were designed as an integral part of a city plan. This first took place with the replanning of Paris by Napoleon III, implemented by *Haussmann (1809–91) as Prefect of the Seine (1853–69). He regarded the creation of a network of public spaces as being an essential element in the revitalization of Paris, and the new and remodelled parks were one of his proudest achievements (see his *Mémoires*, 1891, iii. 175).

His first work was the remodelling of the existing layout of the *Bois de Boulogne, a work on a very large scale (850 ha.). The formation of the two lakes and the irrigation of the dry, sandy soil, tasks which had proved beyond the technical competence of the *paysagiste* *Varé (1802–83), were carried out by the engineer *Alphand (1817–91). An artificial hill, the Butte Mortemart, was made from the excavations for the lake, and curving walks were conducted through the woods. A similar design was carried out at the Bois de Vincennes (begun 1858) on the east side of Paris, although this did not repeat the popular success of its western counterpart.

From c.1860 Alphand was joined by the horticulturalists *André (1840–1911) and *Barillet-Deschamps (1824–75), who cultivated exotic plants in the Jardin d'Acclimatation, Bois de Boulogne, with the aim of introducing them into public parks. At the *Parc Monceau (from 1861) Barillet-Deschamps introduced a new style of 'decorative horti-culture', *subtropical bedding, in which foliage plants such as pampas grass and bamboos were seen in 'little dells', a style which made a great impression on William *Robinson.

However, Alphand continued to be responsible for the basic layout of public parks, including two completely new ones—Parc Montsouris and his most striking achievement, *Buttes-Chaumont (1864–9). Haussmann himself admit-ted that the idea of reclaiming abandoned chalk quarries in an industrial area to make a public park was 'at first sight bizarre' (op. cit., p. 234). The 25-ha. site was transformed at great expense, with the creation of a lake from which rose a 50-m. high rock surmounted by a round temple.

One of the most striking features of Alphand's designs, even though he himself considered it to be 'an element which must be completely subordinated to the rest of the composition, and which should only be dealt with after the composition as a whole is finished' (*L'Art des jardins*, 1886, p. 216), is the path system. Paths must lead to their goal (the exit to the park, a point of view) by a 'continuous movement', being neither serpentine nor sinuous (which would 'betray a certain confusion'); and the line of vision is always at a tangent to the curve of the path (ibid., p. 219). This system is most appropriate for undulating ground, while straight paths are suitable for level or regularly inclined ground.

During mainly the last seven years of Haussmann's administration, Alphand also designed 24 public gardens, called 'squares' but bearing little resemblance to their English inspiration. Most of these were very small and offered little opportunity for design, the most notable exception being the Square des Batignolles (1862–3).

The parkway system. In the writings and work of F. L. *Olmsted the public park assumed even greater importance than it had done in the Parisian park system. His pamphlet *Public Parks and the Enlargement of Towns* (1870) put forward the idea that parks could become the focal points around which a new town could be structured.

The parks would be linked by formal parkways, large-scale avenues inspired by the Avenue de l'Impératrice, Paris, for walking, riding, and driving carriages (see his *Report . . . [on] Prospect Park*, 1868). The parkways were for pleasure journeys only, and commercial traffic used a clearly separated system. Olmsted was unable to create parkways in New York as he had wished, but the parkway system was partly realized in Buffalo and, on a more impressive scale, Boston.

Olmsted had already designed the first public park in the United States, *Central Park, Manhattan (1858). He was greatly influenced by the ideas of A. J. *Downing (1815–52), the first American to campaign for public parks (from 1848), while his practical inspiration derived from his visit to Birkenhead Park in 1850, when he was greatly impressed by the fact that 'in democratic America, there was nothing to be thought of as comparable with this People's Garden' (*Walks and Talks of an American Farmer*, 1852, p. 79).

In design terms, Central Park carries the circulation system devised by Paxton one step further, by sinking the transverse roads carrying commercial traffic below the level of the park. The parkway system can be considered the logical extension of this idea beyond the boundaries of the park. The interior of the park is quite different from Birkenhead, in that Olmsted and his partner Calvert Vaux aimed to create a variety of rural scenes, very much in the picturesque manner.

Private gardens and public parks. During the period so far, what was the relationship between the design of private

gardens and public parks? The design of Birkenhead Park owed little if anything to earlier garden design, but one contemporary garden type, *Italian gardens, had some influence upon other public parks. The first terraced garden in this style was *Trentham Park (1840) designed by Charles *Barry (1795–1860), seven years before it was first used by Paxton, at Coventry Cemetery (1847).

At Coventry a single terrace is a viewing platform, but at Crystal Palace there are two terraces linked by flights of steps. The larger terrace, 550 m. long × 170 m. wide, is sited on a hillside commanding extensive views and was originally furnished with numerous garden features— flower-beds, statues, and fountains. Although majestic in scale it does not have the same dramatic character as *Shrubland Park (1851–4). Paxton favoured the use of the terrace even on restricted sites with no outward views, such as the 5-ha. People's Park, Halifax (1857).

From the early 1840s there is in general a distinction between landscape gardeners and what would later be called landscape architects. Paxton, who had earlier been a gardener, was increasingly concerned with the public park. *Kemp (1817–c.1890) and Edward *Milner (1819–84), both gardeners at Chatsworth under Paxton, partly followed his example: the former worked mainly as a park designer, in Paxton's formal manner, while the latter designed many gardens in the 'landscape manner', as well as public parks.

The distinction is slightly blurred when applied to the leading garden designers. Charles Barry, who was in any case primarily an architect, and *Beaton (1802–63) were involved in garden design, but not at all in parks; William *Barron, head gardener at *Elvaston, produced one park design at Abbey Park (1877–81), Leicester; W. A. *Nesfield was mainly concerned with private gardens but did give advice on the royal parks; while *Marnock (1800–89), predominantly a gardener, also designed parks.

In France, Haussmann found that *paysagistes* such as Varé lacked the necessary technical skills, and the parks were laid out by engineers such as Alphand or horticulturalists such as Barillet-Deschamps. André went on to design numerous gardens, but Alphand's park style probably had little influence on garden design. In the United States Olmsted's major concern was with park design, with the exception of *Biltmore (from 1888), where scientific forestry was his main interest.

Planting design in parks and gardens. The bedding system (see *bed, bedding) so popular in public parks from about the 1860s for about half a century had originated with private gardens in the 1840s. In the development of this style, subtropical bedding originally devised by Barillet-Deschamps and popularized in England by John Gibson at Battersea Park in the early 1860s was the major contribution from parks.

Barillet employed this style of planting at Parc Monceau, but perhaps it can best be seen in its proper context at the Square des Batignolles, where the path system from which the planting was to be viewed was laid out *de novo*. William Robinson noted 'a group of the variegated maize springing

out of a mass of dwarf *Phlox Drummondi* . . . a magnificent group of *Caladium esculentum*, springing out of *Lobelia Paxtoni*; behind it a dense mass of the Pampas Grass, in front of groups of Poplars and Cedars' (*The Parks and Gardens of Paris*, 1869, p. 92).

The decline of the public parks. By the end of the 1860s, most of the major cities in England and France had been provided with public parks. Inspired by their example, most European countries (with the major exception of Germany where the most important developments did not begin until the 1900s), Latin America, and some European colonies followed suit, while rarely offering any new design solutions.

The development of parks in Germany began rather later, as the replanning of Berlin in the 1830s by Schinkel did not involve the creation of new city parks, but the remodelling by Lenné of the former royal park, the Tiergarten (given to the city 1840). Berlin did not have public parks until the Humboldthain Park (1869) and the Treptower Park (final plan 1874), both by Gustav *Meyer (1816–77). He was greatly influenced by Schinkel, especially in his use of the hippodrome form, a distinctive feature of German parks well into the 20th c.

In France the *Bühler brothers, Denis (1811–90) and Eugène (1822–1907), worked out a very simplified schema for park design, often used perhaps because of its manageability. It consisted of a few functional paths curving around vast open spaces of grass dotted with clumps of trees all of a single variety, a considerable distance apart; few shrubs and hardly any flower-beds (although their *Parc de la Tête d'Or at Lyons was influential for its *mosaiculture*); and extensive stretches of water. They created numerous parks in their manner, for example the *Jardin Thabor at Rennes; and their influence may be seen at, for example, the *Bois de la Cambre, Brussels.

In England, the last major work of this era is Sefton Park, Liverpool (1868). A competition-winning design by André and Hornblower, it uses Alphand's path system but to much less effect than its Parisian counterparts because of the flat site. For the rest of the century, although the pace of park-building continues to increase into the Edwardian period, the creative design impulse is almost extinct until the arrival of *Mawson. There are perhaps three major reasons for this. First, continuing a development noted above, the park increasingly becomes merely a site for horticultural displays; secondly, landscape design became a very low priority, as the parks superintendents, nurserymen, and borough surveyors came to play a dominant role in the choice of site and layout of new parks; and, finally, the growing importance of sport.

It would be tedious to document the second reason in detail, but the third is of some importance in the overall development of the public park. Although Birkenhead Park had included an area set aside for sport, this was simply an open space, which formed only a subordinate part of the overall plan. The first writer to suggest that special areas should be set aside for sport was Joshua Major, who had laid out three parks in Manchester in 1844 with areas available

for this purpose. While arguing for a general playground of 5–6 ha. in the centre of the park, he also made it clear that other playgrounds were to take advantage of 'every nook or recess which was to spare' (*The Theory and Practice of Landscape Gardening*, 1852, p. 193). With the rise of organized sport in the 1870s came a more urgent demand for a narrower range of sports, and attendant facilities. The first park specifically designed to meet this need seems to have been West Park, Wolverhampton (1879), the competition for which was won by a nurseryman, without a landscape designer even taking part.

Park design eventually did revive in the early 20th c. in Britain with the work of Thomas Mawson. But it was now even more firmly integrated with city planning than it had been in France in the earlier period, to the extent that it developed quite separately from garden design. In the rest of the 20th c. its development in Britain and elsewhere has been the province of *landscape architecture. P.G.

The twentieth century. The shortage of labour and the resultant increase in maintenance costs led to the decline of many European public parks during the early part of the century, and it was a struggle to keep abreast of the changing recreational needs which followed. Germany was one of the first countries to respond in the first two decades of the 20th c. with a number of new parks, especially in Berlin and in Hamburg, where the first new park in Germany—the Stadtpark—was created in 1910. But one of the most significant was the Bos Park, near Amsterdam in the Netherlands, started in 1934. It successfully integrated sports grounds, a lake with a rowing course, a wild-flower island, nature reserves, entertainment areas, and walks and rides into a reclaimed and forested landscape. With the German examples and the remarkable Swedish park system in Stockholm, this has continued to be a model for new parks in the latter part of the century. In the years immediately following the Second World War the German *Gartenschauen* were adapted to provide new infrastructure to many destroyed cities, as well as providing a stimulus for design. Their example has been followed, with varying degrees of success, in several other European countries, including Austria and Switzerland, and, most recently, Britain. The British New Towns (which in many ways resembled *Garden Cities) contributed less in the way of innovative park design than in their overall park-like ambience, with the exception of a small urban water park at Hemel Hempstead and some ambitious proposals for Milton Keynes, so far only partly realized. The International Garden Festival at Liverpool in 1984 (IGF 84) and its successors to be held at Stoke-on-Trent and Glasgow are beginning to provide the necessary design incentives.

Apart from garden shows, events such as national festivals, World Fairs, and the Olympics provide opportunities for the creation of new parks. The Olympia Park at Munich, with a range of hills built out of building rubble, is an outstanding example. Another is the design for the Parque del Este intended for the 1960 International Exhibition at Caracas in Venezuela by Roberto *Burle Marx.

Unfortunately the exhibition never took place and the park design has been only partially implemented. Burle Marx was subsequently appointed designer for major university, zoological, and botanic gardens in Brasilia, the new capital of Brazil.

More recently, work has begun on a number of imaginative designs for parks in France, by Michel Corajoud and others; the international competition for La Villette in Paris produced some exciting urban designs, one of which is under construction, and John Mayson Whalley of Derek Lovejoy & Partners has designed two innovative parks, at Cergy-Pontoise and La Courneuve. Italy is also awakening to the need for landscape design and planning, to structure the rapid urban expansion; and two cities—Modena and Brescia—have commissioned Sir Geoffrey *Jellicoe to design new parks. Pressures on land use and the need to attract, entertain, (and educate) the public has led to the development of 'theme' parks. These vary from combinations of funfare and fantasy, as in North America's Disneyland parks and their offshoots, to more serious themes such as archaeology, agriculture and farm buildings, sculpture (see *sculpture garden), water, nature, wildlife, and even *cemetery parks. M.L.L.

Pückler-Muskau, Hermann, Prince of (1785–1871), German landowner and landscape gardener, who after a first study tour of England began work in 1816 on the park at *Muskau under the perceptible influence of Humphry *Repton. He went to England again between 1826 and 1829 before extending the park to c. 750 ha., which then had to be sold because of financial difficulties. After moving to the old family estate at *Branitz he laid out a 70-ha. park (1846–71). He travelled in Africa and the Near East between 1834 and 1840 and visited England again in 1851, subsequently writing a number of works assessing the impressions gained on his travels.

Pückler also carried out extensive work at *Babelsberg for the future Emperor Wilhelm I, and advised on and influenced the design of various parks, such as Bad Liebenstein, Tiefurt, Ettersburg near Weimar with its famous Pückler-Schlag (executed by *Petzold), and Coblenz.

Thanks to his social position, he spread the picturesque style on the Continent, creating extremely picturesque, extensive parkland areas, with no thought for agricultural or economic problems. In his flower gardens he made great use of *carpet bedding. Through his lavish work *Andeutungen über Landschaftsgärtnerei* (Stuttgart, 1834), he exerted a strong influence on contemporary garden design. Petzold is regarded as his disciple and through his own work and writings made Pückler-Muskau's ideas more widely known. H.GÜ.

See also TIEFURT.

Puławy, Poland, was established at the end of the 18th c. around the residence of the Czartoryski family. The 35-ha. park was the work of many artists, particularly the garden designer James Savage (1740–1816) and the architect, Chrystian Piotr Aigner (1756–1841), who worked closely

with the founder of the park, Duchess Izabela Czartoryska (1746–1835), the author of *Various Thoughts on the Creation of Gardens* (Wrocław, 1805).

The entrance to the residence, 47 km. from Lublin, is located on an escarpment. The long drive bordered with four rows of linden trees runs through to a garden court with a pool and fountain. On the plateau, this extensive park, with picturesque groups of trees and shrubs and various internal views of numerous park structures and partly incorporated old *allées*, stretches on both sides of the palace. The most magnificent and popular structures are the Temple of Sibyl (1798–1802), modelled on the Temple of Vesta at Tivoli, and the Gothic House (completed in 1809). Other notable preserved structures include the Marynka palace (1791–4) and the conservatory with a four-column Doric portico (*c.*1790). On the hill there is a marble sarcophagus (1801) reminiscent of the then recently discovered tombstone of Scipio Barbatus (Roman consul 298 BC). In the lower park there is a long lake close to the escarpment and magnificent old trees. Previously there were rustic structures such as a fisherman's house and a Dutch house, but only the Chinese pavilion now remains. Also to be found were stones bearing inscriptions related to the place of their origin, one of which was devoted to Delille, whose poem 'Les jardins' (Paris, 1801) made the park famous. The park itself and the most important parts of its layout are now preserved as a public park. L.M./P.G.

Pulham, James (*c.*1820–98), English rockery builder, was the son of one of the pioneers of Portland cement manufacture, and began in the late 1840s to use his cement as an ingredient in the construction of artificial rock-work. Masses of clinker were assembled, cement was poured over them, and they were moulded into boulder-like formations, arranged in strata; the result was on occasion so accurate as to deceive naturalists. Pulham's most important commissions were for rockeries at Battersea Park—probably the most accessible example of his work today—Lockinge House, Fonthill Abbey, and Sandringham. Rockeries for conservatories and terracotta designs were also important for the firm, which continued its work under the direction of James Robert Pulham (1873–1957), but increasingly after the turn of the century natural stone was employed. The firm's most important 20th-c. commission was for the rock garden at Wisley (1910–12). B.E.

See also SHEFFIELD PARK.

Rockwork in Battersea Park, London, by James Pulham

Pushkin, near Leningrad, Soviet Union. See TSARSKOYE SELO.

Putbus, Rostock, German Democratic Republic. A baroque garden dating from *c.*1725 was followed after 1820 by a 75-ha. landscape garden, in the creation of which *Lenné was probably involved. The Schloss stood in the middle of the park beside a pond; it had to be demolished in 1961–2.

In the middle of the well-proportioned grounds next to the former Schloss terrace with its fountain lies a swan pond. Directly adjacent among groups of old trees are a number of impressive façade structures: the Marstall (1821–4), the Ape House (1830), and the Pheasant House (1835, now demolished). The original Spa Assembly Room (1844–6) was rebuilt as a church in 1891–2. The architectural features on the north side of the park are the long Orangery (1824; rebuilt 1853, as the Spa Administrative Offices and library), the Mausoleum (*c.*1850), and a café (built in 1828–9 as a residential building) with a rose-garden.

Many extremely rare species of ancient trees embellish the scenes of the park which also open out towards the Island of Vilm and the Greifswald coast. H.GÜ.

Qasr-i Qajar, Tehran, Iran, the Castle of the Qajars, was built by Fath Ali Shah at the beginning of the 19th c. It lay immediately to the north of the city of Tehran, its size being *c.*8 ha. Most of its area was on level ground divided by straight paths into regular rectangular sections. A much smaller walled-in area, with a pool at its foot, rose in terraces up the adjacent hillside. D. N. Wilber records an early description of poplars, willows, fruit-trees, and many roses, as well as the royal castle itself with rich finishes of ebony, ivory, mosaic and painting, pools, and canals. The garden remained until the mid-20th c. when the expansion of Tehran caused it to be built over. J.L.

Qian Long Garden, Beijing, China, built for Emperor Qian Long in the 1880s, is one of three gardens that still exist within the walls of the Imperial Palace. Located near the north-east corner of the Palace, the garden consists of five parts or courses arranged consecutively along a north–south axis, in form somewhat like a courtyard house with a garden or courtyard separating each of its halls. Each is 37 m. wide, and the whole series 60 m. long with a total area of around 0·6 ha. As, out of filial piety, Qian Long did not wish to rule longer than the 61 years of his grandfather Kang Xi, he named most of the buildings to suggest the retirement he planned in the sixtieth year of his reign. Between the buildings the courtyards are laid out in the style of south-east China, freer and more lyrical in design than the other parts of the Imperial Palace. Pavilions, **lang,* rockeries, and artificial hillocks seem to be arranged spontaneously, but are in fact carefully placed in relation to each other to create a subtle balance of high and low, foreground and background, solid and void.

Besides its central hall, the most interesting pavilion in the first course is the Xi Shang Ting, commemorating an ancient ceremony for dispelling bad influences. Since the great calligraphist Wang Xi Zhi used the character *Xi* in his 'Preface for the Anthology on Orchid Pavilion', the floor here is engraved with the pattern of a running brook, an allusion to the 'wine-cup stream' where the original poems in the anthology were composed (see **Lan Ting*). The gardens of the third and fourth courses are almost entirely made up of rockeries and artificial hillocks built up over grottoes and with halls and pavilions scattered among them; but, in contrast, the second and fifth courses are simply planted with trees and flowers in paved ground. A famous well where Lady Zhen, royal concubine of the Emperor Guang Xu, was compelled to commit suicide in 1900, is on the east of the fifth course. The whole garden was restored and opened to the public in 1982. G.-Z.W./M.K.

See also JIN SHAN; YU HUA YUAN.

Quaracchi, Villa, Florence, Italy. Although it cannot be unquestionably attributed to **Alberti,* it does conform to the principles of garden design set out in his *De re aedificatoria libri X* (1452). A detailed description is given in the diary for 1459 of its owner Giovanni Rucellai, for whom Alberti had designed a *palazzo* in Florence.

Many of the main features were still medieval—arbours, a mount, pergolas (Rucellai calls them 'the most striking feature'), an aviary, and a rose garden; and the simple axial plan of the garden which already existed was not made more symmetrical or well proportioned. What was distinctive was the siting of the house on a small eminence (Alberti's treatise had recommended hillside sites); the planting of topiary in the form of clipped hedges and box figures (a reminiscence of the villas of **Pliny* the younger); and the continuation of the main axis on the other side of the Pistoia road by an avenue of trees leading down to the Arno. Rucellai's description suggests that the moat around the house was decorative rather than defensive. At variance with the classical tradition, there does not seem to have been any statuary. P.G.

Queen's Gardens, Perth, Western Australia. The original designer, a Sydney landscape gardener, Mr Ferris, showed an imaginative vision by transforming what had previously been clay pits into serpentine lakes decorated with rustic bridges, weeping willows, bamboos, and palm trees; dumps of waste soil became grassy mounds which added interest to the flat site by partly concealing some of the vistas.

Queen's Gardens were opened to the public on 9 Oct. 1899, when hundreds of citizens travelled by the newly installed electric tramcars to admire this park of sweeping lawns, screens of trees and shrubs, gay flower-beds, and an annual flowering of water-lilies on the lakes, where black swans, white swans, and colourful ducks gave animation to the scene. In subsequent years the gardens were extended to the eastern end by the city gardener, J. G. Braithwaite. Hundreds of roses and up to 24,000 miscellaneous plants were added to flower-beds and borders each year; 10 varieties of water-lilies grew in the lakes, and in 1900 'more than a hundred trees were planted for persons who had paid the cost of same'.

Privacy and the feeling of a 'secret garden' were provided

by planting around the boundaries judiciously arranged trees—London plane trees, Moreton Bay figs, bamboos, poplars, and cypresses—many now grown to majestic maturity, with their variety of form, colour, and texture giving changing interest throughout the seasons. R.O./J.O.

Queluz, Palace of, Estremadura, Portugal, was built in 1758 for Dom Pedro, the second son of João V, by the architect Mateus Vicente de Oliveira, and in 1762 Jean-Baptiste Robillon, the French architect and sculptor, laid out the gardens. The Portuguese Government now maintains the palace as a residence for entertaining its foreign guests.

A long terrace, its important balustrade broken by plinths supporting urns, links the palace to the garden. Flowers in profusion fill the box-edged beds that line up into alleys. Fine statuary, befitting Robillon, ornaments the central basins, the fountain of Neptune being the most impressive. Clumps of dark, clipped foliage break the symmetry. It is a spacious, colourful parterre, in keeping with the pale-pink façade of the palace. A beautiful staircase, dividing into two half-way up, balustraded, and with wide, curving flights of steps, leads down to a lower garden. This is cut across by a Dutch canal, now dry. Blue-and-white *azulejo* panels of shipping scenes, rising as if out of the water, line the sides. Rococo bridges, charming with polychrome tiles and statuary, straddle over it. On festive occasions barges used to glide past carrying performing musicians, and the sound of oboe and flute was also to be heard coming from thickets of orange and bay trees. More lavishly than any other in Portugal, the gardens of Queluz display the graceful ingenuities of the 18th c. B.L.

Quincunx, literally an arrangement by fives, applied to trees arranged one at each corner of a square, with one in the centre. Defined more enigmatically by Sir Thomas Browne in *The Garden of Cyrus* (1658) as: 'five trees so set together, that a regular angularity, and thorough prospect was left on every side. Owing this name not only unto the quintuple number of trees, but the figure declaring that number, which being double at the angle, makes up the letter X, that is, the emphatical decussation, or fundamental figure.' A feature of 16th- and 17th-c. English gardens, thereafter it is only to be found in orchards or forest plantations. P.G.

Qu-Jiang, Shenxi province, China, named after the River Qu which ran through it, covered an area of come 182 ha., in a scenic site south-east of Changan in the Tang dynasty (*c.*5 km. south of what is now the city of Xian). Earlier, Emperor Wen Di (581–600) of the Sui dynasty, delighted by the lotus which completely filled the river there, had frequented this place and called it the Lotus Garden. Later, during the Kaiyuan years (713–42) of the Tang dynasty, the river was dredged and the banks embellished with many buildings such as the Purple Cloud Tower and Coloured Cloud Pavilion. Three times a year on the festivals of Middle Harmony (first of the second lunar month), Double Three (third of the third month), and Double Nine (ninth of the ninth month), the emperors held imperial court banquets there. Then the inhabitants of Changan came out in crowds to temporary bazaars set up under coloured tents, silk shades, and screens, while gaily embellished boats floated on the river. The great Tang Emperor Xuan Zong and his favourite concubine Yang Yu-huan (or Guifei, meaning Precious Concubine) often made excursions to this garden. D.-H.L./M.K.

Qu qiao is a type of flat, stone, zigzag bridge often seen in small Chinese gardens. Usually with three or five (but sometimes with as many as nine) turns, they are often lower than the banks they join. Originally they had low or even no balustrades but, with the opening of gardens to the public, railings have usually been added for safety. X.-W.L./M.K.

Rābi 'a-ud-Daurāni, Mausoleum of, Aurungabad, India, built by the 5th Mogul Emperor *Aurangzīb in memory of his first wife, has a design and layout which echo those of the *Taj Mahal. The central tomb, the supporting minarets, and the long canal are all repeated, and the whole has a certain charm. But the perfect balance and proportion of Shāh Jahān's Taj is lacking, a clear indication that a decline in quality has begun. S.M.H.

Ram Bagh, Agra, India. The 1st Mogul Emperor *Bābur's memoirs describe in detail the first garden he laid out by the river at Agra: the transformation of a flat site into a garden of great beauty. Various alternatives have been suggested as to its location, but the probability is that the site was that of the Ram Bagh, lying on a curve of the River Jumna. This, although much changed, is almost certainly the oldest surviving Mogul garden, and the details of design are in their simplest forms. A large well, an aqueduct, and water channels were first built, while the layout of the garden was the classic Mogul one of geometrical walks and terraces, which here are raised some 3 m. above the ground so as to bring them level with the blossom of the surrounding fruit-trees; narrow irrigation channels run down the centre of the walks to water the trees planted at intervals. At the corners are *chabutras* on which to rest and enjoy the view. Some fine pavilions overlooked the river, while provision was also made for dwelling houses and hot baths. The planting would originally have been one of fruit and flowers, but the site was later overgrown with forest trees. Also known as the Garden of Rest, it was probably here that Bābur was buried, before being taken to his final resting-place at Kabul.
 S.M.H.

Rambouillet, Yvelines, France. The park of a feudal château on the edge of a large forest was drastically reshaped by the financier, Fleuriau d'Armenonville, in 1699. Terraces were made and parterres laid out, framed with lime trees in *quincunx, while a network of canals was dug, creating geometric islands peopled with statues. These vast gardens *à la française* were later embellished by the Comte de Toulouse. His son, the Duc de Penthièvre, used a little valley south-west of the château to make a *jardin anglais* where in 1779–80 the architect Paindebled put a grotto surmounted by a Chinese kiosk, a cottage whose rustic exterior conceals a room entirely decorated with shells, and a hermitage inhabited by a 'real hermit'. Later, when Louis XVI acquired the estate privately, he called on Hubert *Robert to supervise the arrangement of 'l'enclos de la laiterie' which includes one of the most perfect examples

of 'pastoral' architecture—the dairy constructed by Thévenin in 1787 for Marie-Antoinette. A severe stone façade leads to a marble salon and a cold room ending in a grotto in which water pours among ivy and ferns; it is the setting for the group *Amalthée et sa chèvre* by the sculptor Julien. Besides this there was a big ornamental orchard, and another *jardin irrégulier* adjoining the experimental farm where the king raised merino sheep.
 M.M. (trans. K.A.S.W.)

Ranelagh Gardens, Chelsea, London. See PLEASURE-GARDEN.

Rastrelli, Bartolomeo Francesco (1700–71), Italian architect and garden designer, came to Russia from Italy in 1716 with his father Carlo Bartolomeo Rastrelli, the sculptor. He studied architecture in St Petersburg (Leningrad) and in France and became the leading architect in Russia in the mid-18th c. He considerably extended the palace at *Peterhof (Petrodvorets) and built the Yekaterininsky Palace at *Tsarskoye Selo (Pushkin) and the Winter Palace and the Smolny Cathedral in St Petersburg. Among the many gardens he laid out or remodelled were the *Summer Garden in St Petersburg and Annenhof in Moscow. His work as a garden designer was distinguished by the intricacy of his parterres, his liberal use of water and statues, and his exceptional baroque garden buildings, particularly the Grotto and the Hermitage at Tsarskoye Selo (though he did not lay out the garden there). His influence was very considerable. S.P.

Rauwolf, Leonhardt (d. 1596), German physician and plant collector. See PLANT COLLECTING.

Raxa, Majorca. The estate was called Araxa during the Moorish period. Subsequently it passed into the hands of the Counts of Montenegro, of whom one, Cardinal Don Antonio Despuig, reconstructed the house and developed the garden in the Italian manner *c.*1745. From Italy, where he had carried out excavations at Herculaneum, he brought back Roman antiquities. He also introduced a number of exotic plants.

The house is a typically Majorcan structure with a few very Italian features such as a loggia, built around a large sloping courtyard. The approach is from the side through a gate-tower along a terrace with a classical balustrade. Below it are orange groves divided by raised walks; behind and above, the terraced garden rises very steeply. This is bisected by a monumental stone staircase decorated with small

classical figures, urns, and leonine masks through which water spurts. At the top is an *exedra with Tuscan columns containing a statue and a water-spouting gargoyle. The lower terraces are shaded by trees and shrubs; the upper ones, which are very narrow, are planted with a few shrubs and succulents. From one of them a winding path leads to a great reservoir fed by the Canet springs, and said to be built on Moorish foundations. Another typically Moorish element is the ramped path which rises diagonally across the terraces to a *mirador on the hilltop. M.L.L.

See also MAJORCA.

Rea, John (d. 1677), English nursery gardener, had a garden in Shropshire, in the village of Kinlet near the Worcestershire border. His skill was famous among his contemporaries, and his book *Flora*, first published in 1665, gave instructions for 'all requisites belonging to a florist', as well as guidance on the principles of garden design and construction. John *Evelyn praised the 'very usefull book concerning the culture of flowers' and, 300 years later, Blanche Henrey described it as 'the most important English treatise on gardening to be published during the second half of the seventeenth century'. Rea's views on garden design were probably influenced by Le Nôtre, whose pupil he may have been. The first dedicatory letter in *Flora* is addressed to Charles, 4th Baron Gerard, whose garden at Gerard's Bromley in Staffordshire Rea had designed. The second dedication is to Sir Thomas Hanmer of Bettisfield, Flintshire, in thanks for 'many noble and new varieties' from his collection of plants, a collection glimpsed in the 1659 *Garden Book of Sir Thomas Hanmer*, published in 1933.

S.R.

Reale, Palazzo, Caserta, Italy. See LA REGGIA.

Red Fort, Delhi, India, was a part of *Shāh Jahān's new city at Delhi, Shahjahanabad, but by no means all. A canal to provide water was built by 'Ali Mardān Khān along the main street, the Chandni Chauk, while outside the Fort lay richly planted gardens.

The Fort itself was surrounded on three sides by a moat, filled with fish, and within there lay a complex of houses, palaces, and gardens, all irrigated by running water. The principal buildings were sited overlooking the river, below which stretched a long level space that provided for all kinds of spectacle to be watched from above.

Two gardens were combined in one grand design: the Hayat Baksh, or Life-giving Garden, and the Mahtab Bagh, or Moonlight Garden. These were planted in contrasting colours: the Hayat Baksh glowing in red and purple, the Moonlight Garden in pale colours only.

The Mahtab Bagh is lost, but the Hayat Baksh remains in part. It was designed as a water-garden, with at its centre a great tank for bathing in which is set a red sandstone pavilion, the Zafar Mahal, added by Bahadur Shah in the 19th c. Details everywhere were lavish: delicate pavilions, illuminated waterfalls, gold and silver vases of flowers, and many hundreds of fountains. The palaces along the river

front remain, carefully restored, together with a mosque, the Moti Masjid, added by *Aurangzīb. Much, however, has been lost: the entrance canal and moat have been filled in, the water everywhere is lacking, the flower gardens have been replaced by trees and grass, and much of the old inner city by official buildings.

Of all the Mogul gardens, the Red Fort would perhaps gain the most by some restoration of the water. S.M.H.

Redouté, Pierre-Joseph. See BOTANICAL ILLUSTRATION; JOSÉPHINE.

Regency gardening accommodated the revived interest in horticulture in England which was reflected in the formation of the *Royal Horticultural Society in 1804. In the fashionable *cottages ornés the accent was on the interaction of house and garden with flower-filled conservatories and creeper-covered verandah columns in the manner of *Repton's *Endsleigh. The precedent for the Regency picturesque shrub plantations and island beds had been set by William *Mason at *Nuneham Park and *Mount Edgcumbe, where flower gardens were enclosed from landscaped gardens not by walls but by natural flowing shrubberies. Henry Phillips used the name 'Sylva Florifera' for this type of planting in his book of that name (1823) and it was seen as a natural development from *picturesque landscape gardening, with flowers also being 'amenable to the rules of composition', in the words of W. S. *Gilpin. Picturesque shrub plantations drew inspiration from scenery observed in the New Forest by the Revd William *Gilpin where 'frequent tufts of sweetbriar, box or thorn steal on the greensward' of the forest lawns breaking the spaces into a 'mossy maze', in Mason's words. Shrubberies with serpentine paths and mixed flower and shrub plantations were particularly suitable for perambulations in public parks and were extensively used by John Nash in his metropolitan schemes and in his designs for the *Royal Pavilion at Brighton. Henry Phillips and W. T. *Aiton provide evidence of the range of plants used in Regency gardening. M.L.B.

See also SCOTNEY CASTLE.

Regent's Park, London, once part of the Royal Chase, consisted mostly of fields and pasture prior to 1811. Then Nash designed for the Prince Regent (later George IV) an elaborate architectural complex embracing a park (149 ha.) and linking it via Portland Place and Regent Street with *St James's Park. Buildings were very much part of the scenery, in the form of villas and surrounding terraces. Open to the public in 1838, the park developed in true Victorian manner in its mixture of walks, flower gardens, lake, recreation areas, and special facilities, e.g. botanical and zoological gardens. In the present day, it has, interestingly, assumed some of the role of the old pleasure-gardens with its bandstand and open-air theatre. M.W.R.S.

Register of Parks and Gardens of Special Historic Interest in England. See CONSERVATION AND RESTORATION OF HISTORIC GARDENS IN BRITAIN.

Rehe Xing Gong, Chengde, China. See BI SHU SHAN ZHUANG.

Renishaw Hall, Derbyshire, England, has gardens of *c.*1·4 ha. designed by Sir George *Sitwell *c.*1890. Box-edged beds were designed by Inigo Thomas, and Gertrude *Jekyll supplied plans for flower-bed planting. The garden front is in a series of terraced level lawns, stairways, pools, fountains, and classical statuary, an attempt to create an Italian garden on English soil. The end terrace looks down on a lake created by Sir George in 1890 and up over thick woodland to fine, long views. There is a wilderness, a Gothic temple and arch, a ruined polygonal aviary, and a vinery claimed to be the most northern in the country.

K.LE.

Rennes, Ille-et-Vilaine, France, Jardin Thabor. See JARDIN THABOR.

Repton, George Stanley (1786–1858), English architect, was Humphry *Repton's youngest son. He entered John Nash's office in *c.*1802, specializing in cottage designs, and in particular collaborating on the picturesque village of *Blaise Hamlet (1810–11). In 1805 he assisted his father and brother, John Adey Repton, on designs for the *Royal Pavilion, Brighton, and in 1809 on their plans for a *cottage orné at Endsleigh for the Duke of Bedford. After leaving Nash's office, where he had risen to become chief assistant, in *c.*1820 he established a successful practice as a designer of country houses, principally in a neat and austere classical style.

K.S.L.

See also ENCOMBE.

Repton, Humphry (1752–1818), came to be the leading English landscape gardener of his period by a circuitous route. After an unsuccessful business career he decided to sink his capital in purchasing a small estate at Sustead, near Aylsham, Norfolk. His 10 years here were important in equipping him for his future career, for he learnt the practical aspects of husbandry and land management while at the same time receiving helpful advice on planting from Robert Marsham of Stratton Strawless; he read widely in the literature of landscape gardening, especially in the library of his friend, William Windham of Felbrigg; and he pursued his interest in botany, with his friend James Edward (later Sir James) Smith who bought *Linnaeus's collections.

A series of ephemeral occupations—which included making sketches for Blome's *History of Norfolk* (1781 onwards), being personal assistant to William Wyndham (then Chief Secretary to the Lord Lieutenant of Ireland), art critic, and essayist—did little to solve Repton's financial problems, which had grown acute by the summer of 1788, despite his move five years earlier to a cottage at Hare Street, Romford, in Essex. During the course of a sleepless night he conceived the idea of taking up the profession of landscape gardening, which had been lacking an outstanding practitioner since the death of 'Capability' *Brown in 1783. Repton immediately wrote to various friends soliciting support, and by Sept. 1788 he was surveying the site of his first commission for Jeremiah Ives (former Mayor of Norwich) at Catton, near Norwich.

Early in the following year he was carrying out schemes for Brandesbury (a vanished seat in what is now Brondesbury, London), *Holkham Hall, *Sheffield Park, and Welbeck. Bulstrode and Cobham Hall were among the commissions which came in 1790, by which time he had firmly established himself as the leading landscape designer of his day. His rapid success was in large measure due to the attractive manner in which his recommendations were presented to his clients, these being in the form of a manuscript text bound in leather and interspersed with drawings, often with moveable flaps showing the grounds before and after improvement. He ultimately claimed to have prepared over 400 of these so-called Red Books (from the colour usually adopted for the binding), but less than half that number can now be traced.

In general, Repton's landscape principles followed closely those of his predecessor Brown, for whom he expressed general admiration, but his plantations tended to be thicker, while the small buildings in the grounds frequently assumed a rustic rather than a classical character. Later he began to adopt an element of formality in the immediate environs of the house, using terraces with balustrades and steps, or trellised enclosures for flowers. He also took a particular interest in such details as lodges and cottages, conservatories and 'winter corridors', which were covered walks for exercise in bad weather. His schemes, however, were seldom on so extensive a scale as Brown's, nor did they involve the massive construction work which the latter undertook. Several of Repton's commissions were in fact concerned with alterations within landscapes created by Brown some decades earlier.

Repton's literary and artistic ability enabled him to produce four illustrated books on landscape gardening as well as one on his designs for orientalizing the Prince of Wales's villa at Brighton (see *Royal Pavilion), where he had carried out minor alterations to the grounds between 1797 and 1802. Of the former, the first appeared in 1795 under the title of *Sketches and Hints on Landscape Gardening*, and it included references to 57 Red Books already prepared by that date. His second book on the same subject was *Observations on the Theory and Practice of Landscape Gardening*, published in 1803, and including 'Some remarks on Grecian and Gothic Architecture' as well as extracts from various Red Books. It also contained Repton's tribute to his predecessor, Lancelot Brown, and a list of the latter's architectural works compiled from manuscripts lent by Brown's son and his son-in-law, Henry *Holland. A short essay by Repton entitled *An Inquiry into the Changes of Taste in Landscape Gardening* appeared in 1806, having originally been intended as material for Thomas Martyn's edition of Philip Miller's *Gardeners Dictionary*. The Brighton Pavilion designs were published in 1808 from the original illustrated manuscript, which is now in the Royal Library at Windsor Castle. Repton's last published work was *Fragments on the Theory and Practice of Landscape Gardening* in which he was

assisted by his son John Adey *Repton. It came out in 1816, two years before his death, and in the preface Repton commented with regret on the decline which was by then noticeable in his profession, which he attributed partly to taxation and partly to a new type of owner 'solicitous to *increase* property rather than to *enjoy* it' and anxious to 'improve the value, rather than the beauty', of his newly purchased estate.

Repton's *Sketches and Hints* involved him in a controversy over the *picturesque with Richard Payne *Knight and Uvedale *Price (authors of a didactic poem, *The Landscape*, and *Essay on the Picturesque*). Knight, having been shown the Red Book for *Tatton Park, picked out for ridicule a footnote proposing that some of the milestones on the estate should be embellished with the owner's coat of arms. Although this was to provide Thomas Love *Peacock with the character of Mr Marmaduke Milestone in *Headlong Hall*, these sallies did no serious damage to Repton's reputation and his successful practice in the early 1790s attracted the attention of the architect John Nash, then anxious to widen his own connections.

At the outset of his new career Repton had been hampered by a lack of architectural expertise, although he had no doubt that it was 'absolutely necessary for the landscape gardener to have a competent knowledge of architecture'. For some years, when architecture was involved in his commissions he had relied on assistance from architect friends such as James or Samuel Wyatt, or the younger William Wilkins. It was probably for this reason that when, on becoming acquainted with John Nash in *c*.1795, the idea of collaboration arose, Repton felt that it might be advantageous. To Nash, with his shrewd business instincts, Repton's wide circle of influential friends and clients appeared to offer potentialities. It was agreed that Repton should recommend Nash for any architectural work required in the course of his commissions, and that for these introductions Nash should pay him 2.5 per cent of the cost. The arrangement began promisingly enough with *Corsham Court where Paul Methuen had consulted Repton on alterations to the grounds in 1795. In the following year Methuen was considering James Wyatt for additions to the house, but either his plans did not meet with approval or else Repton persuaded Methuen to obtain alternatives from Nash, who in due course was given the commission. The seemingly obliging Nash had in the mean time found a place in his office for Repton's eldest son, John Adey Repton, now 21, who, although almost stone deaf from infancy, showed remarkable talent as a draughtsman, having already been employed for a time by William Wilkins. It later transpired that Nash, with little experience of Gothic work, had set young Repton on to preparing the designs for the north front of Corsham which he then presented to Methuen as his own, and there were later found to be other instances in which he had taken the credit for designs produced by his able draughtsman.

At first unaware of this, Repton continued the collaboration and produced settings for Nash's houses at Southgate Grove and Sundridge Park in 1797, and Casina at Dulwich in the following year. Luscombe, near Dawlish, for which Repton produced a Red Book in 1799 recommending the building of 'a castle which by blending a chaste correctness of proportion with bold irregularity of outline ... has infinitely more picturesque effect than any other stile of building', again saw the introduction of Nash as architect and resulted in a successful joint production. By this time, however, their collaboration was in jeopardy. Although the rift may have been exacerbated by Nash's exploitation of John Adey Repton, the major cause was his ruthless self-advancement at the elder Repton's expense. In the summer of 1797 the latter had been summoned to Brighton to advise on improving the gardens of the Prince of Wales's villa. As this involved a new conservatory, Repton honoured his agreement by recommending Nash for this small building, little thinking that from it would stem nearly 30 years of royal patronage for the architect, to the exclusion of the designs for remodelling the villa in a 'Hindu' style which Repton was to prepare in 1806. It is evident that no further collaboration took place after 1800, when John Adey Repton, unhappy at being used as a 'ghost' in Nash's office, left to join his father as an architectural assistant. By this time, however, Repton's second son, George Stanley *Repton, had entered Nash's office as a pupil, and being a more resilient character not only held his own with his employer but later became his chief assistant until 1817, when he married the daughter of Lord Chancellor Eldon and later set up his own successful practice.

There is no doubt as to the influence of Repton's theories of landscape design on Nash during their short collaboration, and it continued through George Stanley Repton in the ensuing years when he was assisting Nash in preparing sketches for the laying out of *Regent's Park and *Blaise Hamlet, as well as the alterations made to *St James's Park and the gardens laid out for Royal Lodge in Windsor Park. Among Repton's more important landscape commissions executed between 1800 and 1810 were *Cassiobury Park, Ashton Court, *Woburn Abbey, *West Wycombe Park, *Harewood House, Hylands, Oulton Hall, Stanage Park, Shardeloes, Panshanger, and Harlestone. His designs prepared for Bayham Abbey, Great Tew, and a new quadrangle for Magdalen College, Oxford, were not, however, carried out.

On 29 Jan. 1811 Repton received serous injuries when his carriage overturned on the way home from Sir Thomas Lennard's house, Belhus, in Essex. This was to leave him a semi-invalid for the rest of his life, but with the help of his elder son he was in time able to undertake a few more commissions including alterations to the grounds at *Ashridge, where he devised a 'monks' garden', a rosarium, and an *American garden. He also made improvements to the lake at Dagenham for Sir Thomas Neave, and designed some cottages at Gunton for Lord Suffield. More important, however, was the creation of *Sheringham Bower and its grounds for Abbot Upcher in 1812. In the still extant Red Book Repton remarked that the site had 'more of what my predecessor called *Capabilities*' than any other which he had encountered. 'This', he added, 'may be

considered my most favourite work.' Repton died from a seizure on 24 Mar. 1818, and was buried in a plot adjoining the south wall of Aylsham Church where a Gothic headstone is inscribed with a verse he had composed some time before. D.N.S.

See also ATTINGHAM PARK; CONSERVATORY; ENGLAND: THE EIGHTEENTH CENTURY; ENDSLEIGH; LONGLEAT HOUSE; MUSKAU; PETZOLD; PÜCKLER-MUSKAU; SEZINCOTE; VALLEYFIELD; WIMPOLE HALL.

Repton, John Adey (1775–1860), English architect, was the eldest son of Humphry *Repton. From 1789 to 1796 he worked in the office of William Wilkins, and from 1796 to 1800 in that of John Nash. At this date, his father, breaking his partnership with Nash, asked his son to undertake the architectural work of his own practice. His significance for the history of gardens is thus as an influence on his father. A Gothicist and an antiquarian himself, and responsible for many buildings in the neo-Tudor style, he led his father to design gardens that were increasingly formal, historicist, and small-scale.

After his father's death in 1818, John Repton inherited all his books and papers, drawing on them for the biography of Repton of which he is thought to be the author, and which precedes Loudon's collected edition of his works. In 1821–2 he worked at estates in the Netherlands and Germany, including those of Prince Pückler-Muskau at *Muskau in Silesia, and of Prince Hardenberg at Neu Hardenberg and Glienicke. In 1823 he designed garden furniture, including a Hardenberg *basket for the Dowager Lady Suffield at Gunton, Norfolk, but practised only sporadically thereafter. K.S.L.

See also BLICKLING HALL; CONSERVATORY.

Rheinsberg, Potsdam, German Democratic Republic. In 1734 the future Friedrich II of Prussia took over the territory of Rheinsberg and from 1734 to 1739 had the Schloss rebuilt by Kemmeter and Knobelsdorff; Knobelsdorff also drew up the plans for the 16-ha. park. There is a plain lawn *parterre on the island on which the Schloss stands. A short main axis with a long transverse axis leads from the wing of the Schloss to make the best use of the terrain. Work stopped in 1740, and in 1744 the property passed to Prince Heinrich (1726–1802), brother of Friedrich II of Prussia, who subsequently continued work on the park until 1778. Impressive avenues of lime and sentimental areas continue into the adjacent Boberow Forest.

Along the short main axis stretching from the south wing of the Schloss lies an orange parterre with the Sphinx Steps (by Glume) and at the end a columned portal with Flora and Pomona, to the east of which are a pyramid (the burial place of Prince Heinrich), a hedge theatre, and a Chinese pavilion (1765, not preserved).

Along the long transverse axis, which extends between a gentle range of hills and the Grienerick Lake, lies an oval *rond-point with the Salon, the central building of a former orangery, and wood-like *bosquets, originally enclosed by hedges. The allée terminates in the Egeria Grotto, an extensive feldspar grotto by the lake. Three wide terraces with an obelisk (1791) lie on the shores of the lake opposite the Schloss.

It is the harmony between the rococo garden with its hills and the large expanse of lake which makes the Rheinsberg Park so impressive. Extensive reconstruction began in 1975. H.GÜ.

Rhododendron. Although each species of *Rhododendron* individually occupies a limited geographical area, representatives of the genus are found in all continents except South America and tropical Africa. Most of those cultivated in the temperate world are native to the Himalayan region, China, and Japan with some from western Asia and Europe. The more tender species can be cultivated in greenhouses and conservatories and in most tropical regions.

Rhododendrons range from small, prostrate shrubs 20 cm. high to trees over 20 m. high but several of the tropical species are epiphytic. The leathery leaves usually last for more than one season except in the subgenus *Azalea* in which all species are deciduous. Most species prefer acidic soil and being sensitive to both the full exposure of the midday sun and cold winds generally grow better in semi-woodland situations. However, they do not thrive in close juxtaposition to surface-rooted trees such as elms, limes, poplars, and sycamores. Ideally they are best in groups of similar-sized plants.

The common rhododendron (*R. ponticum*), which is native to the Iberian peninsula and the eastern Mediterranean region, was introduced into Britain in 1763 and widely planted both as an ornamental shrub and a game covert. Its uncontrollable growth has meant that today it is considered the major weed of commercial forestry, particularly in Scotland, though it does have a use as a windbreak sheltering the less hardy species of the genus.

The first species to be brought to Britain, *R. hirsutum*, introduced in 1656 from Central Europe, is unusual in that it will tolerate a limy soil. Another early introduction was the Alpen rose (*R. ferrugineum*) which has been cultivated for over 250 years. Sir Joseph *Hooker was responsible in the mid-19th c. for many introductions from the Himalayas such as *R. falconeri* and *R. thomsonii*; and even today new species and forms are being brought into cultivation.

Although there are over 600 species of *Rhododendron* with every colour represented except purest blue, plant breeders continue to raise a large number of hybrid groups and many thousands of cultivars. There are now plants available for flowering at all seasons and almost every colour combination has been achieved. A major advance has been the production of the 'Indian Azaleas' used as pot plants: they are complex hybrids derived from the Chinese *R. simsii*.

Many of Britain's most widely known and visited gardens feature rhododendrons. This is for several reasons: they can present a spectacular show of large flowers early in the spring; they are usually easy to obtain and cultivate; and for historical and geographical reasons many major gardens are

situated on suitable soils and have the correct climate. Thus there are superb collections in Wales (*Bodnant), Scotland (Brodick on the island of Arran and Gigha in the Inner Hebrides), and on the sandy soils south of the River Thames (*Windsor Great Park, *Kew, *Wakehurst Place, *Sheffield Park, Nymans, and Leonardslee, West Sussex).

However, it is becoming increasingly recognized that some of the massive 19th-c. plantings can disfigure important designed landscapes of earlier periods: for example, at *Stourhead the original grand classical concept of Henry *Hoare's pleasure-garden with its lakes and temples has been obscured in some places and overwhelmed in others by the great plantings of rhododendrons of the Victorian era.

P.F.H.

Ribbon wall. See SERPENTINE WALL.

Richard, a dynasty of French gardeners and botanists of Irish origin. **Claude I Richard** came to France as a refugee with James II in 1690. His son, **Claude II Richard** (1705– 84), worked for an English nobleman at Saint-Germain where he assembled and acclimatized many rare plants. When his employer returned to England, the garden was given to his gardener, who set up as a nurseryman. About 1750 he was appointed *jardinier-fleuriste du roi* and charged with the creation of a new flower garden at Trianon (see *Versailles: Grand Trianon). In the glasshouses he constructed he created suitable conditions for growing seeds and plants which Le Monnier, doctor to Louis XV, acquired from plant-hunters all over the world. He was the first in France to cultivate species requiring a particularly light acid soil, such as rhododendrons. He listed the plants and seeds at Trianon, which he offered in exchange to all the important botanical gardens of the time. He frequently entertained Bernard de Jussieu and corresponded with Philip *Miller. *Linnaeus wrote to him in 1764 expressing astonishment at the number of rare plants he had procured, particularly those from Peru. In 1764 the Trianon collections numbered more than 4,000 species; and Claude Richard had earned the title of *jardinier-botaniste du roi*. A plan of the garden was made in 1774 (now in the collection Le Rouge, Musée Carnavalet) shortly before it was suppressed when Marie-Antoinette transformed Trianon.

Claude's son, **Antoine Richard** (1735–1807), was sent by the king on plant-hunting missions to Mont-Doré (1758), Spain, Portugal, and the Balearic Islands (1760–4); and later to North Africa and the Middle East. He was appointed *jardinier-botaniste* at Trianon in 1767. It was he who planted the new Trianon, designed by Mique, in the landscape style, incorporating a collection of exotic species acclimatized by his father and himself. Respect for his knowledge and integrity enabled him to save Trianon from destruction after the Revolution, and to transport the rarer plants to the old Potager du Roi (Versailles). The new garden, of which he was director, formed the basis of a School of Botany, and included a remarkable collection of plants for medicinal use, and a nursery of fruit-tree grafts.

Less is known about Antoine's brother, **Claude III**

Richard (c. 1730–c. 1788). He was first employed in the royal nursery of the Roule, north of the Champs-Elysées. When it was decided to move this, c. 1753, he was entrusted with the creation of a new nursery at Auteuil. His eldest son, **Louis-Claude-Marie Richard** (1754–1821), studied botany and architecture and achieved considerable success as a landscape architect. He was chosen by the Académie des Sciences for a mission to Guiana as *naturaliste du roi* in 1781. The collections he made included more than 3,000 plant specimens, annotated and illustrated by drawings.

K.A.S.W.

Richelieu, Indre-et-Loire, France. The château and town were designed by Jacques *Lemercier for Cardinal Richelieu (1585–1642). Conceived in 1628, the work was supervised until 1639 by Pierre Lemercier, Jacques's brother. House, gardens, and town were incomplete at the Cardinal's death, and they were finished by his great-nephew, Armand Jean Vignerot du Plessis, Duc de Richelieu. They are illustrated in engravings of c. 1660 by Jean *Marot.

Richelieu was an attempt to realize the Renaissance town-planner's dream. The extensive grounds of the château (approaching 500 ha.) were laid out in a rectangular grid, with gardens not only on the axis of the château, but along the canalized River Mable at right angles to it, the first time a second major axis was used in a garden plan on this scale. The water from the canal fed the moats surrounding the château, the parterre, and the town itself. These survive; whereas almost the only existing buildings are one of the office pavilions (now a museum) and two architectural 'grottoes' with triangular frontispieces which flanked the parterre and amphitheatre adjoining the forest.

The château was destroyed between 1825 and 1835, and the park sold. Since 1930 it has belonged to the University of Paris and is used as an experimental agricultural centre, where the relics of Richelieu's palace stand in a setting of avenues, cornfields, and canals.

K.A.S.W.

Richmond (*fl.* 1763–85), English landscape designer, first appears as an improver when his design for Danson Park, Kent, was put before Joseph Spence in 1763. He worked on the lake at Shardeloes, Buckinghamshire, and was at Stanmer, Sussex, before going to Saltram, Devon, in 1769. In 1775 he formed the lake and plantations at Stoke House, Buckinghamshire, which his client, John Penn, praised in his 'Account of Stoke Park' (1813). Richmond was at Lee Priory, Kent, in 1780, but he was dead when Humphry *Repton wrote in 1788 that 'the works of Kent Brown and Richmond have been the places of my worship'.

Repton's Red Book for Lamer, Hertfordshire, of 1792 contained a critical, but still generous, appraisal of him: 'he understood perfectly how to give the most natural shape to artificial ground, how to dress walks in a pleasure garden, and how to leave or plant picturesque groupes of trees, his lines were generally graceful and easy, but his knowledge of the Art was rather Technical and executive, than theoretical; he could stake out the detached parts of a place with

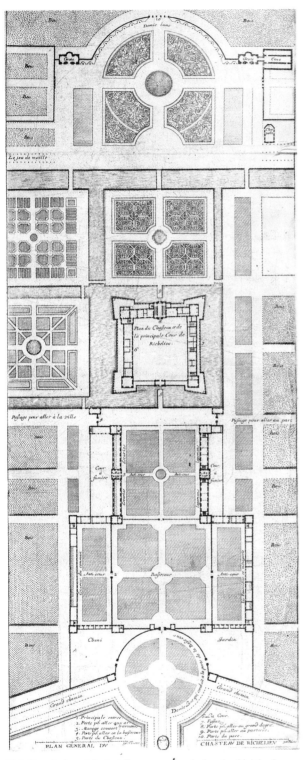

Richelieu, Indre-et-Loire, France, general plan (c.1660) by Jean Marot (Bibliothèque Nationale, Paris)

much taste, but of the great outline he had so little idea that he never delivered any general plan.' D.L.J.

Richmond Gardens, London. See KEW, ROYAL BOTANIC GARDENS.

Rievaulx Terrace, North Yorkshire, England, created by Thomas Duncombe III, was said to be envisaged as a continuation of the *terrace walk at *Duncombe Park. Like it, it is a landmark in the development of the English landscape style, encapsulating as it does anticipations of the later picturesque and romantic styles. Again the terrace walk sweeps in a graceful curve for 0·8 km. above a high wooded escarpment with classical temples at each end— one Ionic (1758) with frescos by Giovanni Borgnis, the other a Tuscan temple. But this terrace follows a serpentine line, and its break from formality is well shown by the waving line of the edging woodland and the width of the walk which varies from 60 m. to 120 m. The vistas of 'moving variation', as Arthur Young called it in 1770, are of the romantically sited and ruined Cistercian Rievaulx Abbey deep in the valley, seen in a score of different views through rides cut in the steeply falling wooded hillside. K.LE.

Rigaud, Jacques (c.1681–1754), French draughtsman and engraver, was born at Versailles and seems to have lived in Provençe until 1720, making topographical drawings and engravings. In 1730 he published *Recueil choisi des plus belles vues des palais, châteaux, et maisons royales de Paris et des environs*, which includes the *Tuileries, *Luxembourg, *Versailles, *Marly, *Meudon, *Saint-Germain-en-Laye, *Fontainebleau, Vincennes, Choisy, *Saint-Cloud, *Sceaux, Bellevue, La Muette, Madrid, *Chantilly, Berny, Clagny, *Rambouillet, Chambord, *Blois, *Anet, Monceaux, and Saint-Maur. He visited England in c.1738–9 and made a series of drawings of *Stowe and *Chiswick House. K.A.S.W.

Rikugien Park, Tokyo, Japan, a *daimyo* *stroll garden, was built by Yanagisawa-Yoshimasa (1658–1714) between 1695 and 1702. The garden was originally designed to represent 88 picturesque scenes based on the old anthology Manyoshu and others. The name Rikugi was derived from the six principles of poetry in the ancient Chinese classics. After the death of Yoshimasa, the garden was abandoned for several years; it was restored in the late Edo period but some of the original features had already been lost. During the early period of Meiji, Rikugien came into the possession of Baron Iwasaki, a businessman who made a careful restoration of the garden. In 1938, the Rikugien property was given to the City of Tokyo by the Iwasaki family and opened to the public.

The garden has a large central pond with small islets and a main island, on which a collection of rare stones is preserved. The south-east portion of the garden consists of flat land with plantings; the rest of the land is connected with mounds of varying height, with the highest point at the north, from where one can overlook the entire garden. S.S.

Rikyu, Sen No (1522–91), Japanese tea master, Zen Bud-dhist priest, and aesthete of the Muromachi/Momoyama periods. Under him, the tea-house was transformed from an open structure with windows and a verandah into an austere enclosed space with one window and a low narrow entrance 25 sq. cm. in size, thus emphasizing the spiritual nature of the tea ceremony. Unlike his famous pupil, *Kobori Enshu, he was a master of contrived naturalism and understatement: having swept his garden of autumn leaves, he would shake a tree and let the leaves that fell lie as they were; at his seaside tea-garden, guests glimpsed the view only when they bent down to the stone laver for ceremonial lustrations. S.J.

Rippon Lea, Victoria, Australia, Sir Frederick Sargood's 11-ha. Melbourne estate (purchased 1868), was created by Victorian commercial success. It is probably the finest example of a late 19th-c. landscape around a suburban mansion still extant in Australia.

The gravel drive, overhung by vast Moreton Bay figs, winds through dense foliage offering occasional views of lawn, a tower, and finally the entrance front, dominated by the *porte-cochère* (carriage porch) and the conservatory.

On the west front of the house there is a view over a formal terrace to a wide expanse of lawn fringed with mature trees—deciduous oaks, elms, and evergreen conifers. To one side of this lawn is the drive; to the other, screened by willows and poplars, is the extensive lake, fed by a stream which emerges from the massive fern-house. Tall palms now thrust through its iron framing and slatted roof. The lake is dotted with islands linked by rustic cast-iron bridges. An *artificial 'hill' of boulders, complete with tunnels and waterfall, and covered by cacti and other succulent plants, is topped with a lookout tower with panoramic views of Port Phillip Bay and Melbourne.

Nearby is the rose-garden and south lawn, habitat of peacocks. Linking this area to the main lawn is the swim-ming-pool, surrounded by 1930s Spanish-style buildings in yellow stucco. H.N.T.

Ritsurin Park, Takamatsu City, Japan. Designated as a 'special place of scenic beauty' in 1953, this 75-ha. garden is now a public park. Originally, the lord Ikoma-Chikamasa built his castle on this site in 1587. Later on, the Ikoma family built Ritsurin-so, the chestnut villa, so called because of the abundance of chestnut trees growing in the area, and constructed a portion of its garden. Around 1643, however, the lord Matsudaira-Yorishige came to take over the place and attempted to restore the former garden. In 1897, permission was given for some 38 ha. of the national forest area to be used for the park. The northern portion of the garden was remodelled in the Western manner *c.*1913.

Ritsurin Park proper contains six ponds and 13 artificial hills of varying heights. The ponds have islands and the bridges and many connecting paths make a large-scale stroll garden, entirely surrounded by moats. The long, curved wooden bridge in the southern pond area is of particular beauty. The garden as a whole has the air of a Western garden, especially of an English naturalistic park. The park is under the supervision of Kagawa Prefecture. S.S.

Rippon Lea, Victoria, Australia, the lake

Robert, Hubert (1733–1808), French painter and garden designer. Admitted to the Académie de Peinture in 1766, he was later invited by the Comte d'Angiviller, *surintendant des bâtiments* to Louis XIV, to provide a landscape setting in the new style for the Bosquet d'Apollon at *Versailles. His success earned him the appointment as *dessinateur des jardins du roi*. Robert, who had made drawings of *Moulin-Joli, Chanteloup, and *Ermenonville, became in his turn a creator of gardens, proliferating *fabriques*, ruins, and memories of Italy at *Méréville and *Betz. He was consulted for the royal domains of Compiègne, *Rambouillet, and doubtless the Petit Trianon. He was also the chronicler of events in the capital (fires, town-planning, revolutionary incidents); and was appointed to the Commission for the conversion of the Grande Galerie du Louvre into a museum (1784), for which he put forward numerous projects. His career was upset by the Revolution, but he subsequently regained his official position. M.M. (trans. K.A.S.W.)

Robin, Jean (1550–1629), French botanist, herbalist, and gardener, was born and died in Paris where he qualified as an apothecary and established a garden in the Ile de la Cité (now Place Dauphine). Henri III granted him the title of *arboriste et simpliciste du roi* and gave him the direction of the gardens of the Louvre, posts which were confirmed by Henri IV and Louis XIII. When the Faculty of Medicine at Paris decided in 1597 to make a botanic garden Robin was invited to draw up the plans. The project for the Jardin Royal des Plantes Médicinales (later the *Jardin des Plantes) was not realized until 1626.

Robin's garden was famous for the number and variety of flowers, many of which were illustrated by Pierre Vallet. Robin set the fashion for the tuberose (*Polianthes tuberosa*); and from seeds from Virginia he grew the first false acacia, which is named after him *Robinia pseudacacia*. He published *Histoire des plantes aromatiques* anonymously, and catalogues of his plants in 1601 and 1619. His work was carried on by his son Vespasian (1597–1662). K.A.S.W.

Robins, Thomas the elder (d. *c.*1770), was an English artist who, until the 1960s, was either wholly unknown or confused with his namesake son, who much later painted beguiling flower pieces on vellum. The discovery of this 'limner of Bath', as he is identified on his tombstone of 1770, now provides the only known pictorial record of English gardens between 1747 and his death. He was much in demand by land-owners who wished to record improvements newly made to their properties.

His earliest painting of a property is a bird's-eye view, oil on canvas, of Charlton Park near Cheltenham, which immediately establishes Robins's most valuable qualities as a garden recorder: the detail is so exact that every herb in the kitchen garden, every tree in an obviously new plantation, and every aspect of daily life that went on in the garden—a game of bowls, the owner and his guests enjoying the view, dairymaids milking, horsemen passing along the main road—are platinum-print clear. The conventions of tilted foreground, bird's-eye perspective, and careful detail are repeated in his other early paintings: Dickie Bateman's house at Old Windsor, Berkshire; Marybone House, Gloucestershire; and the nearby Painswick House.

His only chimerical landscape was a capriccio in which a Bristol cross, Gothic pavilion, Chinese bridge, and fretwork fence tumble over a garden clearly more at home on a Song scroll than in rural England. However, his best paintings—Woodside House, Berkshire; an unidentified Gothic temple; Honington Hall, Warwickshire; and a matching pair from an unidentified garden in Gloucestershire—again incorporate the frame. These are no longer naïve in execution but bewitchingly lyrical and are important for recording garden details including rollers, rakes, and other implements of the time; furniture and small buildings; cascades, grottoes, and *ha-has; and the social life which was, of course, the reason why so much thought and money were expended on the garden. C.G.

Robinson, William (1838–1935), Irish gardener and writer, began his gardening career early in his life on the estate of the Marquess of Waterford at Curraghmore, from which he moved on to a period as a student at the Irish National Botanic Garden at *Glasnevin. His next post was at Ballykilcavan, where he stayed until the winter of 1860–1, when a quarrel with the head gardener caused his departure. It is said that this came so suddenly that the greenhouses in his care cooled off rapidly, with consequent damage to their contents.

In 1861 Robinson moved to London and joined the staff of the Royal Botanic Garden in Regent's Park (on the site of the present rose-garden). From this point, his life as gardener and writer became a horticultural version of the classic Victorian pattern of diligence and energy leading to success, with his preferences having an immense influence on the design of both contemporary and later gardens. At Regent's Park he became the foreman in charge of herbaceous plants, studying the native flora as well as cultivated forms, and making many excursions to look at private or public gardens in other parts of the country. He also began his journalistic work with a series of contributions to the *Gardeners' Chronicle*. He was elected a Fellow of the Linnean Society on 19 Apr. 1866, his sponsors including James Veitch, Charles Darwin, and David Moore, director of the Glasnevin garden. Soon after, he left the Royal Botanic Garden to continue his independent career.

Most of 1867 was spent in France, visiting gardens of all kinds and reporting on the horticultural parts of the International Exhibition in Paris for the *Gardeners' Chronicle*, the *Field*, and *The Times*. The replanning of the centre of Paris in the 1850s and 1860s had made room for the creation of new parks, squares, and boulevards, and the new gardens were being filled with many more plants. Two of Robinson's early books, *Gleanings from French Gardens* (1868) and *Parks and Gardens of Paris* (1869) were results of this journey. So was his reintroduction of that useful French tool, the *sécateur*. Fruit and vegetables were noticed, as well as ornamental plants, and his acquaintance with the

*Vilmorin-Andrieux firm of nurserymen was also established.

Two books first published in 1870, *Alpine Flowers for Gardens* and *The Wild Garden*, reflected particular interests of their author. The first was written 'to dispel a general but erroneous idea, that the plants of alpine regions cannot be grown in gardens', incorporating observations made on his own journeys in the Alps. *The Wild Garden* encouraged 'the placing of perfectly hardy exotic plants under conditions where they will thrive without further care', an idea so important in modern gardens that the book was reprinted in 1977 and again in 1983. Robinson's alternatives to the formal bedding-out of tender plants contributed to a revolution in garden design. His influence still flourishes in the current taste for informality, with bulbs massed among grass, mixed borders of native and exotic plants, and a softer and more subtle use of colour and plant associations.

These favourite Robinsonian themes began to reach a wider audience with the establishment of his weekly journal, the *Garden*, in Nov. 1871. He edited it until 1899, when he was briefly succeeded by his friend Gertrude Jekyll, and the *Garden* became part of *Homes and Gardens* in 1927. His descriptions of plants in the *Garden* lead directly to his most famous book, *The English Flower Garden*, first published in 1883, running to 15 editions during the author's life and several more later. The flood of new plants introduced during the 19th c. was recorded in an illustrated, alphabetical catalogue, with detailed descriptions, making up about two-thirds of the book; the rest gave advice on planning small or large gardens, with lists of appropriate plants for particular situations and purposes and further encouragement for a more natural style of design.

More periodicals were established to propagate Robinson's ideas: *Gardening Illustrated* in 1879, a weekly concentrating on practical information, now merged with the *Gardeners' Chronicle*; *Cottage Gardening* (1892–8), a cheaper weekly for a more humble audience; and finally *Flora and Sylva* (1903–5), a handsome monthly. The flow of books was steady too, mostly on various aspects of gardening, including the culture of mushrooms and asparagus, hardy and subtropical plants, but with occasional excursions to subjects like the design of cemeteries (encouraging cremation) and the management of wood fires. His book on clematis, *The Virgin's Bower* (1912), showed his preference for English plant names. He also edited W. Miller's English translation of the Vilmorin book, *The Vegetable Garden*, published in 1885 and reprinted in 1976.

In 1885 Robinson was able to buy the estate of *Gravetye Manor, where he made the surroundings of the Elizabethan house an example of the kind of gardening he preferred.

S.R.

See also SHRUBLAND PARK; WILD GARDEN.

Rochford family, a dynasty of nurserymen that began with **Michael Rochford** (*c.*1819–83) who came from Ireland in 1840 to be steward at Duncombe Park in Yorkshire. In 1857 he came to London and founded a nursery in the Lea Valley at Page Green, now the site of the Tottenham Hotspur football ground. Here he grew pineapples, grapes, and pot plants, especially ferns, under glass. His six sons were all gardeners, and two of them in particular, Joseph (1856–1932) and Thomas (1849–1901), founded firms which still survive.

Joseph Rochford, with his brother John, began building larger glasshouses, heated, after 1873, by the 'Rochford tubular boiler'. In 1882 Joseph established his own nursery and market garden on 3 ha. at Turnford, near Broxbourne, Hertfordshire, growing cucumbers, lettuces, grapes, pineapples, flowers, and ferns for the London market. Tomatoes were later an important crop, housed in an ever-growing range of glasshouses. Now there are nurseries at Broxbourne, Slough, and Letty Green, near Hertford, with branches in the Isle of Wight and Kenya, run by later generations of the family.

Perhaps the most famous Rochford enterprise is the one started by **Thomas Rochford** in 1888 at Turnford. He concentrated on ornamental pot plants, using a large refrigerator to retard the flowering of lilies of the valley, azaleas, and lilies. Flowers and pot plants were sold in Covent Garden, and by 1914 more palms had been introduced and were being exported in large numbers to the United States. Hydrangeas and ferns were other specialities.

Thomas Rochford's grandson, another **Thomas Rochford** (1904–), enlarged the trade in house plants, so that the nurseries of the House of Rochford were the largest to specialize in this group. As better heating made more houses comfortable for exotic plants, the variety available grew, prompted by Constance Spry, who, in 1947, suggested indoor ivies and the Australian kangaroo vine (*Cissus antarctica*) as good subjects. Betty Rochford's displays of the plants at the Chelsea Show and elsewhere helped their rapid growth in popularity, so that rubber-plants, cacti, poinsettias, saintpaulias, coleus, philodendrons, and many others have become familiar decorative plants.

In 1984 Rochford's no longer found it economic to grow pot plants for sale.

S.R.

Rock-garden. See ALPINE, SCREE, AND ROCK-GARDEN.

Rocque, John (1704/5?–62), French surveyor, probably reached England in 1709 as a refugee, later serving as an apprentice and journeyman. In his first publication, a plan of Richmond (1734), he described himself as 'dessinateur de jardins'. As usual with Rocque, the authenticity of details—extent of plantations, types of trees, garden developments as shown in revisions of plan—cannot be blindly accepted. Further garden plans, notably *Wrest Park (1735), *Claremont (1738), *Painshill (1744), and *Wilton House (1746) followed. Usually the competent survey is more thought-provoking than the marginal pictures, which tend to be unimaginative and may depict humans, animals, or boats out of proportion with the background. Rocque's town plans, including the often-reproduced 'London' (1746), show formal layouts predominating in suburban seats and

details of agribusiness—cherry markets and nursery gardens. H.BI.

Roissy-en-France, Val d'Oise, France. See CARAMAN, VICTOR-MAURICE DE RIQUET, COMTE DE.

Roman, Jacob (1640–1716), Dutch sculptor and architect to William III, was largely responsible for the house and gardens of *Het Loo (1685–92), *Zeist (1685–6), and *de Voorst (1695–7), which Daniel *Marot embellished with ornamentation. The classical plans of Roman's gardens, bounded by *exedra, are reminiscent of those of *Luxembourg and *Richelieu, and are characterized by a sober flat rigidity which was enlivened by Marot's ebullient baroque ornament. F.H.

See also NETHERLANDS: THE DUTCH CLASSICAL GARDEN.

Roman Empire. The model of the Roman house and its garden (see Ancient *Rome) was widely adopted in the provinces of the Roman Empire but though we have many house plans, details of gardens are somewhat lacking. In southern Gaul, however, several cities were provided with quite substantial houses of the *Pompeii type with peristyle courtyards presumably laid out as gardens. Plans exist from Glanum, Lyon, Vaison, and *Vienne. Of these, the large residential suburb of Saint-Romain-en-Gal, on the opposite bank of the Rhône to the centre of Vienne, provides the most relevant examples. Here, a number of the peristyle gardens were, in fact, constructed as pools containing raised ornamental flower-beds edged in brick. Basins of this kind are known at Pompeii and had clearly become popular in Rome, for an elaborate version was created in the Domus Augustina—the Flavian palace built on the Palatine in the third quarter of the 1st c. AD. It is interesting to see Imperial taste so quickly taken up by the provincials.

Another series of exactly similar water-garden peristyles has been exposed in the Portuguese city of *Conímbriga. Of these, by far the most elaborate is the House of the Jets of Water, a luxurious town house copiously fitted with mosaic floors. In the centre of the building is a large rectangular colonnaded courtyard designed as a pool containing six ornamental raised flower-beds. The house is so named because embedded in the walls of the beds, and in the surround to the colonnade, are water pipes providing water under pressure to 400 individual jets. The overall effect would have been much like the gardens of the *Alhambra.

In the more northerly provinces evidence of gardens and gardening is sparse. Only at the elaborate late 1st c. AD palace at *Fishbourne near Chichester (England) have extensive archaeological traces of a formal garden come to light but other sites have produced indirect evidence. Another, more modest, villa at Frocester Court in Gloucestershire fronted on to a walled courtyard which was divided into two by an approach road. On either side of the road, and in front of the villa, patches of prepared garden soil were located, suggesting a series of discrete flower-beds beyond which, on one side, the excavator has suggested that the soil conditions may have been appropriate to an orchard. Similar gardens were probably laid out in most of the large courtyard villas which were such a familiar aspect of the countryside in Britain, Gaul, and Germany, particularly in the later years of the Roman occupation.

Indirect evidence for gardening activity sometimes comes from waterlogged deposits on Roman sites, where pollen, seeds, and fragments of vegetation may be preserved. At the small Roman town of Calleva Atrebatum (Silchester) in northern Hampshire, extensively excavated between 1890 and 1909, waterlogged sediments were regularly excavated and the plants identified. Subsequent additions from other sites have produced a most impressive list of cultivated plants including fruit-trees like plum, walnut, fig, and almond, and herbs such as dill, coriander, fennel, and parsley, together with many others—the plants one might reasonably expect to have been grown in the garden of a comfortable town house.

On a broader front, Roman writers (see e.g. *Pliny the younger) mention a wide range of favoured flowering plants: the attractions of box, ivy, myrtle, laurel, rosemary, and acanthus are frequently described, together with violet, rose, lily, poppy, iris, and chrysanthemum. All are confirmed on the numerous wall-paintings of Roman gardens which still survive. Together they give a picture of massed greenery enlivened by small points of colour, thoroughly suited to the hot Mediterranean climate. How the ideal was transformed to suit more the temperate conditions of the north we have yet to find out. B.W.C.

Romania. Romania's geographic position 'at the crossroads of great empires', as a French author put it, overrun as it was for centuries—before its provinces were reunited and formed into a modern state—by the soldiery who cared about nothing but their billets, and who trampled the frail beauty achieved by the landscape gardener, allowed very few, if any, gardens to survive.

That Romanians were sensitive to the rendering in a limited space of the effect produced by nature in its various and majestic ways, is attested by the account of a Romanian, Constandin (Dinicu) Golescu, who travelled in Austria and Switzerland from 1824 to 1826 and endeavoured to share with his countrymen his admiration for the parks and gardens he visited (*Insemnare a calatoriii mele, Constandin Radovici din Golești, facuta in anul 1824, 1825, 1826* (Bucharest, 1964)). While Golescu (1777–1830) expresses his enjoyment, he cannot help deploring that 'what we put together working during ten years, we lose in one single day', and he goes on to conclude 'only a tenth part of what my own hands have worked . . . and seeded would satisfy me, but now the place itself is barely recognizable . . . and were I to note the destruction in breadth and depth suffered by Romania—five times in the space of twenty-six years—it would take a whole volume to enclose.'

The first garden mentioned by Golescu is that of Baron Brukental at Avrig in Transylvania, and he is immediately faced with the difficulty of expressing—in the still archaic form of his mother tongue—the topical terms used in the

West: 'terraces like a staircase where the degrees would be wide instead of narrow are cut into the hill, some smaller, other larger, supported either by turf or masonry, with huge steps of stone leading up to them; then basins with fountains throwing upwards strong jets of water; rivulets winding all through the garden, then falling into a beautiful cataract, that is a sheet of water falling from a height with speed. Near this, a pavilion covered outside with the bark of trees and roofed likewise, and beautifully ornamented inside. Fruit trees, some local, but also many foreign which have to be taken indoors at wintertime; many kinds of flowers as well, these too, local and foreign, and alleys of tall trees and shorter ones, and some shorn to look like walls. Dark groves and many Embellishments at a great price obtained, and with much effort. And all this, now (1826), much degraded compared to twenty-four years ago when I first got to see it.'

Golescu has a word for all the gardens he visits, intriguing the passers-by with his oriental garb. But it is at the garden at *Schönbrunn, near Vienna, that words fail him: 'no one may enter that garden without being moved one way or another, that is: if he is sad, he would be filled with joy; or being cheerful, he may give in to melancholy, and again, if neither, one of these moods is bound to overcome him—escape is above one's strength. . . A boyar told me', he adds, 'in all humility that he would rather be a gardener there, than in the present down-trodden Romania.'

Back home, on his estate on the outskirts of Bucharest, Golescu created a vast garden which he named Belvedere, and which at the time 'was much admired for its novelty and beauty' and when this comes to be lost, his youngest son, Alexandru, will be teased because at Goleşti, the family seat, 'he works like a slave at his garden, stubbornly trying to make grottoes and waterfalls, and suspended bridges, on flat land!' (Letter of 1858.) M.G.

See also GERNYESZEG; MAIA; SCULPTURE GARDEN; 'SUMMER GARDENS'.

Rome. See ARCADIAN ACADEMY; BELVEDERE COURT; BORGHESE, PALAZZO; BORGHESE, VILLA; DORIA PAMPHILI, VILLA; GIULIA, VILLA; MADAMA, VILLA; PIA, VILLA.

Rome, Ancient

The art of gardens, as it existed and developed in the area once included within the *Roman Empire, was formed at Rome. While retaining certain elements which came from the Orient (Egypt, Persia (Iran), and the Hellenistic world), it formed a synthesis from them and gave them an aesthetic. We have proof of their existence dating from the end of the 2nd c. BC (the 'villa' of Scipio Aemilianus at Rome, near the site of the present Villa Colonna); they developed rapidly from the period of Sulla (c.90 BC), both in the town and on the hills of the 'Castelli' (Tivoli, Frascati, etc.), on the coasts of the Tyrrhenian sea, on both sides of the mouth of the Tiber, and also in the *campagna*. Soon there were gardens throughout Italy (such as the villa of *Pliny the younger in Tuscany), and, eventually, in the Roman world, from Britain to Syria. The art spread to the countries which descended from the Empire, in the East and in the Islamic countries. It was bound up with the architectural traditions and also the style of life characteristic of Roman civilization.

SOURCES. This art, an art composed of notably perishable materials, is known to us from several sources: from representations (pictures); from literary texts (see *Cato; *Columella; *Pliny the elder; *Varro; and *Virgil); sometimes (rarely) from inscriptions; occasionally from more or less well-preserved monuments; and, most importantly, from the gardens of the towns and villas engulfed by the eruption of Vesuvius in AD 79 (*Pompeii, Herculaneum, and Stabies), and also of villas situated elsewhere, the major one being that of the Emperor Hadrian (AD 117–38) at Tivoli.

The available archaeological evidence testifies to two principal types of Roman garden: enclosed gardens (for example, the peristyles of Pompeii), and open gardens (*Hadrian's Villa). In the first type, the architecture surrounds the garden, which is like a room in the house; in the second, the buildings are inserted into the garden, which acts as a framework or as décor. Excavation provides different information in each case: in that of the Pompeian peristyles it allows the (probable) identification of their plant material; in the large villas not in the *campagna* excavation can inform us only about the disposition of the buildings, the statues, the overall design, and, in very few cases, the planting.

ELEMENTS FROM OTHER TRADITIONS. From the *Odyssey* (see *Homer) onwards, the Greek tradition (see Ancient *Greece) was no stranger to the charm of orchards, and of fresh springs gushing out of *grottoes, and these were made the homes of the gods. Classical Greece knew of such gardens, annexed to the sites of cults or planted around the tomb of a hero (such as the garden of the Academos at Athens). Thus we know that plane trees were planted by Timon on the *agora* (market-place) at Athens, a little before the middle of the 5th c. BC. The Academy, until then rather deprived of water, was laid out and irrigated, and *allées* and pathways were established in the leafy shade. This type of garden was to be adopted by the Romans from the beginning of the 1st c. AD. Perhaps Timon got the idea for this planting from the *paradeisos* of the kings of Persia, who enjoyed considerable prestige at the time of the Medean wars: these royal parks were to attract the admiration of the Romans, who were to penetrate into Asia during the course of the 2nd c. BC and who came to know the palaces of the Hellenistic kings.

One should also include among these 'models', or, rather, elements utilized by the Romans, the gardens of *Egypt, which traditionally included a sheet of water, sometimes, where size permitted, a canal upon which one travelled by boat. This idea was also to be adopted by the Romans, who made what they called 'euripes'; for example, in the garden of the house of Loreius Tiburtinus, at Pompeii. But above all it was the gardens of the Ptolemies which caught the Romans' imagination. Alexandria was the town of flowers; under the Lagides, it had also become the town of Dionysus, who was assimilated with the god Serapis; and Dionysus, protector of the Ptolemaic monarchy, was honoured in a landscape made of rockery, covered with ivy and vines. The procession organized by Ptolemy II Philadelphus included among other marvels a chariot bearing a grotto shaded by ivy and yew, out of which flew doves. In the same vein, towards the middle of the 3rd c. BC, the King of Syracuse, Hieron II, had a ship built carrying similar gardens. Already in the 5th c. BC Gelon had laid out gardens around Sicilian towns and dedicated a wood (around a grotto) to the nymph Amalthea, nurse of Zeus. Thus by the end of the 2nd c. BC the Romans had at their disposal the elements which were to constitute their art of gardens, which took various possible forms, such as the sacred landscape, urban promenades, or meeting places for philosophers and for those dedicated to literary activity (as at the Museum of Alexandria and the Academy of Athens). These designs, famous and isolated, of the Hellenistic world, are the origin of countless Roman adaptations and imitations.

THE GARDEN IN THE HOUSE. Whereas in the Hellenistic world gardens were inserted either into public monumental spaces (the *agora*, promenades) or, more frequently, into royal palaces, the layout of the traditional Italian house was modified to accommodate private gardens. Beyond the atrium, a courtyard open to the sky and the centre of family life, there had always existed an enclosed space, the *hortus*, for the cultivation of vegetables. This *hortus* then became a pleasure-garden; surrounded by porticoes, it was the 'peristyle'—the area it marked off was planted with shrubs and flowers, and fountains were laid out there. In fact, the peristyle was an urban building, transposed and adapted to accommodate the garden, which was therefore integrated into daily life. The atrium became a semi-public reception room; but, with the peristyle beyond the *tablinum* which closed it, there opened a new apartment, more private and dedicated to leisure. This enclosed garden symbolized the growing importance accorded to *otium*, to 'free time' and leisure. The décor of these gardens varies, but includes themes of sacred character, especially Dionysiac—for example, *herms representing a god or his followers, statues of fauns, fountains in the form of grottoes; ivy and myrtle (the plants of Bacchus and Venus respectively) form scenery forever green.

This essentially decorative and symbolic art took the name of *ars topiaria* (see *topiaria opera*, *topiarius*, *topiary*), a term whose meaning is often misunderstood. The aim of this art was to represent, with the aid of elements provided by Nature (plants, water, rocks, perspective), composed scenes, or *topia*.

THE GARDEN AND THE SACRED. The relationships which existed between landscape painting (as it developed in Rome) and the art of gardens suggest that both expressed a feeling for Nature in which the presence of divinity is essential. This explains why sanctuaries, tombs, statues, and all kinds of chapels are to be found on paintings and reliefs (the House of Livia on the Palatine; the stuccoes in the Farnesina) and in gardens (the Temple of Venus in the gardens of Sallust, Rome; the Temple of Fortune in the gardens of Caesar; the Temple of Hercules in the villa of Pollius Felix at Sorrento, etc.).

At Hadrian's Villa, the Canopus (see plate VII*b*), reproducing the most eastern branch of the Nile delta, is a real *téménos* (sacred enclosure) dedicated to the god Serapis. In the smallest gardens one is bound to meet at least one Priapus, the god of fertility and symbol of the life which rises up from the ground, in which are laid to rest the ashes of the dead; as one inscription puts it, Priapus is 'the place of life and death'. He was placed in funerary gardens, the cultivated space which occasionally surrounded tombs, and which for the most part consisted of a trellis, a well, and a triclinium for banquets in honour of the dead.

The Roman garden is therefore at the centre of a network of feelings and inclinations, inherent in the Roman sensibility: the sense of universal life, expressed by the presence of divinities; a taste for luxuriant vegetation, picturesque topiary remaining exceptional, answering the desire to unite art and Nature; and flowing water. Notable in this respect are the representations of gardens, on one or more garden walls, such as those of the villa of Livia, the so-called auditorium of Maecenas, and of several houses at Pompeii: beyond a trellis border is to be seen an apparently impenetrable *bosquet* of laurels and myrtles, sometimes with a fruit-tree overlooking the thicket. A frequent motif is that of a serpent coiled round the trunk, watching the fledglings in a nest perched at the top of the tree. It is known that in household shrines the serpent symbolizes the 'genius' of the earth; its presence in a garden is certainly significant.

THE *FABRIQUES. The 'open' garden is the home of buildings, which form an element of the landscape. Urban buildings are placed in it; at first, gymnasia (the villas of Cicero), *allées* surrounded by *bosquets* or porticoes, sometimes with trees replacing the columns, pavilions of various kinds (*diaetae*, towers, little temples) dedicated to leisure, solitary or in company. The villas of Pliny provide the best examples. But dating from the time of Nero (AD 54–68), the garden of the Golden House, on the banks of the lake (the present site of the Colosseum) which was formed at its centre, constituted an entire rustic landscape, with houses, woods, and small-scale pastures, apparently similar to those of the painting and the reliefs of the Augustan period. By giving them a large scale, Hadrian's Villa multiplied these elements in the landscape. Here we see the

very principle of landscape 'in the Roman manner': nature animated by human presence, the juxtaposition of buildings and wild *bosquets*, where the value of nature is realized by artifice. Some representations show how trellis-work, formed from intertwining wood lattice, was used to imitate the forms of masonry; rose bushes were made to climb up the trellis. There were also terraces covered with lawns; and the *allées* were bordered by flower-beds—such plant decoration being considered part of the art of topiary (for a list of the 93 plants cited in the texts or recognized in the paintings, see P. Grimal, *Les jardins romains*, 1969).

In addition to architecture, real or artificial (made up by bowers), Roman gardens contained a great number of statues, either standing alone, or, more commonly, in groups as a *mise-en-scène* of poetical mythological legends (such as the massacre of the Niobe, or the Calydon Hunt). Let us also remember that the arrangements of rock-work, with their artificial grottoes in volcanic stone, were used as pavilions set aside for pleasure (romantic meeting-places described by Horace) or for poetic meditation (the sacred grotto with its freshwater spring symbolized lyric poetry).

THE GARDENS OF ROME. A great number of private parks are known from texts and inscriptions, from the end of the 2nd c. BC. These gardens were established on the hills surrounding the town centre: the Quirinal, Esquiline, and Aventine hills, the right bank of the Tiber, and also the 'hill of gardens', now the Pincio. In the Republican period, the most famous were those of Lucullus and of Sallust; in the Empire, private gardens multiplied, each aristocratic family having its own. But gradually, following confiscation, most of them fell into the hands of the emperors. Thus the famous gardens of Maecenas, on the Esquiline plateau, formed part of the Imperial domain from the period of Tiberius. They were to be incorporated by Nero into the Golden House. From the Antonine period, an important part of the ground occupied by the gardens taken over by the emperors was used for civic buildings (e.g. the Baths of Trajan).

There also existed gardens which were open to everyone, such as the portico at the theatre of Pompey used as a promenade; the portico of Livia, on the Esquiline; the gardens of Caesar on the right bank, those of Agrippa, on the Field of Mars, with its large Euripus and its *bosquets*. One should also mention the Mausoleum of Augustus, surrounded by a sacred wood, and the garden devoted to his two grandsons, Gaius and Lucius Caesar.

The Roman art of gardens established over centuries an aesthetic in which natural objects (such as plants, water, perspectives) are used for the pleasure of the sense, and also for their religious, philosophical, and literary meanings. The frequent use of colonnades made for an intimate union between architecture and nature. The type of terrain upon which these gardens were laid out, for the most part on the slopes of a hill, led to their being divided into level terraces, interconnected by staircases, often monumental, or by gently sloping *allées* (the style of the Italian gardens of the Renaissance). Thus distant perspectives are integrated into the composition of a landscape over which the villa has broad views. P.GR. (trans. P.G.)

Rond-point, a half-circle facing the main entrance of an estate; in parks or woods a large circular clearing (generally with a circle of grass in the middle) where a number of *allées* meet. In towns an open circular area upon which avenues converge as, for example, the *rond-point* of the Champs-Elysées in Paris. D.A.L.

Roof-garden. The roof-garden provided a solution to the problem of the dramatic annual flooding of the Tigris-Euphrates Valley. Inspired perhaps by terraced hillside cultivation and the traditional form of the *ziggurat or stepped pyramid, King Nebuchadnezzar II (605–562 BC), according to Josephus, built the Hanging Gardens of *Babylon for his Persian wife, who was homesick for the tree-covered mountains of her homeland. They were regarded as one of the Seven Wonders of the ancient world and described by the Greek historians Strabo and Diodorus. They were said to cover 1–1.5 ha., built up in ascending terraces 'like a theatre', each c.3.5 m. wide and 5 m. high, built up on a great arcaded structure more than 20 m. high. On top of the arches the builders laid bundles of reeds and natural asphalt covered with layers of brick tiles and thick sheets of lead to provide waterproofing for the decorated state rooms below. Water was raised up from the River Euphrates by means of a screw-pump to a cistern on the highest terrace. The terraces were planted with flowering shrubs and trees including, possibly, larch, cypress, cedar, acacia, mimosa, aspen, chestnut, birch, and poplar.

The immediate successors are less dramatic. The roof terrace, which is a basic element of all houses in countries with low rainfall and mild winters, has probably always been a repository for potted plants. But the additional structure necessary for supporting extensive areas of plants was inevitably limited by cost to buildings of some importance, such as the Villa Diomedes in Pompeii and the Tomb of Augustus (28 BC) in Rome. This was a stepped pyramid on a circular plan built in white Lucca marble in five terraces planted with trees and surmounted by a bronze statue of the Emperor. Justinian I is also recorded as having possessed balcony gardens c.AD 500, and there are further Byzantine examples portrayed in illustrations to the Gospels and prayer-books of the 11th and 12th cs. But little else is recorded before the Renaissance.

The Renaissance and after. The Renaissance brought a renewal of interest in the idea of roof-gardens, influenced perhaps by the revival of classical culture and the fashion for importing plants. About 1400 Cosimo de'Medici built a roof-garden on his villa at Careggi near Florence; a variety of imported plants was used and the garden became a botanical curiosity. The fashion moved north. In Germany Cardinal Johann van Lamberg (1689–1712) constructed terraces above his Passau residence with elaborate parterres surrounded on three sides by walls painted with *trompes-l'œil*; the fourth side being open to view. Grottoes, such as

that at *Wilton House, were constructed with terraces above them, and the flat roof and the cantilevered balcony began to offer opportunities for external planting.

But developments were slow until the 19th c. when Carl Rabbitz (1825–91), a master builder, exhibited at the Paris World Exhibition of 1867 a plaster model of a roof-garden on his Berlin house. Here for the first time was a roof-garden on a bourgeois house in northern Europe, an area of severe winters and high rainfall. The flat roof was water-proofed with Rabbitz's patent vulcanized cement. Unfortunately this was not used by King Ludwig II for his great glass-covered winter garden built at Munich in 1874. As well as luxuriant plants it contained a substantial pool, laid over a bed of thick copper plates on stone arcading. Seepage was extensive and the structure had to be demolished in 1897.

Modern developments. Twentieth-c. developments in the technology of petroleum-based waterproofing materials coupled with wide-span steel and concrete structures paved the way for the future. But newspaper reports of Rabbitz's scheme touched on themes still used in the arguments for roof-gardens: 'beautification' of the city roofscape, the gain of leisure space from congested city development, increased roof insulation, and stabilization of the effects of temperature on roof structure. Le Corbusier advocated roof-gardens as the second of his five points towards a new architecture (*Vers une architecture*, Paris, 1923) 'The roof garden is becoming the favourite place to be in the house and means furthermore for a city, the winning back of the whole of its developed area.' He incorporated them in many of his housing projects including the Domino houses (1914–15), the Pessac estate (1925), and the Villa Savoie at Poissy (1929). They also feature strongly in the Unité d'Habitation at Marseilles (1946–52) and in the later Government buildings for Chandigarh. His supreme skill with architectural form did not, however, extend to the spatial organization of plants, which were not taken very seriously.

It was Frank Lloyd *Wright, a man of rural origins, who saw the need for the proper integration of the organic forms of nature with the geometrical forms of man. This is exemplified in the siting of most of his buildings, in the roof terraces of the Midway Gardens (1914), the Imperial Hotel, Tokyo (1924), and houses such as Fallingwater (1936). The strong horizontal lines of his terrace and balcony balustrades, softened by delicately cascading foliage, became a favourite modern design motif of the period.

Le Corbusier's incentive was taken up in Brazil by Roberto *Burle Marx. Le Corbusier was acting as consultant for Lucio Costa and others in bringing the new architecture to Brazil, which provided the opportunity for Burle Marx to design two roof-gardens for the Ministry of Education building in Rio de Janeiro in 1938, some of the earliest examples of his characteristic fluid style. These were followed by one for the Brazilian Press Association in 1940, and subsequently several more of outstanding quality.

The development of roof-gardens in Britain, a country rich in gardens, has been characteristically slow; and the first was the result of an accident. When Derry & Tom's department store was built in Kensington High Street in London in 1931–3 the building had the structural potential for an additional storey but permission was refused because of the limited length of the firemen's ladder, and a roof-garden was made instead. It comprised a series of traditional gardens including a Hispano-Moorish garden, a Tudor garden, and an English 'woodland garden' with a small stream stocked with fish, arranged around a tea pavilion and service buildings. The whole was surrounded by a high brick wall with windows to view the city. Changes in ownership have unfortunately led to some alterations, and the introduction of exotic birds such as flamingos has led to damage to the vegetation and the loss of the fish. Nevertheless, the gardens, without having any pretensions towards innovative design, are still there after 50 years, a unique oasis high above the streets of London.

The first modern British roof-garden of any size (although no larger than one of the smaller garden courts at Derry & Tom's) was for another department store: Harvey's at Guildford (1956) by (Sir) Geoffrey *Jellicoe. Jellicoe's aim was to make a garden which would be wholly of the 20th c. It is a water-garden in the sky comprising stepping-stones, viewing platforms, and planting beds, all based upon the geometry of the circle, arranged around a small coffee bar and service building. Its popularity was later marred by children dropping objects through the open balustrade and it has had to be closed to the public. Jellicoe's garden has its roots in the concept of the Japanese tea-garden. Another increasingly common type has no cultural precedent. This is the communal private garden commonly associated with covered car-parks attached to large housing and commercial developments, such as the flats in Sussex Gardens, London (1965), by Philip Hicks. This is another water-garden, but based upon the geometry of the square and the rectangle as exemplified in the paintings of Mondrian and the de Stijl movement. Although extremely well conceived it suffers, like some of its successors, from a surfeit of hard exposed open areas in inferior materials.

The tendency in Britain to restrain expenditure both on extra load-bearing structure and on quality materials has led to the treatment of some roofs and terraces as unwanted left-over spaces rather than outdoor rooms which are integral to the buildings. Nevertheless, some good results have been achieved, notably by John Whalley of Derek Lovejoy & Partners for two roof-garden courtyards in Manchester—at the National Computing Centre and the University Computer Building—and a third for a building society headquarters in Halifax. Another roof courtyard in Manchester, by Michael Brown, incorporates an inventive ceramic fountain by Joan Brown.

Greater resources in the United States have produced a number of richly planted multi-level public and private roof-gardens. Notable examples built over car-parks and service areas are at the Kaiser Center, Chicago, by Osmundson and Staley; the First National Plaza, Chicago, by Novak Carlson and Associates; Mellon Square, Pitts-

burgh, by J. O. Simonds; Constitution Plaza, Hartford, Connecticut, by Sasaki, Dawson, de May Associates; and over office accommodation at the Rockefeller Center, New York, and the Standard Oil Building, San Francisco (architects: Hertzka and Knowles). Even more ambitious are such schemes as the 7-ha. rooftop park over the San Francisco International Market Center by Lawrence *Halprin and Associates and the Page High Rooftop Village on top of the Wood Green commercial complex in Haringey, Greater London (architects: Dry, Halasz, and Dixon).

In Britain new underground car-parks under some of the Bloomsbury squares have led to minimal solutions attempting to preserve the status quo. These, however, may well be preferred to the expensively detailed, over-scaled, and draughty spaces of the Barbican, the most extensive comprehensive development in London. More successful are the elaborate Gateway House offices at Basingstoke in Hampshire (1976) by James Russell. This is a ziggurat building enriched by foliage cascading over the garden terraces, which are in themselves quite small. Although there are some difficulties in access for maintenance it is a good example of what can be achieved when resources are matched by adequate attention being given to both the architecture and the landscape design at the design stage.

The simulation of 'wild' landscape using rocks, water, and so-called ecological planting is now becoming more common; it is exemplified in the strongly enclosed roof-gardens on the Bonaventure hotel in Montreal by Sasaki, Dawson, deMay Associates and by the Utetihof Building in Zurich (1980). Less ambitious is the large open garden at the Ministry of Finance in The Hague in which the organic

qualities of the plants are effectively integrated with the geometry of the layout. The designers aimed at a gradual transition from darker colours around the perimeter to lighter colours in the centre in order to create an illusion of greater space.

Spatial contrast may also depend upon views outwards and the relationship with the existing landscape. The Grosse Schwanze Park in Berne (1978) by Willi Leichti depends upon both. It was made on three levels over offices, car-parks, and the main railway station. Its attachment to an existing park with mature trees on the side of a hill made it possible to give the new roof-garden a strong affinity with nature at its back, providing a wooded 'refuge' from which the formal terraces extend, offering a 'prospect' in the panoramic view over the city to the mountains of the Bernese Oberland. Dame Sylvia *Crowe's roof-garden for the Scottish Widows' Fund and Life Assurance Society offices in Edinburgh (c. 1974) has a closer landscape relationship. This is carefully planted to provide a rich environment in itself as well as relating to the adjoining landmarks of the Crags and Arthur's Seat. The garden depends more upon the spatial organization and qualities of the plants than upon the architecture for its effects, a quality shared by Martin Burckhart's small classic made for Ciba–Geigy in Basle in 1966. This is a carefully designed irregular pattern of planting in only 150 mm. of soil on the circular concrete roof of the staff restaurant. Low-growing alpine and rock plants accustomed to poor soils are combined in a composition of grey, green, purple, and pink.

As urban pollution and pressures for space increase, the roof-garden is becoming a normal solution for the roofs of

Roof-garden (1976) at Gateway House, Basingstoke, Hampshire, England, by Arup Associates and James Russell

Roof-garden at Ciba–Geigy headquarters (1966), Basle, Switzerland, by Martin Burckhart

car-parks, and a frequent provision for office and domestic recreation. Its use is supported by studies in West Germany which emphasize the importance of plants in increasing the humidity and acting as filters against dust and as air-purifiers. Such considerations, as well as the more purely social ones arising from a reaction against the hard concrete spaces between buildings, combined with improved technology, are generating a new wave of roof-gardens, both open and closed, in many parts of the world. M.L.L.

Root house, a garden building constructed on a foundation of roots and tree stumps, popular in England in the 18th c. and also in the 19th c., when rootwork was used for many ornamental features less elaborate than a house, such as for seats, bridges, and arbours. Thomas *Wright designed a number of root houses in the mid-18th c. including one which survives at *Badminton. *Hamilton's hermitage at *Painshill was partly of roots. The best surviving example is at Spetchley Park, Worcestershire (Hereford and Worcester), formed from the bases of tree trunks. M.W.R.S.

Roper, Lanning (1912–83), American landscape designer, was educated at Harvard where he took a degree in Fine

Arts. After war service he came to England, making the decision to devote the rest of his life to garden design. He studied at Kew and the Royal Botanic Gardens at Edinburgh. He was a prolific writer, being assistant editor of the Royal Horticultural Society's journal in 1951 and from then until 1975 gardening correspondent of the *Sunday Times*.

His knowledge of plants and plant arrangement was more assured than his use of formal and architectural elements. For these he would often collaborate with architects, as in the case of the central garden at the Royal Horticultural Society at *Wisley. His work included gardens for the new arts buildings at Trinity College, Dublin, for the Aga Khan at Chantilly, and various consultancies for the National Trust. His books included *Royal Gardens* (1953) and *Town Gardening* (1957). He received an award from the American Garden Club, the Veitch Silver Medal of the Royal Horticultural Society in 1959, and a gold medal for garden design in 1980. G.A.J.

See also GLENVEAGH CASTLE.

Rose. The long and curious history of the rose as a cultivated plant is reflected from medieval times in its use as

a symbol. The French poem of the romance of the rose, written early in the 14th c., uses the flower as an emblem for ultimate success in love and in life as a whole, and manuscripts of this poem include many illustrations of contemporary gardens, with roses prominent among their flowers. In Christian iconography the rose may stand for the Virgin Mary and it is often found as an accompaniment in pictures of other saints. Many great medieval churches have circular rose windows, in which stained glass is arranged in a pattern reflecting that of a many-petalled rose.

As a heraldic symbol, the rose is probably most familiar as an emblem of England, the Tudor rose having been formed by the blending of the white (*Rosa alba*) and red rose (the semi-double *Rosa gallica* 'Officinalis') badges of the houses of Lancaster and York in 1486. In the 18th c. a white rose was the Jacobite symbol of the exiled Stuart pretender to the throne.

The number of sayings linked to it reflects the popularity of the rose. 'A bed of roses' is said to refer to the citizens of Sybaris, who enjoyed luxury to the extent of sleeping on mattresses stuffed with rose petals. '*Sub rosa*' or 'under the rose', meaning in strict confidence, is alleged to refer to a Roman habit of having a rose carved on the ceiling of dining-rooms to remind those gathered beneath not to repeat all they heard. In the 16th c. the same symbol was carved on confessionals. Shakespeare's Juliet first said 'A rose by any other name would smell as sweet', while the claim to be near the rose, if not the rose itself, has a Persian origin. Other sayings about roses all the way or everything being roses are more recent examples of the flower as a symbol of success.

About 150 species of rose are found in the Northern Hemisphere, the majority having flowers of some tone of pink, though a few are white or yellow and there are two of true red. No doubt wild roses first came to man's notice because of their supposed virtues, for nourishment was obtained from the heps and fragrance from the petals, dried or distilled. *R. gallica* was particularly rich in these qualities and it is native to the area associated with the cradle of our own civilization in the Middle East. Like *R. phoenicia* and *R. canina* it flowered only at midsummer, but *R. moschata* flowered later and on into the autumn. These are believed to be our ancestral roses. Odd hybrids or sports may have been treasured alongside the species by the early gardeners. A number were preserved and in due course, particularly in the late 16th and early 17th cs., they were illustrated in *herbals and flower books. Their colours were white, pink, mauve, and a purplish maroon. Nearly all flowered only once, but a few, notably the Autumn Damask, flowered again in late summer or early autumn. A few other species and their variants were also known and grown, but they did not enter into the main stream of hybrids. Apart from the Gallica group there were also Damasks for both summer and autumn, and *R. alba*, a hybrid with a white form of *R. canina*. The various groups became intermingled during the first half of the 19th c., when French and English nurserymen raised seedlings by the thousand, but this pursuit did not go on much after 1860.

Between 1792 and 1824 four hybrid roses reached Europe from China, derived from *R. chinensis* (crimson to pink) and *R. gigantea* (pale yellow). These may well have been treasured in China for as long as the European ones, for at least one of them, which we know as 'Parsons' Pink China', 'Old Blush China', or 'Monthly Rose', had been illustrated in *c.*AD 1000. Of the other three, 'Hume's Blush' and 'Parks' Yellow' appear to be lost to cultivation, but 'Slater's Crimson' survives in warm climates like that of Bermuda. Besides a true crimson, inherited from *R. chinensis*, these hybrids also brought the large, long, light yellow petals and the fragrance of tea from *R. gigantea*. All of them were comparatively tender, but they had a propensity for flowering on through the summer until frost ended their growth. It was not long before open pollination produced hybrids between our roses and the Chinese hybrids. Later in the 19th c., when hybridization was better understood, deliberate crosses were made in an endeavour to unite the repeat-flowering habit and new colours and scents of the Chinese hybrids with the greater vigour and hardiness of the Europeans, using in particular the Autumn Damask and its derivatives. The results were first the Bourbon race and later the Hybrid Perpetuals. With increasing use of the tea-scented roses, longer petals and pointed buds were achieved, eventually forming the race of Hybrid Teas.

In 1876 the Royal National Rose Society was formed in England and had a great effect on rose-breeding, for its shows starred ever larger and brighter blooms. In 1891, after many abortive attempts, another great step brought into the race the startling yellow and orange-red of the so-called Austrian Brier, *R. foetida*. Gradually these strident colours invaded all the whites, pinks, crimsons, and pale yellows (the purplish tones not being so much in favour) and today's brilliance was on the way, further fortified by the chance occurrence of an entirely new pigment in 'Gloria Mundi' (1929). It was called pelargonidin and is a dazzling orange-red.

Meanwhile, *R. multiflora* had reached Europe from Japan, some time before 1868. It had small flowers in clusters, borne on short shoots off the previous year's branches. This rose and its derivatives hybridized with the Hybrid Teas to produce the often scentless Ramblers and Dwarf Polyanthas (of which 'Gloria Mundi' was one) and these two groups gave rise to the Floribundas or Cluster Roses. Ramblers and Climbers are the result of hybridizing species with affinities ro *R. moschata* and *R. multiflora* with the large-flowered roses and some of their climbing sports, influenced by the vigorous *R. gigantea*.

Many other species have been used in hybridizing, but none has influenced the main stream. *R. pimpinellifolia*, the Scots Brier or Burnet, had a brief popularity, with its white, pink, and purplish little flowers, yellow when hybridized with *R. foetida*. They are admirable for colonizing sandy soils. The Japanese *R. rugosa* has a similar colonizing habit and has been a parent of many hybrids, although its progeny tend to die out.

In the 19th c. Napoleon's first wife, the Empress Josephine, made a great collection of roses, wild and

cultivated, at her château at *Malmaison. The design of this garden was an innovation, with paths leading the visitor to bed after bed of different plants, in a style later christened the *gardenesque (as opposed to the *picturesque) by J. C. *Loudon. As there were many rambling roses at Malmaison, pillars, arches, and pergolas were used to support them, adding another fashion to contemporary garden design.

In this century, as smaller gardens, changing tastes, and a lack of labour led to different styles, roses have filled a need for long-lasting colour in lawn beds, once these were reclaimed from the *carpet-bedding craze. The recent revival of interest in the so-called 'old roses', belonging to species or varieties grown before the development of the Hybrid Teas, and often distinguished for their fragrance and less formal habit, has added to the range of roses available to maintain this flower's position as one of the most popular in cultivation. The garden writer and flower painter Graham Stuart Thomas (b. 1909), who is also Gardens Adviser and Consultant to the *National Trust, has been especially influential in the popularization of the 'old roses' and his books on roses, *The Old Shrub Roses* (1955) in particular, are widely read.

Rose gardens. Among the most important rose gardens in Britain are those at St Albans, where the Royal National Rose Society has a comprehensive collection and international trial grounds, and Mottisfont Abbey, near Romsey, Hampshire, where the National Trust has formed a collection of old roses. In London, Queen Mary's Rose Garden in Regent's Park was planted in 1931. Elsewhere in Europe, there are the gardens of *Bagatelle and La Roseraie de l'Hay les Roses in Paris. The second of these is especially rich in Climbers and Ramblers, re-creating as far as possible an echo of the Empress Josephine's collection. The rose

garden at Lyons, founded only in 1964, celebrates local associations with rose-breeding and runs an annual competition to choose *la plus belle rose de France*. In East Germany the Sangerhausen Rosarium, 80 km. west of Leipzig, was opened in 1903. Now, with over 6,500 species and varieties, it has one of the most comprehensive collections, accompanied by a rose research institute. West Germany has old-established rose gardens on the island of Mainau in Lake Constance, where a fine collection of shrub roses surrounds a baroque castle, and at Wilhelmshöhe in Kassel, which is a re-creation of an earlier garden. The city of Madrid maintains the Rosaleda del Parque de Oeste, with specially fine Climbers on a long, curved pergola, and in Switzerland there is La Roseraie du Parc de la Grange in Geneva, on the edge of the lake.

The first major public rose garden in the United States was the one established at Elizabeth Park, Connecticut, in 1904, which still contains many of its original roses. The International Rose Test Garden at Portland, Oregon, emphasizes new roses, with a test garden and trial grounds, while the Hershey Rose Garden in Pennsylvania has terraced beds of roses backed by a colonnade, with Climbers, Ramblers, and old roses facing them across a lake. Canada's Centennial Rose Gardens in Burlington, Ontario, were established in 1967 to mark the anniversary of the confederation. They include nearly 3,000 modern varieties and 450 old ones, concentrating on hardiness trials.

G.S.T./S.R./M.GI.

Rose, James (*c.*1910–), is one of the 20th c.'s most influential yet enigmatic American garden designers. With fellow students Dan *Kiley and Garrett *Eckbo, Rose rebelled against the Beaux Arts design traditions offered at Harvard in the mid-1930s, ultimately succeeding in radically changing professional design philosophies.

Rose Residence (1954), Ridgewood, New Jersey, by James Rose

Rose's search for a new style was strongly influenced by the work of contemporary constructivist and abstractionist artists, and by his exposure to oriental philosophies (particularly Zen Buddhism) and life-styles during the Second World War. His work, which is primarily residential, is not well known today; yet it displays a strong sense of spatial structure, an appreciation of the intrinsic qualities of garden materials, an understanding of evolving 20th-c. life-styles, and a sense of how landscape and architecture can merge, which few contemporaries can match. His gardens, such as Rose Residence, Ridgewood, New Jersey (1954), acknowledge the changing character and temporary nature of their components and celebrate the effects of light, shadow, texture, sound, and space.

Rose's writings were published in the magazine *Pencil Points* in the late 1930s, and a comprehensive book of his work (*Modern American Gardens Designed by James Rose* by Marc Snow) was published in 1967. W.L.D.

Rose, John (1629–77), English gardener, made a major contribution to the introduction into England of the *Le Nôtre form of garden design. He studied under him in France and probably later imparted his knowledge to George *London. He was appointed 'Keeper of St James's Garden' in 1666. In this position and his previous one as 'Keeper of the garden of Essex House, Strand', Rose carried out design work, but unfortunately little of it has survived. In addition he was a brilliant horticulturalist and provided the basic information for *The English Vineyard Vindicated* (1666), which was put together from his material by 'Philocepos' (a pseudonym of John *Evelyn). He also wrote *A Treatise upon Fruit Trees*. C.H.

Rosedown, Louisiana, United States, lies in a beautifully restored early 19th-c. plantation. The house was built by Daniel Turnbull for his bride in 1835, of cedar and cypress cut from swamp woodlands in its over 1,200 ha., of which the garden was planned to occupy 11. ha. Martha Barrow Turnbull, who was a daughter of the nearby Highland Plantation owner, was to keep a diary for over 60 years recording the development and maintenance of her garden. In preparation for her dedication she purchased J. C. *Loudon's *Encyclopaedia of Gardening* in November of 1835 and began her planting with 'shrub and rose cuttings'. From that time until her husband's death in 1861, the garden came to be one of the most splendid examples of the formal *ante-bellum*, slave-tended gardens of the southern United States.

A straight avenue from the entrance, lined with now gigantic white oaks, frames the distant, refreshingly simple, white clapboarded, two-storeyed plantation house with its double, pillared verandahs and two fanlit central doors. In contrast to the modest architectural design of the house, there is nothing either simple or obvious about the garden. With a formally laid out, box-bordered 'flower garden' on one side and a parterre on the other, near a small plantation office for a doctor with his medicinal herb garden, the gardens extend on either side of the avenue, towards the

entrance, with winding paths among an extravaganza of azaleas and camellias, shrub roses, sweet olive, evergreen trees, and flowering vines. Several small round summer-houses and a charming, classical, brick tool-house are situated among bordered paths with hedges of *Rosa roxburghi* 'Plena'. Statues appear against flowering screens of native blooming shrubs. A.L.

Rosenbröijer, Maj-Lis (1926–), is a Finnish landscape architect who was prominent in the post-war years. One of the most recent schemes she has designed is the landscape for Alko-Vuoranta (the State Alcohol Training Centre) near Helsinki, where groups of sculptural hardy plants in a raised chequer-board of wooden slats appear to float above the water amongst boulders and pebbles.
 P.R.J.

Rosendael, Gelderland, The Netherlands. During the Middle Ages this ancient seat of the Counts and Dukes of Gelder had a menagerie with parrots and a lion, and also a vineyard. By 1700 the renown of the gardens was due to the owner, Jan van Arnhem; they were eulogized in verse by Johan d'Outrein.

Within a Renaissance layout there were orchards, vineyards, bleaching grounds, and a star-shaped wood with 12 avenues radiating from a mount (the Sterrenberg). Running water was skilfully captured on the hilly site, an unusual phenomenon in the Netherlands, to create cascades and fountains linking *parterres de broderie* with a grotto flanked by busts of Roman emperors. It also allowed a series of four ponds with grottoes and pavilions to be laid out on different levels. Jan van Arnhem commissioned Daniel *Marot to design an octagonal shooting lodge for William III and he adorned a grotto with heads of stags shot by the king.

The alterations made to the gardens by Lubbert Torck in c.1730 reveal a rococo influence and are suggestive of Marot's later work (for example at Meer en Berg and Huis ten Bosch), although the star-shaped wood with *cabinets de verdure* and the spiral labyrinth were borrowed from *Dezallier d'Argenville's *La Théorie et la pratique du jardinage*. Marot designed a pavilion and most probably the elaborate shell gallery with a cascade, both recently restored. In 1836 the gardens were transformed into a landscape park by J. D. *Zocher the younger. F.H.

Rosendal Barony, Hardanger, Norway, is one of the few remaining Renaissance-style gardens in northern Europe. The little whitewashed palace with its formal garden, dating back to 1660–70, provides a striking contrast to the powerful alpine and fjord scenery around.

The garden covers a rectangular area, approximately 50 m. × 60 m. in size, and was originally divided into 12 compartments, with no direct connection between the garden and the palace. The garden was enclosed by a whitewashed stone wall until 1850, when the wall was unfortunately removed. The major feature of interest is the rose parterre, the geometric pattern of which has been

Rosendal Barony, Hardanger, Norway, the rose parterre in a 1962 photograph

preserved in its original shape and reveals a strong influence from the early Dutch gardens. Some of the original box hedges are still alive after more than 300 years, but have developed to a height of *c.*4 m.

Today Rosendal is a rather unique example of Renaissance gardens as they developed in the North Sea countries. It is Norway's only proposal for the ICOMOS list of historic gardens of international significance. It is now the property of the University of Oslo and is open to the public. M.BR.

Rothe, Rudolf (1802–77), Danish landscape architect, served apprenticeships in both *Frederiksberg and Rosenborg gardens, followed by a spell in the botanic garden in Copenhagen and travel abroad. From 1822 to 1833 he was employed by Count A. W. Moltke at Brengtved, where he managed to get an earlier plan of the garden executed, and from 1833 to 1848 he was head gardener at *Fredensborg, where he remodelled the French garden into the woodland park we see today. He later became Chief Inspector of the Danish royal gardens. He published *Extracts from a Garden Diary* (1828), and *An Evaluation of Landscape Gardening in Denmark* (1853), the only historic work existing on this subject, containing detailed observations of the country's trees and nature in general. P.R.J.

Rotunda (or rotundo), in its most simple definition, a small building, circular in plan, usually in the form of a dome supported by a circle of columns. In English garden history the term tends to be applied to open buildings, i.e. with no structure within, although it is also used for some with a colonnade and a room inside. The buildings are classical in style.

Open rotundas are plentiful: a few famous examples are *Vanbrugh's at *Stowe and at *Duncombe Park, Campbell's Temple of Venus at *Hall Barn, the Temple of Aeolus at Kew, and those at Compton Acres, Dorset, and *Hagley. Many have disappeared, e.g. the two Shell Temples in rotunda form at Stowe, and other temples at *Enville and *Studley Royal. Some have lost their dome, such as those at *Petworth or Sutton Park, North Yorkshire.

Among 'closed' rotundas perhaps the best known is William *Kent's Temple of Ancient Virtue at Stowe. This was modelled, as were many of this type, on the Temple of Vesta at Tivoli. Another copy was at *Oatlands Park. Others which may be mentioned are at *Bramham Park, the Mausoleum at *Castle Howard, the Doric Temple at Duncombe Park, the Tuscan Temple at *Rievaulx Terrace, and Adam's Temple at *Audley End.

Sometimes round temples with a straight portico have

been described as rotundas, e.g. the small Ionic temple by the pool at *Chiswick House.

The English garden abroad has often produced rotundas, e.g. at *Schwetzingen and the Temple d'Amour at the Petit Trianon, *Versailles. M.W.R.S.

See also PLEASURE-GARDEN.

Rousham House, Oxfordshire, England, one of the earliest and most admired of English landscaped gardens, embodies the poetic and philosophic ideas of its age. As it stands, it is entirely the work of William *Kent with no later additions; his 'most engaging' according to *Walpole. In 1738 Rousham was one of the first places to partake of *Addison's idea of 'a whole estate thrown into a kind of garden' and *Pope's invitation of 'calling in' the surrounding countryside. The statues look out over the Cherwell to an *eye-catcher outside the boundaries 'calling in' the gentle undulating Oxfordshire scene into the garden and making 'the whole sweet'. Kent used classical buildings within the garden but made use of picturesque Gothic for distant buildings, such as the eye-catcher, the mill, and the remodelled house.

Even before Kent's work for the Dormers, Pope had said that Rousham was 'the prettiest place for water-falls, jetts, ponds, inclosed with beautiful scenes of green and hanging wood that I ever saw'. Two plans of the 1720s, one of which is possibly by *Bridgeman, show the new garden with basins, alley, theatre, and a serpentine walk through a *wilderness to the Cold Bath, and resembling the walk already existing at nearby *Heythrop. Kent's design retained a straight elm walk but modified the ponds and theatre.

Unlike the later total landscape design of house and garden, Rousham depends on movement for effect and it is important to follow the circuit as Kent intended. The documentary sources for this circuit are the estate plan of 1738, drawn up by the Steward in consultation with the gardener John Macclary, and a letter from Macclary in 1750 describing in detail where to walk and what to see from vantage points. The most noticeable change is the viewing of Venus Vale, a long valley with a chain of ponds. In the Bridgeman style of layout the ponds were looked down on from a bastion viewpoint and today, as the visitor is encouraged to drop down from above the seven-arched port-ico Praeneste to the lily-pool, the water is also seen from above. In Kent's design this was the reservoir for the fountains and the Venus Vale was intended to be seen first from below as a climax to the walk with the pond hidden and a *trompe-l'œil* effect of cascades running down the hill. Macclary's 'roundabout walk' shows that Rousham was intended first to be seen as a *ferme ornée* with the garden hidden by a screen of evergreens. The first seat was placed to view the Gothicized house across the *ha-ha and grazed field. The path then joins that from the visitors' entrance lodge, down through serpentine woodland walks to the Cold Bath glade and along by the stream (which was much wider than the rill seen today) to the Temple of Echo by William Townesend.

Two planting aspects from the documents are important. The evergreen screens were enlivened with flowery under-plantings: 'here you think the Laurel produces a Rose, the Holly a Syringa, the Yew a Lilac and the sweet honeysuckle is peeping out from under every Leafe, in short they are so mixt together, that you'd think every Leafe of the Ever-greens produced one flower or another.' The plan dis-tinguishes between trees with underwood planting and open groves, the latter being column-like with bare stems giving stage perspective rather than pictorial effect. In *Walpole's words, by this device Kent 'removed and extended the perspective by delusive comparison'. The dramatized view of the Gothicized roofscape of the house under the slope

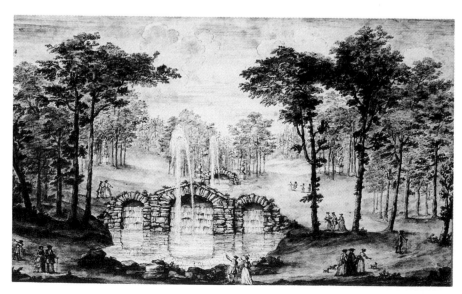

Rousham, Oxfordshire, the Venus Vale, drawing (c.1738) by William Kent

and the placing of the statuary suggests that here too Kent was influenced by stage scenery. M.L.B.

Rousseau, Jean-Jacques (1712–78), French writer. His disapproval of society and its corrupting effects was linked with admiration for unspoilt nature, and a passion for collecting wild flowers and grasses. His views on gardening appear in his novel *La Nouvelle Héloïse* (1761), where (Part IV, Letter XI) he describes the 'Elysée' created by the heroine Julie. In later years he was subject to a persecution mania and rejected man-made gardens in favour of wholly untouched scenery (see his letter to the Duchess of Portland, 12 Feb. 1767) where he indulged in solitary meditation (or 'rêverie', as in the *Rêveries du promeneur solitaire*, 1782), and study of nature (*Lettres sur la botanique*, 1772). He died at *Ermenonville while a guest of the Marquis de *Girardin. C.T.

See also JARDIN ANGLAIS; LISELUND.

Rowallane Garden, Co. Down, Northern Ireland, was begun in 1917 by Hugh Armytage Moore. It is conceived entirely in the style of William *Robinson and its 20 ha. are divided into four sections. The Walled Garden is overlooked by the stable tower and divided into rectangular compartments, many containing the famous plants which bear the garden's name. The Spring Garden, its grass alleys dominated by receding banks of rhododendrons, leads to the Natural Rock-Garden which is arranged amid natural outcrops. The circuit is completed by a wild Woodland Garden through which one returns to the house. Since 1955 it has been in the care of the National Trust. P.B.

Royal Botanic Garden, Scotland. See EDINBURGH.

Royal Botanic Gardens, England. See KEW.

Royal Horticultural Society. In 1804 the first meeting of the Horticultural Society of London was held at Hatchard's bookshop in Piccadilly. There were seven founder members, and their purpose was 'the improvement of horticulture'. The seven founders comprised four amateur and three professional gardeners, a combination which is still reflected in the membership today. The amateurs were John Wedgwood, the eldest son of Josiah Wedgwood, who founded the pottery; Charles Greville, MP, collector of minerals and precious stones (part of his collection was bought by the Trustees of the British Museum); Sir Joseph *Banks, the leading scientist of his age who had sailed round the world with Captain Cook and was at the time President of the Royal Society; and Richard Salisbury, FRS, one of the first fellows of the Linnean Society. The professionals among the founders were William *Forsyth, the King's gardener at Kensington and St James's; William *Aiton, the King's gardener at *Kew; and James Dickson, nurseryman and garden contractor at Covent Garden. Five out of the seven founders are commemorated in generic names of plants: *Grevillea, Banksia, Salisburiana* (now *Ginkgo*), *Forsythia, Dicksonia*.

Since its foundation the Society has become 'Royal' (in 1861) and membership has increased to *c.*92,000, but its aim remains the same as in 1804. During its first hundred years the Society went through several periods of financial precariousness, due either to overspending or to embezzlement by employees. In one particularly severe crisis in 1859 the Society's collections of books and drawings were sold— an irreparable loss.

The main activities of the Society today in the pursuit of better horticulture are shows, demonstrations, education, and publications. There are two centres from which these activities are carried out, the main office in London and the garden at *Wisley. The main office at Westminster includes two exhibition halls and the Lindley library—re-collected since its dispersal in 1859—a lending and reference library of books and periodicals, which also contains a large number of drawings and paintings, many of them commissioned by the Society.

The first modest meetings of members, when papers were read and plants exhibited, have developed into the flower-shows of today, and all but one of these are held in the Society's halls in Westminster from February to November. The exception is the famous Chelsea Flower Show, held in late May in the grounds of the Royal Hospital. The first show at Chelsea was held in 1913 and apart from interruptions due to war conditions it has been held each year since then.

Another long-running task is the testing of new plants for gardens. Today this is done at the Society's fourth garden at Wisley. The Society's first garden (in Kensington) was obtained in 1818, expressly to grow and propagate new fruits and vegetables, and to grow a collection of garden plants from China. A second much larger garden was obtained a few years later in 1821 in Chiswick, where there was more room for the trials and collections of exotic plants. In 1859, under the patronage of Prince Albert, arrangements were made to lease *c.*8 ha. for another garden in Kensington where exhibitions were held. But the Society was soon in financial trouble again, profits from the Kensington garden being spent on such non-horticultural items as statues, and as a result the area leased at the Chiswick garden had to be reduced and some of the glasshouses demolished.

Introduction of new plants from the wild to gardens and greenhouses has been and still is an important interest of the Society. Between 1820 and 1825 six young men were sent to the Far East, North and South America, and Africa to collect new plants for the Society. Among the plants they sent back were the monkey-puzzle, *Primula sinensis*, *Camellia reticulata*, Douglas fir, flowering currant, and clarkia. Another collector was sent to Central America in 1836. After that the Society no longer sent out its own collectors, but joined other individuals and institutions in providing financial support for collectors in return for a share in the material brought back. Among those supported have been *Forrest, *Kingdon-Ward, *Ludlow, and *Sherriff.

Education for the professional has been another major

activity. A two-year course of training in the theory and practice of horticulture is given at Wisley for men and women aged 16 or 17. Young gardeners have always received some training at the Society's gardens, but it has been formalized for over a hundred years, successful students receiving a diploma or certificate. Among the Society's earliest 'apprentices' at the Chiswick garden was Joseph *Paxton, who later became gardener to the Duke of Devonshire and designed the Crystal Palace. In 1913 a high-level examination in practical horticulture was instituted, the National Diploma in Horticulture. This is a non-academic qualification, experience at work being considered essential, and the Diploma ranks with a degree in horticulture for entry to a higher degree, and for certain jobs.

The fourth of the Society's main activities is publication. A periodical was produced soon after the Society started, although initially its appearance was irregular. The present journal (now called *The Garden*) is now in its 108th volume, and is published monthly. Many other books have been published, from simple handbooks for beginners to reports of scholarly conferences, but an important publication for all gardeners today is *The RHS Dictionary of Gardening* (2nd edn. 1956), with its *Supplement* (2nd edn. 1969). E.N.

Royal Horticultural Society's Gardens, Kensington, London. The Horticultural Society of London became the Royal Horticultural Society in 1861, and a new garden was designed as its headquarters in Kensington. The garden was architecturally in the Italian style, with three series of arcades modelled on different Italian originals: the Milanese and Albani Arcades were designed by Sidney Smirke, and the Lateran by Francis Fowke, who also designed the conservatory.

The gardens themselves, laid out by George Eyles to designs by W. A. *Nesfield, were arranged on three levels of terraces with canals, and ornamented with beds in Nesfield's later style, relying heavily on coloured gravels and box. Four such beds represented the heraldic plants of the United Kingdom—the rose, thistle, leek, and shamrock— and were criticized by horticulturists for the absence of plants. A maze of holly and hornbeam also appeared as a Tudor-revival feature (see *Tudor gardens).

The opening of the garden was Prince Albert's last public act; the gardens were superintended by Eyles, but it was not long before a reaction set in against them, and they were condemned as an architectural antithesis to horticulture. In 1888 the Society abandoned the Kensington site, the lease of which had expired, and the grounds were built on; the only feature to remain *in situ* is Joseph Durham's statue of Albert and its accompanying steps, behind the Albert Hall. B.E.

See also WISLEY.

Royal Moerheim Nursery, Dedemsvaart, Overijssel, The Netherlands. See RUYS NURSERY.

Royal Pavilion, Brighton, East Sussex, England, built for the Prince Regent from 1787, was acquired by the town of Brighton in 1850 and its grounds became a public garden. In 1983 the Sussex Historic Gardens Restoration Society and Brighton Borough Council began to reinstate the original layout by interpreting the plan and aquatints in Nash's *Views of the Royal Pavilion* (1826). John Nash's ideas on landscape gardening were influenced by his former partner, Humphry *Repton, whose rejected proposals for the Pavilion had been published in 1808 (the only Red Book generally available). The limited extent of the Pavilion grounds allowed the landscape style to be adapted to the new taste for floriculture. As for other royal grounds, Nash provided the overall plan with paths and shapes of shrubberies and beds, and W. T. *Aiton provided the planting lists. As Aiton was superintendent of the Royal Botanic Gardens at Kew, where plants were being received from China, the Cape, and Australia, the Prince Regent's taste for the exotic at the Brighton Pavilion could be extended to its garden. M.L.B.

Rubens's Garden, Antwerp, Belgium. See BELGIUM: THE SEVENTEENTH CENTURY.

Rueil, Hauts-de-Seine, France, is the site of Cardinal Richelieu's famous garden, coveted by *Louis XIV who sent *Le Nôtre to look at it when he made Versailles. Vestiges remain today in the grounds of the Sandoz Group at Rueil-Malmaison. A house in 14·5 ha. was built by Jean Moisset (d. 1620), tax-collector for Paris, who laid out grounds with walks, vineyards, and ornamental waterworks. Rueil was acquired by Richelieu in 1633. He enlarged the gardens which *Evelyn described in 1644 as a 'vast enclosure . . . containing vineyards, cornfields, meadows, groves . . . and walks of vast length'. The site was a shallow valley, sloping from south to north with some high ground on the west. Water was brought 2 km. in ducts to supply a large architectural cascade, devised by Thomas *Francini, designed by Jacques *Lemercier, and built by Jean Thiriot. It was the prototype of others at *Saint-Cloud and *Chantilly.

North of the house two large ponds were linked by a canal with an architectural grotto. The canal and the lower pond form part of a modern garden designed by André de Vilmorin in the Sandoz grounds. Other important features were the Grotte de Rocaille, closing the vista at the northern end of the *allée* from the cascade, and a full-scale *trompe-l'œil* triumphal arch by Jean Lemaire (1598–1659) painted on a wall closing the orangery.

The gardens were illustrated in a series of engravings (1661) by Israel *Silvestre and Nicolas and Adam *Perelle, when the cascades, fountains, and basins had been repaired, and in some cases altered, by Richelieu's niece and heiress, the Duchesse d'Aiguillon (d. 1675). The park was neglected and the waterworks ruined by 1719. A.-N. Dezallier d'Argenville reported in 1762 that the grottoes, cascade, and triumphal arch had disappeared. The estate was confiscated in 1794, and sold as lots. K.A.S.W.

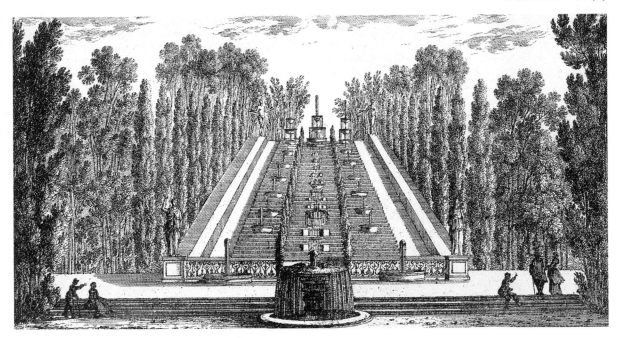

Rueil, Hauts-de-Seine, France, the Grande Cascade, engraving (1661) by Perelle after Silvestre

Ruin. Ruined buildings were often part of the picturesque 18th-c. English landscape garden, partly for visual and partly for associative effect, calling to mind transience, decay, and the passing of earlier glories. Some landowners were fortunate enough to have real ruins at hand, such as Aislabie at *Studley Royal, where Fountains Abbey, although not brought fully into the landscape until 1768, was intended to close the main vista. Another example is Rievaulx Abbey, below the curving *Rievaulx Terrace (see also *terrace walk).

Usually, however, the owner had to create his own ruins, which could take a number of classical or Gothic forms. In 'church Gothic' style there were a ruined priory at The *Leasowes, a ruined chapel at *Woburn Farm, and a ruined abbey at *Painshill. The idea of the sham castle was popularized by Sanderson *Miller, several of whose works were deliberate ruins. The effect of his castle at *Hagley Hall moved *Walpole to say of it that it had 'the true rust of the Barons' Wars'. There were genuine ruined medieval castles at *Hawkstone Park and *Piercefield.

Some ruins were for satirical effect, such as William *Kent's broken walls and rubble at *Stowe which represented the Temple of Modern Virtue. As for classical ruins, *Chambers's ruined arch at *Kew survives, as do *Hamilton's Roman Mausoleum at Painshill and the ruins at *Shugborough. Batty *Langley even published designs for ruins.

In England there was sometimes a dynastic concern, to create the feeling of a family lineage stretching back, whereas in Europe the motives were primarily associative and philosophical. The ruined Temple of Philosophy at *Ermenonville (1776) indicated the incomplete and disjointed state of human thought. The colossal ruined column at the *Désert de Retz was intended to convey the vastness of the works of ancient civilizations, as compared with contemporary architecture, and at *Betz, from 1780, the Princesse de Monaco designed a complete landscape of Gothic ruins. In Germany, at Hohenheim, the park was made to appear laid over the ruins of an old city, fragments of which rose up through the grass, and at Würzburg, Gothic ruins ornamented a garden that was still symmetrical in layout. The fashion spread wide, and ruins featured, for example, in many Czech and Polish gardens. M.W.R.S.

Ruiz Lopez, Hipólito (1754–1816) and **José Antonio Pavón y Jiménez** (1754–1840), Spanish botanists, were sent to collect in Chile and Peru in 1777, in collaboration with the French botanist and physician Joseph Dombey (1742–96) who had helped Jean-Jacques *Rousseau in some of his botanical explorations. Two artists, Joseph Brunete and Isidro Gálvez, were added to the company. The collections made by members of the expedition, including antiquities, minerals, and 'natural curiosities', as well as seeds and dried and living plants, were shared between the botanic gardens in Madrid and Paris, though the Spaniards claimed the lion's share after a disastrous fire and shipwrecks had destroyed many consignments. Dombey returned to Cadiz in 1784; the others stayed on till 1788 before returning to Spain to work on their flora of Peru and Chile, based on the 3,000 descriptions and over 2,000 drawings they had collected. Although Ruiz worked on the *Flora Peruviana* until his death, and Pavón went on with it,

only a prodrome and three volumes were published, from 1794 to 1802. Useful plants were of especial interest to the colonial authorities, so that species of *Cinchona* (the source of quinine) were studied, and the value of the monkey-puzzle as a timber-tree for ship-building was explored.

Other southern conifers were also sent back to Europe. Pavón later sold specimens and seeds of these and other plants to A. B. Lambert, the English botanist who wrote a large, finely illustrated book on the genus *Pinus*. S.R.

Russia and the Soviet Union

There were gardens in Kiev, belonging to princes and monasteries and laid out by Greek gardeners in the 11th c., gardens in Suzdal and Vladimir in the 12th c., and extensive gardens in Moscow by the end of the 15th c. An early 17th-c. plan of Moscow published in Amsterdam suggests that there were then many gardens, among them the Tsar's apothecary's garden, shown with an avenue of trees, and the large imperial garden, dating from 1495, by the river opposite the Kremlin, laid out with straight paths and rectangular divisions. There were hanging gardens in the Kremlin in the 17th c. with pools fed by pumped water, summer-houses, paths, and flower-beds.

During the reign of Ivan IV (1533–84) numerous estates were established around Moscow, combining some formally laid-out areas with groves, meadows, and ponds. Utility was an important element in early Russian gardens. A great deal of fruit and some cereals were grown; birch and cedar groves were planted; and there were fish-ponds and bee-hives. There were many orchards on Ivan's estate at Kolomenskoye. On the estate of Tsar Aleksei Mikhailovich (1645–76) at *Ismailovo there were elaborate garden layouts, which showed the influence of the western European Renaissance garden, but a wide range of fruit and cereals was grown within these formal frameworks. Melons and grapes were both cultivated here, and interesting experiments were undertaken into the acclimatization of plants.

PETER THE GREAT. Great advances were made in the art of garden design during the early years of the 18th c., and, as with the remarkable progress made by Russia in so many fields, Peter the Great (1682–1725) was not only the driving force but also the source of many ideas. In England he is remembered for riotous behaviour in John *Evelyn's garden at *Sayes Court, where he instructed his companions to push him repeatedly in a wheelbarrow into a holly hedge; but he was deeply interested in the art of garden and park design, and his visits to gardens in Berlin, the Netherlands, and France were of great importance to the development of that art in Russia. He took back with him books on gardening and engravings of gardens, and he arranged for others to be purchased and sent to him in St Petersburg (Leningrad). He engaged, among others, the architects Trezzini, Braunstein, and *Le Blond and the gardener Jan Roosen to create new gardens in Russia and to train Russians in their skills.

Dutch gardens had a particular attraction for him, and their influence was evident in the first major garden in St Petersburg, the *Summer Garden, and in the Monplaisir garden at *Peterhof (Petrodvorets). But the French formal garden was the major influence, and Le Blond the most important of the designers he engaged, though plans in Peter's own hand show that he was much more than a mere patron and made a significant personal contribution to the shaping of the city's new gardens. He was directly concerned in arranging for the supply of plants from abroad and from other parts of Russia, in the import of sculpture from Italy, in the development of nurseries, and in the establishment of schools for gardeners and architects. Some Russian features were retained in the new gardens, particularly the planting of fruit bushes in formal areas and the use of native trees, including clipped fir trees and junipers. Among the great gardens made during Peter's reign were the Summer Garden, Peterhof, Prince Menshikov's garden on Vasilevsky Island, *Strelna, *Oranienbaum (Lomonosov), Ekaterinhof, and Dubki, all in or near St Petersburg; Peterholm and Alexanderschantz near Riga; and *Ekaterintal (Kadriorg) near Tallinn.

During the reign of the Empress Elizabeth (1741–61) palaces became more magnificent and gardens more elaborate. It was for Elizabeth that *Rastrelli rebuilt the palace Yekaterininsky at *Tsarskoye Selo (Pushkin) and designed superb baroque pavilions for the remodelled gardens. The refashioning of Ropsha near St Petersburg, the palace garden in Kiev, and *Kuskovo and *Arkhangelskoye (later considerably altered) near Moscow date from this period.

THE LANDSCAPE PARK IN RUSSIA. The introduction of the landscape park to Russia was encouraged by the example of Catherine the Great (1762–96). 'I now love to distraction gardens in the English style,' she wrote to *Voltaire in 1772, 'the curving lines, the gentle slopes, the ponds in the forms of lakes, the archipelagos on dry land, and I scorn straight lines and twin allées. I hate fountains which torture water in order to make it follow a course contrary to its nature; statues are relegated to galleries, halls, etc; in a word, anglomania rules my plantomania.' This enthusiasm was reflected in the 'Table and Dessert Service, consisting of 952 Pieces, and ornamented in Enamel, with 1244 real Views of Great-Britain', including many of landscape parks, which Catherine ordered from Wedgwood and Bentley. She sent the *Neyelovs to England to study English models and she invited John *Busch to work for her in Russia, where he played a major role in laying out the landscape of a

Tsarskoye Selo, near Leningrad, plan (*c.*1790) of the Yekaterininsky Park by John Busch

large area at Tsarskoye Selo. The landscape design at *Pavlovsk was begun by Charles *Cameron and then continued by Vincenzo Brenna and Pietro *Gonzaga over a period of 40 years to create Russia's greatest, and one of the world's greatest, landscape parks. Catherine's favourite, Prince Potyomkin, shared the Empress's enthusiasm for the English style. William Gould from Lancashire planned the gardens of his Tauride Palace (only 25 ha.) in St Petersburg and, in J. C. *Loudon's view, 'displayed great judgement in forming the ponds, out of which he got sufficient materials to make an agreeable variety of swells and declivities'. There was a covered winter garden there, too, where the walks 'meander amidst flowering hedges and fruit-bearing shrubs, winding over little hills, and producing, at every step, fresh occasions for surprise' (H. Storch quoted by Loudon). When Potyomkin was travelling to the Crimea with several hundred serfs to lay out the grounds of his residence there, an English-style garden was made around his travelling pavilion wherever he stopped.

Landscape planning soon enjoyed a wide following. The *ukaz* issued by Peter III releasing the nobility from compulsory service and the Charter to the Nobility of 1785 encouraged owners to settle on their estates and to develop industry and agriculture there. When they turned to

gardening, the landscape style, emblematic of freedom, was a natural choice. 'Rural beauties and romantic scenes, assembled with so much taste in English gardens' were more in accord with the spirit and the aspirations of the times than 'the sculptured hedges, stiff Dutch walks, wildbeast boxwood, pond Neptunes and sea-shell bowers of Europe'. Apart from their sentimental appeal, landscape parks also made better economic sense. The writings of A. T. *Bolotov provided a great deal of valuable advice not only on agricultural improvements and estate management but also on the Anglo-Russian style of gardening and landscape design, retaining some formality near the house, which he advocated. The works of English authors were also read and some appeared in Russian. William Coxe, who travelled to Russia in 1772, found at Mikhalkovo, the home of Prince Peter Panin, that 'the grounds were prettily laid out with gentle slopes, spacious lawns of the finest verdure, scattered plantations, and a large water fringed with wood ... The English taste can certainly display itself in this country to great advantage, where the parks are extensive, and the verdure, during the short summer, uncommonly beautiful. Most of the Russian nobles have gardeners of our nation and resign themselves implicitly to their direction.'

Elevated sites were favoured for country seats, usually

with a wide grass slope descending to a river or lake. Meadows were often preferred to lawns and were mown only twice a year to encourage the growth of wild flowers. Garden temples were very popular, and Cameron's Temple of Friendship at Pavlovsk, a domed rotunda with Doric columns, was the inspiration of many similar structures, usually sentimentally named, in Russian parks. Temples, some of them based on English designs, were particularly abundant at Prince Kurakin's Nadezhdino in Saratov, where they celebrated Concord, Glory, Patience, Gratitude, Friendship, and Sincerity. The Russian Gothic style, inspired by early Russian architecture, was also used in garden buildings and is particularly associated with the architects V. I. Bazhenov and M. F. Kazakov. They designed the buildings at Tsraitsyno, which are all in this style, in a landscape setting. The area near the house was often formal, as Bolotov had recommended, and straight avenues were frequently planted, usually of lime or birch. This formality, the choice of site, and the use of native trees all helped to give Russian parks their own particular character. N. A. *Lvov, who held views similar to those of Bolotov, designed parks which incorporated all these elements, among them Wedenskoye and Voronovo near Moscow and Nikolskoye near Torzhok. Among the best-known estates near Moscow are Sukhanovo, where the impressive mausoleum of the Volkonskys stood out among the buildings of the park; Marfino, with a formal and a landscape park; Seredniko, associated with the poet Lermontov; and Kuzminki, with its many garden buildings and striking cast-iron ornaments. Notable parks in the Ukraine are *Aleksandria, near Belaya Tserkov, and *Sophievka, near Uman. Of the many Crimean estates, Kiskov, Gurzov, and Alupka are among the most important. Edward Blore, Sir Walter Scott's architect at Abbotsford, though he never visited the Ukraine, sent the Anglophile Count Vorontsov a set of drawings for the palace at Alupka in a mixture of English Tudor, English Gothic, and oriental styles. It was built in the 1830s and 1840s with a formal Italianate garden of terraces, flights of stone steps, statues, and fountains, surrounded by a lush landscaped park with spectacular natural landscape beyond.

But the building of country seats, which had been checked by the French invasion of 1812, was subject to other pressures in the decades which followed. The capitalization of agriculture was subverting traditional land use, and the life-style of the owners of estates was becoming increasingly insecure, since it was sustained by an indefensible social system which was to end with the abolition of serfdom in 1861. As early as 1827 Pushkin wrote: 'The Moscow villages are deserted and sad. The sound of the horn is no longer heard in the groves of Sviblovo and Ostankino. Lamps and coloured lanterns have ceased to light up the English walks, once planted with myrtle and orange-trees and now overgrown with grass . . . The great house is falling into ruin.' The maintenance of many parks was beyond the means of their owners, and the sound of the axe in the cherry orchard was to signal the end of a way of life. A few parks continued to be made for the very rich, such

as *Palanga on the Baltic designed by Edouard *André, and, of course, there were new gardens on a smaller scale, but there was no longer the universal commitment to an ideal which had inspired the making of the formal gardens of the 18th c. and the landscape parks which followed.

LANDSCAPE DESIGN IN THE SOVIET UNION. The Revolution in 1917 put an end to large private parks and gardens in the Soviet Union, and their place was taken by public works of landscape architecture. Much attention has been paid to the provision of green open spaces in towns, while Parks of Culture and Rest, offering a wide range of facilities for physical recreation, entertainment, and relaxation in landscaped settings, have become a feature of Soviet cities. The first of these parks to be completed was Gorky Park in Moscow. In 1933 work was begun on the Central Park of Culture and Rest in Leningrad, which was to embrace Yelagin, Krestovsky, and Kameny Islands. Unfortunately A. S. Nikolsky's most impressive plans for what promised to be a masterpiece of Soviet landscape architecture have not yet been fully realized. The superimposition of a network of straight paths, a big wheel, and other apparatus on the 1820s English-style layout of Yelagin Island, with its winding ways and series of picturesque pools, was not altogether felicitous, but a good deal of sensitive restoration has been carried out in more recent years and is continuing. After the Second World War Krestovsky Island, on which Nikolsky's Kirov sports stadium stands, was rededicated as the Primorsky Victory Park, one of the numerous victory parks which continue a tradition, begun at Peterhof, of celebrating military success in park architecture. Another architectural consequence of the war is the very moving *Piskaryovskoye Cemetery for the countless victims of the siege of Leningrad, while the Forest Cemetery outside Tallinn is also impressive in its simplicity. Not the least of the achievements of Soviet landscape architects is the remarkable standard of restoration of the great historic parks. P.H.

See also KOMAROV BOTANICAL INSTITUTE GARDEN.

Ruys, Mien (1904–), Dutch landscape architect, is one of the key figures in the development of the modern garden in the Netherlands. Her father was founder in 1888 of the *Ruys Nursery at Dedemsvaart which later developed an international reputation and was instrumental in developing more than a hundred new varieties of plants.

Mien Ruys began work by designing borders for the garden architecture department which her father had established in 1917. Later she broadened her practical experience by working for Wallace and Sons in England (1928) and attending lectures on garden architecture at Berlin-Dahlem (1929). This was followed by attendance at lectures in architecture at Delft, which helped to develop the strong interest in architectural form which is apparent in her work. In 1943 she joined the Dutch CIAM group 'De 8 en Opbau', a group of progressive architects who advocated functionalism, dispensing with unnecessary ornament. From 1951 to 1954 she lectured at the Technical University, Delft.

Garden at Leeuwarden, Netherlands, by Mien Ruys

From a beginning with country-house gardens, her work expanded to include garden and landscape design for housing estates, offices, and industrial complexes such as the Van Nelle Fabriek in Rotterdam. Her designs combine clarity of concept with richness of detail, particularly in the planting, which derives in part from her re-evaluation of the English cottage garden. In 1955 she founded the magazine *Onze Eigen Tuin* ('Our Own Garden'), and her book of perennials *Het Nieuwe Vaste Planten Boek* ('The New Perennial Plant Book') is well known. W.J.C.B./M.L.L.

Ruys Nursery (now Royal Moerheim Nursery), Dedemsvaart, Overijssel, The Netherlands, is the outstanding Dutch nursery for perennial plants and one of the largest in Europe during the first half of the 20th c. Founded by Bonne Ruys in 1888, the nursery soon had a large export market abroad, in particular to the United States, Scandinavia, and England. Between 1899 and *c.*1950 more than a hundred new cultivars were raised, the most spectacular being the first perennial pink delphinium, *Delphinium ruysii* 'Pink Sensation', introduced in 1936. Among others were Belladonna delphiniums, astilbes, heleniums, and phlox

(*Delphinium* 'Moerheimii' (1911), *Astilbe* hybrids 'Professor van der Wielen' and 'Betsy Cuperus' (1917), *Helenium autumnale* 'Moerheim Beauty' (1930), and *Phlox paniculata* 'Mia Ruys' (1930) are still on the market).

An indubitable asset to the nursery was Mien *Ruys, landscape architect and daughter of the founder, who from 1925 onwards demonstrated the use of the nursery's plant material by laying out model borders and small gardens at the nursery. Today under Theo Ruys, grandson of the founder, the nursery leads in the export of roses. F.H.

Ryoan-ji, Kyoto, Japan, was the most profound and austere of the Zen Buddhist gardens of contemplation and the most famous example of dry landscape (**kare-sansui*). In its initial stages it is thought to have been the work of Hosokawa Katsumoto (1430–73) but it was destroyed by fire in 1488. Its restoration (*c.*1488–99) is ascribed to Soami and the design undoubtedly shows the influence of Song and Yuan black and white painting. The floor is a plain rectangle of raked quartz (*c.*256 sq. m.), bounded on two sides by the temple verandah and by 1·5-m. high walls with tops of sloping tiles on the south and west. On it are 15 rocks, set out in five groups of five, two, three, two, and three each, an arrangement of esoteric significance governed by mathematical relationships whose underlying harmonies link the onlooker to nature in the abstract. S.J.

Ryoan-ji, Kyoto, Japan, rocks through the snow

Sackville-West, Victoria (Vita) (1892–1962), English poet, novelist, and gardener, married Harold Nicolson in 1913. They began gardening at their first home at Long Barn, Sevenoaks Weald, Kent, during and after the First World War. He was responsible for the layout and she designed the planting. In 1930 they bought *Sissinghurst Castle and together they created the garden there. Between 1947 and 1961 she wrote a weekly column called 'In Your Garden' for the *Observer*, which earned her the affection of thousands of gardeners and would-be gardeners. Collections of these articles have been printed in book form, of which the latest is *V. Sackville-West's Garden Book* (1983).

Sissinghurst Castle's garden, now owned and conserved by the National Trust, remains as her memorial, but she most wished to be remembered as a poet. Much of her poetry springs from her love of her native Kentish Weald and her gardening; many of her *Collected Poems* (1933) and her epic poems *The Land* (1926) and *The Garden* (1946) express the depths of these feelings. *The Garden* is possibly the best evocation of the spirit and fascination of gardening in the English language. J.BR.

Sahelion-ki-Bari, Udaipur, India, is the Garden of the Maids of Honour, who by tradition were sent by the Mogul emperors to the Maharana of Udaipur, reversing the more usual procedure. Its date is uncertain but its details suggest it to be fairly late. Its chief features are a square pool with a circular pavilion, from the roof of which water cascades down, two smaller pavilions with revolving metal birds, and a large round pool filled with lotus on whose leaves fountain jets can be made to simulate the sound of light raindrops falling or the heavy rain of the monsoon. S.J.

Saiho-ji, Kyoto, Japan. Built in 1339 in the transition between the Kamakura and Muromachi periods, this paradise garden was designed by Muso Soseki (1275–1351), a Zen Buddhist priest, sometimes called Muso Kokushi. His many garden creations include *Tenryu-ji in Kyoto.

The original Saiho-ji garden extended much further up the slopes of Mount Arashimaya, but the lake at the bottom (the 'golden pond') was always the principal feature, its shores loosely scattered with pavilions, unlike the Heian paradise gardens whose arrangement followed a predetermined course. The central hall on the west side was the model for the *Kinkaku-ji and *Ginkaku-ji pavilions.

The lake, divided in two by islands, is shaped like the Japanese character for 'heart' or 'spirit', as was the case in many gardens of the period. In later gardens a different

character was sometimes used to determine the shape of the lake. Round the lake the paths are arranged to reveal changing views of symbolic significance. At an upper level is a dry landscape garden (*kare-sansui) in front of a small Zen temple. The garden is also known as Koke-dera (moss garden) from the hundreds of different mosses that cover the ground in the pond area. They date from the Meiji era (beginning in 1868) when the monastery was too poor to maintain the gardens properly, but are now one of the main attractions. S.J.

Saint-Cloud, Hauts-de-Seine, France, has a château which was rebuilt by Philippe, Duc d'Orléans, brother of Louis XIV, in 1675; it was used by Marie-Antoinette, Napoleon, Charles X, Louis-Philippe, and Napoleon III and was burnt down in 1870.

For nearly a century from 1577 Saint-Cloud belonged to the Gondi family, which provided two bishops and the first archbishop to Paris. *Evelyn, who went there in 1644, dismissed the house as 'not very considerable' but commended the gardens—'rarely watered and furnished with fountains, statues, groves'. He particularly noted the fountain of Laocoön, 'throwing water near forty feet high'. Thomas *Francine, a neighbour of the Gondis, contrived these waterworks, some of which, as at Saint-Germain, activated musical instruments. The extent of the gardens was not very great and the perspectives were prolonged, where necessary, by paintings in *trompe-l'œil*.

In 1658 the villa was purchased by the Duc d'Orléans, known in Court language as Monsieur. In 1675 he employed *Hardouin-Mansart to rebuild the château on more grandiose lines for his second wife Liselotte, daughter of the Elector Palatine. Unlike his brother, Monsieur did not hunt. He was a lover of nature and would permit venerable trees to be felled only if the necessity was absolute, an attitude which often frustrated *Le Nôtre in his designs.

The site of Saint-Cloud was its greatest attraction but its narrowness imposed certain restrictions. Monsieur placed his main emphasis on the two wings which enclosed the forecourt, having his own rooms on the south side and the Galerie d'Apollon on the north. The main axis of the gardens was thus from north to south. The whole scene is admirably depicted in the great aerial view by Allegrain at Versailles and the details in a set of engravings by *Silvestre and *Perelle now in the Louvre. To the north, the windows of the Galerie d'Apollon looked out towards the village over a parterre which once ended in a *trompe-l'œil* by Boulogne of the Temple of Flora. To the south, the private apartments

commanded the avenue towards Sèvres, the Allée des Goulottes.

Between this axis and the Seine the falling away of the ground provided the opportunity for the main architectural feature, the Grande Cascade, which happily survives. Designed originally by Antoine Le Pautre (1612–91), it was enlarged in 1697 by Hardouin-Mansart. Three great ramps, separated by the twin arches of a grotto, descend steeply in a succession of vases and basins, each receiving the water from the one above and tossing it up again in a new fountain.

To the west, opposite the main body of the building, the ground was cast into terraces up to the level of the forest, through which a long *percée* was contrived. Here was the Jet de la Grande Gerbe, a fountain that thrust its water 12 m. into the air with such force, Martin Lister (1698) noted, that it emitted sounds 'like the crack of a pistol'.

Although the château has gone without a trace, the magnificent site survives as a public park which incorporates not only the cascade, but some other features of the original gardens. I.G.D.

St Gall (or St Gallen), Switzerland, was the seat of a famous early Benedictine monastery founded where St Gall, an Irish hermit, built his cell in AD 614. As one of the chief centres of learning and education in the Carolingian Empire the monastery maintained an important library, in which has survived a parchment plan for an ideal monastery, addressed to Gozbert, Abbot of St Gall from 816 to 836. For the three gardens shown on the plan, see *Carolingian gardens. J.H.H.

Saint-Germain-en-Laye, Yvelines, France, has an important former royal estate overlooking the Seine west of Paris, with an old castle, rebuilt by *François I, a large park, and a terrace promenade over 3 km. long designed by *Le Nôtre and *Hardouin-Mansart. In addition to the old castle, the Château-Neuf formerly stood on the edge of the escarpment. It was begun for Henri II by Philibert de *L'Orme, and completed (1599–1610) for Henri IV.

Terraced gardens descended to the river in seven stages. Ground rendered unstable by quarrying was buttressed by massive ramps (the upper one still exists) beneath which old excavations were turned into galleries and grottoes, furnished with *automata worked by water and devised by Thomas *Francine. The fourth terrace and the roofs of two galleries at right angles to it formed a continuous promenade looking down on the Jardin en Dentelles which is laid out in compartments with the royal monograms. The galleries terminated in two pavilions. The Pavillon du Jardinier

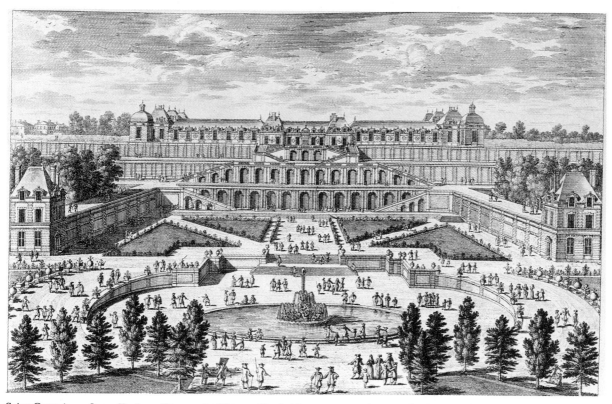

Saint-Germain-en-Laye, Yvelines, France: the Château-Neuf with an unexecuted project for the parterre, engraving (c.1665–70) by Perelle (Bibliothèque Nationale, Paris)

(now called the Pavillon de Sully) on the north-east corner exists as a private residence. Below the Jardin en Dentelles the ground sloped and was planted with fruit-trees. Engraved 17th-c. bird's-eye views show an elaborate water-garden at the lowest level, with a door opening to the river, but it is doubtful if it was ever made in this form.

The Château-Neuf was the favourite residence of Louis XIII. After his death in 1643 it was neglected. The terraces collapsed in 1661, and were rebuilt by *Louis XIV. There were also gardens for the private use of the king and queen adjoining the Château-Neuf on the north and south. The latter was redesigned by Henriette d'Angleterre (sister of Charles II) when she lived there as the wife of Philippe, Duc d'Orléans, Louis XIV's brother. It had parterres of cut turf, and she called it 'the bowling-green', thus introducing *boulingrin as a French gardening term.

The grounds between the old château and the Château-Neuf were redesigned by Le Nôtre between 1663 and 1675, giving them a unity they had not before possessed, and linking them with the terrace promenade made between 1669 and 1673. The Château-Neuf was assigned to the exiled James II in 1688. It was demolished by Charles, Comte d'Artois (Charles X), between 1777 and 1782 to make room for a grandiose project by F.-J. *Bélanger, which was not built. Subsequent urban development has completed the destruction of the terraces. The old castle is now a museum of archaeology. The park (part of which is laid out as a jardin anglais) and the terrace promenade are open to the public. K.A.S.W.

St James's Park, London, lying between St James's Palace and Whitehall, was first laid out for Charles II, soon after his restoration in 1660, by André *Mollet, who had worked for the King of Sweden and was later, with his brothers, to be employed by Louis XIV, to whom Charles II had applied for the services of Le Nôtre, himself formerly apprenticed to the Mollets' father, Claude.

In his book Le Jardin de plaisir (1651) André Mollet advocates, for the main outline of the grounds of a palace, a vast *patte d'oie, its three avenues radiating from double semicircles of trees to the seemingly limitless horizon. To a king who had not long since been an exile in France the notion appealed at once. From The Retir'd Gard'ner (1706), translated from the French by *London and *Wise, we learn that 'a great number of acacias' had been planted in the walks of St James's Park, but in the great storm, which alarmed Queen Anne, who saw and heard it from St James's Palace, these trees were so badly damaged that what was left of them had to be felled. As at Hampton Court, the middle 'toe' of the goose-foot at St James's took the form of a canal, enlivened with waterfowl which nested on an island. The more exotic birds were kept in Birdcage Walk. Between the north side of the park and St James's Palace Charles and his friends played paille-maille (a crude form of croquet), which gave its name to Pall Mall.

In Queen Anne's reign (1702–14) only Henry Wise, whom she had appointed Ranger, was allowed to ride on horseback through the park. The Duke of Buckingham, who had built a house (rebuilt as Buckingham Palace) at the western end of the canal, was grudgingly permitted access by coach, but soon offended the Queen by overstepping his eastern boundary. While Sarah, Duchess of Marlborough, was still in favour, the Queen rashly allowed her to build Marlborough House in part of the royal garden, with Wren as her architect, with whom of course she fell out; but by 1711, when the house was finished, the Duchess was no longer persona grata with her royal neighbour.

In the reign of George IV (1820–30) the park was remodelled by John Nash. The canal became a lake, spanned by a suspension-bridge, later to be replaced by an offensively unromantic slab of concrete. D.B.G.

St Paul's Walden Bury, Hertfordshire, England, is probably the best surviving example, not excluding Hampton Court, of an English domestic park of the early 18th c. laid out under the influence of Le Nôtre. The birthplace of Queen Elizabeth the Queen Mother, the park was restored by Sir David Bowes-Lyon, whose work is being continued by his son Simon.

Although alterations and adjustments to the network of avenues were made in the 19th c., the 40-ha. park with its converging avenues is a completely unified composition with the north façade of the house. The avenues are outlined with clipped beech hedges recalling the *charmilles of Versailles and the vistas are closed with sculptures and temples, some original but for the most part acquired during the present century. Interspersed within the formal pattern, but not competing with it, is romantic woodland scenery developed during the past 50 years, some of it inspired by the Himalayan travels of the present owner. G.A.J.

Saint-Simon, Louis de Rouvroy, Duc de (1675–1755), French memoirist. His Mémoires and their appendices (ed. Chéruel, 13 vol., 1904–6) provide comment on *Louis XIV's passion for gardens (VIII. ix), on the expense this involved (VIII, notes, vi) and on the career of Le Nôtre (II. viii). These observations occur in the context of an over-riding antipathy towards Louis XIV and his policies, which explains much of the author's hostility towards the king's garden projects. Saint-Simon stresses Louis's preference for the unfavourable site at *Versailles in order to 'tyrannise nature'. For Saint-Simon Versailles, and then *Marly, were signal instances of Louis's spendthrift bad taste—sites which were utterly unwelcoming, marshy, malodorous, unhealthy, and where magnificence was added to magnificence, crushing, gorgeous, and vulgar. In contrast he approved the delights of Trianon, the ménagerie, and Clagny. Both at Versailles and at Marly lack of water led to foolish, costly schemes, to divert the Eure and build the 'Machine de Marly', to pump water from the Seine. Marly, though intended as a 'hermitage', a modest retreat, cost more than Versailles and was a monument to extravagance, to the king's bad taste, and to his 'proud pleasure in compelling nature'. C.T.

Saiwaen, Singapore. See JURONG JAPANESE AND CHINESE GARDEN.

Sakuteiki, probably the oldest known document in the world concerning the technical description of the art of garden construction, is attributed to Tachibana-no Toshitsuna (1028–94), a Japanese court nobleman of the late Heian period. Toshitsuna collected together secret knowledge on the making of gardens already extant in his day, and incorporated in it his own knowledge based on experience.

Sakuteiki describes the basic layout of noblemen's estates in the prevalent style of the Heian period called *shindenzukuri*: in conformity with the 'aspect of divination' for the orientation of the mansion, its main courtyard or 'south garden' is to be viewed from the main house. It also describes the direction of the flow of the garden stream, the pond, and stone placement.

While the document is full of descriptions about religious significance and taboos, particularly on the stone arrangement, the technical instructions about the construction of waterfalls and the variety of naturalistic scenery are so thorough and excellent that they became the ultimate guides for Japanese gardeners throughout the succeeding generations. Modern designers also find invaluable suggestions in *Sakuteiki* for their creation of truly aesthetic and dynamic works in the art of stone placement, and also in other aspects of garden construction. S.S.

Salle de verdure, a central space within a **bosquet.*
 A.M.P.

Salutation, The, Sandwich, Kent, England, was designed in 1911 in Queen Anne style by *Lutyens for the Farrar brothers. The old walls bounding the site, which are characteristic of the Sandwich townscape, were retained and Lutyens ingeniously sited the house and arranged the garden in a series of vistas and enclosures which give complete seclusion whilst allowing practical and visual links with the outside world. This is one of Lutyens's most highly integrated house and garden designs. No planting plans of Gertrude *Jekyll have been found but it seems certain that she visited the Farrars and advised on the garden, which has always been planted in her style. I.L.P.

Samarkand, Uzbekistan, Soviet Union, lies in a plain. At the time of the Timurids, descendants of Tamerlane (late 14th c. until early 16th c.) there were many well-watered gardens modelled on the Persian (Iranian) tradition. Generally they had a centrally located pavilion, channels on the main axis, pools, fountains and cascades, and high enclosing walls penetrated by arched entries. Gardens on hillsides or river banks were terraced. There were cypress, elm, plane, poplar, sycamore, and willow trees grouped as single species; and amaranthus, calendulas, carnations, cornflowers, hyacinths, lilacs, lilies, roses, and tulips planted in regular beds. There were also orchards and vineyards. Erected in the royal gardens for celebrations and receptions were circular tents and awnings of red cloth and embroidered silk, supported by wooden poles rather than stays.

One particular location is reportedly described in the 15th c. by Clavijo, Ambassador of Henry III, King of Castile and Léon (*Narrative of the Embassy of Ruy Gonzales de Clavijo to the Court of Timur at Samarkand 1403–6,* Hakluyt Society Papers 1870) as 'a large garden with many different shade and fruit trees. It contained basins and skilfully laid-out lawns, and there was so wide a space by the garden entrance that many people could take delight in sitting here in summertime, by the water and under the trees.'

A further description by Clavijo is as follows: 'We found it to be enclosed by a high wall which in its circuit may measure a full league around, and within it is full of fruit trees of all kinds save only limes and citron-trees which we noted to be lacking. Further, there are here six great tanks, for throughout the orchard is conducted a great system of water, passing from end to end: while leading from one tank to the next they have planted five avenues of trees, very lofty and shady, which appear as streets for they are paved to be like platforms. These quarter the orchard in every direction, and off the five main avenues other smaller roads are led to variegate the plan . . . In the exact centre there is a hill, built up artificially of clay brought hither by hand; it is very high and its summit is a small level space that is enclosed by a palissade of wooden stakes.

'Within this enclosure are built several very beautiful palaces, each with its complement of chambers magnificently ornamented in gold and blue, the walls being panelled with tiles of these and other colours. This mound on which the palaces have been built is encircled below by deep ditches that are filled with water, for a runlet from the main stream brings this water which flows into these ditches with a continuous and copious supply. To pass up unto this hillock to the level of the palaces they have made two bridges, one on the other part, the other opposite. . . . There are to be seen many deer which Timur has caused to be caught and brought hither, and there are pheasants here in great abundance.'

In his memoirs *Bābur gives the following description of the garden of Darwesh Muhammad Tarkan. 'It lies overlooking the whole of Qulba Meadow, on the slope below the Bagh-i Maydan. Moreover it is arranged symmetrically, terrace above terrace, and is planted with beautiful narwan and cypresses and white poplar. A most agreeable sojourning place, its one defect is the want of a large stream.'

The gardens of Samarkand and their supporting gardening tradition declined after the 17th c. owing to general political unrest in the region. J.L.

Sandemar, to the south-east of Stockholm, Sweden, is a manor-house on the coast of the Baltic. The building in wood with four wings dates from *c.*1670 and is representative of the more unpretentious architecture of the period. The contemporary garden is the best preserved baroque garden in Sweden. The original parterres are simplified, but the clipped globes of lilac, the hedges, the pyramids of fir, and the wooden sculptures painted white—the whole surrounded by clipped lime trees in six rows—are practically unchanged. Although the fir pyramids have grown out of proportion the garden gives a vivid impression of the

gardens of the time, adapted as they were to a hard climate and modest means. G.A.

Sanspareil, Bayreuth, Bavaria, German Federal Republic, is quite different in character from the Margravine Wilhelmine's other garden at the *Eremitage, Bayreuth. It is a rocky grove filled with beech trees which had its origin in the unusual landscape of Franconian Switzerland. Alongside large masses of rock stand isolated boulders whose strange shapes excite the onlooker's imagination. From this setting the Margravine Wilhelmine drew the inspiration for her idiosyncratic garden which was really in the landscape style. The design of the grove was based on literary allusions drawn from *Les Aventures de Télémaque*, the famous novel by Fénelon; Wilhelmine interpreted the centre of the grove as the magical island of Ogygia on which Télémaque was shipwrecked during his search for his father Odysseus. The garden was intended to represent the setting of his adventures and as the novel had a didactic purpose, visitors to the grove were to relive Télémaque's experiences and thus undergo a process of purification.

Work on the garden was begun in 1774. Only a very few buildings were included in the design and of these only two remain. The Morgenländischer Bau in the style of a rustic hermitage is built around an old beech tree which stands in a tiny court (since replaced). Also interesting is the theatre, built as a ruin and set in a grotto in one of the rocks.

Sanspareil is regarded as probably the earliest example of a landscape garden on the Continent. U.GFN.D.

Sanssouci, Potsdam, German Democratic Republic. Work on the 290-ha. park went on almost continuously from 1715 to 1913, but it was extended mainly between 1826 and 1860, and again between 1902 and 1908.

In 1715 Friedrich I of Prussia laid out a kitchen garden, sarcastically called the Marlygarten, which was also used for recreation. In 1744 his son Friedrich II had a vineyard with six curving parabolic terraces planted 250 m. away and at right angles to the pleasure-house belonging to the garden. Each terrace was divided by 28 glazed windows and 16 yew pyramids. Adjoining the vineyard stands the summer Schloss Sanssouci, built in 1745–7 to plans by Knobelsdorff. Vineyard and Schloss are situated on a hill and afford a splendid view of the countryside. The extensions to the garden took as their starting-point the heights on which the buildings stand. In 1745 the terraces were extended to the south by a parterre comprising eight compartments to which a fountain and pond with a gilded Thetis group were added in 1748. Valuable statues by Pigalle and Adam animate the surroundings of the fountain. On the far side of the moat a short *allée* with the two famous sphinxes by Ebenhech (1755) leads through agricultural land to the gardeners' houses (1752).

East of the terraces there originally stood a hothouse (1747), which was replaced in 1755 by the picture gallery. A

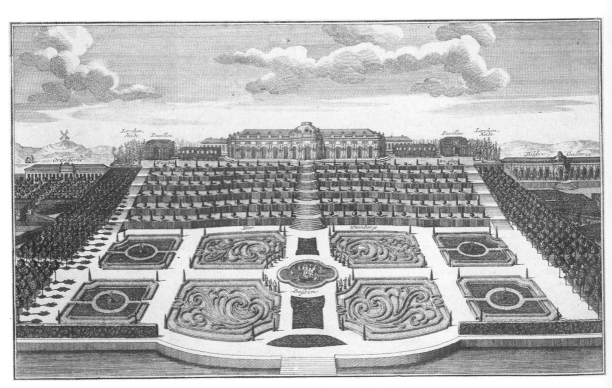

Sanssouci, Potsdam, German Democratic Republic, engraving (after 1755) by J. F. Schleuen

Dutch garden (1764–6) was laid out on the terraced beds, separated from the Oranier *rond-point with its fountain and hedged paths by a marble parapet with 12 sculptures of groups of children (1763–6).

The Neptune Grotto (1751–7, by Knobelsdorff), with a small flower parterre and a rhomboid hedged area, forms another, separate garden room. Beyond it is the Obelisk Portal (1747, by Knobelsdorff) with a small flower parterre and, 120 m. away, the obelisk (1748, also by Knobelsdorff). The various sections of the garden lie along the avenue which leads to the Neues Palais, 2 km. away.

To the west of Schloss Sanssouci are the Neue Kammern, which were built in 1747 as an Orangery on what was originally a fruit garden. They were rebuilt in 1771–4 as lodgings for guests. The garden was subsequently reconstructed a number of times, in 1955 as a rose-garden.

The remaining parts of the garden are divided into *bosquets*; two *allées* with fountains run through them diagonally to the west, and in this part stands the Chinese teahouse (1754–7, by Büring) with its own garden which later became the centre of several vistas.

In the adjoining oak and beech plantations stood a marble *colonnade (1751–63, by Knobelsdorff), which was demolished in 1797. At the end of the main avenue stands the Neues Palais (1763–9) by Büring, Manger, and Gontard. To the east of the large parterre with its statuary stand the Freundschaftstempel and the Antikentempel (both 1768, by Gontard).

Charlottenhof Park. In 1825 the future Friedrich Wilhelm IV was given a small estate adjoining Sanssouci by his father which he had redesigned as a landscape park from 1826 by *Lenné; it was called Charlottenhof after the previous owners. In 1826–8 the old manor-house was completely rebuilt to plans by Karl Friedrich *Schinkel and connected directly to the park by a terrace enclosed by a pergola and *exedra. To the east lie a regular flower garden and a small waterworks (not preserved) by the so-called machine pond, formed by extending a moat on which building materials were transported to the Neues Palais.

At the northern end of this pond stands the group of buildings known as the Roman Baths, built in the style of Italian villas: the Court Gardener's House (1829), the Tea Pavilion (1830) in the shape of a prostyle, the Hall of Arcades (1833, by Schinkel), and beyond, the Roman Baths (1834–6, by Persius) and the Servants' House (1832–3). Small, lavish flower gardens and fountains surround the buildings in front of which, facing the park, lay the Italian cultivation area with subtropical plants.

To the west, by the Schloss Charlottenhof, lie the Poets' Grove, based on ancient models, with statues of famous poets and a cast-iron fountain; a large lawn with the Ildefonso group; and the vast open space of the hippodrome surrounded by trees (1836). A bronze monument to Friedrich II of Prussia by C. D. Rauch, which originally stood in Berlin, was erected here in 1961. Beyond the hippodrome lies a pheasantry (1841–4) with a group of Italianate buildings.

Lenné connected the Charlottenhof Park with the Frederican park round Sanssouci itself by means of an indirect route and three long axial vistas, so contrived that the eye is always directed inside the park, as there is no connection with the surrounding countryside.

In 1827 a large area of land, known as the Hopfengarten, was purchased to the north of the Neues Palais, and Lenné redesigned this as an elaborate landscape garden with statuary, a lake, and canals connected to the palace moat. The beauty of the garden prompted Friedrich Wilhelm IV to erect a bust of Lenné by C. D. Rauch.

After his accession in 1840 Friedrich Wilhelm IV extended the Sanssouci Park, particularly to the north. On a level with the Obelisk Lenné laid out a vineyard (1847) in the form of an Italian vineyard with a Vintner's House (1849, by Hesse and Stüler). Plans were made for a triumphal avenue to lead to the Schloss Sanssouci and on to the Orangery, but only the triumphal gate was built.

North-west of the Neue Kammern the Nordic and Sicilian Garden was created in 1857 with a large terrace and the Orangery (1,300 m. long, built in 1851–60), which in addition to the plant-halls contains ceremonial rooms, including the Raphael Room, and living appartments. The regular terraces, in which Lenné introduced many Italian Renaissance elements into the garden, were not completed. The building plans were drawn up by Persius and Stüler from sketches by the King.

As the building which was to be the termination of the planned triumphal avenue was not connected to the Frederican park, Wilhelm II had the so-called Jubiläumsterrasse built in 1913 which H. Zeininger joined to the main avenue of the park by a 110 m.-long parterre. To the west of the Orangery, G. *Potente had laid out a 25-ha. landscape garden in 1902–8 which formed the termination of the park on the north-west side at the Belvedere.

Extensive reconstruction work was carried out by Dr Gall and Georg Potente from 1922 to 1937; further work was undertaken from 1964. H.GÜ.

Saut de loup, a deep trench or ditch dug at the further end of of an *allée to prevent trespassing without interfering with the view. A *ha-ha (French *ah-ah!*) is an extended *saut de loup*. D.A.L.

Savill Garden, The, Windsor Great Park, Berkshire, England, which occupies c.14 ha., was begun in 1932 by E. H. (later Sir Eric) Savill (1895–1980), the Deputy Ranger of Windsor Great Park. The soil is Bagshot sand above clay, acid and reasonably retentive of water.

Many fine old trees including some ancient oaks are retained for shelter and shade. The garden is crossed diagonally by a system of streams and ponds. In the larger, woodland part are extensive plantings of rhododendrons and azaleas with lilies; also of camellias and magnolias, including three from North America, *M. macrophylla, M. tripetala,* and *M. virginiana.* By the waterside are primulas, meconopses, hostas, gunneras, rheums, ferns and, through the woodland, witch hazel, dogwood, and corylopsis beside

more commonly seen trees and shrubs such as prunus, philadelphus, malus, and others. In the Alpine Meadow the ground is carpeted in spring with small daffodils, crocuses, fritillaries, and other smaller bulbous plants. Apart from the woodland garden there are herbaceous borders, beds for roses of different kinds, and a large temperate house, chiefly for tender rhododendrons from Burma, China, and Java.

D.W.

Sayes Court, Deptford, London, was acquired by John *Evelyn in 1652. His new 'great garden' consisted of elaborate grovework, a large orchard, and a terrace flanked by holly and barberry hedges. His garden 'elaboratory' opened on to his private garden for flowers and herbs. Wide experimentation with alaternus, bay, laurel, cypress, walnut, and other trees laid the basis for his *Sylva* (1664). In 1698 he rented Sayes Court to Peter the Great of Russia, who enjoyed being wheeled through the holly hedge in a wheelbarrow and who also caused other devastation.

D.L.J.

Scandinavia includes *Denmark, *Norway, and *Sweden, and, from a historical and cultural point of view, *Finland and Iceland. The climate ranges from marine in the west and south-west (partly tempered by the Gulf Stream in winter, but open to cold air streams from the east which can cause hard winters) to humid continental in the centre and subarctic in the north. The terrain is low and undulating in Denmark, but mountainous in Norway and western Sweden with swift-flowing streams and a coastline indented with fiords. In eastern Sweden and Finland the land slopes very much more gently and there are thousands of lakes. A large proportion of the land is forested, natural deciduous trees in Denmark, coniferous elsewhere. Some of the region lies within the Arctic Circle, where tundra predominates. Denmark and Sweden have the best farmland.

In the sphere of garden and landscape design there is such a unified and common approach that it is difficult to distinguish between the countries. Denmark is also part of the land mass and cultural axis which extends right through Germany and the Netherlands and terminates in Switzerland. Not surprisingly, in garden and landscape design, town planning and nature conservation they also have much in common.

For more than 800 years Danish village affairs were settled by village assemblies, when each member would sit on a granite boulder placed to form a circle, usually under a tree or near a pond, a landscape tradition which may partly account for the continued use of the circle today. The square and circle were much used by the Vikings and pervade all Scandinavian landscape art. From neolithic times the circle and cross were often found inscribed in red on grey granite megaliths and testify to the earliest Scandinavian design.

The remote and wild nature of Norway and Iceland may have precluded the necessity to create designed landscapes and gardens, and one will seek in vain for historic landscape gardens comparable to those elsewhere in Europe (the exceptions in Norway are *Lurøy and *Rosendal Barony). This is offset by some of the largest nature reserves in the world. For example, Norway has one of the largest national parks, some 1·5 million ha. in extent. Both Norway and Sweden have vast hydroelectric power resources, and their integration into the landscape has, with the advance of motorways, meant a shift of emphasis to landscape planning, with a stress on recreational use of the landscape and the creation of nature reserves. Skåne, the southern part of Sweden, is very Danish in character: this coincides with the northern limits of the beech tree (the national tree of Denmark). There are also strong historical links between Skåne and Denmark, therefore it is not so remarkable that the garden tradition and historic manor-houses are very similar.

Landscape architecture. The limited range of plant material for use in landscape design may have given rise to the sophisticated Scandinavian landscape style, whose high standard is undoubtedly contributed to by the excellence of domestic architecture, an emphasis on the principle of 'small is beautiful' and on detail design, and, above all, a desire to keep everything simple and uncluttered. The Scandinavians are mainly a race of outdoor fanatics and nature lovers, and the short summers have forced landscape architects to think of the garden as an outdoor room, an extension of the house. The pragmatism and practicality pervading all Scandinavian design has given rise to a clean, clear-cut sense of aesthetic values.

Scandinavian landscape architects are also illusionists; their careful planting compositions and juxtapositioning, skilful use of foliage and trunk forms, singularly decorative paving patterns, achievement of compartmentalized spatial urban environment of apparent freedom and simplicity, and their air of deceptive casualness and optical abstraction—all combine to form an amalgam of sculptural gardening much admired by the rest of the world.

P.R.J.

Sceaux, Hauts-de-Seine, France. In 1670 the domain of Sceaux was purchased from the Duc de Gesvres by Jean-Baptiste Colbert, Louis XIV's great minister, who enlarged the château and added one notable garden building, the Pavillon d'Aurore, a rotunda with a dome painted by *Le Brun, which still survives.

*Le Nôtre was called in to design the gardens and the park. He had to move 10,000 cu. m. of earth to achieve his design of creating two axes converging at right angles upon the château which stood in the north-east corner of its terrain. From the garden front the main perspective towards the west plunged down into the valley and rose again towards the Coteaux de Châtenay, while another perspective opened towards the south, with the elaborate cascades bringing their tumultuous waters down to the great *pièce d'eau* of the Octogone. The cascades were originally ornamented with statues by Girardon and Coysevox which have since disappeared. The *mascarons* which have replaced them were carved by Rodin in 1900.

Colbert's son, the Marquis de Seignelay, increased the

layout, adding the sumptuous *orangerie* by *Hardouin-Mansart and the immense canal. These extensions were carried out by François Leclerc. Seignelay lived in great style at Sceaux and entertained Louis XIV to a lavish spectacle, the *Idylle de Sceaux*. On his death in 1690 the estate passed to the Duc du Maine, an illegitimate son of Louis XIV, and finally to the Duc de Penthièvre, who died in 1793. Sceaux was deserted and the château was pulled down. It was replaced by the Duc de Trévise with the undistinguished building which today houses the Musée de l'Ile de France.

The gardens were restored in the 1850s, following the main lines traced by Le Nôtre. Only the area west of the canal differs significantly from the original layout. It now centres on the Pavillon du Hanovre, built in the Boulevard des Italiens by Chevotet in Louis XV's reign and transported to Sceaux in 1930, where it is now the centre of a famous garden of dahlias. I.G.D.

Scheemakers, Peter (or Scheemaeckers, Peeter) (1691–1781), a Dutch sculptor and caster, left Antwerp in 1735. He had a statuary near Hyde Park Corner, London, where several such yards, opened by Dutch craftsmen, were centred. His work at *Rousham, contemporary with William *Kent's landscape, includes his *Lion attacking a Horse* and *A Dying Gaul*, both after originals in the Capitoline Museum in Rome, and he collaborated with Pieter Rysbrack on the Temple of the Worthies at *Stowe. There are also examples of his work at *Shugborough, *Chiswick House, and on several tombs in Westminster Abbey. He sometimes worked under the name of Peeter Gaspar. K.N.S.

Schijnvoet, Simon (1652–1727), was a Dutch architect, engraver, and art collector whose garden designs of Petersburg in the province of Utrecht (1717) and Soelen (c.1720) anticipate the rococo. He also published designs of such garden ornaments as vases, pyramids, and memorial columns (*Voorbeelden der Lusthof-Cieraden*, 'Models of Garden Ornament', c.1717). F.H.

Schinkel, Karl Friedrich (1781–1841), German architect and city planner who always aimed to integrate landscape and architecture, rather than to create buildings as self-contained monuments. Formally, he aimed to do so by means of a modern interpretation of classical forms.

He worked closely with *Lenné, designing a People's Hall and Rotunda for his *Volksgarten* at Magdeburg (1824), and at *Klein-Glienicke. Lenné's work at the *Tiergarten, Berlin (for which Schinkel designed a Corinthian tea-house in the Schlosspark Bellevue, 1824), was very strongly influenced by Schinkel's 1835 plan for the section of the Tiergarten where it meets the Brandenburg Gate.

In the narrower sense of landscape design Schinkel's opportunities were limited. His proposal for revitalizing the Grosse Stern, Tiergarten, by providing a circle of low, clipped hedges, was not implemented. His greatest opportunity came at Charlottenhof (*Sanssouci), Potsdam, where

in his Römische Bäder (1834–6) he succeeded by ingenious changes of level in creating the impression of the picturesque grouping of Italian vernacular architecture, which he had often sketched on his first visit to Italy (1803–5). On a grid plan he made clever and unexpected use of open and closed spaces, and changes of level to create a minor masterpiece. The hippodrome form which he used here (and also in his 1835 plan for the Tiergarten) was derived from the gardens of *Pliny the younger's Tuscan Villa. It was to become a favourite form with later park designers (especially Gustav *Meyer). P.G.

See also CHARLOTTENBURG.

Schleissheim, Bavaria, German Federal Republic. As a result of his marriage to a daughter of Emperor Leopold I, Max Emanuel, Elector of Bavaria, had hopes for the Spanish throne for his small son, who had in fact already been adopted by the childless Karl II. This was the impulse behind Max Emanuel's extensive building programme, as the modest Renaissance Schloss in Schleissheim did not match up to his hopes for the future. Work on a new garden Schloss, the Lustheim, was begun in 1684 (architect, E. Zuccalli) and on the Neues Schloss in 1701 (architects, E. Zuccalli and J. Effner). The baroque garden lies between these two buildings.

The design of the garden can be explained by Max Emanuel's personal history: as Governor of the Spanish Netherlands he had lived in the province for c.10 years from 1692 and there became acquainted with Dutch canal-building. He also spent a lot of time near Paris and was able to study Versailles and other French baroque gardens. The first plan for the garden at Schleissheim was drawn up by E. Zuccalli (who had also built Lustheim) but it was the design by Dominique Girard, whom Max Emanuel engaged from Versailles, which was actually used.

Canals play the predominant part in the layout: not only is the garden bounded by canals but the middle axis is formed by a canal, which terminates in a cascade at the end of the parterre nearest the Neues Schloss. Water was used in a particularly original way in the garden around Lustheim: a circular canal surrounds the building, giving the impression that the Schloss and its parterre are on an island—the island of Cythera. The subsidiary canals were originally used to transport building materials.

Bosquets containing garden rooms were placed on either side of the central canal. All the paths in the *bosquets* are hedged. The parterre is slightly sunken. At each end of the two long beds which flank the middle axis stands a round *bassin* with a fountain. A similar solution was later suggested by Girard for the parterre at Augustusburg.

Very little remains of the statuary which stood at the cascade and in the parterre. However, as the garden was never turned into an English landscape park it now ranks next to *Herrenhausen as the best-preserved baroque garden in the German Federal Republic. U.GFN.D.

Schlosshof, Nieder Osterreich, Austria. The palace was acquired and rebuilt in 1725 by Prince Eugene of Savoy, the

hero who saved Austria from the Turks; it was altered by Maria Theresa in 1755. The architect for the palace was Fischer von Erlach and for the gardens possibly Lukas von Hildebrandt. Through the painting by Bernardo Bellotto (1720–80) in the Kunsthistorisches Museum in Vienna, it is possible to reconstruct on the site a garden that was in grandeur second only to the *Belvedere and *Schönbrunn. Beginning as a semi-fortified manor it was enlarged with great gardens extending from existing ramparts. The Bellotto painting was made in 1758 and shows how the extra storey added by Maria Theresa disturbed the proportions and relationship of building to formal gardens, a field in which Hildebrandt was a master.
<div align="right">G.A.J.</div>

Schoch, Johann George (1758–1826), German landscape gardener, was a member of the important gardening family which was particularly active in the Dessau–Wörlitz cultural circle. After an apprenticeship at *Wörlitz Schoch planned and executed the landscape garden at Dieskau near Halle (1778–84). He travelled in France and England (1784–8), and from 1788 was again at Wörlitz, where he made extensions to the park around the Stein and Pantheon to specifications by Prince Franz of *Anhalt, and carried out landscape work in the Elbe meadows. After 1817 he influenced the maintenance of the park and continued work in the Elbe meadows; he also planned the Reilsberge Park near Halle, and the parks at Hohenpriessnitz and Braunschweig. He wrote *Versuch einer Anleitung zur Anlegung eines Gartens im englischen Geschmack* (1794).
<div align="right">H.GÜ.</div>

Schönborn, Nieder Osterreich, Austria, was built for Friedrich von Schönborn by Johann Lukas von Hildebrandt and completed in 1717. Though avenues run out on all sides, they do so for no purpose, suggesting how small a part the countryside plays in the Austrian garden. The palace, the orangery, and most of the avenues still exist, but garden features have been altered or removed and the park has been partially 'landscaped'. Despite these handicaps, this distinguished and interesting baroque garden with its peculiar converging lines of the central enclosure, can still be appreciated.
<div align="right">G.A.J.</div>

Schönbrunn, Vienna, Austria, was the palace of the Habsburg dynasty from its beginnings as a hunting-box (destroyed by the Turks in 1683) to the scene of the abdication of the Emperor Charles in 1918. Five years after the raising of the siege of Vienna in 1688, the Emperor Leopold I commissioned from Fischer von Erlach designs to rival *Versailles, on a site which was level to the north, with a sudden short rise to the south.

The first designs were prodigious. Von Erlach placed the palace on the rising land to the south with a great architectural garden and a cascade of seven streams leading towards the plains, with the distant city as a background. This was abandoned because of cost, the palace being placed at the lower level facing the hill. In general, the present palace garden and park are as designed by von Erlach (with the assistance of Adrian Steckhoven, von Hohenburg, and others). Later additions which did not substantially alter the composition were made by Maria Theresa in 1744, the architect being N. Pacassi. The menagerie was added in 1752 as a special feature reflecting an interest of Maria

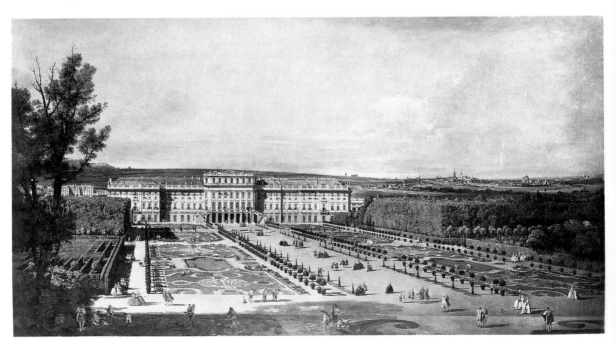

Schönbrunn, Vienna, garden side of the palace, oil painting (1759–60) by Bellotto (Kunsthistorisches Museum, Vienna)

Theresa's husband; the birds are said to have come from the aviary of the *Belvedere palace. The dramatic *Gloriette, which occupies the site originally planned for the palace, was made in 1775. The first appearance of sham Roman ruins came in 1778 under the influence of Winckelmann. The sculptors throughout included Beyer, Hagenauer, and Platzen.

Although Schönbrunn is impressive on account of sheer size, it is technically not as mature as any of the designs of Le Nôtre which it sought to emulate. The huge afforested park is divided by avenues with spectacular clipped walls of trees into squares and rectangles, with occasional diagonals centring on architectural features. Like Versailles, the gardens seem carved out of a forest. The principal parterre garden extends as an open rectangle approximately the same width as the façade of the palace. The first view from the palace of this long, simple rectangle, enriched with sculpture and water, and the distant hill crowned with the Gloriette seen in silhouette against the sky, is spectacular. Adjoining the palace there is a *giardino segreto fashioned out of trellis, while among the woods there are hidden *bosquets and the like. G.A.J.

Schönbusch, Bavaria, German Federal Republic, may be regarded as one of the first classical landscape gardens in Germany, as it had none of the romantic elements which F. L. Sckell still used in his design for Schwetzingen, for example. The same classical simplicity characterizes the small Schloss which the Elector and Archbishop of Mainz, Friedrich Karl von Erthal, had built as a hunting-lodge in 1778 by his minister Count W. von Sickingen and the Portuguese architect J. E. d'Herigoyen.

An artificial lake with an island was created directly in front of the Schloss, giving a broad vista of the Aschaffenburg Schloss. Boats and gondolas sailed on the lake. The island, which housed a large number of birds, can only be reached by a swing bridge. Sckell probably worked on the grounds from 1785, and he was also responsible for the creation of the second lake, the Oberer See. The main problem in the park has always been the shortage of water and the Oberer See has now dried out; a meadow covers the site and gives no clue to the original shape of the lake.

Several small one-roomed buildings are scattered throughout the park: the Freundschaftstempel, a classical building erected between 1799 and 1802 to plans by d'Herigoyen; the Philosophenhaus, also in the classical style; and the Speisesaal, built in 1792 for festive occasions, and of a highly original design, with concave interior walls. The four niches between the 12 french windows are decorated with paintings of river scenes and the flat cupola in the ceiling is painted to represent the sky. This, combined with the actual view of the park through the french windows, gives the illusion that the room is open on all sides.

In the so-called Tal der Spiele were placed various amusements, including a 'carousel with two gigs and four horses', a skittle-alley, and a rocking-chair; of these, only an open wooden pavilion built in the Chinese style survives. In order to emphasize the landscape style a little village with Dutch cottages was built in the park and, in another part, a number of shepherds' huts, all of them originally with thatched roofs. U.GFN.D.

Schrebergarten. See KLEINGARTEN.

Schwarzenberg Palace, Vienna, Austria, was built by Heinrich Mansfield, Count of Fondi. Begun in 1697 from designs possibly by Lukas von Hildebrandt, it was completed in 1715 by Fischer von Erlach after the original owner had died, and then passed to the Schwarzenberg family. The palace is one of a group beside the *Belvedere palaces, dominating the Schwarzenberg Platz.

The gardens are shown accurately in the painting by Bernardo Bellotto (1720–80) in the Kunsthistorisches Museum in Vienna. Though one side has been curtailed to widen the Prinz Eugen Strasse and the gardens are not quite so well preserved as those of its neighbours, the palace has aged with great charm. Basically it is a baroque shade garden with an open terrace on the higher ground whence there is a view of the city similar to that of its neighbour and rival, the Upper Belvedere. G.A.J.

Schwerin, Schwerin, German Democratic Republic. The Schloss, which was virtually rebuilt between 1843 and 1857 by A. Demmler in the French Renaissance style, stands on a small island reached by two bridges. The 1·8-ha. garden around the Schloss was created in the mid-19th c. to plans of *Lenné by the Schwerin Director of Gardening, T. Klett. The terraces which contain extensive grottoes afford wonderful views over the 19-km. Schwerin Lake; there are very valuable plantations.

The present 20-ha. park has been used as a fruit and vine garden since the 16th c. and has a drainage system. The French architects Lacroix and Vandeuille began work on a new system in 1672 but gave up the attempt almost in the first stage of planning. Considerable alterations were made in 1708, especially to the canal system for draining the very wet terrain.

In 1748–56 J. Legeay drew up and executed new plans for the park. The axis of the park is aligned upon the bridge to the Schloss, and this was taken into account when the Schloss was rebuilt. Between two existing canals which are connected to the Burg and Fauler Lakes lies a long cross canal. Three gently rising bumps in the ground were intended as the site for a series of cascades, but only the earth was moved away. The canal almost formed a circle in front of the Schloss, surrounding an oval lawn. Low hedges bounded the garden at the bridge. The garden has an extremely valuable collection of 14 statues from the atelier of B. Permoser; the originals have been put in store and replaced by copies. The statues were originally created in 1720 for a garden in Hamburg and brought to Schwerin only in 1752.

The garden was altered from 1860 onwards by T. Klett: a section of the southern, circular canal was filled in and the pergolas bounding the garden were planted with trees. In

1883 the equestrian statue of Duke Friedrich Franz II was erected.

From 1840 onwards the park was extended and redesigned in landscape style to plans of *Lenné. The baroque central section was preserved and work begun again on the series of cascades planned by Legeay. The small Greenhouse Schloss dating from 1835–7 was also integrated into the new design. The straight canal arm leading to the Fauler Lake was reconstructed as a curve, to harmonize with the park. The southern extension of the park was to be connected with the surrounding lakes by long vistas; these plans were not completely executed. Several façade structures (temples) act as *eye-catchers.　H.GÜ.

Schwetzingen, Baden-Württemberg, German Federal Republic, was in the 18th c. the summer residence of the Palatine court. The central part of the Schloss was originally a medieval moated castle which was rebuilt and extended after it had been destroyed in the Thirty Years War (1618–48). The redesigning of the Schloss was above all the work of Karl Theodor who became Elector of the Palatinate in 1743. He commissioned the famous theatre architect Alessandro Galli da Bibiena who, together with the architect Nicolas de Pigage, built the two circular buildings which gave the court gardener J. Ludwig Petri the inspiration for the circular parterre. On the west the parterre was bounded by two curved pergolas constructed of trellises. A broad axis connects the Schloss with the town and at the same time leads through the garden into the surrounding countryside. A large rectangular pond was placed at right angles at the end of the baroque garden. The cross-shaped arrangement of the avenues of limes emphasizes the garden's highly original circular design. *Bosquets* lay beyond the avenues.

The garden contained a great deal of statuary and many fountains (such as the Stag Fountain) as well as various buildings, such as the Orangery by Pigage which has a parterre enclosed by a ditch, and the rococo theatre of 1752, also by Pigage, which stands behind the northern building. It is worth mentioning here that the court orchestra in nearby Mannheim was regarded as one of the finest in Germany and that the Mannheim School exerted a very definite influence on the music of the time. Pigage was also responsible for the once beautifully furnished bath-house which stands in the *bosquet*. Next to the bath-house is a delightful waterwork representing water-spouting birds, presumed to have originated from *Lunéville; immediately adjacent are aviaries full of live birds.

The 'Court and Pleasure Gardener' Friedrich Ludwig von *Sckell redesigned the outer areas of the garden in the English landscape style from 1776. The rectangular pond became a 'natural' lake. The design of buildings for the new park was again given to the architect and Director of Gardening, N. de Pigage, and he built the Waldbotanik Temple, the Roman aqueduct, the Temple of Mercury, and the Turkish mosque which had its own garden.

Work on the garden was practically complete when Sckell went to Munich in 1804 after the Elector Karl Theodor had transferred his residence from Mannheim to Munich in 1778 upon succeeding to the throne of Bavaria. The parterre was reconstructed in 1974 to the original design by Petri.　U.GFN.D.

Sckell, Friedrich Ludwig von (1750–1823), was the first great German landscape designer to have been influenced by the English landscape style. He studied in England, where he was rather eclectically influenced by *Brown and *Chambers.

In his first period, from 1776–1804, he was employed at *Schwetzingen by Karl Theodor, and worked for many neighbouring princes. He also laid out the fortifications of Mannheim as a public promenade. During this period he began to reject the pre-romantic sentimental style in favour of neo-classicism.

His second period began with his assumption of full responsibility for the *Englischer Garten, Munich, where he had worked since 1789. Here he aimed to lay out a *Volksgarten* (see *public parks: the *Volksgarten*), although he was more influenced by the narrowly stylistic aspects of *Hirschfeld's conception. His memorandum of 1807 makes it clear that he had long disapproved of exotic buildings and sentimental monuments, and that a *Volksgarten* must take the middle course between princely magnificence and a park. His other major work during this period was *Nymphenburg.　P.G.

Sckell, Johann Conrad (1768–1834), German landscape gardener and plant-collector, was a member of an old gardening family which had been active in Thuringia since the end of the 17th c. After working on the Eisenach Park from 1796 to 1834 he was at Belvedere near Weimar, where he continued the extension of the park. His most important contributions were to extend considerably the Orangery built by his predecessor J. F. Reichardt, and to found the splendid and extensive plant collections. He travelled to the Netherlands in 1803. His collections of rare plants were illustrated in the *Catalogus Belvedereamus* (Weimar, 1820). Karl August of Sachsen-Weimar, *Goethe, and *Humboldt supported his work, studied botany under him, and increased the plant collections by gifts of seeds. He was succeeded as director of the Belvedere collections by his brother Johann Christian (1773–1857).　H.GÜ.

Scotland. Scotland's position on the north-western edge of Europe and its largely highland topography does not at first sight suggest a rich source of gardens, even when the warming effects of the Gulf Stream round its western coast are taken into account. Yet much of the terrain is benign and fertile with rich vegetation in the folds of the hills or along the courses of the rivers, where there is shelter and good drainage, and particularly from the 18th c. onwards this lesson of nature was heeded by Scots gardeners who began to improve Scotland's topography in terms of agriculture, horticulture, and arboriculture. Because they were well educated and well trained, they were much in demand south of the Border, and by the mid-18th c. the head gardeners of

many English estates were Scottish (see, for example, Thomas *Blaikie; William *Forsyth; James *Fraser).

There is little that can be said with certainty of Scottish gardens before the late 16th c. Strongholds such as Edinburgh or Stirling had their own tiny gardens, and there must have been larger gardens of conventional medieval layout attached to the great houses, but of these nothing remains. Falkland Palace in Fife (Fife Region) still possesses the original area of garden, which includes a very late 16th-c. tennis-court; but its present layout is due entirely to Percy Cane. There were extensive terraced gardens at Linlithgow, the favourite royal seat, but our knowledge of these too is tantalizingly imprecise. The *King's Knot at Stirling Castle alone survives in sufficient form to attest to an ambition of the Stuart kings of Scotland equal to that of the new Bourbon family at *Saint-Germain-en-Laye in France. But that ambition was achieved more fully when James VI of Scotland succeeded to the throne of a united England and Scotland and moved to London in 1604.

The early 17th-c. walled garden of the Lindsay family at *Edzell in the Mearns (Tayside Region), of similar extent to its contemporary Hatfield in England, has, unusually, walls enriched by planetary deities and other emblematical sculptures of fine masonry, and these have survived because it would have been difficult and expensive to alter. Aberdour in Fife (Fife Region) also survived but its form had to await archaeological investigation to be revealed as the archetypal 17th-c. Scottish garden: three L-shaped terraces descend from a large irregular house; orchards lay at the bottom and fruit-trees were trained on the flanking walls, but the plants and other furniture of the terraces remain unknown.

Two of a group of gardens connected with Sir William Bruce of Kinross (d. 1710) and Alexander Edward (1651–1708) bring Scottish gardens more into line with advanced Continental practice. Balcaskie in Fife (Fife Region) has the earliest regular terraces, with their governing axis aligned on the Bass Rock as the picturesque terminal focal point, and house and forecourt were integrated with the garden into a coherent whole. This manner, best practised by *Le Nôtre in France, was further developed by Bruce at Kinross (Tayside Region) where, fortunately, contemporary design drawings survive to indicate the form and extent of his plantations beyond the walls of the gardens.

By the beginning of the 18th c., gardens in Scotland, as in England, grew to a size large enough to allow for landscape designing, notably at *Hamilton Palace, but also at *Hopetoun House and at *Alloa. All these schemes were fundamentally derived from architecture and were on occasion designed by architects, as at *Arniston House by William *Adam. The first of a somewhat different type is to be found at Tyninghame, East Lothian (Lothian Region), a planted estate whose form developed over a period of time, rather than being designed at the beginning and in relation to the house and its immediate surroundings.

Tyninghame's owner, Lord Haddington, was from 1724 a member of the Society for the Improvement of Knowledge in Agriculture, which was led by the Duke of Atholl, whose plantations at Blair Atholl, Perthshire (Tayside Region),

were extensive, somewhat irregular like some of Charles Bridgeman's designs, and the site of the first introduction of the larch into Scotland in 1737. The members of the Society of Improvement, as it was more familiarly known, tried various methods of reclaiming land, introduced scientific agriculture, and planted—planted on a scale hitherto unheard of. It is to the Improvers, and to their sons and grandsons, that to a great extent we owe the structure of the Scottish landscape as it exists today.

Sir John *Clerk of *Penicuik was an Improver too, but with a rather different point of view from his fellows. He had been planting at Penicuik since the very beginning of the 18th c. but c.1735 began to see new possibilities in the development of the landscape—the exploitation of poetic and historic allusion; with him began the art of landscape, or place-making. Gardens treated in this way were given sense and form by exploitation of the topography, by skilful plantation, and by an association of ideas usually achieved by building or sculpture. By contrasting a pastoral landscape with the dark, tortuous, and horrid entrance to a grotto at Penicuik, the Cave of Hurley, Clerk purposely recalled the Cumaean Sibyl's cave near Naples, and by allusion suggested Aeneas' quest for a new country. Of course, this kind of landscape gardening was attractive even without a full understanding of its designer's purpose. The manner was perfected by Lancelot *Brown, in whose hands in England its pastoral qualities were fully exploited, but although Brown's kind of landscape design was practised in Scotland (especially by Thomas *White the elder and his son) it was neither native to Scottish tradition nor particularly suited to the topography.

More appropriate to the Scottish terrain and circumstances was a more generalized system of improvement and planting, using, where possible, the more poetic or artistic characteristics of place-making. Only such a flexible scheme could take advantage of the varieties of countryside, and, too, the varieties of intention—ranging from pure agricultural improvement to the introduction of exotic shrubs and forest trees.

The lure of history in the association of ideas led in due course in the early 19th c. to the re-creation of older styles of gardens. Initially this was somewhat imprecise, as in *Drummond Castle Gardens where the old-time qualities were suggested by the main structural lines of the scheme. By the end of the century artists like Sir Robert Lorimer attempted rather more in scholarly restoration of gardens as suitable adjuncts to the renovation of 17th-c. houses such as Earlshall in Fife (Fife Region) or Balmanno in Perthshire (Tayside Region).

The mild soft climate of the west coast and islands of Scotland provides ideal conditions for woodland gardens and for the growing of rhododendrons in particular, once shelter-belts have been established to give protection from the Atlantic gales. Osgood Mackenzie began planting at *Inverewe as early as 1862 and Crarae on Loch Fyne (Strathclyde Region) has a unique collection of unusual conifers and exotic rhododendrons, now maintained by the Forestry Commission. Other notable 20th-c. rhododen-

dron collections are in the island gardens of Brodick Castle on Arran, Achamore on Gigha, and Kiloran on Colonsay (all in Strathclyde Region).

Other 20th-c. gardens, as new creations, are relatively rare. Where they exist they usually attempt some kind of recollection of a past type such as the marvellously idealized 18th-c. creation in the very 20th-c. garden at Manderston, Berwickshire (Borders Region). A less specific conception of 18th-c. attitudes is evident in the pocket landscape of Boharm, Banffshire (Grampian Region)—a garden, incidentally, designed very much with 20th-c. means of maintenance in mind. A recent garden which draws much of its inspiration from places such as Penicuik and ideas such as those first expounded by Lord Kames in the 18th c. is Ian Hamilton *Finlay's garden, *Little Sparta, where objects in the landscape and areas of plantation are given meaning and form by its maker's strong poetic imagination. W.A.B.

See also BARNCLUITH HOUSE; BOUTCHER, WILLIAM; CASTLE KENNEDY GARDENS; EDINBURGH, ROYAL BOTANIC GARDEN; KAMES, HENRY HOME LORD; MAVISBANK; NASMYTH, ALEXANDER; NEWLISTON; PINEAPPLE, THE; PITMEDDEN; POLLOK HOUSE; VALLEYFIELD.

Scotney Castle, Kent, England, is an outstanding example of the late Regency picturesque (see *regency gardening), in that the siting of a new house and the laying out of its grounds were carried out at the same time. In 1836 Edward Hussey consulted William Sawrey *Gilpin who recommended siting the new house 300 m. north and 25 m. above the ruined castle and moat—a site which also gave views eastward over a wide pastoral valley. In accordance with Gilpin's principles (as stated in his *Practical Hints on Landscape Gardening,* 1832) the house was placed on a terrace with groups of trees framing the view.

Yet the boldest effect, the opening of a quarry between the new house and the ruin, was probably suggested not by Gilpin, but by the architect of the house, Salvin. The picturesque conception predominated even after taste had changed—Hussey rejected plans submitted by W. A. *Nesfield in 1847 and 1849 for elaborate Dutch *parterres on the terrace and the old castle forecourt. Already existing trees on the slope, notably several great limes, were supplemented by a succession of Lawson cypresses, introducing a series of vertical notes; white-flowered hybrid rhododendrons and, in the quarry, azaleas and red Japanese maples were probably planted in the early 1900s. The garden, which now belongs to the National Trust, was a major source of inspiration to its then owner, Christopher *Hussey, in his rediscovery of the *picturesque. P.G.

Scree garden. See ALPINE, SCREE, AND ROCK-GARDEN.

Sculpture garden. The flourishing of art in the 20th c., and, in particular, the art of sculpture without any overt religious or political significance—at least in the West—has created a market and a need for public exhibition, which has been expressed in different ways. First, temporary public exhibitions have become common in public parks in certain countries; secondly, some of these have developed logically into the form of sculpture parks; and thirdly, some sculptors have developed their own versions of 'environmental sculpture'. Gustav Vigeland, for example, worked for many years during the early part of the 20th c., patiently hacking out his own very personal concept of the meaning of life on an island in an Oslo fiord. This small formal garden, probably best known for its pillar of writhing bodies, has become a public park. Another is the Carl Milles Garden in Stockholm, a series of paved terraces with pools and fountains extending down a steep hillside to the river. It is characterized by light airy sculptures, all carefully arranged to be seen at their best, either at ground or water level, or more significantly, on pedestals to be seen against the sky. Both these are gardens designed to contain sculptures. Attempts to conceive the garden as sculpture, as in some more recent American examples, are less common.

Some small courtyards for the Beinecke Rare Book and Manuscript Library at Yale University, the Chase Manhattan Bank, and the IBM building in New York, have provided Isamu *Noguchi with fertile ground for his environmental sculpture. The first is treated as a square composition of white marble rectangles containing a white marble ring suspended, as it were, in motion, and a cube balanced on its corner. The second, less successful because it is too complicated by small elements, is circular—paved with elegantly undulating stone setts incorporating a small pool and some dwarf plants; the third contains positive and negative elements represented by a circular pool with fountains and a contrasting circular dome. All, in their purity of form and their mathematical symbolism, carry echoes of the symbolic gardens of the Zen period in *Japan, as well as of the great astronomical sculptures of the Mogul Empire at Delhi and Jaipur.

Such small 'hard' spaces, which depend little upon the skills of others, such as landscape designers and gardeners, are relatively easily managed. Brancusi's patrons were more ambitious. Several of his sculptures, including three of his most outstanding works—the *Gate of the Kiss,* the *Table of Silence,* and the *Endless Column*—have been aligned along a mile-long axis through the town of Tirgu Jiu in south-west Romania. But the parkland setting of the first two seems to detract from the quality of the sculptures, causing them to be regarded more as decorative elements than as true works of art with the capacity to surprise and disturb.

In private gardens where there is room for trial and error, these problems are more easily solved. Two significant types are those used experimentally to display sculpture like that of Barbara Hepworth at St Ives in Cornwall and Henry Moore at Much Hadham in Hertfordshire; and those which are specifically designed as gardens, such as that of the architect Frederick *Gibberd at Harlow in Essex. All are essentially informal in the English tradition, but very different in character and scale. That of Barbara Hepworth is an intimate space filled with exotic vegetation against which her pure forms are displayed. It expresses well 'the fundamental and ideal unity of man with Nature' which she

Five Figures from the *Family of Man* (1970) by Barbara Hepworth at the Yorkshire Sculpture Park, Bretton Hall, Wakefield, Yorkshire

considered to be one of the basic impulses of sculpture. Gibberd's is more architectural: designed as a series of carefully controlled vistas linking a sequence of spaces, it is peopled with sculptures and *objets trouvés* along the side of a small river valley.

The contemporary public sculpture garden or park has a variety of objectives. Primarily it is to display sculpture to the public. But this might comprise existing sculptures which are introduced, those which are made for particular spaces, and spaces which are enclosed around specific sculptures. A classic of the first type is the Abby Aldrich Rockefeller Sculpture Garden at the Museum of Modern Art in New York. Originally designed by Philip Johnson and James Fanning in 1955, it was extended in 1964 by the landscape architects Zion and Breen, and has again recently been extended. It has not been treated merely as a repository for sculpture; but in it the carefully selected sculptures and other elements, including pools, fountains, planting, and trees, are unified into an exemplary composition with carefully arranged steps and paving. Other American examples, such as the Hirshorn Sculpture Garden on Washington Mall are less successful, suffering from overcrowding both of people and design elements. Circulation is also a problem in the visually appealing Norton Simon Garden, Pasadena, California, and that of the Los Angeles County Museum.

The tendency to overcrowd such gardens with exhibits is only partly resisted in the Billy Rose Sculpture Garden at the Israel Museum in Jerusalem (1965) by Isamu Noguchi and Lawrence *Halprin. In one area, finely textured concrete walls are arranged to form outdoor rooms inhabited by carefully selected sculptures; but in others, large numbers of diverse pieces of sculpture are seen together, with a consequent loss of dramatic effect. As the trees grow this will be less extreme, but that will take time. This is less of a problem with the limited collection at the Maeght Foundation at St Paul de Vence, the result of a collaboration between a number of artists and the architect José Luis Sert, dedicated to the love and understanding of modern art.

Where the landscape is mature the problem of enclosure can be more easily solved, as has been achieved in two of the earliest outdoor art museums, that of Louisiana in Denmark and Kröller-Müller in the Netherlands. The Louisiana Museum is in a 19th-c. house and garden originally occupied by a Danish nobleman, sited on the sound facing Sweden 30 km. north of Copenhagen. It was named in memory of his three wives, all called Louise. The architects Jorgen Bø and Wilhelm Wohlert decided to use the old house as an entrance pavilion, linking it with a sequence of new galleries by a series of wood and glass walled corridors. The result is a minimal architecture, to a large extent merged with the mature trees of the wooded perimeter of the site, and allowing an unusually close contact both with nature and with the sculptures arranged around the site. Some of these are in the open; others in a variety of enclosures, each of different character, linked by carefully detailed paths. The whole is a successful amalgam of landscape, architecture, painting, and sculpture.

The Kröller-Müller Museum was built in 1961, on a much larger site in the Otterlo hunting forest, to house the art collections of Helène Kröller. These are exhibited in the old house and in a new glass-walled building which divides the forest site between the long formal approach and the informal forest clearing occupied by the pool. The sculptures are arranged in spaces along the axis, and informally beyond the pool, which is graced by an elegant floating fibreglass abstract 'swan' (by Marta Pan), drifting with the wind. Jan *Bijhouwer, the landscape architect, has been careful to allow the scale of the 11-ha. site to prevail over the exhibits, skilfully balancing the intimacy of the enclosed spaces with the expansiveness of the open views.

The Louisiana and Kröller-Müller Museums have set a precedent which is being followed in many countries and on a wide variety of sites, some of very large area. The Storm King Art Center in New York State extends to over 80 ha., the Yorkshire Sculpture Park at Bretton Hall covers 105 ha., and the Welsh Sculpture Park at Margam, which has a variety of landscape types from formal gardens, through parkland with lakes and woods, to an Iron Age hill fort, occupies 352 ha. The long views obtained in such large open spaces demand sculptures of architectural dimensions to register effectively, and they can easily be lost. Most of the smaller sculptures are better placed in the confined spaces which can be achieved in a garden or courtyard setting, as in the Sutton Manor Arts Centre at Sutton Scotney in

Kröller–Müller Sculpture Garden, Otterlo, Netherlands, by J. T. P. Bijhouwer

Hampshire. This and the Yorkshire Sculpture Park have affinities with the English country park.

By contrast some of the more recent sculpture parks are deliberately sited in natural or semi-natural landscapes. The Portland Clifftop Sculpture Park is in a series of derelict stone quarries (in which some workshops are incorporated) overlooking the sea. One at Grizedale in Cumbria and two in Scotland, administered by the Scottish Sculpture Trust, at the Landmark Visitors' Centre, Carrbridge, and at Glenshee, Perthshire (Tayside), are in even wilder territory. The first two are organized as extensive 'sculpture trails' through the forest, and the other comprises a group of sculptures sited on the ski slopes of Glenshee. The opportunities for a synthesis between art and nature are unsurpassed. But most of the sculptures do not yet quite live up to it, unlike Henry Moore's King and Queen gazing majestically over the Scottish moorside on the private Glenkiln estate at Shawhead, Dumfries.

The stated aims of most of these are to present the sculpture of the 20th c. to a wider public. At the same time there are undercurrents in the work of some artists who cannot conceive of art as something to be put on exhibition. The land artist Richard Long sees his art more as a documentation of experience than as any mark upon the landscape. Christo makes his impact dramatic but transient in such works as *The Running Fence*. More accessible to the public is the work of such artists as Ian Hamilton *Finlay. Finlay, who describes himself as a poet and a gardener, has (with Ron Costley) designed a garden at the Max Planck Research Centre near Stuttgart, which is centred upon the idea of 'the word' to give it meaning, rather than merely the arrangement of sculptural forms always seeking to express deeper meanings. He is in the process of creating a unique garden around his cottage, *Little Sparta, near Dunsyre in Scotland. The nearest parallel is William *Shenstone's *ferme ornée* The *Leasowes, which has a lineage that goes back to the Chinese poet-scholar's garden of the Ming period (1368–1644). Such gardens as 'The Garden of the Unsuccessful Politician' (*Zhou Zheng Yuan) were at once a mode of retreat from the official world and a poetic appropriation of the universe, expressed in its complementary characteristics of *yin* and *yang*. M.L.L.

Secret garden. See GIARDINO SEGRETO.

Sedding, John Dando (1838–91), was an English architect, a member of the Art Worker's Guild, and an artist by temperament. He possessed considerable understanding of plants and their values in the garden. He favoured formalism and opposed the views of William *Robinson, but did so

in a far more kindly and less violent manner than the protagonist, Sir Reginald *Blomfield. Shortly after his early death, his book, *Gardencraft, Old and New*, was published. He had a great passion for trimmed yew hedges and arcades and other forms of topiary. C.H.

See also ARTS AND CRAFTS GARDENING.

Seifert, Alwin (1890–1972), German architect and garden designer, was one of the key figures in opening up the rural landscape to the influence of the garden designer. He is associated above all with the building of the autobahns during the 1930s, when he was made responsible for their integration into the landscape.

Seifert initially trained and practised as an architect but was involved in designing gardens from the very beginning of his career. His early work was of considerable quality in terms of its design and detailing, but was essentially uninnovative, following on from the traditions of the formal garden style which gained popularity around the turn of the century. After the Second World War he developed and published his ideas on organic farming and gardening. In 1954 he was appointed to the Chair of Garden and Landscape Design at the Department of Architecture of Munich Technical University. R.STI.

Sen No Rikyu (1522–91) was the great Japanese tea master of the Momoyama period (1573–1603) who brought about the *wabicha* style of *cha-no-yu* or the tea-ceremony cult, which preferred the simpler forms of *cha-no-yu*, emphasizing its spiritual quality as against the style of pomp and gaudiness. The art and philosophy of Sen No Rikyu thus had a tremendous influence at the early stage of the development of the *roji* (dewy path) style of the Japanese garden.

By birth, Rikyu was a son of the merchant family Tanaka of the lively trading town of Sakai. Early in life he took to the pastime of tea-drinking in the society of merchants, and later he studied the art under the tea master Take-No-Jōō (1502–55) who had inherited the spirit of *wabicha* from its founder Murata-Shukō (or Jukō). Rikyu served the warlord Oda-Nobunaga, then the all-powerful military lord Toyotomi-Hideyoshi. When Hideyoshi held the so-called 'golden tea party' at the Imperial Palace in 1585, Rikyu was given the title of Koji and had the honour of offering tea to

Sento Gosho, Kyoto

Emperor Ogimachi; from then on Rikyu became the leading figure in the world of *cha-no-yu*.

The life of Rikyu had a most tragic ending. For reasons still not clear, Hideyoshi suddenly placed him in confinement in Sakai, and then ordered him to commit *seppuku*, the 'honourable' ending of the life of *samurai*. The date of his self-termination was 28 Feb. 1591, the day still observed today by the descendants of the Sen families, home of the foremost schools of *cha-no-yu* in Japan. S.S.

Sento Gosho, Kyoto, Japan, is the garden of a palace for retired emperors, built in 1634 (in the early Edo period) for ex-Emperor Gomitsunoō. The designer was Kobori Enshu. Its three sections are in consciously differing styles, *shin*, *gyo*, and *so* (finished, intermediary, and rough). In the formal *shin* section the palace (since destroyed) looked on to a long narrow lake for boating, its beach covered with individually chosen Odawara stones, each sent wrapped in cotton out of respect for the stones. The lake has a tortoise island with rock composition. A packed-earth bridge, arched to allow the passage of boats, separates this section from the next two. Nearby is one of two tea-houses, its small enclosed garden a bare patch of earth crossed by a path of magnificent water-worn stepping-stones. A farm for the education of noble children in the rigours of common life formed part of the estate. (See *previous page*.) S.J.

Serlio, Sebastiano (1475–1554), Italian architect, worked mainly in Rome and the Veneto until 1540, when he entered the service of *François I at *Fontainebleau under Primaticcio. He designed the château of *Ancy-le-Franc in Burgundy, the first entirely in an Italianate style, incorporating the garden in a rectilinear plan. Serlio had little opportunity to practise, however, and his influence was mainly through his treatise, *Tutte l'opere d'architettura*, published in five books between 1537 and 1547. The fourth book contains the first designs for ornamental parterres to be printed in France. K.A.S.W.

See also WOLLATON HALL.

Serpentine, crinkle-crankle, or ribbon wall, a wall for growing fruit, dating in England from the middle of the 18th c., whose curving lines gave added strength and did away with the need for thickness or buttressing, thus making it economical to build. (Crinkum-crankum is another common variant of the name.) Designed to run east and west, the bays in which the trees were planted reflected the sun and encouraged the ripening of the fruit. Built on solid foundations, it was made of brick, or a composition of chalk, or mud and straw, and sometimes the coping was carried out in tiles or thatch.

An early brick serpentine wall at West Horsley Place, Surrey, appears on a plan of 1736, and many exist in Suffolk (see *Heveningham) and Hampshire, where some were built during the Napoleonic Wars (1793–1815). J.O'N.

See also DUNCOMBE PARK.

Serpentine walls

Serres, Olivier de (1539–1619), French agriculturalist and author. His *Théâtre d'agriculture et mesnage des champs* was published in 1600, the most substantial work (over 1,000 pages) to have been printed on managing an estate; while partly drawing from older texts it embodied de Serres's own experience. For the part on gardens he owed much to conversations with Claude *Mollet who provided diagrams of parterres in the *Tuileries, *Saint-Germain-en-Laye, and *Fontainebleau.

After de Serres's death his domain, Pradel, was besieged by royal troops in 1628, and razed by order of Richelieu. Gardens and orchards were not spared, and de Serres's library and papers were destroyed. A fragment of the old house remains in a later building. The estate is used as a post-graduate school run by the Ministère de l'Agriculture. K.A.S.W.

Sessé y Lacasta, Martin de (d. 1809) and **José Mariano Mociño** (1757–1820), were both physicians, the first a Spaniard, the second born in Mexico of Spanish parents. In 1787 the resources of the Spanish American colonies began to be investigated by a group of scientists, including Sessé, Mociño, and the artist Atanasio Echeverria y Godoy, who explored Mexico, Central America, the Caribbean, and the Pacific coast of North America as far as Alaska. Plants were sent to the botanic garden in Madrid, followed by manuscripts and drawings when the travellers returned to Spain in 1803. Several species of dahlia and *Zinnia elegans* appear to have been among the plants new to Europe.

By the time the expedition was over enthusiasm for the project had waned, so that Sessé and Mociño's books on the flora of Mexico and New Spain remained unpublished till the 1880s. Their collection of *c.*2,000 drawings (1,800 of plants, the rest of animals) was taken by Mociño to Geneva, where some of them were copied for A. P. de Candolle. Later in the 19th c. the drawings were returned to Spain and the Barcelona library of the Torner family, from which they

were acquired by the Hunt Institute for Botanical Documentation in Pittsburgh in 1981. S.R.

Seville, Spain. See ALCÁZAR; PATIO DE LOS NARANJOS.

Sezincote, Gloucestershire, England, was acquired by Sir Charles Cockerell in the early years of the 19th c. As architect for a new mansion he engaged Thomas Daniell, who was inspired by Indian architecture and had written a book on the subject which created a short-lived fashion. Sezincote expresses his ideas perfectly, a strange amalgam of Palladian and Indian styles, and the garden, in the design of which Humphry *Repton played a part, has a similar dichotomy. Much of it is traditional landscape but the ornamentation is almost exclusively Indian, with a temple containing a figure of the goddess Souriya, an Indian-style bridge over a stream with crouching bulls on its balustrade, a bronze serpent ascending a pole, and a mushroom-shaped fountain.

Much new planting has been carried out during the 20th c., particularly round the stream where there is now a profusion of bloom and foliage. Graham Thomas designed a canal pool beside the house and in front of the fine curving conservatory, and a recent owner, Cyril Kleinwort, designed a little pavilion in Indian style to overlook this area. A.H.

Shaftesbury, Anthony Ashley Cooper, 3rd Earl of (1671–1713), English politician and philosopher, gave the lead in promoting the concept of the Man of Taste. By his writings, *The Moralists* (1709) and *Characteristics of Men, Manners, Opinions, and Times* (1711), he allied reason and virtue and linked aesthetics with the moral sense: 'what is beautiful is harmonious and proportionable; what is harmonious and proportionable is true; and what is at once both beautiful and true is of consequence agreeable and good.' His Neoplatonic idea of Beautiful Nature gave the philosophical basis to mid-18th-c. idealized landscaped gardens. He commended rocks, caverns, cascades, and grottoes and anticipated *Addison and *Pope in preferring the *wilderness in Nature to the 'mockery of princely gardens'. M.L.B.

Shahdara, Lahore, Pakistan. Earlier known as the Dilkusha Gardens, this had been the pleasure-garden of Nūr Jahān, wife of the 4th Mogul Emperor *Jahāngīr. After his death at Rajauri, the emperor's body was brought to Lahore for burial. Nūr Jahān herself designed his tomb (see *tomb garden) in her retirement. The garden was on a very large scale, and the outer courtyard or *sarai* provided a series of alcoves for the use of travellers. The inner garden, too, is spacious, with fine raised causeways, canals, and tanks. Brick, the traditional material of Lahore, which lacked stone, is widely used. There are fine star patterns in the causeways. The tomb itself bears some resemblance to the tomb of *I'timād-ud-Daula at Agra, but the loss of its central feature, probably a dome, results in an imbalance between the tomb and its surroundings. Internally, there are some fine flower inlays. S.M.H.

Shah Goli, Tabriz, Iran, the Royal Pond, was founded by the Qajars in the 18th c. It is located on the east edge of the city of Tabriz in north-west Iran and is 9.3 ha. in area. The main feature of the garden is the large, square, artificial lake of 5.75 ha. fed by hillside springs. An adjacent hill that is terraced and contains fruit-trees affords a panoramic view of the surrounding valley over which the lake, almost at the level of its surrounding wall, seems poised. At the foot of the terraced hill is a causeway leading to the centre of the lake and to an octagonal pavilion that was perhaps once domed. J.L.

Shāh Jahān (1592–1666), 5th Mogul Emperor (1628–58), first travelled with his father *Jahāngīr to Kashmir, and later made his own contributions to the gardens at *Shalamar there. For a time he was in rebellion against his father, but in due course succeeded to the throne. He married Mumtaz Mahal, the niece of Nūr Jahān, Jahāngīr's Persian Empress, and his greatest work, the *Taj Mahal, was her memorial.

Shāh Jahān's reign saw a vast extension of luxury of every kind; his palaces were a setting for court life and ceremonial, and his jewels were world-renowned. Designers and craftsmen of every kind were welcomed to his court, from both Europe and Asia. Persian character returned to his buildings and gardens, and quality and design were superb. White marble, with inlays of precious and semiprecious stones (*pietra dura*), was widely used, and the representation of flowers in both inlays and carvings reached an astonishing realism. His palaces and gardens at the *Red Fort, Delhi, and the Fort at Agra, the *Shalamar Bagh, Lahore, and the Taj Mahal, show that his real genius for building lay in the level sites of the Indian plains. An exception was the *Chasma Shahi garden on the slopes above Lake Dal, Kashmir. There were many other minor works, such as the Black Pavilion in the *Shalamar Bagh, Srinagar, additions to *Lahore Fort, and pavilions at Ajmer.

Towards the end of his life, however, Shāh Jahān's health and character declined, and he was deposed by his son *Aurangzīb, and imprisoned in the Fort at Agra, where he remained until his death. His reign saw the zenith of Mogul building, and with his successor there began a slow decline. S.M.H.

Shakkei, the Japanese word for 'borrowed landscape', used in describing gardens where external views form an integral part of the design, similar to *jie jing* in China. Outstanding examples are: *Ginkaku-ji; *Shinju-an Garden; *Shugaku-in Imperial Villa; *Tenryu-ji Abbot's Garden. S.J.

Shalamar Bagh, Delhi, India, one of three great gardens named Shalamar, was built in Delhi by A 'Azzu-un-Nisa, a favourite wife of the Mogul emperor *Shāh Jahān. It was of great size, with a wide central canal, and a series of pavilions and pools, including an octagonal pool reminiscent of *Vernag. The garden played its part in history: Shāh Jahān

opened it ceremonially in 1650, Aurangzīb was provisionally crowned here following his deposition of his father, and in 1739 the Persian Nadir Shah camped there before his massacre of Delhi, and seizure of Shāh Jahān's Peacock Throne. Much had been destroyed by the end of the 18th c., and little trace of it now exists. The remains were recorded by the Archaeological Survey of India in 1903, and give an impression of its former immense size. S.M.H.

Shalamar Bagh, Lahore, Pakistan. These pleasure-gardens were laid out on the instructions of the 5th Mogul Emperor *Shāh Jahān to celebrate the completion, in 1633, of a canal bringing water to Lahore from the River Ravi. The garden itself was completed in c.1642, being opened ceremonially by the emperor. On a vast scale, it comprised three terraces on dropping levels. The principal feature was a wide canal, with, on the middle terrace, a great reservoir filled with fountains, a marble platform at its centre.

Once the garden was a place of great luxury, with marble and agate pavilions, the cascades decorated with lights at night, and golden vases filled with flowers by day. The plantings were rich: orange, apricot, peach, plum, quince, and many other fruits, together with flowers and aromatic plants. Brick is finely used in some of the parterres, and also in the great boundary wall, patterned with decorative alcoves. The garden was also provided with baths, and both Shāh Jahān and *Aurangzīb used it as a royal camping ground.

Little remains of the original buildings, for they were stripped in the 18th c. for use at the Golden Temple at Amritsar. The existing pavilions are largely restorations in brick and plaster. The emperor's marble throne, a fine water-chute or *chadar, and a lotus fountain jet remain as an indication of the former quality of the buildings. The garden is, however, still maintained in good condition. The place of entry to the garden has been reversed, so that the levels are viewed in the opposite direction from that first intended. S.M.H.

Shalamar Bagh, Srinagar, Kashmir. The name Shalamar (Abode of Love) was given to three great Mogul gardens: in Kashmir, Lahore, and Delhi. The garden on Lake Dal was first laid out by the Emperor *Jahāngīr c.1620 and later added to by his son *Shāh Jahān. It is generally considered to be outstanding for its perfect proportions and refinement of detail.

A stream at the head of the garden was diverted to form the central canal, which originally flowed right through the three squares that form the structure of the garden to join with the waters of the lake. The original approach, now severed by a modern road, was by way of a long canal from the lake, providing a magnificent arrival at the whole garden. It came first to the Diwan-i-Am, the Hall of Public Audience, where the emperor sat on his black marble throne, sat over a waterfall, to show himself to his people.

Beyond this, the garden comprised two parts: the emperor's private garden and the *zenana or ladies' garden.

Each of these was a square of approximately equal size, with water, fountains, and pavilions set centrally. The emperor's garden contained the Diwan-i-Khas, or Hall of Private Audience, built across a cascade; only its base remains, but the stone throne in front of the cascade is intact. The zenana garden, its entrance guarded by two small pavilions, contains the magnificent black marble pavilion built later by Shāh Jahān—the climax of the garden—completely surrounded by water and fountains. Its dome has, however, been replaced by a three-tiered roof. Details throughout were perfectly conceived and executed. The cascade behind the Black Pavilion includes rows of niches, called *chini-kanas, in which lights were set to glimmer through the falling water, while the causeways to the pavilion were arcaded to allow the water to move freely through. An illusion of great depth was thus created, although the water was comparatively shallow. Everywhere there were fountains operated by gravity which sent up great plumes of water rather than the modern sprays. On either side of the central canal tall oriental plane trees (chenars) separate the centre of the garden from the orchards of Persian tradition, which are at a lower level. Two-storeyed *gazebos at the corners give glimpses of the outside world. In recent years artificial lights and other additions have been made.

S.M.H.

Shangri-La Hotel Garden, Singapore. The garden, designed by Bell, Collins, & Associates, is dependent on its relationship with the building and, in particular, the new north wing built in the 1970s. It can be divided into three sections. Open-access corridors step inwards over a courtyard water-garden at upper ground-floor level. This pebbled water-garden is draped overhead with asparagus fern and heavily planted with ground-cover plants, ferns, specimen palms, and trees. Water flows from this garden to a waterfall and a second garden at ground level containing heavy foliage planting, cycads, musa, and foliage trees; overhead balconies are draped in pink bougain-villaea. This garden leads into the swimming-pool area, planted with coconut palms, shade trees, and traveller's palm, and beyond the pool is a third garden, dominated by 30m.-high giant bamboos native to the site and under-planted with alpinias, heliconias, philodendron, and spathophyllum.

Like much of the design of central *Singapore the garden has a tropical American flavour. A particular feature of the design is the natural ventilation of the coffee shop with air breezes funnelled through to the upper courtyard water-garden, but the most striking effect of all is afforded by the pink bougainvillaeas cascading over curved white balconies. N.Y.

Sharawadgi, or Sharawaggi, as Horace Walpole spelled it later, was first used by Sir William *Temple in his essay, *Upon the Gardens of Epicurus,* written in 1685, and first published in 1692: 'Their [the Chinese] greatest reach of Imagination is employed in contriving Figures, where the

Beauty shall be great and strike the Eye, but without any order or disposition of parts, that shall be commonly or easily observ'd. And though we have hardly any Notion of this sort of Beauty, yet they have a particular Word to express it; and where they find it hit their Eye at first sight, they say the *Sharawadgi* is fine or is admirable, or any such expression of Esteem.'

Temple wished to indicate that what the Chinese meant by this term are 'Forms [of gardens] wholly irregular' in contrast to the regular English gardens of the time in the French or Dutch manner. As a result of his introducing this concept Temple is considered the originator of the English landscape garden movement.

Sharawadgi is not a Chinese word: 'Of unknown origin; Chinese scholars agree that it cannot belong to that language' (*OED*). Various attempts have been made to find its roots and hence its original meaning. The most sensible explanation is the one which equates *Shara* with *Shui* and *Wadgi* as a compound of *Hua* (flower) and *Chi* (account)—that is the whole being a treatise on *feng shui* or geomancy. Other possibilities suggested are *Sa-lo-kwai-chi* meaning careless grace, and impressing and surprising; or *Sorowaji*, i.e. *Sorou*, a word used for asymmetrical design. Possibly Temple made the word up. Even so, he would have wished to incorporate actual Chinese words; dictionaries and word-lists as well as persons learned in the Chinese tongue (e.g. Bodley's Librarian, Dr Hyde) existed. An actual Chinaman had even come to England in 1687. If Temple had read descriptions of Chinese gardens in contemporary travel books, he must have noticed a discrepancy between his ideas and these descriptions. Moreover, Chinese scholars in the United States have denied the existence of the Sharawadgi principle in Chinese gardens before 1700.

S.L.

Sheffield Park, Sussex, England, is a landscape garden of 40 ha. The two 'Woman's Way' lakes were designed by 'Capability' *Brown for John Holroyd, first Earl of Sheffield, in 1776. Humphry *Repton also worked here in 1789 and was responsible for a string of small lakes up to the mansion. The third earl extended the lakes considerably and employed *Pulham & Sons to make the cascades in 1883; many conifers and rhododendrons were planted in the late 19th c. This chain of lakes with mature planting was used by Arthur Soames between 1909 and 1934 as the basis for a collection of trees and shrubs, notable for their autumn colour, including many specimens of *Nyssa sylvatica*. The deep lime-free soil allows a wide range of choice trees and shrubs as well as rhododendrons and other ericaceous plants to be used. Notable specimens include *Pinus montezumae* and *Eucalyptus gunnii*. In the lakes are a number of good water-lilies and in the autumn there is a pair of borders devoted to *Gentiana sino-ornata*—a Chinese gentian of startling colour. A recent addition to the garden is the Queen's Walk, which goes behind the third lake, providing a long view towards the house, and which was laid out in Queen Victoria's jubilee year (1887). The gardens are owned by the National Trust.

P.M.

Shell-work, the placing of shells in patterns to form either ceilings or a *grotto effect which became very popular in Europe in the 18th c. There are excellent examples in England, France, the Netherlands, and Germany. At *Woburn Abbey a whole room has been given a grotto-like effect. Here the grotto is in the house, whereas at Goodwood House (West Sussex) the Duchess of Richmond and Gordon began to decorate a separate small pavilion with shells arranged in a neo-Pompeian style (1739). At Goldney House, Bristol, an underground grotto was formed with special natural lighting effects—small domes and shafts were constructed to allow rays of light into the shell-covered spaces which form the grotto. In a room in the *Eremitage, Bayreuth, Wilhelmine, the sister of Frederick the Great, surprised her guests with jets of water from fountains hidden in the floor—rocks and shells in elaborate rococo designs covered the floor, walls, and domed ceiling. Shell-work is also found out of doors—at the Palace of *Fronteira, Lisbon, the façade of a rotunda next to a pool is decorated with shell-work and *azulejo tiles. A modern example is the Villa *Vizcaya, Florida.

G.W.B.

Shenstone, William (1714–63), English poet and landscape theorist, and creator of his own much admired landscape garden at The *Leasowes. A contemporary of Dr Johnson and Richard *Graves at Pembroke College, Oxford, he was included by Dr Johnson in his *Lives of the Poets* (1779–81), and Graves became his biographer with his *Recollections of Some Particulars in the Life of the late William Shenstone, Esq.* (1788).

In addition to the creation of his landscape garden, Shenstone is also remembered for his essay 'Unconnected Thoughts on Gardening', published posthumously in 1764 in the second volume of *The Works in Verse and Prose, of William Shenstone, Esq.* In the essay Shenstone stated that 'Gardening may be divided into three species—kitchen-gardening—parterre-gardening—and landskip, or picturesque-gardening'. This last, Shenstone contended, consisted 'in pleasing the imagination by scenes of grandeur, beauty, or variety. Convenience merely has no share here; any farther than as it pleases the imagination.' In a few pages Shenstone brilliantly analyses the elements of picturesque gardening with some memorable words of advice that have been much acted upon and frequently quoted.

In creating The Leasowes, Shenstone overspent, much to his remorse. He was also troubled by depression. Johnson wrote that 'he spent his estate in adorning it, and his death was probably hastened by his anxieties. He was a lamp that spent its oil in blazing.' *Girardin erected a memorial to him at *Ermenonville.

P.E.

See also ENVILLE; WIMPOLE HALL.

Shephard-Parpagliolo, Maria (d. 1974) was one of the most outstanding garden and landscape designers of this century. Born in *Italy, she had a humanistic education and later specialized in archaeology. In 1929 she began to contribute articles on gardens and landscape design to the

RAI new offices garden (1966), Rome, by Maria Shephard-Parpagliolo

magazine *Domus*. In order to learn more of the subject she came to England where she worked for Percy *Cane. She travelled widely in Europe looking at gardens and in 1936 spent several months in Germany studying the work of such designers as Herman *Mattern and Otto *Valentien. She began work herself with the Italian architect Piccinato on the designs for the 1942 World's Fair in Rome which was abandoned due to the war. Having married an Englishman, she began work in England with Frank *Clark for the Festival of Britain (1951) and for a number of London County Council schools.

She had intended to practise in England but, when in 1954 an Italian development company asked her to set up a design office for them in Rome, she felt she could not refuse. In fact it took 10 years, during which time she was involved in work all over Italy. This included a number of large housing estates, a tourist village, and a number of gardens, including those for the Radio Audizione Italiana (Radio/Television) building and the Hilton Hotel in Rome. In them she reveals a mastery of spatial organization using all the elements of landscape design to make places which are distinguished by an atmosphere or character which is at once timeless and totally of its time and place. M.L.L.

Shepherd, Thomas (d. 1834), the first nurseryman and landscape gardener to operate in Australia, was an important and influential advocate of the British landscape movement as promoted by *Brown and Humphry *Repton. For 20 years he was a nurseryman at Hackney near London, but a decline in business determined him to emigrate to New South Wales, where he hoped to take up a grant of land.

Arriving in 1826 he unsuccessfully attempted to establish a 'nursery and fruit garden'. As a last resort he gave a series of public lectures on horticulture and landscape at the recently established Mechanics' School of Arts in Pitt Street, Sydney. His lectures were published in 1835 and 1836, as the first books on gardening related to Australian conditions.

The entrance drive and front offered the most scope to colonial gardeners, as here scale could be achieved easily and cheaply. He advocated two ideal settings for houses: 'in an open valley between two hills or high land, on a gentle swell with a base of large dimensions'; or, on a 'flat piece of land upon the side of a steep hill'. However, the extent of his influence is uncertain as no actual landscape design can be attributed to him. H.N.T.

See also AUSTRALIA.

Sheringham Hall, Norfolk, England. Both the house and grounds at Sheringham 'Bower', as it was originally called, were the conception of Humphry *Repton and his son John Adey *Repton who were consulted by Abbot Upcher after his purchase of the estate in 1811 (see plate XVII*b*). It was then decided to abandon the old house on the outskirts of the village, and to build what the elder Repton described as 'an appropriate gentlemanlike residence' in a more picturesque situation against a wooded hillside with distant views to the sea. The house was scarcely completed at the time of Abbot Upcher's death in 1819, only a few months after that of Humphry Repton, and several years elapsed before the former's son, Henry Ramey Upcher, began to appreciate the unique qualities of the place and developed a particular interest in plant-collecting. As a result several rare specimens of rhododendrons and azaleas from the Himalayan foothills were introduced in the grounds, laying the foundations of the fine collection to be seen there today. D.N.S.

Sherriff, George (1898–1967), British plant-hunter. See LUDLOW, FRANK.

Shi Tao was the alias used by the Chinese aristocrat, Zhu Ruoji (1642–1718), an artist in garden design, poet, calligrapher, and outstanding (and unorthodox) landscape painter. He was born into the imperial family in the last years of the Ming dynasty. His father, Prince of Jingjiang in Guangxi, was killed by a traitor after the Manchus (Qing) overthrew the Ming government in 1644, and thereafter Zhu hid his identity and lived in seclusion. Converted to Buddhism, he became a monk with the name of Yuanji, often mistaken as Daoji (Tao Chi), or the Monk of the Bitter Cucumber, and most of his later life was spent wandering. In old age he finally settled in *Yangzhou where he lived by selling his paintings. He was famous for his skill in piling rocks and many fine gardens in Yangzhou such as Pian shi shan Fang (the Chamber of Rock Flakes) and Wan Shi Yuan (the Garden of Ten Thousand Pieces of Rock) are believed to be his works. Part of the former still exists.

D.-H.L./M.K.

Shi feng are rocks placed in courtyards, along streams, or at other places in Chinese gardens as centre-pieces of interest or elements in a view. Sometimes a few pieces are set up together to suggest from a distance a range of mountains. Sometimes, as in the back entrance courtyard of the *Wang Shi Yuan, they may be composed with a magnolia or bamboos against the plain background of a whitewashed wall. But large or unusual rocks, perhaps with an impressive provenance like the Cloud-Crowned Peak in *Liu Yuan, Suzhou, or strangely-shaped rocks, like the specimen rocks in the *Yu Hua Yuan, Beijing, may also be set up alone, in a special pavilion, or on a marble plinth, rather as is sculpture in European gardens. Such rocks—the best (*Taihu rocks) come from Lake Tai in Jiangsu province—are prized as nature's sculpture for their aesthetic markings, swoops, and hollows, and occasionally—as in the Song imperial garden *Gen Yue, or the present-day *Shi Zi Lin—for their amusing likenesses to animals or men. X.-W.L./M.K.

See also JIA SHAN; SHI SUN.

Shinju-an Garden, Kyoto, Japan, lies to the north of the main temple complex of Daitoku-ji. This small garden of only 0·14 ha. is a designated historic site and place of scenic beauty. The temple of Shinju-an is associated with the Zen priest Ikkyu (1394–1481) who lived there. The existing abbot's hall and other structures were rebuilt in 1638 and the garden itself was built probably around that time.

The abbot's garden on the east side is known for its rock arrangement in the group arrangement of *shichi-go-san* or 7, 5, and 3, attributed to the celebrated tea master Murata-Shukō (or Jukō). To the east of this garden is a low clipped hedge line, which continues to a sparse grove, thence to an earthwork wall. Formerly the peak of Mount Hiei was viewed from this garden as the *shakkei or 'borrowed scene'. The south side of the abbot's garden was white-sanded, but is now covered with mosses, with a fine pine tree in the centre. The stepping-stone path leading from the priest's living quarters to the main entrance is notable for its use of fairly large pieces of stone. The wicket gate in the north of the east garden connects it to a *roji* (dewy path) garden of another property, interesting for its tea garden. S.S.

Shinso, Japanese art connoisseur and painter. See SOAMI.

Shiraz, Iran. See BAGH-I DELGOSHA; BAGH-I ERAM; BAGH-I GULSHAN; BAGH-I TAKHT; CHEHEL TAN; HAFT TAN; NARENJESTAN-I QAVAM.

Shi sun means bamboo-shoot rock. In many Chinese gardens stalactites, usually 2–3 m. in height, are set into the ground among other rocks or trees. They are so called because their elongated, pencil-thin shape suggests bamboo shoots and consequently, as in the *Cang Lang Ting in Suzhou, or *Yu Hua Yuan in Beijing, bamboos are often planted near them. X.-W.L./M.K.

Shi Zi Lin, Jiangsu province, China, though by no means the best, is perhaps the most famous of the celebrated city gardens of *Suzhou. Commissioned by a Buddhist monk, Tian Ru, in memory of his teacher, and built in 1336 during the Yuan dynasty, it originally formed the northernmost section of the Temple of Bodhi Orthodoxy, in the north-west district of the city. This was already sometimes known as the Lion Grove Temple with several levels of meaning hidden behind the name: for example, one interpretation is that the teacher, Zhong Feng, once lived in retreat by the so-called Lion Cliff at Tien Mu mountain; another that over half the garden is given over to an extended false mountain (*jia shan*) of rocks often thought to resemble lions.

The whole garden (long since separated from the temple by a wall) now covers about 0·8 ha. Entering from a tree-lined street, the visitor finds himself in a high, whitewashed enclosure. Wide steps lead to a covered entrance gate and an elegant courtyard surrounded by finely carved balustrades. From here, narrow corridors zigzag past grand halls into further courtyards which gradually become less formal. A rock in one corner assumes the shape of a prancing lion then, as the visitor passes, seems only a rock again; windows (*lou chuang*) start to take on playful

Shi Zi Lin, Suzhou, China, the plum door

shapes—of scrolls or pomegranates. As usual in these complex gardens, there are several ways to go, all of them eventually leading to the irregularly shaped pool and the great rockery and various garden buildings that surround it. One corner of the pond is not very successfully taken up with a 20th-c. concrete pavilion in the shape of a stone boat (*fang*). A more elegant feature is the long *lang*, enlivened with windows and calligraphic stones let into the walls, which runs irregularly round much of the boundary wall. The pavilion on the north bank of the pool contains a fine wooden *bian* with its name, Zhen Qu (the Pavilion of Genuine Delight), carved on it in the calligraphy of the Qing Emperor Qian Long. Both he and his grandfather Kang Xi visited the garden several times during their southern tours and the gardens they subsequently commissioned at the imperial resort at Chengde (see *Bi Shu Shan Zhuang*), north of the Great Wall, and at *Yuan Ming Yuan near Beijing were both influenced by the Stone Lion Grove.

The garden's most notable feature is its rockery. According to records, more than ten well-known artists were commissioned to work on its design and one of them, Ni Zhan (perhaps the greatest painter of the Yuan period) left a scroll of it in his inimitably austere style. Little remains today of the garden he recorded. From a distance, the eye wanders restlessly over the strange rocks and hollows reflected in the slatey gleam of the lake. But close-up the 'mountain' (*jia shan*) is a labyrinth with grottos and interior caverns. Tiny paths wind up through it to give sudden glimpses, through sharp fissures or from its top, of the lake, the garden, or other visitors as they cross on different levels. It is an evocation of the mountains of the Chinese Immortals, strange, flamboyant, and removed from ordinary life. G.-Z.W./M.K.

Shotover, Oxfordshire, England, is a rare survival of the type of garden referred to by *Switzer as 'natura-linear'. The house was built in 1718 for the Oxford scholar James Tyrell, a close friend of John Locke and Robert Boyle, and is attributed to William Townesend, the Christ Church mason. A temple in Oxford college Gothic, almost certainly by Townesend, is the earliest example of Gothic revival and, as at *Stowe, was used with political intent to commemorate the triumph of Whiggery over arbitrary government. The west front gardens planned by Colonel Tyrell were completed by 1720 and the obelisk and octagon temple by William *Kent added later. The Tyrell family died out in the early 1740s and the estate passed to a Hanoverian family who seldom visited and made no fashionable improvements. Only minor alterations have been made to its original layout. M.L.B.

Shrubland Park, Ipswich, Suffolk, England. The present garden dates from 1851-4, when Sir Charles *Barry was called in to make alterations to the house; Gandy-Deering's conservatory and Donald *Beaton's maze survive from the earlier state. Barry created a series of Italianate terraces stretching down the steep slope from the house, consisting of a balcony garden, and two terraces connected by a great

staircase of 137 steps, dividing into a crescent at the bottom. From a loggia on the lower terrace further steps descend to the informal park. His architectural features—balustrading, loggias, stairs—unify the garden in a Renaissance Italian style, despite the inclusion in the more distant parts of the garden of a Swiss cottage and, later in the century, a Japanese garden.

Barry left the planting to the successive head gardeners Davidson and Foggo, who turned the upper terrace into a panel garden for bedding in large masses, and created a series of intricate gardens along the terraces. The slopes on either side of the great staircase were informally planted with box and shrubs, and quickly became referred to as a wilderness. In the 1880s William *Robinson simplified some of the planting, and introduced a *wild garden, but the greatest simplification occurred when many of the terrace beds were grassed over after the Second World War. B.E.

Shugaku-in Imperial Villa, Kyoto, Japan, was begun *c*.1655 by the ex-Emperor Gomitsunoō who also made the garden of Sento Gosho. Lying in the foothills of Mount Hiei, the gardens extend for 2.6 ha. and contain three separate villas, linked by pine avenues and set against a background forest of 16 ha. The two lower villas approximate to the *shinden-zukuri* style; the upper villa is both a stroll garden and a superb example of *shakkei ('borrowed landscape'). From the Rinun-tei pavilion above the large artificial lake all Kyoto can be seen within the encircling bowl of hills. The slopes below the pavilion are thickly planted with clipped evergreens that follow the contours, occasionally interspersed with cryptomerias, down to the lake where the shadowy outlines of their reflections suggest the 'entrance to the mermaid's palace', an effect dear to the hearts of Chinese designers.

The lake, once used for boating, is retained by an earth dam with four tiers of stone walls concealed from outside by three tiers of tall hedges topped by solid clipped shrub-planting with a row of large maples. The garden has two waterfalls, Male and Female, and a tea-house (Kyusui-tei) on an island linked to its neighbour by a bridge in bastard Chinese style, built in the 19th c. S.J.

Shugborough, Staffordshire, England, is a park whose importance lies in its being the site for a varied collection of buildings, advanced for their date. Unlike contemporary parks such as The *Leasowes or *Stourhead, the buildings seem to be somewhat randomly scattered rather than sited according to a programme.

The Chinese House (completed 1747), once standing on an island in an artificial canal and reached by a Chinese bridge, is an early example of *Chinoiserie, probably inspired by the visit to Canton of Admiral Anson (1697–1762), who laid out the grounds from the 1740s. The Shepherd's Monument (before 1758), an arbour based on a marble relief by Peter *Scheemakers after N. Poussin's *Et in Arcadia Ego*, may have been designed by Thomas *Wright (cf. his *Six Original Designs for Arbours*). Near the River Sow are ruins, put up *c*.1750 and traditionally thought to

Shotover, Oxfordshire, bird's-eye view, engraving (1750) by Bickham

incorporate fragments from the former palace of the Bishops of Lichfield. The Doric Temple, ascribed to James 'Athenian' Stuart, is one of the first neo-Greek temples in England, probably designed at the same time as a similar temple at *Hagley Hall in 1758. The temples and monuments dotted around the park are a landmark in the development of English neo-classicism—but in architecture, not in landscape. The most striking, a copy of the Arch of Adrian in Athens (after 1761), is sited on the brow of a distant hill.

The property was acquired by the National Trust in 1966. 　　　　　　　　　　　　　　　　　　　　　　P.G.

Sicily. See ITALY: PRE-RENAISSANCE GARDENS.

Siebold, Philipp Franz von (1791–1866), was a German physician who worked for the Dutch East India Company at Deshima in Japan from 1826 to 1830. He later established a nursery at Leiden, which acted as a channel for the introduction of Japanese plants to Europe, especially azaleas, bamboos, camellias, hydrangeas, and lilies. More Japanese ports were opened to foreigners in the 1850s, and Siebold returned to the country in 1859, staying for another three years and bringing back, among other plants, *Spiraea thunbergii* and *Prunus sieboldii*. With the help of J. G. Zuccarini he published a flora of Japan (1835–42), illustrated with reproductions of drawings by native artists. 　　　　　　　　　　　　　　　　　　　　　　S.R.

Sieglitzerberg, German Democratic Republic. See ANHALT-DESSAU.

Sigiriya Gardens, *Sri Lanka. This water-garden and two further outlying gardens demonstrate an apparent link with Achaemenid Persian influence some seven centuries before the precursors of the Persian-inspired *chahar bagh* of Mogul India. Surrounding these are traces of more extensive gardens and garden pavilions set in among wooded boulder-strewn margins, very much Buddhist in inspiration. The remains of similar gardens may be seen serving many excavated Buddhist monasteries; those at Mihintale and Ritigala are typical and show striking resemblances to later Chinese and Japanese gardens. 　　　　　　　　N.T.

Silvestre, Israel (1621–91), French topographical draughtsman and engraver. His etchings are the most important record of 17th-c. French gardens. When young he went to live with his uncle, Israel Henriet, who gave drawing lessons to Louis XIII and set up as a publisher of engravings. Henriet signed his work, 'Israel excudit' which has led to it being confused with that of Silvestre. Silvestre went to Italy c.1640 and on his return worked in his uncle's studio with Stefano Della Bella by whose style he was much influenced. On the death of Henriet in 1661, Israel Silvestre was his sole heir. In 1664 he was appointed king's draughtsman and engraver. He was received as a member of the Academy of Painting and Sculpture in 1670, and given the hereditary post of drawing master to the royal children in 1675. Some of his best work was done between 1642 and 1664. The style is free and has an air of topographical exactness; 'vues faites sur le naturel', as he sometimes put it. After 1664 the engravings are more detailed and highly finished. He had a number of collaborators either working on the same plate or engraving after his drawings. The chief of these were the *Perelles; others were Della Bella, Jean Marot, and Jean *Le Pautre.

Besides views in Italy and general landscape views in France he recorded over 50 châteaux, including important series of *Fontainebleau (30), *Liancourt (22), *Rueil (19), *Tanlay (15), *Saint-Cloud (11), *Saint-Germain-en-Laye (15), *Vaux-le-Vicomte (14), and *Versailles (25). 　　　　　　　　　　　　　　　　　　　　　　K.A.S.W.

See also MEUDON; TUILERIES.

Singapore, an island republic, contains one of the most extensively landscaped cities in the world. Originally tropical forest and swamp, much of the island is now urbanized, with only small areas of natural forest, such as the Bukit Timah Nature Reserve, remaining in the island's centre, and pig-, poultry-, and fish-farms, swamps, and reservoirs to the north. Through the 1970s and 80s, and accompanying the rapid development of industry and high-rise housing, the government has placed enormous emphasis on planting programmes, so that much of the developed area of the island resembles a giant garden in which high-rise buildings and new road systems merge. Older low-rise suburbs remain, but they, too, are dominated by tree planting, shrubs, and vines, for the island has an uncomfortable climate ideally suited to the luxuriant growth of tropical vegetation. The main shopping street and tourist centre, Orchard Road, has the appearance of a long shaded garden, paved in quarry tiles, with fountains and low seats.

The city has fine zoological gardens and a number of parks; some, like Fort Canning, long established; others, like the East Coast Park, dominated by groves of trees, rolling lawns, paths, and cycleways, and containing a swimming lagoon, large sports facilities, a crocidilarium, holiday chalets, restaurants, and shopping facilities. The bird park at *Jurong, in the west of the island, is dominated by an enormous aviary contained by netting across a valley, and the grounds are heavily planted. Unusually, at the centre of the city, opposite City Hall, the Supreme Court, and St Andrews Cathedral, is the *Padang*, the original open green dating from Singapore's foundation.

The Bukit Timah Nature Reserve occupies 75 ha. of the total area of 2,785 ha. and is protected by the Nature Reserve Ordinance. It contains one of the largest areas of remaining natural forest on the island and has been a botanical collecting ground for more than a hundred years, supporting a very varied flora, dominated by an extraordinary number of trees, many of which are dipterocarps with trunks rising straight for 50–70 m. The ground flora is restricted, but beneath the main tree-strata climbing palms, rattans, and epiphytes are common as well as understorey trees. The Reserve is in the centre of the island and includes Singapore's highest hill (162·5 m.), from which there are

excellent views north to the Malaysian peninsula, and west and south to the Singapore Straits; there are a number of interesting trails through the Reserve. Fauna includes the long-tailed macaque, the tree-shrew, the flying lemur, and squirrels, as well as the reticulated python and the cobra. There are large numbers of butterflies and an incessant drumming of cicadas which, like the large numbers of birds in the upper tree canopy, are heard rather than seen.

The state depends heavily upon tourism and has undertaken a substantial investment in hotels, many of which have gardens. One of the finest, designed by the Hawaiian landscape architects, Bell, Collins, & Associates, belongs to the *Shangri-La Hotel. N.T.

See also SINGAPORE BOTANIC GARDENS.

Singapore Botanic Gardens. Originally founded in 1822 by Sir Stamford Raffles as a garden for economic plants on Government Hill, the gardens were closed in 1829 and re-established by the Agri-Horticultural Society in 1859 on 25 ha. of the present site. In 1866 a further 10 ha. were acquired, the lake was excavated, and the superintendent's house built; it is now a school of horticulture.

The gardens are firmly linked with the history of the Malayan rubber industry. About 1890 the Director, H. N. Ridley, successfully tapped Para rubber trees (*Hevea brasiliensis*) growing in the gardens from seedlings supplied by Kew in 1877. This method provided good quality rubber while permitting the trees to produce latex from repeated excision of the bark. In its early years the gardens' primary function was concerned with economic botany but by the 1920s there was a shift towards plant ecology, taxonomy, and horticulture and from the 1960s the gardens have become increasingly important as a public park.

The pioneer work of R. E. Holttum on the hybridization of orchid species and the selection of cultivars established Singapore as one of the leading orchid-growing countries of the world. Many of these orchids are on display in the new orchid garden established in the early 1980s. A great part of the grounds is like a park and includes a small nature reserve of the natural jungle that formerly covered the island. There are fine collections of shade trees and the large palm collection has species from all over the world; the gardens also contain collections of flowering shrubs, gingers, and cacti. During the 1980s the gardens are to be expanded a further 15 ha. to the north to include an arboretum of fruit-trees and a learning centre cum exhibition hall. N.T.

Singraven, Denekamp, Overijssel, The Netherlands. In 1660, within the encircling arm of the Dinkel River, Gerhard Sloet built a house on the foundations of a medieval manorial farm and Renaissance Franciscan convent. No records exist of the gardens before the 18th c. The watermills, however, were immortalized in two paintings by Hobbema. In 1868 the 18th-c. woods with radiating avenues were replaced by a deer-park in which the river was diverted to form a romantic lake encompassing an island planted with oaks. Clumps of oaks and beeches adorned the meandering Dinkel and a grand avenue led to the Italianate house.

In 1922 the last owner, W. F. J. Laan, unified the park with its surroundings by adding woods as a backdrop to meadows and he embellished the park with 17th- and 18th-c. statues and urns. With the assistance of Leonard Springer, he laid out an arboretum, containing mainly a collection of deciduous North American and Asian trees.
 F.H.

Sissinghurst Castle Garden, Kent, England, is famous throughout the world as the epitome of the English garden, intimate in scale and rich in plants, its infinite variety given cohesion by subtle colour schemes and the unifying effect of a strong architectural framework. This is the style of Lawrence Johnston, contemporary with the later stages of *Hidcote, created with equal originality by the combined talents of Vita *Sackville-West, the supreme artist-plantswoman, and her husband Harold Nicolson, who was able to help to give form to the planted areas and to link them together by strong axes into a satisfying design. The garden consists of a series of enclosed gardens or outdoor 'rooms', asymmetrically arranged; formal in shape but informally planted.

The moated site was first occupied by a medieval manor and was developed in the 16th c. by ancestors of Vita Sackville-West, Sir John Baker and his son Sir Richard Baker, who made a substantial courtyard house of which only the gatehouse and tower survive. The house fell into disrepair in the 18th c. and the ruins were owned by the Cornwallis family in the 19th c. who added the farmhouse and kept the existing buildings intact. The Nicolsons bought it as a forlorn but romantic ruin in 1930 and laid out the main essentials of the garden before the Second World War began, during which there was an inevitable decline. Following 1945 Vita Sackville-West restored and perfected the garden while it matured. Five years after she died in 1962 it was given to the National Trust by her younger son, Nigel Nicolson. Since then this small 4-ha. garden, made for the enjoyment of family and friends, has had to accept increasingly large numbers of visitors and much restoration has been necessary. Nevertheless a high standard of upkeep has been set and maintained. J.S.

Sitwell, Sir George Reresby (1860–1943), English writer on gardens and a deeply-cultivated and often perversely idiosyncratic aristocrat, was the father of Dame Edith, Sir Osbert, and Sir Sacheverell Sitwell. His book *On the Making of Gardens* (1909, 1949) was written from the conviction that 'if the world is to make great gardens again, we must discover and apply in the changed circumstances of modern life the principles which guided the garden makers of the Renaissance'. The garden at the family seat, *Renishaw Hall, was designed partly to conform to this conviction.

In 1925 Sir George went to live at the Castello di Montegufoni in Italy, where he was to work on the castle gardens for over 15 years. He removed the vegetables from the terraces, planted Tuscan roses in their stead, and moved

quite a large oleander from the courtyard to the centre of a box parterre which he created in the Cardinal's Garden, planting stocks and ranunculus in it. In 1931 he made a new layout with a double axis beneath the old castle ramparts and in 1939 renovated the 17th-c. grotto. K.LE.

Sliding hill. See MONTAGNE RUSSE.

Sloane, Sir Hans (1660–1753), Irish physician and plant-collector, studied medicine and botany in London, Paris, and Montpellier before settling in London in 1684. Three years later he travelled to the West Indies as physician to the Governor of Jamaica, returning after 15 months (and the death of his patron) with 800 plant specimens, described in a catalogue published in 1696, and enough material for the two large volumes of his *Voyage to . . . Jamaica* (1707–25) which were dedicated to Queen Anne, one of his patients. He was President of the Royal College of Physicians from 1719 to 1735 and of the Royal Society from 1727 to 1741, corresponding with botanists and helping to support many plant-collectors, among others *Catesby, John *Bartram, and *Houston. In 1712 he bought the manor of Chelsea, which included the *Chelsea Physic Garden founded by the Society of Apothecaries in 1673. The Society was granted a lease in perpetuity in 1722, when Sloane also secured the appointment of Philip *Miller as curator of the garden. In later years the landlord remained a generous patron.

After Sloane's death his library of manuscripts and books and his natural-history collections were bought by the nation for £20,000, becoming the nucleus of the British Museum, which was opened in 1759. S.R.

Snowshill Manor, Gloucestershire, England, designed by its owner, Charles Paget Wade, is broadly in the compartmentalized, *Hidcote style, an interconnecting series of outdoor 'rooms', here becoming a fascinating series of terraces, steps, and slopes, each partly concealed from the next by walls and arches. Wade was an artist-craftsman in the tradition of William Morris, Ernest Gimson, and the Barnsley brothers and his absolute belief in the rustic ideal and his interests in heraldry, medievalism, and astrology were expressed in the garden in a variety of surprising ways, giving an intensely individual, indeed eccentric, quality to the place. Seats and woodwork are painted 'Wade Blue', a powdery dark blue with touches of turquoise.

The central core of the garden is based upon a design by M. H. Baillie-Scott but Charles Wade modified, extended, and elaborated the layout over 35 years. He transformed 'a wilderness of chaos', a nettle-covered slope, into an intriguing pattern of spaces supported firmly by traditional Cotswold walls; richly ornamented and planted in the deceptively casual 'cottage garden' style with blue, mauve, and purple predominating. A spring was channelled into a series of small cisterns and troughs to link the various levels with the sound of water.

Charles Wade gave the property to the National Trust in 1951. J.S.

See also ARTS AND CRAFTS GARDENING.

Soami (1472–1523), Japanese art connoisseur and painter of the Muromachi period (1335–1573), was also known by the name of Shinso. Soami was the last of the three well-known generations of the Ami family—his grandfather No-ami, his father Gei-ami, and himself. They all served the Ashikaga shogunate primarily as appraisers of the *objets d'art* then being imported from China.

Soami, like his forefathers, took an interest in *sumie* painting besides his own court duty. He belonged to the social class called *Dō-bō-shū*, another faction of which—Zen-ami—was concerned with the exterior work of gardening and rock placement. Since Soami was not only master of interior decoration, including bonsai and flower arrangement, but was evidently well informed about the aesthetic treatment of exterior building, such as the principle of *ts'an-shan ch'eng-shui* (see *Tenryu-ji Abbot's Garden), it is highly probable, though the record is not yet clear, that his advice to Zen-ami in the latter's work would have been influential in those formative days of the Zen garden.

Several *sumie* paintings are attributed to Soami (such as the *fusuma* landscape painting at the Daisen-in temple of Daitoku-ji in Kyoto) but none have so far been proved to be absolutely authentic. The paintings clearly show the influence of the Southern Song masters of China such as Mu Hsi and Yü Chien. S.S.

Soil-type gardens. New gardens are usually initiated for a variety of economic, cultural, and social reasons that bear little direct relationship to the soil itself. Nevertheless, once the decision to create a garden is made, the soil is probably the most important factor in determining the form and constituent plants of the garden. Extreme soil types, such as unstable salt-impregnated sand, acid moorland peat over hard granite, or soft crumbly chalk, all require particular care both in the cultivation techniques to be used and the choice of plants to grow.

During the last hundred years or so a new trend in garden planning has developed—the garden conceived because of the unusual local soil conditions. Thus, today, there are chalk gardens, peat gardens, clay gardens, and sand and gravel gardens, in addition to water-gardens and rock-gardens (see *water in the landscape, and *alpine, scree, and rock-gardens).

Perhaps the best known of all soil-type gardens are those created on the very shallow and dry soils of the chalk Downs of southern England. Chalk gardens should be successful, as the native chalk flora is much more species-rich than that of any other British soil. Of particular interest is the chalk garden developed by Sir Frederick Stern at Highdown in West Sussex. The plants amassed over 60 years in this once derelict chalk-pit include native British species and exotic introductions. Another notable example is at Sainte-Preuve in France.

Clay is a major and essential constituent of garden loam but when it is the predominant soil fraction the soil is unmanageable, being very heavy, sticky, and frequently waterlogged. Nevertheless, many food crops perform well on clay soils and recently several specialized ornamental

gardens have been created on them. A good example is the Dutch garden at Walenburg, near Utrecht, situated on the very heavy clay of the Rhine Valley.

On dry acid soils *heather gardens can be planted, and on wetter moorland soils, where a thin layer of acid peat overlays impervious rock, peat gardens have been created. As peat is now available relatively cheaply, beds of compressed peat-blocks are a feature in many gardens.

Gravel banks and loose sand occur in many parts of Britain and although the 'soil' they provide is poor in nutrients and very dry, nevertheless many plants will grow in these deposits. A scree garden, made of gravel on a steep slope so as to resemble a mountain scree, will support many unusual plants. Good examples of scree gardens are at the botanic gardens at Kew and Edinburgh.

Many of the municipal gardens in seaside towns are built on almost pure sand. The plants chosen are tolerant of drought and salt-laden air but thrive in the relatively equable climates found on the coast. P.F.H.

Soi Siyapa (Soi Ekamai), Bangkok, Thailand. It is very much the custom in Bangkok for a landowner to develop a compound site as a related group of houses, either for the family 'clan' or as a speculation for letting (*farang*) to higher income groups or expatriates. In Soi Siyapa a compound for four houses has been designed by Phaitoon Osiri, one of Thailand's few professional landscape architects. It is stylistically Japanese with stone lanterns and protruding rocks. An undulating stream binds the site together like a ribbon and the landscape flows around the houses uniting them skilfully without apparent subdivisions of lots, yet providing areas of privacy to each house. It is with the range of medium-scale tropical plants that the character becomes more Siamese than Japanese, particularly in the use of papyrus and aroids and the close clipped sculptural groups of *Ixora coccinea*. M.L.

Solander, Daniel Carlsson (1736–82), Swedish naturalist. See LINNAEUS AND HIS STUDENTS.

Sonoma, California, United States. See EL NOVILLERO.

Sophievka, Ukraine, Soviet Union, has a landscape park near Uman laid out towards the end of the 18th c. by Count Pototsky for his wife Sophia on the steep and rocky sides of the valley of the River Kamenka. The principal features of the park are two artificial lakes, the Upper and the Lower, with their associated springs and cascades. The winding walks along the thickly planted shores afford pleasant views, and the path to the Upper Lake is so contrived that the mirror surface of the lake reveals itself most unexpectedly and effectively. A small island planted with tall poplars is reminiscent of *Ermenonville. The Elysian Fields have a rock labyrinth, arbours, and a grotto with an echo. There is a good range of trees in the park. S.P.

Sørensen, Carl Theodor (1899–1979), Danish landscape architect, was born in Germany of Danish parents and grew up in North Jutland. His early ambition was to be either a printer or a gardener. After an apprenticeship at a manorhouse in Jutland he worked in the drawing office of the landscape architect Erstad Jørgensen before starting his own practice in 1922, working for a short time with G. N. *Brandt.

At the Royal Academy of Fine Arts, Copenhagen, where he began to lecture in 1940 and was professor from 1954 to 1961, he came to be regarded as the father of Danish landscape architecture, and he received many international awards. His influence was far-reaching and when he retired in 1960 he had carried out over 2,000 commissions. In his later years he lived in a penthouse at the top of a tower block in Bellahøj, a suburb of Copenhagen, for which he had designed the landscape, including the well-known amphitheatre. He always claimed that he had discovered Europe too late, and would enthuse about French and Italian gardens, regarding *Le Nôtre as the world's greatest landscape architect.

He wrote many articles for newspapers and periodicals, and was co-author of *Buske og Træer* ('Shrubs and Trees') (1947), and *Frilandsblomster* ('Herbaceous Plants') (1949). In 1931 he wrote *Parkpolitik i Sogn og Købstad* ('Park Politics in Parish and Borough'), a book which confronts the problems relating to the design and development of parks. It is still relevant today, its most important contribution being the idea of adventure playgrounds which spread through Europe and America. *Om Haver* ('About Gardens') was published in 1939, and followed 20 years later by a comprehensive historical survey of gardens, *Europas havekunst fra Alhambra til Liselund* ('Europe's Garden Art'). In 1966 he produced a series of ideograms for designers in *39*

Garden at Hellerup, Copenhagen, Denmark, by C. Th. Sørensen

Haveplaner ('39 Garden Plans'). His autobiographical work, *Haver: Tanker og arbejder* ('Garden Thoughts and Works') (1975), is a testimony to his dominating influence in Scandinavian landscape design.

He carried out some very large projects, but often said that the smaller ones gave him most pleasure as a designer. Of the smaller gardens his series of rectangular spaces laid out on a diagonal axis are memorable, as is his sunken garden of concentric ovals, both now regarded as classics. This preoccupation with geometric forms—especially the circle—is apparent in much of his work. In his design for Vitus Bering's Park at Horsens in Jutland, he introduced a *tour de force* of enclosed clipped geometric plant forms which included the triangle, square, pentagon, hexagon, septagon, octagon, circle, and oval, all carefully co-ordinated. He considered that shape and form, texture and colour, were of overriding importance, and that only about 10 trees, shrubs, and herbaceous plants are needed as a basic plant vocabulary. He was strongly influenced by G. N. Brandt and outstanding landscape gardeners such as J. K. Jørgensen, former head gardener at the Danish Royal Horticultural Society.

P.R.J.

South Africa

Gardening began in South Africa in 1652, when Jan van Riebeeck, the first Commander of the Cape, arrived to establish a refreshment station for the ships of the Dutch East India Company, en route from Europe to the East. Van Riebeeck planted a vegetable garden and an orchard on the north-facing slope of Table Mountain, above Table Bay, where a perennial stream provided water for the plants. It was strictly a practical garden with rectangular beds surrounded by high hedges as protection against the strong winds.

In 1679 a great gardener arrived in the Cape as Governor, Simon van der Stel. At the time of his arrival farms in the country districts were taking over the work of providing ships with fresh produce and, at the same time, the great era of botanical exploration had commenced. New plants and plant specimens were arriving constantly in the Cape from the rich flora of the country and also from the West. The Governor planned the expansion of the original Company garden into a garden of acclimatization for trees, shrubs, and herbs from all lands. The new garden was planned in the style of *Le Nôtre, with an oak-lined avenue running by the main canal, down the length of the garden from south to north. On either side of the main avenue, known today as Government Avenue, the rectangular vegetable beds were replaced by formal gardens, pools, canals, groves of palms from the East and eucalypts from the Antipodes, and intersected by geometrically designed walks. Much of the original layout in that part of the garden which has survived can still be discerned. The South African Museum building lies at the south end of the garden and at the north end is the South African Library.

To the east of the garden, a house called Tuynhuys was

Groote Schuur, Cape Town, South Africa, drawing (1816) by Quirijn Maurits Rudolph ver Huell (Gemeentemuseum, Arnhem)

built for the Governor; it is now the residence of the State President. Like so many South African gardens, it was inspired by nostalgia for Europe. It has recently been restored as an example of formal Dutch design, with neat low hedges and clipped citrus trees, to a plan drawn by Josephus Jones in 1795.

Governor Simon van der Stel did not confine himself to improving the Company garden; he was interested in making the Cape a beautiful, civilized, and productive land. Oak trees (*Quercus robur*) were, he felt, trees of great importance for timber, shelter, and beauty and he made it a law that every farmer who received a land grant, must plant at least a hundred oak trees. Oak avenues and tree-shaded gardens have become one of the loveliest features of the Cape. In summer the great banks of *Hydrangea macrophylla* var. *hortensia*, which grow in their shade, are beautiful.

During the 19th c. pioneers were arriving at other South African ports—in Natal and the eastern Cape—as well as in Cape Town. English settlers brought with them cuttings of roses, lavender, and rosemary, seeds of delphiniums and hollyhocks, and the roots, bulbs, and tubers of the plants they had loved at home, and they created corners reminiscent of England in their new country. As they moved inland from Cape Town, Durban, and Port Elizabeth, these plants became an integral part of South African gardens. A lovely example of these gardens of remembrance is the rose-garden at the Drostdy Museum in Swellendam, Cape, established in 1900. It is a tiny but exquisite garden whose focal point is a wrought-iron gazebo covered with climbing roses, which was designed by Gwen Fagan, who works closely with her husband, the architect, Gawie Fagan. They have designed the restoration of many historic buildings and their surrounding gardens.

Late in the 19th c. Cecil John Rhodes bought the estate Groote Schuur (dating from 1657), near Cape Town, on the eastern slopes of Table Mountain. He commissioned Sir Herbert Baker to build a new house for him in the lovely and gracious Cape Dutch style of building. Around the house a formal garden was laid out in a series of terraces, the rose-garden and the great horseshoe of hydrangeas being noteworthy features. In the glen and under the trees more hydrangeas were planted, which are very beautiful at Christmas time. Unfortunately, the cost of labour has made it necessary to replace much of the formal garden with its time-consuming carpet-bedding programmes, with a more informal and park-like garden, but the original rose-garden remains. Cecil Rhodes left the Groote Schuur estate to the nation. The house is the country home of the State President, and much of the land was given for the University of Cape Town and the famous Groote Schuur Hospital.

There are few areas in South Africa where the rainfall is sufficient to create woodland and rhododendron gardens in the English manner, but in the mist belt of the lower slopes of the Drakensberg mountain range, which stretches from southern Natal to the northern Transvaal, the plants of the great English arboreta will grow. Many lovely gardens have been created in these districts in the 20th c. They lack the statuary and classic temples and ruins of their English counterparts, but have breath-taking views and mountain vistas. Good examples of these are Grey Mists at Haenertsberg in the north-eastern Transvaal, Benvie at Karkloof, Natal, and *Hunterstoun at Hogsback.

The subtropical areas of the Natal coast are ideal for plants which thrive in hot moist climates, and there gardens were created with cannas, palm trees, anthuriums, the flame-coloured flowers of *Pyrostegia venusta*, bougainvillaea, and other tropical plants mixing with annuals and roses from the Old World. The Durban Botanic Garden and *Amanzimnyama at Tongaat are fine examples of subtropical gardens. The tropical gardens are rarely designed on a formal plan, but are park-like with dense shelter-belts of shrubs and trees, wide lawns, fountains, palms, and flowering trees. The Durban Botanic Garden is laid out on slopes, high enough to catch cool breezes, and its beautiful collections of palms, trees, orchids, and water-lilies are superbly displayed.

Many of the cities of South Africa are planted with semitropical flowering trees, such as *Jacaranda mimosifolia*, which makes Pretoria in the Transvaal a mist of blue-mauve flowers in the early spring, and *Delonix regia*, which flames into glorious flower in Durban and Nelspruit in December. Until recently, the City Parks Departments used extensive displays of bedding plants on the road edges, but gradually shrubs and ground-covers are taking their place and more and more indigenous plants are being used. The designs of Roberto *Burle Marx, with wide sweeping lines and big solid blocks of colour, have had a strong influence on public gardens and roadside plantings.

When gold was discovered in the Orange Free State in an area of flat monotonous landscape, bitter winter frosts, and hot summers, the Anglo-American Corporation asked a landscape artist, Joan Pim, to advise on and design the layout of the gardens of the new town, Welkom. Joan Pim's style is highly individual and could be termed the style of the enchanted forest, for she uses trees to disguise and transform an ugly view into a beautiful landscape. For example, mine-dumps are hidden by block plantings of conifers, and a building is disguised by the growth of *Cupressus sempervirens* var. *stricta*, slender and tall between the lines of windows. Joan Pim's plans for the islands at intersections in the main roads entering Welkom were also drawn from forest inspiration, with low plantings, leading up to higher and higher growing trees. She was always careful in her choice of plants that varieties chosen would grow well in each garden under the climatic conditions of the district, and in the local soil type. She would soften a straight line with curved planting, and was a master of surprise, a sudden long and lovely vista, or an enchanted clearing in her carefully planned forest.

See also BRENTHURST.

As South Africa became more of an industrial and mining country than a pastoral land, the cities grew rapidly and people, impatient for beauty, used a large number of annuals which are still a feature of many Orange Free State and Transvaal gardens and can be seen to perfection in the

terraced gardens of the Union Buildings in Pretoria and on the farm Randfontein, near Kroonstad in the Orange Free State.

In the town of Stellenbosch, much of the history of gardening in South Africa is displayed. It is a university and a farming town, with a tradition of pride in its history, beauty, and gardens. The old oak trees which line the streets have great character and the modern groundcover plantings around some of the new University buildings such as the Conservatoire of Music are superb, boldly planned blocks of colour and contrasting shape and texture with minimum upkeep problems. The University Hortus Botanicus, under the curatorship of Wim Tijmens, is a miracle of planning, with a maximum number of interesting features fitted jigsaw fashion into a very small area.

Two other great gardens in Stellenbosch are at Old Nectar, and Rustenberg. The garden at Old Nectar is reminiscent of *Sissinghurst and *Hidcote; romantic garden rooms lead one into the other with beautifully planned colour effects and lovely creepers, the central focus of the garden being the old Cape house which is a national monument. Rustenberg has two gardens, one complementing the other. The first, near the house, is a series of small gardens, each a perfect entity: a yellow garden, a red garden, a white garden, a garden of euphorbias, irises, and cistus, a herbaceous walk, a herb garden, a water-garden. In total contrast to these is the wild garden which was planned around a grove of silver trees, *Leucadendron argenteum*, and where the plantings are so skilled that they look completely natural.

In 1913 a new concept entered South African gardening and has become an increasingly important factor. The National Botanic Gardens of South Africa began with the creation of the first garden to specialize in indigenous plants only, at Kirstenbosch on the slopes of Table Mountain, near Cape Town. Later, regional gardens were planned and are in the process of being established in the major climatic regions of the country. For example, the garden at Worcester on the border of the Karoo desert region is one of the five great succulent gardens in the world. Each regional garden specializes in the specific flora of the surrounding country: for example, in the Lowveld Botanic Garden at Nelspruit grow the lovely trees of the eastern Transvaal such as *Pterocarpus angolensis* (kiaat), *Sclerocarya caffra* (marula), *Ficus* species (wild fig), as well as the beautiful *Gerbera jamesonii* (Barberton daisy), *Alsophila dregei* (tree fern), and several species of *Encephalartos* (cycads). Other regional gardens under the control of the National Botanic Gardens of South Africa at Kirstenbosch are the Orange Free State Botanic Garden (Harrismith), Natal Botanic Garden (Pietermaritzburg), Karoo Botanic Garden (Worcester), Harold Porter Botanic Garden (Betty's Bay), and the Transvaal Botanic Garden (Roodepoort). Further gardens are being planned at Port Elizabeth, East London, and possibly the north coast of Natal.

Others have followed the example of the National Botanic Gardens and have designed gardens specially to display the native flora, such as the garden at Ramskop, Clanwilliam, which grows the brilliantly coloured spring flowers of the north-western Cape; the Wilds, Johannesburg; the aloe collection of Mr and Mrs Giddy in Natal; the garden of the Botanical Research Institute, Pretoria, Transvaal. More and more gardens in South Africa are now landscaped to echo the magnificent scenery of the country, to use the interesting rocks of the mountains and koppies, and to grow the local plants, which include some of the most beautiful flowers in the world.　　　　H.B.R./J.G.R.

See also MINTAKA.

South America

The subcontinent of South America covers more than 1,813 m. ha., one-eighth of the earth's surface. It is dominated and divided by the Andes which extend almost from Panama to Tierra del Fuego in the extreme south. Among them are Aconcagua, the highest peak in the Western Hemisphere (6,959 m.), and a number of active volcanoes which have earned the description 'ring of fire', skirting the Pacific. Although much is lowland there are three areas of ancient highlands cut by deep valleys. These include the Guiana Highlands in the north (up to 2,800 m.), the Brazilian Highlands rising steeply from the Atlantic coastal plains to 2,884 m., and the low plateau of the Patagonian cold desert. The lowlands of the centre and the east are drained by three great river systems: the Amazon, the Orinoco, and that which ends in the Rio de la Plata, incorporating the Paraguay, Parana, and Uruguay rivers.

The mountain barrier of the Andes, the extreme variations in terrain, and the extent of the land mass from the tropics to 50° south (only 1,050 km. from Antarctica) give rise to enormous variations in climate and vegetation. This ranges from the true Equatorial rain forest of the Amazon Basin, the tropical and temperate grasslands of the plateaux, and the narrow western coastal strip which divides into Equatorial forest in the north, desert in Peru and northern Chile, and Mediterranean and southern temperate forests.

When the *conquistadores* arrived from Spain and Portugal in the early part of the 16th c. they found an elaborate Inca culture extending from Ecuador through Peru to northern Chile. They reported seeing parks, gardens, and zoos with ornamental plants and sculptures. These were served by sophisticated irrigation systems which are still in use in the Otavalo region of northern Ecuador. (There is evidence of links with the Aztecs of Mexico, who are believed to have been keen horticulturalists.)

Under the treaty of Tordesillas (1494), Spain and Portugal agreed to split South America between them. All the

land to the east of 50° west was claimed by Portugal, and all that to the west by Spain. By the 1530s there were several major conquests under way: Pizarro in Peru, Quesada in Colombia, Cortés in Mexico. The pre-Columbian settlements were destroyed and replaced by European ones, modelled on directives from the state and the church in Spain and Portugal. The central square of a town was the political and social focus surrounded by civic buildings and the church or cathedral.

Among the earliest gardens were those made by the missionaries to provide food, herbs, and medicinal plants as well as places for prayer and contemplation, arranged in series of walled enclosures. Private houses also followed the Iberian pattern with assimilated Moorish influences such as gardens contained within courtyards, balconies, and verandahs (see *Spain; Gardens of *Islam). The Spanish colonial economy in the west at first depended upon the mining of gold and silver, but as the supply dwindled colonists began to grow cash crops. Horticulture and agriculture became increasingly important, changing the face of the landscape. In the eastern countries this happened much earlier; the Portuguese developed farming, including crops of tobacco and sugar-cane, and later maize and wheat, cattle and sheep.

In 1810 Argentina overthrew the viceregal government, and during the next two decades all the major South American countries became independent. This was celebrated typically by the creation of public squares and parks containing statues of heroes and monuments to nationalism, which incorporated promenades and viewing and resting places. Buenos Aires, the capital of Argentina, now has over 150 parks.

It was not, however, until the dislocation of trade during the two world wars that South America really began to assert its economic and stylistic independence from Europe and North America. The new industrial and commercial classes began to commission artists, architects, and designers who were able to give true expression to their national identity. This began in Brazil with a small group, including Lucia Costa, Oscar Niemeyer, and Roberto *Burle Marx, working with Le Corbusier on the Ministry of Education building in Rio de Janeiro in 1938, and came to fruition with the creation of the new capital, Brasilia. Burle Marx briefly extended his practice into Venezuela, but there have otherwise been few significant developments in the field of garden design.

The last decades of the 20th c. have, however, seen the development of the profession of *landscape architecture which is concerning itself with the wider issues of urban design and development, the creation of new urban, regional, and national parks, and the pressing problems of deforestation and erosion. K.E.K.W.

BRAZIL. Modification of the natural landscape of Brazil began in 1500 after colonization by the Portuguese. This started with the export of timber, especially the Pau Brasil (*Caesalpinea echinata*), which gave its name to the country, and continued with the sugar cycle, a monoculture which

began in the north-eastern state of Pernambuco with the introduction of African slaves. New rural landscapes were created by the establishment of building complexes to house the farmers and their workers.

In the 17th c. the Dutch invaded (see *Dutch Colonial Gardens: Brazil) and Mauricio de Nassau (*Johan Maurits) came to Pernambuco, bringing artists and naturalists with him; Mauristadt became celebrated for the first Brazilian Botanical and Zoological Gardens. Large palm trees were transplanted, and one African baobab (*Adansonia digitata*) from the period is still growing in a central plaza of Recife. There were a number of private gardens at this period but Brazilian garden design began officially with the formal French style of the Public Mall in Rio de Janeiro (1783) by Mestre Valentim.

In the 18th c. an urban structure was developed in the State of Minas Gerais ('General Mines') to accommodate the commercial activities associated with the Gold Rush, including the city of Ouro Preto, now listed by Unesco as an international monument. Following the Portuguese model, the city consists of winding streets with the buildings lining the pavements, climbing the slopes, and converging on the Civic Mall which contains the City Hall, the jail, and the churchyard.

In the 19th c. Brazil entered the coffee cycle. Beginning in the surroundings of Rio de Janeiro, it continued through the Paraiba Valley into the state of São Paolo, deforesting and transforming the landscape with coffee plantations and the urbanization of the hinterland of the State of São Paolo. The devastation left by the abandonment of the land after its use for coffee was so serious that in 1850 the city of Rio de Janeiro began to fear for its water supply. In 1808, due to the invasion of Portugal by the Napoleonic army, Brazil became the temporary headquarters of the kingdom. Dom João VI brought with him a French mission, including many artists and scientists, who introduced the idea of siting houses in the middle of their plots as well as contributing much to the urban landscape. A botanical garden was established in Rio de Janeiro in 1808.

Brazil became a republic in 1889, one year after the abolition of slavery. From this time, labour for the extensive industrialization was provided by immigration, of Italians, Portuguese, Spanish, Japanese, and Germans. The first garden designer of any significance was the French engineer and botanist Glaziov, who lived in Brazil from 1858 to 1897, designing many parks and gardens in the English style, mostly in Rio de Janeiro. His most important contribution was the use of native plants.

From the end of the 19th c., urban parks in the *gardenesque style began to appear in all the cities. (Jardim da Luz and the Parque da Aclimação in São Paolo, Park Halfeld in Juiz de Fora, and Passeio Público in Curitiba are examples.) At the beginning of the 20th c., the French architect Bouvard designed some of the most significant parks in São Paolo, including: Praça Ramos de Azevedo in front of the Municipal Theatre, incorporating a curved line of palm trees and a number of sculptures; and the Parque Dom Pedro II, occupying the marshland in the middle of

the city—now destroyed by the road system. These were followed by a number of parks, including the Campo da Redempção (now the Parque Farroupilha) in Porto Alegre, created in the 1930s by the French urban planner, Alfred Agache.

The first modern landscape design was carried out by the Brazilian architect and urban planner Atilio Correa Lima for the hydroplane station in Rio in the 1940s. But without doubt, the father of modern garden and landscape design is Roberto Burle Marx, whose designs express an exemplary skill in the organization both of plants and built elements in a totally contemporary idiom (see plates IIIa & b). Burle Marx is identified with a group of architects and designers originally associated with Le Corbusier on the Ministry of Education building in Rio (1938), who worked together on many projects in the ensuing years, culminating in the creation of the new capital city Brasilia in the 1960s. Other garden designers of significance include Carlos Perry in Rio, and Waldemar Cordeiro, a painter who has designed gardens in a remarkably personal style in São Paolo.

Following the impetus of such designers, the creation of the Faculty of Architecture and Urban Planning in the University of São Paolo helped to consolidate the profession of landscape architecture under Roberto Coelho Cardozo. American born and educated, Coelho Cardozo introduced the concept of landscape in relation to the city and its people, akin to that of Garrett *Eckbo. Although still involved in the design of gardens, the profession has been, in the last 20 years, represented by government institutions, the departments of parks and gardens, and by individuals in private practice including Fernando M. Chacel, Miranda Magnoli, and Rosa Grena Kliass. It is more developed in São Paolo and Rio de Janeiro, due perhaps to the influence of Burle Marx in the former and the Faculty of Architecture in the latter; also the presence of an infrastructure established historically by European botanists, nurserymen, and gardeners. Many of these have been working towards the introduction of new plants into the gardens, especially those of native origin.

In 1976, under the influence of IFLA, Rosa Grena Kliass, together with 31 landscape architects, founded the Brazilian Association of Landscape Architecture (ABAP). R.G.K.

CHILE. The Spanish *conquistadores* found in central Chile a landscape and climate similar to those of the Mediterranean. Initially the cities were laid out in the grid pattern required by the Laws of the Indies, with each block divided into lots, and houses constructed round interior courtyards or patios. The first courtyard gave access to coaches, the second gave on to the living quarters and was the natural centre of outdoor family activity, while the third served as kitchen garden and orchard. There were irrigation channels to keep the gardens watered, clean, and fresh. The design of the second courtyard garden was simple, with a central fountain and a profusion of perfumed plants, both native and imported, as described so well in 1824 by the English

traveller, Maria Graham. Plants in the kitchen garden included wild grape-vines and European fruit-trees.

Many new flowering plants were introduced in the 19th c. With the boom in saltpetre and mining, European travel became more commonplace towards the middle of the century, and the character of the 'informal' garden underwent a remarkable change. Symmetrical flower-beds were introduced, with borders of boxwood trimmed in the French style, and grass lawns in keeping with the romantic fashion of the time. The typical urban plan, with one house joining the next in an uninterrupted line, was broken here and there by splendid mansions, set in vast gardens. A taste for the picturesque expressed itself, even in the centre of Santiago, in lakes, bridges, meandering pathways, ivy-covered Roman gateways, grottoes, and exotic plants.

At the same time large houses on the outskirts of Santiago established extensive gardens in a variety of styles, and many of these have been maintained up to the present day. Mariano Egana's Peñalolen Park near Santiago, set in the foothills of the Andes, makes use of the clear waters from the mountains, which are led by gravity down through a series of waterfalls, fountains, jets, cascades, and still, light-reflecting ponds. The style is that of Renaissance Italy, mingling native *peumo* (*Peumus boldus*) and quillai (*Quillaja saponaria*) trees with a wide variety of flowers brought specially from Europe. Other gardens include the Vergara country estate in Viña del Mar, a mixture of private park and botanical garden which merges with the natural vegetation of the valley slopes; the Meiggs Estate, on which work began in 1858, an exotic garden with a variety of exotic plants from the West Indies, managed by Drummond, the English landscape gardener; Lota Park near the city of Concepción, owned by the Cousiño Goyenechea family, noted for its exceptional plant life; as was Macul Park, with its lakeside vineyard, its avenue of oak trees, limes, and beeches, and grottoes and bridges very much in the Chinese style.

Of the various public parks, especially worth mentioning is Santa Lucía Hill, highly romantic in style, with ornamental urns and sculptures, set in the centre of the city of Santiago, and created between 1872 and 1875. The estate belonging to the Agricultural College, with its lake, hot-houses, botanical garden, and exhibition centre, covered some 80 ha. by the beginning of the 20th c., including both park and cultivated land. Another park, named after its donor, Luis Cousiño, was the work of the Spanish town planner Mañuel Arana Borica who modelled it on the Bois de Boulogne in Paris; it has an extensive network of carriageways, a lake, islands and fountains, and 60,000 specially planted trees. Numerous other public and private gardens of a picturesque, romantic character were made by Guillermo Renner, a landscape designer from Alsace.

The Santiago Metropolitan Park was created at the beginning of the 20th c., and is especially associated with Alberto Mackenna, the Mayor, and a French designer Charles Thays. In 1910 George Dubois, the French landscape designer, created the Forestal Park in the English landscape tradition, with leafy trees standing in open grass meadows, and the great lake that provides the setting for the

Palace of Fine Arts. Along the banks of the Mapocho he laid out a riverside walk flanked by four rows of tall oriental plane trees.

Attitudes to landscape design were changed fundamentally between 1930 and 1950 when the Austrian designer Oscar Prager settled in Chile, bringing with him experience of studies in Italy and Japan and work carried out in the United States (California), and Argentina. He rediscovered the flora of Chile and combined it with wild trees and shrubs. He brought out the essential character of the natural plant life in his use of the scrub and woodland indigenous to the damp lands of the central region, opening up and highlighting superb views across expanses of grass and ground-cover plants, framed by trees and by the larger, imposing background of the high mountains behind Santiago. Providencia Park and many other public parks and privately owned gardens are monuments to this new approach to using space. His gardens are especially notable for the geometrical precision of the network of paths, steps, and areas of water, which contrast with the irregular patterns of the plants and trees. Prager managed to achieve a sensation of great freedom and closeness to nature. But the accelerating urban development of the past 20 years has destroyed the sense of city landscape and the parks have suffered from neglect. S.M./M.V.

COLOMBIA. The extreme diversity of land configuration, meteorological characteristics, and cultural development of Colombia has led to the division of the population into small groups that display a wide variety of cultural characteristics. There is little evidence of pre-Columbian gardens but there are indications that the Indians valued shade trees and ornamental plants, particularly those with brightly coloured flowers. During the colonization period following the conquest, houses were built with patios containing symmetrical designs based upon Spanish models of which well-preserved examples can still be seen. The Spanish influence is, however, less strong than is usually thought. Gardens evolved in several different styles according to the geographical and cultural identity of the region, and some of these have been reconstructed.

Modern gardens in Colombia follow what could be called an international style: agreeable, mostly symmetrical combinations of form, colour, and texture, not identified with any specific tradition. Unfortunately the desire for and appreciation of new things led to an imitation of foreign styles using exotic plants instead of the immensely varied native species. However, a small number of professional landscape architects have worked extensively on gardens in Colombia and pioneered a definitive national style using native species. These include Alfonso and Michele Cescas Leyva, Lyda Caldas de Borrero, Alfonso Robledo, Ernesto Guaqueta, and Graciela Mejia. G.AP./M.F.

URUGUAY. The earliest gardens, those of the colonial period, were associated with villas and later urban public spaces. In the 19th c. foreign designers were brought in: notably Edouard *André, Charles Thays, and Charles Racine from France, and Juan Veltroni from Italy. They were succeeded in the 20th c. by Uruguayan specialists, including the architect Mauricio Cravotto, Professor of Urban Planning and Landscape Architecture, the agronomist Carlos Pellegrino, Professor of Ornamental Horticulture, and the architects Juan Scasso, Emilio Massobrio, and Roberto Elzaurdia (of the Administration of Public Spaces of the Municipal Government of Montevideo); all of these were instrumental in the adaptation of landscape design to modern conditions. Work includes tourist complexes at the Arapey and Daymán thermal springs in the western region, and a large number of gardens along the Atlantic coast and the River Plate in the eastern region, particularly in the summer resort of Punta del Este which was the subject of a building boom until 1981. Although not associated with any identifiable design school, many of these garden and landscape designs showed a sensitivity to the natural environment which is dominated by pine woods.

In the northern region, at Rivera City, Roberto Elzaurdia has designed for the Municipal Government building in the Barón de Rio Branco Square, a landscape adapted to local ecological conditions. Important landscape and garden design work has also been carried out in Montevideo, including public spaces and the Botanical Garden, which has been renovated according to the original design by the botanist José Arechavaleta and Roberto Elzaurdia (1980).

At present there is a clear reforming movement based upon the desire to express contemporary social and cultural values by garden and landscape design appropriate to the late 20th c. R.M.E.

VENEZUELA. It is difficult to identify any outstanding garden design before the establishment of the Republic in 1821. At that time the modest city of Caracas, at the head of a valley 900 m. above sea level, was surrounded by haciendas which gave it an open park-like setting. In 1859 a promenade designed on English lines was constructed by the Polish engineer Lutowski. The plaza of Caracas occupies a place of special importance because it became the prototype for other plazas throughout the country in honour of the liberator Simón Bolívar. Initially a market square, it was laid out in 1809 as a public park with gardens incorporating fountains, statuary, and sitting areas arranged in terraces enclosed by balustrades. These provided the basis for the subsequent design by the French engineer Alfredo Roudier, associated with the Cathedral, the Archbishop's Palace, the University, and Government House. Roudier's geometric layout consisted of symmetrical paths dividing the square into eight planted rectangles, which became known as the British Flag design; it was adopted for all plazas dedicated to Simón Bolívar throughout the country.

The park of El Calvario, situated on a hill near the centre of Caracas, incorporates a reservoir in the form of a lagoon, and was originally designed by Urdaneta in the English manner with trees and flower-beds, but it was almost immediately modified to incorporate some final classical touches of French design at the behest of the President.

The great axial sequence of terraces with balustraded steps, and flower-filled *ronds-points*, was in the event reduced to modest proportions; nevertheless the park remains as one of the most important examples of 19th-c. Venezuelan design. President Guzmán Blanco was responsible also for other areas such as the Carabobo Park with a *rocaille* of fountains surrounded by 300 trees, the Plaza de Abril, incorporating a fountain with a marble basin among the trees, and two other plazas in the form of double crosses.

From the same period are the gardens of the Capitol, which were arranged in a square on the diagonal of the Plaza Bolívar. This principle of urban open-space structure was continued by Luciano Urdaneta, who set out axes with circular or elliptical spaces at their junctions, containing fountains surrounded by informal planting. These provided the pattern for later developments in Caracas, and in other cities such as Valencia and Maracaibo.

In contrast to the formality of the urban squares, natural vegetation was used extensively during the 19th c. in some of the resorts, such as the Lakeside Club and Los Haticos in Maracaibo, Macuto on the Caracas littoral, and the thermal spas of San Juan de los Morros and Las Trincheras.

Theoretical studies in the 19th c. were dominated by Dr Adolf Ernst, founder of the Venezuelan Society of Natural Sciences and Professor in the Central University. He published works on many aspects of botany, including some on the ornamental plants of the country, and was unusual in his admiration for the native flora, which he expressed in his *Flowers and Gardens of Caracas* (1895). Another author, less well known, was the engineer Julio Churion, who, in *The Causes of Drought and the Necessity of Afforestation* (1877), described the dangers implicit in the cutting, clearing, and burning of the forests covering the ravines which carried water down to the valley of Caracas.

During the long period of government of Juan Vicente Gómez (1908–35), several important landscape designs were realized. In the new district of El Paraiso in the south of Caracas a new type of private housing was introduced in the form of the quinta or villa based upon French and North American examples of the detached house surrounded by gardens; the Boulton family villa is an outstanding example of the type. Another innovation was the planting of pavements with trees. Beginning in 1920, the lands formerly given over to the cultivation of sugar and coffee in the wide valley on either side of the River Guaire were gradually incorporated into the city. This included, in 1925, the public park of Los Caobos, named after its beautiful trees. In 1929 the North American practice of *Olmsted Brothers was brought in to design the park-like setting for the Country Club. Major park and garden developments were also undertaken in other parts of the country, notably in Maracay, where the President/Dictator had his residence.

The Kern Residence at Caracas, Venezuela, by Stoddart and Tabora

The small city was transformed with grand formal avenues, a monumental plaza, and zoological and hotel gardens with parterres of flowers.

At the end of the dictatorship of Gómez, the architect Carlos Raul Villanueva designed a neo-classical park with gardens on the site of the old prison in Caracas, and a new university complex which incorporated a sculpture garden. The Botanical Garden, meanwhile, suffered considerably due to the lack of skilled designers capable of drawing up an effective phased master-plan.

In 1950 the new government under Pérez Jiménez developed the Military School complex in Caracas with a formal axial treatment of boulevards, plazas, park, and gardens, with baroque detailing. But it was not until 1955, with the increasing prosperity of the oil industry, that a contemporary approach to garden and landscape design began to appear. This was with the appointment of Roberto Burle Marx from Brazil to participate in the design of some private coastal resorts on the littoral of Caracas. This he undertook with the architects Stoddart and Tabora, whose office in Caracas was largely responsible for the emergence of contemporary landscape design in Venezuela.

The first major work of the partnership was the Parque Nacional del Este planned for the International Exhibition in Caracas in 1960. It was an ambitious design incorporating a wide variety of gardens including cascades and fountains, ceramic tile and mosaic walls, and areas with special plant associations, contrasting form, texture, and colour. Unfortunately the fall of Pérez Jiménez in 1958 caused the exhibition to be abandoned, and the park was curtailed. It remains, however, as the first substantial modern park in Caracas and in Venezuela.

The practice was also commissioned in 1957 to design the gardens for the Palacios Residence, which is sited on a small hill with a splendid view over the valley of Caracas. The garden begins with a formal terrace and lawn designed to accommodate large numbers of guests (the owner was an art collector famous for his receptions), and continues with a naturalistic arrangement of trees and shrubs interspersed with winding paths to sympathize with the slopes of the hillsides.

Another design by the Burle Marx group, the Delfino Garden, was completed in 1961 on a boulder-strewn site at the foot of Mount Avila. The garden was visualized as flowing around the rocks and into the shadow of the old established mango trees, and in order to maintain continuity with the landscape, the high boundary walls were concealed by vegetation.

The practice of Stoddart and Tabora has continued independently with a number of significant projects, including a park for the Zulia University in Maracaibo (1964), a private garden for the Milada Neumann residence on the outskirts of Caracas, and a large number of residential, hotel, office, and club gardens. L.M.Z./J.G.S.

Southcote, Philip (1698–1758), was an English country gentleman who, after marrying the 67-year-old Duchess of Cleveland in 1733, used her money to create *Woburn Farm, one of the first of the *fermes ornées. Southcote was influenced and assisted in gardening by Robert James, 8th Lord Petre (see *Thorndon Hall). He was also a friend to Peter *Collinson and Joseph Spence, and his acquaintances included Philip *Miller, *Pope, Lord *Burlington (who designed a summer-house at Woburn), and William *Kent, of whom Southcote said 'I prevailed on Kent to resume flowers in the natural way of gardening' (1752, quoted in Spence's *Anecdotes). He is also known to have advised on garden work at *Wimpole Hall. R.H.

Soviet Union. See RUSSIA AND THE SOVIET UNION.

Spain

ISLAMIC GARDENS. Although Spain was an important part of the Roman Empire from the 1st to the 3rd cs. AD (its conquest was virtually complete by AD 133), there is no record of significant gardens having been attached to the thousands of villas built by the Romans. It was not Roman classicism but Islamic civilization which left a decisive imprint on Spain, which was to endure even after the Moors themselves lost political power. (See Gardens of *Islam.) This is true even though many Islamic gardens were built over Roman sites.

The Muslim conquest of AD 711–14 affected only south-central and north-east Spain. The conquerors brought scientific skills far in advance of the Visigothic kings they replaced, or indeed of any of the other regimes of western Europe. In particular their horticultural technique was very advanced, and continued to develop throughout their rule. The knowledge gathered at Baghdad from c.830 was brought to Spain from c.880. Cordoba became a major centre of botanic studies in the 10th c. The application of this knowledge to gardens was set out in treatises by, among others, Ibn al-'Awwam (the *Book of Agriculture*, late 12th c.) and Ibn Luyun (*Treatise of Agriculture*, 1348).

Equally important was their version of the idea of the Islamic garden. Its expression took different forms from Persian (Iranian) or *Mogul gardens in that there were no large pools of water; gardens were urban in character and generally small—even when large they were divided into small linked enclosures.

One of the first acts of the first independent emir at Cordoba in the mid-8th c. was the creation of a garden. The first of the rulers of the Western Omayyad Caliphate of Cordoba (929–1031) created an outstanding garden at *Medina Azahara, reportedly employing 10,000 labourers for over 40 years to do so. It consisted of canals and

fountains spread out under a marble terrace, all laid out on a simple quadripartite plan. By the 10th c. there were reportedly many thousands of gardens in the countryside around Cordoba. An 11th-c. text describes the *Patio de los Naranjos, Cordoba, as a beautiful courtyard of white marble, with a channel bordered by trees.

Seville, conquered by the Arabs in 712 (reconquered by St Ferdinand in 1248) also had beautiful gardens. Little is known of their appearance before the 12th c., although recent excavation has apparently revealed that in the palace of Qasr al-Mubarak the sides of the sunken flower-beds were stuccoed and painted. This type of decoration does not seem to have become as important as the tile decorations (*azulejos) of *Portugal. The *Patio de los Naranjos adjoining the mosque, begun in 1171 by Yusuf II, has a similar arrangement to its namesake in Cordoba, in that the flow of water from tree to tree by channel is controlled by wooden blocks. The garden of the *Alcázar palace, Seville (first built in the 12th c.), is the largest (nearly 16 ha.) surviving garden in Spain which preserves the Moorish tradition. It consists of several arcaded courtyards with a low pool in the centre, and a large central area having eight sections divided by clipped hedges. However, much of its basic Moorish structure is overlaid by Renaissance additions, such as the pavilion built by the Emperor Charles V (Charles I of Spain) (1516–56) in the 16th c.

Even after the fall of Cordoba and Seville in the middle of the 13th c. Moorish influence continued, amalgamated with Spanish-Christian forms in the Mudejár style. The Christian adoption of Moorish gardens was due to King Peter the Cruel (1334–69), who rebuilt the Alcázar at Seville and created extensive gardens there. (See also *Alcázar Nuevo, Cordoba.)

Muslim Spain was now confined to Granada, until its conquest in 1492. Here gardens were set on the hillsides, and views of the nearby town could be seen through a pierced wall or from an open terrace. Of all the Muslim gardens those of the *Alhambra and the *Generalife are the most magnificent. Though much altered, they are the only remaining gardens in Europe to date from the 13th and 14th cs., and their strong Islamic character remains intact. The Alhambra, a royal residence established in the middle of the 13th c., has three main courtyard gardens, the Court of the Pool, the Court of the Lions, and the Court of Daraxa. Later planting of box and myrtle (the Court of the Pool is now more commonly known as the Court of the Myrtles) does not obscure the richness of the decoration or the striking economy of effect in the use of water. At the Generalife, the sultans' summer residence, the Court of the Long Pond is the main focus. As at the Alhambra, water bubbles from low jets and runs through a channel almost at the level of the pavement. The upper garden, created from perhaps 1319 onwards, has a U-shaped pool enclosed by cypresses, which seem to have been the original planting, and higher still, a cascade. The lush gardens contrast strongly with the surrounding harsh mountain landscape—the very embodiment of the Islamic ideal of the garden as a paradise.

RENAISSANCE GARDENS. The Emperor Charles V (1516–56), the first of the Habsburg kings, built a new palace entirely Italian in character but neither he nor any other Spanish monarch created any large-scale gardens in the

Patio de los Naranjos, Seville

Tata, Hungary. The vast English garden (now a People's Park) originally covered about 240 ha., including a lake created by the draining of a marsh (carried out by J. Mikoviny, after 1747). Horse-chestnuts, planes, maples, poplars, limes, many varieties of pine, tulip trees, and various exotic plants enriched the vegetation of the garden. There were several architectural structures, including the unique artificial ruins built by Charles de Moreau in 1801, in imitation of a church nave and including Roman and medieval fragments, as well as tombstones. A Turkish pavilion and a Chinese tea-house are known to have existed, but no plan or document relating to the garden survives. It is thought that the engineer Francis Böhm may have worked here.

Today most of the former park, including the mansion, serves as a training centre for sportsmen. A.Z./P.G.

Tatton Park, Cheshire, England. The straight beech avenue, once the main approach, survives from the formal park surrounding the early 18th-c. house. Humphry *Repton's advice that the avenue be broken into clumps was not followed, although he did manage to resite the drive from Knutsford on a new curving line. The proposal in his Red Book that near Tatton 'a *mere* stone, with distances, may be made an ornament to the town, and bear the arms of the family' evoked a satirical response from Payne *Knight, thus beginning the *picturesque controversy, and was parodied by Thomas Love *Peacock in *Headlong Hall*. By 1814 Lewis Wyatt had designed a flower garden, of which an alcove (Lady Charlotte's Arbour) and a fountain survive; in 1818 he added the splendid orangery.

In the 1850s *Paxton designed the Italianate terraces with grand flights of steps, a central fountain basin, flower-filled vases, and colourful bedding-out. The Fernery, mainly planted with *Woodwardia radicans*, is attributed to him.

The Golden Brook is an informal garden lake with a Shinto Temple at one end overlooking the *Japanese Garden, laid out in 1910 and probably the best example of its kind in England.

Tatton Park now belongs to the National Trust.
J.S./P.G.

Tè, Palazzo del, Mantua, Lombardy, Italy. Situated on the periphery of Mantua, this square, single-storeyed palace, built between 1525 and 1535 by Giulio Romano for Federico II Gonzaga, is one of the first Mannerist *palazzi*. Passing under the arches of the Cortile d'Onore (see *cour d'honneur*), one enters through the superbly decorated loggia. From here opens the former parterre garden, once lavishly ornamented—now merely maintained as a herb garden—enclosed by a semicircular *exedra of the 17th c. To the left is the Casino della Grotta, arranged around a central *giardino segreto* with the grotto, once adorned with bronze statues, at the far end. To the right are the porticoes of the old stables. Through the central arch of the exedra, flanked by Tuscan pilasters, one passes into the *boschetto* (copse). From here winding footpaths run the length of a

flood embankment which forms a terrace some 200 m. long, at the end of which formerly extended great nets for catching game-birds. H.S.-P.

Tehran, Joan. See GULISTAN PALACE; QASR-I QAJAR.

Tempietto, literally a small temple, usually derived from the Tempietto next to the church of S. Pietro in Montorio, Rome, designed by Bramante. The only modern building included by *Palladio in *I Quattro Libri* (1570), it proved as influential an example for garden architecture as the ancient Pantheon. Widely found in the 18th c., perhaps the most outstanding examples are: at *Duncombe Park, on the famous terrace walk; at *Stowe, carefully sited on a knoll; the Temple d'Amour, *Chantilly, a remarkable example of *treillage*; and at *Pavlovsk, in the Soviet Union. P.G.

Temple, a fashionable garden building in the 18th and 19th cs. when the classical English landscape was developing; it was usually built to form a focal point, often in stone, with planting to enhance the overall scene. A fine example may be seen at *Chiswick House. There are several at *Stourhead, including the Temple of Flora and the Pantheon, beautifully sited by the lake to be reflected in the water, as one moves around the landscape. At *Stowe there are several fine examples designed by William Kent.

A 'ruined' ivy-clad temple, looking like a Gaspard Poussin painting, was constructed at Highclere, Hampshire. As in many other examples, the original inspiration was the Temple of Vesta, near Rome. Adjacent to Fort Henry at Exton Park in Leicestershire is one of the only remaining bark temples constructed entirely of wood and bark. This was the scene of summer evening parties where the fashionable élite gathered for moonlight parties and entertainment. Temples became a feature of the *jardin anglais*, and are found all over Europe in examples too numerous to mention. G.W.B.

See also FABRIQUE; PAVLOVSK; ROTUNDA; STUDLEY ROYAL; TEMPIETTO.

Temple, Sir William (1628–99), English statesman, essayist, and keen gardener. In 1663, at his house at Sheen, Surrey, he planted an orangery and cultivated wall fruit which John *Evelyn thought the 'most exquisite'. After being envoy to Brussels and The Hague for some years he withdrew again to Sheen and enlarged his garden. But once again he was called out of retirement to negotiate a treaty with the Dutch (1678) and after the successful conclusion of this he bought *Moor Park Mansion, where he constructed a garden with a canal, four large *parterres, and a bowling-green after the Dutch style to which he had become accustomed in the Netherlands.

In his *Upon the Gardens of Epicurus* (written in 1685 but not published until 1692) Temple mentions Chinese landscape design, the first reference in English literature, and outlines what he says the Chinese call *Sharawadgi, which signifies the spirit of the perfect garden (see *Chinoiserie). This was in the informal, freer style adopted by *Pope and

with new terraces enclosed by cypress hedges clipped in a spiky, punk-like fashion.

Tourist developments on the Spanish coast have fostered many gardens associated with hotels and tourist housing developments. On the Costa del Sol, Vincente Benlloch La Roda designed Los Monteros near Marbella in 1962: it consists of a hotel and villas grouped around a woodland garden. Many of these tourist schemes have been designed by overseas designers. The Chilean, Jaime Larrain, designed the Puente Romano apartment scheme west of Marbella (1979–83) around a series of gardens and courts linked by a stream which flows to the beach and the sea. The Jardines de las Golondrinas (begun 1981) follow a similar plan (designers: Vincente Benlloch La Roda with British architects Sidell Gibson; landscape architects Brian Clouston & Partners), incorporating a series of swimming-pools with islands of palm and *Strelitzia* as the focus of the gardens. R.H.

See also MAJORCA.

Span Estates grew out of a disillusionment with the standards of post-war housing in England. The architect G. Paulson Townsend withdrew from practice to apply himself to estate development together with the architect Eric Lyons and the contractor Leslie Bilsby. The objective was to '*span* the gap between the suburban monotony of the typical spec development and the architecturally designed, individually built residence that has become (for all but a few) financially unattainable'.

Over the next 20 years Span Estates completed over 50 schemes comprising over 2,000 dwellings and 70 shops on sites in the Greater London area and a few provincial towns. The objectives were to create modern well-designed dwellings economically within carefully designed landscape settings which would 'foster a sense of Village Green community', and to encourage the involvement of residents. Although occasionally designed on undeveloped sites (Ham Common), the majority were built on the sites of mature (often Victorian) gardens or at least sites with mature trees. The numbers generally were small, varying from *c*.five to 50 dwellings, with only occasionally larger numbers (Ham Common, Byfleet, New Ash Green). All are characterized by careful attention to the design, detailing, and maintenance of the gardens. These include small private spaces linked with community spaces which are maintained through the residents' associations. The last project, the village of New Ash Green in Kent, is the most ambitious, comprising several hundred dwellings, with shops, workshops, and studios, although it has suffered from the withdrawal of support by the Greater London Council.

The schemes are remarkable for the careful siting and the consistently high design quality of the buildings, for the spatial organization, and for the high quality of detailed design of the landscape surroundings. For this, much of the credit is due to the architect and landscape architect Ivor Cunningham, and to the Danish landscape architect Preben *Jakobsen, particularly in the field of planting design.

M.L.L.

Sphinx. Adaptations of the ancient sphinx, with a human head on a lion's body, feature in European sculpture and decorative art from the Middle Ages onwards, drawing on both the Egyptian type (male, couchant with striped, lappeted head-dress) and the classical (female, couchant or seated, often winged). In garden usage they make an early appearance at Bomarzo (see Villa *Orsini) in Italy (1552–63), on guard at the entrance to the Bosco Sacro, their inscription posing the riddle of the garden. The placing of a pair supporting bronze putti at the head of the steps to the Bassin de Latone at *Versailles (Lerambert and Houzeau, 1670) marks their entry into the formal repertoire of garden statuary; they are most common in gardens of the period 1720 to 1770 as a free rococo interpretation of the ancient prototypes, flanking entrances, steps, and avenues. Later examples are more closely imitative of ancient originals, though the rococo type persists into the 20th c., with the facial features sometimes embodying an actual portrait.

H.W.

See also EGYPTIANIZING GARDENS.

Spring, the medieval English word commonly used for a plantation or nursery of young trees, or for a coppice.

J.H.H.

See also VIRGULTUM.

Sri Lanka. The culture of Sri Lanka has been greatly influenced by her proximity to India and her strategic position in the Indian Ocean. Sri Lanka has always been a cosmopolitan country; she has produced great civilizations, been plagued by invasions, and settled by Indian, Malay, Arab, African, Chinese, and European peoples. Sri Lanka's attraction has also been her fertility, diversity of natural resources, varied climate, and dramatic scenery. The centre of the island is dominated by high ranges of hills and mountains from which flow the many rivers swelled by seasonal monsoons. For four months the south-west monsoon waters the verdant southern coast, while the shorter north-east monsoon relieves the dry northern plains. It was to these plains close to India that the first settlers came.

Sri Lanka was invaded in the 6th c. BC by Aryan peoples from northern India, from whom the modern Sinhalese descend. They developed an advanced and sophisticated civilization founded on irrigated agriculture. Early in the 3rd c. BC they converted to Buddhism, which gave them a unity of purpose and culture through the repeated Hindu and foreign invasions that followed. Invasions by Pandyan, Chola, and rival Tamil kingdoms continued through the first millennium of the Christian era, but despite this Anuradhapura remained for over a thousand years the central Sinhalese kingdom, until it was sacked and looted by the Cholas in AD 993. After the 6th c. AD *Polonnaruwa rose in importance, becoming first the Chola capital, and subsequent upon liberation in the late 11th c., the new Sinhalese capital.

Extensive remains of these two cities and many other temple sites remain today. The civilizations depended on settled agriculture, born out of vast irrigation tanks and

canal systems which stored the monsoon rains and watered the dry north. Many of the plains are still littered with these ancient tanks, some, such as the great Parakrama Samudra at Polonnaruwa, covering as many as 2,300 ha. and irrigating over 8,000 ha. of paddy. Upon this foundation grew a most sophisticated architectural and cultural heritage, primarily Buddhist, dominated by great dagobas, temples, and monasteries, but also with great secular palaces and pleasure-gardens. Perhaps the most magnificent palace of all was that built on the 200-m. high Sigiriya rock in the 5th c. AD, which was occupied for a mere 18 years. Later in the 12th c. the great palaces of Polonnaruwa helped contribute to the bankruptcy of the kingdom and the resurgence of the Chola empire, a Tamil kingdom in Jaffna, and barbaric invasions from Malaya and Sumatra. Tanks, temples, and public buildings returned to swamp and jungle and Sinhalese power retreated south to Kotte (near Colombo) and the more inaccessible hill kingdom of Kandy. A brief resurgence in Sinhalese power occurred under Chinese overlordship in the 15th c. before a dark era of European conquest.

European conquests began in 1505. The Europeans brought their own traditions, new agricultural crops, and a widening of trade, but for the first 350 years, and particularly under Portuguese and Dutch rule, they also brought great cruelty, exploitation, and missionary zeal. The Dutch who succeeded in 1795 were more interested in trade, and they have left important architectural legacies such as the Dutch mercantile houses on the site of the old Portuguese fort at Galle, and the canals at Negumbo (near Colombo).

Although the British finally subdued the last Sinhalese kingdom at Kandy in the early 19th c., good administration and a resurgence in the island's economy was ushered in only from the mid-century. The great British legacy, apart from administration and new communications, was the development of the plantation economy, with the opening up and deforestation of much of the island's hill country. Although nutmeg, cinnamon, areca, and pepper had been cultivated for some time, the British introduced rubber plantations to the south-western lowlands, allowed the domestic coconut industry to flourish, and cleared the hills, first for coffee, and subsequently for extensive tea plantations. With the growth of the plantation economy came the need for botanical research and the development of botanical gardens. Peradeniya Gardens near Kandy was first established in 1821 and remains one of the world's great botanical research stations. Situated on a bend in the Mahaweli-Ganga River, it covers 60 ha. and contains 10,000 trees grouped botanically, including great avenues of palmyra, cabbage, and royal palms (planted in 1885, 1905, and 1950). There are flower and spice gardens, collections of palms and bamboos, orchid houses, a fernery, and a collection of medicinal plants. Further up-country, in the hills, Hakgala Gardens were founded in the 1860s as an experimental cinchona plantation.

Another achievement of the British administration was to inaugurate the process of excavating and restoring the island's classical ruins, including many ancient irrigation tanks—a process which continues today. They were also responsible for establishing a number of wildlife reserves.

With Independence in 1947 the economic basis of the island has been broadened. Investment in plantations has declined, social welfare and education and the industrial basis of the country have been expanded, and from the early 1970s a rapid growth in tourism occurred bringing a new architectural boom and a pan-tropical leisure culture. With tourism has come the creation of the national parks, based on the old British reserves, the two most important being at Yala and Wilpattu. There has also been a growing concern for ecological conservation, especially in view of the sharp increase in population, and historic cities have received great attention, particularly under the Cultural Triangle Programme of the United Nations.

In the 1970s massive investment in new irrigation and hydroelectric schemes, particularly the Victoria dam and Mahaweli-Ganga River diversion scheme, can be expected to shape new landscapes into the 21st c. and lead to the resettlement of the dry northern plains.

Classical gardens. None of the classical gardens of Sri Lanka remain in their original state, but relics and new excavations provide clear evidence of their importance in the early cities, and the close link between Buddhist culture and the natural world. Flowers, particularly from the temple trees (frangipani), are important in Buddhist ceremonies, and stone friezes, guardstones, and moonstones with carved Buddhas and animals, particularly elephants, can be found both in buildings and on outside walls and pavements. Bathing pools, either in monastic courtyards or pleasure-gardens, reflect the keen interest and dependence on all forms of water.

Colonial up-country gardens. The British created a wide range of gardens and parks. To the visitor up-country it is quite possible to consider the ordered tea plantations as one vast garden, precipitous slopes clad with tea bushes, shaded by silk oak (*Grevillea robusta*) and dadap (*Erythrina lithosperma*), ridges planted with eucalyptus to control soil erosion, estate bungalows shaded by yellow flame (*Peltophorum pterocarpum*) and red-flowering African tulip trees (*Spathodea campanulata*), the landscape punctuated by silver tea factories and the occasional giant *Albizzia falcata* hung with beehives. In this landscape the British created, around their early 20th-c. bungalows, temperate gardens, green lawns, annual flower-beds with dahlias and cannas, edged by fruit-trees, and clumps of *Cupressus macrocarpa* (Monterey cypress). The central town in this landscape is Nuwara Eliya at a height of 2,000 m., a miniature English country town with a racecourse, a baronial club, 'Tudor' hotels, and a well-tended golf-course. Eight km. from the town commanding long views over the Welimada valley lies that most English of subtropical gardens at Hakgalla. Founded by J. K. Nock in 1861 as an experimental cinchona plantation, the gardens at a height of 1,700 m. cover 23 ha. with a temperature range from 38 to 82 °F and a rainfall of *c.* 140 cm. They contain fine tree clumps of mature *Cupressus*

macrocarpa, Michelia species, groups of cryptomeria and specimen trees such as podocarpus, agathis, *Quercus serrata*, and box. Flower gardens, sweeping hillside lawns, and a wild garden of giant tree-ferns (*Cyathea*) complete the scene. Today Hakgalla survives but many of the estate managers' gardens are in decline, a result of lower salaries and the need to grow vegetables to supplement incomes.

Town parks. The British left a legacy of town parks and shaded streets. The most important was Victoria (now Viharamahadevi) Park in Colombo, developed on the site of a large cinnamon plantation. The park is one of the few open spaces in Colombo, and although not well maintained it contains fine clumps of trees, lotus ponds, an open-air theatre, and a children's garden. At the centre of the town by the fort is Galle Face Green and by it the fine old colonial hotel, the Galle Face with its verandahed garden fronting the sea. In the fort area, in the grounds of the President's house, are the lush Gordon Gardens laid out in 1899, once a public park and maybe so again with the transfer of government to Kotte.

In Kandy there is the small Castle Hill garden commanding fine views through pink tabebuia trees across the Kandy lake to the Temple of the Tooth. In Nuwara Eliya there is the small Victoria Park, and along the sea front at Galle the old Portuguese ramparts to the fort provide a wide undulating expanse of lawn that rings the old Dutch buildings.

Twentieth-century gardens. Special mention should be made of the tiny island garden at Tabrobane, 50 m. offshore at Weligama. This was developed between 1911 and 1939 as a private paradise for the Count de Mauny-Talvande. It offers an eclectic mixture of Dutch and Italian detail in an octagonal plan which extends out into a profusion of bougainvillaea and a rich display of tropical flowering trees and shrubs.

Tourism has encouraged the building of many new hotels, few of which display any understanding of local architectural traditions. Their gardens often occupy the remnants of coastal coconut plantations, and are pleasant but unremarkable. One exception is to be found at the Sigiriya Village Hotel, close by the rocktop palace, which is skilfully planted as a sequence of delightful courtyards by the landscape designer Bevis Bawa. Also significant are the garden courts of several hotels by his architect brother Geoffrey, including the Bentota Beach and the Serendib at Bentota and the Triton at Ahungalla. But the finest modern gardens on the island are those that they created for themselves north of Galle. N.T.

See also ANURADHAPURA GARDENS; SIGIRIYA GARDENS.

Srinagar, Kashmir. See AKBAR; CHAHAR CHENAR ISLAND; CHASMA SHAHI; NASIM BAGH; NISHAT BAGH; SHALAMAR BAGH.

Stair, John Dalrymple, Earl of (1673–1747), was one of a group of improving landowners, active in Scotland in the

The architect's own garden at Lununganga, Sri Lanka, by Geoffrey Bawa

18th c., who shared an interest in increasing the productivity of their estates. This involved very extensive plantations of woods, and very often the making of gardens as well. All were, more or less, politically active and aware of developments in architecture, music, and literature as well as the improvement of their estates. The Duke of Atholl, the Earls of Haddington and Hopetoun, Lord Cathcart, Sir John *Clerk of Penicuik and many more were of this group, but Stair is typical.

Stair furthered the career of William *Adam and employed him at *Newliston and on his Galloway estates certainly as architect and possibly as garden designer. Stair also employed William Boutcher who made a plan for the grounds at *Castle Kennedy in 1722. Stair oversaw the work himself, not unusually for an improving landlord, and was probably responsible for the considerable changes made to the original design. He also employed his dragoons in making the banks and other works somewhat in the style of fortifications. W.A.B.

Standish, John (1814–75), English nurseryman, was born in Yorkshire but came south with his father, who was a gardener at *Bowood. About 1840 he started a nursery at Bagshot, where **Charles Noble** (d. 1898) became his partner in 1848. Some of Robert *Fortune's new plants,

including *Cryptomeria japonica*, were offered for sale at the nursery in that year, and many more of Fortune's plants were later made available, with *Mahonia japonica* recommended as 'hardy as the holly'.

In 1852 Standish and Noble's *Practical Hints on Ornamental Plants and Planting* gave advice on the new Sikkim rhododendrons, sent home by J. D. *Hooker. Five years later the partnership was dissolved. Standish went on to develop some outstanding hybrid rhododendrons in his new nursery at Ascot, while Noble established the Sunningdale Nursery at Windlesham, where Harry White (1857–1938) later grew and hybridized many of the new rhododendrons from the Himalayas and western China. In more recent years the nursery has been associated with the revival of interest in old shrub roses. S.R.

Stanstead House, Sussex, England, the seat of Richard Lumley, 1st Earl of Scarborough, is said to have been built by William Talman from 1686, in which case George *London would probably have laid out the garden. Stephen *Switzer listed Stanstead in *Ichnographia Rustica* (1718). The *Kip view shows the greenhouse and stables flanking a plain forecourt and a large parterre, walled from the encircling park, at the rear. There was also, in its own enclosure in the park, a curious orangery garden around a fountain pool with similarities to that at *Chiswick House in the 1720s. Horace *Walpole gave a footnote to his remark in his essay *On Modern Gardening* that 'a great avenue cut through woods . . . has a noble air, and . . . announces the habitation of some man of distinction': 'Of this kind one of the most noble is that of Stanstead . . . traversing an ancient wood for two miles and bounded by the sea. The very extensive lawns at that seat, richly inclosed by venerable beech-woods, and chequered by single beeches of vast size, particularly when you . . . survey the landscape that wastes itself in rivers of broken sea, recall exact pictures of Claud Lorrain.' D.L.J.

Statuary was an important feature in ancient *Greece and in the gardens of ancient *Rome, especially in association with tombs or sacred groves. The tradition was not fully revived until the creation of the *Belvedere Court (1505) which contained an area specially designed for a collection of statues. Thereafter statuary was a dominant feature in Italian gardens, at first located in a *fountain as the focal point of the gardens (as at the Villa *Medici, Castello and at the Palazzo *Doria Principe). In the Mannerist period it played an important part in establishing the iconographical programme, most notably at the Villa *d'Este, Tivoli, where the statues were taken from the nearby *Hadrian's Villa. Most of this collection was dispersed during the 18th c., but at the Villa *Orsini, Bomarzo, the series of fantastic giants and monsters still exists. Unlike the original arrangement of statues at the Villa d'Este they do not stand in any immediately intelligible spatial relationship to one another.

Statuary was equally important in the great gardens of 17th-c. France. Louis XIV removed the statues of *Vaux-le-Vicomte to *Versailles where the leading sculptors of the day were employed in creating a large number of statues to illustrate various themes (such as the seasons), often placed to great dramatic effect (as in the Bassin d'Apollon). In the first half of the 18th c. in England, sculpture was also important, for example at *Stowe (see also *van Nost), but *Brown and his successors had little use for it. In the *jardin anglais*, following the example of The *Leasowes, sculpture was associated with sentimental inscriptions (see, for example, *Ermenonville). P.G.

See also LEADWORK; SCULPTURE GARDEN.

Staunton, Sir George Leonard (1737–1801), Irish diplomat and plant-collector, studied medicine in Montpellier. He lived for some years in the West Indies where he met Lord **Macartney** (1737–1806), another Irishman, who took him on an embassy to China in 1792–4. Staunton, who later wrote the official account of the mission, was particularly interested in botany and presumably supervised the two 'botanic gardeners' included in the party, David Stronach and John Haxton. Botanical advice came from Sir Joseph *Banks, who wanted, among other treasures, more specimens of the tree peony, which had arrived in England twice before, only to be killed by winter weather. Tea plants were also in demand for an attempt at growing them in Bengal. On the journey within China the party visited several gardens, including the famous royal one at Jehol. They are described in Macartney's journal and other accounts of the expedition, Macartney concluding that 'there is certainly a great analogy between our gardening and the Chinese; but our excellence seems to be rather in improving nature, theirs to conquer her and yet produce the same effect.' Lists of plants seen or collected were made, over 200 specimens being brought home. New plants successfully introduced to Europe included the climbing, evergreen Macartney rose, *Rosa bracteata*, and the herbaceous perennial, *Macleaya cordata*. S.R.

Steele, Fletcher (1885–1971), American landscape architect. After attending the Harvard School of Landscape Architecture from 1907 to 1909 he travelled extensively in Europe. Later he was influenced by Le Corbusier and the Modern Movement in architecture, and more specifically by the work of the contemporary French garden designers *Vera, Legrain, and Guevrékian, particularly in their use of the broken axis, manipulation of levels, and use of mirrors and perspective. Their influence may be seen in his own work, notably in his redesign of a neo-classical garden at *Naumkeag, Stockbridge, Massachusetts, on which he worked from 1925 to the late 1930s. In the Blue Steps (of concrete painted light blue) rising in sweeps over small cascades through a birch wood, which he created, selecting trees of various sizes, he has successfully re-interpreted Renaissance forms in terms of the modern concern for values of space, form, texture, and colour. Such concerns are expressed in his writing including *New Pioneering in Garden Design* (1930), *Landscape Design of the Future* (1932), and *Modern Garden Design* (1936). M.L.L.

Stirling Castle, Scotland, King's Knot. See KING'S KNOT.

Stone trough. It was during the 1920s that the idea of growing alpine plants in old stone sinks and troughs really took off, largely due to that great English plantsman and garden innovator, Clarence Elliott. He wrote widely on the subject, encouraged the art from his nursery, and for many years before the Second World War showed these miniature rock-gardens at the Chelsea Flower Show. Nowadays they have become almost a necessity to any keen alpine plantsman, for in the tiny area of a trough refinements of soil and situation can be devised to suit the easiest or the most wayward plants. J.EL.

Stourhead, Wiltshire, England, now owned by the National Trust, is a Palladian house built by Henry *Hoare I, the banker, between 1718 and 1724; the grounds were laid out by Henry Hoare II, including a chain of lakes and a circuit walk with a grotto and temples designed by Henry Flitcroft. William *Gilpin wrote in 1775: 'The improved grounds consist of three parallel vallies; all of them closed at one end by an immense terrace, running several miles in length . . . But although Mr. Hoare has taken all three . . . within his improvements, he has *adorned* that only which lies nearest his house.'

The design evolved over 30 years, beginning with a grass terrace walk at the edge of the plateau west of the house, terminating in an obelisk. The River Stour, rising in a valley to the north-west (Six Wells Bottom), formed a series of ponds. Some were combined to form a large lake (*c.*1754), which is the foreground to a prospect seen from high ground on the east. The buildings were made in sequence round the lake. The Temple of Flora (1745) originally overlooked a rectangular basin with an architectural cascade. The grotto (1748) has a circular domed chamber, with a recess in which springs from the hillside are channelled to form a cascade under a Sleeping Nymph. They also issue from an urn in the River God's cave, where

Cheere's fine statue, recalling *Tiber* in Salvator Rosa's picture of the *Dream of Aeneas*, points the way. Inscriptions on the original entrance to the grotto and on the Temple of Flora refer to the *Aeneid*. The Watch Cottage was given pictorial significance by Sir Richard Colt Hoare, who added the Gothic porch and seat (1806). The Pantheon (1754), a domed rotunda screened by a recessed portico, dominates the scene, a symbol of the classical ideal, housing Michael Rysbrack's *Hercules* (commissioned in 1747) and other statues. Across the water, the five-arched bridge (1762) with Stourton church and village form what Hoare called 'a charming Gaspard picture'. East of the dam (1754) the path crosses the public road by a rock bridge (before 1765) and climbs to the Temple of Apollo (1765), looking down on what Horace Walpole described as 'one of the most picturesque scenes in the world'. The path returns through a grotto at the Bristol Cross (1373, erected at Stourhead 1765).

The hanging woods with many fine beeches are a notable feature of the lakeside, which has been enriched by ornamental trees, particularly conifers planted in the 19th and 20th cs. Sir Henry Hugh Arthur Hoare increased the variety of shrubs. From 1923 he replaced *Rhododendron ponticum*, first introduced in 1791, with other species and hybrids, whose flowering in late spring is now an additional attraction. There are three other 18th-c. monuments on the estate: in Six Wells Bottom, St Peter's Pump (from Bristol, erected at Stourhead 1768); the Convent in the woods; and Alfred's Tower (1772), 48 m. high, on the edge of the escarpment overlooking the Somerset plain. K.A.S.W.

See also ANHALT-DESSAU.

Stowe, Buckinghamshire, England, was owned by the Temple family from 1593 and transformed into one of the world's outstanding landscape gardens by four successive owners: Sir Richard Temple (1634–97); Viscount

Stourhead, Wiltshire, drawing (1790) by S. H. Grimm (British Library)

Stowe, Buckinghamshire, the
Temple of Ancient Virtue and
the Elysian Fields

*Cobham (1675–1749); Richard Grenville, Earl Temple (1711–79); and George Grenville, 1st Marquis of Buckingham (1753–1813). Much visited and publicized, it had enormous influence on garden design, especially after experiments there in 'natural' gardening in the 1730s. It is historically important because it remained at the growing point of taste throughout the 18th c., exhibiting every stage of the garden revolution. Its final phase of idealized landscape still survives relatively intact.

In c.1680 Sir Richard demolished his existing house and built a new one higher up the hill, changing the axis. To the south he laid out a garden of three formal compartments, one below another in terraces. But, reluctant to lose his old garden, he incorporated it (at a slant) in the lowest level, keeping also an old walled garden to its west. Thus, even in its first phase, the Stowe layout, though otherwise typical, was asymmetrical and had an oblique cross-axis.

Cobham made only minor alterations until he engaged *Bridgeman, with *Vanbrugh as architect, to create a princely garden (1715–26). An open court with a canal was laid out on the north side; on the south, the three compartments were thrown into a single great *parterre, below which an avenue led down to a large octagonal pond. No expansion eastwards was possible, as the approach road ran close up that side, but Bridgeman, inspired perhaps by Vanbrugh, skilfully exploited the awkwardness of the site, adopting as key features the irregularities forced on the unknown Caroline designer. His layout, covering c.11 ha., remained geometrical but was developed asymmetrically to the west; it was bounded by a *ha-ha, one of the earliest, beyond which lay farmland. To decorate the garden, Van-

brugh provided temples and other architectural furniture, the first of those which *Walpole later described as 'that Albano glut of buildings'—Cobham, it seems, enjoyed visibly illustrating his family motto, *Templa quam dilecta*.

After Vanbrugh's death the gardens were further extended by Bridgeman to the west and doubled in size (1727–32). He now introduced semi-natural features within the geometric design, leaving Home Park unimproved as rough pasture but surrounding it with straight walks, and constructing the 4·5-ha. lake with straight sides but no formal shape. This stage of the gardens was described by Gilbert West in his poem *Stowe* (1732), and recorded by Rigaud (1733) in drawings which were later engraved.

By building a new approach road right round the western extension, it became possible to close the old road and take in 16 ha. on the eastern side. But fashion was changing, and the first part to be completed, the little valley known as the Elysian Fields, was laid out 'after Mr. Kent's notion' (c.1735). All straight lines were avoided and a sequence of 'natural' pictures was created. As the buildings were by William *Kent, the garden design was probably his too, though there is no certain evidence. He seems not to have been concerned in the further part of the eastern area, Hawkwell Field, which was developed in the early 1740s and where the buildings (all by James *Gibbs) stood free among the grazing animals. The guiding hand was probably that of Cobham himself, aided later by 'Capability' *Brown, head gardener from 1741; and these two were almost certainly responsible for Cobham's last gardening enterprise, the Grecian Valley, a further development of Kent's

ideas which came close to idealized landscape. The influence of the new 'natural' gardens was immense, and was increased by the guidebooks which Seeley and others produced from 1744 for almost a century.

The areas first laid out now looked old-fashioned, and though the parterre had already been replaced by lawn in the 1740s, the freeing of the garden from Bridgeman's apparent stiffness fell to Earl Temple, who was effectively his own garden designer after Brown's departure in 1751. His changes were not dictated merely by taste, but were a response to developing problems; for, as the trees matured, Cobham's narrow avenues and miniature temples looked out of scale and absurd. So, after a tentative start, Temple cut down avenues, thinned plantations, and threw the gardens wide open; ponds were grassed over or made into informal lakes; buildings were remodelled, moved, or replaced, to harmonize with the new scale and feeling of the gardens. The climax of his improvements was to build a triumphal arch (although this is sometimes attributed to Thomas *Pitt) on the horizon (1765) as a focus for the main vista, completing the return view nine years later by rebuilding the house in neo-classical style as a backdrop to the idealized landscape.

The main lines were established before Temple's death (1779), but his work was finished by the 1st Marquis with sympathy and extravagance. In the 19th c. the family's money luckily ran out before its taste. Bankruptcy was followed by a sale in 1848 and two generations of retrenchment, until the property was finally sold and Stowe became a school (1923). An attempt is now being made to restore the 32 surviving garden buildings and their landscape setting, so far as is possible, to their state in 1800. G.B.C.

Strawberry Hill, Twickenham, London. See WALPOLE, HORACE.

Strawberry Hill Farm, Western Australia, is on the site of the first farm (1827) to be established on the western side of the Australian continent. In 1833 the third Government Resident, Sir Richard Spencer, established the present garden. He named the property after *Walpole's famous garden at Twickenham.

The original layout was largely utilitarian, as befitted a working farm; but elegance was achieved by old-fashioned English flowers planted around the house—great bushes of lavender, marguerite daisies, Michaelmas daisies, and Shasta daisies, hedges of hawthorn, privet, and broom; and the gorse which Sir Richard had first planted as hedges to restrain his stock now spreads over the hillsides.

Anticipation and surprise has been achieved by dipping the 400-m. long drive down through a shady hollow with a stream passing under a culvert, so that the house is concealed until the closer view is obtained. Bordering the drive is informal mingling of tall Norfolk Island pines (*Araucaria heterophylla*) with indigenous peppermint trees (*Agonis flexuosa*), purple prunus, cypress, Lombardy poplars, figs, and the sweet-secreted pittosporum, while downstream there is a copse of

silver poplars. Blackberries and blue periwinkle are used as ground cover. Pink *Amaryllis belladonna* spring up each year, as does the blue lily of the Nile (now called agapanthus).

After the deaths of Sir Richard and Lady Spencer, the property gradually deteriorated, until in 1888 it was saved from ruin by Francis Bird, an architect, who with his family sympathetically restored the house and grounds. In 1963 it was vested in the National Trust of Australia (Western Australia) who have adapted the 4 ha. of grounds for public use. R.O./J.O.

Strelna, Soviet Union, was a residence of Peter the Great, 22 km. west of Leningrad. Like *Peterhof (Petrodvorets) and *Oranienbaum (Lomonosov) it stood on a natural terrace (12 m. high) overlooking the Gulf of Finland, from which it was separated by the Lower Park (45 ha.). During the years 1716–18, C. Rastrelli (father of Bartolomeo *Rastrelli and primarily a sculptor), *Le Blond, S. Cipriani, and Niccolo Michetti each in turn prepared plans for Peter. Nothing came of the plans of Rastrelli and Cipriani. Le Blond's plan is the most impressive. A central canal and two side canals run from the foot of the terrace to the sea. They are transversed by a fourth canal dividing the park into rectangles treated with great diversity. Only the main lines of Le Blond's plan—the canals and the splendid lime avenues—seem to have been realized, for Michetti was working here in the 1720s (Le Blond died in 1719) and he probably devised the final details of the park. A Polish visitor in 1720 wrote: 'After dinner we went to the Versailles garden, which is quite large and extends to the sea-shore. There are a number of canals flowing into the sea, a covered walk planted with limes, labyrinths, many fountains and many beautiful features. By the shore a grove, surrounded by canals, is reserved for wild animals.'

The palace and the park, grown less formal than in the 18th c., suffered greatly during the Second World War, but some restoration has taken place. P.H.

Stroll garden, a type of Japanese garden in which, as the visitor strolls round, different aspects of the garden are gradually revealed. P.G.

See KATSURA IMPERIAL VILLA; RIKUGIEN PARK; RITSURIN.

Studley Royal and **Fountains Abbey,** North Yorkshire, England. The gardens were the creation of John Aislabie, Chancellor of the Exchequer (1714–18), who, ruined by the collapse of the South Sea Bubble (1720), retired to his estate in 1722 and until his death in 1742 worked to make the finest formal water-garden in the country. The waters of the River Skell in its narrow, wooded valley were captured to make a large lake, grotto springs, a long formal canal, and the moon pools—one round and two crescent-shaped. By the side of the moon ponds is the Temple of Piety (*c.*1728), before the canal debouches over a formal cascade between two Fishing Pavilions into a large pool. There are no records to show who designed the Temple of Piety but what

Studley Royal, Yorkshire,
England, view of the Moon
Ponds

evidence there is would seem to indicate that John Aislabie was his own architect and that Richard Doe, a Westminster mason, was the builder. Research into the original temple design points to an engraving of the Temple of Jupiter by Antonio Labacos of two centuries before.

The well-wooded, steep hillside above the water has a vista walk approached by a long, twisting grotto tunnel. On the walk are an octagonal Gothic temple (c. 1740–50) and a rotunda, apparently stone built but actually of wood. The walk leads to a surprise view on the summit of Tent Hill where the eye is led along the canalized and cascaded River Skell to what is probably the noblest monastic ruin in Christendom, Fountains Abbey, which did not come into the possession of John's son William until 1768, 50 years after his father had made it the romantic culmination of his garden vista.

On the opposite bank to the Temple of Piety, on a plateau above high beech and yew, is Colen Campbell's Banqueting House (1727–30) from which are long views of most of the garden features. Deer roam the park and the approach to it from Studley Roger, a small hamlet, is by a long avenue of trees aligned on the towers of Ripon Cathedral some 3 km. away. The house, which has no part in the alignment of the layout, was burned down in 1946, but on the same level is the magnificent stable-block of 1728 by Campbell. K.LE.

Sturefors, Ostergötland, Sweden, one of the best preserved Swedish 18th-c. manor-houses and gardens, was built in 1704 by Nicodemus *Tessin the younger on a cape in a big lake. A formal garden in close connection with the house was laid out by Tessin in the French manner with *parterre de broderie* (now grass), a long central axis, arbours, and a maze. Avenues of lime frame this part. A cross-axis at right angles leads to the kitchen garden and an orangery. Later in the century an elongated pond and a classical temple on the top of a hill were added at the end of the central axis. An English landscape garden was laid out about the same time which in character has much of the *jardin anglo-chinois* style in a small-scale Continental version. A flower meadow with a Chinese pavilion, and an imitation of the *Ermenonville poplar island are charming features.

G.A.

Stuttgart, German Federal Republic. See KILLESBERG.

Suan Pakkad, Bangkok, Thailand. The garden at Suan Pakkad Palace was started in 1952 by Prince and Princess *Chumbhot with the re-erection of some old Thai buildings to make a suite of reception rooms and to house their large collection of art and artefacts dating from the second millennium BC to the 19th c. AD.

The main pavilion is built on a substructure of cylindrical concrete columns in place of the original teak, and on the garden side they rise straight out of a curved pool, with water-lilies, thalias, cannas, spathiphyllums, and weeping willows, which seems to become part of the teak-floored banqueting room which appears to float upon it. Across a wide lawn and backing on to the quiet *klong* (navigable waterway) which bounds the garden is the famous Siamese Lacquer Pavilion, on massive teak columns, which once stood on the riverside at Bang Kling near Ayudhya.

Another pool, seen through the framework of branches of a large and sculptural frangipani (*Plumeria rubra* var. *acutifolia*), separates the area of the garden open to the public

from the private residence. Suan Pakkad has many rare and unusual plants including a *Phyllocladus*, a fine specimen of white *Erythrina indica* from Hawaii, and a striking group of royal palms (*Roystonea regia*).

There are many influences at Suan Pakkad and the stones set as sculpture among informal planting have an echo of Japan, but with the water treatment and the informality of the *klong* it is essentially Siamese at a highly sensitive level. M.L.

Suan Sampran, The Rose Garden, Nakorn Pathom, Thailand, is far more than a rose garden remarkable though the growing of roses is in this part of the world; it is more in fact a public pleasure-garden comparable with many in other countries. It has something of the Copenhagen *Tivoli about it though quieter and more restful, but contains 'something for all the family'. As it is only *c.*40 km. from Bangkok families of all nations flock to it at the weekend.

Suan Sampran was created by Khunying Walee Yuvabul, wife of a former Mayor of Bangkok and Khunying Urai Leuamrung, on a tract of land surrounded by a belt of casuarinas, and bordered by a quiet unpolluted river in the late 1960s. It offers a fine lake for water sports, a quieter lake with skilfully sited weekend 'chalets', and a wide range of amenities, as well as a nursery garden which specializes in roses and other more tropical plants for sale. Floating restaurants with canopies are moored along the river bank, among willows and callistemon.

Both hard surfaces and ground cover are well detailed with stone flags set within broad-leafed Malaysia grass (*Axonopus compressus*) and areas of *Sansevieria hahnii* among gnarled tree roots. Casuarina hedges are cut in sculptural shapes and shady walks connect the varied compartments. M.L.

Subtropical bedding, the use of plants with large, variegated, brightly-coloured or otherwise ornamental leaves, planted in informal groups in which the picturesque effect of the individual plants was more important than the pattern of the bed. Among the favoured plants were *Begonia rex*, dieffenbachias, crotons, philodendrons, and musas, as well as pampas grasses and eventually bamboos. The use of such plants for outdoor bedding was pioneered by *Barillet-Deschamps in the Paris parks, especially the *Parc Monceau, in the 1860s, and spread to England through the work of John Gibson at Battersea Park at the end of the decade; its popularity lasted until the late 1880s. B.E.

Sudan. Completely new parks and gardens are a rarity in *Africa; especially so in such relatively undeveloped countries as the Sudan. The new World Trade Centre in Khartoum was designed to incorporate representative plants from all the different regions of the Sudan as the basis of a new national garden. Designed by James Sutton, it comprises a series of garden compartments irrigated by a canal from the Blue Nile. It is an outstanding achievement

as one of the few major modern gardens to have been created in Africa in the 20th c. M.L.L.

See also MIDDLE EAST.

Sui Yuan, Jiangsu province, China, was a garden located at the foot of a range of hills in the city of *Nanjing (formerly Nanking) and originally owned by Sui He De, a high official in charge of the imperial fabric industry at the time of the Qing Emperor Kangxi. The fame of this garden dates from the 18th c. when it was bought and renovated by a well-known poet and playwright, Yuan Mei (1716–98). Although it was destroyed during the Taiping rebellion (1851–64), contemporary paintings and descriptions emphasize its close relationship to the site, laid out around a small lake in a natural valley and so well protected by hills and steep cliffs that it had no need of walls, only a gateway. Literally translated, *Sui Yuan* means the 'to go along with garden': while views were 'borrowed' (see *jie jing) from the scenery round about, its various buildings and trees were placed to look as if they had appeared spontaneously among the contours of the hills. Undulating *lang* made it possible to walk to most of the different set-pieces even in wet weather, and causeways connected by bridges made such good use of reflections that the whole atmosphere was said to resemble gardens by the famous West Lake of *Hangzhou. Although a number of fine single stones were set up as sculptural pieces in the paved courtyards, Sui Yuan, unlike almost all other Chinese gardens, had no great rockery: with an abundance of natural rocks all around, it had no need of one. C.-Z.C./M.K.

See also JIA SHAN.

Summer Garden, Leningrad, Soviet Union, Peter the Great's first garden in St Petersburg, was begun in 1703, and is still Leningrad's most important open space. The present area is 11 ha., but it was once much larger and included what are now the Field of Mars, the Mikhailovsky Garden, and the Engineers' Castle. Among those who worked there were the architects Ivan Matveyev, Mikhail Zemtsov, *Le Blond, and *Rastrelli, and the master-gardeners Jan Roosen and Ilya Surmin. Peter himself was also directly involved in the planning of the garden.

The early layout reflected the Dutch gardens, which Peter had visited and admired, and the great French gardens, which, at that time, he knew only from books and engravings. Lines of trees were rigorously clipped into smooth green walls or into green tunnels, and single trees were shaped into balls, cubes, and pyramids. There were pavilions, a grotto, and many fountains, fed by the River Fontanka, hence its name. In the 1720s Zemtsov laid out a labyrinth with fountains which incorporated gilded statues illustrating *Æsop's Fables*, a theme which Peter later introduced to the park at *Peterhof (Petrodvorets). Peter arranged for trees to be brought from different parts of Russia as well as from western Europe, and for statues to be purchased in Italy. In 1736 there were more than 200 statues, and, though the number is now down to *c.*90, it is

still an important collection. Among later features, particular mention should be made of the splendid wrought ironwork of Yu. M. Velten's railings (1770–84).　　P.H.

'Summer Gardens', Romania. In the excessively hot summers, Romanian townsfolk took refuge in public gardens, where they could find buffets, refreshment of all sorts, and music. Besides the more celebrated parks surrounding Bucharest or even in its very centre, there also mushroomed in the provinces very modest bowers where iced drinks and rustic suppers were served. These were—and still are—a characteristic feature of any Romanian community large or small.　　M.G.

Summer Palace, Peking (Beijing), China. See YI HE YUAN.

Sutherland, John (1745?–1826), Irish landscape gardener. 'To the Noblemen and Gentlemen of Ireland. As I have had the honour of being employed by the most respectable part of the Nobility and Gentry of this Kingdom, and now from the decline of old age, I find that I cannot fulfil any more of my engagements, I recommend Mr. Arthur Snow as a fit and proper person. We have been concerned together upwards of thirty years in making approaches, Ornamental planting and all other improvements.' So John Sutherland announced his retirement from practice two months before his death in Dublin. Since the 1780s he had been the most celebrated of the landscape gardeners in Ireland who followed the style of 'Capability' *Brown. His first known commission is the design of the house and park at Derrymore, Co. Armagh, for Isaac Corry, Lord Chancellor of Ireland. Soon he was working at Slane Castle, Co. Meath, at the same time that 'Capability' Brown was submitting designs for the enlargement of the house and for the stables. Sutherland proceeded to create the landscape settings for no fewer than five of John Nash's country houses in Ireland: Rockingham, Co. Roscommon, *Caledon, Co. Tyrone, Lough Cutra Castle, Co. Galway, Shane's Castle, Co. Antrim (where his portrait by Martin Cregan still hangs), and Gracefield Lodge, Co. Laois. Of his work at this last, J. N. Brewer wrote in 1825: 'Mr Sutherland has here displayed great judgement . . . in altering and embellishing the grounds without injuriously divesting them of timber.'

Sutherland appears to have avoided the criticism levelled at Brown for his widespread felling of trees during the redesign of old parks. He rejuvenated the park at Ballyfin House. In 1801 he designed the garden of Mountjoy Square in Dublin. Like Brown, he executed a number of architectural commissions. At Caledon and at Oakport, Co. Roscommon, he designed greenhouses; at New Castle Castle, Co. Longford, a park bridge; at Rockingham, a series of castellated follies and lodges; at Donard, Co. Wicklow, a stable block; and at Oakport, the house itself and all its offices.

Towards the end of his life, Sutherland, like Brown, was subjected to the criticism of a rising generation of landscape gardeners, one of whom, Edmund Murphy, wrote of his park at Ely Lodge, Co. Fermanagh: 'there are many plantations designed about twenty years ago by Mr. Sutherland.

These afforded until recently a perfect example of the serpentine outlines so much admired by him but which harmonised indifferently with the bold projections and deep and irregular lines of the natural woods'.

Sutherland's last commission was for an approach to Mount Shannon, Co. Clare, for another Lord Chancellor of Ireland, the 1st Earl of Clare.　　P.B.

Sutton Place, Surrey, England, is a large symmetrical courtyard house, built on the manor granted to Sir Richard Weston by Henry VIII in 1521. The great gatehouse was demolished in the 18th c. but the walled kitchen gardens and remnants of an avenue remained until the beginning of the present century, when the long grass terrace with its clipped yews and other features was made. In 1980 the estate was acquired by Stanley J. Seeger. He appointed Sir Hugh Casson as architectural consultant for the house and Sir Geoffrey *Jellicoe as landscape consultant for the gardens.

In his design Jellicoe set out to juxtapose irrational elements 'representing the mysterious aspects of the mind and subconscious within the classical values which have evolved through history'. The allegory of creation, life, and aspiration is symbolized by a Moss Garden, a Paradise Garden, a Music Garden, and a Surrealist Garden, and a formal space containing a large relief sculpture in white marble by Ben Nicholson, all surrounded by an 'Arcadian' landscape with lake, river, woodlands, and farmlands. The allegory will be complete when the elaborately designed water gardens are executed, and the imagery will be complete with the projected Henry Moore sculpture overlooking the lake. (*See over*).

An unusual and remarkable aspect of the scheme is the management proposals drawn up by Marian Thompson after detailed ecological studies. They strike a balance between public access and conservation, and have produced spectacular meadows of wild flowers adjoining the formal gardens.　　M.L.L.

Suzhou, China, is an ancient city of white-washed houses, willow avenues, themples, and bridges. This 'Venice of the East' lies on a network of canals west of Shanghai and some 19 km. from Lake Tai, in the south of Jiangsu province. A garden belonging to Ku Pichiang was recorded in the area in the 4th c. but the town itself was built up by He Lu as his capital in the 6th c. During the Five Dynasties period (907–960) the Wu and Yue kingdoms around it suffered little from the fighting and became the richest provinces in China. From 852 to 932 the ruler of the area, Qian Liu, put his son in charge of Suzhou where he led the local gentry in building gardens—including his general, Sun, who made a villa on the site where the *Cang Lang Ting now stands.

During the Yuan period (1279–1368), a number of officials, who refused to serve under a foreign dynasty, retired to the city and, in the Ming and Qing, still more built gardens in their retirement. Surrounded by rich agricultural lands 'of fish and rice' and a prosperous silk industry, Suzhou became not only wealthy but a great centre of art

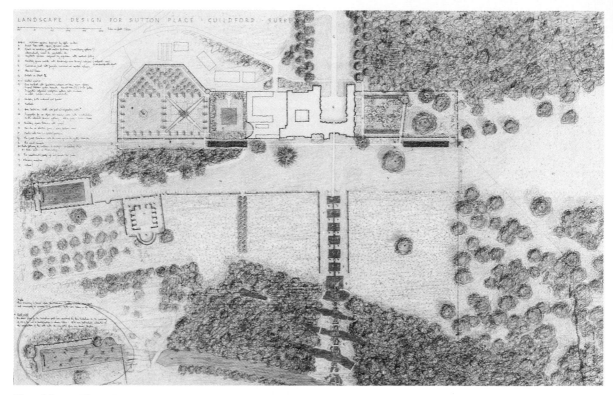

Plan of Sutton Place, Guildford, Surrey, by Geoffrey and Susan Jellicoe

and scholarship—and the city from whence came more successful candidates in the imperial examinations than any other in China. After achieving political appointments and amassing (usually) large fortunes, many of these men retired to Suzhou to build gardens. Ideally situated with plentiful water, pleasant hills beyond the town, a genial climate, the finest garden stones (*Taihu rock) nearby and excellent communications by canal for importing others, Suzhou also offered them a pool of skilled garden craftsmen. Though many villas were damaged during the Taiping rebellion (1851–64) some hundred were recorded in the 1950s, and nine of the largest have been restored and opened to the public: *Cang Lang Ting; *Zhuo Zheng Yuan; *Wang Shi Yuan; *Liu Yuan and Xi Yuan Si; *Yi Yuan; *Ou Yuan; *Shi Zi Lin and *Huan Xiu Villa.

An old and much quoted saying goes 'Above is Heaven, below are *Hangzhou and Suzhou.' M.K.

Sweden. In 1143 the first Swedish monastery, Alvastra, was founded by French monks closely following the European models with their herbal and medicinal plantings in square beds. These were followed by the deer and pleasure parks of the Middle Ages. A flower meadow at Glimmingehus still survives from this period. The order of St Birgitta built its parent abbey in Vadstena, where the general outlines of convent gardens can still be observed and some flowers, such as *Leucojum vernum*, have survived to this day.

Renaissance gardens. The Renaissance kings of the Wasa dynasty had a passion for buildings and gardens. Foreign architects and gardeners were commissioned, and one of them, the Italian Franciscus Pahr, made a drawing (c. 1572) for a small parterre, Renaissance in outline, for a courtyard in Uppsala Castle. This is the oldest known Swedish garden plan. Two gardeners, the Frenchman Jean Allard and the German Hans Friese, above others, developed gardening. Friese, commissioned by Gustavus I (from 1545, still active in 1579), laid out several pleasure-gardens, among them the Royal Garden (Kungsträdgården) in Stockholm, then used mostly for growing vegetables. Allard, employed by Eric XIV in 1563, was ordered to modernize the Royal Garden; he introduced a more architectural layout, making it rectangular instead of square and creating a genuine pleasure-garden. He also built an orangery there, the first in Sweden. Extensive works were constructed in the gardens of the Wasa kings: garden houses, aviaries, and mazes. Horticulture was improved by acquiring seeds, plants, and fruit-trees, often imported by the nobility.

From the early 17th c. there are pleasure-gardens of a more elaborate kind, with arbours, canals, ponds, groves, and parterres of interlaced patterns. The *Hortus Palatinus garden at Heidelberg, which had impressed Gustavus II Adolphus (1611–32), may have had some influence. As a rule, though, the gardens seem to have been very simple in an older tradition, and with no relationship to buildings.

On becoming a great power after the Thirty Years War (1618–48), Sweden wished to celebrate this new position, and many palaces and gardens were built on a grand scale. The art-loving Queen Christina summoned architects and gardeners, the foremost being Simon de la Vallée (in Sweden 1637–42) and André *Mollet (in Sweden 1648–53). The two had co-operated in the Netherlands on royal palaces and gardens, and La Vallée began to introduce Mollet's gardening ideas in Sweden. Mollet's first commission was to modernize the Royal Garden, Stockholm, where he laid out a big *parterre de broderie, imported plants, and built orangeries. His most notable achievement was the publication in Stockholm of Le Jardin de plaisir (1651). He played an important part by introducing the modern French garden style into Sweden. The architects Nicodemus *Tessin the elder and Jean de *la Vallée, son of Simon, developed these ideas further. After studying in France, both made numerous projects for great houses and gardens, many of which were realized. Count M. G. de la Gardie, a grand potentate with original ideas on gardening, was one of La Vallée's chief employers. Venngarn Castle, with a Franco-Italian terraced garden, is among the works carried out for him.

Tessin the elder is chiefly associated with the garden of the royal castle of *Drottningholm, for which he drew several interesting plans. However, the plan eventually executed was by *Tessin the younger, who was familiar with contemporary garden design and had personal contacts with André *Le Nôtre. Although strongly influenced by the French style, Tessin's garden plans bear his own mark, Drottningholm being the best example. Many other gardens were planned on a grand scale with the help of skilled gardeners, often foreign, but were seldom fully executed or with such magnificence and detail. One of these gardeners, Johan *Hårleman, often co-operating with Tessin the younger, designed some of the best gardens in the French style. Well-preserved gardens from the period are *Sandemar, Steninge, and *Sturefors.

The era of great mansions and gardens ended with the wars at the beginning of the 18th c. The wealthy bourgeoisie did not aspire to rival royalty and their gardens assumed a more intimate character. The main principles were still those of the baroque but applied with less formality. More flowers and verdure are characteristic. Good examples are Ovedskloster by Carl Hårleman and Osterby by Adelcrantz. Gunnebo near Gothenburg, a well-preserved, slightly Italianate terraced garden from the end of the century, is unique.

*Chinoiserie came into fashion by the middle of the 18th c. *Chambers with his Swedish connections may have had some influence but the result is chiefly seen in plans and garden pavilions. An exquisite example is the folly Kina in the Drottningholm park. The fully developed English landscape garden was introduced by F. M. *Piper at the end of the century. The royal parks at *Haga and Drottningholm are his foremost and best-preserved works. Other noteworthy examples of this style, which prevailed during the 19th c., are Forsmark (Piper), Varnanas (from the 18th c.),

Ryfors (designed by the English landscape architects Henry and Edward *Milner), and *Adelsnäs.

During the same period gardeners replaced architects in designing gardens and the influence of Germany greatly increased. Horticulture developed and provided the material for gardens characterized by *carpet bedding, shrubberies, foreign trees, and winding paths. K. Forsberg, who won a certain renown by winning the prize in a competition for laying out the *Bois de Boulogne, designed this kind of garden. In his plans he tried to combine irregularity with symmetry. G.A.

The twentieth century. The reaction by the Swedish Arts and Crafts Movement to over-decorated architecture was paralleled in garden design, where the aims were for simplicity, and harmony between buildings and landscape, with an emphasis on spatial concepts and rhythm. This approach was heralded by E. G. A. *Asplund (1885–1940) and S. Lewerentz in their design for a woodland *cemetery in Stockholm, which expressed new ideas for manipulating space. Planting was no longer treated in isolation but was subordinated to the totality of the composition, harmonizing with the asymmetrical layout of the buildings.

The influence of Swedish 'national romantic' timber architecture was also reflected in garden design, with parallels throughout Scandinavia. Private gardens with symmetrical plans were in vogue at that time, and the importance of the smaller terrace garden was emphasized by Rudolf *Abelin in *Villa Trädgården* ('The Villa Garden') (1903) following studies he had had made of classical parterre gardens. He created a series of pastiches at Norrviken Gardens, Bastad (1906–20), which included

'Borrowed landscape' (1960) at the Villa Gadelius, Lidingö, Sweden, by Walter Bauer

Renaissance, baroque, romantic, Dutch, Japanese, and rose gardens. William *Robinson's ideas on *wild gardens were developed in Germany by Karl *Foerster, who has had a profound influence on the use of hardy plants in Scandinavia since about 1935.

Landscape architecture. The Swedish Institute of Landscape Architects (FST) was founded in 1923 by S. A. *Hermelin, who was also responsible for the new direction in garden art. Many landscape architects trained abroad, particularly in Germany, and a close co-operation developed between architects and landscape architects, notably the architects Gunnar Asplund, Cyrilus Johanson, and Erik Lundberg, and the landscape architects S. A. Hermelin, G. Reutersward, Inger Wedborn, Magnus Johnson, and later Eric Anjou, Walter and Lisa *Bauer, Ulla Bodorff, and Holger Blom. One of their basic demands was for sunshine and later in the 1950s and 60s for the ability to use large machinery for earth moving, which resulted in more undulating and stylized contouring.

Problems associated with landscape design were given a boost in *Trädgårdskonst* ('Garden Art') (1948), a collective work by Gregor Paulsson, S. A. Hermelin, Holger Blom, Walter Bauer, and Carl G. Dahl, which dealt with the modern garden and park. The inhuman scale and anonymity of buildings in the 50s and 60s and the land-absorbing car-dominated environments with dull planting are questioned by Eivor Bucht in her books *Inte bara Berberis* ('Not only Berberis') and *Vegetationen i Tio Bostadsomraden* ('Vegetation in 10 Housing Schemes') (1973), which clearly indicate the wear and tear and associated vandalism prevalent at the time. The mid-70s saw a positive change, the demand for variation, and a growing awareness of people's needs, in particular the handicapped. This has now begun to show itself in an improved environment. P.R.J.

See also MARTINSSON, GUNNAR.

Swift, Jonathan (1667–1745), Irish poet and satirist. As Dean of St Patrick's Cathedral, Dublin, he obtained near the Deanery his future garden, which he called Naboth's Vineyard as he had to eject the lessee. It was about the same size as the central feature of *Pope's garden at Twickenham, but Swift was largely concerned with practical horticulture such as the growing of fruit-trees and providing a paddock for his horses. He visited Pope at Twickenham in 1727 and saw the improvements made by Pope and his friends in their gardens. Swift helped many of his own friends in Ireland to landscape in this style: among others, Knightley Chetwode at Woodbroke, Patrick Delany at Delville, and Sir Arthur and Lady Acheson at Market Hill. The *Journal* and some of his poems describe these activities. E.M.

Swimming-pool. The universal private swimming-pool is modern, made possible by a high standard of living and modern techniques. Historically pools played a consider-able part in social life varying from the ablution (rather than swimming) pools of Islam to the older grand public baths of classical Rome.

Today, standard pools can be bought and installed with heating at a relatively low cost and, being mass produced, in a very short time. The essential circulating pump is easily concealed beneath paving or nearby bushes. Standard pools are rectangular and have surrounding pre-cast paving between the water and the grass necessary for sun bathing. Because a rectilinear shape is so harsh in a garden, pools have recently been designed in romantic biological curves rather than in straight lines. The pioneer was the now famous pool at *El Novillero, Sonoma, California, designed by Thomas *Church in 1947–8.

Unhappily the idea of a form related to the human body has been copied insensitively throughout the world, being generally known as 'kidney-shaped'. The design of the small garden swimming-pool is in its infancy and its poetry together with its attraction as a social centre can inspire the creative imagination. G.A.J.

See also PAGE, RUSSELL.

Swiss garden. Switzerland became part of the tourist's itinerary when peace returned to Europe at the end of the Napoleonic Wars in 1815. The vogue for Alpine scenery, Swiss cottages, and peasant costume which soon followed was readily absorbed into the cult of the *picturesque. In English landscaped gardens Swiss chalets to house estate workers were placed in remote settings and backed by dark firs with 'peasant' and scenery in romantic juxtaposition. Thus at *Alton Towers an old Welsh harper was retired to a Swiss cottage on the heights; a lock-keeper at *Cassiobury Park, gamekeepers at *Nuneham Park and *Blenheim, and an old woman retainer at Hartwell became part of the Swiss picturesque. It was P. F. Robinson, the architect of the Swiss Cottage in London, who first showed the picturesque possibilities of chalets with projecting roofs, Swiss cowhouses, and rustic bridges. M.L.B.

See also MÉRÉVILLE; SWISS GARDEN, THE.

Swiss Garden, The, Old Warden, Bedfordshire, England, created in the 1820s by Lord Ongley, is the outstanding example of the Swiss *picturesque. The Swiss chalet is the main feature of a number of contrived vistas. The unusually smooth hill on which it stands is suggestive of the work of the architect John Buonarotti Papworth (1775–1847), who lived nearby; he recommended the use of unpeeled bark for rustic buildings in the Swiss manner and may have designed this chalet with its pillar and thatch and interior decoration of bark and fir-cones. Reminiscent of his work at Whiteknights, where there was also a Swiss cottage of unpeeled bark, are the iron frames for trailing plants which form arches across the winding glades. The garden (now under restoration) includes a grotto-fernery, a thatched tree shelter, a stream, and fine specimen conifers. There is a very picturesque estate village in fir trees where the women were required to wear tall hats and red cloaks. M.L.B.

The Swiss Garden, Old Warden, Bedfordshire

Switzer, Stephen (1682–1745), English writer and garden designer, was apprenticed at Brompton Park nurseries (*c.* 1698) with George *London, with whom he became involved in laying out *Castle Howard, especially Wray Wood. In 1704 he formed the gravel-pits to the north of Kensington Palace into a planted amphitheatre.

In 1705 he went to *Blenheim as a clerk and worked variously with Henry *Wise and John *Vanbrugh in planting out, securing stone, and searching out forest trees on neighbouring estates. His greatest job there was digging the foundations of Vanbrugh's bridge, and canalizing the River Glyme.

After Blenheim Switzer worked for the Bertie family in Lincolnshire, where his most notable design was at Grimsthorpe. He transformed the existing layout of garden and woodland by simplifying the parterres of the garden, opening the garden to the wood, and by bounding the whole by a terrace walk in imitation of a field fortification. Thus garden, wood, and adjacent landscape became parts of the same composition.

In 1715 he published *The Nobleman, Gentleman, and Gardener's Recreation*, the first volume of what was to be his major work, *Ichnographia Rustica* (3 vols., 1718), which drew on his early experience to propose a theory of landscape design. He argued that a whole estate was to be the subject of design, to be accomplished by establishing one or two great axial lines (his 'boldest Strokes'), which would link the house and estate in the grand manner. All other parts of the estate and garden would be positioned with regard to use and good sense, the qualities of the ground, prospect, and agricultural improvement or forest plantation (see *England: the Eighteenth Century).

The best surviving example of his theory is *Cirencester Park (*c.* 1714). In his later work, the distinction between the estate and the garden became increasingly blurred, as in his design for Nostell Priory, West Yorkshire (*c.* 1734), now owned by the National Trust. Here the great axial lines no longer play a dominating role, for most of the scheme consists of a variety of forms grouped about the central lake. The 'parterre' feature is insignificant, and in the disposition of trees and the encircling plantation the scheme anticipates aspects of *Brown's style.

In 1724 Switzer had set up in Westminster Hall as a seedsman, a very lucrative trade. He continued writing on various agricultural and gardening topics, and it was as a writer rather than as a 'professor' of laying out grounds that he achieved some renown.　　　　　　　　　　W.A.B./P.G.

See also CLAREMONT LANDSCAPE GARDEN; STANSTEAD HOUSE.

Switzerland

THE MIDDLE AGES AND THE RENAISSANCE. The earliest example of garden design in Switzerland is a Carolingian plan dated AD 816 and preserved at St Gall (see *Carolingian Gardens). The drawings for the cloisters, vegetable and herb gardens, and orchards can be seen as prototypes or models for later garden layouts in Europe. In Switzerland itself monastery gardens have ceased to exist apart from a few herb gardens belonging to nunneries. But the peasant or cottage garden of today may be considered the descendant of the medieval monastery garden, a type highly developed in Switzerland which remains a typically Swiss achievement.

In central Switzerland peasant gardens have been particularly well preserved and remain an important feature of farms. As a rule they are laid out in front of the farmhouse as a rectangle or area surrounded by a wooden fence. The layout within the enclosure tends to be cruciform in shape and frequently contains a round bed at its centre. All sections are enclosed by low box hedges and the paths are strewn with tanning bark. Flowers and herbs are to be found in the beds close to the kitchen with vegetables a little further off. From the 16th c. the shapes and divisions of the beds became more diverse and a larger selection of plants became available. Ornamental and kitchen gardens were

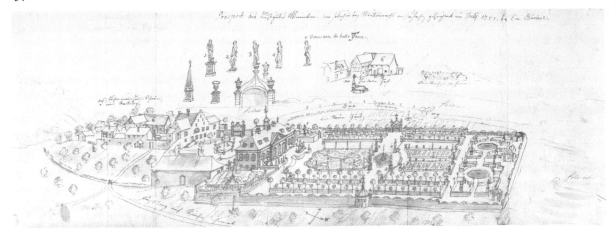

Wenkenhof, Basle, Switzerland, drawing (1751) by Em. Büchel (Staatsarchiv, Basle)

small in size, appropriate to horticulture in the rural areas of Switzerland.

In the Middle Ages Swiss castle precincts and town gardens were relatively modest due to an absence of large towns or princely courts. Only towards the end of the period did green areas take shape in the form of tree-covered urban squares in whose shade gatherings, fairs, and games could take place, such as the Petersplatz in Basle and the Lindenhof in Zurich (c.1435 and c.1500 respectively), both of which have survived, only the trees having been renewed.

The influence of the Renaissance on gardens in Switzerland during the first half of the 16th c. is confined to an interest in natural sciences. For example, Konrad von Gesner (1516–65), the famous scientist, historian, and doctor of Zurich, wrote a well-known book, *Horti Germaniae* (1559); Renwart Cysat, an apothecary from Lucerne, laid out a herb garden, studied the local flora, and corresponded with humanists in Germany and Italy; and a famous Basle doctor and teacher, Felix Platter, from 1575 owned a botanical and zoological garden containing lemon, orange, and bay trees.

During the second half of the 16th c. the first country seats were built outside the walled towns. Owned mainly by Swiss officers serving in the French army, their garden layout follows French examples. New gardens were often added to late Gothic country houses. They were surrounded by walls featuring corner pavilions, and provided with promenades, hedge-theatres, ponds, and ornamental flower-beds. In a modest way they imitated French examples.

THE SEVENTEENTH AND EIGHTEENTH CENTURIES. Under the influence of Versailles, French garden design became dominant in Switzerland during the 17th and 18th cs. There were, however, variations in different parts of the country and Italian and German influences also played a part. *Parterres on level ground with the axis leading towards the buildings are found mainly in gardens near the larger towns and along the lakes. Italian influence was widespread in hilly areas and produced gardens with artificially created terraces to accommodate the parterres on high ground (see Schloss *Bothmar).

Trade and industry as well as military service with foreign princes brought about a quick dissemination of French landscape art in Switzerland. At the end of the 17th c. Solothurn, the seat of the French ambassador, became an important centre of influence (see the Villa V. *Vigier). In this area plans for country houses and gardens were usually ordered directly from Paris.

Berne followed Solothurn in adopting the French baroque garden, many by the French architect Joseph Abeille. Due to their elevated position many of these gardens afforded views of the surrounding countryside. They usually incorporated a tree-lined entrance avenue, a promenade, and a parterre of *broderie* or of lawn on an artificially created terrace in front of the house, the parterre being therefore restricted in size. In contrast with Berne and Solothurn the relatively important baroque gardens in Basle were owned by rich merchants rather than patricians. The usual practice here was to start by laying out extensive gardens before the houses were built. A typical garden in Basle (see *Wenkenhof) is laid out on level ground terminated by a hedge, and is well supplied with statues of ancient gods, sphinxes, and wrought-iron gates. The close proximity to France and the wealth of the owners produced the largest baroque gardens in Switzerland.

During the 18th c. French influence in landscape architecture was more strongly felt in French-speaking than in German-speaking parts of Switzerland (see for example *Hôtel du Peyrou and *Le Bied). International trade and commerce were the basis for lakeside and vineyard baroque gardens. Country seats and gardens were designed largely by French architects and there were obvious differences between the parterre gardens of the plains and terraced gardens.

Most baroque gardens in French-speaking Switzerland lie in an elevated position above a lake amid vineyards. As a rule they consist of an artificial (garden- or viewing-) terrace

with a *parterre de broderie* which adjoined the lake and was flanked by orchards and vegetable gardens; the tree-lined approach was from the back (see *Creux de Genthod). The most magnificent example of this kind was a garden designed by French architects between 1764 and 1767 belonging to Schloss Crans between Geneva and Lausanne, whose chief attribute was a star-shaped entrance behind the house. These country houses usually belonged to bankers, tradesmen, and patricians, but the philosopher Voltaire owned one near Geneva—Les Délices, built in 1755—which had a garden.

Towards the end of the 18th c. C. C. L. *Hirschfeld described the particular characteristics of Swiss baroque gardens in his *Theorie der Gartenkunst* ('Treatise on the Art of the Garden') (1779–85), in which he praised the situation of the country houses and the combination of kitchen and ornamental gardens. He takes particular note of hedges with globes and pyramids and clipped openings and of yews shaped into crowns and pointed pillars. Even fruit-trees were pruned into ball or conical shapes. Lawns and orchards were contained within the gardens. As land was valuable there remained little space for purely ornamental gardens, but according to Hirschfeld these were designed in the French manner.

Elsewhere in Switzerland, the Italian example was more influential. Near lakeside towns like Zurich terrace gardens were built, their axis parallel to the shore or orientated towards the lake. The inclusion of clipped yews in the shape of globes or pyramids was a characteristic of these gardens, the vertical elements giving a sense of enclosure. The most interesting terraced gardens came into being in the 18th c. above the town of Neuchâtel and belonged to the country seats of Grande Rochette (1729), and Petite Rochette (1746). Situated amidst former vineyards, the terraces, connected by ramps and staircases, are reminiscent of Italian examples.

In Switzerland, as elsewhere, the French baroque garden was supplanted by the *jardin anglais. In this field Switzerland itself was influential beyond its borders. As early as 1720 the Bernese poet and botanist Albrecht von Haller described in his poem *Die Alpen* the happiness of man in an unspoilt natural landscape; Jean-Jacques *Rousseau found this happiness at Clarens near Lake Geneva and wrote about it in his novel *Julie, ou La Nouvelle Héloïse* (1761); and the poet Salomon Gessner (1730–88) from Zurich tried to capture the moods of nature in his idylls; all three prepared the ground for the spread of the English landscape garden on the Continent. A particularly striking example was the *Hermitage at Arlesheim, near Basle.

THE NINETEENTH CENTURY. Towards the end of the 18th c. the outer areas of French baroque gardens began to be altered in accordance with the English style. The beginning of the 19th c. saw the rise of the English landscape garden, which influenced newer garden types and was the favourite style right into the 20th c. (see Villa *Belvoir, Zurich; Villa *Mon Repos, Lausanne).

The luxurious parterres disappeared from the baroque country seats and the new classical villas were surrounded by English gardens, either small or large, which usually consisted of large lawns with grouped trees, ponds, grottoes, and peripheral paths. The designers of these gardens were mostly local architects, but early on architects from France and Germany made a contribution—Johann Michael Zeyer (1770–1843), a court gardener from Baden, worked in Basle; the botanist Philippe de Clairville in Winterthur; and the botanist Augustin Pyramus de Candolle in Geneva.

The first English parks came into being in Geneva at the beginning of the 19th c. through alterations to the baroque gardens of La Grange and Eaux-Vives, which lie today near the centre of the town. Their creators were citizens of Geneva who had fled to England and returned home after the liberation of the city, where they helped spread the English style in garden design. They confined themselves to remodelling the terrain and planting clumps of trees and shrubs, and did not include the grottoes, memorials, and pavilions common in romantic gardens. The tree-lined avenues at the backs of the gardens remained intact. New grounds designed during the 19th c. are the villa-gardens close to the lake near Sécheron which have more recently been combined to form the park Perle du Lac. The main feature of these parks is their position close to the lake, designed to include lake views into the landscape.

Swiss public parks and promenades were also constructed in the style of the English landscape garden. Initially the promenades consisted of simple tree-lined avenues. Later, when fortifications had become obsolete, ramparts were often replaced by wide extensive green belts particularly in Basle, Solothurn, and Winterthur. In Basle this work was not started until 1860 and before proceeding the city took the expert opinion of C. von Effner, the designer of the Hofgarten in Munich. In Geneva in 1854 a so-called *jardin anglais*—a public park—took the place of older fortifications by the lakeside. A similar *jardin anglais* was laid out in 1865 at Neuenburg.

In the public gardens of Switzerland, in the town parks or pleasure-gardens (*Volksgärten*), the English garden style predominated well into the 20th c. Towards the end of the 19th c., however, under French influence, large tree-lined boulevards began to appear in the cities, the best-known examples being the Bahnhofstrasse in Zurich and the Avenue Léopold Robert in La Chax-de-Fonds. A growing interest in botany coincided with the introduction of the English landscape garden. Botanical gardens with palm houses were built, mainly by the universities of Basle, Geneva, and Zurich.

The second half of the 19th c. is a time of multiple styles in landscape architecture in Switzerland. For formal layouts use was made of geometric French designs but for more intimate or private use the English garden style was preferred; both styles can be found side by side in the parks of spas, mountain resorts, and private estates.

The first of three country house gardens to be established by the Thunersee between 1848 and 1852 was the park of Schloss Schadau where a marshy walled garden was transformed into a large park with gravelled paths, benches, and

hot-houses. Not far away at Hilterfingen a park was created for Schloss Hünegg (1861–6) where the sloping terrain of the park above the lake comprises not only a lawn framed by rare trees but also, in front of the house, a terrace with flower-beds, a delightful garden pavilion, and a grotto. More impressive still are the gardens of Schloss Oberhofen am See which were begun in 1844 and continued to be expanded into the 20th c.; a whole array of historicist garden designs—a parterre with box ornaments, an English park with extensive lawns and clumps of trees, a garden pavilion by the lake, a pagoda, a chalet—contribute to make this a particular gem of landscape architecture.

In eastern Switzerland at Winterthur and in Zurich, the well-known landscape designer Konrad Löwe and the garden designer Evariste Mertens were influential in those days. Mertens moved to Zurich where he joined Fröbel, became a pioneer of modern landscape architecture, and contributed to making Zurich the centre of landscape design in German-speaking Switzerland. Zoological gardens, too, have their origins in the 19th c. Animals had previously been kept in the old castle and town moats, one of which, the Bärengraben in Berne, still exists today. Urbanization during the 19th c. awakened an interest in animals and their landscapes.

Among the numerous memorial gardens—another 19th-c. innovation—the garden of the lion memorial at Lucerne of 1821 is the most notable. Designed as an English landscape garden by Konrad Stadler, the principal feature is a rocky alcove with a lion by Bertel Thorwaldsen and a pond in front of it. Areas of water are also intended to create a distance between viewer and memorial, as at the Ile Rousseau of 1838 in Geneva, the Ile la Harpe at Rolle, and even the reformation memorial of 1917 in Geneva.

The design of Swiss *cemeteries in the 19th c. was influenced by the English landscape style as well. The closest approximation to a natural landscape was achieved as early as 1909 in the forest cemetery of Schaffhausen, which was laid out by Hans Grässel, the creator of the forest cemetery in Munich. The large cemeteries dating from the early 20th c. varied between geometric and naturalistic design. The well-known landscaped cemeteries in eastern Switzerland such as at Zurich and Winterthur, which became famous outside Switzerland, came into existence only later. H.-R.H. (trans. R.L.)

THE TWENTIETH CENTURY. After the First World War foreign design had become quite unsuited to Swiss economic and social conditions, in particular the limited and expensive living space. The optimal use of this space became a new preoccupation which prompted the question: 'what is the purpose of a garden and what needs does it fulfil?' The landscape architect was committed to finding an answer, not only to what was technically possible but to what was aesthetically satisfying. It became the designer's role to rethink the relationship of man and his immediate environment, from childhood to old age, in the family, at school, at work and leisure, in sickness and in health; even in death.

Beginning with the private garden as an extension to the

Mountain garden, Herrliberg, Switzerland, by Walter and Klaus Leder

house, the need was to satisfy a number of functions within a limited space and to create a spatial and visual harmony between built elements and surfaces and plants. The shortage of building space forced designers into making the best use of the available possibilities, and Switzerland became noted early for the detailed quality and integration of the gardens and landscape designs for housing estates, schools, hospitals, and public buildings. Schools and sports grounds especially were noted for the pleasant quality of their environments in contrast to the high wire fencing and acres of tarmac which were common in France and Britain. The dual use of sports facilities by schoolchildren and the adult population became common.

The same high quality of design and implementation has extended to office buildings, factories, and other places of work, where the garden surroundings are used by staff and often by the public as well. Roof terraces and gardens are common. In Berne the railway station, which is built over some of the ancient city walls, is itself covered by layers of offices with terraces terminating in a *roof-garden linked to a mature wooded hilltop from which a magnificent view of the Bernese Alps is obtained. Some years ago the city of Zurich gave building permission for the administrative offices of a large bank with the proviso that the roofs be covered with plants to present a better view from the neighbouring heights. In Basle eight large subterranean car-parks have been covered with roof-gardens. The shortage of space has also led to the use of cemeteries as public parks and gardens.

LANDSCAPE ARCHITECTURE. In the years between the two World Wars the fight for modern landscape planning and

design was waged in Zurich by Kluegelfuss and Schadlich, in Orten by Vivell, and by the leading practices of Evariste Merthus and his sons Oskar and Walter Merthus. K. Frobel provided employment for Gustav Ammann who later started his own office. Ernst Kramer and Walter Leder in Zurich, J. E. Schweitzer in Gland, Ernst *Baumann in Thalwil, and Franz Vogel in Berne also belonged to this first generation whose practices were continued by their sons. It is thanks to the efforts of these and many others over the last 50 years that co-operation with architects and engineers has become possible and it is to be hoped that it will continue in the field of garden design and landscape planning.

R.A. (trans. R.L.)

See also WILD GARDEN.

Sydney Botanic Gardens, Australia, are a microcosm of garden development in Australia, from the squared plots of the first garden to the belated attempts to introduce the 18th-c. landscape style, and succeeding fashions.

The area was officially inaugurated as a botanic garden after 1816, with Charles Fraser as Superintendent. By 1825 he had introduced nearly 3,000 new specimens of food plants and fruit-trees and at this time 2 ha. to the west were added to the Middle Garden. Here Fraser departed from the system of straight walks and the plan took more irregular forms. On the upper side of the main dividing walk were grown trees collected in the brush-jungle forests of the central eastern coast of Australia, including the silky oak (*Grevillea robusta*) and Moreton Bay or hoop pine (*Araucaria cunninghamii*).

The Lower Garden, partly laid out by Charles Fraser from 1820 to 1831, was finished to Surveyor Mitchell's plan of 1833. The Upper Garden on the southern boundary was originally a kitchen garden of 2·2 ha. for the Governors. It was later used as a propagating ground.

H.N.T.

Tabriz, Iran. See FATHABAD; SHAH GOLI.

Tai, in Chinese garden design, is an observation platform or terrace often on a hill, or by a pond where it is usually an extension of the court in front of a hall. It is especially used for admiring the garden by moonlight. X.-W.L./M.K.

Taihu rock. At least since the Northern Song dynasty (960–1127), the rocks most highly prized for piling artificial 'mountains' (*jia shan*), bordering hills, and particularly as single pieces of nature's sculpture (*shi feng*) in Chinese gardens have come from Dong Ting Shan, an island in Lake Tai (Taihu) near *Suzhou, Jiangsu province. They are grey limestone boulders excavated from the water where waves, hammering against small, harder stones embedded in the rock, have eroded them into peculiar shapes and textures. Those that are wrinkled, emaciated, and full of jagged holes are considered the best and, in the Song dynasty, were some of the most expensive objects in the empire. Although, originally, Taihu stones lost value if improved by human hands, a local industry developed which encouraged the natural weathering process by placing in the lake suitable specimens of limestones for later harvesting. Books on rock collecting, like Du Wan's *Yun Lin Shi Bu* (*Du Wan's Stone Catalogue of Cloudy Forest*, trans. Edward H. Schafer, Berkeley, 1961) written *c.*1125, constantly warned connoisseurs to beware of fakes. Two genuine Tai stones famous today are the Exquisite Jade rock in *Yu Yuan, Shanghai, and the Cloud-Crowned Peak, in *Liu Yuan, Suzhou.

 X.-W.L./M.K.

 See also HUANG SHI; SHI SUN.

Taiwan. See BAN QIAO.

Taj Mahal, Agra, India. Mumtaz Mahal, the best-loved wife of the 5th Mogul emperor *Shāh Jahān, died in 1631 following the birth of her 14th child. Over the next 22 years (1632–54) her tomb evolved, to become the most perfect building of the Mogul era.

 The surrounding layout is recorded in a plan of 1828, prepared by the Surveyor-General of India, Colonel Hodson. It shows the garden as it originally was: the classical four-fold plot of the paradise garden (see Gardens of *Islam). The tomb, however, was not placed at the centre, as were those of *Humāyūn and *Akbar; it stands instead at the end of the garden on a raised terrace overlooking the River Jumna, a climax in white marble.

 The gatehouse and surrounding walls are of red sandstone, as are the two buildings flanking the tomb: a mosque and an assembly hall. Two pavilions, again in red sandstone, mark each end of the cross-axis, while at the centre lies a raised marble reflecting pool. The Surveyor-General's plan shows the garden to have been subdivided into an intricate pattern of squares, and François Bernier, in his memoirs, refers to parterres filled with flowers. The tree planting would almost certainly have been of fruit, with taller shade trees along the walks, and the causeways are slightly raised to allow irrigation of the garden. The star patterns of the parterres along the canals can still be seen, but the flowers and fruit have disappeared. The character of the garden has been much altered by the informal planting of large trees, giving the garden a European, rather than a Mogul, appearance. The details throughout are impeccable. The river terrace is paved with black and white ripple paving, to simulate water, with the corners accented by octagonal pavilions. The curve of the Jumna here provides a romantic view of the Red Fort, the site of Shāh Jahān's imprisonment. In his captivity he was able to see, across the water, his greatest achievement, the Taj Mahal, and in due course was buried there beside his wife. S.M.H.

 See also MOGUL EMPIRE.

Tamerlane (1336–1405), Mongol conqueror. See Timūr Leng.

Tang. See TING (hall).

Tanlay, Yonne, France, has a moated castle transformed between 1643 and 1648 by Pierre Le Muet for Michel Particelli, Seigneur d'Hémery, *intendant et contrôleur générale des finances*. The forecourt is dominated by Le Muet's gatehouse, with two heavily rusticated obelisks flanking the bridge across the moat. This is fed by a canal in the park, 526 m. long × *c.*25 m. wide, at the head of which stands Le Muet's imposing Château d'Eau, a rusticated screen disguising the pond in which the waters are collected. The effect of great length is offset to some extent by an avenue of limes planted at the top of a bank which rises towards the head of the canal, so that the avenue is wider at one end by over 6 m. In 1704 Tanlay passed to Jean Thévenin, Marquis de Tanlay, in whose family the château has remained. K.A.S.W.

Tapis vert, literally 'green cloth', is a stretch of grass cut in a regular (usually rectangular) shape; a feature in French 17th-c. gardens, such as *Versailles. P.G.

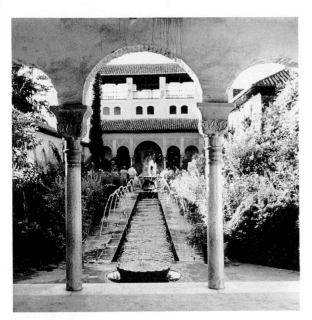

Generalife, Granada

house and garden round a dominant central axis so typical of the *Le Nôtre manner. On the other hand, its grandiose marble cascade rivalled that of *Marly, probably its inspiration.

After the death of Philip V (1746), no new royal gardens were created, although Isabella Farnese's son Charles III was inspired by La Granja to create the gardens of Palazzo Reale (*La Reggia) at Caserta. In 1752 plans were drawn up for a garden at the Queen's own palace, Riofrío (near Segovia), but were not executed, as the Queen came to live permanently at the court.

LATER DEVELOPMENTS. The 'English' style of garden design had little influence in Spain, with the exception of various additions to Aranjuez. Certainly it did not result in any completely new gardens on a large scale—there is no Spanish counterpart to the *jardin anglais. The Spanish botanists *Ruiz Lopez and Pavón y Jiménez, *Sessé y Lacasta and José Mariano Mociño, made important expeditions to Central and South America, but with no apparent impact on the design of gardens. Towards the end of the 18th c. a number of properties on the outskirts of Barcelona had gardens in a neo-classical style. With the exception of one outstanding example, *El Laberinto, most of these were destroyed as the town spread.

The 19th c. does not offer any significant developments in garden style. With the exception of Gaudí's *Parque Güell in Barcelona, a distinctively Spanish style of garden design did not emerge in the early decades of the 20th c.

P.G.

CONTEMPORARY GARDEN AND LANDSCAPE DESIGN. Although there is a professional institute, the Instituto de Estudios de Jardineria y Arte Paisajista, most modern garden and park design is by architects. The offices of the architect, Ricardo Bofill and his Taller de Arquitectura, at St Just d'Esvern near Barcelona include hanging gardens of cypress trees and *Carpobrotus* growing from the roofs of a converted cement factory. In Valencia they designed a neo-classical park (1980) on the site of the 8 km.-long, dry bed of the diverted River Turia which runs through the city. Groves, esplanades, lakes, a forum, and an amphitheatre are set in groves of trees through which the old bridges of the city cross.

In Madrid there is a similar linear park, the Avenida de la Illustracion, on the line of a former motorway reservation; this was designed by Jeronimo Junquera and Perez Pita in 1982 and construction began in 1984. In Barcelona a series of new squares and parks has been begun since the appointment of Oriol Bohigas as Director of Planning in 1981. The Parque de l'Escorxador by Antoni Solanas and Andreu Arriola (begun 1981) consists of formal groves of palm trees set in and contrasted with informal rocky pine woodland groves. This park is also decorated with some 30 pieces of sculpture by Joan Miró. On the slopes rising to Tibidabo west of the Parque Güell, José Martinez-Lapena and Elias Torres have designed the Jardines de Villa Cecilia. These are an extension and remodelling of an existing villa garden

Italian style. Indeed, garden design was not of great importance, perhaps because of a peculiar development in the life of Spanish noble society in the 15th and 16th cs.—the combination of monastery and palace, where devout exercises alternate with formal ceremonial occasions, even feasting. Charles's son Philip II (1556–98) built the Escorial Monastery and Palace (from 1563) in this spirit. It has numerous inner courtyards yet they do little to alleviate the bleak spaces of this gloomy building. He did, however, make an interesting garden at *Aranjuez, a shooting-box which he converted into a permanent summer residence. His Flemish upbringing led him to prefer the Dutch style of small compartments with clipped hedges.

The last of the Spanish Habsburg gardens was *Buen Retiro. Despite many striking features, such as a great square *bassin and the large lake, the design lacks overall coherence, and is rather provincial for its date (from 1628 onwards). It marks the end of the Italian influence upon Spanish gardens.

THE BOURBON PERIOD. Although markedly different from any previous gardens of Spain, those of the first Bourbon King Philip V (1700–46) are also quite different from the French models (such as his grandfather *Louis XIV's *Versailles) he may have wished to copy. He initially made Buen Retiro his residence, but the plans for the garden he requested from Robert de Cotte were not used. Instead, he concentrated on remodelling Aranjuez and creating *La Granja. The parterre, avenues, *treillage, the use of certain plants new in Spain (box, lime, and yew), and hornbeam hedges—all introduced at Aranjuez—are the limit of French influence. His major creation, La Granja, which covers 140 ha., does not exhibit the overall integration of

his friends. The young Jonathan *Swift was Temple's amanuensis from 1689 until Temple's death, and was inspired by both the theory and practice of Temple's gardening. E.M.

Temple gardens. See EGYPT, ANCIENT: LANDSCAPE DESIGN AND TEMPLES; MESOPOTAMIA.

Tenryu-ji Abbot's Garden, Saga, Kyoto, Japan. This 1·2-ha. site was originally the villa of the ex-emperor Gosaga. Later, the shogun Ashikaga-Takauji built the Zen temple of Tenryu-ji here at the request of the priest Muso-Soseki (1249–1388).

The present garden of Tenryu-ji, which centres around the pond called Sogen-chi, is only a portion of the large-scale garden conceived by Soseki (later called Muso Kokushi), involving the view of Arashiyama for *shakkei* ('borrowed landscape'). Nevertheless, the existing stone placement in and around the waterfalls in strikingly bold and dynamic ways seems to indicate Soseki's familiarity with the principle of *ts'an-shan ch'eng-shui* of Southern Song painting. In the Kamakura and Muromachi periods, particularly in the 14th and 15th cs., not only rock arrangement but also the art of trimming plants in the creation of Zen gardens developed considerably. The pond itself is in the form of a promontory in the foreground as viewed from Hojo, the priest's hall; this is a stroll garden.

Muso Kokushi's period was one of transition from the earlier Heian period to Zen culture, and the earlier style can be seen in the gentle shoreline of the pond as well as elsewhere in the garden. S.S.

Term, a statue or bust like those of the god Terminus, representing the upper part of the body. A.M.P.

See also HERM.

Terrace, Terrace garden. The first great terrace landscape known to history is that of Queen Hatshepsut (c. 1500 BC) at Thebes in Egypt. In an almost unbroken sequence of dynasties devoted to the introvert, this extraordinary concept of a tomb cut in the mountains, preceded by three terraces overlooking the distant city and the Nile, heralds the creation of the great materialistic garden terrace of classical and Renaissance Rome. There were no terraces in Greece, since there were no private mansions, and it was left to Rome to create terraces, not only for viewing the countryside, but to enhance the sense of power of society and its domination over nature.

The tradition of the terrace was carried through to the Middle Ages by the walk on the summit of castle walls, the countryside being considered hostile and to be viewed from a position of safety. The first signs of a relationship between gardens and country came from the Arabs in Spain, best illustrated by the 13th-c. gardens of the *Generalife in Granada which stretch along the hill slopes beside the Alhambra.

Two centuries later, and very similar in disposition along the hillside, was created the first truly terraced garden of the Renaissance: the Villa *Medici at Fiesole overlooking Florence and the Arno valley. It was here that Lorenzo de' Medici's Platonic Academy used to meet, undoubtedly stimulated by the long terraces and their harmony with the immediate and distant view. The most famous terrace gardens of the Renaissance and arguably of all time, were those of the Villa *d'Este at Tivoli, made in 1550; an abundant flow of water from the highest level ensures a spectacle of falling water and fountains unequalled even in the present century of the electric pump. In France terraces designed by Le Nôtre were on a grander scale than those in Italy, but in general, as at *Saint-Germain-en-Laye, they lay along the land rather than being carved from it.

For a brief period in 18th-c. England under the influence of 'Capability' *Brown, the terrace as a podium to a building was eliminated, but his successor Humphry Repton restored to a romantic park those parts around the house, including the terrace, which seem common to the domestic design of any age. On a larger scale terraces formed an important feature of *Italian gardens of the Victorian period (as, for example, at *Shrubland Park). G.A.J.

See also DUNCOMBE PARK; ISOLA BELLA; POWIS CASTLE; RIEVAULX TERRACE; SANSSOUCI; TAI TERRACE WALK.

Terrace walk. The terrace has existed throughout the history of gardens. In the 18th c. there is, however, a particular application which accords with the development of the natural and picturesque English landscape. A number of fine grassed terrace walks were created, which enabled the visitor to see the grounds of the countryside to special advantage: the terrace could be long and straight, a relic of an earlier formal layout, as at *Oatlands Park, or curving in a more natural form, as at *Duncombe Park, *Rievaulx Terrace, *Castle Howard, or *Farnborough Hall. By planting on the hillside below the terrace at Rievaulx, the views to the ruined abbey below could be controlled by the designer, just like the circuit walks at The *Leasowes and *Woburn Farm.

One particularly interesting motif common to several of the terrace walks is that of the bastion. There appears to be some evidence that French and Dutch garden designers were familiar with military textbooks and the design of fortifications, and the bastion does feature in English gardens: e.g. in a heavily 'military' layout at Grimsthorpe, Lincolnshire; in the terrace at Duncombe Park (for which Vanbrugh was responsible, thus providing a link with *Blenheim and Castle Howard and Vanbrugh's fortification work there); and in Sheridan's Walk at *Polesden Lacey, Surrey. There are also bastions in the long, curving terrace at Farnborough Hall, looking out over the sites of Civil War battles, so the military associations are both evident and appropriate. Goldney exhibits both a straight terrace and a separate projecting bastion. M.W.R.S.

Tessin, Nicodemus the elder (1615–81), was a German fortifications engineer who went to Sweden in 1636, where he practised as an architect. He started work on the royal palace of Drottningholm in Stockholm, levelling and laying

out the parterre garden between 1664 and 1667; his work was completed by his son. P.R.J.

Tessin, Nicodemus the younger (1654–1728), Swedish architect, travelled widely in Europe for a number of years from 1674. When he was in England, Christopher Wren suggested to Charles II that he ought to secure Tessin to work for him. Tessin wrote, drew, and collected drawings on such a prolific scale that the Tessin Collection at the National Museum in Stockholm contains almost a more comprehensive assembly of material on French architecture and gardens of the period than is to be found in France.

*Drottningholm, dubbed the 'Versailles of the North', was his *magnum opus*. The garden reflects 300 years of garden history—baroque, rococo, the English park style, romanticism, with a touch of 1880's formalism—but the main composition is totally Tessin's. The parterre was after a pattern from *Vaux-le-Vicomte, and there are other similarities—the menagerie was a copy of *Le Vau's plans for one at *Versailles. During the 1690s there were problems with defective earthworks and differential settlement, when the parterre was relaid by J. *Hårleman. Many of the sculptures at Drottningholm were plundered from Frederiksborg Castle in Denmark and Wallenstein's palace in Prague; Tessin used these for a composition in the fine Hercules fountain which can still be seen today. Apart from the groves, which were bordered by eight rows of lime trees and have been replaced by grass lawns, all the main features of Tessin's plan from 1723 were restored in the 1950s and 60s: the parterres, the containing walls, the basins with fountains, the plateaux with bordering hedges and topiary, etc. The superb cascades have been freely adapted by Ivar Tengbom using Tessin's model.

Tessin made proposals for the Louvre and Versailles, which were shown to Louis XIV by his associate G. J. Adelcrantz (1668–1739). At Versailles he suggested a grand Apollo temple as a *point-de-vue* for the large canal. He managed to design and build a castle at Roissy for the Comte d'Avaux in 1696. In Sweden he designed gardens for manor-houses, such as Steninge, Sturefors, Krageholm, Rosersberg, and Stora Wäsby. Unfortunately his plans for Frederiksberg and Clausholm were never realized. P.R.J.

Thailand is a country rich in vegetation both indigenous and introduced. It is fertile and well watered and the rate of growth is prodigious. Temperatures seldom fall below 70°F or exceed 95°F; rainfall varies between 127 and 203 cm. per annum. Humidity in the vast Bangkok plain, which drains into the Chao Phraya River, is high for 10 months of the year. Strong winds are very unusual.

The Thais are a plant-loving people, as the popular plant markets prove, and from the cool waterside houses raised on stilts along the *klongs* (the navigable waterways which traditionally formed the communications network of the country) to the hot urban concentration of modern Bangkok, plants are generally in evidence. Quite apart from the growing of fruit, vegetables, spices, and herbs there is a strong vernacular tradition of potted and suspended plants.

Thailand is rich in wild orchids, and hybridization is widely practised. Orchid fancying, though led by the very rich who have enormous collections, spreads throughout all levels of society, and a suspended group dangling from the palm-thatched (or corrugated iron) verandah of a humble house is as common as a dahlia patch in a Western suburban garden. Further indigenous delights of Thailand are the masses of lotus, pink and white, and nymphaea (water-lilies), which colonize still water and line the roads where drainage pits have been dug. The lotus is regarded with a certain veneration, and is used a good deal in religious offerings.

In spite of this background peculiarly Siamese styles in gardening are limited to a number of details including miniature gardens, water parterres, and the use of gnarled and clipped trees, which possibly derive from the Chinese origins of the Thai people when they were driven south in the 13th c. by Kublai Khan. One of the best examples is in the courtyard of the Chakri Hall of the Old Royal Palace in Bangkok and some groups of even more Chinese influence exist within the courtyards of the Wat Po, the Temple of the Reclining Buddha. Miniature gardens are generally made in stone or ceramic dishes placed somewhat formally around a courtyard or terrace. Typical small water pavilions are perched above a pond afloat with lotus and reached by a small bridge, for contemplation or chat at the cool end of the day.

In the 19th c. the pleasure-gardens of the royal summer palace of *Bang Pa-In were an eclectic essay which drew upon the late Renaissance in Europe, the Gothic, and the Chinese style, but they are not typical of Thailand.

Though there is a thriving Department of Botany at Chulalongkorn University, under the direction of Professor Krasin Suvatabundhu, and Kasetsart University specializes in agrarian studies, it is remarkable that Thailand has not yet established a Botanical Garden. The range of trees, shrubs, and foliage plants available is, however, large and, in addition to indigenous species, includes most of the international tropical humid flora. With the inevitable international approach to living in the open air, fostered by the sophisticated communications systems of the late 20th c., it is not surprising that garden design tends at least to be climatic/regional rather than ethnic/national. But with the undoubted facility which the Thais have for keeping a balance between Western influence and their inherited culture a true Siamese character is often discernible beneath the surface.

It is only in the last 30 years that an awareness of the possibility of an indigenous style seems to have emerged, in spite of Japanese and Western influence. It has been launched by true amateurs with means, rather than the community at large, headed by the work, writings, and social involvement of the late M. R. *Pimsai Amranand, whose book *Gardening in Bangkok* (1970) is an invaluable source of reference, and Princess *Chumbhot, who created *Suan Pakkad in Bangkok and the country park of *Wang Takrai, both now accessible to the public. The influence of William Warren through his writings for the *Bangkok World* and as a designer has also been considerable. James Thompson's

lush and deeply tropical garden surrounding his house in Bangkok is both cool living space and a setting for a fine collection of Siamese art, but otherwise a more Western tropical conception (see *James Thompson Garden). The most remarkable public venture is the Rose Garden (*Suan Sampran), outside Bangkok, which started as a private venture. It is a pleasure-garden catering for most recreational tastes, international in its ingredients but with a distinctive Siamese flavour.

A gifted group of younger architects and landscape designers is now emerging, who show signs of graduating from the Western influence in their training to develop a 20th-c. character of their own. Particularly interesting is the work of Phaitoon Osiri and also the compound designed by Chaiya Pulsirivong, which contains both his own and the *Pimsai Garden.

Other private gardens of interest in Bangkok include those for M. R. Kukrit Pramoj House, Hok Lok Siaw House, Saeng-Arun House, Rolf von Bueren House, Paul Berli House, William Warren House, and the Kittikachorn and Kittyachorn gardens recently developed at Pak Kred, Nonthaburi, near Bangkok. Two other recent gardens of note are at the new *Bangkok Hilton International Hotel in Wireless Road, and the new *Bangkok Australian Embassy, a water-garden on a grand scale with very effective balcony planting around an inner courtyard.

<div align="right">M.L.</div>

See also BANGKOK ASIAN INSTITUTE OF TECHNOLOGY; BANGKOK BRITISH EMBASSY; LURSAKDI GARDEN; PLAI NA; SOI SIYAPA.

Theatre. The garden theatre is one of the most attractive inventions of the Italian Renaissance, and the inspiration of all later designs. Raphael's theatre of the Villa *Madama near Rome was a revival of the Roman amphitheatre, but subsequently the small green intimate theatre was adopted almost as a necessity in a great Italian garden. Perhaps the most charming is that of the Villa *Marlia near Lucca (late 17th c.) in yew, with footlights and prompter's box in *Buxus sempervirens* (box); even when not in use this theatre conjures up imaginings and thus justifies itself as a permanent garden decoration. As the garden theatre spread northwards, so its use became restricted owing to uncertainties of climate. Without the alternative of wet weather accommodation, an open-air theatre is too great a risk, but as a garden folly it can scarcely be equalled. A restored example north of the Alps is that which forms part of the pattern of *Herrenhausen in Hanover (late 18th c.).

<div align="right">G.A.J.</div>

See also VEITSHÖCHHEIM.

Theobalds Park, Hertfordshire, England, the most important Elizabethan garden, was created by William Cecil, Lord Burghley, during the decade 1575–85. Its plan derived from early Tudor palace gardens but it was on a much larger scale. Although the house passed to James I in 1607 there were no radical alterations to the garden layout which consisted of (1) a square Privy Garden to the west, below the private appartments, laid out in raised walks,

hedges, arbours, and knots; and (2) the Great Garden to the south, also square and beneath the state appartments, which was nearly 1 ha. in size and was divided into nine knots or squares, the central one containing a fountain. Other features included a marble obelisk, a sundial, a knot of the royal arms, and busts of Roman emperors. The whole was encompassed by a canal. The layout, probably the joint work of Burghley and John *Gerard, the herbalist, was influenced by France, although its visual appearance was probably Antwerp Mannerist. There were later additions: an artificial river (1602–3) and two ponds, an island, a mount, and a second river with other decorative features (1625–6).

<div align="right">R.S.</div>

Theophrastus (c.370–286 BC), Greek thinker, universal writer, and botanist, was a pupil first of Plato, then of Aristotle, whom he succeeded at the Lyceum, the research institute founded by Aristotle, whose garden and walk were used as a place of study. His *Enquiry into Plants* contains a systematic classification of all known plants, the first in Western literature. It includes Eastern plants such as the cotton-plant and the banyan, described by followers of Alexander the Great, and of plants from northern Greece and Asia Minor on which his students had presumably reported. He left his garden to his disciples, making provision for certain slaves to be emancipated provided that they maintained the garden for a period. It was probably used in part to study plants, and may have been the first botanic garden.

<div align="right">C.T.</div>

Thomson, James (1700–48), Scottish poet, went to London, where he became a member of the *Burlington circle in 1725. His most influential poem, *The Seasons*, was first published in complete form in 1730 with illustrations by William *Kent. In it he eschewed the 'forced unaffecting fancies [and] little glittering prettinesses' of early 18th-c. pastoral verse, claiming to go back to the 'native poetry' of Restoration times. What reads like mere list-making today was then considered a highly original attempt to describe the English countryside in naturalistic detail. Despite many traditional and deistic elements, *The Seasons* taught people to look, and became a favourite source of quotation for the English landscape school. Lord Lyttelton erected a seat as a shrine to Thomson's memory at *Hagley Hall.

<div align="right">K.S.L.</div>

Thorndon Hall, Essex, England, was the home of Lord Petre (1713–42), a friend of John *Bartram, Peter *Collinson, and Philip *Miller, and one of the leading botanists and gardeners of his generation. Writing to *Linnaeus, Collinson described Petre's early death as 'the greatest loss that botany or gardening ever felt in this island; he spared no pains or expense to procure seeds and plants from all parts of the world, and then was as ambitious to preserve them.'

He moved to Thorndon in 1732, engaging a French surveyor, the Sieur Bourginion, to help plan the gardens, which were probably influenced by his stay in France (1729–30). Drives, canals, a great avenue of transplanted elms (a successful operation that may have followed the

methods used by *Le Nôtre at *Versailles), and ponds were among the earliest changes, with the establishment of nurseries to provide the material for later planting.

Plantations of trees were on a massive scale—nearly 5,000 in the spring of 1740 alone: conifers, cedars of Lebanon and Virginia, tulip trees, larches, chestnuts, and other exotics. Another 50,000 trees were added in the next two years, with evergreens and deciduous varieties mixed in clumps and thickets bordered with shrubs. His importations of exotic trees and shrubs, particularly those of North America, attracted a visit from Horace *Walpole in 1754, to view 'the famous plantations and buildings'. Petre's greenhouses were no less well stocked than his nurseries, for his collection of tender exotics was rivalled only by those at the *Chelsea and *Oxford gardens. He successfully grew pineapples, limes, bananas, and passion-fruit, and the camellia was among the shrubs that first flowered in England under his care. One of his gardeners was James *Gordon, later a famous nurseryman. The plants from his nurseries—200,000 at the time of his death—were sold at auction.

Most of the earlier design was destroyed by 'Capability' *Brown—traces of his plan still remain, though most of the park is now a golf-course. S.R.

Thouin, Gabriel (1747–1829), French garden architect and brother of the botanist André Thouin, is best known for his classification of garden types in *Plans raisonnés de toutes les espèces de jardins* (1819–20). In his search for a practical method he concerned himself with well-planned paths related to a large circular *allée*, secondary paths being functional. He gave attention to the co-ordination of scenes within the garden, making great lawns up to the approaches of the house, with groups and clumps of trees, interior viewpoints, and long *coulées* (paths) between the clumps which, despite the intended intimacy of the whole, sometimes run off towards the landscape outside. His codification of the *jardin anglais* determined its development throughout the 19th c. in France. D.A.L.

Thunberg, Carl Peter (1743–1828), Swedish botanist. See LINNAEUS AND HIS STUDENTS.

Thury-Harcourt, Calvados, France. See HARCOURT, FRANÇOIS-HENRI.

Tiefurt, Weimar, German Democratic Republic. The Ilm almost forms a semicircle around the Tiefurt Schloss which was originally a small manor-house. The 15·8-ha. park lies in the Ilm meadows and extends up to the slopes of the Loh Wood.

Work was first begun on the park by K. L. von Knebel; from 1781 it was extended by Duchess Anna Amalie who set up a Muses' Court there, which was visited by Wieland and *Goethe. She built a tea-house and Temple of the Muses in the Ilm meadows, and erected a monument to Mozart and Herder. Three almost parallel paths lead up the narrow hillside and afford views far into the Ilm valley. A rock grotto, known as Virgil's Grave, memorials to Wieland,

Duke Leopold of Braunschweig, and others, and an Amor also date from this period; the Moss Hut, Hermitage, and a small hothouse have disappeared.

By c.1840 the grounds had become so overgrown that *Petzold, aided by *Pückler-Muskau, carried out extensive restorative work between 1845 and 1850, at the same time extending the park to follow the course of the Ilm and thereby changing its aspect. Extensive reconstruction took place c.1970. H.GÜ.

Tiergarten, Berlin, like the *Bois de Boulogne, Paris, or *St James's Park, London, is a park which has undergone several transformations. Lying just west of the Brandenburg Gate, on the route to Charlottenburg and Potsdam, it likewise has become surrounded by the city.

In 1527 Prince (later Elector) Joachim II bought the land, a swampy forest, to make a royal game preserve. As late as 1685 (in La Vigne's plan of Berlin) it remained woodland crossed by footpaths. From 1697 avenues were cut through the woods and Friedrich Wilhelm I reduced the area of the hunting park.

The first transformation of the uncultivated woodland into a park followed the French pattern, under the guidance of Friedrich II's Director of Royal Palaces and Gardens, Georg Wenzeslaus von Knobelsdorff (1699–1753). By the time of his death he had almost completed laying out sections of the park in a complex series of *allées* and *ronds-points*, the largest being the Grosser Stern. None of this is exceptional, but it pleased the francophile king who commented: 'He has made the Tiergarten into a most agreeable place through the variety of its *allées*, hedges, and salons, and through the attractive mixture of different kinds of foliage. He has embellished the park with statues and water displays'.

Following the influence of *Wörlitz, but on a much reduced scale, the English landscape style was introduced into two small areas of the park—the Court Gardener Sello created the Rousseauinsel (1792) and the Luiseninsel (1810) in the Neue Partie, and in 1786 the Schlosspark Bellevue (the area still exists), possibly by J. A. *Eyserbeck. This did not alter the main features of the park—there still remained about 100 *allées*, broad ones for driving, and narrow ones for walking.

The first plan by *Lenné (1818) did not alter Knobelsdorff's axial system but in his 1819 plan he aimed to create a *Volksgarten*, containing 'people's salons' decorated with statues commemorating patriotic heroes, replacing the earlier classical statues admired by the Court. This was very much in the spirit of the *Volksgarten*, as proposed by C. C. L. *Hirschfeld (*Theorie der Gartenkunst*, Leipzig, 1785, Bd. V p. 72).

Despite over a century of improvement, much of the park was still swamp-ridden and inaccessible. In his 1832 plan, carried out from 1833 to 1840, Lenné proposed to remedy the situation, creating sinuous streams and winding footpaths. However, during the course of this work, he seems to have understood the value of the structure given by Knobelsdorff's work, and his 1836 plan offers a simplified

geometric composition of circles and *allées*. His last detailed plan for an area within the Tiergarten is that of 1837 for the Schlosspark Bellevue.

Like *Schinkel who in 1835 had submitted an austerely neoclassical plan for the Tiergarten at the point at which it met the Brandenburg Gate, he had come to recognize that the park was part of the overall planning of the city. In April 1840 Lenné submitted his plan (revised 1844) for the embellishment of Berlin and its surroundings. As an integral part of this plan the Tiergarten was enlarged by the addition of the former Exercise Ground to the north-east, bringing the park to its present size of 240 ha.

When Friedrich Wilhelm IV came to the throne in 1840 a number of changes were made, most importantly the creation of the first public zoological garden (1844) in Germany, on the site of the former Pheasantry. Lenné resigned in 1848, and perhaps it is no accident that there were no significant later developments. The Tiergarten did not follow the later 19th-c. development of public parks in offering recreational facilities, as the Friedrichshain and Treptower parks, among others, were developed to cater for this need. P.G.

Timūr Leng (1336–1405), founder of the Timurid Empire, and the ruthless conqueror known to the West as Tamerlane the Great, was also a lover of gardens. To his capital at *Samarkand he brought artists and craftsmen from the conquered territories, including Delhi, to make it one of the most magnificent cities of his day. The Spanish ambassador to his court, Ruy Gonzales de Clavijo, described its superb gardens, which were to have great influence on his descendant *Bābur, when he visited Samarkand as a young man. S.M.H.

Ting, or hall (not the same character as *ting meaning pavilion), is often the main and also the loftiest structure in a Chinese garden. Usually facing south in a dominant position to secure the finest view, a *ting* is elaborately decorated and furnished, and a focal point in the garden. It is distinguished from a *tang* (also a hall) by its timbers, which are circular in cross-section instead of square. However, one distinctive type of hall (like those in the *Liu Yuan and *Shi Zi Lin) has one half made of circular and one half of square timbers. They symbolize conjugal felicity, and are called Mandarin Duck halls, after these domestic birds who are thought to remain with one mate for life. X.-W.L./M.K.

Ting, meaning pavilion, is a structure for repose and viewing—an essential element in Chinese garden planning ('once you have a *ting* you may say you have a garden'). Commonly found by water, on a hill, among trees, or in the corner of a courtyard, it is characterized by a roof supported by free-standing pillars without windows or walls. *Ting* may be square, oblong, hexagonal, or octagonal, even round, or cross- or fan-shaped. Some, called 'half *ting*' (such as the one called There is Another Way to Heaven in the *Zhou

Zheng Yuan) lean against a wall, or are connected to other buildings by *lang. X.-W.L./M.K.

See also FANG; GE; LOU; XIE; XUAN.

Tintinhull House, Tintinhull, Somerset (Avon), England, has a small garden which successfully combines the formal and the informal in an asymmetrical layout relating to the small 17th-c. house with a Queen Anne façade. Some of the elements were established during the early part of the 20th c. (possibly with some advice by Harold *Peto) but the present garden is largely the work of Captain and Mrs P. E. Reiss who developed it over a period of 20 years from 1933. In 1953 the property was given to the National Trust.

The main axial walk marked by cones of box extends through a long narrow space which is divided into three: the Eagle Court, the Azalea Garden, and the Fountain Garden. These spaces are directly linked with three larger courts: the Kitchen Garden, a central court containing a canal pool, and the Cedar Court containing some old yews and dominated by a great cedar of Lebanon. The whole comprises a series of carefully proportioned spaces, each with its own character and clearly defined views, containing free-growing plants which have been selected for specific effects. M.L.L.

Tivoli, Copenhagen, Denmark. For the summer visitor to Denmark, Copenhagen and Tivoli are almost synonymous. Tivoli came into being in 1843 as a countermeasure to the sterner necessities of the times and the lack of public parks in the town, and has only survived as a piece of late romantic landscape layout due to the fact that it lies in the middle of the town, where short leases serve as a deterrent to major developments.

The fundamental plan follows the original star-shaped pattern of an old fortification. Along the indented line of the fortification the promenade is laid out to form a double avenue; on the other side the ground falls away towards a covered bridge over what was a defensive moat and is now contracted to a small lake. The central dominant feature in the layout is a little promenade, zigzagged to encourage the visitor to discover what is around the next bend. The falling ground within the two divergent corners of the promenade has been used for amphitheatres, one for stage performances and the other for a concert hall. The more important buildings are elegant in form with Chinese and Moorish influences, and most remain as they were built over a hundred years ago.

Since Tivoli was first laid out, many alterations have been made; a parterre garden by G. N. *Brandt was constructed near the lake in 1943, a mixture of water and flowers, with beechwood tub fountains (due to lack of concrete) placed irregularly amongst elliptical planting beds. Simon Henningsen and Eywin *Langkilde designed the hanging gardens and the children's sculptural play area in the 1950s. Tivoli should be seen both during the day and at night-time, when a myriad of tiny lights, retained when the gas jets were converted to electricity, preserve a very idyllic atmosphere. In 1961 Eigil Kjær designed the circular pool with

transparent cylindrical bubble fountains, and Bjorn Winblad designed the other fountains and decorations.

<div align="right">P.R.J.</div>

Tivoli, Italy. See HADRIAN'S VILLA; D'ESTE, VILLA.

Tomb garden, a distinctive type of *Mogul garden, uniting the idea of the Persian paradise garden and the Tartar tradition of garden tombs. The first of the genre—*Bagh-i Bābur, the tomb garden of the first Mogul Emperor, *Bābur (1508–30), was relatively simple; and it was *Humāyūn (1530–56), who in other respects made little contribution to garden design, whose tomb garden (*Humāyūn's Tomb) illustrated the Mongol tradition in which the garden was treated as a pleasure-ground during the owner's lifetime, looked after by the priests, with the produce of the garden paying for its maintenance. After the owner's death, the central pavilion became his mausoleum.

There are large-scale tomb gardens at *Shahdara, surrounded by raised causeways, canals, and tanks; but the greatest of them all is the *Taj Mahal (1632–54). Thereafter, the quality of tomb gardens declined dramatically, as at the mausoleum of *Rābi '-ud Daurāni.

<div align="right">P.G.</div>

See also I'TIMĀD-UD-DAULA.

Tonnelle, a tunnel-shaped trellis or a series of arches over which climbing plants are trained; a bower or arbour so made.

<div align="right">D.A.L.</div>

See also BERCEAU.

Topia, literally the elements typical of a place. The term comes from painting and was introduced in classical Antiquity when the walls of porticoes were enlivened with landscape paintings: paintings of the sea, rivers, springs, rustic retreats, mountains, shepherds, and flocks. These images were taken by the *topiarii* (see *topiarius) into the open space of the portico and became the theme of gardens, at least in those which lent themselves to such treatment. The *topia* which can be seen in the peristyles of *Pompeii are only a reduced version of those which adorned the big gardens of the villas (see Ancient *Rome, for the concept of 'open gardens'). The Amaltheum of Atticus, in his villa of Buthrote, is one example: an *allée* of plane trees bordered by a stream led to a grotto in which there was a statue of a nymph nursing the infant Zeus. Here we have the origin of the *nymphaeum.

The practice of painting *topia* was revived in the Renaissance, either in the form of representations of contemporary gardens (as at the Villa *d'Este, Tivoli, and the Villa *Lante) or as general landscape scenes (cf. the recently restored examples at the Villa *Giulia).

<div align="right">P.GR. (trans. P.G.)</div>

Topiaria opera, a term used by the ancient Roman encyclopaedist *Pliny the elder to indicate kinds of landscape or ornamental garden, and in the singular form *opus topiarium* to describe the whole art of ornamental gardening. It has often been interpreted as meaning 'topiary' in the modern sense, mainly because Pliny at one stage refers to cypress trees being cut 'into tableaux of *opus topiarium*: hunt-scenes, fleets of ships, and all sorts of images'. But he clearly regards hedge- and tree-clipping as merely one aspect of *opus topiarium*, and elsewhere he describes as 'topiariae' plants which could never have been cut into shapes (kidney vetch, periwinkle, maidenhair, acanthus, hound's tongue). Moreover, the invention of tree-clipping (*nemora tonsilia*) is ascribed by him to a Roman named G. Matius who was active at the end of the 1st c. BC, half a century after the first mention of '(ars) topiaria' in surviving literature.

Ornamental gardening was introduced to Rome in the luxury villas of the Roman aristocracy during the 1st c. BC, and, like many of the arts and amenities adopted in that period, it came from Greece. It is first mentioned in a letter of Cicero, a great philhellene, written to his brother Quintus in 54 BC, in which he alludes to the use of ivy to adorn the podium and colonnades of a villa, apparently as a backdrop to Greek-style statuary. The Latin term is indeed of Greek origin, being derived from *topia*, that is 'landscapes'. The categories of landscape created, or re-created, by gardeners are listed by Pliny as 'woods, groves, hills, fish-pools, canals, streams, shores', and landscaped parks incorporating some of these features are sketched in numerous Roman paintings of contemporary villas. In recent years a Greek prototype, complete with artificial grottoes and bases for statuary, has been recognized outside the city of Rhodes.

<div align="right">R.J.L.</div>

Topiarius, the Roman term for a landscape or ornamental gardener (see *topiaria opera). *Topiarii* were generally slaves of Greek extraction working in the service of wealthy Roman families, notably the Imperial family. Many are named on gravestones; most come from the city of Rome, but there are also examples from areas of Italy where luxury villas were established, such as Como, Tivoli, and Anzio.

<div align="right">R.J.L.</div>

Topiary, the art of shaping trees and shrubs by clipping and training, has been practised at least since the time of *Pliny the elder (1st c. AD) (see *topiaria opera) who described 'hunt scenes, fleets of ships and all sorts of images' in cypress. Clipped box was also used in Roman gardens, sometimes spelling the name of the master or topiarist, or as an edging of complex plan to articulate garden space.

During the Middle Ages plants were trained and clipped into simple non-representational shapes, often on withy frames. Illustrations showing such ornaments are rare before 1400.

The first real topiary revival took place in early Renaissance Italy. *Hypnerotomachia Poliphili* (1499) illustrates designs for both simple topiary shapes—spherical, mushroom, and ring standards—as well as complicated assemblages of human figures, urns, and other architectural forms. At the Rucellai garden, Florence, created in the second half of the 15th c., 'spheres, porticoes, temples, vases, urns, apes, donkeys, oxen, a bear, giants, men, women' were all formed of various evergreens on bound withy frames. In England similar work was described at

Patterns for topiary, from Matthias Diesel, *Erlustierende Augenweide in Vorstellung hortlicher Gärten und Lustgebäude* (?1717)

*Hampton Court in 1599 by Thomas Platter, a German visitor.

In the 16th and early 17th cs. almost any plant seems to have been subjected to the shears, regardless of its suitability. Barnaby Googe (*Foure Bookes of Husbandry*, 1577) mentions the popularity of rosemary, especially amongst women who trimmed it into 'the fashion of a cart, a peacock, or such things as they fancy'. *Parkinson (*Paradisus*, 1629) recommends privet: 'it is so apt that no other can be like unto it, to be cut, lead, and drawn into what forme one will, either of beasts, birds, or men armed or otherwise.' Lawson (*A New Orchard and Garden*, 1618) writes of the gardener shaping 'your lesser woods'. For knots, Parkinson states that box was a novelty 'only received into the gardens of those that are curious'. Thrift, he writes, is 'the most commonly received' and hyssop, lavender, germander, and thyme were commonly used.

Sir Francis *Bacon's essay, *Of Gardens* (1625) mentions the use of juniper, but advocates the simplification of elaborate topiary images: 'I, for my part, do not like images cut out in juniper or other garden stuff—they be for children. Little low hedges round like welts, with some pretty pyramids I like well, and in some places fair columns.' This presages the increasingly architectural use of topiary in the 17th c., either as simple geometric shapes used as vertical emphasis in a parterre or to define a walk or terrace, or as pure architecture—called by John *Evelyn 'hortulan architecture'. The more frivolous species of topiary sculpture continued throughout the 17th c. and into the 18th but became increasingly the province of parvenu tradesmen, as suggested by Pope's famous lampoon 'Catalogue of Greens' in his essay on gardens, published in the *Guardian*, 1713.

With the later 17th-c. French-inspired garden of parterres, *palissades*, and *cabinets de verdure*, topiary became the primary component of garden design. Evergreens became increasingly important and holly, yew, box, bay, laurel, phillyrea, and alaternus were all widely used as topiary subjects. *London and *Wise (translators, from the French, of *The Retir'd Gardner*, 1706) advocate *Rhamnus alaternus* in the form of a 'bush, bowl or other figure' set in open ground or grown in cases to ornament terraces or courtyards. Sir Thomas Hanmer (*The Garden Book of Sir Thomas Hanmer*, 1659, 1st pub. 1933) recommends *Phillyrea latifolia* and *P. angustifolia* 'fit for clipping into pyramids or balls or other figures as the Myrtles are'. John Evelyn's garden at *Sayes Court had 'four large round philareas smooth clipped raised on a single stalk from the ground, a fashion now much used'.

'Hortulan architecture' is described in some detail by John *James (*The Theory and Practice of Gardening*, 1712): 'Palisades are often cut into Arches . . . and Balls or Vases may be made on the Head of each Peer; the Vases are formed by Shoots of Horn-beam rising out of the Palisade . . . This Decoration composes a kind of Rural Architecture, like that we call the *Rustick Order* of a Grot or Cascade . . . Natural Arbors are formed only by the Branches of Trees artfully interwoven, and sustained by strong latticework, Hoops, Poles etc. which make Galleries, Porticoes, Halls and Green Vistas, naturally cover'd. These Arbors are planted with Female-Elms or *Dutch* Lime-Trees, with Horn-beam to fill up the lower part.'

By the second half of the 18th c. topiary had become synonymous with all that was old-fashioned or in bad taste, but its use was revived as early as 1804 by Humphry *Repton in the antiquarian garden he designed for the Duke of Bedford at Aspley Wood Lodge, *Woburn Abbey. By the later 19th c. topiary specimens, usually in yew, which had survived in cottage gardens were admired by the exponents of the *Arts and Craft movement, and its use is

recommended in works by J. D. *Sedding (*Garden Craft Old and New*, 1891) and Reginald *Blomfield (*The Formal Garden in England*, 1892).

The Book of Topiary (1904) by C. H. Curtis and W. Gibson states that exhibits of trimmed trees appeared at the London horticultural shows *c.* 1900. These were largely supplied by the appropriately named Highgate nurserymen Wm. Cutbush and Son. To supply the increasing demand Herbert Cutbush scoured the Netherlands for mature specimens in farmhouse gardens; a few nurserymen in the Boskoop district then still specialized in cultivating clipped trees, and Cutbush imported these also to supply the English market. Topiary specimens are now sadly difficult to find in Britain, only standard and pyramid bay and box being generally available, in the main still imported from the Netherlands and Belgium. G.R.C.

See also COMPTON WYNYATES; ELVASTON CASTLE; LEVENS HALL; POWIS CASTLE.

Topkapi Saray, Istanbul, Turkey, the great palace of the Osmani Sultans on the site of the old Acropolis of Byzantium, was begun in the 15th c. and continued to the 19th c. The grounds are on a hill to the east of the old city of Istanbul, on a site of *c.* 6·2 ha. that once extended further to the water's edge. The site commands a view of the junction of the Bosporus to the north with the Sea of Marmara to the south. The palace buildings are freely disposed amidst courtyards and gardens containing pools and fountains; and once there were vineyards and orchards. All parts of the complex were originally related to a specific segment of the palace community as well as to its supreme executive and judicial council. The gardens contain much luxuriant planting, but do not wholly follow Islamic tradition since the local climate renders irrigation unnecessary.

Of the various courts, the first was open to the public and performed general service functions; but the second court contains in addition to kitchen and stables, the Diwan-i Am (public audience hall) where councils of state were held. It was therefore once the scene of pageantry, set amidst fountains and cypress trees. Offices for court and government officials, the palace school, the Sultan's reception room and private apartments, and the harem surrounded the third court. The fourth court, linked to the third by a marble terrace containing a pool, also formed part of the Sultan's private domain. It is a large enclosed garden at several levels, and contains a number of pleasure pavilions, or kiosks. It once contained a tulip garden, the site of tulip festivals in the early 18th c. Here, night-time banquets were illuminated by candles carried on the backs of turtles, while in the trees caged nightingales sang. Today it contains a hexagonal pool and a finely carved marble fountain, its tiers more typical of Islamic fountains in Turkey than elsewhere. The large fifth court once served as a hunting- and sports-ground, but also contained flower, fruit, and vegetable gardens. Extending to the Golden Horn at Saray Point, its original design is now lost. J.L.

Torlonia, Villa, Frascati, Lazio, Italy. Scipione Borghese, who later owned *Mondragone, began large-scale work here in 1607. An aqueduct was built to carry water from the

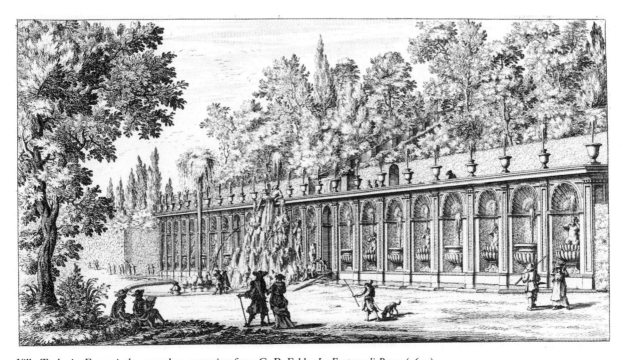

Villa Torlonia, Frascati, the cascades, engraving from G. B. Falda, *Le Fontane di Roma* (1675)

springs of Canalicchio to the villa. At the top of the hill is a wide circular space containing the vast *bassin* of the water reservoir. The water flows through a stone mask into the cascade, designed by Carlo Maderna, which consists of three oval *bassins*, bordered by curving flights of stairs, with an inclined plane between each one. The water falls into a large semicircular *bassin* in front of the retaining wall, where it is forced into a powerful jet rising high in the air, or falls in a veil of water into a final *bassin*. The wall itself contains 22 niches (originally 10, but extended by Maderna after 1621), each containing a basin in the form of a shell, from which rose a water jet. On the piers between the niches, water jets spouted from 24 urns. The cascades are not on the central axis of the house, as they had to be constructed on the only considerable slope on this rather level site; and the house had been built in the 1560s. Instead, an axis was created on the cascades, running through the flower parterre, once richly adorned by sculptures, which was entered from the *giardino segreto* next to the house.

The second phase of the design began in the 1680s. The parterre garden was replaced by groups of oaks forming shaded pathways. The second major alteration was to the retaining wall which supported the main garden level. Into the wall was cut a system of four staircases and two intersecting ramps, of which the central axis is not determined by the cascades. The lower terrace is nearly 100 m. long, but only 9 m. wide, which means that an ever changing set of perspectives is revealed to the spectator walking towards the *casino*.

The villa was destroyed in 1944 but the system of fountains and part of the park remains, now an undistinguished public garden. P.G.

See also ITALY: ROMAN BAROQUE GARDENS.

Torrigiani, Villa, Camigliano, Tuscany, Italy. Laid out for the Santini family in the second half of the 18th c., the garden today consists mainly in a lemon garden leading by twin double stairways to a sunken *giardino segreto*. Guests to this garden and parterre might find themselves imprisoned by secret jets of water (*giochi d'acqua*) cutting off their escape and surprising them elsewhere, even in the apparent safety of the little temple of Flora at the end of the garden, and even on the terrace above. G.A.J.

Tournefort, Joseph Pitton de (1656–1708), French botanist. See PLANT COLLECTING.

Tradescant, John the elder (*c.*1570–1638), and his son, **John** the younger (1608–62), English gardeners and collectors, were probably from a Suffolk family. They were responsible for the introduction of many plants to England. The elder John was successively gardener to Robert Cecil, 1st Earl of Salisbury, Lord Wotton, George Villiers, Duke of Buckingham, and finally Charles I and his queen, Henrietta Maria. This series of powerful patrons gave him a chance to travel and to make the acquaintance of other travellers, who sent him plants. In 1609 he went to the Low Countries, just before beginning his work for Lord

Salisbury at *Hatfield House, where he laid out and furnished the gardens. To add to his botanical resources he made another journey to the Low Countries and France in 1611, collecting trees, especially fruit-trees, and flowers. Lists of his purchases survive in the Hatfield archives, and in the Bodleian Library, Oxford, there is a book known as 'Tradescant's Orchard', containing 65 drawings of fruit possibly cultivated at Hatfield.

Other Salisbury properties, in London and at Cranborne in Dorset, were also in Tradescant's care until 1614, when he moved to Canterbury, where Lord Wotton had bought St Augustine's Palace from Lord Salisbury. In 1618 he went with Sir Dudley Digges to Russia. His diary of this journey is also in the Bodleian, and his botanical collections may have included the Siberian larch and a purple crane's-bill. He explored parts of northern Africa in 1620–1 during the blockade of Algiers, and returned to France in 1625 with his new employer, Buckingham, whose garden at Newhall in Essex was being richly stocked. Buckingham's expedition to the siege of La Rochelle took Tradescant back across the Channel in 1627, when his military activities did not exclude botany, for he brought back the 'greatest Sea Stocke Gilloflower' (*Matthiola sinuata*) and several kinds of *Cistus*. After the assassination of Buckingham, Tradescant became keeper of the royal gardens at Oatlands, Surrey, in 1630, refusing the opportunity of becoming custodian of the Oxford Physic Garden, which was offered to him in 1637.

In 1617 Tradescant had become a member of the Virginia Company, a channel for his introduction of many North American plants, including the spiderwort (*Tradescantia virginiana*), Virginia creeper (*Parthenocissus quinquefolia*), and stag's horn sumach (*Rhus typhina*). John *Parkinson's *Paradisus* (1629) and *Theatricum Botanicum* (1640) and Thomas Johnson's edition of *Gerard's *Herball* (1633) have several references to plants first seen by the authors in the Tradescants' garden at Lambeth, bought by the elder John *c.*1626, by which time his son had left the King's School, Canterbury, to become his father's assistant.

Four years before the death of the elder Tradescant in 1638, **John Tradescant the younger** became a freeman of the Gardeners' Company, and he succeeded his father as the royal gardener at Oatlands. He made three visits to Virginia, in 1637, 1642, and 1654, adding more North American plants to the Lambeth garden and to the stock of cultivated plants in England. Some of these are listed in the 1656 catalogue of the Lambeth collections, including the American cowslip (*Dodecatheon meadia*), the tulip tree (*Liriodendron tulipifera*), and the swamp cypress (*Taxodium distichum*).

Both Tradescants were also collectors of curiosities of all sorts for their museum, nicknamed the Ark. In 1650 Elias Ashmole made the acquaintance of John Tradescant, whose son, the third John, died in the same year. After the death of the younger Tradescant in 1662, the contents of the museum passed into Ashmole's hands. He added his own collections and gave the whole assemblage to the University of Oxford, where the Ashmolean Museum was founded in 1683.

The Tradescants, father, son, and grandson, are buried in a tomb in the churchyard of St Mary's, Lambeth, a redundant church taken over by the Tradescant Trust in 1976. The church is now a museum of garden history, surrounded by a memorial garden containing some of the plants associated with the Tradescants. S.R.

Tree house, as the name suggests, a building constructed in the branches of a tree. Although still popular for children, the tree house has virtually disappeared as an ornamental garden building. One large timbered English example survives at Pitchford Hall, Shropshire, in a lime tree. The style is generally mid-18th c. but the framing is much earlier. In the 16th c. there were several tree houses in southern Europe and Italy, and Celia *Fiennes described an elaborate one at *Woburn Abbey in 1697. M.W.R.S.

Trees and shrubs in gardens. Perennial plants that have rigid woody living parts persisting above the ground throughout the seasons and from year to year are technically either trees or shrubs. If there is a single main stem or trunk it is a tree, shrubs having several stems arising at or just above the soil level. This distinction between trees and shrubs is not always clear-cut as many species can develop a range of forms depending on their environment and cultivation techniques, particularly when young.

*Climbers and dwarf, spreading woody plants, such as rock-garden species (see *alpine, scree, and rock-gardens) and *heathers, are correctly subshrubs and are not included in this account. Examples of true trees and shrubs dealt with in greater detail elsewhere in this book include *roses, *rhododendrons, and *conifers. Reference should also be made to *arboreta and pineta.

The main stems and branches of woody plants increase in length and girth each season and, theoretically, there is no limit to tree and shrub growth. In practice, disease and decay of the oldest wood, coupled with storm and human damage, generally prevent trees from growing indefinitely. Also many of the smaller branches are shed each year. Nevertheless, many woody plants can live for several centuries, particularly oaks and many conifers.

Trees and shrubs are found in about half of the 350 different families of flowering plants. Some families are exclusively composed of woody species such as the Fagaceae (oaks, beeches) whereas others have only a few woody representatives such as the Solanaceae (nightshades, potatoes, tomatoes) in which the genus *Datura* has a few shrubby species.

Some plant families such as the Rhizophoraceae (mangroves) are confined to the tropical and subtropical regions but many others have woody species in all climatic zones. Examples of these latter include the Celastraceae (spindle trees) and Tiliaceae (jutes and limes).

Most trees and shrubs grow naturally in communities (woods, forests, copses, and thickets) with either many individuals of the same species or mixed with many other woody species. In temperate zones a single species tends to be dominant in woodlands, whereas in tropical rain forests over 100 species can be co-dominant. The association of tree species with each other and with other plants in natural vegetation is not a random occurrence. Geographical and ecological factors such as soil type, climate, and past and present land use are the main factors controlling types of woodland and forest.

Woodland gardens, in which varying successful attempts to re-create a woodland scene with its constituent wild species have been made, are found throughout the temperate regions. Most are based on an already existing woodland and enhanced by the introduction of selected cultivars of native species or exotic related species in the shrub and herbaceous layers. By careful yearly management and continual seasonal maintenance in order to increase the impact of the more colourful and unusual plants and to control the natural succession of the more rampant and duller species, it is possible to create a spectacular 'wild' woodland. The effect is often improved by the addition of a woodland stream—either by creating a completely artificial one or by re-routing and emphasizing a natural watercourse. Well-known examples of woodland gardens include Knights-hayes Court in Devon, the *Savill Garden in Windsor Great Park, and the Benmore Younger Botanic Garden in Strathclyde Region in Scotland.

Trees, and to a lesser extent shrubs, have been harvested and cultivated for timber for construction, and wood for fuel, fencing, and many other uses since the earliest times of civilization. Today commercial forestry is a major industry and substantial user of land in most countries. The cultivation of trees in gardens is rarely for timber production although mature trees often have a high timber value. Trees and shrubs are grown in gardens for a variety of purposes but the primary use is as essential elements of the overall garden design. They give diversity to the landscape at all scales and in all seasons. A group of trees is often the only topographical feature in an otherwise flat landscape.

Another common use of trees and shrubs is to provide a sun, wind, rain, or frost shelter; the success of many domestic and public gardens depends on a well-designed and maintained wind-break of evergreen trees, underplanted with shrubs. By strategically positioning single trees or a narrow belt of trees, a permanent visual screen can be created to hide an ugly landscape and to detract from excessive motion. Trees also can act as sound deflectors but it is arguable whether they can absorb noise.

With the destruction of hedgerows and their trees and the replacement of broadleaf woodlands by sterile coniferous forests, trees and shrubs in gardens are invaluable as miniature wildlife reserves. They are often marketed as suitable for the encouragement of birds and insects and the general increase of public interest in wildlife conservation has encouraged this trend. Shrubs such as *Buddleia davidii* (butterfly bush) attract large numbers of insects when in flower. Among suitable trees for birds are those that produce nesting spaces, such as *Cupressus macrocarpa* (Monterey cypress), or autumn berries, such as *Crataegus monogyna* (common hawthorn) or *Sorbus aucuparia* (mountain ash).

Since early times trees and shrubs have been grown as boundaries indicating different land uses and ownerships. Rows of native trees and shrubs planted to form hedges were well known in medieval gardens at least from the late 11th c. Associated with their use as property and direction indicators is their great value as protective barriers either to keep grazing stock and human trespassers out or to prevent domestic animals and young children from straying.

However, the main uses of trees and shrubs in gardens are based on their individual ornamental value and edible produce, these two characteristics often being related. The design features of trees and shrubs include overall shape and profile, the overall appearance, arrangement, shape, size, texture, and colour of the bark, branches and twigs, leaves, buds, flowers, and fruits, and the scent of the leaves, flowers, and fruits in many species. The sound of rustling leaves, as in the aspen (*Populus tremula*), is important in some plants. These design features can all vary from season to season and with the age of the plant. Of particular importance is the change of leaf colour in the autumn. The tree planting in such gardens as *Sheffield Park was based partly on this feature. Many trees and shrubs possess more than one of the important characteristics, for example *Prunus* species and cultivars have unusual overall profiles, shining red bark, and heavily scented masses of flowers followed by colourful and edible fruit, although in most species the leaves are dull. Birches (*Betula* species) have a paper-thin, peeling white, pink, or red bark, and the delicate leaves turn to a rich mixture of reds, yellows, and browns in the autumn. The catkin flowers are very attractive but the fruits are not noteworthy.

Apart from crop plants and their associated weeds, exotic trees and shrubs were among the first plants to be introduced to the British Isles from the European mainland, North Africa, and the Near East. Probably the first plants of this type to be introduced were roses, but trees such as the cypress (*Cupressus sempervirens*) and the plane (*Platanus orientalis*) were also introduced as early as the 14th c. The pomegranate (*Punica granata*), Spanish chestnut (*Castanea sativa*), mulberry (*Morus nigra*), and medlar (*Mespilus germanica*), although grown primarily for their fruits, are also ornamental species and were certainly introduced in Roman times before AD 500. The common horse-chestnut (*Aesculus hippocastanum*) was first grown in England in the early 17th c. and the evergreen oak (*Quercus ilex*) probably a century earlier.

Later introductions have been from North America, temperate South America, China, Japan, and the Indo-Himalayan region and relatively more recently from Australia, New Zealand, and South Africa. At the same time there has been a continuous programme of tree- and shrub-breeding and selection. Today this programme is scientifically based and aimed mainly at producing faster growing timber trees, improved palatability and longer storage life of edible fruits, and an overall increase in disease resistance and greater tolerance of climatic extremes. Nevertheless, horticulturalists also carry out *hybridization programmes particularly with trees and shrubs in which the floral charac-

teristics are the important garden feature. Hence today's magnolias owe much to the work of Charles Raffill at Kew and Todd Gresham in California. Among the shrubs and small garden trees plant breeders have been particularly active: *Syringa* (lilac) has a range of cultivars among its species, notably *Syringa vulgaris* with cultivars whose double and single flowers vary from purest white to deepest purple and are all sweetly scented. The breeders in this group were Victor and Emile Lemoine of Nancy, France, and Alice Harding in England. Probably the most extensive hybridization has been carried out among the roses and rhododendrons.

Most of the work of the tree- and shrub-breeders would not have been possible without the endeavours of the plant-collectors. Perhaps the greatest collector of all time was Ernest H. *Wilson (1876–1930) who brought many valuable ornamental plants from China such as *Acer griseum*, *Berberis* species, *Davidia involucrata*, *Magnolia delavayi*, and *Viburnum davidii*. Almost as prolific collectors from the same region were George *Forrest (1873–1922) who introduced the 'Forrestii' cultivar of *Pieris formosa*, *Sorbus harrowiana*, *Hypericum forrestii*, and *Rhododendron sinogrande*, and the earlier Robert *Fortune (1812–80) who was responsible for *Ilex cornuta*, *Prunus triloba*, *Cryptomeria japonica*, and *Callicarpa dichotoma*. North American plants such as *Abies grandis*, *Abies procera*, *Garrya elliptica*, *Ribes sanguineum*, and many *Pinus* species were introduced by David *Douglas (1798–1834) while South American introductions such as the Chilean monkey-puzzle (*Araucaria araucana*) were made by Archibald Menzies in 1795, and *Berberis darwinii* in 1849 and *Thuja plicata* in 1853 by William Lobb. Pre-eminent among the Himalayan collectors were Frank *Kingdon-Ward (1885–1958) and many of the herbarium botanists who sent back to Europe seeds and living plants, as well as collecting much material for scientific study.

Today in gardens throughout the British Isles there are well over 9,000 species and cultivars of native and introduced ornamental trees and shrubs and over 4,000 different fruit-trees and bushes. Stocks of many of these are available from commercial nurserymen such as *Hilliers of Winchester. Not all of these are hardy throughout the country and occasional prolonged and severe winters can seriously damage or even kill many plants, but these conditions rarely occur simultaneously throughout the British Isles and replacement plants can easily be obtained. P.F.H.

Treillage, trellis work, a traditional garden craft for supporting climbing plants. Pierre *Le Nôtre submitted the construction of trellis and vine supports as his *chef d'œuvre* for acceptance as a member of the Corporation of the Gardeners of Paris (1599). Materials used were willow and nut poles. In the 17th c. trellis work was made of Spanish chestnut and was painted. The elaborate architectural pieces in gardens of the late 17th c. and early 18th c. were, at least partly, of iron. K.A.S.W.

See also ARANJUEZ; HAGA.

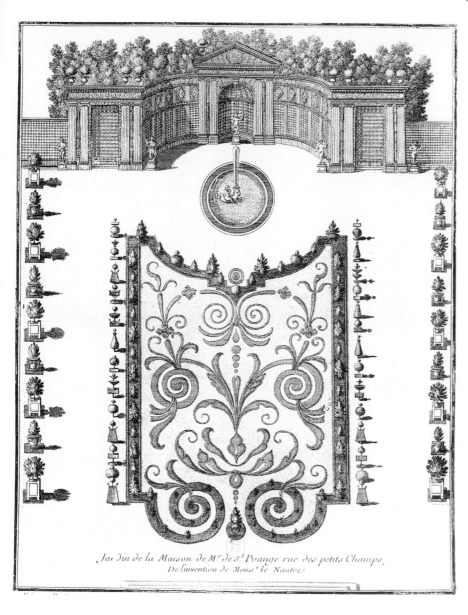

Jardin de la Maison de M.ʳ de S.ᵗ Poange rue des petits Champs,
De l'invention de Mons.ʳ le Nautre

Design for a treillage portico
and a parterre by A. Le
Nôtre, engraving (*c.*1700) by
Perelle (Bibliothèque
Nationale, Paris)

Trengwainton Garden, Cornwall, England, is a plant-collector's garden, a considerable part of which lies beside a very long drive and a stream which flows close to it, the rest being around the house from which there is a fine landscaped view of Mount's Bay. Five walled enclosures near the entrance contain some of the tenderest plants, which in most parts of Britain would require greenhouse protection, and more grow in another enclosure behind the house. Rhododendrons and hydrangeas dominate the drive-side garden with Asiatic primulas beside the stream but the collection contains a great range of plants, notably acacias, callistemons, camellias, magnolias, and michelias. It was made by Sir Edward Bolitho from *c.*1897; the National Trust which now owns Trengwainton has further diversified the planting.　　　　　　　　　　　　　A.H.

Trentham Park, Staffordshire, England, contains 25 ha. of flat pleasure-grounds and gardens with *c.*200 ha. of rising parkland to west and south. Early in the 18th c. there were formal gardens here and a small lake with a causeway walk across it. 'Capability' *Brown laid out the park and greatly extended the lake.

Between 1834 and 1842 Sir Charles *Barry laid out new formal Franco-Italianate gardens between the house and lake for the Duke of Sutherland, with elaborate *parterres of flower-beds, fountains, statues, vases, stone balustrading,

Trentham Park, Staffordshire, from E. Adveno Brooke, *Gardens of England* (1858)

and stone temples and pavilions. The gardens are now greatly simplified but some restoration is in progress. P.H.

Tresco Abbey, Isles of Scilly, England. Augustus Smith leased all the islands from the Duchy of Cornwall in 1834 and built himself a house on Tresco. The Gulf Stream drift ensures an exceptionally equable climate but the islands are exposed to severe gales. Smith laid out the garden in terraces much as it is today but died in 1874 before an adequate protective belt of evergreen trees had been established. Once the shelter was there the collection grew rapidly with the added protection of abnormally tall clipped hedges and is now the best of its kind in Britain, particularly rich in Southern Hemisphere flora. Smith died childless and Tresco Abbey passed to his nephew Thomas Algernon Smith Dorrien, later changed to Dorrien-Smith. It is still owned by this family. A.H.

Trianon. See VERSAILLES: GRAND TRIANON: PETIT TRIANON.

Triggs, H. Inigo (1876–1923), English architect and garden designer, studied architecture at the Royal Academy in London, thereafter specializing in the design of country houses, mostly in the south of England. He took an increasing interest in the layout of their gardens, becoming one of the first authorities on the history of the formal garden in Britain. Although published 10 years later than *Blomfield's The Formal Garden in England (1892), his book, Formal Gardens in England and Scotland,* was more effectively illustrated with photographs and drawings to support his theories. He also wrote books on Inigo *Jones (1900), *The Art of Garden Design in Italy* (1906), *Town Planning, Past,*

Present and Future (1909), and *Garden Craft in Europe* (1913). M.L.L.

Trompe-l'œil, a deceptive device, usually a painting on a wall at the further end of a short *allée*, that prolongs its perspective and makes it look much longer than it actually is. Against a blind wall, a trellis can be set representing the frame of a *tonnelle* shown in perspective, as a *trompe-l'œil*. D.A.L.

Tropical plant. See HOT-HOUSE PLANT.

Trough. See STONE TROUGH.

Tsarskoye Selo (Pushkin), Soviet Union, lying 22 km. from Leningrad, has two palaces: the baroque Yekaterininsky ('Catherine's' after Catherine I, 1762–96), given its final form by *Rastrelli for the Empress Elizabeth (1741–61), and the neo-classical Alexandrovsky by Quarenghi for Alexander I (1801–25), with their contiguous parks (102 ha. and 200 ha.).

Catherine I had a small house here with gardens in the Dutch style by Jan Roosen in the 1700s, but more imposing gardens in the grand manner accompanied the rebuilding of the palace, and those in front of the 300 m.-long east façade have survived. Beyond a striking parterre of arabesques lies a large formal composition of rectangles formed by straight *allées* and a canal. Eighteenth-c. Italian statues grace the avenues where the trees and *bosquets* were once meticulously clipped to form green walls. Among the impressive garden buildings, Rastrelli's Hermitage and Grotto are particularly outstanding.

When Catherine adopted the English style of landscape design with passionate enthusiasm (thereby demonstrating

her enlightened outlook) John *Busch and Vasily *Neyelov were called on to refashion the rest of the park. Earth was moved, trees were planted, the large rectangular basin became a 'natural' lake, 'natural' pools and watercourses were formed, and a range of new garden structures in the exotic styles fashionable in western Europe were built. A number of monuments were erected to commemorate victories over the Turks, among them Rinaldi's obelisk and rostral columns and Velten's Tower-Ruin. Vasily Neyelov's Palladian Bridge owes much to the bridge at *Wilton, though its setting recalls *Stowe. Tsarskoye Selo is particularly rich in Chinese buildings. Velten's Creaking Pavilion was set in a *Chinoiserie water landscape of tightly twisting banks and islands, preparing us for the Chinese Village, which is reached by way of the Grand Caprice, the Chinese summer-house on an archway spanning the drive to the palace, based on an archway in Fukien. The Chinese Village, in what is now the Alexandrovsky Park, was the largest group of Chinese buildings in Europe and was the work of V. I. and I. V. Neyelov and Charles *Cameron.

Cameron designed other buildings and bridges in the park, but his most important contribution was the elevated neo-classical covered promenade adjoining the palace, which Catherine allowed to be called the Cameron Gallery. Cameron placed it along the boundary between the formal garden and the newly planned landscape, where it served as a viewing platform for both and was also the focal point of the whole of the visible landscape. At the end of the 18th c. this included the model town of Sofia with its cathedral, also planned by Cameron. The streets of the new town were related to the composition of the park, and the lines along which they were laid out radiated from the Cameron Gallery.

The square formal part of the Alexandrovsky Park is surrounded by a canal and divided into four by intersecting avenues. In one of the quarters stands an artificial hill, Mount Parnassus. The park was extended in the 1820s in the landscape style by A. A. Menelas.

Wanton destruction and pillage by the occupying forces during the Second World War was followed by painstaking and admirable restoration. P.H.

See also RUSSIA AND THE SOVIET UNION: PETER THE GREAT.

Tub. See POT.

Tudor garden. The revival of interest in Tudor architecture in early Victorian times in England led to attempts to create gardens suitable in style to Elizabethan or Jacobean dwellings. Early revivalist designers like *Nesfield offered geometric parterres based on what they thought of as Italian precedents (see *Italian garden), but often based on the plans of *Le Nôtre's period; such *parterres usually gave on to open vistas and were planted with exotic bedding plants. During the 1850s and 1860s an increasing number of Tudor features—*mazes, *mounts, patterns created with coloured gravels or in the shape of monograms—were incorporated, but without affecting the late 17th-c. inspiration of most parterre designs.

An alternative was to use a planting scheme based on period precedent; this was largely accomplished by topiary during the early Victorian period, in gardens such as *Elvaston Castle, but herbaceous borders became popular as a way of achieving this effect. From the 1870s onward, enclosed gardens replaced the open parterre as appropriate Tudor style, increasingly planted with old-fashioned flowers. By the end of the century the herb garden had emerged as a further refinement, as had the Shakespeare garden, planted only with flowers mentioned in his plays; the most famous example of this was the Shakespeare garden at Stratford-upon-Avon, planted by Ernest Law shortly before the First World War. B.E.

See also ROYAL HORTICULTURAL SOCIETY'S GARDENS, KENSINGTON.

Tuileries, The, Paris, were created between 1564 and 1572 by *Catherine de Medici, remade between 1594 and 1609 by Henri IV, and transformed between 1666 and 1671 by André *Le Nôtre for Louis XIV. The gardens were open to the public from the early 17th c. onwards and are now one of the principal promenades of *Paris.

The site, formerly used for manufacturing bricks and tiles, was acquired by *François I to build a palace, a project ultimately realized by Catherine. The planting was supervised by Bernado Carnesecchi; the chief gardener was Pierre Le Nôtre. The layout of the *allées*, dividing the area into rectangular compartments, persists; but in Catherine's day pleasure and utility were to some extent combined, and the regularity of the layout was offset by considerable variety in the planting of the rectangles, some with fruit-trees or with groves in *quincunx, others containing features such as a labyrinth, and a giant sun-dial. Somewhere, probably attached to a building, there was a ceramic grotto by Bernard *Palissy. The compartments nearest the palace were laid out with dwarf shrubs and flowers in ornamental designs, and surrounded, in the customary way, by a low fence of trellis, with arbours at each corner. Beyond these, the three main *allées*, running east–west, were planted with fir, elm, and sycamore respectively.

Catherine left the palace incomplete, but used the gardens which, until 1664, were separated from it by a wall and public road. The gardens were the setting for a lavish entertainment given to the Polish ambassadors in 1573, when they came to present the crown of Poland to the future Henri III. They were almost destroyed during the siege of Paris by Henri IV. He restored them, adding the terrace which runs along the Rue de Rivoli, and which was lined with a double row of mulberry trees. Some 15,000–20,000 of these were planted in the garden, and a building was set up for the cultivation of silkworms and the early processing of silk. The terrace overlooked a row of ornamental parterres, bounded on the other side by an *allée* covered by a wooden *berceau* 600 m. long, punctuated by eight pavilions facing the transverse *allées*. Among the vegetal adornments were *palissades of jasmine, quince, pomegranate, judas

trees, and other shrubs and flowers. Gardeners in charge of different areas included Claude *Mollet, formerly gardener at Anet; Jean Le Nôtre, father of André; and Pierre Desgots, who married André Le Nôtre's sister. Each had a house built into the wall of the garden next to the Seine.

In 1664 these houses had to be vacated to make room for the Grande Terrasse along the river, which was part of a new design by André Le Nôtre. The wall and road separating the garden from the palace on the east were suppressed, and replaced by a terrace overlooking a large *parterre de broderie* with circular basins and fountains. The garden, now linked with the palace, was arranged symmetrically about the central axis with compartments of *broderie* or turf, trees planted in quincunx, or *bosquets* planted with spruce, horse-chestnut, and yew. The western boundary of the garden had previously slanted inwards towards the river; at the centre was a semicircular wall known as the Echo: outside was the orangery and a flower garden called, after its creator, the Jardin de Renard. All this was now taken into the garden and enclosed by a terrace. Le Nôtre's wide central *allée* gave the garden a marked axis, which was extended beyond the wall in an avenue (the future Champs-Elysées) in the direction of *Saint-Germain-en-Laye. The Cours de la Reine, made for Marie de Medici along the river, formed the second arm of a projected *patte d'oie*. To give an uninterrupted view from the palace to the horizon, the terrace on the west was open in the middle, except for a *grille*, access being by curved ramps on either side.

During the reign of Louis XV important sculpture was brought from *Marly, particularly the *Chevaux de Marly* by the brothers Coustou, which were set up at the entrance to the Champs-Elysées in 1794. Other works were subsequently brought from *Versailles, *Fontainebleau, *Sceaux, and *Ménars. A notable collection of statues by Maillol now adorns the gardens laid out on the site of the palace, which was burnt during the Commune of 1871, and finally removed in 1884. The opening of the Tuileries to the Louvre has left the small Arc de Triomphe du Carrousel, erected by Napoleon I in 1806–8, at the east end of a vista extending to the Arc de Triomphe in the Place de l'Etoile. Le Nôtre's design thus forms the basis of the axis of modern Paris.

K.A.S.W.

Plan of house and garden at Halland, Sussex, by Serge Chermayeff and Christopher Tunnard

Tulip. Tulips are such a familiar ingredient of the English garden today that it is hard to remember that the most popular kinds (cultivars of *T. gesneriana*) did not reach this country until towards the end of the 16th c. It was Busbecq, ambassador from the Holy Roman Emperor Ferdinand I to Suleiman the Magnificent, Sultan of Turkey, who first observed them in 1554 growing in Turkish gardens (see *Turkey: the tulip age) near Adrianople (Edirne). Mistaking the words of his guide, who was comparing the shape of the flower to that of a turban (*tulipand*), he established a name that has been perpetuated in the Western world; the Turkish (and Iranian) name is in fact *lalé*.

Busbecq carried back bulbs to Vienna, where they were bred and swiftly disseminated throughout western Europe by *Clusius. So popular did the tulip become that in the Netherlands in the 1630s there occurred the famous tulipomania, during which rare sports (produced by a virus which causes bulbs to 'break' unpredictably) fetched such fabulous sums that rash speculators were often reduced to bankruptcy. The craze, in a less exaggerated form, spread to England and France, and at a later date recurred in Turkey. In the middle of the 19th c. tulip societies flourished in northern England and in the Midlands.

The true origin of the garden tulip, now available in innumerable cultivars, is probably to be sought not in Turkey but in the Pamir-Alai and T'ien Shan mountains of Central Asia; there seems also to be a subsidiary distribution centre in Armenia and north-west Iran. About 180 species of the genus *Tulipa* are now known, some of which are natives of western Europe, and there are patriotic British botanists ready to claim that *T. sylvestris* is indigenous in certain parts of southern and eastern England. Many of the medium-height and shorter species have become essential features of every rock-garden, and some, such as *T. greigii* and *T. kaufmanniana*, have been successfully crossed to produce ravishingly beautiful hybrids.

About 1885 the famous Dutch firm of E. H. *Krelage obtained from an amateur grower in Lille a splendid collection of tall and vigorous 'Flemish' tulips which, with the permission of Darwin's son, Krelage renamed after the great naturalist. Broken forms he called 'Rembrandts'—perhaps an unfortunate choice since the uninformed wrongly assume them to be those that figure in 17th- and 18th-c. Dutch and Flemish flower-pieces. More recently, Darwins have been crossed with the enormous scarlet *T. fosterana* (this is now the correct spelling) from Turkestan to give the New Darwin Hybrids. Mendel tulips, a cross between the early-flowering 'Duc Van Tol' and the Darwins, came from Krelage in 1921.

Today the choice of hybrids and cultivars is almost

House and garden (1936) at Halland, Sussex (viewed from the south-east), by Serge Chermayeff and Christopher Tunnard

endless. For many people the so-called 'lily-flowered' varieties, with their elegantly pointed petals, are among the most attractive; others may prefer the wild baroque extravagance of the 'parrots'. Almost every colour except blue is now to be had, in both early- and late-flowering, double or single forms. W.J.W.B.

See also DE KEUKENHOF.

Tully, Co. Kildare, Ireland, a *Japanese garden of 0·4 ha., was begun in 1906 for the 1st Lord Wavertree and designed by the Japanese gardener, Tassa Eida, its tea-house, stone lanterns, bonsai, and a model village in Fujiyama lava being imported from Japan. The path through the garden has been devised as a symbol of man's pilgrimage through life. From the Gate of Oblivion it passes through a cavern and winds along the Path of Childhood, up the Hill of Learning, across the Bridge of Matrimony until it finally passes out through the Gateway of Eternity. The garden (at present being restored) is in a Japanese style which had already been influenced by Western horticultural traditions. P.B.

Tunnard, Christopher (1910–79), English landscape architect, was almost alone in England in interpreting into landscape the modern movement in architecture of the 1930s. He was educated in England, including a period in the Royal Horticultural Society's garden at Wisley. After working as an assistant to Percy *Cane, he set up in private practice in 1934. His major publication, *Gardens in the Modern Landscape* (1938), was a pioneer work in presenting landscape as an art independent of the academic traditions upon which the designs of contemporary English gardens were usually based. His pre-war gardens include St Ann's Hill, Chertsey (architect Raymond McGrath) and Halland, Sussex (architect Serge Chermayeff, *see pp. 566 & 567*). He was responsible with H. F. *Clark for the first major English landscape exhibition at the Royal Institute of British Architects in 1939. After this he emigrated to the United States, where he was invited to teach landscape first at Harvard and subsequently at Yale. His later published books reveal an uncertainty regarding his attitude to the Modern Movement, and his place in landscape history is secured more by his initial work in England. G.A.J.

Turfed seat. A feature of many enclosed medieval gardens was the raised seat or bench covered in turf. It was built against the outer wall or a central tree or fountain. Small flowering plants were often planted in the turf, such as camomile, daisies, violets, and strawberries. The seats were supported by wattle, boards, brick, or stone. Turfed mounds also doubled as seats, and some seats were inset in a thick hedge.

First mentioned by Albertus Magnus in *De Vegetabilibus et Plantis* (*c.*1260), turfed seats are plentifully illustrated in medieval books and manuscripts. M.W.R.S.

Turkey

TURKISH GARDENS IN OTTOMAN TIMES (1324–1922). The Turks are nomadic in origin and in some ways remain wanderers at heart, retaining a nomad's delight in nature in its virgin state and a love of the open air tempered by respect for its primeval powers. Accustomed as they had been to worshipping the elements, it was not until their conversion to *Islam that they found delight in gardens, seeing them as pale reflections of Muhammad's Garden of Paradise. However, Sultan Muhammad II's (1421–51) success in destroying the old Turkish families and in convincing all his subjects, regardless of rank, that their lives and properties were at a sultan's disposal, proved a serious obstacle to the establishment of hereditary estates.

Early Ottoman gardens. Although little is known as yet about Anatolia's earliest gardens they must have existed at such Seljukid palaces as Kubadabad, near Beyşehir, for Kiliçarslan IV's (1226–64) palace at Konia contained a kiosk, mistakenly called the Alaeddin, the ruins of which still survive. By Ottoman times kiosks had become essential to every garden of any pretensions (see *Ottoman kiosk). Joseph Grelot, who visited Constantinople (Istanbul) in *c.*1680 noted (in *A Late Voyage to Constantinople*, 1683) that 'the Turks take great delight in such buildings, there being few Serraglios which have not several belonging to them.

Some in the middle of the Gardens, for the benefit of the fresh air, others at the seaside, where there is any conveniency; others upon the tops of their houses like cover'd platforms.' An enchanting 16th-c. kiosk could still be seen some years ago overhanging the Bosporus at Anadolu Hissar. Built for Selim II it was called the Tulip Kiosk after the painted frieze within it showing single examples of all the varieties of *tulips in cultivation at the time. The Baghdad Kiosk in the Seraglio (the *Topkapi Palace in Istanbul) is a 17th-c. Turkish masterpiece in the Persian style.

Smaller Ottoman gardens were not divided into quarters as were the Persian, yet, like the latter, they consisted of square or rectangular walled enclosures which were often paved with marble slabs. According to Robert Withers (1650) Turkish gardens 'contained fountains in such abundance that almost every walk has two or three of them; such great delight doth the Grand Turk and all Turks in general take in them.' Where water had to be husbanded the fountain consisted of a jet set in a basin with the spray falling back into the container. Upright fountains—fountains of tears representing the celestial Salsabil (the fountain in Paradise)—were also economical and valued for the sound of water gently dripping from scalloped cup to scalloped cup, each of which projected from a marble slab which was

often carved with floral or foliage scrolls. Noisier fountains served to ensure the privacy of exchanged confidences. Whenever possible gardens also contained square or rectangular pools or marble basins capable of serving as ablution pools. Those on sloping ground sometimes overflowed into a series of diminishing basins to disappear in some low-lying glade.

Existing trees were always retained; where lacking, they were planted in rows along both sides of a straight path. Sweet-scented climbers were trained up the trunks of trees growing close to the house, or, failing them, on trellises. Rectangular flower-beds bordered the paths, linking the trees. Each bed was devoted to a single genus, often planted with little regard for colour. The beds nearest to the house were generally filled with roses, the flower which sprang from Muhammad's sweat, the petals of which were never allowed to lie on the ground. Tulips, the emblem of the House of Osman and Sultan Ibrahim's favourite flower, filled many beds; others contained carnations, hyacinths, and, under Muhammad IV, ranunculuses. Most sultans loved their private gardens, which were situated in the Seraglio's fourth court and extended over several levels. (See also *Byzantium, Gardens of.)

After the conquest of Byzantium. In 1427 Muhammad II moved his capital from Bursa to Edirne where he enclosed 700,000 sq. m. of land on which to build his palace and kiosks as well as his administrative buildings and domestic offices. On conquering Constantinople in 1453 he transferred his court there and moved into a palace built for him on the third of the capital's seven hills, but in 1453, using his Edirne palace as a model, he started building his permanent headquarters (now known as the *Topkapi Saray), on the site of the town's ancient acropolis. In 1465 it was ready to receive him and was to serve as the sultan's main residence till 1853, when it was abandoned in favour of new palaces built on the European shore of the Bosporus. Until the construction of the railway its grounds extended from the town's first hill to Seraglio Point and included what is now Istanbul's main park.

As at Edirne, Constantinople's Seraglio contained many buildings. In addition to the sultan's palace and harem it possessed several mosques and baths, vast kitchens and stables, administrative and domestic offices, barracks, schools, and an armoury, successive rulers adding to the number by building their own kiosks. Surplus plants from its 12 gardens were sold regularly in the town's main flower market. Nine hundred and twenty gardeners were needed to maintain its pleasure-grounds, orchards, and kitchen gardens. The Head Gardener carried a high rank at the Porte; it was his privilege to steer the sultan's barge, often his duty to serve as executioner. Private gardens must, however, have been rare in 16th-c. Constantinople for Ogier Ghiselin de Busbecq, the Holy Roman Emperor's ambassador to the Porte from 1554 to 1563, lived in a house which had no garden 'to take a walk in, nor so much as a path or shrub or patch of grasse on which to refresh the eye'. Yet, in Constantinople under Murad III (1574–95) model

gardens a square mere in size and made of wax or sweetmeats complete with walks, hillocks, flowers, and fruit-trees, were carried on slings in festive processions by slaves.

In large gardens nature rather than artistry dictated the layout for little attempt was made at landscaping a site, nor was there any desire for statuary or balustrading. Grelot noted with disdain that 'the Gardens have no Order'. In 1559 Thomas Dallam spent some months in Constantinople installing an organ in the Seraglio for the sultan. He was shown more of the Topkapi Saray than any of his Western contemporaries but he was too nervous to inspect it carefully and could only record that 'the Walks are, as it were, hedged in with stately cyprus tres, planted with equal distance one from tother, betwyxt them and behind them smaller tres that beare the excellent fruits'. Withers (*A Description of the Grand Signor's Seraglio or Turkish Emperor's Court*, 1650) mentioned seeing some 'fine greene grass plots on which Gazelle doe feed and bring forth young'; this must refer to the second court, that of the Divan. Later travellers mention areas reserved for archery, wooden javelin throwing (*jerid*), polo, hunting, and coursing.

The Tulip age. Although the tulip was cultivated by the Ottomans from the start of the 16th c. they did not succumb to the tulipomania which raged in the Netherlands between 1634 and 1637. However, the craze persisted in western Europe in a modified form until 1836 and it was from western Europe that it reached Turkey early in the 18th c., making so sharp an imprint on its arts and literature that the period is known as the Tulip Age. Ahmed III encouraged its cult by setting a fashion for seasonal and picnicking gardens, in April entertaining his guests on Seraglio Point by illuminating his flower-beds and trellises by candles and tiny oil-lamps backed with mirrors, sometimes even attaching lights to his tortoises and letting them free among his tulips. His successor, Mahmut I, preferred to place wooden pyramids and tiers in his garden, filling the latter with vases of tulips, oil-lamps, glass balls filled with coloured liquids, and caged canaries.

After signing the peace treaty of Passarowitz (1718) Sultan Ahmed appointed Mehmet Effendi as his envoy to the French court. The young diplomat was impressed by France and fostered the tulip cult by sending his sultan some rare bulbs of the flower together with some engravings of *Versailles, *Marly, and *Fontainebleau. Ahmed was so captivated by the French palaces that he decided to build one for himself at Sadiabad near The Sweet Waters of Europe, above Eyub on the Golden Horn. The layout of its grounds centred on an artificial cascade, a *chagleyan* (tinkling sound), which gushed over marble slabs through a series of pools as it rushed from one terrace to another. Forty orange trees in tubs, 170 kiosks, and numerous villas belonging both to Turkish and to foreign notables completed the scheme. Sadly, nothing survives, the site having been built over.

By the end of the 16th c. the sultans, their relations, and some distinguished foreigners were building their palaces

and houses along the shores of the Bosporus, adorning them with formal terraces and parterres of the French type. Two of the most important were designed by the landscape painter Antoine Ignace Melling whom the Russian ambassador had brought to Constantinople. He laid out the grounds and decorated the interior of Hadidje Sultan's palace at Ortakoy and built for her brother Selim III (1789–1807) the Cheragan Palace on the shore of the Bosporus where it has stood since 1910 as a burnt-out shell. Melling himself sent to Schönbrunn for Jacob Ensle, sometimes called Jacques, to become his assistant and head gardener.

The S-shaped beds in Hadidje Sultan's garden may perhaps have reflected English influence but it was that of Italy, alongside Germany's, which prevailed when the French lost favour following Napoleon's rise to power. Then formal bedding was much esteemed as were terracing, noble flights of steps, and, as at Dolma Bahçe, urns and garden ornaments. Later, under Abdul Aziz (1861–76) and Abdul Hamid (1876–1908), fear of assassination prompted a return to earlier traditions and although use was made of terracing, now combined with topiary, as at Yildiz, shrubberies, pools, fountains, and kiosks were once again highly prized. T.T.R.

POST OTTOMAN EMPIRE. Following the collapse of the Ottoman Empire in 1922 a new nation was born under the leadership of Kemal Ataturk. It was under his initiative that a new stimulus to gardening developed. He sent a young officer, Sami Bey, to France to study gardening. The officer returned to Ankara and was instructed to organize the Cankaya Palace Gardens. In 1933 Ataturk established a large forest farm in Ankara and in 1936 a fine garden was created for him at the Termal Hotel in Yalova. About this time work started on the Izmir International Fair. From a mosquito-infested derelict area a fine park was created within which gardens, buildings, and other facilities were set.

During the 1950s many villa gardens were built over or fell into disuse. The economic conditions did not allow the creation of new public gardens or even adequate maintenance of existing ones. In the last decade, however, an increasing number of villa gardens have been constructed throughout the country. This revival is even clearer in the treatment of historical gardens. After years of neglect the once fine gardens of *Yildiz Park, Camlica, and *Emirgan Park in Istanbul have been restored by the Turkish Touring and Automobile Association (TTOK). Turkey is now moving into a phase of increasing development of public parks and exhibition sites, tourist villages, hotels, and private villas, all of which have stimulated a renewed interest in garden design. R.ST.

Turkish tent, brought into the English landscape garden by a taste for the exotic in the 1750s, at the same time as *Chinoiserie. Henry Keene designed a tent for *Painshill of blue and white canvas on a brick base; there was a similar one at *Stourhead, although one visitor, John Parnell, found it inferior to its Painshill cousin. A supper-box or pavilion in Vauxhall Gardens was decorated as a Turkish tent. Turkish tents were also built in other parts of Europe, for example at *Drottningholm in Sweden, at Bellevue in Ireland, and at the *Désert de Retz and Groussay in France. M.W.R.S.

Turner, Richard (c.1798–1881), was a Dublin ironmaster whose Hammersmith Iron Foundry was responsible for the most important range of iron conservatories during the Victorian period. Works for which he was either partly or solely responsible include the Palm House, *Kew, the Palm House, Belfast Botanic Gardens, and the Curvilinear Range, Dublin Botanic Gardens, *Glasnevin. His conservatory for the former garden of the Royal Horticultural Society at Kensington (see *Royal Horticultural Society's Gardens) has been demolished and his brass model for a

Turkish Tent at Drottningholm, Stockholm, Sweden, designed in 1781 by Carl Frederic Adelcrantz

Winter Garden for the King of Prussia lost. Of his medium-sized conservatories for country houses the most important extant are at Ballyfin, Co. Laois, *Kilruddery, Co. Wicklow, and Marlfield, Co. Tipperary, while those at Woodstock, Co. Kilkenny, and St Ann's, Dublin, have been demolished. Of his smaller models, those at Rokeby Hall, Co. Louth, and Rath House, Co. Laois, remain and of his more utilitarian hot-houses, those at Aras an Uachtarain (the President's House), Dublin, and Bellevue, Co. Fermanagh, are the most interesting.

Turner's conservatories were in a curvilinear style with domes, barrel-vaulted galleries, and semicircular apses. His ornamental garden ironwork also included railings like those round the park of Trinity College, Dublin, and bridges like that in Cahir Park, Co. Tipperary. His style influenced provincial Irish ironmasters like Pearce of Wexford and Malcolmson of Waterford. P.B.

Turner, William (c. 1508–68), who has been called the father of English botany, was educated at Cambridge, where he studied medicine and took holy orders. His sympathy for the Reformers led by Latimer and Ridley drove him into exile abroad in 1540. He returned in 1547, becoming physician to the Duke of Somerset. At this time he also had a garden at Kew. In 1550 he was appointed Dean of Wells, but three years later Mary's accession sent him back into exile for another five years.

His *herbal (1551–68) was the first in English to include original material about native plants. It was preceded by a Latin catalogue of plants, sometimes with Greek and English names added, published in 1538, and *The Names of Herbes*, which appeared 10 years later, an extended catalogue in English. These two little books and the herbal contain the first English records of many plants, the results of Turner's own explorations.

He also studied animals, publishing a small book on British birds and collecting information on local fishes.

 S.R.

Twickel, Delden, Overijssel, The Netherlands. The history of the castle gardens can be traced from the 17th to the 20th cs. In c. 1700 the early 17th-c. square Renaissance garden, surrounded by a canal and trees and containing orchards, bleaching grounds, and knot and kitchen gardens flanked by wooden tunnels, developed into a baroque rectangle with an exedral termination. Daniel *Marot con-tributed a design for parterres, and for *bosquets* whose design resembles those at Kensington Gardens (c. 1710). To accommodate a picturesque *anglo-chinois* garden, the canal around the rectangular framework was enlarged in c. 1790 to form a lake and sinuous waterways, within which lay a 'French wood' with a hermitage in a tree, an 'English park', and remnants of the Renaissance orchard; outside lay a deer-park, a mount, a gardener's cottage, a chapel, and along the lake a fisherman's hut, a ferry boat, and an ice-house.

In c. 1830 J. D. *Zocher the younger removed nearly all traces of associative elements and, with an emphasis on water and trees, simplified the gardens according to Brownian principles. Between 1886 and 1890, Eduard *Petzold and Edouard *André contributed designs; the former, landscape parks in the spirit of *Pückler-Muskau and the latter, formal parterres near the orangery. In 1907 a menagerie of topiary animals populated the orangery garden and in the park a rose-garden was laid out by Rabjohn. In 1920 Baroness van Heeckeren laid out a rock-garden, on the site of the picturesque deer-park, under ancient oaks with fine shrubs and herbaceous plants, such as *Enkianthus cernuus* var. *rubens, Stewartia pseudocamellia, Kirengeshoma palmata, Primula auricula, Smilacina racemosa,* and *Trillium grandiflorum*. F.H.

Tyringham, Buckinghamshire, England. In the setting of a house originally built by Soane in a Humphry *Repton park, *Lutyens in 1924 determined his grandest formal garden—a faint reverberation from *New Delhi. A sheet of water 30 m. wide runs axially northward from the house for some 150 m., spanned by a grass causeway. On this, twin stone columns topped by lead animal water-jets stand above a circular pool, marking the division of the canal into two sections, the longer formed as a bathing-pool with steps descending under water. At either end of the causeway stands a classical domed pavilion of stone, one built as a Temple of Music (with an organ below a grille in the floor), the other as a changing-room; the approaches from the house are by gravel walks and planted enclosures of box topiary along each side of the pool. The view down the long water is of open fields, formerly framed by a double avenue of elms. Created for the banker and theosophist F. A. Koenig, this garden of c. 1.5 ha. appropriately evokes a strong impression of dignity and serenity. The layout has been preserved and can be seen on application to the present owners, the Tyringham Clinic. I.L.P.

Umbrella (or umbrello), in garden terminology a seat round an upright stem beneath a shade at the top. It was popular in England in the 18th and 19th cs. and several designs for umbrellas are to be found in the pattern books of the mid-18th c. An equivalent term is parasol seat. There was a Chinese umbrella at *Stourhead drawn by F. M. Piper, and *Stowe had more than one umbrella.

<div style="text-align: right">M.W.R.S.</div>

United States

GARDENS OF THE EARLY SETTLERS. The 'gardens' seen by the early explorers on the shores of North America were the work of Indian tribes who populated, however sparsely, those unexplored coastal cliffs and meadows. That the settlers referred to them as 'gardens' reveals both the skill of the natives and the inclinations of the settlers. For, in early 17th-c. colonial America, gardens were symbols of survival (see also *Dutch colonial gardens: New York). Explorers had reported upon the fertility of the soil, the prevalence of springs, the overwhelming plenty of wild fruits, the availability of timber for building and burning, the quantities of fish, and—being quite honest—the extremes of climate, the hordes of insects, and the dearth of gold.

The first pictures of American gardens in the New World were John White's drawings for Thomas Hariot's *Briefe and True Report of the New Found Land of Virginia*, published in 1590 by the equally enterprising De Bry of Frankfurt. The engraving by De Bry of 'The Towne of Secota' shows the sophistication of arrangements for convenience and beauty: huts in rows; neatly trimmed edges around a dance circle and a fire; a border of melons; a circular bed of tobacco; sunflowers grown separately in ornamental groupings; and Indian corn in blocks surrounded by paths. A look at the original sketch reveals White's town as having none of the amenities assumed by De Bry—in fact, the various crops, apart from the corn, are not even included.

The gardens of the New World as undertaken by the settlers of Virginia and New England began with the standard garden practices of their native countrysides, the villages and hedged fields of their origins. First accounts of the substance of New England gardens show an overriding purpose of comfort beyond mere survival. John Josselyn left careful descriptions of the gardens of the first half of the 17th c. in New England. He made two visits: in 1638, for little over a year; and in 1693 for eight years. His two books, *New England's Rarities* (1672) and *An Account of Two Voyages to New England* (1673), give us a painstaking account of the plants grown in gardens 'such as are common with us in England' and those 'as are proper to the country'. Many are listed for their medicinal uses since he was given to treating his neighbours, as when he restored a man to health after a heat-stroke by a week's diet of pure spirits in a 'Syrup of clove gilliflowers'. As he also fancied himself as a cook, we have an attractive assortment of herbs needed for the proper cooking of an eel.

His accounts of flowers grown, native or imported, follow exactly the order in the 1633 edition of *Gerard's Herball*, edited by Thomas Johnson. Where Gerard makes no mention of several commonly encountered New England wild flowers, Josselyn has essayed to draw them himself, such as 'Skunk Cabbage' (*Symplocarpus foetidus*), 'Winter Green' (*Goodyera pubescens*), and 'the Hummingbird Tree' (*Impatiens biflora*), and 'one with flowers shaped like the head of a serpent' (*Chelone glabra*). He mentions raised beds but no overall design.

The design of early gardens had to depend upon convenience and efficient management. With stock allowed to wander, fencing was regulated by law. Houses built along main streets are recorded as having gardens on one side and orchards on the other and so on for miles. With houses built around a green, gardens and orchards extended to the rear. All were recorded in the mid-17th c. by Edward Johnson in his *Wonder Working Providence of Sions Saviour in New England* as 'bright with a variety of flowers'.

Ship timbers from North America had been of paramount importance to naturalists like John *Evelyn, but they soon yielded first place to new plants sought out by English botanists. While the younger *Tradescant on his voyages to Virginia in 1637, 1642, and 1654 found conditions still so primitive that he profited chiefly by having a species of modest merit named after him, later botanists sent by Bishop *Compton were more successful. Traffic in possibly useful plants gradually gave way to English demands for ornamental plants and trees as soon as sea captains could be persuaded to take care of living specimens on decks and even in their cabins. One of the leading London plant-collectors was Peter *Collinson (1694–1768), whose American correspondent was John *Bartram

(1699–1777) in Philadelphia. Between them they introduced over a hundred new plants to thrive in English gardens. In turn, English garden bulbs were strewn across Pennsylvanian uplands and the present miles of box borders in Virginian gardens probably derive from these exchanges. (See *Whipple House Garden; Colonial *Williamsburg).

Settlers were progressive in adding to traditional English *cottage garden stand-bys the beautiful plants and trees of their new countryside. But as yet design followed planting convenience, although in the Carolinas and further west as time went on, even into the 19th c., an 'English' garden meant one with a geometric design, however simple.

THE DEVELOPMENT OF AN AMERICAN STYLE. The first American to bestir himself to improve public taste was Thomas *Jefferson of Virginia. Intent upon moulding a new nation, he also designed appropriate buildings and gardens for his friends as well as for his own country estate at *Monticello. George *Washington was another amateur architect and landscape gardener (see *Mount Vernon) as well as an ambitious agronomist and nation-builder. He brought in many native trees and shrubs from his rides about his farms to embellish his gardens and he also patronized the *Prince Nurseries on Long Island and the *Bartram Nurseries near Philadelphia.

During this period of rapid development a distinctively American feature of the garden scene was the layout of planters' gardens along the coast and on tidal rivers from Maryland to South Carolina. Some of the large river plantations standing high above rivers had a splendid succession of terraces or falls (as they were called) between each house and its river. The falls were handsome architectural features and not to be cut up by flower-beds or other planting. A fine series of examples is represented by the *James River Plantations.

A breakthrough in American gardening came in 1803 when Jefferson quietly doubled the size of the United States by means of the Louisiana Purchase. The rich lands to the west of the original colonies were suddenly opened up and American gardeners and European botanists eagerly awaited the discovery of new plant material. In 1801 André *Michaux published his still definitive volume on American oaks; his son François André *Michaux made a study (published between 1810 and 1813) of the naturalization of American trees on French soil. Enthusiasm for American plants ran so high that in 1822 the younger Michaux designed his tomb near L'Oise in France to be surrounded by American trees; and *American gardens were a popular feature in Regency England.

The houses and gardens of the traders along the Missis-

Riverside plantation garden, United States, oil painting (c.1825) by an unknown artist (Metropolitan Museum of Art)

sippi (as for example, at Natchez) are quite different from the planters' houses of the east coast, where the owners lived beside their wharves and among their tobacco fields. Here cotton or sugar-cane were the crops and the owners of the vast plantations congregated into congenial groups. Like future American suburbs of affluence, similar, equally grand, town houses were surrounded by well-tended formal urban gardens. Today wistaria climbs to the tops of gigantic trees and the patterns of paths and flower-beds have been greatly simplified, but the atmosphere of mutual affluence is still rampant. Everything abounds—tulips and roses, lilies, azaleas—while the houses rise rather massively, not unlike those of the East India Company's merchants along the River Hooghly in Calcutta.

Until the Louisiana Purchase, the gardens on the North American seaboard had been, at first, the traditional settlers' gardens contrived from essential plant material efficiently laid out for constant use, and then—with relaxation from early strains and uncertainties—an elaboration of much the same materials arranged for enjoyment. Early settlers had gardened alone and on their own with what help they could expect from indentured equals who left to make their own homes as soon as indebtedness was paid off—a mutually ambitious arrangement for forming a new sort of social structure on untried land. The larger holdings and greater garden plans south of New England and New York were largely dependent upon slave labour, but even with slaves to do all the heavy work, slave-holders like Washington, Jefferson, and Lady Skipwith were deeply involved in designing and maintaining their own gardens and seem to have felt competent to please themselves with little reference to what was taking place abroad.

With the arrival in the 19th c. of English writers come to study new government and institutions and to publish their findings on all matters American, the debate of what really constituted a garden was joined. While Mrs Trollope and the Basil Halls had been impressed, on journeys up the Hudson, by lawns running down to the water, cottages embowered with vines and surrounded by gay shrubberies, and great estates overlooking beautiful stretches of the river for miles, they had to remark on the lack of planned landscape design, comparable to what they admired in England. Americans, rather pleased with their own efforts, tactfully explained that while landscape planning in England depended upon judicious planting, in the New World it relied upon skilful cutting. Though suiting their gardens to their own sites and tastes had sufficed for many years, Americans were open to innovations, which slowly began to be introduced. Surprisingly, the definition and example of natural landscape design in what came to be considered the English school was brought to American gardens at second hand in the person of André *Parmentier.

That the idea had been arrived at through the early landscape design of 'rural cemeteries' is shown from the earliest years when the most beautiful spots—usually hilltops—had been set aside as burying-grounds in towns where the farms and plantations on the eastern seaboard had designed their own family burial sites. This was notice-

able at Mount Vernon where a tomb is set into a hillside, at Monticello, which has carefully designed monuments in a grove, at Lady Skipwith's, where the family burial plot is like a smaller walled garden below the large one, and at General Jackson's *Hermitage (Nashville, Tennessee) where the family tomb occupies a corner of the formal garden.

It was from this idea of a rural cemetery, laid out in a natural manner with both indigenous and exotic trees and shrubs and frequented for pleasure by an admiring public (see *Mount Auburn), that the possibility of American public parks was first put forward towards the middle of the 19th c. by the arbiter of American gardening, Andrew Jackson *Downing. He also adapted to American conditions the ideas of John Claudius *Loudon. Abandoning any idea of imposing English principles upon American ways of life, Downing set out to address the problems of the American public directly. To do so, he achieved a series of metamorphoses in Loudon's definitions, in particular, of the picturesque and the beautiful. His first book, *A Treatise on the Theory and Practice of Landscape Gardening* (1841), was the first important American book on the subject, and on the infinitely varied soils and climates of North America. An ex-nurseryman and an expert gardener, he had early on laid out his own *Newburgh Garden. In 1850 he visited England and secured the services of Calvert Vaux to help him in Washington, in laying out the grounds of the Capitol, the White House, and the new Smithsonian Institution. After Downing's early death, Vaux carried out their joint plans, and became involved in the planning of *Central Park, New York, a milestone in the development of landscape design in the United States.

While Downing had sought to adapt Loudon's views to American conditions of soil, society, and climate, he presented in full Jane *Loudon's advice in her *Gardening for Ladies*, published in the United States with an introduction by Downing in 1849. For Downing was anxious to persuade American women to undertake gardening activities on their home grounds. Like all women in frontier societies, American women had enjoyed a position of favour and influence. Allowed to be arbiters in the home, the purveyors of both education and taste, they suddenly found themselves singled out by both sentimentalists and budding scientists to further for Americans the popularization of the plant world. Two dissimilar pressures to this end arose separately. The first was seemingly frivolous—a cult of the 'language of flowers', an idea not entirely new, but now vastly celebrated in little gift books. Secondly, it was decided in the 19th c. that botany was a subject which should be universally taught in public schools.

Furthermore, thought of as more adapted to women's tastes in fancy-work, it was small wonder that the use of the giddily bright small annuals from Texas and Mexico, which flooded the garden market, resulted in the completely new sort of garden design known as bedding-out—in *carpet and ribbon bedding.

With Downing's untimely end the void left in guiding American taste in landscape design was rushed into by several of his avowed disciples. There was a spate of small

books on the subject of every man building his own home and laying out his own garden and grounds to suit. Builders presented sketches and plans, all more or less elaborate according to the size desired, all premised by the idea that every American man could and should have his own home. Styles were borrowed with reference to the climate and existing landscape, Gothic being acceptable in both cottage and mansion, and in both wood and stone, while Tuscan was favoured by those for whom bricks were available.

The ideal American suburban garden was defined by Frank J. Scott in his *The Art of Beautifying Suburban Home Grounds of Small Extent* (1870), dedicated to Downing, which offers two main ideas which have become ingrained in the designing of landscape and gardens in American small towns. Often puzzling to foreigners, gently derided by the French as *jardins communicants*, the practice is to maintain a series of adjoining front lawns the length of town or city blocks. The passing stranger can enjoy an uninterrupted expanse of groomed greenery while the owners of the symmetrically placed individual houses achieve privacy and their own styles of gardening only in the rear of their property. Scott presents the social obligation behind this sacrifice of space. 'It is,' he says, 'unchristian to hedge from the sight of others the beauties of nature which it has been our good fortune to create or secure.' Walls, high fences, belts of trees, and shrubbery, 'used for that purpose only' are simply means 'by which we show how unchristian and unneighborly we can be'. To Scott we owe also the then novel idea of compatible gentlemen buying up a desirable piece of property to build upon and landscape to suit themselves. A.L.

See also CHARLESTON; GARDEN CLUBS IN THE USA; MOUNTAIN SHOALS; ROSEDOWN.

THE RISE OF LANDSCAPE ARCHITECTURE. Frederick Law *Olmsted's work at Central Park (from 1857) initiated a marked change of direction away from garden design (see *public parks: the parkway system). For the next 30 years, his own practice concentrated on large-scale *landscape architecture, such as parks in Boston, and the Yosemite conservation scheme. Reviewing this period, he himself noted (in 1888) that there were very few landscape gardeners 'who have shown or are likely to possess any respectable power of dealing with the problems of the class that properly come before the Parks Commission of a large and growing city'. The only exceptions Olmsted admitted were his old partner, Calvert Vaux, Jacob Weidenmann, and H. W. S. Cleveland. Apart from his *Beautifying Country Homes: A Handbook of Landscape Gardening* (1870), little is known about Weidenmann's work, apart from his pioneering role in the movement for park-like cemeteries. Cleveland is an equally shadowy figure. He set up an office for 'ornamental and landscape gardening' as early as 1855, and although he subsequently had offices in Chicago and Minneapolis, we do not know what his garden designs were like.

The Country Place era. The opportunity for garden design came with the Country Place era, which lasted from the 1880s to the 1920s. American individualists and financiers spent their vast, virtually untaxed fortunes in conspicuous consumption—buying large country places and laying out gardens to match, often in a (just) recognizably European style, in order to achieve cultural status. One of the earliest and most magnificent was *Biltmore, begun in 1880. The François I style of the house finds an odd complement in the garden, modelled after aspects of *Vaux-le-Vicomte by Olmsted. However, the Italian villa, not the French château, was to be the source of inspiration for later gardens of this era.

Charles A. *Platt's *Italian Gardens* (1894) was the first of a series of books by American visitors (including the novelist Edith Wharton) recording their enthusiastic appreciation of the integration of indoor and outdoor space, and the happy relation between architecture and site so typical of the Italian villa. Platt's first major commission was Faulkner Farm, Brookline, Mass. (1897), the first of a long series of

Charles A. Platt's own garden, Cornish, New Hampshire, United States

designs mainly on the east coast, strongly architectonic in character, but never formulaic. A more literal version of the Italian Renaissance than Platt would have designed is *Vizcaya, Florida (1912–16); more imaginative, and coming towards the end of this era, is *Dumbarton Oaks, Washington (1921–47), designed by Beatrix *Farrand.

See also HEARST GARDENS; LONGWOOD GARDEN; NAUM-KEAG; OLD WESTBURY GARDENS.

The era offered so many opportunities for lavish spending on gardens that it was possible to work in a variety of styles. An outstanding example is the work of Jens *Jensen, who practised what came to be known as the 'Prairie Style'—the use of native trees, shrubs, and wild flowers. However, Jensen was perhaps rather an exception in his knowledge of native plants and their design application.

Increasing taxation and the great crash of 1929 effectively put an end to the creation of large-scale landscape gardens, and the initiative eventually passed again to landscape architecture. P.G.

See also ARNOLD ARBORETUM; LAFAYETTE GREGG GARDEN; MISSOURI BOTANICAL GARDEN.

MODERN GARDEN DESIGN. Modern art and architecture is essentially a 20th-c. phenomenon, although its roots can be traced back into the 19th. It was basically a response to the impact of industrial technology on cultural life and the environment. Artists began to see the world in many new and different ways, and architects developed new building forms to house new functional and social demands with new building technologies, and to respond to the new vision of the artists. Landscape architects were slow to respond to these influences, seeing themselves as closer to nature than to technology, but eventually could not resist the influences from the allied arts. Not only were they timely, but they were ultimately much more interesting than the old tried-and-true formal–informal Beaux Arts system.

Response in North America came in the 1930s. It began in San Francisco, in the office of Thomas *Church, and in Cambridge, Massachusetts, at Harvard University's Graduate School of Design, in the work of three students—James *Rose, Daniel Urban *Kiley, and Garrett *Eckbo. These four, soon reinforced by many others, began the search for new landscape and garden forms to complement the new forms that art and architecture were bringing into the world. However, the landscape response was bound to be different, because it had to create connections between that new vision and the ongoing world of nature.

Before the modern movement there were two basic plan patterns. One was formal, geometric, axial, and symmetrical. The other was informal, irregular, ungeometric, and asymmetrical. All of these terms may be good or bad as design criteria, depending on how they are used and interpreted. However, continuous and more or less mechanical repetitious use of certain basic patterns, and the adjustment of problem situations to these fixed vocabularies rather than the reverse, had created near-total sterility in conventional landscape and garden design.

Inspiration from modern art and architecture came as a fresh ventilating breeze through this restricted and stuffy warehouse of standardized forms. It soon became clear that there were not just two kinds of form to use in solving landscape problems, but dozens, hundreds, limitless possibilities. The forms were not applied to the problems but grew from them. They were not based on the separation of man and nature—formal and informal—but on their possible integration in various proportions. The designer did not approach the problem with a limited preconceived vocabulary to which it must adjust. Rather, he or she approached it with an open mind, aware of 20th-c. culture in general, but focused on analysis of the problem—including both site and client—and deriving from that the forms for the solution, the design plan.

Often, in the early days, one could trace clearly the movement of forms from modern art and architecture into the landscape vocabulary. Some of these forms became habitual, used repeatedly and often in haste, and became clichés comparable to the clichés of the traditional Beaux Arts. But the general impact of modern design on garden and landscape was invigorating, refreshing, inspiring, challenging, and often charming and beautiful.

Modern design swiftly became the dominant garden and landscape vocabulary through the middle third of the century. An entire generation of design firms established reputations as modern designers—names like *Halprin, Royston, Sasaki, Walker, and Friedberg dominate the field. However, these successful offices are only incidentally garden designers; their primary work is larger-scale public and private development. Garden design has been distributed among hundreds or thousands of smaller offices, and their work is not necessarily consistent or self-conscious in its design vocabularies. It is easy for them to sink back into the old long-established formal–informal design vocabularies.

What does a modern American garden look like? How do we identify it? The Californian garden for outdoor living was the prototype but not the only form. It concentrated on patio, terrace, and play space, particularly on lots of less than a half acre. Plants were used to augment living activities—trees for shade, shrubs for enclosure, grass for play surfaces, ground-cover plants elsewhere. Particularly in the eight-month dry season climate of California and the south-west the maintenance of only such hardy functional plantings was a great boon to the expanding generations of new suburban home owners whose interest in and knowledge of plants and planting were limited.

The inspiration of outdoor living produced many delightful gardens which maximized the living space within their boundaries and expanded their owners' horizons. The idea spread far beyond California, around the world in fact, to meet and merge with older Latin, Mediterranean, and Moorish prototypes.

The more aesthetic or esoteric aspects of garden design, the garden as art, have also been expressed in modern vocabularies. These have been interlocked with living elements. Americans rarely produce or attempt gardens for

pure artistic contemplation, as the Japanese do so well. But there have been many examples of sculptural, painterly, and architectural forms in modern gardens, particularly on larger sites such as the famous *El Novillero garden by Thomas Church. Roberto *Burle Marx, in Brazil, is the outstanding practitioner of modern garden design as art.

It is probably true that modern garden design in the United States may be characterized as having free irregular geometric plans which combine rectangular, angular, and curving patterns. These patterns are, to a great extent, created by structural elements: paving edges, steps, terraces, retaining walls, fences, screens, trellises, walls, pergolas, pools. Planting tends to follow and reinforce these patterns, but not to the extent of precise trimming. Thus the modern garden has tended to displace the old formal garden forms, which trace back through Europe to the Middle East. The urge to informal or naturalistic gardens, particularly in the northern and eastern temperate climates of the United States, still tends to follow Olmstedian, Reptonian, or romantic precepts. Often the comfortable modern living garden is ensconced in settings of natural meadow, woodland, or chaparral slope.

Modern American landscape design began with large ideas and bold all-encompassing theories (Eckbo, *Landscape for Living*, 1950) but in the course of adjusting to the realities of professional practice gradually took on the characteristics described above. While in theory it set out to bridge the gap between human and natural design—formal and informal—it never fully succeeded, although here and there it made long steps.

In the 1960s new political and social forces came into play, finding modern design a part of the establishment structure. The general push to correct injustices and further minority interests produced two forces which have had substantial impact upon landscape architecture as a profession, and garden design as an activity associated with it. These two forces are the environmental movement and the community participation movement.

Concern for the environment quickly had a political impact in the form of broad protective legislation, and professional impact in doubling the size of the profession of landscape architects, the only one fully competent to work between man and nature. The impact of environmentalism on modern design has been to weaken it by equating it with development, as something undesirable. The central problem, the bridging of the gap between human culture and nature, remains to be solved.

Community participation in the environment, outside of private gardens, means design participation by users. Essential though this is politically, it carries with it a certain tendency to reduce design to an average, practical, or median level. The average citizen may not be prepared to engage in sophisticated or esoteric design explorations. However, this may be more a problem of language than of motivation. This can have an effect on private gardens. It can be seen in American garden journalism, where repetition of safe precedents—formal, informal, or modern—has replaced new, daring, or exploratory efforts, or a continuation of the search for meaningful form. Post-modernism, in garden design as in architecture, may be merely a retirement into tiresome or startling eclecticism. G.E.

See also NEUTRA, RICHARD; NOGUCHI, ISAMU; WRIGHT, FRANK LLOYD.

Uruguay. See SOUTH AMERICA.

Utens, Giusto (d. 1609). Between 1599 and 1602 this artist of Flemish origin executed for the *salone grande* at the Villa di Artimino a series of lunettes (tempera on a canvas 142 cm. × 240 cm.) of gardens in the area around Florence. We know that Utens personally visited every villa to draw the dimensions of the buildings and the surrounding terrain. The perspectives are sometimes falsified so as to be able to show in one single view all the elements of the property, which in reality could not be included in one view—all the trees, whether ilexes or cypresses, are of the same height, and no distinction is made between the various types of cultivation. Eighteen are said to have been completed, of which 14 survive: 11 in the Museo Topografico, Florence, 3 in the collections of the Soprintendenza di Beni Artistici e Storici, Florence. Among the gardens illustrated are *Il Trebbio and *Pratolino. P.G.

See also ITALY: FLORENCE AND GENOA IN THE SIXTEENTH CENTURY.

Vacherot, Jules (1862–1925), French garden designer, very quickly became head gardener of the city of Paris. A disciple of *Le Nôtre, *Alphand, and *Barillet-Deschamps, he created a number of public and private gardens, among them the gardens round the Tour Eiffel, the Trocadéro, the Champs-Elysées, and the Grand Palais in Paris; the residence of King Leopold II of Belgium at Saint-Jean-Cap-Ferrat on the *Côte d'Azur; and the garden of M. Potin at Neuilly-sur-Seine. He worked in a mixed style, uniting the geometric and landscape manner. A typical example of his work was the park of the Château de Bijou.

Finally, he was for a long time President of the Committee for the Art of Gardens of the Société Nationale d'Horticulture de France, and professor at the Ecole Municipale d'Horticulture of Saint-Mandé in the Paris region.

C.R./S.Z.

Valdštejn (Wallenstein) Garden, Prague, Czechoslovakia, is situated in the Prague Historic Reserve, in Malá Strana (Lesser Quarter), and is 1·6 ha. in area. In 1623 Count Albrecht Valdštejn (of Wallenstein) demolished an entire medieval town quarter in order to build on its site a palace with four courts and a garden, designed by Andrea Spezza in an early baroque style. The whole garden space is dominated by the *sala terrena* by G. B. Pieroni, with paintings and stucco decorations by B. Bianco. In the parterre facing the imposing building is situated the bronze fountain (by Adrian de Vries, 1626) with the Renaissance statuette of Venus (by Benedikt Wurzelbauer, 1599). An avenue of bronze statues of antique deities and heroes, also by Adrian de Vries (1627), lies on a low terrace. The original sculptural adornments of the garden were taken to Sweden in 1648 as war spoils; they were replaced by copies in 1914.

A clipped hornbeam avenue of *bosquets* leads from a baroque *bassin* to a large square pool with a round island in the middle accented by a statue. The whole garden space is isolated from the surrounding town by the walls of the palace, the arcaded façade of a riding-school (now a gallery), and a very high wall covered with artificial stalactite decorations, against which leans an aviary decorated in the same way as the grotto by the *sala terrena.*

Several trees were planted in the new style of the 19th c. in the part of the garden near the surrounding wall. The parterre decoration and its terrain have undergone many changes up to the present day. After 1945 the design of the restoration adhered to the preserved character and historical features of the garden. The ornamental flower and box parterre is limited by the free area of the public open-air auditorium, in front of a *sala terrena* for concerts and theatre performances. The mighty 19th-c. scheme of chestnut trees has been left near the high wall of the garden.

O.B.

Valentien, Otto (1897–), German garden designer, studied at the Royal Horticultural College at Berlin-Dahlem, and during the 1920s rose to become the leader of the design section of the well-known horticultural firm of L. Spath in Berlin, the nursery of many 20th-c. German garden designers. From there he moved to Stuttgart to set up his own practice and became well known for his unobtrusive and naturalistic design style. He has been especially influential through his writings on the design of gardens and particularly of *cemeteries; his books, which are filled with clear and economical line drawings, were published over the period from 1932 to 1958, some of them going into several editions. In 1961 he gave up practising as a garden designer to devote himself fully to painting.

R.STI.

Valleyfield, Fife (Fife Region), Scotland. In *c.*1800 Sir Robert Preston of Valleyfield called on Humphry *Repton, as the most distinguished 'professor' of landscape gardening, to transform his grass parks (in the Scottish sense, i.e. regular fields) and wooded valley into a landscape. Repton responded by sending his two sons to make a survey, from which he made a design and then sent his sons back to Fife to execute it. His solution was to take the drive through the wooded valley, which opens into the Firth of Forth, past various romantic ornaments upwards to the park—in the English sense now, since it was to be diversified by trees and shrubs and given a 'natural' appearance.

Repton saw Valleyfield as an encouragement to Scottish landowners since it was 'A specimen of the powers of Landscape Gardening in that part of Scotland where the Art had only been introduced by imitators of Mr. Brown's manner'. West Fife is not remarkably rugged and yet Repton saw the relative wildness of the valley and burn, and the relative bleakness of the upper parks as specially Scottish, and, typically, sought to modify his design to suit those circumstances. Whether he also saw the delightful and highly artificial flower garden as particularly suited to a Scottish context we do not know, but Repton certainly appreciated the contrast provided by flower garden, grand scenery, and picturesque approach. The site is now completely derelict.

W.A.B.

Valmarana, Villa, Vicenza, Italy, is situated on the slopes of Monte Bérico, overlooking Palladio's Villa Rotonda. Begun in 1669, probably by Antonio Muttoni, and completed by

his son in the early 1700s, the villa became known as the Villa dei Nani after the dwarf figures adorning the boundary walls. It stands at the centre of a narrow strip of land divided into separate levels. Supported on two sides by balustraded terraces, it is approached from the south by a narrow gravel drive flanked by high hedges. The main entrance is through one of the two porticoed gateways, crowned with stone vases, which open on to a gravelled terrace with a central lawn and rose-beds. On the south corner is the *foresteria* (guest-house), whose portico turns at right angles to face the villa, forming the entrance from the stable courtyard. Steps lead down past a covered rose-walk, overlooking the lower terrace, laid out with parterres, a walled *giardino segreto*, and a cypress avenue. H.S.-P.

Vanbrugh, Sir John (1664–1726), English dramatist and architect, was the designer of *Castle Howard, *Blenheim, and other spectacular houses. Though never a professional landscape gardener, he has been claimed as a pioneer of the English landscape movement on both 'picturesque' and 'associational' grounds. His intuitive feeling for the setting of his architecture—for 'the conduct of the background', as Sir Joshua Reynolds called it in his *Thirteenth Discourse*—can be seen in the belvedere at *Claremont, the monumental bridge at Blenheim, or the skyline at King's Weston, Avon. These buildings differ in scale and mood, but they share a visual concern with the landscape setting that justifies Reynolds's description of him as 'an architect who composed like a painter'. He was also sensitive to the evocative, associational quality given to a building by its style or history. He pleaded successfully for the retention of the Holbein Gate in Whitehall, unsuccessfully for the old manor at Woodstock. From his earliest ventures in architecture he was preoccupied with battlements and turrets, thinking it 'absolutely best' to give Kimbolton 'something of the Castle air', and building a massive curtain-wall with towers and bastions on the approach to Castle Howard; his attitude is one of the earliest examples of the romantic feeling for the Middle Ages. He also designed an assortment of evocative garden buildings, mostly classical but including an 'Egyptian' pyramid at *Stowe.

There is no evidence that he ever planned a garden layout himself, but at Eastbury, Stowe, and Claremont he was architectural partner to *Bridgeman, just then breaking away from rigidly formal designs; and as close friend and adviser to Carlisle and *Cobham, he was involved in the development of Castle Howard and Stowe, two gardens which set the pace in the new art of landscape design. Vanbrugh's connection with all of these can hardly be a coincidence. There is even a case for claiming that in the first quarter of the 18th c. his genius was the most important single stimulus to gardening imagination. G.B.C.

See also DUNCOMBE PARK; ENGLAND.

Van Campen, Jacob (1595–1657), was a Dutch painter and the foremost exponent of Dutch classical architecture, as at Mauritshuis in 1633 and the Amsterdam Town Hall in 1640–7. He was also an influence on the Dutch classical

garden. He advised Constantijn *Huygens on the sylvan-Edenic design of *Hofwijck (1639–42) which was based on the Vitruvian human figure. The Italianate garden of Elswout (*c.*1645), containing a grove with avenues radiating from a circular temple pavilion and formal garden with box parterres and statues, is attributed to him.

His most significant contribution was his design in the 1650s for Prince Johan Maurits of Nassau-Siegen of the terraced amphitheatre garden at *Cleves, where in a sylvan park van Campen created an exciting design which was baroque in conception and skilfully linked art with nature. From a Palladian semicircular gallery on a hillside, a series of ponds, cascades, and emblematic statues led down into a deer-park where a long canal with two square island parterres flanked by lime trees extended the axis of the gardens into the far distance. F.H.

Van der Groen, Jan, was Dutch gardener to the Prince of Orange. His popular gardening handbook, *Den Nederlandtsen Hovenier* ('The Dutch Gardener'), was published in 1669 and at the same time in French and German translations, followed by numerous editions up to 1721. Mainly concerned with horticulture (the cultivation of greenhouse plants, trees, shrubs, herbs, vegetables, fruit-trees, bulbs, annuals, and perennials), the manual illustrated many outmoded models of parterres and mazes, mainly derived from D. Loris (*Le Thrésor des parterres de l'univers*, 1579), Vredeman *de Vries, and Laurembergius. Although no longer fashionable in the Netherlands, these designs were erroneously considered abroad as typically Dutch, a misconception which survives almost to the present day. The only designs of any interest were classical models of latticework portals, galleries, and obelisks based on designs by Pieter *Post, which were in extensive use during the 1650s. F.H.

Van der Voort, Pieter de la Court (1664–1739), Dutch merchant and art connoisseur and patron, was the first garden theorist of the Netherlands. His gardening treatise was published anonymously in 1737, and was followed by later editions and translations in French and German (*Aenmerkingen over het aenleggen van pragtige en gemeene Landhuizen, Lusthoven, Plantagiën en aenklevende Cieraden*, 1737, 1763, and 1766; *Les agrémens de la Campagne*, 1750; *Anmüthigkeiten des Landlebens*, 1758).

Concerned with small country-house canal gardens, he advocated, like *Dezallier d'Argenville, simplicity of line and the subordination of art to nature, with trees, hedges, *bosquets, and water forming the main components. A garden, he writes, should be adapted to the geographic conditions of the site and unity of design should be achieved by following the laws of proportion and optics. Dutch Régence in concept, his treatise also reflected rococo and picturesque elements, for he recommended that parts of the garden and its boundaries should be concealed from view and that ornaments should be placed in appropriate settings to evoke a certain mood or sentiment. F.H.

See also NETHERLANDS: RÉGENCE, ROCOCO, AND FRENCH PICTURESQUE.

Van Laar, G. was a Dutch nurseryman whose name is connected with his publication *Magazijn van Tuin-Sieraden* ('Magazine of Garden Ornament') of 1802 (later edns., 1814, 1838, and 1860), a garden pattern-book which reflects the extremes of *anglo-chinois* taste in the Netherlands. It contains tortuous garden plans for small properties and an eclectic choice of picturesque furnishings, largely derived from foreign examples, such as Chinese pavilions, Greek temples, Swiss bridges, medieval ruins, hermitages, Russian gardeners' cottages, Turkish mosques, and sepulchres. F.H.

Van Nost, John (d. 1729), was a Flemish sculptor and decorator who established a statuary and studio near Green Park, London. He was assisted by Carpenter (Carpentiere) and later by his own son Anthony from whom John *Cheere took over the yard. The best remaining examples of van Nost's work in lead are at *Melbourne Hall: the Vase of the Four Seasons (the central figure at a *rond-point*), two figures as *eye-catchers (Perseus and Andromeda), and a set of four quarrelling boys. At *Rousham, Venus, flanked by two attendants astride swans, gazes upon Venus's Vale.
 K.N.S.

See also ANGLESEY ABBEY.

Varé, Louis-Sulpice (1802–83), French garden designer, was at first gardener to the King of Holland at Saint-Leu-la-Forêt, but was called upon in 1852 to design the *Bois de Boulogne where he created the present undulating layout, established the first big plantations, and made the lakes. He has been accused of confused planting and errors in estimating the levels of the water which were afterwards corrected by *Alphand and *Barillet-Deschamps. But in what some regarded as his mistakes others can see a picturesque effect. Varé designed the north part of *Bagatelle, continued towards Neuilly, with the grotto and the *pièce d'eau*. He also worked at Ferrières (where *Paxton built a château for the Rothschilds), at Ognon (north-east of Senlis), and at Nointel (east of Clermont in Oise), and he designed the north-east section of the park at *Dampierre. D.A.L.

Városliget (Stadtwäldchen), Budapest, Hungary. A very sandy area on the outskirts of the town was first planted with trees *c.*1750—this had to be replanted twice. In *c.*1817 a competition for the layout of this vast park (*c.* 1 sq. km.) was won by H. *Nebbien. He submitted a series of 13 designs and a rather lengthy description. At the entrance he intended to erect a huge structure, a kind of triumphal arch crowned by sculpture. A lake with an island, and many paths, small and large, permitted various outdoor occupations. Planes and limes as well as various shrubs were planted and enriched the colour scheme of the garden.

It is not known whether work was begun according to his plans, as the only available information dates from the 1830s. However, for many years the park followed the outlines of Nebbien's design. Lithographs from the 1840s by Rudolf Alt show the romantic character of the park. In later years, it was repeatedly transformed, but remains an impressive 'English' garden till the present day. A.Z./P.G.

See also HUNGARY.

Varro, Marcus Terentius (116–27 BC), Roman scholar, began the *De re rustica* when he was 80 years old as a practical manual for his wife, who had recently acquired a farm. Varro, a learned scholar, draws on previous literature, as well as on his personal experience. His manual, longer, better organized, and more literary than *Cato's, is immensely practical and often quoted but it contains little about gardens. In Book 1, which deals with agriculture, he recommends that it is profitable on farms near a city to have gardens on a large scale; to grow, for example, violets and roses and many other products for which there is a demand in the city (1.16.3). But he also advises planting flower gardens for the pleasure they afford (1.23.4). In the yearly work schedule he notes the time for planting lilies, crocus, and roses. But in this passage he contradicts his previous recommendation, for he says violet beds on a farm are not profitable, because the beds must be formed by heaping up the soil and irrigation and heavy rains wash these away and make the ground poorer (1.35.1). W.F.J.

Vatican gardens. See BELVEDERE COURT; PIA, VILLA.

Vauxhall, New Spring Gardens, London. See PLEASURE-GARDEN.

Vaux-le-Vicomte, Seine-et-Marne, France, André *Le Nôtre's first great garden, was made between 1656 and 1661 for Nicolas *Fouquet, *surintendant des finances* to *Louis XIV, and restored from 1875 onwards by the industrialist Alfred Sommier and his son Edmé with the help of Achille Duchêne.

The original design was the result of co-operation between *Le Vau, *Le Brun, and Le Nôtre, assisted by Claude Robillard, *fontainier*, and the flower-gardener, Antoine Trumel. The château, raised on a platform surrounded by moats, is integrated with the courtyards and offices into a perfectly proportioned whole, with gardens framed in trees descending the gently sloping site to the valley of the Anqueil. Water is carefully disposed in basins to catch reflections; subtle use is made of changing levels. From the house the central axis of the garden continues beyond the valley in a vista terminated by a colossal *Hercules*, without any indication of the second major axis formed by the great canal (over 900 m. long) at right angles to it. This is dramatically revealed on reaching the Grandes Cascades whose existence below the line of approach is also unsuspected. Facing the Cascades on the far side of the canal is the Grotte, a massive wall with seven round-headed niches containing rock-work cascades, flanked by two grotto-like recesses with giant reclining river gods by the sculptor Lespagnandel. The Grotte supports a balustraded

VEVE ET PERSPECTIVE DV IARDIN DE VAVX LE VICOMTE.

Vaux-le-Vicomte, Seine-et-Marne, France, general view, engraving (c.1665) by Perelle

terrace from where, with the Grandes Cascades in the foreground, the gardens and the château are seen to great advantage.

The symmetry about the central walk is broken by secondary axes at right angles to it with a west to east orientation. The first descends in three stages to a water-garden, formerly focused on the basin and fountain known as the Couronne. The second and principal transverse axis is a walk crossing below the *parterre de broderie*, with gates on the west, leading to the *potager* (kitchen garden), and on the east rising in a stairway of fountains called the Grilles d'Eau. This axis is reinforced by two canals on either side of the steps leading to the third parterre whose central walk was formerly lined with fountains and known as the Allée d'Eau. The third transverse axis is implied by the Confessional, a cryptoporticus with a terrace above, east of the rectangular basin immediately before the Grandes Cascades.

The ultimate principle of the gardens at Vaux is not symmetry but balance. They have to be seen as the immediate precursor to *Versailles, a setting for lavish entertainment more suited to princes than to private individuals. The spectacular reception held when the château and gardens were complete was described by the poet Jean de la Fontaine (1621–95) in his letter to Maucroix (22 Aug. 1661) and in his unfinished allegorical poem, the *Songe de Vaux*. On Fouquet's arrest soon after their completion they went

into decline, most of the statuary and even many of the trees being taken by Louis XIV for his own gardens. The *terms designed by Nicolas Poussin are at Versailles. In 1705 Vaux was sold by Fouquet's widow to Marshal de Villars whose son sold the lead of the waterworks, the decoration of the fountains, and, in 1764, Vaux itself. The new owner was the Duc de Choiseul-Praslin, cousin of Louis XV's minister, in whose family it remained until 1875. The second Duchesse de Choiseul-Praslin saved it from total destruction during the Revolution by an appeal to the commissioners for the arts. The last *duc* to live there committed suicide in 1847 while awaiting trial for the murder of his wife.

When Alfred Sommier acquired the château in 1875 the gardens had to be virtually reconstructed. Most of the statuary had gone, and the architectural features had collapsed and decayed. The Grilles d'Eau were not replaced in their entirety; the Allée d'Eau not at all. Despite this the restored Vaux is the finest and best kept example of a classical French garden (apart from Versailles), and a lasting memorial to the genius of Le Nôtre. K.A.S.W.

Veitch family, a dynasty of nurserymen whose London garden was outstanding in the late 19th and early 20th cs. **John Veitch** (1752–1839) came from Jedburgh to work in Sir Thomas Acland's garden at Killerton, near Exeter, late in the 18th c. In 1808 he founded a nursery nearby, at

Budlake, and in 1832, in partnership with his son James (1792–1863) and later his grandsons, James (1815–69) and Robert (1823–85), moved the business to Mount Radford, Exeter. The younger **James Veitch** added a London garden to the firm in 1853, when he bought the Royal Exotic Nursery of Knight and Perry in the King's Road, Chelsea. This Veitch is the one commemorated in the Veitch Memorial Fund of the *Royal Horticultural Society, set up soon after his death in recognition of 'his skill as a cultivator, his genius as an organizer, and his enterprise in sending forth plant collectors to various parts of the globe'.

Later additions to the empire included nurseries at Feltham (specializing in seeds and vines), Langley (fruit-trees), and Coombe Wood (azaleas and rhododendrons). Until 1863 the Exeter and London gardens were a joint enterprise, but after that **Robert Veitch & Son** (Peter (1850–1929)) took over at Exeter, leaving **James Veitch & Sons** (John Gould (1839–70), Harry James (1840–1924), and Arthur (1844–80)) to run the Chelsea nursery and its satellites, which became a leading national and international organization. Sir **Harry Veitch**, the last head of the London business, which was closed in 1914, was trained at the *Vilmorin-Andrieux nurseries in France. The Exeter branch of the family maintained a nursery there until the 1960s, but its site is now included in the grounds of Exeter University.

From its earliest days, the Veitch nursery enlarged its stock by sending plant-hunters to promising regions. In 1840 **William Lobb** (1809–63), a member of the staff, went to Brazil, staying in South America for eight years and introducing *Berberis darwinii*, among other plants. From South America he went on to California, sending home the huge wellingtonia, *Sequoiadendron giganteum*, and several kinds of ceanothus, before eventually retiring there. **Thomas Lobb** (1811–94), William's brother, travelled in Burma and the East Indies, bringing back many orchids, a speciality of the firm, as well as hoyas and rhododendrons. Later plant-hunters included John Gould Veitch in Japan and Australasia, Peter Veitch in Australasia and Borneo, *Maries in China and Japan, *Wilson in China, and c.20 others. So many new plants were introduced via the Veitch nursery that over 400 of them were illustrated in *Curtis's Botanical Magazine*.

The Veitch nursery also produced many important hybrid plants, especially the first man-made hybrid orchid, *Calanthe* × *dominii*, named in honour of John Dominy, who in 1856 crossed *C. masuca* and *C. furcata* to produce it. Another Veitch hybridist, John Seden, bred more orchids, as well as tuberous begonias, gloxinias, apples, and other fruits. S.R.

Veitshöchheim, Bavaria, German Federal Republic. The Hofgarten in Veitshöchheim must be the most original of all surviving rococo gardens of this period. It served first as a pheasantry, fruit, and kitchen garden, and also as a flower garden around the summer-house of the prince bishops of Würzburg. There was also a carp pond. The garden, which was almost rectangular in shape, was redesigned as a

pleasure-garden at the beginning of the 18th c. The most important of the prince bishops who undertook work on it was Johann Philipp Franz of Schönborn (1719–24), who also initiated the building of the Residence at Würzburg; Prince Bishop Adam Friedrich of Seinsheim (1755–79) completed the garden. After numerous alterations the final rococo garden was begun in 1763, probably with the assistance of the master gardener J. Prokop Mayer who was also working on the Hofgarten at Würzburg. It is clear from the position of the garden—at the side of the Schloss and with no axial connection or alignment to it—that the representative function of the French-style baroque garden was not the object here. The Hofgarten is rather a hedge garden divided by longitudinal and transverse axes formed by hedged walks which meet at right angles; short diagonal walks make the garden appear confusing despite its very regular design. Small hedged garden rooms were formed at some of the intersections of the walks. They are of varied design, some with small Chinese pavilions, hedge arbours, and small fountains.

The most delightful feature of the garden is the rococo statuary by the sculptors Johann Wolfgang van der Auvera, Ferdinand Tietz (or Dietz), and Johann Peter Wagner, which is placed all over the garden. There were originally c.300 sculptures, some of which have now been replaced by copies. The subjects range from gods, allegories of the arts, and the four seasons, to musicians, noblemen, and ladies of the court. Tietz even produced stone seats in fanciful rococo shapes. The focal point of the garden is the so-called Grosser See, a large irregularly shaped *bassin* created in 1702–3. Tietz carved the statuary for the lake in 1765–6: Mount Parnassus rises from the centre surmounted by the winged horse Pegasus who strains towards Olympus. A hidden glockenspiel provided a delightful accompaniment when the fountains played. Other features of the garden are the Kleiner See, the hedge theatre, and the Belvedere above the grotto house.

The Schloss itself stands on a slightly raised terrace within a small parterre. Fine stairways sweep down to the hedge garden. The whole garden is surrounded by a high wall and covers an area of c.475 m. × 270 m. Fortunately, it was not rearranged in the landscape style, so that despite increasing decay and damage during the Second World War when the cascade was destroyed, it could be restored in its original form. U.GFN.D.

Venezuela. See SOUTH AMERICA.

Venice, Italy. The early history of the Venetian settlements, let alone of their gardens, is unclear; but by the 9th c. there are records of Benedictine communities in the lagoon self-sufficient with fresh water, salt pans, and orchards. Present-day churches recall by their names other early garden features: S Francesco della Vigna (vineyard), Madonna dell'Orto (orchard/garden). Religious communities continued to provide the most extensive and visible gardens: in 1494 Pietro Casola recorded 'many beautiful gardens . . . especially those belonging to different religious orders'.

The *Certosa* (Carthusian monastery), founded in the 12th c., had expanded to include large orchards and vegetable gardens by the time Coronelli engraved it in 1696, besides the usual small garden for each cell. Other islands were maintained as gardens by other orders, though they are now ruined. There is still a vegetable garden run by the Servite nuns in the Cannaregio area of the city. Another early garden contribution from churches was the *campi* (meadows), by which all city squares except the Piazza are known; unpaved until quite late, as Carpaccio's (active *c.*1488–1525/6) paintings show, their grassy and flowery areas served as public assembly areas in each parish.

The first clear indication of secular gardens comes in the woodcut view of the city by Jacopo de' Barbari (1500). On the Giudecca he shows a traditional Venetian layout: from the water frontage a hallway leads through the building to a courtyard, decorated with potted flowers and a well-head under which a cistern stored rainwater, and then to a small geometrical garden designed to be viewed from the **piano nobile*. If there was room, pergolas, orchards, vineyards, and vegetable patches extended beyond. Space was always scarce, so it was largely on the city perimeter—Giudecca, the area now occupied by the station and the Fondamenta Nuove—and on islands like Murano that some famous Renaissance gardens were established. None survive, but we have (albeit somewhat rhetorical) accounts, which can be supplemented indirectly from visual sources.

Leading families had gardens on the Giudecca—the Gritti, Barbaros, Mocenigos, Vendraminis—as did leading humanists like Pietro Bembo, Pietro Aretino, Marcolini, and Jacopo Sansovino. Aretino described Marcolini's garden as delightful with cool shades, fragrant flowers, much bird-song; there were lawns, columns, grottoes enriched with shells and corals, marble loggias illusionistically painted inside, where 'you . . . at the same moment enjoy the splendour of the sea and the beauties of mountains, woods, and flowers'. Titian possessed a fine garden 'beautifully laid out', according to Priscianese. This repertoire of loggias, pergolas, flower-beds, screens dividing parts of the garden, elaborate seats, and sculptures can also be deduced from paintings by Tintoretto, Veronese, Lotto, Pozzoserrato, and Caliari. A fine garden screen and pavilions survive in Palazzo Benci (now a hospital). On Murano were more elaborate villa complexes: in the 16th c. Andrea Navagero had an orchard and plantations laid out in **quincunx* and topiary, as had the Queen of Cyprus, Caterina Cornaro (1454–1510); a Mocenigo garden *casino* survives and is being restored (1982). Venetians had a taste for exotic flowers—carnations from Damascus, as Sansovino testified.

The layout of Venetian city gardens has remained conservative, largely unchanged from Barbari's depictions. This relative lack of stylistic change can be partly explained by state subsidies (from 15th c.) for reclaiming land on terra firma, where wealthier families escaped summer heat and experimented with new garden styles. The city gardens (as correspondence reveals) were essentially private domains. In the 17th c. some larger gardens were redesigned *à la française* (as shown in Ughi's 1721 map of the city or Guardi's drawing (in the Ashmolean Museum, Oxford) of the Palazzo Contarini dal Zaffo alla Misericordia) and given a *casino* (summer-house cum study/library) at one end—an example survives at Palazzo Zenobio near the Cármini (S. Maria del Carmelo).

Two further events in Venice's garden history were the creation of public gardens under Napoleon (opened in 1807, designed by Antonio Selva, and now used in part for the Biennale) and of a botanical garden (near S. Giobbe, now built over) initiated in 1810. Another small public garden near Piazzale Roma was created out of Papadopoli land in 1920.

Most gardens within the city have been constantly divided between families along with their palaces or have been built upon. Some sites of famous gardens (Palazzi Albrizzi, Foscarini or Foscari) are ruined; on others, only sculptural remains or dilapidated portions survive. Many sites are hidden behind walls (though revealed in aerial photographs taken by Giacomelli) or glimpsed through *claire-voies*. A few gardens have been reconstituted this century; including one at the Hotel Cipriani on the Giudecca. The most unusual and famous modern garden was made by an Englishman called Eden, also on the Giudecca: it was very much a Victorian flower garden, with shell instead of gravel paths, and traditional Venetian features like well-heads, pergolas, fountains, and a splendid view over the lagoon. This Garden of Eden is, too, threatened by neglect. J.D.H.

Vera, André (*fl.* 1919–50), French garden designer and author, was a fervent defender of rationality in garden design, and long considered the theorist of the modern garden. Much influenced by the cubist movement, he rejected irregular designs in favour of straight lines and geometric forms. He worked for a long time in collaboration with his brother Paul, who was a designer and belonged to the cubist group. André Vera carried out several public and private gardens, in particular at Saint-Germain-en-Laye (begun 1920, *see over*), west of Paris, and at Honfleur (1930) in Normandy. C.R./S.Z.

See also FRANCE: REVIVALS AND MODERN GARDENS.

Vernag, Anantnag (Islamabad), Kashmir, the favourite garden of the Mogul Emperor **Jahāngīr* and his wife Nūr Jahān, is based on an ancient spring with a tradition of snake worship. The design now comprises an octagonal pool, surrounded by arcaded recesses, from which a canal, nearly 300 m. long, extends to the river. A smaller canal forms a cross-axis. A palace was built round the pool by Jahāngīr, and **Shāh Jahān* added other buildings, but little trace of them remains.

An inscription records a date of 1609 and Jahāngīr's employment of Haidar Malik, known for his skill in the management of water. Although the remains of the garden are simple, the site as a whole has a romantic quality. The sharp contrast between the level garden, and the steeply rising hills behind, the brilliant blue-green water of the pool, with its great fish just as in Jahāngīr's time, and above

Garden (1920) at Saint-Germain-en-Laye, Yvelines, France, by André and Paul Vera

all the situation—serene, remote, to be reached only with difficulty—explain the emperor's devotion. It had been his choice for his burial place, a wish not to be fulfilled. He died near Rajauri, one of the resting places on the road from Kashmir, and his body was brought down to Lahore to be buried. S.M.H.

Versailles, Yvelines, France, begun as a small hunting lodge by Louis XIII, was greatly enlarged by *Louis XIV and became the seat of the Government and the Court. The vast plan embraced town, palace, and gardens, which included the Menagerie at the south end of the canal, and the châteaux of Trianon and Clagny.

The gardens of Versailles are still essentially those of Louis XIV, *Le Nôtre, and *Le Brun. *Louis XV did not do much, except at Trianon. Louis XVI replanted all the trees and made important modifications, but the pressure to recast the whole area in the form of a *jardin à l'anglaise* was resisted. *Blondel, the 18th-c. architect and critic, summed up the situation accurately: 'the gardens of Le Nôtre were better suited to set forth the magnificence of a great Prince than to offer to the mind a peaceful walk and a retirement conducive to philosophy.' They were therefore better suited to Versailles. The replantation of 1775 respected the broad outlines traced by Le Nôtre.

Those who wish to see the creation of Louis XIV as it was are well advised to start in the Galerie of the Grand Trianon, where 21 canvasses by Cotelle, two by Allegrain, and one by J.-B. Martin give a wonderful contemporary depiction of the main features of the gardens.

Seldom can 100 ha. of land have undergone such a metamorphosis. The Duc de *Saint-Simon described the original site as 'the most sad and barren of places, with no view, no water and no woods'. Colbert warned Louis of the great difficulties and expense confronting him, but Louis was undeterred. 'It is in the difficult things,' he wrote in his memoirs for his son, 'that we show our quality.' The Palace

and its gardens were to be the visible symbol of Louis's own conception of the role of the French monarchy. He took the sun as his emblem and it was to provide the iconography for the whole layout—'this vast mythological poem in honour of Apollo,' as Mauricheau-Beaupré puts it, 'which dominates the whole decoration of the gardens.' Apart from the actual mythology of Apollo, this theme could be made to embrace such topics as the hours of the day, the seasons of the year, the four quarters of the globe, and the seven ages of man. Since Diana was Apollo's sister, scenes of hunting could be included which were appropriate to that great dynasty of Nimrods, the Bourbons.

Le Brun was the author of the entire sculptural ensemble of the gardens from 1665 to 1683, but it was Le Nôtre who ordained the layout of the whole Grand Design, giving the land a new shape, now making use of the natural declivity of the site (from the Palace to the Canal there is a drop of 32·5 m.) to form a series of terraces, now hollowing out a vast amphitheatre for the Parterre de Latone, now clothing the slopes with woods and hedges within which were contrived *cabinets de verdure* of an astonishing architectural elaboration.

Le Nôtre has taken the points of the compass for his main axes, making the long perspective *à perte de vue* from the windows of the Grande Galerie towards the setting sun. To the north he sheltered the gardens from the cold winds by a tall *charmille* that formed a continuation to the walls of the Palace. To the south he opened the vista to the summer sun, across the terrace of the Orangerie (see *orangery) to the Heights of Satory, where he planned a monumental cascade which, however, was never realized, probably due to lack of water.

Versailles was not endowed by nature with this commodity, and yet a garden such as Le Nôtre was planning depended upon a supply of water in copious abundance. It was over this question that Louis was nearest to being defeated, but with the help of the Abbé Picard, an astro-

nomer who was the first to apply telescopic lenses to the instruments of surveying, a network of reservoirs was created west of Saint-Cyr. By 1678 this had augmented the supply of water considerably. In 1680 Arnold de Ville and Renequin Sualem, both from Liège, began the construction of a gigantic pump at Bougival, the Machine de Marly. Fourteen enormous water-wheels forced the waters of the River Seine up the 162 m. of hillside to the Aqueduc de Marly at a rate of some 5,000 cu. m. of water daily. Thanks to the hydraulic expertise of François and Pierre de *Francine there were 1,400 fountains to be supplied and although those nearest to the Palace displayed for most of the day, the use of the others had to be rationed. Elaborate instructions were given to the *fontainier* Claude Denis to ensure that the fountains came on just before the King arrived in any particular part of the gardens.

In 1685 the great engineer Vauban was commissioned to bring the River Eure from Pontgouin, upstream of Chartres, to Versailles. This required 110 km. of canal. Thirty thousand soldiers were detailed as the task force for this colossal undertaking. The most spectacular part of the project was at *Maintenon, where the artificial river was to recross its own valley at a height of 72 m. above ground. The Aqueduc de Maintenon remains today a solitary witness to a scheme which never came off. In 1688 the soldiers were

recalled to service at Neustadt. The work was never resumed.

The largest of the *pièces d'eau* is the great cruciform Canal, 1,800 m. from east to west and 1,500 from north to south. On its waters a whole flotilla of miniature battleships, shaloupes, frigates, and gondolas, all exquisitely carved and brilliantly gilded and canopied in rich materials, fringed and tasselled with gold silk, was ready to take the Court on evening excursions. One of the boats was always reserved for Lully's orchestra. For the big receptions of the Court the Canal was illuminated. In 1770 a fabulous firework display was given for the wedding of the future Louis XVI and Marie-Antoinette. The illumination of the Canal, a spectacle to which 200,000 of the public were admitted, is brilliantly captured in an engraving by Moreau.

The largest of the artificial lakes, the Pièce d'Eau des Suisses, was begun in 1678. It was closely linked with the gargantuan Orangerie constructed by *Hardouin-Mansart at the same time as his building of the Aisle des Princes. It was named after the regiment of Swiss Guards who were employed on the excavations. Madame de Sévigné, in a famous letter to Bussy-Rabutin, tells of the 'prodigious mortality of the workmen, whose bodies are carried out every night by the cartload'. The men were killed by the marsh gas released by their colossal excavations. Not only

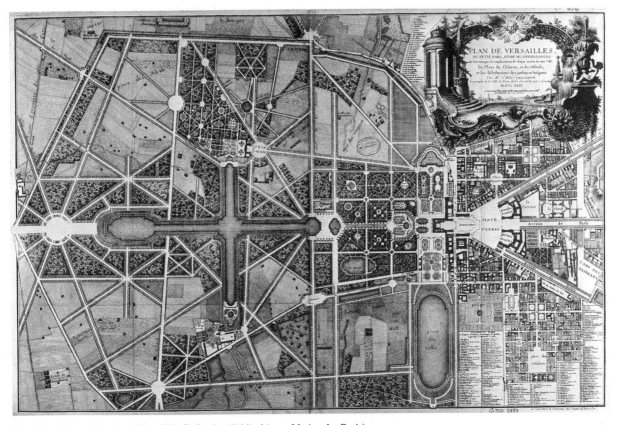

Versailles, Paris, plan (1746) by Abbé Delagrive (Bibliothèque Nationale, Paris)

did the gardens of Versailles cost an incalculable sum of money; they entailed an appalling loss of human life.

Once the new contours had been established the process of refinement and redecoration continued until the end of the reign. The embellishment of his garden was probably Louis's favourite pastime. The area immediately adjacent to the château was left open and flat as a series of parterres. This formal zone was regarded as the necessary intermediary between the architecture of the façades and the *bosquets*—ornamental features enclosed by trees—which formed the next stage. Beyond the *bosquets* stretched the park, its woodland pierced with a network of intersecting alleys, and beyond the park was the landscape of nature. The parterres were kept low to allow the architecture to be seen to its best advantage. As Ralph wrote in his contemporary *Critical Review*, 'the eye is best satisfied by seeing the whole at once'. It was virtually only in the parterres that flowers were planted and the three great parterres of Versailles accounted annually for 150,000 plants. But the real flower garden was at Trianon.

From the Parterre d'Eau, which lies beneath the windows of the Grande Galerie, the main perspective of the gardens leads by way of the Parterre de Latone down the Tapis Vert (or Allée Royale) to the Bassin d'Apollon and so to the Canal (see *Atget). The statuary announced the main theme of the decorative ensemble. Latona was the mother of Apollo. She is shown appealing to Zeus for protection against the peasants of Lycias who were pelting her with clods of earth. Zeus retaliated by turning them into frogs. The Bassin d'Apollon shows the moment of sunrise; the chariot of the Sun is labouring to get clear of the water before it breaks forth upon another day. The whole group, the masterpiece of Jean-Baptiste Tuby (1670), gives the most magnificent impression of eruption as the tritons scatter to either side and announce on their raucous conches the advent of *Le Roi Soleil*.

The *bosquets* occupy the area to right and left of the Tapis Vert. Trees were planted by the thousand by means of a *machine pour transplanter des arbres*, so that even those with a circumference of 1·5 m. could be brought from the neighbouring forests. Embowered among these plantations are the architectural surprises of the garden.

On the south side, near the Bassin de Latone, is the Salle du Bal or Bosquet des Rocailles—so called from the thousands of shells specially imported from Madagascar. The sloping ground has been hollowed out into the form of a steep-cut arena, with cascades tumbling from tier to tier between gilded *guéridons* (small ornamental tables) on which

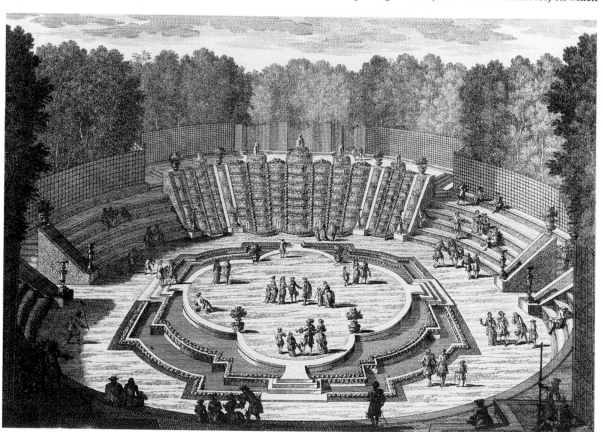

Versailles, Paris, La Salle du Bal, engraving (c.1685) by Perelle

candelabra could be placed, bringing the magic of candle-light to the nocturnal festivities of the Court.

Further down on the same side is the Colonnade, the most elaborately architectural of all the *bosquets*. It was designed in 1685 by Hardouin-Mansart, but nearly all the great names associated with sculpture at Versailles were involved in its production. In the centre was placed a marble group of the rape of Proserpine, the last and greatest work of Girardon.

Some 70 sculptors were employed in the gardens, of whom perhaps Coysevox, Coustou, Tuby, Le Hongre, Girardon, Marsy, Van Cleve, and Regnaudin were the greatest. But the important fact is that they formed, under the tutelage of Le Brun, a school of artists which achieved an astonishing homogeneity of style. Only the real expert can distinguish their work.

On the north side of the Tapis Vert are the Bains d'Apollon. The figures of Apollo and his horses being rubbed down after a hard day's ride were complementary to the group in the Bassin d'Apollon. They represent sunrise and sunset. The group of the Sun God and his nymphs is by Girardon and Regnaudin; the groups of horses by Marsy and Guérin. Originally these stood in the Grotte de Thetis which adjoined the old château on the north side. In 1776 Louis XVI asked the painter Hubert *Robert to design a new setting for the statues in keeping with an already romantic age. The result was the enormous rock with its cavernous recess representing the Palace of Thetis. It was the last important ensemble to be set up in the gardens of Versailles.

The Bains d'Apollon lie just beneath the Parterre du Nord; at the far end of this is the Fontaine de la Pyramide, one of the earliest of the fountains to survive in its original position. It was the work of Girardon and was completed in 1672. Originally the figures of tritons, dolphins, and cray-fish were gilded and the other ornaments bronzed. It is composed of four marble saucers of diminishing size, down which the water, cascading from one to the other, formed, as Félibien puts it, 'so many crystal bells'.

Next to the Pyramide is the Bassin des Nymphes. The slope of the ground dictates a high reredos and this has been used by Girardon for a delightful bas-relief of ladies bathing; it is executed in lead which was, as always at Versailles, gilded and regilded every year. The design is attributed by Charles Perrault to his brother Claude, but it clearly reflects that of a painting by Domenichino.

At the bottom of the slope known as the Allée d'Eau is the huge ensemble of the Bassin de Neptune. It is preceded by the Bassin du Dragon in which the fountain was made to play at two different heights—27 m. if the King was in that part of the gardens, 11 if he was not. The Bassin de Neptune was designed by Le Nôtre in 1679 but it was not completed until 1741, when, under the architect Gabriel, the finishing touches were put by Adam, Lemoyne, and Bouchardon. Adam had some difficulty in obtaining payment. Two years after he had finished he had still received no money. This sounds the key note of the history of Versailles in the 18th c. Payment was seldom punctual and contractors incurred

huge debts. The Marquis de Marigny towards the end of Louis XV's reign complained that he 'hardly had the disposition of a single penny for the relief of a throng of wretches who are dying of hunger and to whom wages are due for a year and a quarter'. D'Argenson predicted that 'buildings are bringing desolation to the country and will be the ruin of it'. The gardens of Versailles played their part in the calamity that was to come. I.G.D.

The Potager du Roi was made between 1677 and 1683 to the design of J.-B. de *la Quintinie. The site of the new garden, adjoining the Rue des Tournelles, was chosen to be near the palace but, as La Quintinie explains in his *Instructions*, was otherwise quite unsuitable, being marshy with a large pond. This was filled above the level of the surrounding ground with the sand excavated from the large ornamental lake called the Pièce d'Eau des Suisses, so called because of the regiment of soldiers employed in its construction. Topsoil was brought from the nearby hills of Sartory. The new *potager* was a walled rectangular area of 8 ha. with 29 separate enclosures providing suitable conditions for all kinds of fruit and vegetables, including exotics such as sago-palm. The central area was surrounded by a terrace suffi-ciently high for vines to be grown against the walls. It was divided into 16 raised beds, rounded and slightly sloped so that the surplus water was directed into dry stone channels, and discharged into the lake. A large round basin with a fountain occupied the centre. The *potager du roi* has been conserved in its original form; since 1874 it has been a state school of horticulture, and is now designated the Ecole Nationale Supérieure d'Horticulture. K.A.S.W.

The Grand Trianon. Louis XIV was passionately fond of flowers and among the first embellishments of his father's hunting-lodge at Versailles was the Parterre des Fleurs, 'rempli de mille espèces de fleurs'. But when Le Vau began to envelop the original building in the stone palace of the Château Neuf, the parterre disappeared.

In 1669 it was re-created at the north end of the Canal, where the hamlet of Trianon was cleared away to make room for a pavilion in the 'Chinese' taste, covered with blue and white Delft tiles from which it took its name of Trianon de Porcelaine. This was replaced in 1687 by the Trianon de Marbre or Grand Trianon.

The gardens at Trianon were an attempt to defy the restrictions imposed by the seasons. Orange trees were planted, not in tubs, but in the soil. When winter came a greenhouse was raised over them. Flowers were bedded out on the coldest days and replaced, if necessary, during dinner, so that Louis could take his friends round a summer garden on a January afternoon. To achieve this *Le Bouteux, a nephew by marriage of Le Nôtre, kept the almost unbelievable number of 1,900,000 flowerpots and the Navy was used to bring flowers from warmer lands. 'I beg you,' wrote Colbert to the *intendant des galères* at Marseilles, 'to buy all the jonquils and tuberoses you can find.'

The gardens of Trianon have retained the main features designed by Le Bouteux, Le Nôtre, and Hardouin-

Mansart, this last being responsible for the elaborate architectural ensemble of the Buffet d'Eau. One of the more charming features, however, was destroyed in 1776. The trees had been planted close to the western extremity of the château which retains the name of Trianon-sous-Bois. In the angle formed between this wing and the Galerie was contrived the little Jardin des Sources, which seems to have belonged in spirit to a more romantic age. It was described by 'Liselotte', Duchesse d'Orléans, whose windows opened on to it: 'a little *bosquet* so densely planted that at high noon the sun's rays do not penetrate. Some fifty springs rise from the ground and become little rivulets, hardly a foot across, so that one may step over them. They run between lawns which form little islands large enough to set a table and chairs . . . it is a most agreeable place.' In the next angle of the building was a little garden private to the King, in which many of the rarest and most sweetly scented flowers were cultivated.

In 1749 Louis XV and the Marquise de *Pompadour extended these gardens eastward to form the 'New Menagery'—in reality a farmyard, but which was made the excuse for building Gabriel's exquisite rotunda, the Pavillon Français. In the following year Claude II *Richard—described by Linnaeus as 'the ablest gardener in Europe'—was put in charge of a new botanical garden in the same area. This garden, with its enormous greenhouses, became a centre of botanical research and Bernard de Jussieu, the 'Newton of Botany', was brought here from the *Jardin des Plantes in Paris. All this, wrote Delille, was 'worth all the marble that our gardens have lost'.

In 1761 Louis and the Marquise de Pompadour decided that they needed a further residence on the spot and Gabriel was commissioned to draw up the plans for the Petit Trianon. I.G.D.

The Petit Trianon was given by Louis XVI in 1774 to Marie-Antoinette, whose first concern was the rearrangement of Louis XV's old gardens in the irregular style. A first project by the botanist Richard was rejected as too *chinois*; and advised by the Comte de *Caraman and Hubert Robert Marie-Antoinette employed Richard Mique to make a plan, conceived as a miniature landscape open to the surrounding country; hills were created overhung by rocks and skirted by little rivers. In front of Gabriel's *château-pavillon* the queen installed a Chinese *jeu de bague* with dragons and peacocks of painted wood. The severe lines of the Temple d'Amour (1778), the Belvedere, and the little theatre add a neo-classical note to the gardens.

The Hameau (1785) has the appearance of a stage village. Marlborough's tower dominates the landscape in which are arranged: the farm, the cowshed, and the dairies; the ballroom in the form of a barn; and a succession of half-timbered rustic houses with thatched roofs used as private apartments, surrounded by the vegetables and fruit bushes of the kitchen garden. This creation, one of the most celebrated of the time, marks the limits of a style which tends to spill over into affectation. M.M.

The Parc Balbi. Adjoining the south side of the Potager du Roi, it was designed by J.-F.-T. Chalgrin for Anne de Caumont la Force, Comtesse de Balbi, mistress of the Comte de Provence (Louis XVIII). It was begun in 1786, laid out in the style of a *jardin anglais*, with a lake, reached by Chinese bridges, and a grotto giving access to a belvedere surrounding it. This survives, although Madame de Balbi's *pavillon* which stood in the south-west corner was destroyed shortly after the Revolution. The park belongs to the Ecole Nationale Supérieure d'Horticulture, and since 1960 has been restored according to the original plan. K.A.S.W.

Vertugadin, literally a semicircular pad worn by women round the hips to puff out the skirt; in gardens a curved grass bank, or amphitheatre, narrowing at both ends, as at *Chantilly. D.A.L.

Vienne, Rhône, France. Recent archaeological discoveries at Vienne itself and, on the right bank of the Rhône, at Saint-Romain-en-Gal, a district in ancient Vienne, a town of Narbonnais Gaul, have revealed not only interesting details of domestic architecture, but also the presence of gardens in almost all the houses.

They are of three types. The simplest is that of the house with a peristyle courtyard, open to the sky, furnished with plants, shrubs in pots or in plant-stands; the walls at the back of the peristyle are decorated with very 'naturalistic' frescos of plants and birds (see *topia). Much more frequent is the type of house with a large peristyle garden, sometimes with two peristyles, embellished with U-shaped *bassins*, surrounded by porticoes, on to which the state rooms open. In this case, the garden may occupy a considerable area: one example measures 36 m. long × 30 m. wide. The third type is the house with a central peristyle garden, adapted to domestic space; it shows that a great need for gardens was felt even where the living area was very small.

It is important to emphasize how numerous and how extensive both gardens and *bassins* were. They both originated in ancient *Rome. They may have been intended as 'gardens of delight', but they also had a practical function in contributing to the lighting and ventilation of the house. Their Roman character is expressed in their situation and internal layout and they serve to reinforce the originality of the domestic architecture of Vienne. M.LE G. (trans. P.G.)

Vigier, Villa V., Solothurn, Switzerland, has a baroque garden which *c.*1777 took the place of a 17th-c. garden whose high wall, originally incorporating corner turrets, was retained. In 1777 the turrets were removed and the wall opened up with a gate to emphasize the central axis. An avenue of lime trees was laid out on the south side. Grass surrounded by box-hedges has taken the place of former *broderie* ornaments. The topiary areas near the entrance and at the centre remain the particular attraction of this garden. They echo the vertical emphasis of earlier Renaissance gardens and restrict the field of vision. A tendency to retain earlier forms is typical of Swiss baroque gardens.

H.-R.H. (trans. R.L.)

See also SWITZERLAND: THE SEVENTEENTH AND EIGHTEENTH CENTURIES.

Vignola, Giacomo Barozzi da (1507–73), usually known simply as Vignola, an Italian architect involved in the most important developments in Roman landscape design from the 1550s until his death. These included the Palazzo *Farnese, Caprarola; Villa *Giulia, Rome, and the Villa *Lante, Bagnaia. It is, however, difficult to identify precisely what his contribution was, since no plans indicating his intentions for landscape design have survived. Yet, given his evident sensitivity to site and given that he was the only leading designer involved, it is a reasonable assumption that he was largely responsible for siting the buildings and for the overall layout. P.G.

Villandry, Indre-et-Loire, France, has a 12th-c. and Renaissance château, with 18th-c. terraces and canals, restored by Dr Joachim Carvallo between 1906 and 1924 to make gardens on three levels. The Jardin d'Ornement, adjoining the south side of the château, has four compartments designed in box by the Spanish artist Lozano, symbolic of *l'amour tendre* (hearts, flames, and masks), *l'amour volage* (butterflies and fans), *l'amour folie* (a labyrinth of hearts), and *l'amout tragique* (sword and dagger blades). The box parterre is continued with other designs, and extends at right angles, overlooking the Jardin Potager, consisting of nine large squares with vegetables planted in geometric patterns inspired by engravings by *Du Cerceau of 16th-c. gardens. The main axis of the garden is an avenue of limes, which separates the Jardin d'Ornement and the Jardin Potager from the Jardin d'Eau. Here is an ornamental basin from which a canal joins the castle moats, crossing the avenue at right angles. The geometry of the garden and the hierarchical arrangement were associated in Carvallo's mind with ideas of absolute order, at the same time theological, social, and aesthetic; and the antitheses of the *jardin anglais*, associated with *Rousseau and 'the principles of an absurd egalitarianism, contrary to nature and good sense'. K.A.S.W.

Villette, Val d'Oise, France, has an exquisite small château designed c.1663 by François *Mansart and completed by *Hardouin-Mansart, with a 17th-c. water-stairway (the Rivière) on the axis of the house. In 1824 the architect J. Lalos redesigned the gardens in the picturesque style. They were restored *à la française* by the present owner, M. Robert Gerard, who furnished them with statues and vases made originally for Marly and Choisy. A colossal *Neptune* from Saint-Ouen has been placed in the niche of the *buffet d'eau* at the head of the Rivière, one of the very few 17th-c. cascades now in working order. K.A.S.W.

Vilmorin-Andrieux, the firm of French nurserymen still headed by members of the Vilmorin family, was founded in the 18th c., its nucleus being the older business of Le Febvre, a seedsman and nurseryman whose garden in Paris was visited by Martin Lister in 1698, when 'the Tulips were in their prime; indeed, he had a very large and plentiful Collection'. Pierre Geoffroy (d. 1728) took over from Le Febvre, and his daughter married Pierre Andrieux, who, before 1769, became the partner, and later the father-in-law, of Philippe de Vilmorin (1746–1804), who introduced many new plants to France, particularly American ones. Both Andrieux and Vilmorin held royal appointments, and the firm supplied seeds and plants for the gardens of the *Tuileries.

The first Vilmorin nursery garden was in the Rue d'Orillon, and the shop on the Quai de la Mégisserie also dates from the 18th c. A broadsheet of 1769 offers a large range of flowers, trees, shrubs, vegetables, and pasture grasses, while a catalogue of 1771 contained over a hundred pages, with a great variety of fruit as well as flowers. Later gardens were in the Rue de Reuilly and, from 1815, at Verrières, c.15 km. south of Paris, where an arboretum was established. Later still came an outpost at Antibes and a nursery at Orléans.

Pierre Philippe André de Vilmorin (1776–1862), described by J. C. *Loudon as 'an accomplished gentleman and scholar', enlarged the firm's reputation, as well as planting many new or rare trees in his own garden at Les Barres. Henry de Vilmorin (1843–99), his grandson, was a friend of William *Robinson and a botanist who enriched the stock of conifers, herbaceous plants, bulbs, and alpines. Robinson supervised the translation of *The Vegetable Garden*, one of many books published by the firm, which appeared in English in 1885. Many of the Chinese plants collected by P. G. Farges in the 1890s were propagated by Henry's brother Maurice (1849–1918), including *Deutzia vilmorinae*, incarvillea, and davidia. Many new varieties of bearded iris were also introduced at the same period. More recent Vilmorins have maintained both the botanical and horticultural traditions of the family, and the firm remains among the leaders in the richness and variety of its stock. S.R.

Vingboons, Philips (c.1607–78), Dutch architect, was an exponent of the Dutch classical canal garden whose designs of houses and gardens for the Amsterdam merchant aristocracy were published in 1648 (*Afbeeldsels dervoornaemste Gebouwen*, 'Representations of the Principal Works of Architecture', followed by later revised editions up to 1736). In this work are two ideal plans of c.1640 of an Italianate villa with surrounding canal gardens which embody the classical principles of symmetry and proportion and are well adapted to the flat Dutch landscape.

The simplicity and largely utilitarian nature of the gardens recall those of the Veneto. In one, a rectangular plan (350 m. × 420 m.), contained by water and trees, encapsulates in the centre a moated house and courtyard along whose axis are placed three square orchard islands. The influence of this plan abroad is reflected in Jean de *la Vallée's design of Ostermalma in Sweden of c.1660 (Sten Karling, *Trädgardskonstens historia i Sverige*, 1931). F.H.

Viretum, in classical Latin turf, greensward; during the Middle Ages (often spelt *virectum*) the word acquired the

meaning of a pleasure-ground for recreation, confused with both *virgultum* and *viridarium*. J.H.H.

Virgil [Publius Vergilius Maro] (70–19 BC), Roman poet and gentleman farmer. The *Georgics*, regarded by many as Virgil's most polished work, is a poem of 2,188 lines on farming; as a literary masterpiece, it is more noted for its charm of expression than for its practical advice on husbandry. The four books into which the poem is divided treat of the cultivation of crops; trees, including the olive, and the vine; farm animals; and beekeeping. The references to gardens are incidental, and appropriately occur in Book 4. Violet beds are mentioned, also garden plots, guarded by Priapus, the god of fertility, that woo bees with the fragrance of their yellow flowers. Also mentioned are the double flowering rose-beds of Paestum, the late-flowering narcissus, the shoot of curled acanthus, ivy, and myrtle. The garden of an old man of Corycus is described; his land was too poor for grazing or for growing the vine, but planted in flowers and trees, it was a haven for bees. Bordered with white lilies and verbena and poppy, it also contained hyacinths and roses and a great variety of trees set in rows.

 W.F.J.

See also COLUMELLA.

Virginia Water, Surrey, England. One of the grandest schemes of ornamental improvement in the mid-18th c. was that in Windsor Great Park by William Augustus, Duke of Cumberland. He moved to the Great Lodge as ranger in 1746. His architect for the various garden buildings was Henry Flitcroft. Large payments were made to the nurseryman Thomas Greening for the plantations installed on the brows of the hills overlooking the valley of a stream called the Virginia Water. A 6-m. dam was built in 1749, and embellished by rockwork, a cascade, and by a grotto in 1754. A 50-ton ship's hulk was fitted up as a 'Mandarin Yacht'. A large Chinese pavilion was placed on the lakeside, and a triangular Gothic belvedere on Shrubs Hill to the south. A mighty single arch bridge spanned the water. Severe floods broke the dam in 1768 and again in 1782. After the latter occasion a higher dam was built on a new line, and this remains today. The new cascade, constructed of massive boulders from Bagshot Heath, excited much admiration, but was a source of disagreement between Thomas Sandby, the deputy ranger, and John Robinson, the Surveyor General of Woods and Forests, in 1788. D.L.J.

Virgultum, from the Latin *virgula*, a twig or sapling, and with the primary meaning of a copse or shrubbery. In the Middle Ages it was sometimes used as a synonym for *viretum* and *viridarium*, but more specifically for a plantation of young trees or tree-nursery (see *imp-garden*), and for a coppice. In both of these latter meanings the English equivalent was *spring*. J.H.H.

Viridarium, in classical Latin already used for a plantation of trees and specifically for a pleasure-garden. In the Middle Ages it became the usual term for the larger garden or planted grounds (as opposed to *herbarium*), the typical *locus amoenus*, translated by Ælfric in 995 as the 'luffendlic stede' or lovely place for recreation. It might also have merely the basic meaning of any garden, in Old English *wyrttun*, an enclosure of plants. Since pleasure-grounds were commonly planted with fruit-trees, though for beauty rather than for crops, *viridarium* was often Englished as orchard (contrasting, however, with *pomarium*). The word had a wide currency in the Romance languages: Italian *verziere*, French *verger*, Catalan, Spanish, and Portuguese *vergel*. J.H.H.

Vista, an early 17th-c. word coined to describe a closely framed view such as an avenue, a sequence of openings, a forest glade, and so forth. Its value to garden design became apparent when the enclosed medieval walled garden gradually expanded into walled gardens of more than one compartment—preparing the way for a unity of design in the 17th c. A vista lent itself to two main optical illusions of perspective: increased or shortened distance. The former can be seen in the main avenue at the Villa Dona dalle Rose (*Giardino Barbarigo*), near Padua, which decreases in scale and space as it recedes from the house; the latter in the central axis at *Versailles*, where *Le Nôtre applied his technique of a garden or park that increases in scale as it leaves the mansion.

In all periods the vista is associated with the idea of an expansion into the environment and reliance upon the imagination to create further distances. G.A.J.

See also DUI JING.

Vizcaya, Villa, Florida, United States, built as a winter home between 1912 and 1916 by James Deering, is an Italian Renaissance palace with 14 ha. of gardens overlooking Biscayne Bay, near Miami. It is the best reproduction of a 16th-c. Italian garden in the United States. Approached through a grove of native trees, one enters the oval plaza in front of the *palazzo* with its fountains reminiscent of the Villa *Lante. From the south terrace is a sweeping view of the formal gardens with their fountains, and two *allées* of clipped live oak (*Quercus virginiana*) lead to the *casino* on the far hillock. Equally impressive is the view in the opposite direction with the red-tiled, creamy-yellow palace, framed with graceful coconut palms, as a backdrop.

Like all true Italian gardens these are not flamboyantly colourful. Rather, the effect is created by delicacy of design emphasized by the neatly-sheared plants such as the ever-dependable *Jasminum simplicifolium* which edges many of the beds. The garden ornaments, including sculpture and urns, are mainly Italian of the 17th and 18th cs.—the only antique fountain is the Bassani di Sutri (from the town near Rome) to be found in the rose-garden east of the mound. However, in addition to the main garden are the intimate grottoes, the circular Tea Garden and maze, the Theatre Garden with orchestra and seats of grass, and the Inner Courtyards with their colourful pot plants. E.F.S./P.G.

Volksgarten. See PUBLIC PARKS: THE VOLKSGARTEN.

Voltaire [François-Marie Arouet] (1694–1778), French writer. Though he suggests in *Candide* (1759) that his only interest in garden-cultivation is that it should be useful, he himself cultivated several gardens, e.g. at Les Délices from 1755, and at Ferney from 1760, both for pleasure and for profit. In gardening his attitudes were conservative and had little room for the 'English' fashion, though he was aware of its existence (see his letter to Sir William *Chambers, 7 Aug. 1772). His correspondence and household accounts reveal a deep interest in the productive aspects of gardening. C.T.

Vondelpark, Amsterdam, The Netherlands, Amsterdam's largest public park, and named after Joost van den Vondel, the 17th-c. Dutch poet, was partially laid out through private enterprise in 1865 and completed in 1877 according to plans by J. D. *Zocher the younger (1791–1870) and his son L. P. Zocher (1820–1915). Water circumvented and intersected the narrow strip of marshland in an undulating manner and groups of trees were placed to create unexpected vistas. By 1874 a music pavilion and a dairy had been erected and in 1881 a large Second Empire pavilion.

During the 1930s a tennis club was established and also a rose-garden which was modernized in 1954. The park became the property of the municipality of Amsterdam in 1953. Because of the high level of the water-table, little remains of the Zochers' planting except for several oaks and willows. Today such trees as *Taxodium distichum*, *Pterocarya stenoptera*, *Catalpa bignonioides*, *Sophora japonica*, and *Ginkgo biloba* may be seen. F.H.

Voorst, De, Gelderland, The Netherlands. See DE VOORST.

Voort, Pieter de la Court van de (1664–1739), Dutch merchant and art patron. See VAN DE VOORT.

Vredeman de Vries, Hans (1527–1606), Dutch painter and designer. See DE VRIES.

Vrijburg Palace, Brazil. See DUTCH COLONIAL GARDENS: BRAZIL.

Wad, Peter (1887–1944), Danish landscape architect, had a private practice in Odense, Fyn, which included numerous private gardens, public parks, and churchyards on the island of Fyn. Strongly influenced by his contemporary, C. Th. *Sørensen, their reciprocal experiments in the 1920s and 1930s using the circle and more organic forms point in the same direction. Wad's work is characterized by clear form and spatial concepts related to central axial pathways. Hedges predominate as enclosure elements, used as long narrow galleries with a grass or gravel floor, or in broader contexts as double-sided herbaceous borders. His curved gardens a decade later point to more free and experimental design forms, some associated with spiral or fan shapes.

P.R.J.

Wah Bagh, Hasan Abdal, Rawalpindi, Pakistan, originally a camping ground of the Mogul emperors, was named traditionally by *Akbar, said to have exclaimed 'Wah Bagh' ('What a garden!') on first visiting the site. It lay near the road to Kashmir, and would have been chosen both for the beauty of the site and for the spring at the top of the hill. A summer-house and tank were created there in Akbar's time, and a later garden palace is usually attributed to *Jahāngīr.

The garden fell into disrepair, but has recently been acquired by the Government Department of Archaeology. Clearance work has revealed the Royal Bath complex, and other interesting features.

S.M.H.

Wakehurst Place Garden, West Sussex, England. The most important period of development of this estate came in the 20th c. when for 35 years it was owned by Gerald Loder, later Lord Wakehurst. Stimulated by the surge of new and exciting introductions he and his head gardener Alfred Coates planted a vast collection of plants, especially rhododendrons, magnolias, and conifers. Many of the original introductions came from collectors like *Farrer and *Wilson, and later *Forrest, *Kingdon-Ward, Rock, and Yu, and still remain there.

In 1936 the estate was bought by Sir Henry Price who, until he died in 1963, continued vigorously to restore and develop the house and garden, which now has more than 7,500 distinct plants. He bequeathed it to the National Trust and in 1965 it was leased to *Kew, who quickly realized its value: first for developing generic collections more suited to the moister climate and soil, such as *Rhododendron, Hypericum, Acer, Betula,* and *Salix;* secondly for maintaining groups and plant associations traditional to the garden, such as Comber's collections of Southern Hemisphere plants, the heath garden, and the pinetum; and

thirdly for acting as a conservation area for the native flora of this part of Sussex and for threatened plants of the British and European flora. As befits a botanic garden, educational, scientific, and research programmes are also being developed.

The planting is predominantly informal with a woodland garden in the style of William *Robinson. Only in the walled garden near the house is there any formality: part is Sir William Boord's yew-hedged pleasure-garden, with pool and fountain, and the rest has been planted recently with the popular silver- and grey-foliaged plants and soft-coloured flowers in pinks, blues, and mauves.

J.S.

Wales. With the exception of *Erddig and *Powis Castle there does not seem to have been in Wales an equivalent of the type of formal garden common in England at the end of the 17th c. Perhaps because of the rugged mountainous terrain, its distance from the seats of power, or its economic backwardness, Wales was completely bypassed by the 'Capability' *Brown revolution. Unlike Scotland or Ireland it did not even produce a local version of the Brown style, or any native designers or gardeners of note.

It was not until the taste for the *picturesque towards the end of the 18th c. (beginning with William *Gilpin's tours of the 1780s) that the scenic beauties of Wales came to be appreciated. Even then, however, garden design was confined to the borders, such as Uvedale *Price's *Foxley or Payne *Knight's Downton. The major exception was *Hafod, the most splendid realization of Price's picturesque principles anywhere in the British Isles. From 1783 Thomas Johnes laid out an extensive system of walks to display its beauties, and planted more than 2 million trees on the mountains.

When Thomas Johnes left Hafod in 1815, there was no successor as garden designer. Wales was unaffected by the historicist revivals of the Victorian era, perhaps because there was no earlier tradition to serve as a stimulus. This century has seen something of a change, with *Bodnant Garden, which combines dramatic views organized from a series of terraces and rich planting; and Clough *Williams-Ellis's layout of Portmeirion.

P.G.

Walled garden. Whether in Mesopotamia or the Nile valleys, gardens that appeared as something more than irrigated fertile fields of production were almost immediately walled for protection and privacy. The essential quality of the symbolic Paradise garden of Persia (Iran) lay in its conception of heaven brought to earth, and protected from its hostility (see Gardens of *Islam). The small walled

garden of the average prosperous Egyptian in Thebes was so beloved by him that he wished to take it with him into the next world. The idea of the walled garden passed through Graeco-Roman Alexandria to reach a climax of design in the patio gardens of *Pompeii enclosed with the domestic structure. Roman gardens in general were not contained by walls, but walled gardens reappeared in the Middle Ages, when their potential for growing plants both for food and for medicinal use was of first importance.

With the coming of the Renaissance the walled garden first expanded, then duplicated itself. The development is particularly marked in France in the châteaux of the Touraine, especially at Blois where the spaces were enormous and the contents enriched with vine arcades and countless garden delights. In England, with its peculiarly domestic character, the walls of both kitchen and flower garden were made of brick with lime mortar and were warm and friendly for fruit and climbing plants. Until the 18th-c. landscape revolution in England the walled garden— whether kitchen or flower—had always been adjacent to and an extension of the house; now it was banished, became only a garden for kitchen produce or flowers for the house, and was totally separated from the mansion as something unworthy of being seen. The walled garden returned to popularity in the 19th c., but in the 20th c. the cost of brick walls over 2 m. in height is so considerable that they are rarely made. G.A.J.

See also SERPENTINE WALL.

Wallenstein Garden. See VALDŠTEJN GARDEN.

Wallich, Nathaniel (1786–1854), a Danish-born botanist, became Director of the *Calcutta Botanic Garden in 1815 and stayed in India for most of the next 30 years, travelling in the Himalayas, Burma, and Nepal, and encouraging local collectors to bring him plants from regions not open to Europeans. Large quantities of live plants, bulbs, and seeds were sent back to both *Kew and *Edinburgh, with several species of cotoneaster, *Bergenia ligulata, Cardiocrinum giganteum, Geranium wallichianum, Pinus wallichiana,* and *Morina longifolia* among the novelties. Another of Wallich's additions to the Calcutta garden was *Amherstia nobilis,* a tree bearing racemes of bright red flowers which later became a spectacular stove-house plant in colder countries. On leave from India in 1828, Wallich brought back large collections of living plants and dried specimens to London and spent the next five years there working on *Plantae Asiaticae Rariores* (1830–2), a record of his studies of the flora of India and neighbouring countries, illustrated with lithographs from drawings by native artists. S.R.

Walling, Edna (1896–1973), was the key landscape designer to practise in Australia during the first half of the 20th c. English-born, she arrived in Melbourne in 1916 aged about 20.

Her first works are English-inspired, and appear to be strongly influenced by the writings of Gertrude *Jekyll:

pergolas, gates, fences, walls, paths, and planting are virtually identical in concept and detail to those illustrated in her books. These first gardens were awkward equally in design and execution. The drawing style is stiff and unnatural whilst the gardens themselves are composed of disjointed elements. Gradually Edna Walling evolved a distinct and confident style of drawing and design, the latter utilizing curving and flowing lawns set with stone flagging and edged by low rock walls, with circular and semicircular steps linking the various levels. Ponds, formal flower-beds, pavilions, and tea-houses were typical features.

Formality dominated her gardens until the 1940s, although there was usually a 'natural' area where the garden could go 'wild'. Shrubs and smaller trees were confined to large massed beds and specimen trees were carefully located on the large sweeping lawns. At Cruden Farm (1931) near Frankston, Victoria, the tall white trunks of the lemon-scented gum (*Eucalyptus citriodora*) define the margin of the gently curving drive which terminates in a turning circle before the tall white columns of the house. Close by are walled flower gardens, entered through arched gateways. To the north, well-kept lawns lead the eye out from the house into the countryside.

Later, as can be seen at Markdale (1947) near Crookwell, New South Wales, her designs became more relaxed, with softly framed distant vistas and sweeping, banked lawns emphasized by curved stone walls and massed heath planting. From the lake and along the garden's walks which are lined with pergolas, the cupolas of the house provide a central focus. At Kildrummie, Holbrook, New South Wales, she revived the *ha-ha, providing effortless visual transition between garden and landscape, and this became a characteristic feature of new gardens in this district.

Her many articles in *Home Beautiful* and her popular books—*Gardens in Australia* (1943), *Cottage and Garden* (1947), *A Gardener's Log* (1948), and *The Australian Roadside* (1952)—told of a relaxed blending of plants and architectural trim: steps, railings, pergolas, pools. Here was a form of gardening well suited to typical Australian conditions, with a mixture of plants ideal for the climate, such as heat-loving Westmorland thymes, which prefer rocky conditions, and native species. Field-stone formed walls and defined the margins of pools; changes in ground level, and any natural features—trees, plants, boulders—were emphasized by careful planting. Sharp boundary lines were softened by planting and distant elements drawn into the garden composition. The initial Edwardian style was tempered as she embraced both rational and bush garden philosophies.

At Mooroolbark, near Melbourne, Edna Walling built herself a stone cottage and later designed further houses set in a common landscape—the Bickleigh Vale village estate. This was a landscape of great natural beauty, with tall eucalypts, wattles, and pittosporums. Here Edna Walling began propagating native plants, and this interest altered her approach to garden design. In her later works native plants are grouped to make vistas and spaces and to provide fast-growing, hardy specimens. H.N.T.

Wallington, Northumberland, England. The layout of the park and gardens is largely the achievement of Sir Walter Calverley Blackett, who inherited in 1728 and employed the architect Daniel Garrett to remodel the house and to design a number of garden buildings over the next 40 years. The earliest plan for the pleasure-grounds, in the semi-formal style of *Bridgeman, appears to tally with estimates submitted by a Mr Joyce in 1737.

Three ponds shown on Joyce's plan still survive in the West Wood, but the main part of the garden now lies to the east of the house, across the Cambo road. This includes the China Pond, called after the 'Chinese House' erected here in 1752 but no longer surviving, and the Garden Pond, which originally lay within a large walled formal garden. The Portico House, a gardener's cottage designed by Garrett, still stands in the centre of the north wall overlooking a series of terraces descending to the pond. But in the 1760s Sir Walter demolished the south and west walls, planting up the area informally as an extension of the East Wood, and creating a new walled garden in the dell below, dominated by another pavilion called the Owl House, after the Calverley crest which surmounts its pediment. 'Capability' *Brown probably helped Sir Walter with these alterations, and certainly made plans c.1765 for the pleasure-ground at Rothley Lake, a short distance away on the Rothbury road, including a grotto and tea-house in the Gothic style. Thomas Wright of Durham designed a mock fort, Codjah's Crag, on a hill above this lake in 1769, and may also have given advice on the landscape nearer the house.

Sir Walter Blackett's successors, the Trevelyans, replaced the vegetables in his walled garden with exotics and shrubs, built the glasshouses here in the early years of the 20th c., and created a terrace and pool at the west end in the 1930s. The fine series of late 17th-c. lead figures along the terrace came from the Blacketts' house in Newcastle, Anderson Place. Since 1958 Wallington has belonged to the National Trust. G.F.A.J.-S.

Walpole, Horace, 4th Earl of Orford (1717–97), was the youngest son of Sir Robert Walpole, the first English Prime Minister. In 1747 he acquired Strawberry Hill, a small villa on the Thames at Twickenham, which he transformed into a Gothic castle of irregular plan.

The design of the grounds uses several characteristic features of the mid-18th-c. landscape school: a *ha-ha, a lawn planted with trees in clumps of three and four, and, on the south, a belt plantation through which runs a serpentine drive. It is unusual in its abundance of flowering shrubs, in its paved terrace near the house, covered with plants in pots, and in its string of small, more formal gardens on the north side of the house. Walpole's most successful stroke was to incorporate into the view from the house the animated prospect of the Thames. He also had his own nursery here.

Walpole's essay *On Modern Gardening* (written between 1750 and 1770) hails William *Kent as the founder of the English picturesque tradition of park design, citing John Milton and Claude Lorrain as his inspiration, but Walpole differs from Kent in preferring to retain avenues and some neatness around a house. It is significant that Humphry *Repton in his *Observations* acknowledged the importance of Walpole's essay, since in his small garden at Strawberry Hill Walpole was in many respects Repton's precursor.

K.S.L.

Wang Chuan Villa, China, a country estate at the entrance to the valley of Wang Chuan, south-west of Lan Tian county in Shaanxi province, is perhaps the most famous private domain in Chinese history. It belonged to the Tang-dynasty poet and painter Wang Wei (699–759) who, retiring there from the then capital some 50 km. away, recorded it in poetry and painting on a long (and often copied) hand-scroll.

The valley was what the Chinese call a 'suddenly-opened-up space' with partially flat, partially undulating ground, a stream, a lake, and an island surrounded by layers of steeply folded hills. Along the rocky shore Wang Wei described 20 views, usually focusing on or seen from a different lodge or summer-house. Some of these were double-storeyed halls, with upturned eaves above open balconies; others like The Cottage in Bamboo Forest or Apricot-Veined Cottage reflected an ideal of rustic simplicity. Flowering fruit trees, willows, and *wu-tung* trees (*Firmiana simplex*) grew around them, making each a little green cell of its own, while stiff pine trees grew thickly on the hills behind. The villa itself lay to the south near the Lu Yuan, or Deer-Park Temple, a rambling series of rooms, pavilions, and halls connected by bridges, winding paths, and *lang* walkways. Wang Wei's great scroll made sure of his garden's continuing fame, but it was his own character, as poet, musician, painter, calligrapher, and man, that ensures its place in Chinese culture. G.-Z.W./M.K.

Wang Shi Yuan, Jiangsu province, China, situated in 0.6 ha. in the south-eastern district of *Suzhou, has been the site of a garden since the 12th c. Among the smallest of the famous gardens restored in this city, like them it is hidden away behind high white-plastered walls. Three large, dark, and formal halls, symmetrically placed one behind the other with living accommodation above and tiny, open courts between them, occupy the south-east corner of the site, and the garden—informal, intricate, sparkling, and lively—gains much from this juxtaposition.

Originally built in 1140 by Shi Zhengzhi, a cultivated scholar-official, the garden surrounded his library, the Studio of Ten Thousand Scrolls, and he called it Yu Yin (Fisherman's Retreat) to suggest his love of simple pleasures. After him, the garden slips into obscurity until it reappears in records of 1760 undergoing formidable rebuilding by the second of its great designers, Song Zenghuan. A Vice-Director of Imperial Entertainment at the court of Qian Long, Song gave the garden the name it still has today, Wang Shi, after his own pen name meaning Master of the Fishing Nets—a nice allusion to the original garden.

Again neglected (by the late 18th c. only the pond

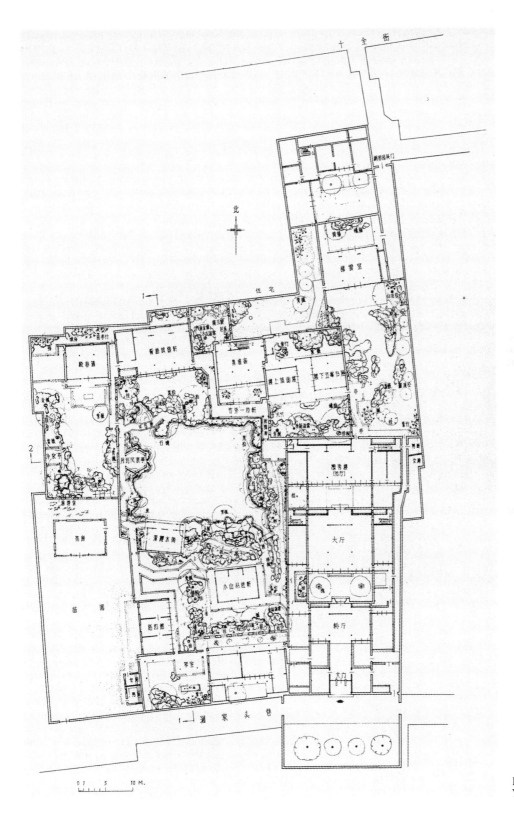

Plan of Wang Shi
Yuan, China

remained), the Wang Shi Yuan was rescued by Qu Yuancun who had it rebuilt by local craftsmen to his own design. He chose many of the names (such as 'A Branch Beyond the Bamboo' and 'Washing Cap-String Pavilion') which, with their allusive literary references, are part of the pleasures offered by the garden. Since then, successive owners have elaborated a composition of more than 10 tiny, enclosed gardens and over a dozen different halls and pavilions around the central pond.

Though two doorways connect it directly with the house, the garden has its own small entrance off a narrow alleyway between houses along busy Youyi Street. Its simple door leads on to a plain corridor open to the sky between white walls. At the end, a sharp right-angled turn reveals a small rectangular courtyard, a fine water-modelled *Taihu rock standing among other stones and shrubs, and full-length pivoting windows which open into a hall. From here there are several ways to go, for the garden is a composition of courtyards fitted together as intricately as a Chinese puzzle. At the beginning they act as a kind of layering, gradually separating the visitor from the world of the city outside. The culmination of this process is the little rocky-bordered lake—the enclosing courtyards opening at last on to what seems by comparison far wider than its 350 sq. m. area, with trees and shrubs half hiding many different buildings scattered irregularly around the water's edge.

On the bank opposite the house, raised on rocky stilts above the water, its swooping eaves and trellised seats reflected below, is the Pavilion of the Moon Appearing and the Breeze Arriving. As the focal point of the garden, its function is partly to lure the visitor to explore further, since to reach it he has had to choose to go either left or right around the lake. Either way, he will be diverted from his path by many unexpected delights: to the left the Barrier of

Clouds Hall with its glassy interior hidden from the lake by a high rocky bank; the little Lute Garden with its secret courtyard beyond a bamboo grove; the nursery garden with its rows of seasonal flowers in pots, and the Washing Cap-String Pavilion, its terrace overlooking the pool. To the right, a covered walkway zigzags to some smaller garden courts, and thence to the garden's most formal building, the Hall for viewing the Pines and Seeing a Painting, set back from the lake with its windows opening out on to a low bank still nurturing a group of aged cypress and *Podocarpus*. Beyond this lies the peaceful, rocky-bordered courtyard of the Late Spring Studio, used as a model for the Astor Court garden in the Metropolitan Museum of New York. In a second, smaller studio, tucked into the most westerly corner of this court, a well-known painter Chang Da-chien worked in the 1930s. Although in this garden each individual building, and the house and its small yards are all strictly rectangular, the different parts do not fit together perfectly and left-over slivers of space are planted with bamboo and rocks to bring light and air into even the smaller rooms.

Wang Shi Yuan is one of the most intricate and subtle of Suzhou's old gardens—exceptional in the grace of its swoop-eaved porches, in the balance of high and low, open and enclosed spaces, and in the fine quality of its building and decoration, well restored and preserved. Usually the garden most liked by foreigners, it still retains the feeling of a place long and deeply loved. M.K.

Wang Takrai, Nakorn Nayoke, Thailand, the Pool of Takrai, named after an indigenous waterside tree, *Rotula aquatica*, is a country park created by Princess *Chumbhot in the foothills of the Kao Yai Range *c.* 150 km. north-east of Bangkok near the famous waterfalls at Salika and Nangrong. *Pimsai describes it as 'the nearest we have to a botanical garden', and it contains a collection of tropical plants from all over the world. There are wide areas of grass (*Zoysia matrella*) and precipitous mountain streams feed a great pool within a grove of enormous madeua trees (*Ficus glomerata*). In addition to a collection of native Thai plants many annuals from temperate climates have been allowed to naturalize. Among the most impressive trees are the erythrinas (including a group of *E. christa-galli*), *Bombax malabaricum*, and various cassias and jacarandas, tabebuias, phyllocladus, and cochlospermums. M.L.

Wardian case, named after Nathaniel Bagshaw Ward (1791–1868), who accidentally discovered the principle that a sealed glass case could form a self-sustaining environment for plants, since the water transpired by the plants condensed inside the case and was re-used. These cases began to be used in the late 1830s to ease the problems of importing living plants from abroad; Ward's name was also applied to cases used for ornamental indoor planting, even though he himself did not pioneer this use. He described his discovery in *On the Growth of Plants in Closely Glazed Cases* (1842). Wardian cases ranged from simple bell-jars to miniature conservatories, and were most frequently used for ferns and foliage plants, sometimes with small-scale

Wang Shi Yuan, Suzhou, China

rock-work. Their use, and survival rate, declined after the end of the 19th c. B.E.

Warnau, Hans (1922–), Dutch landscape architect, in his training period worked on landscape restoration in the war-damaged provinces of Holland and Zeeland. Later he worked on playgrounds for the Town-Planning Department of Amsterdam under C. van Eesteren (1953). After entering into partnership with P. A. M. Buys and J. Meyers, Warnau together with van Eesteren worked on the masterplans as well as on the environmental design for the first residential areas of the new towns of the IJsselmeerpolder, Biddinghuizen, Dronten, Swifterbant, and Lelystad (1970). During this period he was successful in three competitions for urban park design. His landscape plan for the Grote Waal housing project at Hoorn, designed together with J. Kalff, was awarded the title of 'Experimental Plan' by the Ministry of Housing and Town Planning.

In 1984 J. Meeus described Warnau's work in this period as 'post-modern' and related his concepts to those of L. Migge. In the later period of his career Warnau was appointed a consultant for three land consolidation projects in the Amsterdam-Utrecht agglomeration by the National Land-use Authority. His contributions to these areas have well-balanced agrarian and urban qualities. In 1976 he retired from practice to take up full-time teaching at Wageningen Agricultural University. W.C.J.B.

Warwick Castle, Warwickshire, England, has gardens which are mainly mid-18th c. with 19th-c. additions, extending to some 30 ha. The gardens in their present form were created by Lord Brooke, who employed 'Capability' *Brown from the 1740s to the 1760s. It was Brown's first independent commission, and as the finished work was much praised by Horace *Walpole, it enabled Brown to develop his country-wide practice. The old formal garden 'without the Castle wall', which was in existence when Queen Elizabeth visited the castle in 1576, was removed and the ground shaped in sympathy to the Mount and to frame a view to the Castle Park. Tree belts, clumps, and specimens were planted, notably cedar of Lebanon. A new carriage route was made and the courtyard levelled and made into lawns with Scots pines planted to complement the picturesque scene. In the 1750s Brown was also commissioned to begin the improvements to Castle Park across the River Avon. The park was completed by the 2nd Earl during the 1780s.

The 'Gothick' conservatory (c.1787) is sited on rising ground to give a noted view from the terrace across Pageant Field to the confluence of the River Avon and Castle Park. In 1869 a *parterre garden (now called the Peacock Garden) was laid out in front of the conservatory, from plans prepared by Robert *Marnock. P.E.

Washington, George (1732–99), President of the United States (1787–97). Despite his political opposition to England, George Washington's respect for and correspondence with English agriculturists continued all his life. While he had an extensive library devoted to agriculture and animal husbandry, the only English garden authority he consulted appears to have been the volume of Batty *Langley's *New Principles of Gardening*, ordered from his London agents soon after his marriage. Washington appears to have adopted terms like 'shrubbery' from it, but little else in all the designs and plantings he made for the grounds and gardens of his 'home farm' of *Mount Vernon. His interest in flowers appears to have been minimal compared to his intense interest in native flowering trees and shrubs and he may have left the planting and extensive flower-gardens to his wife Martha. His liking for 'the clever sorts' of flowering trees and shrubs, discovered and collected while hunting or riding daily on his far-reaching farming operations, was exceeded only by his experiments with grafting fruit-trees, preparing soils, and planning procedures for diversified crops. A.L.

Watelet, Claude-Henri (1718–86), French painter, was a friend of François *Boucher and Hubert *Robert. He designed the gardens of *Moulin Joli and was the author of *Essai sur les jardins* (1774). The book is partly a classification of gardens according to their character (*ferme ornée*, Picturesque, Poetic, Romantic), with echoes of *Whately, but briefly and in general terms. Essentially it is a plea for simplicity and naturalness in gardens, and against theatrical effects and ostentation, whether in the forms of the big architectural gardens of *Le Nôtre or of the newer fashion of the *jardin anglo-chinois. Watelet was acquainted with J.-J. *Rousseau, and his sentiments are Rousseauesque.
 K.A.S.W.

Water in the landscape. 'And a river went out of Eden to water the garden'.

Islam. In the Paradise Gardens of *Islam, water was an essential feature. Canals were arranged to intersect in the middle to make the fourfold plot (*chahar bagh*) divided by the four Rivers of Paradise. At the crossing there would be a pavilion or a square water-tank with lotus-flowers floating on the surface. The concepts of Persian gardens were spread throughout the civilized world by conquest, notably by Muslim Arabs who overthrew Persia (Iran) and Syria before invading Spain and taking Cordoba in 750, bringing with them the desert tribesman's longing for water and shade.

At Cordoba the *Patio de los Naranjos is divided in the middle into three rectangles planted with orange trees, the bases of which are connected by narrow irrigation channels fed by the overflow of *fountains. The basins of the fountains and the jets themselves are low, not rising more than 15–30 cm. Hispano-Moorish gardens reached their highest development at Granada; in the *Alhambra there are four courtyards or patios, in each of which water is a major feature. The *Generalife has a long central canal with many fountain jets playing inwards from both sides, taller jets than many others seen in Spain. This whole garden is full of water: looking down from the Pabellon Norte, one sees a

circular fountain with flowers in pots set around its rim and, at one side, a flight of steps with rills of water at either side to make cool handrails.

The *Mogul Empire developed the Persian tradition of garden design in which water played such an important part. At Kabul, *Bābur, the first of the great Moguls, made many gardens, among them *Bagh-i Wafa, the Garden of Fidelity, designed as a traditional fourfold plot full of running water which dictated the pattern of the garden; the flower-beds were sunk to allow water to percolate into them and the pathways raised to provide firm going. The climate of this part of India is hotter than that of Persia and Babylonia and for this reason there was more emphasis on the provision of large tanks for swimming and bathing, particularly in the women's quarters. The air was cooled by the spray of fountains, and long sheets of still water suggested stillness and repose, in contrast to the movement of water coursing down marble chutes (*chadar). The *Taj Mahal follows the traditional fourfold design, but the tomb-temple instead of being at the middle of the four canals is at one end overlooking the world outside. In the mountains in Kashmir where the court moved in the hottest times was *Shalamar Bagh (c.1619). It consisted of three gardens, in one of which stands the Black Pavilion at the crossing of four canals, surrounded by cascades seen against the snows of the mountains beyond.

China. In this country of mountains, large rivers, and wide inlets of the sea there developed a reverence for wild nature. Paintings of landscapes and poetry evoked by landscape inspired the making of their gardens. They had a genius for the management of water, making lakes with islands strung together with high semicircular bridges giving back perfect circles in reflection. Marco Polo wrote of the lake at Beijing, 'There are upon the lake a great number of pleasure vessels or barges . . . and truly the gratification afforded in this manner upon the water exceeds anything that can be derived from amusements on the land.'

Japan. In Japan, also, water in the landscape was greatly desired. Lakes were made in the shape of a tortoise or a crane, waterfalls were introduced to sparkle and animate the scene. Where it was impossible to bring water into a garden, its courses were suggested by stones laid as if they made the bottom of a stream, or a bed of sand shaped out to indicate a pool.

Classical antiquity. In classical antiquity, too, water had played a part in the cult of the gods. In the *Odyssey* *Homer described a Sanctuary of Nymphs at Ithaca, a basin with streams gushing downwards from rocks, an anticipation of the *nymphaeum. *Pliny the younger described the extensive waterworks at the garden of his Tuscan Villa, all fed and worked from a spring on high ground behind, and there are still substantial remains of *Hadrian's Villa, Tivoli, where water is articulated in streams, canals, pools, and fountains.

Italy. Much of the spirit and detail of these classical gardens was refined and perfected in the Renaissance, especially at the Villa *d'Este at Tivoli. It exhibits the most dramatic, imaginative, and ingenious use of water ever seen—the sheer magnificence of the hundred fountains, the curious *automata, singing birds silenced by the appearance of an owl, a water-organ, and a noisy dragon fountain. At the Villa *Lante water is used in a different way. From the top of the garden the ground falls alongside a stone water channel scalloped into a sequence of crayfishes through which a stream of water courses down, and on past a long stone dining-table with a rivulet of water running through it. There are the expected *giochi d'acqua, and in a recess above them a female figure from whose breasts run thin streams of water. From a point a little in front of her feet another thin

Villa d'Este, Tivoli, the Pathway of a Hundred Fountains, from G. B. Falda, *Le Fontane di Roma* (1675)

jet rises and then falls down from between her thighs. In the Frascati area, the use of dramatic *cascades is best seen at the Villa *Aldobrandini and the Villa *Torlonia.

See also GARZONI, VILLA.

France. By contrast, French 16th- and 17th-c. gardens made effective use of large canals, rather than cascades, the major exceptions being *Chantilly, *Sceaux, and *Saint-Cloud, and the very influential example at *Marly (see also *La Granja). This was pioneered by Philibert de *L'Orme at *Anet, where the canal was used to drain marshy ground. The other origin of the French canal was the moat which surrounded fortified châteaux.

In 17th-c. France the genius of *Le Nôtre could never have been expressed without the employment of water, although he was continually hampered by the restricted supply of water at sufficient pressure to make fountain displays. At *Vaux-le-Vicomte, *bassins* offer a neutral silver blankness, a framed reflection of the château, or simply a reflection of cloud and sky. A feature of the design is the brilliant treatment of falling levels, which conceal the existence of the long canal on the cross-axis. Just before this canal the visitor comes upon the square *bassin*, called the Grand Miroir d'Eau, and turning back can see it reflect the whole façade of the château from far away—the position and proportions of the *bassin* have been exactly calculated by Le Nôtre for this purpose. At *Versailles the Parterre d'Eau with its two rectangular pools reflects the immense façade of the château and provides a link to the garden beyond, looking down to the Fountain of Latona, then on into the distance to the beginning of the Grand Canal where, in the time of Louis XIV, there were not only pleasure boats, but also scale models of merchants ships and warships. Beyond the Orangery is the 700-m. long lake, known as the Pièce d'Eau des Suisses. The water parterre is a notable feature of Chantilly.

Russia. Le Nôtre's 'doctrine' was carried to St Petersburg (Leningrad) by his disciple, Jean-Baptiste Alexandre *Le Blond, who arrived in Russia in 1716 and made a summer garden alongside the Fontanka Canal, the water from which was used to supply the fountains. He also designed and began to make the gardens at *Peterhof (Petrodvorets), which had extravagant waterworks tumbling over marble steps into a marble basin, and running on down through the magnificent long canal towards the sea (see plate XIV). In another, later, cascade, the Golden Mountain, the steps over which the water rushes are golden, and there are gilded bronze statues disposed around.

England. The dramatic cascade at *Chatsworth is something of an exception, as in the gardens of the later 17th c. the canal was the rule (see *Hampton Court). It is interesting that by the middle of the 18th c. the landscape school disapproved of fountains because they were unnatural while waterfalls were acceptable because they occurred naturally. In 'Unconnected Thoughts on Gardening' (*c.*1755),

*Shenstone wrote: 'The fall of water is Nature's province— only the vulgar citizen . . . squirts up his rivulets in jettaux.' Instead the self-styled improvers made irregular lakes. Water is used on a grand scale in the parks of 'Capability' *Brown: for example, at *Blenheim he joined lakes to make one large expanse of water, spanned by *Vanbrugh's bridge; at *Bowood the lake has been given appropriate additions of a grotto and cascade; and at *Nuneham contours and planting were designed to bring the River Thames into the picture.

In the 19th c. achievements such as the Emperor Fountain, Chatsworth, with a jet of 88 m., are of hydraulic rather than aesthetic interest. The main innovative use of water is to be found in *public parks, one of the earliest examples, *Birkenhead (1843), also being the finest. Here the path system closely follows the sinuous edges of the lakes, a pattern to be followed in many 19th-c. public parks.

<div style="text-align: right">P.G./D.W.</div>

Water in the modern landscape. A major change in the use of water is due to the development of synthetic means of waterproofing from the late 19th c. onwards. *Roof-gardens—once considered hazardous—are now common, especially in countries of high development densities such as Switzerland. They are often adorned with pools and fountains arranged over offices and car-parks. Among early examples are the first public gardens by Roberto *Burle Marx at the Ministry of Education and the Resurgeros Insurance building in Rio de Janeiro (1938/9).

Membranes of butyl rubber and polythene have displaced puddled clay as guaranteed methods of waterproofing. Bodies of water can now be created where the ground is geologically unsuitable: for example, in the desert, where lakes of fresh or salt water have become a feature of some of the new palace gardens. (See *Middle East.) While major reservoirs are still normally sited in geologically appropriate regions, many more ornamental lakes, especially when associated with buildings, have synthetic linings. At York University the lake functions as a balancing reservoir which has been carefully integrated with landscape and buildings to give it the semblance of a river. It falls, from its source in fountains near the buildings, via a series of weirs, through a landscape which gets progressively more informal and naturalistic.

In the new town of Hemel Hempstead Sir Geoffrey *Jellicoe harnessed an actual river, using it as a barrier between the bustling town centre and the lushly planted mounding which conceals the car-park on the other side. The idea of using water deliberately as a barrier has been exploited in a number of 20th-c. examples. A canal has been used as a substitute fence along the road frontage of some factories, and a small pool has been employed as a tempting hazard, for children, adjoining the gate at the Boltons School in Chelsea, London. But it is as an animal barrier that water comes into its own. At Whipsnade Zoo a giraffe and some other animals are seen by the public as though across a water-hole; at London Zoo the water is formalized into a canal; and at Chester Zoo the visitors take to the

water, travelling in water buses between unfenced 'islands' inhabited by animals.

See also ZOOLOGICAL GARDEN.

Water is used symbolically in the small courtyards by Isamu *Noguchi for the Beinecke Rare Book and Manuscript Library (1963) at Yale University, the Chase Manhattan Bank (1964), and the IBM Headquarters (1964) in New York. Also, less explicitly, the symbolism is apparent in the exquisite pools, fountains, and channels of the Mexican architect Luis *Barragán, who was inspired by the Moorish gardens of Spain and the great wooden aqueducts used to carry water over the villages of his native Guadalajara.

Although the design of fountains and 'waterworks' has advanced surprisingly little in relation to the possibilities of the technology of pumps and pipework, there are some outstanding examples. The German *Gartenschauen competitions have produced some exciting ideas such as the forest of vertical fountain jets contrasted with simulated wave movements at *Karlsruhe (1967) and the decorative use of jets resembling fire-hoses at Hamburg (1963). Also in the Schlossgarten at Stuttgart the German designers have effectively developed the idea of Wasserspiele—literally water-games—in a variety of ways.

The Mogul use of water as a curtain has been taken further in the Museum of Anthropology (1964) in Mexico City, in which a central sculptured column is screened by a ring of fine falling jets (see also *Mexico). Later Isamu Noguchi made a 30-m. high tower with a similar water curtain for Expo 70 at Osaka, Japan.

Such ideas are magnificently combined at the Lovejoy Plaza (1961), in Portland, Oregon, by Lawrence *Halprin and Partners. With great imagination the designers have reinterpreted public needs in an amalgam of symbol, spectacle, and experience through steps and paving, channels, waterfalls, pools, and fountains. The inspiration is said to have come from the rushing rivers and falls of the High Sierras, but there is an echo also of many public fountains, as well as of that seminal work of Frank Lloyd *Wright, Fallingwater, at Bear Run, Pennsylvania, in which the house is built over a waterfall. The Lovejoy Plaza is the first and perhaps the only public square which has come to terms with the needs of the late 20th c., combining the great civic qualities of past examples with the sense of hazard, of adventure, and excitement appropriate to the present time.

The use of water as a kinetic medium rather than a kinetic element, is relatively rare, but occurs in the Tilting Fountain by Richard Huws at the back of Liverpool City offices (1968). A series of buckets fill and tilt in irregular sequence, providing fascinating visual and aural interest. It occurs also most prolifically in the works of Jean Tinguely (1925–), such as the series of fountains adjoining the Centre Pompidou in Paris. It is a surprising and slightly chaotic collection of machines of the 'Heath-Robinson' type, which pulsate, revolve, and squirt water in a variety of ways. Some are abstract, and some are personalized into brightly coloured monsters. Like the Lovejoy Plaza, it is a place of fun. M.L.L.

Waterland, Velsen, Noord-Holland, The Netherlands. In c.1720 the gardens were laid out by an Amsterdam merchant. With an emphasis on the natural rather than the artificial, and with trees as the predominant structural element, the gardens embody the ideals of the Dutch Régence garden of which they are an early example (see The *Netherlands: Régence, Rococo, and French picturesque). In articulation they anticipate the picturesque.

Laid out on an irregular terrain covering c.12 ha., the gardens were conceived as a labyrinth. The main feature was a large pond from which five avenues radiated through woods terminating in such pictorial elements as an intimate verdant room with a triumphal arch, a *Turkish tent, and moving pictures of boats on a lake nearby, provided by a camera obscura in a tunnel. The presence of these last two features in a garden was unprecedented at the time, one evoking distant lands and the other representing science in the service of nature. F.H.

Water-tank. See CISTERN.

Webb, John (1754–1828), English architect and landscape designer, was a pupil of William *Emes, with whom he worked from 1782 to 1793. He later developed a large practice of his own, particularly in the Midlands and northern England. He worked in the style of *Brown, as at Maer Hall, Staffordshire, where he made a lake and planted trees for Josiah Wedgwood in 1808. Webb was later influenced by Humphry *Repton and introduced more formal features near the house. K.M.G.

Weikersheim, Baden-Württemberg, German Federal Republic, had been the ancestral seat of the Counts of Hohenlohe since the Middle Ages. The original moated stronghold was rebuilt as a Renaissance castle from 1585 onwards. Especially interesting is the hall in the south wing facing the garden; the lavish decorations of this unique banqueting-hall originate from 1600–3.

At the beginning of the 18th c. the interior of the east wing was redesigned and a market-place integrated into the forecourt of the Schloss. Of the same date is the baroque garden which has survived almost in its original state; it replaced the Renaissance garden and is laid out as a rectangle, covering an area of c.230 m. × 120 m. In 1708 Count Karl Ludwig of Hohenlohe commissioned Daniel Matthieu, to whose design work on the garden was begun. Between 1719 and 1723 the Orangery was built as the termination of the middle axis, to a design by the architect Johann Christian Lüttich; this highly original building ranks as one of the most interesting of its type. It consists of two wings extending across the whole width of the parterre with a semicircular recess in the middle opening up to give a vista of the Tauber valley. An equestrian statue of Count Carl Ludwig originally stood in the recess.

The simple parterre is decorated with 53 statues, mainly by Johann Jakob Sommer and his sons, of which 16 set on a balustrade are dwarfs which caricature members of a court. There are further statues on the island in the central

pond. The garden at Weikersheim is regarded as the finest and best-preserved baroque garden in Franconia.

<div style="text-align: right">U.GFN.D.</div>

Weimar, German Democratic Republic. See BELVEDERE; ILM PARK.

Weldam, Goor, Overijssel, The Netherlands. The gardens of the castle, with their baroque rectangular outline surrounding the house and moat and contained by water and trees, most probably date from the late 17th c. when projecting wings were added to the mid-17th c. house and outbuildings to flank the forecourt. No contemporaneous plan exists, but a map of 1783 shows a series of compartments, laid out on parallel axes, which undoubtedly were mainly utilitarian in nature.

With the exception of the planting of such specimen trees as Arolla pines (*Pinus cembra*), swamp cypresses (*Taxodium distichum*), and weeping ashes (*Fraxinus excelsior* var. *pendula*), few structural changes took place in the 19th c. A plan of 1878 made by Eduard *Petzold for Count William C. Ph. U. Bentinck was never executed. His design replaced part of the 17th-c. rectangular outline with curving avenues and contained scattered groups of trees and shrubs with the interpositioning of carpet bedding. Petzold made a separate plan for the park.

Edouard *André's plan of 1886 showed not only respect for Weldam's origins but also for the evolutionary process. Within the earlier outline, André laid out on parallel axes such 17th-c. elements as *parterres de compartiments*, a *parterre de broderie*, a maze, and a beech tunnel. He retained the 19th-c. trees and introduced such contemporary amenities as flower-beds and a conservatory. As an integral part of the house and subordinate to the underlying structure, André's plan may be regarded as the first and the finest example in the Netherlands of the reconstruction of a 17th-c. Dutch garden.

<div style="text-align: right">F.H.</div>

Well-head and crane. Ornate well-heads were to be found particularly in *Venice, whence some were removed to other countries. Examples either Italian in style or actually from Italy are at Hestercombe House, Somerset, and at Drove House, Norfolk. Well-heads are sometimes only dummies for effect, i.e. they are not standing above a real well. To the stone or brick well-head there is often attached a crane, the superstructure with its device for hauling water from the well. The basic design of a typical Italian well-head is a circular opening with a square or angled external facing which is moulded or carved.

<div style="text-align: right">M.W.R.S.</div>

Wenkenhof, Riehen, near Basle, Switzerland, was built after 1736 on a gently sloping site for Johann Heinrich Zäslin and because of its opulence was known as the little Versailles of Basle. As early as 1803 the baroque layout was replaced by an English garden, and the *parterre de broderie*, the figures, and the vases were removed. In 1920 the basic features of the original French garden were reconstructed. The large parterre is framed by avenues of trees and the

intersection of the main and the lateral axis emphasized by a fountain. The bottom of the garden featured the usual hedge typical of Basle. Its size and endowment make this the most beautiful French baroque garden in *Switzerland.

<div style="text-align: right">H.-R.H. (trans. R.L.)</div>

Westbury Court Garden, Gloucestershire, England, was inherited in 1694 by Maynard Colchester from his grandfather Richard and during the next decade, before *Kip's engraving of 1705, the major part of the garden was made. Since then the house has been demolished and rebuilt three times and the site and its immediate curtilage is now an old people's home. But remarkably the main part of the garden, lying to the east, remained largely unaltered for 250 years. It has now been restored by the National Trust, as far as possible according to Maynard Colchester's meticulous account-book, which confirms the accuracy of Kip's engraving.

The extensive use of water was common in gardens of the time but the result at Westbury differed from contemporary designs by *London and *Wise. The neighbouring Boevey family at Flaxley had Dutch connections and certainly the design of the summer-house, with its great height combined with the low-lying site, the canals, the intricate topiary, the sense of enclosure and independence from the house, and above all the horticultural emphasis, resulted in a garden more Dutch than French in character. Bulbs of many kinds were planted as well as shrubs, especially evergreens for clipping into shapes. But the main emphasis was on useful plants: fruit-trees were trained on the walls and an orchard of plums (still common in the neighbourhood) surrounded the extensive vegetable garden. There were fish and eels to be had from the canals.

The National Trust has restored the garden, which was derelict when acquired in 1967. A small walled garden with its adjacent *gazebo, thought to have been built between 1715 and 1745, has been used to make a little formal flower garden with arbours to house a collection of contemporary plants, and the design of the original parterre near the house has been re-created nearby.

<div style="text-align: right">J.S.</div>

West Indies. See CARIBBEAN ISLANDS AND WEST INDIES.

Westport House, Co. Mayo, Ireland, a neo-Palladian house, was built to the designs of Richard Castle to look over the island-studded Clew Bay on the western shore of Ireland. Bridges and cascades had been formed over the adjacent river by 1752. The 2nd Earl of Altamont (d. 1780) made an artificial lake between the house and the sea. In 1818 a magnificent gateway was erected to the designs of Henry *Holland, 'Capability' *Brown's son-in-law, at the entrance to the park. In 1913 the 6th Marquess of Sligo laid out an Italianate garden in front of the house based on that at the Villa San Remigio, Lake Maggiore, Italy, which had been made c.1860 by another member of the family.

<div style="text-align: right">P.B.</div>

West Wycombe Park, Buckinghamshire, England, was acquired by the Dashwood family in 1698 when the 17th-c.

mansion stood in modest grounds in the valley near the village. In 1710 the 1st Baronet began the new house on the south side of the valley, from which there were fine views of the surrounding hills and the church-capped hill of West Wycombe, overlooking the valley through which runs the River Wye or Wick, which was soon to be dammed to make a lake and cascade. The 2nd Baronet, Sir Francis Dashwood, succeeded his father in 1724 at the age of 16 but it was not until the 1730s, after tours of Italy, that he began the extensive alterations that made West Wycombe one of the most admired and influential of 18th-c. landscapes.

The early 18th-c. formal layout was recorded in paintings by William Hannan and in a survey map by Maurice-Louis Jolivet who, with Sir Francis, was probably responsible for the design. It was confined mostly to the area north of the house where the lines of the baroque avenues, the curiously informal lake, and the much simplified rococo cascade remain. As well as providing a variety of walks and views it was intended as a setting for spectacular displays and a fleet of four vessels and a fort enabled sham battles to be staged.

Following the setting up of the Society of Dilettanti in 1734 Sir Francis remodelled the house and employed Nicholas Revett to design classical buildings to embellish the park, beginning with the Temple of the Winds. When the west portico of the house was built in 1770, it was designed to be seen as a feature of the landscape rather than as part of the house—a fundamental change. The main approach was altered to the present winding route from the north-west and Thomas Cook was employed to lay out its surroundings to the modern taste. By 1780 he had extended the park to the east and south in the style of his mentor Lancelot *Brown and created settings for Revett's buildings.

Humphry *Repton was called in by the 2nd Sir John Dashwood-King after he succeeded in 1793 and some of his recommendations are recorded in his *Observations*. He removed overgrown trees near the lake but most of his other plans were never followed. The property was given to the National Trust by Sir John Dashwood in 1943.　J.S.

Whately, Thomas (d. 1772), was an English politician who occupied minor positions, including that of Under Secretary of State to Lord North (1771–2). He is not known to have designed or advised on the making of any gardens, but his anonymously published *Observations on Modern Gardening, Illustrated by Descriptions* (1770, 5th edn. 1793) was of considerable influence on two accounts. It contains detailed descriptions of the most outstanding examples of the English landscape garden, such as at *Hagley Hall, The *Leasowes, *Painshill, *Woburn Farm, and *Stowe—descriptions of great value today as many of these gardens no longer exist or are sadly altered.

His book was much used in his own day as a guide for foreign travellers (it soon appeared in French and German translations). Of equal importance was its vindication of the claim made in its opening sentence: 'Gardening, in the perfection to which it has been lately brought in England, is entitled to a place of considerable rank among the liberal arts.' His claim met with ready acceptance among his French readers (see *Latapie) and he undoubtedly was a formative influence upon the development of the *jardin anglais*.　P.G.

Whipple House Garden, Ipswich, Massachusetts, United States. A plan for the representation of the earliest sort of garden prevalent in New England was designed by Arthur Shurcliff, who had so cleverly enlarged the original plan of the Governor's Palace Garden in *Williamsburg to accommodate vast crowds instead of gatherings of colonial Virginia landowners and officials. Inside a split rail fence are six raised beds, boarded and pegged and surrounded by wide paths paved with crushed clamshells. Each bed is c.2·5–3 m. square, centred by a rose-bush: *Rosa gallica* 'Officinalis' or *R. gallica* 'Versicolor'. Beds are edged with pinks (*Dianthus gratianopolitanus*), strawberries (*Fragaria virginiana*), marjoram (*Origanum onites*), and other suitable border-bonding plants. Ann Leighton has filled the beds compactly with nearly a hundred sorts of plants, for each of which there is local 17th-c. documentary evidence. Research into inventories, letters, wills, cures for measles, recipes for cooking eels and jams, travellers' accounts, and especially John Winthrop, junior's 1633 seed bill from a London 'grocer', identified the plants upon which the settlers depended. From the roadsides and meadows were brought back 'escaped' wild flowers, like the ragged robin (*Lychnis flos-cuculi*), yarrow (*Achillea millefolium*), tansy (*Tanacetum vulgare*), and lady's bedstraw (*Galium verum*). The opium poppy, *Papaver somniferum*, which Samuel Sewall impatiently deemed the Boston doctors' chief remedy, grows here, as does the poisonous monkshood, *Aconitum napellus*, brought by John Winthrop, junior— perhaps only for ornament as he also brought wolf-killing dogs. With names of the growers attached to each plant, even the vaguest surmises as to purposes and uses reveal much of the character of the times and the people.　A.L.

White, The Revd Gilbert (1720–93), English clergyman and naturalist, lived at The Wakes, Selborne, Hampshire, where he acted as curate-in-charge for much of his life. His house is now a museum. Better known as the author of *The Natural History and Antiquities of Selborne* (1789) his *Garden Kalendar*, kept from 1751 to 1768, is a unique gardening book. Unlike most garden calendars which make recommendations of what should be done, White describes the actual work he carried out from day to day. His descriptions of The Wakes' trees, flowering plants, fruit, and vegetables provides the clearest account of what a mid-18th-c. country garden of modest size was like. He may, however, have been exceptional in his passion for raising fine melons and also for making a *ha-ha across his relatively small lawn to allow an uninterrupted view of Selborne Hanger.　M.L.B.

White, Thomas the elder (1736–1811), and **Thomas White** the younger (c.1764–1811), were perhaps the most successful followers of Lancelot *Brown. Their practice was based in Nottinghamshire and then Durham, and

covered the northern part of England and much of Scotland. In Scotland their commissions included Airthrey Castle, Stirlingshire (Central Region) (now the site of Stirling University); Castle Fraser, Aberdeenshire (Grampian Region); Dalmeny, West Lothian (Lothian Region); and many others, probably c.100 in all. Like Brown, their style was predictable—undulating lawn diversified with clumps of trees and scattered individuals, encircled by a belt of woodland. Occasionally the scene was further enlivened by ornamental buildings.

A reaction to making places in this style had begun in the late 18th c. when it was perceived that both history and wilder scenery suffered. By the 1820s this reaction had become widespread and in his *Encyclopaedia of Gardening* J. C. *Loudon condemned the Whites' professional talents simply by identifying them with Brown's. Loudon's attitude is perfectly correct—neither White had eyes for Scottish topography, certainly not of the wilder sort. They were obviously convinced that the landscape style of improving grounds was right, and, like Brown, found ways of making the place conform to the ideal. W.A.B.

Whitton, Middlesex, England, was the 22-ha. estate of the 3rd Duke of Argyll from 1722 to 1761. It contained a nursery with one of the largest and best collections of trees and shrubs, especially exotics, in the country at the time. Many of these came from North America, through the agency of Peter *Collinson, whom Argyll employed from 1748. In 1762, after Argyll's death, much of the collection was transferred to *Kew. M.W.R.S.

Wideville, Yvelines, France, has the most important surviving example of a French 17th-c. architectural *grotto, built between 1630 and 1636, at the same time as the château, for Claude de Bullion, *surintendant des finances* to Louis XIII. The grotto is a room facing the château on the axis of the parterre; it is decorated with polychrome shell-work, considerably damaged during the Second World War, but now restored. The façade in the form of a triumphal arch has three bays whose arched openings are closed with wrought-iron *grilles. Attached columns support the entablature, and a pedimented panel over the central bay is supported on either side by statues of river deities. It has a rustic style of decoration, and was originally extended on either side by wings in the form of walls with statues. These, and the basin which it overlooked, have long disappeared. The façade resembles the Medici fountain at the *Luxembourg with which it is contemporary. Thomas *Francini was responsible for the waterworks at both places. K.A.S.W.

Wiesenburg, Potsdam, German Democratic Republic. Around a medieval castle, which was restored from 1864 to 1867 and extended in parts by the addition of neo-Renaissance wings, lay a 600-ha. zoological garden. A part of this was separated off and, after the purchase of meadowland by the castle, transformed into a 150-ha. park (today 85 ha.). The zoological garden was dispersed in 1867 and the remaining area (450 ha.) turned into a park, particularly

where it merges with the surrounding countryside. The first rhododendrons were planted c.1850; they have since flourished and have reached heights of up to 5 m.

The castle moat was filled in in 1864 and by building a series of terraces (c.1870–2) it was possible to connect the castle with the parterre (1873) with its tufa grottoes. The existing pond was extended (1870–1) and later joined to the new pond (1879–81). On the terraces are terracotta statues and reliefs by A. Calandrelli; near the Schloss is a small garden house.

Three large axial vistas connect Schloss, park, and countryside and divide the park into large sections which contain many beautiful trees, such as very old oaks, beeches, and limes. H.GÜ.

Wilanów, Warsaw, Poland, has a park and palace which were established at the end of the 17th c. as the residence of King Jan III Sobieski, and further developed twice—in the second half of the 18th c. when owned by the Lubomirski family, and then at the beginning of the 19th c. by the Potocki family.

The oldest part of the garden, still preserved, was developed under King Jan III Sobieski by Augustyn Locci and Adolf Boy. The park is in two styles: the central part close to the palace is 17th- and 18th-c. baroque; the periphery (first half of the 19th c.) is romantic. A *patte d'oie* of three *allées* radiates from the residence. Along the main axis lies the palace courtyard with a lawn and fountain in the centre (early 19th c.). Behind the palace there are two terraces leading down to the lake. The upper terrace is of a *parterre de broderie*, with fountains and sculptures. The edge of the terrace is supported by a wall adorned by beautiful, decorative sculptures on the stone balustrade. On one side is a noteworthy flower garden, neo-Renaissance in style, with a fountain and box parterre dating from the middle of the 19th c. The lower terrace has sculptures, a fountain, and a row of *bosquets* with magnificent trees, 10 m. high.

The rest of the natural park is covered with rich water features and views of the surrounding areas and of the garden layout as a whole. The main points of interest are: a monument of the Raszyn battle (1809); a Roman bridge; a Chinese summer-house; a sarcophagus over the pond; a cascade; a pseudo-medieval pump-house; and, facing the lake, a conservatory with a classical portico. The restoration of the park was carried out in 1948–50 and 1962–7 by Gerard Ciołek. L.M./P.G.

Wildenborg, De, Gelderland, The Netherlands. See DE WILDENBORG.

Wilderness, or wildness. Though the term has sometimes been used to signify a place where wild plants are cultivated (see the *wild garden), in late 17th- and 18th-c. Europe it was the most common name used to designate a wooded feature with (usually winding) paths running through it.

This version of the *bosquet* developed while the formal garden still held sway (see, for example, *England: 1660–1714), and the early exemplars were formal in many

respects. In England the 17th-c. prototype, Wren's wilderness at Hampton Court, planted in 1689 by *London and *Wise, was geometrical in design with *allées, based on two principal vistas, intersecting to form a St Andrew's cross. In Henrietta Maria's garden at Wimbledon the wilderness had 18 allées of gravelled earth and was similarly formal; however, it is interesting to note an early wilderness c.1660 at Bedford House in London which consisted of 'an elaborate series of alleyways running maze-like between trees and shrubs' (Miles Hadfield, A History of British Gardening, 1960).

In the next century, however, informal winding paths were an essential element. This type of wilderness may be seen as a 'natural' labyrinth supplying in the landscape garden that element of mystery and surprise provided in earlier gardens by the formal *maze (see Christopher Thacker, 'The Long Labyrinth of Darkness — The Landscape Garden and the Maze' in Daidalos, vol.3, March 1982). Wray Wood at *Castle Howard was first designed having straight allées but the scheme implemented from 1718 onwards consisted of a series of meandering paths leading from one group of sculpture to another.

Similar developments were taking place on the Continent. At *Eremitage near Bayreuth a wilderness was made c.1715 with irregular paths through woods leading to seven 'hermits' huts'. Other examples were at Cleves, *Duin-en-Berg (c.1730), and Sanspareil (c.1744), and at Schloss *Benrath where the original arrangement of formal allées through the bosquet was linked in the 1750s by a sequence of serpentine paths.

The wilderness supplied the need for enclosed regions in gardens which were increasingly open; there the 'explorer' might seek his own spiritual origins and experience the sensation of being lost (though comforted by the knowledge that he would emerge safely in the end). In the Grand Trianon at *Versailles this idea found early expression c.1669 in the Jardin des Sources — a densely shady triangular area, planted with fruit-trees, where a multitude of springs arose, creating a series of irregular water channels amid the grass. *Rousseau took up the same themes in his novel Julie, ou la Nouvelle Héloïse (1761) in which the hero becomes lost in a garden and imagines himself on an uninhabited island.

As the century advanced the concept of wildness became increasingly contrived and bizarre. An important influence was the European idea of Chinese gardens, especially as expounded by William *Chambers, whose categorization of them into 'the pleasing, the terrible, and the surprising' (Dissertation on Oriental Gardening, 1772) probably owed more to *Burke's views on the beautiful and the sublime than to Chinese garden philosophy. An echo, too, of the quest for intense emotion and experience may be found in the German literature of Sturm und Drang. The wilderness was pushed to extremes, now incorporating *grottoes, *ruins, and even underground passages and waterways (as at Wörlitz, which boasted an artificial volcano, with a labyrinth inside it) — far removed from the original pursuit of naturalness and primeval innocence. P.J.C.

See also ADDISON, JOSEPH; ENGLAND: THE DEVELOPMENT OF ENGLISH STYLE; FONTHILL; FRANCE: LE JARDIN ANGLAIS; NETHERLANDS: RÉGENCE, ROCOCO, AND FRENCH PICTURESQUE; NONSUCH PALACE.

Wild garden. A 'wild garden' may seem a contradiction in terms, for the dictionary definition of garden is 'cultivated, not wild'. Historically, gardens have usually been thought of as oases of order, safely enclosed against the surrounding dangers of uncontrolled nature.

But the cultivation of wild plants does in fact go back to the beginning of garden-making and the first plants to be nurtured were wild species, often selected for their medicinal value. The delightful illustrations of Le Roman de la Rose show medieval gardens where flowers grow freely in grassy plots within the castle walls, and lawns studded with daisies were as highly prized as they were execrated by a later generation of green keepers.

But in general the gardens of Europe developed on geometric lines. A hint of other possibilities is given in the 17th c. in *Bacon's essay Of Gardens (1625), in which he describes a large area of his ideal garden as a 'heath or desert'. His description of the heath is charming, picturing a series of molehills, each covered with a different wild plant, thyme, violets, and primroses (though one may doubt whether primroses would really thrive on molehills).

During the 18th c. stirrings towards more natural gardens were voiced by *Pope and *Addison, who craved 'the beautiful wilderness'. This new outlook was fuelled partly by an awakening interest in China, where a very different concept of gardens had originated. In Gardens in Time the authors quote from a poem of 179 BC describing a vast and magnificent garden which could be termed wild in the true sense, comprising gorges, water-courses, and great expanses of flowers growing in natural conditions. While the English landscape parks evolved in this 18th-c. climate of informality, they were too well groomed to be classed as wild, and it was their smooth, civilized appearance which gave rise to the criticism of the *picturesque school, headed by Payne *Knight and Uvedale *Price, whose influence encouraged the development of gardens which could be termed wild: places where gorges and tangled vegetation formed compositions more complex and detailed than those of smooth grass and wide expanses of water.

But the strongest impetus to the wild garden was given in the 19th c. by William *Robinson and Gertrude *Jekyll. Their ideas are set out in Robinson's The Wild Garden (1870) and Jekyll's Wood and Garden (1899) and examples of their work can still be seen today. At *Gravetye Manor Robinson developed a wild garden extending from the terrace of the old manor-house to a string of lakes in the valley below. Flowers, naturalized in the grass slopes, formed the equivalent of an alpine meadow, flanked by great Sussex oaks which were hosts to rampant climbing plants. The native loosestrife mingled with more exotic plants along the lakeside. Gertrude Jekyll, at her home of *Munstead Wood, naturalized shade-loving plants within her woodland. Both these gardens show the importance of

composition and some unifying element in the natural scene; without this, it may be wild, but it is not a garden. At Gravetye, cohesion is given by the land-form, the lakes, and the strength of the surrounding woodlands. At Munstead there is the strong vertical of the tree-trunks flanking the rides of differing proportions and the contrast of thick undergrowth and open glade. The frame is firm while the furnishing changes with the seasons.

Several notable gardens derive their unity through the circumstances of climate. *Tresco Abbey in the Isles of Scilly and Cotehele in Cornwall are both given composition and cohesion by the strong form of their semitropical vegetation, while *Inverewe on the west coast of Scotland is unified by its successful struggle against the Atlantic gales, tempered by the mildness given by the North Atlantic Drift.

It is difficult to make a clear distinction between informal gardens and wild gardens, for many of the most successful informal gardens include an element of the wild. The valley at *Bodnant is a well-known and successful example, and it is difficult to decide whether the *Savill Garden is 'wild' or 'informal'. In *The English Flower Garden* (1883) Robinson characterizes wild gardening as 'the placing of perfectly hardy exotic plants in places where they will take care of themselves' and he cites as examples 'Winter Aconites flowering under a grove of naked trees in February . . .

Apennine Anemones staining an English grove blue'. His definition seems to exclude native plants, whereas purists might consider that they alone are admissible. The more liberal interpretation is that both natives and exotics have a place, provided they grow in a way which appears natural and which creates a scene of beauty, which is, after all, the object of a garden.

A wild garden is most effective when it represents a definite plant community, everything in it being a part of the total environment. For this reason, many successful wild gardens are on sites which have some unifying character, such as heathland, chalk-pit, or stream-side. Woodlands have this unifying quality to a superlative degree, providing conditions in which a wide range of plants, native and introduced, can naturalize themselves with a minimum of after-care, a condition which does not apply to all types of wild garden. It is, for instance, very difficult to reproduce the conditions of sheep-bitten turf which encourage the growth of downland flowers, while a stream-side, left to itself, may quickly be taken over by rushes, losing both contrasts of foliage and views of open water.

Supposed ease of maintenance is one of the reasons for the present interest in wild gardens. But a more valid reason is the disappearance of so many wild flowers from the countryside, due partly to the spread of towns, but even

'Wild Garden', Aesch am Willersee, Switzerland, by Willi Neukom

more to modern farming methods. A healthy reaction to this deprivation is to bring wild flowers into our gardens and cities. The flowery meadow, developed by Robinson at Gravetye, is now a fashionable type of garden, while those fortunate enough to have a wood can follow and extend Gertrude Jekyll's methods.

Some of these ideas are being extended into town parks and industrial open spaces. The Netherlands and West Germany were pioneers in creating wild flower parks, even including areas where children could recapture the lost joys of picking wild flowers. As pressures increase, there is a growing need to give asylum in our cities and gardens to the displaced wild plants and their attendant wildlife; butterflies are as much a part of the garden as flowers. Reinforcing this urge to retain a semblance of the old countryside, the pressures of city life stimulate a desire for some compensating freedom in our gardens. Just as in the early gardens men sought order and symmetry to counter the wildness of the world around them, so now they seek the infinitely more subtle order of natural growth. S.C.

See also ANNE'S GROVE; ECOLOGY AND GARDENS.

Wilhelmshöhe, Hessen, German Federal Republic. Landgrave Karl of Hesse-Kassel chose the slopes of the Habichtswald outside Kassel as the site for the lavish garden which he ordered to be laid out in the Italian baroque style around the hunting-lodge of Weissenstein; work was begun in 1701 to plans by the Italian architect Giovanni Guerniero. The focal point and central axis was to be the series of cascades. The idea came from the villas at Frascati (see Villa *Aldobrandini) which the Landgrave saw while visiting Italy in 1699–1700, but it was translated into gigantic proportions at Weissenstein. The difference in height between the octagonal Wasserschloss at the head of the cascades and the Schloss itself is more than 200 m., over a distance of more than 1,000 m. Only the upper third of this fantastic plan of grottoes and cascades was ever completed. Guerniero, who compiled a magnificent collection of engravings for Weissenstein, left Kassel in 1715. A bronze copy of the Farnese *Hercules*, the emblem of Kassel, was set up on the octagonal reservoir.

Building was stopped for a variety of reasons. The change in the prevailing taste of the time can be seen in the work carried out under Karl's grandson, Friedrich II. Hirschfeld wrote in 1785: 'Here temples are built for the gods, hermitages for the philosophers of Greece, and even caves for the witches.' The Chinese village, Mulang, with its pagoda is also of this period.

Friedrich's son, Landgrave Wilhelm IX (from 1803 Elector Wilhelm I), undertook the final rearrangement of the garden into an English landscape park. From this time date the Aqueduct and the Löwenburg, both by the architect H. C. Jussow. The Löwenburg was built as a ruined medieval castle in accordance with the taste for chivalric romance prevalent between 1794 and 1798; the interior of the castle is beautifully decorated. Wilhelm IX's main contribution was the building of the new Schloss, now

The Octagon and cascade at Wilhelmshöhe, Hessen, German Federal Republic, aquatint (c. 1820) by Martens after Müller

known as Wilhelmshöhe in his honour, to plans by the architect S. L. du Ry.

Wilhelmshöhe is the only garden in Germany which reveals an Italian influence in its baroque phase. The waterworks are still operative. U.GFN.D.

William and Mary. Gardens, renewed or created, by Prince William III of Orange (1650–1702), King of England (1688–1702), and Mary (1662–95) in the Netherlands were transitional in style, in part Renaissance and in part baroque. An emphatic baroque central axis and French ornamental flourish in the form of curvilinear parterres, richer and more elegant adornment, and Franco-Italian fountains, cascades, and statues were incorporated into the framework of the Dutch classical garden. However, the interiors of these Franco-Dutch gardens remained autonomous with little progression from the complex to the natural.

Existing gardens belonging to the Prince of Orange were refurbished soon after his marriage in 1677. An asymmetrical curvilinear water-maze, reminiscent of that at Versailles, and an 'Arbour of Venus round a great Pond' (Edward Southwell's Journal, 1696) were laid out at Dieren (c. 1677). By means of a dominant axis leading through a large parterre garden and dense woods, *Honselaarsdijk (c. 1678)

was transformed into the most baroque of their gardens. At Huis ten Bosch (House in the Woods) Pieter *Post's design was replaced (*c.*1686) by parterres flanked by *bosquets* inspired by the Parterre de l'Orangerie at *Chantilly. *Het Loo (1686–95), the most ornate of all Dutch gardens and the only new one laid out by the royal couple, reflected their ultimate taste in gardening. The general layout was similar to the pre-Le Nôtrean *Luxembourg, while in scale and intricacy the Great Garden, in axial alignment with the palace, was reminiscent of a French trianon or pavilion garden. The lavish ornamentation, for which Daniel *Marot was largely responsible, made the fame of the gardens.

In England, their gardening tastes are reflected in the compartmented and intricate plan of *Kensington Gardens and in the alterations at *Hampton Court where Marot, in marked contrast with Wren's simple designs, laid out intricate *parterres de broderie* for the Great Fountain Garden and possibly the Privy Garden and Wilderness too. There is an unmistakable Dutch look about the elongated rectangular plan (unexecuted) by Talman for the Trianon gardens at Hampton Court, which is reinforced by the long arbours with openings and the *parterres de pièces coupées* in the manner of *de Vries. F.H.

William Curtis Ecological Park, London. See ECOLOGY AND GARDENS.

Williamsburg, Colonial, Virginia, United States. The architecture and gardens of Williamsburg, capital of Virginia from 1699 to 1781, were restored from 1926 onwards. Only those plants known to have been originally used in Virginian gardens were included; and in the case of

Gardens in Colonial Williamsburg, Virginia, United States

the Governor's Palace, the original plan was followed. The fundamental research was carried out by Arthur Shurcliff, and the original operations were funded by the Rockefeller Foundation.

During the 18th c. Williamsburg preserved the Dutch–English tradition of parterre gardens and geometric (rather than figurative) topiary, except that yaupon (*Ilex vomitoria*) tended to replace box (*Buxus sempervirens*). The largest gardens (*c.*4 ha.) are those of the Governor's Palace, Palace Green. The upper garden, directly behind the ballroom, is symmetrical about its central axis which runs northward from the house. It consists of 16 diamond-shaped parterres enclosing a dense growth of periwinkle (*Vinca minor*) and English ivy (*Hedera helix*), and 12 cylindrical topiary yaupons. The ballroom garden on both sides of the house is of the same simple geometric type. The lower garden, separated from the upper by a broad east–west cross-axis, has a similar layout, but is more brightly planted with red tulips (*Tulipa gesneriana*) in April and large beds of perennials in the summer. The final cross-axis is marked by a tunnel made of American beech (*Fagus grandifolia*), with *gazebos at each end. Beyond the north gate is a maze (modelled after the one at *Hampton Court, though planted in American holly, *Ilex opaca*, rather than yew, *Taxus baccata*); an elaborate mound, which insulated the ice-house; and, further to the west, a canal. Only Everard House, across Palace Green, also has this feature, which is so typical of Dutch gardens.

The citizens' gardens are usually on 0·4 ha. of ground conforming to the planning rules laid down by Francis Nicholson, the first Governor (1698–1705). A large part of these gardens was for vegetables and herbs; the ornamental part followed the style of the Palace gardens, on a considerably reduced scale. One of the best gardens was apparently that of John Custis (1678–1749), who obtained many plants from Peter *Collinson. P.G.

Williams-Ellis, Sir Clough (1883–1978), Welsh proselytizer as well as architect, planner, conservationist, and garden designer. His early practice as an architect consisted mainly of designs for new or alterations to existing country houses, gardens, and estate buildings, though it later included schools, public buildings, roads, and town planning reports.

He bought the Aberia estate near to his home, Plas Brondanw, Merioneth (Gwynedd), in 1925, renaming it Portmeirion. The existing house was opened to the public as a hotel in 1926. The picturesque and whimsical assemblage of buildings and gardens formed by him there between 1925 and 1970 presented not only an opportunity to experiment with architectural form, style, and picturesque planning, but was also intended to supply a model for sensitive holiday development. Moreover, it acted as a repository for demolished architectural fragments of note which are incorporated into both gardens and buildings. Italian coastal villages and gardens supplied the general, though not detailed, inspiration for this late expression of picturesque theory.

Clough Williams-Ellis campaigned for popular enlightenment in the matter of architecture planning and conservation, and also promoted the National Trust, the Council for the Preservation of Rural England, and the National Parks in several publications: *The Pleasures of Architecture* (1924), *England and the Octopus* (1928), *Britain and the Beast* (ed., 1937). As early as the 1920s he had the idea of preserving and making viable redundant country houses and their estates by conversion to multi-occupation coupled with limited planned development of their parks, in an attempt to save them from demolition and the speculative builder. From the 1930s onwards he was a champion of modernism as well as neo-Georgian and neo-vernacular architecture (*Architecture Here and Now*, 1934, with John Summerson).

His best gardens are Plas Brondanw, Gwynedd and Oare House, Wiltshire, both of which are architectural and formal, though they are not self-contained and take full advantage of the surrounding countryside. Williams-Ellis designed particularly good gates, garden furniture, and stone ornament in an attenuated neo-Georgian manner under the influence of the style of the Paris 1925 exhibition.
G.R.C.

Willmott, Ellen Ann (1858–1934), English gardener and author. Her garden at Warley Place in Essex, described in *Warley Place in Spring and Summer* (1909), was well known for its collection of trees and shrubs, lilies, daffodils, alpine plants, and especially for *Crocus vernus*, which grew wild in large drifts. In 1978 part of the site of this garden became the Warley Place Reserve of the Essex Naturalists' Trust. Miss Willmott also had gardens at the château of Tresserve, near Aix-les-Bains, from 1890 to 1920, and at Boccanegra, on the Italian Riviera near *La Mortola, from 1905 to the early 1920s.

Her skill as a gardener and her patronage of plant-collectors, especially E. H. *Wilson, are commemorated in the names 'Warley' or 'Willmott' which are still attached to many cultivars or species associated with her, from roses and lilies to crocuses. Miss Willmott's ghost, a popular name for the large pale sea holly, *Eryngium giganteum*, is said to refer to either the lady's prickly temperament or her habit of encouraging the spread of this plant by scattering its seed in gardens she visited. Her love of roses is demonstrated by the two large volumes of her book, *The Genus Rosa* (1910–14), published in parts at her own expense. The coloured plates are by Alfred Parsons, RA (his original water-colours for them are now in the library of the Royal Horticultural Society) and the Kew botanist, J. G. Baker, contributed to the text.

Miss Willmott was awarded the Victoria Medal of Honour by the Royal Horticultural Society in 1897, and in 1905 she was one of the first women admitted to the fellowship of the Linnean Society.
R.D./S.R.

Wilson, Ernest Henry (1876–1930), English plant-collector, worked in a nursery in Solihull before going to *Kew, where, in 1898, he was chosen to collect in China for the

*Veitch nursery. He went to China by way of the United States, visiting the *Arnold Arboretum near Boston and meeting its director, C. S. Sargent. From San Francisco he sailed to Hong Kong, visited Augustine Henry at Szemao for advice about the davidia, whose seed was a prime target, and made his headquarters at Ichang. His Chinese travels took him to Szechuan, Hupeh, and the Yangtze River system. After two journeys for Veitch in 1899–1902 and 1903–5 Wilson's later expeditions were made for subscribers and the Arnold Arboretum, which he joined as a member of its staff in 1909, eventually succeeding Sargent as director. He returned to China early in 1907 for two years and made another visit in 1910–11, before turning his attention to Japan in 1914 and again in 1917–19. *Lilium regale*, probably his best-known introduction, cost him a broken leg as he travelled through the Min River gorges. Among other familiar plants, he brought back *Hydrangea sargentiana*, *Lonicera nitida*, *Jasminum primulinum*, c.60 rhododendrons, and, from Japan, the evergreen Kurume azaleas and many flowering cherries. He also sent seed of c.2,000 plants and dried specimens of many more.
S.R.

Wilton House, Wiltshire, England. The garden and landscape have been developed by so many people that it is difficult to determine exactly who was responsible for what and rather remarkable that the final result is so coherent and impressive. It began c.1632 with an elaborate formal design by Isaac de Caus for the 4th Earl of Pembroke and it is possible that some of the magnificent cedars which still thrive at Wilton were planted soon after this. About 1700 the 8th Earl began to exchange the complexities of the early *parterres for the simplicity of a formalized landscape but it was his successor, the 9th Earl, often known as the 'Architect Earl', who really began to make the garden as it is today. With the aid of dams, he greatly widened the little River Nadder and in 1737 he designed the beautiful Palladian bridge, the first of its kind in Britain, to span the slow-moving river he had created.

The 10th Earl engaged Sir William *Chambers to improve the site still further and one of his additions was the little white *casino which is still an *eye-catcher among the trees on rising ground on the far side of the water meadows between the Rivers Nadder and Wylye. The 11th Earl employed James Wyatt in 1801 and put the final touches to this idyllic landscape; he also restored formality to a small area near the house where he created an Italian flower garden overlooked by a triple-arched loggia.

Finally, in 1971 David Vicary designed for the forecourt a formal garden surrounded by pleached limes and with a fine fountain gushing water at several levels as its centrepiece.
A.H.

Wimbledon House, London, was begun by Thomas Cecil, 1st Earl of Exeter (1542-1622), in 1588. The garden is known from a plan made by Robert Smythson in 1609. It developed in three phases. (1) 1588-1609: a series of square and rectangular gardens were laid out next to the house along the lines of those at Theobalds with focal points

Wilton House, Wiltshire, the Palladian Bridge

including a banqueting house and a pillar. (2) *c.*1609: a dramatic extension of the planting took place including a long lime walk, an orchard, and a vineyard. This is marked by a concern for vistas and perspective effects. (3) 1641–2: in 1639 Charles I purchased the house for his queen Henrietta Maria, who employed André *Mollet to replan the gardens. The formal planting of *c.* 1609 was retained and regularized with the introduction of a maze and a *wilderness in the new style. Most of the old Elizabethan gardens were swept away to make room for four *parterres, two with fountains and *parterres de broderie*. The garden was still in order when handed over to Parliament in 1649. R.S.

Wimpole Hall, Cambridgeshire, England, followed almost every fashion in landscape gardening from 1690 to 1810. An engraving by *Kip of 1707 shows elaborate formal gardens, possibly by George *London and Henry *Wise. In the 1720s the gardens were extended on the south side by Charles *Bridgeman, continuing the system of axial avenues and *bassins*, but with serpentining paths in the woods, and bastions and ha-has like those at *Stowe.

The landscape style arrived between 1749 and 1754 when Robert Greening (helped by Sanderson *Miller and

William *Shenstone) grassed the parterres on the north side, and 'naturalized' many other features. 'Capability' Brown continued this transformation from 1767, felling Bridgeman's north avenue, planting belts of trees, and making three serpentine lakes. He also built a Gothic tower, designed much earlier (*c.*1750) by Sanderson Miller.

These were the last substantial changes. William *Emes's proposed alterations (recorded in his plan, 1790) were not carried out; and of Humphry *Repton's usual optimistic range of suggestions, in his Red Book (1801), few were adopted. Restoration work is in progress following the devastation of large areas of the park by Dutch elm disease in recent years.

Wimpole Hall was acquired by the National Trust in 1976. P.G.

See also ENGLAND: THE EIGHTEENTH CENTURY.

Window-box. Medieval gardens were often no more than enclosed courtyards with a few plants in the grounds but with window-boxes on almost every window-sill. An early 15th-c. illustration shows a window-box in France: its surprisingly modern appearance suggests that they must have been developed considerably earlier.

Window-boxes are increasingly common today, particularly in inner city areas where there are few, if any, private gardens. They must have existed in the intervening centuries but were rarely treated as special features and are recorded only sparsely. Possibly many of the early plantings were of culinary and scented herbs, and today herbs are grown in window-boxes outside kitchen windows. Spring bulbs, summer bedding plants, and tender greenhouse specimens are frequently grown and a more recent trend has been the introduction of permanent plantings, such as dwarf conifers, fuchsias, decorative ivies, and hebes.

P.F.H.

Windsor Castle, Berkshire, England. When improvements to the Upper Ward at Windsor Castle started in 1674, the medieval arrangement of the Garden Plot to the south, the Little Park to the north and east, and the Great Park lying detached and 1·6 km. to the south remained. However in that year the siege of Maestricht was re-enacted for Charles II in the Little Park below the north terrace, and from this time onwards there were intermittent attempts to create a formal setting based on an axis through the Upper Ward.

A 5-km. long elm avenue was planted in 1680 from a hill in the Great Park and across the intervening farmland, but not across the Garden Plot where there was a new house and extensive gardens, shown on *Kip's view as the Duke of St Albans'. In 1698 Claude Desgotz, nephew and successor of André *Le Nôtre, travelled to Windsor with George *London to give a design for the 'Maestricht Garden', but neither this, nor one by Christopher Wren, were implemented beyond smoothing the slope below the terrace and making a new orchard. Henry *Wise attempted in 1708 and again in 1713 to complete his wilderness design for the garden for Queen Anne, but the frequent inundations from the river, and then the queen's death, frustrated it. D.L.J.

Windsor Great Park, Surrey, England. See KENT, NATHANIEL; RHODODENDRON; SAVILL GARDEN; VIRGINIA WATER.

Winter garden, originally a ground planted with conifers for winter display, or with plants at their most decorative between November and April; later the phrase could be used for the domestic conservatory. But its most widely accepted significance was as a replacement of the term 'people's palace', for a glasshouse offering facilities for public entertainment. The pioneer building of this sort was *Paxton's Crystal Palace, whose suitability for exhibitions prompted a number of imitations. Such buildings tended to be built of iron long after most domestic conservatories had reverted to wood as a cheaper and more easily replaceable material; iron could be wrought into finer ornamental details, and after the example of Alexandra Palace in north London, which burnt down shortly after opening, fireproof construction was widely insisted upon. After the 1870s masonry construction was often employed for the ground floors. The use of winter gardens for band concerts, danc-

ing, and eventually roller-skating pushed horticultural display into a subordinate role, and later examples often had no permanent planting except for movable tubs. Most winter gardens have been destroyed in the present century, but good surviving examples in different styles can be seen at Alexandra Palace (gutted 1980), Great Yarmouth, and Blackpool. B.E.

Wise, Henry (1653–1738), was master-gardener to Queen Anne and, with his partner George *London, the last of the great English formalists. Of their activities in Britain *Switzer wrote: 'The planting and raising of all sorts of trees is so much due to this undertaking that 'twill be hard for any of posterity to lay their hands on a tree in any of these kingdoms that have not been a part of their care.' About 1688 London took Wise into partnership at Brompton Park Nurseries in Kensington, which ran to 40 ha. and produced not only what John *Evelyn called 'a very brave and noble assembly of the flowery and other trees . . . evergreens and shrubs', but vegetables, herbs, fruit-trees, and flowers.

In the reign of William and Mary (1689–1702) London and Wise were called in to plan and plant gardens as widely separated as those at Chelsea Hospital, Longleat House, *Chatsworth, *Melbourne Hall, and *Castle Howard. In 1699 Wise began work at *Hampton Court, and went on to plant the chestnut avenue in Bushy Park. Both partners worked in the grounds of Kensington Palace on King William's mock fortifications in topiary; but before 1700 it had been agreed that, in general, Wise should concentrate on the royal parks and gardens while London rode about the country, advising estate owners on what and how to plant.

With the accession of Queen Anne in 1702 Wise, as her master-gardener, was commanded to alter many of King William's designs. At Kensington he made a sunken garden out of a gravel-pit; while at Hampton Court he uprooted box edging and transplanted lime trees 30 years old. He was responsible too for 'her Majesty's chaise-ridings' (in her high-wheeled gig) as well as for Hampton Court's maze, which was part of the formal wilderness on the north. At *Blenheim, from 1705 to 1716, Wise was involved in making the bastioned 'military' and kitchen gardens, for planting immense elm avenues, and for linking *Vanbrugh's vast bridge to the sides of the valley. Lesser works included, on the east, a formal flower garden for the 1st Duchess of Marlborough (for whom also he made a garden at Marlborough House), and for Marshal Tallard, Marlborough's prisoner, a small formal garden at Nottingham. Retiring from royal service in 1728 Wise settled with his family at Warwick Priory where in 1738 he died, leaving a large fortune. D.B.G.

See also WINDSOR CASTLE.

Wisley, Surrey, England, became the site of the fourth garden of the *Royal Horticultural Society in 1903, when Sir Thomas Hanbury, owner of *La Mortola, presented 24 ha., including the famous woodland garden established by George Fox Wilson c.1880. Later additions expanded the

area of the garden to 80 ha. and it is the centre of the Society's practical and scientific activities.

The soil is sandy, rainfall averages 660 mm. a year, and part of the garden lies in a frost pocket, but in spite of these natural disadvantages a very wide range of ornamental plants is grown, showing gardeners what can be done in difficult circumstances. The wild and woodland gardens remain. A range of glasshouses was added in 1905, a pinetum started in 1907, and a large rock-garden was built in 1911 to the designs of Edward White. These smaller, specialized gardens, like the later heather and peat gardens, provide ideas on design and planting for owners of smaller gardens. As instruction is Wisley's chief purpose, design is not always given equal importance, but a formal garden, with a canal and a walled area, was planned by Sir Geoffrey Jellicoe and Lanning Roper in the 1960s. The walled garden includes a formal section where bedding plants are used and another part with informal mixed plantings of perennials in muted colours. The Laboratory, which provides useful wall space for climbers and less hardy plants, has a pseudo-Tudor exterior that blends well with the garden.

A new glasshouse, built at the same time as the formal garden, displays plants in sections adjusted to different temperatures, and has room for some of the plant trials too. Following a tradition established in 1818, many trials of new cultivars of flowers and vegetables are carried out, at least 45 being in progress in any single year. The fruit trials were taken over by the Ministry of Agriculture in 1960, although a collection of fruit-trees and soft fruit is still maintained, with a model vegetable garden.

Wisley's association with several recent plant-hunting expeditions has given it a fine collection of bulbs from Turkey, Afghanistan, Iran, and neighbouring regions, which are planted in raised frames and attract great interest in the spring. E.N.

Woburn Abbey, Bedfordshire, England, although it had had a large deer-park and small garden for more than 200 years, had little in the way of adornment until the 1760s when Sir William *Chambers spanned a stream with an imposing bridge supporting obelisks. Two decades later Henry *Holland raised the ground before the south front so that the long windows of his new library could open directly on to a lawn. Holland's other works in the grounds included the sculpture gallery—originally intended as a greenhouse—and the Chinese dairy overlooking a small lake some distance to the north-east, these being linked by a long covered walk or corridor.

A comprehensive scheme for laying out the grounds as a whole only emerged when the 6th Duke of Bedford consulted Humphry *Repton who produced an unusually large and handsome Red Book of proposals in 1802. These included the enlarging of the stream to form a serpentine river, a private garden for the family, a 'dressed flower garden', and an *American garden, in addition to considerable further planting in the park. Repton also built a new greenhouse adjoining the sculpture gallery, and replaced

Chambers's bridge with one of more modest proportions. Set back from the north drive to the house he devised a rustic retreat known as the Thornery, put up in 1808 and consisting of a small dining-room over an equally small kitchen, the walls of the former being painted with floral frescos by Augustine Aglio. Writing in his last book, *Fragments . . . on Landscape Gardening* (1816) Repton was able to say that his proposals had 'nowhere been so fully realised as at Woburn Abbey'. D.N.S.

Woburn Farm (or Wooburn), Surrey, England, was bought by Philip *Southcote in 1735 and gradually extended to 57·5 ha. The ornamented farm (*ferme ornée*) straddled a bluff on the south edge of the Thames flood plain with views to Chertsey bridge and east to St Paul's Cathedral. Along the northern boundary was a small stream; a tributary penetrated the estate and was used to form a winding river-like lake near the house, with a grotto which survives (*see over*).

The farm was two-thirds pasture with cattle and sheep and one-third arable. Around the fields and connecting temples and garden buildings were sand-walks with, on one side, an 18th-c. herbaceous border consisting mainly of hollyhock, lily, golden rod, and crown imperial with an edging of pinks, behind which mixed shrubs, including roses, syringa, sweet briar, and lilac, added to the old hedgerow. Southcote in c.1752 described it thus: 'All my design at first was to have a garden on the middle high ground and a walk all round my farm, for convenience as well as pleasure: for from my garden I could see what was doing in the grounds, and by the walk could have a pleasing access to either of them where I might be wanted.' R.H.

Wollaton Hall, Nottingham, Nottinghamshire, England, was built from 1580 for Sir Francis Willoughby (1546–96) by Robert Smythson, and it is likely that the unique arrangement of the garden, which we know only from a plan by John Smythson, Robert's son, was due to Willoughby. Unlike any other Elizabethan garden it was disposed in an absolutely symmetrical way in alignment with the house. The actual gardens, three in all, were at the back with the middle one, laid out in quarters with a fountain at the centre, flanked by two others, one of which was also divided into quarters. The source is ultimately from *Scrlio, via *Du Cerceau's *Les plus excellents bâtiments de France* (1576, 1579). R.S.

Women as gardeners seem to have been appreciated first as competent weeders, for early records tell us of payments made to them for this labour. Those who did not need to work for their living were not encouraged to dirty their hands, though some medieval gardens were planned for their benefit, sometimes almost as decorative cages, and feminine taste may have been consulted in their design. The early link between women and flowers stresses the ornamental quality of both. A lady might supervise her flower garden, but the vegetables were her husband's con-

Woburn Farm, Surrey, engraving (1759) by Luke Sullivan

cern, except for herbs and other medicinal plants, at least according to Thomas Tusser late in the 16th c.

William Lawson's *Countrie Housewifes Garden*, first published in 1617, was the first book aimed at female gardeners, and gave advice on flowers, with designs for knots, as well as herb and kitchen gardens and the care of bees. Perhaps the readers of the three editions of this book were the forerunners of those who cared for the cottage gardens of a later period. A hundred years after Lawson, Charles Evelyn's *The Lady's Recreation* concentrated on flowers and greenhouses.

Early in the 18th c. the Duchess of Beaufort was remarkable for her skill in cultivating the rare plants in her collection, and she is the only woman listed *c.* 1730 among a dozen people whose 'care and industry' had contributed so much to 'the improvement of our English gardens'. Another important patron of gardening and botany was Queen Charlotte, wife of George III, whose influence helped to enrich *Kew. Many women, including the Queen and her daughters, painted flowers too, and several actually published their work.

Perhaps it was the 19th-c. development of new suburbs, each house with its own garden, that encouraged more women to become active gardeners, advised, for example, by the books and periodicals of Jane *Loudon and her husband. Victorian fashions, like those for the collection and cultivation of ferns, also appealed to a feminine audience, which had been introduced to botany as a suitable pastime.

Two women, Gertrude *Jekyll and Victoria *Sackville-West, might plausibly be claimed to be among the major influences on the planting of modern gardens as their taste filtered down from the large scale of their own creations to the smaller one of most of their readers, for both, like Jane Loudon, spread their gospel as gardening journalists. Eleanour Sinclair Rohde, their contemporary, led a revival of interest in herbs and herb gardens, designing several herself.

Women as designers of gardens seem to have had few opportunities until late in the 19th c., when Beatrix *Farrand was the only woman among the 11 founders of the American Society of Landscape Architects in 1899. *Dumbarton Oaks in Washington is probably the best known of her designs. Later landscape architects, like Dame Sylvia *Crowe and Brenda *Colvin, have worked in several countries, as well as their native Britain. S.R.

See also FAIRBROTHER, NAN; LINDSAY, NORAH; SHEPHARD-PARPAGLIOLO, MARIA.

Woodland garden. See TREES AND SHRUBS IN GARDENS.

Woods, Richard (1716–93), English surveyor and land-scape designer, worked during the second half of the 18th c. He prepared plans for at least 24 places, mostly in south-east England. His earliest known commission in 1749 was at Byfleet in Surrey for Joseph Spence, the poet and writer on landscape gardening. In 1768 he settled in Essex, taking up the lease of North Ockendon Hall Farm from Richard Benyon. He spent the rest of his life in that locality and most of his later commissions were in Essex or were for members of Essex families. Until 1780 he continued to supervise the laying out of Colonel Rebow's Wivenhoe Park (now the site of the University of Essex), forming a beautiful lake and adding garden buildings. In 1770–1 he was engaged at three places in Essex: at Belhus Park, Aveley; at Great Myles's, Kelvedon Hatch; and at Hare Hall, Romford. In 1774 he was invited to design the park at Brocket in Hertfordshire, a miniature masterpiece of 18th-c. landscape gardening. Brocket Hall, like Wivenhoe, rises from a lawn sweeping up from the edge of a fine sheet of water. Among his last works, he designed the park and garden buildings at Copford Hall (1784–92) for John Haynes Harrison, and from 1791 to 1793 he received payments from Lord Petre for unspecified works at Thorndon Hall.

Richard Woods was born in the same year as Lancelot *Brown but while both men were employed on different occasions at Hartwell, Belhus, Wardour, and Thorndon, they are not known to have collaborated. Their two names are linked with that of another designer, also an exact contemporary, James Paine. Woods laid out parks at five places for which Paine designed houses. Employed by City merchants and prosperous Essex squires, Woods enjoyed local patronage but did not gain admission to the charmed circle of Whig aristocrats and *cognoscenti*. H.P.

Woolmers, Longford, Tasmania. Approaching Woolmers, one's first view of the grounds is from a bridge over the Lake River to the octagonal pump-house. On the hill-crest a substantial brick-built store is topped by a large water-tank disguised by arcading. The ridgetop drive is defined by a line of poplars whilst the house is concealed by a thicket of pines and cypresses.

Leaving the river, the road winds up the hill to the entrance gates; paralleling the drive is the open expanse of the plain, and a picturesque group of buildings—bake-house, cottage, and store. Latticed timber gates hung on grand rusticated piers are part of a high wall which encircles the garden. A dense planting of exotic trees overhangs the wall, and both screen the house. The centre-piece of the garden is the white gravel carriage circle with its pond and Coalbrookdale cast-iron fountain. Beyond is a second pair of grand gates and, through circular openings in a remark-able zigzag topped hedge, the surrounding countryside is glimpsed.

Clipped hedges and hardy old-fashioned shrubs edge the paths and beds of the garden. Among them are the winter-blooming laurustinus (*Viburnum tinus*), the white-flowered Portuguese laurel (*Prunus lusitanica*), the sweet bay or Grecian laurel (*Laurus nobilis*), sweet-smelling lilac (*Syringa*

vulgaris), and common privet (*Ligustrum vulgare*). Old trees—chestnut, oak, elm, lime, cedar of Lebanon, dog-wood, holly—form a summertime canopy to this part of the garden.

Two subtle cross-axes, centred about the carriage loop and fountain, give the garden its strong structure. One is formed by the drive and related gateways, and the second by paths, porches, and latticed archways linking the house, stables, and, beyond this, the enormous grid-plan orchard, and the kitchen and picking garden, bounded by two rows of old *radiata* pines. Thus by meticulous planning the Vic-torian social structure was carefully maintained. The inner garden was a private preserve for members of the family and their guests, whilst carefully screened from view the everyday domestic and agricultural services functioned out of sight of both visitor and household, yet conveniently located and readily accessible. H.N.T.

Wörlitz, Halle, German Democratic Republic, has the earliest landscape park in Germany, laid out between 1765 and 1817 after previous and subsequent visits to England by Prince Franz of Anhalt-Dessau and his gardeners Eyser-beck, Neumark, and Schoch. The park is the crowning achievement of the so-called Dessau–Wörlitz cultural cir-cle, who were responsible for an artistically arranged land-scape area covering over 25 km. which extends from Kühnau near Dessau to the Rehsener Lake near Wörlitz. The Kühnau, Georgium (see J. F. *Eyserbeck), and *Luisium parks and the hermitage of Sieglitzerberg (see *Anhalt-Dessau) are notable features, while the economic aspects of the area were not neglected.

The Wörlitz Park (120 ha., 40 ha. of which is parkland, the rest agricultural areas and lakes) forms part of an area of agricultural meadowland which extends into the park and which contains the long Wörlitz Lake and two other lakes, so-called *Walllöcher* (formed when flood water broke through the Elbe dikes). At a considerable distance from the park are buildings (observation posts on the dike) with classical façades, which extend the character of the park into the surrounding area.

The main English influences on Wörlitz were *Claremont, *Stourhead, *Stowe, and The *Leasowes; Italian influences, above all from Naples and southern Italy, are to be seen especially in the so-called New Gardens by the Stein.

The park comprises five sections created more or less simultaneously, apart from the last two sections. The two plans purported to be by J. F. Eyserbeck (1763–4) are not designs but plans made to record the completed work. Work was carried out by the Prince himself, apparently without a drawn plan, although the idea for the park was clearly defined. Much damage was caused by flooding in 1770; this made it necessary to reinforce the dikes and lay out the gardens again.

The Schloss Garten was begun in 1765 around a hunt-ing-lodge (1698), with the building of the so-called Englis-cher Sitz, modelled on Stourhead, and the Schwanenteich with winding paths along its banks. The Grüner Berg was

built up on the banks of the lake, and land was bought so that the park could be extended with the Princess's Garden, a pheasantry, and a stopping place for gondolas.

The Neumark Garten was named after the gardener who worked on it. Building of a canal in 1781 gave the garden an island-like character; the area was divided into regular sections which were used as a tree nursery and a market garden. Along the canal lay a labyrinth, a circular building with statues in the niches (1783; modelled on Stowe), forcing walls, a pergola with the Eisenhart (a pavilion over the canal grotto), and a library. The 'island' is encircled by an embankment with various seats, some raised, particularly in the part which connects with the Isle of Rousseau (1782), which has poplars and a commemorative urn to *Rousseau, similar to *Ermenonville. In the area leading to the labyrinth are an Elysium and the Damenplatz with trees, some of which, such as the tulip trees, are very large.

The Schoch Garten was named after the gardener who worked on it until 1793. Work was begun in 1766, at almost the same time as work on the Wolf canal and the nymphaeum; the Grove of Diana and the New Bridge were built later. In 1773–4 the Gothic House was built, partly in north Italian Gothic style. It was extended in 1785–90 in English Gothic style (with further extensions in 1811–13); old and valuable Swiss painted panes are set in the windows. Other features include a chain bridge (1781) on a Swiss model; the Temple of Venus (1793–7) with a romantic rocky area and grottoes; the Temple of Flora with a flower theatre (1797); the Luisenklippe (1798); and a monument (1801–5, in memory of the Prince's ancestors) with an ancient Roman column. These buildings are focal points in the extensive garden which seems to stretch over a wider area than it actually is because of the agricultural acreage, and which is connected with the other gardens by means of vistas, some very narrow, often planted at regular intervals along their length.

The Garden on the Weidenheger was laid out between 1781 and 1788 on the north-east shore of the lake; it is a small garden with statuary designed to be effective when seen from a distance, and a root house.

The New Gardens were laid out by J. G. Schoch in a sentimental-romantic style with many elements reminiscent of Italy and the ancient world. There are a large number of canals; the Stein was erected in 1788–94—a fantastic structure resembling a natural rock which dominates the eastern part of the park. The Grosses Walloch is connected to the lake by canals, and building was carried out there in 1795–6: a Pantheon, an Italian farm, the Isle of Herder with Cippus, and a Grotto of Amalie with statues of Anacreon and Sappho. The buildings are surrounded by small, compact gardens; the areas between them are given over to agriculture. After the work was completed in 1796, only minor alterations were made. H.GÜ.

Wotton, Surrey, England, belonged to John *Evelyn's father, to his elder brother George from 1640, and at length, in 1699, to Evelyn himself. The moated manor-house stood in a secluded valley at the head of the River Tillingbourne.

Aged 23, Evelyn built himself an arbour as a philosophic retreat in 1643. His brother George further allowed him in 1652 to make new gardens in the Italian manner. The hill south of the house was cut into a terraced mount, with a portico and a grotto at its base and the ground between it and the house laid out as a *parterre with a fountain. A leat from a nearby rapid stream was used to carry away the spoil from the mount and to fill up the moat, and then became, and remains, the water supply to the fountain. Evelyn was afterwards very proud of the Wotton garden, and boasted of it to Sir Thomas Browne and John Aubrey. A number of Evelyn's drawings of Wotton of various dates survive.

D.L.J.

Wrest Park, Bedfordshire, England. What is known as the Great Garden was made between 1706 and 1740 for the 1st Duke of Kent. Its main feature is the Long Water, a canal-like lake centred on the house and with a beautiful pavilion (the Banqueting House), designed by Thomas *Archer in 1711, at its far end. The canal is enclosed, in the French manner, by dense plantations of trees criss-crossed by *allées with various small buildings, monuments, and other ornaments at key intersections. A bowling-green to the west is overlooked by a handsome building, known as the Bowling-Green House, said to be the work of Batty *Langley.

Between 1758 and 1760 the Duke's daughter, the Marquise de Grey, and her husband, the 2nd Earl Hardwick, engaged 'Capability' *Brown to improve the place. Contrary to his usual practice, he confined his alterations to the perimeter around which he created a serpentine, river-like lake. In 1834 the 2nd Earl Grey began to demolish the old house and build a new one at almost twice the distance from the Long Water. This drastically altered the perspective of the garden and necessitated the construction of extensive new terraces laid out in matching *parterres, an area now known as the French Garden. To the west of this a large orangery was also built to the design of Clephane.

A.H.

Wright, Frank Lloyd (1867–1959), was an architect in the American tradition of Emerson, Thoreau, and Whitman. Like the Spanish architect Gaudi he derived strength and inspiration from the soil, from natural growth and the use of natural materials, with which he had early contact on his uncle's farm. A second strong influence was his Froebel schooling which gave him a sense of order, proportion, and geometric relationships. Although he did not reject the machine, he did not feel constrained to express a machine aesthetic, like many of his European counterparts. He was more concerned to achieve 'repose', a restful environment conducive to mental health and contentment.

His greatest architectural achievement was to create a new concept of space in which rooms could overlap and interpenetrate both horizontally and vertically. This provided opportunities for subtle effects of natural lighting and views; and, by extension, it reduced the barriers between house and garden. Rooms became spaces defined by function, and there was no longer any rigid distinction between indoor and outdoor spaces. This is particularly evident in

Fallingwater (1937), Bear
Run, Pennsylvania, by Frank
Lloyd Wright

his house for Edgar J. Kaufmann at Bear Run, Pennsylvania (1937). Fallingwater is a complex in which stream, waterfall, rocks, house, and trees are so inextricably interwoven as to defy description either as architecture, engineering, or landscape design. His own house and studio at Taliesin West (1937) has also a strong landscape affinity, but this time with the desert. In it Wright used forms, materials, and colours which were carefully selected to harmonize with the desert and its plants. Of the large number of buildings which he designed, most are distinguished by their sensitive siting, and by their originality, particularly in the use of geometry, which has had a profound influence on all the environmental professions. M.L.L.

See also ROOF GARDEN: MODERN DEVELOPMENTS.

Wright, Thomas (1711–86), was an English astronomer and adviser on many gardens. Apart from his scientific writings, his two-part work *Universal Architecture* contained designs for rustic arbours and grottoes (reissued as *Arbours and Grottoes*, 1979). He advised on more than 30 gardens, including several in Ireland. His main work was at *Badminton House, *Shugborough, and Stoke Gifford, Gloucestershire.

Wright designed many garden buildings, often in a primitive manner (e.g. *root houses), although he also employed classical, Chinese, and Gothic styles. The Avery Architectural Library of Columbia University, New York, holds 175 of his sketches. He designed elaborate flower gardens and rosaries at a time when flower-beds were relatively uncom-

Würzburg, German Federal Republic, the Bishop's Residence, design for the east garden, engraving (after 1773) by Johann Prokop Mayer

mon in landscaped grounds. His designs were individualistic, and he does not fit in easily to the traditional account of the 18th-c. landscape movement. M.W.R.S.

Wroxton Abbey, Oxfordshire, England, has gardens laid out in the first half of the 18th c. and now extending to some 22 ha. around the mainly 17th-c. house. In 1727 the 2nd Baron Guilford employed Tilleman Bobart (a pupil of Henry Wise) to construct a formal canal garden on the east side of the house. From 1737 to 1751 the 3rd Baron, later 1st Earl of Guilford, had the Bobart layout grassed over and incorporated into an early example of a landscape garden, with a water-garden further down the valley, reflecting the owner's enthusiasm for the rococo. From the 1740s Sanderson *Miller designed a number of original garden buildings and structures, including the eye-catching 'Gothick' Dovecot, the Drayton Arch, and the Temple-on-the-Mount. A formal flower garden was laid out in the mid-19th c. on the south side of the house, after Lady Susan North had received advice from W. A. *Nesfield.

From 1978 a continuous programme of restoration has taken place for the new owners, Fairleigh Dickinson University of New Jersey, United States. P.E.

Würzburg, Bavaria, German Federal Republic. The Residence of the prince bishops of Würzburg was situated directly by the fortifications of the town, so that only a small area was available for the Hofgarten. A further difficulty was that the shape of the garden was already predetermined by the two triangular bastions standing in front of the Schloss on the garden side. A great deal of skill and imagination was required if an interesting solution was to be found to the problems posed by the site. All of the leading architects involved submitted proposals: Balthasar Neumann, Maximilian von Welsch, J. Michael Fischer, F. J. M. Neumann, the son of Balthasar, and even François Cuvilliés the elder. All of the designs envisaged the integration of the bastion on the upper level and only differed in points of detail.

However, it was not until 1774 that a design by J. P. Mayer, court gardener to Prince Bishop Adam Friedrich of Seinsheim, for whom he also laid out the garden at Veitshöchheim, was considered acceptable and work begun. Stairways adorned with statues lead on to the rampart and enclose the garden which is divided in a unique three-dimensional arrangement by supporting walls, landings, embankments, stairs, and ramps. The garden is lavishly decorated with pergolas, balustrades, and sculptures. The plans for cascades were never executed. U.GFN.D.

Wuxi, Jiangsu province, China, founded some 3,000 years ago, lies on the north-eastern shore of Lake Tai (see *Taihu rocks) and has long been famous for its gardens: Li Yuan, built in 1929; the Ming-dynasty Mei Yuan, or plum-tree garden, with 10,000 plum trees planted this century; Turtle-head garden, on a promontory in the lake overlooking the pavilion-embellished 'islands of three hills'; and Xi Hui Park, containing within it the *Ji Chang Yuan, originally laid out in the 16th c. M.K.

Xie is a type of spacious garden pavilion in China. All of its sides open, with pivoting windows and doors, and it is characteristically built beside lakes or streams to afford the enjoyment of water. X.-W.L./M.K.

See also FANG; GE; LOU; TING; XUAN.

Xie Qu Yuan, Beijing, China, is situated on the eastern side of Wan Shou Shan hill in *Yi He Yuan (the Summer Palace). This walled garden-within-a-garden was started in the latter half of the 18th c. on the orders of the Emperor Qian Long; it was originally known as Hui Shan Yuan, since it was planned and built after the style of the *Ji Chang garden in Hui Shan, Wuxi, which had pleased Qian Long on his southern tours. It is a garden of pavilions and open walkways centred on an irregular reflecting pool. A large artificial hill laid with *Taihu rocks hides a cascade called Yu Qin Xia (the Gorge of Jade Music), named after the Stream of Octave in the Wuxi garden. During reconstruction at the end of the 19th c., the Han Yuan Tang was added on the western shore of the pond and, flanked by two wings of covered corridors connecting the buildings on both sides of the pond, became the garden's main hall. The bridge cutting across the south-east corner of the water is called Zhi Yu, meaning Understanding the Fishes, after the anecdote from an ancient work of philosophy in which Zhuang Zhi, looking down from a bridge, remarks on the happiness of the fish below. 'You are not a fish, so how can you tell?' answers Huizi. 'You are not me,' says the philos-opher, 'so can you be sure I don't understand the pleasure of fishes?' D.-H.L./M.K.

Xing Qing Palace, Shaanxi province, China. The construction of this Tang-dynasty palace began in 714. Covering 135 ha. within the city wall in the north-eastern part of Changan (Xian), where Emperor Xuan Zong and his brothers lived before he came to the throne in 713, its main gate differed from the usual layout of most imperial palaces in facing west instead of south. In front of the complex of halls and courts lay an 18-ha. oblong lake, the Dragon Pool, surrounded by pavilions and flower gardens. Emperor Xuan Zong's famous concubine Yang Yu-huan (Guifei) once accompanied him to a pavilion in the garden to see the peonies, an occasion described by the Tang poet Li Bai (Li Po) as 'the mutual appreciation of the world's fairest flower and rarest beauty'. D.-H.L./M.K.

See also HUA QING GONG.

Xuan is a type of pavilion in Chinese garden design. Originally the *xuan* was a platform under the front eaves of a hall; now it generally denotes a small building or covered corridor with low walls between its supporting pillars. In Chinese gardens the *xuan* is usually a minor building used for leisure, sited to make use of the better views of a pond or hill. X.-W.L./M.K.

See also FANG; GE; LOU; TING; XIE.

Yangzhou (formerly Yangchow), Jiangsu province, China. Recorded from the Han dynasty (206 BC–AD 220) and long famous in China for its culture and charm, Yangzhou grew prosperous both because of its position on the left bank of the Grand Canal at its junction with the Yangtze (Chiangjiang) River, and its long association with the salt trade. In the Song dynasty it was already well known for its rock gardens, and under the Qing was famous for its peonies. The painter and garden-designer *Shi Tao made many gardens around the city and today several small but interesting gardens, also laid out under the Qing, remain along the shores of the Narrow West Lake, Shou Xi Hu, an elongated serpentine pool crossed by a decorative bridge surmounted by five pavilions, which was built in 1775. Within the city, two interesting but currently somewhat run-down gardens, *He Yuan and *Ge Yuan, are open to the public. M.K.

Ye Tao, alias Jing Cheng and Qing Chuan, was a native of Qingpu, a county town some 20 km. west of Shanghai, China. He is best known for his landscape paintings, but when the imperial garden, *Chang Chun Yuan, was being built in Beijing at the end of the 17th c., almost every tree and rock in the garden was planned and laid by his hand.

C.-Z.C./M.K.

Yi He Yuan, Hobei province, China, located *c.*10 km. north-west of Beijing, is a walled imperial retreat widely known as the Summer Palace. Over a thousand years ago the hill in this great garden, while still in its natural state, was called Weng Shan, the Jar Hill, and water from several springs converged on its slopes to form the small Weng Shan lake. During the Ming dynasty (1368–1644), dikes were made for paddy-fields and lotus and other aquatic plants were grown in the lake until gradually the well-tended fields came to resemble the countryside south of the Yangtze (Chiangjiang) River known in China as Chiangnan. In the early 18th c., the Qing Emperor Kang Xi started to reside here occasionally, and in 1750, Emperor Qian Long began relandscaping the entire area. The lake was dredged and enlarged, dikes built to divide it, and the hill remade. Two years later, as the garden began to take shape, a new name was chosen for it, Qing Yi Yuan or the Garden of Clear Ripples. Weng Shan became Wan Shou Shan or Longevity Hill, and the lake Kunming Hu. Construction continued for 14 years and, of all the pleasure-grounds he had built in and around the Western Hills, this became the Emperor's favourite: 'Where in all Yan shan is the mind so free?' he wrote in a poem, 'Peerless sight, the wind and moon over Lake Kunming.'

In 1860 Qing Yi Yuan was burnt down by the combined forces of Britain and France and only a few structures in stone and bronze survived. But six years later, the Empress Dowager Ci Xi diverted funds allocated for establishing a national navy to its rebuilding. After nine years of construction it was finally given the name it still has today, Yi He Yuan, or Garden of Happy Harmony, to honour her wish for the conservation of peace. Despite minor changes to its many buildings, it was virtually a reproduction of the old park and represented a high point in the development of Chinese landscape gardening. In 1900 after the Boxer rebellion, it was again destroyed by an allied force of eight countries, then renovated once more in 1903. Finally, in 1961, restored yet again, it was listed as a Key National Place of Historic and Cultural Importance.

The estate falls into two parts: to the north, Wan Shou Shan hill falls steeply to the irregular ribbon of the narrow 'back lake' behind it; and Kunming lake, which occupies three-quarters of the total 300 ha., stretches out in front of it to the south. None of this, however, is visible from the main entrance in the east, which leads into two large courtyards enclosed by red walls and dominated by Ci Xi's throne hall. A complex of palace courts, including a large open theatre in a courtyard, stretches from here along the northern shore of the lake towards the hill, but if the visitor avoids these and instead walks past some low mounds to the left, he will find himself as if by chance, facing the whole horizontal expanse of Kunming lake, with the outlines of the Western hills lying beyond it like a screen. To the left the 17-arch marble bridge of Qian Long draws the eye across the water to the rocky South Lake Island with its Dragon King Temple. To the right a series of buildings, their yellow roof-tiles gleaming against the hillside like a waterfall, rise steeply up the slope of Wan Shou Shan to the massive octagonal Tower of the Fragrance of the Buddha (where the Emperor and Empress attended religious services) and the Hall of Dispelling the Cloud, which dominate the summit.

Along both sides of this steep axis various smaller buildings build up to the main halls, enhancing by contrast the solemnity, grandeur, and compactness of the central complex. Along the whole length of the shore there runs an unbroken white marble balustrade, curving out into the lake to emphasize the central axis. And behind it, dividing the narrow space before the steep rise of the hill, is the famous covered gallery 1,728 m. long with its 273 bays brilliantly coloured with little vignettes of garden scenes and flowers painted beneath the eaves.

The back lake and hill area embrace all the places to the north of Longevity Hill, a large part of which is taken up by

The marble boat (*fang*) at
Yi He Yuan, Beijing, China

its steep northern slope. Except for a specially designed
lamasery (lama monastery) with terraces and a pagoda in
Tibetan style in the centre of the slope, the buildings here
were sparsely laid out and, since most were reduced to ashes
by the foreign invaders, only broken walls and ruins remain
to give an idea of what they were like.

The so-called back lake is actually a long watercourse
winding for about 1,000 m. along the northern foot of the
hill. The north bank was piled up with mud dug from this
excavation, creating the expectation of a contrasting
expanse of open land beyond. The middle part of the lake is
relatively narrow. In Qian Long's time rows of make-believe
shops simulating a riverside street in *Suzhou were lined up
along the bank and, though these have long since disap-
peared, the name remains. North-east of this there is the
*Xie Qu Yuan, a garden-within-a-garden, built during the
reign of Emperor Qian Long, in imitation of the *Ji Chang
Yuan in Wuxi.

It is, however, the great expanse of the front lake that
makes the garden. Here the monotony of the surface is
broken by the flowing lines and pavilion-bridges of Xidi, the
West-Dike, which divides it into three unequal spaces. The
largest of these is the eastern lake, focused on South Lake
Island and its 17-arch bridge with, beyond, a group of small
islands that take their names from the legendary homes of
the Immortals: Penglai, Fangzhang, and Yingzhou. The
Xidi was built after the fashion of a famous dike built by the
poet Su Dongpo in *Hangzhou, where weeping willows line
the water's edge in the manner of waterside villages south of
the Chiangjiang (formerly Yangtze River). Here the
panorama of the lake 'borrows' scenes (see *jie jing*) of the
Jade Fountain Hill and the whole sweep of the Western
Hills beyond the garden walls. G.-Z.W./M.K.

See also FANG.

Yildiz Park, Istanbul, Turkey. The gardens were described
at the time of Ahmed III towards the middle of the 18th c. as
follows: 'The festive celebrations held there by the sultan
and his vizier are well known, the groves becoming
renowned as "Ciragan" (The Illuminations), from the
fabulous moonlight festivities of lamps and flowers held
among the sultry foliage of these luminous shores' (Celik
Gulersoy). However, the palace groves were at that time
preserved in their natural state, unbroken by terraces and
roads, the slopes being covered with acacias, almond trees,
cypresses, and giant maples. It was not until the middle of
the 19th c. that the natural forested appearance was
changed. Sultan Abd al-Hamid II (1876–1909) adorned the
area with lodges and pavilions, linking them with a road, and
employed a large team of local and foreign landscape
gardeners to arrange the gardens and add trees from
Europe. Such was the cost of the work it was said that he
spread gold over every square metre of the groves.

In 1979 the TTOK began to restore the pavilions and the
gardens. Both the Malta and Cadir pavilions have now been
transformed into cafés and tea-rooms with adjacent terraces
and colourful gardens. In addition two new conservatories
have been created. The Pink Conservatory, close to the
Malta Pavilion, is constructed of glass with a floor of marble
and furnished in pink and red tones, reflecting the colours
of the sunset and the Judas trees. The Green Conservatory,
appearing like a glass sphere in a sea of trees, takes its theme
from the varied hues of park greenery. R.ST.

Yi Yuan, Jiangsu province, China, built between 1862 and
1908 by Gu Wen Bin, a high official of the Qing dynasty, is
the most recent of the famous old city gardens in *Suzhou.
Typically, Gu chose a site which, in its eastern section, had
been occupied since the Ming dynasty (1368–1644) by the

house of a Minister of Government Affairs, Wu Kuan. The western part, however, was an addition designed by his son, Gu Cheng, with several well-known artists of the time, including the painter Ren Bo Nian, as his advisers.

For historians its chief interest lies in the way these men have borrowed themes and motifs from more ancient Suzhou gardens. Its double *lang* or covered walkway was probably inspired by the one at *Can Lang Ting; its artificial 'mountain' by the great rockery at *Huan Xiu Villa; its rock-bordered lotus pond by the *Wang Shi Yuan; its boat-shaped pavilion by the one called Fragrant Land at *Zhuo Zheng Yuan. In each case, the borrowing is subtle, more adaptation than direct copy, and the whole garden so skilfully developed in the comparatively small area (c.0·6 ha.) that Yi Yuan is often said to offer the best of all the gardens in the region south of the Chiangjiang (formerly Yangtze River).

The entrance is by way of a pleasant wide courtyard with high, whitewashed walls and a floor worked in a flower design of soft pink and grey pebbles. The garden divides roughly into an eastern part, composed mostly of buildings and small courtyards intricately related, and a western part arranged around the hills and ponds. This also is divided into two parts hidden from each other by the steep and rocky outlines of a large artificial hill (*jia shan) built up with hidden grottoes below and slivers of stalagmites standing, like stone needle-points, among the *Taihu rocks and shrubs above. The whole makes what the Chinese call a fine 'facing view' for the Lotus Root Fragrance Pavilion on the opposite bank. From here, the pond runs westwards through a steep bottle-neck, then expands to the north-west, where the Painting Boat Studio, a double-storeyed *fang or stone-boat pavilion, looms over the water. Still further west lies another small enclosure of the type the Chinese call a garden-within-a-garden, separated from the rest by a *lang* and containing within it the Hall of Pure Dew. C.-Z.C./M.K.

Young, Arthur (1741–1820), an English agriculturalist and writer, travelled extensively and wrote fully in *Tour in Ireland* (1780), *Travels in France during the Years 1787, 1788 and 1789* (1792), and *Autobiography*, published in 1898. He had a horticultural knowledge of trees, shrubs, and grasses; an artist's eye for scenery (he drew well); and an understanding of the social problems of husbandry, including the miseries of absenteeism in Ireland and antiquated methods of agriculture in France. He showed an acquaintance with the aesthetics and practice of landscape gardening without the excesses of either the Brownian or the picturesque schools; above all, he wrote with great vivacity, and is undoubtedly the greatest writer on agriculture in the 18th c. E.M.

Yuan Ming Yuan, Hobei province, China, located in the north-west outskirts of Beijing, is only about half a kilometre east of *Yi He Yuan; the ruins of this great imperial park are also known as the Old Summer Palace. It was once joined to the *Chang Chun Yuan, or Garden of Everlasting Spring and Wan Chun Yuan, or Garden of Ten-Thousand Springs, and all three were collectively known as Yuan Ming Yuan, or Garden of Perfect Brightness. Regrettably, this masterpiece of classic Chinese gardening was destroyed and looted in October 1860 by the combined forces of Britain and France but its ruins, landscaped extensively with trees since 1956, draw an increasing number of visitors today.

The predecessor of Yuan Ming Yuan was a private garden owned by a relative of the Ming emperors. In 1707, the Emperor Kang Xi of the Qing dynasty gave it to his fourth son, Yin Zhen, who, when he came to the throne as the Emperor Yong Zhen in 1723, ordered it to be expanded into an imperial garden and gave inscriptions for the creation of 28 separate scenes. During the reign of the Emperor Qian Long (1736–95), another 12 scenes were added and later Chang Chun Yuan and Wan Chun Yuan, forming a triple layout, were built to the east and south-east. The total area of the three gardens with a circumference together of c.10 km. was 350 ha., of which Yuan Ming Yuan covered 200. The terrain was rather flat with water flowing through it from the Jade Fountain of the Western Hills. The hills and mounds were all man-made and among them the water surfaces, sometimes in large sheets—as the Fu Hai or Sea of Felicity covering some 500 sq. m. in the centre of the three gardens—sometimes irregularly shaped, and sometimes in tortuous brooks or wide canals, altogether occupied over a third of the total area.

Yuan Ming Yuan is celebrated for the many smaller gardens, each with its own characteristic features, contained within it, so that it has long been called the garden of ten thousand gardens. There were some 150 specific scenes, among them 40 dominant ones celebrated in poems by the Qing emperors and painted by many artists (some of these are now in the Bibliothèque Nationale, Paris). In most of these architecture played an important role. In the south were palace halls for holding court and attending to state affairs, and also buildings for living, some enclosing tiny gardens. Other gardens contained various structures within them, some built in a rustic style and others lavishly. Many of the scenes were modelled after famous sites south of the Chiangjiang (formerly Yangtze River): Three Deeps Reflecting the Moon, the Autumn Moon over the Quiet Lake, Winding Courtyard with Wind-Blown Lotus, and Sunset Behind the Thunder-Peak Pagoda were all borrowed from *Hangzhou, while *Suzhou was represented by *Shi Zi Lin, and Hainin by *An Lan Yuan. A great library, Wen Yuan Ge, where the Si Ku Quan Shu or 'Four Vaults of Classics' were once stored, was built after the design of Tian Yi Ge in Ningbo, Zhejiang province; temples for worshipping the Buddha and commemorating the sages, halls for attending ceremonies and for stage performances, mountain villages and mock-up shopping streets, and facsimiles of the mythical island homes of the Chinese Immortals were all constructed in Yuan Ming Yuan.

To the north of Chang Chun Yuan once stood a group of peculiar structures, known as Xi Yang Lou. Unique in China when they were built for the Qian Long Emperor, they were designed in a Western style under the supervision

of Père Giuseppe Castiglione and his Jesuit and other colleagues serving in the imperial court. Ruins and contemporary etchings show that these marble buildings (which included fountains and a water clock), though fundamentally baroque in style, were—as in the glazed tiles which top the walls and roofs—also distinctly Chinese in many of their details. G.-Z.W./M.K.

Yuan Ye is a three-volume treatise of 'Garden-making and Landscape Architecture' (literally Garden Tempering), which was completed in 1634 by *Ji Cheng (Chi Cheng), a prominent Ming-dynasty landscape designer. It is the most famous and comprehensive work on the subject in Chinese. The first volume has chapters on construction, selecting and investigating sites, placing garden buildings and artificial hills, and on their design and that of latticework grids for doors, windows, and ceilings. The second concentrates entirely on balustrades. The third consists of six chapters:

on doors and windows, on walls, pavings, the construction of artificial hills, the selection of rocks, and on 'borrowing' views (see *jie jing*). The first four and last three chapters give detailed descriptions on both theory and practice, and are considered to contain the essence of Ji Cheng's message.

Evocative descriptions suggest moods and inspire themes for a garden rather than presenting specific or logical arguments, for the author insists that 'though there are principles (in gardening) there are no rules'. For a city garden he advises a secluded site, ideally with a distant view of mountains: 'let the swallows fly in with the wind. The petals of the flowers hover like snowflakes ... let your feelings dwell among hills and valleys; there you may feel removed from all the unrest of this world.' For Ji Cheng gardening is based on illusion, and what must be captured is the 'life-spirit' both of the particular place and of nature itself—even within the confines of a city. C.-Z.C./M.K.

Yugoslavia

Various cultures—Roman, Byzantine, Islamic, and Middle European—have left their imprints on the territory of present-day Yugoslavia. This is reflected also in visual arts, and not least in garden art. Archaeological excavations have furnished evidence of gardens that existed as part of the chain of Roman villas along the Yugoslav Adriatic coast from the south to the Brioni Islands and the Istrian Peninsula in the north. Nothing more substantial remains than garden fragments, mosaics, terraces, and ponds, not even within the monumental Diocletian Palace, where post-Roman development has eliminated all traces of what used to be the emperor's gardens.

In the south of Yugoslavia the Macedonian and the Serbian kingdoms continued the Byzantine art of building in the period from the 12th c. till the Turkish occupation in the 14th and 15th cs. Together with the building of impressive churches and royal residences, the Byzantine gardening tradition was also accepted (see *Byzantium). Nothing remains of this but written descriptions.

THE GARDENS OF DUBROVNIK. About a millennium after the decline of the Roman tradition, a new garden culture came into being in the unique small city-state, the Republic of Dubrovnik (known at that time as Ragusa) on the Adriatic coast. Due to its convenient geographical and strategic position, Dubrovnik was able to develop political independence and good trade connections between the hinterland and western Europe. When the Turks occupied the Balkans Dubrovnik established connections mainly with Italian towns which were also a source of cultural influences, and this led to the creation of what is known today as the Dubrovnik Renaissance. As a parallel to the Italian Cinquecento, humanist and natural sciences flourished here too, as well as poetry, drama, and music. Many noble families had

fine houses built and also gardens laid out for pleasure.

Inside the city walls there was little space left for gardens, which were made around the suburban villas or summer residences in the surrounding areas, many on hill slopes. A native chronicler Filip de Diversis describes a part of the city in 1440 as 'a safe and large harbour, embellished by numerous vineyards in the surrounding area, monumental palaces and wonderful gardens'. However, gardens of a more elaborate design did not appear until the middle of the 16th c. Typical of their layout were terraces, and a frequent use of pergolas which covered paths or walks and thus contributed to further spatial subdivision. As a rule the garden was used for both pleasure and utilitarian purposes. This is best reflected in the choice of plants: besides the native shade trees and evergreens there were vines on pergolas, and various fruit-trees are mentioned in contemporary sources. The basic layout of the garden was regular with a frequent subdivision into four or more rectangular parts or terraces. On the other hand, no trimming of plants into geometrical figures has yet been proved. Due to a general shortage of water there were none of the *giochi d'acqua* so typical of the Roman or Tuscan gardens, but instead smaller fountains and irrigation devices were used and sometimes given a more interesting form. In a couple of gardens, situated along the coastline, there were large ponds connected with the sea by canals. Enclosed by high walls, the ponds contributed a powerful visual element and at the same time introduced the immense phenomenon of the sea into the garden.

As a whole, this legacy could be classified as a specific type of the proto-Renaissance garden. During the 16th and 17th cs. it spread far beyond the Dubrovnik area, northwards and on to the islands. Unfortunately the majority of these gardens have disappeared; a good number have only

structural fragments remaining today and only a few survive in a rather integral form like the summer residences of Sorkočević and Skočibuha. The original layout of the later ones can still be made out.

Among the gardens from this period the oldest one is Trsteno near Dubrovnik, a summer residence with a garden already finished in 1502 for the family Gučetić. The original geometrical design has been blurred by an exuberant vegetation of which a few very large plane trees survive from the very beginning of the garden. In 1736 a large baroque fountain was added which today makes a strong formal feature.

The best preserved garden of the period belongs to Sorkočević's villa at Lapad, Dubrovnik, which is small in size—c. 2,500 sq. m. The villa, in the Gothic-Renaissance style, opens on to the lower terrace through a beautiful loggia with a view on to a rectangular *bassin* connected to the sea. There is an upper terrace with geometrical beds and a pergola. Another garden, belonging to Sorkočević's family, ornaments the summer residence in Rijeka Dubrovačka. Like the villa at Lapad, it was built at the seaside in the second half of the 16th c. Of the original structure there remains the geometrical division of the four-part parterre; pergolas with carved stone pillars; and a large flight of steps which served as an access from the sea. The building with the surrounding land is used as a tourist facility and this has set certain limits to the reconstruction of the garden which has been carried out in recent years. In a more derelict state are two important gardens of this period of the Skočibuha family on the island of Sipan with an interesting terraced articulation and rich pergolas.

Dubrovnik also possesses two cloister gardens of an early date. The first is in the Franciscan monastery and was built in 1317 by Mihoje Brajkov. The cloister garden is divided in the middle by a path and a double row of stone benches terminated at one end by a fountain. This is quite an exceptional arrangement compared to the usual cross-walk division familiar elsewhere in Europe. The cloister belonging to the Dominican monastery in Dubrovnik was built in the 15th c. Apart from some peripheral planting its main part is now paved. Also of interest are smaller cloisters in Stone and in the Dominican monastery in Trogir where the municipal lapidarium is situated.

THE SLOVENIAN BAROQUE. Another important development took place during the 18th c. in the north-western part of the country, mainly in Slovenija, then still a part of the Austro-Hungarian Empire. By the end of the 17th c. Turkish penetration northwards was stopped, and a more peaceful life together with a flourishing of the arts began. Increased wealth enabled the aristocracy to build or rebuild manor-houses and palaces with gardens. The leading examples of this period were the royal residences of *Schönbrunn and *Belvedere in Vienna with their stately baroque gardens. The country aristocracy could not afford gardens of such a size and sophisticated design; yet some gardens were laid out in a genuine baroque grand manner

demonstrating also the conceptual unity of the palace and garden.

Only one typical example of this rich heritage remains in a largely intact form in Dornava near Ptuj. Originally a 14th-c. manor-house, in the first part of the 18th c. the palace and the garden were redesigned in a baroque style for the Count Attems. The main feature is a 1·8-km. long garden axis beginning with a sculpture and a long avenue of trees that ends in a forecourt in front of the palace. On the other side the axis is first carried on by a courtyard enclosed from three sides by the palace and two lateral wings. Then comes the 90-m. long four-part parterre with a large circle in the centre decorated by a sculpture of Neptune in a small *bassin*. The final part was an orchard used as an equivalent of the baroque *bosquet*. The garden had a rich sculptural programme of which the main part is still in existence. Today the palace houses a children's hospital and the garden needs careful reconstruction.

Similar development can also be traced in north-western Croatia and Vojvodina, though gardens here were smaller in size and of a less complex design. Characteristically enough, the baroque layouts generally appeared on the large estates in the long stretch of the Pannonian plain from Styria to Vojvodina. In this open land they were more exposed and vulnerable to war destruction over the centuries, and only fragments of them have survived to the present day.

THE ISLAMIC INFLUENCE. Five centuries of Islamic presence in the southern parts of Yugoslavia resulted in an opulent architectural creativity which is still visible in the design of cities, mosques, and residences in Bosnia, Macedonia, and Serbia. Garden culture was expressed on a smaller scale, mainly in the courtyards of houses or religious buildings. While there are hardly any of the house gardens left, some fine examples of courtyards with fountains, pavements, and planting can be seen in the mosques in Sarajevo, Mostar, and elsewhere. In addition, mention must be made of the highly interesting Muslim graveyards which are masterpieces of landscape design. Among numerous sites in Bosnia and Macedonia the most notable is Alifakovac in Sarajevo with its dominating position, beautifully designed tombstones, and their excellent spatial distribution.

THE LANDSCAPE STYLE. The landscape style did not arrive in Yugoslavia until the 19th c. It is represented by only one important creation, a contribution of G. Haulik, the Bishop of Zagreb, who from 1846 on laid out the large park of Maksimir on the outskirts of the city. It was intended for the education, recreation, and enjoyment by the city population—a unique motivation for creating such a large structure at that time. The straight entrance avenue leads to an elevated kiosk, a one-storey building which dominates the park, and from which the view opens in four directions into well-designed dales with lakes that constitute the main visual feature of the park. The lakes offer interesting landscape scenery, but this has deteriorated after the 20th-

c. introduction of the zoo. Due to ageing of the vegetation and to overgrowth, the garden needs reconstruction and this is now under way. Another landscape garden in Croatia is Opeka near Varaždin. Begun in the 19th c., it has picturesque scenes made by open lawns which are enclosed by large exotic broad-leaved and coniferous trees. The original layout has been considerably changed through unchecked growth and by horticultural varieties introduced since the horticultural school was built there. Interesting elements of landscape style are to be seen at the Arboretum Volčjipotok near Ljubljana. There is also a terraced Italianate geometrical parterre. Both were laid out at the end of the 19th c. and the beginning of the 20th c. Since 1956 the layout has been greatly extended as a demonstration garden with numerous collections of exotic and horticultural plants for study and educational purposes.

Some notable city parks of the late 19th c. and the 20th c. are Tivoli in Ljubljana, Zrinjevac in Zagreb, Kalemegdan in Belgrade, and Gorica in Ohrid. D.K.O.

Yu Hua Yuan, Beijing, China, is a rectangular garden, some 130 m. × 90 m., covering c.3 ha. within the dusty red walls of the imperial city and immediately south of its northern gate. In fact the garden is the last in the vast processional sequence of gates, halls, and courtyards that lead north from Tien An Men Square to Coal Hill (*Jin Shan). Coming after the culmination of this sequence of the triple halls of state on their marble terraces, it is a deliberate anticlimax, a place where the emperors could relax after the awesome formalities of court ceremony. On first acquaintance, however, it suggests only a very controlled loosening of decorum since the plan is meticulously symmetrical, the trees in rows, the flowers (peonies in late spring, chrysanthemums in autumn) in beds, and the ground paved: but within this formal framework there are many unexpected effects.

Originally laid out during the Ming dynasty in the 15th c., the garden now owes much to Qing rebuilding. Its main hall on the central axis is the Qin An Dian, the Hall of Divine Tranquillity, enclosed in its own red walls and with green bamboos planted nearby. In front of them, a collection of rare and strangely shaped stones has been set up on carved marble plinths. Pebble pictures (*luan shi pu di) in traditional designs of flowers, pavilions, and trees—mixed ingenuously with a bicyclist or a 1920s motor car—have been worked into the pathways. Three 'false mountains' (*jia shan) of water-modelled stone make it possible to climb up above the pavilions; but it is in its junipers, *Juniperus chinensis*, planted in the mid-14th c. under the Ming, that the magic of the garden lies. The bark of these extraordinary specimens seems to swirl round the knots and contours of their ancient trunks like water in a turbulent stream, while above the enclosing walls and imperial yellow roofs, twisted branches braced with huge wooden props hold up a feathery canopy of needles, swaying freely against the brilliant northern sky. G.-Z.W./M.K.

See also QIAN LONG GARDEN.

Yu-Hwa Yuan, Singapore. See JURONG JAPANESE AND CHINESE GARDEN.

Yun qiang, or cloud wall, is a wall, usually plastered and white- or occasionally colour-washed, which surrounds a Chinese garden or separates its interior spaces. Its top often undulates in waves which suggest floating clouds, hence its name. However, since the coping is often made of grey roof tiles, it may also look like a flying dragon and (as in the *Yu Yuan in Shanghai) may even have a dragon's head carved at its end; for this reason it is also called a dragon wall. Such walls capture the dancing shadows of leaves nearby, but they also form the plain backdrop against which the garden designer 'paints', with living trees and rocks, a three-dimensional landscape scroll. X.-W.L./M.K.

Yu Yuan, Shanghai, China. A provincial governor of Sichuan, Pan Yun Duan, built this complex garden in his home city of Shanghai between 1559 and 1577 for his father, Pan En: its name means 'to please the old parent'. The garden, then one of the most famous in the region south of the Chiangjiang (formerly Yangtze River), covered c.5 ha., but in 1760 part of it was bought, renovated, and renamed Xi Yuan (the West Garden), since its neighbour *Nei Yuan was then named Dong Yuan, or East Garden. From the first half of the 19th c. it was used by some craft and merchant guilds, and a market gradually emerged in its south-western part. The large tea-house reached by a rather crudely designed zigzag bridge, now outside the garden, is supposed to have inspired the English 'willow-pattern' plate design in the 19th c. It was seriously damaged both in 1855 when the government put down the uprising of the Dagger Society, which used the garden's Dian Chun Hall as its headquarters, and again in 1862 when it was used as a military camp during the Taiping rebellion. From 1956 it was restored by a grant from the People's Government; however, although the Nei Yuan was included in it, it occupies today only about half of its original site. In 1982 it was named a Key National Place of Historic and Cultural Significance.

The garden falls into three main parts. In the first, the main feature is a large artificial hill of yellow rock (*huang shi), with the elegant Ming-dynasty Cui Xiu Tang, or Hall of the Assemblage of Grace, below it to the east and, on its top, the Wang Jiang or Viewing the River pavilion which 'borrows' views of the Huang Pu River from beyond the eastern wall (see *jie jing). This rocky hill, designed and laid out by *Zhang Nan Yang, a late Ming-dynasty master of the art of rockery, is the biggest to have survived in China. At the end of the Qing dynasty a realistically modelled dragon's head was added to the undulating wall which surrounds this rockery and three similar heads cap the ends of other walls in the garden. Although these are rather amusing, connoisseurs of gardens find them somewhat jarring—the additions of Guild merchants lacking the subtle refinement of China's scholarly tradition. South of the rockery, a waterfall once fell into the deep pool that lies between it and the large and

Yu Yuan, Shanghai, China,
the Dragon Wall

elaborately finished Yan Shan Tang, or Hall of Looking Up to the Mount, with small, sculptured elephants standing on its roof. Other lively figures—of soldiers on horseback and monsters spitting out roof-beams—which prance across several of the Yu Yuan's deep roofs, are, like the dragon heads, additions by the Guild merchants. In the same idiom but in keeping with scholarly ideals are the very finely crafted brick reliefs let into many of the walls. Two streams flow out of the pond, one north-eastwards back to the rocky hill, the other eastwards, beside a double, zigzag *lang and through a half-moon opening to a pool in front of the Wan Hua Lou, or Storeyed Pavilion of Ten Thousand Flowers. Beyond the next dragon wall, the garden is densely composed with a number of pavilions set on rockeries, and halls, including a sheltered stage with the Dian Chun Tang facing it to accommodate the audience. At the less intensely designed southern end of the garden, through a gateway surrounded by two more dragon heads, a magnificent standing rock over 5 m. high named Exquisite Jade is said to have been earmarked, during the Song dynasty, for the imperial garden *Gen Yue. Beyond it, enclosed by rocks and walls, lies the *Nei Yuan. D.-H.L./M.K.

Zeist, Utrecht, The Netherlands. In 1685 William, Count of Nassau-Odijk (1632–1705), a cousin of William III, commissioned Jacob *Roman to design a country house and the main lines of a 23-ha. garden at Zeist and Daniel *Marot to decorate both. The Roman–Marot collaboration in the gardens produced a Franco-Dutch style in which a French baroque flourish was adapted to the rigid rectangular framework of the compartmented Dutch classical canal garden. The gardens were composed of a self-contained and highly intricate semicircular parterre island with hippodrome-shaped *berceaux* followed by kitchen gardens and *bosquets*, and the whole area was bisected by a dominant central axis leading from the house on the island. With their rectangular shape and emphasis on parallel axes, Zeist and such other Franco-Dutch gardens as Heemstede and *de Voorst exerted an influence in Germany and it was to appear later in England. F.H.

Zelazowa Wola, Poland, the birthplace of Frédéric Chopin (1810–49), has a monument park designed in memory of him by Franciszek Krzwyda-Polkowski (1881–1949), the founder of contemporary Polish landscape architecture. The park is a magnificent example of modern garden design. The ground slopes slightly towards the valley of the River Utrata. Around the manor, as the centre of the spatial arrangement, are the main components of the layout—the garden court with a pool, the terrace on the escarpment with a pergola, and an oval garden *salon*. There is also a rich collection of *c.*600 species and varieties of ornamental trees and shrubs. L.M./P.G.

Zenana, part of a house or garden in Mogul India reserved for women (particularly those of high caste) and in which they were secluded. J.L.

See also LAHORE FORT; NISHAT BAGH.

Zhang Lian (b. 1587), like many other Chinese garden designers and rock-artists, studied painting in his youth and his work shows his grasp of the principles of composition in traditional landscape painting. Born in Huating, now Songjiang County, Shanghai, he worked for some 50 years in the late Ming and early Qing dynasties south of the Chiangjiang (formerly Yangtze River), where many gardens were made under his direction. According to records, his famous works included Fu Shui Shan Zhuang, or Villa of Whisking Water in Changshu, and White Sand with Green Bamboos and Precipice of River Village in Yangzhou, but none still exists.

His son *Zhang Ran also became a well-known garden designer. D.-H.L./M.K.

See also JI CHANG YUAN.

Zhang Nan Yang (b. 1517), known also as Shanren, was a master of the art of piling artificial hills and was responsible for the large rockery in *Yu Yuan, the most famous old garden in his native city of Shanghai, China. As a boy he learned painting from his father (they were not related to the other Zhang family of rock-artists) and his rockeries, which characteristically have no earth visible anywhere, owe much to his grasp of the principles of composition in Chinese landscape painting. C.-Z.C./M.K.

Zhang Ran was a 17th-c. Chinese artist, skilled in building artificial hills during the Qing dynasty; he was the son of another well-known garden designer *Zhang Lian. Responsible for Yin Tai in Nanhai, Yu Quan or Jade Spring in the western suburbs of Beijing, and *Chang Chun Yuan, he worked in the service of the Imperial Court, Beijing, for more than 30 years, and was famous for his ingenious handling of water surfaces and his natural-looking rockeries. C.-Z.C./M.K.

See also ZHONGHAI AND NANHAI.

Zhonghai and Nanhai, China. Among the citizens of Beijing, the names of these two great water-gardens in the centre of their city are usually run together as Zhong Nan Hai, Central (and) Southern Sea. In fact, they are a southerly continuation of the lake and park of *Beihai, the Northern Sea, which, until Yuan Shi Kai separated them in 1912 to make his Imperial Palace, were together called the Three Seas. When first dug out in the late 12th and early 13th c. under the Jin and Yuan dynasties, the lake of Zhonghai was, with Beihai, part of the Tai-yi (Pool of Heavenly Water). Nanhai was built later, under the Ming, but today, while Beihai is a public park, only part of Zhong Nanhai is open to the public. The total area of both parks is some 100 ha., most of it water. The lake in Zhonghai is long and narrow, running from north to south, its shores densely planted with trees which surround, among others, the Ten Thousand Good Deeds Hall and the Thousand Sage Hall enclosed in flower-planted courtyards. A mid-lake Pavilion of Water and Cloud, reflected in the water to the east, balances the Zi Guang Ge or Tower of Propitious Omens to the west. A dike, some 100 m. wide, divides the two lakes and where this joins the western shore, some 30 courtyards are grouped around the Ju Ren Tang or Hall of Living Benevolence, and Huai Ren Tang or Hall of Cherishing

Benevolence. Huge blue-green pines, cypresses, willows, yulan magnolias (*Magnolia denudata*), and crab apples are planted among them. The lake of Nanhai is roughly circular. On the small island, Ying Tai, lying off its northern shore, the Emperor Guang Xi was imprisoned after 1898 by his aunt, the formidable Empress Dowager Ci Xi, for his attempt at constitutional reform. G.-Z.W./M.K.

Zhuo Zheng Yuan, Jiangsu province, China, the largest of the old private gardens in *Suzhou, was first built between 1506 and 1521 during the Ming dynasty by a Court Examiner, Wang Xian Chen, on his retirement. Its name is variously translated as the humble, foolish, or unsuccessful politician's garden. Wen Cheng Ming, one of the Four Great Painters of the Ming, lived here for a time and left a record of it in two albums of poetry and drawings.

It is regarded as the 'quintessence of a water-garden'— more than half of it is taken up by a complex arrangement of irregular and interconnecting pools. In fact, it is almost a water labyrinth, with large reflective areas divided by islands in the northern part and long fingers of water winding south under bridges into secret backwaters. Though its buildings are grand and their workmanship fine, it is said to have the atmosphere of the water villages in that prosperous and lovely area south of the Yangtze River (Chiangjiang) known in China as Chiangnan. The most important building is the formal Hall of Distant Fragrance, standing back from the south bank of the lake in the centre of this part of the garden. Northwards, it looks across water to two mounded green islands, embellished with the Pavilion of Fragrant Snow and Glorious Clouds and a little gazebo called Waiting for the Frost.

In the north-west corner, a peninsula planted with flowering shrubs is encircled by roofed and open walkways which zigzag along the edge of the water. In the south-west, a further series leads to a group of secluded rooms and tiny, planted enclosures culminating in the Blue Waves Water Courtyard overlooking a shadowy pool. The south-east section is separated from the water by a hill and an undulating grey wall enclosing courtyards which, with their fine proportions and delicate pebble-patterned floorings, are some of the most appealing in the garden. To the north, on the easternmost shore of the lake, stands the unusual Bamboo Quiet Resort, a square pavilion with a large circular moon door (*di xue*) cut in each wall to frame the view.

All these buildings are arranged according to the principles of 'facing views' (*dui jing*) and 'borrowing views' (*jie jing*) so that, as the visitor moves through the garden, the views compose and recompose themselves around him, sometimes formally and sometimes in the distance as if by chance.

Of the other two sections of the garden, the western is the most interesting: a garden in its own right, it was originally built by a family named Zhang at the end of the Qing dynasty and named Bu Yuan. It, too, is a water-garden, forming a happy imitation of the Zhuo Zheng garden's theme. Its most notable feature is the Thirty-Six Mandarin Duck Hall, a large square building with blue glass panes. Beyond it, the pool winds round and elongates into a rocky channel giving the illusion of a stream disappearing out of sight behind a distant summer-house, though in fact it stops at the garden wall.

By comparison, the eastern section is much less densely arranged, with only three or four pavilions and one large hall spread out along paths that meander among irregularly planted trees, low hills, and waterways.

Now classified as a Key National Place of Historical and Cultural Importance, only the middle section of Zhuo Zheng Yuan corresponds to the original site. C.-Z.C./M.K.

Ziggurat garden. There is no positive evidence for their existence. The excavator of Ur in southern *Mesopotamia deduced the presence of trees on the ziggurat of the late 3rd millennium, but there is no confirmation for this from texts or representations. S.M.D.

Zocher, Jan David the younger (1791–1870), was the most eminent Dutch landscape architect of the 19th c. who created in the Netherlands romantic landscape parks on Brownian-Reptonian principles. Combining his talents as landscape painter and architect, for which he was trained at the Beaux Arts in Paris and in Rome as winner of the Prix de Rome, Zocher's plans reflect a mastery of integrating natural scenery with structure. Skilfully adapted to the site and its surroundings, his designs are characterized by simplicity of line, harmony of form and colour, and an Arcadian orchestration of water, lawn, and trees. Among his better known works are Haarlemmerhout (1827), *Twickel (c. 1830), and *Rosendael (1836). He became an honorary member of the Royal Institute of British Architects in 1838. F.H.

Zoological garden. From the garden inhabited by wild birds it is but a short step to the idea of the aviary, and thence to the concept of the menagerie and the wildlife park. The Assyrian kings made hunting parks which they planted with trees from Chaldea and other places. They are described by the Persian word *pairidaēza* which the Greeks translated as *paradeisos*. They were created, according to Sennacherib (705–681 BC), as much for the benefit of the people as for the rulers' pleasure. The Egyptian Queen Hatshepsut from 1495 BC sent an expedition to Somalia which brought back monkeys, leopards, a giraffe, and many birds. Rameses II (1279–1213 BC) had lions, giraffes, and ostriches. But it was the Chinese Emperor Wen Wang (c. 1000 BC) whose collection comes nearest to suggesting the concept of the modern zoo, for it was called the Garden of Intelligence. Of its aesthetic qualities we cannot judge, but it was sufficiently sophisticated for the Empress Tanchi to build a large deer-house entirely in marble.

The menagerie has persisted in many forms as a spectacle of curiosity, from an exhibition hall for performing dogs, dancing bears, and bull-fighting, to the circus and the zoo. A menagerie was created at *Schönbrunn in 1752, and at the *Jardin des Plantes in 1794. But it was not until the public parks movement of the 19th c. that it became firmly associated with public gardens. When the Zoological

Zhuo Zheng Yuan, Suzhou, China, plan

Society of London was formed in 1826 'for the advancement of zoology and animal physiology', the few remaining animals from a collection established by Henry III were transferred from the Tower of London to John Nash's Regent's Park. The Zoological Gardens (as they were called) provided opportunities for serious zoological study as well as for breeding and public enjoyment, which depended both upon the spectacle of the animals and the gardens.

Bristol Zoo, established in 1836, had broader aims: 'to promote the study of zoology, arboriculture and horticulture' and 'to carry on, encourage and support research'. At Bristol little has changed, and the gardens still occupy a large part of the site. But London Zoo, like most metropolitan zoos, has been compelled to move with the times. It includes virtually every type of exhibition building that has evolved during the last 150 years, many of excellent quality. But the environment—the 'garden' spaces in between—has inevitably suffered.

The new approach to the display of animals pioneered by Hagenbeck at Hamburg in 1907, and followed at Paris in 1934, could only be adopted for new zoos where space was available. This was the principle of the 'barless' zoo, in which predator, prey, and other related animals could all be seen together in vistas across consecutive enclosures which were separated by moats and concealed fences, and framed by artificial 'mountains' and clumps of trees. The illusion was similar to that sought by the exponents of the English landscape movement of the 18th c., but infinitely more dramatic. Hagenbeck's ideas prompted the directors of London Zoo to establish a country parkland zoo at Whipsnade in 1931; and more recently the developers at Milwaukee, Toronto, and elsewhere from the late 1950s, to create zoos of a kind and scale never previously conceived.

In these most progressive zoos the garden has become more integrated—more a part of nature—simulating the natural habitat of the animals being exhibited; at the same time reflecting the trend towards the conservation of all forms of wildlife. The park zoo pioneered at Whipsnade, in which bison and wallabies could be seen freely grazing the chalk downs, has now been supplanted by more ambitious concepts of wildlife parks in which visitors can drive their own cars through areas inhabited by lions or giraffes; or be driven—among more dangerous animals—in armoured buses, as at Tokyo Zoo. Thus the roles of visitors and animals have been reversed; the larger the space the better it is for the animals, but the more difficult they are to see.

At the other extreme are the totally artificial environments of the zoos being developed in the countries of the Middle East. In these largely enclosed structures, lions and polar bears equally can survive; and the 'gardens'—areas of planting—need equally to be controlled to simulate the appropriate habitat. M.L.L.

See also TIERGARTEN.

Zorgvliet, Zuid-Holland, The Netherlands. In 1674 Hans Willem Bentinck (1649–1709), a favourite courtier of William III, created Earl of Portland in 1689, bought this property outside The Hague which formerly belonged to Jacob Cats, popular Dutch poet and statesman. Bentinck retained two dominant Mannerist features of Cats's garden—a Mount Parnassus and a circular maze with a mount, both of which were surrounded by terraced walks—and upon the advice of *Johan Maurits extended the gardens to include a meandering stream and dunes whose natural beauties were considered an essential part of the geometric plan.

An unusual architectural feature was a monumental semicircular orangery (c.1675) which terminated the main axis leading from the modest Cats villa. It was probably inspired by *van Campen's Palladian gallery designed for Johan Maurits at *Cleves and it later served as a model for the orangery at Gaibach, Germany, as well as for one of *Marot's engravings. Extravagant Italianate grottoes and cascades, *treillage arbours and portals, square 'cradle-walks', aviaries, and elongated parterres de broderie adorned the gardens whose general layout had little cohesive integration. In 1689 Bentinck was appointed superintendent of William and Mary's gardens in the Netherlands and in England.

Today Zorgvliet is the official residence of the Prime Minister. F.H.

Zug, Szymon Bogumił (1733–1807), was the most influential and energetic propagandist of the English picturesque garden among the Polish neo-classical architects of the 1770s and 80s. Born in Merseburg in Saxony, he worked there and visited Italy before coming to Poland in 1756. His first important garden, at Solec on the outskirts of Warsaw, was begun in 1772, for one of the relatives of King Stanisław August Poniatowski; others employed him at Książęce (1776) and Góra (1779). His best suburban garden was probably (for all of them have disappeared) either Powązki, laid out in the mid-1770s for Izabela Czartoryska (see *Puławy) or Mokotów ('Mon Coteau') of 1774. The former was based on a series of views radiating from a group of cottages; the latter was a long rectangle divided by a wood which hid from the house the lake with its islands and bridges and (in Zug's words) 'un aspect vraiement champêtre'. In 1778 he began the still well-preserved garden at *Arkadia. In the mid-1780s he contributed an account of the beginnings of Polish picturesque gardening to the French edition (1779–85, Vol. V) of Hirschfeld's *Théorie de l'art des jardins*.

Zug's town architecture is notable for its classical clarity—notably the cylindrical Lutheran Church of 1777 in Warsaw. In his garden buildings, however, he popularized the new eclecticism; he built villas with asymmetrical turrets and imitations of rustic water-mills, and experimented not only with 'Gothic' structures but also with the inflation of an architectural detail (such as a capital) into part of a building. The passage of time has made his garden plans hard to evaluate, but Arkadia at least has preserved an evocative melancholy. It is odd that a designer who emphasized so much the importance of true English models should apparently have relied entirely on his patrons' descriptions of them. D.B.K.

BIBLIOGRAPHY

INTRODUCTION

The bibliography does not claim to be a definitive list of all the books and articles on the subject of garden design and garden history. In place of a lengthy unstructured list, it aims to provide a guide to further reading.

As a rule, and particularly in those cases such as 18th-c. England and 17th-c. France where the literature is especially extensive, we have selected those works which we consider the most informative and original. We have departed from this rule in areas where the literature, though not necessarily of a very high standard, nevertheless represents the only source. This applies particularly to the 20th c.: although books about gardens and gardening have recently become a major publishing activity, very little of this literature is about modern garden design. Whereas historic gardens have been the subject of detailed analysis by historians, designers, and horticulturalists, the 20th c. is perhaps too close to us in historical perspective to have had the benefit of such attention in all but a few cases. Thus, with the exception of Jekyll and Lutyens, Burle Marx, Church, and Barragán, very few modern garden designers have been the subject of books or exhibitions, and it has seemed reasonable to be less selective in this area. Beyond the small number of references we have been able to cite, the reader may find it useful to refer to journals such as *Anthos, Garten und Landschaft, Haverkunst, Landscape Architecture,* and *Landscape Design.*

To avoid duplicating material which can easily be found elsewhere, we have wherever possible referred to other more specialist publications which contain detailed bibliographies on particular subjects—marked by an asterisk (*). This method of providing a selective and informative bibliography applies particularly to England, which has a very extensive literature. We have not normally given references to works dealing with individual gardens. Where such references are given, they are to sources which either contain valuable information not to be found in the histories of the countries concerned, or they are the only source of information on the subject. The reader is therefore referred to standard works which contain bibliographies for individual gardens.

Books or articles which deal principally with other aspects of a designer's or an artist's work, but contain very little that is relevant to his work in garden or landscape design, have not been included—readers who require this kind of information should consult the standard reference works on those subjects, such as *The Oxford Companion to Art* and *The Oxford Companion to the Decorative Arts.*

References in the text to travellers' accounts are not usually duplicated in the bibliography. Nor, in general, are works written by the subject of an entry, since these too are normally mentioned in the text; instead, the bibliography concentrates on works *about* rather than *by* the individuals in question.

NOTES

(i) an asterisk (*) indicates that the work contains an extensive bibliography, or other useful reference material;

(ii) the place of publication is London (for works in English) or Paris (for works in French), except where indicated;

(iii) the date is normally that of the most recent edition.

ABBREVIATIONS

GH = Garden History, Journal of the Garden History Society

LD = Landscape Design (journal of the Institute of Landscape Architects, formerly *ILA Journal*)

BIBLIOGRAPHY

1. The 'Current Bibliography of Garden History' first appeared in the *Journal of Garden History*, Vol. 3 no. 4 (1983), pp. 347–81.

2. Desmond, Ray. *Bibliography of British Gardens.* Winchester, 1984.

3. Henrey, B. *British Botanical and Horticultural Literature before 1800.* 3 vols., Oxford, 1975.
See also CANADA.

GENERAL

Allen M. & Jellicoe, S. *The New Small Garden.* 1956.

Beardsley, J. *Earthworks and Beyond.* New York, 1984.

Clifford, Derek. *A History of Garden Design.* 1962.

Crowe, Sylvia. *Garden Design.* 1981.

Eckbo, Garrett. *Art of Home Landscaping.* New York, 1956.

Emanuel, M. (ed.). *Contemporary Architects.* 1980.

Fairbrother, Nan. *Men and Gardens.* 1956.

Gothein, M.-L. *A History of Garden Art.* (Translated from the German by Laura Archer Hind) 2 vols. New York, 1928.

Hellyer, A. *Shell Guide to Gardens.* 1977.

Jellicoe, G. A. & S. *The Landscape of Man.* 1975, 2nd. edn. forthcoming 1986.

Jellicoe, S. & Allen, M. *Town Gardens to Live In.* 1977.

Kassler, E. *Modern Gardens and the Landscape.* New York, 1964.

Majdecki, Longin. 'A History of Gardens' (book in Polish). Warsaw, 1981.

Oldham, J. & R. *Gardens in Time.* Sydney, 1980.

Shepheard, P. *Gardens.* 1969.

Shepheard, P. *Modern Gardens.* 1963.

Sørensen, C. Th. *Europas havekunst fra Alhambra til Liselund.* Copenhagen, 1959.

Thacker, C. *The History of Gardens.* 1979.

Tunnard, C. *Gardens in the Modern Landscape.* 1948.

Wright, Richardson. *The Story of Gardening.* New York, 1934.

ARKADIA

Wegner, Jan. *Arkadia* (in Polish). Warsaw, 1948.

AUSTRALIA

Tanner, Howard & Begg, Jane. *The Great Gardens of Australia.* Melbourne, 1983.

AUSTRIA, BAROQUE GARDENS

Jellicoe, G. A. *Baroque Gardens of Austria.* 1932.

Neubauer, Erika. *Lustgärten des Barock.* Salzburg, 1966.

Neubauer, Erika. *Wiener Barockgärten in zeitgenössischen Veduten.* Dortmund, 1980.

BARRAGÁN, LUIS

Ambasz, E. *The Architecture of Luis Barragán.* New York, 1976.

BAUMANN, ERNST

Baumann, Ernst. *Neue Gärten/New Gardens* (bilingual edition). Zurich, 1965.

BEE BOLE

Crane, Eva. *Archaeology of Beekeeping.* 1983.

BELGIUM

Balis, J. *Hortus Belgicus.* Brussels, 1962.

Pechère, R. *Parcs et jardins de Belgique.* Brussels, 1976.

BELOEIL

de Ligne, Prince. *Coup d'œil sur Beloeil* . . . 1786; with an introduction by the Comte E. de Ganay, 1922.

BELVEDERE COURTYARD

Ackerman, J. S. *The Cortile del Belvedere.* Rome, 1954.

BLENHEIM

Green, David. *Blenheim Palace.* 1952.

BOMARZO

*Weil, Mark S. & Darnall, Margaretta J. 'Il Sacro Bosco di Bomarzo: Its 16th-c. Literary and Antiquarian Context', *Journal of Garden History*, Vol. 4 no. 1 (1984), pp. 1–90.

BOTANICAL ILLUSTRATION

Blunt, Wilfrid. *The Art of Botanical Illustration.* 1950.

Henrey, B. *British Botanical and Horticultural Literature before 1800.* 3 vols., Oxford, 1975.

BOTANIC GARDEN

Hyams, E. & Macquitty, W. *Great Botanical Gardens of the World.* 1969.

BOYCEAU, JACQUES

Hazlehurst, F. H. *Jacques Boyceau and the French Formal Garden.* Athens, Georgia, 1966.

BRIDGEMAN

Willis, Peter. *Charles Bridgeman and the English Landscape Garden.* 1978.

BRITAIN

There is a very extensive literature on particular gardens and gardeners, for which the reader is referred to the following sources:
1. *Country Life* index.
2. Desmond, Ray. *Bibliography of British Gardens.* Winchester, 1984.
3. Hadfield, M., Harling, R., & Highton, L. (eds.). *British Gardeners: a Biographical Dictionary.* 1980.
4. Harris, John. *A Country House Index.* Isle of Wight, 1971.

Amherst, A. *History of Gardening in England.* 1896.

*Desmond, Ray. *Bibliography of British Gardens.* Winchester, 1984.

Elliott, Brent. *Victorian Gardens.* Forthcoming 1986.

Hellyer, A. *Shell Guide to Gardens.* 1977.

Hussey, Christopher. *English Gardens and Landscapes, 1700–1750.* 1967.

Jacques, David. *Georgian Gardens.* 1983. (Contains extensive information on lesser-known designers and gardens.)

Malins, E. *English Landscape and Literature, 1660–1840.* 1967.

Strong, Roy. *The Renaissance Garden in England.* 1979.

Stuart, David. *Georgian Gardens.* 1979.

Turner, Tom. *English Garden Design: History and Styles since 1650.* 1986

Willis, Peter & Hunt, John Dixon. *The Genius of the Place: The English Landscape Garden, 1620–1820.* 1975.

BROWN, LANCELOT
Stroud, Dorothy. *Capability Brown*. 1975.

BULGARIA
Sougarev, D. T. 'Parks, Gardens and Landscape Architecture' (book in Bulgarian). Sofia, 1976

BURLE MARX
Bardi, P. M. *The Tropical Gardens of Burle Marx*. 1964.

BYZANTIUM
Littlewood, A. R. 'Romantic Paradises: the Role of the Garden in the Byzantine Romance'. *Byzantine and Modern Greek Studies*, Vol. 5 (1979), pp. 95–114.
Schissel. O. 'Der byzantinische Garten' Akademie der Wissenschaften in Wien. Phil.-hist. Klasse, *Sitzungsberichte*, 1942, (221.2). Vienna.

CANADA
Baeyer, E. von. *A Preliminary Bibliography for Garden History in Canada*. 1983.

CASERTA
Venditti, Arnaldo. 'L'opera napoletana di Luigi Vanvitelli: la reggia di Caserta', in di Stefano, R. (ed.), *Luigi Vanvitelli*. Naples, 1973, pp. 101–29.

CEMETERY
*Auxelles, Robert. *Dernières Demeures*. 1965.
Curl, James Stevens. *The Victorian Celebration of Death*. 1980.

CHANTILLY
de Broglie, Raoul. *Chantilly* (in French). 1964.

CHINA
Keswick, Maggie. *The Chinese Garden, Art, History and Architecture*. 1978.
Siren, Osvald. *Gardens of China*. New York, 1949.

CHINOISERIE
Siren, Osvald. *China and the Gardens of Europe of the Eighteenth Century*. 1950.

CHURCH, THOMAS
Church, Thomas. *Gardens are for People*. First edn. 1955, second edn. with an introduction by Michael Laurie, New York, 1983.

COLOUR
Lancaster, Michael. *Britain in View: Colour and the Landscape*. 1984.

CONSERVATORY
Koppelkamm, S. *Glasshouses and Wintergardens of the Nineteenth Century*. 1982.

COTTAGE GARDEN
Scott-James, Anne. *Cottage Gardens*. 1981.

CZECHOSLOVAKIA
Dokoupil, Z. & authors' collective. 'Historic Gardens in Bohemia and Moravia' (book in Czech). Prague, 1957.

Wirth, Zd. 'The Gardens of Prague' (book in Czech). Prague, 1943.

DENMARK
Boye, G. *Anlaegsgartneri*. Copenhagen, 1959.
Boye, G. *Havekunsten i kulturhistorisk belysning*. 2 vols. Copenhagen, 1972.
Bruun, Andreas. *Danske Haver i Dag*. Copenhagen, 1971.
Elling, Christian. *Den Romantiske Have*. Copenhagen, 1979.
Lund, Hakon. *De kongelige lysthaver*. Copenhagen, 1977.
Sørensen, C. Th. *Europas havekunst fra Alhambra til Liselund*. Copenhagen, 1959.

D'ESTE, VILLA
Coffin, David R. *The Villa d'Este at Tivoli*. Princeton, 1960.

EGYPT
Hennebo, D. 'Betrachtungen zur altägyptischen Gartenkunst', *Archiv für Gartenbau*, 3, Heft 3 (1955), pp. 175–218.

FARRAND, BEATRIX
McGuire, D. (ed.). *Beatrix Farrand's Plant Book for Dumbarton Oaks*. Washington, 1980.
McGuire, D. K. & Fern L. (eds.) *Beatrix Jones Farrand: Fifty Years of American Landscape Architecture*. Dumbarton Oaks, Washington DC, 1982.

FINLAY, IAN HAMILTON
Bann, Stephen. *The Poet's Garden: Notes on a British Tradition*. 1981.
Bann, Stephen. 'A Description of Stonypath', *Journal of Garden History*, vol. 1 no. 2 (1981), pp. 113–44.

FISHBOURNE
Cunliffe, Barry. *Fishbourne: a Roman Palace and its Garden*. 1971.

FOLLY
Jones, Barbara. *Follies and Grottoes*. Rev. edn. 1974.

FOUNTAIN
Falda, G. B. *Le Fontane di Roma . . .* Rome, 1675–91.
MacDougall, Elisabeth (ed.) *'Fons Sapientiae': Renaissance Garden Fountains*. Washington, 1978.
MacDougall, E. and Miller, N. *Garden Fountains in Illustrated Books*. New York, 1977.
Miller, N. *French Renaissance Fountains*. New York, 1977.

FRANCE
Hazlehurst, F. Hamilton. *Gardens of Illusion*. 1980.
Les Jardins 1760–1820. Pays d'illusion, terre d'experiences. (Catalogue of exhibition at the Hotel de Sully, Paris, 1977.)
*Wiebenson, Dora. *The Picturesque Garden in France*. 1978.
*Woodbridge, Kenneth. *Princely Gardens: the Origins and Development of the French Formal Style*. 1986.

GARDEN CITY
Creese, Walter. *The Search for the Environment: the Garden City Before and After*. Yale, 1966.

GARDEN ELEMENTS

Hunt, Peter. *The Shell Garden Book*. 1964.

Jekyll, G. & Hussey, C. *Garden Ornament*. 1927.

GARDEN TOOL

Sanecki, Kay N. *Old Garden Tools*. 1979.

GARTENSCHAU (GARDEN SHOW)

Allinger, G. *Das Hohelied von Gartenkunst und Gartenbau*. Hamburg, 1963.

Bareham, Peter. 'A Guide to the Federal German Garden Exhibitions', *LD*, Feb. 1983.

GERMANY

Hammerbacher, H. *Die Hausgärten in Berlin und seine Bauten*. Berlin. 1975.

Hennebo, Dieter & Hoffmann, A. *Geschichte der deutschen Gartenkunst*. 3 vols. Hamburg, 1962–3.

Koch, H. *Sächsische Gartenkunst*. Berlin, 1910.

König, D. *Parks und Gärten in Schleswig-Holstein*, Heide, 1967.

Rave, P. O. *Gärten der Goethezeit*. Leipzig, 1941.

Rave, P. O. *Gärten der Barockzeit*. Stuttgart, 1951.

GRANADA

Prieto Moreno, Francisco. *Los jardines de Granada*. Madrid, 1973.

GROTTO

Miller, N. *Heavenly Caves*. New York, 1982.

GUILFOYLE, W. R.

Pescott, R. T. M. *W. R. Guilfoyle 1840–1912—The Master of Landscaping*. Melbourne, 1974.

HERBAL

Anderson, F. J. *An Illustrated History of Herbals*. New York, 1977.

Blunt, Wilfrid & Raphael, Sandra. *The Illustrated Herbal*. 1981.

HUNGARY

Rapaich, Raimund. 'Gardens in Hungary' (book in Hungarian). Budapest, 1940.

Zádor, Anna. 'The English Garden in Hungary', in Pevsner, N. (ed.), *The Picturesque Garden and its influence outside the British Isles*. Washington, 1974, pp. 77–99.

INDIAN SUB-CONTINENT. See MOGUL EMPIRE

IRAN

Wilber, Donald N. *Persian Gardens and Garden Pavilions*. Vermont, 1962.

See also ISLAM.

IRELAND

Bowe, Patrick. 'Some Irish Landscape Gardeners', in *National Trust Studies*, 1981.

Brady, Aidan & Nelson, E. C. (eds.). *Irish Gardening and Horticulture*. Dublin, 1980.

Malins, E. & Bowe, Patrick. *Irish Gardens and Demesnes from 1830*. 1980.

Malins, E. & the Knight of Glin. *Lost Demesnes*. 1976.

ISLAM

Lehrman, Jonas. *Earthly Paradise: Garden and Courtyard in Islam*. Berkeley, 1981.

MacDougall, E. & Ettinghausen, R. (eds.). *The Islamic Garden*. Washington, 1976.

Moynihan, Elizabeth B. *Paradise as a Garden in Persia and Mughal India*. 1980.

Sordo, Enrique. *Moorish Spain*. 1963.

ITALY

Acton, Harold. *The Villas of Tuscany*. 1984.

Franck, C. L. *The Villas of Frascati*. 1966.

*Masson, Georgina. *Italian Gardens*. 1966.

*Mignosi, A. T. *Villa e Paese. Dimore nobili del Tuscolo e di Marino*. (Catalogue of an exhibition held at the Palazzo Venezia, Rome, 1980.)

Shepherd, J. C. & Jellicoe, G. A. *Italian Gardens of the Renaissance*, 1925, 4th edn. forthcoming 1986.

JAPAN

Kuck, Loraine *The World of the Japanese Garden*. 1972.

Sakuteira. *The Book of Gardens*. (Translated from the Japanese by Shimoyama.) Japan, 1976.

JARDIN ANGLAIS

*Wiebenson, Dora. *The Picturesque Garden in France*. 1978.

JEKYLL, GERTRUDE

Brown, Jane. *Gardens of a Golden Afternoon*. 1982.

KENT, WILLIAM

Woodbridge, Kenneth. 'William Kent as Landscape-Gardener', *Apollo* (Aug. 1974), pp. 126–137.

KITCHEN GARDEN

Leach, H. M. 'On the Origins of Kitchen Gardening in the Ancient Near East' *GH*, Vol. 10 no. 1 (1982), pp. 1–16.

Malinowski, B. *Coral Gardens and Their Magic*. Vol. 1: *The Description of Gardening*. 1935.

KNOT

Woodbridge, Kenneth. 'Rise and decline of the garden knot', *Architectural Review* (June 1979), pp. 324–9.

LANDSCAPE ARCHITECTURE

Aldous, Tony & Clouston, B. *Landscape by Design*. 1979.

Jellicoe, Geoffrey & Susan. *The Landscape of Man*. 1975, 2nd edn. forthcoming 1986.

Laurie, Michael. *An Introduction to Landscape Architecture*. 1975.

Newton, Norman T. *Design on the Land*. Cambridge, Mass., 1971.

Rettig, S. & Harvey, S. (eds.) *Fifty Years of Landscape Design 1934–84*. 1986.

Simonds, J. O. *Landscape Architecture*. 1961.

LANDSCAPE INSTITUTE

Fricker, L. J. 'Forty Years A-Growing', *LD*, May 1969.

LE NÔTRE

de Ganay, E. *André Le Nostre. 1613–1700.* 1962.

Hazlehurst, Franklin H. *Gardens of Illusion. The Genius of André Le Nostre.* Nashville, 1980.

LINNAEUS

Blunt, W. & Stearn, W. T. *The Complete Naturalist: a Life of Linnaeus.* 1971.

LOUDON

MacDougall, E. (ed.) *John Claudius Loudon and the early Nineteenth Century in Great Britain.* Washington, 1980.

LUTYENS *see* JEKYLL

MAJORCA

Byne, A. & Stapley, M. *Majorcan Houses and Gardens.* 1928.

MARLY

Weber, Gerold. 'Der Garten von Marly', in *Wiener Jahrbuch für Kunstgeschichte* 1975 (XXVIII Sonderdruck), pp, 55–105. Vienna.

MEDICI FAMILY

Mignani, Daniela. *Le Ville Medicee di Giusto Utens.* Florence, 1980.

MEDIEVAL GARDEN

Harvey, John H. *Mediaeval Gardens.* 1981.

Maclean, Teresa. *Mediaeval English Gardens.* 1981.

Stokstad, M. & Stannard, J. *Gardens of the Middle Ages.* Kansas, 1983.

MESOPOTAMIA

Andrae, W. 'Der Kultische Garten', *Welt des Orients*, Vol. 1 (1952), pp. 485–94. Vienna.

Duval, Jean. *Les Jardins suspendus de Babylone.* Geneva, 1980.

Nagel, W. 'Wo lagen die "Hängenden Garten" in Babylon?', in *Mitteilungen der Deutsch-Orient Gesellschaft*, 110. 1978. Vienna.

Oppenheim, A. L. 'On Royal Gardens in Mesopotamia', *Journal of Near Eastern Studies*, Vol. 24 (1965), pp. 328–33.

MOGUL EMPIRE

Crowe, Sylvia, Haywood, Sheila, Jellicoe, Susan, & Patterson, Gordon. *The Gardens of Mughal India.* 1972.

Moynihan, Elizabeth B. *Paradise as a Garden in Persia and Mughal India.* 1980.

MOSAÏCULTURE

Elliott, B. 'Mosaïculture: its Origins and Significance', *GH*, Vol. 9 no. 1 (1981), pp. 76–98.

NESFIELD, W. A.

Elliott, Brent. 'Master of the Geometric Art', *The Garden* (Dec. 1981), pp. 488–91.

NETHERLANDS

Bienfait, Anna G. *Oude Hollandische Tuinen.* The Hague, 1943.

Bijhouwer, J. T. P. *Leven met Groen in Landschap, Stad en Tuin.* The Hague, 1960.

Heemschut serie. *Nederlandsche tuinen en Buitenplaatsen.* The Hague, 1942.

Hopper, Florence. 'The Dutch Régence Garden', *GH*, Vol. 9 no. 2 (1981), pp. 118–35.

Hopper, Florence. 'The Dutch Classical Garden and André Mollet', *Journal of Garden History*, Vol. 2 no. 1 (1982), pp. 525–40.

Kuiper, W. *Dutch Classicist Architecture: a Survey of Dutch Architecture, Gardens and Anglo-Dutch Relations from 1625 to 1700.* Delft, 1980.

Springer, Leonard A. 'Old Dutch Gardens and Their History', *Eigen Haard*, 1889. (A series of articles in Dutch.)

NEW ZEALAND

Matthews, Barbara. *Gardens of New Zealand.* Wellington, 1984.

NORWAY

Schnitler, Carl W. *Norske Haver i Gammel Tid.* 2 vols. Oslo, 1915.

Schnitler, Carl W. *Norske Haver i det XVIII og XIX aarhundrede.* Oslo, 1916.

NURSERYMEN

Harvey, John H. *Early Nurserymen.* 1974.

NYMPHAEUM

Neuerburg, N. *L'Architettura delle fontane e dei ninfei dell'Italia antica.* Naples, 1965.

OXFORD COLLEGE GARDENS

Batey, Mavis. *Oxford Gardens.* 1982.

PARIS

Robinson, William. *The Parks, Gardens and Promenades of Paris.* 1869.

PAXTON

Chadwick, G. F. *The Works of Sir Joseph Paxton.* 1961.

PICTURESQUE

Hussey, Christopher. *The Picturesque.* 1927.

PLANT COLLECTING

Coats, Alice M. *The Quest for Plants. A History of the Horticultural Explorers.* 1968.

PLEASURE-GARDEN

Wroth, Warwick. *The London Pleasure Gardens of the Eighteenth Century.* 1896.

PLINY THE YOUNGER

Tanzer, Helen H. *The Villas of Pliny the Younger.* New York, 1924.

POLAND

Ciolek, G. 'Gardens in Poland' (book in Polish). Warsaw, 1952.

POMPEII

Jashemski, W. F. *The Gardens of Pompeii, Herculaneum and the Villas Destroyed by Vesuvius.* New York, 1979.

PORTUGAL

Levinge, Barbara. 'Casas, Quintas and Palaces. Country House Gardens of Portugal', *Country Life* (Nov. 1978), pp. 1388–9.

PUBLIC PARKS

Chadwick, G. F. *The Park and the Town.* 1966.

Zaitevsky, Cynthia. *Frederick Law Olmsted and the Boston Park System.* Harvard, 1982.

PÜCKLER-MUSKAU

Zahn, Fritz. *Fürst Pückler-Muskau als Gartenkunstler und Mensch.* Cottbus, 1928.

REPTON, HUMPHRY

*Carter, George, Goode, Patrick, & Laurie, Kedrun. *Humphry Repton. Landscape Gardener 1752–1818.* (Catalogue of the exhibition at the Sainsbury Centre/Victoria & Albert Museum, London, 1983.)

Loudon, J. C. (ed.). *The Landscape Gardening . . . of Humphry Repton.* 1840. (Contains Repton's major writings on landscape gardening.)

ROME

Grimal, P. *Les jardins romains.* 2nd edn. 1969.

MacDougall, Elisabeth B. & Jashemski, W. (eds.). *Ancient Roman Gardens.* Washington, 1981.

ROOF-GARDEN

Gollwitzer, G. *Dachflächen.* Munich, 1971.

Gollwitzer, G. & Wirsing, W. *Dachgärten und Dachterrassen.* Munich, 1962.

Whalley, J. 'The Landscape of the Roof', *LD*, May, 1978.

ROSE, JAMES

Rose, James C. *Creative Gardens.* New York, 1958.

Snow, Marc. *Modern American Gardens designed by James Rose.* New York, 1967.

ROUSHAM

Woodbridge, Kenneth. 'Kent: the Rousham letters', *Apollo* (Sept. 1974), pp. 282–91.

RUIN

Hartmann, Günther. *Die Ruinen im Landschaftsgarten.*

RUSSIA

Dubyago, T. B. 'Russian Formal Gardens and Parks' (book in Russian). Leningrad, 1963.

Iljin, M. 'Russian Parks of the Eighteenth Century', *Architectural Review* (Feb. 1964), pp. 100–11.

Kennett, Victor & Audrey. *The Palaces of Leningrad.* 1973.

SCOTLAND

Cox, E. H. M. *A History of Gardening in Scotland.* 1935.

Tait, A. A. *The Landscape Garden in Scotland 1735–1835.* Edinburgh, 1980.

SCULPTURE GARDEN

Strachan, W. J. *Open Air Sculpture in Britain.* 1984.

Tucker, William. *The Language of Sculpture,* 1974.

SOUTH AFRICA

Fairbridge, Dorothea. *Gardens of South Africa.* 1924.

SPAIN

de Casa Valdés, Marquesa. *Jardines de España.* Madrid, 1973.

Harvey, John H. 'Spanish Gardens in their historical background', *GH*, Vol. 3 no. 2 (1975), pp. 10–21.

Sordo, Enriquo. *Moorish Spain.* 1963.

STOURHEAD

Woodbridge, Kenneth. *Landscape and Antiquity: Aspects of English Culture at Stourhead 1718 to 1838.* Oxford, 1970.

SWEDEN

Karling, Steen. *Trädgårdskonstens historia i Sverige intill Le Notrestilens genombrott.* Stockholm, 1931.

Martinsson, Gunnar. *En bok om Trädgårdar.* Stockholm, 1957.

Schnitler, Carl W. *Trädgårdskonstens Historie i Europa.* Stockholm, 1917.

SWITZERLAND

Hauser, Albert. *Bauerngärten der Schweiz.* Munich, 1976.

Heyer, Hans-Rudolf. *Historische Gärten der Schweiz.* Bern, 1980.

See also BAUMANN.

TESSIN

Josephson, Ragnar. *N. Tessin* (in Swedish). Stockholm, 1930.

TIERGARTEN, BERLIN

Bartels, Elizabeth Heekin. 'Berlin's Tiergarten: Evolution of an Urban Park', *Journal of Garden History*, Vol. 2 (1982) pp. 143–74.

UNITED STATES OF AMERICA

Brattleboro Museum and Art Center. *Built Landscapes: Gardens in the Northeast.* Brattleboro, Vermont, 1984.

Leighton, Ann. *American Gardens in the Eighteenth Century: For Use or For Delight.* Boston, 1976.

Leighton, Ann. *Early English Gardens in New England: 'For Meate or Medicine'.* 1970.

Newton, Norman T. *Design on the Land.* Cambridge, Mass., 1971.

Ray, Mary Helen & Nicholls, Robert P. *A Guide to Significant and Historic Gardens of the United States.* Athens, Georgia, 1982.

Stone, Doris M. *The Great Public Gardens of the Eastern United States.* Athens, Georgia, 1982.

VENICE

Damerini, Gino. *Giardini di Venezia.* Bologna, 1931.

VERSAILLES

de Nolhac, P. *La Création de Versailles.* 1925.

de Nolhac, P. *Versailles au 18ème Siecle.* 1926.

de Nolhac, P. *Versailles Résidence de Louis XIV.* 1925.

Marie, A. *Naissance de Versailles: le château—les jardins.* 2 vols. 1968.

VIENNE

Le Glay, Marcel. 'Les jardins à Vienne', in MacDougall, Elisabeth B. & Jashemski, W., *Ancient Roman Gardens*, Washington, 1981, pp. 49–65.

WATER IN THE LANDSCAPE

Jellicoe, G. A. & S. *Water: the Use of Water in Landscape Architecture*. 1971.

WISE, HENRY

Green, David. *Gardener to Queen Anne. Henry Wise and the Formal Garden*. Oxford, 1956.

ZOOLOGICAL GARDEN

Hancocks, D. *Animals and Architecture*. 1971.

ACKNOWLEDGEMENTS

THE editors and publishers wish to thank the following who have kindly given permission to reproduce illustrations on the pages indicated:

Academy Editions, London (from Maggie Keswick, *The Chinese Garden*): 113; Marina Adams: 234; Aerofilms: 146; Akademie der Künst, Berlin, Architectural Collections: 191; Alinari: 6, 286; Architectural Press: 101 (Dell and Wainwright), 397 *top* (Julius Shulman); Arup Associates Architects, Engineers, and Quantity Surveyors: 480 (photo by Richard Einzig); Ashmolean Museum, Oxford: 166; Atget/ © Arch. Phot., Paris, SPADEM: 25; Bahá'í World Centre: 282 *top*; Barnabys Picture Library: 17; Walter Bauer: 543; C. Baumann & Co.: 41; Bayerische Verwaltung der Staatlichen Schlosser, Garten und Seen, Munich: 406; Ben Gurion University: 282 *bottom*; Bibliothèque Nationale, Paris: 11, 16, 106, 194, 337, 349 *bottom*, 409, 471, 489, 495, 563, 581, 585, 586, 598; Bibliothèque Royale, Brussels: 162; Barbara Bini and Accademia Americana, Rome: 287; Bodleian Library: 454, 517 (from Gough Maps 26 f71); W. C. J. Boer and P. A. M. Buys: 61, 394; Donna Bona Borromeo: 281; Brattleboro Museum and Art Center, Vermont (Alan Ward Photos): 185, 389, 483, and back end papers; The British Architectural Library, RIBA, London: 126, 178, 208, 575; British Library: 73, 168, 214 (photo by Peter Parkinson, supplied by Newcastle University Library), 221, 252, 356, 361, 377, 392, 402, 413, 432 *top* and *bottom*, 442, 450 *top*, 536, 558, 559; Trustees of the British Museum: 18, 612; John Brookes: 424; Jane Brown: 348; Andreas Bruun (photos by Morten Bo Dk): 78 *top* and *bottom*; Professor Magne Bruun, Agricultural University of Norway: 485; Richard Bryant: 534; Bulloz: 85; Dr Roberto Burle Marx: 84; G. Carter: 606; Cavalieri Hilton International: 289; Sir John Clerk of Penicuik, Bt.: 427; C. Cottrell-Dormer Collection: 486; Geoffrey Collens: 328; Country Life: 14, 43, 55, 173, 192, 271, 301; Country Life Books: 99, 149, 311, 537; Dissing & Weitling/Strüwing reklamefoto: 291 *top*; Dumbarton Oaks, Trustees for Harvard University: 140 and front end papers; Mrs Dundas-Bekker: 2; Garrett Eckbo (photo by Frank J. Thomas): 152; Dr Brent Elliott: 462; English Heritage (photo by Manchester City Art Galleries): 75; English Life Publications: 109; T. Charles Erickson and Yale University: 401; Gabinetto Fotografico, Sopr. Gallerie, Florence: 61; Gemeentemuseum, Arnhem: 522; Lady Gibberd, and Henk Snoek Photography: 227; Patrick Goode: 57, 95, 147 *bottom*, 299; Lawrence Halprin (photo by Roy Flamm): 241; Hanover Technical University Library, Haupt Collection: 262, 307, 616; Peter Hayden: 425, 570; Arthur Hellyer: 298; History Museum, Moscow: 318; Jakobsen Landscape Architects and Urban Designers: 292; Japan Information Centre: 308; Sir Geoffrey Jellicoe: 302; Susan Jellicoe: 117, 124, 184, 216 *bottom*, 226, 294, 509, 607, 609; KLM Aerocarto: 44; A. F. Kersting: 240; W. Kessels and M. Endler: 51 *top*; Maggie Keswick: 304, 341, 515, 619, 624; Kunsthistorisches Museum, Vienna: 502; Mark Lancaster: 132; Michael Lancaster: 39, 159, 280, 352, 423 *top*, 531; Klaus Leder: 548; Professor Jonas Lehrman: 8 *top* (from Lehrman, *Earthly Paradise*, Thames & Hudson), 8 *bottom*, 530; Leiden, University Library, Collectie Bodel Nijenhuis: 260; Erica Lennard and The British Architectural Library, RIBA, London: 206; HRH The Prince of Ligne (Splendid Colour): 51 *bottom*; Liverpool City Libraries: 458; Frances Loeb Library, Harvard University: 56; Derek Lovejoy and Partners: 418; Frances Bell Macdonald: 33, 98, 446; Magyar Nemzeti Museum, Budapest: 265; J. March-Penney/ Camera Press, London: 372; MAS and Patrimonio Nacional: 321; Georgina Masson, *Italian Gardens*, Thames & Hudson: 412; Archiv Mattern: 359; Merseyside Development Corporation: 216 *top*; The Metropolitan Museum of Art: 405 (Harris Brisbane Dick Fund, 1941, 41–72), 573 (Gift of Edgar William and Bernice Chrysler Garbisch 1963); Willi Moegle/Archiv Mattern: 312; Mount Vernon Ladies' Association: 384; Musée du Vieux-Geneve: 131; Musées Nationaux, Paris: 368, 370, 421; Museum of Modern Art, New York: 128; Willi Nahs (11/682111): 220; The Hon. David Nall-Cain: 276; Nanjing Technical College (reproduced from Liu Dunzhen, *The Classical Gardens of Suzhou*, 1979, Chinese Construction Industry Press): 595, 596, 627; National Trust: 539; Neukom and Neukom: 103 (W. Roelli, Zurich), 605 (F. Maurer); Notman Photographic Archives, McCord Museum of McGill University: 90; Lady O'Neill: 510; Oxford County Libraries: 414; Trustees of the Estate of Russell Page: 416; Painshill Park Trust: 417; Rondal Partridge: 119, 160; René Pechère: 50; Plansammlung der Universitätsbibliothek der Technischen Universität, Berlin: 40; Professor Pietro Porcinai (Studio Casali): 450 *bottom*; Milan Posselt: 79; Man Ray: 584; Rijksmuseum, Amsterdam: 80; Rijksmuseum Kröller-Müller, Otterlo, The Netherlands: 508; Rijksuniversiteit, Utrecht, RANH Prov. Atlas ZK II A 26 nr 76/ KHI Utrecht (photo G. Th. Delemarre): 147 *top*; C. G. Rosenberg and The Swedish Institute: 24; Royal Horticultural Society: 15, 94, 120, 172, 250, 345, 423 *bottom*, 564; Mien Ruys: 493 *top*; Professor and Mrs Rycroft: 13; Stephen Scrivens of Technical Landscapes: 274; Maria Shephard-Parpagliolo: 514; Peter Shepheard, *Modern Gardens*, Architectural Press, 1953: 161, 397 *bottom*, 566; Harry Smith Horticultural Photographic Collection: 100; Trustees of Sir John Soane's Museum: 243; C. Th. Sørensen: 521; D. T. Sougarev: 82; Staatliche Schlösser und Gärten Potsdam-Sanssouci: 498; Staatsarchiv Basel, Bildersammlung: 546 (Falkeysen, Fb 1, 7); Stoddart, and Tabora Arquitectos: 528; Richard Stringer and National Trust of Australia: 472; Suppop, Prague: 300; Sutton Place Heritage Trust: 542; Takeji Iwamiya, from Loraine Kuck, *The World of the Japanese Garden*, 1982; John Weatherhill: 493; Technische Universität, Berlin: 222 (Garten Kunst 1900), 223 (Gartengestaltung der Neuzeit, Leipzig 1912); Neil Thompson: 306; Trustees of the Victoria and Albert Museum: 65; Peter Walser: 188; Warsaw Technical University, Archive of Landscape Architecture: 22; Western Pennsylvania Conservancy (photo Harold Corsini): 615; John Mayson Whalley, Derek Lovejoy and Partners: 215, 481; Yorkshire Sculpture Park, Bretton Hall College (from W. J. Strachan, *Open Air Sculpture in Britain*, Zwemmer: 507; Anna Zádor: 179

Picture Research by Sandra Assersohn